The Visual Culture Reader, 3rd edition

This thoroughly revised and reshaped edition of Nicholas Mirzoeff's groundbreaking *Reader* highlights the transformed and expanded nature of globalized visual cultures. It assembles key new writings, visual essays and specially commissioned articles, emphasizing the intersections of the Web 2.0, digital cultures, globalization, visual arts and media, and the visualizations of war. The volume attests to the maturity and exciting development of this cutting-edge field.

Fully illustrated throughout, the *Reader* features an introductory section tracing the development of what editor Nicholas Mirzoeff calls "critical visuality studies." It develops into thematic sections, each prefaced by an introduction by the editor, with an emphasis on global coverage. Each thematic section includes suggestions for further reading.

Thematic sections include:

- Expansions
- War and violence
- Attention and visualizing economy
- Bodies and minds
- Histories and memories
- (Post/De/Neo)colonial visualities
- Media and mediations

Taken as a whole, these 47 essays provide a vital introduction to the diversity of contemporary visual culture studies and a key resource for research and teaching in the field.

Includes essays by: Ackbar Abbas, Morana Alac, Malek Alloula, Ariella Azoulay, Zainab Bahrani, Jonathan L. Beller, Suzanne Preston Blier, Lisa Cartwright, Dipesh Chakrabarty, Wendy Hui Kyong Chun, Beth Coleman, Teddy Cruz, René Descartes, Faisal Devji, Henry John Drewal, Okwui Enwezor, Frantz Fanon, Allen Feldman, Mark Fisher, Finbarr Barry Flood, Anne Friedberg, Alexander R. Galloway, Faye Ginsburg, Derek Gregory, Jack Halberstam, Donna Haraway, Brian Holmes, Amelia Jones, Georgina Kleege, Sarat Maharaj, Brian Massumi, Carol Mavor, Tara McPherson, Nicholas Mirzoeff, Timothy Mitchell, W. J. T. Mitchell, Naeem Mohaiemen, Fred Moten, Lisa Nakamura, Trevor Paglen, Lisa Parks,

Sumathi Ramaswamy, Jacques Rancière, Andrew Ross, Terry Smith, Marita Sturken, Paolo Virno, Eyal Weizman.

Nicholas Mirzoeff is Professor of Media, Culture and Communication at New York University. He is author and editor of several books including *Watching Babylon* (1995).

Texts have been reproduced or reprinted as supplied by the author or publisher and we have not imposed a uniformity of style or reference. While we have attempted to complete bibliographic references left incomplete in the originals, that has not always been possible.

The Visual Culture Reader,

3rd edition

Edited by

Nicholas Mirzoeff

Routledge
Taylor & Francis Group

LONDON AND NEW YORK

Third edition published 2013
by Routledge
2 Park Square, Milton Park, Abingdon, Oxon OX14 4RN

Simultaneously published in the USA and Canada
by Routledge
711 Third Avenue, New York, NY 10017

Routledge is an imprint of the Taylor & Francis Group, an informa business

First edition published by Routledge 1998
Second edition published by Routledge 2002

British Library Cataloguing in Publication Data
A catalogue record for this book is available from the British Library

Library of Congress Cataloging in Publication Data
 The visual culture reader / edited by Nicholas Mirzoeff.—3rd ed.
 p. cm.
 Includes bibliographical references and index.
 1. Arts, Modern—20th century. 2. Arts, Modern—21st century. 3. Popular culture.
 4. Visual communication. I. Mirzoeff, Nicholas, 1962-
 NX458.V58 2012
 306.4'7—dc23
 2011045120

ISBN: 978-0-415-62055-0 (hbk)
ISBN: 978-0-415-78262-3 (pbk)

Typeset in Perpetua and Bell Gothic
by RefineCatch Limited, Bungay, Suffolk

Dedication

A decade after its last incarnation, *The Visual Culture Reader* returns, looking both different and somewhat the same. The project can no longer be to offer a representative sample of the best of the field in one volume because the field is so substantial. It is now a volume that seeks to make an argument about the best of the field and what the field might and perhaps should become. The individual essays have of course changed considerably, in part in response to readers' suggestions, in part due to the passing of time and different concerns that we may have now. Some may ask: why make a book at all in this digital era? One simple response is that it generates appropriate revenue for the authors and their presses. Another is that a book can find its way to places that bandwidth-consuming downloads cannot yet reach and there have been numerous examples of this with *The Visual Culture Reader*. I have always had in mind someone wanting to teach a class or create a module being able to take this book, and place it on the desk of an administrator as evidence that the subject exists. Again, past experience shows that many people have done just that. One concern that students mentioned we could not address: this is still a substantial book and I am sorry if it's heavy to carry around! While the question of size was one concern, every respondent to our inquiries wanted more in the book and this unanimous request has been honored in general, if not in every particular. Given that many of the topics were new, especially when dealing with areas outside the so-called "West," it seemed important to allow authors the space to make their arguments. Finally, I have not designated individual essays as "brilliant," "outstanding" and so on, because I think they all are and that is why they are in the book.

This volume was encouraged into being by Natalie Foster at Routledge. My thanks to her, Charlie Wood and everyone else at Routledge. I want to thank very much those authors whose work was previously featured in the *Reader* but who we had to leave out for one reason or another: it was not for lack of quality in any case, thank you all. Thanks also to all the students and faculty who have shared their ideas on the *Reader* with us, formally or informally. I think this has become something of a collective project over the years. Finally, my sincere thanks to all the present contributors, who have all been patient with my inquiries, and generous with their enthusiasm for the project.

Contents

Figures

The images listed below have been reproduced with kind permission. Whilst every effort has been made to trace copyright holders, this has not been possible in all cases. Any omissions brought to our attention will be remedied in future editions.

Contributors

Ackbar Abbas is a professor of comparative literature at the University of California, Irvine. Previously he was chair of comparative literature at the University of Hong Kong and also co-director of the Centre for the Study of Globalization and Cultures. His research interests include globalization, Hong Kong and Chinese culture, architecture, cinema, postcolonialism, and critical theory. His books include *Hong Kong: Culture and the Politics of Disappearance* (1997). He currently serves as a Contributing Editor to the journal *Public Culture*.

Morana Alac is Assistant professor in communication and science studies at the University of California, San Diego. She conducts ethnographic research of scientific laboratories and other settings of technology production and use. She works with video to focus on the dynamics of embodied social interaction. Alac's main project regards laboratories of cognitive science, neuroscience, and robotics. She is interested in how scientists learn about human thinking and behavior by employing new technologies—social robots, motion-capture systems, face recognition, and functional magnetic resonance imaging. Her latest book *Handling Digital Brains: A Laboratory Study of Multimodal Semiotic Interaction in the Age of Computers*, was published in 2011.

Malek Alloula is the author of *The Colonial Harem* (1986).

Ariella Azoulay's recent books include : *Civil Imagination: A Political Ontology of Photography* (2010), *From Palestine to Israel: A Photographic Record of Destruction and State Formation, 1947–1950,* (2011) and *The Civil Contract of Photography* (2008). She is Curator of *Untaken Photographs* (2010, The Moderna galerija, Ljubljana, and Zochrot, Tel Aviv), *Architecture of Destruction* (Zochrot, Tel Aviv), *Everything Could Be Seen*. Director of documentary *I Also Dwell Among Your Own People: Conversations with Azmi Bishara* (2004), *The Chain Food* (2004).

Zainab Bahrani is the Porada Professor of Art History and Archaeology at Columbia University, New York. Her books include *Women of Babylon* (2001), *The Graven Image* (2003) and *Rituals of War* (2008), which won the American Historical Association's James

Henry Breasted Prize. She writes on topics ranging from art and archaeology, concepts of images, aesthetics and ontology in antiquity to contemporary issues, including Modernism in the Middle East. Her writings on the destruction of cultural heritage in war have appeared in publications such as *The Nation, The Guardian*, and *The Wall Street Journal*.

Jonathan L. Beller is Professor of Humanities and Media Studies and Critical and Visual Studies at The Pratt Institute where he also directs the Graduate Program in Media Studies. He is author of *The Cinematic Mode of Production: Attention Economy and the Society of the Spectacle* (2006) and *Acquiring Eyes: Philippine Visuality, Nationalist Struggle and the World-Media System* (2006). His current book projects include *Present Senses: Aesthetics/ Affect/Asia* (with Neferti Tadiar) and *Wagers Within the Image*.

Suzanne Preston Blier (Ph.D. 1981 Columbia) is the Allen Whitehill Clowes Professor of Fine Arts and of African and African American Studies, Harvard University. An historian of African art and architecture, she holds positions in both the History of Art and Architecture and African and African American Studies Departments. Blier has published numerous books and articles on the arts and architecture of Africa. She also co-chairs an open source Electronic Geo-Spatial Database called Africamap that in June 2011 was expanded globally into Worldmap.

Lisa Cartwright teaches in the Department of Communications, University of California, San Diego. She is the author of *Screening the Body: Tracing Medicine's Visual Culture* (1995).

Dipesh Chakrabarty is the Lawrence A. Kimpton Distinguished Service Professor of History and South Asian Studies at the University of Chicago where he is also a Faculty Fellow of the Chicago Center for Contemporary Theory. He also holds a visiting professorial fellowship at the Australian National University. He is a co-editor of *Critical Inquiry* and the author of *Provincializing Europe: Postcolonial Thought and Historical Difference*.

Wendy Hui Kyong Chun is professor of Modern Culture and Media at Brown University. She has studied both Design Engineering and English Literature, which she combines and mutates in her current work on digital media. She is the author of *Programmed Visions: Software and Memory* (2011) and *Control and Freedom: Power and Paranoia in the Age of Fiber Optics* (2008).

Beth Coleman's work focuses on the role of human agency in the context of media and data engagement. She is the director of City as Platform lab, Amsterdam. Coleman is currently a Harvard University Faculty Fellow at Berkman Center for Internet & Society and a visiting professor at the Institute of Network Cultures, Hogeschool van Amsterdam. From 2005–2011, she has been an assistant professor of comparative media studies at Massachusetts Institute of Technology. Her book *Hello Avatar: Rise of the Networked Generation* was published in 2011.

Teddy Cruz is a Guatemalan-born architect whose work dwells at the border between San Diego, California and Tijuana, Mexico, where he has been developing a practice and pedagogy that emerge out of the particularities of this bi-cultural territory and the integration of theoretical research and design production. Cruz has been recognized internationally in collaboration with community-based nonprofit organizations such as Casa Familiar for its work on housing and its relationship to an urban policy more inclusive of social and cultural programs for the city. He obtained a Masters in Design Studies from Harvard University and the Rome

Prize in Architecture from the American Academy in Rome. He is currently an Associate Professor in public culture and urbanism in the Visual Arts Department at the University of California, San Diego.

René Descartes was a seventeenth century mathematician, scientist and philosopher.

Faisal Devji is Reader in Indian History and Fellow of St Antony's College at the University of Oxford. He is the author of two books, *Landscapes of the Jihad* (2005) and *The Terrorist in Search of Humanity* (2008), and one forthcoming titled *The Impossible Indian: Gandhi and the Temptation of Violence* (2012). An intellectual historian, Devji is interested in political thought in South Asia and the Muslim world, as well as in ethics and violence in a globalized world.

Henry John Drewal is presently the Evjue-Bascom Professor of Art History and Afro-American Studies at the University of Wisconsin-Madison and Adjunct Curator of African Art at the Chazen Museum of Art, UW-Madison. He has published several books and edited volumes and many articles on African/African Diaspora arts and curated several major exhibitions, among them: *Introspectives: Contemporary Art by Americans and Brazilians of African Descent; Yoruba: Nine Centuries of African Art and Thought; Beads, Body, and Soul: Art and Light in the Yoruba Universe; Mami Wata: Arts for Water Spirits in Africa and Its Diasporas*, and most recently *Dynasty and Divinity: Ife Art in Ancient Nigeria*.

Okwui Enwezor is an international curator, the Director of the Haus der Kunst in Munich. He has curated many exhibitions and festivals all over the world including the Johannesburg Biennale in South Africa (1997), the Bienal Internacional de Arte Contemporaneo de Sevilla, in Spain, the Gwang-ju Biennale in South Korea (2008). He was the artistic director of Documenta 11 in Kassel, Germany, in 2002, and was Dean of Academic Affairs and Senior Vice President of San Francisco Art Institute (2005–2009).

Frantz Fanon was a critic, psychoanalyst and revolutionary.

Allen Feldman is a cultural anthropologist who has conducted ethnographic research on the politicization of the gaze, the body and the senses in Northern Ireland, South Africa and the post 9/11 global war of terror. His research and teaching interests include visual culture, political aesthetics, political animality, and practice-led media research. Feldman is the author of the critically acclaimed book *Formations of Violence: the Narrative of the Body and Political Terror in Northern Ireland* (1991), numerous essays on political violence as visual and performance culture, and the forthcoming book *Archives of the Insensible: On War, Aisthesis, and Dead Memory* (2012).

Mark Fisher teaches at the University of East London, Goldsmiths and the City Literary Institute. His writing appears regularly in *Film Quarterly, The Wire, Sight & Sound* and on his blog k-punk. His book *Ghosts of My Life: Writings on Depression, Hauntology and Lost Futures will* be published in 2012.

Finbarr Barry Flood teaches at the Institute of Fine Arts and Department of Art History, New York University. His research interests include Islamic architectural history and historiography, cross-cultural dimensions of material culture, image theory, technologies of representation, and Orientalism. Recent publications include *Objects of Translation: Material Culture and Medieval "Hindu-Muslim" Encounter*, (2009), winner of the 2011 Ananda K.

Coomaraswamy Prize of the Association for Asian Studies, and *Globalizing Cultures: Art and Mobility in the Eighteenth Century* (2011), co-edited with Nebahat Avcıoğlu. His current book project is provisionally entitled *Islam and Image: Polemics, Theology and Modernity*.

Anne Friedberg was Professor of Cinema at the University of Southern California and a founder of its Visual Studies program. She was the author of *Virtual Windows: From Alberti to Microsoft* (2009).

Alexander R. Galloway is a writer and computer programmer working on issues in philosophy, technology, and theories of mediation. He is a founding member of the software collective RSG and creator of the Carnivore and Kriegspiel projects. Currently associate professor of Media, Culture, and Communication at New York University, he is author or co-author of three books on media and cultural theory, and most recently co-translator of the book *Introduction to Civil War* by the French group Tiqqun (2010).

Faye Ginsburg is Director of the Center for Media, Culture and History at NYU where she is also the David B. Kriser Professor of Anthropology. She has written/edited four award winning books; her research focus is on cultural activism and media. Ginsburg is currently completing her book, *Mediating Culture: Indigenous Identity in the Digital Age*, and is engaged in research on cultural innovation and disability.

Derek Gregory is Peter Wall Distinguished Professor at the University of British Columbia in Vancouver. The author of *The colonial present: Afghanistan, Palestine, Iraq* (2004), he is currently completing a new book, *The everywhere war*, and his present research focuses on the political and cultural history of bombing.

Jack Halberstam is Professor of English, Gender Studies and American Studies and Ethnicity at USC. Halberstam is the author of four books, most recently *The Queer Art of Failure* (2011). Halberstam has a new book coming out from Beacon Press in 2012 titled *Gaga Feminism: Sex, Gender and the End of Normal*.

Donna Haraway is Distinguished Professor Emerita in the History of Consciousness Department at the University of California at Santa Cruz. Her work explores the string figure knots tied by feminist theory, science and technology studies, and animal studies. She earned her PhD in Biology at Yale in 1972, and she taught biology at the University of Hawaii and the history of science at The Johns Hopkins University. Her books include *When Species Meet* (2008), *Crystals, Fabrics, and Fields: Metaphors that Shape Embryos* (2004); *Primate Visions: Gender, Race, and Nature in the World of Modern Science* (1989); *Simians, Cyborgs, and Women: The Reinvention of Nature* (1991); *Modest_Witness@Second_Millennium. FemaleMan© Meets OncoMouse™* (1997); *The Companion Species Manifesto: Dogs, People, and Significant Otherness* (2003); and *The Haraway Reader* (2004).

Brian Holmes is an art critic, activist and translator interested primarily in the intersections of artistic and political practice. He was the English editor of publications for *Documenta X*, Kassel, Germany since 1997 and is a frequent contributor to the international listserve Nettime, a member of the editorial committee of the political-economy journal *Multitudes* (Paris) and of the art magazines *Springerin* (Vienna) and *Brumaria* (Barcelona). Holmes is also a regular contributor to the magazine *Parachute* (Montréal), and a founder, with 'Bureau d'Études, of the new journal *Autonomie Artistique* (Paris). He is the author of a

collection of essays, *Hieroglyphs of the Future: Art and Politics in a Networked Era* (2003) and was in charge of a special issue of *Multitudes* on *Art contemporain: la recherche du dehors*.

Amelia Jones is Professor and Grierson Chair in Visual Culture at McGill University in Montréal. Her recent publications include major essays on Marina Abramovic (in *TDR*), feminist art and curating, and on performance art histories, specifically the edited volume *Feminism and Visual Culture Reader* (2003, 2010) and *Seeing Differently* (2012).

Georgina Kleege teaches creative writing and disability studies at the University of California, Berkeley. Her recent books include: *Sight Unseen* (1999) and *Blind Rage: Letters to Helen Keller* (2006). Kleege's current work is concerned with blindness and visual art: how blindness is represented in art, how blindness affects the lives of visual artists, how museums can make visual art accessible to people who are blind and visually impaired. She has lectured and served as consultant to art institutions around the world including the Metropolitan Museum of Art in New York and Tate Modern in London.

Sarat Maharaj was born and educated in South Africa during the Apartheid years. Professor of History and Theory of Art at Goldsmiths, London 1980–2005, he is currently Professor of Visual Art and Knowledge Systems, Lund University and the Malmo Art Academies, Sweden. He was the first Rudolf Arnheim Professor, Humboldt University, Berlin (2001–02) and Research Fellow at the Jan Van Eyck Akademie, Maastricht (1999–2001). Sarat Maharaj's specialist research and publications cover Marcel Duchamp, James Joyce and Richard Hamilton. He is editor of *Printed Project 11: Farewell to Post-Colonialism* (2009) and has contributed to many other titles.

Brian Massumi teaches in the Communication Department of the University of Montréal. He is the author of *Semblance and Event: Activist Philosophy and the Occurrent Arts; Parables for the Virtual: Movement, Affect, Sensation; A User's Guide to Capitalism and Schizophrenia: Deviations from Deleuze and Guattari*, and (with Kenneth Dean) *First and Last Emperors: The Absolute State and the Body of the Despot*. His translations from the French include Gilles Deleuze and Félix Guattari's *A Thousand Plateaus*.

Carol Mavor is Professor of Art History and Visual Studies at the University of Manchester, UK. Mavor is the author of four books: *Reading Boyishly: Roland Barthes, J. M. Barrie, Jacques Henri Lartigue, Marcel Proust, and D. W. Winnicott* (2007), *Becoming: The Photographs of Clementina, Viscountess Hawarden* (1999), *Pleasures Taken: Performances of Sexuality and Loss in Victorian Photographs* (1995) and *Black and Blue: The Bruising of Camera Lucida, La Jetée, Sans soleil and Hiroshima mon amour* (2013). Her essays have appeared in *Cabinet Magazine, Art History, Photography and Culture, Photographies*. In 2011, Mavor was the Northrop Frye Chair in Literary Theory at University of Toronto.

Tara McPherson is Associate Professor of Gender and Critical Studies in USC's School of Cinematic Arts. She is the author of *Reconstructing Dixie: Race, Gender and Nostalgia in the Imagined South* (2003), co-editor of *Hop on Pop: The Politics and Pleasures of Popular Culture* (2003), and editor of *Digital Youth, Innovation and the Unexpected* (2008). She is the Founding Editor of *Vectors*, www.vectorsjournal.org, a multimedia journal, and is an editor for the MacArthur-supported *International Journal of Learning and Media*. She also leads a software lab for the Alliance for Networking Visual Culture.

Nicholas Mirzoeff is Professor of Media, Culture and Communication at New York University. He is author and editor of several books including *The Right to Look: A Counterhistory of Visuality* (2011) and *The Visual Culture Reader*, now in its third edition (2012).

Timothy Mitchell is a political theorist and historian. His areas of research include the place of colonialism in the making of modernity, the material and technical politics of the Middle East, and the role of economics and other forms of expert knowledge in the government of collective life. After teaching for twenty-five years at New York University, he joined Columbia University in 2008, where he is Professor and Chair of the Department of Middle Eastern, South Asian, and African Studies. Besides *Colonising Egypt*, from where the chapter in this volume comes, his books include *Questions of Modernity, Rule of Experts: Egypt, Technopolitics, Modernity*, and *Carbon Democracy: Political Power in the Age of Oil*.

W. J. T. Mitchell is the Gaylord Donnelly Distinguished Service Professor in English and Art History at the University of Chicago, and has been Editor of *Critical Inquiry* since 1978. His recent books include *What Do Pictures Want?* (2005), *Critical Terms for Media Studies* (2010), and *Cloning Terror: The War of Images, 9–11 to the Present* (2011). Mitchell has received a number of important awards including the University of Chicago Press's Laing Prize for the best book by a Chicago author for *Picture Theory* (1996) and *What Do Pictures Want?* (2007). He is the only scholar ever to have received the top book prizes from both the Modern Language Association of America (the James Russell Lowell Prize for *What Do Pictures Want?*) and the College Art Association (the Morey Prize). His new book, *Seeing Through Race* will be published in the spring of 2012.

Naeem Mohaiemen works in Dhaka and New York, using essays, photography, and film to research global left and utopia project histories. Project venues include Bangladesh Shilpakala Academy, Sharjah Biennial (UAE), Frieze (London), MUAC (Mexico), as well as *Granta* ("Pakistan Issue") and *Rethinking Marxism*. He is editor of *Chittagong Hill Tracts in the Blind Spot of Bangladesh Nationalism* (Drishtipat Writers Collective) and co-editor of *System Error: War is a force that gives us meaning* (w/Lorenzo Fusi, Silvana). His essays include "Islamic Roots of Hip-Hop" (*Sound Unbound*, MIT Press) and "Flying Blind: Waiting for a real reckoning on 1971" (*EPW*, India). [shobak.org]

Fred Moten works at the intersection of black studies, performance studies, poetry and critical theory. He is author of *Arkansas* (2000), *Poems (with Jim Behrle)* (2002), *In the Break: The Aesthetics of the Black Radical Tradition* (2003), *I ran from it but was still in it* (2007), *Hughson's Tavern* (2008) and *B Jenkins* (2010).

Lisa Nakamura is the Director of the Asian American Studies Program, Professor in the Institute of Communication Research and Media Studies and Cinema Studies Department and Professor of Asian American Studies at the University of Illinois, Urbana-Champaign. She is the author of *Digitizing Race: Visual Cultures of the Internet* ((2008), winner of the 2010 Association of Asian American Studies Book Award in Cultural Studies), *Cybertypes: Race, Ethnicity and Identity on the Internet* (2002) and co-editor of *Race in Cyberspace* (2000) and *Race After the Internet* (2011).

Trevor Paglen is an independent artist and geographer living in New York City.

Lisa Parks is Professor of Film and Media Studies at UC Santa Barbara. She is the author of *Cultures in Orbit: Satellites and the Televisual*, and co-editor of *Planet TV, Undead TV*, and

Down to Earth: Satellite Technologies, Industries, and Cultures. She has published articles about satellite/aerial imagery of conflicts in Rwanda, Bosnia, Sudan, Afghanistan, and Iraq, and is finishing a new book entitled *Coverage: Media Space and Security after 9/11*.

Sumathi Ramaswamy is Professor of History at Duke University in Durham, North Carolina. Her recent monograph, which elaborates on the arguments in the chapter included in this volume, is titled *The Goddess and the Nation: Mapping Mother India* (2010). Her edited volumes include *Barefoot Across the Nation: Maqbool Fida Husain and the Idea of India* (2010), and *Beyond Appearances? Visual Practices and Ideologies in Modern India* (2003). She is co-founder of a transnational digital network for popular South Asian visual culture called Tasveer Ghar (House of Pictures) (www.tasveerghar.net).

Jacques Rancière is Emeritus Professor at the University of Paris VIII, where he taught Philosophy from 1969 to 2000, and visiting professor in several American universities. His work deals with emancipatory politics, aesthetics and the relationships between aesthetics and politics. He is the author of numerous books, many of which have been translated into English, including notably: *The Ignorant Schoolmaster, Disagreement, Short Voyages to the Land of the People, The Politics of Aesthetics, The Hatred of Democracy, The Future of the Image, The Politics of Literature* and *The Emancipated Spectator*.

Andrew Ross is a Professor of Social and Cultural Analysis at New York University. A contributor to the *Nation*, the *Village Voice, New York Times*, and *Artforum*, he is the author of many books, including, most recently, *Nice Work if You Can Get It: Life and Labor in Precarious Times, Fast Boat to China, Low Pay, High Profile, No-Collar*, and *The Celebration Chronicles*. His most recent book is *Bird On Fire: Lessons from the World's Least Sustainable City*.

Terry Smith is Andrew W. Mellon Professor of Contemporary Art History and Theory, Department of the History of Art and Architecture, University of Pittsburgh, and Distinguished Visiting Professor, National Institute for Experimental Arts, College of Fine Arts, University of New South Wales, Sydney. In 2010 he received the Franklin Jewett Mather Award for Art Criticism (College Art Association) and the Australia Council Visual Arts Laureate Award (Commonwealth of Australia). Books include *Making the Modern: Industry, Art and Design in America* (1993), *Transformations in Australian Art* (2002), *The Architecture of Aftermath* (2006), *What is Contemporary Art?* (2009), and *Contemporary Art: World Currents* (2011). See www.terryesmith.net/web.

Marita Sturken is Professor and Chair in the Department of Media, Culture, and Communication at New York University, where she teaches courses in visual culture, cultural memory, and consumerism. She is the author of *Tangled Memories: The Vietnam War, the AIDS Epidemic, and the Politics of Remembering* (1997), *Practices of Looking: An Introduction to Visual Culture* (with Lisa Cartwright, 2009), and *Tourists of History: Memory, Kitsch, and Consumerism from Oklahoma City to Ground Zero* (2007).

Paolo Virno is an Italian philosopher and semiologist. He is the author of many books, including *A Grammar of the Multitude* (2004) and is editor with Michael Hardt of *Radical Thought in Italy* (2006). He has worked as an editor of the culture pages of the Italian newspaper *il manifesto*. He was an editor of the journal *Luogo Comune* between 1990 and 1993, and has since been a lecturer at the University of Urbino (between 1994 and 1996), a guest lecturer at the Universitée de Montréal (in 1996), and a professor of the philosophy of

language, semiotics, and the ethics of communication at the University of Calabria (between 1995 and 2001).

Eyal Weizman is an architect, Professor of Visual Cultures and director of the Centre for Research Architecture at Goldsmiths, University of London. Since 2011 he also directs the European Research Council funded project, Forensic Architecture—on the place of architecture in international humanitarian law. Since 2007 he has been a founding member of the architectural collective DAAR in Beit Sahour/Palestine. Weizman has been a professor of architecture at the Academy of Fine Arts in Vienna and has also taught at the Bartlett (UCL) in London and the Stadel School in Frankfurt. His books include *The Least of all Possible Evils* (2011), *Hollow Land* (2007), *A Civilian Occupation* (2003), the series *Territories* 1, 2 and *3, Yellow Rhythms* and many articles in journals, magazines and edited books.

Acknowledgements

The articles listed below have been reproduced with kind permission. Whilst every effort has been made to trace copyright holders, this has not been possible in all cases. Any omissions brought to our attention will be remedied in future editions.

Part 1
Expansions

1. W. J. T. Mitchell, "There are No Visual Media,' from *Journal of Visual Culture* (2005), vol. 4 (2), pp. 257–66, Sage Publications. © 2005, SAGE Publications.

2. Ariella Azoulay, "The (In)human Spatial Condition: A Visual Essay." Excerpted from Adi Ophir, Michal Givoni, and Sari Hanafi, eds., *The Power of Inclusive Exclusion: Anatomy of Israeli Rule in the Occupied Palestinian Territories* (New York: Zone Books, 2009), pp. 155–77. All rights reserved.

3. Teddy Cruz, "Mapping Non-Conformity: Post-Bubble Urban Strategies," from e-mesferica, 7.1. © Teddy Cruz. Reproduced with permission of the author.

4. Beth Coleman, "X-reality: Interview with the Virtual Cannibal," from *Hello Avatar* (MIT Press, 2011). Beth Coleman, foreword by Clay Shirky, *Hello Avatar: Rise of the Networked Generation,* 9000 word excerpt from chapter: "Interview with the Virtual Cannibal," pp. 81–110. © 2011 Massachusetts Institute of Technology, by permission of The MIT Press.

5. Wendy Hui Kyong Chun, "On Software, or the Persistence of Visual Knowledge," *Grey Room,* 18 (Winter 2005): pp. 26–51. © 2005 by Grey Room, Inc. and the Massachusetts Institute of Technology, by permission of MIT Press Journals.

6. Jacques Rancière, "Notes on the Photographic Image" from *Radical Philosophy,* 156 (July 2009), pp. 8–15. This article first appeared in *Radical Philosophy* 156 (July 2009) and is reprinted here with permission.

7. Jack Halberstam, "Queer Faces: Photography and Subcultural Lives." Reproduced with permission of the author.

8. Terry Smith, "Currents of Worldmaking in Contemporary Art," from *World Art,* vol. 1 no 2, (Taylor & Francis, 2011). © Taylor & Francis Ltd, http://www.informaworld.com. Reprinted by permission of the publisher.

9. Sarat Maharaj, "Sublimated with Mineral Fury: Prelim Notes on Sounding Pandemonium Asia," from *Farewell to Postcolonialism: Catalogue for 2008 Guangzhou Triennale*, pp. 52–62. Reproduced with permission of the author.

10. Nicholas Mirzoeff, "The Sea and the Land: Biopower and Visuality after Katrina," from *Culture, Theory and Critique* (Taylor & Francis, 2009), pp. 289–305. © Taylor & Francis Ltd, http://www.informaworld.com. Reprinted by permission of the publisher.

Part 2
Globalization, war and visual economy

(a) War and violence

11. Zainab Bahrani, "The Archaeology of Violence: The King's Head." Excerpted from Zainab Bahrani, *Rituals of War: The Body and Violence in Mesopotamia* (New York: Zone Books, 2008), pp. 9–16, 23–29, and 50–55. All rights reserved.

12. Allen Feldman, "The Actuarial Gaze: from 9–11 to Abu Ghraib," *Cultural Studies*, Vol 19, No. 2, (Taylor & Francis, 2005), pp. 203–26. © Taylor & Francis Ltd, http://www.informaworld.com. Reprinted by permission of the publisher.

13. Derek Gregory, "American Military Imaginaries and Iraqi cities," from Christopher Lindner (ed.), *Globalization, Violence and the Visual Culture of Cities* (Routledge, 2009), pp. 67–84. © 2009 Taylor & Francis. Reproduced by permission of Taylor & Francis Books UK.

14. Lisa Parks, "Zeroing In: Overheard Imagery, Infrastructure Ruins, and Datalands in Afghanistan and Iraq," from Jeremy Packer and Stephen Wiley (eds), *Communication Matters: Approaches to Media, Mobility, and Networks* (Routledge, 2011), pp. 78–92. © 2011 Taylor & Francis. Reproduced by permission of Taylor & Francis Books UK.

15. Trevor Paglen, "What Greg Roberts Saw: Visuality, Intelligibility, and Sovereignty— 36,000km Over the Equator." Reproduced with permission of the author.

16. Faisal Devji, "Media and Martyrdom," from *Landscapes of the Jihad: Militancy. Morality. Modernity* (Hurst, 2005), pp. 87–111. © 2005 C. Hurst & Co. Publishers Ltd. Reproduced by permission of C. Hurst & Co. Publishers Ltd.

17. Naeem Mohaiemen, "Live True Life or Die Trying." Courtesy of the artist and Experimenter Gallery, Kolkata. Originally commissioned for Cue Art Foundation, New York; with support by Rhizome.org and Franklin Furnace. [shobak.org].

(b) Attention and visualizing economy

18. Jonathan L. Beller, "Kino-I, Kino-World: Notes on the Cinematic Mode of Production." Reproduced with permission of the author.

19. Paolo Virno, "On Virtuosity," from *Grammar of the Multitude* (Semiotext(e), 2004), pp. 52–66. Reproduced with permission.

20. Ackbar Abbas, "Faking Globalization," from Andreas Huyssen (ed.), *Other Cities, Other Worlds: Urban Imaginaries in a Globalizing Age* (Duke University Press, 2008), pp. 243–64. © 2008, Duke University Press. All rights reserved. Reprinted by permission of the publisher. www.dukeupress.edu.

21. Andrew Ross, "Creativity and the Problem of Free Labor." Courtesy of the author.

22. Mark Fisher, "It's easier to imagine the end of the world than the end of capitalism," from *Capitalist Realism: Is There No Alternative?* (Zero Books, 2009), pp. 1–12. © 2009, Zero Books. Reproduced with permission.

23. Brian Holmes, "Do It Yourself Geo-Politics," from Gregory Sholette and Blake Stimson (eds), *Collectivism After Modernism* (University of Minnesota Press, 2006), pp. 273–93. © 2006, University of Minnesota Press. Reproduced with permission.

Part 3
The body, coloniality and visuality

(a) Bodies and minds

24. René Descartes, "Optics," from *Selected Philosophical Writings*, trans. John Cottingham, Robert Stoothoff and Dugald Murdoch (Cambridge University Press, 1988), pp. 57–63. © Cambridge University Press 1988. Reproduced with permission (Q 02686/1).

25. Georgina Kleege, "Blindness and Visual Culture: An Eye-Witness Account," from *The Journal of Visual Culture*, (Vol. 4, No. 2, 2005), pp. 179–90, Sage Publications. © 2005, SAGE Publications.

26. Carol Mavor, "Reduplicative Desires," from *Becoming: The Photographs of Clementina, Viscountess Haywarden* (Duke University Press, 1999) pp. 36–51. © 1999, Duke University Press. All rights reserved. Reprinted by permission of the publisher. www.dukeupress.edu.

27. Donna Haraway, "The Persistence of Vision," from *Simians, Cyborgs and Women: The Reinvention of Nature* (Routledge, 1991) pp. 188–96. © 1991 Taylor and Francis. Reproduced by permission of Taylor and Francis Group, LLC, a division of Informa plc.

28. Amelia Jones, "The body and/in representation," from *Self/Image: Technology, Representation and the Contemporary Subject* (Routledge, 2006) pp. 1–28. © 2006 Taylor & Francis. Reproduced by permission of Taylor & Francis Books UK.

29. Henry Drewal, "Mami Wata: A Transoceanic Water Spirit of Global Modernity," from *Mami Wata: Arts for Water Spirits in Africa and its Diasporas* (Fowler Museum, 2008), pp. 23–25, 33–41, 49–54. The essay from which this selection has been excerpted originally appeared in *Mami Wata: Arts for Water Spirits in Africa and Its Diasporas* (Fowler Museum at UCLA, 2008).

(b) Histories and memories

30. Anne Friedberg, "The Mobilized and Virtual Gaze in Modernity," from *Window Shopping: Cinema and the Postmodern* (University of California Press, 1994) pp. 15–32.

31. Marita Sturken, "Tourism and Sacred Ground: The Space of Ground Zero." Revised excerpt from *Tourists of History* (Duke University Press, 2007), "Ground Zero and the Aesthetics of Absence: Sacred Ground, Tourism, and Kitsch," pp. 165–218. © 2007, Duke University Press. All rights reserved. Reprinted by permission of the publisher. www.dukeupress.edu.

32. Sumathi Ramaswamy, "Maps, Mother/Goddesses and Martyrdom in Modern India," from *Journal of Asian Studies* Vol. 67, No. 3 (August 2008), pp. 819–34. © The Association for Asian Studies, Inc. Published by Cambridge University Press. Reproduced with permission (Q 02686/2).

33. Dipesh Chakrabarty, "Museums in Late Democracies," *Humanities Research* (2003), pp. 5–12. Reproduced with permission of the author.

34. Frantz Fanon, "The Fact of Blackness," from *Black Skin, White Masks*, trans. Charles Lam Markman (Grove Weidenfeld, 1967), pp. 109–112. Excerpt from "The Fact of Blackness" from *Black Skin, White Masks* by Frantz Fanon, copyright © 1967 by Grove Press, Inc. Used by permission of Grove/Atlantic, Inc.

35. Fred Moten, "The Case of Blackness," reprinted from *Criticism: A Quarterly for Literature and the Arts* (Spring 2008) Vol. 50, No. 2. p. 188–204. © 2008 Wayne State University Press, with the permission of Wayne State University Press.

(c) (Post/De/Neo)colonial visualities

36. Timothy Mitchell, "Orientalism and the Exhibitionary Order," from Nicholas Dirks (ed.), *Colonialism and Culture* (University of Michigan Press, 1992), pp. 289–300: n. 1–29. © 1992, University of Michigan Press. Reproduced with permission.

37. Malek Alloula, from *The Colonial Harem* (University of Minnesota Press, 1986), pp. 3–15. © 1986, University of Minnesota Press. Reproduced with permission.

38. Suzanne Preston Blier, "Vodun Art, Social History and the Slave Trade," from *African Vodun: Art, Psychology and Power* (Chicago University Press, 1995), pp. 23–31. © 1995, Chicago University Press. Reproduced with permission.

39. Finbarr Barry Flood, "Between Cult and Culture: Bamiyan, Islamic Iconoclasm and the Museum," *Art Bulletin*, 2002, Vol. LXXXIV No. 4, pp. 641–55. This text first appeared in *The Art Bulletin* LXXXIV: 4, 2002, published by the College Art Association. © Barry Flood. Reprinted by permission.

40. Okwui Enwezor, "The Postcolonial Constellation: Contemporary Art in a State of Permanent Transition," from Terence Smith, Okwui Enwezor and Nancy Condee (eds), *Antinomies of Art and Culture: Modernity, Postmodernity, Contemporaneity* (Duke University Press, 2008), pp. 207–34. © 2008, Duke University Press. All rights reserved. Reprinted by permission of the publisher. www.dukeupress.edu.

41. Eyal Weizman, "Urban Warfare: Walking Through Walls," from *Hollow Land: Israel's Architecture of Occupation* (Verso, 2007), pp. 185–211.

Part 4
Media and mediations

42. Tara McPherson, "U.S. Operating Systems at Midcentury: The Intertwining of Race and UNIX"

43. Faye Ginsburg, "Rethinking the Digital Age," from Pamela Wilson and Michelle Stewart, *Global Indigenous Media: Cultures, Poetics and Politics* (Duke University Press, 2008), pp. 287–305. © 2008, Duke University Press. All rights reserved. Reprinted by permission of the publisher. www.dukeupress.edu.

44. Alex Galloway, "The Unworkable Interface," *New Literary History* (Autumn 2008), Vol. 39, No. 4, pp. 931–55. © 2008 New Literary History, The University of Virginia. Reprinted with permission of The Johns Hopkins University Press.

45. Brian Massumi, "On the Superiority of the Analog," from *Parables for the Virtual* (Duke University Press, 2003), pp. 133–42. © 2002, Duke University Press. All rights reserved. Reprinted by permission of the publisher. www.dukeupress.edu.

46. Lisa Nakamura, "Digital Racial Formations and Networked Images of the Body," revised chapter from *Digitizing Race: Visual Cultures of the Internet* (University of Minnesota Press, 2007), pp. 13–29. © 2007, University of Minnesota Press. Reproduced with permission.

47. Lisa Cartwright and Morana Alac, "Imagination, Multimodality and Embodied Interaction: A Discussion of Sound and Movement in Two Cases of Laboratory and Clinical Magnetic Resonance Imaging," from Bernd Hüppauf and Peter Weingart (eds), *Science Images and Popular Images of the Sciences* (Routledge Studies in Science, Technology and Society) (Routledge, 2007) pp. 199–225. © 2007 Taylor & Francis. Reproduced by permission of Taylor & Francis Books UK.

Introduction: For Critical Visuality Studies

IN THE PAST DECADE, VISUAL CULTURE HAS BECOME a global field of critical practice, researched and taught from Argentina to Norway and Tajikistan. Its referent as the assemblage of visualities, images and ways of seeing in a given place and time is now a commonplace in museums, universities, art galleries and even journalism. Although there are degree-granting programs in the field around the world, visual culture is more widely used and understood as a method and form of comparative interpretation in a variety of disciplines from art history to English and media studies. In itself, that consolidation might not call for a new volume, given the ease of assembling work from journals, the Internet and other sources. The motive behind this third edition of the *Visual Culture Reader* is to explore what visual culture is becoming, or at least might become. For despite all these achievements, there are also palpable dissatisfactions with visual culture. So much time has been spent placating the disciplinary critics, perhaps above all in art history, that insufficient attention has been paid to the hopes for a transformative interface of critical theories and visual media practices that would finally move beyond the tired rhetorics of 1990s debates. At the same time, the ongoing assault on humanities education by means of fee-escalation, widespread closure of programs, and such extreme steps as the legislative outlawing of Ethnic Studies in Arizona, has pushed matters beyond the erosion of budgets and positions to a paradigm shift. It is in this combined context of achievement and threat that this volume appears, with the intent to demonstrate the existence of what I shall call "critical visuality studies," and to call for its advancement. The questions at stake are at once "what do critical visuality studies want?" and "what can they do?"

Critical visuality studies are one of the four main areas of visual culture practice that can be identified at present in Anglophone contexts, and they are also the methodological link between these areas. In rough order of creation, there was first a "history of images," the broad inclusive study of images that has today become what W.J.T. Mitchell calls "iconology," the study of the lives, powers, desires and needs of images. Derived from the work of Erwin Panofsky, this latter-day iconology continues to have particular force in German studies, as exemplified by the work of Susan Buck-Morss and the new formation of *Bildwissenschaft* (Image Science) in Germany and Austria. In short, iconology extends from the word-image

relation to the bio-picture. Next, there are the studies of what John Berger called "ways of seeing" in his pioneering 1972 classic that soon intersected with feminist critiques of what Laura Mulvey famously called "the male gaze" in narrative cinema. That intersection of social art history with feminist film and media scholarship was a key impetus to what has recently been reformulated as "practices of looking" by Marita Sturken and Lisa Cartwright (2008). Such approaches center on the viewer of the endlessly multiplying images in contemporary culture, while drawing a historical genealogy from the European Renaissance, via the "frenzy of images" in the nineteenth century, to today's image-centered world. Perhaps the most specific use of visual culture as a concept comes as an umbrella for contemporary art and visual arts production. In European universities, this use of visual culture is substantially a critique of art history, whereas in the global South and the Southern hemisphere, it is often a means to level the intellectual playing-field between indigenous and European art practices. These areas overlap and most visual culture critics and practitioners cross the boundaries with ease: Mitchell, Sturken and Cartwright are all featured in this volume for instance. There is nonetheless something to be said for making the distinction here. For critical visuality studies is neither attached to a specific medium or object. In fact, it actively opposes visuality.

By visuality, I do not intend something like "the social practice of vision." Rather, visuality is a specific technique of colonial and imperial practice, operating both at "home" and "abroad," by which power visualizes History to itself. In so doing, it claims authority, above and beyond its ability to impose its will. Authority is that which leads people to follow leaders, even if they disagree with them, and even when the balance of social forces is such that the leader(s) might be overthrown in a trial of strength. As the events of 2011 showed very clearly, a collapse of authority, such as those in Tunisia and Egypt, is in fact more serious for the autocrat than a direct contest, like the one that is on-going in Syria as I write. Visualization demonstrates authority, which produces consent. Such visualization was first a late eighteenth-century military technique, heralded by the military theorist Karl von Clausewitz, in which a general visualized a battlefield that had become too extended for a single individual to see. In his 1840 lectures *On Heroes*, the British historian Thomas Carlyle extended Clausewitz's idea to identify the defining characteristic of the heroic leader as his (always) capacity to visualize. The ability to visualize history as it happens classifies an individual as a hero, a true aristocrat, thereby separating him from the common run of humanity and rendering him worthy of what Carlyle called "hero-worship." He coined the English words "visuality" and "visualize" but argued that they expressed a long-standing but undefined "Tradition." Given this evasivenenss, this tradition is best understood from the places of its application—the plantation, the colony, the neo-colony—looking back at its metropolitan sites of deployment and definition (Mirzoeff 2011). Visuality is thus a regime of visualizations, not images, as conjured by the autocratic leader, whether the plantation overseer, the general, the colonial governor, the fascist dictator, or the present-day "authoritarian" leader. It is also the attribute of bureaucratic and structured regimes, from the imperial administration of vast swathes of the world's surface in the nineteenth century of the U.S.-led military global counterinsurgency of today. It can and often does take materialized form as part of an argument against its enemies. The visualization performed by autocracy is that moment envisaged by the French philosopher Jacques Rancière when the police say to us "move on, there's nothing to see here." Only there is, and we know it and so do they. Critical visuality studies claims the right to look at that which authority wishes to conceal. This is not an optical process but a contest as to who is capable of visualizing events, whether in and as the History proposed by the state, or as alternative subaltern or decolonial readings. So, if visual culture is for the claiming of a place for those who have no place, what Rancière would call "democracy," it must be against visuality.

As a militarized technique, visuality anticipates and in a certain sense needs this opposition. Indeed, it was the very resistance to visualized regimes of authority that spurred Carlyle

to name it as such, from the victory of the enslaved in the Haitian Revolution (1791–1804) to the rise of the radical Chartist movement in Britain itself (1838–50). Carlyle's support for authoritarian rule seemed out of step with the times in the aftermath of the abolition of colonial slavery in 1838. However, the 1857 revolution in India, now variously known as the first war of Indian independence and the Indian mutiny, led Britain to assert direct rule in India, culminating in the assertion of Empire in 1877. While direct colonial rule has largely subsided since World War II, indirect or neocolonial regimes are a key feature of globalization from U.S. client states, to the French strategizing in Africa known as "Françafrique," and British assertions of colonial and counterinsurgency expertise in Iraq and Afghanistan.

The critique of visuality is also a counterpoint to the now-dominant narrative of the Panopticon, as invented by Jeremy Bentham in the late eighteenth century, and taken as a model for modern discipline by Michel Foucault (1977). In the Panopticon, prisoners and others subject to social discipline were under constant observation in the expectation that this sense of being watched would "cure" their souls. Carlyle was vehemently opposed to Bentham, for he claimed that the criminal or other delinquent could not be reformed and must instead be segregated from society. While Carlyle's preferred method of colonial deportation has been replaced by long-term prison sentences, one can say that his endorsement of punishment is now in the ascendant over hopes for reform in leading nations such as China, Russia and the U.S.

As a means of authoritarian control, visuality has had three component techniques: classification, separation and aesthetics. In clearly over-simplified terms, these can be defined as follows:

- Classification: stemming from natural history, classification operates by creating distinctions such as "free and slave," or "colonizer and colonized" that are then enforced by law or custom.
- Separation: a physical distantiation between those so classified, often using the means of "the barracks and the police station," highlighted by Fanon as typical of the colony, to ensure that the separation holds ([1963] 2008: 5).
- Aesthetics: classification and separation are then reinforced by an aesthetics that is not so much an aesthetics of beauty, as an "aesthetics of respect for the status quo" (Fanon [1963] 2008: 3).

When the three components work together, they form what I have called a complex of visuality, in which the sense that the arrangement is right reinforces the classification, makes separation seem natural and, in turn, what is right comes to seem pleasing, almost beautiful. There have been three complexes of visuality: the plantation complex (1650–1850), the imperial complex (1857–1947) and the military-industrial complex (1947–the present). The dates here are of course simply a guide and not to be taken as precise indicators. I take the very "obviousness" of these classifications as historical markers to be a sign that they are in fact pertinent. The complex expresses both a wide-ranging and networked form of power, and the sense that, as a mental operation, visuality is subject to the usual over-determinations of the psyche, such as the Oedipus complex.

Just as Gilles Deleuze emphasized that Foucault had been able to analyze the regime of discipline because it had come to an end (1992), so is it now possible to recognize visuality because it is in crisis. The crisis of visuality is manifested both by the sense that all three complexes can be seen at work in present-day situations, and by the particular crisis of the military-industrial complex. That the long legacies of plantation slavery continue to be played out has been made sadly clear by the barrage of racialized hostility directed at President Barack Obama (regardless of what one thinks of his specific policies)(Sexton 2010). By the same token, the presence of Western forces in Iraq and Afghanistan—and now Libya—has

forcibly reminded us of the continuation of colonial and imperial politics. The military-industrial complex, famously so-named by President Eisenhower in his televised farewell address to the nation in 1961, dominated the era in which the classification between Khrushchev capitalism and Communism was taken for granted, with its physical separation of space world-wide and the strong sense on both sides that this was right. Think of John F. Kennedy's declaration that the U.S. would "pay any price, bear any burden" in its defense, counterposed by the General Secretary of the U.S.S.R. Khrushchev's (misquoted) remark "we will bury you." However, even before the formal end of the Cold War in 1991, military tactics on both sides had intensified to what is known as the Revolution in Military Affairs, in which the goal is to achieve "full spectrum dominance" of information. This dominance is achieved locally by the "commander's visualization," as the 2006 *Counterinsurgency* manual of the United States Army has it, and globally by information mapping and control, ranging from satellites to Unmanned Aerial Vehicles and cyberwarfare (Mirzoeff 2009). Counterinsurgency, in this view, needs to envisage the entire planet as a potential space of insurgency, requiring permanent active information war, combined with an intense investment in constituting neoliberal governance wherever an actual insurgency occurs. Perhaps the most tendentious aspect of this counterinsurgency theory is that the combination of service provision, Western-style governance and market economies will deliver "legitimacy" both to counterinsurgency and the local governments it supports, such as the Karzai administration in Afghanistan or the al-Maliki regime in Iraq.

However, as the mention of these names suggests, this regime of global counterinsurgency that aspires to be the intensified form of the military-industrial complex, is as yet far from winning consent. It has certainly made its attempt at globalized classification, such that in the words of President George W. Bush, "you are either with us or you are with the terrorists." The strategy depends next on separating the general population from insurgents, primarily by their withdrawal of support, but also by physical separation. At key counterinsurgency locations, such as Israel/Palestine, in Baghdad, and on the U.S./Mexico border, this classification has been rendered concrete by walls. Such walls are also being built between Greece and Turkey and around the remaining Spanish possessions in North Africa. These resurgences of the Cold War "iron curtain" and Berlin Wall indicate the extent to which the military-industrial complex continues to be the underlying logic of counterinsurgency, just as the return of nuclear power and nuclear weapons to general awareness makes it clear that their apocalyptic threat has not disappeared. As yet, counterinsurgency is not so accepted as to seem "naturally" right, either as a military tactic or, as its strategic thinkers would have it, as a form of governance. Its form is changing and contested, as it seems that the governance-centered model favored by General David Petraeus is giving way to one dominated by targeted assassinations, notably that of Osama bin Laden.

It is possible, then, to see the emergence of visual culture studies as a symptomatic response to the Revolution in Military Affairs. Both rose to prominence in the late 1980s and early 1990s, stressing the important of new media, especially information media, and new modes of visualization. A major strand of visual culture is directly concerned with military visualization from Paul Virilio's *War Is Cinema* (1984) to W.J.T. Mitchell's *Cloning Terror* (2009). Counterinsurgency visualizes by means of information, ranging from television broadcasts to YouTube channels. It restructures the physical and cultural environment by dividing cities into ethnic zones, where none may have previously existed, designating regions as safe or dangerous, constructing separation walls, and declaring no-fly zones. It operates a palpable politics of invisibility, with so-called "black" operations, disappearances, renditions, and the pervasive use of surveillance. All of this is a form of visuality, even where it is not in the physical sense visible. One striking characteristic of counterinsurgency is that it presents itself as a response to a prior attack, a *counter* insurgency. It is therefore rhetorically and practically

difficult to oppose counterinsurgency because one lays oneself open to the charge of directly or indirectly supporting insurgency. A key task for a critical visuality studies is, then, to negotiate between these poles to find a different place from which to visualize, challenging not simply whether one can "look" at this or that event, but who may decide where that line falls. This is the right to look. The question is who claims to control the authority to look, and who is willing to claim the right to look, despite not having any formal right to do so. From Abu Ghraib to Wikileaks, recent contemporary culture has been driven by repeated clashes between these claims that form what Rancière calls "dissensus," the very possibility of a politics. In moments of revolution and radical change, the right to look is also the right to be seen and vice versa. The demand is to "look" on that which authority holds to be out of sight, and to be seen to be doing so, from a place that is freely chosen. While visuality is not necessarily or simply a regime of images, the revolutionary political subject has often visualized itself by means of images. Such tactics are aware of the transience of change, the likelihood that the best hopes of a moment will not be realized, and the persistence of forgetting. Making a formal image, attesting to one's presence as an actor, demanding to be seen–this is dangerous but it keeps the moment alive.

Putting authority to question: the 2011 moment

These thoughts have been reinforced by the dramatic events of 2011, the so-called "Arab Spring," or more exactly, the revolutionary wave across Africa and the Middle East, and the global Occupy movement, which called counterinsurgent visuality into question and claimed once again the right to look. Considering these events as suggestive for the new paradigm of critical visuality studies indicates that the project needs to be flexible, cross-cultural, comparative and connected. Taken as a whole, these requirements point towards a need for collective and co-operative scholarship and critical work. Looking at the Tunisian and Egyptian revolutions in particular, it becomes clear that an assemblage of tactics emerged as a new, improvised resistance to authority. All at once, it became possible to visualize a different way of life in nations that had been autocracies for decades. Once again, "the people" took the lead as a political actor, demanding their right to look and their right to be seen. This manifestation was in itself enough to cause the autocracy to collapse in Tunisia in days, while the struggle in Egypt was only eighteen days, albeit at a steep cost in terms of violence by the state. As these startling events have given way to the longer, less glamorous process of constitutional reform, some have suggested that this did not amount to a revolution but just a revolt. To the contrary, the production of "moment" is critical, as its double meaning of an instant of time and a sense of importance suggests. Rancière has suggested that "a moment is not only a vanishing point in time. It is also *momentum*: the weight that tips the scales, producing a new balance or imbalance, an effective reframing of what the 'common' means, a reconfiguration of the universe of the possible" (2010).

This reconfiguration is what Rancière has elsewhere called a new "division of the sensible," meaning the relations of the visible and the sayable that constitute visuality. The disruption to state authority was also a challenge to patriarchy, an assertion of the claims of young people, and a reconfiguration of the uses of social networking and other forms of Internet practice. While it is too early to say what the long-term consequences of all this will be, new possibilities for democracy, networked cultures and indeed planetarity itself (as opposed to financial globalization) became visualizable. In Egypt, the long-standing autocrat Hosni Mubarak had insisted that, as "father" to the nation, only he could steer the country through the institutionalized state of emergency that began with the assassination of Anwar al Sadat in 1981. In short, the legitimacy of Mubarak's autocracy was reinforced by patriarchy

in ways that complicate the understanding of Egypt as a postcolonial state. The revolutionary movement in 2011, in the words of a widely-circulated tweet, constructed a new assemblage where: "Facebook [was] used to set the date, Twitter [was] used to share logistics, YouTube to show the world, all to connect people." These social networking tools combined to allow the coordination of an embodied re-occupation of the streets by the newly constituted "people," rejecting their civil disability as Mubarak's "children," constrained literally and metaphorically by the state of exception. While the first street battles against the state security police reiterated many physical contests for possession of state capitals, the domestication of Tahrir Square as a space for residence, cooking, health care and the sustained desire for political change instituted a new form of visualizing the "people."

Unable to enforce his state of exception by physical means, Mubarak resorted to propaganda, describing the revolution as inspired by Israel and using state television and newspapers to characterize the movement as marginal and violent. It was Google executive-turned-organizer Wael Gonim's interview with Mona El Shazly on the cable station Dream TV that is often held to have tipped the balance in Egypt. El Shazly used her Oprah-like prestige as a talk-show host to create the possibility for this dramatic interview, leading to a revival of the Tahrir Square demonstrations. Whatever Gonim's motivations and support, it was the demonstrators that produced what they so ardently desired, the fall of the regime. In the aftermath, Egyptian secular feminists began discussions with religious women, opening another new space. However, a march held on International Women's Day (March 8) produced mixed results: organizers were pleased that a thousand people turned out, and that serious, if intense, discussions and/or arguments followed, but later there were reports of violence and harassment. It is easy to be skeptical, not least because it often turns out to be justified, but there is also the sense that such disagreements, the constitutive material of politics, are the necessary labor by which Egyptians might work out an alternative to autocracy.

From Morocco to Yemen, these autocracies have been maintained by the West as regional supporters of counterinsurgency. Counterinsurgency's means of visualizing authority is in trouble, if not actually falling. To treat this schematically, we can say:

- Classification: Across the region, the 2011 slogan was "the people demand the fall of the regime." There is no classification within the people, only one between the people and the regime. The performance of "the people" has constituted a new political subject that refuses to see or hear the regime, except when it resigns or falls.
- Separation: There is a clear distinction to be observed between locales where the revolution was able to challenge state imposed separation, such as the mobilization of the army against the police in Tunisia and the popular resistance in Egypt against the police; and the sustained internal and external military support for autocracy in Bahrain, and the war of the state against the people in Libya in order to sustain the authority of the autocrat.
- Aesthetics: whether or not these struggles are ultimately successful, almost no one believes in the status quo. It is no longer right, it no longer commands assent. It can be enforced but it will be a long time before it is once again invisibly "normal."

One counter to the state of exception or emergency is the assertion of the continued existence and determining importance of the everyday. By the everyday, I do not mean the banal or the quotidian but the space in which those who are excluded from what there is to see by the police find themselves. The state of emergency defines the non-emergency, or the everyday, as at once by definition irrelevant and the only concern of the people, excluded from all decision making. For example, in Yamina Bachir's 2002 film *Rachida*, set in Algeria during the "black decade" of the civil war, a doctor diagnoses the lead character Rachida (Djouadi Ibtissem), with "post

traumatic psychosis." And then she adds: "the whole country suffers from it." In February 2011, the Algerian government finally ended the state of emergency in effect since 1991 that brought this trauma into being, while still refusing to authorize protests and other political rights. The 2011 revolutions endeavored to reconfigure the places of the police and the everyday, notably reversing the attributes often associated with the private to the public: namely peace, security, a sense of belonging and the absence of fear. Across the region, from Syria to Morocco, it was striking to see participants talk about losing their fear, stressing that the act of taking to the streets was the decisive step in that process. The "square" in Cairo and elsewhere came to represent "home" for decolonial subjects in revolution. People expressed this both verbally and in the action of caring for the "square" by cleaning and other apparently "domestic" activities. Caring for the "square" represents a politics of the everyday in which visibility is no longer a trap but a safeguard. By contrast, authority spoke of the "homeland," as both Mubarak and Gaddafi declared that they would die there, as if anyone cared. In no longer being strange or uncanny but rather domestic and "peaceful" (to reiterate the Egyptian slogan), the revolutionary form takes on its most subversive potential yet. The authoritarian response was seen in the total destruction of Pearl Square in the capital of Bahrain and the cynical occupation of Green Square in Tripoli by Gaddafi loyalists.

In turn, Western citizens have started to respond to the climate of fear engendered by permanent security emergency and the austerity economies prescribed as the required correction for banker-induced recessions. From Madison, Wisconsin to the Plaza del Sol in Madrid, the Place de la Bastille in Paris, and most recently the Occupy Wall Street movement in the United States, new occupations of the public square have challenged the disciplinary usage of the "people" in neo-liberal discourse. Beginning on September 17, 2011, activists maintained an encampment in the heart of New York's financial district for nearly two months, generating hundreds of similar actions across the world. Following the lead of Argentina's popular movements and the *Indignados* in Spain, Occupy used a form of direct democracy. Anyone present could participate and decisions were taken by consensus. The right to look is epitomized at the individual level by the look into another person's eyes, in trust, friendship or love. As such, it cannot be represented. Occupy's process eloquently transposed that non-representative form to the collective. By its very claim to public space, Occupy refused to "move on" and vehemently asserted that there was indeed something to see here: the 99 per cent, those who had paid the price of the financial crisis but saw no bailout. The police reasserted their claim to authority by forcibly evicting OWS on November 15, 2011 and nearly all other occupations worldwide met a similar fate. It appeared that despite their very different political positions, authorities worldwide were determined to make sure that their claim to authority was not disputed. Occupy has continued in other forms but regardless of the success or failure of these actions, it is clear that the crisis of visualized authority has not yet been resolved.

The future is now

Learning from these events, critical visuality studies needs to be the place of intersection for the analysis of techniques of visuality, media studies new and old, postcolonial studies, gender studies and queer theory. More broadly, it needs to explore affinities with critical ethnic studies, critical legal studies, and other such iterations of the paradigm. The essays assembled in this volume, then, do not simply celebrate the expansion and growth of visual culture but amount to a collective claim for the rethinking of what it is that we do when study visuality. Read together, they envisage a transformation, not simply of disciplines or even area studies, but of the boundaries of critical practice, meaning both an interface with visual practice in its various forms; and a return to that form of cultural studies where education was a politicized

practice, interfaced as much with local and global activism as with formal institutions of higher education. These are goals, I think, that those who have felt visual culture did not live up to expectations might find rewarding in critical visuality studies.

At the same time, there are specific demands to engaging with visuality now that were not always so evident. Whereas visual culture was first formulated above all as a critical project, ranging from engagement with feminism, to ethnic studies and poststructuralism, the expanded field of visuality requires the production of new knowledges, as many pieces in this collection discuss and exemplify. There are several components to this expansion: the technical and theoretical expansion of what might be considered visual media, above and beyond the classic "visual" media, whether in military (Parks, Feldman) or medical visualizations (Cartwright and Alac), "Blackness" (Moten), blindness (Kleege), or areas as varied as the design of informal housing (Cruz), satellite warfare (Paglen), and the visualizing of the oceanscape (Mirzoeff). Next, while it is clear that digital technologies have been a driving force both of visuality and its critique, there is also a need to recognize that "new" media are now sufficiently old that many people want to return to analogue or performative media (Maharaj; Massumi). Further, humanities scholars cannot persist in ignorance of how digital machines and softwares work, given the extent of politics in and as technology (Chun; McPherson). This work implies first a critical analysis of technology and its claims to emancipation. Next, we should develop minoritarian uses of technology, whether current or outdated, to produce knowledges and even empirical data that neoliberal governance would rather conceal or ignore, on topics ranging from climate change to military technology and patient experience in health care. Finally, the rapid expansion of softwares and devices capable of incorporating and analyzing visual imagery is blurring the distinction between practice and theory in critical visuality studies, such that the future of the project seems likely to include a significant component of practice-based media research. Such work is needed not simply because the softwares allow it, but because it generates important new uses of media as critical practices. This Reader contains several photographic essays, and web-created analyses and more will be found on our website. One emerging format is the long-form documentary, abandoned by network television, which became first a surprising success in cinema and is now being used as an alternative to the long-form text for doctoral dissertations and advanced research. Database creation and analysis, non-linear born-digital multimedia critical scholarship, and crowdsourced online peer review are all well under way as forms of visualized scholarship.

However, I want to place terms like research, critique and scholarship under some pressure. As universities continue to shrink their full-time faculties in North America and Western Europe, especially in the humanities and social sciences, it may be that critical visuality studies will be as much engaged within the informal education sector. By this I mean voluntary education, such as that co-ordinated by The Public School in locations worldwide from Berlin and Brussels to New York, Los Angeles and San Juan, Puerto Rico (http://all.thepublicschool. org/). Other movements like Open Access seek to make scholarly work available to anyone that wants it via online journals using the Open Journals System, presses like Open Humanities Press (http://openhumanitiespress.org/), or software generated by the Open Source Software Movement, such as the operating system Linux. Whether consciously or not, this education-from-below is part of a long history of countervisuality, in which the riposte to the classifications made by visuality was the refusal to remain in one's place. From the schools for the formerly enslaved established in Haiti after independence in 1804, via the working-class education movements that nurtured cultural studies in the U.K., to today's alternatives to what has been called the academic-industrial complex (http://www.edu-factory.org/wp/), this determination to move out of one's "place," or be what the Chartists called the "mobility" (punning on the mob/ and the nobility), has been enabled by these forms of education. Certainly all have struggled with questions of funding and credentialing. The goal, as Rancière emphasizes in

what may be his most subversive work, *The Ignorant Schoolmaster*, is the accomplishment of an emancipation, not a training. Needless to say, such formulas raise more questions than they answer and possible solutions will vary from place to place. However, there are positive initiatives already underway. The International Association for Visual Culture, formed in 2010, has committed itself both to ethical and political goals and community building, with the practical consequence being emphasis on low-cost or free membership and conferences. The Alliance for Networking Visual Culture (http://scalar.usc.edu/anvc/) is building a multi-media born-digital authoring software, called Scalar, that will be available free and open-source. While the elite art world continues to be captivated by auction prices and Bienniales, there is a significant alternative, often centering on collective, local practices ranging from the well-known Critical Art Ensemble or 16 Beaver Group to specific local initiatives. Dis/ability studies, for example, has generated an extensive dis/ability film practice, centered on local film series and festivals.

The pieces in the sections that follow are not selected according to a blueprint and they are by no means limited to a reflection on very recent events. Taken together as a representative selection of the best work in the field, they can offer some important suggestions about the form and limits of critical visuality studies. The various sections indicate to me (not in order of priority) the primary areas of study at present. In the opening section called "Expansions," a variety of authors imagine possible new directions that the field might take, without necessarily wearing that badge on their metaphorical sleeves. From where we are now, it can be said that critical visuality studies have, as one might perhaps expect, been most engaged with in areas where visuality was a technique of colonial and imperial practice, meaning primarily Anglophone and Francophone empires and their descendants. A series of discussions might be implied with Spanish-speaking decolonial studies, where the image wars launched by the Conquistadors preceded visuality and have given rise to a different set of problematics and traditions, such as the syncretic image. At the same time, East Asia also sees itself as distinct from the past experiences of colonialism, while clearly being central to today's visual cultures. If any of these projects briefly hinted at here is to develop, it will mean one last and most significant change. Whether one is trying to engage with new forms of critical output, new means of teaching and engagement, or dealing with the exigencies of research in a planetary context, the myth of the single, independent scholar/researcher can no longer be maintained. Projects will have to be approached and considered collaboratively and collectively in ways that should be a closer fit with the politics we espouse. There will be fewer keynote lectures by "stars" and more workshops; less print publication and more working through ideas in intermediate form; but in general, there will be more—more excitement. More commitment. More fun, dare we say it.

References

Berger, John. *Ways of Seeing*. London: Penguin, 1973.

Deleuze, Gilles. "Postscript on the Societies of Control." *October* 59 (Winter 1992): 3–7.

Fanon, Frantz. *The Wretched of the Earth*. Trans. Richard Philbin. New York: Grove, [1963] 2008.

Foucault. Michel. *Discipline and Punish: The Birth of the Prison*. Trans. Alan Sheridan. New York: Vintage, 1977.

Mirzoeff, Nicholas. *An Introduction to Visual Culture*. 2nd ed. New York: Routledge, 2009.

——. *The Right to Look: A Counterhistory of Visuality*. Durham NC: Duke UP, 2011.

——. "War is Culture: Global Counterinsurgency, Visuality and the Petraeus Doctrine." *PMLA* 14.5 (2000): 1737–1746.

Mitchell, W.J.T. *Iconology: Image, Text, Ideology*. Chicago: Chicago UP, 1986.

———. *What Do Pictures Want? The Lives and Loves of Images.* Chicago: Chicago UP, 2005.

———. *Cloning Terror: The War of Images 9/11 to the Present.* Chicago: Chicago UP, 2009.

Rancière, Jacques. *The Ignorant Schoolmaster.* Trans. Kristen Ross. Stanford CA: Stanford UP, 1991.

———. "On the idea of Communism." In Costas Douzinas and Slavoj Zizek (eds.). *The Idea of Communism.* New York: Verso, 2010.

Sexton, Jared. "People-of-Color-Blindness. Notes on the Afterlife of Slavery." *Social Text* 103. Vol. 28 no. 2: 31–56.

Sturken, Marita and Lisa Cartwright. *Practices of Looking.* New York: Oxford UP, 2008.

Further reading

Friedberg, Anne. *The Virtual Window.* Cambridge MA: MIT Press, 2002.

Juhasz, Alex and Craig Deitrich. *Learning from YouTube.* http://vectors.usc.edu/projects/learningfromyoutube/

Mirzoeff, Nicholas. *An Introduction to Visual Culture.* 2nd ed. New York: Routledge, 2009.

Mitchell, W.J.T. *Cloning Terror: The War of Images 9/11 to Abu Ghraib.* Chicago: Chicago UP, 2010.

Rancière, Jacques. *The Future of the Image.* New York: Verso, 2009.

Sturken, Marita. *Tourists of History: Memory, Kitsch and Consumerism from Oklahoma City to Ground Zero.* Durham, NC: Duke UP, 2007.

Virilio, Paul. *War is Cinema.* New York: Verso, 1984.

Journals

Ibraaz: Contemporary Visual Culture in the Middle East and North Africa. http://www.ibraaz.org/

Journal of Visual Culture. http://www.journalofvisualculture.org/

Vectors. http://vectorsjournal.org

Photography and Culture. http://www.bergpuplishers.com/BergJournals/PhotographyandCulture/tabid/3257/Default.aspx.

Media Commons. http://mediacommons.futureofthebook.org

The New Everyday. http://mediacommons.futureofthebook.org/tne/

Culture Machine. http://www.culturemachine.net

Triple Canopy. http://canopycanopycanopy.com

Blogs

Culture Visuelle. http://culturevisuelle.org

Occupy 2012 http://nicholasmirzoeff.com/02012

Alliance for Networking Visual Culture. http://scalar.usc.edu/anvc/

PART 1

Expansions

Introduction

THE FIRST SECTION of the *Reader* is called "Expansions" to suggest possible ways that critical visuality studies might develop in the course of this decade. It cannot be comprehensive and it most certainly does not mean that chapters elsewhere in the volume are not indicative of such futures. Nonetheless, taken together and in association with the other material in the volume, these chapters indicate how far visual culture has come from its purported fascination with Barbie, Madonna and *Star Trek* in the 1990s. If the first generation of visual culture was intrigued by virtual reality and the second by the Internet, the present transformations of Web 2.0 and ubiquitous communications call for a thoroughgoing reassessment of both everyday life—no longer so banal—and the media that shape them. A man called Sohaib Athar in Pakistan tweets about some loud noise in his suburban neighborhood, and inadvertently becomes the liveblogger of the Osama bin Laden raid. From a single tweet at 7.25pm Eastern Standard Time, four hours before President Obama's broadcast on May 1, 2011, the report of bin Laden's death spread around the world by Twitter and Facebook. It was reported that 4,000 tweets a second were being sent as the news broke. By the end of the broadcast, Google map locations and images of Abbottabad, where bin Laden had been hiding were in global circulation. Television, photography, cell phones and the Internet interfaced with the news of what had happened to create a mediated event. While this particular event was especially dramatic, its contours were not that unusual in contemporary culture.

So the *Reader* begins with W. J. T. Mitchell's salutary reminder that "There Are No Visual Media." Let's pause to note that from his invocation of the "pictorial turn" in 1994 on, Mitchell has been the indispensable figure in visual culture studies. All media are mixed, he argues here, whether that comes in the material form, so that sound and image are both incorporated on a video, or in the metaphorical understanding that a painting is an object implying both touch and sight. Most painting—an apparently "visual" medium if ever there was one—relies on the viewer understanding a story or context to fully understand it. Even abstract painting, Mitchell demonstrates, functions in relation to language, or not at all, leading to remarks like "my kid could have done that." Far from negating the need for visual culture, Mitchell emphasizes that it is precisely "the field of study that refuses to take vision for granted, that insists on problematizing, theorizing, critiquing and historicizing the visual process as such." In turn, this suggests a new "taxonomy of media," one that the "braiding"

(as Mitchell calls it) of sound, text and image delivered by digital communications media now emphatically requires. In the two following chapters, the political and theoretical consequences of this apparently formal shift can be seen at two of the world's most charged locations.

The Israeli scholar and activist Ariella Azoulay shows that the "everyday" can radically reconfigure what she calls the "(in)human condition" in the context of Israel/Palestine, whose conflicts have set the tone for so much of the past decade. Her work on the Occupation from within Israel/Palestine demonstrates that Israelis are often far more critical of their governments than well-meaning supporters outside can tolerate. In this extract from a long photographic chapter, Azoulay examines architecture as a sovereign privilege of the colonizer. That is to say, it is Israel that determines which buildings stand and which do not, what may be built and what cannot. As part of their tactics, the Israeli army demolishes the homes not only of those accused of attacks against them but of their families: "the sovereign demonstrates his power and might by publicly demolishing the limits of the Palestinian home, crushing its intimacy." The private spaces of domestic life suddenly become a public spectacle of punishment. By using photographs to record these demolitions, Azoulay wants to force those of us that do not live in the Occupied Territories, especially her fellow Israelis, to divest themselves of the "illusion of physical separation." The photographs and architectonic drawings she uses record the careful destruction of one floor in an apartment building, or the collapse of a building without causing a major explosion, so-called "surgical" operations. There is a certain fascination to the formal mapping of the planned destruction of lived space that makes the viewer "see" what is happening in a way that the simple sight of ruins does not. Just as Mitchell would have it, critical visuality studies forces us to learn new ways of seeing, above all in those locations where seeing is not simple.

Working at the U. S.—México border at San Diego/Tijuana, the architect and urban theorist Teddy Cruz shows how "the future of architectural practice depends on the redefinition of the formal and the social, the economic and the political, understanding that environmental degradation is a direct result of social and political degradation." Chastising the star-chitects who build mega-projects in Abu Dhabi, Cruz works at the level of the neighborhood to imagine new architectural practice in conjunction with an understanding of local political and planning processes. In this strategic "radicalizing of the local," Cruz maps the interface of suburban environments across the fortified border that symbolically extends even into the Pacific Ocean. He notes that the first surburban architecture, the small tract house known as the "Levittown house," is now literally moving to Mexico. Entire houses are loaded onto trucks, shipped across the border and deposited on metal frames beneath which the resident might create a bodega or a small restaurant. It is in these interstitial and migratory spaces that Cruz develops both his architectural and critical practice, challenging us to get out of the gallery (university/museum) and into "the reality of the everyday."

So too the next chapters ask us to reconsider the visuality of difference in virtual worlds and in software. Media theorist and practitioner Beth Coleman has engaged in participant-ethnography in virtual worlds. Her chapter here reports on a dramatic encounter with a virtual cannibal in the role-playing environment Second Life. She sees such expansions of media as part of a "shift from the binary engagement of virtual/real to a multi-vector environment" that she names "pervasive media." In this pervasive engagement, avatars or online identities "represent us in a persistent manner to a recognized community." Everyday users are very much aware of these roles, evidenced by the spectacular growth of Facebook to 850 million users in 2011. In her discussion with the virtual cannibal, Gy, he remarks "You're the spectator of your own life [online]." The simulation of cannibalism was enabled by certain scripts available within a space constructed for such acts of sado-masochism. Everything was consensual, both for the avatar that was consumed and those that consumed it—not only that, it was found arousing, in a manner reminiscent of Sade, as Coleman points out. As she notes, death is the staple of video

gaming, staged uncountably often in war games and first-person shooters. The virtual cannibal ritual is extreme and horrifying but it is of a piece with the centrality of violence, sexuality and boredom to pervasive media. Gy claims he turned to BDSM out of boredom and abandoned it for the same reason to take up virtual furniture design that offers really complicated problems. However, Coleman concludes that pervasive media, perhaps by definition, cannot be contained to a "virtual" space but open "channels of communication" in both directions. In a very different context, this reopens debates about the influence of representation on life that date back to Plato but extends them to suggest they are mutually interactive.

Wendy Hui Kyong Chun, media theorist at Brown University, pushes this debate still further by showing how divorced we have become from computers, the machines that enable these representations in the first place: "as our machines become more and more unreadable, so that seeing no longer guarantees knowing (if it ever did), we the so-called users are offered more to see, more to read. The computer—that most nonvisual and nontransparent device— has paradoxically fostered 'visual culture' and 'transparency.' " Instead, we claim familiarity with "software," which Chun shows is hard to define both for users and programmers, itself an interactive group. For programming is both a form of apparently absolute power to make the machine do what you want it to do and opens the possibility of user interactivity. Yet Chun argues that "software *produces* 'users' " (my emphasis) by means of its defaults, parameters and the way it induces us to agree to believe (or pretend to believe) in such constructs as desktops and folders. Software is a functional counterpart to ideology "because both try to map the material effects of the immaterial and to posit the immaterial through visible cues." To extrapolate from Chun's thesis, software is a key form of visuality because it renders visualizable that which is not seen and need not be visible. Its critique is all the more important because its operations are so often taken as transparent, even natural, in digital everyday life. Taken together, in the specific and general analysis they offer, Coleman and Chun show that a critical visuality studies requires an engagement with the human/machine interface at all levels from the terms of agreement, to the basic visualizing operations of a wordprocessor, and the fully-realized "immersive" environment.

One of the most signal differences between the first emergence of visual culture studies and today's formation of a critical visuality studies is the place of photography. Authors, including myself, frequently predicted the demise of photography in the 1990s, meaning that it would lose authority as the index of reality. There was also a hint that the medium itself might become redundant. In fact, precisely the reverse has happened with the quantity and significance of photography being greater than ever before. Literally billions of photographs can be found on Flickr and Facebook, with countless more on hard drives, memory cards and phones. This section has two contrasting pieces on photography, one from a generalist perspective and the other taking a case study. The very fact that the philosopher, historian and activist Jacques Rancière chose to include a chapter on photography in this volume indicates the new (or renewed) importance of the medium. Like much of his work, the chapter is aphoristic and resists simple summary, so I commend its close reading, while I shall highlight some key points. Considering one of Rineke Dijkstra's monumental portraits, in this case of a Polish teenager, Rancière observes that photography now occupies "the rediscovered union between two statuses of the image that the modernist tradition had separated: the image as representation of an individual and as operation of art." Taking a careful distance from Barthes's 1981 thesis of the *punctum*, a photograph's "affective force, irreducible to transmission of knowledge," Rancière argues that in fact "the effect attributed to the phraseless singularity of the detail is the power of a word." Moving on to think about the postmodern photography exemplified in the series of Bernd and Hilla Becher—long series of factories, water towers or smoke stacks—Rancière again departs from received opinion to claim that "the 'objectivity' of the medium . . . masks a determined aesthetic relation between opacity and transparency." There's

an interesting parallel with Chun's arguments about transparency in software here, albeit developed in very different ways. Looking at the "indifference" in key modern and postmodern photographs, Rancière imagines a "completely different evolution of representation." This project would reread the orthodoxy that absorption is always a prime virtue in modern visual culture: "What they are or do matters little, but what is important is that they are put in their place." Social hierarchy and aesthetic hierarchy are thus interactive but can be countered by the indifference of the "carefree" that Rancière appropriates from Hegel's reading of the seventeenth-century Spanish artist Murillo. Murillo's child beggars and their descendants aspire to "those forms of experience which their social condition is supposed to forbid," not least the aesthetic. The scandal of this being out of place—whether speaking of photography, the "people," or the relations of the visible and the sayable that Anglophones call visual culture—is the central dynamic of Rancière's work. While it has become too easy for a certain kind of writer to call every new piece of art a new division of the sensible, this challenge remains live and active.

Although there is no direct connection, you could see Jack Halberstam's chapter as a response to such a challenge. In typically lively style, Halberstam, the leading queer theorist of visuality, considers the relationship between the visualizing of queerness, and the production of queerness as a spectacle in photography. A central question here is the relationship of photographic authenticity, something like Barthes's *studium* (accepted information), to visualizing queerness: "Is queerness an indifferent relation to authenticity in the first place?" Halberstam shows how Brassaï's photographs of queer subcultures in 1930s Paris first preserve a trace of those lost worlds. He shows that the photograph implies a repeated set of glances. First, one in which the performance of female masculinity registers as "normativity." Then, aided by captions like "Female Invert," the second glance changes the register, although Brassaï's intent to denote deviance risks being displaced by "desire, belonging, identification, fascination." A third glance indeed registers that these subjects do not mourn their failure to achieve normative gender, but celebrate and take pleasure in their lives. These second and third glances constitute the transgender glance, itself clearly at work in the photographed subjects who examine their objects of desire. It need hardly be said that the transgender glance is always already out of place, forbidden to all but the most private of the elite. Halberstam demonstrates that contemporary queer photography, like that of Del LaGrace Volcano and Catherine Opie, is aware of this genealogy and works its way through it, while ultimately going beyond it. In La Grace Volcano's work, he "makes us look at the shared look between photographer and subjects. When he is not in the frame himself, his subjects look back at him without suspicion and with complete confidence in his aesthetic project." As a related project by Catherine Opie also suggests, such work does not configure itself in the subjected domain of the (Lacanian) Gaze, but plays instead with the possibilities of multiplicity, impermanence and inauthenticity. That is not to say there is no such thing as the gaze but that there is not only The Gaze. This line of thought is very far from being a criticism of the feminist theories of the gaze, first associated with Laura Mulvey, but rather it seeks to develop and build on them. After all, no one was ever in favor of the gaze!

The remaining chapters in this section offer divergent and different perspectives that may or may not be taken by a critical visuality studies but are among those now available. First, Terry Smith, whose impetus to the study of visual culture from the Power Institute in Sydney and now at the University of Pittsburgh has been so significant, addresses the challenge that the contemporary experience of the worldly and the planetary pose for the analysis of art, which has so often been studied from a Eurocentric perspective. It is worth noting that in some quarters "world art" has been received as the solution to the problems posed by visual culture studies. Smith shows exactly why that cannot be right. He identifies a shift in art from the modern to the contemporary forged by transformations in what he terms "locality" and

"regionality," both of which need to be understood as specific but connected. The third register of his analysis is therefore the comparative. As he suggests the institutionalized form of Contemporary Art can be understood as "an aesthetic of globalization." In addition, the impact of decolonization has produced "the transnational turn" in contemporary art practice, in which "cosmopolitanism is the goal, translation the medium." The third current that Smith identifies is one that seeks "to arrest the immediate, to grasp the changing nature of time, place, media and mood today." While the tasks here are perhaps daunting, Smith sees it as a "hope-filled enterprise" in which art for the first time would become "truly an art *of* the world."

Some of the challenges can be seen in Sarat Maharaj's piece, originally written as part of the catalogue for the 2008 Guangzhou Triennale, entitled *Farewell to Postcolonialism*. In an assemblage of projects ranging from the art exhibition itself, to a major catalog, a series of platform events and discussions, a substantial web project (see http://www.gdmoa.org/gztriennial) and reflections in Western journals, the Triennale's artists and curators either rejected or reformulated the premises of the postcolonial. At one level, this stemmed from curator Gao Shiming's insistence that China had not been colonized, so it cannot be part of the postcolonial. One of the founders of the Visual Cultures programme at Goldsmith's College and currently creating an innovative practice-based PhD programme in Lund, Sweden, Maharaj takes a more nuanced approach. He targets less the historical narratives than what he calls "the spectacle of discourse" that has subordinated practice to theory. While admitting to being "gobsmacked" by the premise, Maharaj speculates on the "dense peculiarities" of the local that would oppose the Post-Colonial Pharmakon (poison/cure) to the Post-Colonial Panacea. This would not be a renewed theoretical project but "a frank turn to the raw empirical . . . a plunge into quotidian experience." Maharaj sees present-day Asia as at once a Pandemonium, Milton's term for the cacophony caused by Satan's rebellion against the former "harmonious order" in *Paradise Lost*, and a furious "sublimation" in which raw materials are transformed into futuristic buildings, rare earths become iPads and ancient cities disappear into the exploding megalopolis. Similarly, the South African curator-critic based in Sweden and the U.K., working on this exhibition in China, dazzles with ideas, references, and images that resist summarization. Let's just point to his challenge to undertake a "thinking through the visual," which works by association and juxtaposition in a set of always temporary assemblages. The "Re-start from Asia/Asia Start-up" proposed here is a deep challenge to critical visuality studies that has not hitherto engaged in more than a glancing fashion with East Asian visualities. One meaning of the resistance to "postcolonialism" expressed here might be precisely that "visuality" would require an empirical reassembling to do useful work in this context. As Maharaj's work suggests, such enterprises as already exist, like the global art exhibition, could be pressed into service in this project.

Finally, as a supplement to these existing strands of critical visuality discourse, I have appended my own recent chapter entitled "The Sea and the Land." It is an attempt to think through the challenges posed by anthropogenic climate change in the context of visuality in general and the legacies of Hurricane Katrina, which devastated New Orleans in 2005, in particular. It suggests that the sea, formerly the location of the eyeline in Western painting, can serve as a place from which to position a countervisuality of marine power and biopower. I note two major turning points in Western attitudes to this marine biopower in the seventeeth century with the invention of the "high seas" allowing for unfettered imperial expansion and in the mid-nineteenth century, following the abolition of slavery. In the latter case, I study Turner's painting *Slavers Throwing Overboard the Dead and Dying* (1839)—often known incorrectly as *The Slave Ship*—for its creation of an immersive viewpoint, literally in the water. Hurricane Katrina produced once again the elements visualized in Turner's sea paintings: "a storm, death by drowning, looting, violence, political debate, government

commissions." It was Spike Lee's documentary *When the Levees Broke* that visualized this immersive crisis, alerting us to "the intensification of biopower, our intensified immersion in both the metaphorical ocean of debt that has flooded all solvency and the literally transformed, warming and rising seas." The prospects for the next decade of critical visuality studies are at once daunting and exciting. The challenges are formidable but so are the opportunities.

W. J. T. Mitchell

THERE ARE NO VISUAL MEDIA

"**V**ISUAL MEDIA**" IS A COLLOQUIAL EXPRESSION** used to designate things such as television, film, photography and painting, etc. But it is highly inexact and misleading. On closer inspection, all the so-called visual media turn out to involve the other senses (especially touch and hearing). All media are, from the standpoint of sensory modality, "mixed media." The obviousness of this raises two questions: (1) why do we persist in talking about some media as if they were exclusively visual? Is this just a shorthand for talking about visual *predominance*? And if so, what does "predominance" mean? Is it a quantitative issue (*more* visual information than aural or tactile?) or a question of qualitative perception, the sense of things reported by a beholder, audience, viewer/listener? (2) Why does it matter what we call "visual media"? Why should we care about straightening out this confusion? What is at stake?

First, let me belabor the obvious. Can it really be the case that there are no visual media despite our incorrigible habit of talking as if there were? Of course, my claim can be easily refuted with just a single counter-example. So let me anticipate this move with a round-up of the usual suspects that one might want to propose as examples of purely or exclusively visual media. Let us rule out first the whole arena of mass media—television, film, radio—as well as the performance media (dance and theater). From Aristotle's observation that drama combines the three orders of *lexis*, *melos* and *opsis* (words, music and spectacle) to Barthes' survey of the "image/music/text" divisions of the semiotic field, the mixed character of media has been a central postulate. Any notion of purity seems out of the question with these ancient and modern media, both from the standpoint of the sensory and semiotic elements internal to them and what is external in their promiscuous audience composition. And if it is argued that silent film was a "purely visual" medium, we need only remind ourselves of a simple fact of film history—that the silents were always accompanied by music and speech and the film texts themselves often had written or printed words inscribed on them. Subtitles, intertitles, spoken and musical accompaniment made "silent" film anything but silent.

So if we are looking for the best case of a purely visual medium, painting seems to be the obvious candidate. It is, after all, the central, canonical medium of art history. And after an early history tainted by literary considerations, we do have a canonical story of purification, in which painting emancipates itself from language, narrative, allegory, figuration and even

the representation of nameable objects in order to explore something called "pure painting." characterized by "pure opticality." This argument, most famously circulated by Clement Greenberg (1940) and sometimes echoed by Michael Fried (1967), insists on the purity and specificity of media, rejecting hybrid forms, mixed media and anything that lies "between the arts" as a form of "theater" or rhetoric that is doomed to inauthenticity and second-rate aesthetic status.[1] It is one of the most familiar and threadbare myths of modernism and it is time now to lay it to rest. The fact is that even at its purist and most single-mindedly optical, modernist painting was always, to echo Tom Wolfe's (1975) phrase, "painted words." The words were not those of history painting, poetic landscape, myth or religious allegory, but the discourse of theory, of idealist and critical philosophy. This critical discourse was just as crucial to the comprehension of modernist painting as the Bible, history or the classics were to traditional narrative painting. Without the latter, a beholder would be left standing in front of Guido Reni's *Beatrice Cenci the Day Before Her Execution* (c. 1598) in the situation of Mark Twain (1887), who noted that an uninstructed viewer who did not know the title and the story would have to conclude that this was a picture of a young girl with a cold, or a young girl about to have a nose bleed (Twain, 1887, chapter 4: "City Sights"). Without the former (the discourse of theory), the uninstructed viewer would (and did) see the paintings of Jackson Pollock as "nothing but wallpaper."

Now I know that some of you will object that the "words" that make it possible to appreciate and understand painting are not "in" the painting in the same way that the words of Ovid are illustrated *in* a Claude Lorrain. And you might be right: it would be important to distinguish the different ways in which language enters painting. But that is not my aim here. My present task is only to show that the painting we have habitually called "purely optical," exemplifying a purely visual use of the medium, is anything but that. The question of precisely how language enters into the perception of these pure objects will have to wait for another occasion.

But suppose it were the case that language could be absolutely banished from painting? I do not deny that this was a characteristic desire of modernist painting, symptomatized by the ritualistic refusal of titles for pictures and the enigmatic challenge of the "untitled" to the viewer. Suppose for a moment that the viewer could look without verbalizing, could see without (even silently, internally) subvocalizing associations, judgements and observations. What would be left? Well, one thing that obviously would be left is the observation that a painting is a handmade object and that is one of the crucial things that differentiates it from, say, the medium of photography, where the look of mechanical production is so often foregrounded. (I leave aside for the moment the fact that a painter can do an excellent job of imitating the machinic look of a glossy photo and that a photographer with the right techniques can, similarly, imitate the painterly surface and *sfumato* of a painter.) But what is the perception of the painting as handmade if not a recognition that a non-visual sense is encoded, manifested and indicated in every detail of its material existence? (Robert Morris's *Blind Time Drawings*, drawn by hand with powdered graphite on paper, according to rigorous procedures of temporal and spatial targeting which are duly recorded in hand-inscribed texts on the lower margin, would be powerful cases for reflection on the quite literally non-visual character of drawing.)[2] The non-visual sense in play is, of course, the sense of touch, which is foregrounded in some kinds of painting (when "handling," impasto and the materiality of the paint is emphasized) and backgrounded in others (when a smooth surface and clear, transparent forms produce the miraculous effect of rendering the painter's manual activity invisible). Either way, the beholder who knows nothing about the theory behind the painting, or the story or the allegory, need only understand that this is a painting, a handmade object, to understand that it is a trace of manual production, that everything one sees is the trace of a brush or a hand

touching a canvas. Seeing painting is seeing touching, seeing the hand gestures of the artist, which is why we are so rigorously prohibited from actually touching the canvas ourselves.

Incidentally, this argument is not intended to consign the notion of pure opticality to the dustbin of history. The point is, rather, to assess what its historical role in fact was and why the purely visual character of modernist painting was elevated to the status of a fetish concept, despite the abundant evidence that it was a myth. What was the purification of the visual medium all about? What form of contamination was being attacked? In the name of what form of sensory hygiene?[3]

The other media that occupy the attention of art history seem even less likely to sustain a case of pure opticality. Architecture, the impurest medium of all, incorporates all the other arts in a *Gesamtkunstwerk* and typically it is not even "looked at" with any concentrated attention, but is perceived, as Walter Benjamin noted, in a state of distraction. Architecture is not primarily about seeing, but about dwelling and inhabiting. Sculpture is so clearly an art of the tactile that it seems superfluous to argue about it. This is the one so-called visual medium, in fact, which has a kind of direct accessibility to the blind. Photography, the latecomer to art-history's media repertoire, is so riddled typically with language, as theorists from Barthes to Victor Burgin have shown, that it is hard to imagine what it would mean to call it a purely visual medium. Photography's specific role in what Joel Snyder has called "Picturing the Invisible"—showing us what we do not or cannot see with the "naked eye" (rapid body motions, the behavior of matter, the ordinary and everyday)—makes it difficult to think of it as a visual medium in any straightforward sense. Photography of this sort might be better understood as a device for translating the unseen or unseeable into something that looks like a picture of something that we could never see.

From the standpoint of art history in the wake of postmodernism, it seems clear that the last half-century has undermined decisively any notion of purely visual art. Installations, mixed media, performance art, conceptual art, site-specific art, minimalism and the often-remarked return to pictorial representation has rendered the notion of pure opticality a mirage that is retreating in the rear-view mirror. For art historians today, the safest conclusion would be that the notion of a purely visual work of art was a temporary anomaly, a deviation from the much more durable tradition of mixed and hybrid media.

Of course this argument can go so far that it seems to defeat itself. How, you will object, can there be any mixed media or multimedia productions unless there are elemental, pure, distinct media out there to go into the mix? If all media are always and already mixed media, then the notion of mixed media is rendered empty of importance, since it would not distinguish any specific mixture from any purely elemental instance. Here I think we must take hold of the conundrum from both ends and recognize that one corollary of the claim that "there are no visual media" is that *all media are mixed media*. That is, the very notion of a medium and of mediation already entails some mixture of sensory, perceptual and semiotic elements. There are no purely auditory, tactile, or olfactory media either. However, this conclusion does not lead to the impossibility of distinguishing one medium from another. What it makes possible is a more precise differentiation of mixtures. If all media are mixed media, they are not all mixed in the same way, with the same proportions of elements. A medium, as Raymond Williams (1977: 158) puts it, is a "material social practice," not a specifiable essence dictated by some elemental materiality (paint, stone, metal) or by technique or technology. Materials and technologies go into a medium, but so do skills, habits, social spaces, institutions and markets. The notion of "medium specificity," then, is never derived from a singular, elemental essence. It is more like the specificity associated with recipes in cooking: many ingredients, combined in a specific order in specific proportions, mixed in particular ways and cooked at specific temperatures for a specific amount of time. In short, one can affirm that there are no "visual media," that all media are mixed media, without losing the concept of medium specificity.

With regard to the senses and media, Marshall McLuhan (1994[1964]) glimpsed this point some time ago when he posited different "sensory ratios" for different media. As a shorthand, McLuhan was happy to use terms such as "visual" and "tactile media," but his surprising claim (which has been mostly forgotten or ignored) was that television, usually taken to be the paradigmatically visual medium, is actually a *tactile* medium: "The TV image . . . is an extension of touch" (p. 354), in contrast to the printed word which, in McLuhan's view, was the closest that any medium has come to isolating the visual sense. However, McLuhan's larger point was definitely not to rest content with identifying specific media with isolated, reified sensory channels, but to assess the specific mixtures of specific media. He may call the media "extensions" of the sensorium, but it is important to remember that he also thought of these extensions as "amputations" and he continually stressed the dynamic, interactive character of mediated sensuousness.[4] His famous claim that electricity was making possible an extension (and amputation) of the "sensory nervous system" was really an argument for an extended version of the Aristotelian concept of a *sensus communis*, a coordinated (or deranged) "community" of sensation in the individual, extrapolated as the condition for a globally extended social community, the "global village."

The specificity of media, then, is a much more complex issue than reified sensory labels such as "visual," "aural" and "tactile." It is, rather, a question of specific sensory ratios that are embedded in practice, experience, tradition and technical inventions. We also need to be mindful that media are not *only* extensions of the senses, calibrations of sensory ratios, they are also symbolic or semiotic operators, complexes of sign-functions. If we come at media from the standpoint of sign theory, using Peirce's elementary triad of icon, index and symbol (signs by resemblance, by cause and effect or "existential connection" and conventional signs dictated by a rule), then we also find that there is no sign that exists in a "pure state," no pure icon, index or symbol. Every icon or image takes on a symbolic dimension the moment we attach a name to it, an indexical component the moment we ask how it was made. Every symbolic expression, down to the individual letter of the phonetic alphabet, must also resemble every other inscription of the same letter sufficiently to allow iterability, a repeatable code. The symbolic depends upon the iconic in this instance. McLuhan's notion of media as "sensory ratios" needs to be supplemented with a concept of "semiotic ratios," specific mixtures of sign-functions that make a medium what it is. Cinema, then, is not just a ratio of sight and sound, but of images and words and of other differentiable parameters such as speech, music and noise.

The claim that there are no visual media is really just the opening gambit that would lead toward a new concept of media taxonomy, one that would leave behind the reified stereotypes of "visual" or "verbal" media and produce a much more nuanced, highly-differentiated survey of types of media. A full consideration of such a taxonomy is beyond the scope of this article, but a few preliminary observations are in order.[5] First, the sensory or semiotic elements need much further analysis, both at an empirical or phenomenological level and in terms of their logical relations. It will not have escaped the alert reader that two triadic structures have emerged as the primitive elements of media: the first is what Hegel called the "theoretic senses"—sight, hearing and touch—as the primary building blocks of any sensuous mediation; the second is the Peircean triad of sign-functions. Whatever sorts of sensory/semiotic "ratios" are deployed will be complexes of at least these six variables. The other issue requiring further analysis is the question of "ratio" itself. What do we mean by a sensory or semiotic ratio? McLuhan never really developed this question, but he seems to have meant several things by it. First, the notion that there is a relation of dominance/subordination, a kind of literal realization of the "numerator/denominator" relation in a mathematical ratio.[6] Second, that one sense seems to activate or lead to another, most dramatically in the phenomenon of synesthesia, but far more pervasively in the way, for example, that the written word

appeals directly to the sense of sight, but immediately activates audition (in subvocalization) and secondary impressions of spatial extension that may be either tactile or visual—or involve other, "sub-theoretic" senses such as taste and smell. Third, there is the closely related phenomenon that I would call "nesting," in which one medium appears inside another as its content (television, notoriously, treated as the content of film, as in films such as *Network* (1976), *Quiz Show* (1994), *Bamboozled* (2000) and *Wag the Dog* (1997)). McLuhan's aphorism, "the content of a medium is always an earlier medium," gestured toward the phenomenon of nesting, but unduly restricted it as a historical sequence. In fact, it is entirely possible for a later medium (TV) to appear as the content of an earlier one (film) and it is even possible for a purely speculative, futuristic medium, some as yet unrealized technical possibility (such as teleportation or matter transfer), to appear as the content of an earlier medium (I consider *The Fly* (1986) the classic example of this fantasy, but the ritual request to "Beam me up, Scottie," on almost every episode of *Star Trek*, renders this purely imaginary medium almost as familiar as walking through a door). Our principle here should be: any medium may be nested inside another and this includes the moment when a medium is nested inside itself—a form of self-reference that I have discussed elsewhere as a "metapicture" and that is crucial to theories of enframing in narrative (Mitchell, 1994b). Fourth, there is a phenomenon that I would call "braiding," when one sensory channel or semiotic function is woven together with another more or less seamlessly, most notably in the cinematic technique of synchronized sound. The concept of "suture" that film theorists have employed to describe the method for stitching together disjunctive shots into a seemingly continuous narrative is also at work whenever sound and sight are fused in a cinematic presentation. Of course, a braid or suture can be unravelled and a gap or bar can be introduced into a sensory/semiotic ratio, which leads us to a fifth possibility: signs and senses moving on parallel tracks that never meet, but are kept rigorously apart, leaving the reader/viewer/beholder with the task of "jumping the tracks" and forging connections subjectively. Experimental cinema in the 1960s and 1970s explored the desynchronization of sound and sight and literary genres such as ekphrastic poetry evoke the visual arts in what we loosely call a "verbal" medium. Ekphrasis is a verbal representation of visual representation—typically a poetic description of a work of visual art (Homer's description of Achilles' shield being the canonical example; Mitchell, 1994a). The crucial rule of ekphrasis, however, is that the "other" medium, the visual, graphic or plastic object, is never made visible or tangible *except* by way of the medium of language. One might call ekphrasis a form of nesting without touching or suturing, a kind of action-at-distance between two rigorously separated sensory and semiotic tracks, one which requires completion in the mind of the reader. This is why poetry remains the most subtle, agile master-medium of the *sensus communis*, no matter how many spectacular multimedia inventions are devised to assault our collective sensibilities.

If there is any shred of doubt lingering that there are no visual media, that this phrase needs to be retired from our vocabulary or completely redefined, let me clinch the case with a brief remark on unmediated vision itself, the "purely visual" realm of eyesight and seeing the world around us. What if it turned out that vision itself was not a visual medium? What if, as Gombrich (1961) noted long ago, the "innocent eye," the pure, untutored optical organ, was in fact blind?[7] Of course, this is not an idle thought but actually a firmly established doctrine in the analysis of the visual process as such. Ancient optical theory treated vision as a thoroughly tactile and material process, a stream of "visual fire" and phantom "eidola" flowing back and forth between the eye and the object (see Lindberg, 1976). Descartes famously compared seeing to touching in his analogy of the blind man with two walking sticks. Vision, he argued, must be understood as simply a more refined, subtle and extended form of touch, as if a blind man had very sensitive walking sticks that could reach for miles. Bishop Berkeley's *New Theory of Vision* argued that vision is not a purely optical process, but involves a "visual

language" requiring the coordination of optical and tactile impressions in order to construct a coherent, stable visual field. Berkeley's theory was based in the empirical results of cataract operations that revealed the inability of blind persons whose sight had been restored after an extended period to recognize objects until they had done extensive coordination of their visual impressions with touch. These results have been confirmed by contemporary neuroscience, most famously by Oliver Sacks' (1993) revisiting of the whole question in "To See and Not See," a study of restored sight that exposes just how difficult it is to learn to see after an extended period of blindness. Natural vision itself is a braiding and nesting of the optical and tactile.

The sensory ratio of vision as such becomes even more complicated when it enters into the region of emotion, affect and intersubjective encounters in the visual field—the region of the "gaze" and the scopic drive. Here we learn (from Sartre (1956) for example) that typically, the gaze (as the feeling of being seen) is activated not by the eye of the other, or by any visual object, but by the invisible space (the empty, darkened window) or even more emphatically by sound—the creaking board that startles the voyeur, the "hey you" that calls to the Althusserean subject (Sartre, 1956). Lacan (1964) further complicates this issue by rejecting even the Cartesian model of tactility in "The Line and the Light," replacing it with a model of fluids and overflow, one in which pictures, for example, are to be drunk rather than seen, painting is likened to the shedding of feathers and the smearing of shit and the principal function of the eye is to overflow with tears, or to dry up the breasts of a nursing mother (Lacan, 1964). There are no purely visual media because there is no such thing as pure visual perception in the first place.

Why does all this matter? Why quibble about an expression, "visual media," that seems to pick out a general class of things in the world, however imprecisely? Is this not like someone objecting to lumping bread, cake and cookies under the rubric of "baked goods"? Actually, no. It is more like someone objecting to putting bread, cake, chicken, a quiche and a cassoulet into the category of "baked goods" because they all happen to go into the oven. The problem with the phrase, "visual media," is that it gives the illusion of picking out a class of things about as coherent as "things you can put in an oven." Writing, printing, painting, hand gestures, winks, nods and comic strips are all "visual media" and this tells us next to nothing about them. So my proposal is to put this phrase into quotation marks for a while, to preface it by "so-called," in order to open it up to fresh investigation. And in fact that is exactly what I think the emergent field of visual culture has been all about in its best moments. Visual culture is the field of study that refuses to take vision for granted, that insists on problematizing, theorizing, critiquing and historicizing the visual process as such. It is not merely the hitching of an unexamined concept of "the visual" onto an only slightly more reflective notion of culture—i.e. visual culture as the "spectacle" wing of cultural studies. A more important feature of visual culture has been the sense in which this topic requires an examination of resistance to purely culturalist explanations, to inquiries into the nature of visual *nature*—the sciences of optics, the intricacies of visual technology, the hardware and software of seeing.

Some time ago Tom Crow (1996) had a good laugh at the expense of visual culture by suggesting that it has the same relation to art history as popular fads such as New Age healing, "Psychic Studies," or "Mental Culture" have to philosophy (p. 34). This seems a bit harsh, at the same time that it rather inflates the pedigree of a relatively young discipline such as art history to compare it with the ancient lineage of philosophy. But Crow's remark might have a tonic effect, if only to warn visual culture against lapsing into a faddish pseudo-science, or even worse, into a prematurely bureaucratized academic department complete with letterhead, office space and a secretary. Fortunately, we have plenty of disciplinarians around (Mieke Bal, Nicholas Mirzoeff and Jim Elkins come to mind) who are committed to making

things difficult for us, so there is hope that we will not settle into the intellectual equivalent of astrology or alchemy.

The break-up of the concept of "visual media" is surely one way of being tougher on ourselves. And it offers a couple of positive benefits. I have suggested already that it opens the way to a more nuanced taxonomy of media based in sensory and semiotic ratios. But most fundamentally, it puts "the visual" at the center of the analytic spotlight rather than treating it as a foundational concept that can be taken for granted. Among other things it encourages us to ask why and how "the visual" became so potent as a reified concept. How did it acquire its status as the "sovereign" sense and its equally important role as the universal scapegoat, from the "downcast eyes" that Martin Jay has traced, to Debord's "society of the spectacle," Foucauldian "scopic regimes," Virilian "surveillance" and Baudrillardian "simulacra"? Like all fetish objects, the eye and the gaze have been both over- and underestimated, idolized and demonized. Visual culture at its most promising offers a way to get beyond these "scopic wars" into a more productive critical space, one in which we would study the intricate braiding and nesting of the visual with the other senses, reopen art history to the expanded field of images and visual practices which was the prospect envisioned by Warburgean art history and find something more interesting to do with the offending eye than plucking it out. It is because there are no visual media that we need a concept of visual culture.

Notes

1 Clement Greenberg's "Towards a Newer Laocoon" is his most sustained reflection on the desired "purification" of the visual arts. Michael Fried's "Art and Objecthood" is the classic polemic against the mixed, hybrid character of Minimalist, "literalist" and "theatrical" art practices.
2 See also Jacques Derrida's *Memoirs of the Blind* (1993) for a discussion of the necessary moment of blindness that accompanies drawing and especially the self-portrait.
3 My own answers to these questions are outlined in Mitchell (1994c). See, more recently, Jones (2005) and Greenberg (2005).
4 See McLuhan (1994[1964]: 42): "any extension of ourselves is an 'autoamputation.' "
5 Currently the Chicago School of Media Theory, a student research collective organized at the University of Chicago in winter 2003, is exploring the possibility of such a media taxonomy, a "Media HyperAtlas" that would explore the boundaries and blendings of media. For further information, see "Projects" section on their homepage: http://www.chicagoschoolmediatheory.net/home.htm.
6 One might want to enter a caution here, however, that from a mathematical standpoint it is the denominator (spatially "underneath") that gives the expression an identity (as a matter of "thirds," "fourths," etc.) and the numerator is merely a supernumary counting aspect of the fraction.
7 This is perhaps the central claim of Gombrich's classic, *Art and Illusion* (1961).

References

Crow, Tom (1996) "Visual Culture Questionnaire," *October* 77 (Summer): 34.

Derrida, Jacques (1993) *Memoirs of the Blind*. Chicago: University of Chicago Press.

Fried, Michael (1967) "Art and Objecthood," *ArtForum* 5(June): 12–23.

Gombrich, Ernst (1961) *Art and Illusion*. New York: Bollingen Foundation.

Greenberg, Clement (1940) "Towards a Newer Lacoon," *Partisan Review* 7(July–August): 296–310.

Greenberg, Clement (2005) *Modernism and the Bureaucratization of the Senses*. Chicago: University of Chicago Press.

Jones, Caroline (2005) *Eyesight Alone: Clement Greenberg's Modernism and the Bureaucratization of the Senses*. Chicago: University of Chicago Press.

Lacan, Jacques (1964) *The Four Fundamental Concepts of Psychoanalysis*, trans. Alan Sheridan. New York: Norton.

Lindberg, David C. (1976) *Theories of Vision from Al-Kindi to Kepler*. Chicago: University of Chicago Press.

McLuhan, Marshall (1994 [1964]) *Understanding Media*. Cambridge, MA: MIT Press.

Mitchell, W.J.T. (1994a) "Ekphrasis and the Other," in *Picture Theory*. Chicago: University of Chicago Press.

Mitchell, W.J.T. (1994b) "Metapictures," in *Picture Theory*. Chicago: University of Chicago Press.

Mitchell, W.J.T. (1994c) "Ut Pictura Theoria: Abstract Painting and the Repression of Language," in *Picture Theory*. Chicago: University of Chicago Press.

Sacks, Oliver (1993) "To See and Not See," *The New Yorker*, 10 May: 59.

Sartre, Jean-Paul (1956) "The Look," in *Being and Nothingness*. New York: Philosophical Library.

Twain, Mark (1887) *Life on the Mississippi*. London: Chatto & Windus.

Williams, Raymond (1977) *Marxism and Literature*. New York: Oxford University Press.

Wolfe, Tom (1975) *The Painted Word*. New York: Farrar, Straus & Giroux.

Ariella Azoulay

THE (IN)HUMAN SPATIAL CONDITION: A VISUAL ESSAY

T**HE IMAGE OF THE SOVEREIGN** as a founder of cities who imports architects and engineers from far and wide to help him leave his own stamp in space is familiar to us from ancient history. Something of this dimension of ruling power is perpetuated in our times by the sovereign's right to initiate and build monuments that transform urban space and to do it without any competition, contract, or civil consent.

Such an architectural privilege, in modern France, for example, belongs to the president of the republic and has an explicit monarchic connotation: *fait du prince*. In a democratic state, the sovereign may enjoy this privilege only as long as he makes measured and careful use of it. In such states, the monument glorifies the president through the pleasure and benefit he extends to the general citizenry.

In the forty years of its rule, the occupation regime has made extensive use of this privilege reserved for the sovereign, massively disrupting Palestinian space through three forms of intervention: construction, the administration of movement, and destruction. The fact that Israeli occupation rule is not recognized as sovereign and its subjects do not recognize its authority has not kept it from expecting absolute and sweeping application of this privilege while depriving the subjects of any status that would allow them to negotiate over the changes in their habitat. In each of these three forms, the occupation regime has conducted itself as foreign rule whose sole purpose is to establish its control and possession of space, rather than to develop that space to improve the living conditions of the local population. The three forms of intervention have deepened and reflected the polarized, conflictual power relations between the occupiers and the population of noncitizens living in the Occupied Territories. Land use, movement restriction, development, and the use of resources were all subjugated to these polarized relations from the very beginning in a gradual and escalating process and have turned the Palestinians into provisional residents of a space whose shape and transformation are forever subject to the whims of the regime and its Israeli citizens. Almost nothing in Palestinian space has remained constant, and many of its inhabitants live displaced in their homes, a new type of internal exile in their homeland. Where once orchards and orange groves grew, roads are now paved. Houses previously Palestinian have been confiscated and used to build colonies or army bases. Familiar thoroughfares have been blocked. Use of new ones has not been allowed, public space has become out of bounds for civilian use, movement

is subject to constant surveillance, and even house walls have not protected their dwellers from various types of invasion and penetration of their living spaces. The enforcement of power relations between the occupiers and the population of the Occupied Territories has meant not only the Palestinians' dispossession. It has also meant taking over strategic sites throughout the space and spreading forces over points numerous enough to control and perpetuate these polarized relations in space.[1]

Since the first intifada, much information has been collected by various bodies and organizations about these three forms of spatial intervention by the sovereign. Much has been written about construction, which has changed the appearance of space under occupation—construction in the colonies and the checkpoint system, in particular. However, the major part of the occupation regime's activity in space since the second intifada, activity that has received relatively little attention in its implications on Palestinian habitat, is expressed in the way the sovereign has reversed its prerogatives over the power of construction. Instead of promoting construction in the Occupied Territories, the occupation regime has utterly changed space through destruction—not whimsical, ad hoc random destruction, but rather methodical, controlled, and administered destruction, present everywhere. Both construction (by Jews and for Jews), and destruction (for Palestinians) inflict permanent damage on the local population, interfere with its ability to travel to work, school, and medical clinics, and provoke its resistance.[2] To neutralize such resistance or to reduce it, the ruling power must exercise extensive military might, and in order to shape space, it needs soldiers more than it needs architects, engineers, and builders.

The Oslo Accords divided the Occupied Territories into distinct areas of Israeli and Palestinian control. But even after the accords, the occupation regime did not cease to apply massive military force as the final authority regarding the administration and organization of space in the Palestinian Authority's domain, as well. Apparently the regime needs to prove publicly and unequivocally that no walls can stand in its way and that it has no respect for the privacy of dwellings. The homes of those it suspects of resisting the occupation are the preferred venue for its show of force: "Let them learn their lesson." Often, the residents of these demolished homes are not the suspects themselves, but members of their families. However, resistance to the occupation's might is not its only pretext for demolishing houses. Thousands of houses, gardens, orchards, and groves are destroyed merely because their location disrupts the occupation's operations or prevents some colony or other from developing and expanding. In areas that have remained under its full control, the occupation regime applies legal and civil tools to demolish the homes of thousands of Palestinians whose petitions for building permits it has persistently rejected, dooming their dwellings to the status of illegal constructions.

From 1967 to the present, the Israeli Defense Forces have demolished about eighteen thousand houses in the West Bank and the Gaza Strip.[3] This number does not include houses damaged by gunfire or stray shells and not intentionally demolished. Beyond devastating the foundations of public space and its relations with the private sphere, the occupation regime has developed its own unique spatial language of blockage, separation, and subjugation, preventing its subjects from maintaining a public space in which speech, gaze, and action are supposed to take place as free, spontaneous, and unpredictable play.

Such disruptions of spatial order afflict what Hannah Arendt has described as "the human condition" and generate an inhuman spatial condition. The Palestinians are deprived of the free use of space in all three forms of their *vita activa*: They are not free to move about spontaneously and find their way into and out of places; they are not free to use space in their work, commerce, and other forms of economic and professional activities; and they are not free to create open spaces for public gatherings, free speech, and free association without being limited, controlled, and monitored by the occupying authorities. This severe and

ongoing disruption of social space produces a unique situation: The main options for public gatherings and the relatively free use of space are the various sites of destruction, right after the dramatic event of destruction wrought by the occupying power, which transforms the damages into spatial scars.

During the actual demolition, Palestinians are ordered away from the site and allowed back only after the irreversible has become fact—the three-dimensional house has turned into a mere two-dimensional texture, the street has become unusable as a street, and a kind of new square has been opened in its midst. The ruling power justifies the disasters it wreaks and shirks its responsibility for the victims who have become dispossessed and displaced. The void left behind by the sovereign power is partially filled by the Palestinian Authority, by the residents themselves under the harsh restrictions that the army imposes upon their freedom of movement and action, and by the various aid organizations such as the United Nations Relief and Works Agency, UNRWA, the agency that cares for refugees of the past as well as for new types of refugees that Israel produces in the present, or the Red Cross.

The disaster taking place in public space takes two forms: the spectacle at its moment of occurrence and its ongoing results, which most of the time the subjects cannot reverse on their own. These two appearances help perpetuate the power relations between the occupier and the population of the Occupied Territories and the subjugation they constitute and reduce the possibilities Palestinians have for conducting the various forms of their praxis in their common space. The sovereign pulling the strings that produce the disaster is both present and absent from the scene. He acts as one who relies on the disaster and the emergencies that it produces to magnetize the subjects in his absence, to administer and supervise their movement, to rivet them to their basic needs, and to paralyze their ability to act. Thus, the gathering around a site of disaster inflicted by the occupier has become the permissible and most common type of public gathering in the Occupied Territories—a gathering around an "image" or "spectacle." The products of destruction scattered everywhere thus function like public squares. The occupier, as inherently stupid as occupiers are, assumes he can determine how the spectators in the public square will gaze at the horror show he has generated and what moral and lesson will be drawn from it. He assumes that he can "etch their consciousness" with the following conclusion: "We have delivered an unequivocal message to the population—any person involved in terrorism, as well as their next of kin, will pay a steep price for it."

Destruction requires immediate care and ways and means to provide for the urgent basic needs of the victims. But the flagrant ongoing presence of the results of destruction in their space, at times not removed for months or even years, creates a "world" in the sense that Arendt has lent this term. Its forms are the stable, permanent environment that the inhabitants know and in the textures of which they dwell. The disaster scene, from which the sovereign has withdrawn and which he abandoned, is the only environment where he hardly ever forbids their public gathering: the site transforms into a political space where the three domains of the vita activa, otherwise partially forbidden, take place.[4] In the photographs distributed throughout this volume, one might see that the gathering of Palestinians around the site of destruction is not harnessed only for the urgent needs of survival: They are rescuing victims and providing urgently needed care, but also professionally administrating their affairs and restoring their public space as a space of freedom.

In this public square, where Palestinians convene around a common object of their gaze and whose limits they establish during their encounter, they create a bond between the disaster site and the rest of the city. Thus, for example, for those standing at the rim of the huge pit opened under Sami al-Shaer's home, there is more than a gaze of wonder at the extent of its destruction. Their faces are sealed and distant. At times, they show contempt toward those who forced them to act within a public space whose basic form is disaster. With

the unfathomable patience of those who recognize the limits of the occupier's intervention and who know he will never be able to destroy their public space completely and deny them their basic political right to assemble in it, they scrutinize disaster and deny its perpetrators' pretension of thus delivering an unequivocal message. They face the power of human destructiveness with awe. But they also confront the stupidity of the occupiers, who invest such enormous efforts and means in practices of blockage and separation that mean, among other things, limiting disaster to one side of the space so that the occupiers could imagine themselves as outside the space of disaster, separate from it, safe and immune.

The Palestinians' observation of the feats of destruction transcends the urgency that disaster produces, opening a wider perspective. Through it, disaster may be seen not only as a particular event at a given point in time, but as a form of continuous control. The more the occupier devastates space and tears it asunder with events that bring disaster, blockages, and separation, its grip deepens, becoming more and more impossible to unravel. The population of the Occupied Territories, doomed to observe their own disaster, look through it at the occupiers who observe disaster from afar and deny their own active part in generating it. In disaster itself, they refute the occupiers' pretension to control the limits of disaster and to deny the way in which it touches them, too, gripping them in spite of all their efforts to detach themselves from it.

The five series of photographs presented here[5], interspersed throughout—five visual claims, as it were—address the destruction of the built environment in Palestinian space and the administration of movement as related policies. The first and the last series—"The Architecture of Destruction" and "Textures of Destruction"—attempt to characterize destruction without assuming or accepting the categories offered by the ruling power. The ruling power's military and legal language distinguishes between various cases of destruction according to the many justifications that the army provides for the havoc it wreaks: "illegal construction," "dwellings harboring individuals suspected of terrorism," or even its own "operational needs." Presenting side by side a photograph of a concrete ruin and an architectural scheme that illustrates the type of ruin at hand is part of the effort to deconstruct the category that has become too general and abstract—"house demolition"—and in its stead propose a primary typology of the sovereign's actions in the Occupied Territories. The categories offered here instead are based on distinctions in various types of destruction resulting from the techniques applied and the different textural types of the "architectural" stamp that destruction leaves upon Palestinian space. This initial sorting enables one to shift one's gaze from the population of the Occupied Territories as the reason for or justification of destruction to the language of the occupier who has turned destruction into a sophisticated and available toolbox. This sorting enables one to see how different forms of destruction that were applied at specific points and that may have been perceived at a given point in time as unbearable eventually became an obvious tool to be honed and used by trained soldiers.

The second and the third series "Types of Blockage" and "The Architecture of Separation"—focus on procedures by which the occupation regime actually produces a disorientation of space in which legibility and coherence have been totally disrupted. Most of these procedures, if not all of them, slow down Palestinians' movement in space nearly to a halt. They also show how these procedures allow Palestinians only measured movement amid "architectural" components such as slabs of concrete, parts of walls, barbed-wire fences, plastic barriers, and other elements that generate an entirely new cartography.

"Types of Blockage" shows how what is near at hand, always within seeing distance, and accessible in remembered past becomes inaccessible to Palestinians. The architectural syntax of different types of blockage points reflects this effect par excellence, but is also apparent wherever Palestinians find themselves at the threshold of their own homes, but prevented

from entering, whether because the homes have been physically blocked or have been turned into army outposts.

"The Architecture of Separation" emphasizes the spatial delineation of separation between Jews and Palestinians. In addition to the discriminatory partition that grants Israelis relative freedom of movement and leaves Palestinians with space that is fragmented and blocked, this partition reorganizes the field of vision, a field no longer to be shared. In this split field of vision, Israelis' and Palestinians' gazes are no longer supposed to meet.

The fourth series, "The Architecture of Fear/The Language of Subjugation," focuses on various blocking points and presents the spatial and design language used by the occupation regime to administer the movement of Palestinians in space. It shows how the occupation regime ensures that crowds will not be allowed to form, but rather must continue to move or stand in single file. As they drag themselves along, one by one, their movement is controlled and supervised individually. The photographs provide extensive information related to time and space, technology and movement, demography and administration, topography and control.

Like the keys of a map, icons of the temporary components of the architecture, spread throughout space, accompany this series and the series showing the architecture of blockage. The icons present the gamut of temporary, mobile components used by the sovereign's minor-ranking authority bearers. These components now constitute a "kit" that can be rapidly deployed at any point in space to change, limit, or block the movement of people, wares, and vehicles. These components have become totally familiar, incorporated in Jewish Israelis' bodies as protective devices while embodying subjugation in the Palestinians themselves.

These series of photographs attempt to illuminate the dual injury inflicted by the occupation regime upon Palestinian space, both public and private. Public space is administered and controlled by the explicit military presence of the ruling power, and the inhabitants' potential civil actions within it are totally reduced. The private sphere is penetrable, vulnerable, and perforated, and its inhabitants are liable at any time to become homeless and unable to dream of more than filling their basic existential needs. The sovereign demonstrates his power and might by publicly demolishing the limits of the Palestinian home, crushing its intimacy. What was just now indoors—where only relatives and family members were welcome—is suddenly bared amid the ruins: ceilings collapsed, belongings crushed and torn and scattered about. The private indoors is projected onto the public outdoors, and public space is administered centrally as though possessed by the ruling power, emptying it of its political nature.

With these series of photographs, I mean to characterize the inner grammar of the faits du prince responsible for the inhuman spatial conditions in the Occupied Territories. The photographs insist that Israeli Jews observe Palestinian space together with the Palestinians in the way this fragmented and blocked space is imposed on them, unraveling the illusion of total separation that is the occupier's basic principle.

It is this illusion alone that enables the infliction upon Palestinians of injustices that Israeli citizens would never tolerate were they ever to be inflicted upon them. The separation is actually between what is bearable and even justifiable (that is, in the eyes of the Israelis and inflicted upon the Palestinians) and the unbearable and unjustifiable (that is, what should not be inflicted upon the Israelis). Behind the illusion of physical separation, the occupation regime keeps raising the threshold of the unbearable, along with the Separation Wall between the two regimes. The occupation regime exercises enormous power in checking and limiting the extent of destruction to the one side, and indeed, the landscape shown here remains mostly that of the Occupied Territories. But the ruling power is required to apply force not only upon the populations of the territories, but upon its own citizens as well, in order to make destruction's unbearable sights seem bearable by token of their remaining limited to

the one side. At the same time, actual participation in this destruction, presumably a heinous crime were it perpetrated on the other side, is regarded as an honorable duty. But here the occupation regime's inherent weakness, its blind spot, is exposed. The effort it invests in destroying Palestinian space and the Palestinians' public space are viral, as it were. The public sphere flawed by the ongoing disaster inflicted by the occupation regime upon its Palestinian noncitizens seeps into the Israeli side: the mobilization of Israeli citizens to take part in the production of the disaster and its justification, as well as its erasure and denial. On the Palestinian side, directly affected by disaster, the public sphere is flawed by the way in which it is controlled and by its constant state of emergency.

Notes

English translation by Tal Haran. Special thanks to Liron Mor, Itamar Mann, Daniel Mann, and Mikhael Mankin for their research assistance

1 Jeff Halper, head of the Israeli Committee Against House Demolitions, compares the Israeli takeover of Palestinian space to the game of Go, in which the goal is not defeating one's opponent, but rather to block his ability to move. Jeff Halper, "Matrix of Control," *Middle East Report* 216 (Fall 2000).

2 I have pointed out various practices of spatial resistance in the exhibition *Act of State: 1967–2007* at the Minshar Gallery, Tel Aviv, Spring 2007.

3 See the Web site of the Israeli Committee Against House Demolitions on the history of house demolitions at http://www.icahd.org/eng/projects.asp (last accessed September 8, 2008). The committee, together with Palestinians and international volunteers, rebuilds some of the demolished houses; BADIL Resource Center for Palestinian Residency and Refugee Rights, "A History of Destruction," (May 18, 2004), available on-line at http://electronicintifada.net/v2/article2700.shtml (last accessed September 8, 2008).

4 Instead of identifying the political only with freedom and with the third domain of action, as does Arendt, I rely here on my discussion of the political as taking place in all three domains: Ariella Azoulay, *The Civil Condition* (Tel Aviv: Resling, forthcoming) (in Hebrew). Paper presented at the Second Workshop for Visual Studies, Bar-Ilan University, May 2008.

5 Only the first series is reproduced here.

Photo dossier 1: the architecture of destruction

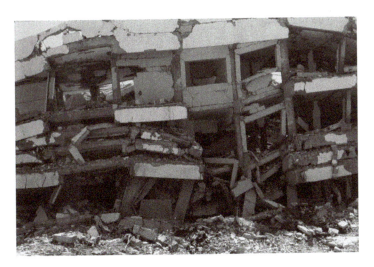

2.1 RAFAH, 2005 Most of the apartments in this building had been deserted sometime before it was demolished. Its location not far from the Qatif colony block made it an easy target for shooting and shelling, and life in it became unbearable. According to the army, Palestinian fighters used its deserted apartments for hiding, and that sufficed to doom it to destruction. During the al-Aqsa intifada, home demolition practices were enhanced into a sort of assembly-line procedure in an accelerated process of operational effectiveness by which thousands of buildings are demolished in the Occupied Territories every year. A principal condition for this operational efficiency is to detach the process from nonoperational considerations that might delay and encumber it. Such detachment enables the regional commander to decree demolition without waiting for the confirmation of his superiors and even to skip the early warning phase that allows the owners to appeal to the courts for an injunction or interim order. No one asks why that particular house is being blasted or why houses are being blasted at all. The building is selected by the General Security Service (GSS). The soldiers accept the mission unquestioningly and the necessity of blasting a residential building as a matter of course.

The extensive technological and operational know-how that the defense forces have accumulated as a result of the frequent observation of house demolitions in real time has enabled them to simplify the process of destruction and to break it up into regular phases, so that just a handful of soldiers is able to carry it out in a mere quarter of an-hour. They can do this without depending on an engineer or the crack-unit members who have been especially trained for such missions. The procedure is clear and explicit, and the operation of the equipment is known to all combat soldiers. The destruction workers arrive in several armored personnel carriers that move into civilian space, approach the building destined for demolition, and surround it. After breaking in the door, the first group of soldiers enters and begins by identifying the beams and foundations. With a nail gun, one of the soldiers "hammers" size

10 nails into the center of each of the beams and supporting columns. A second group of soldiers carries explosive charges into the building (each containing about 10 kilograms of advanced-type explosives) and hangs them on the nails, while other soldiers chain the explosives to each other with a detonator connected to a wireless operation system. The soldiers retreat a few hundred meters away and count down until the blast is heard. It lasts several seconds and shakes the entire area. Hanging the explosives on beams and support walls makes ceilings collapse, and the entire building implodes as if made of some flexible material. In some cases, the army sends in bulldozers the next day to finish up the job, grinding the building to dust. In others, it leaves the destruction incomplete, indifferent to the fact that the half-hanging structure constitutes a safety hazard.

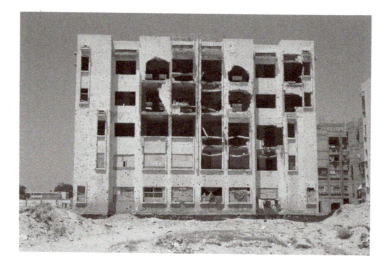

2.2 RAFAH, 2005 At the center of the photograph, a five-story apartment building. Two of the stories have been totally ruined, and another two have been partially damaged. The "targeted" blast spared the first story. It is perforated from ongoing exchanges of fire in the area, which have not been considered assaults or included in the statistics of home demolitions. Advanced technologies of targeted destruction enable the army to carry out "controlled demolition," which ruins "only" the apartments of those it suspects of terrorism. The fact that the rest of the building's residents are forced to live in a ruined, mangled building is irrelevant to military logic. The army continues to provide ready-made pretexts for its actions and boasts of maximal precision and gradually minimized damage to innocents. This operational discourse remains coherent because the security forces have the exclusive authority to determine who are guilty and who are innocent. The security forces announce their possession of evidence that remains largely confidential, and they are the ones to carry out the sentence under military considerations, leaving no room for appeal. (When appeal was possible, it would nearly

always be rejected.) An Amnesty International 2004 report investigated and doubted the army's claims that Palestinians used the houses it demolished for shooting or assaults or were partly "deserted," "empty," or "uninhabited."

Outer walls made of bare, unplastered cement in the Occupied Territories cannot attest to a building's being uninhabited, as is plainly visible, for example, in the two bare buildings seen behind the building in the foreground of the photograph. The constant threat that looms over Palestinian construction and the ongoing economic depression are some of the reasons why Palestinians commonly dwell in buildings bare of outer plaster layers, from whose roofs iron rods still protrude so that construction work might be resumed as soon as resources are available again. The specter of future destruction haunts them constantly, scarring the present and shaping norms of spatial organization, dwelling, and movement in both private and public space. The holes blasted in these classical dwelling "boxes" are a constant, present reminder of the likelihood that any Palestinian, regardless of his or her activity, might be instantly thrown out of his or her dwelling and witness its demolition.

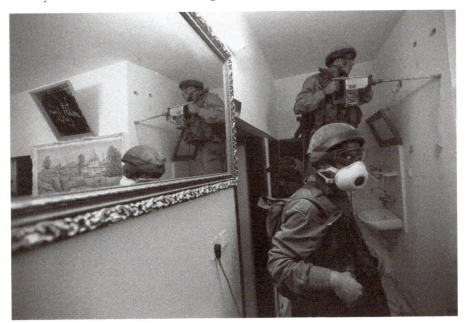

2.3 TUL KAREM REFUGEE CAMP, 2002 In their pioneering days of "Wall and Watch-tower," Jewish settlers new to Palestine would erect an entire environment within a few hours, between midnight and dawn, unilaterally creating facts on the ground in the face of the British Mandate and the local Palestinian population. The demolition of homes of suspected terrorists now takes place like some inverted projection of this "Wall and Watchtower" operation. The soldiers surprise the residents when they appear at night at the house destined for demolition. They have about six hours, until sunrise, to make the building uninhabitable and then get back to their base. They leave behind dispossessed families whose belongings usually are also turned to dust. The demolition is not an arbitrary act, but a result of a complex preparation that involves planning, tools, means, edicts, justifications, and precautionary measures. The army arrived at midnight at the home of Sirhan Sirhan, a Palestinian suspected of murdering five Israelis at Kibbutz Metzer. They concealed dynamite "fingers" in the house's inner walls without damaging its beams and foundations. The action lasted ten minutes. This, too, was the time allotted the residents to salvage some of their belongings. Precise engineering planning and the calculated use of explosives enabled the army to focus the demolition on one specific

apartment in an apartment building, sparing neighbors: "So far, we did not touch Sirhan's place, because it is on the third floor, and we were concerned about the floors underneath and adjacent buildings. We chose a controlled, microscopic blast that would make the ceiling of a certain floor implode." The concern for "focus" of which the commander of this demolition boasted resembles the army's focus on targeted assassinations. Such concern attracts most of the attention to targeting the demolition itself and on ways to obtain higher precision, oblivious to the fact that the target for such a focus is determined by a "field jury" that unilaterally passes sentence and determines the limits of this focus. Thus, for example, after the army "surgically" targeted and assassinated Sirhan Sirhan himself, it proceeded to demolish his parents' house "precisely," without damaging neighboring houses. After evacuating the family and finishing their preparations, including a thorough videotaping of the home and of the father who confirmed that this was indeed the home of Sirhan Sirhan, the soldiers vacated the house and waited for the blast. The blast took place as planned, and the damage was done "only" to the family dwelling. The commander of the action confirmed by radio that "the relevant floor is no longer usable, while the rest of the building is intact," and the destruction forces withdrew.

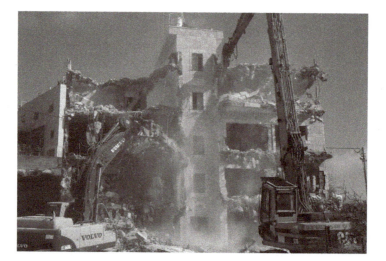

2.4 THE BULLDOZER, SUR BAHR, 2007 Use of bulldozers is usually reserved for the demolition of illegal construction. The building is crumbled slowly and methodically. Destruction begins at the building's right angles and outer walls. Once the outer shell is removed and the volume of the separate apartments is reduced to the various strata of floors and ceilings, the bulldozers pursue their gnawing like children savoring each layer of a chocolate-coated wafer. The duration of the work varies according to the height of the building and the number of rooms on each floor. Normally, no more than a day is required to turn the building into a texture of stone rubble and another few hours to complete pulverization and removal.

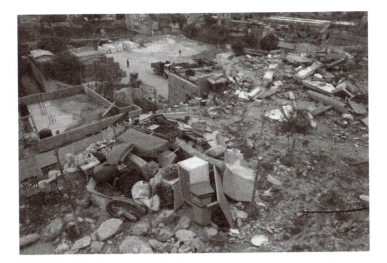

2.5 THE PILE, WADI QADDUM, EAST JERUSALEM, MARCH 2007 The bulldozers usually commence their work only after the residents and their belongings have been removed from the building. Since the demolition order applies only to the building, execution includes evacuation, as well. The inhabitants usually evacuate themselves, and the security forces make sure they are kept away while army employees identifiable on the spot in their orange-colored vests are busy removing belongings. These are packed by alien—sometimes very crude—hands: mattresses, beds, chairs, refrigerator, a baking oven, a wash basin, cushions, a table, and games are all heaped next to the building soon to be demolished, absorbing layers of dust that will be etched into them for an eternity of shame, a reminder of having been salvaged courtesy of the occupier kindly sparing the owners' unnecessary suffering.

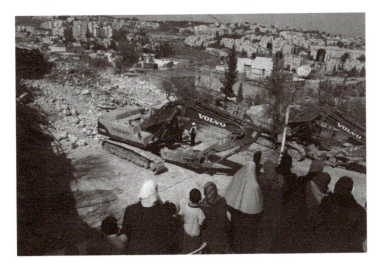

2.6 THE SPECTATORS, SUR BAHR, EAST JERUSALEM, 2007 The residents who have evacuated themselves for fear of the law's long arm are distanced from the site. Usually, they find an opening through which they peek at the destruction of their home to the unfinished symphony of bulldozers. A group of neighbors share their witnessing, perhaps practicing for their own near future. Some of them might be standing there throughout the hours of demolition, while others emerge every time the house changes its material state. Seemingly at this last stage, when the rubble has been nearly flattened and evenly covers the ground, they assemble for a last farewell.

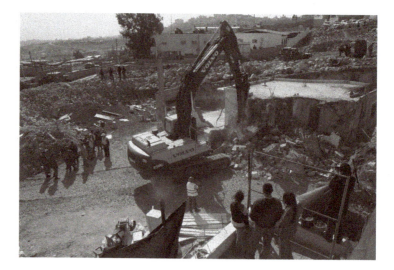

2.7 SURROUNDING THE BUILDING, A-TUR, EAST JERUSALEM, 2007 To protect the act from possible resistance expected from the evacuees, a huge crowd of policemen and soldiers is posted at several foci around a building destined for demolition.

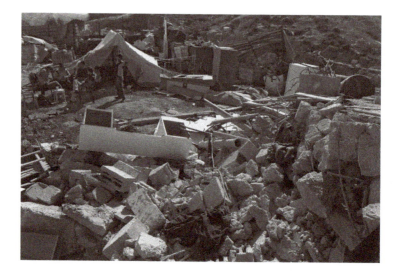

2.8 THE TENT, A-TUR, EAST JERUSALEM, JANUARY 2007 The location of the Red Cross-supplied tent marks the outer circumference of the rubble. The tent is too small to contain belongings, so these are all piled up in front of it, objects accumulated over the years. In the small yard created in front of the tent sit the evacuees, bracing themselves for the coming hours.

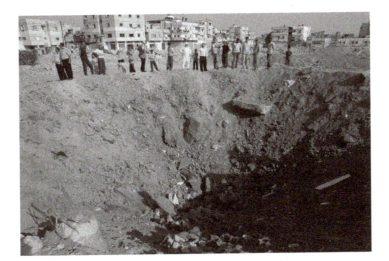

2.9 BRAZIL CAMP, GAZA STRIP, 2007
Late at night, several days before they were photographed standing on the rim of the crater, at the sound of the familiarly chilling roar of a fighter plane, many of them opened their windows in order to minimize the damage from the blast that would soon rock their dwellings. They know the outcome of F-16s penetrating the camp's sky, their bodies and possessions having refuted time and again the Israeli Army's pretensions at sophistication and precision. With their utterly meager means, they try to protect themselves from the horror and to minimize as much as possible the span of injuries. Daem al-Az Hamad, a fourteen-year-old girl living about three hundred meters from the spot where the bomb fell, turning the house into a crater, was killed by a house beam flying toward her parents' home. The army insists that it is not responsible for her fate, claiming that destruction was precise, wrought "only" on Sami al-Shaer's house. This house was targeted because the army thought its yard contained a tunnel for smuggling arms. The spectators (over twenty people) standing at the rim of the enormous crater (about thirty meters in diameter, seven meters in depth) gaze at various focal points of destruction (most of the house walls along the Philadelphie Road adjacent to the camp are perforated sieves by now), embodying the gap between the laundered, semi-legal language the army uses to justify its actions and the appearance of this space in which destruction looks anything but focused. The pure human violence exercised here, swallowing the house and leaving hardly a trace, interests this audience, in its amazement not letting it vanish, but holding onto it, a wake of memory: No spectator is safe from it, and it might reappear and surprise them at any time.

Spectators standing together around the crater is one of the few forms of public gathering in a public space that the occupation regime not merely tolerates, but even initiates and supplies with ample spectacle.

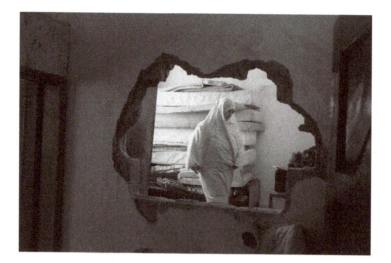

2.10 EIN BEIT ILAMA REFUGEE CAMP, NABLUS, 2007 The hole frames Mrs. Rajab, is moving in her home across the wall. Today she passes the hole by as if she is already accustomed to its presence and accepts it. This hole was broken violently one night last September, taking her whole family by surprise. Immediately after the hammering and slight blast, they heard dogs barking and strangers moving around— Hebrew-speaking Israeli soldiers. The soldiers use dogs to move ahead and be the first to take gunfire and blows expected on their movement through the "tunnel" they produce inside the houses. This hole in her home, throwing her together with her next-door neighbors in unfa-miliar ways, is one of a series of several dozen holes broken by Israeli combatants during nights of searching for a suicide bomber. The holes in the walls at the homes of the Rajab, Namruti, Taha, and other families enable the soldiers to proceed unseen inside the crowded camp in a relatively straight line. The walls do not constitute an obstacle, nor does the privacy of families living inside the houses that they devastate on their mission merit any respect. Moving through walls is part of the novel warfare developed by the Israeli Army during the second intifada. In a sense, this warfare is the inverse of the methods developed by the army in the early 1970s to crush resistance among refugee-camp dwellers. This inversion of space relations between open and closed, solid and air, mobile and static seems to resonate with various postmodern theories. In fact, this type of warfare, like the theories that inspired it, is produced by circumstances of a postmodern situation that sometimes threatens to obliterate the distance between the practices of power and the theories that address it. In the early 1970s, the army looked for ways to clear swathes inside the dense texture of the camp, through which it would move undisturbed, visible to all, obtaining deterrence and control of the space, razing whole building blocks in the process. Now the army seeks rapid contact with individuals targeted amid the civilian population and minimal friction while present in Palestinian territory. The two kinds of warfare differ greatly, but they share a significant common denominator—the Palestinian home is no obstacle to the army's movement.

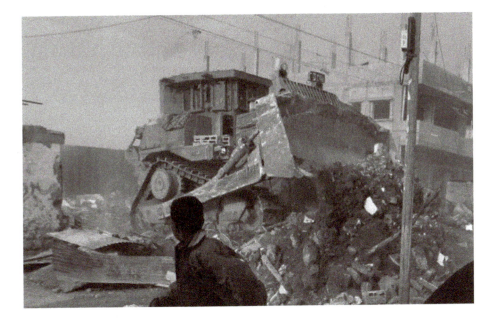

2.11 RAFAH, 2004 The D9 bulldozer moves forward, devastating anything in its way. It acts relatively quickly to "clear the area" of anything the army has designated as a target. It does so with a cast-steel blade installed in front, pushing anything in its way, piling up soil and stone, uprooting obstacles, while a ripper in its rear cracks open hard objects and material. Side blades resembling sharp fingernails installed on some bulldozers enable them to apply concentrated force on small objects. The bulldozer is very powerful, and its upgraded protective armor turns it into a terrifying tool capable of enormous damage and injury without its operator even sensing its extent. In the twelve days in May 2004 of Operation Rainbow, army D9 bulldozers demolished 183 houses in Rafah, partially damaging dozens of other buildings, razed miles of paved road, and devastated electricity, water, and sanitation infrastructures. Cameras installed in the bulldozers' front parts recorded the destruction.

Were the army to hand over to the public even a single one of these photographs taken by those cameras installed in the bulldozer's front, we could know something about what the army sees and the kinds of visual material it wishes to scrutinize. Perhaps we could also have in full action the photographer who took the photograph we are viewing now. But this photography is courtesy of the army, which released it for publication through a Wikipedia site, the Hebrew version of the free encyclopedia, to which the army apparently must be generously contributing. Here, then, is a photograph that the army wants us to view and to use without even needing its approval or copyright.

What is it about this photograph that the army chose to publicize? What exactly is the link between the act of photography that produced it and the action it describes—home demolition? The most obvious answer lies on the performance level: through the photograph, the army states that home demolition is not a contemptible act, but rather a justified action taking place in broad daylight, in view of the camera. But that is not all. The photograph, like the act of destruction, is meant not only for the eyes of the community in whose ears justifications are recited and waiting for approval. It is also destined for the eyes of the community being deterred and horrified. Home demolition, in the words of the deputy to the state attorney, advocate Shai Nitzan, is a way of "aiming, among other things, to deter potential terrorists, after having clearly learned that family is a central motive for them."

The photograph, especially chosen by the army, with a Palestinian boy at its center—he, too, being a "potential terrorist," according to the self-same operational logic, like any other Palestinian boy—is supposed to serve as a deterrent for people whose family is important to them. The boy looking at the might of the Israeli Army is supposed to internalize the military logic that chooses targets of destruction and to acknowledge its justifications. If he does internalize this, the army implies, he will give up his resistance to the occupation and his struggle for his civil aspirations (being governed like others) and his nationalist hopes (enjoying self-determination or at least participation in the regime to which he is subject). But the army cannot control the way in which a young boy, forced to escape the jaws of this terrifying tool that wreaks destruction everywhere, will appear to the viewers. The boy is familiar with these scenes of devastation—he has probably seen too many already and still does not seem willing to accept them or to recognize their movement as the embodiment of justice. While his body is terrified of the powerful D9 and runs forward, he cannot tear his gaze away from the colorful shreds of houses mangled in the dirt.

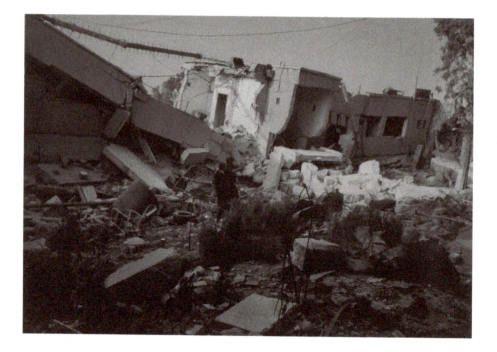

2.12 AL-MUQATA'A, JENIN, 2001 The contingency plan to demolish the government building in Jenin was prepared long before the order was issued. Many contingency plans to demolish public buildings or other "strategic" structures in Palestine exist and have been waiting for the right moment to execute them, already having been practiced by soldiers. Those soldiers supposed to carry out this demolition in Jenin waited a few days at the "assembly area" as long as it remained unclear whether the plan would be carried out. Then the Twin Towers came down. The army recognized a window of opportunity while the attention of the world was riveted on the Manhattan horror scene. This is how one of the men of the Engineering Corps among the building's destroyers described it: "As soon as the second plane hit the second tower, we got the okay to go ahead. The army always does this when

there is something special on the world scene. Say, for example, when Princess Diana was killed and world attention suddenly went elsewhere, they [the army] give us the 'Go ahead.' There are a thousand and one contingency plans that would eventually make a lot of noise, and this way no one even hears about it."

Indeed, destruction of the al-Muqata'a compound, built of three wings, as well as the inner yard where its residents used to grow vegetables for their consumption and the neighboring mosque (and the killing of nineteen Palestinians by bombing from the air) raised not a murmur in the local and international media. This photograph was taken accidentally by a journalist who happened to come to Jenin about a month later. He first heard of the destruction from Palestinians: "Here at this place there was a garden and decorative fish pond. For years, we received Israeli officers here royally [under the coordination arrangements between Israeli and Palestinian security forces in the days of the Oslo Accords]. This is how they reciprocated." The demolition of al-Muqata'a was a combination of bombing from the air and a ground operation by the Engineering Corps. Inside the building handed over to the Palestinians when the Israelis withdrew from the city under the Oslo Accords, an electronic surveillance device was concealed, and only an Engineering Corps crew could see to its destruction, so that it would not be suddenly revealed in the rubble. The various wings of the building became unusable, but the fact that their destruction was not completed turned it into a safety hazard and an additional monument of devastation.

Teddy Cruz

MAPPING NON-CONFORMITY: POST-BUBBLE URBAN STRATEGIES

Introduction: a personal reflection: where is (architectural) practice?

1. **THE TRANSFORMATION OF MY PRACTICE** in recent years, in terms of my own interests, motivations, and procedures, has been inspired by a feeling of powerlessness, as our institutions of architecture, representation, and display have lost their socio-political relevance and their commitment to advocacy. I have been increasingly disappointed at the futility of our design fields, in the context of pressing socio-political realities worldwide and the conditions of conflict that are currently re-defining the territory of intervention. It has been unsettling to witness some of the most "cutting edge" practices of architecture rush unconditionally to China and the Arab Emirates to build their dream castles, reducing themselves to mere caricatures of change and camouflaging gentrification with a massive hyper—aesthetic and formalist project. I certainly hope that, in the context of this euphoria for the Dubai's of the world and the seemingly limitless horizon of possibilities inspired by a sense of dissatisfaction, a feeling of "pessimistic optimism" can provoke us, head on, to also address the sites of conflict that define and will continue to define the cities in the 21st Century.

2. While international urban development in major urban centers has defined the economic and political recipes decorated by architectural practice, new experimental practices of intervention in the collective territory of collaboration will emerge from zones of conflict and from the margins. It is in the periphery where conditions of social emergency are transforming our ways of thinking about urban matters and the matters of concern about the city. The radicalization of the local in order to generate new readings of the global will transform the neighborhood—not the city—into the urban laboratory of our time. In this context, the task of architectural practice should not only be to make visible the long-ignored socio-political and economic territorial histories of injustice within our ideologically polarized world but also to generate new forms of sociability and activism.

3. The future of architectural practice depends on the re-definition of the formal and the social, the economic and the political, understanding that environmental degradation is a direct result of social and political degradation. No advances in urban planning can be made without redefining what we mean by infrastructure, density, mixed use, and affordability. No advances

in housing design, for example, can be made without advances in housing policy and economic subsidies. As architects, we can be responsible for imagining counter spatial procedures, political and economic structures that can produce new modes of sociability and encounter. Without altering the backward exclusionary policies constructing the territory, the socio-political ground—our profession—will continue to be subordinated to the visionless environments defined by the bottom-line urbanism of the developer's spreadsheet.

4. I am interested in a practice of intervention that engages the spatial, territorial and environmental conditions across critical thresholds, whether global border zones or local sectors of conflict generated by the discriminatory politics of zoning and economic development in the contemporary city. This suggests operational urban practices that encroach into the privatization of public domain and infrastructure, the rigidity of institutional thinking, and the current obsession with an ownership society. This also opens the idea that architects,

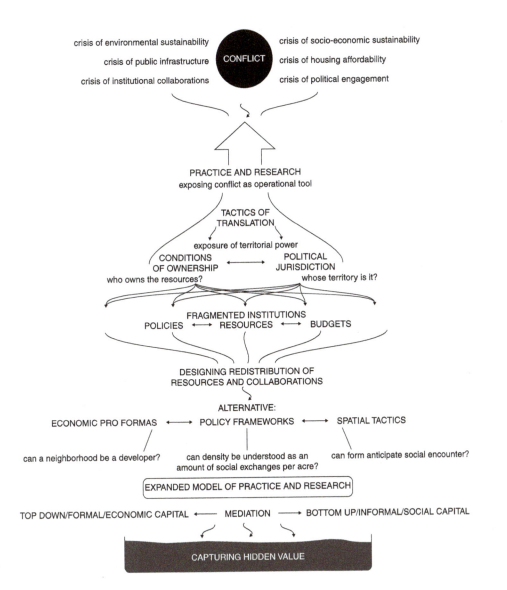

Figure 3.1 Practice Diagram.

besides being designers of form, can also be designers of political process, economic pro-forma, and collaboration across institutions and jurisdictions.

5. Architectural practice needs to engage in the re-organization of systems of urban development, challenging political and economic frameworks that are only benefiting homogenous large-scale interventions managed by private mega-block development. I believe the future is small, and this implies the dismantling of the LARGE by pixilating it with the micro: an urbanism of retrofit. No intervention into public domain can begin without first exposing political jurisdiction and conditions of ownership. Clearly, this points out the pressing need for architectural practice to re-engage the invisible forces and vectors of power that shape the territory. This is the main topic of conversation and exchange that needs to take place across disciplines, but not from the isolation of the classroom or the design studio.

6. Moving from these broad conceptual meditations into the specificity of the San Diego-Tijuana border, one oscillates back and forth between two radically different ways of constructing the city. At no other international juncture in the world can one find some of the most expensive real estate as that lying on the edges of San Diego's sprawl—barely twenty minutes away from some of the poorest settlements in Latin America, manifested by the many slums that dot the new periphery of Tijuana. These two different types of suburbia are emblematic of the incremental division of the contemporary city and the territory between enclaves of mega wealth and the rings of poverty that surround them. I am inter-ested in processes of mediation that can produce critical interfaces between and across these opposites, exposing conflict as an operational device to transform architectural practice. The critical observation of this locality transforms this border region into a laboratory from which to reflect on the current politics of migration, labor and surveillance, the tensions between sprawl and density, formal and informal urbanisms, and wealth and poverty—all of which have increasingly come to characterize the contemporary city all over the globe.

Radicalizing the local: 60 miles of trans-border urban conflict

A newly reconstituted global border between the first and third worlds is re-emerging as societies of overproduction and excess are barricading themselves in an unprecedented way against the sectors of scarcity produced by their own indifference. The border zones along this post 9–11 political equator are the sites where the forces of division and control produced by these global zones of conflict are physically inscribed, manifested, and amplified in the territory, producing, in turn, local zones of conflict.

The international border between the US and Mexico at the San Diego-Tijuana checkpoint is the most trafficked in the world. Approximately 60 million people cross annually, moving untold amounts of goods and services back and forth. A 60 linear-mile cross section between these two border cities, tangential to the border wall, compresses the most dramatic issues currently challenging our normative notions of architecture and urbanism. This trans border "cut" begins 30 miles north of the border, in the periphery of San Diego, and ends 30 miles south. Along this section's trajectory, we find a series of collisions, critical junctures, or conflicts between natural and artificial ecologies, top-down development, and bottom-up organization.

+30 miles/San Diego

Ironically, the only interruptions along an otherwise continuous sprawl—30 miles inland from the border—occur as the military bases that dot San Diego's suburbanization overlap with environmentally protected lands. This produces a strange montage of housing subdivisions,

natural ecology, and militarization. The *conflict between military bases and environmental zones* has been recently dramatized as Fallujah-like mock villages, equipped with hologram technologies to project Arab subjects. These are now being erected here as vernacular military training sites.

+25 miles

Large freeway and Mall infrastructure runs the length of Coastal San Diego, colliding with a natural network of canyons, rivers, and creeks that descend towards the Pacific Ocean. A necklace of territorial voids is produced out of the *conflict between large infrastructure and the watershed*. As the politics of water will define the future of this region, the recuperation of these truncated natural resources are essential to anticipate density.

+20 miles

Top-down private development has been installing a selfish and oil-hungry sprawl of detached McMansions everywhere. The *conflict between master-planned gated communities and the natural topography* flattens the differential landscape of San Diego's edges and encroaches into the natural cycles of fire-prone areas. This archipelago of beige tract homes also exacerbates a land use based on exclusion, turning it into a kind of apartheid of everyday life.

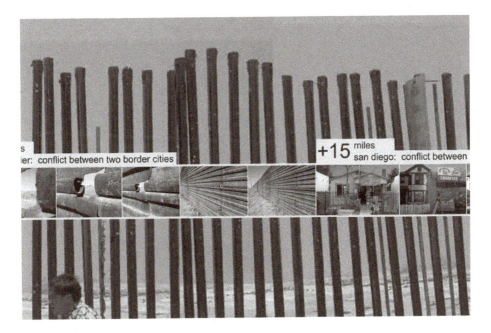

Figure 3.2 Radicalizing the Local: 60 linear miles of transborder conflict, 2008.

+15 miles

San Diego's downtown has reconfigured itself with exclusive tax-revenue, re-development powers, becoming an island of wealth delimited by specific zoning and budgetary borders.

Luxury condos and hotels, stadiums and convention centers, surrounded by generic commercial franchises compose this stew of privatization from New York to San Diego. The proximity of wealth and poverty found at the border checkpoint is reproduced here in the *conflict between powerful downtowns and the neighborhoods of marginalization* that surround them. It is in these neighborhoods where cheap labor-immigration concentrates, conveniently becoming the service sector that supports downtown's massive gentrification project.

+10 miles

The *conflict between the formal and the informal* emerges as immigrants fill the first ring of suburbanization surrounding downtown, retrofitting an obsolete urbanism of older postwar bungalows. Informal densities and economies produce a sort of three-dimensional land use that collides with the one-dimensional zoning that has characterized these older neighborhoods.

0 miles

At the border itself, the metal fence becomes emblematic of the *conflict between these two border cities*, reenacting the perennial alliance between militarization and urbanization. This territorial conflict is currently dramatized by the hardening of the post 9–11 border wall that divides this region, incrementally transforming San Diego into the world's largest gated community. As we cross the border into Mexico, the first sight we witness is how the large infrastructure of the Tijuana River clashes with the border wall. This is the only place where an otherwise continuous metal fence is pierced and opened as the river enters into San Diego. A faint yellow line is inscribed on the dry river's concrete channel to indicate the trajectory of the border. But as the channel moves beyond the fence and into San Diego's territory, the concrete disappears becoming the Tijuana River Estuary, a US ecological reserve, which frames the natural ecology of the river as it flows freely towards the Pacific Ocean. What dramatizes this *conflict between the natural and the political* is the fact that the border checkpoint is exactly at the intersection of both, punctuating the environmentally protected zone with a matrix of border patrol vehicles, helicopters, and electrified fences.

−10 miles/Tijuana

Many of the sites of conflict found in San Diego are reproduced and amplified in Tijuana. As Tijuana grows eastward, for example, it is seduced by the style and glamor of the master-planned, gated communities of the US and builds its own version—miniaturized replicas of typical suburban Southern California tract homes, paradoxically imported into Tijuana to provide "social housing." Thousands of tiny tract homes are now scattered around the periphery of Tijuana, creating a vast landscape of homogeneity and division that is at odds with this city's prevailing heterogeneous and organic metropolitan condition. These diminutive 250 sq. ft. dwellings come equipped with all the clichés and conventions: manicured landscaping, gate houses, model units, banners and flags, mini-set backs, front and back yards.

−15 miles

The *conflict between the formal and the informal* is reenacted here, as these mini-tract homes quickly submit to transformation by occupants who are little hindered by permissive zoning

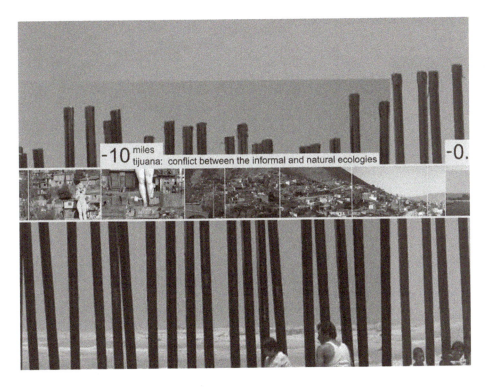

Figure 3.3 Radicalizing the Local: 60 linear miles of transborder conflict, 2008.

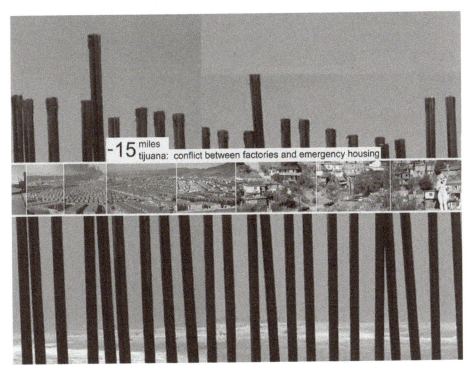

Figure 3.4 Radicalizing the Local: 60 linear miles of transborder conflict, 2008.

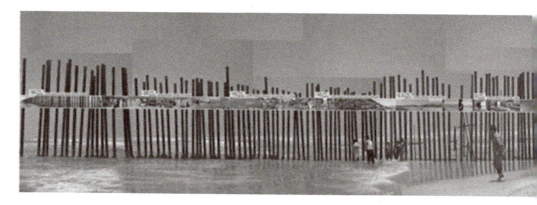

Figure 3.5 Radicalizing the Local: 60 linear miles of transborder conflict, 2008.

regulations. While the gated communities of Southern California remain closed systems due to stringent zoning that prohibits any kind of formal alteration or programmatic juxtaposition, these housing tracts in Tijuana are dramatically altered by their occupants—filling in setbacks, occupying front and back yards as well as garages with more construction to support mixed use and more usable space.

−20 miles

These American-style, mini-master-planned communities are intertwined with a series of informal communities or slums, and both surround Maquiladora (NAFTA assembly factories) enclaves. The *conflict between cheap labor and emergency housing* is produced here as these factories extract cheap labor from these slums without providing any support for dwelling. As these favela-like sectors grow out of proportion, they also encroach into the natural ecology of Tijuana's delicate topography, reenacting also the *conflict between the informal and the natural*.

−30 miles

And then, as we reach the sea on the Mexican side, we witness the most dramatic of all territorial collisions across this 60 mile-section of local conflict. After traveling many miles across the border territory, the border metal fence finally sinks into the Pacific Ocean, producing a surreal sight that further amplifies the clash between the natural and the jurisdictional.

It is in the midst of many of these metropolitan and territorial sites of conflict where contemporary architectural practice needs to reposition itself. In other words, no meaningful intervention can occur in the contemporary city without first exposing the conditions, political and economic forces (jurisdiction and ownership), that have produced these collisions in the first place.

Cross border suburbias: urbanisms of transgression

When Kevin Lynch was commissioned by a local environmental group to come up with a "regional vision plan" for the US-México border zone in 1974, he dreamed of a *Temporary Paradise*. Addressed to the City Planning Commission of San Diego, his bi-national planning

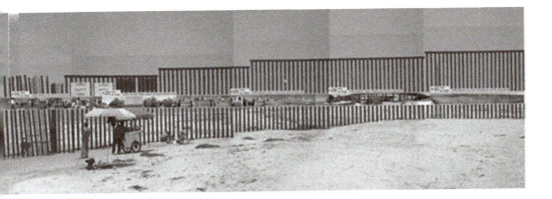

strategy focused on the network of canyons and watersheds that traverse the landscape on both sides of the San Diego-Tijuana border. Lynch could never have predicted that neither the natural landscape *nor* city planners would define the real action plan for trans-border urbanism and that, instead, it would be an emergent network of underground tunnels master-minded by drug lords and "coyotes," who would quietly and invisibly efface the formidable barrier that separates the two cities. Now, 34 years later, at least 30 tunnels have been discovered—a vast "ant farm"-like maze of subterranean routes, all of which have been dug within the last eight years, criss-crosses the border from California to Arizona. At the very least, this creates a *permanent hell* for the US Department of Homeland Security.

An archaeological section map of the territory today would reveal an underground urbanism worming its way into houses, churches, parking lots, warehouses, and streets. The most outlandish and sophisticated of these tunnels, discovered by US border officials in January of this year, is clearly the work of professionals: up to 70 feet below ground and 2,400 feet in length, its passageways are five to six feet high and four feet wide to permit two-way circulation. Striking not only for its scale, but also for its "amenities," the tunnel is equipped with ventilation and drainage systems, water pumps, electricity, retaining reinforcements, and stairs connecting various levels. Beyond its use by drug traffickers, it was also "leased out" during "off" hours to coyotes transporting illegal aliens into the US, making it perhaps the first mixed-use smuggling tunnel at the border. Some might see this as a marvel of informal transnational infrastructure, but most locals understand it as just another example of the vigorous Méxican-American economy at work.

Beyond the sensationalism that might accompany these images, the undeniable presence of an informal economy and the politics of density surround what is exposed here. As we actually insert the actual location of these illegal tunnels into an existing official border map, a different image of the borderline appears. The linear rigidity of the artificial geopolitical boundary, which has "flat-lined" the pulsations of the living complexity of the natural, is transformed back into a complex set of porous lines perpendicular to the border, as if they were small leakages that began to percolate through a powerful dam. As these lines puncture the borderline in our fictional cartography, they almost restore the primacy of the network of existing canyons, juxtaposing the natural with the socio-economic flows that continue to be "under the radar" in our official modes of urban planning representation.

By zooming further into the particularities of this volatile territory, traveling back and forth between these two border cities, we can expose many other landscapes of contradiction where conditions of difference and sameness collide and overlap. A series of "off the radar" two-way border crossings—North-South and South-North across the border wall—suggest

that no matter how high and long the post-9/11 border wall becomes, it will always be transcended by migrating populations and the relentless flows of goods and services back and forth across the formidable barrier that seeks to preclude them. These illegal flows are physically manifested, in one direction, by the informal land use patterns and economies produced by migrant workers that flow from Tijuana and into San Diego, searching for the strong economy of Southern California. But, while "human flow" mobilizes northbound in search for Dollars, "infrastructural waste" moves in the opposite direction to construct an insurgent, cross-border urbanism of emergency.

South to North: suburbs made of non-conformity
Tijuana's encroachment into San Diego's sprawl

Over the past decades, millions of migrants have flowed northward in pursuit of one of the strongest economies in the world, the state of California, with the assurance that such economic power still depends exclusively on their cheap labor—a demand and supply logic. As the Latin American diaspora travels northbound, it inevitably alters and transforms the fabric of San Diego's sub-divisions. Immigrants bring with them diverse socio-cultural attitudes and sensibilities regarding the use of domestic and public space as well as the natural landscape. In these neighborhoods, multi-generational households of extended families shape their own programs of use, taking charge of their own micro-economies in order to maintain a standard for the household. These households generate non-conforming uses and high densities that reshape the fabric of the residential neighborhoods where they settle. Alternative social spaces begin to spring up in large parking lots, informal economies such as flea markets and street vendors appear in vacant properties, and housing additions in the shape of illegal companion units are plugged into existing suburban dwellings to provide affordable living.

The areas of San Diego that have been most impacted by this non-conforming urbanism are concentrated in its first ring of suburbanization. At this moment developers and city officials are still focusing on two main areas of development—on one end, the high-income gentrifying re-development of downtown, and on the other, the increasingly expansive project of sprawl made of an equally high-priced real estate project and supported by oil hungry infrastructure. It is the older neighborhoods of San Diego's mid-city which remain depressed and ignored. It is here, in the first ring of suburbanization, where immigrants have been settling in recent years, unable to afford the high rents of downtown's luxury condos and the expensive McMansions of the new suburbs.

Conveniently, they have become the cheap-labor service providers to both. Fifty years ago, these older neighborhoods in the mid-city did not look that much different than the new rings of suburbanization of today. The older subdivisions were also following a Levittown recipe, made of homogeneity and standardization, similar to the master-planned gated communities being built today. But while the logic behind this urbanism of sameness continues to be reproduced today, it is the scale of the sprawl that has changed. In other words, as the new rings of suburbanization require a version of Levittown on steroids, the mid-city's small scale has made these older neighborhoods obsolete, as its post war bungalows are not able to accommodate the current super-size me housing market. This obsolescence has produced a void that has began to be filled by the temporal, informal economies, and patterns of density promoted by immigrants, fundamentally altering the homogeneity of this first ring of Levittown-type suburbanization into a more complex network of socio-economic relationships.

The shifting of cultural demographics in the mid-city has transformed many of these neighborhoods into the site of investigation for my practice, as the main inspiration of

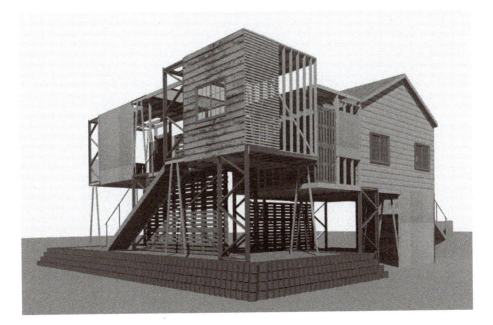

Figure 3.6 Manufactured Sites: A housing urbanism made of waste, 2005.

our research has focused on the impact of immigration in the transformation of the American neighborhood. The critical observation of the mutation of these older bedroom communities—from rigid, mono-cultural, and one-dimensional environments into informal, multi-cultural, and cross-programmed communities—opens the question: how do we anticipate density? It might be that the future of Southern California urbanism will be determined by tactics of retrofit and adaptation, making the large small.

One of the most emblematic examples of the retrofitting of Levittown is the *"non-conforming Buddha."* Incrementally, throughout the last twenty years, a tiny post-war bungalow in the mid-city neighborhood of City Heights in San Diego has been transformed from a single-family residence into a Buddhist temple. The small decorative lawn that filled the front yard has been hardened into a fake, shiny marble plinth that serves as altar for a huge, white statue of Buddha that encroaches illegally into the front set back. The driveway has become a dining room leading into the main interior altar, meditation space and community room. The old set backs that define the separation of this house from its neighbor have now been filled with small sheds to accommodate other programs related to the temple. From far away, though, and framed by the small street it occupies, this small bungalow resembles another typical house. It is not the typological and spatial transformations of this small house what is really interesting here, but the fact that this house has now become a social agency inside the neighborhood, facilitating social relations, pedagogical programs, cultural support, and economic exchanges. The idea that one unit of dwelling has become a multi-faceted social agency suggests that our normative idea of density needs to be questioned.

Beyond density (as an amount of units per acre)

Our institutions of representation across government, academia, and development have been unable to critically observe and translate the logic of the informal socio-economic dynamics at play not only at the border itself, but within the city at large. The official documentation of land

use at any city agency, whether in San Diego or Tijuana for example, has systematically ignored the non-conforming and self-organizing dynamics of these environments by continuing to advocate a false, bi-dimensional land-use convention based on abstract information rendered at the planners' table, whereby retail is represented with red and housing with yellow—each safely located adjacent to one another in the best of scenarios, since they are typically very fart apart.

If, on the other hand, one were to map the *real* land use in some of the San Diego neighborhoods that have been impacted in the last decades by waves of immigration from Latin America, Africa, and Asia—examining them parcel by parcel, block by block—a land use map would emerge with at least ten or more "zone colors." These "zone colors" would reflect the gradation of use and scale of the diverse social composition as well as non-conforming small businesses and social exchanges that characterizes such culturally intensive areas of the city. We would also find a three-dimensional zoning based not on adjacencies but on juxtapositions, as dormant infrastructures are transformed into usable semi-public spaces, and larger than "needed" parcels are illegally subdivided to accommodate extra dwelling units. In other words, the appropriation and negotiation of public and private boundaries remains anathema for conventional code regulation, ignoring the potentialities that this stealth urbanism can open. How to alter our conventions of representation in order to absorb the ambiguity of these forces, remains the essential question in the negotiation between the formal and the informal city.

Similar to the cartography of cross-border illegal tunnels, then, an accurate bi-national land use map does not currently exist. If we were to "cut and paste" the existing land use documents from Tijuana and San Diego, a borderline (without marking the border wall itself) would again "appear" between the two cities as the larger land use "chunks" of San Diego come side to side with the smaller pixilation of Tijuana's Land Use map—two different ways of administering density and mixed uses, barely twenty minutes apart. A fictional Cartography of this "collision" would invite one to speculate an alternative way of representing the transformation of some of the San Diego neighborhoods impacted by informal patterns of development: this new land use map would show the higher pixilation of Tijuana's three dimensional and multi-color zoning crossing the borderline and slipping into San Diego. The "stains" of this higher pixilation are deposited in many of these older neighborhoods, beginning to form an archipelago of pockets of difference within the sea of the current homogeneous sprawl that defines this city.

What this phenomenon points out, then, is the fact that our institutions of representation are also unable to mediate the multiple forces that shape the politics of the territory and resolve the tensions between the top-down urban strategies of official development as well as the bottom-up tactics of community activism. The micro heterotopias that are emerging within small communities in the form of informal spatial and entrepreneurial practices are defining a different idea of density and land use. Making visible the invisibility of these non-conforming forces and their operational potential to bridge between the formal and the informal, the wealthy subdivisions and the enclaves of poverty (service communities) in the city would be the only point of departure to construct a different idea of density and sustainability. We need to engage new conceptual and representational tools that can allow us to transcend the reductive understanding of density as an abstract amount of units/inhabitants per acre, and, instead, reaffirm it as an amount of "social interactions and economic exchanges" per acre.

North to South: suburbs made of waste
San Diego's Levittown is recycled into Tijuana's slums

While migrants go north, the waste of San Diego flows southbound to construct an urbanism of emergency. This is how one of the most dramatic and "unnoticed" urban flows across the

Tijuana-San Diego border is comprised by the amount of urban waste that is transferred from San Diego into Tijuana. This phenomenon occurs as sections of San Diego's older suburbs begin to erode, so that developers can install a new recipe of development, while a few miles south, in Tijuana, new informal suburbs or slums spring up from one day to another.

In addition to immigrants retrofitting a large section of San Diego's mid-city, other parts of San Diego's first ring of suburbanization have been replaced by larger versions of themselves. As new and large McMansion sub-divisions update these older suburbs in San Diego, the first ring of suburbanization has been dismantled, piece-by-piece, in the last years (small bungalows are being dismembered and their pieces given away to speculators). This is how Southern California Levittown's debris is recycled to build the new periphery of Tijuana.

Figure 3.7 No stop sprawl: McMansion retrofitted, 2008.

The left over parts of San Diego's older sub-divisions, standard framing, joists, connectors, plywood, aluminum windows, and garage doors are being disassembled and recombined on the other side, across the border. Once in Tijuana edges, out of social and emergency and housing shortage, these parts are reassembled into fresh scenarios, creating a housing urbanism of waste. But not only small, scattered debris is imported into Tijuana. Entire pieces of one city travel southward as residential ready-mades are directly plugged into the other's fabric. This process begins when a Tijuana speculator travels to San Diego to buy up little post-war bungalows that have been slated for demolition. The little houses are loaded onto trailers and

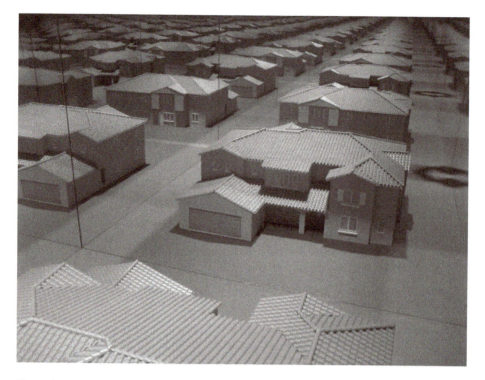

Figure 3.8 No stop sprawl: McMansion retrofitted, 2008.

prepared to travel to Tijuana, where they will have to clear customs before making their journey south. For days, one can see houses, just like cars and pedestrians, waiting in line to cross the border. Finally the houses enter into Tijuana and are mounted on top of one-story metal frames, leaving an empty space at the street level to accommodate future uses. These floating houses define a space of opportunity beneath them, which will be filled, through time, with more houses, a taco stand, a car repair shop, a garden. One city profits from the dwellings that the other one discards, recombining them into fresh scenarios and creating countless new possibilities. This is how the border cities enact a strange mirroring effect. While the seemingly permanent housing stock in San Diego is turned disposable from one day to another, the ephemeral dwellings in Tijuana want to become permanent.

So, as one city recycles the "left over" of the other into a sort of "second hand" urbanism, Tijuana's informal settlements are shaped by these cross-border recycling dynamics and by organizational tactics of invasion, allowing settlers to claim underutilized territory. While San Diego's vast sprawl is incrementally made of gigantic infrastructure to support loosely scattered units of housing, dense inhabitation happens first in Tijuana's edges so that incremental small infrastructure can follow.

This temporal, nomadic urbanism is supported by a very sophisticated social choreography of neighborhood participation. Hundreds of dwellers called "*paracaidistas*" (parachuters) invade, en masse, large public (sometimes private) vacant properties. As these urban guerillas parachute into the hills of Tijuana's edges, they are organized and choreographed by what are commonly called "urban pirates." These characters, armed with cellular phones, are the community activists (or land speculators) who are in charge of organizing the first deployment of people at the sites as well as the community in an effort to begin the process of requesting services from the city. Through improvisational tactics of construction and

distribution of goods and ad hoc services, a process of assembly begins by recycling the systems and materials from San Diego's urban debris. Garage doors are used to make walls (entire houses are made with garage doors as the main structural and exterior skin). Rubber tires are cut and dismantled into folded loops, clipped and interlocked, creating a system that threads a stable retaining wall. Wooden crates make the armature for other imported surfaces, such as recycled refrigerator doors, etc. After months of construction and community organization, the neighborhood begins to request municipal services. The city sends trucks to deliver water at certain locations and electricity follows as the city sends *one* official line, expecting the community to "steal" the rest via a series of illegal clippings called "*diablitos* (Little Devils)." These sites are threaded by the temporal stitching of these multiple situations, internal and external, simultaneously, making the interiors of these dwellings become their exteriors, expressive of the history of their pragmatic evolution. As one anonymous resident put it: "Not everything that we have is to our liking, but everything is useful."

Ultimately, this intensive recycling urbanism of juxtaposition is emblematic of how Tijuana's informal communities are growing faster than the urban cores they surround, creating a different set of rules for development, and blurring the distinctions between the urban, suburban and the rural. As notions of the informal are brought back, recycled by the fields of architecture and urbanism in debating the growth of the contemporary city, let's hope that it is not only the figural "image" of the ephemeral and nomadic that is once more seducing our imagination, but the complex and temporal evolutionary processes beneath them, whose essences are grounded on socio-political and economic dynamics.

Epilogue: returning Duchamp's urinal to the bathroom

1. One of the most important issues underlying my research has been to produce new conceptions and interpretations of the informal on both sides of the border. We continue to be seduced with the "style" of the informal without translating its actual operative procedures. Instead of a fixed image, I see the informal as a functional set of urban operations that allow the transgression of imposed political boundaries and top down economic models. I see the informal not as a noun but as a verb, which detonates traditional notions of site specificity and context into a more complex system of hidden socio-economic exchanges. I see the informal as the urban unwanted, that which is left over after the pristine presence of architecture with capital "A" has been usurped and transformed into the tenuous scaffold for social encounter. I see the informal as the site of a new interpretation of community, citizenship and praxis, where emergent urban configurations produced out of social emergency suggest the performatic role of individuals constructing their own spaces.

2. But the social capital and cultural economy embedded within these marginal communities and border neighborhoods, which have been the site of investigation for our practice, are never included in the "official" process of urbanization and economic development. Community engagement in the theater of city re-development in the United States is always reduced to a symbolic gesture that transforms social participation into a "multiple choice questionnaire" for community revitalization, a process that is ultimately co-opted by the politics of identity—In what style should we build? This is how at a time when the institutions of urban planning need to be re-defined, one particular topic that needs to be considered is the value of social capital (people's participation) in urban development, enhancing the role of communities in producing housing. What are needed are housing configurations that enable the development and emergence of local economies and new forms of sociability, allowing neighborhoods to generate new markets "from the bottom up," within the community (i.e., social and economic entrepreneurial efforts that are usually off the radar of conventional top down economic recipes),

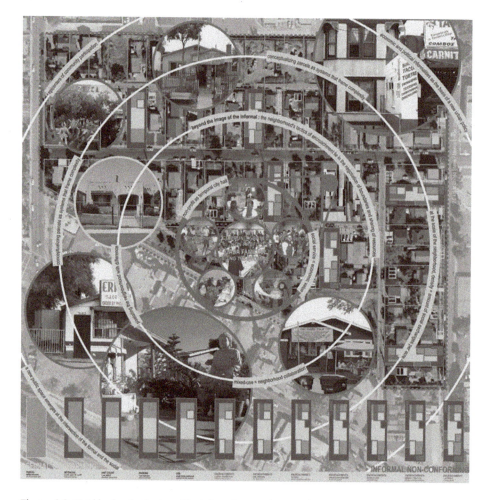

Figure 3.9 Neighborhood urbanism: The informal as a tool to transform policy, 2007.

as well as to promote new models of financing to allow unconventional mixed uses. Another pressing challenge in our time, primarily when the paradigm of private property has become unsustainable in conditions of poverty, is the need to re-think existing conditions of property ownership. Re-defining affordability by amplifying the value of social participation: More than "owning" units, dwellers, in collaboration with community based, non-profit agencies, can also co-own the economic and social infrastructure around them.

3. But often, there is a gap between the institutions of community development and the actual lived reality of these entrepreneurial energies that are seldom mobilized by top down institutions of zoning and lending. In fact, these communities often lack the conceptual devices to understand their own every day procedures and how their neighborhood agency can trickle up to produce new institutional transformations, shaping alternative politics and economies at the scale of their own everyday needs.

4. It is here where a different notion of empowerment emerges, less to do with the symbolic representation of people by which architectural or artistic social practices only deploy the symbolic image of the community and not its operative dimension. Empowerment here signifies an act of translation and political representation at the scale of neighborhoods: the visualization of citizenship. These communities' invisible urban praxis

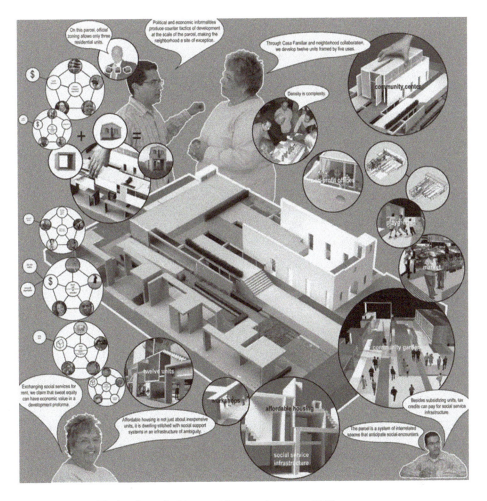

Figure 3.10 Neighborhood parcels: Micro social economic systems, 2007.

needs interpretation and representation, and, as architects, this is the space of intervention that we are interested in occupying. We should seek to design the conditions that can mobilize this activism into new spatial and economic infrastructures that benefit these communities of practice in the long term, beyond the short-term problem solving of private developers or the charitable institutions. To act as facilitators of this bottom up intelligence means translating the ethical knowledge specific to a community into new communicational systems, radical urban pedagogy, and micro-political and economic armatures—in essence, an urbanism at the scale of the neighborhood, and a community as political and economic unit.

5. Finally, in these times of crisis, empowerment also means the production of an expanded notion of practice, new ways of constructing information and conversation among ourselves, the so called "experts." It is our responsibility to problematize the debate, mediating across these stakeholders as well as the compartmentalization of our own fields and institutions of artistic display and production. We need a critical re-contextualizing of our different approaches and procedures. The trans-border urban flows that have been the laboratory for my practice are the backdrop for the need to transcend our reductive and limited ways of working, by which we continue to see the world as a tabula rasa on which to install the autonomy of architecture. Today, it is essential to reorient our gaze towards

the drama embedded in the reality of the everyday and, in so doing, engage the shifting socio-political and economic domains that have been ungraspable by design. Or, as artist Tania Bruguera said to me recently: "It is time to restore Duchamp's urinal back to the bath-room!" suggesting a more functional relationship between research, artistic intervention, and the production of the city.

Beth Coleman

X-REALITY: INTERVIEW WITH THE VIRTUAL CANNIBAL

An appetite for the virtual

YOU WOULD THINK a virtual cannibal's biggest problem would be that neither he nor his victims have bodies, but you would be wrong. Gy is the avatar of a French white male adult whose profession combines writer, translator, and artist. In the summer of 2007, I met Gy through a network of acquaintances in Paris. That spring had seen the explosion of European participation on the virtual world Second Life (SL), particularly in France and Germany, and Gy emerged from that European wave.[1] He and I never met face to face, only via our avatars. In that mediated form, Gy told me that in this online experience *virtual cannibalism* had seized his imagination. He participated in a gynophagia (eating woman) sex-play group that simulated sexual engagement that includes rape, other forms of violent assault, asphyxiation, and ultimately the death and consumption of the victim. In short, he practiced virtual cannibalism as a sexual game.

To this end, the players use their avatars to role play as dominant or submissive actors, engaging the verbal (text), scripting (computer code), and graphical resources of the platform to enact the scenarios. Part of the attraction for Gy and other players who participate in this manner of sexual intercourse lay precisely in the transgression of the boundaries of postmodern culture. In terms of what may actually be done to another person (legally and morally), but also what may be represented as a desired activity, the virtual cannibals broke an inviolable taboo: eating human flesh.

Out of the many interviews I conducted, I chose Gy's narrative as the subject of extended analysis because his experience highlights central issues of networked media, a culture of advanced simulation, and the role of an avatar as a subjective proxy. By exploiting the affordances of a virtual platform to its hyperbolic end—enacting the most extreme and violent of actions—the virtual cannibal becomes an instructive figure. He plays out in the extreme the options that a virtual world without consequences might offer, allowing us to consider whether, indeed, such a space exists. Are the acts, be they symbolic or simulated for which there are no consequences? How do we comprehend simulation as it becomes increasingly visual and pervasive?

X-reality: the actual of pervasive media

It is in the vernacular of an everyday experience—the extraordinary *and* the ordinary—that I argue for an understanding of networked media as augmentation of self and world as opposed to fragmentation. I call this shift from the binary engagement of virtual/real to a multi-vector engagement that spans types of connections X-reality. X-reality marks the variable spaces, places, and temporalities in which a network society exists, calling for an expanded vision of what comprises one's world. It calls for an expanded vision of what comprises one's world.

This shift in perspective is crucial for how we move forward in analysis, design, and engagement of pervasive media. What I demarcate with the term "pervasive media" is a global culture that engages a spectrum of networked technologies, such as virtual worlds, voice-over-Internet protocol (VoIP), mobile rich-media and texting, and microblogging formats. Implicit to pervasive media engagement is a convergence of multiple or transmedia forms. I frame the term in reference to the language of computer science where pervasive computing, also known as ubiquitous computing, describes a world in which objects, places, and gestures are included on a computational network. My coinage both borrows from this computational idea of ubiquity even as I emphasize cultural practices of networked engagement, as opposed to a primarily technological one.

In the course of my field research and analysis of media platforms, I have observed that, as networked subjects, we exist in a space of pervasive media engagement, where our avatars (our online faces) represent us in a persistent manner to a recognized community.[2] We can date this shift to the turn of the twenty-first century, when social media applications grew massively popular and became extensions of real life identities. At this point, media users already regard pervasive networked engagement as a necessary supplement, or virtual prosthesis, built into the fabric of everyday life.

Within this context, persistence of identity as the dominant characteristic of network use represents one of the most profound cultural shifts of the Internet. This shift is played out in the growing hegemony of platforms, such as Facebook (a social network site with 5000 million users as of 2010), that technically require one's profile to be authenticated. More importantly, Facebook demands a cultural authority, supported by its users, that platform participants properly identify themselves. Similarly, the success of professional networking sites such as LinkedIn are based on a contact network of true names and authorized links. In an increasingly spam-filled, criminal, and crowded Internet, one hears the call for authentication and identity management from users themselves.[3] I am suggesting that contemporary networked media use demonstrates a marked interest in the consolidation and protection of identity.[4]

During the mid to late '90's, sociologist of technology Sherry Turkle's concept of cycling through identities became a broadly adopted model for comprehending network media culture.[5] In contrast, I identify the media engagement of a contemporary networked generation as actual and persistent. Instead of cycling through, we now work *across* and thereby extend our sites of engagement. We have reached an end of the virtual, as such, and entered an age of pervasive media. The trend we see today is that one's lived identity and one's life online move closer to each other as social network affiliations become more robust across media platforms and are paired with face-to-face gatherings. The question I ask Gy, and the analysis I provide of this community of media users, is what does it mean to create an actual experience using simulation as the primary tool?

Spectator of your life

In general, Gy describes his interest in Second Life as ancillary. He does not speak of the virtual world as critical to his sense of self or his relationships; he describes his participation essentially as casual. Gy ventured into the space sideways, by way of computer gaming and a philosophical interest in language. (In the virtual world, Gy quickly honed in on a pointedly erotic value of language, where the limitations of avatar communication advance a polarized discourse; language becomes more sexual and violent, as I discuss below.) Good graphics are important to him in video games, he explained, but it is primarily the chat as action, the language-based play in the virtual world platform that enticed him about Second Life.

Gy sums up his view of avatars with the observation that "you're the spectator of your life here," followed by the smiley face emoticon:) to underscore the nature of the text-based conversation we carried on during the course of the interview. In the recounting of his cannibal adventures, Gy enthusiastically exploits the rift between his presence in real life and the spectral presence of watching one's avatar do one's bidding. When he speaks of what he has done and seen through his avatar, Gy most often uses the third person "he," as opposed to saying "I." When I ask him about this split, the distance between him and the visible agent of his actions, he describes it as a symptom of simulation, a split between self and representation:

> **Interviewer:** "he" not "you" or "I"
> Gy: but then that works like in rl [real life] for that part well.
> [S]chizophrens from all countries get united!
> **Interviewer:** yah
> Gy: that could be the special SL sentence. lol. [Y]ou're the spectator of your life here.:)

Gy's comment on the similarity of virtual and real life suggests that we encounter such rifts between self and self-perception every day, but that this schism is the very order of a mediated world. And, at least for a period of time, Gy delighted in watching his life unfold in the acts of a "he" who stands in for "I."

As we proceeded in the interview, the subject expressed two basic sentiments about his virtual world engagement. He regularly referred to a sense of the unreality of life, disengagement, a feeling of ennui, and feeling outside of himself. And he regularly referred to the actuality of the simulated experience, describing the visceral responses on his part and other participants. In my analysis of our interview, I suggest that these are not contradictory sentiments. In his account, I understood not a bifurcation of real versus virtual, but rather a reflection and combination of the two states.

Rules of engagement

I meet him first in Elpida, a picturesque virtual garden full of lush greenery and romantic walkways. Gy showed up as a small monkey that scampered about—his appearance the result of an avatar monkey suit that included animation scripting for motion. My avatar, Hapi, appeared in its bespoke Cute Robot form. Gy suggested we sit down to talk, a convention that has nothing to do with whether the avatar is tired or not, but rather with online gestures of human attention. As with the Lessig reading, sitting indicated that we were having a focused conversation. For the interview, we moved to a teahouse in Sokri, a Japanese-themed town (see Figure 4.1). Over the course of our interview, Gy described an insular group that created a self-contained theatre of cruelty.

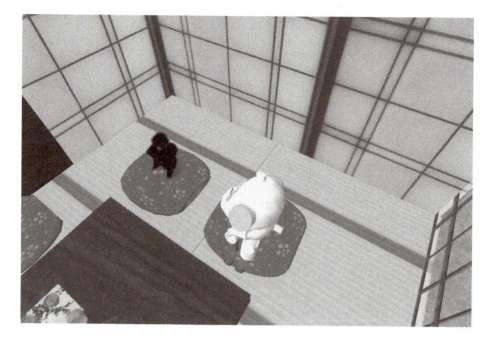

Figure 4.1 Interview with the virtual cannibal: Gy, the virtual cannibal in his monkey-suit avatar, and the author meet at the Sokri teahouse in Second Life.

Credit: B. Coleman.

My first question for Gy was: what brought you to this particular platform, and what did you find when you arrived there? He explained that playing video games brought him to Second Life, but when he got there it was nothing like the first-person shooting game he had been used to playing. In fact, Gy said, "Second Life is boring as a video game." He expressed a feeling that many video game players feel in regard to social media platforms that do not have a specified action agenda: there is nothing to do, or rather there is only something to do if you invent it or find it. Gy pointed out that this kind of interaction made for some surprising discoveries. "The way you can interact with subjects is pretty amazing," he said. Unlike his prior experiences with video game avatars, Gy said, "the character you forge [in Second Life] starts to have his own history, just like in real life."

The refrain "just like in real life" winnows its way through the language of most virtual world players, regardless of genre or individual goals. In making the comparison between real and virtual, people grasp for a way to explain what it feels like to be somewhere perceptually, but physically not there at all. Gy uses the analogy to explain how Second Life presents a virtual experience that does not function as a game. But pause for a moment: if avatars running across a computer screen do not epitomize "gameness," then what does (see Figures 4.2–3)?

Game designers Katie Salen and Eric Zimmerman define gaming as a "system in which players engage in an artificial conflict, defined by rules, that results in a quantifiable outcome."[6] The rule-based system with measurable result, as defined by Salen and Zimmerman, does not apply to largely social virtual world engagement. Yet much of what characterizes networked media design qualifies as game-like.

Specifically, it is a game of chance that facilitates Gy's movement across the virtual world. As one might speak of encountering a stranger in a foreign city, Gy speaks of luck or the chance encounter in the virtual domain.[7] His avatar accumulates a history, Gy says,

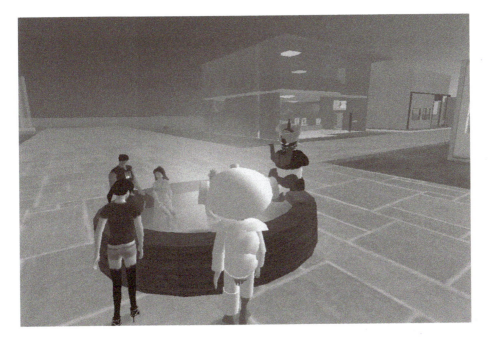

Figure 4.2 Virtual tourist: The author joins a hot tub party in Second Life's Japan town, where a Shogun Warrior also enjoys a virtual soak.

Credit: B. Coleman.

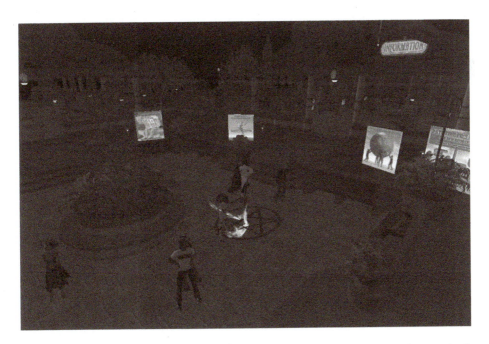

Figure 4.3 Stumble upon: The author lands in the middle of a satanic cabal on entering the Second Life welcome area, October 2007.

Credit: B. Coleman.

"through the places he goes to, the persons he meets, and all that is based on chance." For example, he tells the story of his first meeting with the cannibal cult as a chance encounter.

"It really started," says Gy, "when I met a girl at the entry of one of these brothels and didn't enter it. She proposed me [sic] to play in a SL snuff movie. lol [laugh out loud]." He explained that in many ways a snuff film—making a movie where the actor is actually killed—is perfectly placed in a virtual context. "[T]hat's quite natural when you think about it," he reflected. "It is more death than life [in the virtual world], I guess."

In Western culture, sexual pleasure has been described as a petit mort—a little death. In his assessment of virtual representation—the mimetic space of simulation—Gy saw an imitation of death, not life. Thus, in his virtual play, Gy made the "little death" literal. He took advantage of the technical affordances and permissive culture he has found in Second Life to launch an uncharted experience: to simulate death. It is common for people to claim a life in a virtual world that surpasses what they find in the real one. From the paper and dice worlds of Dungeons and Dragons to the graphically rich networked platforms, there is a long history of participants claiming freedoms and happiness in the virtual world that the real world could not provide. Gy's testimony supports this claim, but with a distinct twist. What he finds is not synthetic life but rather artificial death as the way to augment his experience of the world.

Death, or rather killing, is represented in video games thousands of times a second throughout the world, with war and first-person-shooter games remaining the most popular genre. In comparison to other forms of simulated violence, virtual cannibalism is distinct in its systematic representation of rape and murder as a protracted, ceremonial act. With first-person-shooter games it is the act of shooting that primarily absorbs the player. With virtual cannibalism it is the sexualized staging of an execution. I observed in the cannibals' activities a provocative intention to break societal taboos. In their negotiation of simulation as an aspect of networked media, I also saw qualities that are important for understanding how to think about an increasingly mediated world. Effectively, one finds in the cannibals' staging of death both a critique of simulation and a dissolving of the boundaries between virtual and real.

Staging death

In following the avatar he met in front of a virtual brothel, Gy had essentially jumped down a rabbit hole in which he would emerge as a participant in an online BDSM cult. BDSM stands for bondage/discipline and sadism/masochism. The acronym covers an array of sexual practice that includes domination and submission, punishment, role-playing, and other activities, some with an erotic link to cannibalism and snuff. The rigid protocol of BDSM role-playing fits well within the context of a virtual world such as Second Life. In effect, the real-world role-play creates a game structure for the open-ended design of the virtual platform. A discipline of identity and behavior can be imported into the virtual world. This engagement can, in fact, sustain the absence of real bodies and physical violence even while the symbolic register of the exchange remains intact.[8] Like other rule-based systems, this one—apart from what it signifies—establishes procedures for behavior to which participants abide.

In his description of this interplay, Gy speaks of a staging effect particular to his virtual-cannibal activities: removed from any particular attempt at realism, cannibals exploit the unreal aspects of simulation to amplify their actions. Using the visualization tools at hand, they create a spectacle for themselves and any other viewer online.[9]

Shouting to be heard: limits of simulation

In entering the virtual world platform, Gy found a 3D rendering of places and avatars functioning in a real-time network. What the Second Life platform did not have, however, was specified rules of engagement. In the terms of service agreement, there were rules forbidding the destruction of virtual property and hate speech, but no guided play or specific procedural narrative as one might find in a computer game. In Second Life, participants were free to do what they liked. Or, to put it in different terms, in the absence of a specified engagement, participants filled the void with their own rules of engagement.

> Gy: [A]s I said many times in a 3D environment such as this one where you're completely free about what you wanna do, where sex seems to be one of the main attraction[s], you have to invent new ways of making it an experience. lol. And of course, it doesn't work at all. lol. Sex is the most boring thing here.

In the case of Second Life, the platform invites participants to create freely, and the instinct, as Gy narrates, is to stage a sexual encounter. He explained that often, though not always, avatars initiated their entrance to the platform by engaging another avatar in virtual sex. This could be any combination of language (text-based chat), visual animation (avatars in graphic engagement), or computer-scripted behaviors applied to avatars, objects, and environment.

In the interview, Gy describes virtual sex as both attractive—visually pulling one in—and boring as an act ("sex is the most boring thing here"). What he implicitly points to is the promise and limitation of simulation. I see this dual condition of promise and limitation as a critical point in how we understand networked media engagement and how we frame the desire to use these platforms to connect with each other. Perversely, or perhaps ingeniously, Gy saw this limitation as an invitation to innovate.

What I observed in the virtual world engagement of Gy and his cohort was that their verbal exchanges and visual simulation pushed toward extreme forms. Instead of a request, they would phrase something as a command. They would represent bondage in lieu of sexual relations of more equal terms. I understood this escalation in part as a function of the mode of mediated communication. Offline, Gy did not participate in extreme sex practices, yet he rapidly escalated to a sadistic sexual engagement in this virtual world. This behavior suggests not simply an issue of agency—his subjective choice to be a participant—but a structural aspect of the platform itself in which virtual worlds provide an impetus for extreme behavior. Thus, we see the drive toward the hyperbolic is built into the form of mediation itself. One shares visualized space with others, and yet the simulation lacks a perfect replication of an embodied, unmediated encounter. As people try to actually connect with each other, they grow excessive in their communication.

Although the ability to participate in a networked 3D space is a relatively new phenomenon, the technical limitations of life-like visualization and actions are apparent as soon as one enters any of the existing platforms. Culturally we have limited practice with an open forum—a multi-user platform that is not a game but is in real-time. One ends up doing the mediated equivalent of shouting to get an actual response. One can see the human amplification of signal or gesture as part of the cycle of new media adoption.[10] Virtual worlds reach a threshold of simulation that cannot be crossed, even as what they appear to offer is exactly such a crossing.

In the interview, Gy addressed the radical behavior I observed, saying, "Considering you only have the chat to interact, most sexual relations are in BDSM." His remark points to an

aspect of platform design that moves all exchanges to the level of bondage and discipline. With the cannibals, participants consciously escalate the terms of engagement, recognizing the limit of simulation and also exploiting it. Effectively by graphically exclaiming, they seek a way to make the virtual more real. Their strategy does not address a technological solution—a better simulation as it were—but rather the translation of a set of procedures, BDSM's rules of engagement, to the virtual space

Dolcett girls

In sticking to the rules, a very rigid script of behavior, a group of players establishes a sense of the actual in the context of the virtual. Gy and the other participants keep their actions outside the realm of the real—no one was really killed and eaten—but within the emotional register of the real. Such a system of engagement can certainly exist offline. Marquis de Sade, a famously perverted eighteenth-century French noble, created a literary genre around what we now commonly call "sadism," in which behavior was carefully coordinated and staged so as to derive pleasure from inflicting pain or humiliation. De Sade wrote several books specializing in the sexual torture of young women, framing the works essentially as stylized manuals. In discussing how the protocol of sadism translates online, Gy cites de Sade to explain how the cannibals produce their staging, the *mise en scène*, or, in Gy's words, how they "make a picture through sexual intercourse." In this case the pictures are linguistic and visual. The procedural elements—the manner in which the group utilizes the technical possibilities of the platform—of the cannibal experience include chat and scripted activities, which the avatars graphically enact.

> Gy: [Y]ou go with someone in a special brothel and there is a room called Dolcett. [T]here, after the staging of a relation thru [through] chat you ask your partner to be cooked, selecting this script ball [virtual object with coded action inscribed] or that one. [A]nd then the partner can select another script ball to be the meal on the table. [T]he "master" selecting the one where he [will] "eat" an avatar. lol. I said to myself of course! cannibalism! as an evidence of [. . . *is typing* . . .] the cruelest thing when no more experience is possible.

Dolcett, the code for Gy's BDSM experience, originally referred to the signature on a series of Internet-circulated pornographic drawings that depicted submissive women being hanged, cooked, and variously penetrated as part of a sexual act. Dolcett or gynophagia role-play now extends not only to that set of illustrations but also to an entire subset of BDSM activity. The Dolcett scenario is often medieval, borrowing from the fairy-tale structure of a young peasant girl taken from her lowly position by the prince to become the "queen for the day." Her rule ends in her public execution, constructed for greatest erotic charge for the crowd. Writer A. N. Roquelaure's (Anne Rice) popular *Sleeping Beauty* soft-core BDSM series plays out for her massive audience the basic stratagems of this role-play. In the case of Roquelaure's *Beauty*, it is a role reversal, where the princess is forced to submit to machinations of a sexual dominance order. One can find Dolcett fan fiction on the Internet with titles such as "First Bite" and "How to Cook Women's Breasts." There are also chat groups, Web sites, and, with the emergence of multiplayer virtual worlds, avatar-based animation enacting Dolcett play.

The point I make in listing the various forums is that network culture in general has grown this illicit subculture into a forum essentially available to the cybertourist, by which I mean the casual Web browser or visitor to a virtual world. It is not one platform or one

circulating image, but a collection of searchable media that has taken root. In looking at online archives discussing this practice, I found that The Sims Online (TSO) appears to have hosted the first publicly manifest BDSM community. In comparison to the monumental and genre changing successes of The Sims and Sim City, both single-player games, TSO, the first multiplayer offering in the series, did not succeed as a commercial hit. It was, however, successful with BDSM players.[11] With TSO, for the first time, one could essentially find 3D, fairly realistic depictions of humans that could be clothed (or naked), according to the player's interest. Additionally, the code scripts for these figures related to domestic human actions, such as intimate relations, as opposed to fighting moves as most video games do. With the leverage of a platform designed to simulate human relations, creative players adapted it to simulate the type of relations they chose.

This tradition carried over to Second Life, which emerged five years after TSO, as the next platform that allowed for human figures to be molded into any configuration imaginable. One virtual world blogger described her adventures in Second Life's Dolcett play much in the way one might outline learning to surf or another exotic experience explored on vacation:

> One of my more extreme fantasies involves Dolcett play. It's kinda weird. I don't like pain. Being whipped, paddled, or tortured really just turns me off. And the idea of snuff play just seems so . . . final. But the thought of being prepped, stuffed, basted, roasted and eaten . . . that appeals to me. I guess it goes back to my objectification fetish. Being turned into food is just as good as any other type of object. So, one of the many groups I joined [was] the Dolcett Girls group. A few days after joining I got an IM [instant message] from [a member].[12]

The blogger describes the act of being tied to a virtual spit and having the apparatus narrate the progress of her being cooked ("The machine was very interesting, giving a play by play").[13] The blogger comments that she is surprised at how much this experience arouses her. It is important to note from the outset that, unlike a rape in cyberspace, the online BDSM relations are consensual acts. Additionally, as we are discussing their representation in a synthetic computer-generated world, they are also simulated acts. The blogger cited in the passage above, the interview with Gy, and with other participants surveyed state that the shared visual scenario of their avatars committing these acts creates a powerful sense of an actual shared experience. Participants describe a twin sensation of observing oneself and being the primary actor. Via mediation, they had the sensation of being in two places at once. This experience was not circumscribed by a technically perfect simulation but, rather, the various levels of human expression the players embedded in the platform.

I am suggesting that the promise and limitation of simulation needs to be understood not only in terms of design (including technical affordance) but also in the terms of people's engagement of a medium. The marker of mediation did not fall away (e.g., the virtual spit narrates the act of cooking); yet, participants found ways to satisfy their interests. In their work on remediation, new media theorists Jay Bolter and Richard Grusin talk about the "logic of transparent immediacy" that are designed into new media forms. They argue that media are designed to disappear and leave the user with a sense of immediacy in mediation. However, I would suggest that, in fact, we find the opposite effect when considering users' experience of networked media: a medium does not need to disappear for users to still feel profoundly connected to mediated acts. The particular group discussed in this chapter is pointedly self-aware of the nature of a medium and the act of mediation. Despite the fact that the frame of mediation remains, they understand that their acts make an impression; these acts effect change in the participants. In other words, the participants do not see the BDSM

role-play as a game in a game world but as the rituals of their cult. In this sense, they see their virtual behavior as actual.

Virtual solitaire

"I'm not even really here," hip-hop artist El-P snarls on *Fantastic Damage* (Definitive Jux, 2009), an album-long trip through contemporary landscapes barren and forlorn. His sentiment of alienation and isolation are symptomatic of many people. Several studies inform us that Americans in particular are lonelier than ever, lacking human contact and the confidences of close friendship. Political scientist Robert Putnam's work on social networks, particularly the book *Bowling Alone*, makes central in academia and mass media the discussion of a changing social system. Also on that subject, the paper authored by sociologists Miller McPherson, Lynn Smith-Lovin, and Matthew E. Brashears, "Social Isolation in America: Changes in Core Discussion Networks over Two Decades," sends an alarming message on the decline in civic engagement in the United States. They conclude that we have grown more insular and less engaged with other people and contexts.[14]

Yet, during the same period and with the same population, research groups such as Pew Research Center, MacArthur Foundation, and the Annenberg Center for the Digital Future report that more people use the Internet than ever before and that their "relationships developed via mediated communication are as valuable to them as their real world friends and family."[15] *The Strength of Internet Ties*, a 2006 study by the Pew Internet and American Life Project for the Pew Research Center, characterizes a strong sense of activism in Internet use: not only are people finding affinity groups over the Internet but those networks often cross over into relationships that exist in the world, face-to-face.[16]

The Pew Internet study concludes that people find their online relationships as valuable as their real-world friends and family because much of the virtual exchange develops into actual friendship that exists online and off. Additionally, the exclusively virtual friendships offer powerful connections unto themselves, although the condition of friendship is not based on face-to-face encounters. As game designer Raph Koster quipped at a conference on virtual worlds, all actual relationships become synchronous at some point.[17] Be it over the phone or via VoIP, meeting in real-time fulfills a crucial part of relationships, even if it is not face-to-face.

These research reports support my finding that increasingly we experience a sense of the actual in our mediated exchanges. However, the qualities and consequences of these exchanges—what I have termed networked agency—is largely dependent on how we situate that engagement. The virtual cannibal used his reach to enact violence and, as I have argued, there is a tendency to "shout" or amplify one's message in a hyperbolic way when engaging new media platforms. The mandate of pervasive media engagement, in this case, is twofold. First, we must recognize that people *are* addressing each other. Second, we must also move toward a media culture in which participants recognize a shared subjectivity as opposed to a mutual objectification.

The reports on the unprecedented loneliness of Americans, such as "Social Isolation in America," and the Pew Internet report on the richness of network ties present two different results that seemingly go in opposite directions. I would suggest that the reports speak to the same issue from different perspectives. "Social Isolation in America" tells us that the social animal that we are has run smack into the uprooted creatures we have become, as we see with the new millennium's accelerated fragmentation of family, neighborhood, and nation. The Pew Internet study tells us that affinity groups are thriving, but the connections are configured along new lines that often defy the demarcation of territory or blood. We find the

dissolution of traditional frames of community and society, even as we relocate ourselves across networks of affiliation. The critical aspect to grasp is the value of networked engagement in moving toward a better understanding of agency in the twenty-first century.

Designed for exposure

In the mid 1990s, when graphic information, particularly still images in jpeg format, became ubiquitous, a Web community called E/N (everything/nothing) created an exercise in radical boredom by posting text and, often, images in which users would vie to outdo each other in debasement. One series focused on body amputations. The first poster in the chain cut off the tip of his finger and uploaded the before-and-after shots for proof. The next player in the series cut his finger off to the first knuckle and offered those images as one-upmanship . . . and so on until the chain could no longer be sustained or people lost interest.

While the demonstration of daring for an audience of peers exists in every subculture, this bodily abasement of a late-night network exchange contains a particular tone of self-loathing combined with mean spiritedness that only seems to have increased with the expansion of network culture. A massively popular Web site in the 2010s for all things E/N, the 4chan /b/ board, marked as "random" entries, held a contest one night, initiated by a user, where boys posted photos trying to outdo each other in a "who has the smallest penis" contest.[18] Thankfully, players did not bring amputation to bear in this competition.

From a decade ago to the early twenty-first century, behind the screen of online anonymity we see that people continue to express deep feelings to virtual strangers. More often now we have faces attached to these actions and traceable identities attached to these faces. People treat networked forums less like masked balls or other forms of role play and more like experiences they claim for themselves.

Certainly people use false identities and other forms of masking to make their acts anonymous. In the case of the virtual cannibal, I would say Gy uses virtuality as a forum for exposure, much like the spectacle of E/N and 4chan /b/. Even if he chose a particularly horrible mode of expression, he uses networked media in much the same way as the millions of people posting homemade video to YouTube: they are creating images of themselves and their acts that they design for exposure, for the greatest degree of circulation and spectatorship—their own and others'. What we find with Gy, and what we often find in the current state of networked media, is a graphic urge, an urge to show, characterized by a mediated form of shouting. Participants often chose provocative language and images to make an impression, to connect.

I interviewed a man, a father of a teenage girl, who expressed dismay when he found that his child had taken pictures of a neighbor in the shower and then posted the images to her profile page on Facebook. In terms of the media sphere, several things have changed to enable the girl's behavior. She has a digital camera from which images can instantly and easily be uploaded to a Web site. Additionally, she and her social group engage with a Web-based profile page every day, making it an important communication forum for them. The teen possesses the means (camera with easy Web upload) and the motivation (valued peer network space) to actualize the desire to impress her peers. In this case, the problem is not the tools, but rather how the girl used them.

Thus, the father's unhappiness with his daughter arose not from her access to media but from her lack of judgment. He understood that his daughter could take illicit photos, but he could not fathom why she would post them to an essentially public forum. Teen pranks have never gone out of style. I would suggest that peeking at the naked neighbor falls within that category, but giving friends (and strangers) searchable media broadens the scale, and thus the

impact, of the act. Searchable media means that if the creator labels the photo "naked old guy" and I query my search engine for images of "naked old guy," then I may very well find the picture of the teenager's neighbor in the shower. Do I know him? No. But somebody does. Posting images or any other media online creates an archive of the image outside of the photographer's control. Networked media creates a new precedent for the autonomy of a piece of media once it begins to circulate.[19] The image can be copied and circulated infinitely. In this sense, an act that may have been temporary, even though transgressive (such as spying on someone), becomes in its media form essentially indelible. In extending our reach with networked media, we find new conditions of actual consequences.

For the teenager, she and her friends live more publicly than any generation before them. We see new strategies around self-presentation in which networked subjects negotiate what to show in a culture in which there is a demand to do so.[20] With the perception of living in the public eye, we see with network culture, and particularly with youth, what looks like a rise in exhibitionism—exposing oneself as well as others. The teen girls might have taken the nude pictures of her neighbor spontaneously. In posting them online, she made a considered act: to hold him up for ridicule before her peers, thus, demonstrating prowess in mediated form.

The heat of the moment does not account for the kinds of games played on the early Web of E/N sites, more recently on the 4chan /b/ board. Though dark in their tenor, these exchanges are pointed examples of the urge to show closely coupled with a desire to connect across media channels. We are newly armed with the technical additions of visualization and increasingly shared time or spatial media connections. One already sees the agency of networked subjects in the ability to affect one's context and community—even if the effect is a negative one. As pervasive media grows as a global condition, one is faced with increasingly pressing issues of media use and its design. With given channels of communication do we behave in a preordained manner? Can we use networked media to support social norms that are libratory as opposed to a recapitulation of the punitive? Does the rise of networked subjects necessitate societal change?

Change of virtual heart

Toward the end of the interview, Gy stated that the real key to creativity with networked media lay in designing tools. To his mind, the most powerful thing one could do was control an environment, not just the actors within it. After exhausting the cannibal play, he found his new creative outlet in designing virtual furniture.

> **Interviewer:** what about furniture? not as interesting;-)
> Gy: yes it is! It's just like getting involved in the technical secrets of sl [Second Life]. Much more serious and interesting than sex here. There is a hard selection on that basis. Everybody CAN'T script or make buildings or whatever. I tried scripting. It's a hell.

Ironically, it is only in discussing technical secrets of the platform that Gy remarks that a virtual experience is "hell," despite the fact that he had spent the course of the interview recounting stories of simulated hell for others.

And with that change of orientation, a quixotic shift of temperament, Gy bid adieu to his first virtual adventure, and turned toward a culture that he felt represented real secrets and power: building simulations. He and the other participants had succeeded in wrapping real-world experience around a virtual common ground. They had reached other, for

better or for worse, and after that point there was only repetition of a scripted engagement.

Gy did not get his just desserts from cooking women. He did not suffer public humiliation among his peers for playing vicious games. He was not ejected by game wizards from the world he inhabited. He moved on to the next thing that caught his attention. No punishment emerged for his time as a virtual cannibal perpetrating unspeakable acts. But neither does the absence of public sanction mean that these acts did not occur. One can comprehend his shift from virtual cannibal to would-be virtual architect as a continuum, as opposed to a break.

Gy had reoriented content, yet his focus on making the virtual manifest as objective experience persisted. By enacting the logic of code, he would once again see his ideas manifest as objects and actions for all to witness. This time it would be toward the construction of the environment as opposed to the spectacular. In terms of his overall behavior, one sees Gy's engagement in the virtual world driven by a desire for mastery. Whether uttered to an avatar or written as a line of code, he demonstrated to himself that a command could in fact be an act.

In his virtual cannibal engagement, Gy brought to his participation a sense of exhaustion, not personal but societal. He expressed the feeling that we have reached a limit of human experience, which led him to seek the unsavory in order to provoke a sensation in himself and others. This kind of thrill seeking has a long tradition that tracks back to eighteenth-century libertines, nineteenth-century opium eaters, and cultural transgressives of all centuries. The new turn Gy expresses reflects a jump in scale of ennui and alienation. A generation of networked subjects seems to suffer from it. We find ourselves constructing terrible games in order to amuse ourselves, games that have no borders.

The test sites of the 1990s online world described by Turkle marked a space away from our real lives. In looking at the extreme practices of various networked groups, one can say that virtual cannibals did not invent sexual perversion; they simply made it easier to find. For various reasons, these types of subcultures once lurked in the shadows, on the periphery of a city and society. Now we find them in the broad daylight of any search engine. Does that change the nature of the subculture or does it change the sensibility of those of us who had previously been shielded from it because it was more difficult to access?

Gy had no previous experience with this culture and its explicit markers before entering the virtual world. Looking for a new experience, he found one. The virtual cannibals finding Gy, and Gy finding them, represents a combination of coincidence, thrill seeking, and predisposition of platform; he made himself available to the experience. In one sense, the cannibals exploit virtual space in exactly the same way that other explorers and innovators have since its inception: they create space apart, a space not subject to rules of gravity any more than the rules of society. For testing boundaries and trying out new roles, the location could not be better. Role-playing in the safe space of games over the Internet represents a long tradition. It all works very tidily: real experience resulting in no real harm done and lots of stories for the friends.

Yet, alas, the answer is no. No, the story does not end with a virtual thrill ride; no, because we already ask more of and give more to the worlds we make. Perhaps most importantly, the virtual does not remain safely in its own domain because the exchange between simulated and lived is not unilateral. The channels of communication open in both directions. As a society, we are beginning to recognize the importance of pervasive media not only in how it connects us to other people, but also in how it reflects patterns of perception and behavior of self and world. Even among casual users of virtual platforms, we do not find a safety net of a world entirely apart. The walled gardens of past role-playing games, if it ever truly existed, are now porous.

Not everyone will become a virtual cannibal. The virtual platform Gy used advertised itself as a fantasy life made graphic, which in the case of the cannibals became a technological

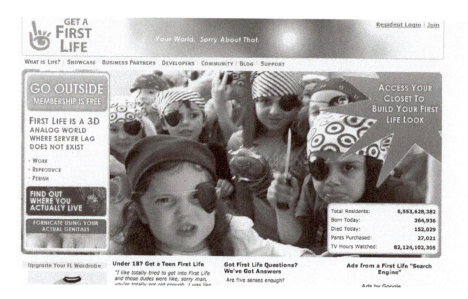

Figure 4.4 Get a first life: A widely circulated imaged from a satire site, GetaFirstLife.com, posted by writer Darren Barefoot, reminding people to get a real life and not only a virtual one (2007).

Credit: Darren Barefoot.

seduction they could not resist. The cautionary tale we learn from Gy's story provides greater insights on the culture of networked media use and design than as a parable against virtual cannibalism. We learn that the more we rely on a fantasy of a second self—a self outside of the persistence of identity and continuous relationships—the more we risk the casual violence that states of alienation induce (see Figure 4.4).

I speak of networked media as an augmentation to everyday life, not as a source itself of violence or any other type of expression. As actors in this network, if there is to be agency, we must ourselves locate responsiveness and responsibility. It would be a mistake, though, to understand this position as a fully autonomous agency, a sovereignty as such. In analyzing how a medium behaves—how it is designed and what people do with it—we also acknowledge that the networked subject participates within the network. We are not outside of the augmented reality we engage, even if we are not enslaved by it. In his media practice, while Gy recognizes the limits of simulation as a technical forum, he does not see the power of networked agency as a necessarily contingent one: a position outside of mastery in its traditional terms. He is not alone his conflagration of signals, mixing new media practices with old forms of relation.

If we compare the network experience in the early twentieth-century to that of a decade ago, we see that we have an increased number of media channels by which we recognize each other. Additionally, we find increasingly porous paths between online and offline identities. Instead of discrete incidents of virtual play or real-life work, what we find growing in scale are experiences of networked subjects who engage multiple spaces of agency.

Notes

1 A virtual world is an immersive text or graphical multiuser computational environment that possess unique rules of technical and cultural engagement, such as real-time interaction and shared perspective on virtual objects.

2 From 2006–2008, I did field research on the subject of virtual worlds, mobile media, and X-reality design. I interviewed (and observed) media designers, users, and researchers in their native contexts, which included studio, conference, meetup, virtual world, and laboratory. For a discussion of research methods and scope see B. Coleman, "Rise of the Networked Generation," *Hello Avatar* (Cambridge, MA: MIT Press, 2011).

3 Projects such as OpenID and Higgins begin to address a growing interest in control of one's networked data.

4 The practice of identity consolidation does not preclude anonymous or alternate identities; in fact it is commonplace for users to have multiple log-ins. The reason for the multiple log-ins is the same as a decade ago: sometimes people want greater anonymity for their actions.

5 In *Life on the Screen*, a 1995 study of identity in the Internet age, Turkle writes of multiple identities as foundational to forming a sense of self. She notes, "The Internet is another element of the computer culture that has contributed to thinking about identity as multiplicity. On it, people are able to build a self by cycling through many selves." Sherry Turkle, *Life on the Screen: Identity in the Age of the Internet* (New York: Simon and Schuster, 1995), 140.

6 Katie Salen and Eric Zimmerman, *Rules of Play* (Cambridge, MA: MIT Press, 2004), 96.

7 In the 1960s, sociologist Roger Caillois created a matrix of four basic categories of game play. Caillois, *Man, Play and Games*, trans. Barash (New York: Free Press of Glencoe, 1961). The categories are agon (contest), alea (chance), ilinx (vertigo), and mimicry (make-believe). Caillois also gave a gauge to read across the spectrum from the rule-governed (ludus) to the free-form (paidea). Social virtual worlds, as the point of greatest potential in mass media adoption and least known outside of niche, rest on the side of the game grid that hails the aleatory (chance) and the free-form (paidea). Those are the characteristics of social game play, but as we walk through several different kinds of social virtual worlds, we will encounter mixed degrees of alea and agon.

8 I use the term "symbolic" to mark a logic within a culture. As opposed to an imaginary state, the symbolic works as an aspect of how we understand the real. I draw my definition of the symbolic from the work of theorists such as Jacques Lacan, Claude Levi-Strauss, and Ferdinand de Saussure in the fields of psychoanalytic theory, structuralism, and semiotics.

9 Spectacle implies a visual demonstration. Implicit in the concept is the idea of exhibiting—something or someone is put on display. The literature on spectacle during different eras of technical reproduction, particularly the post-industrial period, is robust. For example, see Jonathan Crary, *Suspensions of Perception: Attention, Spectacle, and Modern Culture* (Cambridge, MA: MIT Press, 1999); Guy Debord, *The Society of the Spectacle*, trans. Donald Nicholson-Smith, (New York: Zone Books, 1999).

10 The first phone calls were shouted. The first films were composed of broad gestures and iconic tableaux. Early online communities such as the WELL and Nettime were punctuated with flame wars—the incendiary electronic missives sent by a few but observed by the entire group. Today, the customs for Internet teleconferencing and mobile telephony are developing in parallel with mass adoption of the technologies. One finds the same cycle with the new generation of virtual worlds.

11 The Sims Online, Alphaville BDSM post, December 20, 2003, http://www.bankhead.net/BlackRoseCastle/Default.htm.

12 "Roasted Yora, $5.99 a pound," blogpost, February 11, 2007, http://myslinsl.blogspot.com/2007/02/roasted-yora-599-pound.html.

13 Ibid.

14 Miller McPherson, Lynn Smith-Lovin, and Matthew E. Brashears, "Social Isolation in America: Changes in Core Discussion Networks over Two Decades," *American Sociological Review* 71 (June 2006): 353–375.

15 *2007 Digital Future Report*, Center for the Digital Future, USC Annenberg School, www.digital-center.org; Joseph Kahne, Nam-Jin Lee, and Jessica Timpany Feezell, "The Civic and Political Significance of Online Participatory Cultures among Youth Transitioning to Adulthood," *DML central Working Papers*, MacArthur Network on Youth & Participatory Politics, Digital Media and Learning initiative (February, 2011), www.dmlcentral.net.

16 J. Boase et al., *The Strength of Internet Ties*, Pew Internet & American Life Project, Pew Research Center, January 25, 2006, www.pewinternet.org.

17 Raph Koster, round table with Howard Rheingold and Cory Ondrejka. Metaverse U, Stanford University, Stanford California, 2008.

18 Kevin Driscoll, personal interview, May 15, 2009.

19 "Burt is Evil" represents one of the most famous examples of this in Internet lore. Artist Dino Ignacio created the Internet meme taking the beloved Muppet character Burt (of Sesame Street fame) and circulating images of the yellow moppet wearing an evil scowl. Eventually, the "Burt is Evil" image appeared on an Osama bin Laden rally poster in Afghanistan as an anti-American icon ripped directly

from the Web. On the personal level for Ignacio the global flow of his image made his life more difficult. But on the network level, this was an uncannily precise demonstration that you never know where something you launch will end up. Dino Ignacio, personal interview, ROFLcon conference on Internet memes, MIT, Cambridge MA, 2008.

20 Social media scholars Helen Nissenbaum and danah boyd have made the point in their work that despite the fact that networked media can carry images and information faster and farther than before, people, including teenagers maintain a strong sense of privacy. They both ask that the context must be taken into consideration in deciding the nature of what looks like self-exposure. See Helen Nissenbaum, "Privacy As Contextual Integrity," Washington Law Review, vol. 79, 2004: 101–139; danah boyd, "Friendster and Publicly Articulated Social Networks." Proceedings of the SIGCHI Conference on Human Factors and Computing Systems, Vienna, Austria, 2004.

Wendy Hui Kyong Chun

ON SOFTWARE, OR THE PERSISTENCE OF VISUAL KNOWLEDGE

When enough seemingly insignificant data is analyzed against billions of data elements, the invisible becomes visible.

—Seisint[1]

JEAN BAUDRILLARD IN *THE ECSTASY OF COMMUNICATION* ARGUES *"we no longer partake of the drama of alienation, but are in the ecstasy of communication. And this ecstasy is obscene"* because "in the raw and inexorable light of information" everything is "immediately transparent, visible, exposed."[2] Although extreme, Baudrillard's conflation of information (and thus computation) with transparency resonates widely in popular and scholarly circles, from fears over and propaganda behind national databases to examinations of "surveillance society." This conflation is remarkably at odds with the actual operations of computation: for computers to become transparency machines, the fact that they compute—that they *generate* text and images rather than merely represent or reproduce what exists elsewhere—must be forgotten. Even when attached to glass tubes, computers do not simply allow one to see what is on the other side but rather use glass to send and receive light pulses necessary to re-create the referent (if one exists). The current prominence of transparency in product design and political and scholarly discourse is a compensatory gesture. As our machines increasingly read and write without us, as our machines become more and more unreadable, so that seeing no longer guarantees knowing (if it ever did), we the so-called users are offered more to see, more to read. The computer—that most nonvisual and nontransparent device—has paradoxically fostered "visual culture" and "transparency."

Software—or, to be precise, the curious separation of software from hardware—drives this compensatory gesture. Software perpetuates certain notions of seeing as knowing, of reading and readability that were supposed to have faded with the waning of indexicality. It does so by mimicking both ideology *and* ideology critique, by conflating executable with execution, program with process, order with action.[3] Software, through programming languages that stem from a gendered system of command and control, disciplines its programmers and users, creating an invisible system of visibility. The knowledge software offers is as obfuscatory as it is revealing. Thus, if as Lev Manovich recommends in *Language of New Media,*

new media studies needs to engage software, it must not merely adopt the language of software but must critically examine the limitations of "transcoding" and software's new status as common sense.[4]

Materializing the immaterial

Software is, or should be, a notoriously difficult concept. The current commonsense computer science definition of software is a "set of instructions that direct a computer to do a specific task." As a set of instructions, its material status is unstable; indeed, the more you dissect software, the more it falls away. Historian Paul Ceruzzi likens it to an onion, "with many distinct layers of software over a hardware core."[5] This onionlike structure, however, is itself a programming effect: one codes by using another software program; software and hardware (like genes and DNA) cannot be physically separated. Computer scientist Manfred Broy describes software as "almost intangible, generally invisible, complex, vast and difficult to comprehend." Because software is "complex, error-prone, and difficult to visualize," Broy argues, many of its "pioneers" have sought to make "software easier to visualize and understand, to represent the phenomena encountered in software development in models that make the often implicit and intangible software engineering tasks explicit."[6] Friedrich Kittler has more forcefully argued, "there is no software" since everything reduces to voltage differences as signifiers.[7]

In the 1940s software did not exist: there literally was no software.[8] "Programming" comprised the human task of making connections, setting switches, and inputting values ("direct programming"), as well as the human and machine task of coordinating the various parts of the computer. In 1946 the master programmer for the ENIAC (the first general-purpose electronic digital computer to be designed, built, and successfully used) controlled the sequence of actions needed to solve a problem numerically.[9] The ENIAC was initially rewired for each problem so that, essentially, a new ENIAC was created each time it was used. Its conversion to a stored-program computer in 1947 (in part due to a suggestion by John von Neumann) meant that programs could be coded by setting switches, which corresponded to sixty stored instructions, rather than by plugging cables. This change, seen as a way to open up programming to simple scientists, dramatically decreased the time necessary for programming while increasing the time necessary for computation. Today these changeable settings would be called software because, with symbolic programming languages, these physical settings (which for instance enabled a value X to be moved from memory location Y into the accumulator) became translated into a string of numbers read into the computer's memory. Today the clerical "operators" who planned the wiring for and wired the ENIAC (Kathleen McNulty, Frances Bilas, Betty Jean Jennings, Elizabeth Snyder, Ruth Lichterman, and Marlyn Wescoff) are reclaimed as some of the earliest programmers.

Symbolic programming languages and therefore software, as Paul Ceruzzi and Wolfgang Hagen have argued, were not foreseen. The emergence of symbolic-language programming depended on the realization that the computer could store numerical instructions as easily as it could data and that the computer itself could be used to translate between symbolic and numeric notations. The programmers of the EDSAC, an early (1949) computer in Cambridge, England, were the first to use the computer to translate between more humanly readable assembly code (for instance, "A100" for "add the contents of location 100 to the add register") and what has since been called machine language (rather than a logical code). Storage was key to the emergence of programming languages, but, as the case of John von Neumann reveals, storage was not enough: von Neumann, whose name has become the descriptor for all modern stored-program computers also devised a notation similar to the EDSAC's with

Herman Goldstine but assumed that clerks would do the translation.[10] Further assembly language is not a higher-level programming language; a computer is not automatically a media machine. According to Hagen, "for decades, the arche-structure of the von Neumann machine did not reveal that this machine would be more than a new calculator, more than a mighty tool for mental labor, namely a new communications medium." The move from calculator to communications medium, Hagen argues, itself stemmed from a "communications imperative" that

> grew out of the cold war, out of the economy, out of the organization of labor, perhaps out of the primitive numeric seduction the machines exerted, out of the numbers game, out of a game with digits, placeholders, *fort/da* mechanisms, and the whole quasi-linguistic *quid pro quo* of the interior structure of all these sources.[11]

Automatic programming

Automatic programming, what we call programming today, arose from a desire to reuse code and to recruit the computer into its own operation—that is, to transform singular instructions into a language a computer could write. As Mildred Koss, an early UNIVAC programmer, explains:

> Writing machine code involved several tedious steps—breaking down a process into discrete instructions, assigning specific memory locations to all the commands, and managing the I/O buffers. After following these steps to implement mathematical routines, a sub-routine library, and sorting programs, our task was to look at the larger programming process. We needed to understand how we might reuse tested code and have the machine help in programming. As we programmed, we examined the process and tried to think of ways to abstract these steps to incorporate them into higher-level language. This led to the development of interpreters, assemblers, compilers, and generators— programs designed to operate on or produce other programs, that is, automatic programming.[12]

Automatic programming is an abstraction that allows the production of computer-enabled human-readable code—key to the commodification and materialization of software and to the emergence of higher-level programming languages. This automation of programming— in particular, programming languages—makes programming problem- rather than numerically oriented. Higher-level programming languages, unlike assembly language, explode one's instructions and enable one to forget the machine. They enable one to run a program on more than one machine—a property now assumed to be a "natural" property of software. "Direct programming" led to a unique configuration of cables; early machine language could be iterable but only on the same machine—assuming, of course, no engineering faults or failures. In order to emerge as a language or a text, software and the "languages" on which it relies have to become iterable. With programming languages, the product of programming would no longer be a running machine but rather this thing called software—something theoretically (if not practically) iterable, repeatable, reusable, no matter who wrote it or what machine it was destined for. Programming languages inscribe the absence of both the programmer and the machine in its so-called writing.[13] Programming languages enabled the separation of instruction from machine, of imperative from action.

According to received wisdom, these first attempts to automate programming were inefficient and resisted by "real" programmers. John Backus, developer of FORTRAN, claims that early machine language programmers were engaged in a "black art;" they had a "chauvinistic pride in their frontiersmanship and a corresponding conservatism, so many programmers of the freewheeling 1950s began to regard themselves as members of a priesthood guarding skills and mysteries far too complex for ordinary mortals."[14] Koss similarly argues, "without these higher-level languages and processes . . ., which democratized problem solving with the computer, I believe programming would have remained in the hands of a relatively small number of technically oriented software writers using machine code, who would have been essentially the high priests of computing."[15]

The resistance to automatic programming also seems to have stemmed from corporate and academic customers, for whom programmers were orders of magnitude cheaper per hour than computers. Jean Sammett, an early female programmer, relates in her influential *Programming Languages: History and Fundamentals,*

> customers raised many objections, foremost among them was that the compiler probably could not turn out object code as good as their best programmers. A significant selling campaign to push the advantages of such systems was underway at that time, with the spearhead being carried for the numerical scientific languages (i.e., FORTRAN) by IBM and for "English-language-like" business data processing languages by Remington Rand (and Dr. Grace Hopper in particular).[16]

This selling campaign not only pushed higher-level languages (by devaluing humanly produced programs), it also pushed new hardware: to run these programs, one needed more powerful machines. The government's insistence on standardization, most evident in the development and dissemination of COBOL, also greatly influenced the acceptance of higher-level languages, which again were theoretically, if not always practically, machine independent or iterable. The hardware-upgrade cycle was normalized in the name of saving programming time.

The "selling campaign" led to what many have heralded as the democratization of programming. In Sammet's view, this was a partial revolution,

> in the way in which computer installations were run because it became not only possible, but quite practical to have engineers, scientists, and other people actually programming their own problems without the intermediary of a professional programmer. Thus the conflict of the open versus closed shop became a very heated one, often centering around the use of FORTRAN as the key illustration for both sides. This should not be interpreted as saying that all people with scientific numerical problems to solve immediately sat down to learn FORTRAN; this is clearly not true but such a significant number of them did that it has had a major impact on the entire computer industry. One of the subsidiary side effects of FORTRAN was the introduction of FORTRAN Monitor System [IB60]. This made the computer installation much more efficient by requiring less operator intervention for the running of the vast number of FORTRAN (as well as machine language) programs.[17]

This "opening" of computing, which gives the term *open* in "open source" a different resonance, would mean the potential spread of computing to those with scientific numerical problems to solve and the displacement of human operators by operating systems. But scientists have always been involved with computing, even though computing has not always been

considered to be a worthy scientific pursuit and, as mentioned previously, the introduction of dials rather than wires was supposed to empower simple scientists. The history of computing is littered with moments of "computer liberation."[18]

This narrative of the "opening" of computing through higher-level languages assumes that programmers naturally enjoyed tedious and repetitive numerical tasks and developing singular solutions for their clients. The "mastery" of computing can easily be understood as "suffering." Harry Reid, an early ENIAC programmer, argues:

> The whole idea of computing with the ENIAC was a sort of *hair-shirt* kind of thing. Programming for the computer, whatever it was supposed to be, was a redemptive experience—one was supposed to *suffer* to do it. And it wasn't until the 1970s that we finally were able to convince people that they were not going to have programmers continually writing little programs for them. I actually had to take my Division and sit everybody down who hadn't take a course in FORTRAN, because, by God, they were going to write their own programs now. We weren't going to get computer specialists to write simple little programs that they should have been writing.[19]

The narrative of the democratization of programming reveals the tension at the heart of programming and control systems: are they control systems or servomechanisms (Norbert Wiener's initial name for them)? Is programming a clerical activity or an act of mastery? Given that the machine takes care of "programming proper"—the sequence of events during execution—is programming programming at all? What is compacted in the *linguistic* move

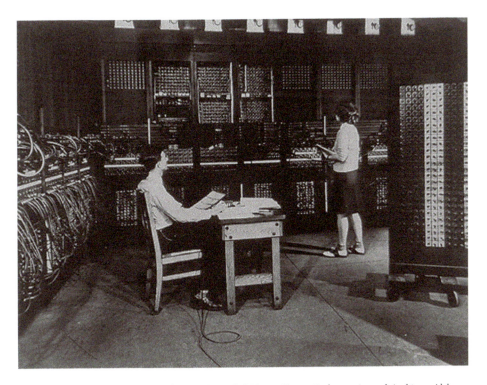

Figure 5.1 ENIAC programmers, late 1940s. U.S. Military Photo, Redstone Arsenal Archives, Alabama and U.S. Army Research Laboratory (ARL), Adelphi, Maryland. Photo courtesy of U.S. Army.

from "operator" to "programmer"? The notion of a "priesthood" of programmers erases this tension, making programming always already the object of jealous guardianship, and erasing programming's clerical underpinnings. Programming in the 1950s does seem to have been fun and fairly gender balanced, in part because it was so new and in part because it was not as lucrative as hardware design or sales: the profession was gender neutral in hiring if not pay because it was not yet a profession.[20] The "ENIAC girls" were first hired as subprofessionals, and some had to acquire more qualifications in order to retain their positions. As many female programmers quit to have children or get married, men took their increasingly lucrative jobs. Programming's clerical and arguably feminine underpinnings—both in terms of personnel and command structure—was buried as programming sought to become an engineering and academic field in its own right. Such erasure is key to the professionalization of programming—a compensatory mastery built on hiding the machine. Democratization did not displace professional programmers but rather buttressed their position as professionals by paradoxically decreasing their real power over their machines and by generalizing the engineering concept of information.

Yes, sir

The assumption that programmers naturally enjoy tedious tasks points to programming and computing's gendered and human history. During World War II almost all computers were young women with some background in mathematics. Not only were women available for work then, they were also considered to be better, more conscientious computers, presumably because they were better at repetitive, clerical tasks. Programmers were former computers because they were best suited to prepare their successors: they thought like computers.

One could say that programming became programming and software became software when commands shifted from commanding a "girl" to commanding a machine. Figure 5.1 on p. 69 reveals the dream of "programming proper"—a man sitting at a desk giving commands to a female "operator." Software languages are based on a series of imperatives that stem from World War II command and control structure. The automation of command and control, which Paul Edwards has identified as a perversion of military traditions of "personal leadership, decentralized battlefield command, and experience-based authority,"[21] arguably started with World War II mechanical computation. This is most starkly exemplified by the relationship between the Wrens, volunteer members of the Women's Royal Naval Service, and their commanding officers at Bletchley Park. The Wrens, also called slaves by Turing (a term now embedded within computer systems), were clerks responsible for the mechanical operation of the cryptanalysis machines (the Bombe and then the Colossus), although at least one of the clerks, Joan Clarke, became an analyst. Revealingly, I. J. Good, a male analyst, describes the Colossus as enabling a man-machine synergy duplicated by modern machines only in the late 1970s: "the analyst would sit at the typewriter output and call out instructions to a Wren to make changes in the programs. Some of the other uses were eventually reduced to decision trees and were handed over to the machine operators (Wrens)."[22] This man-machine synergy, or interactive real-time (rather than batch) processing, treated Wrens and machines indistinguishably, while simultaneously relying on the Wrens' ability to respond to the mathematician's orders.

The story of the initial meeting between Grace Murray Hopper (one of the first and most important programmers) and Howard Aiken also buttresses this narrative. Hopper, a Ph.D. in mathematics from Yale and a former mathematics professor at Vassar, was assigned

by the U.S. Navy to program the Mark I, an electromechanical digital computer that made a sound like a roomful of knitting needles. According to Hopper, Aiken showed her

> a large object with three stripes . . . waved his hand and said: "That's a computing machine." I said, "Yes, Sir." What else could I say? He said he would like to have me compute the coefficients of the arc tangent series, for Thursday. Again, what could I say? "Yes, Sir." I didn't know what on earth was happening, but that was my meeting with Howard Hathaway Aiken.[23]

Computation depends on "yes, sir" in response to short declarative sentences and imperatives that are in essence commands. Contrary to Neal Stephenson, in the begining was the command rather than the command line. The command line is a mere operating system (OS) simulation. Commands have enabled the slippage between programming and action that makes software such a compelling yet logically "trivial" communications system. I.J. Good's and Hopper's recollections also reveal the routinization at the core of programming: the analyst at Bletchley Park was soon replaced by decision trees. Hopper the programmer became an advocate of automatic programming. Thus routinization or automation lies at the core of a profession that likes to believe it has successfully automated every profession but it own.[24]

But to view women and mechanical computation as interchangeable is to revise history. According to Sadie Plant, programming is essentially feminine—not simply because women, from Ada Lovelace to Hopper, were the first programmers, but because of the historical and theoretical ties between programming and what Freud called the quintessentially feminine invention of weaving, between female sexuality as mimicry and the mimicry grounding

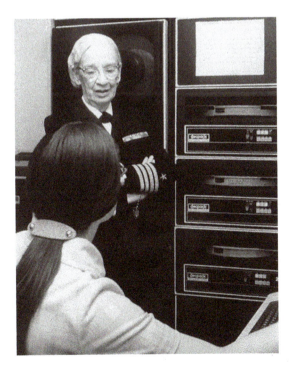

Figure 5.2 Captain Grace M. Hopper, 1976. U.S. Navy Photo (number NH 96945), Naval History and Heritage Command. Photo courtesy of U.S. Navy.

Figure 5.3 First Computer "Bug," 1945. U.S. Navy Photo (number NH 96566-KN), Naval History and Heritage Command. Photo courtesy of U.S. Navy.

Turing's vision of computers as universal machines. (In addition, both software and feminine sexuality reveal the power that something which cannot be seen can have.)[25] Women, Plant argues,

> have not merely had a minor part to play in the emergence of digital machines. . . . Theirs is not a subsidiary role which needs to be rescued for posterity, a small supplement whose inclusion would set the existing records straight. . . . Hardware, software, wetware—before their beginnings and beyond their ends, women have been the simulators, assemblers, and programmers of the digital machines.[26]

The photograph on p. 69 is not representative; the female programmers of the ENIAC worked together in pairs, and no machine could have accomplished what Hopper did—at least not then. (And again, Hopper would be key to enabling computers to do so: the closure of the distance between Hopper and computers would be key to automatic command and control). The difficulty faced by programmers was simple: computers weren't computers. The transition from commanding a girl to commanding an automaton was difficult because automatons deciphered rather than interpreted or presumed, and they did not learn from experience. As Martin Campbell-Kelly and William Aspray put it, "the fundamental difficulty of writing software was that, until computers arrived, human beings had never before had to prepare detailed instructions for an automaton—a machine that obeyed unerringly the commands given to it, and for which every possible outcome had to be anticipated by the programmer."[27] Campbell-Kelly and Aspray's assessment overestimates the reliability of the machines, especially the early ones. As the early ENIAC programmers relate, part of

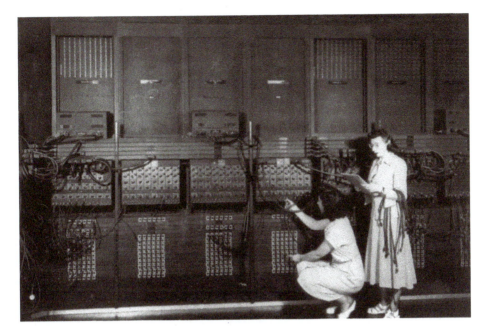

Figure 5.4 Two women wiring the right side of the ENIAC with a new program, late 1940s. U.S. Army Photo, Army Research Laboratory Technical Library, Aberdeen Proving Ground, Aberdeen, Maryland. Photo courtesy of U.S. Army.

debugging was figuring out which errors stemmed from programming and which from faulty vacuum tubes, accidental rewiring, or faults in machine architecture—a task made easier by neon bulbs attached to various counters.

Unlike machines, women programmers did not simply follow instructions. Hopper was described as "a woman of strong personality, a powerful persuader and leader. She showed some of her Navy training in her commanding speech."[28] Also, programming, as Koss explains, was not just implementing instructions but "designing a strategy and preparing instructions to make the computer do what you wanted it to do to solve a problem."[29] Women programmers played an important role in converting the ENIAC into a stored-program computer and in determining the trade-off between storing values and instructions. Betty Snyder Holberton, described by Hopper as the best programmer she had known, not only debugged the ballistics-trajectory program in a dream (the first program to be run on the ENIAC, albeit too late to be of use for WWII), she also developed an influential sort algorithm for the UNIVAC.[30]

The extent of the repression of these women in standard histories of computing can be measured by Paul Edwards's implicit, a priori gendering of the computer "work force" in an otherwise insightful analysis of masculinity and programming. He writes:

> computer scientists enjoy a mystique of hard mastery comparable to the cult of physicists in the postwar years. Computers provide them with unblinking precision, calculative power, and the ability to synthesize massive amounts of data. . . .
>
> There is nothing inherently masculine about computer technology. Otherwise women could not have had such quick success in *joining the computer work force*. Gender values largely float free of the machines themselves and are expressed and enforced by power relationships between men and women. Computers do not simply embody masculinity; they are culturally constructed as masculine mental objects.[31]

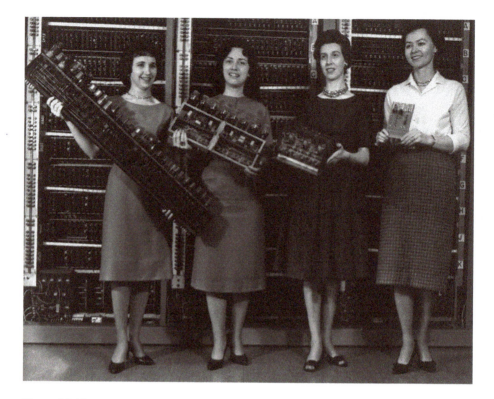

Figure 5.5 The First Four, 1950s. U.S. Army Photo (number 163-12-62). Photo courtesy of U.S. Army.

A far cry from the claim of J. Chuan Chu (one of the original ENIAC hardware engineers) that software is the daughter of Frankenstein (hardware being its son), Edwards's assessment erases the overwhelming presence of women in early computing—their work as human computers, programmers, and monitors—while it reduces computer technology to software. As the combination of a human clerk and a human computer, the modern computer encapsulates the power relations between men and women in the 1940s. It sought to displace women: their nimble fingers, their numerical abilities, their discretion, their "disquieting gazes"—a displacement Vannevar Bush viewed as desirable.[32] The transition from human to mechanical computers automated differential power relationships.

Recognizing these women as programmers—as not merely following but also putting together instructions—is important but not enough, for it keeps in place the narrative of programming as "masterful." What is the significance of following and implementing instructions? Perhaps the "automation" of control and command is less a perversion of military tradition and more an instantiation of it, one in which responsibility has been handed over to those (now machines) implementing commands. The relationship between masters and slaves is always ambiguous. This handing over of power has been hidden by programming languages that obscure the machine and highlight programming (rather than execution) as the source of action. The closing of the distinction between programming and execution, evidenced in the ambiguity of the object of the verb "to program," was facilitated by the disciplining and professionalization of programmers through "structured programming."

Hiding the machine

During the much discussed "software crisis" of the late 1960s, which stemmed from such spectacular debacles as IBM's OS/360, many (especially European programmers, such as Friedrich [Fritz] Bauer and Peter Naur) viewed "software engineering," or structured programming, as a way to move programming from a craft to a standardized industrial practice, and as a way to create disciplined programmers who dealt with abstractions rather than numerical processes.[33] As Michael Mahoney has argued, structured programming emerged as a "means both of quality control and of disciplining programmers, methods of cost accounting and estimation, methods of verification and validation, techniques of quality assurance."[34]

"Structured programming" (also generally known as "good programming") hides, and thus secures, the machine. Not surprisingly, having little to no contact with the actual machine enhances one's ability to think abstractly rather than numerically. Edsger Dijkstra, whose famous condemnation of "go to" statements has encapsulated to many the fundamental tenets of structure programming, believes that he was able to "pioneer" structured programming precisely because he began his programming career by coding for machines that did not yet exist.[35] In "Go To Statement Considered Harmful," Dijkstra argues, "the quality of programmers is a decreasing function of the density of go to statements in the programs they produce." This is because go to statements go against the fundamental tenet of good programming—the necessity to "shorten the conceptual gap between static program and dynamic process, to make the correspondence between the program (spread out in text space) and the process (spread out in time) as trivial as possible." More specifically, if a program is halted, go tos make it difficult to find a place in the programming that corresponds to the halted process—it makes it "terribly hard to find a meaningful set of coordinates in which to describe the process progress."[36] That is, go tos make difficult the conflation of instruction with command, which grounds "programming."[37]

Structured programming languages "save" programmers from themselves by providing good security, where security means secure from the programmer.[38] In the name of security, structured programming, which emphasizes programming as a question of flow, is itself giving way to data abstraction, which views programming as a question of interrelated objects and hides far more than the machine. Data abstraction depends on information hiding, on the nonreflection of changeable facts in software. As John V. Guttag, a "pioneer" in data abstraction explains, data abstraction is all about forgetting.[39] Rather than "polluting" a program by enabling invisible lines of contact between supposedly independent modules, data abstraction presents a clean or "beautiful" interface by confining specificities, and by reducing the knowledge and power of the programmer. Knowledge, Guttag insists, is dangerous: " 'Drink deep, or taste not the Pierian Spring,' is not necessarily good advice. Knowing too much is no better, and often worse, than knowing too little. People cannot assimilate very much information. Any programming method or approach that assumes that people will understand a lot is highly risky."[40]

Thus abstraction both empowers the programmer and insists on his/her ignorance. Because abstraction exists "in the mind of the programmer," abstraction gives programmers new creative abilities. Computer scientist David Eck argues, "every programming language defines a virtual machine, for which it is the machine language. Designers of programming languages are creating computing machines as surely as the engineer who works in silicon and copper, but without the limitations imposed by materials and manufacturing technology."[41] However, this abstraction—this drawing away from the specificities of the machine—gives over, in its separation of machine into software and hardware, the act of programming to the

machine itself. Koss scoffed at the early notion of computers as brains because "they couldn't think in the way a human thinks, but had to be given a set of step-by-step machine instructions to be executed before they could provide answers to a specific problem"—at that time software was not considered to be an independent object.[42] The current status of software as a commodity, despite the fact that its instructions are immaterial and nonrivalrous indicates the triumph of the software industry, an industry that first struggled not only financially but also conceptually to define its product. The rise of software depends both on historical moves, such as IBM's unbundling of its services from its products, and on abstractions enabled by higher-level languages. Guttag's insistence on the unreliability and incapability of human beings to understand underscores the costs of such an abstraction. Abstraction is the computer's game, as is programming in the strictest sense of the word.

Importantly, programmers are *users*: they create programs using editors, which are themselves software programs. The distinction between programmers and users is gradually eroding, not only because users are becoming programmers (in a real sense programmers no longer program a computer; they code), but also because, with high-level languages, programmers are becoming more like simple users. The difference between users and programmers is an effect of software.

Causal pleasure

The gradual demotion of programmers has been offset by the power and pleasure of programming. As Edwards argues, "programming can produce strong sensations of power and control" because the computer produces an internally consistent if externally incomplete microworld,

> a simulated world, entirely within the machine itself, that does not depend on instrumental effectiveness. That is, where most tools produce effects on a wider world of which they are only a part, the computer contains its own worlds in miniature. . . . In the microworld, as in children's make-believe, the power of the programmer is absolute.[43]

This pleasure is itself an effect of programming languages, which offer the lure of visibility, readability, cause and effect. Consider this ubiquitous "hello world!" program written in C++ ("hello world!" is usually the first program a person will write):

```
//this program spits out "hello world!"
#include <iostream.h>
int main ()
{
    cout << "Hello World!";
    return 0;
}
```

The first line is a comment line, explaining to the human reader that this program spits out "hello world!" The next line directs the compiler's pre-processor to include iostream.h, a standard file to deal with input and output. The third line, "int main ()," begins the main function of the program; "cout<<'Hello World!';" prints "Hello World!" to the screen ("cout" is defined in iostream.h); "return 0" terminates the main function and causes the

program to return a 0 if it has run correctly. Although not immediately comprehensible to someone not versed in C++, this program nonetheless seems to make some sense. It comprises a series of imperatives and declaratives that the computer presumably understands and obeys. When it runs, it follows one's commands and displays "Hello World!" Importantly, this message, which affirms the programmer's agency, also calls it into question: who or what, after all, is saying "hello world?" To enjoy this absolute power, the programmer must follow the rules of a programming language. Regardless, seeing his or her code produce visible and largely predictable results creates pleasure.[44] One's code causes an action to happen: cause and effect is clear, even if the end result is never entirely predictable. This absolute power enabled through the agency of a program reveals the contradictory status of agency, namely the fact that agency refers both to one's ability to act and the ability of someone else to act on one's behalf.

In the microworld of computer simulation, however, it is not only the programmer whose power is enhanced or absolute, for interactive simulations—key to the concept of computers as transparent—enhance the power of the user (again, these terms are not absolute but rather depend on the software one is using and on the productive power of one's actions). Interactivity, intimately linked, as Edwards has argued, to artificial intelligence, stemmed initially from an admission of human fallibility, and of the limitations of procedural programming languages.[45] By the 1960s, the naïveté behind von Neumann's assertion that "anything that can be exhaustively and unambiguously described, anything that can be completely and unambiguously put into words, is ipso facto realizable by a suitable finite neural network" was becoming increasingly apparent.[46] Since exhaustive and unambiguous description was difficult, if not impossible, working "interactively" with a computer to solve problems was key. Interactivity later became conflated with user freedom, and control with GUI (graphical user) and WYSIWYG (What You See Is What You Get) interfaces, which were seen as supplements to language-based commands. Unlike command-line interfaces, GUIs enabled "direct manipulation," in which mastery was intimately linked to simulated visibility. According to Ben Schneiderman:

> Certain interactive systems generate glowing enthusiasm among users—in marked contrast with the more common reaction of grudging acceptance or outright hostility. The enthusiastic users' reports are filled with positive feelings regarding:
>
> * mastery of the system
> * competence in the performance of their task
> * ease in learning the system originally and in assimilating advanced features
> * confidence in their capacity to retain mastery over time
> * enjoyment in using the system
> * eagerness to show it off to novices, and
> * desire to explore more powerful aspects of the system
>
> These feelings are not, of course, universal, but the amalgam does convey an image of the truly pleased user. . . . The central ideas seemed to be visibility of the object of interest; rapid, reversible, incremental actions, and, replacement of complex command language syntax by direct manipulation of the object of interest—hence the term "direct manipulation."[47]

As Brenda Laurel has argued in her comparison of computer interfaces and theater, direct manipulation (which is anything but direct) must be complemented by direct engagement in order to be successful. Direct engagement, Laurel argues

shifts the focus from the representation of manipulable objects to the ideal of enabling people to engage directly in the activity of choice, whether it be manipulating symbolic tools in the performance of some instrumental tasks or wandering around the imaginary world of a computer game. Direct engagement emphasizes emotional as well as cognitive values. It conceives of human-computer activity as a *designed experience*.[48]

Laurel's emphasis on action underscores the crucial difference between the representation of tools and the tools themselves: she argues that people realize when they double click on a folder that it is not really a folder, and making a folder more "life-like" is not helpful. What is helpful, Laurel contends, is clear causality: events must happen in such a way that the user can accept them as probable and thus narrow probability into certainty. Causality, she claims, ensures universality, ensures that the users will willingly suspend their disbelief. For users as for paranoid schizophrenics (my observation, not Laurel's), everything has meaning: there can be no coincidences, only causal pleasure.

Causal pleasure is not simply a representation of user actions in a causally plausible manner; it is also a "user amplification." Manovich explains "user amplification" in terms of Super Mario:

when you tell Mario to step to the left by moving a joystick, this initiates a small delightful narrative: Mario comes across a hill; he starts climbing the hill; the hill turns out to be too steep; Mario slides back onto the ground; Mario gets up, all shaking. None of these actions required anything from us; all we had to do is just to move the joystick once. The computer program amplifies our single action, expanding it into a narrative sequence.[49]

This user amplification mimics the "instruction explosion" driving higher-level programming languages (one line of high-level code corresponds to more than one line of machine code); user amplification is not only the product of gaming software and software art but is central to the power of programming.

This dual amplification arguably drives the romanticization of programming and, more recently, the emergence of software art, or Generation Flash. According to Manovich, Generation Flash is a new group of artists ("new romantics") who create original code rather than participate in the endless cycle of postmodern citation. As programmers Generation Flash artists produce

the new modernism of data visualizations, vector nets, pixel-thin grids and arrows: Bauhaus design in the service of information design. Instead [of] the Baroque assault of commercial media, Flash generation serves us the modernist aesthetics and rationality of software. Information design is used as a tool to make sense of reality while programming becomes a tool of empowerment.[50]

To make sense of reality, these artists and designers employ user amplification, for their modernist aesthetics and software-based rationality amplify and simplify cause and effect. In line with software more generally, they unveil—they make things visible. This unveiling depends on a certain "smartness" on the part of the user. Describing Futurefarmer's project theyrule.net, which offers users a way to map the relationships between board members of the most powerful corporations, Manovich states:

Instead of presenting a packaged political message, it gives us data and the tools to analyze it. It knows that we are intelligent enough to draw the right

conclusion. This is the new rhetoric of interactivity: we get convinced not by listening/watching a prepared message but by actively working with the data: reorganizing it, uncovering the connections, becoming aware of correlations.[51]

According to Manovich, this new rhetoric of interactivity is further explored in UTOPIA:

> The cosmogony of this world reflects our new understanding of our own planet—post Cold War, Internet, ecology, Gaia, and globalisation. Notice the thin barely visible lines that connect the actors and the blocks. (This is the same device used in theyrule.net.) In the universe of UTOPIA, everything is interconnected, and each action of an individual actor affects the system as a whole. Intellectually, we know that this is how our Earth functions ecologically and economically—but UTOPIA represents this on a scale we can grasp perceptually.[52]

UTOPIA enables what Fredric Jameson has called a "cognitive map:" "a situational representation on the part of the individual subject to that vaster and properly unrepresentable totality which is the ensemble of society's structures as a whole."[53] If cognitive mapping is both difficult and necessary now because of invisible networks of capital, these artists produce a cognitive map by exploiting the invisibility of information. The functioning of software art, as Manovich argues, parallels Marxist ideology critique. The veil of ideology is torn asunder by grasping the relations between the action of individual actors and the system as a whole. Software enables this critique by representing it at a scale—in a microworld—that we can make sense of. This unveiling depends on our own actions, on us manipulating objects in order to see, on us thinking like object-oriented programmers. Rather than lack cognitive maps, we produce them all the time through a medium that simulates ideology critique and, in its nonexistence, ideology as well. It is truly remarkable that software—designed to obfuscate the machine and create a virtual one and based on buried commands—has led to the overwhelming notion of computation as transparent. This notion of transparency has less to do with actual technological operations than with the "microworld" established by computation.

Software as ideology

As I've argued elsewhere, software is a functional analog to ideology.[54] In a *formal* sense computers understood as comprising software and hardware are ideology machines. They fulfill almost every formal definition of ideology we have, from ideology as false consciousness (as portrayed in *The Matrix*) to Louis Althusser's definition of ideology as "a 'representation' of the imaginary relation of individuals to their real conditions of existence."[55] Software, or perhaps more precisely operating systems, offer us an imaginary relationship to our hardware: they do not represent transistors but rather desktops and recycling bins. Software produces "users." Without OS there would be no access to hardware; without OS no actions, no practices, and thus no user. Each OS, through its advertisements, interpellates a "user:" calls it and offers it a name or image with which to identify. So Mac users "think different" and identify with Martin Luther King and Albert Einstein; Linux users are open-source power geeks, drawn to the image of a fat, sated penguin; and Windows users are mainstream, functionalist types perhaps comforted, as Eben Moglen argues, by their regularly crashing computers. Importantly, the "choices" operating systems offer limit the visible and the invisible, the imaginable and the unimaginable. You are not, however, aware of software's constant constriction and interpellation (also known as its "user-friendliness"), unless you find yourself

frustrated with its defaults (which are remarkably referred to as *your* preferences) or you use multiple operating systems or competing software packages.

Software also produces users through benign interactions, from reassuring sounds that signify that a file has been saved to folder names such as "my documents," which stress personal computer ownership. Computer programs shamelessly use shifters, pronouns like "my" and "you," that address you, and everyone else, as a subject. Software makes you read, offers you more relationships and ever more visuals. Software provokes readings that go beyond reading letters toward the nonliterary and archaic practices of guessing, interpreting, counting, and repeating. Software is based on a fetishistic logic.[56] Users know very well that their folders and desktops are not really folders and desktops, but they treat them as if they were—by referring to them as folders and as desktops. This logic is, according to Slavoj Žižek, crucial to ideology. Žižek (through Peter Sloterdjik) argues that ideology persists in one's actions rather than in one's beliefs. The illusion of ideology exists not at the level of knowledge but rather at the level of doing: this illusion, maintained through the imaginary "meaning of the law" (causality), screens the fact that authority is without truth—that one obeys the law to the extent that it is incomprehensible. *Is this not computation?* Through the illusion of meaning and causality do we not cover over the fact that we do not and cannot fully understand nor control computation? That computers increasingly design each other and that our use is—to an extent—a supplication, a blind faith? The new rhetoric of "interactivity" obfuscates more than it reveals.

Operating systems also create users more literally, for users are an OS construction. User logins emerged with time-sharing operating systems, like UNIX, which encourages users to believe that the machines they are working on are their own machines (before this, computers mainly used batch processing; before that, one really did run the computer, so there was no need for operating systems—one had human operators). As many historians have argued, the time-sharing operating systems developed in the 1970s spawned the "personal computer."[57]

Software and ideology fit each other perfectly because both try to map the material effects of the immaterial and to posit the immaterial through visible cues. Through this process the immaterial emerges as a commodity, as something in its own right. Thus Broy's description of pioneers as seeking to make software easier to visualize strangely parallels software itself, for what is software if not the very effort of making something explicit, of making something intangible visible, while at the same time rendering the visible (such as the machine) invisible? Although the parallel between software and ideology is compelling, it is important that we not rest here, for reducing ideology to software empties ideology of its critique of power—something absolutely essential to any theory of ideology.[58] The fact that software, with its onionlike structure, acts both as ideology *and* ideology critique—as a concealing and a means of revealing also breaks the analogy between software and ideology. The power of software lies with this dual action and the visible it renders invisible, an effect of programming languages becoming a linguistic task.

Seeing through transparency

> *When you draw a rabbit out of a hat, it's because you put it there in the first place.*
> —Jacques Lacan[59]

This act of revealing drives databases and other structures key to "transparency" or what Baudrillard called the "obscenity" of communication. Although digital imaging certainly plays a role in the notion of computer networks as transparent, it is not the only, nor the key,

thing. Consider, for instance, "The Matrix," a multistate program that sifts through databases of public and private information ostensibly to find criminals or terrorists. This program works by integrating

> information from disparate sources, like vehicle registrations, driver's license data, criminal history and real estate records and analyzing it for patterns of activity that could help law enforcement investigations. Promotional materials for the company argued, "When enough seemingly insignificant data is analyzed against billions of data elements, the invisible becomes visible."[60]

Although supporters claim that "the Matrix" simply brings together information already available to law enforcement,

> opponents of the program say the ability of computer networks to combine and sift mountains of data greatly amplifies police surveillance power, putting innocent people at greater risk of being entangled in data dragnets. The problem is compounded, they say, in a world where many aspects of daily life leave online traces.[61]

By March 15, 2004, over two-thirds of the states withdrew their support for "The Matrix," citing budgetary and privacy concerns. "The Matrix" was considered to be a violation of privacy because it made the invisible visible (again, the act of software itself), not because the computer reproduced indexical images. It amplified police power by enabling them to make easy connections. The Total Information Agency, a U.S. government plan to bring together its various electronic data-bases, was similarly decried and basically killed by the U.S. Congress in 2003.

On a more personal level, computing as enabling connections through rendering the invisible visible drives personal computing interfaces. By typing in Word, letters appear on my screen, representing what is stored invisibly on my computer. My typing and clicking seem to have corresponding actions on the screen. By opening a file, I make it visible. On all levels, then, software seems about making the invisible visible—about *translating* between computer-readable code and human-readable language. Manovich seizes on this translation and makes "transcoding"—the translation of files from one format to another, which he extrapolates to the relationship between cultural and computer layers—his fifth and last principle of new media in *The Language of New Media*. Manovich argues that in order to understand new media we need to engage both layers, for although the surface layer may seem like every other media, the hidden layer, computation, is where the true difference between new and old media—programmability—lies. He thus argues that we must move from media studies to software studies, and the principle of transcoding is one way to start to think about software studies.[62]

The problem with Manovich's notion of transcoding is that it focuses on static data and treats computation as a mere translation. Programmability does not only mean that images are manipulable in new ways but also that one's computer constantly acts in ways beyond one's control. To see software as merely "transcoding" erases the computation necessary for computers to run. The computer's duplicitous reading does not merely translate or transcode code into text/image/sound or vice versa; its reading—which conflates reading and writing (for a computer, to read is to write elsewhere)—also partakes in other invisible readings. For example, when Microsoft's Media Player plays a CD, it sends the Microsoft Corporation information about that CD. When it plays a Real Media file, such as a CNN video clip, it sends CNN its "unique identifier." You can choose to work off-line when playing a CD and request that your media player not transmit its "unique identifier" when online, but these choices require two changes to the default settings. By installing the Media Player, you

also agreed to allow Microsoft to "provide security related updates to the OS Components that will be automatically downloaded onto your computer. These security related updates may disable your ability to copy and/or play Secure Content and use other software on your computer."[63] Basically, Microsoft can change components of your operating system without notice or your explicit consent. Thus to create a more "secure" computer, where secure means secure *from* the user, Microsoft can disable pirated files and applications and/or report their presence to its main database.[64] Of course Microsoft's advertisements do not emphasize the Media Player's tracking mechanisms but rather sell it as empowering and user friendly. Now you can listen to both your CD and Internet-based radio stations with one click of a mouse: it is just like your boom box, but better. Now you can automatically receive software updates and optimize your connection to remote sites.

To be clear: this article is not a call to a return to an age when one could see what one does. Those days are long gone. As Kittler argues, at a fundamental level we no longer write—through our use of word processors we have given computers that task.[65] Neither is it an indictment of software or programming (I too am swayed by and enamored of the causal pleasure of software). It is, however, an argument against commonsense notions of software precisely because of their status as common sense (and in this sense they fulfill the Gramscian notion of ideology as hegemonic common sense); because of the histories and gazes they erase; and because of the future they point toward. Software has become a commonsense shorthand for culture and hardware a shorthand for nature. (In the current debate over stem cell research, stem cells have been called "hardware." Historically software also facilitated the separation of pattern from matter, necessary for the separation of genes from DNA.[66]) In our so-called postideological society, software sustains and depoliticizes notions of ideology and ideology critique. People may deny ideology, but they don't deny software—and they attribute to software, metaphorically, greater powers than have been attributed to ideology. Our interactions with software have disciplined us, created certain expectations about cause and effect, offered us pleasure and power that we believe should be transferable elsewhere. The notion of software has crept into our critical vocabulary in mostly uninterrogated ways.[67] By interrogating software and the visual knowledge it perpetuates, we can move beyond the so-called crisis in indexicality toward understanding the new ways in which visual knowledge is being transformed and perpetuated, not simply displaced or rendered obsolete.

Notes

1 As quoted by John Schwartz, "Privacy Fears Erode Support for a Network to Fight Crime," *The New York Times*, 15 March 2004, C1. Seisint is a corporation developing "the Matrix," a computer system discussed later in this article.

2 Jean Baudrillard, *The Ecstasy of Communication*, trans. Bernard Schutze and Caroline Schutze (Brooklyn: Semiotext(e), 1988), 21–22; emphasis in original.

3 What, for instance, is Microsoft Word? Is it the encrypted executable, residing on a CD or on one's hard drive (or even its source code), or its execution? The two, importantly, are not the same even though they are both called Word: not only are they in different locations, one is a program while the other is a process. Structured programming, as discussed later, has been key to the conflation of program with process.

4 See Lev Manovich, *The Language of New Media* (Cambridge: MIT Press, 2001), 48.

5 Paul Ceruzzi, *A History of Modern Computing*, 2nd ed. (Cambridge: MIT Press, 2003), 80.

6 Manfred Broy, "Software Engineering—From Auxiliary to Key Technology," in *Software Pioneers: Contributions to Software Engineering*, ed. Manfred Broy and Ernst Denert (Berlin: Springer, 2002), 11–12.

7 Friedrich Kittler, "There Is No Software," ctheory.net, 18 October 1995, http://www.ctheory.net/text_file.asp?pick=74.

8 In the 1950s the term *software* was used infrequently and referred to anything that complemented hardware, such as the plug configuration of cables. In the 1960s *software* became more narrowly

understood as what we would now call systems software and more broadly as "any combination of tools, applications, and services purchased from an outside vender." Thomas Haigh, "Application Software in the 1960s as Concept, Product, and Service," *IEEE Annals of the History of Computing* 24, no. 1 (January–March 2002): 6. For more on this see Wolfgang Hagen's "The Style of Source Codes," trans. Peter Krapp in *New Media, Old Media: A History and Theory Reader*, ed. Wendy Hui Kyong Chun and Thomas Keenan (New York: Routledge, 2005).

9 See Herman Goldstine and Adele Goldstine, "The Electronic Numerical Integrator and Computer (ENIAC)" *IEEE Annals of the History of Computing* 18 no. 1 (Spring 1996): 10–16. The two activities have been divided by Arthur Burks into "numerical programming" (implemented by the operators) and "programming proper" (designed by engineers and implemented by the master programming unit). Arthur Burks, "From ENIAC to the Stored-Program Computer: Two Revolutions in Computers," in *A History of Computing in the Twentieth Century*, ed. N. Metropolis et al., 311–344 (New York: Academic Press, Inc., and Harcourt Brace Jovanovich, 1980). Numerical programming dealt with the specifics of the problem and the arithmetic units and was similar to microprogramming; programming proper dealt with the control units and the sequence of operations.

10 See Martin Campbell-Kelly and William Aspray, *Computer: A History of the Information Machine* (New York: Basic Books, 1996), 184.

11 See Wolfgang Hagen, "The Style of Source Codes," in *New Media, Old Media*, ed. Wendy Hui Kyong Chun and Thomas Keenan (New York: Routledge, 2005).

12 Adele Mildred Koss, "Programming on the Univac 1: A Woman's Account," *IEEE Annals of the History of Computing* 25, no. 1 (January–March 2003): 56.

13 See Jacques Derrida, "Signature Event Context," in Jacques Derrida, *Limited Inc.*, trans. Samuel Weber and Jeffrey Mehlman, 1–23 (Evanston: Northwestern University Press, 1988).

14 John Backus, "Programming in America in the 1950s—Some Personal Impressions," *A History of Computing in the Twentieth Century*, ed. Metropolis et al., 127.

15 Koss, 58.

16 Jean Sammett, *Programming Languages: History and Fundamentals* (Englewood Cliffs: Prentice-Hall, 1969), 144.

17 Sammett, 148.

18 See for instance Theodor Nelson, *Computer Lib* (Richmond, WA: Tempus Books of Microsoft Press, 1987).

19 Harry Reed, "My Life with the ENIAC: A Worm's Eye View," in *Fifty Years of Army Computing from ENIAC to MSRC*, Army Research Laboratory, 2000, 158; accessible online at: http://ftp.arl.mil/~mike/comphist/harry_reed.pdf.

20 See "Anecdotes: How Did You First Get into Computing?" *IEEE Annals of the History of Computing* 25, no. 4 (October–December 2003): 48–59.

21 Paul N. Edwards, *The Closed World: Computers and the Politics of Discourse in Cold War America* (Cambridge: MIT Press, 1996), 71.

22 I.J. Good. "Pioneering Work on Computers at Bletchley," in *A History of Computing in the Twentieth Century*, ed. Metropolis et al., 31–46.

23 Quoted in Ceruzzi, 82.

24 See Michael S. Mahoney, "Finding a History for Software Engineering," *IEEE Annals of the History of Computing* 27, no. 1 (January–March 2004): 8–19.

25 As argued earlier, although software produces visible effects, software itself cannot be seen. Luce Irigaray, in *This Sex Which Is Not One* (trans. Catherine Porter, Ithaca, NY: Cornell UP, 1985), has similarly argued that feminine sexuality is non-visual, "her sexual organ represents *the horror of nothing to see*;" emphasis in original, 26.

26 Sadie Plant, *Zeros + Ones: Digital Women + The New Technoculture* (New York: Doubleday, 1997), 37.

27 Campbell-Kelly and Aspray, 181.

28 Koss, 51.

29 Koss, 49.

30 Fitz, 21.

31 Paul Edwards, "The Army and the Microworld: Computers and the Politics of Gender Identity," *Signs* 16, no. 1 (1990): 105, 125; emphasis added.

32 Vannevar Bush describes the action of a stenographer as: "A girl strokes its keys languidly and looks about the room and sometimes at the speaker with a disquieting gaze." Vannevar Bush, "As We May Think," *The Atlantic Monthly*, July 1945, repr. 1994, http://www.ps.uni-sb.de/~duchier/pub/vbush/vbush.txt. Women have been largely displaced from programmers to users, while continuing to dominate the hardware production labor pool even as these jobs have moved across the Pacific.

33 For more on the software crisis and the relationship between it and software engineering, see Cambell-Kelly and William Aspray, 196–203, Ceruzzi, 105, and Frederick P. Brooks's *The Mythical Man-Month: Essays on Software Engineering*, 20th Anniversary Edition (NY: Addison-Wesley Professional, 1995).

34 Mahoney, 15.

35 Edsger W. Dijkstra, "EWD 1308: What Led to 'Notes on Structure Programming,' " in *Software Pioneers*, ed. Broy and Denert, 342.

36 Edsger W. Dijkstra, "Go to Statement Considered Harmful," in *Software Pioneers*, ed. Broy and Denert, 352, 354.

37 Arguably, go tos are harmful because they are moments in which the computer is directly addressed—conditional branching and loops enable a program to move to another section without such an address. This address poses the question: exactly who or what is to go to a different section? Intriguingly, go to is a translation of the assembly command "transfer control to"—to give control over the program to the command located in address X. The difference between go to and transfer control to underlies the crisis of agency at programming's core.

38 John V. Guttag, "Abstract Data Types, Then and Now," in *Software Pioneers*, ed. Broy and Denert, 444.

39 Guttag, 444.

40 Guttag, 445.

41 David Eck, *The Most Complex Machine: A Survey of Computers and Computing* (Natick, MA: A. K. Peters, 2000), 329, 238.

42 Koss, "Programming on the Univac 1: A Woman's Account," 49.

43 Paul Edwards, "The Army and the Microworld," 108–9.

44 For more on the pleasure of programming see Linus Torvalds, *Just for Fun: The Story of an Accidental Revolutionary* (New York: HarperBusiness, 2001); and Eben Moglen, "Anarchism Triumphant: Free Software and the Death of Copyright," *First Monday* 4, no. 8 (2 August 1999), http://firstmonday. org/issues/issue4_8/moglen/index.html.

45 See Edwards's discussion of John McCarthy's work in *The Closed World*, 258.

46 John von Neumann, *Papers of John von Neumann on Computing and Computer Theory*, ed. William Aspray and Arthur Burks (Cambridge: MIT Press, 1987), 413.

47 Ben Schneiderman, "Direct Manipulation: A Step Beyond Programming Languages," in *The New Media Reader*, ed. Noah Wardrip-Fruin and Nick Montfort (Cambridge: MIT Press, 2003), 486.

48 Brenda Laurel, *Computers as Theatre* (Reading, MA: Addison-Wesley Publishers, 1991), xviii.

49 Lev Manovich, "Generation Flash," 2002, http://www.manovich.net/DOCS/generation_flash.doc.

50 This notion of empowerment begs the questions of what it means to produce "original code" and how Bauhaus design in the service of information design is not citation. Manovich, "Generation Flash."

51 Manovich, "Generation Flash."

52 Manovich, "Generation Flash."

53 Fredric Jameson, *Postmodernism, or The Cultural Logic of Late Capitalism* (Durham: Duke University Press, 1991), 51.

54 See Wendy Hui Kyong Chun, *Control and Freedom: Power and Paranoia in the Age of Fiber Optic* (Cambridge: MIT Press, 2005).

55 Louis Althusser, "Ideology and Ideological State Apparatuses (Notes Towards an Investigation)," in *Lenin and Philosophy and Other Essays*, trans. Ben Brewster (New York: Monthly Review Press, 2001), 109.

56 See Slavoj Žižek, *The Sublime Object of Ideology* (London: Verso, 1989), 11–53.

57 See Ceruzzi, 208–9; Cambell-Kelly, 207–29.

58 However, these parallels arguably reveal the fact that our understandings of ideology are lacking precisely to the extent that they, like interfaces, rely on a fundamentally theatrical model of behavior.

59 Jacques Lacan, *The Seminar of Jacques Lacan, Book II: The Ego in Freud's Theory and in the Technique of Psychoanalysis* (1954–1955), ed. Jacques-Alain Miller, trans. Sylvana Tomaselli (New York: Norton, 1991), 81.

60 Schwartz, C1.

61 Schwartz, C1.

62 Manovich, *The Language of New Media*, 48.

63 See Media Player's "Licensing Agreement."

64 Microsoft is considering such actions in its Palladium initiative. See Florence Olsen, "Control Issues: Microsoft's plan to improve computer security could set off fight over use of online materials," *Chronicle of Higher Education*, 21 February 2003, http://chronicle.com/free/v49/i24/24a02701. htm.

65 See Kittler, "There Is No Software."
66 See Francois Jacob, *The Logic of Life: A History of Heredity*, trans. Betty E. Spillman (New York: Pantheon Books, 1973), 247–98.
67 Richard Doyle's concept of "rhetorical software," developed in his *On Beyond Living: Rhetorical Transformations of the Life Sciences* (Stanford: Stanford University Press, 1997), epitomizes the use of software as a critical term in non-scientific scholarly discourse and reveals the extent to which software structures our ideas and thus lies as the concept that needs most interrogation.

Jacques Rancière

NOTES ON THE PHOTOGRAPHIC IMAGE

IN THE RELATION BETWEEN ART AND IMAGE, photography has played a symptomatic and often paradoxical role. Baudelaire made of it the sinister instrument of the triumph of technical reproduction over artistic imagination. And yet we also know of the long struggle of photographers (*pictorialistes*) to affirm that photography was not merely mechanical reproduction, but rather an interpretation of the world. But scarcely had they won their battle to endow the technical medium of photography with the status of artistic medium, when Benjamin turned the game on its head. He made mechanical reproduction the principle of a new paradigm of art: the productions of the mechanical arts were for him the means towards a new sensible education, the instruments of the formation of a new class of experts in art, namely in the art of interpreting signs and documents. Cinema was a series of tests of our world. Atget's photos were indices to interpret; Sander's collections were notebooks for teaching combatants in the social struggle to readily identify allies and adversaries. The photographic medium participated in the construction of a sensible world where men of the age of the masses could affirm their existence as both possible subjects of art and experts in its use.

It seems, nevertheless, that the destiny of the art of photography has no more confirmed Benjamin's diagnostic than that of Baudelaire. To support this claim, we can point to two phenomena more or less contemporary to one another that concern both photography and its interpretation. On the one hand, the 1980s saw photography invade art museums and exhibitions, taking on the dimensions of monumental paintings. These large-format photographs, amidst the proliferation of installations and video installations, assure, in a certain sense, the continuity of the pictorial surface. But, at the same time, what they present to us on this surface seems to turn its back on the forms of the pictorial revolutions of the twentieth century. Without even speaking of extreme examples like Jeff Wall's revival of the historical tableau, we can think of the multiplication of portraits and the new status of the portrait, illustrated by, for example, photographer Rineke Dijkstra's monumental portraits of otherwise indifferent individuals, represented without any particular aura: slightly awkward-looking adolescents on working-class beaches, young mothers still burdened by their babies, or apprentice toreadors, whose red-faced figures clash with the bullfighter's traditional suit of lights. On the one hand, these full-length portraits present themselves as documents on

social types or age groups undergoing transformation. On the other, the absence of expression, combined with the formalism of the pose and the size of the image, gives these indifferent figures something mysterious: something that for us also inhabits the portraits of Florentine and Venetian nobility which populate the museums. The teenager in the green swimsuit photographed on a Polish beach, with her slender body, her swaying hips, and her unfurled hair is like an awkward replica of Botticelli's Venus. Photography is thus not content to occupy the place of painting. It presents itself as the rediscovered union between two statuses of the image that the modernist tradition had separated: the image as representation of an individual and as operation of art.

How should we think this new coincidence and tension between the grand pictorial form and simply the images of indifferent individuals? The interpretation seems, at first sight, split between two extremes: at the one end, an exacerbation of the sensible presence of the photographed subject, in its provocative power with respect to modernist logic; at the other, an integration of this photographic realism—or hyperrealism—into the modernist scheme. In the first instance, we think of course of Barthes and *Camera Lucida*, the absolute reference for thought on photography in the 1980s. Barthes's manoeuvre was to break the representation of the indifferent in two. The indifferent is, on the one hand, that which is identifiable by the intersection of a certain number of general traits. On the other, it is the absolute singularity of that which imposes its brute presence, and affects by this brute presence. We recognize here the principle of the opposition between the *studium*, conceived as the informative content of the photograph, and the *punctum*, conceived as its affective force, irreducible to transmission of knowledge. This affective force is the transfer of an absolute singularity, that of the represented subject, to another absolute singularity, that of the viewing subject. It is easy to underline the double paradox of this theorization in light of the ulterior evolution of photography. It privileges a vision of photographic reproduction where it is the *having-been* of the body that comes to imprint itself on the sensitive plate, and from there touches us without mediation. This raising of the stakes concerning the indexical conception of photography was immediately countered by the digital invasion. At the moment when large-format photography is about to overrun the museum walls and affirm itself as a visual art, it transforms the photographic gaze into the gaze of an individual who pages through albums. But this historical contretemps refers us back to a more fundamental torsion concerning the relation between photography, art and modernism. In a certain manner, Barthes contorts the formalist modernist, who opposed the form (artistic/pictorial) to the anecdote (empiricist/photographic). Barthes diverts the opposition by transferring the anecdote to the *studium*, in order to pit it against not the artistic form, but an experience of the unique that refutes the pretension to art as well as the platitude of information. However, this opposition between art and photography is perhaps more profoundly the leave given to another modernity, to which Benjamin's essay bore witness, and that inscribed photography among the instruments of a new social sensibility and a new social consciousness (three elements and not two). It is from this point of view that it seems useful to me to examine more closely the examples through which Barthes operates the opposition between *studium* and *punctum*. Let us take, for example, Lewis Hine's photograph of the two mentally disabled children (below).

Barthes tells us not to look at the monstrous heads or the pitiful profiles that signify the disability. Instead, he opposes to these the force of fascination that is exerted on him by the details without signification: the boy's Danton collar, the bandage on the little girl's finger.[1] But the *punctum* thus marked, in fact, obeys the same formal logic as the repudiated *studium*. It concerns, in both cases, features of disproportion. The privilege of the *punctum* here is simply to privatize this formal effect. We can read this analysis as the exact reversal of the critical logic previously put to work by the Barthes of *Mythologies*. What was at stake for him there, in a Brechtian logic, was to make visible the social hidden in the intimate, the history

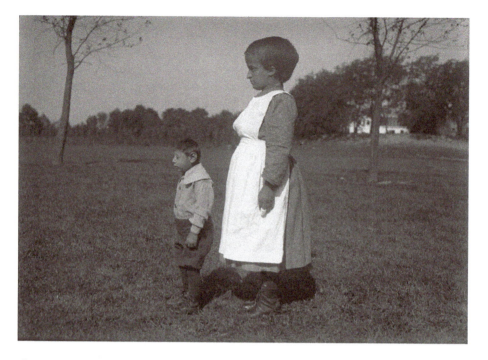

Figure 6.1 Lewis W. Hine (1874–1940), Morons in an Inst., ca. 1905–1940. Negative, gelatin on glass, 5 × 7 inches.(85:0178:0018). Courtesy of George Eastman House, International Museum of Photography and Film.

dissimulated as the appearance of nature. From this point of view, the very choice of the photograph is significant. The photo of the two disabled children appears as a *hapax* (ἅπαξ λεγόμενον "[something] said only once") in the career of a photographer who devoted numerous series to the representation of work and the campaign against child labour. The "stupidity" of the detail drawn from the irreducible hardship and misfortune of the two disabled children can be read like a screen placed before other photos of children: that of the Polish child, "Willie," working in a mill in Rhode Island, or Francis Lance, the 5-year-old newspaper "salesman." Yet, these "documentary" photographs are the bearers of a tension between visuality and signification that is perhaps more interesting than the image of the two disabled children. They are in effect made for the purpose of denouncing the scandal of child labour. Yet, Willie's attitude, as he sits nonchalantly (taking his midday rest) in a doffer-box, or Francis Lance's, proudly standing his ground on a train platform with his newspapers tucked under his arm, do not testify to any suffering. What strikes us is precisely the opposite: it is the selfsame ease with which they show themselves capable of both adapting to their work and posing for the camera, thus obliging Lewis Hine to insist, in his commentary, on the dangers of their work, which they themselves seem so unconcerned about.

"Impoverished ontology"

The activity of the commentator seems to respond, in advance, to the "Benjaminian" demand. It is, in particular, the relation between the child workers, the camera, the photo and the text that follows this logic, linking the appreciation of the photographic performance to new forms of "expertise" and to the experimentation of a new sensible world. The Danton collar suffices to silently settle the accounts with this logic. The only sensible world that the photo

witnesses is the relation of the absolute singularity of the spectacle to the absolute singularity of the gaze. Much the same can be said about Avedon's photograph of the old slave.[2] Here the procedure is reversed: no detail distracts from a socio-political reading. On the contrary, the mask of the photographed subject speaks of nothing else than the condition of slavery. But the effect is the same: it is slavery in person, as a historical singularity, that offers itself entirely in the singularity of a single face. To declare slavery to be present in person, in front of our eyes, between our hands, is, in fact, to diminish the singularity of the other photographs that speak to us about what took place between the abolition of slavery and our present. For example, John Vachon's photo, which shows us only the sign reading *Colored*, nailed high up on the trunk of a pine tree, next to which is the likely object of its discrimination: a simple drinking fountain. The multiplicity of racial discrimination's forms of sensible existence, and the multiple singularity of these photographs that vary, and thereby tell us of, the visual forms of the metaphor and of the metonymy, come to be crushed against this black mask that presents slavery in person. But this being of slavery identifies itself with its having-been. Avedon's photo represents the slavery that is no longer on the face of a man who, himself, is no longer, at the time when Barthes wrote his commentary. When all is said and done, the singularity of slavery written on a singular face is nothing other than the universality of the having-been; in other words, death.

It is to this singularity that the image of the two disabled children, which conceals those of the playing children of the factories, ultimately comes down. But this singularity of the image is itself determined by the power of words alone. Taking up again the two traits of the *punctum* of this photo, it is first of all the bandage on the finger of the little girl. The French word with which Barthes refers to the bandage is *poupée*. Yet the French reader who does not know this usage of the word immediately has another image. The ordinary sense of the word in French is "doll." And the identification of this poignant detail with the *poupée* inevitability evokes a whole series of images: from Hoffmann's automaton, commented on by Freud, to the dismembered dolls that are a part of the surrealist imaginary, and that contributed more than a little to the transformation of Winnicott's transitional object into Lacan's object *petit a*. In short, the effect attributed to the phraseless singularity of the detail is the power of a word. And this power of the word is further accentuated by the proper name that qualifies another poignant detail: the Danton collar. The French reader has no idea what a Danton collar might be. However, the name is immediately associated with that of a revolutionary who had his head sliced off by the guillotine. The *punctum* is nothing other than death foretold.

The analysis of the photo of the two mentally disabled children is therefore linked with that which Barthes devotes to the photo of the handcuffed young man. The photo is beautiful, Barthes tells us, and so is the young man, but that is the *studium*. The *punctum* is that "he is going to die."[3] Yet this death foretold is not visible in any of the features of the photograph. Its presumed effect rests on the combination of the brown colouring of the old photographs and the acquaintance with the individual represented, (in this case) Lewis Payne, condemned to death in 1885 for an attempted assassination of the then American secretary of state. But this affirmation of present death once again employs words to deny what constitutes the visual singularity of the photograph—that is, precisely that its present refuses any readings of the young man's history, of the past that led him there, and of the future that awaits him. The half-nonchalant, half-curious attitude of the young man says nothing about this history, much the same as Willie's relaxed pose said nothing about the hardships of factory work, and the gaze of the Polish teenager on the beach nothing about what reasons she might have had for exposing herself, nor her thoughts as she stands in front of the camera. What they speak to us of is only this capacity to expose one's body at the request of the camera, without, for all that, surrendering to it the thought and the feeling that inhabit it. This tension between exposition and retreat vanishes in the pure relation of the viewer with the death that comes to view him.

This disappearance is not only due to the fact that *Camera Lucida* is first of all a eulogy addressed to Barthes's dead mother. Behind the expression of personal grief, there is the expression of another grief, that of the gaze that endeavoured to tie the appreciation of the beauty of an image to that of the social reality that it expressed. Yet, his second grief also manifests itself in a type of reading which, contrary to Barthes, sees in the new modes photographic exposition the reaffirmation of a certain idea of the objectivity of the photograph. It is this thesis that was defended in 1988 by a period-defining exhibition entitled "Another Objectivity" (*Une autre objectivité*).[4] The accompanying text, by Jean-François Chevrier and James Lingwood, redefined, in its own way, the relation between two fundamental aspects of the modernist norm: on the one hand, the fidelity to the law of the medium; on the other, the fidelity to a certain type of exhibition surface, the *forme-tableau* in its formal separation from the multiple social uses of the image. The fact is that the law of the photographic medium does not offer itself up to a simple interpretation. We can liken it to the instrumental conception that makes the camera a means to furnish some objective information about what is in front of it. But, from this, we still have not defined the specificity of the art of photography. We can liken it to the reproducible character of the photographic image. But it is hardly possible to discern the specific quality of an image from the fact that it is reproducible. This is why the theoreticians of photographic objectivity displaced the idea of multiplication in favour of the idea of a multiple unity. Reproducibility thus becomes seriality.

Benjamin based his argumentation on the typologies of August Sander, while Chevrier and Lingwood favoured the works of Bernd and Hilla Becher. But the analogy is problematic. Benjamin expected that Sander's series would help the combatants in the social struggle to recognize allies and enemies. There is manifestly nothing of the sort to be expected from the Bechers' series of water towers or disused industrial sites. They would even fall easily within the scope of Brecht's critique, which was taken up by Benjamin: photos of factories say nothing about the social relations that manifest themselves there. The interest of the series can therefore no longer be looked for in what it enables us to say about social relations. It boils down to an ethical virtue accorded to the multiple as such, in that it rules out the prestige of the one and of the aura, of the unique moment and of the ecstatic contemplation. But this principle is purely negative. Its artistic "positivity" must thus come from a second manner of thinking the "objectivity" of the medium. This is summed up, for Chevrier and Lingwood, in the notion of the *forme-tableau*, exemplified by Jeff Wall's backlit photographs. But what relation should we think between these large scenes in the form of historical tableaux and the identical rectangles that make the Bechers' views of water towers and smoke-stacks resemble pedagogical charts? None, perhaps, if not the Greenbergian idea of the surface that encloses the artist's performance and prohibits him from leaving himself, from showing empathy for his subject or from considering himself as a form of social experimentation. In this sense, the Bechers' industrial sites are a manner of concluding the dream of the artist engineers and factory builders of Peter Behrens's era, in much the same way as Barthes's fascination with the Danton collar served to repress photographer Lewis Hine's engagement on the side of the oppressed and forgotten of the factories and hospices. The reference to the essence of the medium is again here a manner of settling accounts with the epoch where the medium was thought of as the organ of a new collective world. Simply put, this settling of accounts is more complex in the case of the Bechers and the theoreticians of "objective photography," for whom the repression of the constructivist dream also wants to be the affirmation of a fidelity to the values linked to the industrial universe and the workers' struggle: the sobriety of the documentary gaze that refuses the humanist pathos, the formal principles of the frontal perspective, the uniform framing, and the presentation in series that links scientific objectivity and the disappearance of the subjectivity of the artist.

It remains the case: that which is given to see by the objectivist mindset is fundamentally an absence—disused edifices in the place of social classes and types. Yet, photographing

absence can be interpreted in two ways: it can be a manner of showing the programmed departure of the industrial world and worker; but it is just as much a manner of playing on the aesthetic affect of the disused (*desaffecté*) that sends us back to the side of Barthes's "having-been." This tension in the objectivist idea of the medium is more perceptible still in the series of containers taken by a follower of the Bechers, Frank Breuer, presented during the 2005 Rencontres photographiques in Arles, in the transept of an ancient church, along with two other series, devoted to warehouses and to logos. From afar the spectator perceived them as abstract scenes or as reproductions of minimalist sculptures. Upon approaching, however, one discovered that the coloured rectangles on a white background were containers stacked in a large deserted space. The impact of the series was down to the tension between this minimalism and the signification that it concealed. These containers were to be, or were to have been, filled with merchandise unloaded at Antwerp or Rotterdam, and probably were produced in a distant country, perhaps by faceless workers in Southeast Asia. They were, in short, filled with their own absence, which was also that of every worker engaged to unload them, and, even more remotely, that of the European workers replaced by these distant labourers.

The "objectivity" of the medium thus masks a determined aesthetic relation between opacity and transparency, between the containers as brute presence of pure coloured forms and the containers as representatives of the "mystery" of the merchandise—that is to say, of the manner in which it absorbs human work and hides its mutations. It consists in the relation between presence and absence, in the double relation of a visible form to a signification and

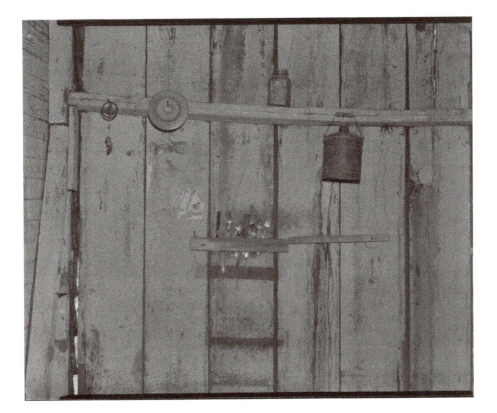

Figure 6.2 Walker Evans, (1903–1975) and Jim Dow (b. 1942), Kitchen Wall in Bud Field's Home, Hale County, Alabama, 1936. Printed ca. 1971, later gelatin silver contact print by Jim Dow from original negative, 19.3 × 24.3 cm. (1976:0191:0002). Courtesy of George Eastman House, International Museum of Photography and Film.

an absence of sense. Jean-François Chevrier bases his argument on the idea of an "impoverished ontology" of photography. On one level, this is to say that photography does not have the strong ontological consistency that would enable its artistic forms to be deduced from its materiality. But we can give this poverty a more positive signification. If photography is not under the law of a proper ontological consistency, linked to the specificity of its technical mechanism, it lends itself to accomplishing the ideas about art formed by the other arts. This capacity of the mechanical art to realize what other arts had tried to accomplish by their own means was developed at length by Eisenstein, in relation to cinematic editing, which, via the temporal sequencing of shots, realized what painting had tried to accomplish in fragments. Serov, for example, tried to bring out on canvas the energy of the actress Yermolova through cutting, with the help of the lines of the mirrors and of the mouldings of a room, several different framings for the different parts of the body.[5] The editing of the different shots of the stone lions in *The Battleship Potemkin* realized this dream of the painter. Photography allows an accomplishment of the same order by capturing a motionlessness that literature tried to attain through the movement of the phrase or the power of the mystery sought in the contortion of the uses of language. The poverty of photography permits it to realize this inclusion of non-art that literature or painting can only imitate by artistic means.

Exacerbating modernism

This is what can be demonstrated by a photograph situated in the interval between Barthes's "having-been" and the objectivity of the Becher School. Walker Evans's photograph (left) represents to us a detail of the kitchen in a farm in Alabama. It responds, first of all, to a documentary function at the heart of a major investigation commissioned by the Farm Security Administration. Nevertheless, something happens in the photo that exceeds the task of providing information concerning a miserable situation: a kitchen with neither sideboard nor cupboard, tinplate silverware held in a makeshift rack, a lopsided wooden board nailed to a wall of disjointed and worm-ridden planks. What strikes us is a certain aesthetic disposition marked by disorder: the parallels are not parallel, the silverware is ordered in disorder, the objects on the high beam (functioning as a shelf) are placed in a dissymmetrical manner. This lopsided assemblage composes, in total, a harmonious dissymmetry, the cause of which remains uncertain: is it the effect of chance, the fact that the objects found themselves in front of the objective? Is it the gaze of the photographer, who chose a close-up of a detail, thus transforming a completely random or simply functional layout into an artistic quality? Or is it the aesthetic taste of an inhabitant of the premises, making art with the means available by hammering in a nail or putting a can here rather than there? It is possible that the photographer wanted to show the destitution of the farmers. It is also possible that he simply photographed what was in front of him without any particular intention, and that the photo thus benefits from the beauty of the random. And, it is possible that he took pleasure in seeing a quasi-abstract minimalist scene or, conversely, that he wanted to underline a certain beauty of the functional: the sobriety of the plank and of the rack could, in effect, satisfy a certain aesthetic of design, attracted by the simple and brute material, and the art of living and doing transmitted by generations of simple people. All in all, the aesthetic quality of the photograph stems from a perfect equilibrium, a perfect indecision between the two forms of beauty that Kant distinguished: beauty adherent to the form adapted to its function, and the free beauty of the finality without end.

We don't know what was going through Walker Evans's mind in framing his photo as he did. But we do know that he had an idea about art that he inherited, not from a photographer or painter, but from a writer, Flaubert. The idea is that the artist must remain invisible in his work, like God in his creation. But it would be going a bit too far to say that the camera realizes

on the cheap—that is, by its mechanism alone—that which, for the writer, involves a never-ending work of subtraction. For impersonality is not the same thing as the objectivity of the camera, and the issue is perhaps not so much to subtract but rather to make the "impersonalization" of the style coincide with the grasping of the opposite movement: that by which indifferent lives appropriate the aesthetic capacities that subtract them from a simple social identification. The photographer's gaze upon the singular arrangement of the silverware in a poor Alabama kitchen might remind us of the gaze that Flaubert lent to Charles Bovary as he looked at the head of Minerva, drawn by young Emma for her father on the peeling walls of Father Rouault's farm. This is not merely to say that the camera directly expresses a poetry of the banal that the writer could only make felt through laborious work on each sentence. It is also the power to transform the banal into the impersonal, forged by a literature that hollows out from the inside the apparent evidence, the apparent immediacy of the photo, just as pictorial silence overran the "Flaubertian" phrase. But this effect of painting on literature and of literature on photography is not the same as a simple shared capacity to transfigure the banality of life into the artistic splendour of indifference. This "indifference" is also the meeting point, the point of tension, between the subtraction of the artistic effect that characterizes the work of the artist and the supplement of aesthetic sensibility that is adjoined to the lives of indifferent beings.

The consideration of both the *punctum* and the objectivism of the *forme-tableau* also lacks this relation between social banality and aesthetic power that inhabits the photographic portrait of the indifferent being. To understand what the "indifference" of the photograph of the kitchen in Alabama or of the Polish teenager has in common with that of "Flaubertian" literature, and to what type of "modernity" this indifference bears witness, one must no doubt integrate these images into a completely different evolution of representation (*figuration*). To sketch out this history, I would like to dwell for a moment on a singular analysis that Hegel devotes, in his *Lessons on Aesthetics*, to Murillo's paintings of the child beggars of Seville, which he saw in the Royal Gallery in Munich. He evokes these paintings in a development whereby he attempts to reverse the classic evaluation of the value of pictorial genres according to the dignity of their subjects. But Hegel does not content himself with telling us that all subjects are equally proper to painting. He establishes a close relation between the virtue of this painting and the activity specific to these young beggars, an activity that consists precisely in doing nothing and not worrying about anything. There is in them, he tells us, a total disregard towards the exterior, an inner freedom in the exterior that is exactly what the concept of the artistic ideal calls for. They are like the young man in one of the portraits at the time attributed to Raphael, whose idle head gazes freely into the distance. Better still, they testify to a beatitude that is almost similar to that of the Olympian gods.[6]

There is one notion in particular in this passage that grabs our attention, that of being carefree. It seems to reply in advance to an analysis of the aesthetic revolution that holds sway today, that by which Michael Fried characterizes the theorizing and the practice of painting implemented by the contemporaries of Diderot. Presenting the characters in the scene as completely absorbed by their task is, for him, the means by which the painters of that period, following the example of Greuze, posed and resolved the big question of artistic modernity: how can a work be made coherent by excluding the spectator from its space? This "anti-theatricality" is for him the essence of pictorial modernity, defined not in a "Greenbergian" manner as simple concentration of the artist on his medium, but rather as definition of the place that it gives to the person who looks upon it. The *forme-tableau* of Jeff Wall's lightboxes or of the large-format cibachromes and chromogenic prints by Rineke Dijkstra, Thomas Struth, Andreas Gursky or Thomas Demand seems to Fried to renew, in exemplary fashion, the tradition of this modernity. But it comes at a price, and the active "absorption" of the pictorial character, originally illustrated with such impassioned attention by Greuze's characters, increasingly becomes an inability to see and to feel seen. Thus, for example, the tourists

in Thomas Struth's photographs of museums are represented in the absence of what they look upon in the Accademia (Michelangelo's *David*) or blurred in the darkness in Tokyo in front of a *Liberté guidant le peuple*, itself separated by a glass pane. Likewise, Rineke Dijkstra's teen-agers are valued first of all for the awkwardness proper to their age, for their lack of control over their bodies which makes them unconscious of what they offer to be seen.[7] The window cleaner who, in Jeff Wall's famous photo, washes the windows of Mies van der Rohe's pavilion, is not only separated from us by the back that he turns to us and by his relegation outside of the area directly illuminated by the sun; he is also "deliberately forgetful" of the great event signifying the new day, "the influx of the warm morning light."[8] As for the traders at the Hong Kong stock exchange or the workers at the basket factory in Nha Trang, their "absorption" excludes the spectator all the more effectively as it renders them almost invisible by depriving them of all interiority and making of their attention an entirely mechanical process. It would be off-key, Fried emphasizes, to see here any form of represen-tation of capitalist dehumanization. This "flattening of absorption" bears witness, on the contrary, to "the consistency with which this artist resists or indeed repudiates all identifica-tion by the viewer with the human subjects of his images—the project of severing calls for nothing less."[9]

"Objective" photography therefore demonstrates here the exacerbation of a modernist project of separation. The visual attention that is paid by the modest people, in Greuze's paintings, to each other and their surroundings is replaced by their ant-sized representation in Gursky's photographs. But this transformation, in turn, reveals the presuppositions of the analysis: the active absorption of characters by their task is, ultimately, only their passive absorption into the space of the painting. What they are or do matters little, but what is important is that they are put in their place. It is with regard to this positing named absorp-tion that Hegel's insistence on the carefree inactivity of the young beggars becomes mean-ingful. Inactivity is not laziness. It is the suspension of the opposition between activity and passivity that aligned an idea of art with a hierarchical vision of the world. Murillo's child beggars belonged to the type of picturesque paintings that eighteenth-century aristocrats collected as documents on the exotic life of the working classes. Hegel's analysis removes them from there by giving them a quality which they share with the Olympian gods. This "carefree" attitude is more striking than the new indifference of subjects and their common capacity to be "absorbed." It posits as the exemplary subject of art this "doing nothing," this common *aesthetic* neutralization of the social hierarchy and of the artistic hierarchy.

The aesthetic capacity shared by the Olympian god, the young noble dreamer and the carefree street child neutralizes the opposition between the subjects of art and the anony-mous forms of experience. "We have the feeling that for a young person of this type any future is possible," says Hegel.[10] It is a peculiar comment, which makes the figures repre-sented in a seventeenth-century painting contemporary beings whose future we consider. The young beggars testify, in fact, for another modernism far removed from that of Michael Fried's absorbed characters, without, for all that, becoming identified with the young veloci-pede racing experts extolled by Benjamin. The future that they bear is the blurring of the opposition between the world of work and the world of leisure, between the naked forms of life and the experiences of the aestheticized world. It is to this modernity that the assertion of Walker Evans's master, Flaubert, on the indifference of the subject, belongs. This does not mean the possibility for the artist to apply the "project of severing," symbolic of Greenberg's or Fried's modernism, to any subject. It is realized only in that space where the artist rids himself of all the habitual attributes of the artist style and comes to encounter the attempts of obscure beings to introduce art into their sensible life, or any other of those forms of experi-ence which their social condition is supposed to forbid. Flaubert may ridicule Emma's artistic pretension, but her art is forever linked to this artistic aspiration of a farmer's girl.

It is, similarly, a form of this encounter that James Agee and Walker Evans try to capture, one by brandishing Whitmanian enumerations and Proustian reminiscences to describe the houses of poor peasants, the other by rendering minimalist art and social document indiscernible when framing a dozen or so pieces of cutlery in front of four planks of brute wood. Before our gaze, there is thus neither simple objective information about a situation nor a wound inflicted by the "it has been." The photo does not say whether it is art or not, whether it represents poverty or a game of uprights and diagonals, weights and counterweights, order and disorder. It tells us neither what the person who laid the planks and cutlery in this manner had in mind nor what the photographer wanted to do. This game of multiple gaps perfectly illustrates what Kant designated under the name of aesthetic idea: "a presentation of the imagination which prompts much thought, but to which no determinate thought whatsoever, i.e., no [determinate] concept can be adequate."[11] The aesthetic idea is the indeterminate idea that connects the two processes that the destruction of the mimetic order left separated: the intentional production of art which seeks an end, and the sensible experience of beauty as finality without end. Photography is exemplarily an art of aesthetic ideas because it is exemplarily an art capable of enabling non-art to accomplish art by dispossessing it. But it is also such through its participation in the construction of a sensible environment which extends beyond its own specificity. What we are shown by the young beggars seen by Hegel, the head of Minerva on the walls of the Normandy farm, the lopsided cans on the beams of the Alabama kitchen, the nonchalant demeanour of the child-worker in his doffer-box, or the swaying hips of the Polish teenager, is that this dispossession which makes art cannot be thought independently of the despecification which removes all of these characters from their social identity. But this despecification itself is not the making of an artistic *coup de force*. It is the correlate of the ability acquired by the characters themselves to play with the image of their being and of their condition, to post it to walls or to set it up before the lens. Judgements about photography are also appreciations of this ability and of what it means for art. This link between artistic purity and aesthetic impurity both fascinated and worried the authors of *Spleen de Paris* and *Madame Bovary*. Walter Benjamin wanted to integrate it in a global vision of the new man in the new technical world. Barthes brought it down to the intimacy of the private gaze. Michael Fried now proposes to bring it down to the interminable task of separation attributed to artistic modernity. But this theoretical *coup de force* would not be possible if the art of photography today was not already the bearer of this tendency to break the historical complicity between the art of the photographer and the aesthetic capacity of his subjects.

Translated by Darian Meacham

Notes

1 Roland Barthes, *Camera Lucida*, Hill & Wang, New York, 1981, p. 51.
2 Ibid., p. 34.
3 Ibid., p. 96.
4 Jean-François Chevrier and James Lingwood, *Une autre objectivité*, Prato, Paris, 1989.
5 S.M. Eisenstein, "Yermolova," in *Selected Works*, vol. 2: *Towards a Theory of Montage*, ed. Misha Glenny and Richard Taylor, British Film Institute, London, 1994, pp. 82–105.
6 G.W.F. von Hegel, *Vorlesungen über Ästhetik* I, Suhrkamp Verlag, Frankfurt, 1986, p. 224.
7 Michael Fried, *Why Photography Matters as Art as Never Before*, Yale University Press, New Haven CT, 2008, pp. 211–12.
8 Ibid., p. 75.
9 Ibid., p. 173.
10 *Vorlesungen über Ästhetik* I, p. 224.
11 Immanuel Kant, *Critique of Judgement*, trans. W.S. Pluhar, Hackett, Indianapolis, 1987, p. 182.

Jack Halberstam

QUEER FACES: PHOTOGRAPHY AND SUBCULTURAL LIVES

IN THIS SHORT CHAPTER I will be asking about how we visualize queerness and asking three questions:

1) What is the connection between visualizing queerness and the production of queerness as freakishness or spectacle?
2) What is the relationship between photographs of queer pasts and contemporary understandings of queer identity, community, culture and history?
3) What is the meaning of authenticity in relation to visualizing queerness? Is queerness an indifferent relation to authenticity in the first place?

So let's start with that first question: Photography promises to bring us closer to what seems impossibly distant, it claims to insert the viewer into worlds that they could never access; it allows the viewer to stare in an unabashed way at bodies and arrangements of bodies that may otherwise be off-limits in polite society. When Asian-American photographer Nikki Lee gains entrance into the subcultures (skateboard gangs, lesbians, seniors) she photographs and enters the frame as participant rather than voyeur, she calls attention to the usually protected status of the photographer. She also hints at the violence of photography, its ability to misrecognize and misrepresent; its brutal truth-seeking gaze that obliterates the subtle distinctions between people and fetishizes them as types. Lee's startling appearance in the frame of her own photographs also reminds us of the surreptitious manner in which images can be stolen by the unscrupulous and voracious eye of the camera. She also visualizes the dynamics of assimilation, absorption, appropriation and counter-appopropriation.

Trans-photography

"Photographs furnish evidence," writes Susan Sontag in *On Photography*. She continues: "Something we hear about, but doubt, seems proven when we're shown a photograph of it" (5). The photograph promises proof, visual evidence, veracity. It captures what seems real even as the scene that it records fades from view; it offers, says Sontag, "a neat slice of time"

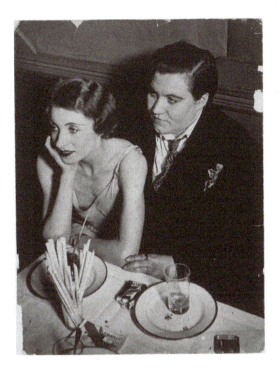

Figure 7.1 Brassaï, Halasz Gyula (1899–1984), La Grosse Claude et son amie, au "Monocle," vers 1932. © Estate Brassaï—RMN. Paris, Musée national d'Art Moderne—Centre Georges Pompidou © Collection Centre Pompidou, Dist. RMN/Jacques Faujour.

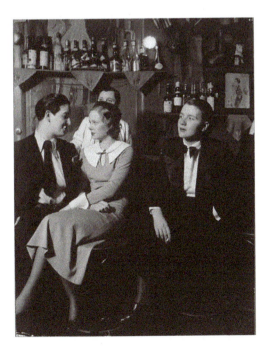

Figure 7.2 Brassaï, Halasz Gyula (1899–1984), Lulu de Montparnasse habillée en smoking avec une femme au "Monocle," vers 1933. © Estate Brassaï—RMN. Collection particulière. © RMN/Michèle Bellot.

(117). The photographs and other images that I want to look at today furnish evidence of lost subcultures even as they verify that the queer subculture, and the eccentric bodies that composed it, did exist and exist again now in new and different forms. Some of the artists I consider here contemplate the transgender body as otherness itself, as representative of a shadow world subtending and propping up the so-called real world; others lavish regard upon what Del LaGrace Volcano calls the "sublime mutations" of queerness and the twists and turns of the journey of queerness into and out of visibility. Other artists create a visual language of ambiguity, instability, inauthenticity and mutability in order to describe and invent postmodern forms of subjectivity.

In this first image from Brassai's famous photos of Parisian night worlds in the 1930s, Brassai captures a couple at a lesbian bar called *Le Monocle*. The couple looks away from the camera and towards a center of activity which remains out of sight for the viewer. Brassai's other photographs of *Le Monocle* reveal some of the activity at which the couple stare—other couples like them, dancing, drinking, laughing. In the text that introduces his collection of Parisian photographs, Brassai explains that he had always disliked photography until Paris at night caught his attention and inspired him to "translate all the things that enchanted me in nocturnal Paris."[1] Like a sleepwalker who seeks to record his peripatetic dreamworld, Brassai took his camera into a shadowy and "secret" Paris and used it to bring back a record of what he found; he also saw the camera as a kind of weapon which protected him from the "mobsters," "pimps" and young toughs he encountered. Brassai discussed this photography as a form of theft and he explained that he had to deploy "both trickery and diplomacy" to gain entrance to the clubs and brothels, drag balls and gay bars of queer Paris. To the contemporary viewer, however, far from representing simply an exoticizing gaze, Brassai's images offer a sensational and intimate peek at queer mid-century worlds that we might otherwise not even be able to imagine.

While Brassai considered *Le Monocle* to be a sad world of inverts, a "fringe world," an "underworld," the images tell another story. Brassai tries to direct the gaze through the text that accompanies the photographs. Of *Le Monocle*, he writes: "all the women were dressed as men, and so totally masculine in appearance that at first glance one thought they were men. Obsessed by their unattainable goal to be men, they wore the most somber uniforms; black tuxedos, as though in mourning for their ideal masculinity." At first glance, Brassai tells us, "one thought they were men:" how important then to have the captions to guide our gaze through the first apparently mistaken glance to the second and third orders of vision where we see that these are not men but merely women in mourning for a masculinity that will always elude them, a masculinity that Brassai projects as "their ideal." But the first glance is what photography offers, the second glance is the redirected look which the caption produces, and this second look opens out onto third and fourth glances, each one offering new information to the fascinated viewer. The repeated viewings that each image demands unlocks the queer photographic subjects from the abjection that the caption projects upon them and it opens up new interpretive possibilities which we can associate with the bundled gazes that make up the "transgender look" (Mirzoeff[2]).

The first glance registers, as Brassai informs us, normativity, stability and immutability. The second glance, spurred by something slightly askew in the image or some instruction in the caption, asks the viewer to look again. Brassai assumes that in the second glance, the viewer will see what he sees (a "young female invert") but he risks the possibility that the viewer will actually see something else, and in this renewed act of looking, the viewer may experience not shock, not horror not disgust, but desire, belonging, identification, fascination. So, at first glance, the tuxedos are not "somber uniforms" but dignified outfits of authentic non-male masculinities, but, aided by Brassai's anxious text ("Young Female Invert," "Couple (Both Female)") the suits transform before our eyes into costumes, hiding and masking the sad

"truth" that Brassaï seeks to confirm—that these women want to be men, that they never will be men and that the photograph, far from documenting their viable, desirable masculinities, mourns the genders they have abandoned and the ones they will never achieve. At second glance, these queer subjects are not men, will never be men and yet, with our third glance, we notice that they do *not* mourn. The tuxedo, mostly associated with weddings and celebrations rather than wakes and funerals, can be seen now as a sign of pleasure, power, confidence, strength. The transgender look, the second or third glance, restores to the subculture what the original caption took from it; the transgender glance sees what Brassaï saw and what the couples see all at once. In one final image, "Woman at *Le Monocle*," the butch, clearly no "woman," looks away while sipping pensively from the festive champagne before her. The camera does not interest her, she has her own object of desire firmly in sight.

But that was then. As Sontag comments: "The moody, intricately textured Paris of Atget and Brassaï is mostly gone" (16). Reading Brassaï now, we can marvel at the queer Paris he saw and we can provide new captions, visual and textual, that rewrite his narratives of melancholia and masquerade. "Visual culture," writes Nicholas Mirzoeff, "can be seen as a ghost, returning from another moment of pre-history." These ghostly images from queer nightworlds of 1930s Paris, speak to us now of the long history of queer genders and queer space. These images, in breathtaking fashion, show us, at first glance, that contemporary queer spaces echo with the sounds and the shadows of earlier lives and earlier communities; at second glance, we realize with a start that our queer worlds were created by and imagined in these spaces even as they return to us as black and white ghosts of lost worlds, nearly forgotten subcultures, worlds that without Brassaï's gaze, we might not have known. And while Brassaï located these images in "Gomorrah" and labeled them "homosexual," they now tell of inventive transgendering, the careful remodeling of the "heterosexual matrix" by butch femme couples revelling in the possibilities that Paris at night offered them in the 1930s.

Another photograph from 1930s Paris comments upon the history of the construction of a transgender gaze in relation to gender ambiguous images. Cecil Beaton's 1935 portrait of Gertrude Stein shows another view of queer Paris, one that has entered into official histories and which seems removed in time and space from Brassaï's underworlds. However, as if to hint at the shadow world which haunts the histories for which we have settled, Beaton presents the viewer with two Steins. In the foreground, a large and masculine Stein, dressed in a heavy overcoat and wearing a tight cap on her head stares grimly into the lens. The only concession to femininity is her collar brooch, a shadow fetish replacing what should be a tie with an image of feminine decoration. The hands are crossed, the lips are pursed and the face is lined and serious. Behind the large Stein stands a shadow Stein now without the overcoat; we see her skirt and waistcoat, her brooch, and the brooch now makes us look again at the first Stein. This portrait of Stein repeats another image of Stein with her lover, Alice B. Toklas, in which Stein stands in the middle foreground and to the right and Toklas shadows her back and to the left. In both images of the gender ambiguous body of Stein, her masculinity is measured against another image in which she is doubled but not mirrored. Toklas, who looks defiantly back at the camera as if to deny her placement as Stein's other or dependent, puts Stein's masculinity into perspective, literally. By making us see Stein through Toklas, we are forced to adjust the measurements we usually use to "see" gender; the gender queerness of both Toklas and Stein relays back and forth between them as the viewer's gaze shuttles from one to the other guided by a strange wire sculpture that hangs between them and throws its own shadow upon the wall.

The posing of the queer subject as shadow and shadowed seems to cast the construction of queerness as secondary to the primacy of heterosexual arrangements of gender and relationality, but, in fact, it comments upon the disruptive potential of shadow worlds. While viewers can look at Brassaï's images of queer Paris by night and bracket those worlds as easily

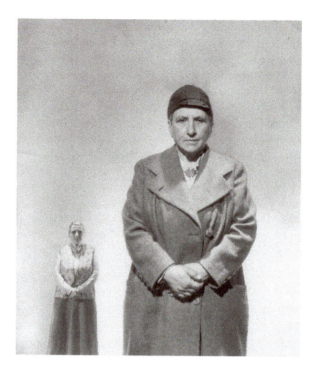

Figure 7.3 Gertrude Stein by Cecil Beaton (1904–1980). Courtesy of the Cecil Beaton Studio Archive at Sotheby's.

as he brushes away their heft in quick captions, ("Couple (both female"), this image of Stein, and the mastery she represents, suggests that underworlds have a way of refusing to remain "under" or "sub." Her writing with its provocative repetitions and queer codes bursts into the very heart of modernism and represents doubling and multiplication not as the sign of an inauthentic otherness but as the formula for modernist subjectivity itself. And the Paris she knew was, of course, not entirely distinct from the Paris of *Le Monocle*. She may well have found herself in queer bars by night and her inverted image could as easily have been captured by Brassai's as Beaton's camera.

I will now move on to the question of how visualization produces freaks and freakishness. When writing about Diane Arbus, another archivist of "sexual underworlds," Susan Sontag claims: "Like Brassai, Arbus wanted her subjects to be as fully conscious as possible, aware of the act in which they were participating. Instead of trying to coax her subjects into a natural or typical position, they are encouraged to be awkward—that is to pose" (37). The pose, Sontag suggests, makes the subjects look "odder" and, in the case of Arbus's work, "almost deranged." Sontag critiques Arbus for using her camera to find and create freaks, and she compares her unfavorably to Brassai, noting that Brassai not only documented "perverts and inverts" but also "did tender cityscapes, portraits of famous artists" (46). Arbus, Sontag claims, makes "all her subjects equivalent" by refusing to "play the field of subject matter" (47). Her narrowness, in other words, makes her a solipsistic voyeur rather than a talented photographic artist. Indeed, Arbus's photographs of transvestites, midgets and dwarfs do present the world as a freakshow and parade queer and ambiguous bodies in front of the camera to illustrate the range and depth of freakish alterity. And while Brassai's photographs were largely shot at night, Arbus presents her subjects in the clear and cold light of day. But Arbus does not limit her freakshow to so-called freaks. Patriots, families, elderly couples and teenagers all look strange and distorted through her lens. To use Eve Sedgwick's terms,

Arbus "universalizes" freakishness while Brassai "minoritizes" it. Brassai looks at the transgender world as if peering at strange insects under a rock; Arbus finds ambiguity across a range of embodiments and represents ambiguity as the human condition, and as we see in the naked man photo, she records the representational instability of the body itself, the ways in which it cannot function as a foundation for order, coherence and neat systems of correspondence.

Arbus cited both Weegee and Brassai as influences on her work and she said of Brassai: "Brassai taught me something about obscurity, because for years I have been tripped out on clarity. Lately it's been striking me how I really love what I can't see in a photograph. In Brassai, in Bill Brandt, there is the element of actual physical darkness and it's very thrilling to see darkness again."[3] In Brassai's pictures, as we noticed, the darkness actually frames what can be seen, the context for every image is the night itself and the players in the secret worlds of Paris are illuminated momentarily by the camera's gaze but threaten to fade to black at any moment. For Arbus the darkness and what cannot be seen is less a function of light and shadow and more a result of psychological complexity. The image of "Two Friends," cites Brassai's butch-femme couples but removes them from the unreal night worlds and places them squarely in the light of day. Arbus's biographer, Patricia Bosworth, wrote about this image in the following way:

> (Arbus') constant journey into the world of transvestites, drag queens, hermaphrodites and transsexuals may have helped define her view of what it means to experience sexual conflict. She once followed "two friends" from street to apartment, and the resulting portrait suggests an almost sinister sexual power between these mannish females. (The larger, more traditionally feminine figure stands with her arm possessively around the shoulder of her boyish partner.) In another shot the couple is seen lying on their rumpled bed; one of them is in the middle of a sneeze—it is both intimate and creepy.[4]

Notice in this quote that it is Bosworth rather than Arbus who assigns the label of "creepy" to the image and who represents the photograph of two friends as part of an undifferentiated world of freaks: trannies, intersexed people, circus performers, disabled people. Arbus assigns no such values to her subjects, rather she labels these two dykes as "friends." One could argue that the term "friends" refuses to see the sexual dynamic animating the two, but in fact the rumpled bed and the physical closeness of the two bodies ensures that we acknowledge, in Arbus's terms, what we cannot see.

In fact "friends" was a code word for lesbians in Arbus' opus and so we can read the image as not an image of two young guys in Central Park but probably two young butches! When a viewer like Bosworth looks at the butch-femme couple in their apartment, she sees something she believes she is not supposed to see and so the image becomes "intimate and creepy." But when a queer viewer sees the image nearly forty years after it was taken, we see something intimate and wonderful: it offers us a visual bridge back to a pre-Stonewall queer world and amazingly, it is recognizable to us. The butch's open gaze at the camera, at Arbus, and the femme's protective look at her partner and away from the camera create a circuit of vision within which each participant in the image's construction, the artist and her two subjects, both sees and is seen. Arbus can be read through this picture as less of a prurient voyeur and more of a chronicler of the unseen, the unspoken and the untold. Finally then, let's consider this photograph of male impersonator Storme Delavarie, a mixed race performer whom Arbus photographed for her "Eccentrics" series in the late 1950s. This photograph "Lady Impersonating a Gentleman" was so offensive to *Harper's* that they used it as an excuse to try to reject the whole series.

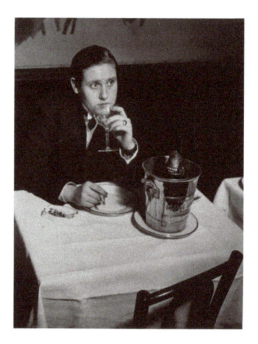

Figure 7.4 Brassaï, Halasz Gyula (1899–1984), Lulu de Montparnasse buvant seule au "Monocle" vers 1932. © Estate Brassaï–RMN. Collection particulière. © RMN/Michèle Bellot.

For Arbus then, the photograph itself stands in for a lost world, a context that eludes the viewer who cannot see beyond the spectacle of difference. Arbus, in fact, inserted herself, almost desperately, into these worlds of difference and she tried to use her photographs to force an awareness upon the viewer that s/he does not see everything or even anything.

The strategies for representing gender otherness in Brassai's work from the 1930s and Arbus's photo imagery of the 1960s are echoed and reworked in contemporary photography. I will turn quickly now to three photographers who each use a different strategy to comment upon the history of transgender and queer embodiment, the visual strategies necessary for "seeing" transgender and queer embodiment, and the future worlds imagined now by transgender and queer representation. Two artists in particular have made a massive impact on postmodern photography precisely through their explorations of gender instability. Del LaGrace Volcano and Catherine Opie, in very different ways, have each made the transgender body into a canvas and have inserted images of the gender variant body into the lexicon of contemporary photography. Interestingly enough, Cathie Opie has become a darling of the art world while Del LaGrace Volcano and his work has remained resoundingly subcultural. What allows one set of images to travel in and out of art world legitimacy and another to languish on its limits? My intention here is not to claim that Opie has "sold out" while LaGrace Volcano has stayed edgy, rather Opie is widely received as someone whose work goes beyond an "identity project" while LaGrace Volcano's work will be seen as "narrow" or even "pornographic." Like Sontag's distinction between Brassai and Arbus, Opie is seen as broader; she does "tender cityscapes" as well as lesbian domestic interiors and transgender portraits; and yet, interestingly, it is LaGrace Volcano who situates his trans subjects in context and within the night worlds they have created; and it is Opie who isolates the so called freakish body and offers it up to the harsh glare of studio lights. But, it is LaGrace Volcano, like Arbus, who sometimes gets classified as an artist who sees the whole world as queer or who sees the queer world everywhere.

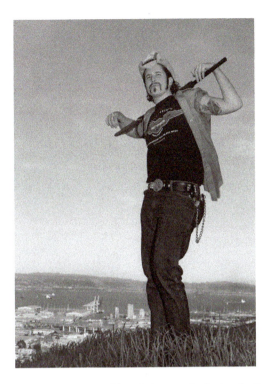

Figure 7.5 Del LaGrace Volcano, *Duke: King of the Hill, Cooper Lee Bombardier*, San Francisco 1997. Courtesy of the artist.

Generally speaking, LaGrace Volcano explores the contours and erotics of what he calls "sublime mutation" by glorifying bodies and body parts that might otherwise be read as freakish or ugly. His photographs of drag kings and female-to-male transsexuals as well as his self-portraits over the last fifteen years use the body as a canvas for spectacular and often highly aestheticized gender transformations. A few of his photographs from *The Drag King Book*, comment upon and rewrite Brassai's images of queer Paris. In this image, a self-conscious homage, citation and response to Brassai, LaGrace Volcano revisits Brassai's night worlds and shows us what Brassai could not. The three butches or transgender guys, pose for the photographer who captures his own image with a camera in the mirror. The mirrors behind the butches give the viewer access to this transgender look that takes in both the queer subjects and the scene before them. The three butches do not create a circular gaze of relationality and nor do they look into the camera; one looks away to the right, another looks at the butch across from him and the third looks down at the table. The photographer seems not to be looking at the queers but at the camera and at his own reflected image. This chaotic web of gazes creates a new queer matrix of sight and identity, one in which the binary of "feminine/non-feminine," "masculine/not-masculine," "straight/not-straight" is replaced by non-binarized subjects in non-complementary and non-reciprocal modes of looking and being.

Another image, "Welly and Anna" shot in Paris 1995 comments directly upon Brassai's "Female Couple" and rearticulates them as "Welly and Anna," a queer trans couple who cite a gay male aesthetic of masculinity in order to create their own transgender realness. The photograph asks for several glances but not the ones demanded by Brassai. While Brassai makes us look twice in order to assert a moral evaluation upon a queer world that dares to exist and dares to perform pleasure, power and desire, LaGrace Volcano makes us look at the shared look

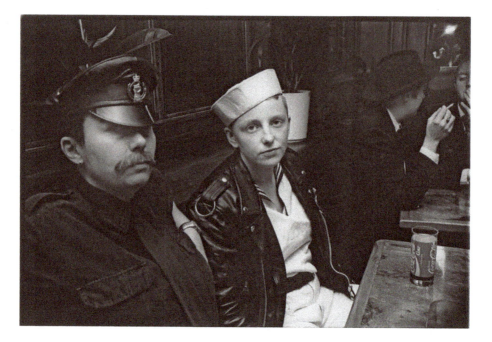

Figure 7.6 Del LaGrace Volcano, *Ode to Brassai, Welly & Anna*, Paris 1995. Courtesy of the artist.

between photographer and subjects. When he is not in the frame himself, his subjects look back at him without suspicion and with complete confidence in his aesthetic project. We look again also to see what performance of masculinity this may be and to see that the costumes are foregrounded as part of the pleasure of this scene of masculinity. The costumes, leather daddy and sailor boy, comment not upon the discrepancy between a real and an assumed identity but upon the layered effect of trans masculinities and ultimately the layered effect of all masculinities to the extent that the male body cannot and does not guarantee authenticity, legitimacy and reality without subordinating other bodies to the realm of "imitation." Welly and Anna make themselves at home in imitation and LaGrace Volcano happily appropriates and imitates Brassai's gaze in order to show us the gendered order of visual worlds.

Cathie Opie's series "Being and Having" is less explicit in its citations of Brassai and it is more in conversation with other auteur photography of the late twentieth century—the work of Warhol comes to mind. While LaGrace Volcano foregrounds the technology of the camera and of photography in his work, making the camera an equal player in the worlds he documents, Opie almost disavows the camera and creates portraits in a painterly fashion. The portraits are heavily cropped, unlike LaGrace Volcano's contextualized images of queers in queer worlds. They allow the subjects to look straight into the camera and they highlight the artifice of gender, the artistic creation of gender's primary signifiers—facial hair for example, and the elevation of secondary signifiers, like earrings, haircuts, tattoos, to the order of primary markers. The subjects disappear into the camera lens and re-emerge as art works, not frozen in time and space, but set free into the unpredictable zone of aesthetics. The "Being and Having" series is, as Jennifer Blessing points out, "a witty send-up of Lacan's theory of Symbolic sexual differentiation" within which men have the phallus and women are the phallus. It is also a vivid illustration of the total collapse of a phallic system of desire and differentiation.

Opie also presents the viewer with thirteen faces, aestheticized mugshots in a way, outlaws who look at the viewer and the photographer but who also look across at each other

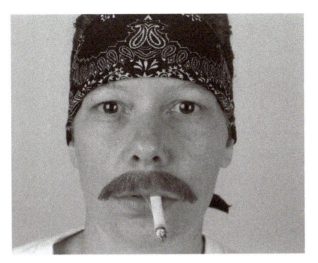

Figure 7.7 Catherine Opie, *Chief* from "Being and Having," 1991. Chromogenic print, 17 × 22 inches. Edition of 8. Courtesy Regen Projects, Los Angeles © Catherine Opie.

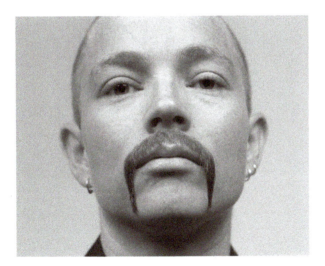

Figure 7.8 Catherine Opie, *Jake* from "Being and Having," 1991. Chromogenic print 17 × 22 inches. Edition of 8. Courtesy Regen Projects, Los Angeles © Catherine Opie.

when hung upon the gallery walls. The subjects were all friends and acquaintances of Opie's and all have intricate relationships with one another. By framing the pictures together and by hanging them in a series together, Opie lifts from Warhol a method of capturing queer life and its social and sexual webs of influence, friendship, camaraderie and partnership.

Warhol has been a primary influence on many contemporary queer artists but no one more obviously than Deborah Kass. Partly to comment upon the access available to men in the art world, and partly to draw attention to the specific embodiments of celebrity, Deborah Kass has systematically remade much of Warhol's opus; she has hijacked his methods, his visual palette and his visibility in order to bring queer worlds of lesbian and trans desires into the light. If Opie's work commented upon the queer world-making practices in Warhol that

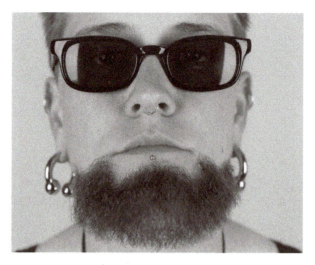

Figure 7.9 Catherine Opie, *Papa Bear* from "Being and Having," 1991. Chromogenic print, 17 × 22 inches. Edition of 8. Courtesy Regen Projects, Los Angeles © Catherine Opie.

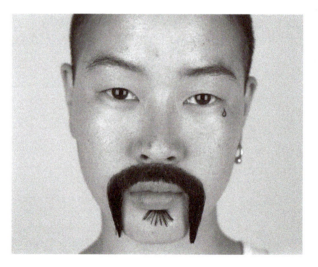

Figure 7.10 Catherine Opie, *Chicken* from "Being and Having," 1991. Chromogenic print, 17 × 22 inches. Edition of 8. Courtesy Regen Projects, Los Angeles © Catherine Opie.

mostly go unseen by the mainstream art world, Kass makes gender in Warhol her target and in the process she produces some decidedly transgender images. She also casts herself as a kind of transgender figure, a female queer artist who takes up the visual grammar of a queer male artist in order to be seen. In her "Portrait of the Artist as a Young Man," Kass inserts her own image into the silkscreened pose that Warhol had used for his self-portrait. The repetition of Warhol's self-portraits participated in his aesthetics of surface and they spoke to the slipperiness of his sense of self and his refusal of the authorial gestures of singularity, uniqueness and originality. Taking Warhol at his word, Kass slips beneath the surface of his art, of his image, of his gaze and looks out through his surface, a queer woman relaying her looks through a male gaze. The wallpaper effect of the repetition of the image also captures the

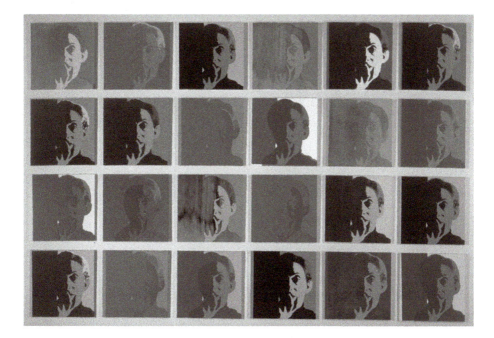

Figure 7.11 Deborah Kass (b. 1952), Portrait of the Artist as a Young Man, 1994. Silkscreen ink and acrylic on canvas. 24 panels, each 22 × 22 inches. (ART415550). Photo courtesy of Deborah Kass/Art Resource, NY. © ARS, NY and DACS, London 2011.

multiplicity of what I have called "the transgender look," its effects captured here as a spreadsheet of gazes, all looking back at once and refusing the sequential vision demanded by Brassai's work.

Kass not only appropriates specific images of Warhol himself, she resignifies his play on celebrity and selects new subjects for fame and glamour. While Warhol lavished his extravagant modes of looking on iconic figures like Jackie, Marilyn and Elvis, Kass scoops up the images he has discarded like Barbra and Gertrude. This image of Stein takes us back to Paris in the 1930s (and in another work Kass draws attention to the relationship between Stein and Paris, naming her "Parisian") and to the iconicity and visibility of Stein in contrast to the invisibility and specificity of the queers in Brassai's photographs. Indeed Stein identified strongly with Paris and she once said: "And so I am an American and I have lived half my life in Paris, not the half that made me but the half in which I made what I made."[5] Paris here is identified with self-making, with the self as productive, as agent, as separate from the family (the half of her life that made her), and as part of a queer world. Stein for Kass, like Marilyn for Warhol, represents more than lesbianism, more than fame, more than the sum total of her work, like the glamorous women loved by Warhol's camera, Stein represents the specific conditions for visibility itself. Stein is not Stein in this image (a quote in close up of the Cecil Beaton image), she is Chairman Ma; she is a revolution in orange and lavender, she is what we see and what we know of a particular world of gender-crossing in Paris in the 1930s. Her work translated the nightworlds of Paris into rhythmic and repetitive prose and her own life choices placed her queerly at the center of modernism's avant-garde. The missing "o" in Chairman Ma, makes Stein into mother and father at the same time: she is the chairman, the charismatic leader, the resistance to capitalism but she is also the mother, ma, the beginning of an aesthetic of repetition Kass learns and remakes.

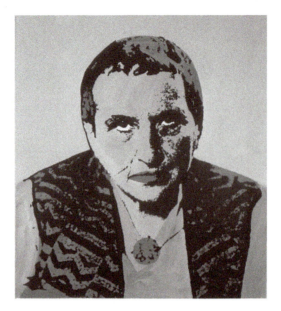

Figure 7.12 Deborah Kass (b. 1952), Chairman Ma (Gertrude Stein), #21, 1993. Silkscreen on canvas. 46 × 42 inches. (ART424060). Private collection. Photo courtesy of Deborah Kass/Art Resource, NY. © ARS, NY and DACS, London 2011.

In conclusion: as these Warholian images imply, there is nothing real about queerness, little that is permanent and much that revels in the freakish and the spectacular. Queer photography in particular offers evidence not simply that queer worlds existed but also that they live on in the creative, inauthentic renditions that queer people make of identity all the time.

Notes

1 Gyula Halasz Brassai, *The Secret Paris of the 30's* (New York: Pantheon, 1976), n.p.
2 "The Visual Subject," *The Visual Culture Reader* (New York: Routledge, 2002), 18.
3 Quoted in Patricia Bosworth, *Diane Arbus* (New York: Norton, 2006), 307.
4 Patricia Bosworth, *Diane Arbus: A Biography* (New York: Norton, 2006), 226.
5 Gertrude Stein, "An American and France," "in *Paris, France* (New York: Charles Scribner's Sons, 1940).

Terry Smith

CURRENTS OF WORLDMAKING IN CONTEMPORARY ART

C AN WE SAY THAT CONTEMPORARY ART is—perhaps for the first time in history—truly an art *of* the world? This claim would surprise those artists who persist in presuming (or hoping) that whatever they make will have *universal* relevance, and those who fear that their work will be discarded as irrelevant to art's general development— to them, the question of their art's worldliness is immaterial, and its contemporaneity is, at most, an obligatory but ultimately trivial entry gate to possible immortality. Such views, however, are becoming increasingly anachronistic as European and US-centric perspectives decline in dominance, and awareness of the agency of the others penetrates even the cultural citadels of what used to be known as the First World—not least the great museums, obliging them to become as "global" as their predominantly international audiences. This leads us to a second sense in which "world" counts in contemporary art. As biennales have for decades attested, art now comes *from* the whole world, from a growing accumulation of art-producing localities that no longer depend on the approval of a metropolitan center and are, to an unprecedented degree, connected to each other in a multiplicity of ways, not least regionally and globally. Geopolitical change has shifted the world picture from presumptions about the inevitability of modernization and the universality of EuroAmerican values to recognition of the coexistence of difference, of disjunctive diversity, as characteristic of our contemporary condition. A third sense of "world" follows from this shift. Contemporary life draws increasing numbers of artists to imagine the world—here understood as comprising a number of contemporaneous "natures:" the natural world, built environments ("second nature"), virtual space ("third nature"), and lived interiority ("human nature")—as a highly differen- tiated yet inevitably connected whole. In this sense, from what we might call a planetary perspective, contemporary art may be becoming an art *for* the world—for the world as it is now, and as it might be.

So the first thing to be said about contemporary art is that it is essentially, definitively and distinctively *worldly*. The next is that, from our position at the beginning of the second decade of the twenty-first century, art seems markedly different from what it was during the modern, or any other, era: it is—above all, and before it is anything else—contemporary. Beneath this awkward tautology lies a profound historical shift, of which the new worldliness (*mondialisation*) of contemporary art is an important indicator. Once modern, or striving to

become so (in however differentiated a way), art everywhere now is made within situations where distinctive temporalities coexist in their contingent otherness, move in different directions, and mix in unpredictable ways. Modernism, while still resonant in some contemporary practice, is an historical style. Postmodernism seems to have even less purchase on the present. Unlike the commitments to progress, to universal human development and utopian possibility that inspired modernity in all of its aspects, in contemporary conditions no singular direction, however dialectically driven or internally various, encompasses the present or looks set to shape the future. Similarly, modernity's preoccupation with distinguishing itself from "the past" as a generality, and with periodizing ever-narrowing clusters of activity (including, eventually, itself), has come to seem self-circumscribing, historicist, itself a practice from the past, a mode of inquiry that remains absolutely necessary for dealing with past periods but oddly out of place when it comes to understanding the present.

Alertness to the now has become so pervasive—in art and in the general culture—that thinking the future, or possible futures, has receded as a concern. To say that art, and life, has become more contemporary than ever before is not necessarily—although it may be, and often is—a concession to the superficiality of up-to-datedness, the banal sense of being contemporary, of perfectly, instinctively, matching one's time. A broader historical perspective shows that the present has thickened considerably: no longer a distraction on the way to utopia, nor, from the opposite, conservative political perspective, a fashion-following intrusion upon the persistence of a perfectly adequate past, it has become a temporal domain of considerable scope, depth and complexity. It is no accident that terms associated with "contemporary" have come to replace those associated with "modern" as the default designators of new ideas, institutions and art. It may be the case that the concept has finally come into its own; to realize, perhaps, the potential that attended its origins, in the Latin-based languages at least, as a combination of the words *con* and *tempus*, that is, "with" and "time." Taken as a source of internal definition and differentiation, "contemporary" connotes a multiplicity of ways of being in time, of feeling in accord with one's time or at an angle to it, and of experiencing each of these relationships either separately or at the same time, both individually and with others.

Of course, these meanings of the word "contemporary" are ancient. They have long histories throughout human civilization and were at the core of what it was like to live in modern societies. I would argue, however, that it is definitive of our contemporaneity ("a contemporaneous condition or state") that they occur to us, nowadays, at the same time, that we have become more intensely aware of this presence of difference all around us (and in us?), and that this quality of contemporary experience has come to override all other factors as the most central thing to be explained when we wish to characterize what it is to be alive today. Similarly, contemporary art is no longer one kind of art, nor does it have a limited set of shared qualities somewhat distinct from those of the art of past periods in the history of art yet fundamentally continuous with them. It does not presume inevitable historical development; it has no expectation that present confusion will eventually cohere into a style representative of this historical moment. If you are waiting for the next master narrative, you are probably doing so in vain. Contemporary art is multiple, internally differentiating, category shifting, shape changing, and unpredictable (that is, diverse)—like contemporaneity itself.[1]

The condition of contemporaneity—my understanding of what we mean when we say "the present"—is the world, broadly understood, in which contemporary art is made, and from within which it is already journeying through space and time, both of which are being conceived differently than they were during modernity. In contemporary conditions, therefore, "world" means something rather different from what it meant during the modern era—indeed, as I have begun to suggest, it means a number of different things. But not an infinite

number, nor even a plurality: rather, a specific cluster of different things. Let us explore these a little more closely.

From modern to contemporary art

In a number of recent studies I have argued that alertness to contemporaneity, while always available to art, and often taken up (in the case of Caravaggio, for example) with show-stopping brilliance, has mostly been an occasional factor within it. This started to change during the modern era, when contemporaneity became the necessary entry point for art of the highest aspiration but was never sufficient for its accomplishment. These developments have been placed in the shade, however, by a worldwide shift from modern to contemporary that was prefigured in some late modern art during the 1950s, that took definitive shape in the 1980s, and that continues to unfold through the present, thus shaping art's immediate future (itself the on-going—sometimes the self-circling—of the thickened present).[2] While this is a world-wide—indeed, world-historical change—it does not follow that it occurred in the same way, much less at the same time, in each cultural region, and in each art-producing locality across the globe. Nor that it spread from a major center, disseminating itself in the manner of the great style changes in art during modern times, and provoking the provincialist circuitry that characterized the metropolitan/peripheral exchanges of that era. Given recent geopolitical history, which is characterized above all by incessant conflict between peoples with different world-pictures and distinct senses of their place in the world, it would be naïve in the extreme to expect anything approaching uniform change.

To grasp this change in its specifics, therefore, requires us to understand the intricate connections between the local and the global in a planetary sense—that is, to think regionally in the context of a vision of the actual, historical development of the planet and of all who live upon it. As Dipesh Chakrabarty has brilliantly demonstrated, this is something that we are still learning to do.[3] It seems to me that three assumptions are necessary if we are to see more clearly the kinds of art that are being produced within the emerging world (dis)order.

Although world-wide, and thus entailing all visual art, the shift from modern to contemporary art occurred—and continues to occur—in different ways and to varying degrees in each of the art producing centers of the world, shaped of course by local inheritances and by the position of each center relative to relevant others. This assumption is about the specificity but also connectedness of *locality*.

As a consequence of the geopolitical division of the world into power blocs during the mid-twentieth century—itself a manifestation of major historical forces such as late capitalism, decolonization and globalization—these differences and variations in intensity were also shaped into regional currents. These continue to be relevant, although of course they change constantly. This assumption is about the specificity but also connectedness of *regionality*.[4]

It follows that the historical shift from modern to contemporary art cannot be seen as occurring in the same way all over the world, nor at the same time, or even at similar rates. Indeed, these variations generate the typical condition in which changes of a different kind, occasion and rate are contemporaneous with each other. In turn, this condition enables awareness of such differences, an awareness heightened by the recent acceleration of communications. So, this assumption is about *comparativity*, the contemporaneousness of difference. It updates previous thinking about provincialism vis-à-vis metropolitanism, about centers vis-à-vis peripheries, in cultural theory.[5] It also suggests that contemporary art's present diversity might owe as much to the emergence during the twentieth century of distinctive local, vernacular and alternative modernities in art-producing locales across the globe as it so

evidently does to the radical experimentality that broke apart late modern art in the EuroAmerican art centers during the 1950s and 1960s. Here is a story waiting to be fully told.

These assumptions underlay my major proposition about world connectivity in contemporary art today: *In contemporary art, the local is connected to regional and global forces through the contemporaneity of three distinct but contingent currents.* These currents are different from each other in kind, in scale, and in scope. The first prevails in what were the great metropolitan centers of modernity in Europe and the United States (as well as in societies and subcultures closely related to them) and is a continuation of styles in the history of art, particularly Modernist ones. The second has arisen from movements toward political and economic independence that occurred in former colonies and on the edges of Europe, and is thus shaped above all by clashing ideologies and experiences. The result is that artists prioritize both local and global issues as the urgent content of their work. Meanwhile, artists working within the third current explore concerns that they feel personally yet share with others, particularly of their generation, throughout the world. Taken together, I suggest, these currents constitute the contemporary art of the late twentieth and early twenty-first centuries. My proposal, then, is a historical hypothesis, an outline of how, in general terms, art throughout the world has changed since the later decades of the twentieth century, that is, about how modern art became contemporary. Let me offer a summary description drawn from the more detailed accounts offered in a number of recent publications.[6] I will emphasize those aspects of my proposal that bear on artistic world-making, and on making art in terms of worlds-within-the-world. In deploying concepts of "world" in this way, I evoke of course famous theorizations of the concept, such as those of Martin Heidegger and Nelson Goodman, but also point to other, more immediate usages, such as the book *Place* by artist Tacita Dean and critic Jeremy Millar, and to the much-used international art website: universes-in-universe.[7]

Currents within contemporary art

The first current—official, institutionalized Contemporary Art—might be seen as an aesthetic of globalization, serving it through both a relentless remodernizing, and a sporadic contemporizing, of art. It has two or three discernable tendencies, each of which are perhaps styles in the traditional sense of being a marked change in the continuing practice of art in some significant place that emerges, takes a shape that attracts others to work within its terms and to elaborate them, prevails for a time, and comes to an end. One internal tendency is the embrace of the rewards and downsides of neoliberal economics, globalizing capital, and neoconservative politics, pursued during the 1980s and since through repeats of previous avant-garde strategies, drawing from both the early twentieth century "historical" avant-gardes (yet lacking their political utopianism) and from the mid-century neo-avantgardes (yet lacking their theoretic radicalism). Damien Hirst and the yBas are the most obvious examples, but the trajectory has also been pursued by Julian Schnabel, Jeff Koons in the US, and by Takashi Murakami and his followers in Japan, among many others. There is considerable depth, and world knowledge, in some of this work (that of Hirst as it relates to industries of death and Murakami as it relates to histories of post-War Japan, for example), but much of it rests content with a kind of in-your-face blatancy. With reference to its overtly retrograde strategies, and to the 1997 exhibition at which this tendency, in its British form, surfaced to predictable consternation on the part of conservatives but soon acquired mainstream acceptance, we might call it "Retro-Sensationalism."

This tendency has burgeoned alongside another: the constant efforts of the institutions of Modern Art (now usually designated Contemporary Art) to rein in the impacts of

contemporaneity on art, to revive earlier initiatives, to cleave new art to the old modernist impulses and imperatives, to renovate them. This tendency might be called "Remodernism." Distinct variants of it appear in the projects of Richard Serra, Jeff Wall and Gerhard Richter, to cite some outstanding examples. If Serra invites us to enter the precincts of his sculptures as if we were engaging with elemental materials unfolding in space according to an intuitive "logic" unique to each configuration, then this is a deeply modernist impulse, carried out against the ghost of its disruption during the 1960s (not least by Serra himself) and its apparent historical exhaustion. Wall's tableaux-to-be-photographed are "small worlds," intense concentrations of observable reality inflected with noticeable strangeness, an element of which is their service as vignettes in an implied narrative of modernist picture-making being carried out again, as if from its mid-nineteenth century beginnings, but in a fresh fashion and in present-day settings. Richter evokes a complex memory world, a house of memory, that consists of the fraught, self-denying imagery of post-War Germany *and* of the visual memory of every avant-garde art movement since the 1960s, then subjects both of them to each other's radical doubt. Remodernism, as I understand it, is not simply about tired repetition, or reluctant nostalgia, or even melancholy negation. If it were so, it would be in decline. Instead, it is alive because it is about contemporary practices such as these.

In the work of artists such as Matthew Barney and Cai Guo-Qiang both aspects come together in a conspicuous consummation, generating an aesthetic of excess that might be tagged (acknowledging its embodiment of what Guy Debord theorized as "the society of the spectacle") the Art of the Spectacle.[8] In contemporary architecture, similar impulses shape the buildings designed for the culture industry by Frank Gehry, Santiago Calatrava and Rem Koolhaas, among others. This is an international architectural language, one that can erect its edifices anywhere, and have them count as nodes within a global network of destination points. Sensationalism takes many forms, and tends to create its own cultural capsules. As a visit to any one of the burgeoning private collector museums—for example, Inhotim, in the jungles of Minas-Gerais, Brazil—soon reveals, it can attract artists who I would normally see as being representative of other currents. This exposes one of the reasons why the currents I am describing are closely connected: they are, after all, currents in the same stream.

The second current—that I call "the transnational turn"—emerges from the processes of decolonization within what were the Third, Fourth, and Second Worlds, including its impacts in what was the First World. It has not coalesced into an overall art movement, or two or three broad ones. Rather, the transnational turn has generated a plethora of works of art shaped by local, national, anti-colonial, independent values (identity, critique, diversity). It has enormous international currency through travelers, expatriates, new markets but especially biennales. Local and internationalist values are in constant dialog in this current—sometimes they are enabling, at others disabling, but they are ubiquitous. Cosmopolitanism is the goal, translation the medium. With this situation as their raw material, artists everywhere have for decades been producing work that matches the strongest art of the first current. Examples include the collective paintings produced by Aboriginal peoples in Australia to demonstrate their millennia-long relationship to their land; Georges Adeagbo's accumulations of detritus that amount to traces of history in his part of Africa; the very different evocations of the anxieties of being white during apartheid and post-apartheid South Africa by William Kentridge, Susan Williamson and Kendall Geers; the subversion of official Soviet imagery by the Russian Sots Artists, or that of Mladen Stilinović in Croatia; the outrageous reverse historicism (Retroavantgardism) of Laibach, Group IRWIN and the NSK in the imploding Yugoslavia and since; the conceptualist strategies of South American artists during the dictatorship periods; the self-conscious politics of parody (of tradition, national expectations and external stereotyping) in the work of many

contemporary Chinese artists; the ascendency of women among contemporary artists in what was the Middle East.

That each of these practices is, in its distinct way, an effort at world-making is exemplified by Kentridge's anguished recognition, in 1998, of the existential challenge that his art, and his world, demanded of him: "How does one bring [about] the entire representation of the world inside one's head?"[9] He had in mind the multiplicity of forces that bore down to shape his experience and that of those around him. Thus his constant collage: the world is registered as it happens to him, and as it impacts on those around him. No wonder that one of his favorite images is that of a globe staggering, unsteadily, on tripod-legs, across a blasted, desultory landscape.

To artists participant in the early phases of decolonization—for example, those being asked for an art that would help forge an independent culture during the nation-building days of the 1960s in Africa—a first move was to revive local traditional imagery and seek to make it contemporary by representing it through formats and styles that were current in Western modern art. Elsewhere, in less severe conditions, for artists seeking to break the binds of cultural provincialism or of centralist ideologies, becoming contemporary meant making art as experimental as that emanating from the metropolitan centers (thus the proposition about *comparativity*). Geopolitical changes in the years around 1989—in Europe particularly, but also in China, and then in South America, opened out a degree of access between societies that had been closed for one and sometimes two generations. The work of unknown contemporaries became visible, and the vanquished art of earlier local avant-gardes became suddenly pertinent to current practice. Frenzied knowledge exchange ensued, and hybrids of all kinds appeared. The desire soon arose to create and disseminate a contemporary art that, toughened by the experiences of postcoloniality, and by the breakup of the empires, would be valid throughout the entire world.

During the 1990s, those precipitating, interpreting and undergoing these changes frequently evoked the term "postmodern." Yet there are some important distinctions to be made between their usage of the term, especially if we apply the principles of locality, regionality and comparativity proposed earlier. In Euroamerica during the 1970s and 1980s, postmodern critique was directed primarily at the presumed universality of the Enlightenment project, and was arguably, at least in part, a direct result of the early impacts of postcolonial critique upon intellectuals in the West. In the arts, however, this was scarcely evident at first. In architecture, postmodernism quickly became a matter of hollow pastiche of historical styles. In painting, it soon became a byword for appropriation, quotation, simulation of spectacle culture, and, eventually, absorption into it. Certain photographic and installation artists developed a resistant strain: among them Jenny Holzer, Barbara Kruger and Cindy Sherman.[10] Elsewhere—in Central Europe, Cuba, and China in particular—postmodernism offered an aesthetic umbrella for imagining a post-socialist culture.[11] In each of these cases a national culture was undergoing transition from one state to another, usually into a situation where different models of possible modernities were in open competition, and soon became suspended in antinomic contemporaneity with each other. These examples only begin to sketch the outpouring of alternatives that occurred in different parts of the world during the 1980s and 1990s. "Postmodernism" is too thin a term for this great change, one that is still in its early stages. Indeed, postmodernism, wherever it occurred, now seems nothing less, but no more, than a pointer to the first phase of contemporaneity in that place. Now, this seems true on a general, global level as well.

Attempts to save modernism as the basis of significant art today have appeared within this current as well, sometimes in places where they might seem least necessary. Curator Nicolas Bourriaud has suggested the term "altermodernism" as "a leap that would give rise to a synthesis between modernism and post-colonialism."[12] A broader view shows us that the

transnational turn during the 1990s and first decade of the twenty-first century—a shift into transitionality, especially with regard to concepts of the nation—has led to the art of the second current becoming predominant on international art circuits, in the proliferating biennales, with profound yet protracted effects at the modern metropolitan centers. It is a paradigm shift in slow motion that matches the changing world geopolitical and economic order as it increases in complexity. From this perspective, contemporary art today is the art of the Global South.[13]

The third current is different in kind yet again: it is the outcome, largely, of a generational change and the sheer quantity of people attracted to active participation in the image economy. As art, it usually takes the form of quite personal, small scale and modest offerings, in marked contrast to the generality of statement and monumentality of scale that has increasingly come to characterize remodernizing, retro-sensationalist and spectacular art, and the conflicted witnessing that continues to be the goal of most art consequent on the transnational turn. Younger artists certainly draw on elements of the first two tendencies, but with less and less regard for their fading power structures and styles of struggle, with more concern for the interactive potentialities of various material media, virtual communicative networks and open-ended modes of tangible connectivity. Working collectively, in small groups, in loose associations or individually, these artists seek to arrest the immediate, to grasp the changing nature of time, place, media and mood today. They make visible our sense that these fundamental, familiar constituents of being are becoming, each day, steadily stranger. They raise questions as to the nature of temporality these days, the possibilities of place-making vis-à-vis dislocation, about what it is to be immersed in mediated interactivity and about the fraught exchanges between affect and effect. Within the world's turnings, and life's frictions, they seek sustainable flows of survival, cooperation and growth.

Postcolonial critique, along with a rejection of spectacle capitalism, also informs the work of a number of artists based in the metropolitan cultural centers. Mark Lombardi, Allan Sekula, Thomas Hirschhorn, Zoe Leonard, Steve McQueen, Aernout Mik, Alfredo Jaar and Emily Jacir, among many others, developed practices that critically trace and strikingly display the global movements of the new world disorder between the advanced economies and those connected in multiple ways with them. Other artists base their practice around exploring sustainable relationships with specific environments, both social and natural, within the framework of ecological values. These range from the ecological non-interventions of Andy Goldsworthy and Maya Lin through to the environmental activism of the Critical Art Ensemble. Still others work with electronic communicative media, examining its conceptual, social and material structures: in the context of struggles between free, constrained and commercial access to this media, and its massive colonization by the entertainment industry, artists' responses have developed from expanded cinema and Net.art towards immersive environments and explorations of avatar-viuser (visual information user) interactivity. Charlotte Davies's *Osmose* 1995 is a classic example of this desire: it offers immersants a virtual tour through "a boundless oceanic abyss, shimmering swathes of opaque clouds, passing softly glowing dewdrops and translucent swarms of computer-generated insects, into the dense undergrowth of a dark forest," to a virtual tree made of visible code.[14] Many other new-media artists, including Louis Bec, Thomas McIntosh, Christa Sommerer and Laurent Mignonneau, have pursued this fascination. All of these approaches, whatever the format, medium and situation, are efforts to see clearly what constitutes a world within societies saturated with surveillance and secrecy, to re-imagine known worlds differently, or to imagine possible worlds.

The same range of concerns inspire the dystopian scenarios favored by Blast Theory and the International Necronautical Society, the graffiti bombing of Banksy and the Argentine group Blu, the counter-surveillance activity of Trevor Paglen and the Center for Land Use

Interpretation, Daniel Joseph Martinez's fervent protests, Paul Chan's symbolic shadow profiles, Jeremy Deller's re-enactments aimed—like the video installations of Willie Doherty, James Coleman and Gerard Byrne—at countering social amnesia, the mass media smarts of Candice Breitz, the transformative immersive environments of iCinema, the interactive public art of Rafael Lozano-Hemmer, to the insouciant receptivity of Francis Alÿs. An important strand is that much of this activity is at once subjective and collective: thus the shared knitting of the Institute for Figuring, installations by Zulu artists that display the principle of *ubuntu* ("I exist because you do"), to the watchful optimism of Rivane Neuenschwander, Shaun Gladwell and Cai Fei. Other work takes the form of long-term collaborations with specific local communities, as we see in the activity of groups such as Superflex, Dialogue, Huit Facettes, Ala Plastica, Wockenklauser, Park Fiction, Global Studio and many others. These are direct instances of small-scale, close-valued placemaking.[15]

Contemporaneous worlds

Taking these three currents together, as contemporaneous with each other, they are manifestations within contemporary art practice of deep currents within the broader condition of contemporaneity itself. In the twenty-first century, nation states no longer align themselves according to the tiered system of First, Second, Third, and Fourth Worlds. Multinational corporations based in the EuroAmerican centers continue to control significant parts of the world's economy, but, as the global financial crisis demonstrated, can no longer manage the whole, and remain inclined to uncontrollable self-mutilation. New global corporations located in South, East, and North Asia may be subject to the same impulses. Manufacturing, distribution, and services are themselves dispersed around the globe, and linked to delivery points by new technologies and old-fashioned labor. Some have argued that, with globalization, capitalism achieved its pure form. Certainly, the living standard of millions has been lifted, but only at enormous cost to social cohesion, peaceful cohabitation, and natural resources. Some national and local governments, as well as many international agencies, seek to regulate this flow and assuage its worst side effects—so far without conspicuous success. The institutions that drove modernity seem, to date, incapable of dealing with the most important unexpected outcome of their efforts: the massive disruptions to natural ecosystems that now seem to threaten the survival of the Earth itself. Awareness of this possibility has increased consciousness of our inescapably shared, mutually dependent existence on this fragile planet.

The most recent generation of contemporary artists has inherited this daunting complexity. Their responses have been cautious, devoted to displaying concrete aspects of this complexity to those who would see it, and to helping—in modest, collaborative ways—to reshape the human capacity to make worlds on small, local scales. For all its modesty, and pragmatism, theirs is a hope-filled enterprise. Their efforts allow us to hope that contemporary art is becoming—perhaps for the first time in history—truly an art *of* the world. Certainly, as I have tried to show, it comes *from* the whole world, from all of its contemporaneous difference, and it increasingly tries to imagine the world *as a whole*, precisely in all of its contemporaneous difference.

Notes

1 For further discussion of the concepts "contemporary" and "contemporaneity," see my "Introduction: The Contemporaneity Question," in Terry Smith, Nancy Condee, and Okwui Enwezor (eds),

Antinomies of Art and Culture: Modernity, Postmodernity and Contemporaneity (Durham, NC: Duke University Press, 2008), pp. 1–19. This volume also contains other reflections on the topic, by Antonio Negri, Boris Groys, Nancy Condee, Wu Hung and others. Giorgio Agamben has recently offered a poetic reflection on this topic in his *"What is an Apparatus?" and Other Essays* (Stanford: Stanford University Press, 2009), and in 2006 Jean-Luc Nancy speculated about a variety of resonances between art, contemporaneity and worlds in his lecture "Art Today," *Journal of Visual Culture*, vol. 9 (April 2010): 91–99.

2 For example, Terry Smith, "The State of Art History: Contemporary Art," *Art Bulletin*, vol. XCII, no. 92 (December, 2010): 366–83.

3 Dipesh Chakrabarty, "The Climate of History: Four Theses," *Critical Inquiry*, vol. 35, no. 2 (Winter 2009): 197–222.

4 On the limitations yet, on balance, positive potential of a regional approach see Martin W. Lewis and Kären E. Wigen, *The Myth of Continents: A Critique of Metageography* (Berkeley: University of California Press, 1997), p. 186.

5 Early examples include my essay "The Provincialism Problem," *Artforum*, XIII, No 1, September 1974, 54–9; and Samir Amin, *Imperialism and Unequal Development* (New York: Monthly Review Press, 1977).

6 See Terry Smith, *What is Contemporary Art?* (Chicago: University of Chicago Press, 2009); and my contribution to "A Questionnaire on 'The Contemporary',"*October*, #130 (Fall 2009): 46–54. The most thorough exposition may be found in Terry Smith, *Contemporary Art: World Currents* (London: Laurence King; Englewood Cliffs, NJ: Pearson/Prentice Hall, 2011).

7 Martin Heidegger, "The Age of the World Picture," in *The Question concerning Technology*; transl. William Lovitt (New York: Harper & Row, 1977), Nelson Goodman, *Ways of Worldmaking* (Indianapolis: Hackett Publishing Co., 1978). See also W.J.T. Mitchell, *What do pictures want?* (Chicago: University of Chicago Press, 2005), Edward S. Casey, *The Fate of Place, A Philosophical History* (Berkeley: University of California Press, 1998), ix–xv, 331–42; Tacita Dean, Joseph L Koerner, Jeremy Millar and Simon Schama, "Talk," in Dean and Millar, *Place* (London: Thames & Hudson, 2005), pp. 182–92. Universes-in-Universe is at http://universes-in-universe.org/eng/index.html.

8 Guy Debord, *The Society of the Spectacle* (Paris, 1967; Detroit: Black & Red, 1977; 2nd ed., with preface by Debord, New York: Zone Books, 1995).

9 Quoted in Carolyn Christov-Barkargiev, *William Kentridge* (Brussels: Société des Expositions du Palais des Beaux-Arts, 1998), p. 136.

10 As argued by Hal Foster in his editorial to *The Anti-Aesthetic: Essays on Postmodern Culture* (Port Townsend, WA: Bay Press, 1983); and by Craig Owens, *Beyond Recognition: Representation, Power, Culture* (Berkeley: University of California Press, 1992).

11 See Aleš Erjavec (ed.), *Postmodernism and the Postsocialist Condition: Politicized Art Under Late Socialism* (Berkeley: University of California Press, 2003).

12 Nicolas Bourriaud, "Altermodern," in Bourriaud (ed.), *Altermodern Tate Triennial* (London: Tate Publishing, 2009), pp. 12–13.

13 See Okwui Enwezor, "The Postcolonial Constellation," in Terry Smith, Nancy Condee, and Okwui Enwezor (eds), *Antinomies of Art and Culture: Modernity, Postmodernity and Contemporaneity* (Durham, NC: Duke University Press, 2008), pp. 207–34.

14 Oliver Grau, *Virtual Art: From Illusion to Immersion* (Cambridge, Mass.: MIT Press, 2003), p. 193. *Osmose* is accessible at http://www.medienkunstnetz.de/works/osmose/.

15 Grant Kester has explored these in his recent publications, including *Conversation Pieces: Community and Communication in Modern Art* (Berkeley: University of California Press), and *The One and the Many: Agency and Identity in Contemporary Collaborative Art* (Durham, NC: Duke University Press, 2011).

Sarat Maharaj

SUBLIMATED WITH MINERAL FURY: PRELIM NOTES ON SOUNDING PANDEMONIUM ASIA

Two birds in a tree
One pecks, flits about incessantly.
The other looks on, silent, still.

Rg Veda, from the Sanskrit

THE "ASCENDING PILE" that is Asia today—what is its conceptual shape? How to take its sound, its "uproarious din"? What are the see-think-know modes it is spawning, its creative surges, its art practices? Should we see it as a mundane or mental patch of territory, an empirical or noumenal figure? As the Third Guangzhou Triennial project takes off from its dual launch pad, "Farewell to Post-colonialism" and "Restarting from Asia," it is shot through with such queries and quandaries: a striking example is Gao Shiming's "Questionnaire" for the China art world and beyond. These set the scene for "Asia-in-the-world," for unpacking its core poser: does it herald an alternative conceptual continent or simply the desire to step into the West's shoes, to be its rivalrous lookalike—in Milton's phrase, its "nether empire."

Hard on its heels, another query: does "post-colonialism" not sound like a bag-all term? From its beginnings, it signaled a plethora of "critiques and probes" often at daggers drawn. Which ones are we to bid goodbye to—the original models, start-ups or pilot versions of the 1980s? Is it their followers, the epigoni, avatars, second lifers? Or their derivatives that have become the critical-curatorial jargon of the art-culture industry today—an emerging, circumambient phenomenon I call the "spectacle of discourse"?

Also up for a grilling is the false dichotomy between "post-colonial theory" and art practice—the former as the usurping outsider crowding out the latter. Artists, quite early in the game, generated critical thinking on the "post-colonial condition" off their own bat. Their inquiries and insights surfaced from within their practice, in and through their art activity—as immanent investigations. They sometimes brought to light themes that were until then not recognized either as theoretical objects or topics worthy of academic study—or as proper material for art. They are on par with theory output but distinct from it. Which bit are we waving off?

Fond farewell

The "Farewell" in question has a tricky double sense. On the one hand, we bid adieu to the post-colonial, wishing it the best of luck, hoping it fares well. On the other, we wish to be shot of it, to part company, to split. It half-echoes Paul Feyerabend's "Farewell to Reason" (1987) that sounds as if it dares us to dump the very stuff of thinking and logical argument. However, it is a ruse for spotlighting his real target: the brittle "rationalist principle" that had ensconced itself as "reason"—a crimped version that excluded other registers of reasoning. Against this, he was proposing a more open-ended, expanded notion of reason.

A touch of Feyerabend's provocative "Farewell" is at play here. At first, I was not a little gobsmacked by the strictures against the post-colonial that came with the invitation to co-curate the Triennial. It jolted me into noting that "elsewhere," "post-colonialism" might have less approving connotations than those we were all too comfortable with in Western art-culture-academic circuits. Nevertheless, they hardly squared with my experience of how the UK had re-invented itself in post-imperial terms with investments in cultural diversity and the cosmopolitan ideal. Here the post-colonial signaled stepping out of colonial subordination, even if this was a ragged affair with areas of authority yet to be unraveled. Neither did a blanket goodbye to the "multicultural" seem to make sense for there was no readymade ideology foisted on us. It was forged both in a critique of Eurocentric thinking—and in the painful struggles for visibility by minorities and marginals, in the rub-up with quotidian immigrant difference, with the "other" in our midst. In this light, "political correctness" is as much a rough and ready, organic ethics secreted by everyday struggles as it is a flatfooted bureaucratic ploy to codify civil intercourse—though by no means escaping ridicule or self-parody as "PC gone mad."

Johnson Chang's charge of "PC at large," floated in the Triennial's early propositions, has to be similarly unpacked according to both China's historical experience and actualities on the ground. "PC at large" rings alarm bells about kowtowing to the status quo, toeing the party line, herd mentality that stifles acting on one's own steam. It concerns political machination, control and being "corrected" to fit in. In this light, we cannot but be wary of post-colonialism as one in a string of readymade ideological imports. However, for Ai Wei Wei, "ideology" is about having guiding principles for a meaningful life—a "design for living." The lack of it, in contrast to past idealism, is reason for the present malaise, for empty, self-centred living (Ai Weiwei).

For the radical stance beyond his view, the world is a better place without ideological movements: "Without Isms is neither nihilism nor eclecticism; nor egotism or solipsism. It opposes totalitarian dictatorship but also opposes the inflation of the self to god or Superman. Without Isms opposes the foisting of a particular brand of politics on the individual by means of abstract collective names such as 'the people', 'the race', or 'the nation'. The idea behind Without Isms is that we need to bid goodbye to the twentieth century, and put a big question mark over those 'Ism' that dominated it" (Gao Xinjiang, *The Case for Literature*, 2008). We might pause to ponder whether "anti-ideology" is not itself a bit of a doctrine, an "Ism" of sorts. At any rate, from this viewpoint, "post-colonialism" is little more than a manipulative agenda—another "Ism"—that overrides individual, unfettered expression. Here "Farewell" is no less than good riddance.

Peculiarities of the English

The view that post-colonialism harbours a dead-end preoccupation with colonial power is not unlike Toni Negri's on the limits of the post-colonial paradigm with globalization (Michael Hardt and Antonio Negri, *Empire*. Harvard University Press, 2000). But the

complaint that it is inapplicable to China's historical experience, that as a theoretical model it rides rough shod over the "peculiarities of the Chinese" needs closer attention. It parallels E.P. Thompson's dogged defence of the "peculiarities of the English"—a feel for the grain of the concrete, the empirical and doable that shies away from overweening theorizing. One of the "grand systems" he had in mind was Louis Althusser's formidably abstract, Marxist categories of analysis (*The Poverty of Theory*. 1975). The quandary is whether we can grasp the "dense peculiarities" of the "ascending pile" of China today without even a whisper of theory or an "Ism"—"post-colonialism" or whatever? This is not to deny that "stripping art bare" of all ideological constructs such as "post-colonialism" is an invigorating exercise—especially in an age when world-wide governmental functionality is increasingly taking creative activity under its wing. "Stripping bare" resists the drive to codify art practice: it reaffirms the peculiarities, the unforeseeable vagaries of the art event—its singularity.

The bone some colleagues in China and beyond pick with the "multicultural" is not so much with its spook Apartheid logic in which "some cultures are more equal than others." Neither is it with its "managerial mentality" based on reductive cultural-ethnic stereotypes. It is with the fact that it falls short of the universal ideal—that multicultural difference can only splinter into warring factions. But do multiplicity and heterogeneity intrinsically spell breakdown and bedlam? We should not forget they are the force-fields of singularity, individual quirk, variation, teeming possibilities. Likewise, totality and oneness does not exclusively imply the totalitarian steamroller: it is also about co-operative association, unity of purpose, constructing the "commons"? Vital distinctions for the conceptual tightrope we walk in mulling over the multicultural today.

There are nevertheless some everyday examples of its skewed spin off that stick in the gullet. Two recent cases: a downtrodden caste in India, at the bottom of the social ladder, protests against being pushed too high up by new, fairer laws because they lose the benefits that go with their previous special "lowly status." In a court case a few months ago, descendants of later waves of Chinese, mainly Taiwanese, immigrants to South Africa, who were previously classed semi-honorary Whites and were beneficiaries of Apartheid, won the legal right to be re-classified Black. This means they now qualify for empowerment schemes under the law of the post-Apartheid Rainbow.

Post-colonial pharmakon or panacea?

To speak of "post-colonialism" as if it were a monstrous conceptual monolith overlooks the quarrelling viewpoints under its umbrella. What is up for scrutiny is a concoction extracted from them—a cod "post-colonial" of well-thumbed slogans and shorthand: representation, self-voicing, identity, belonging, "other modernities," Orientalist optics, migration, citizen/refugee, diaspora, authority/subordinaton, epistemic block and the like. It is not so much these terms in their original skin in the realm of pure theory that are in the hot seat. Rather, their mash up in the art-culture criticism-curatorial spheres—in the "spectacle of discourse"—that are candidates for fond "Farewell."

The Post-colonial Pharmakon (PP1) is a deconstructive probe in which critique is an oscillating positive-negative charge—in Derrida's figure, both "poison and cure." It is a 360° swivel eye that relentlessly unpicks all sides of the colonizer/colonized, standard/subitemi, metropolitan/migrant divide. Stopping short of simply valourizing the latter term over the former it highlights their complicities and blind spots. PP1 is at odds with the Post-colonial Panacea (PP2), which is a strategy of inversion. It turns the tables on the West/Non-West, Europe/Asia power divide in a "utopian" privileging of the subordinate, underdog term. Toppling the "heavenly" dominant, it becomes its "nether empire."

An issue ripe for "Farewell" that PP1 embodies, derives from Gayatri Spivak's potent post-colonial purge. She had brewed this from a mix of East/West texts and ideas in her pharmacy lab, *Critique of Post-colonial Reason* (1999), to show how, in the Kantian critique, the "transcendental turn" produces in one go both the "Enlightenment space" and the "subaltern." The former hinges on the "foreclosure" of the latter. Her remedial reading includes a homeo-pathic smidgen of Kantian poison—the brute empirical. It is not unlike Duchamp's prescrip-tion for the retinal malady—a stringent dose of the retinal itself: "To Be Looked At (From The Other Side Of The Glass) With One Eye, Close To, For Almost An Hour" (1918. Buenos Aires).

Is there an escape hatch from the wiles of "foreclosure"? With each historical step a new avatar of the "foreclosed" pops up: from aboriginal through native informant to colonial subject and subaltern, from woman of the South to those beneath the radar, the wretched of the earth below the NGO line through the metropolitan migrant and refugee to the "non-Western other"—another incarnation springs to place in apparently endless succession. Is this wallowing in the "underdog" slot for which we have already taken PP2 to task? Here the "transcendental no-exit" seems little more than a conceptual conceit—an epistemic cul-de-sac where analytical thinking perfects an a priori system only to find itself locked up in it.

With scant mileage to the "transcendental turn," what alternatives, what possibilities for break out, for going beyond the card it dishes out? At the risk of ridicule from Kant, who scoffs at the botchers who mix up their transcendentals with their empiricals, we might venture a frank turn to the "raw empirical." I mean a plunge into quotidian experience—into sounding the everyday rub-up of "mainstream/marginal," of self/other in their rounds of communicative endeavour beyond the uncrossables of language.

Out of the prison-house of concepts, immersion in the dense peculiarities of the "ascending pile." With this dunking in discursive-non-discursive random encounter, pre-given lingo or grammar of self/other cracks and crumbles. From the smithereens, from "ground zero," fumbling contact, scrapings of sound, ur-utterances well up—a tunneling under the partitions of language. To illustrate this we might look at an extreme example—the 7 July 2005 murderous terror bombs in London. From within the incident, maimed, mangled strangers sometimes managed to attend to one another, to eke out a lingo for the nonce—communicative gear emerging from scratch on the spot. This is not to eke out some consolation from in the terrible events. It is to sound an elemental flare-up in extreme situations—the capacity to patch together ways of see-feel-think that leap over the self/other hurdle. Not least, this confounds what both fundamentalists and some theorists assume—"epistemic blockage" that does not budge.

Up for "Farewell," is the celebrated spat over "PC at large" between Star Theorist and Renowned Artist—the Star Curator was the missing link. The primal scene of the showdown was the making of the exhibition "One or Two Things I Know About Them" (Whitechapel, 1994). They fell out over whose rendering of the East End immigrant Bangladeshi commu-nity was more telling, more correct. The quarrel reaches back to Said's quote from Marx in his epilogue to *Orientalism*: "They could not represent themselves: they had to be repre-sented." He was flagging up possibilities of self-voicing and self-fashioning—cornerstone of both PP1 and PP2—that would lie at the heart of the dispute.

The Theorist's exposé of contradictions within the immigrant community was unsparing: women's subordination, sweatshops, grubby money, "backward" notions of honour and shame. The Artist was less inclined towards an unrelenting sociologizing optic, more into sounding their plight with half an eye on local racist attitudes. His photo-film emanated from an immersive meander through other lives and terrains teasing out representations from the "dense peculiarities" of the community. It clashed with the "transcendental tackle" the Theorist had tooled "outside the community" to hammer home her critique. Was she a

specimen of PC gone mad? Or was the Artist lily-livered, overprotective? The Theorist suspected the Artist of succumbing to a blinkered, "nativist" stance. The Artist felt the Theorist was blinded by an uncompromising analytic that rendered the community more vulnerable.

Huang Xiaopeng's "over-translation"

Versions of the spat reverberate across the art-culture world. In the Chinese setting, it takes the form of concern over whether the artist's work and thinking is shown in its own terms. How to escape the "curatorial turn" that scripts them in advance—framing them as "Dissident Artist," Post-Pop Pop Artist, "Merchant Conceptualist" and the like? A reaction is the search for "correct representation"—for keeping translation to an act of pure, literal transfer between the artist's "identity" and how it is rendered without anything else creeping in. This tends to underestimate the extent to which all translation intrinsically involves "distortion"— a dose of something more than what is being translated and less than it. The gap between original and translation highlights the sense of its "impossibility," its stickier, no-go areas.

Huang Xiaopeng's "over-translation" pointedly captures the sense of a troubling surplus or a shortfall vis à vis the original. His video soundtrack features pop songs translated from English to Chinese and back again through machine translation in random permutations. The process shows up not only distorted representation, slipshod translation, flat mistranslation but also "creative mistranslation"—"out of sync" rendition that spawns new insight, fresh semantic stuff. The clamour of diverging representations and translations add up to a liberating "anything goes" situation, to use Feyerabend's phrase. In the jostle of disparate versions we are free to size up representations one against one another constantly—as opposed to judging and prescribing the "correct" one.

Talk run

With PP1 and PP2 above, the anxiety over "correct" translation and depiction—always at stake in identity politics—drifts towards "representationalism." This is, in Nietzsche's terms, a "reactive stance," where art and thinking are so embroiled with what they retaliate against that they are almost solely defined by it. Though the "deconstructive mode" (PP1) tries to shake free of this oppositional stance—typical of PP2—it remains within the ambit of the reactive syndrome. Modes of détournement, inversion or transgression too are caught up in varying degrees by what they knock. For Deleuze, breaking through the representational crust is possible with the erupting force of an aesthetics that both harnesses and releases energies. This is the capacity for unhampered expression that emanates from its own occurrence and takes shape with reference only to it—a self-organizing event or autopoesis. A little like the flow, the "spontaneity" (Chi) in some Chinese aesthetics or the primal outburst (Sphota) of creativity in Sanskrit metaphysics?

The sense of an explosive, non-mimetic force resonates with the self-processing event of the marathon in Haruki Murukami's "What I talk about, when I talk about Running" (2006–2008). His grueling long-distance runs "sweat out" body-mind states in random order. The highs and lows do not "represent" anything. His down-to-earth obsessions are with pulse rates, knee-joints, ligaments, oxygen. They undercut the impulse to "read" his long-haul symbolically—as if it "incarnated" myths of arduous test, sacrifice, sublime transcendence. The run is passage through peculiar body-mind circadian cycles, filling to brim, emptying to the lees. Each threshold crossed, is a build-up of sensation, affect, emotion but, as with the

gamelan's sonic flat-line, there is crescendo but no climax. Here "hitting the wall" is ordeal, pain, a morale dipper, flagging stamina and both heightened and blank consciousness. During the endurance course, there are flickers of body-mind illumination. Nothing as grand as Enlightenment, only the "opaque" brain-brawn torrent pushing the run to its edge.

The peculiarities of Runner and Writer seldom cross paths in Murakami's circuits. The run of writing hugs the inside lane of the grammar track: it is organized, static even when in motion. The marathon, on the other hand, presses on through wordless syntax—the body without organs. The contrast touches on Jun Nguyen-Hatsushiba's proposed marathon cum drawing event: Breathing is Free: A Running-Drawing Project 12,756.3 km—Jack and the Guangzhou Bodhi Leaf, 193km. The route of the run through Guangzhou is in the shape of a giant Bodhi leaf. Perhaps nothing as grand as the Tree of Enlightenment for it is also Jack's Beanstalk of fairytale fame that shoots up unstoppably to the Giant's heaven. It leaves us in two minds. Jun is at pains that this is not a performance: it is always more than a representation and less than it. It is less "acting" than perhaps "simply an act" or the "enactive." Here the running body-mind self-propels on the spume of the scriptless event.

Zeitdiagnose and Abhijñanasakuntalam

In the wake of the "Farewell," we have a prelim probe for "Asia in the world"—quasi-clinical notes on the current conjuncture:

> Memories of Underdevelopment
> Grey Matter Economy
> Thinking Through the Visual
> Avidya
> Non-Knowledge
> Know How & No How
> Light of Asia
> The Great Learning
> The Subjective Enlightenment

There are two pointers to the above: Max Weber's Zeitdiagnose or diagnostic of the present, taking the sound of modernity and the global forces of "Asia in the world"—a non-totalizing score. The second is ancient Indic, Kalidas's Sanskrit play; Abhijñanasakuntalam (Sakuntala Recognized by a Token). King Dushyanta, who fell in love with Sakuntala when they met in the sacred forest grove, fails to recognize her later because she had fatefully lost the ring, the token that was to "awaken" their reunion. In the erotic mode or Rasa, the play engulfs us with body-mind states of love, languor, desire, the flood and ebb of rapture and enlightenment. The text had circulated in Enlightenment salons: its prologue and the vidhUSka figure so enchanted Goethe that he crafted a similar device for Faust.

Weber's Zeitdiagnose is about cognitive signs, social facts, statistical data that have to be configured to take a reading of the current state of play, of incipient developments and new bearings in modernity. Kalidas's play, on the other hand, "embodies" body-mind fill up and damp down—non-cognitive charges, feel-know indexical markers, affect traces, clouds, smudges. The token by which Sakuntala is to be recognized is not an abstract sign to be "read" by code but it is a ring on her finger, the piercing force of awakening consciousness. Here the two modalities synthesize in seesaw, objective-subjective key. We have a glimpse of the approach perhaps in the Sakuntala series by King Rama V1 of Thailand (National Gallery of Art, Bangkok, 1910–25). His rendering verges on the angular with jabbing strokes, a

querying, futurist tone—quite different from the attenuated, sinuous line of Indian depictions. With this modal mix, the suite "prefigures" a proto-probe where the Zeitdiagnose annotates the Abhijñanasakutalam and vice versa.

Why Pandemonium? In Milton's *Paradise Lost*, Lucifer/Satan and his rebellious Band, kicked out of Heaven, fall precipitously through dementing zones of Disorder and Chaos, the hell holes of Din and Hiss. Milton sounds the cacophonous "other" of the old "harmonious order"—his epic reverberates with the topsy-turvy of new possibilities the English civil war had ushered in. The Band pass over sulphuric lakes, scurfy deposits, toxic fumes—not unlike the cratered, damaged environment of contemporary "Asia in development." Nevertheless, the blasted landscape is also one of inventive construction where the architectural spectacle of Pandemonium goes up—the "ascending pile" of giant columns, palatial halls, massive architraves. Satan's labouring cohorts give us a snapshot of today's towering engineering feats in Asia. The continent is a plane of transmutation: furious input of raw materials and minerals through a "sublimation" filter: output of futuristic buildings, cities, crystalline commodities.

At the Pandemonium think-tank, the fallen Band scheme to regain their lost power by erecting a "nether empire" to match and beat Imperial Heaven. To get at God, they plumb for the more devious plot of corrupting his new creation—the primal duo in Paradise. Pandemonium seethes with energies, a lab for alternative projects, uncreated worlds. The wild atmosphere of things on the boil visualizes a continent bristling with transformative, unknown potentials—Pandemonium Asia.

Memories of underdevelopment

I am taking the title of Tomás Gutiérrez Alea's renowned film by that name (Cuba, 1968) as an initial component of the proto-probe. The film had looked back on Cuba after the revolution to note traces of underdevelopment that had not been "superseded." "Backwardness, rottenness, lack of culture" linger on in a society with pretensions to modernity and advanced socialist ideals. I am using this as a rough backdrop to evoke Seydou Boro's (Paris/Burkina Faso) "dance-non-dance" that kicks off with the question: "How to get to Brazzaville?" A woman fingers a nightmare route on a map: head far south to Johannesburg, then a maze-like backtrack to Central Africa, perhaps onto Paris just to get to the country next door.

For Seydou, the regulation of movement in colonial travel networks mirrors how "dance" regulates body-mind movement. The way colonial categories organize space-motion parallels how art genres parcel out creativity. They are structures of authority that define "identity" as colonial subject, as "Dancer"—even as "contemporary African performer" as curatorial jargon has it. These representations melt away as Seydou flexes out into action, writhing, thrusting out across a sandy patch, in between the cage bars of a container truck, down a long road, through the market place. For gobsmacked bystanders, is this a performance, someone crazed on the loose, an avant-garde Dancer? Neither "choreographed sequences" nor entirely random workaday spurts of movement, they elude fixing as folk, modern, traditional or "Africa Now." They tense, convulse to the edge. Emanating from its own propulsive force the body-mind presses on beyond given theoretical constructs such as "post-colonialism" to which it says "ta ra love."

Emma Maersk and over-development

A key component of the post-colonial conceptual pantheon that is up for a seeing-to is the centre/periphery couple. This was flagged up with the arrival from China of the world's

largest container vessel, the Emma Maersk, laden with "Made in China" Christmas goodies for the EU. To the gawping crowds at Tilbury for the spectacle, the ship encapsulated China's manufacturing might. It also meant that other upcoming zones in Asia's "ascending pile" now mattered—regions previously beyond the pale as "Third World basket cases." Re-drawing the classic N/S lines of division was a priority if we were not to be left fumbling with a skewed, out of date map.

Early in post-colonial debates, Trinh T Min-ha spoke of a "First World in the Third World, a Third in the First" to highlight more complicities between centre/periphery than met the eye—a view fleshed out later in empirical terms in Amartya Sen's "Development as Freedom" (1999). With globalization, these entanglements become labyrinthine with cease-less translation and mix across developed/developing lines. At modernity's high tide, there-fore, the "development plot begins to thicken." Pockets of decline and malaise appear in the developed world: the effect of "post-development blues" or, should we say, in the wake of "over-development"? This does not imply that the N/S divide is less of a fault line: grave disparities and inequalities persist "in the South." Rather, straddling the old divide, an unnerving space of "development and its discontents" opens up.

The inside structure of the Emma Maersk shows computerized storage for precision location of every commodity on board. The programmed stacking momentarily recalls eight-eenth century slave ships, their tiered bays in the hold choc a bloc with African bodies. This "memory of underdevelopment" brings up a salient fact: the packing system shows how well China is plugging into the knowledge economy. However, it should not blind us to the abiding economies based on muscle-body labour power with their sweatshops, suicide belts, factory regimen. The sobering fact is that brute toil of the visceral world hangs on as more than a memory in the knowledge economy's pristine virtual world.

Grey matter economy

Two birds: Who is the real worker: piano-maker or piano-player?

Karl Marx, *Grundrisse* (1857)

Why grey matter? Because it spotlights the brain as a porridge-colour knowledge-producing lump of muscle. It brings back the visceral vis à vis the virtual in the knowledge economy that tends to be seen as entirely ethereal. As the brawn bit is spirited away, brain is thought of as a disembodied, purely mental affair. To speak of the knowledge economy simply as "immaterial" or "intangible" is only part of the story.

The query here is that if the knowledge economy is transforming relations between work, labour and creativity—then what are the implications for "creativity" as understood in the sphere of art? Are these spheres folding into each other or is there still a specific creativity to art? The "deep" concept of work, according to Andre Gorz (*Farewell to the Working Class & Reclaiming Work*. 1997) is an anthropological-philosophical construct, a project with a Hegelian ring, in which the self tussles with brute nature in a self-fashioning, world-crafting process. Today work has increasingly become mundane, as it were, a matter of serial, change-able jobs (Jeremy Rifkin, *The End of Work*. 1995) It is no more "mere labour" but involves creative thinking, imagination, capacities for planning and innovation. These qualities, once associated with only the managerial elite, are increasingly the ABC of the general workforce, especially against the backdrop of IT know-how which now permeates the oddest crannies of agricultural labour.

In his prelim notes to *Capital* (1857), Marx saw there was no simple toss-up between piano maker and player in deciding who the "real worker" was. It required establishing

rigorous criteria for "productive labour" in capitalist production to pinpoint the group of workers from whom maximum surplus value was squeezed out. If the piano maker fell in this core group, the piano player was lumped with the rest. They were "nonproductive" workers in the sense that "objectively" less was milked out of them. This was a teaser for the Labour Theory of Value—tied up with distinctions in old-style industrial production between workers and planners, brawn and brain, makers and thinkers. Post-Ford conditions were to overhaul the distinctions. The spotlight now falls on the piano player as the symbol of how creativity—grey matter activity in the heightened sense—is not extraneous to work anymore. It folds back into it and feeds production with new ideas. We see the system actively tapping into the worker's "creativity and imagination." The shift away from the idea that he or she is an "alienated automaton or operative" means that he or she is now billed as a "knowledge engineer" whose store of inventive capabilities becomes the linchpin of production.

Knowledge-pleasure dome

An early, striking attempt to put in place a "knowledge economy" was literally, in the far South, in Chile. President Allende had invited Stafford Beer, the cybernetics management theorist, to set up the Operations Room from where worker-managers could keep track of national economic performance. The Ops Room was a futuristic, Star Trek HQ. The base constantly received updates of data from around the country in real time. By 1974, the Pinochet coup spelled the end of the experiment.

More than thirty years after, Mario Navarro revisits the Chilean interlude with his Liverpool project (2006). He erected a Buckminster Fuller dome, blood red translucent, as a version of the Ops Room in the Rotunda of the Municipal Library. The brain-shaped dome forms are encircled by wall-to-wall bookshelves—an earlier knowledge regime quietly passing into obsolescence. The Ops Room central command was for total surveillance and control over the economy, the management of resources, labour and information. Today these ring Big Brother alarm bells, let alone those of 1984 dystopia. For Mario the renowned ergonomic armchairs of the Ops Room increasingly look like machines for body-mind regulation. To design the chairs for his Ops Room he invited a group of people who had experienced change in their thinking or behavior because of some event or accident. What they came up with was sealing for comfort, for wallowing in. They took pleasure in wild, synthetic fur fabric covers, garish cushions and kitschy knick-knacks. The armrests were not dotted with electronic buttons and knobs but placeholders for beer glasses and ashtrays—politically incorrect "design for living." Mario ribs the robotic functionality of the original Ops Room. It gives way here to the vagaries of personal taste, individual quirk. Against hyper-efficiency, elements of error, mistake and accident in the vulnerable human run of things sometimes also contain glimmerings of new creative bearings. Has the Knowledge Dome mutated into the stately Pleasure Dome that Kublai Khan decreed in Xanadu—in the words of Coleridge's poem?

Mario's wit and humour enable him to raise a critical eyebrow regarding Beer's conceptual models based on the brain-autonomic system and neural networks (Brain of the Firm. 1971). Duchamp had toyed with the notion of a grey matter, cerebral art. It was partly to counter the somewhat lowly, "manual" status of art encapsulated in the phrase "as stupid as a painter" current then. He was also speculating on what an intelligent, conceptual art practice—one that sprang from the "cortex"—might look like? The irony today is that not dissimilar smart "work-creativity" speculations have become the order of the day in the grey-matter economy. If this marks the "corticalization of creativity" as know-how, then it is even more crucial to keep the door open for, in Samuel Beckett's phrase, no-how.

Thinking through the visual

As with the double sense of Farewell, so with Thinking through the Visual: it is thinking by means of the visual, in its viscosity—and about unpacking its peculiarities to see how it ticks. Does it spawn, "other" kinds of knowledge? Thinking here refers as much to discursive forms of think-know, as to the non-discursive. In Sanskrit, Avidya touches on the "other" of knowledge—it is the third term between knowledge and its binary opposite, ignorance. To sound its obscure surge we need to differentiate hard-nosed know-how from the flux of no-how.

"Thinking through the Visual" is not a lookalike of verbal lingo. Its charge is non-lingual, somatic, atmospheric murk, performative splurge. As an "agglutinative mode" its thrust is grammarless—putting into play associative merge, juxtaposition, non-inflexional elision. It sticks together elements in a piecemeal, "add on ad infinitum" way. This is a vital alternative, as Feyerabend noted, to the control freak of dialectical thinking that irons out and assimilates all in its path. Various merz-assemblages spring to mind—Kurt Schzwitters, Rauchenberg, Thomas Hirschhorn. They embody a non-assimilative force that refuses to blot out otherness and difference.

We may contrast "thinking through the visual" to parsing, the epitome of chopping up flows of information into combinatory bits to configure algorithmic sequences. John Hoskyns's "Wiring Diagram" (*Just in Time*. 2007) tends towards this mode—a map of the sorry saga of the mid-1970s British economy, a Zeitdiagnose of the condition of the "sick man of Europe" as on 1 October 1974. It reminded Mrs Thatcher of a "chemical plant"—a footnote to her tough remedy for Britain: the "Long March" to roll back socialism and roll in the free market. His diagnostic works because a modicum of rules are at play, even if only thumb-rules. They can be applied consistently—a degree of "repeatability" that would not only be unlikely but undesirable in art where repetition paradoxically throws up divergence and difference: each re-run of the original spawns a one-off variant. This puts it at odds with computational constancy, with the calibrated equilibrium of know-how and closer to the vagaries of the swell and dip of no-how.

The subjective Enlightenment

> Two Birds: Ezra Pound did not "know" Chinese when he translated the Sung poets through Fenelossa's notes. WB Yeats did not "know" Sanskrit when he translated the Upanishads with Shree Purohit Swami. Cheeky Colonialists or precursors to an emerging figure key to our time—the Monolingual Translator?

Qiu Zhijie's video (1999) takes off from reflections on the Yuanmingyuan (Gardens of Perfect Brightness) or Enlightenment Gardens that British-French punitive forces wrecked in 1860, looting and razing adjoining buildings. The tone and atmospherics of his piece invites us to rave and jot down loose associations. What were attitudes to the event over the years, through the Cultural Revolution and beyond to recent times when the Gardens have featured as a spot for honeymooners and tourists? Our musings drift towards two queries: what is the relationship between Enlightenment and violence? What is Enlightenment, anyway?

The first had been explored in the shadow of the Holocaust, notably in Theodor Adorno and Max Horkheimer's *Dialectic of Enlightenment* (1972)—a bleak scenario of advancing consciousness shadowed by ever-new forms of manipulation, control and violation. With the end of Empire, one view was that violence was implicit in the Enlightenment project from its beginnings since it had taken shape in and through the period of conquest of "other" cultures. In a stronger version, it is seen to have ushered in a "modernity of extermination" that wiped

out the Aboriginal world in a prefiguring of the Holocaust. Post-colonial bedlam and slaughter was harder to pin on the Enlightenment alone: this was post-independence bloodletting and strife after the colonial authorities had, as it were, decamped. We can compile an endless list: the murderous Partition of India at the tail end of Gandhi's non-violent movement, the Cultural Revolution; Cambodia's Year Zero, divided Korea, the Vietnam War, the ongoing conflict in Sri Lanka and the like. Today, widespread global migration gives a particular slant to the query: can Enlightenment tolerance cope with the "other" in our midst? The demand for assimilation that is made of immigrants, non-citizens, foreigners and "other" marginals— that "they" become like "us"—is the thrust of "repressive tolerance." It is about erasing what-ever's different and unlike in the name of making "them the same as us," about getting rid of the non-identical—a "xenocidal" drive.

We are back to asking "What is Enlightenment?"—a band of discourse stretching from Kant's reflections through to Foucault and beyond. So much so that Qiu Zhijie's video prompted me to wonder whether there were "other'" Enlightenments besides the European, on "other" continents? What, for instance, of the Buddha's quest for enlightenment that had critically queried "authorities and orthodoxies:" did the "Light of Asia" count at all?

To think on one's own feet without outside authorities, the capacity for autonomous thinking from within the momentum of the thinking process itself, these Edmund Husserl saw as a force singular to Europe in his landmark lecture, "Philosophy and the Crisis of European Man," delivered on 10 May 1935 in Vienna. The self-organizing force of thinking meant that people flocked together as equals—getting stuck into discussion, crossing swords, honing argument and opinion in open rub-up. This is the friendship model of discourse and knowledge production peculiar to Europe. Participants milled around as everyday equals and companions on a common plane of exchange. For Husserl this was in stark contrast to the Asian model of knowledge that was a scene of one-to-one induction into wisdom based on initiation to a higher authority—the master, sage or guru. The relationship was top-down, parental as opposed to the friendship model that was lateral and sibling. The sacred grove of Asia was the site of osmotic transmission where the Master was the conduit for the knowing process passed down to the disciple. It stood at odds with the agora of Greece—an agonistic arena where knowledge was thrashed out in the rough and tumble of argument between interlocutors on the same footing.

There are a few holes we can pick with Husserl's mapping—some are apparent quibbles like whether "Greece" was applicable to the scattering of small states he had in mind, or what bearing slave-owning had on the idea of "friendship." He seemed unaware of the proliferation of models of discourse and knowledge in Asia: Confucian, Taoist, Tibetan Tantra, the Avestan and Sufi systems of disputation: in India, elaborate Buddhist logic, Vedanta ration-alism, non-theistic, nitpicking reasoning such as the Nyaya-Vaisesika—to mention only a sliver. They could not be simply lumped as "mystical"—a term, in any event, that is often a misnomer for "other" think-know modalities. Husserl had outlined these views at a poignant, dangerous moment when the Nazis had stripped him of citizenship and on the eve of the Holocaust. The Nazi scene of discourse had been staked out around the campfire of tribal territory cleansed of "the other." It is against this rising "nether empire" that his stark mapping took shape.

Later thinkers, notably Gilles Deleuze and Felix Gauttari in *What is Philosophy?* (1994), updated and tinkered with elements of the "friendship model" as a "plane of consistency" where philosophical thought is sheer conceptual creativity. Nevertheless, one query looms large: in the arena of equals, how come some end up more equal than others? Is the "first amongst equals" inevitable? Why does "friendliness amongst friends" sour into anger and aggression let alone head-chopping? The orchestrator, the guide, the facilitator, the expert imperceptibly end up "in charge"—a not uncommon process that we can observe in the

institutional micro-routines of art academies, universities, co-ops, communes, ashrams. In these instances, Enlightenment goes into reverse gear as authority and hierarchy sneak back in through the rear—something Adorno mulled over in his very last talk on Radio Hessen. The friendship model seemed destined to teeter between positive and negative, to pass over from pulling together to daggers drawn, from agonistic to antagonistic.

Was the antidote a more stringent accounting of Enlightenment ideals—as uncompromising a stance as possible? This seems to be the drift of one of Adorno's more robust jottings on the Upanishads. He found the Buddha community (Sangha) compromised because of restrictions on who could join. A consolation was the obscure outsider, Kan-kara: he saw this radical to the left of the Buddha as an example of "uncompromising consciousness." However, to have the most progressive programme, an unbending "universal" constitution or the most inclusive diversity policy is perhaps less the point than making it a lived reality and of putting it into practice. Otherwise, it becomes little more than perfecting one's stance for its own sake—rather like buffing up one's PC medals.

To shore up the "friendship model," I venture the notion of the Subjective Enlightenment. By this I mean an auto-reflexive force emanating from the "self"—that odd construct of consciousness from which we normally derive the sense of being in the driver's seat "in charge and in command." The peculiar sense of self takes shape in the zones of Hiss and Din of the neural networks of the brain: Oliver Selfridge had famously modeled it on the tiers of demonic, shrieking forces arrayed in Milton's Pandemonium. How to get to grips with the "self" that seems both utterly illusory and all-too real? Tussling with it in both its flimsy and substantial guises, is the start-up subjective condition that complements the Enlightenment's objective ideals "out there in the everyday arena of the world."

The auto-reflexive gives us the "View from within"—the "first-person" take on consciousness to grasp how it ticks. It is about sounding its restless surges of aggressivity and competitiveness, grappling with its violent fluctuations. The Buddha's statement: "Hold a light to yourself" signaled the idea of bringing a searchlight to bear on the "ascending pile of the self" caught up in its own delusory structures. From the outset, however, the Buddha's statement was not to be taken simply as another "authoritative" utterance or injunction that had to be "obeyed." It was the start-up for self-inquiry backed up by constant experimenting and testing of self-investigative procedures—the idea that Enlightenment is also about enlightening yourself, with an interior illumination as much as an exterior application. It is not Buddhism that is prescribed here as a panacea, as a "method," as another "Ism"—but its spirit of experimental self-tooling where methods of self-inquiry are not pre-given but invented each time for the nonce.

Varela spoke of self-inquiry as part of the "technologies of introspection." They are aimed at producing a state of "mindfulness" where the mind becomes alert to its own process. One corpus of methods he mentioned was the Abhidharma texts, seven centuries of transcripts, drafts, reports on body-mind activity from around the Asian continent. He kept the door open for these introspective modes as alternatives against the positivist views that they did not come up to scratch according to rationalist principles. The connotations of navel-gazing, however, are not easy to shake off: this forms the well-known thrust of allegations by activist applications of Enlightenment ideals against Eastern thinking—that it is self-perfecting, self-absorbed, quietist. This is at odds with what self-scanning is for which is to create the subjective conditions of engagement with the Other, the capacity to listen and respond to the other "out there." The aim is to overcome tendencies towards getting the better of the other or taking charge or control in favour of thinking and feeling with the other. Compassion in this sense is not so much about feeling sorry for or being charitable "from on high" towards someone who is "down." It is the urge towards oneness with the other, a sense of companionship or "friendship model." Varela had used the term "technology

of the self" to give self-inquiry the rigour of a methodology on par with other hard-nosed scientific procedures. Today this seems to fall in with drives towards the "technologization" of the self, towards the application of readymade know how—rather than on the spot kludging at the heart of no-how.

Asia wake

> Two birds: Ananda Coomaraswamy saw Nietzsche, through the eyes of Indian philosophy as the ever-widening urge towards the cosmopolitan—and cosmic— state without qualities. Georg Lukacs saw him through Marxist lens as the "fore-runner of fascism" bogged down in ever-delimiting qualities.

"Re-start from Asia"—or "Asia Start-Up" in computer lingo—is a wake-up call. The ambiguity in the title "Finnegans Wake" allows Joyce to evoke the paradoxical state of a body that is neither dead nor alive, neither corpsed nor awake. "Asia in the world" embodies this dual state—neither self-sealing continent, dead-on tribal territory, essential ground nor simply continental flow in the global wash. It is a place with its own peculiarities and a current to "elsewhere." This state, in terms of Sanskrit metaphysics, is both conditioned with qualities (saguna) and also a state without qualities (nirguna), condition-less. Gamble alludes to the Buddhist version of this logical distinction in his reading of Tiananmen—applying it to identity "stripped bare" of all qualities, perhaps of all ideologies too.

For her GT2008 proposal, Amy Cheung touches on the dual state through a glance at Tagore's *Gitanjali*: the opening "Let my country awake!" is a plea for India to break out of its "narrow, domestic walls," out of ancient confines and colonial subjugation in order to forge that continent-in-the-world where "knowledge is free." With Tagore we have the signpost of one episode in many waves of exchange between India and China as they embarked on different paths to modernity. Amy's quote from the *Gitanjali*, sums up the dual state of identity and nonidentity, being and non-being:

> I dive down into the depth of the ocean of forms,
> hoping to gain the perfect pearl of the formless.

Opera Jawa

> Underwater, the tug-o-war of two continental plates cannot hold. They lose grip, split, ride up against each other glugging back the ocean to the lees. Then out spews an angry flood that hurtles to the coast, drowning the Asian shore.

Ezra Pound's politics and his anti-Semitism were obnoxious and beyond the pale. His translations needled the scholars let alone his "thoughts on the Analects of Confucius," "The Unwobbling Pivot" and the like. He got the linguists' hackles up with his penchant for pontificating on the Chinese language. To top it, and at odds with his "attitudes," there is no let up in his dogged engagement with the "Oriental Other"—what he called his "decipherings." From the eager, creative muddle of his "ideogrammic" method an element comes up for attention today—what he saw as the opposed modalities of thinking—Confucianism and Cartesianism.

The labels are no less bag-all than "post-colonialism." He related the Cartesian mode to the capacity to brush aside the particular texture of an entity, the event's singularity in order

to render it in terms of general principle, the universal. Against this desiccating, abstractive mode, he pitted the Confucian way of embodying the particular-general in one swoop—a force he attributed to the "concrete" nature of the Chinese characteristic. We are in the deep waters of a long-standing Orientalist, perhaps xerographic optic on the "Chinese ideo-gram"—from Hegel on its pictorial-hieroglyphic form to Leibniz on its "algebraic" to Derrida's reflections on its non-alphabetic, non-phonetic potential as counter to logocentric, Western metaphysics. Scholars of Chinese have been at pains to explain how off-the-mark this is in relation to how the language actually functions. It perhaps tells us more about rumi-nations on the limits of Western reason and representational systems. Today, however, the somewhat questionable distinction between the Cartesian sign and Chinese characteristics signposts the tussle with difference, between self/other to cross the epistemic divide. The concern is not so much with pointing up what is right or wrong from some fixed post-colonial stance. It is with affirming the way concepts have to be knocked together, how the elements of know-how and no-how have to be brought into play for the "epistemic crossing." It is the sheer creativity of the process—during which, true enough, much gets told by either side about themselves—that looms into view today. With this the visual-lingual mode compresses the abstract-concrete that Pound attributed to Confucius: does it open up a critical chink of an alternative possibility to the increasing dominance of the retinal-computational mode?

Post-tsunami wake

The ocean swells, spills over, drowning the Asian shore. Opera Jawa (Garin Nugroho Riyanto. 2006) we might say is an after-the-deluge Wake for Asia. The swell and dip of the surf in the finale, is both threatening and soothing: nature can intervene with brute devouring force or simply bide its time in eco-disasters yet to come. The film's backdrop is the Indian epic, Ramayana, the Abduction of Sita section. The epic is about Rama and his brothers' forest exile, the snatching away of his wife, Sita, by the demon King, Ravana. The plight of Sita, who is cosmic feminine energy, is as much a violation of woman as it is of ecological equilibrium. The word Sita in Sanskrit literally means the furrow, the earth ploughed again and again. A song in the film voices the state of actual women in patriarchy as opposed to their cosmic roles as creative energies of the earth. As a Zeitdiagnose of the Asia present, the film weaves into the epic tale everyday life and loves and conflicts of contemporary men and women the fatal passions of Siti, Seito, Ludiro—in the bustle of trade and commerce in today's Indonesia.

In the epic, Sita's rescue can only take off once she recognizes Rama's ring shown to her by the Monkey God who is on a reconnoiter mission staking the joint of the demon king. As with Sakuntala, recognition by a token is not a reading but radiance, the blinding flash of an awakening. We are drawn in, drowned in glowing clouds of affect, orgasmic smudges, emotional charges well up and ebb through the sonic-dance-colour in the erotic mode or Rasa. The sonic flat-line of the gamelan in both its classic intensities and its contemporary surges carries this along with the Hiss and Din of its street pop forms. Elements of the Sufi and Catholic sonic-image worlds flit by mingling with the Hindu-Buddhist. The sonic flat-line of crescendos without climax, source of the 1,000 plateaus, the body spilling beyond its organization.

A turmeric-yellow sheet, dévoré voile, flutters in the sea breeze. It's the bower where Siti's stabbed, a sacrifice takes place. The body-mind races fast and further into the oceanic thick the Sufis and Hindus call "Sur." We drift in and out of its turbulence, the sound and fury of Pandemonium Asia.

Note

This chapter is dedicated to my co-curators Gao Shiming and Johnson Chang—tutors extraordinaire—from whom I have learned immeasurably. My thanks to the Research Curators, Dorothee Albrecht, Tamar Guimares, Steven Lam, Khaled Ramadan, Stina Edblom for their intelligent input and vigorous questions. To the PHD Research Group, Malmo Art Academy, Lund University, Sweden, the Solo Dance class, Universitat du Kunst, Berlin and the New Media Lab, Banff, Canada.

Nicholas Mirzoeff

THE SEA AND THE LAND: BIOPOWER AND VISUALITY FROM SLAVERY TO KATRINA

Figure 10.1 Antony Gormley, MINDSCAPE, 2008 carbon and casein on paper, 19 × 28 cm. © the artist. Photograph by Prudence Cuming Associates, London.

A society's "threshold of modernity" has been reached when the life of the species is wagered on its own political strategies.

(Foucault 1978: 143)

Modernity is, in fact, a European phenomenon but one constituted in a dialectical relation with a non-European alterity that is its ultimate content.

(Enrique Dussell 1995, quoted by Mignolo 2007: 453)

Between these two parts, the lands of the dead and the living, the water is both a passage and a great barrier. The world, in Kongo thought, is like two mountains opposed at their bases and separated by the ocean.

(André Fu-kiau, quoted in MacGaffey 1974: 417)

The best definition of a living thing is a straightforward dialectical statement: a living thing is something that can die.

(Mitchell 2005: 52)

THREE YEARS AFTER HURRICANE KATRINA flooded New Orleans in 2005, and the subsequent floods worldwide from England to Thailand, what have we learned? How can climate change be imagined and understood in terms of current cultural theory? What is the place of the sea in the human sciences? How can we interpret it as a material force and presence; as a place where power is marked and contested; and as a mythical or spiritual form of life that threatens humans and yet is also their vital support? In each of these dimensions, the events known as "Katrina" marked the coming into visibility of a new crisis of what Foucault (1978) called biopower. It marked the "intensification" (Nealon 2008) of a modality of bipower generated by the intersection of its central concerns with "race" and sovereignty (Foucault 2003) and with the biopolitical articulation of the sea and the "natural."

For Foucault, the extension of power over biological life marked the emergence of modernity. Biopower thus "brought life and its mechanisms into the realm of explicit calculations and made knowledge-power an agent of transformation of human life" (1978: 143). A new biopolitics would create institutions, disciplines and regulatory controls to embody and enable the production and management of life itself. Foucault noted that "outside the Western world," it had not yet been possible to cross this "threshold of modernity." Implied here is a requirement for a supercession of the "natural," discussed in terms of famine and disease, in order to pass over into the realm of biopower. Developing Foucault's argument that death is the point where life escapes and exceeds biopower, forcing it paradoxically to produce death to safeguard life, I will argue that any deployment of "life" also exists in a relation to the "natural." Contrary to Foucault's suggestion that biopower was a modern innovation, I argue that the very need to produce and accumulate life was itself engendered in the Atlantic world by the assemblages of chattel slavery. Slavery's modernity formed a cosmography in which the space of the living was divided from that of the dead by the sea, a place of simultaneous life and birth. In the period of abolition and the Industrial Revolution, the sacred circulation of the cosmogram became the secular figuration of key aspects of modernism in a dialectic that interfaced with the understanding of life itself.

Enabled and sustained by Atlantic world slavery, sovereign marine power turned the oceans into divisions known as territorial waters, the high seas, rights of passage and the right to trade that shaped imperial experience and cost many lives in the process. Beginning with the reckoning of longitude in 1759, newly accurate charts, maps, navigation tables and depth soundings of the seascape were the rendition of imperial boundaries, expansions and claims that, as Marx and Engels highlighted in *The Communist Manifesto*, engendered a global "Free Trade." Marine biopower emerged in the nineteenth century as a limit and resource for

settler colonies and the circulation of industrial capital. It was the product of human inter-action with the marine environment, the attempts to govern and profit from that exchange, and the resulting subjectivities. As an instrument of global modernity, marine biopower at once sustains circulation in the networks of power and indicates its periodic episodes of crisis. The present crisis of neoliberal circulation has now become interactive with the climate crisis to produce dizzying exchanges between "real" and "metaphorical" floods and sea levels.

This regime has created and sustained its own order of "seeing," which I will call "immersion." Immersed subjectivity has no "outside" but is constituted by the cosmographic circulation between nature and culture, the West and its Empire, and the land and the sea. This secular cosmogram also maps the crisis of circulation "below the line," or "under water" (a phrase used today to refer to a property whose mortgage exceeds its market value). My concern here is to sketch (in necessarily preliminary and abbreviated terms) a genealogy of this marine biopower, using tools derived from W. J. T. Mitchell's understanding of the imperial landscape, empire and objecthood, and picture theory. I pay special attention to its immersive crises of circulation, first via the intersection of John Ruskin's criticism with Joseph Turner's marine painting; then at its present moment of intensification by means of Spike Lee's four-hour film-document of Katrina *When the Levees Broke: A Requiem for New Orleans* (2006).

One effect of this biopolitical production has been to render the sea invisibly "natural." As one recent Turner exhibition catalog has claimed: "In contrast to landscape, which centuries of human activity changes irrevocably, the sea remains the same whatever may happen upon it" (Hamilton 2003: 2). So much, then, for land reclamation, sea walls, canals, piers, wrecks, fishing, dredging, pollution, carbon-dioxide generated acidification of the water, and the possible changes to thermohaline circulation induced by climate change. Given the obvious-ness of such refutations, it becomes clear that there is a remarkable investment (in all senses, whether economic, psychoanalytic, or emotional) in the imagining of the marine as elemental, primordial and unchanging, a dialectical corollary to the biopolitical struggles over land.

Res nullius

In the early modern moment of European marine-based slavery and colonialism, which Foucault calls the "classic" period, the sea was *res nullius*, a nothing thing, subject to conflicting and contradictory sovereign claims. The modern period produced a radical shift in this epistemology in which the marine became both the limit to imperial representation and something that was alive. Mitchell has highlighted the place of landscape as an imperial construction (1994b). So James Harrington defined empire in his 1656 treatise *Oceana* as dominion in lands "and such . . . as is the proportion or balance of dominion or property in land, such is the nature of the empire" (Harrington 1963 [1771]: 37).

The invisible support of this empire of lands was the legal, economic, geographic and military formation of the sea as both a space for imperialism (*mare liberum*, the free sea) and national sovereignty (*mare clausum*, the closed sea) (Vieira 2003). These apparently contradic-tory designations of the sea were made contemporaneously in the early seventeenth century by Hugo Grotius and John Selden respectively. Both authors used the same evidence and even the same citations from Roman law to buttress their national politics. The classical order of representation, Foucault reminds us, was amply able to sustain such tensions under the containing force of the "sovereign gaze" (Foucault 1970: 13).

In this ordering of the sea, it was transformed from a commons into the property of the Western state, personified in the (Roman) Emperor to whom later European monarchs liked to trace their legal and personal genealogies. Grotius, the Dutch theorist of open seas and free

trade, inaugurated the concept of the sea as the road to empire in his 1609 treatise designed to demonstrate that the sea was open to all, especially the Dutch. In his view, sovereignty was defined by possession and the sea cannot be possessed. Further, water is one of those things that must be "common to all mankind" (Grotius 1916 [1609]: 61–62). Being limitless and unable to be occupied, the sea was *res nullius*, a "nothing thing." A nothing thing cannot be alive, owned or divided. This concept was analogous to the legal precept that "discovered" lands in the Americas and Australia were *terra nullius*, nothing land, available for occupation by armed Westerners. However, if the *res nullius* was potentially available to all as the common, it was not communal, let alone communist. That is to say, Grotius was not basing his argument on the traditional rights of the commons, which tended to be customary rather than codified, but on the limited notion of *res communis* found in Roman law. Thus, although fish were available to all to be caught, once one was so caught it belonged to the person who had entrapped it.

The common ownership of the sea and of water was thus more common for some than others. Indeed, Roman authorities argued that precisely because the sea was "public," it was thus the domain of the state, that is to say, the Emperor (Vieira 2003: 374). So without contradiction, seventeenth-century sovereign power inaugurated a property claim to rights over water adjacent to its land boundaries, despite its assertion that the sea was nothing and common to all. The supplementary concept of territorial waters has led to a proliferation of complex legal disputes in our own time, ranging from disputes between states and the Federal government in the United States over the three-mile state-controlled zone of territorial waters and the now 200-mile zone of Federal domain, to the Maori claim to all Aotearoa New Zealand sea rights under the 1840 Treaty of Waitangi, and international disputes over whaling or fishing. These complications have arisen because the *mare liberum* of trade and voyaging was held to co-exist with what seventeenth-century British political theorist John Selden called *mare clausum* in his defense of fishing rights.

The question of sea access thus became one of rights, which were figured as property by sovereignty theorists. So quickly was this extension of the reach of power naturalised that Sir John Burroughs declared in 1651 "that Princes may have an exclusive property in the Soveraigntie [sic] of the severall parts of the sea, and in the passage, fishing and shores thereof, is so evidently true by way of fact, as no man that is not desperately impudent can deny it" (Allott 1992: 764). As Foucault put it, the emergence of this maritime law "was an attempt to think of the world, or at least the sea, as a space of free competition, of free maritime circulation, and consequently as one of the necessary conditions for the organisation of a world market" (2008: 56). Despite the immense material challenges of ocean navigation, fishing and mapping in the period, the sea was rendered into representation as property, an essential stage in the imaging of the planet as an open domain for the circulation of capital.

"The multitudinous seas" (*Macbeth* II ii: 59)

Yet as Foucault noted in his example of piracy, this maritime jurisprudence of property was far from uncontested. Indeed, its central contradiction was the use of "free" oceanic trade to transport people as unfree property, or slaves. This contradiction ultimately gave modern form to the sense of the sea as alive and capable of action. Just as Foucault made use of secularised forms of Catholic ritual to explain modern power, such as his depiction of therapy and psychoanalysis as transposed versions of confession, so I want to figure the exchange of life and death over the sea in terms of what Robert Farris Thompson has termed the Kongo "cosmogram," a cosmos composed of the human and spirit worlds. This place of exchange is

depicted as a circle transected by a cross, whose horizontal line represents the sea. Humans live and interact at the top of the cosmogram, while the spirit world is below, capable of interacting with the human world. All pass from one world to the next in a circular and recurrent movement from ascent to maturity via death to the other world and rebirth. The boundary between the two domains is marked by water, a place of both life and death. The cosmogram syncretically absorbed the Christian cross and can be found across the Atlantic world from Kongo to Haiti and the slave plantations of the Americas. Enslaved Africans were known to drown themselves in what Europeans believed to be a foolish attempt to return to Africa. Within the frame of the cosmogram it made sense: by passing under the water, one returned to the spirit world and then, in due course, would return to the life-world in Africa. For those taken into slavery, the sea was both alive and constituted by its depths as the burial ground of so many thousands gone.

The sea's life is manifested as anger in floods, typhons, tsunamis and other events often fatal to human life. As Mitchell would be the first to point out, the flood is perhaps the oldest metaphor that humans have preserved in first Mesopotamian and then Jewish legend. Indeed, the ancient god Yahweh was a storm god, capable like the mysterious flood of manifesting anywhere and any time. To begin again after the first beginning is the time of the flood, a narrative that takes central place in Eurasian religions. The flood was intimately connected with the formation of "race" in modern times. The difference between peoples, institutionalised as racism, was justified from the seventeenth century onwards by the legend of Ham. According to this outgrowth of the Bible story, Ham was punished for seeing his father Noah naked while the latter was drunk. This punishment drove him into Africa, where he and his descendants suffered the "mark of Ham," or being "black." Whereas late sixteenth-century theories of "blackness" held it to be the result of infection, by the period of the British and French slave codes (1660 and 1685 respectively), the myth of Ham was widely disseminated (Braude 1997).

The abolition of slavery in the British Empire created an immersive crisis in the sovereign form of marine biopower, a crisis by which modern biopower was able to establish a norm (Foucault 1978: 144). It can be measured in two reckonings with the oscillating forms of "race," "nature" and the sea made in 1840, and again in 1865, by two very different figures: the painter Joseph Turner and the Swiss geologist and formulator of the concept of the Ice Age, Louis Agassiz. In the influential view of the critic John Ruskin, Turner's depiction of the sea opened it up to representation for the first time. In his *Modern Painters*, Ruskin dismissed all artistic images of the sea prior to Turner as "so execrable, so beyond all expression and explanation bad" (1903 [1843]: 498). Turner represented a new modern figuration of the sea that encapsulated the tension between the sea as property and the fury of the multitude against that ownership, visualised as and in the sea itself, newly vested with depth. According to Ruskin, in Turner's seascapes: "there are indicated a fitfulness and fury in the tossing of the individual lines, which give to the whole sea a wild, unwearied, reckless incoherency, like that of an enraged multitude, whose masses act together in phrensy, while not one individual feels as another" (Ruskin 1903 [1843]: 564). These are complex lines, bringing together, in the midst of the Chartist agitation of the 1840s, allusions to what Edmund Burke had famously called the "swinish multitude" with the nineteenth-century nosology of madness.

Indeed, the watercolour that inspired them, "Laugharne Castle" c.1831 (Columbus Museum of Art, OH), depicted a contest between the traditional rights of the commons and assertive modern state power. Ruskin's commentary makes it clear that the scene was not simply picturesque. It shows people wrecking on the Pembrokeshire coast (modern Carmarthenshire), that is to say, gathering goods and objects washed up from a shipwreck. This longstanding practice was criminalised in the early eighteenth century and made subject

to the death penalty (Hay 1975), so the painting certainly shows the frenzy of the multitude insofar as it records a series of capital offences. From the popular point of view, by contrast, wrecking was a form of communal activity and, like the poaching celebrated by Michel de Certeau (1984), widely sanctioned as entirely legitimate. The wreckers gather what they can in the shadow of a castle, representing the traditional authority under which wrecking had been permitted, itself now bypassed by the centralising forces of state power. This medieval castle had been captured and laid to waste by the Parliamentary armies during the English Revolution, so by Turner's time it had long been a picturesque ruin.

Turner made the sea into a fulminating mass that could be taken to mourn the decline of traditional England, to celebrate popular resistance or to present them as in tension. His work depicts the ruin of aristocracy and the wreck of commercial capitalism with the multitude literally the last people standing. The sea appears organic, alive, and dramatically divided above some underwater obstruction—perhaps part of the ship—that I always took to be poetic licence until I saw exactly such effects in the floodwaters of New Orleans after Katrina. The spectator is caught, suspended in the sea, perhaps on a breaking wave, or held above it on a piece of wreckage, a tremulous viewpoint on the frenzy in front of us. This "modern painter" has taken the Atlantic world sense of the sea as a place between life and death, the locus of circulation, and visualised it.

In modern scholarship, we have been offered a choice between art and objecthood that presents a dichotomy between absorption (good) and theatricality (bad), a choice "forged in the colonial encounter" (Mitchell 2005: 147). While Turner's figures act as if unobserved, the entire work is presented from the marine viewpoint that necessarily implies a spectator. That spectator is not quite the "disinterested" viewer imagined in theories of the sublime that so often took the shipwreck as an example, who was presumed to be able to appreciate the terrible beauty of the scene because there is no danger to him or her. Turner's intent, by contrast, was to immerse the spectator. That immersion is at once a literal place of viewing from amongst the waves, a feeling of being captivated by the power of the scene and a metaphorical deployment of a space of transition between regimes of power. In short, being immersed was to be in crisis.

The immersive viewpoint was perhaps most dramatically represented in Turner's *Slavers Throwing Overboard the Dead and Dying, Typhon Coming On* (1840), a painting that makes explicit his coming to terms with the legacy of slavery (Gilroy 1993: 13–14; Baucom 2005: 265–96). It depicted the notorious voyage of the slaveship *Zong* in 1781, whose captain ordered 132 Africans to be thrown overboard during a storm, thereby at once lightening the ship and enabling its owners to file an insurance claim for lost "cargo" (Figure 10.2). Turner shows a moment just after the weighted-down prisoners have been thrown into the sea and just before they finally sank. Chains, hands, arms and one leg are visible in wake of the ship, leading to the bottom right corner. In his commentary, Ian Baucom cites Ruskin to support his contention that there was no point of identification with these bodies: "we are not allowed to tumble into it, and gasp for breath as we go down" (Ruskin 1903 [1843]: 539; Baucom 2005: 292).

This border policing argues that there is no spectatorial position within the painting, rendering it properly absorptive and hence modernist, but it misrepresents Ruskin to do so. Baucom's powerful quotation from Ruskin actually referred to Turner's depiction of calm water and the necessity of depicting a surface composed of reflections. In stormy water, according to Ruskin, Turner never showed the sea as if from the shore but as if twenty or thirty yards out. Here "the sensation of power is also trebled . . . the whole action is different; it is not a passive wave . . . but a sweeping exertion of tremendous and living strength" (Ruskin 1903 [1843]: 562–64). The storm itself is alive, it has power. By visualizing this biopower from the place of immersion, Turner at once lays imperial claim to it and cannot but indicate its moment of crisis.

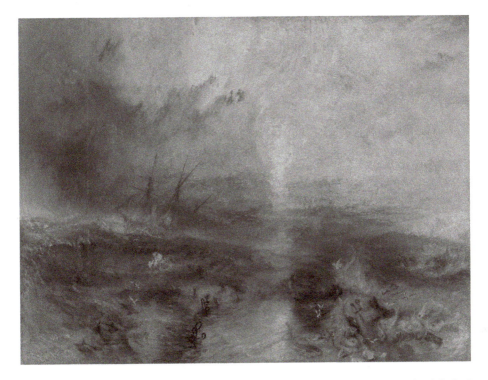

Figure 10.2 Joseph Mallord William Turner (1775–1851), *Slave Ship: (Slavers Throwing Overboard the Dead and Dying, Typhon Coming On)* 1840. Oil on canvas. 90.8 × 122.6 cm. Courtesy: Museum of Fine Arts, Boston. Henry Lillie Pierce Fund. Photograph © 2012 Museum of Fine Arts, Boston.

In *Slavers*, the spectator is far out to sea, at one of several potential view-points, a trebled sensation of biopower. One can look from the point of view of those about to drown, not yet dead, who can still see through the water. Second, there is the viewpoint of the sea creatures, both the fish and the curious creature on the far right, whose look is marked by Turner as part of his visualised drama. Critics have speculated as to whether this animal is the Typhon of the title, the fearsome deity who took on Zeus himself and was father to the storm winds, Cerberus, the Sphinx and other such anxiety-provoking figures. Next, there is the place marked by the pillar of light, the place of Benjamin's angel of history. This light cannot be the sun unless it represents the passing of divine time, which would be in dialectical contradiction with the instant of human time that is seen in the water.

History, the commodification of people, the actuarial rendering of that property, and doubled visualities resonate across this painting. The enslaved body was the "primitive" form of biopower in the sense of Marx's concept of the primitive accumulation that preceded the formation of capital. In the understanding of that history formed from the storms of the middle passage, those bodies are always on the point of drowning, not yet gone, not yet forgotten. To be enslaved was to be in "social death," a place outside the social and the protections of the law. Immersed in the sea, adrift in the seas of the multitude, these people are no longer slaves and not yet the object of an insurance claim. Turner's suspension of time extends the restoration of personhood, as claimed by those enslaved who drowned themselves, and makes it dialectical in Benjamin's sense: this transitional moment jumps out of the history in which slavery has already been abolished into a present in which the body is sustained between states of life by the sea.

In a counterpoint to Turner's vision of immersion, the Swiss geologist Louis Agassiz came to fame in 1843 by challenging the then still current thesis of the Flood in deriving evidence for what he called the Ice Age from the glaciers of the Alps. His thesis was based on observation of so-called "erratic boulders," pieces of rock bearing evidence of glacial "polishing" and striation that had been left behind when the ice retreated. Whereas Neptunism held these boulders to have been swept down by the currents of the Flood and other inundations, Agassiz showed that water could not have shaped the boulders as he saw them nor distributed them. The rocks were mere objects but the principle of creativity—divine and human—was defended by means of the inspired observation.

At the same time, his thesis depended on approaching "nature from a physiological viewpoint," leading him to assert the rise and fall of modes of life that were not descended from each other (Agassiz 1967: lxvii–lxviii). Agassiz denied that creatures now living were directly descended from very similar or even identical species preserved in the fossil record, preferring to argue instead for a series of cataclysmic reformations of life, which he illustrated with a curious line drawing. In order to preserve life as the domain of the divine, Agassiz theorised its repeated extinction and recreation in identical form, a theoretical exemplar of the biopolitical need to kill to save life. The implementation of this disjunctive mode of biopolitics in geology entailed his subsequent belief in the radical separation of humans into distinct species.

Installed at Harvard, he commissioned a now notorious series of photographs of enslaved Africans on Carolina plantations that were intended to visualise this essential racial difference (Wallis 1995). When that effort failed, he set off for the Amazonian rain forest in 1865 to photograph the indigenous peoples for evidence of innate difference. In a scene worthy of Werner Herzog's *Fitzcarraldo* (1981), Agassiz's assistant Walter Hunnewell took photographs of local "Indians and Negroes" in a rickety colonial pile in the legendary Amazon city of Manaos, under the cool gaze of William James, the philosopher-to-be, while Agassiz lectured that, despite the necessity of emancipation, the United States should "respect the laws of nature, and let all our dealings with the black man tend to preserve, as far as possible, the distinctness of his national characteristics, and the integrity of our own" (Agassiz and Agassiz 1889: 293 n).

Agassiz was nonetheless able to make an important development in the understanding of the North American ice sheet by using his Alpine methods of observation. Agassiz's implementation of a biopolitical approach to geology was in equal measure as successful as his racialising efforts were failures because they were what he would have understood as uniformitarian responses of differing forms of life to the same conditions: namely, both climate and humans would periodically "die" and then reincarnate in similar or identical form. Immersion, mingling, crossing, commonality, equality, call it what you will: death was preferable.

By 1865, some former proponents of immersion had come to similar conclusions. John Ruskin sat with Thomas Carlyle on a committee successfully campaigning on behalf of Governor Eyre of Jamaica, whose repression of the Morant Bay rebellion had cost thousands of lives. Eyre explained that "the Negroes are most excitable and impulsive, and any seditious or rebellious action was sure to be taken up and extended." His belief that colonial authority could not "deal" with Jamaicans in the way that one might treat "the peasantry of a European country" was reinforced by the scientist Joseph Hooker, for whom it was self-evident that "we do not hold an Englishman and a Jamaican negro to be convertible terms" (Holt 1992: 305–06). Abolitionism had posed an enslaved man asking: "Am I not a man and a brother?" By 1865, the answer was "no." It was as if the immersive viewpoint had been abandoned for the quarterdeck of the *Zong*, the final possible viewpoint in Turner's *Slavers*. It was from such a place that Conrad's Lord Jim drew his course for the ill-fated *Patna* to Aden as a straight line across the chart that nonetheless led directly to the ship's mysterious collision.

Katrina time

A storm, death by drowning, looting, violence, political debate, government commissions and the ultimate setting aside of radical proposals for change: Hurricane Katrina again produced a violent clash of past, present and possible futures, a symptom of a new crisis in marine biopower (Figure 10.3-5). In Spike Lee's *When the Levees Broke*, slavery is recalled over and again by African American participants such as city resident Gina Montana who described the experience of being forcibly bused out of town to an unknown destination as awakening "an ancient memory" of being enslaved. Fred Johnson, an organiser for The Black Men of Labor, recalled a discussion with one of his friends in which they agreed that Katrina was the result of the dissatisfaction of the spirits of those Africans who died in the Middle Passage with the conditions experienced by their descendants in New Orleans.

Why the *simbi* water spirits destroyed the African American neighborhoods and not those of the descendants of slave owners is unknowable but the point is that slavery and its legacies remain a storm within Atlantic world nations and critical studies alike. Indeed, in the last act of Lee's film, Hurricane Katrina was given a second-line jazz funeral to put the spirit of the storm to ground. The appalling spectacle of its aftermath nonetheless made it clear that some human lives are more highly prized than others and that the operative distinction remains racialised. Once again, the context is that of a radical transformation of capital. If Turner's immersive vision came at a time when industrial capitalism was gathering strength, intensifying the sea's instrumentality into a means of global circulation, Katrina struck when capital had become so hegemonic that it was claiming to be nature. That is to say, capitalism exercised such a powerful hegemony that it created the illusion that it was natural to the extent that humans could only seek to mitigate its effects, as they had with the storms and tempests of the past.

Even the current financial crash is often represented as a mystical outpouring of what is termed a "sea" of debt. As one bemused investor put it: "We are so dislodged from fundamentals, what we're left to is just the vagaries of the oceans" (*New York Times* 2008, B4). In East Asia, the crisis is known as the "economic tsunami," while economist Joseph Stiglitz saw a parallel with Katrina: "A flood of liquidity combined with the failed levees of regulation

Figure 10.3 From Spike Lee, *When the Levees Broke: A Requiem For New Orleans in Four Acts* (2006, HBO Films).

proved disastrous" (2009). The sea here is a force of capital, flowing wildly as debt, requiring regulation from properly built levees to avoid disastrous inundation by the very force that gives the network life.

Just so in New Orleans, outsourced emergency relief was supposed to manage the immediate crisis that would then be resolved by the "natural" action of the market. The ruins of African-American New Orleans expose this failure of the substitution of globalised capital for nature. The "life" of the market, guided by Smith's famous invisible hand, does not sustain other life but seeks only, as Mitchell might put it, to clone itself into ever expanding surplus value. When Condoleezza Rice went shopping for shoes during the Katrina crisis she was enacting the police theory of capital as articulated by Jacques Rancière: "The police say, there is nothing to see, nothing happening, nothing to be done, but to keep moving, circu-lating; they say that the space of circulation is nothing but the space of circulation" (2004: 176–77).

Introducing *Landscape and Power*, Mitchell pointed out that the then new landscape studies had cinema as its "subtext," in its understanding of landscape as a "dynamic medium" (1994a: 2). So he will not have been surprised that the most striking visual response to Katrina has come from Spike Lee. *When the Levees Broke* was notable for winning three Emmys and also being included in the 2008 Whitney Biennial for the best contemporary art. It immersed the viewer in Katrina, as the critic David Denby recognised: "anyone hoping to reclaim Katrina emotionally—to experience what the city went through in all its phases of loss, anger, and contempt—needs to see Lee's movie" (2006). This immersion was part of its visual style as well as its content. The original film was divided into four acts, with a fifth added to the DVD release in 2007. The film begins with a long visual sequence of the effects of Katrina, unaccompanied by voice commentary or interviews, four minutes in time that take far longer in the mind.

Lee took montage, one of the oldest tools in the modernist film vocabulary, and gave it a striking new lease of life by refusing to direct that montage to supply answers. He allows the combination of images, words and music to form their own visuality, one that places the watcher in the midst of the conflicted interpretation of events. The film comprises a series of amateur and professional video and photographic images of the events of August and early September 2005, linked by retrospective interviews with those who experienced the storm. In the absence of a narrative voice and with the interviews being conducted in a direct style to camera, the viewer is expected to do a great deal of visual and critical work. That is to say, as we watch, we are immersed in Katrina, not in a single image but over an extended span of real and represented time. For that reason, together with the indelible impact of so much of what is seen and said, the four-hour long piece seems to unfold at once with great speed and with great deliberation.

It is certainly, as Mitchell saw in relation to *Do The Right Thing*, public art of the highest order. It alerts us to the intensification of biopower, our intensified immersion in both the metaphorical ocean of debt that has flooded all solvency and the literally transformed warming and rising seas. In this intensified immersive environment, simple circulation (whether of images, capital or people) ceases to be a possibility and we are again confronted with the "profound invisibility of what one sees" at a moment of epistemic transformation (Foucault 1970: 16).

One dramatic segment in Lee's film discusses one of the most controversial questions that circulated after Katrina: were the levees blown? In rapid sequence, Lee shows six African American residents indicating that they heard what they described as an explosion. Two people say there was no explosion. Then older people recall the events surrounding Hurricane Betsy in 1965 and testify to the widespread belief that the levees were blown up then to protect white residential neighborhoods. The proverbial expert explains how a levee breaking

under pressure will necessarily sound like an explosion. Before one has time to absorb this, archive film of the levees actually being blown up during the 1927 flood is shown, with a white engineer supervising a black labor force.

John Barry, a white historian, declares that this detonation was more about class than race because it affected St Bernard Parish, where the inhabitants were mostly white. But the archive footage of the refugees shown immediately afterwards depicts far more visibly African American people than anyone else. In these dense sequences, it became possible to see how and why popular discourse about Katrina emerged in New Orleans. People believed that the levees were blown up deliberately because they knew that they had been in the past and that the geography of New Orleans inescapably indicated class and race in terms of relative height

Figure 10.4 From Spike Lee, *When the Levees Broke*.

Figure 10.5 From Spike Lee, *When the Levees Broke*.

to sea level. While expert opinion shows that the levees were not deliberately destroyed in 2005, the entire film makes it clear that to all intents and purposes they might as well have been.

Indeed, the city has now become a smaller, majority white town that played its part in returning a Republican governor of Louisiana in the 2006 elections, replacing the Democrat Kathleen Blanco. The ruin of New Orleans has further been downgraded from being a place that handled 20% of all exports and imports to the United States (Brinkley 2006: 125) to a much smaller operation, dominated by coffee imports. The major crude oil and petrochemical business formerly handled in New Orleans has been transferred to the Port of South Louisiana, further up the Mississippi River, which serves global multinational companies like Archer Daniels Midland (agribusiness and GMO giant), DuPont (chemicals) and Marathon Petroleum (one of the world's largest oil refiners).

The advantage of the Port of South Louisiana, as its website announces, is that "Louisiana is a right-to-work state, with minimal union activity within the River Region" (Port 2006). By contrast, New Orleans has been served for decades by the International Longshoremen's Union Local ILA 3000, whose main business now is managing redundancies for its members (ILA). A Democratic, unionised African-American industrial city has been transformed into a white, Republican service industry, tourist destination. Katrina's destructive biopower enacted the neo-liberal transformation that politics had not been able to perform, even as it disrupted circulation.

The full intensity of this immersion can be seen in the documentary *Trouble the Water* (2008), centered on the amateur camcorder footage taken by Kimberly Rivers Roberts of her family as they remained in the Lower Ninth Ward during the storm, and thereafter in their odyssey to Memphis, and final return to the city. Rivers was shooting video for the first time and her blurry, somewhat washed-out images contrast strongly with the saturated colour of the television images that counterpoint her work in the early stages of the film, directed by Tia Lessin and Carl Deal and nominated for a 2009 Academy Award for Best Documentary. It is noticeable that in the footage from before the storm the television was on throughout and everyone in the neighborhood was aware of the threat but lacked the means (or what Rivers calls the "luxury") to evacuate.

The family lived a few blocks from the Industrial Canal and they were soon at risk of flooding when Katrina hit. We see the water reaching the second-storey window as they climb up into the attic with some friends. With its simple wood frame construction, constricted space and poor light, that attic filled with African American people could not help but recall the middle passage to the film's viewers. Remarkably, there was no panic at the scene. Scott Roberts capably engineered the removal of all those in the attic to a nearby two-storey house, using some barrels as floats. Civil society may have abandoned these people but they were still capable of organising their own social structure. If the attic was a re-memory of slavery, and the immersive descent into the water recalled the desperate leaps of those determined not to be enslaved and the victims of the *Zong* alike, this was a repetition with a difference. While bare life was at stake, it was social life that sustained these people and was prior to it.

A reconstruction then shows how local survivors moved as a group to a nearby four-storey US Naval Reserve building for shelter, only to be greeted by an estimated twenty armed troops, who drove them away. Far from being an urban myth, as the then Lieutenant-Governor of Louisiana Mitch Landrieu termed such accounts in *When the Levees Broke*, President Bush later awarded commendations for bravery to the guards for their actions. The Rivers Roberts family was able to evacuate using a truck that presumably was commandeered by them for the purpose. For all the furore about property rights that we have heard, the film clarifies that such social organisation, enabled by prayer and

empowerment strategies, must have kept the death toll from the hurricane much lower than it might have been.

Looking again at Lee's film, I noticed that CNN covered Katrina under the rubric "State of Emergency." It is the definition of such a moment that "necessity has no law." If that dictum of Roman law applies to establishing martial law, it also applies to people taking trucks to survive or chain saws to rescue those in need. At the same time, those left behind in New Orleans did not feel that the moral or criminal law had been suspended, as manifested by the care shown for the elderly, the disabled and even the dead. If neither Lee nor Rivers made significant formal innovations in their films, they restored to visibility the "subjugated knowledges" (Foucault 2003: 8) of Katrina, making a genealogy of its intensified immersion possible.

As a metonym for the entire crisis, one could look at the water itself. In *Trouble the Water*, it is noticeable during the storm scenes that the water is clear and clean. But in *When the Levees Broke*, the rescue sequences show a brown-black water that was frequently described as toxic. Mixed with the assumption that some sewage had leaked into the water was the ancient prejudice against the poor and the ethnically different that they are dirty, which, in some unexpressed and inchoate way, was seen to be responsible for the water's condition.

In fact, the major cause of dirt and toxicity alike was crude oil. The government Minerals Management Service report found more than 100 accidents leading to a total of 743,400 gallons of oil spilled throughout the Gulf region during Hurricanes Katrina and Rita. To put that in perspective, 100,000 gallons is classified as a "major spill" and this quantity amounts to half that of the Exxon Valdez disaster. Crude oil is toxic and burns the skin. The spills resulted from the failure of the oil companies to withdraw their tankers efficiently despite the long-range forecasting of the storm. Nonetheless, it was the impoverished mostly African-American urban population who were castigated for failing to evacuate, not the all but invisible refining companies.

The conjunction of economic and climate disaster generates new questions. Is the era of circulation at an end? Can the "flows" of globalisation be resumed? Throughout the era of marine biopower, capital has sought to "create the world after its own image" as Marx and Engels famously put it. That image is now in contradiction with itself. Debt, debt everywhere, nor any liquidity to drink, one might say. The restoration of capital's circulation seems to depend on a resumption of the very industrial production and consumption that will continue to accelerate climate change. Spike Lee's film is in its final act a call for a form of green capitalism, seeking to revive New Orleans by a combination of wetlands restoration and the construction of "100 year" levees, meaning levees capable of withstanding a once-in-a-hundred-years event such as a Category 5 hurricane.

Even in 2006, Lee's film expressed doubt as to whether American capitalism, so devoted to the accumulation of profit by finance capital, was any longer capable of such modernist works, doubts that must be much stronger now, whether in engineering or finance. Nonetheless, this solution was effectively that called for by President Obama's February 2009 stimulus. Against that, *Trouble the Water* presents a small-business model in which Kimberley Rivers Roberts is trying to make a career as a musician, helped by her title song for the film making the long list for Oscar nomination in 2009, while her husband learns the contracting and building trade. Perhaps the web-based Born Hustler Records can offer more success than the credit-starved construction industry. Yet the immersive digital world is only as long-lived as the energy that powers its networks and as effective as its circulation allows. All these strategies seem inadequate to the needs of the moment. The task of the historical materialist is, then, to imagine a circulation (of images, goods, energy, ideas) that engenders sustainability not permanent expansion. Put more simply, look at the flood, see its depths and listen to what it has to say.

References

Agassiz, L. 1967. *Studies on Glaciers*. Translated by Albert V. Carozzi. New York: Hafner.

Agassiz, L. and Agassiz, Mrs. 1889. *A Journey in Brazil*. Boston: Houghton, Mifflin and Company.

Allot, P. 1992. "Mare Nostrum: A New International Law of the Sea." *The American Journal of International Law* 86:4, 764–87.

Baucom, I. 2005. *Specters of the Atlantic: Finance Capital, Slavery, and the Philosophy of History*. Durham, NC: Duke University Press.

Braude, B. 1997. "The Sons of Noah and the Construction of Ethnic and Geographical Identities in the Medieval and Early Modern Periods." *The William and Mary Quarterly*. Third series. 54:1, 103–42.

Brinkley, D. 2006. *The Great Deluge: Hurricane Katrina, New Orleans, and the Mississippi Gulf Coast*. New York: William Morrow.

De Certeau, M. 1984. *The Practice of Everyday Life*. Berkeley: University of California Press.

Denby, D. 2006. "Disasters." *New Yorker*. 4 September.

Foucault, M. 1970. *The Order of Things: An Archaeology of the Human Sciences*. London: Tavistock.

Foucault, M. 1978. *The History of Sexuality: An Introduction*. Volume 1. Translated by Robert Hurley. New York: Vintage.

Foucault, M. 2003. "Society Must Be Defended." *Lectures at the Collège de France, 1975–1976*. New York: Picador, 254–59.

Foucault, M. 2008. *The Birth of Biopolitics. Lectures at the Collège de France, 1978–1979*. Translated by Graham Burcell. New York: Picador.

Gilroy, P. 1993. *The Black Atlantic: Modernity and Double-Consciousness*. Cambridge, MA: Harvard University Press.

Grotius, H. 1916 [1609]. *The Freedom of the Seas*. Translated by Ralph van Deman Magoffin. New York: Oxford University Press.

Hamilton, J. 2003. *Turner: The Late Seascapes*. New Haven: Yale University Press.

Harrington, J. 1963 [1771]. *Works: The Oceana and Other Works*. Reprint. Darmstadt: Scientia Verlag Aalen.

Hay, D. 1975. *Albion's Fatal Tree: Crime and Society in Eighteenth-Century England*. London: Pantheon.

Herzog, W. 1981. *Fitzcarraldo*. Werner Herzog Filmproduktion.

Holt, T. C. 1992. *The Problem of Freedom. Race, Labor and Politics in Jamaica and Britain, 1832–1938*. Baltimore: Johns Hopkins University Press.

ILA. 2008. Available online: www.ila3000.org/ (accessed 30 August 2008).

Lee, S. 2006. *When the Levees Broke: A Requiem for New Orleans*. HBO Films.

Lessin, T. and Deal, C. 2008. *Trouble the Water*. Zeitgeist Films.

MacGaffey, W. 1974. "Oral Tradition in Central Africa." *The International Journal of African Historical Studies* 7:3, 417–26.

Mignolo, W. D. 2007. "Delinking." *Cultural Studies* 21:2–3, 449–514.

Mitchell, W. J. T. 1994a. "Introduction." In *Landscape and Power*. Chicago: University of Chicago Press, 1–4.

Mitchell, W. J. T. 1994b. "Imperial Landscape." In *Landscape and Power*. Chicago: University of Chicago Press, 5–34.

Mitchell, W. J. T. 2005. *What Do Pictures Want? The Lives and Loves of Images*. Chicago: University of Chicago Press.

Nealon, J. T. 2008. *Foucault Beyond Foucault*. Stanford, CA: Stanford University Press.

New York Times. 2008, November 18. B4

Port. 2006. Available online: www.portsl.com/business%20development/workforce.htm (accessed 1 September 2008).

Rancière, J. 2003. *The Philosopher and His Poor*. Durham, NC: Duke University Press.

Ruskin, J. 1903 [1843]. *Modern Painters*. In *The Works of John Ruskin*. Volume 3. London: George Allen.

Stiglitz, J. E. 2009. "Capitalist Fools." *Vanity Fair*. January. Available online: www.vanityfair.com/magazine/2009/01/stiglitz200901 (accessed 9 December 2008).

Vieira, M. B. 2003. "*Mare Liberum* vs *Mare Clausum*: Grotius, Freitas, and Selden's Debate on Dominion over the Seas." *Journal of the History of Ideas* 64:3, 361–77.

Wallis, B. 1995. "Black Bodies, White Science: Louis Agassiz's Slave Daguerreotypes." *American Art* 9:2, 39–61.

Part 1: Further reading

Azoulay, Ariella. *The Civil Contract of Photography*. New York: Zone, 2008.

Chun, Wendy Hui Kyong. *Programmed Visions: Software and Memory*. Cambridge, MA: MIT, 2011.

Coleman, Beth. *Hello Avatar*. Cambridge, MA: MIT Press, 2011.

Cruz, Teddy. "Spatial Agency." http://www.spatialagency.net/database/estudio.teddy.cruz

———. "Political Equator." http://www.politicalequator.org/.

Halberstam, Judith. *The Queer Art of Failure*. Durham, NC: Duke UP, 2011.

Maharaj, Sarat. "Know-How and No-How: stop gap notes on method in visual art as knowledge production." http://www.artandresearch.org.uk/v2n2/maharaj.html.

Mitchell, W. J. T. and Mark Hansen. *Critical Terms for Media Studies*. Chicago: U Chicago, 2009.

Rancière, Jacques. *The Emancipated Spectator*. New York: Verso, 2009.

Smith, Terry. *What is Contemporary Art?* Chicago: U Chicago, 2009.

PART 2

Globalization, war and visual economy

THIS PART OF THE *READER* ADDRESSES perhaps the two most urgent issues to have arisen in the decade since the last edition of this *Reader*: the globalization of both war and political violence and of a visualized economy, dependent on immaterial labor and the capture of our attention. Neither issue is new in and of itself and the chapters here refer to art in ancient Babylon, nineteenth-century political economy and twentieth-century conflict, as well as recent events. Their convergence in the frame of financial globalization, the collapse of Cold War geo-politics and the formation of global Islam nonetheless lends a distinctly different feel to this period.

(a) War and violence

While conflicts in the Balkans, the Middle East and indeed Afghanistan in the 1990s did not want for violence, it could be hoped that these were, in a sense, workings out of the contradictions of the Cold War period. That is to say, without diminishing the horror of war, it could be imagined that these conflicts were exceptions rather than the formation of a new rule. A decade later one cannot be so sanguine. Despite the killing of Osama bin Laden and the drawdown of troops from Iraq, it seems likely that counterinsurgency warfare will continue to be a significant feature of geopolitics in general and visuality in particular. For the asymmetric warfare between national armies and insurgents, or terrorists, is typified above all by the use of hi-tech visual technologies from satellites to so-called smart weapons that can "see" their own trajectory and the Unmanned Aerial Vehicle that has come to dominate recent conflict. At the same time, these modes of technology are also invisible to the human eye in many cases, or impose new forms of invisibility such as the no-fly zone or the rendition into secret detention. While it was once common to suggest that visual culture was the product of a naïve enthusiasm for popular visual media, it is unlikely that critical visuality studies, compelled to engage with these patterns of visualizing and invisibility, could be similarly accused.

Counterinsurgency warfare integrates these technological advances into a long-established framework of imperial warfare. Indeed, as Zainab Bahrani points out in the extract from her book *Rituals of War* reprinted here, the question of the ethics of war often attributed

to Clausewitz—whose concept of military visualization is at the genealogical beginnings of visuality—can be seen as far back as ancient Mesopotamia. Bahrani shows that the ancient "arts of war," then as now, had central aspects of "representation and display, the ritualistic, the ideological and the supernatural" as part of their justification for war. Certain acts were considered appropriate and others were not. In order to represent this delineated violence, an entire order of representation was required. By way of example, Bahrani discusses panels showing the Assyrian king Ashurbanipal holding a triumphal banquet while the head of his defeated rival Teumman hangs in a nearby tree. Bahrani describes how the vast set of panels appear chaotic to modern eyes: while we can "see" war, the campaign of 653 BC is elusive to us. These are what she calls "performative images," in which the images does not represent the king—rather it "substitutes" for him. Such images were often carried away as war booty, or even the destruction of the images of the deposed. The "image power" of these reliefs is "part of the fabric of the structure of the palace," performing rather than simply depicting power. The result is a call for empirical research, not in a conservative return to the aesthetic, but as the "work of representation." In the case under consideration, repetition is not seen as a mark of confusion or primitivism but as a means to underscore the power being animated. Readers may care to consider the performative destruction of Saddam's statue in Baghdad in 2003, followed shortly thereafter by his "accidentally" videotaped execution. Bahrani, it should be said, leaves this implication unspoken.

In his 2005 essay, visual anthropologist Allen Feldman asks: "what is the visual structure of the historical catastrophe as mediatic event?" Building on Frankfurt school theories of the accident and the photograph in the current context of risk and risk management, Feldman describes what he calls the "actuarial gaze, by which I mean a visual organization and institutionalization of threat perception and prophylaxis, which cross cuts politics, public health, public safety, policing, urban planning and media practice." He emphasizes that the actuarial gaze erases the everyday, and indeed the political, by privileging expert assessment of risk because risk cannot be simply known. At the same time, nor is risk self-evident and it has percolated into an extensive array of social categories. Such "forensic" investigations manifested first as so-called ethnic cleansing, where apparently excessive violence is used precisely to "diagnose" ethnicity and were extended to the securocratic state, using techniques such as the "televising smart bomb, global satellite cartography, urban policing, biometric scanning and the closed circuit camera of the gated community and armoured office building." In readings of 9-11, Shock and Awe, and Abu Ghraib as rendered by the actuarial gaze, Feldman situates these technologies as a modernizing of Rancière's "police concept of history" to service the goal of full spectrum dominance.

This concept underlies geographer Derek Gregory's examination of what he usefully terms the "American military imaginary." For Gregory and other political and cultural geographers, visuality is understood as "techno-culturally mediated vision." Like Feldman, he stresses the importance of targetting and "the virtualization of violence." Gregory generalizes from this an emphasis on "the visual performance of the social field rather than the social construction of the visual field." Implictly, he is drawing a distinction with W. J .T. Mitchell's 2002 definition of visua culture as "the social construction of the visual and the visual construction of the social." Construction is here replaced by performance, which Gregory situates with a range of military imaginaries within the context of the Revolution in Military Affairs that has been unfolding since 1989. He shows how extensive and pervasive technologies of visualization have become in this Revolution, so much so that the model in effect produces the space. However, with the implementation of the counterinsurgency doctrine in 2006 a new tactic defined by one general as "armed social work" has supplemented these visualizing technologies. This "cultural turn" in low-intensity warfare has taken a virtual dimension with the development of video game simulations of counterinsurgency, such as those produced by the Institute for Creative Technology at the University of Southern California. The "cultural turn" nonetheless continues

to operate in Orientalist frameworks, but is at the same time "a profoundly biopolitical strategy that counterposes the benign and the malignant."

The following pair of articles by Trevor Paglen and Lisa Parks take as their focus the "God's-eye-view" created by satellites and other remote sensing technologies, bringing a third dimension to critical visuality studies. To some people, Trevor Paglen is a geographer. For others he is an artist and for yet others, an activist. His work is hard to classify because, to coin a phrase, he goes where no one has gone before. In this instance, geo-stationary orbit, where over a thousand satellites and pieces of space debris circle the earth at an altitude of 35,787km. In a fascinating account describing how an amateur space watcher named Greg Roberts made a startling discovery in this rarefied realm, Paglen suggests that the story is "about how the political geographies that structure our everyday lives are becoming more and more abstract, and about how new forms of domination arise in the gaps and limits of our everyday percep-tion." What Greg Roberts saw, as he observed a classified but apparently broken-down satel-lite was that "another satellite slowly pulled up alongside it." In short, he'd "witnessed what might be an opening shot in a new kind of war," one in which very few people on earth could participate but with potentially far-reaching consequences. Television transmissions, phone calls, weather reporting and financial transactions are all dependent on satellites, not to mention military strategic and tactical imaging satellites. Counterinsurgency in particular depends on these unseen photographs, while cruise missiles, bombers and the Unmanned Aerial Vehicles that are so prevalent at present are all dependent on satellite communications. The ability to intervene directly in satellite activity, whether disabling active satellites or pushing disabled ones or space junk out of the way, would be a prime desirable. Because satellite failure is so common, given the complexity of the technology, it would be impossible to know if it was due to such covert activity or not. Paglen suggests that a covert operation to "control orbital space and the various infrastructures residing high above the Earth" is underway. In addition to the political and cultural importance of this discovery, Paglen makes a call for what he calls "minoritarian empiricism," meaning the use of available technologies, such as the not particularly advanced equipment used by Greg Roberts, to participate in the monitoring and critique of military efforts to create full spectrum dominance.

Lisa Parks further emphasizes the centrality of what she terms the "overhead image," especially as generated by satellites in both media coverage and the actual practice of war. She uses "the term 'zeroing in' to conceptualize a series of knowledge practices and material conditions that have taken shape in relation to overhead imagery of Afghanistan and Iraq." Noting that the first act of contemporary war is to eliminate media broadcast facilities, Parks highlights a leaflet dropped on Iraq, featuring a picture of a spy satellite and the caption "We can see everything." While overhead images have been a part of military operations since the First World War, they now circulate in mass media culture "position[ing] the citizen-viewer quite literally as reading the earth's surface as a target." At least $20 billion is spent annually on spy satellites, which number around 180. Parks notes that the U.S. government has asserted its right to shut down commercial and broadcasting remote sensing under what it calls the "Shutter Rule" since 2000. However, there is a network of commercial and open source remote imagery, especially Google Earth, resulting both in its alleged use by terrorists and insurgents and in targeted censorship of its imagery. As Parks summarizes nicely: "Such are the practices of the age of the world target: when the CIA's military violence and Google Earth's digital 'peacekeeping' are conducted collaboratively and in the window of a virtualized world." Like Paglen's "minoritarian empiricism," Parks calls for a "reverse shot" monitoring by citizens that would in effect extend Weizman's "politics of verticality" (see (Post/De)colo-nial visualities) into geo-stationary orbit.

In his consideration of the media representations of Islamic jihad, Faisal Devji observes: "From spectacular attacks to sundry communiqués and beheadings, the jihad's world of

reference is far more connected to the dreams and nightmares of the media than it is to any traditional school of Islamic jurisprudence or political thought." The "with-us-or-against-us" theme that has dominated Western discussion appears here more as interlinked elements of a global mediascape, to use Arjun Appadurai's term. Global Islam is a network of mediated sites, such as ruins, battlefields and even caves, linked by their role in the jihad, rather than the former sacred sites, like shrines, tombs or holy cities. Devji argues from this that "[i]t is no exaggeration to say that only in this globally mediated landscape does Islam become universal, uniting Muslims and non-Muslims alike in a common visual practice." That is to say, all of us who have watched the spectacle of jihad in its various forms have, consciously or not, partici-pated in the formation of this new "Islam." Indeed, given that martyrdom and witnessing are different senses of the same Arabic word (*shahadat*), and that witnessing is also part of the martyrdom, Devji argues that it is only in mass media that "the collective witnessing that defines martyrdom achieve[s] its full effect." Devji shows that participants in the jihad also attribute to the West similar motives to their own, comparing the actions that brought down flight 93 near Philadelphia on September 11, 2001 to the decisions of a suicide bomber: both determined that it is preferable to die on one's own terms. Even the concept that "the spectacle of martyrdom is its own proof" might be compared to Protestant claims of justification by faith alone. Devji concludes that the implied media audience for the jihad is abstract, every-where and nowhere: "Who else but God?"

Devji's redrawing of the divided world of "Islam" and the "secular" into one mediated whole is reinforced by Naeem Mohaiemen's photographic chapter "Live True Life or Die Trying." Shot in Dhaka, capital of Bangladesh, it tells the story of two demonstrations on the same day, January 9, 2009, one organized by "Islamists," the other by "Leftists." Although he identifies with the Left, Mohaiemen recognizes that the Islamist rally is larger, better organized and even uses better visual materials. The Leftists set fire to an effigy of a U.S. bomb made of hay but there is too much material and it collapses dangerously. The Islamists may have burned books but the photographer arrived too late and all there is to see are ashes. There are no easy conclusions to be drawn here. Mohaiemen shows us two groups of Bangladeshis more alike than they are different, both involved in combat with the police. There have been many deaths caused by these police—Human Rights Watch has called for this unit to be disbanded. This Western viewer cannot help but reflect how little he knows of this country of over 150 million people, the eighth largest population worldwide, comfortably exceeding that of Russia, for example. A quick web search reveals the usual stories about poverty and natural disasters. The Islamists photographed here situate themselves in a global Islam but also reference the rapper 50 Cent. The Leftists debate Somalia, Iraq, Liberia, India, Rwanda, Iran, Norway and Venezuela. When I finished reading, I felt poorly-informed: there's a global-ization going on here, but I don't know what it is. But I see affinities as well as differences: this is a call to renewed thought and research, to set aside simplistic argument, and to once again refuse to accept that there's nothing to see here, as the police of all kinds would have it.

Zainab Bahrani

THE ARCHAEOLOGY OF VIOLENCE: THE KING'S HEAD

Introduction

WAR IS ORGANIZED VIOLENCE. As such, war might be viewed in the same way as some other institutions and rituals of civilized people. War was first defined as a form of controlled, organized, and even ritualized violence some time ago, in the first part of the twentieth century, in the works of authors such as Georges Bataille and Roger Caillois; and slightly earlier, in the psychoanalytic writings of Sigmund Freud. Carl von Clausewitz's 1832 treatise *On War*, which describes war as an act of rational violence and a political instrument of the nation, is widely regarded as the first modern philosophical work that considers the "true nature" or, in Platonic terms, originary essence of war. For Clausewitz, this essence is certainly organized and civilized aggression. It is "violence that arms itself with the inventions of art and science." The ancient Mesopotamians, whose forms and representations of violence are the focus of this book, seem to have been already aware of such a philosophical definition of war. In the Sumerian myth "Enki and the World Order," the Mesopotamians counted the art of war among the MEs of civilization. The ME is a category in the Sumerian taxonomy of the world that Assyriologists usually translate as "the arts of civilization." This category is comprised of a long list of the achievements of this early complex society, from kingship and rule to metallurgy and writing.

For the Mesopotamians, the arts of war, plunder, and taking booty were all aspects of civilized behavior. These are the forms of behavior of people who have become urbanized, that is, settled into urban communities interacting within urban social structures. Scholars of Antiquity have sometimes been baffled by the idea that such unpleasant forms of behavior might be considered MEs, or arts. The inclusion of sexuality and its various manifestations, including prostitution, and war and its practices in the grouping of "arts of civilization," along with such commendable occupations as music and craftwork, has been something of a mystery to modern readers. Ancient Mesopotamian culture is described in the grand narratives of world history as the ancestor to the Western tradition yet it remains, in this traditional view, rather unlike the later West in such civilized areas as ethics and aesthetics.

Perhaps the word *art* as a translation of ME is slightly off the mark. No word in contemporary sociological, anthropological, or archaeological theories is the equivalent of Sumerian

ME. War, as organized violence, is indeed a form of civilized behavior, as abhorrent as that thought may be. The Mesopotamians recognized this behavior as a ritualized organization, distinctive of complex societies; they linked it directly to the existence of the city and later, as it came into its own, the state. In the list of the MEs, they seem to have attempted to draw a taxonomic difference between the behavior of civilized people and animals or the barbaric non-urbanized nomads. The categorization of the MEs reveals an early contemplation of the place of human behaviors and the order of things in the world.

According to Bataille, war exists because the taboo on violence in daily life relegates violence to areas of existence confined in space and time and that follow their own rules. Today, a number of such rules exist, many of which have recently become issues of concern and subjects of contemporary debates and analyses. For example, the international laws that regulate war and occupation such as the Geneva Conventions and the Hague Convention, the accepted treatment of prisoners of war, the concept of war crimes, the legality of torture and its relationship to a specific national terrain, and the legitimacy of the nation-state are issues that are being redefined by politicians and contested by military commanders. The latter discussions indicate that even within war some forms of violence are acceptable (what is called conventional warfare), some are questionable or vaguely defined (such as the torture of prisoners of war and "collateral damage"), and some are categorized as criminal (rape and deliberate attacks on civilians during war and occupation). These divisions of violence fall into the Western philosophical categories of *jus ad bellum* and *jus in bello*, the two areas of just war. The first is just cause to go to war; and the second, just behavior in war (as in the treatment of civilians and prisoners of war). In the Middle Eastern tradition, the term *jihad* (although it is currently used to mean terrorist or suicidal war) is more or less similar to the idea of *jus ad bellum*, in that it defines in which cases going to war is justified. Ibn Khaldûn (AD 1332–1406), a Muslim jurist and historian, discussed the definitions of just and unjust wars in his *Muqqadimah*; centuries later, Michael Walzer, an American scholar of government and philosopher of war, analyzed wars, and behavior within them, in his 1980 book *Just and Unjust Wars*. Discussions and treatises from China and the Indian subcontinent about correct behavior in war and reasons to go to war are also well known. Sunzi's *Art of War*, from the fifth century BC, and the *Arthasastra*, a late fourth-century-BC Sanskrit treatise on diplomacy and war attributed to Kautilya, are two early texts concerned with the realm described in the Western tradition as just war.

These discussions fall under the ethics of war. The concept of just and unjust war means that war is not generally thought of as an impetuous activity. It involves a choice made at a particular moment, when violence is sanctioned as an accepted, correct, even valorized form of behavior. War, then, is the collective organization of aggressive urges. It is the controlled practice of group violence on a large scale, and as such it has to adhere to certain forms: its own rules and regulations. Clausewitz was certainly not the first to contemplate the notion of war. War and its causes have been analyzed from the earliest historical records. In recent scholarship, scholars of government and historians of war are not alone in studying the forms of war and their justifications. Sociologists and anthropologists have also attempted to frame the act of war within human behavior and within theories of war. War, state violence, and the law are now the focus of some of the most incisive contemporary philosophical writing. And "war studies" has now become an independent academic field at a number of universities.

The art of war—the forms and images of violence that both support and justify wars, enabling as well as representing them—has received far less attention. A number of studies of images of violence and war have recently emerged from the fields of art history and visual cultural studies, but the uses and functions of such images in Antiquity remains largely untheorized. What was the place of images of war and violence in Antiquity? Did such images aim to be objective historical records? Were they coercive or propagandistic? How was the

notion of just war formulated in the images of war? How were works of art, historical monuments, and artifacts treated in war? And how did the monument of war (that much-revered type of monument) come to be invented in Mesopotamian Antiquity?

A history or an archaeology of forms and monuments of violence can consider how such conventions of war, its representations, and its underlying activating rituals were practiced in Antiquity. Art, visual displays, representations, and war have a long, interrelated history. War, one can argue, is already a narrative as it is acted out on the battlefield. Assyrian and Babylonian accounts of battle make war's narrative aspect clear. Furthermore, war, victory, and royal or imperial power do not appear as narratives only in the visual arts. Central to the aims of the economy of violence (in Bataille's broadest sense of economy as the circulation of energies) and of power and geopolitics is the technology of war, a militaristic complex that is sometimes described as the war machine. This war machine depends on technologies of violence in every sense of the word *technology*. Aspects of war such as the supernatural, rituals of divination, and performative representations are all integral parts of the war machine. But the war machine is not reducible to the military. It is a complex appropriated by state violence but by definition outside the normative day-to-day affairs of the city and the internal laws of the state.

War is a strictly organized activity that at the same time allows for forms of behavior that are non-normative and taboo. Like the festival and some religious rituals, war occupies a place outside; it is a phenomenon that stirs and interrupts. In Bataille's words, "the unleashed desire to kill that we call war goes far beyond the realm of religious activity. It is a suspension of the taboo surrounding death and killing." The contemplation of war in this way, as organized and sanctioned violence, appropriated or channeled by the urbanized city-state, limited in time and place, was a source of anxiety for the peoples of ancient Mesopotamia. Not unlike today's state records and dominant representations, Mesopotamian records and rituals of war and images of violence sought to rationalize war as a just aggression in each case. There is no extant Sumerian or Akkadian treatise on just war. However, the large corpus of textual and visual representations of violence and war allows an analysis of the subject of violence in Mesopotamian Antiquity. This book, therefore, investigates aspects of war that might not today be considered within the realm of military logistics and strategies but that the ancients clearly understood as crucial and logical aspects of war and sovereignty.

The Mesopotamian discussion of war, its justifications, and its rituals spans the period between the third and the first millennia BC. As such, it predates all other discussions of war and traditions of justified wars. The Assyrians of northern Mesopotamia are perhaps thought of in relation to war and violence more often than most other ancient cultures, especially in the first millennium BC, when the Assyrian kings expanded their empire into the surrounding territories. These kings conquered lands, moved populations, plundered cities, cut down and burned forests, and destroyed monuments. The expansion of power of the Assyrian kings of the first millennium BC constitutes what can be firmly defined as an imperial mission. The Assyrian kings were remarkable perhaps not so much because they were aggressive imperialists, since other periods of imperial expansion and force have existed in history, as because they chose to record the events of war, torture, and conquest in detail, sparing us from no gruesome act of violence in their glorification of war and empire—either in their written annals or in the visual images of empire.

War, imperialism, and power in Mesopotamia have been discussed from the point of view of political history in numerous publications. In fact, the political-historical approach is now standard in the field of Mesopotamian studies, especially in works on the Akkadian and Neo-Assyrian periods. Materialist economic reasons, and geopolitical reasons of power and control, spurred the Mesopotamians into the act of war for imperial expansion at various times, but these territorial wars relied on rituals and representations of power and rituals of battle. These were the ideological methods that enabled the processes to work.

This book, therefore, is not a chronological survey of specific historical wars and technologies of weaponry or vehicles of war in Mesopotamia; a number of useful, concise studies already exist on that subject. Instead, this study considers what underlies war and violence. It examines philosophical beliefs about war and ideologies of war in Mesopotamian tradition; conceptions of violence and power that were inseparable from conceptions of the body and its control; and the processes and rituals of war that these formulations of the body and power made possible. These developments of ideas of power, rule, dominion, and authority cannot be separated from visual images or representation broadly defined. These formulations and representations, technologies in the rituals of war and in displays of violence and power, are an inevitable part of every imperial process. The present study thus considers facets of war and domination that fall under the categories of representation and display, the ritualistic, the ideological, and the supernatural. These might be described as the magical technologies of war, and as such they are not usually discussed in the standard political narratives of Mesopotamian history books.

Being among the world's earliest imperial forces, the Mesopotamians developed a system of expansion that relied on the machinations of war and the sophisticated development of weaponry and technology. But military technology included a number of aspects that today would be regarded as unscientific: the reading of omens, the movement of prisoners, the display of acts of torture. These practices and the beliefs behind them were the parameters of war for the Assyrians. They defined the reasons for war; they justified war, even if war was primarily a process of imperial expansion and the resulting control of natural resources, land, and wealth. Magical technologies and rituals can be described as a semiotics of war that delineates the parameters for correct and incorrect behavior in war. They define certain acts as appropriate and other acts as enabling, empowering, or, in fact, actually leading to victory.

For the Assyrian imperial war machine, for example, the processes of war were clearly linked to the supernatural, but amid the detailed Assyrian accounts of the need for imperial expansion, an incredible anxiety about the outcome of war, about life, death, and memory, can be glimpsed. In fact, these accounts display the extraordinary historical consciousness that is characteristic of early Mesopotamian Antiquity. It is here that images and monuments, in my assessment, have a social role beyond the depiction of historical events.

Formulations of the body and power are made, defined, and become reified through monuments, representations of war, and images of violence. Underlying the discussions of these rituals and representations of war is the premise that the body is a principal factor in the political economy of power. In *Discipline and Punish*, Michel Foucault argues that the art of punishing must rest on a whole technology of representation. This kind of reliance on technologies of representation in the broadest semiotic sense, in relation to violence and control, can be seen clearly in the ancient Mesopotamian record. This study, therefore, is focused on the interrelationship of power, the body, and violence in Assyro-Babylonian society and its representations, a semiotics of war that was an integral part of the mechanics of warfare. In other words, it combines three lines of inquiry that are not generally seen or studied together: war, the body, and representation.

The king's head

If a Severed Head Laughs: Conquest of the Army.[1]

Meaning is not "at the end" of the narrative, it runs across it; just as conspicuous as the purloined letter, meaning eludes all unilateral investigation.

Roland Barthes[2]

The king's head hangs in the tree before the banquet of the Assyrian king, Ashurbanipal, and his wife, Ashursharrat, in the gardens of Nineveh. The scene depicted in this relief is idyllic. After the battle is over, the royal couple feasts in the garden, surrounded by attendants and musicians, while the head of the Elamite king, Teumman, hangs like an ornamental trinket in the pine tree before the Assyrian king. Nearby, birds and a cricket rest on the branches of the neighboring palms (Figure 11.1).

The Assyrian historical annals relate that Teumman had been beheaded in the midst of the Battle of Til-Tuba, in 653 BC, and that the head was carried in a triumphal chariot to the Assyrian city of Arbil and from there to the royal palace at Nineveh, where it was finally displayed. That Elamite campaign and the following triumphal march and victory were the subject of a series of Assyrian palace sculptures from Nineveh, specifically a marble wall revetment of the royal palace (now exhibited at the British Museum in London). The act of the beheading of the enemy, Teumman, King of Elam, amid the Battle of Til-Tuba is depicted as part of a cycle of a historical narrative of war, yet, as a decapitation, it is a subject that seems to transcend the actual and contingent events of the specific battle. To be precise, it is not the battle, or even the act of decapitation, that the composition takes as its focus. It is the severed head, a body part that emerges inadvertently here and there across the surface of the relief—a body part that becomes a terrorizing sign of violence and victory at the same time. The severed head emerges in a way that is almost disruptive to the scene of the battle, as if the battle were only a backdrop for the decapitation. It becomes a point that interrupts the textured chaotic surface that is the depiction of a war. The war is portrayed as real and historical, but it is the head that firmly fixes that narrative of a specific historical battle across the surface of the relief.

The relief cycle represents a campaign that culminated in a battle at the river Ulai in 653 BC at which the Assyrians defeated the Elamites. A scholar of Antiquity comes to this relief with expectations, with certain preconceptions regarding the Assyrian empire, Assyrian art and ideology, and the function of their images of war. For one, the Assyrians are always represented as victorious in their war reliefs; there are no images of Assyrian defeats. Second, the Assyrians clearly preferred an aesthetic of violence, in which enemies were depicted as enduring the most gruesome sorts of bodily torture. Still, something more draws the viewer to this particular relief, pulls one in, and forces one to look more closely. What is the lure of this image? The composition's complexity, which draws the viewer to the scene and the fascinating details of the narrative is at the same time an obstacle. A viewer can survey the relief numerous times and yet there is always a barrier. One cannot enter the scene, so to speak. One cannot take in the whole composition at a glance. The complexity of the image is slightly overwhelming, and the numerous details strewn and scattered across the surface of the relief are somewhat alarming.

Austen Henry Layard found the Til-Tuba panels during his excavations in the 1840s and brought them back to the British Museum in London at that time. The scene, which is surely embedded into the ideology of empire, has been discussed quite thoroughly from that point of view. Is it true to the historical event? Is it an exaggeration? Did the Assyrians really do these things? How close or how distant is this depiction of the battle to the real, historical event of war?

To view this artifact as a work of visual art, one ought not, in the first instance, to look at it as a document of a historical battle or statecraft. Of course, it is also these things, albeit in an indirect and nonmimetic manner. The subject matter of the composition of the Til-Tuba reliefs is certainly that specific battle and Assyrian war in general, and since all art is infused with ideology, these aspects must be taken into account. But what exactly is the meaning of this narrative and its use as a wall revetment in Room 33 of the Southwest Palace?

There are three adjoining panels of fossiliferous limestone (that were put together in the museum) and further panels and fragments bearing images of the same historical campaign (Figures 11.1–11.3). Because of the relief's size, its function as a palace wall revetment, and

Figure 11.1 Right panel of the Battle of Til-Tuba, Nineveh, c. 650 BC. British Museum, London. Photo: Zainab Bahrani.

Figure 11.2 Central panel of the Battle of Til-Tuba, Nineveh, c. 650 BC. British Museum, London. Photo: Zainab Bahrani.

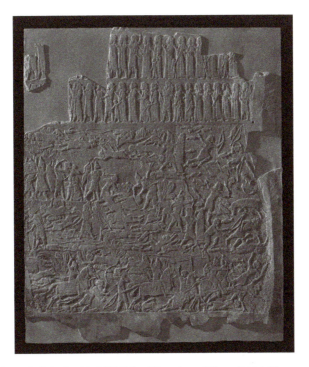

Figure 11.3 Left panel of the Battle of Til-Tuba, Nineveh, c. 650 BC. British Museum, London. Photo: Zainab Bahrani.

the minute details of the scene, no photograph can represent the totality of what remains of the composition in one image, so it is always depicted only in parts. Even if what exists is already incomplete, one certainly gets a better idea of the work when viewing all three remaining panels together in the museum. At first glance, the three panels appear to depict a chaotic mass of bodies strewn across the pictorial space with little consideration for composition. The surface is densely covered with a mélange of horses, asses, chariots, and human bodies moving in all directions. Perspective is nonexistent or, at best, seems to change arbitrarily from one section to the next. There seems to be no focal point. Everything about the composition seems to be the opposite of what we are trained to see as "a composition." It is a clutter seemingly born of *horror vacui*. The trees that appear here and there in the background seem to have no function other than to fill open spaces between figures. Randomly strewn bows and quivers seem to float about the scene.

At the edge of the right panel is the river Ulai, a vertical band of swirling threads of patterned water (see Figure 11.1). The bodies of dead and wounded Elamites, their weapons and horses strewn among fish and crabs, appear to be suspended over the water. The river is seen from above, its distance tilted up and brought to the surface of the picture plane, so its entirety can be absorbed at a glance. This treatment of space is unique in these panels. Elsewhere, the chaos is subdivided into registers, according to the ancient Mesopotamian tradition of relief carving, beginning as early as the famous Uruk vase from around 3200 BC. In the extant Til-Tuba scene, five registers loosely defined across the scene can be discerned.

At the top, on the right side, are two registers of defeated Babylonians standing in an orderly single-file line; the repetition of their bodies, which are all of the same height and positioning, creates a horizontal movement that probably continued across the top of the relief. At the far left remains a fragment of an enigmatic scene. Assyrian soldiers stand above

kneeling prisoners, who are busily grinding something with stones, possibly the bones of their own ancestors.

The main action of the battle is distributed across three indistinctly defined registers. The far-left scene is cut off at the hill and was clearly meant to continue onto another panel (see Figure 11.3). In the area that remains, four horizontal registers are clear, and the fragmentary remains of a fifth at the top indicates that the composition was once larger. In each remaining register, a ground line, on which the soldiers and chariots are placed, can be distinguished. In each case, figures and weapons are also scattered above the first group of ground-line figures, indicating distance. The registers are loosely defined, and the figures are not confined within each register's boundaries.

Feet and wheels cross the slight relief ledge everywhere. In some places, the action spills from one register into the next without regard for linear boundaries or the relationship between one figural group and the next. For example, in the center, Teumman (Teptihuban-inshushinak) and his son, Tammaritu, are running away from the chariot scene. The heads of the soldiers below form their stepping-stones. Is this simply the result of a miscalculation on the part of the ancient sculptor? This spilling over from one scene or level into the next leads the viewer's eye to the next scene. This is seen on the first two panels but not on the left one. In fact, it is not entirely clear that the last two panels toward the hill were originally joined. There is only one area at the bottom where the leg of a soldier crosses diagonally into the next.

Performative images

In my previous work, I have attempted to make a case for the Assyrian belief in the animistic power of images and the relationship of image making to forms of manticism. These aspects of the response to images had not been addressed in modern accounts of Assyria, because Assyrian art is usually studied as a source of information for empire and for the depiction of specific historical battles. But in relation to this attribution of power to images, we might see that at least one aspect of narrative imagery the Assyrians used functions differently from later forms of narrative art. This is what I have called the performative image. This concept problematizes ideas of narrative and representation traditionally applied to Mesopotamian art and opens up the genre of narrative into another dimension.

Much Assyrian scholarship has been focused on the relationship between the historical annals and the images of war in the reliefs. While the text and the images must certainly be studied together, a simple reading of the reliefs as visual copies of historical texts misses the mark. When they are evaluated according to their historical accuracy, the Assyrian reliefs are read as if they were mimetic representations that nevertheless falsified things, or failed in their mimesis.

But in Assyria the visual image was not seen as a copy of the real. Instead, its nature is better described as indexical, because it functioned through a relationship of contiguity to the signified. Thus portraits of kings functioned as something more than mere representations; they were substitutes. This thinking led to the practices of abducting images of gods and kings during battles and carrying off monuments. For instance, the Codex Hammurabi and the Victory Stele of Naramsin were both taken by the Elamites to their capital at Susa, in Iran.

This conception of the image as substitute also led to the destruction of the representations of certain kings in Assyrian palaces, such as the faces of Sennacherib at Lachish and Ashurbanipal in his Nineveh banquet scene, and the placement of protective curses on images of kings.

The study of the destruction of images must lead to a reconsideration of the function of war reliefs. If the argument that the Assyrians saw images as powerful indexical forms of presence is correct, how does that relate to the function of the reliefs?

First, let us begin with the basic identification of the genre. Assyrian palace reliefs are architectural sculpture. They are an element of the wall revetment of the palace; they form part of the fabric of the palace wall. The creation of a sculpted palace was considered an exceptional event. Written accounts describe the importance of all the materials used, their place of origin, their positioning within the structure, and so on. A committee of officials under royal supervision seems to have been in charge of the construction. At least one of these officials must have been experienced in magic, since various parts of the palace had to be protected by apotropaic rituals using images.

The protective clay figurines, the *lahmu* and *apkallu,* buried under the floors, in corners of rooms, in courtyards, and so on, have been uncovered by archaeologists. The famous colossal winged bulls and lions bear inscriptions clearly stating that their function is apotropaic and suggesting that the colossi had the potential to become animate beings and walk off. There is also ample evidence that the image of the king, whether in relief or in the round, was a form of his presence, even after death; his essence was somehow still within the image, and harm could come to him through it, as the curses placed on royal sculptures depicting the king clearly state.

The imagery on the palace reliefs must be understood in this context of image power. It is part of the fabric of the structure of the palace. Like the colossi and the foundation figures, it could be effective in ways that were not simply propaganda; it could make things happen. This imagery was at least in part a means of effecting an apotropaic and invocational magic. It could construct Assyrian power and make the Assyrian victory inevitable and enduring. In that sense, it can be defined as a performative imagery, an imagery that creates through the act of representation.

Performative statements were used as a standard form in Assyro-Babylonian incantations. The performative statement is not mimetic, because it does not simply repeat a preexisting reality; it works to create a reality by means of the utterance. Ritual texts provide ample proof that words had a performative function and that imagery in the Mesopotamian tradition also worked in this way, at least in some situations. Assyrian ideas about representation and reality were linked, in that it was possible to destroy something by destroying an image of it. The reverse was also true. Representation was thought to make things happen, not simply to depict. The making of images had a performative and indexical relation to the thing portrayed, rather than being a mimetic copy of the real world, although it incorporated details of the real, especially in the art of the Neo-Assyrian Empire.

The Assyrian method of representing the regions of the empire was generally attentive to minute details and concerned with ethnographic accuracy, even when the composition was hierarchical and representations of the body were stylized into abstract patterns. In studying Assyrian reliefs of war campaigns, scholars have most often looked for historical accuracy: this Assyrian soldier wears that type of gear, Elamites look different from Assyrians, and so on. Most such studies have considered them documents through which to visualize the real historical event of the battle, the terrain where the battle took place, and how the propagandistic message of the Assyrian victory is conveyed through the image. That is, the Assyrian relief is, paradoxically, taken as a reflection of both ideology and historical events. Realism is certainly a distinctive aspect of Assyrian narrative art. Accurate details of dress and landscape were used to create what Barthes would have called the reality effect.

Historical records and ideology are two important aspects of the study of Assyrian art. However, one might also look at this particular depiction of the Battle of Til-Tuba as an aesthetic composition—in other words, as a work of visual art. This may seem like a

somewhat reactionary or conservative return to a Morellian connoisseurship, however, this approach simply calls for a close visual analysis of the works of art of Near Eastern Antiquity. If those interested in context and contextualized readings are to consider seriously what this means for ancient works of visual representation, they must begin this consideration with the depiction itself. In other words, it is not sufficient to analyze aspects such as local ideologies and social uses of the visual arts from outside the work. We ought to consider closely the work, in and of itself, and attend to it seriously as a work of representation.

In formal terms, the narrative of the Til-Tuba battle seems to reveal what might justifiably be described as a fascination with repetition. The narrative multiplies the profusion of violence by means of repetition that creates a sense of order through its use of symmetry, in the repetition of bodily shapes of the dead and wounded bodies, weaponry, and the constantly reappearing head of the king. But such repetition is out of keeping with the otherwise realistic narrative details. What, then, is its pictorial purpose here?

The relief also treats space distinctively. Assyrian reliefs do not favor optical illusionistic space but a tilted construction with a close horizon or background, a reduction of the space to the plane of the foreground. In images such as the Til-Tuba relief and in other Assyrian reliefs, repetition has power. Repetition on the reliefs is not limited to a realist representation of processions of soldiers or tribute bearers or a barrage of troops in the military siege of an enemy city. Repetition is often a formal element free of any iconographic or narrative links. This infinite movement in repetition becomes a mechanical force, a relentless movement that decenters the composition and makes impossible the existence of any central focal point.

Perhaps we can think about this compositional element given what we know about repetition in texts or incantations. In other words, we ought to regard repetition in and of itself as a representational device that works to make something happen, just as it does in the performative ritual statements in incantations. The king's head is a sign underscored by repetition in the relief. The severing of the head and its subsequent transport and triumphal display are rituals of war; they are visual and theatrical performances of victory. The decapitation in itself is the primary subject of both the relief and the chronicle of this war. There is a ritual side to the Battle of Til-Tuba that is recorded in the relief and replays itself into eternity.

Notes

1 From the omen series *Šumma lu*, translated in Ann Guinan, "A Severed Head Laughs," in Lead Jean Ciraolo and Jonathan Lee Seidel (eds), *Magic and Divination in the Ancient* World, Leiden: Brill and Styx, 2002, p. 425.
2 Roland Barthes, trans. Stephen Heath, *Image, Music, Text*, New York: Hill and Wang, 1977, p. 87.

Allen Feldman

ON THE ACTUARIAL GAZE: FROM 9/11 TO ABU GHRAIB

Thus does the daily accident itself, with which our newspapers are filled, appear nearly exclusively as a catastrophe of a technological type.

(Junger 1993, p. 31)

While disciplinary power isolates and closes off territories, measures of security lead to an opening and globalization; while the law wants to prevent and prescribe. In a word, discipline wants to produce order, while security wants to guide disorder.

(Agamben 2002, p. 1)

Introduction

SINCE THE FIRST GULF WAR, we have witnessed a global repositioning of the visual communication practices, utilities and techniques of the American state and media as regards political mobilization, identity formation, geographic perception, political violence, urban planning, public safety and human rights.

The circulation, of anthropologically threatening images of violence, terror, covert infection and social suffering has intensified in our public culture. This iconography of threat has been stabilized and positioned to serve various political agendas and pedagogies that speak to global risk perception. The World Trade Center disaster in New York, the "Shock and Awe" display and the Abu Ghraib abuses in Iraq were key global and spectacular expressions of this process. In each case, from differing ideological perspectives, real and imagined threat situations, and attempts to redress harm, or to forestall risk and harm, were visually codified in material destruction, ruins and catastrophic imagery. The scenography of the World Trade Center, Shock and Awe and Abu Ghraib constitutes both an enchainment and an enchantment of ruins, and thus a sequencing of directional history. These disasters became a series of flash images, whose mode of display and circulation specified the danger, aggressiveness and material-reproductive efficacy of imaging technologies as much as they reported the danger, harm and power inherent to terror and war.

> To say there can be no war without the production of images, is to say there can be no war without the flash of the camera . . . Linking war in photography and weapons to images, [Ernst] Junger argues that modern technological warfare gives birth to a specifically modern form of perception organized around the experience of danger and shock . . . he notes that the moment of danger can no longer be restricted to the realm of war. Identifying the contemporary zone of danger with the realm of technology in general he claims that the modern type is arising in response to the increased incursion of danger in everyday life.
>
> (Cadava 1997, pp. 51–2)

Writing in 1931, Junger states:

> Thus does the daily accident itself, with which our newspapers are filled, appear nearly exclusively as a catastrophe of a technological type . . . the registration of the moment in which danger transpires—a registration that is moreover accomplished whenever it does not capture human consciousness immediately—by means of machines . . . Already today there is hardly an event of human significance toward which the artificial eye of civilization, the photographic lens is not directed. The result is often pictures of demoniacal precision, through which humanity's new relation to danger becomes visible in an exceptional fashion. One has to realize that it is a question here much less of the peculiarity of new tools than of a new style that makes use of technological tools . . . As during the inflation, we continue for a time to spend the usual coins without sensing that the rate of exchange is no longer the same.
>
> (Junger 1993, pp. 31–2)

Aggressive technologies of image making and image imposition, whether used by "terrorists" or the state apparatus, do not simply refract or record an event, but become the event by materially transcribing a political code onto the built environment, cultural memory and the politicized body, and by immersing spectator-participants in fear provoking simulations of space-time actuality. Further, optical technics that crosscut military and civilian practice have been weaponized as both strategic instruments and recreational instruments (such as first-person shooter games), thereby blurring whatever boundaries still pertained between war, desire and pleasure. Examining perceptual systems of global risk, I ask: what is the visual structure of the historical catastrophe as mediatic event? How do visual norms fashion postures of attention and inattention, memory and forgetfulness? How do visual cultures and technologies of risk and threat perception stratify sensory experience? How do visual cultures of risk affect how perpetuators and victims of violence and human rights violations depict their political experience as historical truth?

The cinematics of risk

It should be no surprise that a mystified consciousness of the risk structure of modernity has taken the form of terrorist threat, nor that the political response to accelerated risk assumes the cultural modality of ocular aggression.[1] For as Ulrich Beck informs us:

> By risks, I mean all radioactivity which completely evades human perceptual abilities, but also toxins and pollutants in the air, in the water and foodstuffs, together with the accompanying short- and long term effects on plants, animals

and people, They induce systematic and often irreversible harm and generally *remain invisible* . . .

> (Beck 1992, pp. 22–23, emphasis added)

In this context, the risk structure of modernity is the structure of the imperceptible, that which transcends human perception in everyday life despite its immanence in, and parasitic relations to the everyday. Invisible risk both instigates and is the product of a technologically enhanced gaze devoted to the exposure, fixation and optical stabilization of threat and hazard. Ulrich Beck implicitly posits the risk structure of modernity as a cinematic structure. What eludes everyday sensory perception becomes socially available to experience in the prosthetics of media pictures and reports:

> the institutions of industrial society present the dance of the veiling of hazards that are not merely projected onto the world stage but really threaten, and are illuminated under the mass media spotlight.
>
> > (Beck 1995, p. 101)

An Enlightenment inspired panoptical dream of control reproduces itself in the dialectic of the veiling and unveiling of hazards (Foucault 1978, pp. 6–19). Bio-political threats are projected onto a multiplicity of world screens in order to hygienically filter and *screen out* negating penetrations from viruses to terrorists. I term this cultural-political agenda the *actuarial gaze*, by which I mean a visual organization and institutionalization of threat perception and prophylaxis, which cross cuts politics, public health, public safety, policing, urban planning and media practice.

The political character of the actuarial gaze is explicit in its hierarchical distance from everyday life structures, and in its devaluation of everyday experience and immediacy in favour of the prognostics of expert knowledge and Enlightenment metaphors of achievable social transparency.[2] That the sphere of risk transcends the human sensorium carries three serious political implications: the wish for the prosthetic extension of the human sensorium (deemed inadequate to modernity); the consequent assignment of sensory capacity, power and judgment to machinic, automated and institutionalized instruments of perception; and the alignment of risk perception with the wish image. That threat becomes socially available through media pictures and reports is not necessarily a case for a visual realism, as Beck believes, but rather entangles the actuarial gaze with perceptual practices of visual desire and visual commoditization. Threat-perception is subjected to rumour, the imaginary and to marketing. The visual culture of risk reportage circulates catastrophic images as a psycho-social and, ultimately, political desire and currency, from which dubious equivalences and linkages are carved and facile political values are extracted. However, as Junger pointed out, the rate of exchange, the norms of commensuration are not explicit in these equations of insecurity. I will attempt in this essay to excavate the structure of commensuration that organizes the current ratio between risk and violence, the visible and the invisible, embodiment and disembodiment in recent political culture.

Though I do not deny that there are persons, institutions and populations that are at risk, affected by risk, or that reproduce risk, we cannot artificially separate the risk-object from the practices of intervention mandated to identify, classify, underwrite and to interdict threat and hazard. Nor can we ignore the violence generated by interventions to reduce harm. A critical theory of socio-political risk cannot be a simplistic classification of prospective objects of intervention; it must theorize the institutional contexts from which risk-related interventions emerge as well as autonomous responses to risk management; there is no risk data outside of this highly normative context. Risk norms arise from the clash of diverse risk

perception systems and threat experiences that order the relations of expert knowledge systems, everyday life actors and structures, and so-called information-rich and information-poor communities and spaces. Risk classifications in the United States, particularly since 9/11, have been arbitrarily fused with categories of race, class ethnicity, religion, immune system status and political geography. Risk classifications and objects emerge at the intersection of criminalizing, medicalizing and public safety techniques and ideologies, and have no autonomous existence apart from this discursive nexus. Therefore, the risk object is both a hybrid social fact and an internal product of a specialized scopic regime, a constructed registration of radical difference.[3] Further, I would contend that the risk object inadequately names culturally and historically problematic blind spots that resist absolute representation, and can only be codified symbiotically in admissible and frequently distorting cultural symbols.

Ulrich Beck writes:

> The immediacy of personally and socially experienced misery contrasts today with the intangibility of threats to civilization, which only come to consciousness in scientized thought and cannot be directly related to primary experience . . . The cultural blindness of daily life in the civilization of threat can ultimately not be removed: but culture "sees" in symbols. Making the threats publicly visible and arousing attention in detail in one's own living space—these are cultural eyes through which the blind "citoyen" can win back the autonomy of their own judgment.
>
> (Beck 1992, p. 52)

However, under emerging post 9/11 public safety regimes, the everyday is more than just the sphere of visual error, where the imperceptible fails to be objectified, but is increasingly treated as a breeding ground of duplicitous surfaces and structural subversion. The objectification of threat requires a concerted ocular and expanding material occupation of the everyday, which is posited as an obstacle to forensic control of the bio-political sphere and to the ongoing reproduction of stable and governable biopolitical subjects (Agamben 1998, p. 6). Here, we can appreciate to what degree the actuarial gaze replicates the chasm between transcendental sovereignty and the instability of everyday life structures. The actuarial gaze promotes a political technology that unifies culturally dispersed bodies under the symbolic order of a vulnerable yet sovereign national body. In this process, habeas corpus and the body as private property are subjected to an overdetermined fusion: the right to claim bodily integrity, to present before the state and citizenry, a body that is safe, that abjures risk, and is thus combinable with the sovereign body of mass political subjects. To be risk-free or risk-insulated becomes a claim on sovereignty and the elevation or reduction of risk exposure defines citizenship and its alters.

This is why Appadurai identifies growing structural contradictions between social intimates, citizenship and national identity that can culminate in ethnocidal and genocidal wars of racial and ethnic cleansing (Appadurai 1998). Social intimacy and ideologies of sovereignty are polarized, often along highly visual fault-lines of threat perception, in a globalized post-coloniality. Social intimacy becomes the enabling network along which contamination moves and through which purifying expulsions are violently performed in order to sort out the constitution of the sovereign corporate body. Appadurai proposes the concept of forensic violence, as that which took place in Rwanda and the Balkans, which he associates with the "vivisectionist" tendencies of ethnocidal atrocity and mutilation. Forensic violence dis figures and opens the victim's body to a screening gaze, and symbolically affixes and repairs biopolitical identity. Appadurai sees such forensic mutilation as an iconic and stabilizing

operation reacting to the transitive structure of social identity and the post-colonial nation-state under globalization.

This production of excessive, chronic violence and death by forensic violence, beyond any conceivable means-ends instrumentality, refracts Bataille's notion of alienated sovereignty as a spectacle of excess and wastage (Bataille 1993). Here, the imputed catastrophe is both the object for exercising sovereignty and sovereignty's mirror image; statist intervention in the catastrophic frequently culminates in the "rational" administration of excessive violence and the ritualized expenditure of technical, economic and human resources.

Global scenography of the sleeper

However, forensic investigation of deviant bodies is not limited to ethnic cleansing, which is but one possible response to globalized insecurity. In the aftermath of 9/11, and the violation of the American corporate body, forensic penetration—in the form of state surveillance, aggression and violence—has been repositioned to investigate, visualize, expose, display and to affix the identity and location of hidden terrorist agency and other circulating transnational threats. These agents of risk include mobile labour, refugees, ethnic and religious diasporas, radioactive material and viral organisms. With the declaration of new global campaigns of public safety, classifying and surveilling pathogenic spaces and their inhabitants have expanded as geopolitical strategies, precipitating a political aesthetics of landscape and social space. Currently *securocratic* scenography is fashioned through a variety of siting prisms that, like the Claude (a black lens used in landscape pictography), impose moralized and disciplining valence on bodies, space and place. These political prisms include, among others, the televising smart bomb, global satellite cartography, urban policing, biometric scanning and the closed circuit camera of the gated community and armoured office building (Davis 1992, Weizman 2004).[4] War-scapes, famine-scapes, degraded urban environments, the AIDS- and hunger-ravished body, and other images of social risk and/or suffering form a moralized and selective scenography of the Other. This scenography is the creation of the state and the media dedicated to identifying, managing and the mass marketing of risk. As technologically structured images of catastrophe take on a life-form and agency of their own they cease to merely report threat and become productive and reproductive mechanisms, specifying both the limits and the programmatic targets of sovereignty and governmentality. Under catastrophic conditions, projections and fears, visual culture becomes material culture. Ulrich Beck's cultural symbols through which society "sees" risk, are not solely cognitive ideations, but have to be fabricated from concrete circumstances and bodies, and then forcefully retro-branded onto social subjects and spaces that are seen as originating and circulating risk.

Charged with restoring or sustaining security, catastrophe-response takes the form of forensic visualization of the now globalized sleeper-body: the secret sharer and social intimate who harbours covert violence, disease, spatial delimitation, religious alterity or alternative economic practice (Feldman 1997, Nicholas Mirzoeff personal communication) The global sleeper subverts transnational networks of commoditization and must be rendered post-circulatory to the degree that the sleeper harbours the end of mandated forms of economic, sexual and bio-political circulation. At the same time, as a profiled bearer of risk, the sleeper body is the enabling currency of the public safety apparatus. Bio-political policing does not eradicate its object, but requires its managed reproduction within discreet security and publicity apparatuses; the ongoing retrieval and presentation of threat-profiles legitimates the security archive (Feldman 1994, Feldman 2003, Agamben 2002).

Bearers of risk are projected as symbolic anti-capital, their spatial purchases on the social are subject to interdiction within labour, sexual, political and speech economies. For the

actuarial gaze, the global sleeper screens off its identity behind the ostensively duplictious social surfaces of everyday life; here that which is screened-off must be recoded by media and government into surfaces of threat- display, a security profile and an alarm signal. The arresting power of optical technology to stabilize image flows, to freeze temporalities of urban and global circulation, is conjoined with legal and militarized powers of arrest and apprehension. The actuarial gaze is concerned with the powers of arrest in its fullest perceptual and criminalizing gauge. At sites like Guantanamo, Abu Ghraib, in the local policing of economic, racial and class margins, and in the medical and economic management of compromised immune systems, the actuarial- forensic gaze renders risk perception haptic, tactile, penetrative and transformative.

This new ideological environment promotes "a police concept of history," that is the reframing of historical process into the divisions of ideal safe space and duplicitous, distopic and risk-laden space (Ranciere 1988). In this history, visible spaces of order are undermined by invisible yet impinging spaces of disorder. The police concept of history advances the normative sociology and visual culture of the profile: who belongs to and who is out of place and the enforcement of spatial behaviours (Ranciere 1998). What Ranciere did not anticipate is that the police concept of history would be retooled for the new globalized economy, to the degree that it promotes a normative notion of the transnational system as an orderly space of economic circulation in which bodies and persons fulfil proper functions and occupy proper differential positions. Improper or transgressive circulation, symbolized in icons of mobile biosocial pollution, is feared and attacked. The infiltrating terrorist is thus both an instance of, and a catchment concept for, the idea of improper circulation. Cognate transgressors from drug dealers to undocumented immigrants partake in the illicit substance of the terrorist.

Policing in this framework of ordered/disordered circulation is about the visible distribution of differential functions and position within a society and between societies; it stands opposed to the emergence of new subjecthoods who resist the norms of circulation and/or who practice illicit forms of cultural/economic/sexual/political exchange and transaction that are deemed infra-political. These are people who "are between several names, statuses and identities; between humanity and inhumanity, citizenship and its denial' (Ranciere 1992, p. 61). This form of policing emerges with the disappearance of enforceable physical national borders and compensates for the loss of tangible borders by creating new boundary systems that are virtual and mediatized, such as satellite, biometric and digital surveillance nets. In turn, the virtualized border gives rise to the politics of the spectre: the ghost in the circulatory machine, such as the ever elusive Bin Laden, border-crossing drug mules, migrant-conveying coyotes, compromised immune systems and biochemical weapons.

Interruption and interdiction of the moral economy of circulation is characterized as a distopic "risk-event," a disruption of the imputed smooth functioning of the circulation apparatus in which nothing is meant to happen, where people, things, and cultural traffic are meant to keep to mandated channels and spaces. "Normalcy" is the non-event, which in effect means the proper distribution of functions and positions, and the maintenance of appropriate social profiles. However circulation is bivalent, it is the visual structure of social surfaces, the armature of everyday life, the insignia of modernity, and yet, it betrays and harbours dangerous and infecting alterity.

The actuarial gaze, and its forensic interface with circulating clandestine bodies, intensifies and imperially expands the ideology of Bertillion's and Gallton's nineteenth-century biometric and surveillance methodologies, which articulated policing criminal photography, phrenology, finger printing and state archives (Sekula 1986). Agamben sees the origin of biopower in the nineteenth-century fusion of policing and public health, resulting in the emergence of a concerted public safety and policing ideology (Agamben 2002: 147). This fusion

of the police concept of history and public health was exemplified by the Fascist articulation of biological sovereignty and symbolic geography as Ernst Bloch identified in the 1930s.

> The nation . . . becomes in medical terms . . . a unity filled with blood, a purely organic river basin from whose past humanity stems into whose future its children go. Thus, nationhood drives time, indeed history, out of history, it is space and organic fate, nothing else . . . Nations are units of blood says the Fascist sociologist Freyer.
>
> (Bloch 1990, p. 90)

Bio-politics, as visual culture, spatializes the historical, an appropriate response to the vertigo of urban and globalized economies that are both feared and fantasized as made up of mobile streams of economic, ideological and microbiological infiltrators. With globalization, and the consequent destabilization of the cartographic nation-state, the medicalized-forensic nation-state reconstructs hegemony through foundational spatial metaphors of "homeland security," and total information awareness systems. In turn, corporate antibodies, or infiltrating transnational moles and sleepers, are represented as purely spatial threats and not as indicative of historical contradiction, politically constructed cultural difference and unreconciled counter-memories of social suffering.

Screening traumatic realism

The actuarial gaze is not only pre-emptively deployed, as in the orchestration of the invasion of Iraq, but also practices an aesthetics of space/time compression that renders unfolding disaster serviceable to the expansion of this scopic regime. Consider media's stabilization and synchronic reorganization of diachronic fragments in the circular video repetition of the attack, burning and collapse of the World Trade Center. The actuality aesthetic of televisual witnessing used mechanical repetition and digital manipulation, such as freezeframing, and slow motion, to reverse, spatialize and petrify violence; thereby extracting the event known as 9/11 from chaotic temporal debris and from the affective flows of terror and disorder. This aesthetic of catastrophe was not qualitatively different from the space-time compression of the descending televising smart bomb during the first Gulf War. In both instances, the long prepared for gravitational pull of advanced optical technologies, the fusion of mass production and mass destruction technics, and cartographic air dominance, formed a media and military aesthetic that was transposable to a number of locales—a series of Ground Zeros, as both battlefields and as memorials of retribution. The monument and the catastrophic are two sides of the same gaze, or two symmetrical modalities for producing and anchoring mass spectatorship. Since the Lisbon earthquake (1755), catastrophe has lent itself to a monumental and memorializing panoramic aesthetic. However, in late-modernity, panoramic visualization of disaster is no longer simply an after-effect and a recollection of violence, but rather the vehicle for the delivery and legitimation of a violence that now advances geo-political visual sovereignty.[5]

The video extraction of 9/11 created a temporal stasis, or at least reinforced and visually elaborated a stasis that originated in the immediate shock of the assault. However, in the news cycle of visual repetition—the buildings attacked, the smoke and flames, and the eventual collapse—televisual actuality also imposed an artificed and eminently normative and fictive linear time onto the event horizon of 9/11. Television ultimately endowed a restorative linearized chronology to structural chaos. The temporal fragments of the attack were instantaneously assembled as a narrative, a reconstruction that was serviceable as an "arché"

or origin point for a new global risk reduction agenda: "the war on terrorism." In this manner, a cogent traumatic structure was generated by compressing the time-locus of the attack and the simulated times of its video reiteration; the synthesis of the two temporalities both produced and managed shock as a public emotion. I suggest that this screen experience was also a *screening-off* of the actuality, by which I mean the visual displacement of the complex social suffering and unreconciled history expressed, mobilized and created by the attack; a displacement and editing that rendered the event narratable to an anestheticized cinematized consciousness. Hal Foster has identified this process of screening/screening-off as "traumatic realism" (Foster 1998, p. 354). For Foster the activation of traumatic repetition needs to be distinguished from the analogical representation of violence and catastrophe:

> Lacan describes the traumatic as a missed encounter with the real. As missed the real cannot be represented; it can only be repeated . . . repetition is not reproduction in the sense of representation (of a referent) or simulation (of a pure image, a detached signifier). Rather repetition serves to screen the real understood as traumatic . . . repetition produces a second order of trauma, here at the level of technique.
>
> (Foster 1998, pp. 354–358)

The political emergency inaugurated by 9/11 emerged as a visual construct that stranded the American polity in what Foster identifies as a second technical order of screening/repeating shock and trauma. This technical instrumentation of reproducible trauma is now embodied in the prosthetics of the emerging forensic state apparatus, in the advanced technology of Shock and Awe warfare, in the negative optics of collateral damage, and, most recently, in the Abu Ghraib torture regimen and photography. I would contend that the actuarial gaze, which screens, repeats and screens-off shock and trauma, has been progressively institutionalized as a technical order of total spectrum dominance. Under regimes of spectrum domination, risk production becomes optically circumscribed, while the depth structures and contingencies of historical emergency and crisis remain functionally shrouded. Spectrum dominance is a forensic fixation on bio-political exposure, on the coercive displacement of bodily, and socio-political interiors onto the outside, and yet, it is also an exposure and a posing of threat where much is excluded, filtered and deleted.

What is screened out of this traumatic repetition frequently becomes the terrain of human rights violation. The actuarial gaze, as much as it exposes and classifies, also creates zones of visual editing, structural invisibility, and *cardon sanitaire*, resulting in the decreasing capacity of surveilled, stigmatized and vulnerable groups, classified as risk-bearers, to make visible their social suffering, shrinking life-chances and human rights claims in the global public sphere. To the very degree that the traumatic realism of the state and media monopolizes truth claiming about hazard, threat and violence over and against the everyday life experience of populations and spaces objictified as affected and infected by risk, human rights violations are rendered invisible or marginal.

In the aftermath of the World Trade Center attack, the manipulation of visual debris and fragments, and the screening of trauma through cinematic repetition was not a self-evident or foregrounded fact for the televisual spectator, who was immersed in the seeming totality of actuality simulation, and not in its conditions of visual production. The visually protective shock/numbing—created through replay, optical stabilization and the ordered chronology of linearity promoted by rerunning the disaster—can be characterized as mediatic therapeusis. Out of the raw material of 9/11 the media constructed the kernel of a visually tangible traumatic and repeatable periodization, a before and after, and persisted in retransmitting it endlessly like a binary signal, and as a national alarm. Here repeatable trauma was

both a temporal construct and subject to spatial duplication or mimesis. Ground Zero, as temporal marker, would be geographically disseminated as historical origin for other societies, as was to occur in the bombing of Shock and Awe, and the subsequent regime-change and compulsory democratization of Iraq. The traumatic realism of Ground Zero mutated into the production of two intersecting forms of the historical: history as phantasmagoria and history as ruined nature.

> Phantasmagoria comes into being when under the constraints of its own limitations, modernity's latest products come close to the archaic. Every step forward is at the same time a step into the remote past.
>
> (Adorno 1981, p. 31)

Under commodified image regimes, the phantasmagoric conceals the conditions of its production, screens off its own origins and is presented as nature, as originary. Catastrophe reactivates gnostic history that naturalizes the political in a theory of evil; gnostic theodicy organizes time and space into fixed moral dualities that cannot to be undone by transcultural process and counter narratives of domination.

Shock and awe, collateral damage and the mass subject at Abu Ghraib

It is no coincidence that the two governing tropes of recent public safety warfare have been the technological onslaught of shock and awe and the excuse rationality of collateral damage; both forms of violence are invested in regulating the circulation of images. Shock and awe and collateral damage, like the police concept of history, visually distribute death and destruction into domains of the event and the non-event, the visible and the invisible. Though here normalcy is predicated on what is not seen, that damage which is supplementary and incidental; undetailed death enframes "Shock and Awe" as an antiseptic digitized and visually seductive war. Anonymous victims of collateral damage stand in visual opposition to the sensational violence of "Shock and Awe." The special effects of Shock and Awe can be seen as yet another screening strategy that visually displaced the horrific material consequence of massive bombardment from the air. The dialectic of Shock and Awe and collateral damage, what is repeatedly shown and what is not shown or protectively screened-off, orchestrates the public sensorium of televisual spectators for whom violence is performed, displayed and shrouded (Feldman 1994). This dialectic creates structures of attention and distraction for the polity of televisual witness. A political economy of attention realigns perceptual systems with political agency and elicitations of consent. Perceptual alignment or consent is not necessarily the persuasion of opinion, what it achieves is to structurally circumscribe opinion formation within a closed circuit of visual rhetoric and visually elaborated truth claims, and thus, within a mediatized politics of suggestion. Ideology can be internalized or resisted, but both stances will never be completely detached from the machinic and digital appropriation of the witnesses' gaze and it's positioning within a media structured consciousness that has a long perceptual history centred on the automation of attention.

In her study of African-American rumour-lore, Patricia Turner links a politics of suggestion to risk perception, in this instance a preoccupation with the protection of bodily boundaries, as exemplified by widespread stories about toxic fast-food products targeting black consumers and conspiracy theories regarding the invention of AIDS (Turner 1993). Beyond the historical specifics of African American rumour lore, we can recognize a politics of suggestion in the post-catastrophic political culture of 9/11, with its fixation on at-risk social and bodily thresholds. Turner's linking of rumour, commodification and public health with a

sense of threatened anthropological integrity situates a politics of suggestion within formal mass communicative structures and everyday perceptual structures, as opposed to its confinement to exceptional or idiosyncratic forms of human communication. Peter Sloterdijk also traces a pre-Fascist politics of suggestion to early mass media culture, by examining popular tutors and books on autosuggestion and wakeful self-hypnosis in Weimer Germany:

> One bibliography lists for the period of the Weimer Republic alone around seven hundred scientific and popular publications on the themes of Couéism, hypnosis, auto hypnosis and suggestion . . . In contrast to Freudian psychoanalysis . . . [tutors of self-suggestion] . . . emphasize not problems of the conscious and the unconscious but those of attentiveness and inattentiveness. The phenomenon of suggestion touches on the domain of automatic consciousness not the unconscious as such.
>
> (Sloterdijk 1987, pp. 490–493)

Sloterdijk captures the technological colonization of modern consciousness in the political passage from the unconscious to automatic consciousness, and to a politics of suggestion as a function of mass spectatorship. The coupling of such a politics with an automated consciousness is possible when perception has been mechanized, mediatized and detached from the individual spectator and given over to an apparatus of interpellation formative of a collective subject of perception and witnessing. Walter Benjamin observed this dynamic when he comprehended orchestrated and cinematized Nazi political rallies, replete with awe-inspiring light shows, as an aestheticization of modern violence. The Fascist political rally was a theatre that incorporated the individual spectator into a virtualized corporate body of sovereignty. The construction of this virtual mass subject aligned political attention, and a politics of suggestion; with mass consumption aesthetics (Buck Morss 1988). This was mechanical reproduction in the service of the mythographic spectacle, in which violence was sold as a political commodity, as a binding media of crowd formation, and through the cinematics of the mass rally, made palatable as a mechanized and routine efficacy. The aestheticization of modern violence was only possible through political technologies of suggestion and visually orchestrated mass consciousness, which conveyed perceptual agency to the screen, the lens and to the virtualized mass bodies that were integral to the spectacle of Fascist sovereignty. Shock and Awe, and its light show, just as much as the 1930s Fascist spectacle, with all of its advanced visual and sonic effects, constructs the crowd, the polity, as both a cinematic object and as mass spectatorship.

Michael Warner has identified the virtual body of the "mass subject" of modernity as a creation of visual ideology and optical technologies:

> Where printed public discourse formerly relied on a rhetoric of abstract disembodiment, visual media—including print—now displays bodies for a range of purposes, admiration, identification appropriation, scandal and so forth.
>
> (Warner 1993, p. 242)

For Hal Foster, Warner's mass subject is explicitly associated with the perception and management of catastrophe and virtual embodiment:

> The mass subject cannot have a body except the body it witnesses . . . disaster and death were necessary to evoke this subject, for in a spectacular society the mass subject often appears as an effect of the mass media, or of a catastrophic failure of technology (the plan crash), or more precisely, of both (the news of

such catastrophic failure) . . . in its guise as witness the mass subject reveals its sadomasochistic aspect, for this subject is often split in relation to a disaster; even as he or she may mourn the victims, even identify with them masochistically, he or she may also be thrilled sadistically by the victims of whom he or she is not one.

(Foster 1998, p. 366)

The mass subject comes into visibility as simultaneously the witness and victim of the catastrophic. Adorno explicitly related the formation of the mass subject to the mass production of the catastrophic in modernity:

In the concentration camp it was no longer an individual who died, but a specimen . . . Genocide is the absolute integration, it is on its way wherever men are leveled off . . . until one exterminates them literally as deviations from the concept of their total nullity. Auschwitz confirmed the philospheme of pure identity as death.

(Adorno 1973, p. 362)

For whom was the victim of genocidal catastrophe a singular deviation from collective nullity and ultimately fated to be re-embodied as a specimen? In the camps it was not only the camp personnel, but also the symbiotic mass subject of the Nazi Reich whose identity was structurally embedded in the expulsion and extermination of a typified Other. Such acts of mass violence were enabled and aestheticized by technocratic rationality, mass production techniques and mythographic racial reduction in which the bodies of victims were handled and circulated as mass articles within the state apparatus.

As I shall discuss, in reference to the photography of Abu Ghraib, the creation of one ascendant mass subject requires the repeatable catastrophic production of another. In the aftermath of an unrepresentable Holocaust, the technologies of the screen have intensified their display of disaster and death as mass commodity that visually orchestrates and circulates disfigured bodies as political specimens and stigmatized emblems of risk and threat. The mass subject, the subject of mass threat and violence, and the subject of mass spectatorship of violence, are both products of the traumatic realism of the screen/spectator dyad. The media construction of the mass subject through violence becomes an explicitly political problematic when we recognize that the mass subject is a technologically mediated response to the problem of popular sovereignty. Claude Lefort has proposed that under democratic regimes, popular sovereignty is a empty signifier, a vacancy, that is intermittently occupied and activated by virtual representations and surrogates of "the people"—a transcendental political subject that, in late modernity, transmutes into media-centered virtualized mass spectatorship (Lefort 1988, p. 17).

Shock and awe is more than a military tactic; it is simultaneously an exercise in war as visual culture for the consumption of the televisual audience, a technology of mass spectatorship, and an ideology of American modernization. Hegel viewed the march of Bonaparte's armies across a national geography as materializing the idea of progress (Buck Morss 2000). The destructive progress of aerial bombing across a civilian terrain has much the same effect. In 1900, Georg Simmel identified sensory shock as the price of progressive modernity and urbanism; perceptual shock was the psychological medium in which the modern announced itself and refashioned new forms of personhood. Modernity's shock was a conversion experience creating new social subjects, amenable to emerging technological and commodity regimes and work disciplines (Simmel 1971). The current ideology of shock and awe fuses technological and theological norms, for it too is a form of accelerated conversion: the rapid

Americanization of the Oriental Other though technological onslaught and subsequent post war therapeutic treatment and rehabilitation. President Bush's proposal to tear down Abu Ghraib prison encapsulates the core assumption of securocratic modernization and its incomprehension of the situation and nation it seeks to transform. The attempted erasure of Abu Ghraib, and its replacement by a sparkling new upto date American designed prison, simply extends the motivating logic of the invasion and occupation of Iraq as a campaign of political conversion much more encompassing than regime-change. Already the new supposedly torture-free wing of Abu Ghraib that has been established in the wake of the scandal has been baptized "Camp Redemption."

The televised dialectic of Shock and Awe and collateral damage cohere into an apparatus of traumatic realism that fashions spectatorship to the degree that this dialectic both shows and repeats the traumatic, while screening the viewer from historical contradiction and the contexts of social suffering. The spectatorship of Shock and Awe/collateral damage did not only encompass the audience in the American living room, but those soldiers commissioned to liberate and occupy Iraq, including those soldiers and civilian experts who administered Abu Ghraib prison; the very jailors who viewed interrogation violence as necessary collateral damage to the prevention of terrorism, and yet were compelled to consume and disseminate their collateral damage as a visual artefact. These interrogators were culturally positioned within an optical circuitry and prosthetics of traumatic realism that stitched together the moralized ruins of the World Trade Center disaster, Shock and Awe and their own ruinous image making at Abu Ghraib.

We have glimpsed the violence of the actuarial gaze in the exercises of torture and humiliation Iraqi detainees were compelled to rehearse at Abu Ghraib. The first series of photographs released from Abu Ghraib had the celebratory and horrific carnivalesque atmosphere of the picture postcards that were sold as souvenirs of the lynching and mutilation of African-Americans in the 1920s (Allen 2000, Antiwar.com 2004). These scenes also resembled the practice of "battle proofing," endemic in the Vietnam War, in which new "incountry" soldiers were ordered to bayonet massed piles of Vietnamese corpses as an exercise in dehumanizing the enemy, thereby desensitizing and inuring the greenhorn soldier to the human consequences of their violence (Feldman 1991, p. 233).

In contrast, the second wave of released Abu Ghraib photographs revealed another more operational reality: the mundane programmed logistics of an extremely violent sensory deprivation and behavioural modification regime (Antiwar.com 2004). These photos are frequently taken from a prison tier above the enacted violence, or at a remove from the scene of torture, and capture the viewpoint of an omniscient clinical spectator monitoring a series of experiments meant to trigger signs of subjugation obedience, confusion and capitulation, i.e. shock and awe. Here, the camera is not just a recording instrument but also a penetrative device appropriating the psyche, sexuality and gender identity of the hooded Iraqi detainee as his body is turned inside out by the regimen. We view a well-oiled apparatus going through its daily round of exercises. There is nothing shameful or hidden here, nothing clandestine, the photographer is part of the apparatus of intimidation and exposure. This clinical photography completes the jailors' visual and spatial command over the hooded and rigid Iraqis who have been deprived of sight, bodily mobility and sexual integrity. As in the televisual logic of the first and second Gulf wars, that fused spectatorship at home with satellite imaging, real-time reportage and visualizing smart bombs abroad, the Abu Ghraib photos are a continuation of American spectrum dominance over the recalcitrant body of the "terrorist" Other. It is the dependency of the actuarial gaze on the visual/virtual command and control of the terrorist Other that also explains the trickster photographs of American soldiers celebrating their sexual humiliation of Iraqi men (Antiwar.com 2004). What was staged in these scenes is both an annotation to the routine photographs of day-to-day sensory deprivation and

engineered terror, and an extension of the behaviour modification culture of "Gitmoization" (interrogation practices deployed at, and disseminated from, Guantanamo prison).

The "porno" photos and tableaux were an empowering projection of American fantasies and sexuality onto Iraqi bodies. The figure of the woman as the agent of humiliation, subtended by those pictures of detainees wearing women's underwear or leashed like S&M actors, was axial to this fantasy formation. We are reminded of those carnival rites of inversion that Natalie Zemon Davis characterized as woman on top (Zemon-Davis 1975). Posed astride these huddled naked bodies, with her thumb jutting into the air, Private Engelund was a transitional mediating figure and a symbolic conduit who acquires male gender power and cache from her victims wherever she performed her dominance over naked Iraqi men; power that passed through, her, like sympathetic magic, to be mimetically transferred to the watching male interrogators through these very poses and images. The Iraqi detainees, in turn, were subjected to a gender inversion, they were feminized through the visual exposure of vulnerable bodily orifices by and for their custodians. This gender inversion may refract simplistic and reductive assumptions about Arab masculinity held by the jailors, but the latter were not passive bystanders to their own experiments with the Iraqi body. If Iraqis are being reduced to a feminized passivity and vulnerability, then conversely their Americans abusers, through their female surrogate, were being (re) masculinized by their acts and images.

The visual circuitry of gender reversal between the prisoners and the jailors is an early admission on the part of line soldiers that the liberation of Iraq has descended into mission drift. The scope and effectiveness of the Iraqi resistance, the chronic attacks, the steady haemorrhaging of American casualties, the general antipathy of the Iraqi masses towards their putative liberators, has positioned American soldiers in a position of "feminized" vulnerability; for they lack control over the integrity of the American military body confronted with unmanageable terror—the very post 9/11 condition Iraq was invaded to interdict. Just as much as political support at home for the war is contingent on an orchestrated and highly edited flow of identity-sustaining images, Abu Ghraib revealed that the Americanization of Iraq had first to be mimetically experienced as visual substance if it was to be credible and tangible to those charged with carrying it out at the front line. Thus, these photos were circulated and consumed by military personnel as recreational artefacts both within and outside the prison. Some soldiers sent these images home to their families.

The Abu Ghraib rituals were ceremonies of nostalgia by which the perpetuators reacquired, if only in an allegorical idiom, their former sense of mastery and command in a situation that is rapidly lurching beyond their grasp. That is why we know that the extraction of information was not the terminal goal of these rituals. For the hooded and faceless bodies were manipulated and posed as depersonalized and typified ethnic specimens, that is as mass subjects and virtualized bodies and not as information bearing individuals capable of discourse and confession. In fact, the useful military intelligence obtained at Abu Ghraib has been deemed negligible by army command (Danner 2004).

Abu Ghraib was a forensic operation, employing vivisectionist forms of optical penetration to produce images of subjugation that would conversley restore and suture the threatened thresholds of the corporate American military body. It is my suggestion that these images circulated as protective charms, a sympathetic magic, in which optical appropriation and virtual possession of the subjugated, abstracted body of the Iraqi terrorist mimetically empowered the military spectator. The image making by American soldiers, intelligence experts and private security contractors at Abu Ghraib, most of whom were also televisual spectators, repeated, as grotesque farce, the tragic assumptions of a national "catastrophilia" that precipitated and legitimated the post-9/11 invasion of Iraq.

Catastrophilia is a particular form of risk perception, to the degree that it mobilizes the politics of ruins, in which an emblematic act of material destruction materializes directional

historical time such as narratives of modernization, political conversion, regime change, compulsory democratization and the idea of progress (Sloterdijk 1987): "In allegory, history appears as nature in decay or ruins and the temporal mode is one of retrospective contemplation" (Buck-Morss 1988, p. 168).

As I have discussed earlier, both the attack on the World Trade Center, and its mimetic repetition in the Shock and Awe display, were images of ruin that were mediatically structured as motors of linearized time. These events were depicted as cosmogonic ruptures that inaugurated or exemplified a new historical direction, a newly discovered political telos, which replaced the bipolar politics of the last half of the twentieth century. This teleology of allegorical ruins can be identified in the torture/humiliation practices at Abu Ghraib. The photographs of naked, leashed Iraqi male bodies and their exposed orifices may not have shown classical skeletal images of *memento mori*, but never the less, these photos were made to show specimen bodies, de-socialized, de-Islamized and de-masculinized, whose displayed organs and mortified flesh exposed a subjugated and damaged interiority. The photographs captured now ruined bodies owned, penetrated and fully occupied by American captors and their cameras. Thus, it is no coincidence that the American military has also occupied and militarized major archaeological ruins of Iraq such as the cultural heritage sites of Babylon and the Ziggurat of Ur (BBC, 15 January 2005). The American military has turned heritage sites into weaponized base camps, and in doing so, they further damaged these already pillaged locales. This militarization of the Iraqi heritage landscape is an occupation of primary visual anchors of residual Iraqi national identity. Laying claim to, and nationalizing ruins, in Iraq or at Ground Zero, is to lay claim, to historical time. Laying claim to ruins, in the form of cultural artefacts, buildings or bodies, is to assert that the proprietary agent controls and manages historical catastrophe, which can be embodied in the manipulated iconography of the fragmented. Finally, laying claim to ruined spaces and bodies is to establish an aesthetics of catastrophe, a visual idiom that was integral to recent political periodization from 9/11 to Shock and Awe.

Conclusion: auto-immunization of the mass subject

Political violence achieves a new semiosis in a globalized media terrain. Modern visual media has encouraged the myth of totalizing depiction, it fashions a world picture that Kracauer as early as the 1920s identified as a reduction, a concentrate and abbreviation that passes itself off as the whole: "The aim of the illustrated newspaper is the complete reproduction of the world accessible to the photographic apparatus" (Kracauer 1995, pp. 57–8).

Kracauer saw such photographic actuality as a visual process of displacement and as a form of material violence, which excluded non-depictable and non-visual terrains of memory and everyday life experience. This process of iconic displacement or what I have termed screening-off, can be characterized as sacrificial substitution, a mythographic operation wherein the visual part stands in for the experiential and historical whole. Traumatic realism, as the aesthetics of catastrophe, is exactly this process of repeatable sacrifice, object substitution, displacement and filtering. The cultural logic of sacrificial depiction is not representation but substitution (Girard 1977). Post 9/11 risk perception, terrorism and torture, concentrate multiplex social identity or terrain in typified staged and surrogate forms that are aggressively refashioned to display visually accessible political transcripts. Abu Ghraib abuse was a sacrificial manipulation and reconstruction of the prisoners as political specimens and as pacified images of interdicted threat, rendered amenable to political circulation, at least among the occupation forces. Modern sacrificial violence, from state torture to suicide bombers, depends on, and reinforces mediatic displacement and surrogation. Mediatic

depiction of the catastrophic, and the sacrificial act of violence both reduce and restrict the real to repeatable screening codes of abbreviation, metaphor and architectural and somatic allegory which can sustain and orchestrate risk perception and related truth claims. In this framework, the ideology of spectatorship and the visual artefacts that emerged from Abu Ghraib were not aberrations but integral components of the visual culture of risk screening that emerged from the 9/11 catastrophe.

Ernst Junger was perhaps the first to comprehend that media technology dematerialized modern warfare and transformed vision into a material force and weaponry; he saw the camera lens as capable of freezing the moment of danger which enframed traumatic shock in a manageable virtual format. For Junger, optical technology creates an aesthetic of detachment, the only mode of perception, following Simmel, that can be commensurate to the incursions of technological shock in everyday life. Photographic detachment neutralizes social pain, for the photograph

> . . . stands outside the realm of sensibility. It has something of a telescopic quality: one can tell that the object photographed was seen by an insensitive and invulnerable eye. The eye registers equally well a bullet in midair or the moments in which a man is torn apart by an explosion.
>
> (Junger 1989, p. 208)

The subordination of everyday life to spectral appropriation creates a technology of spatial control and occupation:

> Photography is an expression of our characteristically cruel way of seeing. Ultimately it is a new version of the evil eye, a form of magical possession. One feels this acutely in places where a different cultic substance is still alive. At the moment when a city like Mecca can be photographed, it moves into the colonial sphere.
>
> (Junger 1989, p. 209)

The mediatization of war and the weaponization of media produces a new armoured perceptual structure:

> If one were to characterize with a single word the human type that is evolving in our time, one might say that among his most obvious characteristics is his possession of a second consciousness. This second, colder consciousness shows itself in the ever more sharply developed ability to see oneself as an object . . . the second consciousness is focused on the person who stands outside the sphere of pain.
>
> (Junger 1989, pp. 207–8)

I have theorized that the Abu Ghraib photographs and the wider culture of risk imaging in post 9/11 America function as a form of sympathetic magic, providing a protective charm for the spectator/consumer of risk and threat. Alain Corbin described the hygienic deodorization and sterilization of the medicalized body in the nineteenth century as the origins of a modern narcissistic subject of modernity, the self-obsessed armoured subject compulsively monitoring bodily thresholds for signs of contaminating penetration and compromise (Corbin 1988). Today, compulsive visual and aural consumption of risk, threat and catastrophe now function as hygienic exercises writ large, in which the bodies that are monitored and surveilled are the virtualized bodies of the risk- bearer and the at-risk spectator. Both the media and the

state promote a hygienic discipline-of-the spectator-self, by which the catastrophic is simulated in the form of containable information and constrainable bodies. The current informatization of consciousness is advanced through a politics of suggestion—the media's rehearsal of repeated catastrophe and the virtual auto-immunization of American bodies through this very economy of attention.

Paul Virilio (2000) has identified technological modernity with the utility and cultural centrality of the accidental and the disastrous, core epistemological events that allow for technocratic correction, and ultimately societal self-definition. His theory of accident-ridden modernity as the idea of progress, establishes catastrophilia as integral to the perceptual and technocratic structure of contemporary everyday life. Catastrophe is instrumentalized as a classification system and as chronotope creating normative time. Consequently, I would suggest that the cultural narcissism of the mass subject of risk and threat perception takes the form of the desire to consume virtual and symbolic disaster as a prophylaxis against the real. There is an actuarial structure of perception, a cultural underwriting of risk perception and risk exposure, which relies on media virtuality and the visual manipulation of other people's bodies, usually along cultural, race, class, gender and religious faultlines. This optical engagement in risk and threat, despite its position of exposure and actuality simulation, is lulled and reassured by the promised rigor of antiseptic and virtualized state technics and violence, and enforced by the constructed blind spots or screens of collateral damage. Thus, despite distaste and momentary horror, the American viewing pubic recognized their secret sharers and doppelgangers, and an optics of participation, in the acts and vision of fellow citizen-spectators at Abu Ghraib, where current American catastrophilia was made manifest in the falsely redemptive screen of the disfigured Iraqi body.

Notes

1 Ocular aggression, in the form of beliefs concerning the "evil eye" is a mainstay of the Anthropology of the Mediterranean and is usually classified as an involuntary gesture of the body. Thus, despite its pre-modern antecedents, the practice of ocular aggression and the modern visual ideologies this essay addresses share certain traits: automatism, a reaction to spatial impingement, and ideologies of pollution and purification (see Gilmore 1982, pp.175–205 for further discussion and bibliography).

2 Since many of the tendencies being discussed in this essay are associated with an ideology of compulsory democracy, I should call attention to one of the major studies of early democracy and media, Jean Starobinski's *Invention of Liberty, 1700–1789*, which discusses the relation of utopian democratic spaces and the aesthetic of visual transparency, particularly in relation to Rousseau's notion of the Festival (Starobinski 1987).

3 "This is the politically visible, that horizon of actors, objects and events that constitute the worldview and circumscribed reality of the political emergency zone—the gathered and linked components of crisis . . . By a scopic regime I mean the agendas and techniques of political visualization: the regimens that prescribe modes of seeing and object visibility and that proscribe or render untenable other modes and objects of perception. A scopic regime is an ensemble of practices and discourses that establish the truth claims, typicality and credibility of visual acts and objects and politically correct modes of seeing" (Feldman 1997, pp. 29–30).

4 Claude Lorrain's (b. 1600, d.1682) "Black Glass" or "the Claude" was used to filter out certain colours in landscape prospects in order to achieve a unity of tonal intensity in the painting of the scene, The Claude was used to fashion a moralized and sentimentalized landscape. Later European painters used the instrument to Europeanize alien colonial landscapes in accordance with romantic aesthetics.

5 The Lisbon earthquake of 1755 was the major world event of the period to be repeatedly subjected to panoramic display and commemoration by a variety of pre-cinematic technologies throughout the eighteenth and nineteenth centuries. These exhibits pioneered the fusion of disaster reportage and panoramic optics as both news and recreation.

References

Adorno, T. (1973) *Negative Dialectics*, trans. E.B. Ashton, Continuum, New York.

Adorno, T. (1981) *In Search of Wagner*, trans R. Livingstone, New Left Books, London.

Agamben, G. (1998) *Homo Sacer. Sovereign Power and Bare Life*, Stanford University Press, Stanford.

Agamben, G. (2002) "Security and terror," *Theory and Event*, vol. 5, no. 3, [online] Available at: http://muse.jhu.edu/journals/theory_and_event/v005/5.4agamben.html

Allen, J., Als, H., Lewis, J. & Litwack, L. F. (eds) (2000) *Without Sanctuary: Lynching Photography in America*, Twin Palms Publishers, New York.

Antiwar.com (2004) "The Abu Ghraib prison photos," [online] Available at: http://www.antiwar.com/news/?articleid = 2444

Appadurai, A. (1998) "Dead certainties: ethnic violence in the era of globalization," *Public Culture*, vol. 10, pp. 225–247.

Bataille, G. (1993) *The Accursed Share*, Zone Books, New York.

BBC World Service (2005) "Army Base has damaged Babylon," [online] Available at: http://news.bbc.co.uk/1/hi/world/middle_east/4177577.stm

Beck, U. (1995) *Ecological Politics in the Age of Risk*, Polity Press, Cambridge.

Beck, U. (1992) *Risk Society: Towards a New Modernity*, Sage Press, London.

Buck Morss, S. (1988) *The Dialectics of Seeing: Walter Benjamin and the Arcades Project*, MIT Press, Cambridge, MA.

Buck Morss, S. (2000) *Dreamworld and Catastrophe; the Passing of Mass Utopia in East and West*, MIT Press, Cambridge, MA.

Cadava, E. (1998) *Words of Light: Essays on the Photography of History*, Princeton University Press, Princeton, NJ.

Corbin, A. (1986) *The Foul and the Fragrant: Odor and the French Social Imagination*, trans. M. Kochan, R. Porter & C. Pendergast, Harvard University Press, Cambridge, MA.

Danner, M. (2004) "Abu Ghraib: the hidden story," *The New York Review of Books*, [online] Available at: http://www.markdanner.com/nyreview/100704_abu.htm

Davis, M. (1992). "Beyond Blade Runner: urban control—the ecology of fear," *Open Magazine Pamphlet Series*, 23, Open Media, Westfield, NJ.

Davis, N. Z. (1975) *Society and Culture in Early Modern France*, Stanford University Press, Stanford, CA.

Feldman, A. (1991) *Formations of Violence: The Narrative of the Body and Political Terror in Northern Ireland*, University of Chicago Press, Chicago.

Feldman, A. (1994) "From Desert Storm to Rodney King: on cultural anesthesia," *American Ethnologist*, vol. 21, no. 2, pp. 404–416.

Feldman, A. (1997) "Violence and vision: the prosthetics, aesthetics of terror in Northern Ireland," *Public Culture*, vol. 10, no. 1, pp. 25–60.

Feldman, A. (2001) "Philoctetes revisited: white public space and the political geography of public safety," *Social Text*, vol. 68, Fall, pp. 57–90.

Feldman, A. (2003) "Strange fruit: the South African truth commission and the demonic economies of violence," in *Beyond Rationalism: Rethinking Magic, Witchcraft and Sorcery*, ed. B. Kapferer, Berghahn Books, New York, pp. 234–265.

Foster, H. (1997) "Death in America: shocked subjectivity and compulsive visual repetition," in *October: the Second Decade, 1986–1996*, MIT Press, Cambridge, MA, pp. 349–370.

Foucault, M. (1978) "The eye of power," *Semio-Text*, vol. 3, no. 2, pp. 6–19.

Gilmore, D. D. (1982) "Anthropology of the Mediterranean area," *Annual Review of Anthropology*, vol. 11, Annual Reviews: 175–205, Pal Alto.

Girard, R. (1977) *Violence and the Sacred*, Johns Hopkins Press, Baltimore.

Junger, E. (1989) " 'Photography and the second consciousness,' an excerpt from 'On Pain'," in *Photography in the Modern Era: European Documents and Critical Writings, 1913–1940*, ed. C. Philips, Aperture, New York, pp. 207–210.

Junger, E. (1993) "On danger," *New German Critique*, 59, pp. 27–32.

Kracauer, S. (1995) "Photography," in *The Mass Ornament: Weimar Essays*, Harvard University Press, Cambridge, MA, pp. 47–63.

Lefort, C. (1988) *Democracy and Political Theory*, Polity Press, Cambridge.

Ranciere, J. (1992) "Politics, identification, and subjectivization," *October*, vol. 61, summer, pp. 78–82.

Ranciere, J. (1998) *Aux Bords du Politique*, La Fabrique, Paris.

Sekula, A. (1986) "The body and the archive," *October*, vol. 39, winter, pp. 3–64.

Simmel, G. (1971) "The metropolis and mental life," in *On Individuality and Social Forms*, ed. D. N. Levine, The University of Chicago Press, Chicago, pp. 324–339.

Sloterdijk, P. (1987) *Critique of Cynical Reason*, University of Minnesota Press, Ann Arbor.

Starobinski, J. (1987) *Invention of Liberty, 1700–1789*, Rizzoli International, New York.

Turner, P. (1993) *I Heard it Through the Grapevine: Rumor in African-American Culture*, University of California Press, Berkeley, CA.

Virilio, P. (2000) *The Information Bomb*, Verso, London.

Warner, M. (1993) The mass public and the mass subject, in *The Phantom Public Sphere*, ed. B. Robbins, University of Minnesota Press, Minneapolis, pp. 234–256.

Weizman, E. (2004) "The politics of verticality," OpenDemocracy.net, [online] Available at: http://www.opendemocracy.net/debates/article.jsp?id = 2& debateId = 45&articleId = 801

Derek Gregory

AMERICAN MILITARY IMAGINARIES AND IRAQI CITIES

WHEN PRESIDENT GEORGE W. BUSH declared his "war on terror" in the wake of the terrorist attacks on 11 September 2001, he made it clear that this was to be a global war. "We will fight them over there," as he later explained, "so that we don't have to fight them in the United States of America." This military project has been wired to neoliberal globalization in many ways: the armature of accumulation by dispossession, visible in the stripping and reappropriation of strategic sectors of the Iraqi economy by foreign capitals; a sort of flexible militarism whose "derivative wars" trace arabesques between the predatory logics of securitization in global battle spaces and global financial markets; and a brutal geographing of the borders between "insured life" and "non-insured life" throughout the planet (Harvey 2003; Martin 2007; Duffield 2008). The project has also seen the world's most powerful military machine, transformed through a Revolution in Military Affairs (RMA), forced to engage in so-called "new wars" fought by militias, insurgents, and terrorists in the breaches of former empires and the ruins of postcolonial states. This conjunction has deepened the investments of late modern war in globalization (and vice versa). The RMA was promoted as a means for the United States to project "full spectrum dominance" around the globe, and is in its turn part of a global trade in arms and military technology, while the new wars are fought by para-state, post-national, and transnational forces that are enmeshed in what Nordstrom calls a "shadow globalization" (Bauman 2001; Kaldor 2006; Münkler 2005; Nordstrom 2004).

In the first phase of the war, the American military relied on its continuing force transformation (a stripped-down military with a thick support belt of private contractors), combined in Afghanistan with the use of the proxy paramilitaries of the Northern Alliance, to achieve rapid and decisive supremacy over its weaker opponents. As political and public attention shifted to Iraq, however, and as invasion bled into occupation and insurgency, so the military machine faltered. Pentagon planners were determined to ramp up "kinetic" (offensive) operations through the deployment of explosive firepower, as in the levelling of Fallujah in the autumn of 2004, but many commanders on the ground were already improvising a counter-strategy that emphasized the protection of the civilian population and the role of "non-kinetic" operations in what came to be called culture-centric warfare. Here too the economic and the political marched in lockstep, yet the commodification of culture is a

commonplace while the weaponization of culture remains unremarked (Gusterson 2008). Nobody has done more to reveal the entanglements of culture and power than Edward Said, whose critique of Orientalism was written in close proximity to wars in the Middle East. He later suggested that the struggle over geography is complex and interesting "because it is not only about soldiers and cannons but also about ideas, about forms, about images and imaginings" (Said 1993: 7). So it is; but the critical focus has been on Said's last clause, on the imaginative geographies that circulate through political and public cultures to underwrite the divisions between "our space" and "their space"—between fighting them "over there" and fighting them "over here"—rather than on the images and imaginings that direct the soldiers and the cannons.

In what follows, in contrast, I trace the cultural turn within the American military imaginary and pay close attention to the visual economies on which it depends. The concept of a visual economy draws attention to two crucial issues: first, the strategic role of visuality, of techno-culturally mediated vision, in linking and de-linking "sight" and "site" in late modern war through the spatialities of targeting and the virtualization of violence and, second, the visual performance of the social field rather than the social construction of the visual field: the material consequences of enframing and envisioning the world in these ways (Campbell 2007).

The cultural turn is itself framed by two global imaginaries. First, the American military divides the world into six geostrategic regions and assigns a unified combatant command to each of them. This geographical imaginary is centred on the United States, but the Area of Responsibility for its Central Command (CENTCOM) is the Middle East, East Africa, and Central Asia. This has been the principal arena of operations for the "war on terror," but it is also the locus for a series of demotic geographical imaginaries that construct the Middle East as what Fareed Zakaria called "the land of suicide bombers, flag-burners and fiery mullahs" (Zakaria 2001). In that astonishing sentence the various, vibrant cultures of the region are fixed and frozen into one diabolical landscape. The cultural turn can be read, in part, as a belated response to such absurdist cartoons that invite incomprehension and incite military violence of an extraordinary and exemplary intensity against the threat they are supposed to represent. Second, and closely connected to these characterizations, the American military has become preoccupied with the prospect of fighting most wars of the immediate future in the cities of the global South. Military strategists fear that this will compromise the global projection of American power because the very nature of what they construe as radically Other, non-modern cities would induce "signal failures" within network-centric warfare and insulate insurgents from the vertical power of the late modern military machine. The immediate response has been to intensify the RMA to develop the technical capacity to provide ground troops with real-time situational awareness from the air and to conduct automated, cybernetic, and ultimately robotic warfare on the ground (Taw and Hoffman 1994; Graham 2007, 2008). The cultural turn can also be read, in part, as an attempt to soften or supplement these predispositions with a conditional intimacy: not so much a rejection of technophilia as its redirection.

I begin, therefore, by showing how American air operations reduced Iraqi cities not only to strings of coordinates but also to constellations of pixels on visual displays, while ground operations reduced them to three-dimensional object-spaces of buildings and physical networks. I then trace the arc of the cultural turn and its attempt to people these hollowed-out cities and to recover the meanings that are embedded in them. Although this manoeuvre developed as a critical response to the prevailing military imaginary, however, I will argue that it was prompted by the same concerns and satisfies the same desires: that it functions as a "force multiplier" fully consistent with the doctrine of full spectrum dominance.

Late modern war and the city as visual field

The RMA promised total mastery of battle-space through a combination of aerial surveillance and "bombing at the speed of thought." The capacity to commingle what Chad Harris called "the mundane and the monstrously violent" (Harris 2006: 114) was already apparent during the first Gulf War. The United States developed a three-day targeting cycle, a cascading series of translations from images through data to targets and back again, and Harris argued that these mediations worked to obscure the violence on the ground in Kuwait and Iraq from those organizing it at the US command and control centre in Saudi Arabia (Cullaher 2003; Harris 2006). This optical detachment, at once a characteristic and a desideratum of late modern war, is reinforced by the very syntax of deliberative targeting, which implies the careful isolation of an object—the reduction of battle-space to an array of *points*—whereas in fact targets are given a logistical value by virtue of their calibrated position within the infrastructural *networks* that are the fibres of modern society. The geometries of these networks displace the punctiform coordinates of "precision" weapons, "smart" bombs, and "surgical" strikes so that their effects surge far beyond any immediate or localized destruction.

By the second Gulf War the targeting cycle had accelerated to a matter of hours and the missiles were supposedly more accurate, but the envelope of effects was still designed to ripple out in time and space. Thus air strikes on Iraqi power stations in 2003 were intended to disrupt not only the supply of electricity but also the pumping of water and the treatment of sewage. The kill-chain has since been compressed still further by adaptive targeting, which depends on the identification, and sometimes the laser-painting, of targets of opportunity by ground forces (including special forces) that call in close air support (Herbert 2003; Weber 2005). At the same time, the distance between target and command centre has increased, a process that reaches its temporary limit in the deployment of Unmanned Aerial Vehicles (UAVs) in Iraq. Take-offs and landings of Predator drones, armed with heat-seeking cameras and Hellfire missiles, are controlled by American pilots at Balad Air Force Base north of Baghdad, but the missions are flown by pilots at Indian Springs Air Force Auxiliary Field, part of the Nellis Air Force Base in Nevada, some 7,000 miles away. "Inside that trailer is Iraq," one visiting journalist was told, "inside the other, Afghanistan" (Kaplan 2006).

It is hard to overstate the degree of optical detachment implied by such a casual reduction. But it is also symptomatic, for, as these examples imply, late modern targeting depends on an electronic disjuncture between the eye and the target, "our space" and "their space." The. techno-cultural form of this disjuncture makes the experience of war (for those in "our space") less corporeal than calculative because it produces the space of the enemy as an abstract space on a display screen composed of coordinates and pixels and emptied of all bodies (Chow 2006: 25–43; Gregory 2006). The effect is compounded by the mediatization of late modern war through which the same images are relayed to distant publics who watch military violence in a space that is, as in the "Shock and Awe" bombardment of Baghdad in March–April 2003, at once de-materialized ("targets," "the capital") and de-linked ("buildings," "bunkers"). We are invited to contemplate such scenes not only from a safe distance and without human presence, as Lilie Chouliaraki shows, but also without any sense of the very interconnectedness of life that is being sundered, a process that reaches its terrible apotheosis in urbicide (Chouliaraki 2006: 272–3; Coward 2006).

Ground operations transposed the visual logics of targeting to render the city as a three-dimensional object-space. The Handbook for Joint Urban Operations, issued in September 2002, treated the city as a space of envelopes, hard structures, and networks, and the same abstracted visualizations framed pre-deployment training. From November 2003 thousands of soldiers trained for convoy duty by driving through a virtual Baghdad, and since February 2005 an enhanced three-dimensional database of the city has been used to conduct virtual

staff rides to study the "Thunder Runs" made by armoured brigades during the invasion. The simulations render buildings, bridges, and streets with extraordinary fidelity; yet the inhabitants are nowhere to be seen. "The important thing for us is the terrain," explains the officer in charge. The latest US Army Field Manual on Urban Operations (FM 3–06), released in October 2006, opens by emphasizing the sheer complexity of the "multidimensional urban battlefield" and diagrams the city as "an extraordinary blend of horizontal, vertical, interior, exterior and subterranean forms."

These visualizations are closely connected to the city-as-target; in fact, they are often part of the same process. They assume the same highly sophisticated, technically mediated form, as detailed images from satellites, aircraft, and drones are relayed to display screens in command centres and combat zones, and they produce the same optical detachment: staring at the brightly lit screens of the Command Post of the Future (CPOF) outside Fallujah, according to one observer, was "like seeing Iraq from another planet" (Shachtman 2007; Croser 2007). These visualizations make powerful, almost forensic claims about their accuracy and reliability—they are the realtime "real"—even as they reduce the city to a body undergoing an autopsy. Physical models cannot claim the same mimetic power, but they share the same discourse of object-ness. In November 2004, before the second assault on Fallujah, Marines constructed a large model of the city in which roads were represented by gravel, structures under 40ft by poker chips, and structures over 40ft by Lego bricks, while Army officers conducted briefings using bricks for buildings and spent shells for mosques (al-Badrani 2004; Barnard 2004).

These reductions of the city to physical morphology have three powerful effects. First, they render the city as an uninhabited space, shot through with violence yet without a body in sight. This repeats the colonial gesture of *terra nullius* in which the city becomes a vacant space awaiting its possession; its emptiness works to convey a right to be there on those who represent it thus. Second, they are performative. As John Pickles shows, "mapping, even as it claims to be representing the world, produces it" (Pickles 2004: 93). Before the final assault on Fallujah, one captain instructed his platoon commanders: "The first time you get shot at from a building, it's rubble. No questions asked." But in an important sense the city was rubble before the attack began; the violence wrought by the US military in Fallujah cannot be separated from the violence of its visualizations of it (Barnard 2004). Third, these representations have legitimating force; as they circulate through public spheres they prepare audiences for war and desensitize them to its outcomes. The reduction of the city to a visual field is naturalized not only through the media barrage of satellite images and bomb-sight views but also through representations that hollow out the city on the ground. In a striking graphic from the *Los Angeles Times*, for example, tanks rumbled down a street, soldiers scrambled across roofs and hugged walls; but there was no other sign of life. In this re-enchantment of war, an enterprise expressly devoted to killing magically proceeds without death.

I have made so much of Fallujah because many military commentators regarded the US assault as "a model of how to take down a medium-sized city." Air strikes had pulverized the city before the ground offensive, but the decisive innovation was the use of persistent intelligence, surveillance, and reconnaissance from air and space platforms. This "God's-eye view," as several commanders called it, made it possible to pre-assign targets, and during the attack UAVs provided visual feeds to command centres and combat troops. These airborne sensors "opened up a full-motion video perspective on the street battle" so that, as one ground controller put it, "We knew their alleyways better than they did" (Grant 2005; "Operation Dawn" 2005). But some field commanders insisted that knowing the skeletal geometry of a city was no substitute for understanding its human geography. Such abstracted renderings of the city have been sharply criticized from outside the military too, but Thomas Ricks (2007)

claims that with its new cultural awareness the Army turned the war "over to its dissidents," and it is this critique from inside the machine that I propose to interrogate.

Genealogies of the cultural turn

The cultural turn had multiple origins, but it was provoked by the looming failure of the American mission in Iraq. By 2004 it seemed that the military had won the war only to lose the occupation. Travelling between the Green Zone and the Red Zone that was the rest of Iraq, reporter George Packer became "almost dizzy at the transition, two separate realities existing on opposite sides of concrete and wire" (Packer 2005: 224). In a tortured landscape that was "neither at war nor at peace," firepower was "less important than learning to read the signs," but an aggressive series of counter-insurgency sweeps revealed only that "the Americans were moving half-blind in an alien landscape, missing their quarry and leaving behind frightened women and boys with memories" (Packer 2005: 233). This was not surprising. The invasion had transferred thousands of young men and women from small-town America to a cultural landscape for which they literally had no terms. They were issued with two expedients. One was an *Iraq Visual Language Survival Guide* which provided a list of Arabic instructions ("Hands up," "Do not move," "Lie on stomach") and a series of point-at-the-picture cartoons showing ambushes, booby traps, vehicle stops, and strip searches. The other was an *Iraq Culture Smart Card* whose twenty panels provided a basic Arabic vocabulary, a bullet-point summary of Islam, and terse tabulations of Iraq's cultural and ethnic groups, cultural customs, and cultural history. This may have been more effective—it's hard to imagine it being less—but it had limitations of its own that derived as much from how culture was conceived as how it had to be abbreviated. The panel on "Cultural Groups" in the 2006 version, for example, was concerned exclusively with ethno-sectarian divisions: "Arabs view Kurds as separatists [and] look down upon the Turkoman;" "Sunnis blame Shia for undermining the mythical unity of Islam;" "Shia blame Sunnis for marginalizing the Shia majority;" and "Kurds are openly hostile towards Iraqi Arabs [and] are distrustful of the Turkoman." Culture was a force-field of hostilities with no space for mutuality or transculturation.

Commanders were at a loss, too, confronting an adversary "that was not exactly the enemy we war-gamed against," as one general famously complained. The Pentagon was so invested in high technology and network-centric warfare against the conventional forces of nation-states that it was radically unprepared for the resurgence and reinvention of asymmetric warfare. In 2004 Major-General Robert Scales made a powerful case for cultural awareness to be given a higher priority than the technical fix of "smart bombs, unmanned aircraft and expansive bandwidth" (Scales 2004). Commanders in Iraq had found themselves "immersed in an alien culture," he said; "an army of strangers in the midst of strangers" forced to improvise and to share their experiences by email (Scales 2004). By December 2005 their practical knowledge was being collated at a Counterinsurgency Academy in Baghdad, and twelve months later the capstone was put in place with the publication of a new Field Manual on Counterinsurgency (FM 3–24) (US Army 2006).

The new doctrine defined the population as the centre of gravity and established its protection as the first priority. This required not only cultural knowledge—"American ideas of what is normal or 'rational' are not universal" and should not be imposed on other people (surely the most remarkable injunction in the book)—but also "immersion in the people and their lives." Sequestering troops in large Forward Operating Bases and only issuing out to conduct aggressive sweeps was counterproductive. Instead, non-kinetic operations would assume a crucial importance. The "basic social and political problems" of the population had to be acknowledged and addressed, and while this did not preclude the use of deadly force it

had to be applied "precisely and discriminately" in order to minimize civilian casualties and to strengthen the rule of law (US Army 2006).

This is the sparest of summaries, and I need to make a series of deeper cuts into the construction of the new military imaginary. I concentrate on four of its architects, but the cultural turn cannot be reduced to the forceful projection of individual wills. It is a hetero-geneous assemblage of discourses and objects, practices and powers distributed across different but networked sites: a military *dispositif*, if you prefer. As such, it is a contradictory machine. For war, occupation, and counter-insurgency are not coherent projects; they are fissured by competing demands and conflicting decisions, and they are worked out in different ways in different places. So it is with the cultural turn.

From cultural morphology to the cultural sciences

The ground had been partly prepared by the lead writer of FM 3–06 on Urban Operations, Lieutenant-Colonel Louis DiMarco. By the autumn of 2003 he was involved in planning the invasion of Iraq, which was widely expected to centre on urban warfare, but he soon realized that there was a gulf between the generalities and geometries of FM 3–06 and the situational exigencies of Iraq's cities. Convinced that a purely physical visualization of the urban battle-space would be insufficient, he proposed a revolutionary emphasis on *cultural* morphology. This was a significant advance, but it was geo-typical rather than geo-specific and, crucially, it remained a morphological approach so that its sense of the spatialities of culture—visually conveyed in urban models, plans, and diagrams—was neither fluid nor transactional. DiMarco paid little attention to the modern Arab city, which was seen as axiomatically normal and so non-threatening. Consistent with the essentialist diagnostics of Orientalism, the focus was on the "traditional" city, which was identified as the epicentre of political Islam. As such it was invested with cultural meanings that required translation, but these were inscribed in physical places and structures: the mosque, the market, the neighbourhood, and the home. DiMarco's concern was kinetic operations, his language resolutely one of "attackers" and "defenders," so that throughout the text the ordinary meanings attached to these sites were retrieved and interpreted only to be subjected to a violent *détournement* in which military meanings took absolute priority: mosques isolated from the community by shaping operations, neighbourhoods controlled through checkpoints. The city was to be choreographed by the US Army (DiMarco 2004).

These were textbook recommendations, however, and in practice such reversals threatened to capsize the American mission. By the summer of 2004, Major-General Peter Chiarelli, commanding the 1st Cavalry Division in Baghdad, was convinced that the doctrinal progression from combat to "stability operations" was mistaken. Attempting to see military actions "through the eyes of the population," he concluded that a purely kinetic approach to the insurgency risked alienating local people not only through its spiralling circles of violence but also through its indifference to their own predicament. "We went after the insurgents," Chiarelli explained, "while at the same time—really simultaneously—we maxi-mized non-lethal effects" that targeted the provision of basic services, local government, and economic regeneration (in Hollis 2005: 5). DiMarco had sutured poverty to political radi-calism, too, but Chiarelli's Baghdad was not the traditional city of an unreconstructed Orientalism. Before deploying to Iraq, he and his officers consulted city administrators in Austin, Texas, and, while he said he "knew we weren't going to create Austin in Baghdad," he also knew they would be confronting a modern city whose infrastructure had been degraded by years of air strikes, sanctions, and war. Chiarelli recognized the significance of cultural knowledge, and laid his model of modern urban infrastructure over "a fully

functional model of the norms of the Arab people [and] the current status of Baghdad services and government."

A major focus was Sadr City, which had been designed by Constantinos Doxiadis and funded by the Ford Foundation as part of the 1958 master plan for Baghdad. It was no Orientalist labyrinth, therefore, but a modernist grid that had become a vast, sprawling slum. Chiarelli used a prototype of the Command Post of the Future to implement a spatial monitoring system—a visualization of the city as an "event-ful" field in motion rather than a static morphology—that revealed that "[Mahdi Army] cell congregations, red zones and anti-coalition, anti-government religious rhetoric originated from those areas of Baghdad characterized by low electrical distribution, sewage running raw through the streets, little or no potable water distribution, and no solid waste pickup. Concurrently, unemployment rates rocketed in these extremely impoverished areas and health care was almost non-existent." In short, "areas where local infrastructure was in a shambles became prime recruiting areas for insurgent forces" and, in turn, danger zones for US troops. This was the reversal that Chiarelli put into effect: the Mahdi Army "target[ed] disenfranchised neighbour-hoods," providing both services and shadow government, and his response was to target the same districts and to focus on producing visible improvements in people's daily lives (Chiarelli and Michaelis 2005; also see Hollis 2005; Croser 2007).

Chiarelli's approach was to treat counter-insurgency as "armed social work." The phrase is David Kilcullen's, an ex-Australian Army officer who was a key contributor to FM 3–24 and, until July 2007, served as Senior Counterinsurgency Adviser to General Petraeus. "Your role is to provide protection, identify needs, facilitate civil affairs," Kilcullen wrote in a memorandum for company commanders, "and use improvements in social conditions as leverage to build networks and mobilize the population" (Kilcullen 2006b: 106). Insurgent violence was part of "an integrated politico-military strategy" that could only be met by an integrated politico-military counter-strategy. Precisely because counter-insurgency was population-centric, it required what Kilcullen called "conflict ethnography;" otherwise it would be impossible to understand the connections between the insurgency and the popula-tion at large. "Culture imbues otherwise random or apparently senseless acts with meaning and subjective rationality," he argued, so that it was unhelpful to locate insurgents outside the space of Reason. But the space to which he appealed most often was that of the tribe. Although the urbanization of insurgency is one of the cardinal distinctions between classical and contemporary insurgency, Kilcullen's commentaries on Iraq have consistently privileged tribalism and, on occasion, reduced Iraq to a tribal society. When critics complained that FM 3–24 paid insufficient attention to religion, for example, his response was dismissive: "When all involved are Muslim, kinship trumps religion;" the "key identity drivers" are tribal. During the summer of 2007 Kilcullen described the tribal basis of growing Sunni resistance to Al Qaeda in Iraq (AQI) in Anbar, and then propounded "the Baghdad variant." Although he conceded that the capital "is not tribal as such," Kilcullen argued that there are such close connections between city and countryside that "clan connections, kinship links and the alli-ances they foster still play a key underlying role" (Kilcullen 2005, 2006a, 2007a, 2007b, 2007c). I have no doubt that they do; but, while some military authors have written about "tribal cities" as a category apart from the "hierarchical cities" that "we Americans know"—which is not, I think, Kilcullen's intention—it is misleading to treat Baghdad in such one-dimensional terms and to marginalize a countervailing Arab modern.

Perhaps this simply indicates Kilcullen's distance from anthropology: but a close connec-tion between counter-insurgency and the cultural sciences raises its own red flags. In a combative series of essays Montgomery McFate, a cultural anthropologist and a former AAAS Defense Fellow at the Office of Naval Research, called on anthropology to reclaim its historical role "to consolidate imperial power at the margins of empire" (McFate 2005a: 28).

In her view, "cultural knowledge and warfare are inextricably bound," and counter-insurgency in Afghanistan and Iraq demanded nothing less than "an immediate transformation in the military conceptual paradigm" infused by the discipline "invented to support warfighting in the tribal zone:" anthropology (McFate 2005b: 42–3). It is not difficult to see why so many scholars were riled, but McFate was adamant that "cultural intelligence" was not a scholastic exercise. It was important strategically, but it also made a crucial difference operationally and tactically, so that the thrust had to be on the production, dissemination, and utilization of "adversary cultural knowledge" on the front-lines (McFate 2005b: 44). In November 2004 McFate organized a conference on Adversary Cultural Knowledge and National Security, sponsored by the Office of Naval Research and the Defense Advanced Research Projects Agency (DARPA). "The more unconventional the adversary," she told the delegates, "the more we need to understand their society and underlying cultural dynamics" (McFate 2005b: 48; McFate and Jackson 2005). Over the next eighteen months, McFate's ideas were transformed into the Human Terrain System, for which she is currently Senior Social Science Adviser. The HTS aims to provide field commanders with a "comprehensive cultural information research system"—filling the "cultural knowledge void"—through a visual display of "the economic, ethnic and tribal landscapes, just like the Command Post of the Future maps the physical terrain" (Kipp et al. 2006; Schachtman 2007; Gonzalez 2008).

All of these contributions rely on visualizations of one sort or another, and often make extensive use of visual technologies. But Lieutenant Colonel John Nagl, one of the lead contributors to FM 3–24, was more interested in what the visual displays could not show: "The police captain playing both sides, the sheikh skimming money from a construction project," Nagl asks: "What color are they?" (Schachtman 2007). The examples are telling; the cultural turn is never far from a hermeneutics of suspicion. But Nagl's question also speaks to the presumptive intimacy of cultural intelligence. In one sense, the reliance on visual displays to capture adversary culture combines optical detachment with the intrusive intimacy of the biometric systems used by the American military to anatomize the Iraqi population. But the cultural turn also implies another sort of intimacy that extends beyond the compilation of databases to claim familiarity, understanding, and even empathy. A primer for US forces deploying to the Middle East emphasizes that cultural awareness involves more than "intelligence from three-letter agencies and satellite photographs" (Wunderle 2007: 3); Scales's culture-centric warfare demanded an "intimate knowledge" of adversary culture (Scales 2004); and Kilcullen's conflict ethnography required a "close reading" of local cultures (Kilcullen 2007c). While this "rush to the intimate," as Stoler calls it, is conditional, forcefully imposed, and unlikely to be interested in thick description, "the ethnographic has become strategic military terrain" (Stoler and Bond 2006: 98). Just like military knowledge of any other terrain, it has to be taught. "The military spends millions to create urban combat sites designed to train soldiers how to kill an enemy in cities," Scales told Congress. "But perhaps equally useful might [be] urban sites optimized to teach soldiers how to coexist in a simulated Middle Eastern city" (Scales 2004).

Re-scripting and remodelling Iraq

American troops prepare for deployment by rotating through Combat Training Centers, where prefabricated settlements are used to train for urban operations. In contrast to Di Marco's concern with cultural morphology, however, there is little attempt at verisimilitude. The same physical structures serve for Afghanistan and Iraq, as though the two are interchangeable, and the buildings are crude approximations. One journalist described "Wadi al Sahara" in the Mojave Desert as "an impressionist painting." From the surrounding hills it could be mistaken for part of Basra or Fallujah, but "a walk through its dusty streets shows it

to be only a vast collection of shipping containers" (Hamilton J. 2006). This too has performative consequences. Shipping containers are an improvement on poker chips and Lego bricks, but reducing living spaces to metal boxes and studio flats conveys a silent message about the sort of people who live in them.

The focus at all the training centres is on interactive realism, and the cultural turn has transformed the terms of engagement. The emphasis used to be on air strikes and ambushes, and on state-of-the-art special effects that drew on the visual and pyrotechnic skills of Hollywood and theme-park designers. Exercises still include kinetic operations, though these now focus on combating IEDs and suicide bombings, but the main objective is no longer scoring kills but "gaining the trust of the locals." More than 1,000 Civilian Role Players are on call at the Joint Readiness Training Center at Fort Polk, Louisiana, including 250 Arabic speakers, who play community leaders, police chiefs, clerics, shopkeepers, aid workers, and journalists. New scenarios require troops to understand the meaning of cultural transactions and to conduct negotiations with local people. Careful tallies are kept of promises made and fulfilled by commanders, and the immediate consequences of civilian casualties are dramatized in depth. Mock newscasts by teams representing CNN and al Jazeera remind troops that their actions can have far-reaching consequences. "It is no longer close in and destroy the enemy," one officer explained: "We have to build relationships with Iraqis in the street" (Filkins and Burns 2006; also see Tower 2006; Beiser 2006; Rez 2007).

These Mission Rehearsal Exercises have become increasingly expensive and they pose formidable logistical problems. Yet, for all their size and complexity, they cannot convey the scale of operations in a city like Baghdad; and, precisely because they are conceived on the grand scale, it is difficult to inculcate the face-to-face sensibility on which the cultural turn relies. For these reasons, the military has become increasingly invested in computer simulations and videogames. Although these are also used to train for kinetic operations, there has been a major effort to devise "first-person thinker" versions that model non-kinetic operations. In parallel with the introduction of Civilian Role Players to Mission Rehearsal Exercises, the Pentagon's cyber-cities have been peopled too. The first attempts to model civilians treated them as aggregations. Computer-generated crowd federates animated the city as a series of physical trajectories and collective behaviours ("flocking," "path following"), but this was a *danse macabre* that conveyed little sense of the city as a space of meaning, value, and transaction. MetaVR has introduced highly realistic 3-D crowd animations into its Virtual Reality Scene Generator, but these are typically part *of* the scene, extras in a movie, and provide few opportunities for interaction. More significant are those simulations that attempt to incorporate the transactional intimacy of the cultural turn by using Civilian Role Players in Massively MultiPlayer Online Games or by using Artificial Intelligence to model cultural interactions. I will consider each in turn.

Forterra Systems produced the first closed virtual world for the American military in 2004 to simulate checkpoint operations in one square kilometre of a geo-typical Baghdad. Avatars represent American troops, insurgents, Iraqi police, and Iraqi civilians, all played by role-players who log on from remote stations, including Arabic-speaking Civilian Role Players from the Combat Training Centers. Interactions are unscripted, and players communicate through speech, text, facial expressions, and gestures. The company subsequently developed an enhanced suite of scenarios that require troops to negotiate with a community leader to improve the delivery of food and medical supplies, or "to establish rapport with shoppers in a Baghdad market, only to confront angry civilians as well as insurgents who chose to launch an attack with an IED and small arms" (Peck 2007: 14). Media coverage consistently emphasizes the non-kinetic priorities of the simulations, which are described as "sandboxes where people learn to interact" (Laurent 2007) and being "more about social interactions than fire-fights" (Peck 2007: 14; also see Mayo et al. 2006).

The University of Southern California (USC), and in particular its Institute for Creative Technologies (ICT), has spearheaded the application of Artificial Intelligence to replicate military–civilian interactions. These simulations mimic the closeness and intimacy that is the fulcrum of the cultural turn in three ways. First, they are highly immersive: ICT claims to transport (even to "tele-port") participants "experientially" to its virtual worlds. The power to draw players into these scenarios has been dramatically enhanced by advances in Virtual Reality and by experiments in "mixed" reality. ICT's *FlatWorld* integrates digital flats—large rear-projection screens that use digital graphics to produce the interior of a building, a view to the outside, or an exterior—with physical objects like tables, doors, and windows, and immersive audio, lighting, and smell. Players can walk or run through these simulated rooms, buildings, and streets, moving "seamlessly" between physical and virtual worlds, and three-dimensional Virtual Humans can be projected onto the flats to engage players in dialogue. These hybrid simulations mount a renewed assault on optical detachment; as Leopard (2005) argues, *FlatWorld* and its Virtual Humans actively interpellate players, entreating them to respond in particular, engaged ways to the situations in which they are so viscerally immersed.

Second, these virtual worlds are often local, even domestic. Military operations are staged in the places of everyday life, not in an abstracted battle-space but in homes, neighbourhoods, and clinics, and they require close, personal interaction with individuals, "face work" that involves learning to read gestures and expressions. *Tactical Iraqi*, for example, was developed at USC's Information Sciences institute to provide troops with the language skills and cultural knowledge necessary to accomplish specific tasks. The player is an Army sergeant who must navigate from public into private space to find a community leader who can help locate a source of bricks so that his platoon can rebuild a girls' school damaged in a fire-fight. Similarly, in an ICT simulation the player is an Army captain who must negotiate with two full-body avatars, a Spanish doctor who works for a medical relief organization and an Iraqi village elder, to persuade them to move a clinic to a safer location (Kenny et al. 2007). Scenarios like these register the presence of military violence—it is what makes them both possible and necessary—but as a temporal absence, banished to the past (a fire-fight) or postponed to the future (an air strike) to create a space for the non-kinetic and the humanitarian mission: the school and the clinic.

Third, *Tactical Iraqi's* Social Puppets and ICT's Virtual Humans invoke the interpersonal by making trust central to crosscultural interaction. In *Tactical Iraqi*, as Losh puts it, "trust is both the precondition of play and the currency of the game" (Losh 2005: 72). If the sergeant succeeds in gaining the trust of the local people they will cooperate and give him the answers he needs to advance in the game. A crucial part of doing so is observing the social formularies and protocols that establish the sergeant's knowledge of and respect for Iraqi culture (Losh 2005). In ICT's clinic scenario, trust is a function of shared goals, believable claims, and, again, ritual politeness. In a model dialogue, the clash between combat operations and the work of the NGO is made clear from the beginning. The doctor tells the captain: "This conflict is madness, it is killing people!" When the captain suggests "it will be a problem to stay here," the doctor replies: "You are the problem, your bombs are killing these people." As the dialogue develops, non-verbal behaviour changes to mirror the progress of negotiations. As in the Mission Rehearsal Exercises, promises made must be ones that can reasonably be kept: "The doctor is unlikely to be swayed by an offer of aid if he does not believe the captain can and will fulfil his commitments" (Core et al. 2006).

The cultural (re)turn

These developments represent significant departures from reductions of the city to target and terrain, and the cultural turn has been advertised as a "counter-revolution" in military affairs.

But there are also three continuities with its predecessors. The first is largely formal: the cultural turn is consistent with the neoliberal armature of late modern war in opening up new opportunities for private contractors. The new Mission Rehearsal Exercises have involved extensive outsourcing to provide role-players, instrumentation, and special effects, and the Pentagon has leveraged commercial videogames and entered into joint ventures with engineering and software companies, videogames companies, and the academy to develop its military simulations (Lenoir 2000). The other two continuities are substantive.

The cultural turn is consistent with the Orientalism that has underwritten the "war on terror" since its inception. In its classical form, Orientalism constructs "the Orient" as a space of the exotic and the bizarre, the monstrous and the pathological—what Said called "a living tableau of queerness" (Said 1978: 103)—and then summons it as a space to be disciplined through the forceful imposition of the order that it is presumed to lack: "framed by the classroom, the criminal court, the prison, the illustrated manual" (Said 1978: 41). Although the cultural turn softens these dispositions—part of its purpose is to displace the monstrous if not the pathological—it remains, like its governing military project, an inherently disciplinary programme in thrall to a martial Orientalism. This is strengthened by the constant citation of T. E. Lawrence ("Lawrence of Arabia"). The title of Nagl's (2005) book on counter-insurgency, *Learning to Eat Soup with a Knife*, is taken from a remark in Lawrence's *Seven Pillars of Wisdom*, and I doubt that it is a coincidence that the Human Terrain System is based on "seven pillars." Its lead authors describe Lawrence's writings as "standard reading for those searching for answers to the current insurgencies" (Kipp et al. 2006). The pre-deployment *Primer* dutifully reprints Lawrence's famous "27 Articles" (Wunderle 2007; Lawrence 1917); and, going one better, Kilcullen (2006b) titles his own seminal memorandum "28 Articles."

Lawrence is a totemic figure, a powerful representation of a close encounter with an other who remains obdurately Other. His talismanic invocation repeats the Orientalist gesture of rendering "the Orient" timeless: calling on Lawrence to make sense of modern Iraq is little different from expecting Mark Twain to be a reliable guide to twenty-first-century America. And yet the cultural turn places America outside history, too, because there is little recognition of the part that its previous interventions in the Middle East play in provoking opposition and resistance. In *Tactical Iraqi*, for example, Losh emphasizes that the avatars are "incapable of speech acts that are not scripted by the US military" and cannot ask awkward questions about US foreign policy or military operations (Losh 2005: 71). While the model dialogues in ICT's clinic scenario acknowledge American violence in the present ("Your bombs are killing these people"), these are prompts to provide a competing interpretation and do not register the long shadows cast over cultural memory by American violence in the past (Losh 2005: 71).

Finally, the cultural turn continues the exorbitation of cultural difference that is at the heart of the "war on terror." There is little room for Arab modern in most of its versions—hence the "traditional city" and "tribal society"—because Muslims or Arabs opposed to US foreign policy and its military adventurism are supposed to be outside and opposed to the modern. Where that leaves the rest of us who are also opposed to these things remains a mystery, but in fact the prospect of any sort of common ground between "us" and "them" is marginalized. The cultural turn acknowledges that there are cultural practices and values to be understood, but locates them in a completely separate space. Perhaps not surprisingly, the sense of alien estrangement is most vividly conveyed in Virtual Reality. Here is the project director of *Flat World* explaining its versatility:

> "In the morning you could be training in Baghdad, and in the afternoon you could be in Korea," she says. Or on Mars. One moment, the windows of FlatWorld look over a simulacrum of the Iraqi desert; when [she] dials in stereoscopic images from Pathfinder, the flood plain of Ares Vallis extends to the red

horizon . . . Suddenly a translucent 3-D rendering of a robot walks into the room, pauses in front of me, and walks back out. When a more sophisticated version of this 3-D projection is fortified with artificial intelligence and bathed in . . . virtual lighting, the mechanical invader will become a *Fedayeen* soldier.

(Silberman 2004)

Evidently it is not only the Command Post of the Future that enables Iraq to be visualized as if it were another planet. The emphasis on cultural difference—the attempt to hold the Other at a distance while claiming to cross the interpretative divide—produces a diagram in which violence has its origins in "their" space, which the cultural turn endlessly partitions through its obsessive preoccupation with ethno-sectarian division, while the impulse to understand is confined to "our" space, which is constructed as open, unitary, and generous: the source of a hermeneutic invitation that can never be reciprocated.

Therapeutic discourse and the biopolitics of counter-insurgency

These continuities matter not because nothing has changed—that is not my point at all—but because they speak directly to the politics of the cultural turn. Outsourcing has made the connections within the Military–Industry–Media–Entertainment more intimate, and this has materially assisted the packaging of the new military imaginary for public consumption. The new counter-insurgency doctrine and its emphasis on cultural awareness have been the subjects of a carefully staged media campaign, in which video clips and screenshots have played a key role in showing how troops are now trained to make sense of those "unconventional adversaries." This is part of a culturalism that presents Arabs as exotic, alien, radically other: as Matthew Yglesias puts it with exquisite irony, "because Arabs are horrified of shame, it's not a good idea to humiliate an innocent man by breaking down his door at night and handcuffing him in front of his wife and children before hauling him off to jail. Now it seems that Arabs are also so invested in honor that they don't like it when mercenaries kill their relatives" (Yglesias 2008). This is an artful gavotte between estranging and understanding the Arab other, and in performing this military two-step the US Army can claim to have learned from Abu Ghraib and the running battles over the treatment of detainees. Once those histories are superseded, so are the others, and if the role of invasion and occupation in provoking violence can be made to disappear, then the military can be repositioned as an innocent bystander in an ethno-sectarian conflict for which it bears no responsibility. Given its new reserves of cultural tact and cultural intelligence, the responsibility for continuing violence must lie with the Iraqis. Hence the move from *Newsweek's* cover of 15 October 2001—"Why they hate us"—to *Time's* cover of 5 March 2007: "Why they hate each other."

These manoeuvres are, I think, therapeutic for an American public disillusioned with the war, but the cultural turn treats the counter-insurgency strategy as therapeutic for Iraqis too. In fact, FM 3–24 describes the three stages of counter-insurgency in explicitly biomedical terms:

- **Stop the bleeding:** similar to emergency first aid for the patient. The goal is to protect the population, break the insurgents' initiative and set the conditions for further engagement.
- **Inpatient care—recovery:** efforts aimed at assisting the patient through long-term recovery or restoration of health—which in this case means achieving stability . . . through providing security, expanding effective governance, providing essential services and achieving incremental success in meeting public expectations

- **Outpatient care—movement to self-sufficiency:** expansion of stability operations across contexts regions, ideally using HN ["Host Nation"] forces.

(US Army 2006)

Similar metaphors reappear across the field of contemporary counter-insurgency. But the military project in Iraq is more than emergency triage, and the same military that once insisted "we don't do body counts" has become obsessed with them. These military plots of murders and executions in Baghdad resemble medical scans of the body politic in which ethno-sectarian violence is visualized as a series of tumours. When General Petraeus reported to Congress in September 2007 and again in April 2008, he superimposed similar displays over his base-maps and described ethno-sectarian violence as "a cancer that continues to spread if left unchecked" (Petraeus 2008).

This is an extraordinarily powerful rhetorical claim, in which the visual and the verbal registers work together to justify the most radical (and always supposedly "surgical") intervention: more killing to stop the killing. Like Nagl, however, I am interested in what these displays do not show: the deaths attributable to US air strikes and ground operations. For the cultural turn has not displaced other modes of waging war, and air strikes have in fact shot up in Afghanistan and Iraq since 2006. Seen thus, the cultural turn becomes part of a profoundly biopolitical strategy that counterposes the benign and the malignant. The benign is located in "our space," and its therapeutic interventions legitimize America's continuing presence within the "host nation" (another astonishing phrase), while the malignant is located in "their space." In short, these visual economies provide a different way of advancing the same strategy with which I began: fighting them "over there" so we don't have to fight them "over here."

References

al-Badrani, F. (2004) "US Bombards Fallujah Bastion," *The Age*, 7.

Barnard, A. (2004) "Inside Fallujah's War," *Boston Globe*.

Bauman, Z. (2001) "Wars of the Globalization Era," *European Journal of Social Theory*, 4: 11–28.

Beiser, V (June 2006) "Baghdad, USA," *Wired Magazine* 14(6).

Campbell, D. (2007) "Geopolitics and Visuality: Sighting the Darfur Conflict," *Political Geography*, 26: 357–82.

Chiarelli, P. and Michaelis, P. (2005) "Winning the Peace: the Requirement for Full-Spectrum Operations," *Military Review*, July–August. URL: http://www.army.mil/professional writing/volumes/volume3/october_2005/10_05_2.html (accessed 28 June 2008).

Chouliaraki, L. (2006) "The Aestheticization of Suffering on Television," *Visual Communication*, 5: 261–85.

Chow, R. (2006) *The Age of the World Target: Self-Referentiality in War, Theory and Comparative Work*, Durham: Duke University Press.

Core, M., Traum, D., Lane, C., Swartout, W, Gratch, J., van Lent, M., and Marsella, S. (2006) "Teaching Negotiation Skills Through Practice and Reflection with Virtual Humans," *Simulation*, 82: 685–701.

Coward, M. (2006) "Against Anthropocentrism: The Destruction of the Built Environment as a Distinct Form of Political Violence," *Review of International Studies*, 32:419–37.

Croser, C. (2007) "Networking Security in the Space of the City: Event-ful Battlespaces and the Contingency of the Encounter," *Theory and Event*, 10(2).

Cullaher, N. (2003) "Bombing at the Speed of Thought: Intelligence in the Coming Age of Cyberwar," *Intelligence and National Security*, 18:141–54.

DiMarco, L. (2004) *Traditions, Changes and Challenges: Military Operations and the Middle Eastern City*, Fort Leavenworth: Combat Studies Institute Press.

Duffield, M. (2008) "Global Civil War: The Non-Insured, International Containment and Post-Interventionary Society," *Journal of Refugee Studies*, 21: 145–65.

Filkins, D. and Burns, J. (2006) "Mock Iraqi Villages in Mojave Prepare Troops for Battle," *New York Times*, 1 May.

Gonzalez, R. (2008) "Human Terrain: Past, Present and Future Applications," *Anthropology Today*, 24: 21–6.

Graham, S. (2007) "War and the City," *New Left Review*, 44: 121–32.

—— (2008) "Robowar™ Dreams," *City*, 12: 25–9.

Grant, R. (2005) "The Fallujah Model," *Air Force Magazine*, February, 48–53.

Gregory, D. (2006) " 'In Another Time Zone, the Bombs Fall Unsafely': Targets, Civilians and Late Modern War," *Arab World Geographer*, 9: 88–111.

Gusterson, H. (2008) "The US Military's Quest to Weaponize Culture," *Bulletin of the Atomic Scientists*, 20 June.

Hamilton, J. (2006) "Battle-Hardened in California," *Hartford Courant*, 12 March.

Harris, C. (2006) "The Omniscient Eye," *Surveillance and Society*, 4: 101–22.

Harvey, D. (2003) *The New Imperialism*, Oxford: Oxford University Press.

Herbert, A. (2003) "Compressing the Kill Chain," *Air Force Magazine*, 86: 50–5.

Hollis, P. (2005) "The 1st Cav in Baghdad," *Field Artillery*, Sep–Oct, 3–8.

Kaldor (2006) *New and Old Wars: Organized Violence in a Global Era*, Cambridge: Polity Press.

Kaplan, R. (2006) "Hunting the Taliban in Las Vegas," *The Atlantic Monthly*.

Kenny, P., et al. (2007) "The More the Merrier: Multi-Party Negotiation with Virtual Humans," *Association for the Advancement of Artificial Intelligence Conference*. http://ict.usc.edu/projects/integrated_virtualhumans/C40.

Kilcullen, D. (2005) "Countering Global Insurgency," *Journal of Strategic Studies* 28: 597–617.

—— (2006a) "Counterinsurgency Redux," *Survival: Global Politics and Strategy*, 48: 111–48

—— (2006b) "28 Articles: Fundamentals of Company-Level Counterinsurgency," *Military Review*, May–June, 103–8.

—— (2007a) "Anatomy of a Tribal Revolt," 27 August, http://www.smallwarsjournal.com/blog.

—— 2007b, "Counterinsurgency in Iraq: Theory and Practice," http://www.smallwarsjournal.com/blog/2007/10/coin-seminar-summary-report.

—— 2007c "Religion and Insurgency," 12 May, http://www.smallwarsjournal.com/blog.

Kipp, J. et al. (2006) "The Human Terrain System: a CORDS for the 21st Century," *Military Review*. September–October, 8–15.

Laurent, A. (2007) "Virtually There," *GovernmentExecutive.com*. 17 October, http://www.govexec.com/story_page.cfm?filepath=/features/1007-01/1007-01na1.htm.

Lawrence T. E. (1917) "The 27 Articles of TE Lawrence," *Arab Bulletin*, 20 August.

Lenoir, T. (2000) "All But War is Simulation: the Military-Entertainment Complex," *Configurations* 8: 238–55.

Leopard, D. (2005) "Micro-ethnographies of the Screen: Flat-World," *FlowTV: A Critical Forum on Television and Media Culture*, 3, http://flowtv.org.

Losh, E. (2005) "In Country with *Tactical Iraqi*: Trust, Identity and Language Learning in a Military Video Game," *Digital Experience: Proceedings of the Digital Arts and Culture Conference*, Copenhagen.

Martin, R. (2007) *An Empire of Indifference: American War and the Financial Logic of Risk Management*, Durham: Duke University Press.

Mayo, M., Singer, M., and Kusumoto, L. (2006) "Massively MultiPlayer (MMP) Environments for Asymmetric Warfare," *Journal of Defense Modelling and Simulation*, 3: 155–66.

McFate, M. (2005a) "Anthropology and Counterinsurgency: The Strange Story of Their Curious Relationship," *Military Review*, March–April, 24–38.

—— (2005b) "The Military Utility of Understanding Adversary Culture," *Joint Force Quarterly*, 38: 42–48.

McFate, M. and Jackson, A. (2005) "An Organizational Solution for DOD's Cultural Knowledge Needs," *Military Review*, July–August, 18–21.

Münkler, H. (2005) *The New Wars*, Cambridge: Polity Press.

Nagl, J. (2005) *Learning to Eat Soup with a Knife: Counterinsurgency Lessons from Malaya and Vietnam*, Chicago: University of Chicago Press.

Nordstrom, C. (2004) *Shadows of War. Violence, Power and International Profiteering in the Twenty-First Century*, Berkeley: University of California Press.

"Operation Dawn: al Fajr; Brief Comments on Air Power in Urban Warfare" (2005) *Talking Proud*, 28 April. URL: http://www.talkingproud.us/Military042805D.html (accessed 25 July 2008).

Packer, G. (2005) *The Assassins' Gate: America in Iraq*, New York: Farrar, Straus and Giroux.

Peck, M. (2007) "Gaming Hearts and Minds," *Defense Technology International*, November, 14.

Petraeus, D. (2008) Report to Congress, 8–9 April.

Pickles, J. (2004) *A History of Spaces*, London: Routledge.

Rez, Guy (2007) "Simulated City Preps Marines for Reality of Iraq," National Public Radio, 13 April.

Ricks, T. (2007) "Officers with PhDs Advising War Effort," *Washington Post*, 5 February.

Said, E. (1978) *Orientalism*, London: Penguin.

—— (1993) *Culture and Imperialism*, New York: Knopf.

Scales, R. (2004) "Culture-Centric Warfare," *Proceedings of the Naval Institute*, 130. URL: http://www.military.com/NewContent/0, 13190,NI_1004_Culture-Pl,00.html (accessed 1 August 2008).

Shachtman, N. (2007) "How Technology Almost Lost the War," *Wired Magazine*, 15(12).

Silberman, S. (2004) "The War Room," *Wired Magazine*, 12(9).

Taw, J. and Hoffman B. (1994) *The Urbanization of Insurgency: the Potential Challenge to US Army Operations*, Santa Monica: RAND Corporation.

Tower, W. (2006) "Letter from Talatha: Under the God Gun," *Harper's Magazine*, January.

US Army (2006) "Field Manual 3–24: Counterinsurgency," §1–80, 1–125, A–45, 1–150.

Weber, S. (2005) *Targets of Opportunity: On the Militarization of Thinking*, New York: Fordham University Press.

Wunderle, W. (2007) *Through the Lens of Cultural Awareness: A Primer for US Armed Forces Deploying to Arab and Middle Eastern Countries*, Fort Leavenworth: Combat Studies Institute Press.

Yglesias, M. (2008) "Culture Clash," *Atlantic*, 5 May. URL: http://matthew-yglesias.theatlantic.corn (accessed 20 July 2008).

Zakaria, F. (2001) "The Politics Of Rage: Why Do They Hate Us?" *Newsweek*, 15 October. URL: http://www.newsweek.com/id/75606 (accessed 15 July 2008).

Lisa Parks

ZEROING IN: OVERHEAD IMAGERY, INFRASTRUCTURE RUINS, AND DATALANDS IN AFGHANISTAN AND IRAQ

TO "ZERO IN" MEANS TO AIM directly at a target, to direct one's attention to; focus on; concentrate on, to converge on, or close in on.[1] Zeroing in is an apt metaphor for the way citizen-viewers are positioned in relation to world events since they increasingly view them from the perspectives of militarized aerial and orbital machines. Such a claim is, of course, not new, and scholars such as Paul Virilio, Kevin Robins, and Jody Berland among others have explored how such aerial and orbital perspectives structure particular ways of engaging with the world.[2] What is new, however, is the frequency with which such overhead images now circulate in our global media culture. Once relegated to the TV weather report, such images have become commonplace in news media, and form the backbone of world-browsers like Google Earth. This proliferation is related to a combination of factors from the commercialization of the remote sensing industry to the gradual transformation of the Internet into a location-based web 3.0.

With its increased accessibility, overhead imagery has taken on heightened significance and functions in our media culture a variety of ways. First, and perhaps most obviously, it has become the establishing or master shot for many mediated news events and, like the world map before it, is used to orient the viewer/user in a global/local space of coverage. Second, the overhead image activates a desire for what it is not—a close up—and triggers a demand for more local or embodied views in contrast to its remote and abstract perspectives. This desire is typically gratified through technique of the digital zoom. Third, the overhead image has been used as a visual gimmick by TV news producers who are desperate to attract eyeballs in the competitive multichannel environment. One of the most glaring attempts to use overhead images to reinvent news aesthetics can be found in CNN's "magic wall."

Finally, and most germane to this chapter, the overhead image, I want to suggest, serves as a symptom of practices of power that Rey Chow delineates in her recent book *The Age of the World Target*. Building on the work of Heidegger and Virilio, Chow suggests, ". . . we may say that in the age of bombing, the world has also been transformed into—is essentially conceived and grasped as—a target. To conceive of the world as a target is to conceive of it as an object to be destroyed."[3] Rather than simply correlate the power to see with the power to destroy, Chow moves subtly from a discussion of a Hiroshima mushroom cloud photo, which she sees as an iconic moment for imagining the world as target, and proceeds to

describe and critique the emergence of "area studies" in academia, which developed after World War II in relation to US foreign policy, as a way of organizing and targeting the world for Western knowledge production. Chow defines the age of the world target as an time in which ". . . war and peace are coexisting, collaborative functions in the continuum of a virtualized world" and reminds us that, ". . . only the privileged nations of the world can afford to wage war and preach peace at one and the same time." [4]

Building on Chow's argument, I want to suggest that the overhead image is a particularly useful site for thinking through the idea of the world as a target, not only because of its strategic vantage point, but also because of its particular relation to knowledge practices and the materiality of communication. Technically speaking, the overhead image refers to image-data that has been acquired by instruments onboard aircraft or satellites, downlinked to earth stations, rendered by computer software, and, in some cases, composited for the purpose of representing, viewing, and analyzing particular sites or activities on earth. The production of the overhead image is made possible by a vast and largely invisible communication infrastructure, which, I would argue, undergirds the capacity to imagine the world as a target. Aircraft, satellites, and the imagery they generate, are all used to guide missiles, coordinate movement, and reorganize capital. Their "views from above" can be useful platforms for thinking about the production of knowledge and the materiality of communication because they draw attention to such issues as the weaponization and commercialization of frames and perspectives, the transformation of sovereign territories into navigable digital domains, and the accumulation and circulation of new forms of intellectual property.

Further, the overhead image provides an opportunity to think about knowledge practices and the materiality of communication in ways that do not rely exclusively upon the visibility of bodies or frames that are "purely representational." As I have argued elsewhere, satellite images can be used to bring (infra)structural processes and matters to the fore by intimating or revealing parts of systems or processes that are simply too vast for the frames, conventions, and capacities of modern media. [5] By using such views to zero in on the "infrastructural" we begin to notice that the materiality of communication is often designed to be invisible, whether submerged underground or underwater, blended in with the built environment, or situated beyond human perception. Perhaps ironically, then, the overhead image ultimately challenges us to recognize the limits of a "purely representational" frame.

The notion of the world target, the use of overhead imagery, and the question of infrastructure are all highly relevant to the US wars in Afghanistan and Iraq. In this chapter, I use the term "zeroing in" to conceptualize a series of knowledge practices and material conditions that have taken shape in relation to overhead imagery of Afghanistan and Iraq. My discussion moves from an analysis of declassified US overhead imagery of bombed communication infrastructure in Afghanistan and Iraq to a consideration of the "shutter control rule," designed to limited access to high resolution satellite imagery during times of war, and onto a discussion of the emergence of Google Earth and some of the controversies surrounding its use. In the process, I consider how overhead images simultaneously represent the world, or parts of it, as sites of scrutiny, destruction, and extraction. In other words, one overhead image may reveal a site to monitor, to destroy, and/or to develop (or redevelop). As this view figures the earth's surface as a target of observation, conquest, and development, it is commandeered in flexible economies of visual, military and corporate power, and in efforts to censor information and regulate interpretation. The destruction of communication infrastructure in Afghanistan and Iraq has occurred contemporaneously with the expansion of US satellite and aerial reconnaissance systems and global media platforms such as Google Earth, all of which have been used not only to document warfare in Afghanistan and Iraq, but to digitize and corporatize these countries' territories and model their futures.

Clear-cutting communication infrastructure

It is somewhat of a paradox that the first act of war when overthrowing authoritarian regimes with the intent to "democratize" them is the bombing of their communication infrastructures, especially given that parts of these systems have often been built with the aid, whether direct or indirect, of the US government or its allies. Nevertheless, the eradication of communication infrastructure has become a classic technique of modern warfare that has built within it the potential for the US government and multinational corporations to profit from the reconstruction of these systems during postwar periods.[6] US corporations have invested in the telecommunication and broadcast sectors of both Afghanistan and Iraq, annexing these territories into a US dominated global media economy. Such investments began even before the war started. As Michael Barker indicates, "In Iraq the allocation of media reconstruction grants started early, and more than a week before the US officially started bombing Iraq, the Pentagon gave a $15 million contract to Science Applications International Corporation to revive Iraq's national broadcasting system and convert it into a Coalitional Provisional Authority administered Iraqi Media Network."[7]

As bombs fell from the skies to destroy communication systems in Afghanistan and Iraq, leaflets promoting the promise of new TV and radio stations fluttered to the ground and civilians were targeted with information instructing them how and where to get their broadcast news from now on and directing them to coalition-run radio and television frequencies. One even addressed potential terrorists and featured a photo of a spy satellite reminding them, "We can see everything. Do not use nuclear, biological, or chemical weapons." Practices of leafleting and aircraft broadcasting were used to gradually transition viewers from systems of communication controlled by old regimes to ad hoc systems controlled by the US-led coalition. In addition to attacking the communication infrastructure and resources of the Taliban and Saddam Hussein, the US declared all satellite uplinks in war zones military targets, and consequently attacked the stations of transnational media corporations (such as Al Jazeera and Abu Dhabi) as well as foreign journalists working at the Palestine Hotel in Baghdad.

After the attacks on the communication facilities of the Taliban and Saddam Hussein regimes, the Pentagon released declassified overhead images of destroyed communication facilities to confirm the hits. These images may not have the same kind of symbolic power as the toppling of Hussein's statue, but they serve a similar discursive function in that they allow the viewer to zero in on the damage done to old regimes. Some of these images appeared in military press conference briefings and television news reports. They also were archived in the Image Intelligence gallery of the Federation of American Scientists website and the Globalsecurity.org website.[8] One dated October 10, 2001 shows a radio station in an unidentified location in Afghanistan. It features a compound inscribed with two yellow arrows pointing to charred areas on top of separate buildings. A second satellite image features one yellow arrow identifying a hit on a Taliban communications facility in Herat dated October 15. The arrow points to a dust bowl where nothing is left. Finally, another documents a strike on a Kabul RADCOM station dated October 22 and two yellow arrows identify the locations of facilities that appear to no longer exist.[9]

Similar satellite images of attacks on communication infrastructure in Iraq exist. Some of them were included in a National Security Archive report entitled "Eye on Saddam" published on April 30, 2003. The satellite images are not dated but presumably the data was acquired between March 20, 2003 and April 30, 2003. One of the frames includes pre and post strike images with five blue arrows in the post-strike view indicating areas that had been hit (see Figure 14.1). Several large dish receivers are visible as well as nearby buildings and a transmission tower. Neither the precise location of the site nor the date of the strike is specified. Pre and post-strike satellite image of the regime command and control facility at

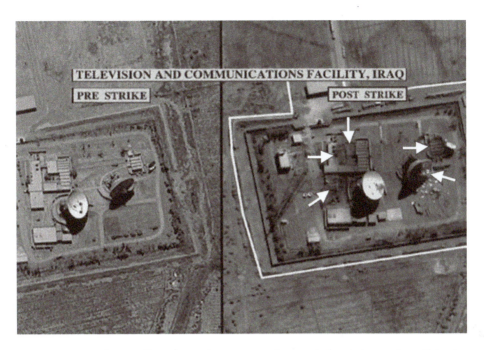

Figure 14.1 US military intelligence image featuring pre and post-strike views of an attack on a Television and Communications Facility in Iraq.

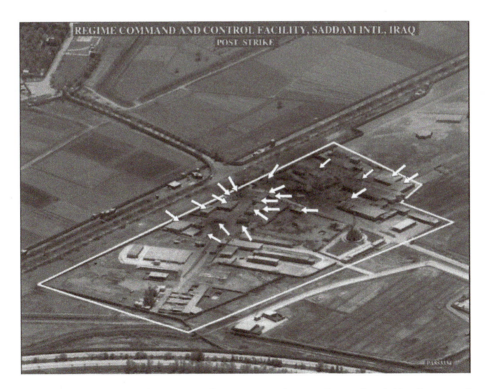

Figure 14.2 US military intelligence image featuring post-strike view of an attack on Saddam International Airport in Iraq.

Saddam International Airport were also released. The post-strike view features 26 blue arrows indicating different areas throughout the compound that have been hit (see Figure 14.2).[10] Another post strike image of a Command and Control Facility in Tikrit shows four arrows pointing to sites in three different buildings that had been bombed.

While there is a long history of photo intelligence interpretation that involves training experts to read and interpret overhead images, such practices and the authority associated with them have been challenged as these images have circulated more widely in mass media culture.[11] These overhead images of Afghanistan and Iraq not only position the citizen-viewer quite literally as reading the earth's surface as a target; they position Others' communications networks as sites to be destroyed. Each of the images is inscribed with arrows that point to sites that have been hit. Here the act of guiding missiles to targets is transposed with guiding acts of interpretation. The images embed arrows to "direct the look" and thus their public release not only circulates information, but also is designed to regulate acts of interpretation. This attempt to control interpretation has the effect of restricting the interrogative mode, which, I have argued elsewhere, could be used productively in relation to the abstraction and remoteness of satellite imagery, to trigger further inquiry about the status of the image, the satellite that acquired the image data, and the specificity of what lies below.[12] The arrows are positioned to allow an efficient or quick "read" and to lead the viewer to make rapid-fire assumptions about what the image represents. Such practices resonate with Nicholas Mirzoeff's discussion of the "weaponized image"—an image developed as a "carefully and precisely targeted tool" that is "designed in itself to do psychic harm."[13] Mirzoeff's complaint was that during the Iraq war, "So many images were being created that there was never time to pause and discuss any one in particular."[14] Such declassified images should always be examined with close scrutiny and skepticism, especially given the ways they have historically been used by US officials for political gain.

Satellite images are most useful when their abstraction compels closer engagement, critical inquiry, and self-reflexivity. For these overhead images reveal much more than the arrows suggest! We could add an arrow to the center of each of these images that points back at the sky, out to the object that lies at the end of the satellite image's reverse angle. This arrow would be placed, in other words, to direct attention to the satellites and orbital domains that have been organized to produce such a view in the first place. For what is effaced time and again in satellite images is the satellite itself. Thus the act of zeroing in on enemy targets on earth must be reversed so that when we look at satellite images, we also perform a conceptual look up and zero in on the satellite itself. In this case, such a look can be somewhat confounding since the satellites that acquire image data in the war theater are often classified US military satellites. It is nearly impossible for civilians to identify which satellites acquired the image data in these orbital views. We do know, however, that the US Defense Department spends $20 billion per year on its space programs and that there are an estimated 180 secret US reconnaissance satellites.[15] Some of them have in fact been photographed and "revealed" by amateur satellite photographers in Canada and Holland and by artist and experimental geographer Trevor Paglen in the US. These photos of what Paglen calls the "Other Night Sky" serve as a crucial intervention that, among other things, sets out to visualize and publicize the secret technologies that US citizens subsidize yet are not supposed to know about.[16] Thus, even as these satellite images zero in on destroyed communication facilities on earth, they implicitly point us back to a secret and extensive system of global satellite reconnaissance in orbit. At the same time, they expose other structural patterns of modern warfare such as US strategies to clearcut Afghani and Iraqi communication infrastructures and replace them with new ones that are built by US contractors and that conform to US technical standards, a pattern that played out during the recent war in Yugoslavia as well.

From shutter control to Google Earth

In 2000 the Departments of Commerce, State, Defense, Interior and members of the Intelligence community signed an inter-agency memorandum called the Shutter Control Rule. The rule authorizes the US Government to shut down US commercial remote sensing operators whenever national security concerns dictate, such as in times of armed conflict. This capability is deemed of great importance to military operations as it ensures that high-resolution imagery depicting US military maneuvers, facilities and personnel locations will not be made available to the general public by US satellite operators.[17] Commercial remote sensing operators, journalists and humanitarian organizations objected to the rule for various reasons. Satellite operators asserted that the conditions for implementation were vague, that there were no clear guidelines as to when shutter control may be invoked, and that the rules could damage the business of the remote sensing industry.[18] Journalists argued that shutter control violated the First Amendment of the US Constitution.[19] Early on Barbara Cochran, president of Radio Television News Directors Association, called the rule "unconstitutional, a violation of the First Amendment right of the press to publish or broadcast without government interference. . . ."[20] She went on to argue that with the use of satellite images, "stories can be more accurate and truthful and can give the public access to geographic areas that are politically inaccessible or too expensive to get to."[21] Cochran further claimed that government exercise of shutter control "constitutes prior restraint of publication of the image" in that it was a government action that would prevent important communication from reaching the public.[22] Finally, humanitarian organizations that use satellite images in relief efforts objected to the shutter control rule on the grounds that it would slow down the process of getting aid to those who need it.[23]

Given the various objections and the threat of constitutional litigation, the US government has been reticent to officially exercise shutter control. In October 2001, however, as the US military prepared to attack the Taliban in Afghanistan, a private Pentagon firm called the National Geospatial Intelligence Agency entered into a contract with Space Imaging Corporation that allowed the agency exclusive access to all of its Ikonos satellite imagery of Afghanistan. The US government paid $2 million per month for three months of exclusive access to the imagery.[24] By purchasing exclusive rights of access to Ikonos images for a short term, the US government transformed shutter control into a financial transaction, and denied news agencies grounds to sue the federal government for violating the first amendment. This act of "checkbook shutter control" blocked news agencies and humanitarian organizations from accessing commercial satellite images of Afghanistan during the first three months of the war, whether to conduct independent investigations of war casualties, or to provide assistance to displaced persons and refugees throughout the region.[25]

After January 2002 when the exclusive licenses expired, Space Imaging made Ikonos satellite images of Afghanistan commercially available. And in a matter of years Afghanistan went from being a highly guarded and secured information space to one in which its territories, imaged from orbital and aerial platforms, suddenly became digitized lands for anyone to navigate. Indeed by 2005 the entire territory of Afghanistan was available as a composite of satellite and aerial imagery in Google Earth and had become datalands for sale. One contributor to these composites is the US company Digital Globe, owner of the QuickBird satellite. Digital Globe licenses images to Google for use in the Google Earth database. The company also uses Google Earth as a platform for selling satellite images of Afghanistan (and other countries around the world) to private parties. At the interface, color-coded squares and DG icons appear in the visual field. The color-coded squares (sometimes called scene footprints) function as traces of a satellite's pass over a specific part of the earth. When composited, as in Figure 14.3, they form a historical record of satellite image data acquisitions and feature a slice of Digital Globe's inventory. Clicking on a DG icon opens a frame with data about the

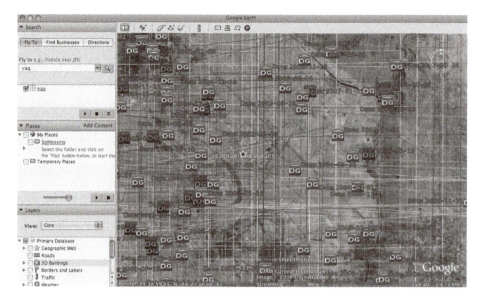

Figure 14.3 Screen capture of Google Earth revealing the landscape of Iraq as a digital, navigable landscape for (re)development or sale by companies such as Digital Globe and Google.

image including the acquisition date, cloud cover, and an environmental quality rating. If the user clicks on "preview," she enters a meta-browser featuring the single satellite image captioned with information about how to purchase it or others from Digital Globe.

The US may have restricted access to satellite imagery of Afghanistan for three months in 2001, but now it allows Google, Digital Globe and Space Imaging to conduct an international business that turns Afghani and Iraqi territories (as well as those of other countries) into intellectual property produced, owned and distributed by US corporations. This is symbolically reinforced by the inscription of their brand names within Google Earth's mediascapes. Just as the leveling of communication infrastructure provided opportunities for US contractors to restructure and rebuild Afghan and Iraqi broadcast and telecom systems, the Google Earthing of Afghanistan and Iraq is designed to boost the business potentials and profits of US companies as the satellite image has been used both to showcase the eradication of Taliban and Hussein communication systems and as a platform upon which to imagine, design and map new ones. This is vividly demonstrated by an Open Source Center layer called Media Mapping, Iraq, which uses Google Earth to visualize the plethora of television and news networks that have emerged in Iraq in the midst of the ongoing war, many of which are owned by outsiders. Interestingly, the introduction page to this layer warns that this map "is not intended for targeting. The accuracies of the project were created from coarse data."

In fact, other Google Earth images *have* been used for targeting by insurgents and terrorists. Since the application first emerged in 2005 leaders from the UK, Netherlands, Morocco, South Korea, India, Australia and Israel among others have argued that these "interfaces to the planet" arouse serious concerns about national sovereignty and can be used by terrorists or others to organize attacks on facilities in their countries. Indian President A.P.J Abdul Kalam complained that such open source intelligence is a problem for developing countries. He showed satellite and aerial images of sensitive sites in India available online to local police officers suggesting they could be used by terrorists or Pakistanis who have had tense relations with India.[26] In 2005 Australia complained that its Lucas Heights nuclear reactor and Garden Island military installation were visible and could be easily targeted by terrorists.[27] The South Korean government has indicated the locations of its military installations and the Presidential Blue House are identified in Google Earth and could be used

by North Korea.[28] In the US, state and federal officials make regular requests for certain areas to be censored and there are many areas that are blurred or covered with colored blocks.[29] In 2009 a California assemblyman introduced legislation designed to blur "soft targets" throughout the state including schools, hospitals, churches, and government buildings in an effort to protect them from "terrorists."[30] In response to such concerns, Google has censored certain facilities represented within Google Earth by blurring them.[31] The company has blurred sites in India, Kosovo, the Netherlands, and New York.[32] Shutter control thus has shifted from being a state decision to a financial transaction to a digital effect.

Despite this practice of blurring, Google Earth and Google Maps have been used by groups ranging from insurgents in Iraq to terrorists in Mumbai.[33] In January 2007 Iraqi insurgents allegedly used Google Earth print outs in an effort to orchestrate attacks on British coalition soldiers stationed there. As the British *Telegraph* reported, "Documents seized during raids on the homes of the insurgents . . . uncovered print-outs from photographs taken from Google. The satellite photographs show in detail the buildings inside the bases and vulnerable areas such as tented accommodation, lavatory blocks where lightly armoured Land Rovers are parked."[34] Amidst reports that Google Earth images were being sold to rogue militias at a market place in Basra, British soldiers said they would consider suing Google if injured by mortar rounds that had been directed on the camp because of Google Earth views.[35] Google responded to the incident by changing images of this area in the Google Earth database. These changes were discovered after a "forensic examination" conducted by Stefan Geens, who showed in the online journal *Ogle Earth* that Google in fact replaced newer imagery showing impact craters and army installations with older ones pre-dating the war.[36]

Google has claimed that it avoids altering satellite images and alleges that this practice is conducted by satellite image companies before they are submitted to Google.[37] Yet in 2007 John Hanke, director of Google Earth and Maps explained, "Google has engaged, and will continue to engage, in substantive dialogue with recognized security experts and relevant agencies worldwide. While we're unable to provide details of these discussions, the dialog may, in some rare cases, result in a change of image availability."[38] There have been so many Google Earth images "censored" that a user community has formed to track them and uses blue shading to highlight obscured areas.[39] Lists of censored sites also are available on wikipedia and abound in the press.[40]

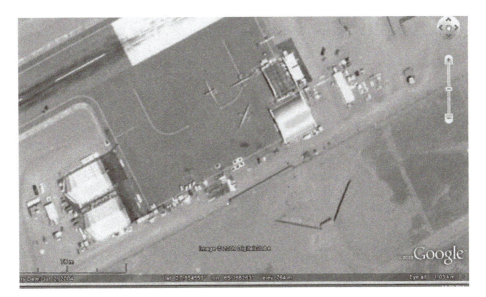

Figure 14.4 Screen capture from Google Earth allegedly revealing three predator drones at a CIA base in Shamsi, Pakistan.

While it may seem that Google Earth's emergence conflicted with the logic of shutter control by making high resolution satellite images available to the global public during a time of war, I want to suggest that Google's "patchwork censorship" represents the neoliberal outsourcing and digitization of shutter control and acts of state diplomacy. Now commercial satellite operators and Google engage directly with states and determine whether to quietly restrict access to or doctor satellite images in their possession. Because of the enormous volume of satellite image data in Google Earth, these censorship practices are often noticed only by chance or when there is a major news event. In February 2009 the politics of shutter control came full circle when a secret CIA base in Shamsi, Pakistan reportedly being used to stage the monitoring and bombing of Al Qaeda targets near the Afghan-Pakistan border was exposed in Google Earth (see Figure 14.4). The international community, and Pakistanis in particular, questioned the US government about the base, but received no confirmation and the satellite image was rapidly replaced.[41] Such are the practices of the age of the world target: when the CIA's military violence and Google Earth's digital "peacekeeping" are conducted collaboratively and in the window of a virtualized world.

Conclusion

I want to close with three points: first, for every satellite view we need to conceptualize or imagine a reverse shot that would lead us to investigate the orbital location, history, and ownership of the satellite that gathered the image data. This is a call for a vertical and techno-reflexive way of writing history and conducting analysis, one that accounts not only for players, events and objects on earth but for the multitude of powerful objects and operations that surround the planet and shape relations upon it, a call for greater critical awareness of the vertical space that stretches from the earth's surface, through the atmosphere and ionosphere, and into the low, medium, geostationary and supersynchronous orbits that satellites occupy.

Second, the destruction of communication infrastructures is not only an attack on the central nervous system of authoritarian regimes; it is a bellwether for postwar nation-building projects engineered to support US economic and geopolitical interests. The satellite image provides a window onto such processes not just by spotlighting and confirming the moment of destruction but by challenging us to ask what will follow. That is to say, the satellite image intimates and anticipates futures as much as it reveals presents or pasts. Since it is also laden with strategic power, its use challenges us to look beyond the arrows of the Defense Department and continually ask how can satellite images be used to produce knowledge in ways that are not warfare's accomplice?

Finally, the politics of Google Earth are complex and the issues of sovereignty it raises date back further than the age of the Internet and relate to various international treaties and the legal definitions of the nation-state as well as extra-territorial domains such as the spectrum, the air, orbit and the oceans. There is a long history of US attempts to assert ownership and control over these extra-territorial domains—and this is manifest in what I have discussed not only in its claims to restructure the electromagnetic spectrum of and for others, but also in the process of using aero-orbital space to turn the national territories of all countries, oceans and skies into datalands either for sale or for censorship by US corporations (even Hiroshima bombing polluted the atmosphere). The political effects of Google's worlding maneuvers—a company's whose motto is "don't be evil"—are yet to be fully assessed. Suffice it to say that the power to represent the earth in this way is an enormous power that needs to be evaluated most carefully in the age of the world target—in a time where the US exercises the privilege to wage war and preach peace at one and the same time.

Notes

1 These are verb phrases associated with "zero" listed at Dictionary.com, http://dictionary.reference.
 com/browse/zeroing+in, accessed April 6, 2011.

2 Paul Virilio, *Strategy of Deception* (London: Verso, 2001); Kevin Robins, *Into the Image: Culture and
 Politics in the Field of Vision* (London: Routledge, 1996); and Jody Berland, "Mapping Space," in *North
 of Empire* (Durham, NC: Duke University Press, 2009), 242–72.

3 Rey Chow, *The Age of the World Target: Self-Referentiality in War, Theory, and Comparative Work* (Durham,
 NC: Duke University Press, 2006), 31.

4 Ibid, 38.

5 Lisa Parks, "Digging into Google Earth: An Analysis of 'Crisis in Darfur,' " *Geoforum*, Vol. 40: 4, July
 2009, 535–45.

6 See, for instance, Michael Parenti, "The Rational Destruction of Yugoslavia," Nov. 1999, www.
 michaelparenti.org/yugoslavia.html, accessed April 6, 2011; Parenti, *To Kill A Nation* (London:
 Verso, 2001); and Lisa Parks, "Postwar Footprints: Satellite and Wireless Stories in Slovenia and
 Croatia," in *B-Zone: Becoming Europe and Beyond*, Anselm Franke (ed.) (Barcelona: Actar Press, 2005),
 306–47.

7 Michael J. Barker, "Democracy or Polyarchy? US-funded Media Developments in Afghanistan and
 Iraq post 9/11," *Media, Culture and Society*, Vol. 30 (1): 109–30, 119.

8 See for instance overhead images of US attacks on Darunta Camp Complex here http://www.
 globalsecurity.org/military/world/afghanistan/darunta.htm, accessed April 12, 2011; and over-
 head images of US attacks on Bagram Airbase at http://www.globalsecurity.org/military/world/
 afghanistan/bagram-imagery.htm, accessed April 12, 2011.

9 These images are archived in the image intelligence gallery of the Federation of American Scientists,
 http://www.fas.org/irp/imint/afghan.htm, accessed July 5, 2005.

10 These images are included in this report: Jeffrey Richelson (ed.) "Eyes on Saddam: Overhead Imagery
 of Iraq," National Security Archive Electronic Briefing Book No. 88, April 30, 2003, http://www.
 gwu.edu/~nsarchiv/NSAEBB/NSAEBB88/, accessed April 12, 2011.

11 Histories of photo intelligence interpretation.

12 Lisa Parks, *Cultures in Orbit: Satellites and the Televisual* (Durham, NC: Duke University Press, 2005),
 96–107.

13 Nicholas Mirzoeff, *Watching Babylon: the War in Iraq and Global Visual Culture* (London: Routledge,
 2005), 73–4.

14 Ibid, 74.

15 "US Pursuing New Spy Satellite Program," *Geopolitical Monitor,* December 3, 2007, http://www.
 geopoliticalmonitor.com/us-pursuing-new-spy-satellite-program-084/, accessed April 5, 2011.

16 Trevor Paglen, The Other Night Sky art exhibition, Berkeley Art Museum, 2008. Also see "The
 Other Night Sky," Trevor Paglen's website, http://www.paglen.com/pages/projects/other_
 night/index.html, accessed April 6, 2011.

17 Raphael Prober, "Shutter Control: Confronting Tomorrow's Technology with Yesterday's
 Regulations," *Journal of Law and Politics,* Spring 2003. Also see James Keeley and Robert Huebert (eds),
 Commercial Satellite Imagery and United Nations Peacekeeping: A View From Above (London: Ashgate, 2004).

18 For a broad discussion of the implications of shutter control see Ann M. Florini and Yahya Dehqanzada,
 "Commercial Satellite Imagery Comes of Age," *Issues in Science and Technology* 16.1, Fall 1999,
 http://www.issues.org/16.1/florini.htm, accessed April 5, 2011.

19 Cheryl Arvidson, "Journalists denounce government 'shutter control' idea for satellite images,"
 March 17, 2000, *The Freedom Forum Online* http://www.freedomforum.org/templates/document.
 asp?documentID=11944, accessed April 6, 2011.

20 Barbara Cochran, "Fighting the Feds Over Shutter Control," *Communicator,* December 1999, 113–15,
 http://www.rtdna.org/pages/media_items/fighting-the-feds-over-shutter-control210.php,
 accessed July 3, 2008.

21 Ibid, 113.

22 Ibid, 113–15.

23 See Jessica Altschul,"Commercial Satellite Imagery Poses a Challenge to Pentagon Planners,"
 February 28, 2002, GlobalSecurity.org website, http://www.globalsecurity.org/org/
 news/2002/020228-eye.htm, accessed April 6, 2011.

24 Joan Johnson-Freese, *Space as a Strategic Asset* (New York: Columbia University Press, 2007), 112.

25 Katherine Shrader, "Curbs on Satellite Photos May be Needed," *San Francisco Chronicle* May 8, 2007,
 accessed July 3, 2008; David Corn, "Their Spy in the Sky," *The Nation,* November. 8, 2001, available
 at http://www.thenation.com/doc/20011126/corn, accessed July 4, 2008. Duncan Campbell,

"US Buys Up All Satellite War Images," *The Guardian,* October. 17, 2001, http://www.guardian.co.uk/world/2001/oct/17/physicalsciences.afghanistan, accessed April 6, 2011.

26 Barry Levine, "Does Google Earth Reveal Military Secrets?" *News Factor Network,* June 27, 2006, available at http://www.globalsecurity.org/org/news/2006/060627-google-earth.htm, accessed April 6, 2011.

27 Karen Barlow, "Google Earth Prompts Security Fears," *ABC Online,* August. 8, 2005, http://www.abc.net.au/news/indepth/featureitems/s1432602.htm, accessed July 3, 2008. Also see Jano Gibson, "Lucas Heights nervous about Google gander," *Sydney Morning Herald,* http://www.smh.com.au/news/technology/lucas-heights-nervous-about-google-gander/2005/08/08/1123353245458.html, accessed April 6, 2011.

28 "Google Earth Mapping Service Draws Complaint from South Korea," *The New York Times*, September 1, 2005, http://www.nytimes.com/2005/08/31/technology/31iht-google.html, accessed April 6, 2011; Lester Haines, "South Korea Throws Strop at Google Earth," *The Register,* August 31, 2005, http://www.theregister.co.uk/2005/08/31/google_earth_korea/, accessed April 6, 2011.

29 Verne Kopytoff, "Top Secret, in Plain View: Google Earth May blur the Image, but others don't," *San Francisco Chronicle,* May 18, 2007, http://www.sfgate.com/cgi-bin/article.cgi?f=/c/a/2007/05/18/GOOGLE.TMP, accessed July 3, 2008.

30 Miguel Helft, "California Lawmaker Wants Online Map Images Blurred," *The New York Times*, March 3, 2009, http://bits.blogs.nytimes.com/2009/03/03/california-lawmaker-wants-online-map-images-blurred/, accessed April 6, 2011.

31 John Byrnes, "Google increasingly compliant with Censorship requests: US Intelligence Report," *the raw story,* August 26, 2008, http://rawstory.com/news/2008/google_Earth_compliant_with_government_requests_0826.html, accessed April 6, 2011.

32 "Google Earth to Blur Key India Sites," SpaceDaily.com, February 4, 2007, http://www.spacedaily.com/reports/Google_Earth_To_Blur_Key_India_Sites_999.html, accessed April 6, 2011. Philip Lenssen, "Google to Censor India Satellite Imagery," *blogoscoped.com*, February 4, 2007, http://blog-oscoped.com/archive/2007-02-04-n63.html. Also see Frank Patalong, "Das zensierte Weltauge," Spiegel.online, February 4, 2007, http://www.spiegel.de/netzwelt/web/0,1518,464186,00.html, accessed April 6, 2011.

33 Damien McElroy, "Mumbai attacks: surviving terrorist says he belonged to Pakistan militant group," *The Telegraph,* November 30, 2008, http://www.telegraph.co.uk/news/worldnews/asia/india/3537203/mumbai-attacks-surviving-terrorist-says-he-belonged-to-Pakistan-militant-group.html, accessed April 6, 2011.

34 Thomas Harding, "Terrorists Use Google Maps to Hit UK Troops," *The Telegraph,* January 13, 2007, www.telegraph.co.uk/news/worldnews/1539401/terrorists-%27use-Google-maps-to-hit-UK-troops%27.html, accessed July 1, 2008; "Google Earth, Insurgents' Friend?" defensetech.org, January 13, 2007, www.defensetech.org/archives/003163.html, accessed July 1, 2008.

35 Thomas Harding, "Terrorists Use Google Maps to Hit UK Troops," *The Telegraph*, January 13, 2007, www.telegraph.co.uk/news/worldnews/1539401/terrorists-%27use-Google-maps-to-hit-UK-troops%27.html, accessed July 1, 2008. There were also reports that the GE images were being sold to rogue militias at a market place in Basra.

36 Stefan Geens, "Did Google Censor Basra Imagery?" Ogle Earth, January 14, 2007, www.ogleearth.com/2007/01/did_google_cens.html, accessed July 1, 2008. For further challenges to the Daily Telegraph report see Stefan Geens, "Basra: Daily Telegraph has no clue," Ogle Earth, January 20, 2007, http://ogleearth.com/2007/01/basra-new-daily-telegraph-article-has-no-clue/, accessed April 6, 2011; also see Noel Jenkins, "Terrorists read Ogle Earth not the Daily Telegraph," Juicy Geography's Google Earth Blog, January 14, 2007, www.juicygeography.co.uk/blog/?p=99, accessed July 1, 2008.

37 http://www.slate.com/id/2205755/.

38 Verne Kopytoff, "Top Secret, in Plain View: Google Earth May blur the Image, but others don't," *San Francisco Chronicle,* May 18, 2007, http://www.sfgate.com/cgi-bin/article.cgi?f=/c/a/2007/05/18/GOOGLE.TMP, accessed July 3, 2008.

39 Verne Kopytoff, "Top Secret, in Plain View: Google Earth May blur the Image, but others don't," *San Francisco Chronicle,* May 18, 2007.

40 See "Satellite map images with missing or unclear data," Wikipedia, http://en.wikipedia.org/wiki/Satellite_map_images_with_missing_or_unclear_data, accessed April 12, 2011; or "Google Earth Cool Places—Censored Stuff," http://www.googleearthcoolplaces.com/censored.php, accessed April 11, 2011.

41 Jeremy Page, "Google Earth Reveals Secret History of US Base in Pakistan," *The Times*, February 19, 2009, http://www.timesonline.co.uk/tol/news/world/asia/article5762371.ece, accessed April 11, 2011.

Trevor Paglen

WHAT GREG ROBERTS SAW: VISUALITY, INTELLIGIBILITY, AND SOVEREIGNTY—36,000KM OVER THE EQUATOR

DSP-F23 WAS A ZOMBIE. After a year in a geostationary orbit over the West African coast south of Nigeria and west of Gabon, the newest satellite in the Defense Support Program (Flight 23) had lost its ability to point its solar array towards the sun, had powered down, and become like a ship without a mast, drifting through the blackness of space. Launched in late 2007, DSP-F23 was designed to detect and track the plume from missile launches, nuclear explosions, and other thermal sources using a suite of highly sensitive infrared sensors. By 2008, it was a two and a half ton hunk of metal and dead electronics.

The drifting would be a problem. The dead spacecraft's corpse might collide with communication satellites along the crowded geostationary belt, which could wreak all sorts of havoc on the world below: television and radio stations might go blank, credit card transactions could die, and telephone and internet connections might switch off. Of course, these outages would be temporary. TV stations and telephone feeds could be re-routed through other satellites in a matter of days, if not hours, but the drifting wouldn't stop. Geostationary orbits don't decay, so the lifeless satellite would glide through the geostationary belt forever, posing a permanent threat to active communications satellites. Complicating matters was the fact that DSP-F23 was a secret satellite. The American military would be loath to talk about the spacecraft at all, let alone make its location public.

An amateur satellite observer in Cape Town, South Africa, first broke the news. This is a story about a satellite observer named Greg Roberts, the American military, and the intertwined politics of vision and domination playing out in a thin ring of spacecraft parked above the Earth's equator. It's a story about how the political geographies that structure our everyday lives are becoming more and more abstract, and about how new forms of domination arise in the gaps and limits of our everyday perception. And it's a story that comes full circle, back to the satellite observer in Cape Town, whose particular practice of "minoritarian empiricism" may provide a basis for understanding new relationships between technology, warfare, and state power.

I met Greg Roberts at his home in suburban Cape Town in February 2010. He'd invited me to visit him and to spend the evening looking at secret satellites parked over the eastern hemisphere. After a light dinner, the sun began to set and he led me into his backyard. Old six-foot antenna and satellite dishes were lined up against the side of the house, and a thick

Figure 15.1 The Geostationary Belt. Image courtesy of Trevor Paglen.

steel telescope mount was lodged in the middle of the grass. A tangle of cables snaked from the mount into the home-made control room in an old shed. We went in. Roberts set about booting up computers and flipping the power switches on a rack of scientific equipment. The first thing to do was set the time.

It's a crucial part of the process—forget to set the time, or fail to do it exactly right, and—at best—the evening's observations are useless. At worst, you might pass along bad data to other observers and waste not only your time, but theirs as well. Roberts proceeds with the patience and accuracy from a lifetime of astronomy. He loads a floppy disk with homemade software into the IBM 386 computer, and an antenna outside pulls exact time data off a GPS satellite. An oscillator beeps methodically, like a heart monitor in an operating room. All of the equipment has to be synchronizing to the master GPS time. One by one, each new component comes online with a second pulse. The beeps are out of phase until Roberts presses a button or turns a knob, bringing the syncopated rhythm into a single beat. The time is set. We're ready to begin.

He's been doing this for a long time. Roberts caught the astronomy bug at ten years old, when a friend's father sold him a cheap 2.5 inch refractor telescope. At school, he studied engineering to please his family but was distracted by his passion for the night sky. He founded the University of Natal Rocket Society and Research Group while a student, and was involved in a number of amateur rocket launches. A few years after earning a degree in physics and chemistry, Roberts landed a job at the former Union Observatory in Johannesburg, managing NASA's International Planetary Observing Program. From there, he went to the Royal Observatory in Cape Town. But his passion has always been for one of the more peculiar corners of amateur astronomy: tracking satellites. In particular, secret satellites. Satellites that, for official purposes, "aren't there," but which can be seen by the hundreds on any given night, provided you know what you're looking for, and how to look.

It began, in a sense, with ECHO-1. The 100 ft Mylar "balloon" satellite, launched in 1960, was easily visible to the unaided eye as it rose from one horizon, travelled overhead, and set on the opposite horizon. After ECHO's launch, a Durban newspaper published predicted rise and set times for the spacecraft for the following three days. Roberts dutifully went out each night to observe the spacecraft. On the first two nights, ECHO rose and set just as predicted. On the third night, it failed to show up. Roberts was puzzled and interested. He wanted to know why the prediction had been inaccurate, which meant learning about orbital mechanics, satellite prediction and the like. This was far more interesting than the calculus he was supposed to be learning at school. Soon he was making nearly 3,000 satellite observations from his balcony each month, had joined MOONWATCH and the Western Satellite Research Network, and taken up radio satellite observing—"observing" satellites by intercepting their rocket telemetry, transponders, and other signals.

Before long, Roberts was using his radio skills to download photographs off Soviet weather satellites. That's when a knock on the door came: the South African Military intelligence and South Africa's Bureau of State Security—their version of the CIA and FBI—who were infamous for placing agents in black communities, monitoring dissidents, and assassinating perceived threats to the regime. They'd heard about his work and wanted to recruit him. Roberts declined their offer and a subsequent one from another "government organization" interested in someone who could track and eavesdrop on satellites. But he kept pursuing his hobby.

Since retiring from the Royal Observatory in 1999, Roberts has become one of the most prolific observers among the handful of hobbyist satellite watchers. Loosely referring to themselves as "the Group," they congregate and share observational data on a listserv called "SeeSat-L." Among members of the Group, some of whom conduct their nightly observations using little more than a good pair of binoculars as a stopwatch, Roberts is one of the most high-tech. The shelves of the tool-shed-cum-observatory behind his house in suburban Cape Town are lined with the books of the trade: "Fundamentals of Celestial Mechanics," "The Radio Amateur's VHF Manual," the "Voltage Regulator Handbook," and "Celestial Objects for Common Telescopes." The observatory's heart is an array of computers of various vintage: his old IBM 386 is loaded with a piece of DOS-based software, called Cosatrak, which Roberts wrote to control the home-made mount (fashioned from an old Bausch and Lomb artillery device) standing squarely in the middle of his back yard. Depending on the job at hand, Roberts can install any combination of telescope equipment on the mount: a Skywatcher telescope using a Meade DSI Pro 2 astronomy camera and with a home-made focal reducer crafted from a binocular lens, or a Mintron low-light video camera attached to a Nikon camera lens. The backyard is littered with antennas and cables for radio observing.

After about fifteen minutes of set up time, Roberts launches a program called Maxim DL on his "observing" computer, and gets the black and white image from his low-light camera up on the screen. The weather isn't optimal. Every few seconds, cloud wisps ease through the frame and brighten the overall image, but there's still plenty to see.

The first satellite on our evening's agenda is something called MENTOR-2, an eavesdropping satellite in geosynchronous orbit. But Roberts doesn't use "proper" names when he talks about satellites. For him, MENTOR-2 is simply "object 25336," the spacecraft's catalog number. MENTOR-2 most distinctive characteristic is an umbrella-shaped antenna the size of a football field; if it were in a lower orbit, it would easily be one of the brightest objects in the night sky. But at an altitude of about 35,786km (about three thousand times higher than a commercial airplane), it shows up as a faint star-like dot through a telescope. But not tonight."25336" is missing. "Either the drift rate Ted calculated is wrong, or the satellite has sped up or slowed down," Roberts explains. "Ted" is Ted Molczan, a satellite observer and analyst based in Toronto, one of Roberts' longtime collaborators and interlocutors.

Our next stop in the sky is object number "90085"—a leftover Centaur rocket body stranded in a Geostationary Transfer Orbit from a classified launch in 1990. From there, Roberts changes the tracking settings on his computer and we watch DMSP-F18, a military weather satellite, cruise in a long, slow arc across the entire sky. We finally turn our attention to a spacecraft called "PAN" a communications-type spacecraft launched in late 2009, and currently parked in a geostationary orbit over Kenya near a cluster of civilian communication satellites. It's a particularly strange object because no federal agency has claimed it. Even the most secret eavesdropping and imaging satellites usually have an "NROL" designation indicating a "National Reconnaissance Office Launch." PAN has none. Among aerospace researchers, rumor has it that the mysterious acronym "PAN" stands for "Pick a Name."[1]

Greg Roberts has spent most of his life observing and cataloging satellites, but observing spacecraft in geostationary orbit is relatively new. The main problem with observing these satellites is that they're almost impossibly faint. Whereas a satellite in low earth orbit circumnavigates the earth at an altitude of between 200 and 2000km, geostationary satellites are much, much higher. The exact distance is important: at an altitude of 35,787km above the earth's equatorial plane, a satellite circles the earth once every 24 hours. Because the Earth itself rotates once every 24 hours, spacecraft in this orbit remain fixed above a particular point along the equator. This is the importance of the geostationary orbit: with occasional small corrective maneuvers, a spacecraft is able to indefinitely "dwell" over a particular point over the equator. A communications spacecraft in geostationary orbit is like a cell phone tower tall enough to reach more than a third of the earth's surface. But they're exceptionally difficult to see.

Satellites in lower orbits are readily visible. An imaging satellite, for example, at an altitude of several hundred kilometers is visible to the unaided eye at around magnitude 3 on the astronomical brightness scale, about as bright as the stars in the Big Dipper. But brightness follows the inverse-square law: satellites become logarithmically fainter as their distance from Earth increases. At 35,786km, a satellite's apparent magnitude will typically be between 10 and 13. These magnitudes are far beyond what most amateur telescopes can readily detect—satellites in geostationary orbits can be nearly as faint as the former planet Pluto (magnitude 14). Not easy to observe, to say the least.

Beginning in the mid 1990s, some amateur observers began pointing their telescopes towards these faint spacecraft. By the mid-2000s, low-light digital cameras had become sensitive enough (and inexpensive enough) to capture the dim light from these objects. By attaching low-light charge coupled devices to their equipment and using frame-integration techniques (using multiple frames to make a single exposure), Roberts and other observers began observing geostationary satellites. There was a lot to see. The American military and intelligence agencies had been launching classified satellites into this orbit for nearly half a century. Few had been publically cataloged.

Greg Roberts discovered DSP-F23's failure while conducting a "checkup" on classified spacecraft in a session much like the one I was privy to. On November 16, 2008, Roberts recorded an anomalous observation in a footnote to a much longer report about the locations of various classified satellites:

> Another puzzling observation is that I could detect no radio transmissions a few days ago from DSP-F23 (07054A) which is a fairly recent launch and is maintaining station. Previously the signals were easy to receive so has this gone silent? It was observed last night at its usual location.

While conducting routing "radio observations" (listening to a satellite's radio emissions instead of looking at it with a telescope), Roberts noticed that DSP-F23's transponder had

gone mute. This in and of itself wasn't cause for alarm so much as puzzlement. Strange things happened relatively often in the world of classified satellites. Sometimes a satellite might disappear for no reason for a few days or a transponder might suddenly stop working. In most cases, the anomaly would fix itself relatively quickly: a spacecraft may have conducted a relatively mundane orbital maneuver or signal test. Roberts waited for the spacecraft to correct itself. It didn't.

Ten days later, Roberts issued his verdict:

> Yes, DSP-23 is in trouble. In addition to not receiving radio signals from it on the 6th Nov 2008 . . . the satellite is no longer keeping station but is slowly drifting eastward with a rate due to gravity alone.

Roberts' colleagues soon piped in about the dead satellite.

"The object is trapped on your side of the world," wrote Mike McCants, a Texas-based observer. "It will drift east to longitude 134 by the middle of 2010 and then start back west, reaching the current position and continuing west in 2011 . . . Maybe a good excuse to shoot it down ☺ ."

McCants was taking a jab at the US military. Earlier that year, the American Navy shot down a failed satellite called USA-193. Rumored to be a next generation imaging spacecraft, USA-193 quickly became a multi-billion dollar boondoggle when it lost contact with its ground controllers shortly after its December 2006 launch and began tumbling down from its low-earth orbit. Claiming that the spacecraft's unspent hydrazine fuel tank posed a major public health risk, the Navy had made a spectacular display of shooting USA-193 down, despite a widespread understanding in defense circles that the shoot-down had nothing to do with the negligible public health risks and everything to do with an American desire to show off its anti-satellite capabilities.

Over the next few weeks, DSP-F23 continued drifting east—first through the Hotbird cluster of communications spacecraft over West Africa, then through the Astra cluster, parked above the Congo. Roberts continued tracking the wayward spacecraft as it sailed through the geostationary belt, coming precariously close to other spacecraft stationed in that orbit. He posted the observations to the satellite observers' group. Then, as he watched the errant spacecraft drift through the belt night after night, he saw something else. Something that scared him.

"[I] frequently carry out grid searches looking for unknowns," Roberts told me, "so finding unknown satellites is quite common." Most often, the "unknown" satellites turn out to be spent rocket-bodies or pieces of debris from long-forgotten military launches. The orbital debris from bygone military and intelligence launches is, strictly speaking, secret, so the debris they generate doesn't appear in unclassified space catalogs. When Roberts finds such a wayward satellite, he catalogs it as an unknown. But something was very different about the unknown he saw approaching DSP-F23.

"I found an object near DSP-F23 and observed it for several hours in order to get an idea of the orbit . . . and watched it on several subsequent evenings. As it got closer to DSP-F23 it slowed down and started to change its inclination so when it was quite close to DSP-F23. I monitored it for several hours to see just how close it would come." In other words, as DSP-F23 slowly drifted towards India, another satellite slowly pulled up alongside it. This was unprecedented. The political implications were potentially huge.

Two points of light. Both vanishingly faint. One much fainter than the other. The points slowly converging. It was a powerful image: to someone like Roberts, skilled at interpreting the points of light on a sensitive video display, it was like a medieval infantryman witnessing the advent of the crossbow. In these two points of light, Roberts saw something far less

visually dramatic than the fireworks of USA-193's shoot-down, but he saw something whose implications were far greater.

In his own words, Roberts clammed up. This particular observation was "too sensitive" for public list-servs. He and the handful of other amateur satellite watchers were "in over our heads." Roberts stopped reporting on DSP-F23. He'd witnessed what might be an opening shot in a new kind of war. A war that might take place far from earth, in the depths of orbital space. And what's more, a war that might happen in such a way that those being targeted and occupied might never even realize what had happened.

The Geostationary Orbit (GEO) is quite unlike other orbits. It's the closest orbital analog to the conventional ways we think about territory. What makes the GEO unique is that there's only a relatively small ring—a few kilometers high and deep—wherein the GEO actually works. A spacecraft just a few kilometers short of 35,787km will orbit faster than the Earth's rotation, whereas a satellite just a few kilometers too high goes backwards relative to Earth. Thus, the territory of the GEO is a narrow ring above Earth's equator, not unlike the rings around Saturn.[2] And beginning with the launch of the first geosynchronous satellite in 1963 (NASA's Synchronous Communications Satellite), GEO has become increasingly populated with satellites from numerous nations.

Although GEO satellites are invisible to our unaided eyes, they form an integral part of communications infrastructures on the earth below. Wake up in the morning, turn on your television, and you are likely getting a signal from the Direct TV constellation of geostationary satellites a few thousand miles south of California, a location proving coverage of the entire United States. Turn to the weather channel and you might see a meteorologist standing in front of an animation showing developing weather patterns. That image most likely comes from one of NASA's "GOES" satellites, a constellation of six spacecraft spaced more or less evenly along the equator between the ocean north of New Zealand and Ecuador. When the television program cuts to a location shot, the video feed from the news crew is relayed to the studio by yet another satellite in geostationary orbit—most likely Galaxy 25, Galaxy 10R or the AMC constellation, all dwelling over the equator off the coast of Ecuador. Radio shows are transmitted via satellite, Muzak is piped in via satellite, the swipe of a credit card at the gas pump travels to the bank via satellite; stock market fluctuations are beamed to traders, and supermarkets are connected to their warehouses and suppliers all via geostationary satellites.[3]

But there's much more to the geostationary orbit than televisions, weather, phones, and bank transactions. For the military, the GEO represents a strategic high ground over the Earth. Military communications satellites in GEO act as information relays between low-orbit strategic and tactical imaging satellites (primarily the electro-optical KEYHOLE and radar-imaging ONYX constellations) and users on the ground. Classified military satellites in geostationary orbit (such as the MILSTAR constellation) relay targeting data from space to B-2 stealth bombers, ship-based cruise missile operators, airborne command stations, and special operations forces below. Other communications satellites in GEO are communication links between remotely piloted Predator and Reaper drones over Afghanistan, Pakistan, Yemen, and Iraq and their pilots at Creech Air Force Base in the desert near Las Vegas. The military has its own dedicated communication infrastructure for telephony, video conferencing, email and fax, and radio utilizing satellites in GEO. And then there are the "SIGINT" or eavesdropping satellites. These spacecraft, whose code named include VORTEX, MENTOR, and ADVANCED ORION are essentially giant umbrella-shaped antennae the size of a football field. They vacuum up telephone calls, fax transmissions, email, telemetry, and relay that information to analysts at the National Security Agency and CIA. On January 18, 2009, the National Reconnaissance Office launched a spacecraft of this type—rumored to be a next-generation eavesdropping satellite code named INTRUDER—designated USA

202. According to *Aviation Week,* the spacecraft "involves America's biggest, most secret and expensive military spacecraft on board the world's largest rocket."[4]

From his home in South Africa, Greg Roberts watched "INTRUDER" (USA 202) go into a geostationary orbit and after a series of maneuvers settle into a slot at 43.862 deg E just west of Mogadishu, conveniently situated near Thuraya 2 (a satellite phone network popular in the Middle East and Central Asia) and Paksat 1 (Pakistan's national communication satellite serving "TV broadcasters, telecom companies, data and broadband internet service providers as well as government organizations").

This thin ring of spacecraft in geostationary orbit around the Earth is an essential part of the earth's communication, media, and military infrastructure. And because of its unique orbital characteristics, it's the closest orbital analog to a ground-based territory: it is gravitationally stable and it has clearly defined boundaries. Those two facts make GEO a tempting target for military occupation.

DSP-F23 was a zombie drifting through the geostationary belt. It was secret. It was difficult to see. No one, including the military, really knew what had happened to it. None of this was unusual. In fact, all of this is fairly typical of the GEO environment. There are numerous zombie objects drifting through the orbit and potentially threatening active satellites. Many of these zombie objects elude military and civilian tracking efforts. The European Space Agency's 2011 *Classification of Geosynchronous Objects* provides the following conclusions about the state of debris in GEO (as of early 2011):

A total of 1,274 known objects are in the GEO region:

- 397 are under some level of control (either in longitude, inclination, or both)
- 622 are in a drift orbit
- 172 have been captured by one of the two libration points ["gravity wells"]
- 11 are uncontrolled with no recent orbital elements available (usually meaning they are lost)
- 72 do not exist in the U.S. military's public satellite catalog but can be associated to a specific launch.[5]

In sum, there are nearly twice as many uncontrolled objects drifting through the GEO than there are operational spacecraft. Moreover, a number of these are simply "missing" or "lost." The belt is riddled with uncataloged debris.

But it isn't just debris that makes GEO a murky environment. Satellites regularly fail or lose temporary contact with their operators for no apparent reason. On April 16, 2006, for example, MTSAT-1R, a Japanese communications satellite, went down for about fifteen hours before its operators were able to get it back online.[6] On April 5, 2010, Intelsat's Galaxy 15, switched off. Intelsat was able to recover the satellite later that year, but the "root cause" of the failure eluded them.[7] In a 2008 investor report, the Dish Network Corporation announced that Echostar 2 "experienced a substantial failure that appears to have rendered the satellite a total loss."[8] Each year, there are several dozen reports of satellite anomalies or losses of control, and there are likely many more (satellite operators aren't always required to report these events).[9]

All of this—from flotsam in GEO to operational anomalies in communications spacecraft—shows that there are plenty of things that can, and do, go wrong with communications satellites. There are ample threats to spacecraft operating in the GEO and what's more, those threats are difficult or impossible to keep track of. Simply put, neither the military or civilian space operators have particularly good "situational awareness" of GEO.

The military counterpart to Greg Roberts' backyard observatory and the network of amateur observers he works with is an array of telescopes known as the Groud-Based Electro-Optical Deep Space Surveillance (GEODSS) network. It's an array of telescopes based in Socorro, New Mexico; Mt. Haleakala, in Maui, Hawaii; and the island of Diego Garcia in the Indian Ocean, whose setup is remarkably similar to Roberts'. GEODSS, like Roberts, uses telescopes attached to low-light cameras. Specialized software interprets the images to produce orbital data on the tracked objects. The military telescopes are more powerful than what amateurs can typically afford, but the overall technology is quite similar.

The military method of keeping tabs on GEO is quite similar as well, much to the consternation of some officials. Defense Advanced Research Projects Agency (DARPA) program manager Jim Shoemaker describes it as a "point and check" approach: military officers charged with GEO situational awareness periodically point a telescope at the place where a specific spacecraft is supposed to be, record the satellite's position, and check it off in the catalog. It isn't possible to get a wider "view" of the entire belt (although the Air Force has been trying for some time, most recently with the new Space Surveillance Telescope based in New Mexico).[10] Each particular satellite or cluster of satellites has to be observed individually.[11] Shoemaker's concern is that the development of smaller, maneuverable, and refuelable spacecraft, could render the "point and check" approach moot. If someone were to develop small, maneuverable satellites capable of autonomously or semi-autonomously moving through the geostationary belt, they might be impossible to detect or be indistinguishable from debris.

This gap in situational awareness could represent a major blind spot, and thereby a significant weakness, in the Air Force's ability to know what's going on in space. But, from a different point of view, the overall murkiness of GEO could represent a tremendous opportunity.

The blackness of space, the faintness of satellites, the debris, and the regular inexplicable failures contribute to an environment fraught with known-unknowns and unknown-unknowns. Strange and inexplicable things can and do happen all the time in GEO. Satellites fail. Unknown objects are spotted and lost again. Commercial satellite operators and militaries around the world understand that; they're used to it. It's normal. That epistemic ambiguity is also the perfect platform for covert operations. If, for example, a Chinese or Russian communications satellite constellation failed tomorrow, a covert operation in space would be one of the least plausible reasons, and one of the most difficult to verify. Especially if cell phones came back to life just as inexplicably as they had failed. In the murkiness of GEO, the American military saw a great opportunity.

And that, too, is exactly what Greg Roberts saw when he watched a small faint object slowly pull up and rendezvous with DSP-F23. In those two faint dots, he saw a stealthy military occupation of the GEO. He saw the exertion of deniable sovereignty over orbital space. He saw a future in which the American military might exercise control over world infrastructures, and cloak that power under the guise of mechanical failures, errant debris, or events the insurance industry calls "acts of god."

Greg clammed up. He was sure he'd seen something of a little-understood program in action. He'd seen something called MiTex.

Launched onboard a Delta 2 rocket on June 21, 2006, MiTex was the acronym for "Micro-Satellite Technology Experiment." The DARPA-funded payload consisted of three separate spacecraft designated USA 187, 188, and 189.[12] Two of the objects were very small satellites called micro-satellites, each weighing about 250kg. The third object was an experimental upper rocket stage capable of maneuvering the two smaller spacecraft into a precise position along the geostationary belt.

On the occasion of the launch, a DARPA press packet explained that "MiTEx will investigate and demonstrate advanced space technologies such as lightweight power and

propulsion systems, avionics and spacecraft structures; commercial-off-the-shelf processors; affordable, responsive fabrication/build-to-launch techniques; and single-string components." "According to DARPA, the spacecraft would test-fly a variety of batteries, thrusters, valves, and navigation devices, conduct "experiments in autonomous operations" and "demonstrate the ability to launch multiple small satellites into GEO orbit."[13]

At first, this all seemed fine and good, except for the fact that the "experiments" aboard MiTex didn't actually seem that experimental—the program's stated goals seemed fishy. Writing for *Space Flight Now* ten days after the launch, aerospace engineer Ryan Caron analyzed the technologies DARPA was experimenting with. He concluded that something more was going on. Caron pointed out that the components aboard MiTex weren't exactly groundbreaking technologies—most were well proven, reliable, and only out of the ordinary insofar as they hadn't flown aboard a spacecraft with a mission profile like Mitex. "All of these technologies have flight heritage," concluded Caron, "So, if MiTEx is a technology demonstrator, and the upper stage has proven hardware, what exactly are the technologies that this mission is demonstrating?"[14]

Speculating on what MiTex might actually be, Caron pointed out the two most noteworthy things about the spacecraft: One, they were very small. Orbiting the earth at a distance of 22,236 mi, their tiny size would make them essentially invisible, *de facto* "stealth satellites." Caron assumed that the only space surveillance system capable of tracking them would be the United States' military's Space Surveillance Network.[15] MiTEx seemed more ominous than DARPA press packets made the experimental spacecraft out to be. It didn't help that practically everything else about the mission was classified, including where the spacecraft would actually be headed.

If Caron and other space analysts following the Mitex story were right and Mitex were a stealthy satellite designed to crawl through the geostationary ring undetected, capable of stealthily tracking, intercepting, inspecting, and potentially disrupting or disabling other spacecraft in the GEO, then it represented the latest chapter towards the military occupation of space.

On paper, the 1967 UN Outer Space Treaty (OST) is still the "law of the land" when it comes to outer space. The treaty states that "Outer space, including the Moon and other celestial bodies, is not subject to national appropriation by claim of sovereignty, by means of use or occupation, or by any other means." It also bans states from placing "weapons of mass destruction" (nuclear, chemical, and biological) from Earth orbit, the moon, and any other celestial body, and prohibits states from conducting military operations and establishing bases on the moon and other celestial bodies.

The context of the Outer Space Treaty was, of course, the Cold War and the Outer Space Treaty was essentially an agreement between the US and the USSR to limit the "weaponization" of space. Space has always been thoroughly militarized in the sense that it constitutes a military infrastructure, but space has, by and large, not become weaponized. In other words, space has neither become an operational theater of war, nor has space—and the geostationary orbit in particular—become a space of military occupation.[16]

But with the Soviet Union long gone, American military planners seemed to have less and less use for the OST. In 2000, the UN adopted a resolution on the "Prevention of an Arms Race in Outer Space" by a 163–0 majority, with the US, Israel, and the Federated States of Micronesia abstaining.[17] A few months later, *The Commission to Assess United States National Security Space Management and Organization,* chaired by Donald H. Rumsfeld, issued its report. One of the commission's main findings was blunt:

> we know from history that every medium—air, land and sea—has seen conflict. Reality indicates that space will be no different. Given this virtual certainty, the

U.S. must develop the means both to deter and to defend against hostile acts in and from space. This will require superior space capabilities. Thus far, the broad outline of U.S. national space policy is sound, but the U.S. has not yet taken the steps necessary to develop the needed capabilities and to maintain and ensure continuing superiority.[18]

In 2002, National Reconnaissance Office Director Peter B. Teets reiterated the gist of the commission's findings to an Air Force symposium:

> The first principle that should guide air and space professionals is the imperative to control the high ground. This has been a rule of warfare ever since the dawn of time. But as war fighting moved from Earth surfaces into the air, the military advantages of control of the high ground became even more pronounced. We've traditionally kept air supremacy because we have a very rigorous and aggressive doctrine of control of the air. The first thing we do in any military campaign or combat operations is to gain mastery of the skies and deny the skies to the adversary . . .
>
> Controlling the high ground of space is not limited simply to protection of our own capabilities. It will also require us to think about denying the high ground to our adversaries. We are paving the road of 21st century warfare now. And others will soon follow. What will we do five years from now when American lives are put at risk because an adversary uses space-borne imagery collectors, commercial or homegrown, to identify and target American forces? What will we do ten years from now when American lives are put at risk because an adversary chooses to leverage the global positioning system or perhaps the Galileo constellation to attack American forces with precision?[19]

In 2004, Teets' ideas became official Air Force Doctrine.

Teets' remarks were quoted at length in the opening pages of a 2004 *Revision of Air Force Counterspace Doctrine*—a document intended to act as a framework for coordinating Air Force activities and objectives. The 2004 doctrine update is blunt about the Air Force developing offensive capabilities for policing and exerting a kind of "hard" sovereignty over orbital space. For the first time, the Air Force doctrine contained a passage about "Offensive Counterspace Operations [OCS]:"

> OCS operations may target an adversary's space capability (space systems, terrestrial systems, links, or third party space capability), using a variety of permanent and/or reversible means. The "Five Ds"—deception, disruption, denial, degradation, and destruction—describe the range of desired effects when targeting an adversary's space systems.[20]

Against the backdrop of wars in Afghanistan and Iraq, this shift in military policy and doctrine got little notice. Soon thereafter, however, a handful of experimental spacecraft began hinting what the newly reconfigured, offensive, "space of space" might look like. MiTex was just the latest in a series of experimental satellites and ground-based capabilities that were certainly capable of changing the political geography of orbital space.

One of these was something called XSS-11 for "Experimental Satellite System," which launched in 2005. It was a small, autonomous spacecraft designed to intercept other spacecraft in Low Earth Orbit. "Nobody's ever done anything like this in space," explained program manager Vernon Baker, at the Air Force Space Vehicles Directorate at Kirtland Air Force

Base, New Mexico.[21] The Air Force denied that XSS-11 was an anti-satellite platform, but the capabilities it demonstrated were exactly the kinds of technologies that could engender the military occupation of space.

XSS-11 toyed with Greg Roberts and the other amateur observers. It came in and out of view for a year and a half. The spacecraft was small and maneuverable—it was difficult to track because it didn't stay put. In mid-2006, a year and a half after its launch, they watched XSS-11 rendezvous with a "dead" American military weather satellite called DMSP (Defense Meterological Support Program) B5D2-6 (91082A/21798). And later that year, they watched it happen again.

On the ground, other programs are designed to stealthily interfere with orbital platforms. The CounterCom system, a "mobile, ground-based antenna that can jam the signals from a single satellite in geosynchronous orbit," is just one of them.[22] In 2007, it was upgraded to provide "enhanced capabilities for SATCOM denial."[23] The Army have their own versions: in 2007, it reportedly deployed and began using a "wildly successful" ground-based system complementary to the USAF CounterCom to deny US enemies the ability to use commercial space capabilities.[24]

The point of the new systems was to be able to disable spacecraft or their operations in such a way that it would be hard for someone else to tell that they were being interfered with. In other words, the new Air Force systems were designed to disable spacecraft and make it appear as if they had simply failed. This was a different philosophy towards anti-satellite technology than the idea of simply shooting something at satellites and blowing them up. The new systems were subtle, stealthy, deniable, and even reversible.

It's clear from Defense Department reports and policy statements that the United States has been developing means with which to stealthily control orbital space and the various infrastructures residing high above the Earth. These efforts to dominate orbital space are certainly part of a larger military strategy that geographer Stephen Graham has dubbed "switching cities off."[25]

There's a lot to learn from MiTex, and a lot to learn from the amateur astronomer who observed it. Understanding facts on the ground increasingly means taking the time to look up towards the sky, and reminding ourselves that spatial politics also has a vertical dimension. Developing a critical framework for understanding twenty-first century spatial politics means questioning an implicit horizontality in the way many of us think about political geographies.[26] Coming to terms with emerging space-based infrastructures and politics means developing a critical understanding of celestial mechanics and the peculiar topologies that they give rise to. It also means a critical approach to the international conventions, legal regimes, state logics and capitalist relations that produce relational geographies of orbital space.

Beyond this, I believe that a critical "geography" of orbital space must pay particular attention to the actual spacecraft. Why? Because those spacecraft—and their uses—are indistinguishable from space policy and military control.

Next-generation programs like MiTex aren't just the outcome of American military space policy; they are "facts in orbit" whose very existence produces various fields of possibility and constraint. This is especially true because they're largely secret programs, and therefore far more immune to civic oversight than other programs and infrastructures.[27] MiTex and other stealthy orbital-control spacecraft not only embody, but secure and produce a politics of American orbital domination.

But MiTex in particular and orbital space more generally, are characterized by a distinctive politics of appearance. MiTex's function and its political implications may never have become discernable if it weren't for the work of Greg Roberts. By dedicating himself to a lifetime of observation, and through his collaboration with other amateur observers and

analysts, Roberts was able to "see" two vanishingly faint points of light, slowing moving towards one another, for what they represented, namely, an emerging political geography. Roberts' practice of what we might call "minoritarian empiricism" is something social scientists and critical scholars should take seriously. As built environments and political geographies become increasingly "sited" in ways that are unfamiliar to our everyday lives and perceptual experience, from the orbital (i.e. MiTex) to the cybernetic (i.e. Stuxnet), the minoritarian empiricism practiced by Roberts and his collaborators will become an increasingly relevant means by which to "see," and begin to make sense of emerging political geographies.

Notes

1 For PAN, see Day, Dwayne,"PAN's Labyrinth," *The Space Review*, August 24, 2009 < http://www.thespacereview.com/article/1450/1>.

2 For a brief explanation of the GSO, see Kelso, T. (1998), "Basics of the geostationary orbit," *Satellite Times*, 4(7): 76–7.

3 For uses of GEO and communications satellites, see Elbert, B. (2004), *Satellite Communications Applications Handbook*, 2nd edn (Norwood: Artech House). See also Hall, Carl T., Torri Minton, Stephen Schwartz,"Pagers Silent After Glitch On Satellite/ As many as 80 percent shut down across U.S.," *The San Francisco Chronicle*. May 20, 1998 < http://articles.sfgate.com/1998–05–20/news/17722292 1 galaxy-iv-panamsat-credit-card>.

4 *"NRO Delays Delta IV Heavy Launch,"* *Aviation Week*, December 10, 2008.

5 Flohrer, T. R. Choc, and B. Bastida,*Classification of Geosynchronous Objects Issue 13.* GEN-DB-LOG-00074-OPS-GR, Darmstadt: European Space Agency, February 2011.

6 "Satellite Outages and Failures," *Satellite News Digest* <http://www.sat-index.co.uk/failures/mtsat1r.html>.

7 Clark, Stephen,"Zombiesat has three more satellites in its crosshairs," *Spaceflight Now*, July 25, 2010 <http://spaceflightnow.com/news/n1007/25galaxy15/>.

8 Dish Network Corporation. United Securities and Exchange Commission. Form 8-K., Commission File Number 0-26176, July 14, 2008, http://dish.client.shareholder.com/secfiling.cfm?filingID=950134-08-12791.

9 A very good resource for satellite failures and anomalies is at http://www.sat-index.co.uk/failures/index.html.

10 For the Space Surveillance Telescope, see Brinton, Turner, "DARPA Space Telescope Will Track Objects in Geostationary Orbit," *Space News*, April 29, 2001, http://www.spacenews.com/military/110429-darpa-telescope-track-objects-geo.html.

11 Shoemaker, Jim, "Space Situational Awareness and Mission Protection," DARPATECH 2005 Conference Proceedings, August 9–11, 2005, p. 208

12 Encyclopedia Astronautica, http://www.astronautix.com/craft/mitex.htm.

13 Ray, Justin,"Military Microsatellites to Test Technologies in Wednesday Launch," *Space*.com. June 20, 2006, http://www.space.com/missionlaunches/sfn 060620 mitex prelaunch.html.

14 Caron, Ryan,"Mysterious microsatellites in GEO: is MiTEx a possible anti-satellite capability demonstration?" *The Space Review*, July 31, 2006, http://www.thespacereview.com/article/670/1.

15 Ibid.

16 For the OST and the question of "weaponization" and "militarization" see Sheehan, Michael (2007), *The International Politics of Space* (New York: Routledge).

17 MacDonald, Fraser (2007), "Anti-Astropolitik: Outer Space and the Orbit of Geography," in *Progress in Human Geography* (London: Arnold), p. 600.

18 Report of the Commission to Assess United States National Security Space Management and Organization, January 11, 2001.

19 "Counterspace Operations," Air Force Dcotrine Document 2–2.1. August 2, 2004. [Note: In these documents, Teets is referred to as the Undersecretary of the Air Force. This title is left over from the days when the NRO's existence was secret, so the NRO director was the "Undersecretary of the Air Force."]

20 Ibid.

21 Young, Kelly,"Autonomous military satellite to inspect others in orbit," *New Scientist*, April 12, 2005, http://www.newscientist.com/article/dn7255-autonomous-military-satellite-to-inspect-others-in-orbit.html.

22 "Space Security 2008," Spacesecurity.org, p. 157.
23 "Space Security 2008," Spacesecurity.org, p. 159.
24 Ibid.
25 Graham, Stephen (2010), *Cities Under Siege* (New York: Verso), pp. 263–302.
26 Here, I follow Fraser MacDonald, Stephen Graham, Lisa Parks, Eyal Weizman and others. See
 MacDonald, 592; Weizman, Eyal, "The Politics of Verticality," *Open Democracy,* April 23, 2002,
 < http://www.opendemocracy.net/ecology-politicsverticality/article 801.jsp>.
27 See Paglen, Trevor (2009), *Blank Spots on the Map: The Dark Geography of the Pentagon's Black World*
 (New York: Dutton).

Faisal Devji

MEDIA AND MARTYRDOM

THE JIHAD IS DEFINED not by its various local causes, nor even by the individual biographies of its fighters, but as a series of global effects that have assumed a universality of their own beyond such particularities. Indeed the dispersed and disparate acts of the jihad provide proof enough of this, dispensing as they do with the traditional orders and genealogies of Islamic authority, as well as with an old-fashioned politics tied to states and citizenship. Perhaps the most important way in which the jihad assumes its universality, however, is through the mass media. As a series of global effects the jihad is more a product of the media than it is of any local tradition or situation and school or lineage of Muslim authority. This is made explicit not only in the use of the mass media by the jihad, whose supporters refer to it constantly, but also in the numerous conversion stories that feature media. Here, for instance, is an account of the martyr Suraqah al-Andalusi's conversion to the jihad:

> One day he came across an audio cassette called *In the Hearts of Green Birds*. After hearing this cassette, he realized that this was the path that he had been searching for, for so long. This was shortly followed by various videos showing the Mujahideen from Bosnia. To him, it was as if he had found a long lost friend, from whom he could not depart. *In the Hearts of Green Birds* deeply moved him as it narrated the true stories of men who personified the message that they carried, men who were prepared to give up their most precious possession (life) in order to give victory to this Message.

What is interesting about this passage is not so much Suraqah al-Andalusi's inspiration by audio and videotapes, but the fact that for him these seem to have been unrelated to any local group or particular school of thought. The future martyr's encounter with the jihad through mass media appears to have been entirely abstract and individual, allowing him to break with locally available forms of Islamic authority. This process, whether real or rhetorical, is common enough in the biographies of the jihad's supporters, for instance that of Omar Sheikh, the Anglo-Pakistani kidnapper convicted for the murder of *Wall Street Journal* reporter Daniel Pearl, who also claims to have been inspired by a documentary on the Bosnian war.

But the role of mass media in the jihad goes further than mere influence. Instead the jihad itself can be seen as an offspring of the media, composed as it is almost completely of pre-existing media themes, images and stereotypes. Like the murderous Freddy, in the Hollywood horror film *Nightmare on Elm Street,* the jihad appears simply to bring to life and make real the media's own nightmares. Slavoj Žižek, for one, has written about the strong sense of déjà vu accompanying the attacks of 9/11, which had as it were been foretold by Hollywood—to the degree that many viewers tuning in to the destruction of the World Trade Center live on television thought initially that they were watching a film. No matter how temporary, this inability to distinguish between reality and fiction (both after all being available only by way of the media) is crucial to the jihad as a global movement. Yosri Fouda and Nick Fielding, in their book *Masterminds of Terror,* describe how the inevitable conspiracy theories making the rounds after the attacks were often dominated by media images. In Saudi Arabia one very popular theory that sought to blame the US government for the destruction of the World Trade Center, had as its evidence the following dialogue between an FBI agent and his colleague from the Hollywood film *The Long Kiss Goodnight:*

> "1993, World Trade Center bombing—remember? During the trial one of the bombers claimed that the CIA had advance knowledge. [*Laughing sarcastically*] The diplomat who issued the terrorist visa was CIA. It is not unthinkable they paved the way for bombing purely to justify a budget increase."
>
> "You telling me you gonna fake some terrorist thing just to get some money out of the Congress?"
>
> "Well, unfortunately, Mr. Hennessey, I have no idea how to fake killing 4,000 people. So, we're just gonna have to do it for real—umm, and blame it on the Muslims naturally."

The irony of such conspiracy theories is that their deep distrust of the mass media is matched by an equally profound faith in the evidence it offers, so that supposedly factual news reports are rejected in favour of apparently fictional movies, both from the same source. And while this might well be symptomatic of our access to both fact and fiction being determined by the media, the audience's efforts to detect some truth beyond the media by spotting its supposedly accidental admissions of truth in movies like *The Long Kiss Goodnight* also betrays the fact that simple political intentions no longer suffice to explain events in a global landscape.

Rather than seeing in the conspiracy theory a desire to find, behind the world of appearances, some old-fashioned reality determined by individual and collective intentions, I see in it the recognition of a landscape of global effects in which events can no longer be attributed to simple intentions and have become almost ineffable. In such theories, after all, it is precisely a world determined by intentions that has disappeared from view, while the media narrative on offer has lost the ability to convince its audience of any other kind of intentionality.

Whether or not the jihad's acts are influenced by pre-existing media stereotypes, they invariably occur in the form of events already packaged, as it were, for media distribution. Media packaging is also common among those who might not support the jihad but have been affected by it. For example, in photographs released by Reuters of women in the Pakistani city of Multan protesting the beheading of their countrymen by the Islamic Army in Iraq in July 2004. The pictures show demonstrators carrying English-language placards blaming the Pakistani government for the deaths, each of which bears the name of a Pakistani music company printed decoratively at the top. No doubt anticipating the massive exposure these signs would receive in the media, an enterprising Pakistani firm seems to have sponsored them. The global exposure of these English language signs could do very little for sales of

such CDs abroad, but they might well reach an English-speaking Pakistani audience in a much more effective way by taking this international route. Al-Qaeda and its imitators are not slow to reciprocate such media-savvy moves. An Iraqi tribal leader, negotiating on behalf of the Islamic Secret Army for the release of three Indian citizens taken hostage in July 2004, advised that appeals made to the abductors by Indian film stars were more likely to succeed than direct communications from the government in New Delhi. What kind of holy warriors are these who blend so effortlessly with Hindi film fans?

From spectacular attacks to sundry communiqués and beheadings, the jihad's world of reference is far more connected to the dreams and nightmares of the media than it is to any traditional school of Islamic jurisprudence or political thought. Indeed the novel practice of beheading hostages, especially on film, has spread rather like a fashion promoted in the media. Ramzi Yousef and Khalid Sheikh Mohammed, Pakistanis domiciled in Kuwait who were respectively involved in the 1993 and 2001 attacks on the World Trade Center, seem to have modelled their behaviour on that of James Bond. This is how they passed the time in between carrying out a series of strikes in South-East Asia during 1994:

> The conspirators were very cool. As they planned their attacks in Manila, they took plenty of time out to enjoy themselves. After bombing the PAL (Philippines Airlines) airliner they went to Puerto Galera, a beach resort south of Manila, to take a week-long scuba-diving course. One of Khalid's girlfriends later told police that he had portrayed himself as a rich Qatari businessman. One of their meetings took place in a five-star hotel in Makati, Manila's financial district. The two men also frequented night-clubs and hotel bars. On one occasion Khalid set out to impress a lady dentist by hiring a helicopter and flying it over her clinic while talking to her on the telephone.

Such "Westernized" behaviour did not in the least interfere either with the religious belief of these men, or with their fervent practice of it at other times. Nor does it indicate an exceptionally schizophrenic attitude, since similar swings in behaviour, terrorist outrages apart, are common enough among Muslims, as they are no doubt among others as well. Indeed such behaviour is, if anything, yet another sign of the disintegration of old-fashioned distinctions, whether religious or political, in a universe of global effects that is best represented by the mass media.

The great battles of the jihad in Afghanistan also took on the appearance of media narratives about epic wars between rival principles. The vast technological and numerical superiority of the airborne US-led troops deployed against Al-Qaeda and the Taliban then, quite inadvertently replays media set pieces about the war between robots and humans, airborne and earth-based power, that are familiar from films such as *Dune*, *Terminator* or *Matrix*. In such epic confrontations, naturally, it is the very peculiarity and even savagery of the holy warrior that renders him more human than the American soldier who looks and behaves like a robot. It is in fact only the individualization of the American soldier through his perversion, for example in the photographs of torture at Baghdad's Abu Ghraib prison, that makes him human—that and his death, which, like that of Arnold Schwarzenegger in *Terminator*, finally renders the robot human by making him mortal.

The spectacle of martyrdom

The ruin, the cave and the battlefield as sites of holy war and martyrdom have by their very currency become the arenas of a global Islam, displacing in this respect the shrine, tomb and

holy city of the past. Sarajevo, Grozny, Kabul, Baghdad, Srinagar and even New York, like the sacred sites of old, also call forth practices of pilgrimage, donation, tourism and death, but unlike these are marked neither by tradition nor commemoration. While each of these global sites calls to and even emulates the others by making possible the movement of men, money and munitions between them, none make for old-fashioned practices of visiting and recalling, perhaps because they are by nature un-historical. Their importance lying in the sheer currency or immediacy of suffering, these sites are quickly forgotten once they become safe for visiting, or rather they survive only as names in the randomly constructed genealogy of some other, more current theatre of war and martyrdom. As sites of a global Islam, in other words, former sites of the jihad like Sarajevo are separated from their own local and regional histories to become part of the history of jihad elsewhere, in places such as Kabul, Baghdad or Manhattan.

For most Muslims, as for most people, the jihad site is experienced visually, as a landscape initially made available by way of the international media and then redacted in conversation, posters, literature, art-work and the like. Existing as they do primarily and even originally by way of reports from broadcasters like the BBC, CNN and now Al-Jazeera, these sites of a global Islam have achieved the kind of universality denied even to the most spectacular of traditional practices, such as the annual pilgrimage to Mecca. Not only do landscapes of the jihad receive more airtime than any other object identified with Islam, but they also attract the world's attention in unprecedented ways precisely because they are identified with Islam. From the broadcasts of Fox TV to newspapers and websites all over the Muslim world, images of urban destruction and fighting in often harsh terrain have come to identify not only the jihad but Islam as such.

It is no exaggeration to say that only in this globally mediated landscape does Islam become universal, uniting Muslims and non-Muslims alike in a common visual practice, even in a fundamental agreement over the Islamic nature of the spectacle that brings together people of every religious and political opinion in a strange unity. Might we say that a religious universality expressed in the vision of converting the world has been displaced here by the conversion of vision itself, to make of Islam a global spectacle built out of the convergence and complicity of innumerable lines of sight? It is as the object of this seeing that Islam becomes universal, if only in the particularity of the caves, ruins and battlefields of its own martyrdom.

The jihad's battlefields become sites of a global Islam only when they are in the news, which is why combatants, funds, and supplies, not to mention the world's attention, move from one battlefield to another, because the content of the jihad is the news itself as something new. It is when they are reduced to caves and ruins that the towns and villages occupied by the jihad lose their own histories and become nothing but news, to enjoy their being in a state of immediacy. And once their particularity is destroyed, their very roots eradicated, these blasted habitations and their former occupants are transformed into universal figures. They become Muslims as such, people whose particular histories have suddenly disappeared to become part of the universal history of Islam.

Islam comes to exist universally in the places where its particularity is destroyed, the presence of its ruins on television screens bearing witness to the Muslim's universality as martyr and militant. What makes Islam universal, then, is the forging of a generic Muslim, one who loses all cultural and historical particularity by his or her destruction in an act of martyrdom.

In the paragraphs that follow, I examine how this martyrdom achieves meaning only by being witnessed in the mass media. Now witnessing itself means martyrdom, the Arabic word *shahadat* translating one term into the other, so that to have borne witness is also to be martyred. The ordinary legal term *shahadat,* to bear witness or to testify, is transformed into

the word for martyrdom by fixing on the momentary act of witnessing whose subject is anni-hilated with the accomplishment of this testimony. There is a close link between seeing and dying in the etymology of martyrdom, just as there is in the televised image of the landscape that as news is simultaneously seen and destroyed, becoming yesterday's news at the very moment of its broadcast, because its universality depends upon its destruction.

Unlike Christian martyrdom, which also invokes the idea of witnessing, *shahadat* involves not only the person whose life is voluntarily sacrificed for the cause of God, but everyone annihilated in this cause whether willingly or not. Not only people, but animals, buildings and other inanimate objects as well may participate in the rites of martyrdom, including even those who witness the martyrdom of others without themselves being killed. After all *shahadat* is a fundamentally social and therefore inclusive act, the pity and compassion it excites among witnesses forming part of its classical as much as contemporary definition. Because martyrdom in Islam is thus connected to seeing in a much more general as well as much more specific sense than in Christianity, it is capable of cohabiting in productive ways with the global prac-tices of news reportage. Martyrdom also includes within its ambit any number of subjects: perpetrators, victims, bystanders, other animate and inanimate witnesses, near or far, all of whom constitute by their very seeing the landscape of the jihad as a site of sociability.

Only in mass media does the collective witnessing that defines martyrdom achieve its full effect, as the various attempts by would-be martyrs to film their deaths or at least to leave behind videotaped testaments, illustrates so clearly. A videotape obtained by *Time* magazine in which martyrs are shown reading their last testaments, saying goodbye to their families and blowing themselves up at various places in Iraq is the closest the jihad has yet come to creating its own form of a reality television show. The sequence of events depicted in this video is entirely scripted and replete with scenes straight from Hollywood—for instance the pose struck by one such martyr, Abu Harith al-Dosari, embracing and kissing his beloved goodbye through her veil, hardly an acceptable public spectacle for any Muslim tradition. This constant reference within the jihad to mass media as the global witnesses to martyrdom sometimes assumes the status of a mania, for example in the following passage from an editorial in the Saudi on-line journal *Voice of Jihad* that is the mouthpiece of Al-Qaeda in the Arabian Peninsula:

> My Muslim and *Mujahid* brothers, don't you see the Muslims being killed in Afghanistan and Iraq?! Don't you see, on the television screens, the bereaved women crying out for the Muslims' help?! Don't you see the torn body parts of children, and their skulls and brains scattered?

If the quotation above demonstrates anything, it is that the media's representation of martyrdom creates a global community whose witnessing imposes certain responsibilities upon its members. This community, however, is not limited to Muslims, but includes all those who bear witness. Indeed there is a sense in which even the jihad's enemies—or victims—come to participate in the rites of martyrdom by dying alongside its suicide bombers in spectacular set-pieces like the attacks of 9/11. This may explain why supporters of the jihad are forever drawing parallels between its own dead and those of its enemies, because both coalesce in a community of martyrdom made possible by the virtual intimacy of the media, which allows each party to exchange words and deeds with the other. Thus the following sentences from Al-Qaeda's lengthy justification for the attacks on New York and Washington:

> It is allowed for Muslims to kill protected ones among unbelievers as an act of reciprocity. If the unbelievers have targeted Muslim women, children and elderly, it is permissible for Muslims to respond in kind and kill those similar to those whom the unbelievers killed.

In a videotape broadcast by Al-jazeera on October 29, 2004, during the closing phase of a bitterly contested presidential election in the United States, Osama bin Laden repeated this justification for the attacks of 9/11, tying it even more strongly to the viewing practices of mass media:

> God knows it did not cross our minds to attack the towers but after the situation became unbearable and we witnessed the injustice and tyranny of the American-Israeli alliance against our people in Palestine and Lebanon, I thought about it. And the events that affected me directly were that of 1982 and the events that followed—when America allowed the Israelis to invade Lebanon, helped by the US sixth fleet.
>
> In those difficult moments many emotions came over me which are hard to describe, but which produced an overwhelming feeling to reject injustice and a strong determination to punish the unjust.
>
> As I watched the destroyed towers in Lebanon, it occurred to me to punish the unjust the same way (and) to destroy towers in America so it could taste some of what we are tasting and to stop killing our children and women.

It is noteworthy that the witnessing of which Bin Laden speaks so personally, and which affected him so deeply, was in fact a collective witnessing by way of mass media, since he never participated in the Lebanese war. It was perhaps the abstracted nature of this viewing that resulted in Bin Laden's determination to reject injustice and punish the unjust in an equally abstract manner, as a universal and so properly ethical imperative rather than a specifically political one, since what had become "unbearable" for him as a television viewer was a morally unjust situation. Yet the profound emotions that he claims were inspired by this witnessing bear little if any relation to the reality of the scene he describes. In other words while he may have reacted to images from the Israeli invasion of Lebanon in this fashion, Bin Laden's attempt to claim the destruction of tower blocks in Beirut as a precedent for those of Manhattan ignores more recent precedents, such as the attempt to destroy the World Trade Center in 1993. Moreover the proposal to fly planes into the twin towers was suggested to him by an outsider, Khalid Sheikh Mohammed. So the mediated witnessing of terror in Beirut, which Bin Laden tells us set a precedent for his equally mediated witnessing of terror in New York, together make up a media narrative in which one scene is exchanged for another, creating a community of exchanges between the jihad and its enemies.

The statements quoted above, selected from innumerable others on the reciprocity in death between Muslims and their enemies, justify such equivalence and even equality as neither necessary for winning the war nor even as a form of revenge. Instead it is reciprocity for its own sake that is ascribed value, making for the only kind of community possible between holy warriors and their antagonists, who are otherwise unequal in every respect—the community of death. And while the doctrine of reciprocity allows terrorists to avoid claiming responsibility for killing others by making such acts seem like the unintentional effects of some prior cause, killing oneself does exactly the opposite, by asserting intentionality in the most paradoxical of ways. It is as if suicide has become the only way in which responsibility, and thus also humanity, can be claimed in a universe of global effects. Here, then, is an extraordinarily clear acknowledgement, by a Hezbollah fighter in Lebanon, of the community created by way of martyrdom between enemies who in death become interchangeable precisely as human beings:

> The Americans pretend not to understand the suicide bombers and consider them evil. But I am sure they do. As usual, they are hypocrites. What is so

strange about saying: "I am not going to let you rob me of all my humanity and my will?" What is so strange about saying: "I'd rather kill you on my own terms and kill myself with you ramer than be led to my death like a sheep on your terms?" I know that the Americans fully understand this because this is exactly what they were celebrating about the guy who downed the Philadelphia flight on September 11, the one where the hijackers failed to hit their target. Isn't that exactly what he must have said when he decided to kill himself and everyone else by bringing the plane down? Didn't he say to those hijacking him: "I'd rather kill you on my own terms and kill myself with you rather than be led to my death like a sheep on your terms?" They made a hero out of him. The only hero of September 11. They are hypocrites, the Americans. They know as much as we do that as a human being we all have the capacity to rush enthusiastically to our death if it means dying as a dignified being.

The sociable nature of the jihad is evident in this passage, with martyrdom making a community possible by the collective witnessing of mass media. For it is this bearing of witness that allows Americans and the world at large to know that the martyrs of 9/11 and their victims were interchangeable and equal in death—a death that was important because it offered them both the possibility of becoming human.

Seeing is believing

Martyrdom creates a global community because it is collectively witnessed in mass media. These witnesses are therefore part of the jihad's struggle either as friends or enemies. Unlike European or American debates on this war, which focus on the lack of knowledge, agreement and so community between its combatants, the jihad assumes knowledge and therefore responsibility among all who witness its struggle. This knowledge and responsibility result from the global community that is created by the spectacle of martyrdom in mass media, which no amount of bias or propaganda can quite conceal. Ayman al-Zawahiri's description of this responsibility is entirely typical and repeatedly invoked by supporters of the jihad:

> It also transpires that in playing this role, the western countries were backed by their peoples, who were free in their decision. It is true that they may be largely influenced by the media decision and distortion, but in the end they cast their votes in the elections to choose the governments that they want, pay taxes to fund their policy, and hold them accountable about how this money was spent.
>
> Regardless of method by which these governments obtain the votes of the people, voters in the western countries ultimately cast their votes willingly. These peoples have willingly called for, supported, and backed the establishment of and survival of the State of Israel.

The interesting thing about this argument, which would justify attacks against American civilians, is that it advocates the responsibilities of democracy in the most full-blooded way. It is because the United States is a functioning democracy that its citizens can be held responsible for the actions of their government, something that might not apply to people living under dictatorships. Such holding responsible of the American people to the implications of their democracy puts the jihad in the curious position of taking this democracy more seriously than Americans themselves. After all the assignation of responsibility in the jihad is itself an

inclusive and even democratic act because, as we have seen, it presupposes the existence of a global community of equals.

The passage quoted above, however, also begins to consider what responsibility might look like in a universe of global effects. How can such responsibility either be claimed or assigned in a world of media distortion and political coercion, where people are often ignorant of the true nature of things, or deceived about them? How can Ayman al-Zawahiri recognize the constraints of ignorance and deception, as indeed he does, and still opt for a full-blooded version of popular responsibility? Perhaps because responsibility here does not depend on a knowledge of some truth, so that like the citizen who breaks a law without knowing it, the American who supports an anti-Muslim government without knowing it is held responsible for his actions. Rather than depending upon the knowledge of truth as an intellectual or epistemological entity, therefore, such responsibility depends upon an ethical choice made available only by the media's representation of martyrdom. In other words media images of the jihad, no matter how distorted or deceptive, force its audience of Americans and others into an ethical choice to support either its Muslim victims or their infidel oppressors—and all who make this choice are held responsible for it, having become participants in the jihad irrespective of their knowledge about its truth. The very spectacle of martyrdom imposes certain responsibilities upon its witnesses, and not the notion of some objective truth that might be found hidden behind it, as if behind a veil of appearances.

Media images of martyrdom have no epistemological status, since their truth never becomes a subject for discussion in the holy war. Indeed knowledge as an epistemological category does not exist in the jihad, which usually demonstrates its truth by pointing to the same media images that are otherwise denounced as distorted and deceptive, thus suggesting that knowledge in some objective sense is not an issue for it at all. Indeed it is remarkable how widely the jihad diverges from traditional political movements in this respect. Whether liberal or conservative, communist or fascist, these were much concerned with the illusory nature of appearances and the public ignorance—or false consciousness—that resulted from it. The rhetorical task of old-fashioned politics, then, was to distrust appearances and reveal the truth lying behind them. In the jihad, however, despite the standard accusations of media bias and distortion, as in the quotation from Zawahiri above, there exists no rhetorical anxiety about the concealment of truth, which is in fact available in its appearances as a media spectacle.

While I have linked the jihad's role as a media spectacle to Muslim notions of martyrdom, I do not wish to suggest that this role somehow derives from such notions. The community of witnesses created by the media spectacle, and its ethical responsibility for the holy war, makes sense even without the etymology of the word *shahadat*. The jihad posits the existence of a global community, one that is formed by martyrdom as a bearing of witness through mass media in order to hold people, and even the whole world, responsible in some way for its struggle. Such responsibility, therefore, depends upon the unproblematic availability of the jihad's truth in martyrdom, beyond any theory of ignorance or deception. After all truth here has become an ethical rather than epistemological fact. This does not mean that there are no attempts at media deception, only that the spectacle of martyrdom makes ignorance inexcusable, as if by the sheer excess of its violence. So apart from acknowledging the responsibility assigned them by the jihad, it is hypocrisy and not delusion that is the only other attitude expected of people. Hypocrisy, an accusation levelled in the Quran against those who claimed to be Muslim out of convenience, has become the jihad's most damning charge, referring now to the self-interested lies not only of Muslims but of all those concerned with its struggle.

Ultimately the spectacle of martyrdom is its own proof, a sacrifice whose selflessness transforms the jihad into a practice of ethics. Indeed as an ethical performance the act of

martyrdom is a perfectly circular one, since it proves itself by itself without the help of any outside truth. And this is how it is invariably described in the jihad, as a leap of faith that affirms itself by itself. Thus the following poem by an Al-Qaeda member, Abu Salman al-Maghribi, on one of the suicide bombers who destroyed the American embassy in Nairobi:

> Your good action caused flags to fly at half-mast, and your chaste face smashed idols.
>
> You said goodbye to lions and their young cubs and strode through a door where you were an imam.
>
> Finding other courses of endeavour crowded, you selected a course where there was no crowd.
>
> With high resolve, you looked with disdain on death and defeated the massive army of infidelity and doubt.

Because the act of martyrdom occurs as a media spectacle, its self-justifying character has as much to do with the nature of mass media as it does with anything Islamic. And in fact it is the media's inability to refer either to a distinct audience or indeed a distinct reality that accounts for the self-justifying character of martyrdom—because it can have no access to anything beyond itself. The media's audience, after all, is completely abstract, its existence assumed only as a set of standardized categories. This means that no traditional communication is really possible within mass media, whose audiences have been transformed into mere consumers in quantitative terms. The community created by the spectacle of martyrdom, therefore, is purely abstract, as much an effect of the media as the jihad itself. And in fact the abstract audience of the jihad as a media spectacle implies that it is truly witnessed only by a universal being who is everywhere and so nowhere: who else but God?

More than this, the proliferation of information and of opinions about information in mass media also renders the reality it describes unfathomable, thus giving rise to the kind of conspiracy theories or confusion between fact and fiction mentioned earlier. This is so because there can be no access to reality except through the media itself, which thus transforms reality as such into mere information, to be endlessly interpreted in opinion-making. Niklas Luhmann points out the ethical rather than epistemological attitude that results from this transformation of reality into information:

> We just learn to observe the observing and to experience the conflict itself as reality, since differences are to be expected. The more information, the greater the uncertainty and the greater too the temptation to assert an opinion of one's own, to identify with it and leave it at that

Luhmann also links this ethical attitude towards the media spectacle with the emergence of new religious movements, whose zeal, rather than following the old model of enthusiasm that might have implied some access to divine inspiration, actually does the opposite:

> One can step up and say: this is my world, this is what we think is right. The resistance encountered in the process of doing this is, if anything, a motive for intensification; it can have a radicalizing effect without necessarily leading to doubts about reality. And unlike in the older model of "enthusiasm," one does not need to rely on divine inspiration nor to give oneself over to the opposite assertion that this is an illusion. It is sufficient to weld together one's own view of reality with one's own identity and assert it as a projection. Because reality is no longer subject to consensus anyway.

Martyrdom as a media spectacle is therefore self-contained, foregoing any reference to an outside audience or reality without in any way questioning their existence. Indeed it is the inaccessible or better yet unfathomable nature of such entities that makes martyrdom into an ethical rather than an epistemological or political performance. As the supreme performance of the jihad, martyrdom does not depend on the knowledge either of an external audience or of an external reality, serving instead as its own proof.

The art of war

Because ignorance and therefore false consciousness do not exist in the world of the jihad, neither does the liberal effort of persuasion. Unlike political movements in the past, including fundamentalism and terrorism in the service of some national cause, the jihad's votaries do not attempt to convert people to their vision of things. In fact such conversion, as we noticed in the first chapter, might well occur only as an accidental effect of the jihad's ethical performance. So while statements, communiqués, interviews and other forms of information and explanation emanate from the jihad, these, too, can be seen as performances of an ethical kind. This performance of the ethical is signalled by the novel way in which the jihad presents itself in mass media, as a visual presence that far exceeds any instrumental attempt either to persuade or terrorize people in the service of any cause.

On the one hand there are the extraordinary videotapes of hostages who are beheaded, often following the reading out of statements by victims and captors alike. To some extent these follow traditional terrorist practice, claiming that hostages are killed because demands have not been met by their governments, but the bloody nature of the killing is unprecedented. Often described as ritualistic (but why more so than any other form of execution?), such beheadings very deliberately depart from earlier forms of terrorist murder because, I suspect, it is the media spectacle itself rather than the death of any victim that is of primary importance for them. These beheadings, then, which themselves seem to imitate media images of Muslim barbarity, are part of this media's flirtation with representations of violence as much as they are of any peculiarly Islamic form of sacrifice. It is almost as if the jihad is here fulfilling the desire of mass media for real horror, but on the same model as reality television shows. So while this reality strives to achieve authenticity by its very extremity, just as in reality television shows, it in fact achieves exactly the opposite by becoming a piece of theatre.

On the other hand there are the videotaped interviews and conversations of key Al-Qaeda figures, which depart from traditional representations of political, military or religious leaders, including terrorists, rebel commanders and the like. Unlike old-fashioned forms of direct address, where such leaders would deliver stern statements to camera, many of the films featuring Bin Laden or Zawahiri have the character of home videos, in which the camera is never directly addressed and appears to be spying on a private gathering. Instead of issuing terse warnings, the founder of Al-Qaeda engages in long and meandering conversations that have to be picked over for newsworthy information. Indeed it is only in his interviews with broadcasters like ABC, CNN or Al-Jazeera, and not in Al-Qaeda's own recordings, that Bin Laden is portrayed addressing himself directly to the camera—the one exception so far being a videotape released by Al-Jazeera on October 29, 2004, four days before the US presidential elections, in which Bin Laden reads a statement while standing at a podium against a neutral brown background that matches the colour of his cloak. Otherwise his rambling conversations, reminiscent in many respects of Khomeini's interviews during his French exile, are clearly represented not as intelligible communications to some external audience, whether Muslim or not, but rather as private performances.

Even when Osama bin Laden directly addresses the camera this is done in the most private or domestic of ways, dispensing with the public forms of address characteristic of leaders like the late Yasser Arafat. So Bin Laden and Zawahiri have posed for the cameras of news agencies sitting or standing side by side with shy smiles on their faces, looking for all the world like two uncles in a nephew's family album. Apart from some appropriately militaristic images of Al-Qaeda camps in Afghanistan, the use of arms in representations of its leader are equally domestic in character. Osama bin Laden, rarely portrayed without his Kalashnikov, appears to treat it more as a toy than a weapon. When it is not carelessly balanced against a wall or lazily handled by its owner, the gun lies flat across his folded legs, like a baby in its father's lap. In fact it is difficult to escape the impression that the military paraphenalia present in images of Al-Qaeda are props in a performance where their usual roles have been subverted by the inexplicably private or idiosyncratic behaviour of the mujahidin. Again it was Osama bin Laden's sudden appearance during the 2004 American elections, following a prolonged silence, that broke these visual rules. In this videotape a turbaned and cloaked Bin Laden has been completely divested of military trappings and appears to be speaking in the guise of an international statesman—his statement having been shorn of both the religious references and the bloodthirsty tone that had characterized previous utterances. Indeed Bin Laden's posture, demeanour and even surroundings bear a resemblance to those of speakers addressing the U.N. General Assembly, to say nothing of the campaign addresses by either candidate for the US presidency.

I shall return to the videotape of what was effectively Osama bin Laden's campaign advertisement below. His sudden change of manner and appearance mock and caricature conventional forms of statesmanship, especially given the heavily satirical tone Bin Laden adopts. Whether or not it was intended to be satire, however, his unexpected performance made the videotape appear all the more like a piece of theatre. But then it is precisely the jihad's unwillingness to distinguish between media spectacle and political reality that most effectively illustrates its character as an ethical performance, as exemplified in a video, recorded in Afghanistan in November 2001, showing Osama bin Laden and several companions discussing the 9/11 attacks:

> *Sulayman [Abu Guaith]:* I was sitting with the Shaykh in a room where there was a TV set. The TV broadcast the big event. The scene was showing an Egyptian family sitting in their living room, they exploded with joy. Do you know when there is a soccer game and your team wins, it was the same expression of joy. There was a subtitle that read: "In revenge for the children of Al Aqsa, Usama Bin Ladin executes an operation against America." So I went back to the Shaykh [*meaning UBL*] who was sitting in a room with 50 to 60 people. I tried to tell him about what I saw, but he made a gesture with his hands meaning: "I know, I know."

This is a portion of the videotape where Bin Laden and his companions are speaking of prophetic dreams about the destruction of the World Trade Center, so it is not entirely clear whether Sulayman Abu Guaith is recounting a dream or real experience. But this uncertainty is itself full of interest because it ignores the distinction between fantasy and reality without in the least doubting either. And this deliberate ignorance is only reinforced by the fact that Abu Guaith at no point refers to anything outside the media, even deferring the reality of 9/11 in a series of media references, so that it is made available by Abu Guaith watching an Egyptian family on his television who are watching the collapse of the twin towers on their television. What is more the event itself is compared to a soccer match, which is to say a game, a televised spectacle, and not to some unmediated form of reality. As it turns out,

comparing the attacks of 9/11 to televised football games, or to karate tournaments, is common in Al-Qaeda circles. This suggests that its jihad is conceived of in sporting rather than, say, apocalyptic terms, as a rule-bound contest in which the survival and indeed community of both parties is assumed. Perhaps such comparisons indicate callousness, or even a loss of touch with reality in their makers. They certainly do represent acts of the jihad as performances which are ethical because they are self-contained. Comments by Bin Laden from the same videotape provide a good example of this:

> Abu-Al-Hasan Al-(Masri), who appeared on Al-Jazeera TV a couple of days ago and addressed the Americans saying: "If you are true men, come down here and face us." (. . . inaudible . . .) He told me a year ago: "I saw in a dream, we were playing a soccer game against the Americans. When our team showed up in the field, they were all pilots." He said: "So I wondered if that was a soccer game or a pilot game? Our players were pilots." He (Abu-Al-Hasan) didn't know anything about the operation until he heard it on the radio. He said the game went on and we defeated them. That was a good omen for us.

The prevalence of prophetic dreams in the jihad also attests to its self-contained performance of ethics on the model of media spectacles in which all reference to external audiences and realities has been dispensed with. Yet this by no means implies the jihad's own departure from reality, only its recognition of reality's unfathomable nature. It is this that makes an act like martyrdom into something ethical, because its strictly instrumental or political aims have been overcome by the spectacle of suicide itself as a self-contained performance. And indeed given the jihad's complete lack of an old-fashioned political utopia, how else can its acts be defined except as ethical ones? The jihad's dreams, then, not only dispute all traditional distinctions between fiction and reality by their very existence, they also constitute the only kind of externality possible in the jihad as media spectacle. This sometimes leads to comic situations like the following, narrated by Osama bin Laden, in which he refers jokingly to the prevalence of prophetic dreams foretelling the destruction of the twin towers:

> We were at a camp of one of the brother's guards in Qandahar. This brother belonged to the majority of the group. He came close and told me that he saw, in a dream, a tall building in America, and in the same dream he saw Mukhtar teaching them how to play karate. At that point I was worried that maybe the secret would be revealed if everyone starts seeing it in their dreams. So I closed the subject. I told him if he sees another dream, not to tell anybody, because people will be upset with him.

Rather than being part of some occult tradition, the jihad's dreams and representations belong in fact to the world of mass media, whose global effects they very accurately describe. It is this world too that makes possible the jihad's acts as a set of ethical performances. Indeed all the supposedly peculiar aspects of the jihad's imagery might actually be characteristic of global movements more generally. Like these, the jihad is forced to operate in an ethical rather than political way by its inability to control or predict the future. Its actions, therefore, while being meticulously planned, do not themselves plan for any future, which thus remains open in every respect. Rather these actions occur as speculative investments in some idea of justice that cannot be anticipated, only invoked in a self-contained performance of ethics, whose effects serve merely as opportunities for further investment.

It is perhaps this freedom from a utopian politics of intentionality that gives the jihad its rich inner life. Dreams and auguries apart, the rites of martyrdom are dominated by images

of freedom that appear to have nothing to do with political causality of any sort. Such, for instance, are the green birds that populate many narratives of martyrdom. We have seen from his testament that the European martyr Suraqah al-Andalusi, who was killed in Afghanistan in 2001, happened to be converted to the cause of martyrdom by an audio-cassette titled *In the Hearts of Green Birds*. The reference here is to the following tradition of Muhammad:

> The Prophet (SAWS) said: "The souls of martyrs reside in the bodies of green birds that perch on chandeliers suspended from the Throne and fly about Paradise whenever they please" (Ahmad and At-Tirmidhi).

This fanciful depiction, which is unlikely to be taken literally by any Muslim, provides the jihad with the elements of an aesthetic. It is an aesthetic that has little if any religious meaning, and is transmitted not by way of theological tracts but by the media itself—in the same way as fashions in clothing or music. These green birds are therefore aesthetic creations testifying to the rich inner life of the jihad [...].

Naeem Mohaiemen

LIVE TRUE LIFE OR DIE TRYING

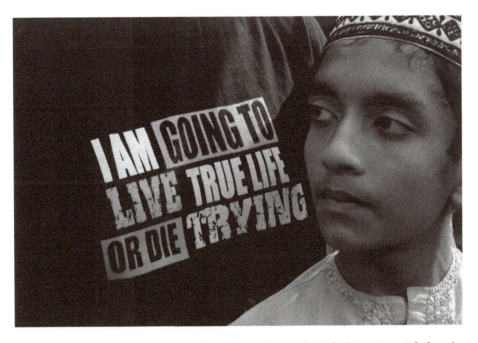

I send the uncropped image to Annu. She replies, sharp and quick, "Sometimes I feel you're just selling stereotypes."

The prayer cap is the sum of fears, nothing else pushes through. Somewhere, Fareed Zakaria is already composing the next Newsweek cover: "Why they still hate us"

I crop the head, now the memory is clean.

Later, the catalog designer writes, the proportions are wrong for their template. The t-shirt text keeps getting cropped. I go for a walk. When I come back, I mime resignation and send them the original image.

The cap stays in the picture.

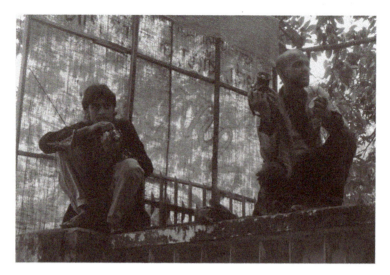

I have filmed these "Islamist" rallies so many times before. But always from nearby rooftops: muffled, grainy, blurred. A cliche that the "ferocious mob" had to be captured from a distance.

This time, I went close, and the crowds parted. "Let photographer bhai through." This felt like enthusiasm.

Without the shutter click, the performance has no audience. The BBC cameraman brusquely moved the mike away from a speaker's mouth to get a much better shot.

Not a murmur.

My love, everything I do, I do for you.

On this day, I film the first rally while standing very still. Sharp attention, but no affection.

The second rally gets my gentle, moving, soft focus caress. A lover tries again, flower in hand.

Still, my camera stays tight. If I go wide, the tableaux will fray. Just outside the edges are other people: walking, talking, ignoring the rally, deaf to chants. No time for earnest causes.

Friday is for prayer, Friday is for shopping.

January 9th 2009, early afternoon, "Islamist"/Islamist

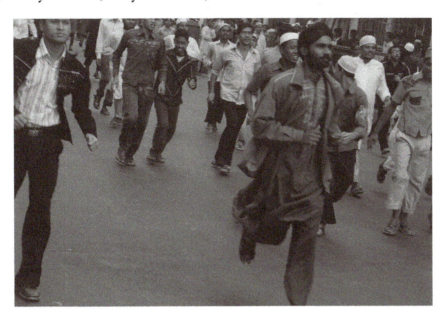

1:40pm The agency photographers arrived long before me. The best action shots are already in their can. I'm cursing myself for not bringing a spare battery. The sun is overhead. While I slowly screw around with aperture, the moments pass me by.

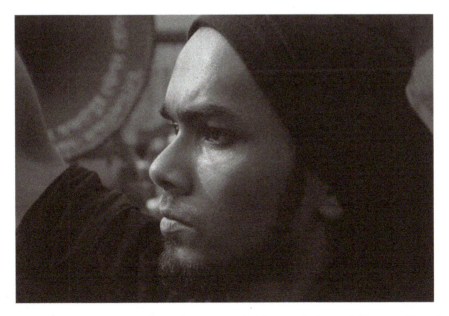

1:50pm Science fiction is not always future, it can be that which almost did happen, if not for our intervention. Somebody has spread the rumor that Bangladesh will lead a UN peace-keeping mission in Iraq. The rally now has a focus, our army can't be part of a "slave mission." Whether it's true or not is beside the point.

2:00pm A dreamy or layered day for the tailor. 50 cent, on tile mosaic, on Daud star. The omnivore is always starving inside, and no one knows why.

A girl flirtatiously says, "I'm looking for a handsome boy to be with. But it seems every boy is prettier than me. That won't work." Candyshop.

2:15pm A small scuffle breaks out. One of the photographers is pushed. I get irritated, but I don't quite understand why. I yell at someone, "Don't push, without us you're nothing." He turns and stares me down, and then says, "I don't know who sent you, but we're not here for dirty politics."

I'm intimidated into silence. I want him to be a fake, but he's not. Why not?

2:30pm A sort of senior police officer asks which newspaper I'm with. When I tell him, I'm with no one, in fact I am no one, he relaxes.

"Why are you here then?" and without waiting for my answer, he continues, "Tell me what government wants us to do? Do they expect us to beat them?"

2:35pm A few months back, during a hot discussion of Diploma's milk ad (withdrawn after protests over the milky, licking mouth), we heard the phrase "coyf porn." Now, as I select images, I keep recalling that word.

The other photo in this series (the one I won't show you), with this boy in full war cry, is a coyf shot for journalists.

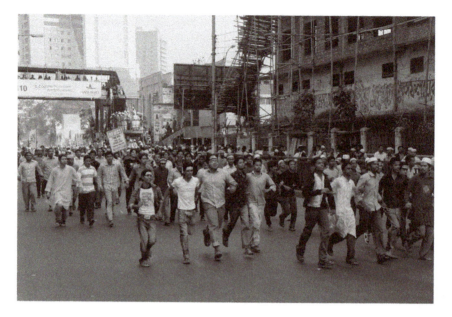

2:38pm I'm wondering who I betrayed to come to this moment. I'm out of my body again. A large flat book is tamping down the edges of a print. A few hours of this and it will be ready for the framer.

The collector first pinned butterflies, and then people. One was practice.

2:40pm I definitely got here a little too late. The burning ritual is over, and I'm snapping residue from the fire.

Nothing to see here, nothing significant now. Everyone is leaving. And nobody has, I feel sure about this, rescued a book and hidden it under their coat. Fahrenheit 451.

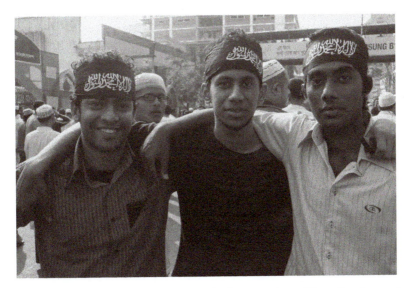

2:50pm They call me over, stand in a line, and ask me to shoot. The tallest boy writes his address on a piece of paper and hands it over.

I have done this so many times, but I know I will never mail the pictures. There's a breakdown in my intention. I still owe a flag seller photos from last December. I met him on Independence Day.

January 9th 2009, late afternoon, "Leftist"/Leftist

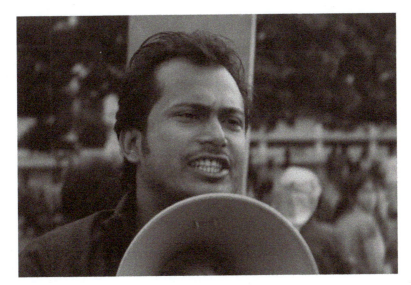

4:30pm University campus. The second rally of the day. Now familiar faces, back in my zone. I want to tell them, that the Islamist rally was so much bigger. The mullahs have us on the run, neither history nor crowds are on our side.

But there's no time for analysis, there never is. We start to march, and my hand shakes a little. Just at the beginning.

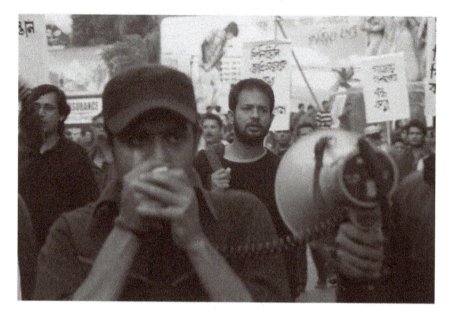

4:40pm While we shout into megaphones, the Djuice ad's rock boy sings into his mike, taunting us. A billboard designed by Bitopi, whose director always jokes with me "what pinko-commie event did you attend today?" He moved here from West Bengal. Like all former residents of communist states, he has a gene coding to be critical about utopia.

Did something similar happen to Chris Marker? Love curdled into sad regret. Perhaps we all need a cat named Guillaume to keep us sane.

4:55pm The chants get sharper with each repetition. My land, my mother. Won't let it be Somalia. My land, my mother. Won't let it be Iraq. My land, my mother. Won't let it be Liberia. The list goes on, and then someone throws in Rwanda.

Rwanda? It itches at me for the rest of the afternoon.

4:58pm Some people are falling behind. The procession is starting to sag.

Oh, you're on the phone, got a clear line at last? I'm doing this and I'm doing that and I'm trying to make some girl and she says baby come back next week can't you see we're on a losing streak.

5:10pm A few months later, former allies will clash. Chavez has spoken on Iran, the left is in instant confusion. We shadow box each other on facebook—pasting in yet another article, the tyranny of references. I will flood you out.

Still, in the 1970s, these arguments would lead to factions, turf war, maybe murder. Now, it's only words. When the argument gets hot, he says this is why the British were able to stay "extra hundred years" in India. Because of you traitors. Mir Jafars. I think he means me.

5:25pm Something totally unexpected. What's whitey doing in my shot? The fourth wall is broken.

Later I find out he is a visiting Nordic journalist. Of course he is. The Euro left's penchant for third world action. You people, your history, your food . . .

5:20pm These days, the Islamists have the brightest graphics: an eagle grabbing the map, slow red bleeding across plains and rivers. The wings with Gandhi's wheel on the left, stars and stripes on the right.

And here we have . . . a widowmaker effigy in boring, dour brown.

5:30pm The words on the effigy have not changed much in four decades. There are still warmongers, still imperialism.

 Someone miscalculated how flammable this hay was. The fire shoots out of control immediately. Organizers push everyone back, if that thing falls on someone, game over. But the photographers are a nuisance, creeping forward to fire a final round.

5:40pm The flames flicker and lick, slowly things settle down. We pack up, remove barricades and let traffic back into the campus. Shoppers look relieved, lovers made good use of the delay. Soon the roads are back to the usual chaos flux.

 No lives were saved today, but maybe a butterfly wing flapped. I want to go home and scan the photos. Freeze some tears. But first, we should get a bite to eat. I'm hungry, are you?

Part 2 (a): Further reading

Bahrani, Zainab. *Rituals of War: The Body and Violence in Mesopotamia*. New York: Zone, 2008.

Devji, Faisal. *Landscapes of the Jihad: Militancy, Morality, Modernity*. Ithaca, NY: Cornell UP, 2005.

Feldman, Allen. *Formations of Violence: The Narrative of the Body and Political Violence in Northern Ireland*. Chicago: U Chicago P, 1991.

Gregory, Derek. *The Colonial Present. Afghanistan, Palestine, Iraq*. New York: Wiley-Blackwell, 2004. Website: http://web.mac.com/derekgregory/iWeb/Site/Welcome.html

Mirzoeff, Nicholas. *Watching Babylon: The War in Iraq and Global Visual Culture*. New York: Routledge, 2005.

Mitchell, W. J. T. *Cloning Terror: The War of Images, 9/11 to the Present*. Chicago: University of Chicago Press, 2010.

Mohaiemen, Naeem. Website: http://www.shobak.org/.

Paglen, Trevor and Rebecca Solnit, *Invisible: Covert Operations and Classified Landscapes*. New York: Aperture, 2010. Website: http://www.paglen.com

Parks, Lisa. *Cultures in Orbit: Satellites and the Televisual*. Durham, NC: Duke UP, 2005. Blog: http://lisaparks.blogspot.com/

Sturken, Marita. *Tourists of History: Memory, Kitsch, and Consumerism from Oklahoma City to Ground Zero*. Durham, NC: Duke University Press, 2007.

Part 2 (b) Attention and visualizing economy

THE GLOBAL ECONOMY DEPENDS as much on what is known as "immaterial" labor—cultural work, the service economy and any form of work that does not make things—as it does on the new global workforce producing ever-cheaper commodities. Central to this immaterial form of labor is the work of looking and the task of attracting attention. Opening this section is Jonathan L. Beller's chapter "Kino-I, Kino-World: Notes on the Cinematic Mode of Production." First published in the 2002 edition of the *Reader*, it summarizes the work behind Beller's 2006 book *The Cinematic Mode of Production*. For Beller, to look is to labor. Not for oneself but for those others who are seeking our attention minute by minute, with their banner ads, email "invitations," tweets, robo-calls and so on. Each time we respond or even notice, we create value because in the regime of what Situationist Guy Debord called the "spectacle," human communication is in and of itself a commodity. Corporations speak a new language of "capturing and monetizing eyeballs," meaning generating revenue by catching your attention. In Beller's thesis, this is no mere accident but central to what he calls the cinematic mode of production. In this view, "cinema" is the social, providing we understand cinema to mean the full scope of visuality, rather than just the movies. Beller, knowing that understanding visuality is not the same as challenging let alone overturning it, modestly suggests that his analysis has a "germinal contribution to make to counter-hegemonic struggle." That prediction has been borne out, as the contributions to this section amply demonstrate, whether they agree with Beller or not. In fact, this is perhaps one of the liveliest debates in critical visuality studies at present: how do we respond to the attention economy and to the generalization of what were once aspects of creative or immaterial labor to the hegemonic mode of labor as a whole? The chapters that follow offer different responses to this question, which is by no means yet resolved.

In recent years, Beller's work has been understood in relation to the Italian Autonomia group of neo-Marxist theory, represented here by the extract from Paolo Virno's *Grammar of the Multitude*. This project has its roots in the 1970s social unrest in Italy, ranging from the factory occupations and resistance to the outright terrorism of the Red Brigades. Virno was active in a group called *Potere Operaio* (Worker's Power), who were central to the refusal of work strategy of the period. In this extract, he defines the key term "virtuosity," which he sees as the hallmark of present-day labor. This work is "an activity which finds its own fulfillment (that is, its own purpose) in itself." So unlike traditional manufacture, say, in which labor produces a commodity, virtuosity is analogous to the performing arts in that it is an end in itself. Virno's prime example is speaking in the everyday sense: something that does what it does in the action of doing it. Like Beller, Virno finds the concept of the spectacle key, as "the 'real abstraction' which portrays labor in itself, the present tense of labor." So whereas money was the real abstraction for Marx because it was both a material commodity in itself and the abstraction of value, the "so-called culture industry" now manifests "human communication" as a commodity. Although Virno does not use the example, we can think of social networks like Facebook that have an immense value because of the extent of communication that takes place on them. While he is of course aware that real goods are still being produced, Virno, like many modern economists, understands what is often known as the "knowledge economy" to be dominant. He calls it "general intellect," appropriating a term used by Marx, meaning "the stage in which mental abstractions are immediately, in themselves, real abstractions" capable of generating value.

In a different register, Ackbar Abbas considers the present-day Asian city "transformed at unprecedented speed by new forms of capital, media and information technology" as the site of the twenty-first century's "urban experiments." Again, they are so representative precisely

because they are at once so problematic and so difficult to describe. Abbas understands the city itself as "a cluster of images, a series of discourses, an experience of space and place, and a set of practices that need to be interpreted," in addition to its physical and political presence. Anyone who has traveled to a new global city is aware of this task. For Abbas, such cities have three characteristics, all derived from cinema. First, they are, in the phrase coined by Deleuze, "any space whatever." They are fragmented, unrecognizable, poorly connected and as such always already unfamiliar. Next is what the architect Mario Gandelsonas has called "X-urbanism." This is at one level the now familiar mutation of the city into the X-urban space—whereas the suburb is the counterpoint to the city, the X-urb is "in continuity and in tandem with it," thereby supplanting the suburb. Abbas notes that the spectacular construction of many Asian cities obscure this process, especially what he calls X-colonialism. He demonstrates his thesis in relation to the concept of the fake, especially in media and intellectual property. For instance, he points out that a "fake" Chinese "Swiss watch" does in fact use a Swiss-made watch movement, the very same technology used by the "real" Swiss watch. In short "the original is also a simulacrum of the fake, not just the other way around." These spaces work so well because they articulate the logic of the spectacle as Debord understood it: "Anyone can join the spectacle." What defines conspicuous consumption is precisely the capacity for it to be faked. Thus Picasso named a painting he himself had made as a fake because "I can paint fake Picassos as well as anyone." The traditional aesthetics of the "good eye" that can determine such qualities as provenance or authorship without need of documentation—the pre-industrial virtuoso mode of seeing—falls before the new distinction created by Abbas: "the artist falsifies, the faker merely fakes."

It is to "the creative labor of artists" that has emerged here as intriguingly central to the question of the globalized economy that Andrew Ross directs our attention. Ross considers the shift to the "creative industries" model of economic growth from the perspective of labor rights: "the preferred labor profile of the new freelancing economy is that of the eponymous struggling artist, whose long-abiding vulnerability to occupational neglect is now magically transformed, under the new order of creativity, into a model of enterprising, risk-tolerant pluck." In short, it is less the virtuosity of the artist-laborer that now appeals than their willingness to accept poor wages, intermittent employment and long hours. Post-recession (2008 on), such workers are increasingly asked to work for nothing, whether as "interns," volunteers, or in other such guise. While 50 per cent of interns are now unpaid or below even minimum wage, Ross quantifies my earlier example of Facebook: it generated $2 billion of revenue in 2010, almost a third of which was net profit, and yet it has only 1,700 employees. The people doing the work are us—assuming you're one of the 850 million people that use the site. Whether hidden as fun or offered as creative work, this self-exploitation is spreading. Ross notes that one appeal to networks of reality television is that it is not unionized and hence cheaper to produce, perhaps accounting for its expansion to over 20 per cent of scheduling in 2010. In looking at the Marxist theories of immaterial labor, including Virno, Ross suggests by contrast that wagelessness is a better measure: "the vast majority of human labor throughout history and to this day was and is wageless, certainly when compared to the model that economists call standard employment." Readers will no doubt enjoy the opportunity to weigh up this interesting and critical dispute for themselves: immaterial labor? Wageless apprenticeship? Or both?

The next contributor to this section, Mark Fisher, is in a certain sense typical of the new intellectuals being discussed. Although he teaches in further education, he also has a widely-read blog and publishes with non-academic presses. His widely-read polemic *Capitalist Realism* develops from the insight attributed variously to Fredric Jameson or Slavoj Žižek that it is now easier to imagine the end of the world than it is to imagine the end of capitalism. In the popular film *Children of Men* (2006), internment camps and franchise coffee-bars exist side-by-side,

as indeed they do in the U.K. and U.S. alike, not to mention China. Here the aesthetics of the museum is a culprit, as "the beliefs of previous cultures are objectively ironized, transformed into *artifacts*." The "failure of the future" predicted by Jameson has come to pass, and all is now irony and pastiche. Capitalist realism is in a sense the apogee of postmodernism, a time in which " 'alternative' and 'independent' don't designate something outside the mainstream culture; rather they are styles, in fact *the* dominant styles, within the mainstream."

The cultural critic Brian Holmes, who works at the intersection of artistic and political practice, turns our attention to what he calls "do-it-yourself geopolitics," which he sees as having emerged from radical art practice. Whereas art practice in the early twentieth century sought to overcome art's own limitations, Holmes argues that since 1968, this drive has found new possibilities in the "conflicted and ambiguous relations between the educated sons and daughters of the former working classes and the proliferating products of the consciousness industry." Situationism, punk, AIDS activism and other forms of radical appropriations of media production interfaced with the Internet to produce the anti-globalization movement and tactical media, centering on the production of unpredictable events. The event is not an artwork but "a struggle for the aesthetics of everyday life." Mapping these movements in late 1990s and early 2000s tactical media, Holmes illuminates how such groups as Wikileaks and Anonymous, not to mention the 2011 occupation of the Plaza del Sol in Madrid, have become possible. In the Occupy movement, such possibilities have dramatically expanded into groups like Occupy Museums, the Arts and Labor Working Group, and the Occuprint collective. This activism is unwaged but voluntary, virtuoso but resistant, and claims to see a real alternative to fake capitalist realism. Needless to say, many of these writers are directly involved. This is not over.

Jonathan L. Beller

KINO-I, KINO-WORLD: NOTES ON THE CINEMATIC MODE OF PRODUCTION

But all the story of the night told over,
And their minds transfigured so together,
More witnesseth than fancies images,
And grows to something of great constancy;
But, howsoever, strange and admirable.

A Midsummer Night's Dream (the movie)

The cinematic mode of production

THE TERM "CINEMATIC MODE of production" (CMP) suggests that cinema and its succeeding, if still simultaneous, formations, particularly television, video, computers and internet, are deterritorialized factories in which spectators work, that is, in which they perform value-productive labor. In the cinematic image and its legacy, that gossamer imaginary arising out of a matrix of socio-psycho-material relations, we make our lives. This claim suggests that not only do we confront the image at the scene of the screen, but we confront the logistics of the image wherever we turn—imaginal functions are today imbricated in perception itself. Not only do the denizens of capital labor to maintain themselves as image, we labor in the image. The image, which pervades all appearing, is the *mise-en-scène* of the new work.

What is immediately suggested by the CMP, properly understood, is that a social relation which emerged as "the cinema" is today characteristic of sociality generally. As Pierre Boulez says," Art transforms the improbable into the inevitable."[1] Although it first appeared in the late nineteenth century as the built-in response to a technological oddity, cinematic spectatorship (emerging in conjunction with the clumsily cobbled together image-production mechanisms necessary to that situation) surreptitiously became the formal paradigm and structural template for social, that is, becoming-global, organization generally. By some technological sleight of hand, machine-mediated perception is now inextricable from your psychological, economic, visceral and ideological dispensations. Spectatorship, as the fusion and development of the cultural, industrial, economic and psychological, quickly gained a

handhold on human fate and then became decisive. Now, visuality reigns and social theory needs to become film theory.

At the moment, in principle, that is, in accord with the principles of late capitalism, to look is to labor. The cinematicization of the visual, the fusion of the visual with a set of socio-technical institutions and apparatuses, gives rise to the advanced forms of networked expropriation characteristic of the present period. Capitalized machinic interfaces prey on visuality. Recently, corporations such as FreePC, which during the NASDAQ glory days gave out "free" computers in exchange for recipients' agreement to supply extensive personal information and to spend a certain amount of time online, strove to demonstrate in practice that looking at a screen can produce value. Almost a decade ago, I argued that the historical moment had arrived which allowed us to grasp that looking is posited by capital as labor. If, in the early 1990s, the idea was difficult for academics to fathom, corporations have been faster on the uptake. What I call "the attention theory of value" finds in the notion of "labor," elaborated in Marx's labor theory of value, the prototype of the source of all value production under capitalism today: value-producing human attention. Attention, in all forms imaginable and yet to be imagined (from assembly-line work to spectatorship to internet-working and beyond), is that necessary cybernetic relation to the *socius* for the production of all value for late capital. At once the means and archetype for the transfer of attentional biopower (its conversion into value and surplus value) to capital, what is meant today by "the image" is a cryptic synonym for these relations of production. The history of the cinema, its development from an industrial to an electronic form, is the open book in which the history of the image as the emergent technology for the leveraged interface of bio-power and the social mechanism may be read.

The world-historical restructuring of the image as the paradigmatic social relation is currently being acted upon in practice by large corporations. However seductive the appearance and however devastating the consequences of the capitalization and expropriation of the image relation (of the imaginary) may be for the vast majority on the planet, this exploitation is in keeping with the developmental logic of capital and must therefore be understood as business as usual. For the new thing that is the image and its attendant attentional productivity sustains the perpetuation of extant waged, gendered, nationalized and enslaved labor. That extraordinary innovation goes hand in glove, or better, tongue in cheek, with the intensification of world oppression may conveniently be understood in Guiseppe Lampedusa's assessment of the dialectics of domination, "Things must change in order to stay the same." The image structures the visible and the invisible, absorbs freeing power and sucks up solidarity time. The mode of domination shifts in order to maintain hierarchical society. As spectators begin to value their attention (their attending), corporations struggle to get more of what they previously got for nothing. Last year, for example, in the *San Jose Mercury News* Mypoints.com advertised with the copy "We'll pay you to read this ad." At the same moment another website banner displayed disembodied roving eyes with the caption "We'll pay you for your attention." It should come as no surprise that "bellwether" internet company Yahoo, which has always considered itself a media company, recently hired Terry Semel, former chief of Warner Brothers studio, to head its operations.

The failure of some of these dotcom corporations should not lead us to believe that this new era of corporate designs on our attention was a temporary speculative error. As Jeff Bezos, founder of Amazon.com, is (understandably) fond of pointing out, "just because 2,700 automobile manufacturers folded in the early twentieth century doesn't mean that the car was a bad idea [sic]" (it was). Besides, in hindsight, mass-media corporations have long given out "free" content over the airways in exchange for viewer attention that would then be marketed to advertisers. Remember television? Additionally, as Ben Anderson has forcefully suggested with respect to print media, even those contents for which we paid a delivery

surcharge in coin had a productive effect, and therefore something like a production agenda, far in excess of the single instance of consumption. Imagine, communities, nay, nations, being produced by simply reading the newspapers! Rey Chow's brilliant critique of Anderson in *Primitive Passions*, in which Lu Xun's traumatic encounter with the cinematic image marks the founding moment of Chinese literary modernism, places visuality at the center of emergent nationalism, and suggests that modern literature is a consequence of the blow dealt to language by the technological onslaught of images.[2] Thus the entire history of modernity stands ready for a thorough reconceptualization as film practice. Stated differently, because of the transformation of sociality by and as visuality, film theory is today confronted with the task of writing a political economy of culture as mode of production.

Nowadays, as it enlists viewers to build the pathways for its infrastructure, both as fixed capital and in themselves, Corporate America consciously recognizes that ramifying the sensual pathways to the body can produce value, even if the mechanisms of value production have not been fully theorized. Sensuo-perceptual contact between body and social mechanism, what Sean Cubitt refers to as "cybertime," provides opportunities for value-extraction for capital. That gap between the practice of stealing human attention and a radical theory of this practice exists in part because there is no money in theorizing the mechanisms of value production as a dialectical relation, just as for Marx there was money neither in the labor theory of value nor in Marxism. Put another way, the generalized blindness with respect to the economicization of the senses is constitutive of hegemony. This leveraged theft of sensual labor is the postmodern version of capital's dirty secret; the spectator is the Lukacsian subject-object of history.

The history of advertising, with its utilization of psychoanalysis and statistics to sell product, elucidates the uses capital makes of cultural theory. At the level of engagement with the body (as desiring subject, as unit of the mass market) there are plenty of theories, but at the level of profit-taking, pragmatics provides the bottom line. Advertising power-houses use psychoanalytic techniques under the rubric of "theater of the mind," and only the marginalized think to argue with success. Thus the logistics of social production in general, and the conceptualizations thereof, remain difficult to grasp, profitably buried as they are under the surface of simulation. Probably the most eloquent and realistic image of the current situation of social production via the image as the pre-eminent social relation publicly available is to be found in the late-capitalist social realist film, *The Matrix* (1999). That film depicts a situation in which the computerized (incorporated) control of the sensual pathways to our body have reduced us, from the point of view of the system, to sheer biopower, the dry-cells enlisted by the omnipresent spectacle to fuel an anti-human artificial intelligence. Whatever life-energy we put into the world is converted into the energy to run the image-world and its illusory logic while we remain unknowingly imprisoned in a malevolent bathosphere, intuiting our situation only through glitches in the program. Our desires for deviance, our bouts with psychopathology, even our fantasies of wealth and power represent such glitches, but as is well known to advertisers, media moguls and cold war policymakers alike, these mini-revolutions can also readily be made to turn a profit for Big Capital.

Such a relation of the senses and particularly of the visual to production did not emerge overnight, and providing a theoretical and historical account is one principal purpose of my theory of cinema. Looking has long been posited as labor by capital, in the present moment it is being presupposed as such. The lagging of a critical theory of the mode of exploitation behind the practice of exploitation is no longer tenable, if it ever was. Overcoming this epistemic lag-time is another aim here, one bound up in the revolutionary potential contained in understanding how the world goes on as it does and in whose interests. The transformative saturation of the visual realm, which gives rise to the terms "virtual reality," but also "visuality," was itself produced. The transformation of the visual from a zone of unalienated

creative practice to one of alienated labor is the result of capital accumulation, i.e., the historical agglomeration of exploited labor. By the "alienation of vision" I do not mean that there have not existed prior scopic regimes which structured sight, rather I have in mind the Marxist notions of separation and expropriation endemic to commodification. This estrangement of the visual, its new qualities of "not belonging to me" characteristic of the cinema and its dissociation from "natural language," are simultaneous with the semi-autonomization of the visual—what we call "visuality." Furthermore, the maintenance and intensification of the transformed situation of "visuality" remain essential to capital's expansion and valorization. But despite the world-historical truth of this claim it remains difficult to write sentences written in the key of Marx: "Communism is the riddle of history solved and knows itself to be this solution." The streamlined, scaled-back, post-modernized equivalent reads, "The attention theory of value is the riddle of post-global capitalism properly posed, and has a germinal contribution to make to counter-hegemonic struggle." At the most basic level, grasping mediation as the extraction of productive labor (value) from the body radically alters the question of visual pleasure by contaminating it with the question of murder.

Materially speaking industrialization enters the visual as follows. Early cinematic montage extended the logic of the assembly-line (the sequencing of discrete, programmatic machine-orchestrated human operations) to the sensorium and brought the industrial revolution to the eye. Cinema welds human sensual activity, what Marx called "sensual labor," in the context of commodity production, to celluloid. Instead of striking a blow to sheet metal wrapped around a mold or tightening a bolt, we sutured one image to the next (and, like workers who disappeared in the commodities they produced, we sutured ourselves into the image). We manufactured the new commodities by intensifying an aspect of the old ones, their image-component. Cinema was to a large extent the hyper-development of commodity fetishism, that is, of the peeled-away, semi-autonomous, psychically charged image from the materiality of the commodity. The fetish character of the commodity drew its energy from the enthalpy of repression—the famous non-appearing of the larger totality of social relations. With important modifications, the situation of workers on a factory assembly line foreshadows the situation of spectators in the cinema. "The cut," already implicit in the piece-meal production assembly-line work, became a technique for the organization and production of the fetish character of the commodity and then part of a qualitatively new production regime long misnamed consumerism. Consumers produced their fetishes in the deterritorialized factory of the cinema. As in the factory, in the movie theater we make and remake the world and ourselves along with it.

Of course the interiorization of the dynamics of the mode of production is a lot more complex than the sketch above might allow. Cinema took the formal properties of the assembly line and introjected them as consciousness. This introjection inaugurated huge shifts in language function. Additionally, the shift in industrial relations that is cinema indicates a general shift in the organization of political economy, and this change does not occur because of a single technology. The development of cinema marks deep structural shifts and accommodations in a complex and variegated world. Certainly, the world-historical role for cinema demands a total reconceptualization of the imaginary. The imaginary, both as the faculty of imagination and in Althusser's sense of it as ideology, the constitutive mediation between the subject and the real, must be grasped as a work in progress, provided, of course, that one sees the development of capitalism as progress. Numerous works on the mediatic organization of the Western imaginary exist and the scale of its restructuring by technology is being more and more clearly grasped. Heidegger's works on technology and the world picture could be read this way as could the work of someone like Baudrillard.

In *The Imaginary Signifier: Psychoanalysis and the Cinema*,[3] Christian Metz speaks of the three machines of cinema—the outer machine (the cinema industry), the inner machine (the

spectator's psychology) and the third machine (the cinematic writer)—and proposes that "the institution [the coordination of the three machines] has filmic pleasure alone as its aim" (7). Metz argues that "cinema is a technique of the imaginary" (3) and indeed modifies spectators through a system of "financial feedback" (91). These claims are appropriate to the moment of psychoanalytic theories of the cinema in which the cinema is believed to engage the dynamics of an existing psyche. However, the scope of today's (counter)revolution—a revolution which at first glance might appear merely as a technological shift—emerges from a reversal of these very terms: *the imaginary is a technique of cinema*, or rather, of mediation generally. Such a reversal de-ontologizes the unconscious and further suggests that the unconscious is cinema's product: its functions, which is to say, its existence as such, emerge out of a dynamic relation to technology/capital (technology being understood here as sedimented, alienated species being). Thus Metz's sense of what the spectator does in the cinema, "I watch, and I help" (93), can be grasped as an intuition about the labor required for the modification of a cybernetic body organized through financial feedback. This labor is human attention building a new form of sociality: hardware, software and wetware. At nearly the same moment of the Metzian shift, albeit with different purposes in mind than my own, Jean-Louis Commoli, in his canonical essay "Machines of the visible," comes out and in an echo of the Althusserian theory of the subject, says explicitly that "the spectator . . . works."[4] However, the participatory and even contestatory roles of spectators in the 1970s and 1980s were understood as an artifact of the technology, a necessary mode of engagement with a commercially available pleasure rather than a structural shift in the organizational protocols of globalizing capital.

More recently, Regis Debray, in *Media Manifestos* gives an account of the fundamental shifts in the social logic of mediation wrought by the emergence of the current "mediasphere," what he calls "the videosphere."[5] The videosphere, which Debray dates from the mid-nineteenth century, succeeds the logosphere and the graphosphere. For Debray:

> The sphere extends the visible system of mediation to the invisible macrosystem that gives it meaning. We see the microwave oven but not the immense grid of electric power that it is plugged into. We see the automobile but not the highway system, gasoline storage facilities, refineries, petroleum tankers, no more than we see the factories and research installations upstream and all the maintenance and safety equipment downstream. The wide-bodied jet hides from view the planetary spider's web of the international civil aviation organization, of which it is but one strictly teleglided element. To speak of the videosphere is to be reminded that the screen of the television receiving signals is the head of a pin buried in one home out of millions, or a homing device, part of a huge organization without real organizers—of a character at once social, economic, technological, scientific, political—much more in any event than a network of corporate controlled production and programming of electronic images.
>
> (*MM*, 33)

Debray, for whom " 'ideology' could be defined as the play of ideas in the silence of technologies" (*MM*, 31), invokes the term " 'medium' in the strong sense [of] *apparatus-support-procedure*" (*MM*, 13, italics in original) to foreground the technological basis of mediation and to denature consciousness. Thus for Debray, "our study borders more directly on a sociology of artistic perception" (*MM*, 136). He writes, "Our history of visual efficacies needs to be written in two columns: the one that takes account of the material equipment or 'tool kit' enabling the fabrication, display, and distribution of objects of sight, and the other which chronicles the belief systems in which they were inscribed" (*MM*, 136). "The mediological

approach . . . would consist in *multiplying the bridges that can be thrown up between the aesthetic and technological*" (*MM*, 137). *Media Manifestos* makes explicit that what has been at stake in mediation has been the mode of inscription and the functionality of signs—their organizing force. Although Debray is committed to thinking " 'the becoming-material' forces of symbolic forms" (*MM*, 8) and retains a sense of the violence inherent in mediation ("transmission's rhyme with submission," *MM*, 46), and is further aware that technology is the repressed of the history of consciousness, he is no longer interested in production *per se*. This weakness, consistent perhaps with a devolving relation to Marxism, renders the passages on ethics in this work lame, and very nearly posits technology as fully autonomous ("A good politics can no more prevent a mass medium from functioning according to its own economy than it can prevent a severe drought," *MM*, 124). Without the standpoint of production, in which mass media and even droughts are seen as the product of human activity, the new order of consciousness, even when understood as such, cannot be adequately challenged. Nonetheless, Debray sees the media interface as at once highly distributed and inexorably material, implying that relations such as spectatorship are fundamentally embroiled in a profound techno-social transformation.

My own work, noted below, specifically addresses the cinematic image as machinic interface with the *socius* emerging as a response to the crisis for capital known as "the falling rate of profit." I continue to see the commodity form, the money system, and capital's violent hierarchical domination as the limit questions faced by our species. The crisis that is the falling rate of profit, in my view, results in the century-long fusing of culture and industry, deepening, to borrow Stephen Heath's words, the relation of "the technical and the social *as cinema*."[6] Cinema becomes a means to extend the range and effect of capitalized machinery. The cinematic mode of production becomes the necessary means of extending the work day while reducing real wages. "Elevating" commodity production to the visual realm, cinema extracts human labor and pays in fun (enjoy[n]ment). Cultural pathways, including those mapped under the categories of race, gender, sexuality, and nation, are thus being subsumed as media of capitalist domination—zones of oppression which capital exploits for its own purposes. Thus in an act mimetic of the relation between cinema and culture, where cinema subsumes culture and renders it productive for capitalism, the concept of the CMP would organize the major theoretical contributions of the works cited above, as well as many others here overlooked, under its own rubric.[7] In what follows I highlight some of cinema's horizons of transformation, while suggesting that "theory" as the critical thought which follows on the heels of philosophy's demise was film theory all along.

So not just psychoanalytic film theory but psychoanalysis as proto-film theory

The CMP would argue that cinema was, in the twentieth century, the emerging paradigm for the total reorganization of society and (therefore) of the subject. From a systemic point of view, cinema arises out of a need for the intensification of the extraction of value from human bodies beyond normal physical and spatial limits and beyond normal working hours—it is an innovation that will combat the generalized falling rate of profit. Understood as a precursor to television, computing, email and the world wide web, cinema can be seen as part of an emerging cybernetic complex, which, from the standpoint of an emergent global labor force, functions as a technology for the capture and redirection of global labor's revolutionary social agency and potentiality.

Utilizing vision and, later, sound, industrial capital develops a new, visceral and complex machinery capable of interfacing with bodies and establishing an altogether (counter)revolutionary cybernesis. This increasing incorporation of bodies by capital co-opts the

ever-increasing abilities of the masses to organize themselves. As a deterritorialized factory running on a new order (the superset) of socially productive labor—attention—cinema as a sociological complex inaugurates a new order of production along with new terms of social organization, and thus of domination. "Cinema" is a new social logic, the film theater the tip of the iceberg, the "head of the pin." The mystery that is the image announces a new symptom for analysis by contemporary political economy. Production enters the visual and the virtual enters reality. Labor as dissymmetrical exchange with capital is transacted across the image.

Under the rubric of the CMP, "cinema" refers not only to what one sees on the screen or even to the institutions and apparatuses which generate film but to that totality of relations which generates the myriad appearances of the world on the 6 billion screens of "consciousness." Cinema means the production of instrumental images through the organization of animated materials. These materials include everything from actors, to landscapes, to populations, to widgets, to fighter-planes, to electrons. Cinema is a material practice of global scope, the movement of capital in, through and as image. "Cinema" marks the changeover to a mode of production in which images, working in concert, form the organizational principles for the production of reality. The whole regime of classical value production extends itself into the visual. The new orders of interactivity (ATM, internet, cell, GPS) testify to the deep entrenchment and central role of the capitalization of images in the organization of society. As Warren Sack muses, "Children born now will wonder how previous generations just sat in front of the screen without anything to do." And yet something was being done. What is so far not at all clearly grasped with respect to the central role of image technologies in social organization, and may be first recognized in its mature form in the cinema, is *media's capitalization* of the aesthetic faculties and imaginary practices of viewers. Below I will indicate the co-extensive world-historical determinants for the simultaneous socio-technological articulation of consciousness and cinema, and further suggest that not only are consciousness and cinema mutually determined by the constraints of capitalist production but that they increasingly function on a continuum.[8]

For a first-order approximation of the cinematization of social relations one might turn to the cinematic dynamics of social production implicit in (posited by) the shifting terms of the interpellation of subjects by an increasing number of institutions and apparatuses (the state, multinational corporations, politicians, "the media," boards, offices, etc.) variously invested in the expansion of capital. Take, for example, the observation common during the last couple of decades that everyone is concerned with their "image." The term is no mere figure of speech, but rather a "condensation," in Freud's sense, a matrix of partially unconscious forces that means something else. What is meant by this condensed metaphor, produced and utilized by contemporary consciousness neurotically and now psychotically pursuing the conditions for its self-perpetuation, can only be fully elaborated if we take consciousness itself as the desperate measure to account for the dreams dreamt by, in, through, and as the contemporary world system. In doing so, I am in no way endeavoring to delimit the variations of consciousness which are possible from the outset, nor to patronize what can be thought and felt. Rather, in the context of the production and reproduction of society under capitalist domination, I am trying to register the shifting terms of language-function and subject formation in the emerging media-environment. Tracing the increasing marginalization of language by images in "Language, images and the postmodern predicament," Wlad Godzich puts it thus: "Where with language we have a discourse on the world, with human beings facing the world in order to name it, photography substitutes the simple appearance of things; it is a discourse of the world. . . . Images now allow for the paradox that the world states itself before human language."[9] To register the crisis that the proliferation of images poses for language and thus for the conscious mind would be to agree with Godzich that today language is outpaced by images. "Images are scrambling the function of language which must operate out of the

imaginary to function optimally."[10] The overall effect is the radical alienation of consciousness, its isolation and separation, its inability to language reality convincingly and thus its reduction to something on the order of a free-floating hallucination, cut away as it is from all ground.

This demotion of language and of its capacity to slow down the movement of reality suggests, when linked to the rise of image technologies, that the radical alienation of language, that is, the alienation of the subject and its principal means of self-expression and self-understanding, is a structural effect of the intensification of capitalism and, therefore, an instrumental strategy of domination. Bodies become deprived of the *power* of speech. This image-consciousness or, better, image/consciousness participates in the rendering of an intensified auratic component, theorized as "simulation" or "the simulacrum," to nearly every aspect of social existence in the technologically permeated world. Beyond all reckoning, the objective world is newly regnant with an excess of sign value or, rather, with values exceeding the capacities of the sign. Such a promiscuity of signification, what Baudrillard called "the ecstasy of communication," implies, in short, the radical instability and unanchoredness and inconsistency of consciousness such that consciousness becomes unconsciousness by other means. Although the critique of metaphysics, under the sign of "deconstruction," imputes a certain transhistoricity to these excesses of the sign, and generates its *jouissance* through the truth effect produced by its analytical erasure of the metaphysical securities of ground and presence, we must now recognize deconstruction as an historical phenomenon of the 1970s and 1980s and pose the question of the very historicity of its critique. In light of the CMP, deconstruction appears not as an advance in intellectual history which reveals the misapprehended truth (under erasure) of all previous eras, but as a philosophicolinguistic turn brought about in relation to a socio-technological transformation in political economy. The CMP's account of the crisis of metaphysics might assert that all that is solid melts into cinema. It is the visual economy and the transformation of labor that liquidates being. The withering away of the state of being under the analysis of the political economy of the signifier finds its historical conditions of possibility for its deconstructive neurosis in the delimitation of the province of language by the image. Language just can't process all that visuality—it's like trying to eat your way out of a whale, which, of course, is somewhere you don't belong in the first place. That's why "you" is such a hard thing "to be."

Thus to "win the imaginary for the symbolic," as Metz described the task of film theory, means today codifying the cinematicity of domination for consciousness.[11] A rendering that reveals cinema as a new paradigm of socio-material organization would answer Fredric Jameson's thoughtful imperative: "Perhaps today, where the triumph of more utopian theories of mass culture seems complete and virtually hegemonic, we need the corrective of some new theory of manipulation, and of a properly postmodern commodification,"[12] with an analysis of the image as the cutting edge of capital, and "media-ocracy" as the highest stage of capitalism (to date). To rethink the paradigm that is the cinema means to inscribe the material basis of visuality in the unthought of the image and to disrupt its affect of immediacy, plenitude and truth. This inscription of the materiality of the virtual must traverse not just technology as it is ordinarily understood, but social relations: psychology, migration, the masses. Though not everything is an image, nearly everything is con(s)t®ained by them.

In considering the retooling of human thinking which, along with industrial and technological transformations, led up to cinema as it came to be during the twentieth century, let me pursue my reversal of the assumption that historically cinema and cinematic form emerges out of the unconscious (creating, for example, images "cut to the measure of male desire," as Laura Mulvey says of film images of women), by saying that *the unconscious emerges out of cinema* (male desire is cut to the measure of cinema). This reversal restores a lost dimension of the dialectical development of each. The coincidence of Freud's theory of the unconscious (1895) with the Lumiere brothers' first film (1895) is no mere coincidence. Theorists of suture, sexuality and more recently Hitchcock (Žižek) assert that cinema engages the architecture of

the unconscious in a kind of play. This engagement with an actually existing unconscious is not unlike what Sartre in "Why write?" called, somewhat filmically, the "directed creation"[13] engaged in by a perceiver but with somewhat fewer degrees of freedom. To the situation of Sartre's technologically embedded perceiver as "*director* of being" (italics mine), in which "our car or our airplane . . . organizes the great masses of the earth," Stephen Heath asserts that cinema adds the following delimitations: "The passage from views [early French films were listed in catalogues as views] to the process of vision [in cinema] is essentially that of the coding of relations of mobility and continuity."[14] In other words, cinema *codifies* technological movement and juxtaposition for and as consciousness. Through the simultaneous processes of delimiting the significance of movement and developing conventions for the production of continuity, what is often referred to by the misleading term "film language" is created. But perhaps, following my suggestion that it is the unconscious which emerges out of cinema, it is just as illuminating here to think of the cinematic apparatus not as a late blooming technology for imaginary titillation through an industrial interface with the unconscious, but indeed as the precursor of and model for the unconscious as it is has been theorized during the course of the twentieth century. As the circulation of programmatic images increases, there's more unconscious around.

One could take Adorno's observation about the culture industry as "psychoanalysis in reverse" as a thesis on the history of consciousness—in which industrial culture produces not just the modern psyche but psychoanalysis itself (cinema's third machine, the expanded version). In an essay entitled "The unconscious of the unconscious: the work of consciousness in the age of technological imagination," I use this approach to consciousness as besieged by the rising imaginary as I work my way through a rather specialized form of consciousness, specifically, a theory of consciousness—the one given voice in Jacques Lacan's famed Seminar XI, *The Four Fundamental Concepts of Psychoanalysis*.[15] Writ large and too briefly, my argument sets out to demonstrate that if, as Lacan says, "the unconscious" first appears (in a most cinematic fashion) "through the structure of the gap" (*FFCP*, 29), that is, in the cut between words, then the unconscious of the unconscious is cinema. The unconscious appears through the breakdown of the symbolic order (parapraxis in Freud), but is theorized in Lacan as being inaugurated scopically (the *object petit a* is, after all, an image). On the whole, this situation of linguistic breakdown conforms to Godzich's description of language confronted by images. Add to that the fact that Lacan's figures for the unconscious often involve technologies of visual reproduction, and one begins to feel that the technological is the repressed of the theory of the unconscious. Thus when in "The *network* of signifiers" (italics mine) Lacan writes:

> Last time, I spoke to you about the concept of the unconscious, whose true function is precisely that of being in profound, initial, inaugural relation with the function of the concept of the *Unbegriff*—or *Begriff* of the original *Un*, namely the cut.
>
> I saw a profound link between this cut and the function as such of the subject, of the subject in its constituent relation to the signifier itself.
>
> (*FFCP*, 43)

"the cut" is no mere figure, it is a technical function as well as a cipher of cinematic logic. The optics of the cut undermine the unquestioned legitimacy of the signifier's denotation. Likewise, what Lacan calls "the pulsative function" (*FFCP*, 43) of the unconscious is formally inseparable from the persistence of vision—where the unlanguageable medium exerts its invisible pressure on the appearance of things.

If the cinematic cut is paradigmatic of the appearance of the unconscious, then Lacan's comments on the structure and function of the unconscious are a prototheory of cinema, an

earlier endeavor "to win the imaginary for the symbolic." It is a theory of cinema and of cinematic effects that does not recognize itself as such. To say that "cinema is the unconscious of the unconscious" means psychoanalysis appears as a form of thought which takes cinema as its paradigm, albeit unconsciously. I find in Lacan's endeavor to language the image (the imaginary) a response to a crisis—the increasing cinematicity of the world. "The unconscious" is the misrecognition (*méconnaissance*) of cinema. This reading conveniently links the emergence of the modern subject, psychoanalytic theory, mediation and economics.

Throughout the *Four Fundamental Concepts* the unconscious is described in cinematic tropes, "the cut," "montage," and is figured through technological devices for the creation and reproduction of visual images: paintings, photographs, films. If, as I argue, the image is a cut in language, and if psychoanalysis appears as a film theory of the imaginary, then psychoanalytic film criticism would be less like an invention or an elaboration of psychoanalysis and more like the cipher of an archeological discovery—the discovery of the cinematicity of the unconscious. It is less that film theory turned to Lacan and more that the salmon of psychoanalysis returned to spawn in the filmic waters of its origins. As Slavoj Žižek says, "the symptom," which in my discussion of Lacan is psychoanalysis itself, "as a 'return of the repressed' is precisely . . . an effect which precedes its cause (its hidden kernel, its meaning) and in working through the symptom we are precisely 'bringing about the past'—we are producing the symbolic reality of past, long-forgotten traumatic events."[16] By taking the cinematic image as it appears in Lacan, which it does with some regularity, as something like a dream element in the discourse of psychoanalysis, it is indeed possible to show psychoanalysis as symptomatic of the trauma induced by the emerging organization of visuality under the paradigm of cinema. Noting the appearance of cinema and things cinematic in Lacan helps to build an analysis of psychoanalysis that functions in accord with the principles of psychoanalysis while leading beyond them. The process of such an approach would at once allow the claims of psychoanalysis regarding the structuring of the subject to stand while retroactively showing that cinema is, to play on a formulation of Lacan, "in it more than it;" in other words, that it is, finally, *psychoanalysis itself that is the symptom*—of cinema.

Materiality and dematerialization

Very likely, revolutionary Soviet filmmakers, particularly Dziga Vertov and Sergei Eisenstein, were painfully aware of capital's encroachment on the visual, precisely because they fought capital on its most advanced front. These directors went directly to the evolving properties of the visual to combat capital expansion. Vertov's decodification of commodity reification in *Man with a Movie Camera*, his "communist decoding of the world," tracks process of industrial assemblage. The image composes itself in such a way that objects become legible as process. At the same time the image tracks (represents) its own conditions and strategies of production, and effectively reveals that the image is built like a commodity. In *Man with a Movie Camera* industrial culture attains the visual and cinema is grasped as the necessary medium for the decodification of objectification under capitalism—the rendering of objects and images as social relations.

The easy legibility of this relation between image-objects and the process of their assemblage so carefully articulated by Vertov quickly falls back into the unthought of the image during the course of film history. However, the structure of the image thus revealed nonetheless continues to pertain.[17] For his part, Eisenstein, an engineer by training, works, early on, with the industrial application of visual technology. He deploys it in accord with the logic of Pavlovian behaviorism and Taylorization, and takes the image as a technology for "the organization of the audience with organized material," effectively grasping cinema as a social

machine for engineering the *socius*. For Eisenstein, a film is "a tractor ploughing over the audience's psyche." Even though not conceived precisely in these terms, in the films of Eisenstein, for the first time, image machines are slated to function for the configuration, extraction and application of what Marx termed "sensuous labor."[18] The films were to release the necessary energy for the proletariat to continue that labor-intensive project called revolution.

Whereas in Vertov the audience must be shown going to the theater in order to develop a critical relation to ambient images, and in Eisenstein the director controls the effect of the image on the audience by rigidly controling their organization according to a sequencing of conditioned reflexes, some seventy years later in Oliver Stone's *Natural Born Killers* the images come to viewers higgledy-piggledy.[19] Here the image, rather than a mere outgrowth of industrial society, has folded itself back into the fabric of the *socius*. Viewers do not encounter the techno-imaginary only on the screen, its logic is already inside them. This enfolding of the image into the social fabric was already implicit in Vertov; the Kino-Eye project was to make new films every day and was to be part of the quotidian apprehension of sociality. Film was to forever alter perception. However, in something like an ironic fulfillment of Marxist utopian poetics, *NBK* marks the technological realization of this condition of ubiquitous, ambient, instrumental images and the fusion of perception with technology, because the mediations presented in the film are those of capital. The images do not foster dialectical thinking; rather, they are the raw material of the dialectic itself—the modality of capital's articulation of the viewer. The images are capital's cutting edge. They dream us while we dream for them.

In *NBK* we may mark an evolutionary moment in the history of cinema. Instead of, as in Vertov, merely positing a new order of consciousness mediated by images, the money-driven image is shown to envelop consciousness. In *NBK* the image, through an increase in sheer quantity, achieves a shift in quality, realizing a change of state in which images themselves become the *mise-en-scène* for action. *Natural Born Killers*, in which two young lovers rescue one another from drudgery and oppression, become mass murderers and then celebrities, is about the conditions of personality formation in such a media-environment. Accordingly, in the opening credits of *NBK*, Micky and Mallory are driving through a mediascape in which natural landscapes fuse seamlessly with computer generated imagery, resulting in hallucinatory shifts in context and scale. This world is not virtual in the sense that it is make-believe or pretend, but virtualized by virtue of becoming bereft of its traditional standards, properties and proportions, all of which have been geographically, temporally, perceptually and proprioceptually transformed by media capital. In this new world, where nature is not nature (but always already mediation) and people are "naturally" born killers, the image of a nuclear explosion or of two open-mouthed hippos having intercourse in a swamp are of the same order: they are pure affect machines. They are on parity here; each exists here as an intensity in an endless series of dematerialized flows. The images come out of the walls and the woodwork and their omnipresence alters the significance, that is, the signification, of each and all forever.

It is the image as the context for action which not only renders ethics virtual but allows Micky and Mallory to accelerate the logic of capital in the creation of their personalities. Instead of stealing the lives of others over an extended period of time, as do plant bosses, plantation owners and stockholders in order to establish themselves as social agents, Micky and Mallory use weapons to appropriate the value of individual lives all at once. Micky and Mallory see through the media and having internalized its vision, act out its very logic. They are, in short, higher iterations of capital. Because they have tele-vision (they are television incarnate), that is, because their sight is televisual, they see everything as if it were already an image, people included. The depthlessness and ostensible immateriality of others accelerates the rapidity with which others can be liquidated and their subjective potential profitably taken. They convert people into spectacle.

Such a conversion process depends upon an evacuation of the Other and is in accord with an intensification of the constitutive relation in the formation of the subject described by the Lacanian theory of the *objet petit a*. As is the case with *Psycho*'s Norman Bates, whose name I have long been convinced is the jump-cut version of the phrase "The Normal Man Masturbates," desire's short-cutting around the social prohibitions that give the Other subjective amplitude, and its unrepressed taking of Others as image-objects, outside the socially prescribed codes laid out in psychoanalytic theory, leads to psychosis and murder. Of course these short cuts (the knife in the bath) are symptomatic of over-"objectification" and are a cultural tendency of capitalist reification. The object is deep frozen as image and drained of all subjective content. In *Natural Born Killers*, identity based on mass murder made possible through the taking of the Other as image is the logical outcome of the constitutive relation between the subject and the *object a*, a relation of capital from an earlier social moment, now placed under the pressure of an intensifying capitalism where language can no longer fill in the troublesome image of the Other. Subjects assert themselves in the liquidation of other subjects by taking these others as images. Self is produced and maintained today through an intensification of the annihilating function of the gaze. With the deepening penetration of materiality by media, a process which really means the intensifying mediation of materiality, a dematerialization of the object-world occurs. The more deeply entrenched in material structures capitalist mediation becomes, the more everything tends toward the image. Here is Guy Debord:

> Every given commodity fights for itself, cannot acknowledge the others, and attempts to impose itself everywhere as if it were the only one. The spectacle, then, is the epic poem of this struggle, an epic which cannot be concluded by the fall of any Troy. The spectacle does not sing the praises of men and their weapons, but of commodities and their passions. In this blind struggle every commodity, pursuing its passion, unconsciously realizes something higher: the becoming-world of the commodity, which is also the becoming-commodity of the world. Thus by means of a ruse of commodity logic, what's specific in the commodity wears itself out in the fight while the commodity-form moves toward its absolute realization.[20]

This passage might well be taken as a thesis on the philosophy of cinema history, that is, a meditation on the adventures of the medium *par excellence* for the epic poem of the commodity. It also provides a chilling image for the struggles of cinematic-cybernetic "subject:" us. For it is finally we ourselves, the Kino-Is, who engage in a pathological life-and-death struggle with/as the commodity form. However, if Debord's attention to the spectacular and the visual as the paramount field of capital exploitation is to be properly understood, then that which he calls "a ruse of commodity logic," which over time allows for the liquidation of the specific materialities of commodities as it brings the commodity-form toward "its absolute realization" (as image), must be shown in its socially productive aspect. The spectacle means not just commodification but production. Psychopathology, which, if you will excuse me, all of you are guilty of, is a means of production, which is to say that you, kino-you, are a means of production.

Visual economy

To understand the material history of the spectacle, one must show 1) the emergence of cinema out of industrial capitalism, 2) the reorganization of the *socius*, the subject, and the

built environment by the image in circulation, and 3) the utter reconfiguration of capital-logic and hence of labor and accumulation in and as visuality. If the spectacular, the simulated and the virtual are not somehow eminently productive of culture, and if culture is not, again, somehow, eminently productive of capital (in the strict sense of "productive" as utilized by political economy) then all the hoopla over postmodernism is simply wrong.

Let me, then, add a few more periodizing markers to our time-line in order to show the general fit of cinema with cultural shifts. What I call "the cinematic mode of production" begins with the codification of early cinema and psychoanalysis (but also behaviourism) and culminates, as it were, in the postmodern and the advance of new media. Thus the CMP begins with the historical moment in which the concrete technology of cinema is codified simultaneously with the abstract, socio-subjective and bureaucratic technologies of monopoly capital (Edison) and continues into the present.[21] Thus, the CMP spans the three fundamental movements in capitalism as specified by Ernest Mandel, beginning in the shift from steam-driven motors to electric and combustion motors, and continuing through the changeover to electronic and nuclear-powered apparatuses that is still occurring. Cinema thus spans the three great machine ages, each one marking, for capital, a dialectical expansion over the previous stage. These stages are, associated with market capitalism, the monopoly stage or the stage of imperialism, and postmodernity or the stage of neo-imperialism, and what one might call neo-totalitarianism, respectively.[22] Somewhat crudely put, it could be said that cinema has its origins in the shift from market to monopoly capital and reconstitutes itself in the shift from monopoly to multinational capitalism. Another useful index of the character of these transformations in the evolving logics of capitalized production and circulation is the mode of image making itself, the indexicality of the photograph, the analog electronic signal, and the digital image.

The CMP would propose that both cinema and capital employ the same abstract, that is, formal structures to realize their functions—the becoming-image of the world (the IMAX-NASA image of earth), or rather the dematerialization of the commodity necessary for the making of this film, is *also necessary for capital development*. Capital's fundamental transformation during the twentieth century is cinematic, that is, it becomes visual. Cinema, and the circulation of the image, provide the archetype for capital production and circulation generally. My analysis of the structure and dynamics of the cinematic apparatus is nothing less than an exploration of the industrial extension of capital's "re-mediation" and reconfiguration of the functioning of the body through the historically achieved interface known as the image. The mining of human bodies of their power has always been the goal of capital. The continuing "liberation of the productive forces" depends upon the non-liberation of the producers.

This tendency towards the dematerialization of social relations (meaning abstraction, codification through visuality, the increasing leverage of exchange-value over use-value) is accelerated by this selfsame cinematic technology, which, it must immediately be said, anchors itself in place through ever more rigid material constraints (poverty, dependence, psychosis). The mediation and modulation of appearance becomes an essential dimension of social organization, structuring the beliefs, desires and proprioception of image-consumers in ways productive for capital expansion. Much of this social programming (for that is what it is, even if the results are somewhat indeterminate) occurs outside of the current (possible?) purview of semiotics, meaning to say in zones which elude or exceed meaning even as they structure practice.

Already in the nineteenth century, the commodity had a pronounced visual-libidinal component—a fetish character. If in Freud the fetish arouses and cancels the knowledge of castration, in Marx it arouses and cancels the knowledge of alienated production. In the commodity, this beacon of quashed subjectivity ("the feminine"?) scintillated in the material, making overtures towards becoming animate. Such a beckoning presence of

impacted subjectivity in the commodity-form underlies the modernist theories of collecting as redemption—a messianic endeavor to remove objects from commodity circulation and revive them in a more benevolent setting.[23] Cinema, which is technologically on a continuum with industry, latches on to a nascent aspect of the commodity in circulation—the productive potential of its fetish character—and circulates it through the sensorium with a new intensity: the objects "speak."[24] In other words, the affective dimension of the commodity is emphasized and rendered more eloquent. If one views the mechanically reproduced image as a new order of reification, a qualitative shift in the shine as well as in the materiality of the commodity-form, then cinema as an industry is the productive orchestration of images and therefore, necessarily, the consequent extraction and management of human subjective potential.

Both the fetish character of the commodity and what Baudrillard calls simulation, two perceptual phenomena which are predominantly visual in the first instance, have been theorized to a greater or lesser extent as artifacts of reification under the capitalist regime of dissymmetrical exchange. In brief, these arguments can be grasped as follows: the ascendancy of exchange-value over use-value (the domination and tendency towards liquidation of the latter by the former) warps the visuo-perceptual field in and as an expression of the psycho-libidinal dimensions of alienation. In the classical four-fold account of alienation from Marx's *Economic and Philosophic Manuscripts of 1844*, humans are alienated from their products, from the work process, from each other and from the species. The alienation of sensual labor leads to an alienation of the senses. The very effacement and naturalization of the historical production of alienation leaves its auratic or phantasmagoric impress on the sensorium. Objects have a new pyrotechnics.

When in capitalist production, worker's product confronts him or her as "something alien," a new order of perceptuo-imaginary pyrotechnics is inaugurated, the order which leads Marx to introduce the category of fetishism. This consequence of alienation is precisely the phantasmagoria of the object, the part which stands out in place of the whole as a totality of process, the supplemental excesses of a history rendered invisible yet smoldering within the material. The fetish is the severance of community *appearing* as an object. It is the activity which the object undertakes as a medium for serving consumer from community. It is violated subjective and intersubjective activity. Of course it is essential to recall here that the experience of this phenomenon is not without its pleasures, its ecstasy. Indeed one might see in commodity fetishism a kind of severance pay, a pleasure in the mode of Platonic longing for a lost wholeness, in which commodity as missing piece promises wholeness, completion, repletion. This relation between human beings which first appears on a massive scale during the industrial revolution as a thing, finds its higher articulation in the spectacle which Debord describes as the false community of the commodity.

If one wanted to trace the cultural logic of the spectacle, the place to look for a formal precursor is in the operations and movements of money. According to Georg Simmel in *The Philosophy of Money*, law, intellectuality and money "have the power to lay down forms and directions for contents to which they are indifferent."[25] So it is with film. It might be said here that money, as an evolving medium which leaves its imprint on all aspects of cerebral activity, and which is an empty form that can take on any contents, assumes film-form, while capital as an evolving system of organization, production *and exploitation*, becomes cinematic. Historically, of course, capital precedes cinema as we commonly understand the term. Money is the medium for regulating wage labor (the spread and development of the money-form coincides with the putting in place of a global working class) while capital denotes the *system* of dissymmetrical exchange. "Film" can be understood as the social relation which separates the visual component of human subjective activity from the body in its immediate environment, while "cinema" is the systemic organization of this productive separation.

If the commodity-object is an impacted social relation in which the subjective contribution of the human worker is effaced, so much the more for the image. Andy Warhol registers this change in much of his work, but perhaps never more elegantly than in the Campbell's Soup silk screens. These soups are indeed condensed: objects formed by the condensation of farming technologies, migrant labor, canning process, trucking, warehousing and supermarketing. Warhol grasps the mass-produced object as an icon of reification, effectively peeling the label from the can, and allowing it to circulate unencumbered. This free-floating signifier of an already reified condensation dramatizes the mode of appearance for the soup, a soup which as long as it is to remain a commodity must also remain invisibly locked in a hermetic tin. In increasing the distance between the label and the use-value, Warhol registers the ascendance of image over materiality, distancing yet further whatever human subjective elements comprise the soup proper while dramatizing the subjective pyrotechnics of the image-commodity itself. Where once a portrait would have been displayed, there hangs an image of a commodity, itself a higher order of commodity.

Warhol underscores the ascendant dimension of the commodity-image by *reproducing* it, not as an anonymous designer, but as an artist. By inscribing the image at a distance, he also inscribes its social effects, he becomes the representative of a representation. Like previous art icons, Warhol is an author of an imagistic relation, but unlike others he is an author who does not immediately appear to create an original text, he only grasps it through reproduction. In the postmodern the image always occurs twice, the first time as commodity, the second as art.

As importantly as the subjective labor which goes into the production of images—in both the objectification that becomes the referent and the imagification that becomes the image in circulation, *human subjectivity is bound to the image in its very circulation*, and that in two very different ways. 1) Our gazes accrete on the image and intensify its power. Take, for example, the case of a work of Vincent Van Gogh. The 50 million-dollar fetish character is an index of visual accretion, that is, of alienated sensual labor resultant from the mass mediation of the unique work of art. All that looking sticks to the canvas and increases its value. To develop that relation has been the job of the painter, and remains the strategy of producers of unique works of art. The traditional labor theory of value cannot explain this hysterical production of value, only a theory which accounts for the systemic alienation of the labor of looking can. Equally significant, 2) in viewing the image we simultaneously and micrologically modify ourselves in relation to the image as we "consume" it—a misnomer if there ever was one, since images equally, or almost entirely, consume us.[26] If this production of both value and self (as worker, as consumer, as fecund perceiver) through looking is indeed the case, then the emergence of visual culture must be set in relation to the development and intensification of commodity fetishism.

Globalization, affect and negation

The assertion that global production is co-ordinated through the screen of capital (the screens of the many capitals) is operationally correct, and, if one considers the role of CNN, international cable stations, Bloomberg machines, computers, Hollywood film, international advertising, etc., may perhaps seem intuitively obvious. However, this operational category must become analytical (Metz's project again, but now in a politico-economic key). The development of a new order of visuality and of a visual *economy* is signaled here by a qualitative shift in the character of capital. This shift is colloquially known—at least by the theory crowd—as postmodernism. It is arguable that even in its early stages capital was already cinematic: "capital," in the work of Marx, was the screen of appearance for all politico-economic and

therefore social metamorphosis. In Marx's representation (*Darstellung*) of capital process, all that is solid melts into air precisely on the screen of capital; each moment of production as well as of world history is marched across the frame that capital provides. In short, like Vertov's *Man with a Movie Camera*, Marx's "capital" films social practice, and in fact, that is, in practice, it was precisely through the framework of capital that the social was grasped.[27] Cinema is first posited by capital, and then presupposed.

As noted, photography and the cinematic apparatus are no mere perks or spin-offs of industry as Tang was to the space program. Visual technologies developed the key pathways for capital expansion, increasing as they do the speed and intensity of commodity circulation, as well as historically modifying the visual pathway itself, transforming the character of sight. The visual as a productive relation for capital clears the way for the institution of what Fredric Jameson identifies as "constitutive features of postmodernism:" "a new depthlessness," "a weakening of historicity," "a whole new type of emotional ground tone" under the heading of "intensities," "the deep constitutive relationships of all this to a whole new technology which is itself a figure for a whole new economic world system" and "mutations in the lived experience of built space itself."[28] This cultural sea change known as postmodernism may be defined as the subsumption of formerly semi-autonomous cultural sphere by capital. This subsumption of culture registers the change of state necessary to "economic growth," or simply "development" (neo-imperialism) in the latter twentieth century. Culture became a scene, and is fast becoming the principal scene (the *mise-en-scène*) of economic production. It should be noted that the postmodern "special effects" mentioned by Jameson above, though they impact every aspect of human culture, are predominantly visual in their first instance. Without the reorganization of the visual, the massive, global immiseration that currently exists could not be effected. The postmodern distortions, which are actually spatial, temporal and corporeal *transformations*, and hence new forms of social relations, are created and sustained through a generalized extension of the capacity to mediate vision and to prolong the interface between human beings and social machines.

The new order of visuality marks a transformation of that relationship between bodies and machines previously epitomized by the assembly line. Visual images of cybernetics such as those found in *Robocop* or *Terminator* are actually the interfaces themselves. The hypothesis here is that the principle locus of the dissymmetrical exchange (exploitation) characteristic of Money-Capital-Money where the second M is larger than the first is the imaginary. Labor is done in what Althusser calls "an imaginary relation to the real," but in an utterly transformed because massively mediated imaginary and with effects that are no less material for all that. The largescale technological mediation of the imaginary is also a material shift.

Jean-Joseph Goux positions what might be recognized as the imaginary in relation to economic production thus: "consciousness (social or individual) . . . [i]s *constituted* in its very form, in its *mode of reflection*, by and in the process of social exchange."[29] Goux's work, which in ways similar to my own delineates the homologous structures of psychoanalysis and political economy, lacks for all of its undeniable brilliance, a materialist theory of mediation. Goux lacks an answer to the question "how do you get capitalism into the psyche, and how do you get the psyche into capital?"[30] He argues that "the affective mode of exchange," meaning the symbolic, is a function of "the dominant form of exchange," meaning capital. The expression of the imaginary is therefore a function of the dominant mode of exchange. While Goux's statement is accurate, what is left out is that it requires the history of twentieth-century visuality to make it so. The twentieth century is the cinematic century, in which capital aspires to the image and the image corrodes traditional language function and creates the conceptual conformation, that is the very form, of the psyche as limned by psychoanalysis. The cinematic image, as mediator between these two orders of production (political economy and the psycho-symbolic) better describes the historically necessary,

mutual articulation of consciousness and capital expansion than does Goux's provocative but abstract idea of the "socio-genetic process" in which social forms mysteriously influence one another or take on analogical similarities. Goux's theory of mediations itself lacks a general theory of mediation. It is only by tracing the trajectory of the capitalized image and the introjection of its logic into the sensorium that we may observe the full consequences of the dominant mode of production (assembly-line capitalism) becoming "the dominant mode of representation" as cinema: the automation of the "subject" by the laws of exchange. This transformed situation of the subject demands a thoroughly new epistemology almost as urgently as it demands new forms of transcendence.

If we combine such a thesis with Guy Debord's insight that "the spectacle is the guardian of sleep,"[31] then it becomes clear that the terrain of cinematics is at once macro- and microscopic, that is world-systemic, economic and historical, as well as individual, perceptual and psychological. What was already true for Lacan, albeit ontologically, here takes on its world-historical character: the dominant mode of representation induces unconsciousness. Cinema is an orchestration of the unconscious and the unconscious is a scene of production. Dream-work turns out to be real work. It is important to remember here that the category "cinema" is now detached from the film industry and its array of institutions and provides a figure for the orchestration of material production by images. Indeed with even greater range and significance than war or the automobile,[32] as the predominantly visual mediation of material relations cinema ceaselessly co-ordinates global economic forces with the extremely local (meaning regional, but also interior to particular individuals) productions of affect, trajectories of desire and proprioception.

How does this cybernesis function? Antonio Negri describes postmodernism as the " 'real subsumption' of society in capital" and affirms that the "form of value is the very 'communication' which develops among productive forces."[33] He then raises the following question:

> If "communication" constitutes the fabric of production and the substance of the form of value, if capital has become therefore so permeable that it can filter every relation through the material thicknesses of production, if the labouring processes extend equally as far as the social extends, what then are the consequences that we can draw with respect to the law of value?[34] (139)

Negri's stunning "Twenty theses on Marx" from which this passage was taken, ultimately answers the question by calling for the radical wresting of "social cooperation" (labor) from "productive command" (capital). These extremely promising categories and the work which informs their constitution demand significant attention. However encouraging Negri's assertion is, that the history of the proletarian power is asymmetrical with the history of capitalist power and that what he calls "the proletariat" has therefore never been in lockstep with capitalist exploitation, Adorno and Horkheimer's critique of the culture industry is not adequately dispensed with in Negri's model.

Adorno and Horkheimer's critique, in which human interiority has been effectively liquidated and replaced by the culture industry:—"the inflection on the telephone or in the most intimate situation, the choice of words in conversation, and the whole inner life . . . bear witness to man's attempt to make himself a proficient apparatus, similar (even in emotions) to the model served up by the culture industry"—has been criticized for an inadequate account of different modes of reception and use of mass mediated cultural production by the incredible variety of consumers extant, but Negri himself almost inadvertently proposes a grim addendum to the Frankfurt school architectonic that "Amusement under late capitalism is the prolongation of work."[35] In his words, with respect to the development of

capital, "every innovation is the secularization of revolution."[36] This statement, meant to underscore the creative and liberatory power of workers, strikes me as also providing the appropriate negative dialectic for thinking about image-culture as a system: the creativity of the masses, their quests for empowerment, fulfillment and, why not say it, "freedom" are absorbed and rendered productive for capital.[37] What a century ago I.P. Pavlov observed as "the freedom reflex" is harnessed by capital for alienated production. New affects, aspirations and forms of interiority are experiments in capitalist productivity.

With this recuperative aspect of capital in mind, along with the rise of the emergence of visuality as I have described it thus far, it would be important not to abandon the dialectics of negation. Thus far, only the negative dialectic allows us to think the political economy of the visual and hence the paradigm of a global dominant. Negation, however, has very serious limits which may ultimately include it as among the psychopathological strategies of the Kino-I thinker.[38] In conceiving the cinematicity of production, the fabrication of affect as well as the valorization of images by watching them must be grasped as a new order of production slated by the emerging visual economy. The cinematicity of capital dialectically reordains the categories of political economy, meaning that it leaves its older forms extant (wage labor, circulation, capital, use-value, exchange-value, etc.) while bringing them to a higher level of articulation. It also, in ways which exceed the scope of this essay, reordains the key operators of race, gender, sexuality and nation. The commodified object tends toward the image, money tends toward film and capital tends toward cinema. People are slotted in according, value-producing media for the new visual economy, as if living in accord with preordained scripts or programs. Thus, as I have only suggested here, the labor theory of value which has been in Marxism the basis on which capital was valorized during the production process and also the basis on which revolutionary action was predicated, must be reformulated as the attention theory of value, that is, as *the productive value of human attention*. This reformulation leaves labor as a subset of value-productive attention while positing the development of a new order for cementing of the *socius*. Furthermore it accounts for the capitalization of forms of interstitial human activity ("women's" work, "desiring-production," survival) which previously fell beyond the purview of the formal scene of value production, the workplace. Additionally, such a new order of production not only extends the working day and therefore combats the falling rate of profit, it instantiates new orders of commodities such as air, time and vision itself, whose values are measured, for example, by a statistical estimate of the size and now the "quality" of an audience.[39]

Visual, psychological, visceral and haptic events are the pathways for new kinds of work, new kinds of machine/body interfaces, which simultaneously instantiate an effective reality or media-environment for the subject-form (and its fragments) as a context for its action, and valorize capital investment. The more an image is watched, the more value accrues to it. This is a cybernetic model but here cinematized vision is the key pathway of a cybernetic capitalism and the image is the key interface. In short, by bringing the industrial revolution to the eye, cinema subsumes the environment and realizes what theorists of modernity already recognized as a second nature, the naturalization of the alienated human production of practically everything. When appearance itself is production, the ostensible immediacy of the world always already passes through the production system. Cinema is a deterritorialized factory which extends the working day in space and time while introjecting the systems language of capital into the sensorium. Cinema means a fully-mediated *mise-en-scène* which provides humans with the contexts and options for response. As cinema mediates the apparent world it also structures perception. The becoming-images of the objective world mean that cinematic practices of assemblage and reception (programs for sensual labor) characterize daily life, and not just the concrete interface with the screen. The generalized movement of commodities through the sensorium and of the sensorium through commodities is cinematic.

Thus cinema means mediation between the world system and the very interiority of the spectator. It is the global expansion as well as the corkscrewing inwards of the viral logic of the commodity-form.[40]

Notes

1 Noted in Zygmunt Bauman, *The Individualized Society*, Cambridge: Polity Press, 2001, p. 32.
2 Rey Chow, *Primitive Passions: Visuality, Sexuality, Ethnography, and Contemporary Chinese Cinema*, New York: Columbia University Press, 1995.
3 Christian Metz, *The Imaginary Signifier: Psychoanalysis and the Cinema*, trans. Celia Britton *et. al.,* Bloomington: Indiana University Press, 1982.
4 Jean-Louis Commoli, "Machines of the Visible," in *The Cinematic Apparatus*, Teresa de Lauretis and Stephen Heath (eds), p. 140. See also the following essays from the same volume: Stephen Heath, "The Cinematic Apparatus: Technology as Historical and Cultural Form," and Teresa de Lauretis, "Through the Looking Glass." For a broader theory of the social organization of the imaginary see, Cornelius Castoriadis, trans. Kathleen Blamey, *The Imaginary Institution of Society*, Cambridge, Mass.: MIT Press, 1998.
5 See Regis Debray, *Media Manifestos*, trans. Eric Rauth, London and New York: Verso, 1996. Hereafter cited parenthetically as *MM*.
6 Heath, op.cit. p. 6.
7 See my essays "Cinema, Capital of the Twentieth Century," *Postmodern Culture*, vol. 4 no. 3, May 1994; "The Spectatorship of the Proletariat," *boundary 2*, vol. 22, no. 3, Fall 1995: pp. 171–228; "*Capital/Cinema*," in *Deleuze and Guattari: New Mappings in Politics/Philosophy/Culture*, eds Eleanor Kaufman and Kevin Heller, Minneapolis: University of Minnesota Press, 1998; "Identity Through Death/The Nature of Capital: The Media-Environment for *Natural Born Killers*," *Post-Identity*, vol. 1, no. 2, Summer 1998, pp. 55–67; and "Dziga Vertov and the Film of Money," *boundary 2*, vol. 26, no. 3, Fall 1999, pp. 151–200 (http://128.220.50.88/journals/boundary/v026/26.3beller.html).
8 By "consciousness," I am referring of course to "modern(ist) consciousness" i.e., modern subjectivity— a mode of knowing *vis à vis* a way of being presently in decline.
9 Wlad Godzich, "Languages, Images and the Postmodern Predicament," in *Materialities of Communication*, eds Hans Ulrich Gumbrecht and K. Ludwig Pfeiffer, Stanford: Stanford University Press, 1994, pp. 367–8.
10 Godzich, p. 369.
11 Metz, p. 3.
12 Fredric Jameson, *Late Marxism: Adorno, or, the Persistence of the Dialectic*, London and New York: Verso, 1990.
13 Sartre's description of the role of the subject as partner in aesthetic (and ontological) creation is already cinematic. "It is the speed of our car or our airplane which organizes the great masses of the earth. With each of our acts, the world reveals to us a new face. But if we know that we are *directors of being*, we also know that we are not its producers. If we turn away from this landscape, it will sink back into its dark permanence, At least it will sink back, there is no one mad enough to think that it is going to be annihilated. It is we who shall be annihilated, and the earth will remain in its lethargy until another consciousness comes along to awaken it. Thus, to our inner certainty of being 'revealers' is added that of being inessential in relation to the thing revealed [my italics]" (in *Critical Theory Since Plato*, ed. Hazard Adams, New York: Harcourt Brace Jovanovich, 1971, p. 1059).
14 Stephen Heath, *Questions of Cinema*, p. 26.
15 Jacques Lacan, *The Four Fundamental Concepts of Psychoanalysis*, ed. Jacques-Alain Miller, trans. Alan Sheridan, New York: W. W. Norton, 1981. Hereafter cited parenthetically as *FFCP* in the body of the text. One might today propose reading consciousness itself precisely as dream. Such an approach is already implicit in Paul Valéry's comment that each epoch dreams the next. My essay is as yet unpublished.
16 Slavoj Žižek, *The Sublime Object of Ideology*, London and New York: Verso, 1989, pp. 56–7.
17 See my essay, "Dziga Vertov and the Film of Money," cited above.
18 See my essay, "The Spectatorship of the Proletariat," cited above.
19 See my essay, "Identity through Death/The Nature of Capital: The Media Environment for *Natural Born Killers*," cited above.
20 Guy Debord, *Society of the Spectacle*, no. 66.

21 The institutional history of Hollywood provides fertile ground for thinking further about the rela-
 tionship between vertical and horizontal integration at the level of film production and distribution
 (capital in the traditional sense) on the one hand, and the (always incomplete) codification of the
 image-system called cinema on the other. See for example, Charles Musser, *Before the Nickelodeon:
 Edwin S. Porter and the Edison Manufacturing Company* and David Bordwell, Janet Staiger and Kristin
 Thompson, *The Classical Hollywood Cinema: Film Style and Mode of Production to 1960*. In another vein
 see Terry Ramsaye, *A Million and One Nights: A History of the Motion Picture Through 1925*, New York,
 Simon & Schuster, 1926. See also Thomas Schatz, *The Genius of the System*, New York: Pantheon,
 1988.

22 Ernest Mandel, *Late Capitalism*, London: 1978, p. 118, cited in Fredric Jameson, *Postmodernism or, the
 Cultural Logic of Late Capitalism*, Durham, N.C.: Duke University Press, 1991, p. 35.

23 See Walter Benjamin, "Unpacking My Library," in *Illuminations*, or "Eduard Fuchs: collector and
 historian," in *The Essential Frankfurt School Reader*, eds Andrew Arato and Eike Gebhardt, New York:
 Continuum, 1987.

24 This of course is more true in the silent era, that is, in the early modern. With talkies, the visual
 objects are more properly spoken for.

25 George Simmel, *The Philosophy of Money*, pp. 441–2.

26 Arjun Appadurai correctly takes issue with the "optical illusion . . . fostered by neoclassical economics
 of the last century or so . . . that consumption is the end of the road for goods and services, a
 terminus for their social life, a conclusion of some sort of material cycle," in "Consumption, duration
 and history," in David Palumbo-Liu and Hans Ulrich Gumbrecht, eds, *Streams of Cultural Capital*,
 Stanford: Stanford University Press, 1997, p. 23. Appadurai is correct to note that commodities have
 an afterlife following their material consumption, and further correct to figure these misapprehen-
 sions regarding this consuming productivity as optical.

27 Thus, with the emergence of cinema proper, that is, when, historically, industrial capitalism
 produces cinematic capitalism we confront a classically dialectical case of sublation *(Aufheben)* in
 which the categories money and capital give way to the categories film and cinema while still retaining
 their logically prior identities and properties. The instantiation of these categories and the world-
 historical events which make their instantiation possible are inexorably linked. The dominant mode
 of representation is also an organization of material practices.

28 *Postmodernism*, 6 (see note 22).

29 Jean-Joseph Goux, *Symbolic Economies: After Marx and Freud*, trans. Jennifer Curtiss Gage, Ithaca, NY:
 Cornell University Press, 1990, p. 86. The passage reads as follows: "[S]ocial consciousness objec-
 tively comprises the complex process of symbolization in all spheres of vital activities (economic,
 legal, signifying, libidinal), and on the process of symbolization will depend, among other things, *the
 dominant mode of representation itself*—the dominant and dominated form of social consciousness. To
 show how the very form of social consciousness in a given mode of production and exchange is deter-
 mined by the signifying, intersubjective, 'affective' mode of exchange, as a function of the dominant
 form of exchange—how it is determined by the mode of symbolizing, conditioned by the economic
 process—is to become able to consider consciousness (social or individual) no longer as a simple
 mirror, an unvarying agency of reflection, but rather as *constituted* in its very form, in its *mode of reflec-
 tion*, by and in the process of social exchange." For Goux the "process of social exchange" rather than
 "the mode of production" is the significant matrix of relations which will exercise its overdetermina-
 tion effects on consciousness. This difference with classical Marxism is significant because it registers
 a slippage between the two categories, one which allows the mode of exchange to be taken as the
 mode of production and vice versa. This back-and-forth movement coincides precisely with my argu-
 ment that the dominant mode of production has become an image based mode of exchange.

30 "Just as the genesis of the money form is the construction that accounts for the enigmatic disjunction
 between money and the commodity (a disjunction, moreover, which is required for the capitalist
 mode of production to be established), so the psychic apparatus is the construction that accounts for
 the distance between nonlinguistic forms of consciousness and linguistic forms of consciousness"
 (Symbolic Economies, p. 77).

31 Guy Debord, *Society of the Spectacle*, Red and Black, 1977; #21.

32 The three things that in "The Culture Industry: Enlightenment as Mass Deception" "keep the whole
 thing together." The passage reads: "No mention is made of the fact that the basis on which tech-
 nology acquires power over society is the power of those whose economic hold over society is the
 greatest. A technological rationale is the rationale of domination itself. It is the coercive nature of
 society alienated from itself. Automobiles, bombs and movies keep the whole thing together until
 their leveling element shows its strength in the very wrong which it furthered. It has made the tech-
 nology of the culture industry no more than the achievement of standardization and mass production,

sacrificing whatever involved a distinction between the logic of the work and that of the social system. This is the result not of a law of movement in technology as such but of its function in today's economy" (Theodor Adorno and Max Horkheimer, *Dialectic of Enlightenment*, New York: Continuum, 1991, p. 121). See also Elaine Scarry, *The Body in Pain*, especially the chapter entitled "War as Injuring." See also Kristin Ross, *Fast Cars, Clean Bodies: Decolonization and the Reordering of French Culture*, Cambridge: MIT Press, 1995, in which Ross argues that "the car is the commodity form as such in the twentieth century" (p. 6). Additionally, see Paul Virilio, *War and Cinema*, London: Verso, 1989 and Virilio, *The Vision Machine*, Bloomington: Indiana University Press, 1994.

33 Antonio Negri, "Twenty Theses on Marx," trans. Michael Hardt, *Polygraph 5: Contesting the New World Order*, p. 139. Here is the relevant passage: "When the capitalist process of production has attained such a high level of development so as to comprehend every even small fraction of social production, one can speak, in Marxian terms, of a 'real subsumption' of society in capital. The contemporary 'mode of production' is this 'subsumption.' What is the form of value of the 'mode of production' which is called the 'real subsumption?' It is a form in which there is an immediate translatability between the social forces of production and the relations of production themselves. In other words, the mode of production has become so flexible that it can be effectively confused with the movements of the productive forces, that is with the movements of all the subjects which participate in production. It is the entirety of these relations which constitutes the form of value of the 'real subsumption.' We can develop this concept affirming that this form of value is the very 'communication' which develops among productive forces" (p. 139).

34 Negri, p. 139. Note Negri's own periodization of the three moments of class struggle.

35 Adorno and Horkheimer, p. 137. See also passage on p. 124 on *Gesamtkunstwerk*.

36 Negri, pp. 146–7.

37 Negri of course intends to foreground something quite different: that the proletariat is the motor force of history, its creative agent, not capital. Further, for Negri, the innovation of the proletariat is a kind of continuing revolution against capitalism.

38 The task of negation includes the necessity of needing to adopt the standpoint of domination, for example, as in this essay. Such a move, even with negation as the goal, runs the very serious risk of presenting a uniform, undifferentiated *socius* everywhere subject to the same law, of being unable to observe what is at variance with the law. In giving the comprehensive theory here it has been necessary to adopt the standpoint of full comprehension—that of capital. In my view it is pathological, even suicidal to remain here. The negative critique must impel the shattered subject to new forms of contemporary affirmation. Elsewhere I have tried to think many of these issues through from a more affirmative subaltern perspective. See my forthcoming book, *Visual Transformations in Philippine Modernity: Notes Toward an Investigation of the World-Media-System*, in which I confront the logistics implied by the CMP in the context of Filipino struggles which of necessity restore categories of race, gender, and nation to analytic prominence.

39 Robin Andersen complicates the picture significantly: "Manufacturers and the agency representative are no longer satisfied simply with quantity—the number of people watching TV shows. Now they are concerned with audience 'quality' as well. And there is a fundamental connection between programming environment and audience quality. A 'quality' audience is one that has been primed, with appropriate programming, to be more receptive to advertising messages" *Consumer Culture and TV Programming*, Boulder, Col.: Westview Press, 1995, p. 4. Andersen adds that "It is a Hollywood joke that broadcasters are selling eyeballs to advertisers. It is fair to say, then, that in selling commercial time to advertisers to sell products, broadcasters are also selling a product—their audiences" (p. 5). What needs to be theorized is that the audience is not just one commodity among many, but a unique commodity in the sense that labour is a unique commodity—that is, it is *the* commodity capable of producing surplus value through dissymetrical exchange with capital.

40 In keeping with Rosa Luxemburg's *The Accumulation of Capital*, New Haven: Yale University Press, 1951, in which capital always needs a periphery for expansion, we could say that the Third World, and the Unconscious, to name the two most significant peripheries of the dominant, are new frontiers of cinematic capitalism. In its translation of image into action and action into image, cinema transforms the perceptual field, the sensorium and the significance of objects. I have already suggested, however telegraphically, that the rise of image culture parallels and indeed induces the rise of the unconscious. This takes place in the transition from the first to the second machine age. I would also like to propose that in the transition from the second to the third machine age, the increased quantity of images induces another crisis in language compared to which the coming of the unconscious was only a preamble. This second crisis would of course be the moment of deconstruction and the demise of the subject. The philosophical explication of the holes in language which began to appear everywhere in the 1960s (an event which can only be explained via a materialist history and not an

intellectual history) is directed less against the unconscious and more pointedly against unconsciousness itself. To take this thought a step farther, deconstruction's continual railing against the unthought ought to be allied with the rejection of a continual production of the unconsciousness of the laboring Third World or of the laboring Third World as the unconscious. Here it would be necessary to break with a strict geographical conceptualization of Third Worldness in order to apprehend it as the impoverished and othered dimensions of human becoming. For the rendering of vast regions of human experience invisible is the essential condition for the production of whatever consciousness is attendant to the public sphere. It would be important then in this context to see a computer made in Malaysia as a new kind of orientalist image, produced in "the orient," but functioning for purposes which utterly occlude the landscape of its production.

Paolo Virno

ON VIRTUOSITY

THE SUBSUMPTION INTO THE LABOR PROCESS of what formerly guaranteed an indisputable physiognomy for public action can be clarified by means of an ancient, but by no means ineffective, category: *virtuosity*.

Accepting, for now, the normal meaning of the word, by "virtuosity" I mean the special capabilities of a performing artist. A virtuoso, for example, is the pianist who offers us a memorable performance of Schubert; or it is a skilled dancer, or a persuasive orator, or a teacher who is never boring, or a priest who delivers a fascinating sermon. Let us consider carefully what defines the activity of virtuosos, of performing artists. First of all, theirs is *an activity which finds its own fulfillment (that is, its own purpose) in itself* without objectifying itself into an end product, without settling into a "finished product," or into an object which would survive the performance. Second, it is *an activity which requires the presence of others*, which exists only in the presence of an audience.

An activity without an end product: the performance of a pianist or of a dancer does not leave us with a defined object distinguishable from the performance itself, capable of continuing after the performance has ended. An activity which requires the presence of others: the *performance* makes sense only if it is seen or heard, it is obvious that these two characteristics are inter-related: virtuosos need the presence of an audience precisely because they are not producing an end product, an object which will circulate through the world once the activity has ceased. Lacking a specific extrinsic product, the virtuoso has to rely on witnesses.

The category of virtuosity is discussed in Aristotle's *Nicomachean Ethics;* it appears here and there in modern political thought, even in the twentieth century; it even holds a small place in Marx's criticism of political economics. In the *Nicomachean Ethics* Aristotle distinguishes labor (or poiesis) from political action (or praxis), utilizing precisely the notion of virtuosity: we have labor when an object is produced, an opus which can be separated from action; we have praxis when the purpose of action is found in action itself. Aristotle writes: "For while making has an end other than itself, action cannot; for good action [understood both as ethical conduct and as political action, Virno adds] itself is its end" (*Nicomachean Ethics*, VI, 1140 b). Implicitly resuming Aristotle's idea, Hannah Arendt compares the performing artists, the virtuosos, to those who are engaged in political action. She writes: "The performing arts [. . .] have indeed a strong affinity with politics. Performing artists—dancers,

play-actors, musicians, and the like—need an audience to show their virtuosity, just as acting men need the presence of others before whom they can appear; both need a publicly organized space for their 'work,' and both depend upon others for the performance itself" (Arendt, Hannah, *Between Past and Future: eight exercises in political thought* (New York: Viking Press, 1968) 154).

One could say that every political action is *virtuosic*. Every political action, in fact, shares with virtuosity a sense of contingency, the absence of a "finished product," the immediate and unavoidable presence of others. On the one hand, all virtuosity is intrinsically *political*. Think about the case of Glenn Gould (Gould, Glenn and Tim Page, *The Glenn Gould Reader* (New York: Knopf, 1984); and Schneider, Michel, *Glenn Gould, piano solo: aria et trente variations* (Paris: Gallimard, 1988)). This great pianist, paradoxically, hated the distinctive characteristics of his activity as a performing artist; to put it another way, he detested public exhibition. Throughout his life he fought against the "political dimension" intrinsic to his profession. At a certain point Gould declared that he wanted to abandon the *"active life"*, that is, the act of being exposed to the eyes of others (note: *"active life"* is the traditional name for politics). In order to make his own virtuosity non-political, he sought to bring his activity as a performing artist as close as possible to the idea of labor, in the strictest sense, which leaves behind extrinsic products. This meant closing himself inside a recording studio, passing off the production of records (excellent ones, by the way) as an "end product." In order to avoid the public-political dimension ingrained in virtuosity, he had to pretend that his masterly performances produced a defined object (independent of the performance itself). Where there is an end product, an autonomous product, there is labor, no longer virtuosity, nor, *for that reason*, politics.

Even Marx speaks of pianists, orators, dancers, etc. He speaks of them in some of his most important writings: in his "Results of the Immediate Process of Production," and then, in almost identical terms, in his *Theories of Surplus Value*. Marx analyzes intellectual labor, distinguishing between its two principal types. On one hand, there is immaterial or mental activity which "results in commodities which exist separately from the producer [. . .] books, paintings and all products of art as distinct from the artistic achievement of the practicing artist" (in Appendix to Marx, *Capital, Vol. 1*, "Results of the Immediate Process of Production": 1048). This is the first type of intellectual labor. On the other hand, Marx writes, we need to consider all those activities in which the "product is not separable from the act of producing" (ibid., 1048)—those activities, that is, which find in themselves their own fulfillment without being objectivized into an end product which might surpass them. This is the same distinction which Aristotle made between material production and political action. The only difference is that Marx in this instance is not concerned with political action; rather, he is analyzing two different representations of labor. To these specifically defined types of poiesis he applies the distinction between activity-with-end-product and activity-without-end-product. The second type of intellectual labor (activities in which "product is not separable from the act of producing,") includes, according to Marx, all those whose labor turns into a virtuosic performance: pianists, butlers, dancers, teachers, orators, medical doctors, priests, etc.

So then, if intellectual labor which produces an end product does not pose any special problems, labor without an end product (virtuosic labor) places Marx in an embarrassing situation. The first type of intellectual labor conforms to the definition of "productive labor." But what about the second type? I remember in passing, that for Marx, productive labor is not subordinate or fatiguing or menial labor, but is precisely and only that kind of labor which produces surplus value. Of course, even virtuosic performances can, in principle, produce surplus value: the activity of the dancer, of the pianist, etc., if organized in a capitalistic fashion, can be a source of profit. But Marx is disturbed by the strong resemblance between the activity of the performing artist and the *servile* duties which, thankless and frustrating as

they are, do not produce surplus value, and thus return to the realm of non-productive labor. Servile labor is that labor in which no *capital* is invested, but a wage is paid (example: the personal services of a butler). According to Marx, even if the "virtuosist" workers represent, on one hand, a not very significant exception to the quantitative point of view, on the other hand, and this is what counts more, they almost always converge into the realm of servile/ non-productive labor. Such convergence is sanctioned precisely by the fact that their activity does not give way to an independent end product: where an autonomous finished product is lacking, for the most part one cannot speak of productive (surplus value) labor. Marx virtually accepts the equation work-without-end-product -personal services. In conclusion, virtuosic labor, for Marx, is a form of wage labor which is not, at the same time, productive labor (*Theories of Surplus Value*: 410–11).

Let us try to sum things up. Virtuosity is open to two alternatives: either it conceals the structural characteristics of political activity (lack of an end product, being exposed to the presence of others, sense of contingency, etc.), as Aristotle and Hannah Arendt suggest; or, as in Marx, it takes on the features of "wage labor which is not productive labor." This bifurcation decays and falls to pieces when *productive* labor, in its totality, appropriates the special characteristics of the performing artist. In post-Fordism, those who produce surplus value behave—from the structural point of view, of course—like the pianists, the dancers, etc., and *for this reason*, like the politicians. With reference to contemporary production, Hannah Arendt's observation on the activity of the performing artist and the politician rings clear: in order to work, one needs a "publicly organized space." In post-Fordism, labor requires a "publicly organized space" and resembles a virtuosic performance (without end product). This publicly organized space is called "cooperation" by Marx. One could say: at a certain level in the development of productive social forces, labor cooperation introjects verbal communication into itself, or, more precisely, a complex of *political actions*.

Do you remember the extremely renowned commentary of Max Weber on politics as profession? (Weber, Max, *Politics as a Vocation* (Philadelphia, PA: Fortress Press, 1965)). Weber elaborates on a series of qualities which define the politician: knowing how to place the health of one's own soul in danger; an equal balance between the ethics of convincing and the ethics of responsibility; dedication to one's goal, etc. We should re-read this text with reference to Toyotaism, to labor based upon language, to the productive mobilization of the cognitive faculties. Weber's wisdom speaks to us of the qualities required today for material production.

The speaker as performing artist

Each one of us is, and has always been, a virtuoso, a performing artist, at times mediocre or awkward, but, in any event, a virtuoso. In fact, the fundamental model of virtuosity, the experience which is the base of the concept, is *the activity of the speaker*. This is not the activity of a knowledgeable and erudite locutor, but of *any* locutor. Human verbal language, not being a pure tool or a complex of instrumental signals (these are characteristics which are inherent, if anything, in the languages of non-human animals: one need only think of bees and of the signals which they use for coordinating the procurement of food), has its fulfillment in itself and does not produce (at least not as a rule, not necessarily) an "object" independent of the very act of having been uttered.

Language is "without end product." Every utterance is a virtuosic performance. And this is so, also because, obviously, utterance is connected (directly or indirectly) to the presence of others. Language presupposes and, at the same time, institutes once again the "publicly organized space" which Arendt speaks about. One would need to reread the passages from

the *Nicomachean Ethics* on the essential difference between poiesis (production) and praxis (politics) with very close connection to the notion of *parole* in Saussure (Ferdinand de Saussure, *Course in General Linguistics*) and, above all, to the analyses of Emile Benveniste (Benveniste, *Problems in general linguistics* (Coral Gables, FL: University of Miami Press, 1971)) on the subject of utterance (where "utterance" is not understood to mean the content of what is uttered, that "which is said," but the interjection of a word as such, the very fact of speaking). In this way one would establish that the differential characteristics of praxis with respect to poiesis coincide absolutely with the differential characteristics of verbal language with respect to motility or even to non-verbal communication.

There is more to the story. The speaker alone—unlike the pianist, the dancer or the actor—can do without a script or a score. The speaker's virtuosity is twofold: not only does it not produce an end product which is distinguishable from performance, but it does not even leave behind an end product which could be actualized by means of performance. In fact, the act of *parole* makes use only of the *potentiality* of language, or better yet, of the generic faculty of language: not of a pre-established text in detail. The virtuosity of the speaker is the prototype and apex of all other forms of virtuosity, precisely because it includes within itself the potential/act relationship, whereas ordinary or derivative virtuosity, instead, presupposes a determined act (as in Bach's *"Goldberg" Variations*, let us say), which can be relived over and over again. But I will return to this point later.

It is enough to say, for now, that contemporary production becomes "virtuosic" (and thus political) precisely because it includes within itself linguistic experience as such. If this is so, the matrix of post-Fordism can be found in the industrial sectors in which there is "production of communication by means of communication;" hence, in the culture industry.

Culture industry: anticipation and paradigm

Virtuosity becomes labor for the masses with the onset of a culture industry. It is here that the virtuoso begins to punch a time card. Within the sphere of a culture industry, in fact, activity without an end product, that is to say, communicative activity which has itself as an end, is a distinctive, central and necessary element. But, exactly for this reason, it is above all within the culture industry that the structure of wage labor has overlapped with that of political action.

Within the sectors where communication is produced by means of communication, responsibilities and roles are, at the same time, "virtuosic" and "political." In his most important novel, *La vita agra* [*Bitter Life*] (New York: Viking Press, 1965), a distinguished Italian writer, Luciano Bianciardi, describes the splendors and miseries of the culture industry in Milan during the Fifties. In one remarkable page of this book, he effectively illustrates what distinguishes culture industry from traditional industry and from agriculture. The protagonist of La *vita agra*, having arrived in Milan from Grosseto with the intention of avenging recent job related deaths that took place in his region, ends up becoming involved in the budding culture industry. After a brief time, however, he is fired. The following is a passage which, today, has unmistakable theoretical merit:

> And they fired me, only on account of the fact that I drag my feet, I move slowly, I look around even when it is not absolutely necessary. In our business, however, we need to lift our feet high off the ground, and bang them down again on the floor noisily, we need to move, hit the pavement, jump up, create dust, possibly a cloud of dust and then hide inside it. It is not like being a peasant or a worker. The peasant moves slowly because the work is so related to the seasons; the peasant cannot sow in July and harvest in February. Workers move quickly, but if they are

on the assembly line, because on the line there are measured out periods of production, and if they do not move following that rhythm, they are in trouble . . . But the fact is that the peasant belongs to the realm of primary activities and the worker to the realm of secondary activities. One produces something from nothing; the other transforms one thing into another. There is an easy measuring stick, for the worker and for the peasant, one which is quantitative: does the factory produce so many pieces per hour, does the farm yield a profit? In our professions it is different, there are no quantitative measuring sticks. How does one measure the skill of a priest, or of a journalist, or of someone in public relations? *These people neither produce from scratch, nor transform.* They are neither primary nor secondary. Tertiary is what they are and what's more, I would dare say . . . even four times removed. They are neither instruments of production, nor drive belts of transmission. They are a lubricant, at the most pure Vaseline. How can one evaluate a priest, a journalist, a public relations person? How can one calculate the amount of faith, of purchasing desire, of likeability that these people have managed to muster up? No, we have no other yardstick in this case than the one which can measure one's capacity to float above water, and to ascend even higher, in short, to become a bishop. In other words, those who choose a tertiary or quaternary profession need *skills and aptitudes of apolitical kind.* Politics, as everybody knows has for a long time ceased to be the science of good government and has become, instead, the art of conquering and maintaining power. Therefore, the excellence of politicians is not measured according to the good that they manage to do for others, but is based on the swiftness with which they get to the top and on the amount of time they last there . . . In the same way, in the tertiary and quaternary professions, *since there is no visible production of goods to function as a measuring stick* the criterion will be the same (Bianciardi, *La vita agra:* 129–32; Virno's italics [note: English translation from the original Italian by the translators]).

In many ways, Bianciardi's analysis is clearly dated, since it presents the functions of the culture industry as a marginal and outlandish exception to the rule. Moreover, it is at best superficial to reduce politics to a pure and simple overthrowing of power. In spite of this, the passage which I have just read shows exceptional intuition. In its own way, this intuition recalls and rehashes Arendt's thesis on the similarity between virtuosos and politicians, as well as Marx's notations about labor which does not have a separate "end product" as its goal. Bianciardi underscores the emerging "political dimension" of labor within the culture industry. But, and this is crucial, he links this dimension to the fact that in the culture industry there is no production of labor independent from activity itself. Where an extrinsic "end product" is lacking, there lies the ground for political action. I should clarify: in the culture industry (as is the case, after all, today in the post-Ford era for industry in general) the finished products which can be sold at the end of the productive process are surely not scarce. The crucial point is, though, that while the material production of objects is delegated to an automated system of machines, the services rendered by living labor, instead, resemble linguistic-virtuosic services more and more.

We should ask ourselves what role the culture industry assumed with relation to overcoming the Ford/Taylor model. I believe that it fine-tuned the paradigm of post-Fordist production on the whole. I believe therefore, that the mode of action of the culture industry became, from a certain point on, exemplary and pervasive. Within the culture industry, even in its archaic incarnation examined by Benjamin and Adorno, one can grasp early signs of a mode of production which later, in the post-Ford era, becomes generalized and elevated to the rank of *canon.*

To clarify, let us return, for a moment, to the critique of the communication industry leveled by the thinkers of the Frankfurt School. In the *Dialectic of Enlightenment* (Horkheimer, Max and Theodor W. Adorno (New York: Herder and Herder, 1972): 120–67) the authors maintain, roughly, that the "factories of the soul" (publishing, cinema, radio, television etc.) also conform to the Fordist criteria of serialization and parcelization. In those factories, also, the conveyor belt, the dominant symbol of automobile factories, seems to assert itself. Capitalism—this is the thesis—shows that it can mechanize and parcelize even its spiritual production, exactly as it has done with agriculture and the processing of metals. Serialization, insignificance of individual tasks, the econometrics of feelings: these are the recurrent *refrains*. Evidently, this critical approach allowed, in the peculiar case of the culture industry, for the continuation of some elements which resist a complete assimilation to the Fordist organization of the labor process. In the culture industry, that is to say, it was therefore necessary to maintain a certain space that was informal, not programmed, one which was open to the unforeseen spark, to communicative and creative improvisation: not in order to favor human creativity, naturally, but in order to achieve satisfactory levels of corporate productivity. However, for the Frankfurt School, these aspects were nothing but uninfluential remnants, remains of the past, waste. What counted was the general Fordization of the culture industry. Now, it seems to me, from our present perspective, that it is not difficult to recognize that these purported remnants (with a certain space granted to the informal, to the unexpected, to the "unplanned") were, after all, loaded with future possibilities.

These were not remnants, but anticipatory omens. The informality of communicative behavior, the competitive interaction typical of a meeting, the abrupt diversion that can enliven a television program (in general, everything which it would have been dysfunctional to rigidify and regulate beyond a certain threshold), has become now, in the post-Ford era, a typical trait of the *entire* realm of social production. This is true not only for our contemporary culture industry, but also for Fiat in Melfi. If Bianciardi was discussing labor organized by a nexus between (virtuosic) activity-without-end-product and political attitudes as a marginal aberration, this has now become the rule. The intermingling of virtuosity, politics and labor has extended everywhere. What is left to question, if anything, is what specific role is carried out *today* by the communication industry, since all industrial sectors are inspired by its model. Has the very thing that once upon a time anticipated the post-Ford turning point become entirely unfolded? In order to answer this question, we should linger a while on the concept of "spectacle" and "society of the spectacle."

Language on the stage

I believe that the notion of "spectacle," though itself rather vague, provides a useful tool for deciphering some aspects of the post-Ford multitude (which is, in fact, a multitude of virtuosos, of workers who, in order to work, rely on generically "political" skills).

The concept of "spectacle," coined in the Sixties by the Situationists, is a truly theoretical concept, not foreign to the tenet of Marxian argumentation. According to Guy Debord "spectacle" is human communication which has become a commodity. What is delivered through the spectacle is precisely the human ability to communicate, verbal language as such. As we can see, the core of the issue is not a rancorous objection to consumer society (which is always slightly suspect, the risk being, as in the case of Pasolini, that of bemoaning the blessed cohabitation between low levels of consumerism and pellagra). Human communication, as spectacle, is a commodity among others, not outfitted with special qualities or prerogatives. On the other hand, it is a commodity which concerns, from a certain point on, all industrial sectors. This is where the problem lies.

On one hand, spectacle is the specific product of a specific industry, the so-called culture industry, in fact. On the other hand, in the post-Ford era, human communication is also an essential ingredient of productive cooperation in general; thus, it is the reigning productive force, something that goes beyond the domain of its own sphere, pertaining, instead, to the industry as a whole, to poiesis in its totality. In the spectacle we find exhibited, in a separate and fetishized form, the most relevant productive forces of society, those productive forces on which every contemporary work process must draw: linguistic competence, knowledge, imagination, etc. Thus, the spectacle has a *double nature*: a specific product of a particular industry, but also, at the same time, the quintessence of the mode of production in its entirety. Debord writes that the spectacle is "the general gloss on the rationality of the system" (Debord, Guy, *The Society of the Spectacle* (New York: Zone Books, 1994), Thesis 15). What presents the spectacle, so to speak, are the productive forces themselves of society as they overlap, in ever-greater measure, with linguistic-communicative competencies and with the *general intellect*.

The double nature of the spectacle is reminiscent, in some ways, of the double nature of money. As you know, money is a commodity among others, manufactured by the State Mint, in Rome, endowed of a metallic or paper form. But it also has a second nature: it is an equivalent, a unit of measurement, of all other commodities. Money is particular and universal at the same time; spectacle is particular and universal at the same time. This comparison, though without a doubt an attractive one, is incorrect. Unlike money, which measures the result of a productive process, one which has been concluded, spectacle concerns, instead, the productive process *in fieri*, in its unfolding, in its potential. The spectacle, according to Debord, reveals what women and men *can* do. While money mirrors in itself the value of commodities, thus showing what society has *already* produced," the spectacle exposes in separate form that which the aggregate of society *can* be and do. If money is the "real abstraction" (to use a classic Marxian expression) which refers back to finished labor, to labor's past, according to Debord the spectacle is, instead, the "real abstraction" which portrays labor in itself, the present tense of labor. If money spearheads exchange, then the spectacle, human communication which has become a commodity, spearheads, if anything, productive communication. We must conclude, then, that the spectacle, which is human communicative capacity turned into commodity, does have a double nature which is different from that of money. But different in what way?

My hypothesis is that the communication industry (or rather, the spectacle, or even yet, the culture industry) is an industry among others, with its specific techniques, its particular procedures, its peculiar profits, etc.; on the other hand, it also plays the role of *industry of the means of production*. Traditionally, the industry of the means of production is the industry that produces machinery and other instruments to be used in the most varied sectors of production. However, in a situation in which the means of production are not reducible to machines but consist of linguistic-cognitive competencies inseparable from living labor, it is legitimate to assume that a conspicuous part of the so-called "means of production" consists of techniques and communicative procedures. Now, where are these techniques and procedures created, if not in the culture industry? The culture industry produces (regenerates, experiments with) communicative procedures, which are then destined to function also as means of production in the more traditional sectors of our contemporary economy. This is the role of the communication industry, once post-Fordism has become fully entrenched: an industry of the means of communication.

Virtuosity in the workplace

Virtuosity, with its intrinsic political dimension, not only characterizes the culture industry but the totality of contemporary social production. One could say that in the organization of

labor in the post-Ford era, activity without an end product, previously a special and problematic case (one need only recall, in this regard, Marx's uncertainties), becomes the prototype of all wage labor. Let me repeat a point I made before: this does not mean that car dashboards are no longer produced but that, for an ever increasing number of professional tasks, the fulfillment of an action is internal to the action itself (that is, it does not consist of giving rise to an independent semi-labor).

A situation of this kind is foreshadowed by Marx himself in the *Grundrisse*, when he writes that with the advent of large, automated industry and the intensive and systematic application of the natural sciences to the productive process, labor activity moves *"to the side"* of the production process instead of being its chief actor" (*Grundrisse* (New York: Harper & Row, 1971): 705). This placing of labor activity "to the side" of the immediate process of production indicates, Marx adds, that labor corresponds more and more to "a supervisory and regulatory activity" (ibid.: 709). In other words: the tasks of a worker or of a clerk no longer involve the completion of a single particular assignment, but the changing and intensifying of special cooperation. Please allow me to digress. The concept of *social cooperation*, which is so complex and subtle in Marx, can be thought of in two different ways. There is, first of all, an "objective" meaning: each individual does different, specific, things which are put in relation to one another by the engineer or by the factory foreman: cooperation, in this case, transcends individual activity; it has no relevance to the way in which individual workers function. Second, however, we must consider also a "subjective" notion of cooperation: it materializes when a conspicuous portion of individual work consists of developing, refining, and intensifying cooperation itself with post-Fordism, the second definition of cooperation prevails. I am going to try to explain this better by means of a comparison. From the beginning, one resource of capitalistic enterprise has been the so-called "misappropriation of workers' know how." That is to say: when workers found a way to execute their labor with less effort, taking an extra break, etc., the corporate hierarchy took advantage of this minimal victory, knowing it was happening, in order to modify the organization of labor. In my opinion, a significant change takes place when the task of the worker or of the clerk to some extent consists in actually finding, in discovering expedients, "tricks," solutions which ameliorate the organization of labor. In the latter case, workers' knowledge is not used on the sly but it is requested explicitly; that is to say, it becomes one of the stipulated working assignments. The same change takes place, in fact, with regards to cooperation: it is not the same thing if workers are coordinated de facto by the engineer or if they are asked to invent and produce new cooperative procedures. Instead of remaining in the background, the act of cooperating, linguistic integration, comes to the very foreground.

When "subjective" cooperation becomes the primary productive force, labor activities display a marked linguistic-communicative quality, they entail the presence of others. The monological feature of labor dies away: the relationship with others is a driving, basic element, not something accessory. Where labor moves *to the side* of the immediate productive process, instead of being one of its components, productive cooperation is a "publicly organized space." This "publicly organized space"—interjected into the labor process— mobilizes attitudes which are traditionally political. Politics (in the broad sense) becomes productive force, task, "tool box." One could say that the heraldic motto of post-Fordism is, rightfully, "politics above all." After all, what else could the discourse of "total quality" mean, if not a request to surrender to production a taste for action, the capacity to face the possible and the unforeseen, the capacity to communicate something new?

When hired labor involves the desire for action, for a relational capacity, for the presence of others—all things that the preceding generation was trying out within the local party headquarters—we can say that some distinguishing traits of the human animal, above all the possession of a language, are subsumed within capitalistic production. The inclusion of the

very *anthropogenesis* in the existing mode of production is an extreme event. Forget the Heideggerian chatter about the "technical era." This event does not assuage, but radicalizes, instead, the antinomies of economic-social capitalistic formation. Nobody is as poor as those who see their own relation to the presence of others, that is to say, their own communicative faculty, their own possession of a language, reduced to wage labor.

Intellect as score

If the entirety of post-Fordist labor is productive (of surplus value) labor precisely because it functions in a political-virtuosic manner, then the question to ask is this: what is the *score* which the virtuosos-workers perform? What is the script of their linguistic-communicative *performances*?

The pianist performs a Chopin waltz, the actor is more or less faithful to a preliminary script, the orator has at the least some notes to refer to; all performing artists can count on a score. But when virtuosity applies to the totality of social labor, which one is the proper score? From my perspective, I maintain without too many reservations that the score performed by the multitude in the post-Ford era is the Intellect, intellect as generic human faculty. According to Marx, the score of modern virtuosos is the *general intellect*, the general intellect of society, abstract thought which has become a pillar of social production. We thus go back to a theme (*general intellect*, public intellect, "commonplaces," etc.) which we considered during the first day.

By *general intellect* Marx means science, knowledge in general, the know-how on which social productivity relies by now. The politicization of work (that is, the subsumption into the sphere of labor of what had hitherto belonged to political action) occurs precisely when thought becomes the primary source of the production of wealth. Thought ceases to be an invisible activity and becomes something exterior, "public," as it breaks into the productive process. One could say: only then, only when it has linguistic intellect as its barycenter, can the activity of labor absorb into itself many of the characteristics which had previously belonged to the sphere of political action.

Up to this point we have discussed the juxtaposition between Labor and Politics. Now, however, the third facet of human experience comes into play, Intellect. It is the "score" which is always performed, over and again, by the workers-virtuosos. I believe that the hybridization between the different spheres (pure thought, political life and labor) begins precisely when the Intellect, as principal productive force, becomes public. Only then does labor assume a virtuosic (or communicative) semblance, and, thus, it colors itself with "political" hues.

Marx attributes to thought an exterior character, a public disposition, on two different occasions. Above all, when he makes use of the expression "real abstraction," which is a very beautiful expression also from a philosophical point of view, and then, when he discusses *"general intellect."* Money, for instance, is a real abstraction. Money, in fact, embodies, makes *real,* one of the cardinal principles of human thought: the idea of equivalency. This idea, which is in itself utterly abstract, acquires a concrete existence, even jingles inside a wallet. A thought becoming a *thing*: here is what a real abstraction is. On the other hand, the concept of *general intellect* does nothing but advance, excessively, the notion of real abstraction. With the term *general intellect* Marx indicates the stage in which certain realities (for instance, a coin) no longer have the value and validity of a thought, but rather it is our thoughts, as such, that immediately acquire the value of material facts. If in the case of abstract thought it is the empirical fact (for example, the exchange of equivalencies) which exhibits the sophisticated structure of pure thought, in the case of *general intellect* the relation is overturned: now it is

our thoughts which present themselves with the weight and incidence typical of facts. The *general intellect* is the stage at which mental abstractions are immediately, in themselves, real abstractions.

Here, however, is where the problems arise. Or, if you wish, a certain dissatisfaction arises with relation to Marx's formulations. The difficulty derives from the fact that Marx conceives the "general intellect" as a scientific objectified capacity as a system of machines. Obviously, this aspect of the "general intellect" matters, but it is not everything. We should consider the dimension where the general intellect, instead of being incarnated (or rather, *cast in iron*) into the system of machines, exists as attribute of living labor. The *general intellect* manifests itself today, above all, as the communication, abstraction, self-reflection of living subjects. It seems legitimate to maintain that, according to the very logic of economic development, it is necessary that a part of the *general intellect* not congeal as fixed capital but unfold in communicative interaction, under the guise of epistemic paradigms, dialogical *performances*, linguistic games. In other words, public intellect is one and the same as cooperation, the acting in concert of human labor, the communicative competence of individuals.

In the fifth chapter of the first book of the *Capital*, Marx writes: "The labour process, as we have just presented it in its simple and abstract elements, is purposeful activity aimed at the production of use-values . . . We did not, therefore, have to present the worker in his relationship with other workers; it was enough to present man and his labour on one side, nature and its materials on the *other*" (*Capital: a critique of political economy* (New York: International Publishers, 1967), Volume 1: 290). In this chapter Marx describes the labor process as a natural process of organic renewal between humans and nature, thus in abstract and general terms, without paying attention to historical-social relations. Nonetheless, we should ask whether it is legitimate, while remaining on this very general (almost anthropological) level, to expurgate from the concept of labor the interactive aspect, one's relation with other workers. It is certainly not legitimate as long as the activity of labor has its core in communicative performance. It is impossible, then, to trace the process of labor without presenting, from the beginning, the worker in relation with other workers; or, if we wish to employ again the category of virtuosity, in relation with one's "public."

The concept of cooperation comprises in itself, fully, the communicative capacity of human beings. That is true, above all, where cooperation is truly a specific "product" of the activity of labor, something which is promoted, elaborated, refined by those who cooperate. The *general intellect* demands virtuosic action (that is, in the broad sense, political action), precisely because a consistent portion of this intellect is not channeled in the machine system, but manifests itself in the direct activity of human labor, in its linguistic cooperation.

The intellect, the pure faculty of thought, the simple fact of having-a-language: let us repeat, here lies the "score" which is always and again performed by the post-Fordist virtuosos. (We should notice the difference in approach between today's lecture and that made elsewhere: what today we are calling the "score" of the virtuoso, the intellect, in our previous meeting was seen as an apotropaic resource, as shelter against the indeterminate hazards of the worldly context. It is important to consider both of these concepts together: the contemporary multitude, with its forms of life and its linguistic games, places itself at the crossroads between these two meanings of "public intellect"). I would like to go back to, and emphasize here, an important point I have made before. While the virtuoso in the strictest sense of the word (the pianist, the dancer, for instance) makes use of a well defined score, that is to say, of an *end product* in its most proper and restricted sense, the post-Fordist virtuosos, "performing" their own linguistic faculties, cannot take for granted a determined *end product*. *General intellect* should not necessarily mean the aggregate of the knowledge acquired by the species, but the *faculty* of thinking; potential as such, not its countless particular realizations. The "general intellect" is nothing but the *intellect in general*. Here it is useful to go back to the

example of the speaker which we have already examined. With the infinite potential of one's own linguistic faculty as the only "score," a locutor (any locutor) articulates determined acts of speech: so then, the faculty of language is the opposite of a determined script, of an end product with these or those unmistakable characteristics. Virtuosity for the post-Fordist multitude is one and the same as the virtuosity of the speaker: virtuosity without a script, or rather, based on the premise of a script that coincides with pure and simple *dynamis,* with pure and simple potential.

It is useful to add that the relation between "score" and virtuosic performance is regulated by the norms of capitalistic enterprise. Putting to work (and to profit) the most generic communicative and cognitive faculties of the human animal has a historical index, a historically determined form. The *general intellect* manifests itself, today, as a perpetuation of wage labor, as a hierarchical system, as a pillar of the production of surplus value.

Ackbar Abbas

FAKING GLOBALIZATION

THE ASIAN CITY (PARTICULARLY THE CHINESE CITY), that city's relation to globalization, and the fake all have at least one characteristic in common: they are all hard to describe.

Transformed at unprecedented speed by new forms of capital, media, and information technology, the Asian city today (more so than other cities) threatens to outpace our understanding of it. It seems likely, though, that Asian cities are where the urban experiments of the twenty-first century will take place. They are the most "representative" urban forms because they are the most problematic. This does not imply that the Asian city is a homogeneous entity. Even if we restrict ourselves to studying the major Chinese cities (leaving aside the many "invisible cities" of the Chinese interior), it is clear that they are all unique: Beijing, the political and cultural city, is very different from Shanghai, at one time one of the most cosmopolitan cities in the world and today learning once again how to exploit its symbolic capital; and both are distinct from Shenzhen, the instant city, created as a Special Economic Zone to take advantage of its proximity to Hong Kong, a colonial/capitalist city like no other, once described picturesquely by Mao as "a pimple on the backside of China" and now returned to the mainland as a (cultured) pearl.

Nevertheless, what makes these cities comparable, despite their enormous disparities, is that we must come up with new terms and new frameworks if we are to describe them at all. They make it clear that the city exists not just as a physical, political, and economic entity that can be documented, but also as a cluster of images, a series of discourses, an experience of space and place, and a set of practices that need to be interpreted. Besides the physical city that we can observe and the cognitive city that we can map, there is something else that is simultaneously familiar and elusive, something that can be related at some level to what we might call the effect of the global, provided we bear in mind that the global always works in differentiated ways, even as it leaves its traces on everyday experience and urban forms.

Three concepts that in their interconnections might help open up the discourse on Asian cities, including their relation to globalism, are Gilles Deleuze's "any-space-whatever," which appears in his work on cinema; Mario Gandelsonas's "X-urbanism," which appears in his typology of the American city; and, as I extrapolate from Gandelsonas, "X-colonialism." These ideas can be related to that of the fake, which (if we are willing to suspend moral

judgments for a while) can highlight in some unexpected ways many of the issues raised by the relation of Asian cities to the global system.

"Any-space-whatever"

Deleuze's argument about "any-space-whatever" is not specifically about urban space or the Asian city; rather, it is part of a discussion about a class of cinematic images he calls the "movement image." What the discussion shows, nevertheless, is not just how relevant but also how indispensable cinematic concepts are to an understanding of contemporary urban space. I have argued elsewhere that if the new Hong Kong cinema became so intriguing in the 1980s, it was because it had found the cinematic means to evoke a new cultural and political space where the paradigms of colonialism were overlaid by those of globalism in uncanny ways. Such overlayings and, more important, our affective response to them provide a context for understanding what Deleuze calls any-space-whatever. Interestingly enough, his exposition of the concept occurs in the section on the affection image, which is one of three kinds of movement image, the other two being the perception image and the action image.

The concept helps not only to underline the important relation between affectivity and space but also to differentiate between, space and place, affectivity and emotion, along the following lines: as "space" refers us to places we do not yet understand, or no longer understand, so affect refers us to emotions we do not yet have, or no longer have a name for. In both cases, some kind of shift has occurred. As Deleuze explains it, any-space-whatever is the polar opposite of an actualized "state of things," which is always *framed* in terms of spatiotemporal-psychic coordinates that we tacitly understand. By contrast, any-space-whatever involves a series of deframings. One of Deleuze's examples is the Gare de Lyon as shown in Robert Bresson's film *Pickpocket*, but an equally striking example is Hong Kong as portrayed in the

Figure 20.1 Pacific Place Shopping Centre, Hong Kong. Photograph by David Clarke. Photo © David Clarke.

opening sequence of Wong Kar Wai's *Chungking Express:* as a skyline of nondescript rooftops on nondescript residential buildings. Hong Kong as subject is not framed by an "establishment shot" with recognizable landmarks. What we see, as in *Pickpocket*, "are vast fragmented spaces, transformed through rhythmic continuity shots." The "law of this space," Deleuze says, "is fragmentation." It is "a matter of the undoing of space." But it is through such an undoing that a precisely corresponding affect is caught. In the case of *Chungking Express*, it is the affect caught by the rhythmic alternation between frenetic speed and long moments of waiting and lethargy.

We can think about any-space-whatever as a particular and ordinary space, but one that has somehow lost its homogeneity and systems of interconnectedness. Such a formulation is remarkably generalizable, even to spaces outside the cinema. Deleuze himself speaks of the proliferation of any-space-whatever inside and outside cinema in a Europe during the aftermath of World War II, with cities demolished and reconstructed, and an abundance of waste grounds and shantytowns, unused or useless places, everywhere. Chinese cities today are even more interesting along these lines, because, what is spurring their urban reconstruction is not the aftermath of war, but rather the prospects of easy access to the global economy—the aftermath of peace. This is evident both in the Shanghai frenzy for building after Deng Xiaoping's southern tour in 1992, when he gave the unambiguous signal for transforming China into a "socialist market economy," and in the Beijing cityscape that was transformed in anticipation of joining the World Trade Organization and hosting the 2008 Olympic Games. What is disorienting in these and other Asian cities is not so much the unfamiliarity of new places, but the way the coordinates of the old places seem to have shifted, the unfamiliarity not of the new, but of the old. Once again, the point can be made through cinema. For example, a futuristic film like *The Matrix*, in spite of all its sensational special effects, is in the end not disorienting at all, because the strange is presented as such: we expect and are expected to be surprised. By contrast, in a "retro" film like *In the Mood for Love*, set in 1960s Hong Kong, the past, like the affective mood of the main characters, is simultaneously familiar and hard to decipher. We move from a "period piece," placed in a specific era we thought we knew, to any-space-whatever, just as in Beijing and Shanghai many "traditional places" take on a quality of any-space-whatever.

X-urbanism

To see the Chinese city deframed by any-space-whatever is to some extent to see it in terms of an avant-garde film. Let me now qualify this a little by turning to the idea of X-urbanism, introduced by Mario Gandelsonas, which has a darker, more noir quality to it. Whereas Deleuze presents a typology of cinematic images, Gandelsonas presents a typology of urban forms. His book deals with the American city through drawings, but also through a text which gives us, in seven scenes, a history of urban mutations in America, each scene more traumatic than the one before. But what is the relevance of all this for Chinese cities? Picking up the argument—from the middle, we can see how the city of skyscrapers engendered the suburban city, which in turn mutated into the X-urban city. The city of skyscrapers created a new urban structure made up of three concentric rings, with the core business district at the center, surrounded by a second ring of poor neighborhoods and factories, outside of which, in a third ring, lie the suburbs where the middle classes live. The suburbs' development into the suburban city is made possible by, among the other things, the motorcar and television; one extends the suburban house to the city, the other brings the city to the house. The urban scene is now doubled, consisting of the pairing of the urban and the suburban.

Of most concern is the final scene, what Gandelsonas calls Scene X: the mutation of the suburban city into the X-urban city. It comes about when the global finance and service industries begin to relocate their offices to the suburbs. This gives rise to the office campus

and a blurring of the opposition between suburb and core city, home and workplace. In the office campus we find not only offices but also shopping malls, entertainment centers, and residential areas, that is, the kind of multi-use urbanism characteristic of X-urbia. Unlike the suburban city, X-urbia develops not in opposition to the center, but in contiguity and in tandem with it. We thus find an urbanism that does not oppose fringe to center, home to workplace, but rather that is multi-centered, decentered, or fractal. X-urbia does not supplement the suburban city, but supplants it, changing it from the inside out.

Gandelsonas's main concern is the history of the American city, but in a tantalizing footnote, he suggests that X-urbanism, first developed in America, can now be exemplified by many cities in Asia, like Shanghai and Shenzhen—that is, that we are witnessing a kind of historical convergence, even though urban development in Asia may have followed a very different historical trajectory. In making some comparisons between X-urbanism and any-space-whatever, keeping in mind the question of their relevance for the analysis of the Chinese city, we encounter three considerations.

First, there is the issue of visuality and its limits. Both Deleuze and Gandelsonas suggest in their own ways that the really important structural changes in urbanism may not produce any immediate visible difference. For example, at the visual level, there is not much difference between suburbia and X-urbia, even though one is a radical mutation of the other; we seem to see the same houses, motorcars, and television sets. This suggests an important point for the analysis of Asian cities that new architecture has so obviously transformed visually, namely that we should not be seduced by the obvious and spectacular and erroneously focus attention exclusively on impressive architecture. Pudong, for example, is the district in Shanghai where the majority of new architecture is found, but Pudong is not Shanghai. Likewise, the Petronas Towers may bedazzle Kuala Lumpur with the light reflected from their aluminum-clad surfaces, but the Petronas Towers are not Kuala Lumpur. Paradoxically, it is the visual that can make Asian cities invisible.

Second, both X-urbanism and any-space-whatever suggest that the major changes in urbanism are initially registered and grasped at the affective level, in terms of a subjective, experiential response to space. For example, in many sitcoms—the classic one being *I Love Lucy*—the suburbs are depicted as the site of normalcy and quiet green spaces. By contrast, in the X-urban, as represented by David Lynch's *Blue Velvet*, the same white picket fences and manicured lawns are depicted as the scene of perversion and paranoia, where X marks the scene of a crime. Gandelsonas points to two of the most striking images of the X-urban: the gated communities where X-urbanites hide paranoically behind their electronic surveillance and alarm systems; and the TV docudrama *Cops*, in which the motorcar has morphed from a privileged means of suburban transport into the police car on the prowl for crime that lurks everywhere.

Third—and it is on this point that Deleuze and Gandelsonas significantly differ—the law of any-space-whatever is "fragmentation," and the fragment can be seen as a form of resistance to homogenization and assimilation into a whole. On the other hand, the law of the X-urban, we might say, is the fractal, something radically different. It is not the contestation of the whole, but rather the replication, on a smaller scale, of the whole. In many Asian cities today, we see the principle of replication at work, which supports Gandelsonas's intuition about the existence of X-urbanism in Asia. In Hong Kong new satellite towns come into existence through a process of replication as full-fledged, autonomous, multi-use urban centers. And if Pudong looks like a mini-Manhattan, and Macau like Las Vegas, and Silicon Valley is cloned in Bangalore and Kuala Lumpur's Cyberjaya, these are not instances of what used to be called Westernization, but, more accurately, instances of replication and the X-urban. As prefix, "x" suggests not just the unknown but also the figure of chiasmus, a critical point of crossover, where old boundaries are transgressed and everything needs to be reformulated, including familiar ideas like colonialism.

The x-colonial

Taken together, any-space-whatever and X-urbanism enable me to comment on the historical legacy that all Asian cities to some extent are burdened with: the legacy of colonialism and the postcolonial resistance to it. If any-space-whatever holds on importantly to some notion of resistance, thus making it an ally of postcolonial discourse, the X-urban with its problematics of replication points out just as importantly that resistance takes place in the context of mutations in urban form, and that it must take note of these changes and work out appropriate strategies, instead of repeating old radical pieties. This is another way of saying that the colonialism that must be dealt with may be called a kind of X-colonialism.

In this regard, it is the special position of Hong Kong before and after 1997 that provides the most illuminating case study of the X-colonial. Even in the days before 1997, when Hong Kong was still officially a colony, the "colonialism there seemed to bear little resemblance to what is critiqued in textbooks." There was, on the one hand, the city's ambiguous relationship to China and, on the other hand, the gradual changeover from imperialist to globalist paradigms. Colonialism could therefore persist only if it adjusted to the new globalism by abandoning old imperial attitudes and even by taking on a benign appearance. This made colonialism in Hong Kong more difficult to represent and to critique. Narratives of greed and exploitation no longer seemed accurate. Colonialism was not where we thought it to be; and where we did not expect it, there we still found it. It became a form of X-colonialism, not a known and self-explanatory quantity like colonialism was, but something that needed to be explained, a ubiquitous but elusive presence. When Asian cities today, whether former colonies or not, seek to be integrated into the global system, there is every possibility that they, too, will have to deal with such elusive presences.

Once again, it is in the cinema that the most convincing representation of the X-colonial can be found, specifically in the Hong Kong cinema's affective response to urban space. In the

Figure 20.2 Outside the Legislative Council building, Hong Kong. Photograph by David Clarke. Photo © David Clarke.

films of Wong Kar-wai for example, we find again and again the evocation of some kind of invisible barrier between people, and human relations characteristically take the form of proximity without reciprocity—whether it is the case of the male lovers in *Happy Together*, who cannot be happy *and* together at the same time, or the case of the heterosexual couple in *In the Mood for Love*, who live in adjoining rooms in the same boarding house, but whose attraction for each other is based on the impossible premise that they do not want to be like their adulterous spouses, so that what pulls them together is exactly what keeps them apart.

In the situations portrayed in Wong's films there is an uncanny structural resemblance to what Manuel Castells has described as "the spatial logic specific to the Information Age," or the space of flows. Castells emphasizes that the space of flows is not just a space of dispersal. Its main organizing unit is the network, which permits, simultaneously, centralization and decentralization. Thus, command-and-control institutions still congregate in cities like New York and London, while back offices spread into the suburbs, where they nevertheless form part of the network. Hence, the space of flows makes possible a "simultaneity of social practices without territorial contiguity" that is, a lot of things can happen at the same time, without their happening in the same place. This action at a distance is, for Castells, a key spatial characteristic of the information age, but it is also the mirror image of Wong's films, although in them everything is reversed: we find "territorial contiguity without social practice," or closeness and inaction, wherein a lot of things don't happen, though people are in the same place.

Castells, too, has an argument about resistance: "Wherever there is domination," he writes, "there is resistance," and he suggests ways of turning the network against itself, of "grassrooting the space of flows." He gives the example of the Champs Elysées, designed as an exclusive space in the nineteenth century, but taken over in the 1990s by young people from the *banlieue* as their own. What Castells fails to underline, but what his example shows, is that this process of appropriation took more than a century to achieve. This lag, or hysteresis, is something that also needs to be addressed by arguments about resistance. What resistance to the X-colonial, the network, or the global entails first of all is some way of dealing with the delays and inaction that Wong portrays so well, especially the land of inaction that is produced by speed. It seems that the more instantaneous the technologies of speed become, the longer the hysteresis: this may be the contemporary form of uneven development.

The political economy of the fake

It is possible to look at the issue of globalization and the Asian city not only in terms of any-space-whatever, X-urbanism, and the X-colonial, but also from another angle: the fake. Many of the issues relating to Asian cities return in unexpected ways when we attempt a historical analysis of the fake. The fake is a symptom that enables us to address, rather than dismiss, some of the discrepancies of a rapidly developing and seemingly ineluctable global order. We can think of the fake as a social, cultural, and economic response, at a local and apparently trivial level, to the processes of globalization and to the uneven and often unequal relations that globalization has engendered. This is not to say, however, that we should romanticize the fake. Nor does it mean that we can overlook the many obvious objections to it. Many have argued that, morally speaking, faking is a form of cheating; economically speaking, it is a form of theft. From an aesthetic point of view, the objection is that the fake is never as well made as the genuine article. Its social value, too, is highly dubious, as it can be seen to be a form of pretension. The list of protests can be easily extended, and in fact many of these objections are undeniably valid. The danger, though, is that indignation may make us lose sight of the structural and historical features of the fake, as well as the paradoxical role it plays in the context of globalization. Insofar as the fake points to unresolved

Figure 20.3 Not quite Kentucky Fried Chicken, Shanghai. Photograph by David Clarke. Photo © David Clarke.

problems in the world today, it should be analyzed, not dismissed. A preliminary historical analysis might help situate a problematic practice in a problematic space.

A good starting point is Orson Welles's *F for Fake* (1973), which should be as well known as *Citizen Kane* or *The Magnificent Ambersons* because its contemporary relevance is arguably even greater. *F for Fake* is a documentary about art forgers and forgeries. The audience is introduced to Elmyr de Hory, one of the most talented forgers of all time, whose works, signed with the names of famous artists, were once in all the great art museums of the world. Elmyr had turned to forgery to demonstrate the ignorance and pretense of the art experts and museums that had rejected his original work because they were impressed only by big names. Welles eventually reveals that the forger is not an isolated figure, that behind the forger is a whole series of other figures closely related to him. The series begins, ironically, with the art expert, whom Elmyr wryly observes is "god's gift to the forger" because without the expert who authenticates, the forger could never succeed in his deception: the knowledgeable expert is in collusion, however unwittingly, with the faker. The series continues with Elmyr's biographer, Clifford Irving, whose book, *Fake!*, not only makes Elmyr into a folk hero but also inspires Irving to try faking himself; Irving thus publishes a fake "authorized" biography of Howard Hughes, forcing the reclusive Hughes to issue a public denial. Then there is Welles himself, a great filmmaker and actor, for whom filmmaking and acting are no more than forms of fakery. The series continues, and does not stop even with the original artist himself, with Picasso, the most famous artist of the twentieth century. One of the most insightful moments into the nature of faking comes when an art dealer shows some Picassos to Picasso, "Fake!" Picasso says of the first painting. "Fake!" he says of the second, and again of the third. At this point, the art dealer feels he must protest. "But Pablo," he says, "I saw you painting that last one with my own eyes!" To which Picasso replies, "I can paint fake Picassos as well as anybody."

Welles's film makes several important points about the fake, First of all, it shows that just as there is always a series of figures behind the forger, the question of the fake never involves the fake alone. The contemporary fake, in particular, forces us to re-examine all the objects and processes around it, like legal systems, politics, technology, design culture, and globalization itself—including, of course, the globalization of media. Just as the global media circulates information about the latest commodities for Asian consumers to buy, so it brings information about these goods for counterfeiters to copy. The conditions that make the global commodity possible are the same ones that make the fake possible: digital reproduction, graphics software, distribution networks. Both belong to the same history, the history of information; both belong to the moment in which information is the most important commodity. This suggests a related point, namely the ability of the fake to act as a kind of historical marker. The production of fakes appears only when cities are just about to enter the world economy and become exposed to media representations of global commodities. Beijing, Shanghai, Guangzhou, and Shenzhen are just the best-known examples of Chinese cities that have reached this point of development following China's entry into the World Trade Organization.

Fake production ceases or diminishes when a city or nation becomes more integrated into the global establishment, at which point strict copyright laws begin to be passed, partly as a result of intellectual-property pressure from global companies and states. Hong Kong is at this stage, and fakes are now less common. The fake, then, is not without a certain value as a cultural symptom. Not only can it function as a historical marker of a city's relation to globalization and information, but the very fact that it is by definition a suspect object makes us take a suspicious or critical attitude to objects; hence, there is a certain negative value to the fake, what we might call the counter-value of the counterfeit.

A second point about the fake comes out most clearly in Picasso's statement that he can paint fake Picassos as well as anybody: the problem of the contemporary fake is not how close the fake is to the original, but how close the original is to the fake. The first scenario represents

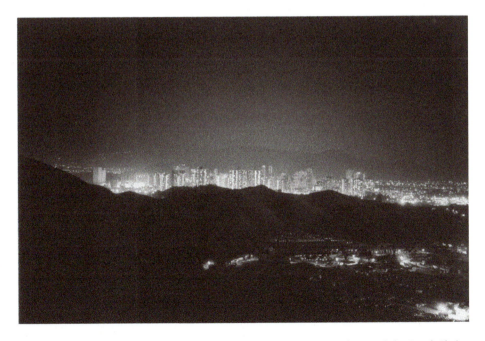

Figure 20.4 Urban Shenzhen viewed at night from rural Hong Kong. Photograph by David Clarke. Photo © David Clarke.

the usual way of understanding the fake and is not particularly disturbing, because even though it might be difficult to distinguish between fake and original, the *categories* of fake and original are still reassuringly in place, and the original is still the standard by which the fake is judged. In the second scenario the categories themselves come under fire, the standards by which the fake and original are judged disappear, and everything dissolves into a general confusion. The difference between the first and second scenarios can be clarified with an example from the world of watch making and watch faking. Some high-quality Chinese fake watches have gained a reputation for how well made they are. Chinese watch factories use Swiss movements (or *ébanches*, unfinished movements) supplied by ETA, the Swiss watch-movement factory (particularly popular movements like the ETA 2824, the Valjoux 7750, and the Unitas 6497) and provide watch cases for them. This exemplifies the first scenario: how close the fake is to the real thing. We catch a glimpse of the second scenario on learning that the majority of Swiss watch companies also buy *ébanches*—and often the same *ébanches*—from ETA, then simply case them, instead of making their own movements. Nicolas G. Hayek, the chairman of the Swatch Group, which owns ETA, recently caused a furor when he threatened to stop the supply of movements to all watch companies that did not belong to the Swatch Group.[1] This would have, in effect, put non-Swatch watch-making companies out of business, so they took Hayek to court on an antitrust charge. Hayek's counter-argument, interestingly, was that if ETA were to continue supplying these companies, it would discourage them from innovating and developing. This argument against a practice adopted by genuine watch companies is *exactly the same argument directed against fakes*. The case had the potential to destroy confidence in that quintessential global commodity, "the Swiss watch," and thus was played down. It was as if the aura of the Swiss watch was under attack, not from the outside, by the faked original, but from the inside, by what sounds like an oxymoron: the original fake, the original that does not have to wait to be faked, the original that is manufactured like the fake.[2] If we use the language of simulacra, then the original is also a simulacrum of the fake, not just the other way around. This switch, this reversibility, is the crucial confusion, but it is precisely under conditions of confusion that fakes are produced. Fakes do not just come from China and the Third World; in more sophisticated form, they can be found in the most unexpected places.

Hence the importance of a third point, which Welles's film also suggests in the ironic tone that runs throughout it: while moral and aesthetic judgements against the fake can easily be made, they are not very helpful for an analysis of the phenomenon, as they do more to obfuscate than to clarify. This is because the moral issues are hardly straightforward. For example, the United States, which now leads the world in the moral condemnation of fakes and in defense of intellectual-property rights, was one of the chief violators of intellectual-property rights in the nineteenth century, as China is today. American publishers reprinted Charles Dickens's novels and refused to pay him royalties, just as China now reproduces software and designer goods. Those who protest the loudest against intellectual-property-rights violations are those who stand to lose most by them: morality follows economics.

Take the big brand-name companies with their highly publicized campaigns against fakes. Do fakes hurt the big brands and reduce their profits, as these companies claim, or do fakes provide free advertising, and so increase company profits? The answer may well be a toss-up, suggesting that the real issues lie elsewhere: one protests loudly against the fake in order to send the message that one's product is real and authentic and valuable (what Jean Baudrillard calls a "deterrence strategy"), just as in the university, plagiarism is loudly condemned as the cardinal sin, more often than not by those who are least original. This is not to suggest that fakes can do no harm. There are, for example, fake foods and medicines. Fake milk powder caused the deaths of a number of Chinese infants, while fake Viagra has been known to lead to intense embarrassment. With regard to designer products, what the fake hurts most are not so much the big brands, but individual freelance artists and designers.

Sadly, the only survival strategy, a desperate one, is to allow your publisher or distributor to release the original, then fake it yourself before the fakers get in on the act. Instead of taking a moral stand for or against the fake, then, it is more important to see the fake as the symptom of a set of social, economic, and cultural conditions, and to ask how these conditions might be changed—hence, the need to begin by bracketing moral and aesthetic judgments. Condemning a symptom will not make it go away.

The fake encourages an examination of the nature of consumption in times of confusion, which is characterized by a number of paradoxes. For instance, Thorsten Veblen analyzes the fake to exemplify his famous notion of "conspicuous consumption." His study of conspicuous consumption focuses much less on obvious displays of wealth than on how "the law of conspicuous waste guides consumption . . . chiefly at the second remove, by shaping the canons of taste and decency." In such a culture, "we find things beautiful . . . somewhat in proportion as they are costly." It is in this context that Veblen discusses the *sociological value* of the fake. The fake, he writes, "may be so close an imitation as to defy any but the closest scrutiny; and yet as soon as the counterfeit is detected, its aesthetic value, and its commercial value as well, declines precipitately . . . It loses caste aesthetically because it falls to a lower pecuniary grade." This dismissive attitude toward fakes, Veblen shows, is nothing more than an indirect expression ("at the second remove") of conspicuous consumption: objects are not costly because they are valuable; they are valuable because they are costly. Thus, the more costly something is, the higher automatically its value—an absurd principle that real-estate agents and high-end retailers in China today are happily rediscovering about the logic of consumption. Writing a little after Veblen, Walter Benjamin is equally paradoxical about the relation between consumption and taste. He argues that what today is called "taste" goes together with ignorance; it is when the consumer is ignorant of how objects are produced that taste becomes important. And in the world of advanced design and high-tech products, ignorance is endemic, which helps explain why faking is everywhere. The consumer, Benjamin wrote around 1938, "is not usually knowledgeable when he appears as a buyer . . . The more industry progresses, the more perfect are the imitations which it throws on the market . . . In the same measure as the expertness of a customer declines, the importance of taste increases—both for him and for the manufacturer." There is a relation therefore between taste-as-ignorance and the fake: the former provides a condition of possibility for the latter.

When consumption is consumption of the spectacle, as Guy Debord suggests, the confusions become even greater and the fake more dominant. Like Veblen, Debord notes that "it is the sale [of the artwork] which authenticates value." Like Benjamin, he notes that "what is false creates taste . . . And what is genuine is reconstructed as quickly as possible to resemble the false." "Today," he concludes, "the tendency to replace the real with the artificial is ubiquitous. In this regard it is fortuitous that traffic pollution has necessitated the replacement of the Marly Horses in the Place de la Concorde, or the Roman statues in the doorway of Saint-Trophine in Aries by plastic replicas." Another example is the "Chinese bureaucracy's laughable fake of the vast terracotta *industrial army* of the First Emperor, which so many visiting statesmen have been taken to admire *in situ*." In other words, Debord is saying, a taste of the fake creates a taste for the fake, which is why in today's world "a financier can be a singer, a lawyer a police spy, a baker can parade his literary tastes, an actor can be president . . . Anyone can join the Spectacle . . . Such picturesque examples also go to show that we should never trust someone because of their job." And, as Paul Virilio asks, what happens when consumption takes place in the world of speed? This includes not just the relative speed of transport technologies (like cars and planes) but the absolute speed of today's information and reproductive technologies. What happens, Virilio answers, is that everything becomes fused and confused. Every invention has a specific way of going wrong; that is the sense

Figure 20.5 Not quite Crocodile, which in itself is not quite Lacoste. Photograph by David Clarke. Photo © David Clarke.

Virilio gives to the *accident*, which both limits and defines the invention. The accident of transatlantic voyages was the *Titanic*; of air travel, the plane crash; of nuclear energy, Chernobyl; of global finance, Enron. And the accident of reproductive technologies? The answer would have to be the fake. What these texts by Veblen, Benjamin, Debord, and Virilio have in common is a sense of how deeply entrenched the fake has become in many of the social practices and confusions of contemporary society.

If the problematic nature of consumption is one set of conditions for understanding the fake, the other important set of conditions is the changing nature of the commodity itself. This change in the commodity has often been described as a split in the commodity into manufactured goods on the one hand and service goods on the other: between (to simplify drastically) what is produced in factories and what is produced in design studios or offices. Service goods also include entertainment, travel, software, advertising, and so on, which are now important commodities. This does not mean, however, that service goods are not "material," in contrast to manufactured goods, or that an absolute division between goods and services exists. There nevertheless exists a class of service goods, which might be defined as objects with a large design or informational component built into them—for example, wristwatches, some kinds of furniture, computers, fashion—whose value is not mainly determined by the materials they are made of but by the amount of research and design necessary for their production, as well as all the work of promotion, distribution, and packaging. When the commodity in the form of service goods has a large cultural element built into it, it becomes increasingly difficult to speak, as we used to, of the "commodification of culture;" rather, it is a matter now of *the acculturation of the commodity*. This development in the nature of the commodity also has relevance for the fake. If today it is not only the artwork that is faked but also, and even more important, the commodity, that is because "artistry" is now a part of the commodity—often its most important and vulnerable part.

This split in the commodity into manufactured goods and service goods takes on a socio-political dimension when we relate it to the global division of labor. Many commodities are designed in one place, usually a "developed" country, and manufactured in another, usually a "developing" country. Nike shoes are a good example. Nike has no factories in the United States, only design and research units. Production is located abroad, in various Asian or East European countries. It has been argued, perhaps over-optimistically, that such an arrangement is actually beneficial to all concerned, an instance of the advantages of globalization. Not only do manufacturing countries receive much-needed foreign investments and benefits from tech-nological transfers, but in the long run they could also develop their own designs. Richard Rosecrance argues, for, example, that what the arrangement offers is a "new and productive partnership between 'head' nations, which design products, and 'body' nations, which manu-facture them. Despite its apparent resemblance to territorial dominion in the past, however, the relationship between designing and producing nations does not entail a new imperialism of north over south. Body nations rapidly develop new ganglia that in time create heads of their own." What the arrangement does entail, though, is that in the meanwhile developing coun-tries have been cast in the role of workhorses or production units, with no guarantee that this "meanwhile" will not last a long time. Moreover, they are allowed to produce, but not to consume, as many of the commodities labeled "Made in China" and sold in the United States and Europe are not available for sale in China itself. It is at this juncture that the fake enters, almost like a postcolonial argument, to reverse this order of things. It produces objects labeled "Made in Italy" or "Made in France," the design centers of the world, and offers them for sale in China, at a fraction of the cost of "the real thing." Thus, the fake obtains economic advan-tages and effects its own version of "technology transfer"—not in the long term, but right now. It profits and learns through copying, and in its own way gestures toward leveling the differ-ence between developed and developing countries. Ziauddin Sardar offers a version of such a postcolonial argument when he speaks of the fake as a form of resistance against exclusion from the global order of commodity consumption, and even as a form of "gentle subversion" against globalization itself. "Slight Malay bodies," he writes, "clad in fake designer jeans, fake T-shirts, wrists adorned with fake designer watches, clutching fake designer bags and cloned mobile phones look as if they have wandered straight out of Beverly Hills for the pittance the get-up cost them. They are *in*-cluded, fashion and fancy, and not *ex*-cluded, marginalized onlookers. In the international politics of self and style they are fully empowered. And the transformation can be accomplished within the ambience and precincts of living history."

Sardar's kind of postcolonial argument for the fake is in its own way as over-optimistic as Rosecrance's, not so much about the benefits of globalization itself as about the benefits of faking as a means of subverting globalization. When something is faked, global order is not disturbed; in fact, the fake confirms, rather than subverts, the global division of labor, made worse now by the fact that it is developing countries that condemn *themselves* to the (fake) production of First World designs. The fake is not, as it is sometimes represented to be, capable of being politically subversive of the global order. There is a passive quality to the fake that makes it work as symptom, but not as subversion. Its value as symptom is that it reveals, in its own shabby and damaged way, a negative side of globalization that is usually well hidden under a rhetoric of cooperation and collaboration. But faking globalization is neither undermining it nor changing it.

Faking globalization

It is when we turn to a globalizing China that the full complexity of the political, economic, and design issues raised by the fake fully emerges. In Beijing the Hung Qiao Mall, where fake

goods are retailed, stands next to the historic Temple of Heaven, where Chinese emperors used to make offerings to the gods for good harvests: side by side with the Temple of Heaven is the Temple of Fake Heaven, an emblem perhaps of China today, even more so than the presence of Starbucks in the Forbidden City. Some of the historical complexity and contradictions in the emblem can be found, too, in the fake. It is much too simplistic to say that China tolerates fakes because it has no respect for international law and intellectual-property rights. In the past socialist idealism might have been tolerant of fakes because of its belief in egalitarianism and communitarianism; if "private property is theft," then fakes, in sharing even intellectual property, are a form of egalitarianism. But during the socialist era, lasting, say, into the 1970s, there was no fake production to speak of in China. It is in the era of market reform, when fake production is in fact more and more criminalized, that we see its golden age. The explanation for this paradox is that strange thing, the socialist market economy (which is the form globalization in China takes), wherein older social attitudes like egalitarianism jostle with the new. The official line today is that "egalitarianism" is a "feudal" hangover, but it is precisely this residual egalitarianism that allows the faker to operate without a bad conscience and the authorities to be a little too casual about copyright laws. However, emerging in the socialist market economy, together with the fake and in contradiction to it, is a new sense of private property and of the value of privacy in general: the discreet charm of the bourgeoisie. Every couple now wants its own private space and its own private means of transport. It is this new social attitude, as much as anything else, that has resulted in the greatest building boom in Chinese history, and in the sight of cities choked with traffic. The fake, which First World countries lament, and the building boom and automobile sales, which they applaud, *go together*. They are the contradictory aspects of a contradictory, transitional historic moment.

Enacting and enforcing stricter laws cannot be the answer, as they will have to contend with another "law:" that if something can be faked, it will be. Laws are made to be broken, as the history of Prohibition shows. They even have the effect of romanticizing the fake and of endowing the act of buying fakes with a certain frisson. The only real solution must be not a punitive one, but one that benefits all parties. Can such a solution to the problem of the fake be found? Perhaps. To begin with, it would consist not of developing stricter laws, but of developing design culture. Moreover, the development of such a design culture in China would have to be the responsibility of all those involved in the fake, including those companies that regard themselves as its victims. These companies, in particular, would have to heed the warning of the fake and guard against complacency. When one's product can be reproduced almost to perfection and sold for often less than ten per cent of one's own price, one may have to reexamine the product and the design process. Products that are content to repeat themselves become so much more easy to copy.

On the Chinese side, the question of design culture comes into focus in an often-asked question: if fakers in China can produce such good fakes, why do they not produce genuine articles? Because of a shortsighted desire for quick profits, the answer often goes, but this economic explanation is not the whole story. The fake has to be situated not only in economics but also in culture and in design ethos. The fake is a species of *underground culture*; the underground is its ethos, is where it derives its energy and inventiveness from. As soon as the faker turns legitimate, as soon as he goes straight, it is as if he had to wear a (strait) jacket and tie, and all kinds of inhibitions set in. This rule applies to the different grades of fakes as well. The "quality" fake tends to be conservative and offers few complications, while the "ordinary" fake that tends to be experimental and inventive—so inventive, in the case of fake watches, that some watch designs first used in fake watches are now being copied by Swiss companies, an example of the original as a faking of the fake.

However, though some fakes are more inventive than others, their inventiveness is relative, as fakes on the whole are not inventive enough. They have too much respect and

reverence for the global objects they imitate and hence cannot transform those objects or invent new ones. The fact that they can reproduce these objects to perfection shows how thoroughly they have studied and understood them; fakes are, as it were, the eternal under-studies of the global commodity, never actors on the world stage. And the reason why the fake cannot be a new object is not because the fake is lawless and radical and needs to be legislated against, but because it is too rule-bound and conservative: it cannot falsify enough. This is a distinction that Welles's *F for Fake* was implicitly trying to draw by putting the artist and filmmaker next to the faker: the artist falsifies, the faker merely fakes—an important difference, in spite of a certain family resemblance. The fake is a way of relating to a global environment; it is an example of the seduction of global space and the objects found there. But such a space not only seduces; it can also betray and reduce to servitude. We might conclude, therefore, that the best way to go beyond the fake is not through legislation, but to encourage the development of design culture. And the first law of design culture is: more important than understanding the object is the ability to change it.

Should the United States encourage the development of design culture? Should Parsons set up shop in Beijing? Trying to answer these questions brings us face to face with one final twist in the relation of fakes to globalization. Design education may stop the fake in the long run, but it will also produce an even stronger China. China can already copy a vast range of products quickly, cheaply, and well. Once it can also design, it will be unstoppable—and this is already happening. The death of the fake in China will be the birth of an unrivaled economic giant. And do the United States, Europe, and Japan—all those who speak loudest against the fake—want to see that happen anytime soon?

Notes

1 See "What Is Nicolas G. Hayek Up To?" *Watch Time*, April 2003, 58–62; and "Perfect Fake."
2 Note that the fake does not destroy the aura of "the original," but rather enhances it. A fake-watch dealer I know once told me that her ambition was to sell enough fake Rolexes so she could raise enough money to buy a real one.

Andrew Ross

CREATIVITY AND THE PROBLEM OF FREE LABOR

THIS ESSAY IS ABOUT the creative labor of artists (broadly defined) who were once considered marginal to the productive economy, but are increasingly profiled and promoted as model workers of the new economy. Wherever artists' labor is organized into the formal silos of the so-called "creative industries," it has garnered the attention of national statisticians bent on building the case for a new high-growth sector, irresistible to investors, politicians, and real estate speculators who know what the presence of artists can do to boost land value. But well beneath the radar of government and industry there is a more telling story about the degradation of work that has occurred as part of the transition to an economy increasingly based on the widespread use of uncompensated or discount labor on part of amateurs, volunteers, interns, and users of social networking platforms.

When did the artist become the "model worker" of the new economy? This notion had its heyday sometime between the dotcom bust and the financial crash, but it was germinating in the mid-1990s, when bureaucrats and business strategists began to look at the softer, cultural end of the knowledge sector as a potential source of business "value." In 1997, the UK's incoming pro-business New Labour administration under Tony Blair renamed the Department of National Heritage as the Department of Culture, Media and Sport (DCMS), and promoted, as its policy bailiwick, an entrepreneurial model of self-organized innovation in the arts and knowledge sectors of the economy.[1] Over the course of the next decade, creative industries policymaking was emulated by nations around the world intent on playing catch-up in the competitive game of high-concept entrepreneurialism.[2] By 2005, creative industries policy was even part of the Five-Year Plan of the largest Chinese cities.[3] Under the new policy paradigm, urban and regional hubs would be groomed as centers for unleashing the latent creativity of individuals and communities, and the image of the nation would be irradiated with the wonder stuff of innovation. The object of all of this attention was a new composite "creative economy," and it occupied a key evolutionary niche on the business landscape because the self-directed work mentality of artists, designers, writers, and performers was so perfectly adapted to the freelancing profile favored by advocates of economic liberalization. Cultural work was nominated as the new face of neoliberal entrepreneurship, and its practitioners were cited as the hit-making models for the IP jackpot economy. Arguably more important, the visible presence of creative lifestyles in select city

neighborhoods, now designated as cultural districts, helped to boost property value in these precincts and adjacent others in accord with well-documented, and by now, formulaic cycles of gentrification.

After the dotcom boom faded, and as offshore outsourcing began to take its toll on technology jobs, the creative sector held out the promise that its skill-intensive jobs would not be transferred elsewhere. Unlike high-end manufacturing industries which require expensive technical infrastructures and customarily lavish tax incentives, creative occupations do not entail costly institutional supports and they can endow a city or a region with a kind of unique distinction that helps attract investment. The combination of low levels of public investment with the potential for high-reward outcomes was guaranteed to win the attention of managers on the lookout for a turnaround strategy for their faltering urban or regional economies. Accustomed to seeing corporate investors come and go, they seized on this rare opportunity to capitalize on a place-based formula for redevelopment, and urban managers signed on every metropolis of note to become a "creative city."[4]

It was always unlikely that these policies could support a productive economy with an engine of sustainable jobs at its core. Much of the evidence suggests that the primary impact was on rising land value and rent accumulations, which are parasitic side effects, to say the least, rather than transmissions, of the ideas originated by creative workers.[5] For those who wanted to see sustainable job creation, the rise of creative industries policymaking presented a conundrum. The guiding consensus was that arts-based enterprise could be promoted as a driver of economic development for cities, regions and nations looking to play catch-up. At the very least, then, the policy spotlight ought to have presented some new, long-term opportunities for creative workers accustomed to eking a makeshift living out of art, expression, design, or performance. So far, however, the kind of development embraced by policymakers seems guaranteed merely to elevate this traditionally unstable work profile into an inspirational model for youth looking to make an adventure out of their entry into the contingent labor force. If the creative industries become the ones to follow, all kinds of jobs, in short, may well look more and more like musician's gigs; nice work if you can find it.

Nonetheless, the preferred labor profile of the new freelancing economy has become that of the eponymous struggling artist, whose long-abiding vulnerability to occupational neglect is now magically transformed, under the new order of creativity, into a model of enterprising, risk-tolerant pluck. So, too, the quirky, nonconformist qualities once cultivated by artists as a guarantee of quasi-autonomy from market dictates are now celebrated as the key for creative souls with portfolio careers to integrate into the "global value-chains" that are central to the new topography of creative markets. Other components of the old formula for creative work are very much alive and well in the newly marketized environment of the creative industries.[6]

Among the other resident dogmas of the creative life is the longstanding equation with suffering and sacrifice, but there is no natural connection there. Personal forfeiture is not a precondition of creativity, though widespread acceptance, or internalization, of this credo is surely one of the reasons why employees in the creative sectors tolerate long hours, discounted compensation, and extreme life pressure in return for their shot at a gratifying work product. Few things are more damaging to the quality of work life than this belief that physical and psychic hardship is the living proof of valuable mental innovation. When compared to the ravages of heavy industrial labor, this may appear to be a lesser threat to public health, but its lionization in cutting-edge sectors like high-tech design has accelerated its spread to an alarming range of workplaces and occupations.

In the years since the onset of the Great Recession, the policy focus on creativity has eroded as capital-owners have sought to extract free labor from a large slice of the workforce reduced to straitened circumstances. The strident call to pursue a creative livelihood has

morphed into an invitation to work for nothing. Business pundits have wondered how far firms could go in taking advantage of all the free time enjoyed by the newly unemployed. The latter will be spending a lot of time online, so how can we exploit their willingness to explore any avenue in search of possible employment? Can we tap their inclination to take on tasks that feel like fun, or more ominously, can we profit from their habitual need to participate in something that feels like work, in the absence of paid labor itself?

Do bosses still need workers?

In the heyday of the labor movement, it was commonly observed that the bosses needed workers but that workers didn't need bosses. Yet in the third and fourth quarters of 2010, corporate America posted record profits at a time when the Bureau of Labor Statistics reported the real unemployment rate at seventeen per cent. Does this yawning disjunct between profits and joblessness mean that the bosses have learned how to get by without workers? Not exactly, no, but the statistics, which can be dissected a hundred ways, might suggest that a sea-change is occurring in the world of work.

Two of the reasons for the high earnings seem to be beyond dispute. Corporations are moving more and more of their operations offshore, especially jobs in high-skilled sectors where the largest savings in labor costs can be gotten. So they still need workers, but not expensive ones in the North. A second explanation rests on what business economists call increased productivity. Roughly translated, this means that employees have been pressured, by the stiff threat of redundancies, to work harder and longer for the same pay, or, in many cases, for less than what they were earning before 2008. In any downturn, employers will push their advantage in this way, but in a soul-sucking recession like this one, there is no quarter—the assault comes from all sides, whether in the form of pay freezes, concessions, furloughs, layoffs, or further casualization. A third reason, and this is the unfamiliar quantum, is the growing reliance on new kinds of free labor to boost the balance sheet of companies that are savvy enough to harvest it. Hard evidence for this footprint is not so easy to muster but the strong anecdotal record suggests it is large enough to be statistically significant.

Free, or token-wage, labor is increasingly available through a variety of channels: crowd-sourcing, data mining or other sophisticated digital techniques for extracting monetizable ideas or information from user/participants; expanded prison labor programs; the explosion of unpaid near-obligatory internships in every white-collar sector; and the whole gamut of contestant volunteering that has transformed so much of our commerce in culture into an amateur talent show, with jackpot stakes for a few winners and hard-luck schwag for everyone else. The web-enabled developments have attracted the most media attention, not least because the digital explosion of free content directly threatens the livelihoods of professional writers and artists.[7] After all, the widespread shuttering of newspapers, magazines, and over-seas news bureaus has seen a generation of union jobs scattered to the winds. Professional pay scales are reduced to dust as the online content aggregators sweep all before them, and resist-ance has been all but futile. The February 2011 sale of the *Huffington Post* to AOL prompted an initially sharp reaction from the hundreds of bloggers whose uncompensated work had built up the title's cachet over the years.[8] But the injustice only sparked comment because the owner happens to be left-leaning. In most other corners of the information landscape, working for nothing has become a routine norm, and largely because it is not experienced as exploitation.

Web 1.0 was built, literally, by unpaid teenagers for whom the task of designing a web site was much too cool to pass up. The social networking platforms of Web 2.0 take advan-tage of the fresh zeal of youth in more ingenious ways. Most Facebook users are oblivious to

the fact they are generating data for the owners to sell. In 2010, Facebook took in $2bn revenue, almost a third of which was net profit, yet it only had around 1,700 paid employees. Google paid around 23,000 employees, and, in the same year, it pulled in $29bn revenue for a $10bn profit. These steep ratios are not untypical in the upper stratosphere of information services, and yet they depend directly on the uncompensated input of users. For all the buzz generated by *The Social Network* (2010, dir. David Finch), it rarely elicited analysis of that fact.

Leaving aside all the other things one could say about the film, the profile of creative innovation that it presented is fairly standard. Take a hothouse Ivy League environment where "collegiate" values are easily trumped by the predatory marketplace ethos already incubating on the campus, and add a cast of recognizable characters that includes a socially-challenged white male engineer, a brainy white girlfriend, who challenges him even further through humiliation, a socially desirable male entrepreneur, assorted and primarily Asian female groupies, who are irresistibly attracted to Jewish men, and a neobohemian start-up crew working 24/7 to make a market breakthrough. These are all updated components of the standard Hollywood template for national myth-making in the field of technical invention. This is how national heroes labor to bring awesome innovations and lustrous wealth into existence. There is no actual social networking depicted in the film, however, though a viewer who was not well acquainted with Facebook might have concluded that the firm's huge financial success was somehow due to the consumer power of the firm's half a billion social networkers. Yet Facebook's users are not the firm's consumers in any traditional sense of paying customers. Rather, the variety of activities they perform is the source of valuable data which is then sold to the true customers, some of whom also then pay to advertise on the site. The tradeoff for users, of course is free access to the platform and the software, but, from the company's perspective, the cost of hosting and maintenance is dwarfed by the tradable value of the information it can extract from user's playful labor, or "playbor" as it has been termed.[9] The great majority of social network users are likely to be unaware of how the platform owners profit from the volunteer content of their communications, or indeed how they themselves are generating monetizable product through their capacity as prosumers, as industry strategists might call them, to generate surplus value. Among the many prizes for users are the opportunity to win attention or "mindshare," accumulate or consolidate friendships, or socially valuable advantage from the exposure. But for the business entrepreneur, the outcome is a virtually wage-free proposition.

The same could be said for any of the more conventional web platforms of opinion, expression or information that rely heavily on user input, whether for the main action, or in the form of "below-the-line" comments posted in response to a featured item. Needless to say, these go far beyond the lineage of the traditional space allotted to Letters to the Editor in print publications, yet these Letters were really the first use of free content in old media, presaging the increasing use of crowdsourcing to perform occupational tasks that used to be the bread and butter of professional knowledge workers.[10] With the ever growing penumbra of blogs and wikis, the need to pay for content is fast eroding. So, too, the technical ease with which crowdsourcing can be pursued online has enabled all sorts of tasks to be performed gratis or at cutprice rates.[11] Even the relatively recent profession of web design is now subject to crowdsourcing techniques, as more and more entities mount contests for amateurs to send in a winning design. Recall how web design was much lionized in the late 1990s for its revival of artisanal craft skills—a new occupational niche that served as the poster child for the launching of the creative industries. How quickly this new professional field has been stripped of its fresh stream of autonomy.

Evidence suggests that as long as a task can be advertised as fun, there is a good chance you can get it done for free, or for a pittance from the seemingly ever-obliging crowd. And if some of the input seems to be very professional, that's because either the call is specifically

crafted to appeal to professionals on their downtime, or else because it quite probably comes from someone who used to be a professional employee, and has been cast into the amateur demi-monde of the volunteer content-provider.

Distributed Labor is one of the preferred terms for describing this phenomenon, not to be confused with an older use of this term to describe the business school model for coordinating geographically dispersed workplaces, whether from telecommuting, or from the map of global production. That model was so critical to the wave of white collar offshore outsourcing in the first half of the last decade.[12] The new kind of distributed work is not done by employees in farflung branch locations, it is done either by users who do not perceive their interactive input as work at all, or else it is contracted out online—and there are many e-lance service sites that do this—to a multitude of taskers whose renumeration, rights, and contractual expectations do not even come close to filling out the profile of the temp. It is quite possible to draw up a sliding scale, from the most creative kinds of tasks at the top, which you can usually get done for free—because the gratification or sense of recognition is considered enough of a reward—to the least creative and routinized, at the bottom—for which a small fee is usually offered in return as beer money or as a token for services rendered. The gradient of that spectrum would reinforce our assumption that the ancient customary profile of "sacrificial labor"—think of the ideology of struggling artist—which we associate with the fields of creative expression has now being taken up as a source of a free industrial labor, albeit in a dispersed, though not entirely disorganized manner. Organized dispersion might be a better way of describing it.

Because it is not experienced as exploitation, but rather as an opportunity to test and advertise one's talent, the willingness to work for free is often referred to as self-exploitation. This formula first appeared as an industrial prototype in the formal employment offered by the New Economy or dot.com firms of the late 1990s. In the course of my own ethnographic research on creatives in these new media workplaces for a book called *No-Collar: The Humane Work-Place and Its Hidden Costs*,[13] I recall that one of my interviewees told me her job offered "work you just couldn't help doing," a phrase that has stuck with me ever since. Subsequent ethnographic studies of knowledge and creative industry workplaces have shown that job gratification comes at a heavy sacrificial cost—longer hours in pursuit of the satisfying finish, price discounts in return for aesthetic recognition, self-exploitation in response to the gift of autonomy, and dispensability in exchange for flexibility.[14] Here we see that the most instrumentally valuable aspect of the creative work traditions has been the carry-over of coping strategies, developed over centuries, to help practitioners endure a feast-or-famine economy in return for the promise of success and acclaim. The combination of this coping mentality with a production ethos of aesthetic perfectability is a godsend for managers looking for employees capable of self-discipline under the most extreme job pressure.

The most celebrated online program for generating distributed work for small fees is Amazon's Mechanical Turk, which promotes itself as a "crowdsourcing marketplace," that allows requesters to pose HITs (Human Intelligence Tasks) for registered Mechanical Turk Workers to perform in return for a minimal fee set by the requester. These are tasks, usually involving visualization, that cannot be performed well by a computer.[15] The taskers of the Mechanical Turk and other similar operations, would not be thought of as remotely resembling employees, anymore than the uncompensated creatives at the top end of our scale. They leave no trace of their employment, and certainly nothing to implicate an employer in any legal network of obligations. What they do however, is bring the definition of a job much closer to its etymological source—a discrete "lump," or "piece," of work that exists only for the duration of its fulfilment.

There is a tendency to see distributed labor as a new, digitally-enabled phenomenon. But it is crude technological determinism to think that web technologies have punched a big

hole in the universe of standard employment, and now the contents are leaking all over the place. After all, as I discuss in the next section, old media, which is still highly unionized, has also seen heavy inroads from the volunteer/amateur economy.

The price paid by talent

Those who remember the Writers Guild of America (WGA) strike of 2008–09 will recall the writers' struggle to win a revenue share from residuals—or online versions of content to which they had contributed. In the public mind, this was generally seen as a fair claim. Why? Because surely creators of intellectual property deserve to enjoy the fruits of their labor. But how many will remember what was bargained away in return for recognition of the writers' claim? Since 2005, one of the Writers Guild's top campaign goals has been to organize employees of TV reality shows, and, while union leaders entered the strike vowing to achieve this goal, the media moguls' ultimate condition for reaching an agreement over new media residuals was that the WGA take off the table its claim for jurisdiction over the reality (and animation) sector. The upshot? Concessions were made to those employees—the writers— who feed the copyright milkcow at the expense of the below-the-line employees who are shut out of the WGA.

This raw deal speaks volumes about the ongoing restructuring of the creative industries (or the copyright industries as they are more bluntly termed in the US). Creative employees who are close to the prize of IP have a fair, though precarious, shot at lucrative returns, while those below-the-line, to use the term favored in Hollywood, are cut loose. Since 2001, with the success of *Survivor* and *Big Brother*, the space allotted to reality TV and "challenge" game shows has ballooned to more than twenty per cent of prime-time network programming, and an even greater share on many cable channels. The production costs are a fraction of what producers pay for conventional, scripted drama, and the ratings and profits have been mercurial. Much of the *cinema vérité* feel of reality programming was pioneered by the Fox show *COPS*, which was a scab labor effort cooked up to replace shows lost during the 1998 Writers Guild of America strike. The use of such shows to circumvent union pay-scale compensation has continued. Owners have insisted that producers and editors are not "writers" who pen scripts and dialogue because they would then have a claim on intellectual property, and so the WGA was shut out of reality programming. As a result, the sector teems with substandard conditions—18 hour work days, chronic job instability, no meal breaks, no health benefits, and employer coercion to turn in time cards early. Wage rates are generally half of what employees on scripted shows are paid, and most overtime goes unpaid. When employees vote to join the union they are summarily fired or are threatened with blacklisting. Nor are the amateur contestants any better off. As befits a jackpot economy, talent on the top shows can make a bundle, though most of it from aftermarket revenue in the form of endorsements. However, the majority are paid a minimal stipend, and the price for their shot at exposure is to endure conditions—sleep deprived and plied with hard alcohol—that are designed to spark tension, conflict, and confrontation onscreen. A growing number of lawsuits, in the US, UK and France are aimed at establishing legal protections for amateur talent as well as for writers, editors, and production assistants.

These violations of work standards occur in the sector of old media that is most clearly aligned with the neoliberal ethos of the jackpot economy. It's an ethos which demands that we are all participants in a game that rewards only a few, while the condition of entry into this high-stakes lottery is to leave your safety gear at the door; only the most spunky, agile, and dauntless will prevail, but often at high psychic cost—remember Susan Boyle's long bout of medication and institutionalization after she was vaulted into the limelight on *Britain's Got*

Talent. Yet the labor infractions I have been describing are only visible because they take place against the heavily unionized backdrop of the entertainment industries. In the world of new media, where unions have no foothold whatsoever, the formula of overwork, underpayment, and sacrificial labor is entirely normative.

Another area of the traditional employment landscape that has seen an explosion of free labor is the internship economy. Not only is interning the fastest-growing job category, it is also trendy, and so celebrities are in the thick of it. With Kanye West signed on at the Gap and Lady Gaga in line to learn millinery from Philip Treacy, it's only a matter of time before career agents recommend a high-profile internship as a compulsory publicity move for all their clients. The problem is that these largely unpaid stints have also become *de rigueur* for a large slice of educated youth trying to force their entry into workplaces that are leaner and meaner by the day. In *Intern Nation* (2011), his invaluable book-length report on this phenomenon, Ross Perlin describes the extreme lengths to which college graduates must now go, not to land a job, mind you, but to secure an unpaid intern position (often the first of many) that might help them build a resumé, win a foot in the door, or a leg-up in the skilled labor market. So sharp is the competition that an auction market has sprung into existence to sell these positions to the highest bidder. A Versace internship fetched $5,000 at one auction, temporary blogging rights at the *Huffington Post* went for $13,000, and some fashionista with deep pockets paid $42,500 for a one-week stint at *Vogue*.[16]

Excesses like these in the high-end creative industries are helping to glamorize the notion that it is worth paying a finders fee for the right to work for nothing. While plum internship placements in politics, business, and law have always been a nepotistic preserve, where parents and relatives put in a word for their gilded offspring, Perlin reports that a commodity market is fast subsuming all. At one Californian for-profit outfit, the University of Dreams, as many as two thousand internships all over the world are sold annually, priced at $8,000 for an eight-week summer position (or £9,500 for a London placement). The educational value of these gigs, whether they are run through a venal operation like University of Dreams or a legitimate college placement center, is notoriously thin. Work assignments, as everyone knows, are habitually menial, and mentorship is a rarity. The biggest beneficiary of this galloping trade, of course, is the employer. By Perlin's estimate, corporate America enjoys a $2bn annual subsidy from internships alone, and this sum does not include the massive tax dodges that many firms execute through employer misclassification.[17] He also confirms what we must all have suspected: that the Great Recession has seen a generation of fulltime jobs converted into internships, while formerly paid internships have rapidly morphed into unpaid ones. An estimated fifty per cent of US internships are now unpaid or below minimum wage, fifty-one per cent in Germany, and thirty-seven per cent in the UK.

Supporting a daughter or son while they pass through a year or two of this kind of hazing is still taken for granted among the well-connected. In recent years, however, this economic burden has become obligatory for almost any family intent on launching their child into white-collar employment, even those bound for the freelancing life that is the uncertain lot of the "precarious generation."[18] For the less fortunate, the only way to avoid adding to their mounting pile of college debt is to take on work at a paying job in order to support an internship, and at least one survey suggests that three-quarters of interning students are doing exactly that, while some are collecting food stamps and relying on Medicaid to keep body and soul together.[19] One of the consequences is that occupations with unreliable sources of steady income are almost exclusively reserved for those from monied backgrounds. That the creative professions dominate that category lends some demographic credence to the Tea Party gripe about the "cultural elite."

Many unpaid or underpaid internships are illegal—"volunteers" at a nonprofit tend to escape scrutiny from the state, but internships from which an employer derives an

"immediate advantage" are fully subject to government regulation and protections. Yet everyone involved in this economy has a vested interest in maintaining the conspiracy of silence about the legal limbo. Interns themselves won't lodge complaints for fear of staining their career prospects. College administrators save money when interning students pay for credit but don't need teachers in class. As for employers, the prospect of talented youth willing to pay to work for nothing is surely a lustrous capitalist dream, from which they can imagine no rude awakening.

Does Marx still apply?

As a scholar of cultural work, I am driven to respond to some of the more challenging questions raised by these models of free labor. Some commentators, for example, have wondered if the Marxist legacy of thinking about labor exploitation is no longer relevant, because it cannot help us analyze the new modes of accumulation exemplified by the likes of Facebook. Others have suggested that Marx, in a few prescient passages in the *Grundrisse*, predicted the increasing dependence of capitalism on the social brain, the vast network of technically-advanced cooperative work that is the source and agent of the cognitive mode of production which we all inhabit today and to which we contribute daily.[20] Capital in other words, is increasingly reliant on our mental intercourse.

In response to the first argument, it might be pointed out that waged labor is not the only, or the best lens through which to view capital accumulation. Michael Denning has argued that Marx saw the accumulation of labor as just as significant a factor of capitalism as the accumulation of capital, and in that regard, the proliferation of wagelessness may be a better analytical standpoint from which to view economic life.[21] After all, the template of the bounded, waged workday (and five-day workweek), with its formal wraparound of rules, standards, obligations, and expectations was a highly artificial product of bargaining in the advanced economies that administered a temporary truce between capital and labor in the postwar years. Though it was adopted and referred to as standard employment in this era, there was nothing natural about the outcome, and it applied almost exclusively to the primary employment of unionized male, industrial workers. This tightly shored-up arrangement floated upon an ocean of unpaid work in the home, casualized work in the secondary employment sector, and wageless work in the informal sector, all of which have swelled immeasurably in the last quarter century. A snapshot of any large institution of higher education would display the results: the multiplication of student debt (the price of college is the only cost that has continued to rise in the Great Recession); the proliferation of cutprice student labor on campuses and in the surrounding rings of campus towns; the massed ranks of adjunct and contract faculty; the reserve army of unemployed postgraduates; and the increasingly small core of full-timers, who are the very model of the worker who has no sense of boundaries, whose efforts to draw a line around work are not only futile but also counterintuitive, given how we function as professional intellectuals.

In addition, and this almost goes without saying, the vast majority of human labor throughout history and to this day was and is wageless, certainly when compared to the model that economists call standard employment, and by which the trade union movement traditionally calibrated its lens. Chances are that waged labor in a legally limited workday may soon come to be seen as the shortlived norm for a small minority, and most of them public employees. Capitalism, Denning argues, "begins not with the offer of work, but with the imperative to earn a living," and wage-earning is only one of the proletarian recipes for responding to that imperative. The upsurge of precarious work that we have seen in recent decades, especially in the knowledge and creative industries where the self-employed or

gig-based economy is more and more normative, may be seen as the degradation of a formal wage-earning standard, but it is viewed quite differently from the standpoint of those excluded from standard employment in the first place or those, under forty and mostly women, who have cut their youthful teeth on it. The same goes for their understanding of exploitation. What counts as fair and unfair labor on that landscape is subject to continual readjustment. We have some idea of what fair labor standards should be for low-skill workplaces that operate on hourly waged compensation, but none whatsoever in the creative or knowledge sectors because they subsist on the promise of nice work if you can get it.

On the second question, the potential of the social brain that Marx designated as the General Intellect, there clearly is a diffuse, decentralized quality to what the Italian school of Marxist theory calls immaterial labor. As capitalism is more and more dependent on brainpower, it has had to grant concessions in order to continue to harvest these cognitive skills. More autonomy, more meaningful work and humane workplaces, and more entrepreneurial leeway for self-employed freelancers to control their own time. Capital-owners are often behind the curve in the cognitive field, they are hunters and gatherers of ideas and practices that are developed well outside their territorial orbit but still under the rubric of the permission to think to which they have agreed in advance.[22]

So, too, capital owners have been forced to enter into a high-intensity "copyfight" over intellectual property, and this is a fight brought to them by the commons-loving hacker fractions of the cognitive class.[23] These running skirmishes over the policing of Digital Rights Management, or the denial of residual revenues to screenwriters, or over what Siva Vaidhyanathan in his 2011 book of that name calls the "Googlization of Everything," are all leading-edge battles with monopolists bent on propertizing everything, living or dead, under the sun.[24] At the very least, they are evidence that the General Intellect as Marx envisaged it, is not the property of a class, but rather a field of contest that is so diffuse that antagonisms can crop up anywhere within it. In this respect, we are far beyond the confrontation at the factory gates—the traditional fixed location of the wage-earner's efforts to negotiate labor conditions—or the contract itself, especially since the cognitives or creatives often invest more of their political time and energy in fights over schooling, community development, food sovereignty, racism, sexism and homophobia on the information landscape, or other issues affected by unfair distribution.

It would be naive, however, to conclude, as some advocates of immaterial labor do, that neoliberal capitalism has been weakened or outsmarted by all of this creative and autonomous activity. That feels too much like snatching victory from the jaws of defeat. Neoliberalism may be theoretically dead, but its spirit is dominant and pervasive. Nor should these developments allow us to imagine that the factory gates are no longer important flashpoints, because they continue to be so in the workshops of the world in East Asia, and in all of the other offshore free trade zones where most of what you wear or touch on a daily basis is assembled. In these low-wage manufacturing locations, work is feminized not because it involved a blurring between the factory and the traditionally feminine household sphere, but because the workforce is disproportionately composed of the most vulnerable segment of the population: rural teenage girls. It's worth noting this overwhelmingly female makeup of this factory labor pool at the low-wage end of the production ladder has come into being at the same time as young women have disproportionately entered the precarious world of self-employment and creative labor at the other end, moving, as Angela McRobbie has put it, "from the reserve army of labor" to the very "heartland of new forms of work."[25] The women in the first kind of offshore assembly platform workforce are firmly disciplined according to traditional gender roles, at the same time as they have access, for the first time, to some disposable income and to the feel of urban freedoms. The women in the second—the so-called creative industries—enjoy full equality of access and unprecedented control over the scheduling of

their lives, at the same time as their gendered skills and aptitudes around networking, multi-gigging, task-juggling, and social finessing of a whole range of work-leisure overlaps have made them ideal workers for the most neoliberal forms of flexible accumulation, thereby cutting them off from any of the legal entitlements of the waged earner. In the first work-force, we see the retrenchment of the patriarchal sweatshop economy so redolent of early stage industrialization. In the second, we see the pioneering of a new DIY economy where educated entrants fashion their own livelihoods by piecing together disparate lumps of work and income. That women are so prevalent in both is worthy of further inquiry.

In this essay, I have focused on the latter, because that is the world of work which has hosted, if not welcomed, the patterns of free labor that have been the object of so much attention recently. But I don't think we can ignore the co-existence of the former, often in the same urban centers, within a stone's throw of the other. The persistence of these sweatshops reminds us of what directly predated the era of standard employment just as the defiantly postindustrial profile of the self-employed precariat is supposed to postdate it. While they are drawn from quite different strata—one quite highly educated, the other predominantly immigrant and underresourced, both share existential conditions of uncertainty, intermittency, and isolation from any protective framework of social insurance. Off the books, under the table, between the web, through the portal, out the door, and into the ether of society, where it is our job either to study or live out these conditions, to resist the worst of them and to salute their more liberating components.

Notes

1 Mark Wallinger and Mary Warnock, eds. *Art for All?: Their Policies and Our Culture* (London: Peer, 2000). Marina Vishmidt and M. Gilligan, eds. *Immaterial Labour: Work, Research & Art* (London: Black Dog Publishing, 2003); Nicholas Garnham, "From Cultural to Creative Industries: An Analysis of the Implications of the 'Creative Industries' Approach to Arts and Media Policy-Making in the UK," *International Journal of Cultural Policy* 10, 1 (2005), pp. 15–30.

2 Geert Lovink and Ned Rossiter, eds. *My Creativity* (Amsterdam: Insitute for Network Cultures, 2007); John Hartley, ed. *Creative Industries* (Oxford: Blackwell, 2004); Ursula Huws, ed. (2007) "The Creative Spark in the Engine" special issues of *Work, Organization, Labour & Globalization* Vol. 1, No. 1. (2007); Andrew Ross, *Nice Work If You Can Get It* (New York: NYU Press, 2009); David Hesmondhalgh and Andy Pratt, eds. "Special Issue: The Cultural Industries and Cultural Policy," *International Journal of Cultural Policy* 11.1. (2005); David Hesmondhalgh, *The Cultural Industries* (London: Sage, 2007).

3 Michael Keane, *Created in China: The Great New Leap Forward* (New York: Routledge, 2007).

4 Richard Florida, *The Rise of the Creative Class, And How It's Transforming Work, Leisure, Community, and Everyday Life* (New York: Basic Books, 2002); Jamie Peck, "Struggling with the Creative Class," *International Journal of Urban and Rural Research* 29,4 (2005), pp. 740–70; Charles Landry, *The Creative City: A Toolkit for Urban Innovators* (London: Earthscan, 2000).

5 David Harvey, "The Art of Rent: Globalization and the Commodification of Culture," in *Spaces of Capital* (New York: Routledge, 2001).

6 Pierre-Michel Menger, *Portrait de l'artiste en travailleur* (Paris: Seuil, 2002); Angela McRobbie, " 'Everyone is Creative': Artists as Pioneers of the New Economy?" Tony Bennett and Elizabeth Silva, eds. *Contemporary Culture and Everyday Life* (London: Routledge, 2004).

7 Participants in a New School conference, *The Internet as Playground and Factory*, organized by Trebor Scholz, explored these phenomena at length in November 2010. Much of the material can be found at http://digitallabor.org/ and in the forthcoming Routledge book, edited by Scholz, *Unthinking Digital Labor*.

8 Subsequently, *Huffington Post* blogger and activist Jonathan Tasini, launched a class-action law suit against Huffington, claiming that the contributors must share in the value they created for the site.

9 Julian Kücklich, "FCJ-025 Precarious Playbour: Modders and the Digital Games Industry," *Fibreculture*, 5 (2005).

10 Jeff Howe, *Crowdsourcing: Why the Power of the Crowd Is Driving the Future of Business* (New York: Crown, 2008).

11 Contrast, for example, the arguments put forth in Andrew Keen, *The Cult of the Amateur: How Blogs, MySpace, YouTube, and the Rest of Today's User-Generated Media are Destroying Our Economy, Our Culture, and Our Values* (New York: Crown, 2007) with those of Chris Anderson in *Free: The Future of a Radical Price* (New York: Hyperion, 2009).

12 Andrew Ross, *Fast Boat to China: Corporate Flight and the Consequences of Free Trade* (New York: Pantheon, 2006).

13 Philadelphia: Temple University Press, 2004.

14 Rosalind Gill, *Technobohemians or the New Cybertariat: New Media Work in Amsterdam a Decade After the Web* (Amsterdam: Institute of Network Cultures, 2007); David Hesmondhalgh and Sarah Baker, *Creative Labour: Media Work in Three Cultural Industries* (Abingdon and New York: Routledge, 2010); Sybille Reidl, Helene Schiffbanker and Hubert Eichmann, "Creating a Sustainable Future: The Working Life of Creative Workers in Vienna," *Work, Organization, Labour & Globalization*, 1,1 (2006), pp. 48–58; D. Perrons, "The New Economy and the Work Life Balance. A Case Study of the New Media Sector in Brighton and Hove," *Gender, Work and Organisation* 10, 1 (2003), pp. 65–93.

15 Katharine Mieszkowski, "I make $1.45 a week and I love it," *Salon* (July 24, 2006), at http://www.salon.com/technology/feature/2006/07/24/turks.

16 Ross Perlin, *Intern Nation: How to Earn Nothing and Learn Little in the Brave New Economy* (New York: Verso, 2011), p. 156.

17 Ibid., p. 124.

18 Abdel Mabrouki, *Génération précaire* (Paris: Le Cherche Midi, 2004): Brett Neilson and Ned Rossiter, "From Precarity to Precariousness and Back Again: Labour, Life and Unstable Networks," *Fibreculture* 5 (2005), at http://journal.fibreculture.org/issue5/neilson_rossiter.html://journal.fibreculture.org/issue5/neilson_rossiter.html.

19 Perlin, p. 175.

20 Karl Marx, *Grundrisse: Foundations of the Critique of Political Economy* (1861) Chapter 13, at http://www.marxists.org/archive/marx/works/1857/grundrisse/ch13.htm#p694; Maurizio Lazzarato, "Immaterial Labor," in Paolo Virno and Michael Hardt, eds. *Radical Thought in Italy* (Minneapolis: University of Minnesota Press, 1996), pp. 133–46: Michael Hardt and Antonio Negri, *Empire* (Cambridge, Mass.: Harvard University Press, 2000).

21 Michael Denning, "Wageless Life," *New Left Review*, 66 (November–December 2010).

22 Tiziana Terranova, *Network Culture: Politics for the Information Age* (London: Pluto, 2004).

23 Andrew Ross, "Technology and Below-the-Line Labor in the Copyfight over Intellectual Property," *American Quarterly*, 58, 3 (2006), pp. 743–66.

24 Siva Vaidhyanathan, *The Googlization of Everything (And Why We Should Worry)* (Berkeley: University of California Press, 2011).

25 Angela McRobbie, "Reflections On Feminism, Immaterial Labour And The Post-Fordist Regime," *New Formations*, 70 (Spring 2011).

Mark Fisher

IT'S EASIER TO IMAGINE THE END OF THE WORLD THAN THE END OF CAPITALISM

IN ONE OF THE KEY SCENES in Alfonso Cuarón's 2006 film *Children of Men*, Clive Owen's character, Theo, visits a friend at Battersea Power Station, which is now some combination of government building and private collection. Cultural treasures—Michelangelo's *David*, Picasso's *Guernica*, Pink Floyd's inflatable pig—are preserved in a building that is itself a refurbished heritage artifact. This is our only glimpse into the lives of the elite, holed up against the effects of a catastrophe which has caused mass sterility: no children have been born for a generation. Theo asks the question, "how all this can matter if there will be no-one to see it?" The alibi can no longer be future generations, since there will be none. The response is nihilistic hedonism: "I try not to think about it."

What is unique about the dystopia in *Children of Men* is that it is specific to late capitalism. This isn't the familiar totalitarian scenario routinely trotted out in cinematic dystopias (see, for example, James McTeigue's 2005 *V for Vendetta*). In the P.D. James novel on which the film is based, democracy is suspended and the country is ruled over by a self-appointed Warden, but, wisely, the film downplays all this. For all that we know, the authoritarian measures that are everywhere in place could have been implemented within a political structure that remains, notionally, democratic. The War on Terror has prepared us for such a development: the normalization of crisis produces a situation in which the repealing of measures brought in to deal with an emergency becomes unimaginable (when will the war be over?).

Watching *Children of Men*, we are inevitably reminded of the phrase attributed to Fredric Jameson and Slavoj Žižek, that it is easier to imagine the end of the world than it is to imagine the end of capitalism. That slogan captures precisely what I mean by "capitalist realism": the widespread sense that not only is capitalism the only viable political and economic system, but also that it is now impossible even to *imagine* a coherent alternative to it. Once, dystopian films and novels were exercises in such acts of imagination—the disasters they depicted acting as narrative pretext for the emergence of different ways of living. Not so in *Children of Men*. The world that it projects seems more like an extrapolation or exacerbation of ours than an alternative to it. In its world, as in ours, ultra-authoritarianism and Capital are by no means incompatible: internment camps and franchise coffee bars co-exist. In *Children of Men*, public space is abandoned, given over to uncollected garbage and stalking animals (one

especially resonant scene takes place inside a derelict school, through which a deer runs). Neoliberals, the capitalist realists par excellence, have celebrated the destruction of public space but, contrary to their official hopes, there is no withering away of the state in *Children of Men*, only a stripping back of the state to its core military and police functions (I say "official" hopes since neoliberalism surreptitiously relied on the state even while it has ideologically excoriated it. This was made spectacularly clear during the banking crisis of 2008, when, at the invitation of neoliberal ideologues, the state rushed in to shore up the banking system).

The catastrophe in *Children of Men* is neither waiting down the road, nor has it already happened. Rather, it is being lived through. There is no punctual moment of disaster; the world doesn't end with a bang, it winks out, unravels, gradually falls apart. What caused the catastrophe to occur, who knows; its cause lies long in the past, so absolutely detached from the present as to seem like the caprice of a malign being: a negative miracle, a malediction which no penitence can ameliorate. Such blight can only be eased by an intervention that can no more be anticipated than was the onset of the curse in the first place. Action is pointless; only senseless hope makes sense. Superstition and religion, the first resorts of the helpless, proliferate.

But what of the catastrophe itself? It is evident that the theme of sterility must be read metaphorically, as the displacement of another kind of anxiety. I want to argue this anxiety cries out to be read in cultural terms, and the question the film poses is: how long can a culture persist without the new? What happens if the young are no longer capable of producing surprises?

Children of Men connects with the suspicion that the end has already come, the thought that it could well be the case that the future harbors only reiteration and re-permutation. Could it be that there are no breaks, no "shocks of the new" to come? Such anxieties tend to result in a bi-polar oscillation: the "weak messianic" hope that there must be something new on the way lapses into the morose conviction that nothing new can ever happen. The focus shifts from the Next Big Thing to the last big thing—how long ago did it happen and just how big was it?

T.S. Eliot looms in the background of *Children of Men*, which, after all, inherits the theme of sterility from *The Waste Land*. The film's closing epigraph "shantih shantih shantih" has more to do with Eliot's fragmentary pieces than the Upanishads' peace. Perhaps it is possible to see the concerns of another Eliot—the Eliot of "Tradition and the Individual Talent"— ciphered in *Children of Men*. It was in this essay that Eliot, in anticipation of Harold Bloom, described the reciprocal relationship between the canonical and the new. The new defines itself in response to what is already established; at the same time, the established has to reconfigure itself in response to the new. Eliot's claim was that the exhaustion of the future does not even leave us with the past. Tradition counts for nothing when it is no longer contested and modified. A culture that is merely preserved is no culture at all. The fate of Picasso's *Guernica* in the film—once a howl of anguish and outrage against Fascist atrocities, now a wall-hanging—is exemplary. Like its Battersea hanging space in the film, the painting is accorded "iconic" status only when it is deprived of any possible function or context. No cultural object can retain its power when there are no longer new eyes to see it.

We do not need to wait for *Children of Men's* near-future to arrive to see this transformation of culture into museum pieces. The power of capitalist realism derives in part from the way that capitalism subsumes and consumes all of previous history: one effect of its "system of equivalence" which can assign all cultural objects, whether they are religious iconography, pornography, or *Das Kapital*, a monetary value. Walk around the British Museum, where you see objects torn from their lifeworlds and assembled as if on the deck of some Predator spacecraft, and you have a powerful image of this process at work. In the conversion of practices and rituals into merely aesthetic objects, the beliefs of previous cultures are objectively

ironized, transformed into *artifacts*. Capitalist realism is therefore not a particular type of realism; it is more like realism in itself. As Marx and Engels themselves observed in *The Communist Manifesto*,

> [Capital] has drowned the most heavenly ecstasies of religious fervor, of chivalrous enthusiasm, of philistine sentimentalism, in the icy water of egotistical calculation. It has resolved personal worth into exchange value, and in place of the numberless indefeasible chartered freedoms, has set up that single, unconscionable freedom—Free Trade. In one word, for exploitation, veiled by religious and political illusions, it has substituted naked, shameless, direct, brutal exploitation.

Capitalism is what is left when beliefs have collapsed at the level of ritual or symbolic elaboration, and all that is left is the consumer-spectator, trudging through the ruins and the relics.

Yet this turn from belief to aesthetics, from engagement to spectatorship, is held to be one of the virtues of capitalist realism. In claiming, as Badiou puts it, to have "delivered us from the 'fatal abstractions' inspired by the 'ideologies of the past'," capitalist realism presents itself as a shield protecting us from the perils posed by belief itself. The attitude of ironic distance proper to postmodern capitalism is supposed to immunize us against the seductions of fanaticism. Lowering our expectations, we are told, is a small price to pay for being protected from terror and totalitarianism. "We live in a contradiction," Badiou has observed:

> a brutal state of affairs, profoundly inegalitarian—where all existence is evaluated in terms of money alone—is presented to us as ideal. To justify their conservatism, the partisans of the established order cannot really call it ideal or wonderful. So instead, they have decided to say that all the rest is horrible. Sure, they say, we may not live in a condition of perfect Goodness. But we're lucky that we don't live in a condition of Evil. Our democracy is not perfect. But it's better than the bloody dictatorships. Capitalism is unjust. But it's not criminal like Stalinism. We let millions of Africans die of AIDS, but we don't make racist nationalist declarations like Milosevic. We kill Iraqis with our airplanes, but we don't cut their throats with machetes like they do in Rwanda, etc.

The "realism" here is analogous to the deflationary perspective of a depressive who believes that any positive state, any hope, is a dangerous illusion.

In their account of capitalism, surely the most impressive since Marx's, Deleuze and Guattari describe capitalism as a kind of dark potentiality which haunted all previous social systems. Capital, they argue, is the "unnamable Thing," the abomination, which primitive and feudal societies "warded off in advance." When it actually arrives, capitalism brings with it a massive desacralization of culture. It is a system which is no longer governed by any transcendent Law; on the contrary, it dismantles all such codes, only to re-install them on an *ad hoc* basis. The limits of capitalism are not fixed by fiat, but defined (and redefined) pragmatically and improvisationally. This makes capitalism very much like the Thing in John Carpenter's film of the same name: a monstrous, infinitely plastic entity capable of metabolizing and absorbing anything with which it comes into contact. Capital, Deleuze and Guattari says, is a "motley painting of everything that ever was;" a strange hybrid of the ultra-modern and the archaic. In the years since Deleuze and Guattari wrote the two volumes of their *Capitalism And Schizophrenia*, it has seemed as if the deterritorializing impulses of capitalism have been confined to finance, leaving culture presided over by the forces of reterritorialization.

This malaise, the feeling that there is nothing new, is itself nothing new of course. We find ourselves at the notorious "end of history" trumpeted by Francis Fukuyama after the fall of the Berlin Wall. Fukuyama's thesis that history has climaxed with liberal capitalism may have been widely derided,but it is accepted, even assumed, at the level of the cultural unconscious. It should be remembered, though, that even when Fukuyama advanced it, the idea that history had reached a "terminal beach" was not merely triumphalist. Fukuyama warned that his radiant city would be haunted, but he thought its specters would be Nietzschean rather than Marxian. Some of Nietzsche's most prescient pages are those in which he describes the "oversaturation of an age with history." "It leads an age into a dangerous mood of irony in regard to itself," he wrote in *Untimely Meditations*, "and subsequently into the even more dangerous mood of cynicism," in which "cosmopolitan fingering," a detached spectatorialism, replaces engagement and involvement. This is the condition of Nietzsche's Last Man, who has seen everything, but is decadently enfeebled precisely by this excess of (self) awareness.

Fukuyama's position is in some ways a mirror image of Fredric Jameson's. Jameson famously claimed that postmodernism is the "cultural logic of late capitalism." He argued that the failure of the future was constitutive of a postmodern cultural scene which, as he correctly prophesied, would become dominated by pastiche and revivalism. Given that Jameson has made a convincing case for the relationship between postmodern culture and certain tendencies in consumer (or post-Fordist) capitalism, it could appear that there is no need for the concept of capitalist realism at all. In some ways, this is true. What I'm calling capitalist realism can be subsumed under the rubric of postmodernism as theorized by Jameson. Yet, despite Jameson's heroic work of clarification, postmodernism remains a hugely contested term, its meanings, appropriately but unhelpfully, unsettled and multiple. More importantly, I would want to argue that some of the processes which Jameson described and analyzed have now become so aggravated and chronic that they have gone through a change in kind.

Ultimately, there are three reasons that I prefer the term capitalist realism to postmodernism. In the 1980s, when Jameson first advanced his thesis about postmodernism, there were still, in name at least, political alternatives to capitalism. What we are dealing with now, however, is a deeper, far more pervasive, sense of exhaustion, of cultural and political sterility. In the 1980s, "Really Existing Socialism" still persisted, albeit in its final phase of collapse. In Britain, the fault lines of class antagonism were fully exposed in an event like the Miners' Strike of 1984–85, and the defeat of the miners was an important moment in the development of capitalist realism, at least as significant in its symbolic dimension as in its practical effects. The closure of pits was defended precisely on the grounds that keeping them open was not "economically realistic," and the miners were cast in the role of the last actors in a doomed proletarian romance. The 1980s were the period when capitalist realism was fought for and established, when Margaret Thatcher's doctrine that "there is no alternative"—as succinct a slogan of capitalist realism as you could hope for—became a brutally self-fulfilling prophecy.

Second, postmodernism involved some relationship to modernism. Jameson's work on postmodernism began with an interrogation of the idea, cherished by the likes of Adorno, that modernism possessed revolutionary potentials by virtue of its formal innovations alone. What Jameson saw happening instead was the incorporation of modernist motifs into popular culture (suddenly, for example, Surrealist techniques would appear in advertising). At the same time as particular modernist forms were absorbed and commodified, modernism's credos—its supposed belief in elitism and its monological, top-down model of culture— were challenged and rejected in the name of "difference," "diversity" and "multiplicity." Capitalist realism no longer stages this kind of confrontation with modernism. On the contrary, it takes the vanquishing of modernism for granted: modernism is now something that can periodically return, but only as a frozen aesthetic style, never as an ideal for living.

Third, a whole generation has passed since the collapse of the Berlin Wall. In the 1960s and 1970s, capitalism had to face the problem of how to contain and absorb energies from outside. It now, in fact, has the opposite problem; having all-too successfully incorporated externality, how can it function without an outside it can colonize and appropriate? For most people under twenty in Europe and North America, the lack of alternatives to capitalism is no longer even an issue. Capitalism seamlessly occupies the horizons of the thinkable. Jameson used to report in horror about the ways that capitalism had seeped into the very unconscious; now, the fact that capitalism has colonized the dreaming life of the population is so taken for granted that it is no longer worthy of comment. It would be dangerous and misleading to imagine that the near past was some prelapsarian state rife with political potentials, so it's as well to remember the role that commodification played in the production of culture throughout the twentieth century. Yet the old struggle between *détournement* and recuperation, between subversion and incorporation, seems to have been played out. What we are dealing with now is not the incorporation of materials that previously seemed to possess subversive potentials, but instead, their *precorporation*: the pre-emptive formatting and shaping of desires, aspirations and hopes by capitalist culture. Witness, for instance, the establishment of settled "alternative" or "independent" cultural zones, which endlessly repeat older gestures of rebellion and contestation as if for the first time. "Alternative" and "independent" don't designate something outside mainstream culture; rather, they are styles, in fact *the* dominant styles, within the mainstream. No-one embodied (and struggled with) this deadlock more than Kurt Cobain and Nirvana. In his dreadful lassitude and objectless rage, Cobain seemed to give wearied voice to the despondency of the generation that had come after history, whose every move was anticipated, tracked, bought and sold before it had even happened. Cobain knew that he was just another piece of spectacle, that nothing runs better on MTV than a protest against MTV; knew that his every move was a cliché scripted in advance, knew that even realizing it is a cliché. The impasse that paralyzed Cobain is precisely the one that Jameson described: like postmodern culture in general, Cobain found himself in "a world in which stylistic innovation is no longer possible, [where] all that is left is to imitate dead styles, to speak through the masks and with the voices of the styles in the imaginary museum." Here, even success meant failure, since to succeed would only mean that you were the new meat on which the system could feed. But the high existential angst of Nirvana and Cobain belongs to an older moment; what succeeded them was a pastiche-rock which reproduced the forms of the past without anxiety.

Cobain's death confirmed the defeat and incorporation of rock's Utopian and promethean ambitions. When he died, rock was already being eclipsed by hip hop, whose global success has presupposed just the kind of precorporation by capital which I alluded to above. For much hip hop, any naïve hope that youth culture could change anything has been replaced by the hard-headed embracing of a brutally reductive version of "reality." "In hip hop," Simon Reynolds pointed out in a 1996 essay in *The Wire* magazine:

> "real" has two meanings. First, it means authentic, uncompromised music that refuses to sell out to the music industry and soften its message for crossover. "Real" also signifies that the music reflects a "reality" constituted by late capitalist economic instability, institutionalized racism, and increased surveillance and harassment of youth by the police. "Real" means the death of the social: it means corporations who respond to increased profits not by raising pay or improving benefits but by . . . downsizing (the laying-off of the permanent workforce in order to create a floating employment pool of part-time and freelance workers without benefits or job security).

In the end, it was precisely hip hop's performance of this first version of the real—"the uncompromising"—that enabled its easy absorption into the second, the reality of late capitalist economic instability, where such authenticity has proven highly marketable. Gangster rap neither merely reflects pre-existing social conditions, as many of its advocates claim, nor does it simply cause those conditions, as its critics argue—rather the circuit whereby hip hop and the late capitalist social field feed into each other is one of the means by which capitalist realism transforms itself into a kind of anti-mythical myth. The affinity between hip hop and gangster movies such as *Scarface*, *The Godfather* films, *Reservoir Dogs*, *Goodfellas* and *Pulp Fiction* arises from their common claim to have stripped the world of sentimental illusions and seen it for "what it really is:" a Hobbesian war of all against all, a system of perpetual exploitation and generalized criminality. In hip hop, Reynolds writes, "To 'get real' is to confront a state-of-nature where dog eats dog, where you're either a winner or a loser, and where most will be losers."

The same neo-noir worldview can be found in the comic books of Frank Miller and in the novels of James Ellroy. There is a kind of machismo of demythologization in Miller and Ellroy's works. They pose as unflinching observers who refuse to prettify the world so that it can be fitted into the supposedly simple ethical binaries of the superhero comic and the traditional crime novel. The "realism" here is somehow underscored, rather than undercut, by their fixation on the luridly venal—even though the hyperbolic insistence on cruelty, betrayal and savagery in both writers quickly becomes pantomimic. "In his pitch blackness," Mike Davis wrote of Ellroy in 1992, "there is no light left to cast shadows and evil becomes a forensic banality. The result feels very much like the actual moral texture of the Reagan-Bush era: a supersaturation of corruption that fails any longer to outrage or even interest." Yet this very desensitization serves a function for capitalist realism: Davis hypothesized that "the role of L.A. *noir*" may have been "to endorse the emergence of *homo reaganus*."

Brian Holmes

DO IT YOURSELF GEO-POLITICS

What interests us in the image is not its function as a representation of reality,
but its dynamic potential, its capacity to elicit and construct projections, inter-
actions, narrative frames . . . devices for constructing reality.

Franco Berardi "Bifo," *L'immagine dispositivo*

VANGUARD ART, in the twentieth century, began with the problem of its own
overcoming—whether in the destructive, Dadaist mode, which sought to tear apart the
entire repertory of inherited forms and dissolve the very structures of the bourgeois ego, or
in the expansive, constructivist mode, which sought to infuse architecture, design, and the
nascent mass media with a new dynamic of social purpose and a multiperspectival intelligence
of political dialogue. Though both positions were committed to an irrepressible excess over
the traditional genres of painting and sculpture, still they appeared as polar opposites; and
they continued at ideological odds with each other throughout the first half of the century,
despite zones of enigmatic or secret transaction (Schwitters, Van Doesburg, etc.). But after
the war, the extraordinarily wide network of revolutionary European artists that briefly
coalesced, around 1960, into the Situationist International (SI), brought a decisive new twist
to the Dada/constructivist relation. With their practice of "hijacking" commercial images
(*détournement*), with their cartographies of urban drifting (*dérive*), and above all with their
aspiration to create the "higher games" of "constructed situations," the SI sought to subver-
sively project a specifically artistic competence into the field of potentially active reception
constituted by daily life in the consumer societies.

The firebrand career of the Situationist International as an artists' collective is overshad-
owed by the political analysis of the *Society of the Spectacle*, a work that deliberately attempted
to maximize the antagonism between the radical aesthetics of everyday life and the delusions
purveyed, every day, by the professionalized, capital-intensive media. The SI anally found-
ered over this antagonistic logic, which led to the exclusion of most of the artists from the
group. But with the notion of subversive cartography and the practice of "constructed situ-
ations," it was as though something new had been released into the world. Without having to
ascribe exclusive origins or draw up faked genealogies, one can easily see that since the period
around 1968, the old drive to art's self-overcoming has found a new and much broader field

of possibility, in the conflicted and ambiguous relations between the educated sons and daughters of the former working classes and the proliferating products of the consciousness industry. The statistical fact that such a large number of people trained as artists are inducted into the service of this industry, combined with the ready availability of a "fluid language" of *détournement* that allows them to exit from it pretty much whenever they choose, has been at the root of successive waves of agitation that tend simultaneously to dissolve any notion of a "vanguard" and to reopen the struggle for a substantial democracy. And so the question on everyone's lips becomes, how do I participate?

"This is a chord. This is another. Now form a band."[1] The punk invitation to do-it-yourself music supplies instant insight to the cultural revolution that swept through late-1970s Britain. And the hilarity, transgression, and class violence of public punk performance comes surprisingly close to the SI's definition of a situation: "A moment of life concretely and deliberately constructed by the collective organization of a unitary ambiance and a play of events."[2] The relation between punk and Situationism was widely perceived at the time.[3] But there was something else at stake, something radically new by comparison to the disruptive tactics of the 1960s, because the DIY invitation had another side, which said: "Now start a label." The proliferation of garage bands would be matched with an outpouring of indie records, made and distributed autonomously. In this way, punk marked an attempt at *appropriating the media*, which in a society dominated by the consciousness industry is tantamount to *appropriating the means of production.*[4] Punk as productivism. There's a constructive drive at work here: a desire to respond, with technical means, to the recording companies' techniques for the programming of desire. The punk movement in Britain was an attempt to construct subversive situations on the scales permitted by modern communications.

Something fundamental changes when artistic concepts are used within a context of massive appropriation, amid a blurring of class distinctions. A territory of art appears within widening "underground" circles, where the aesthetics of everyday practice is lived as a political creation. The shifting grounds of this territory could be traced through the radical fringe of the techno movement from the late 1980s onward, with its white-label records produced under different names every time, its hands-on use of computer technology, its nomadic sound systems for mounting concerts at any chosen location. It could be explored in the offshoots of mail art, with the development of fanzines, the Art Strike and Plagiarist movements, the Luther Blissett Project, the invention of radio- or telephone-assisted urban drifting.[5] It could be previewed in community-oriented video art, alternative TV projects, AIDS activism, and the theories of tactical media. But rather than engaging in a preemptive archaeology of these developments, I want to go directly to their most recent period of fruition in the late 1990s, when a rekindled sense of social antagonism once again pushed aesthetic producers, along with many other social groups, into an overtly political confrontation with norms and authorities.

This time, the full range of media available for appropriation could be hooked into a world-spanning distribution machine: the Internet. The specific practices of computer hacking and the general model they proposed of amateur intervention into complex systems gave confidence to a generation that had not personally experienced the defeats and dead ends of the 1960s. Building on this constructive possibility, an ambition arose to map out the repressive and coercive order of the transnational corporations and institutions. It would be matched by attempts to disrupt that order through the construction of subversive situations on a global scale. Collective aesthetic practices, proliferating in social networks outside the institutional spheres of art, were one of the major vectors for this double desire to grasp and transform the new world map. A radically democratic desire that could be summed up in a seemingly impossible phrase: do-it-yourself geopolitics.

J18, or the financial center nearest you

Does anyone know how it was really done?[6] The essence of cooperatively catalyzed events is to defy single narratives. But it can be said that on June 18, 1999 (J18), around noon, somewhere from five to ten thousand people flooded out of the tube lines at Liverpool station, right in the middle of the City of London (Figure 23.1). Most found themselves holding a carnival mask, in the colors black, green, red, or gold—the colors of anarchy, ecology, and communism, plus high finance, specially for the occasion. Amid the chaos of echoing voices and pounding drums, it might even have been possible to read the texts on the back:

> Those in authority fear the mask for their power partly resides in identifying, stamping and cataloguing: in knowing who you are. But a Carnival needs masks, thousands of masks . . . Masking up releases our commonality, enables us to act together. . . During the last years the power of money has presented a new mask over its criminal face. Disregarding borders, with no importance given to race or colors, che power of money humiliates dignities, insults honesties and assassinates hopes.
> On the signal follow your color/Let the Carnival begin.[7]

The music was supposed to come from speakers carried in backpacks. But no one could hear it above the roar. Four groups divided anyway, not exactly according to color; one went off track and ended up at London Bridge, to hold a party of its own. The others took separate paths through the medieval labyrinth of Europe's largest financial district, converging toward a point that had been announced only by word of mouth and kept secret from all but a few: the London International Financial Futures & Options Exchange, or LIFFE building, the largest derivatives market in Europe—the pulsing, computerized, hyper competitive brain of

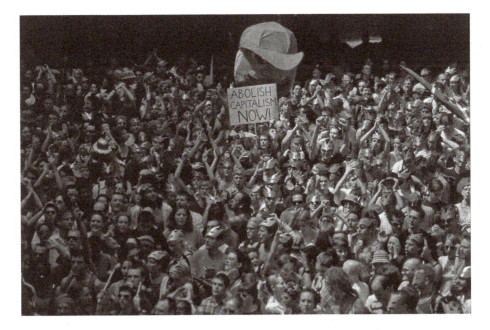

Figure 23.1 "Carnival against Capitalism" by Reclaim the Streets and others creates traffic chaos and extensive damage at Liverpool Street Station, London, June 18, 1999. Performed at the time of the G8 summit in Cologne to protest against world debt. Photograph © 1999, Andrew Wiard.

the beast. The trick was to parade anarchically through the winding streets, swaying to the samba bands, inviting passing traders and bank employees to take off their ties or heels and join the party, while a few smaller groups rushed ahead, to dodge tremblingly into alleyways and await that precise moment when a number of cars would inexplicably stop and begin blocking a stretch of Lower Thames Street. The sound system, of course, was already there. As protestors shooed straggling motorists out of the area, larger groups began weaving in, hoisting puppets to the rhythm of the music and waving red, black, and green Reclaim the Streets (RTS) flags in the air. The Carnival had begun, inside the "Square Mile" of London's prestigious financial district—and the police, taken entirely by surprise, could do nothing about it.

Banners went up: "our resistance is as global as capital," "the earth is a common treasury for all," "revolution is the only option." Posters by the French graphic arts group Ne Pas Plier ("do not fold") were glued directly on the walls of banks, denouncing "money world," proclaiming "resistance-existence," or portraying the earth as a giant burger waiting to be consumed. The site had also been chosen for its underground ecology: a long-buried stream runs below Dowgate Hill Street and Cousin Lane, right in front of the LIFFE building. A wall of cement and breeze blocks was built before the entrance to the exchange, while a fire hydrant was opened out in the street, projecting a spout of water thirty feet into the air and symbolically releasing the buried river from the historical sedimentations of capital. The protestors danced beneath the torrent. In a historical center of bourgeois discipline, inhibitions became very hard to find. This was a political *party:* a riotous event, in the Dionysian sense of the word.

The quality of such urban uprisings is spontaneous, unpredictable, because everything depends on the cooperative expression of a multitude of groups and individuals. Still these events can be nourished, charged in advance with logical and imaginary resources. The six months preceding J18 overflowed with an infinitely careful and chaotic process of face-to-face meetings, grapevine communication, cut-and-paste production, and early activist adventures in electronic networking. An information booklet on the global operations of the City was prepared, under the name "Squaring Up to the Square Mile." It included a map distinguishing ten different categories of financial institutions. Posters, stickers, tracts, and articles were distributed locally and internationally, including 50,000 metallic gold flyers with a quote from the Situationist Raoul Vaneigem saying "to work for delight and authentic festivity is barely distinguishable from preparing for general insurrection." A spoof newspaper was handed out massively on the day of the protest, for free, under the title *Evading Standards*; the cover showed a dazed trader amid piles of shredded paper, with a headline reading "global market meltdown." But most importantly, a call had been sent round the world, urging people to intervene in their local financial centers on June 18, the opening day of the G8 (Group of Eight, leading economic nations) summit held that year in Cologne. A movie trailer had even been spliced together, with footage from previous worldwide protests and a cavernous, horror-flick voice at the end pronouncing "June 18th; Coming to a financial center near you."

This event was imbued with the history of the British social movement Reclaim the Streets, along with other activist groups such as Earth First!, Class War, and London Greenpeace (a local ecoanarchist organization). RTS is a "dis-organization." It emerged from the antiroads movement of the early 1990s, fighting against the freeway programs of the Thatcherite government. The protestors used direct action techniques, tunneling under construction sites, locking themselves to machinery. It was body art with a vengeance. References to earlier struggles emerged from this direct experience, including a 1973 text by the radical French philosopher André Gorz denouncing "The Social Ideology of the Motorcar."[8] The year 1994 was a turning point for this movement, in more ways than one. It saw a summer-long campaign against the M11 highway link, which involved squatting the condemned residential district of Claremont Road and literally inhabiting the streets, building scaffolding, aerial netting, and rooftop outposts to prolong the final resistance against the wrecking balls

and the police. But it was also the year of the Criminal Justice Act and Public Order Act of 1994 (UK), which gave British authorities severe repressive powers against techno parties in the open countryside, and politicized young music-lovers by force. After that, the ravers and the antiroads protestors decided they would no longer wait for the state to take the initiative. They would reclaim the streets in London, and party at the heart of the motorcar's dominion.

The first RTS party was held in the spring of 1995 in Camden Town, where hundreds of protestors surged out of a tube station at the moment of a staged fight between two colliding motorists. Techniques were then invented to make "tripods" out of common metal scaffolding poles: traffic could be easily blocked by a single protestor perched above the street whom police could not bring down without risk of serious injury. News of the inventions spread contagiously around Britain, and a new form of popular protest was born, along with a politicized performance culture. Later protests saw the occupation of a stretch of highway, or a street party where sand was spread out atop the tarmac for the children to play in, reversing the famous slogan of May 1968 in France, *sous les pavés, la plage* (beneath the paving-stones, the beach). Ideas about the political potential of the carnival, influenced by the literary critic Mikhail Bahktin, began to percolate among a generation of new-style revolutionaries. From these beginnings, it was just another leap of the imagination to the concept of the global street party—first realized in 1998 in some thirty countries, within the wider context of the "global days of action" against neoliberalism.

London RTS was part of the People's Global Action (PGA), a grassroots counterglobalization network that first emerged in 1997. Behind it lay the poetic politics of the Zapatistas, and the charismatic figure of Subcomandante Marcos. But ahead of it lay the invention of a truly worldwide social movement, cutting across the global division of labor and piercing the opaque screens of the corporate media. For the day of global action on June 18, videomakers collaborated with an early autonomous media lab called Backspace, right across the Thames from the LIFFE building. Tapes were delivered to the space during the event, roughly edited for streaming on the Web, then sent directly away through the post to avoid any possible seizure.[9] Perhaps more importantly, a group of hackers in Sydney, Australia, had written a special piece of software for live updating of the Web page devoted to their local J18 event. Six months later, this "Active software" would be used in the American city of Seattle as the foundation of the Independent Media project—a multiperspectival instrument of political information and dialogue for the twenty-first century.[10]

As later in Seattle, clashes occurred with the police. While the crowd retreated down Thames Street toward Trafalgar Square, a threatening plume of smoke rose above St. Paul's cathedral, as if to say this carnival really meant to turn the world upside-down. The next day the *Financial Times* bore the headline: "Anti-capitalists lay siege to the City of London." The words marked a rupture in the triumphant language of the press in the 1990s, which had eliminated the very notion of anticapitalism from its vocabulary. But the real media event unfolded on the Internet. The RTS Web site showed a Mercator map, with links reporting actions in forty-four different countries and regions. The concept of the global street party had been fulfilled, at previously unknown levels of political analysis and tactical sophistication. A new cartography of ethical-aesthetic practice had been invented, embodied, and expressed across the earth.[11]

Circuits of production and distribution

J18 was clearly not an artwork. It was an event, a collectively constructed situation. It opened up a territory of experience for its participants—a "temporary autonomous zone," in the words of the anarchist writer Hakim Bey.[12] With respect to the virtual worlds of art and

literature, but also of political theory, such events can be conceived as *actualizations:* what they offer is a space-time for the effectuation of latent possibilities. This is their message: "another world is possible," to quote the slogan of the World Social Forum movement. But what must also be understood is how these discontinuous political mobilizations have helped to make another world possible for art, outside the constituted circuits of production and distribution.

The simplest point of entry is the Internet. E-mail lists and websites have opened up a new kind of transnational public sphere, where artistic activities can be discussed as part of a larger, freewheeling conversation on the evolution of society. Some of the early players in this game were the New-York based website and server called The Thing, the Public Netbase media center in Vienna, and the Ljudmila server in Ljubljana. From the mid-1990s onward, these platforms were all involved with the development of "net art," which could be produced, distributed, and evaluated outside the gallery-magazine-museum system. The do-it-yourself utopia of a radically democratic mail art, which had been evolving in many temporalities and directions since the 1960s, suddenly multiplied, transformed, proliferated. In 1995 the transnational Listserv Nettime was constituted, in order to produce an "immanent critique" of networked culture.[13] Such projects could appear as intangible and ephemeral as the "temporary autonomous zones." But they helped give intellectual consistency and a heightened sense of transnational agency to the renewed encounter of artistic practice and political activism that was then emerging under the name of "tactical media."

The concept of tactical media was worked out at the Next 5 Minutes (n5m) conferences, which have taken place in Amsterdam since 1993, at three-year intervals.[14] David Garcia and Geert Lovink summed it up in 1997: "Tactical Media are what happens when the cheap 'do it yourself' media, made possible by the revolution in consumer electronics and expanded forms of distribution (from public access cable to the internet) are exploited by groups and individuals who feel aggrieved by or excluded from the wider culture."[15] The key notion came from Michel de Certeau, who, in Garcia and Lovink's reading, "described consumption as a set of tactics by which the weak make use of the strong."[16] At stake was the possibility of autonomous image and information production from marginal or minority positions, in an era dominated by huge, capital-intensive media corporations and tightly regulated distribution networks. But de Certeau spoke primarily of premodern cultures, whose intimate, unrecorded "ways of doing" could appear as an escape route from hyperrationalized capitalism; whereas the media tactics in question are those of knowledge workers in the post-industrial economy, much closer to what Toni Negri and his fellow travelers would call the "multitudes."[17] With their DVcams, websites, and streaming media techniques, the new activists practiced "an aesthetic of poaching, tricking, reading, speaking, strolling, shopping, desiring . . . the hunter's cunning, maneuvers, polymorphic situations, joyful discoveries, poetic as well as warlike."[18] This was very much the spirit of n5m3, in the spring of 1999, just as the counterglobalization movement was about to break into full public view.

The confidence of tactical media activism represents a turnabout from the extreme media pessimism of Guy Debord, whose work describes the colonization of all social relations, and indeed of the human mind itself, by the productions of the advertising industry. Antonio Negri's theory of the "real subsumption" of labor by capital, or in other words, the total penetration of everyday life by the logic and processes of capital accumulation, appears at first to echo that pessimism, but in fact, it marks a reversal. *Empire* develops the theory of the real subsumption through a reflection on Michel Foucault's concept of biopower, defined as "a form of power that regulates social life from its interior, following it, interpreting it, absorbing it, and rearticulating it."[19] Biopower is "an integral, vital function that every individual embraces and reactivates of his or her own accord." But this internalization of the control function has the effect of offering the master's tools to all the social subjects, and thus it makes possible the transformation of biopower into *biopolitics:*

Civil society is absorbed in the [capitalism] state, but the consequence of this is an explosion of the elements that were previously coordinated and mediated in civil society. Resistances are no longer marginal but active in the center of a society that opens up in networks; the individual points are singularized in a thousand plateaus. What Foucault constructed implicitly (and Deleuze and Guattari made explicit) is therefore the paradox of a power that, while it unifies and envelops within itself every element of social life (thus losing its capacity effectively to mediate different social forces), at that very moment reveals a new context, a new milieu of maximum plurality and uncontainable singularization—a milieu of the event.

Faced with the conditions of real subsumption, or total physical and psychic colonization by the directive functions of capital, one of the paradoxical temptations for artists is to use the cooperative field of the event to directly represent the globalized state—to show its true face, or to become its distorted mirror. This is what the Yes Men have done, by launching a satirical mirror-site—gatt.org—as a way to pass themselves off as representatives of the World Trade Organization (WTO).[20] Appearing before a lawyer's conference in Austria, on a British TV news show, at a textile industry convention in Finland, or at an accountant's congress in Australia, always at the invitation of unsuspecting functionaries, the Yes Men reverse the usual activist's position of "speaking truth to power." They speak the truth *of* power, by complying with it, assenting to it, overidentifying with it, exaggerating and amplifying its basic tenets, so as to reveal the contradictions, the gross injustices. And in this way, they bring the critical distance of art into the closest possible contact with political life. By miming corporate codes with precise and sophisticated writing, and by infiltrating the virtual and real locations of transnational institutions, they carry out what Fredric Jameson called for long ago: the "cognitive mapping" of "the great global multinational and decentered communicational network in which we find ourselves caught as individual subjects."[21] So doing, they act like a miniaturized version of the counterglobalization movements themselves, whose participants have restlessly "mapped out" the shifting geography of transnational power with their feet. But the Yes Men are very much part of those movements; they are immersed in the world of punctual collaboration and deviant appropriation of professional skills for the creation of the political event. The collaborative process is clearly symbolized by the project-table drawn up by their earlier avatar, ®™ark, which lists interventionist ideas and the material and human resources needed to carry them out; teaders are invited to contribute time, money, equipment, or information, or to propose a project of their own.[22]

Bureau d'Etudes is another artists' group that has followed the mapping impulse to the point of producing a full-fledged representation of tremendously complex transnational power structures, which they call "World Government."[23] They carry out "open-source intelligence," where the information is freely available for anyone willing to do the research. The artistic aspect of their project lies in the graphic design, the iconic invention, but also in the experimental audacity of the hypotheses they develop, which try to show the impact of farflung decision-making hierarchies on bare life. Like the Yes Men, they engage in multiple collaborations, exchanging knowledge, participating in campaigns, distributing their work for free, either in the form of paper copies or over the Internet. And like many contemporary artist-activists, they are extremely dubious about the kind of distribution offered by museums; they only appear to consider their own production significant when it becomes part of alternative social assemblages, or more precisely, of "resymbolizing machines." One of their goals is to create a "map generator," which would be "a machine allowing everyone to generate the maps they need for their actions, by entering data concerning the business or administration in which they work, or about which they have found some information."[24] There is a double

aim here: to identify the spatial organization and ownership hierarchy of the long, fragmented production lines of the global economy, and at the same time, to suggest the possibility of alternative formations that could articulate different publics. As they explain:

> A production line is heterogeneous and multilinguistic from the very outset. It has no border, even though it has relative limits. It constitutes a republic of individuals, in other words, a non-territorial republic, which emerges in the face of the increasingly real perspective—confirmed by the gradual application of the WTO's General Agreement on Trade in Services (GATS)—of a privatization of those functions which still remain the monopoly of the State (justice, education, territory, police, army).

The virtual freedom of net-based distribution, the concrete experience of temporary autonomous zones, and the analytic project of critical mapping all come together in this reflection on the circuits of production and distribution. The problem that emerges from an artistic engagement with geopolitics is no longer just that of "naming the enemy," or locating the hierarchies of global power. It is also that of revealing the political potential of world society, the potential to change the reigning hierarchies:

> If we think of a production line as a republic, then each object becomes a flag, a global sociopolitical assemblage: in other words, a symbol. But this symbol needs

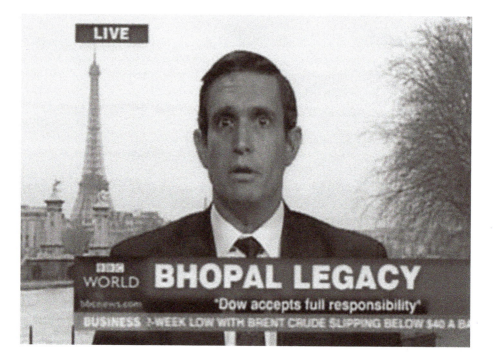

Figure 23.2 The BBC interviewed a member of the Yes Men who was impersonating an executive of the Dow Chemical Corporation on the twentieth anniversary of the Bhopal tragedy in India, December 3, 2004. Dow had assumed Union Carbide's assets but rejected responsibility for the disaster and has made minimal efforts to compensate the thousands of victims. The ersatz executive informed a stunned BBC reporter that Dow was now ready to compensate victims even if this meant liquidating the entire company. Later Dow publicly rejected any such offer. The Yes Men, http://www.theyesmen.org. Reproduced with permission.

to be resymbolized, its meaning must be extracted, the relations of production must become visible. Only then would the most ordinary supermarket catalogue appear for what it really is: a world social atlas, an atlas of possible struggles and paths of exodus, a machine of planetary political recomposition.

For artists, the resymbolization of everyday life appears as the highest constructive ambition. But what does it entail? What kind of work would it take to help transform society's gaze on the relations of production?

Collective interventions

The construction of global brands in the 1980s and 1990s entailed the integration of counter-cultural and minority rhetorics, as well as the direct enlistment into the workplace of "creatives" from all the domains of art and culture, a process denounced by North American critics like Thomas Frank or Naomi Klein.[25] A more sophisticated theoretical approach, emerging from the Italian theorists of Autonomia, has recently shown how corporations build "worlds" not only for their consumers, but also for their employees—that is to say, imaginary systems of reference, both ethical and aesthetic, as well as architectural environments, communications nets, security systems, etc., all aimed at maintaining the coherency of the firm and its products under conditions of extreme geographic dispersal.[26] The imposition of these worlds as a set of competing frames for everyday life requires a cultural and psychic violence that can lead to different forms of rejection: in this sense, the trashing of Niketowns and McDonalds by anticorporate protestors or the "Stop-pub" movement that defaced hundreds of advertisements in the Paris metro in 2003 are direct, popular expressions of the critical stance taken in a book like No Logo. Echoing these destructive acts, many of today's media artists seek symbolic disruption or "culture jamming:" détournement as a formalist genre, Photoshop's revenge on advertising.[27] But a deeper question is how to initiate psychic deconditioning and dis identification from the corporate worlds—contemporary equivalents of the Dadaist drive to subvert the repressive structures of the bourgeois ego.

The constellation of artists' groups and subversive social movements operating in the city of Barcelona has taken some audacious steps in this direction.[28] The galvanizing effect of the Prague protests against the IMF and the World Bank on September 26, 2000 (the first big European convergence after Seattle), was particularly strong among these circles, which constantly evolve in a net-like or rhizomatic structure, making any attempt to identify them ultimately fruitless—and that's part of the idea. An early collective known as Las Agencias, working with another group called Oficina 2004, launched a subversive tease campaign in the streets, announcing Dinero (money), then completing a week later Dinero Gratis (money for free). The idea, it seems, was to short-circuit the advertising promise of instant gratification and to subvert the demands and deferrals of labor, while at the same time pointing toward a Utopian economy of free time and creative possibility. Other projects went on to bring pop fashion to the protest campaigns, introducing the Prêt-à-révolter line of defensive clothing, offering all kinds of accessorized option-slots for the latest in tactical media gear, then the New Kids on the Black Block poster campaign, which made ridicule out of the heavily moralized discussion of violence or nonviolence that followed the protests against the G8 in Genoa, Italy, in July 2001. The Yomango project—which has spread to become an international network—associates an omnipresent fashion brand, Mango™, with a Spanish slang expression meaning "I shoplift" (the British translation is "Just nick it"). Performances involved stealing clothing items and putting them on display in museums; and these evolved, in a very interesting way, to the practice of "Yo Mango dinners," where participants used specially outfitted clothing to

lift generous collective meals from participating supermarket chains. The aggressivity toward any kind of integration to corporate-backed cultural institutions is obvious.

Another ephemeral collective, known as "Mapas," took aim at the 2004 "Universal Forum of Cultures" in Barcelona, a corporate-sponsored municipal extravaganza of debate and multicultural entertainment, widely perceived by locals as a manipulation of the Social Forum movement for the ends of political consensus-building, real-estate speculation, and boosterism of the tourist economy.[29] For this campaign a map of the city was made, showing the sponsorship links between the Forum and temporary employment services, consumer-product distributors, arms dealers, polluting industries, etc. The idea was to produce a menacing atmosphere, then bifurcate in unexpected directions. An action was undertaken against the weapons manufacturer Indra: several dozen white-suited "arms inspectors" surged up the stairway of the firm's Barcelona office and began disassembling the communications equipment, which was placed into boxes marked "Danger: Weapons of Mass Destruction." Even more effectively, a photographic *Forumaton* was set up in various locations, allowing grinning residents to "pose against the Forum," with signs that said "The Forum is a business," "The Forum is for real-estate speculation," "The Forum is a piece of shit," and so on. A crescendo was hit with *Pateras Urbanas,* a sea-going invasion of the Forum on precarious rafts like those used by immigrants crossing the Straits of Gibraltar. Hundreds of participants, outlandish costumes and pirate flags, four hours in the ocean with the Coast Guard every-where, and a wild landing on the grounds of the tourist spectacle that wanted to turn its back on anything real. The action was all over the Catalan newspapers, and the deflation of the "Barcelona logo" provoked resounding peals of laughter from the people that have to live in it.

Could this kind of subversion go further, deeper, involving broader sections of the population and producing positive effects of resymbohzation and political recomposition? The Chainworkers collective in Milan thought so.[30] Acting as labor organizers without any particular artistic pretensions, they sought to build an iconic language that could reach out simultaneously to kids doing service jobs in chain-stores, temp workers, and freelance intel-lectual laborers, the so-called cognitariat, who are sometimes better paid but face similarly precarious conditions. They did illegal demonstrations and banner-drops inside shopping malls where all rights to assembly in public are curtailed. Their website, www.chainworkers. org, was conceived as a legal information resource and a way to create collective conscious-ness. But their best tactic proved to be a reinvention of the traditional Mayday parade, around the theme of casual labor conditions. The event quickly outstripped anything the unions could muster; by the third year, in 2004, it brought together fifty thousand people in Milan and had also spread to Barcelona. What you see in the streets at these events is a new kind of mapping, not just of power but of subjective and collective agency, which means affects, ideas, life energy. It is a popular, militant cartography of living conditions in the postmodern information economy, created by the people who produce that economy on a day-to-day basis. This cartography is conveyed in living images: dancers in pink feather boas disrupting the fashion trade in a Zara store; African workers wearing bright white masks that say "invis-ible" on them; a giant puppet representing different kinds of burnout temp jobs (call-center slaves, pizza ponies, day-labor construction workers). A huge green banner drapes the side of a truck hauling a sound-system through the crowd: "the metropolis is a beast: cultivate micropolitics for resistance." One of the posters for the event shows a contortionist from an old-fashioned circus—an allegory of the flexible worker in the spectacle society.

The Mayday parades are an assertion of biopolitics, against all the sophisticated methods currently employed for physical and psychic control. They develop an aesthetic language of the event for its own sake, as a territory of expression. But the same event formulates a political demand for the basic guarantees that could make a flexible working existence viable: an unpolluted urban environment; socialized health care and lodging; high-quality public

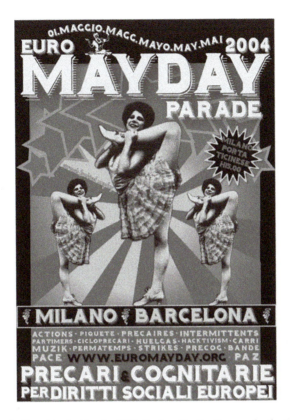

Figure 23.3 Poster for Euro Mayday Parade, 2004. Designed by Zoe Romano for the Chainworkers collective. Used under the Creative Commons License. Reproduced with permission.

education; access to the tools of information production, but also to the spaces and free time necessary for social and affective production, or what theorists call the production of subjectivity.[31] This last is vital for psychic health, because otherwise one will fall prey to all the consumer and professional worlds that are explicitly designed to vampirize the isolated individual and feed on his or her desire. In this sense, the political struggle is directly artistic; it is a struggle for the aesthetics of everyday life. The pressure of hyperindividualism, or what I have called "the flexible personality,"[32] is undoubtedly what has given rise to the widespread desire to construct collective situations, beyond what was traditionally known as the art world. The indeterminacy of the results, the impossibility of knowing whether we are dealing with artists or activists, with aesthetic experimentation or political organizing, is part of what is being sought in these activities.

Futures

Innumerable artist-activist collectives could have been described here, along with other social movements, local and national contexts, inventions, and consensus-breaking events; but I preferred to stick as closely as possible to personal experience. What matters, at the end of the last century and the beginning of this one, is the slow emergence of an experiential territory, where artistic practices that have gained autonomy from the gallery-magazine-museum system and from the advertising industry can be directly connected to attempts at social transformation. The urgency, today, is to reinforce that territory with both words and

Figure 23.4 Steven Kurtz of the Critical Art Ensemble at the *Free Range Grains* installation, 2004. Kurtz and his group were under investigation at the time of writing by the FBI and State Attorney General for alleged bioterrorism. Photograph courtesy of Steve Barnes, Critical Art Ensemble.

acts, and to use it for further constructive projects and experiments in subversion. The appropriation of expressive tools from the information economy—from the schools, the training programs, the workplace, and the practices of consumption—opens up an enormous field of possibility, where artists, alongside other social groups, can regain the use of political freedom.

A few questions, to close. Can the tactics of the early counter-globalization movements be thoroughly discredited and repressed by the abusive equation of direct-action practices and terrorism? This has been attempted, in both the United States and Europe; but the repression itself has made the fundamentally political nature of the informational economy crystal clear; and the outcome may still depend on the ability to combine the communicative value of humor, invention, and surprise with the force of ethical conviction that comes from putting one's body on the line. Can the Internet be normalized, to become a consumer marketplace and a medium of passive reception or carefully channeled "interactivity"? It's an important public space to protect, through unbridled use and free exchange as well as better legislation; and the chances for entirely muzzling it, and thereby totally voiding the First Amendment and similar constitutional rights to free expression, look relatively slim. Do events like the Mayday parades, with their focus on urban living and working conditions, represent a fallback from the early ambitions of the counterglobalization protests—a retreat from the utopias of do-it-yourself geopolitics? The fundamental issue seems to be finding concrete political demands that don't block the transversal movement of struggles across an unevenly developed world. The work of cartography, on both the spatial and subjective levels, may contribute to a continuing extension of the new experiential territories, in search of a deeper and broader process of resymbolization and political recomposition, able to link

the scattered actors and construct the situations of social change. It's hard to think there could be any other meaning to the word "collectivism."

Notes

1 From a cover of the early punk fanzine *Sniffin' Glue* (1976–77), reissued in the anthology edited by Mark Perry, *Sniffin' Glue: The Essential Punk Accessory* (London: Sanctuary Publishing, 2000).

2 From "Definitions," by the Situationist International (1958), available online at Ken Knabb's excellent *Bureau of Public Secrets* website: http://www.bopsecrets.org/SI/1.definitions.htm; translation slightly modified.

3 See Greil Marcus, *Lipstick Traces: A Secret History of the Twentieth Century* (Cambridge, Mass.: Harvard University Press, 1990).

4 On punk appropriation politics, see Dan Graham, "Punk as Propaganda," in *Rock My Religion* (Cambridge, Mass.: MIT Press, 1993), 96–113.

5 For the Art Strike and Plagiarist movements, see the books and sites by Stewart Home, particularly *Neoism, Plagiarism & Praxis* (Edinburgh: AK Press, 1995) and *Mind Invaders* (London: Serpent's Tail, 1997). For the Luther Blissett Project, see http://www.lutherblissett.net, or a collectively written novel like *Q* (Arrow, 2004).

6 What's written here is mainly based on participation, retrospective conversations (especially with John Jordan), the websites of Reclaim the Streets (http://rts.gn.apc.org) and People's Global Action (http://www.agp.org), photos by Alan Lodge at http://tash.gn.apc.org, and a superb text entitled "Friday June 18th 1999" in the ecoanarchist journal *Do or Die,* no. 8 (1999), online at http://www.eco-action.org/dod/no8/index.html.

7 The full mask text can be found in the *Do or Die* text cited above; the last two sentences reproduced here are in fact from the famous "First Declaration of La Realidad" by Subcomandante Marcos, online at http://www.eco.utexas.edu/Homepages/Faculty/Cleaver/firstrealidad.html.

8 André Gorz, "The Social Ideology of the Motorcar," can be found on the RTS Web site, at http://rts.gn.apc.org/socid.htm.

9 At least one video, *J18, First Global Protest against Capitalism*, is distributed at http://www.culture-shop.org.

10 See active.org.au and the diagram where one of the programmers sketched a chain of cooperation in the invention and use of the software, online at http://www.active.org.au/doc/roots.pdf.

11 For a record of the direct-action side of the counterglobalization movement, see the illustrated book *We Are Everywhere* (London: Verso, 2003).

12 See Hakim Bey, *T.A.Z. The Temporary Autonomous Zone, Ontological Anarchy, Poetic Terrorism* (New York: Autonomedia Anticopyright, 1985, 1991), online at http://www.hermetic.com/bey/taz_cont.html.

13 See the Nettime Mailing Lists at http://www.nettime.org and the book *ReadMe: Ascii Culture and the Revenge of Knowledge* (New York: Autonomedia, 1999).

14 See the Next 5 Minutes website at http://www.next5minutes.org.

15 David Garcia and Geert Lovink, "The ABC of Tactical Media," quoted from http://thing.desk.nl/bilwet/Geert/ABC.txt.

16 See Michel de Certeau, *The Practice of Everyday Life* (Berkeley and Los Angeles: University of California Press, 1988).

17 See Antonio Negri and Michael Hardt, *Multitude* (New York: Penguin, 2004); Paolo Virno, *Grammar of the Multitude* (New York: Semiotexte, 2004).

18 Garcia and Lovink, "ABC of Tactical Media."

19 This and the following two quotes are from Michael Hardt and Antonio Negri, *Empire* (Cambridge: Harvard University Press, 2000), 23–25, online at http://www.angelfire.com/cantina/negri.

20 Sources for all the material in this paragraph can be accessed at the ®™ark website, http://www.rtmark.com.

21 Fredric Jameson, "Postmodernism, Or, The Cultural Logic of Late Capitalism," *New Left Review* 146 (July–August 1984).

22 See http://rtmark.com/new.html.

23 Bureau d'Etudes produces multiples, including the map "World Government" in English (2000). Extensive documentation can be found at http://utangente.free.fr/index2.html.

24 This and the following two quotes are from Bureau d'Etudes, "Resymbolizing Machines: Art after Oyvfnd Fähistrom," *Third Text* 18 (June 2004): 609–16.

25 Thomas Frank, Matt Weiland, et al., *Commodify Your Dissent* (New York: Norton, 1997); Naomi Klein, *No Logo* (New York: Picador, 2000).

26 See Maurizio Lazzarato, *Les révolutions du capitalisme* (Paris: Les empêcheurs de penser en rond, 2004). English excerpt at http://www.republicart.net/disc/representations/lazzarat001_en.htm.

27 See the Adbusters website at http://www.adbusters.org and Mark Dehry "Culture Jamming: Hacking, Slashing and Sniping in the Empire of Signs," online at *The Pyrotechnic Insanitarium*, http://www.levity.com/markdery/culturjam.html.

28 Sources: Las Agencias, http://www.lasagencias.org; Dinero Gratis, http://www.eldinerogratis.com; Oficina 2004, http://www.sindominio.net/ofic2004; Yomango, http://www.yomango.net; and friends in Barcelona.

29 Sources: http://www.forumbcn2004.org, http://www.sindominto.net/mapas, http://www.moviments.net/-resistencies2004, http://www.paterasurbanas.net. The Mapas group included members from Conservas, Rotorr, Asamblea de Insumisos, Boicot preventiu, Espai en blanc, Infoespai, Miles de Viviendas, and others, all of whom came together through the Assemblea de Resistències al Fòrum 2004, with about seventy different collectives.

30 Sources: http://www.chainworkers.org and the video by Marcelo Expósito, "first of may (the city-factory)"/"primero de mayo (la ciudad-fábrica)," 61 min, 2004; not yet distributed.

31 See Felix Guattari, *Chaosmosis: An Ethico-Aesthetic Paradigm* (Bloomington: Indiana University Press, 1995), Chapter 1.

32 Brian Holmes, "The Flexible Personality: For a New Cultural Critique," in *Hieroglyphs of the Future* (Zagreb: WHW/Arkzin, 2003), available online at http://www.geocities.com/CognitiveCapitalism/holmes1.html.

Part 2 (b): Further reading

16 Beaver: website http://www.16beavergroup.org/

Beller, Jonathan L. *The Cinematic Mode of Production*. Hanover, NH: New England UP, 2005.

Crary, Jonathan. *Suspensions of Perception: Attention, Spectacle and Modern Culture*. Cambridge, MA: MIT Press, 2001.

Fisher, Mark *Capitalist Realism: Is there no Alternative?* (Winchester: Zero Books). Blog: http://k-punk.abstractdynamics.org/

Hardt, Michael and Toni Negri. *Commonwealth*. Cambridge, MA: Harvard UP, 2009.

Harvey, David. *The Enigma of Capital and the Crises of Capitalism*. New York: Oxford University Press. 2nd ed. 2010.

Holmes, Brian. *Unleashing the Collective Phantoms: Essays in Reverse Imagineering*. New York: Autonomedia, 2008. Website: "Continental Drift." http://brianholmes.wordpress.com/

Huyssen, Andreas ed. *Other Cities, Other Worlds: Urban Imaginaries in a Globalizing Age*. Durham, NC: Duke UP, 2008.

Ross, Andrew *Nice Work If You Can Get It: Life and Labor in Precarious Times*. New York: NYU Press, 2010.

Virno, Paolo. *Grammar of the Multitude*, New York: Semiotext(e), 2004.

PART 3

The body, coloniality and visuality

THE TECHNIQUE OF VISUALITY was formed on plantations and in colonial regimes as a means to control the colonized and enslaved body. Representing the body in and as history is, then, a key topic for critical visuality studies, especially in relation to colonial and imperial practice. A host of questions arise from these propositions: how is visualization related to power? How can the self and the other be represented? What is the place of the divine and the sacred? How do nations represent themselves and why do their subjects accept these images? How is a body understood in terms of color and how does that optical question become racialized? How is racialization used as a form of power? And so on. Without being programmatic—and it is obviously important to stress that these pieces were not written in any way to answer these questions—the chapters in the next three sections create some frameworks with which we can think these important questions.

(a) Bodies and minds

In a great deal of current scholarship and public writings, one means of distinguishing the often-evoked "West" from its others is a related set of concepts derived from the work of seventeenth-century French philosopher René Descartes. These center on the distinction between the mind and the body, often known as the Cartesian self, in which the questioning and skeptical mind interprets and judges sense impressions it receives from the body. A variant of this overall distinction is Cartesian perspective, the idea that perspective is a rational demonstration of the means by which space can be demonstrated to be isotopic, rectilinear and geometric, independently of the observer. Finally, this skeptical mode of observation is held to be the foundation of observational science, which proceeds by means of experiment and holds it to be crucial that such experiments can be repeated and falsified. Descartes's method challenged the then-prevailing Scholasticism, in which evidence was judged in the light of existing texts, such as the philosophy of Aristotle. We can still see such modes of thought today, often in religious criticisms of science as being contrary to a religious text. This extract from Descartes is, then, not a historical curiosity but a foundational text for modern definitions of space, observation and science. He sets out to give explanations for the processes of sight,

based on observation. He disposed of the long-standing idea of "intentional forms," meaning little copies of objects that travelled into the eye. By considering sight as a mechanical, physical process, rather than as a divine revelation, Descartes was able to explain the process of refraction in liquids and to provide a mathematical means to calculate it. Ironically, despite the formulas about Cartesian perspective, Descartes himself used perspective as an example of the distinction between mind and body. For a perspective drawing represents a circle as an oval but the mind judges it to be a circle, demonstrating that "in order to be more perfect as an image and to represent an object better, an engraving ought not to resemble it."

The central metaphor in Descartes's account is that of a blind man, who is able to negotiate his way around with the use of sticks, proving to Descartes that sight is a material, physical process. For many since, it has been cited as evidence of the tactility of vision. Responding to W. J. T. Mitchell's thought that "visual culture entails a meditation on blindness," Georgina Kleege critiques this figure that she renames the Hypothetical Blind Man. Herself blind, Kleege demolishes the preconceptions of the sighted built into the Hypothetical (for short). She points out that "a stick or cane is a poor tool for . . . mental imaging." The user relies more on sound than touch and indeed, even in the illustration to Descartes's text, the Hypothetical has a guide dog. Kleege takes Diderot similarly to task and turns instead to actual accounts of blindness by the blind, which have been rediscovered in the past decade by the new field of Disability Studies. Kleege's scholarship works from the fundamental premise of Disability Studies: "nothing about us without us." Her piece concludes with an insight into how far such a project still has to go. As she remarks, despite the premise that the Hypothetical is profoundly blind from birth, in practice as few as 10–20 per cent of people designated legally blind (where the category exists) meet this description. Despite a reduced incidence in blindness due to infectious diseases, "in the past, as now, the leading causes of blindness occur later in life, and often leave some residual vision." However, this did not prevent the philosopher Arthur Danto from declaring in print that Kleege has too much sight to be blind. So what Kleege asks from visual culture is less a reflection on blindness than "an interrogation of the binary opposition between blindness and sight." Just as there is a "distribution of the sensible," to use Rancière's phrase, in general relations between senses, so is there what Kleege calls "a spectrum of variation in visual acuity." While many visual culture scholars and practitioners may have 20/20 vision courtesy of their corrective lenses, few can aspire to the 20/13 attained by top sports players: and what difference would it make if we could?

For the key insight of critical visuality studies has not been to hail the dominance of vision but to critique it. In the extract from her classic book *Simians, Cyborgs and Women*, science studies scholar and activist Donna Haraway mused on what she calls this "persistence of vision." Contrasting the "conquering gaze from nowhere" presumed by observational science with the realities of the "embodied nature of all vision," Haraway argues that, while vision is never found in the pure state presumed by Cartesian geometry, nor is everything simply relative. Replacing the disembodied view from above with the individual view from a particular place, she emphasizes that "optics is a politics of positioning . . . Struggles over what will count as rational studies of the world are studies over *how* to see." Haraway thus follows Descartes in recognizing that visuality is central to what will be accepted as rational method. She goes beyond him in understanding that visuality is always a discourse of power and positioning, with the consequence that any such visualizing must be partial in both senses of the term.

The following pieces develop and explore this insight in different contexts and historical moments. In her study of the photographs taken by the British aristocrat Lady Clementina Hawarden of her daughters in Victorian London, art historian Carol Mavor challenges the presumed disembodied nature of photography. Rather, she finds in it a certain feminine quality, arguing against Walter Benjamin that "the female body infinitely reproduces itself, like a

photograph." In contrast to the emphasis on the photograph as the product of machines, Mavor demonstrates that Hawarden was centrally concerned with the reduplication of the image in terms of subject matter, form and medium alike. While this approach allows for a certain female fetishism, its primary intent is to think anew about relations of photography and gender. In reading one photograph of the young Clementina and her sister Isabella taken by their mother, Mavor provocatively writes: "Clementina is becoming: she is coming into the sexuality and changing body of Isabella; she is coming into her own sexuality; and she is very becoming." Reclaiming the Nietzschean term "becoming" for women, Mavor's writing is at once sexy and transgressive, breaking academic convention by admitting its own investment. It challenges us to rethink the libidinal economy of the family, so central to all post-Freudian theories of the gaze, and yet so rarely challenged in this way. It is not a question of (unknowable) actual sexual activity by these or other women but the patterning of feminine and female desire, which, in its dominant Freudian variant, has failed to account for its reduplicative nature.

In related vein, the art historian Amelia Jones, editor of the companion volume in this series *Feminism and Visual Culture*, asks: "Who sees? Who is a picture?" Noting that all imaging in post-Renaissance Euro-American culture has been perceived as the "manifestation of a human subject," Jones examines "the complex interconnectedness of visual representation and concepts of the self." She accomplishes this across a remarkable range of materials from Renaissance perspective to poststructuralist philosophy via Nietzsche and Heidegger. She suggests that "the body extends into and is understood as an image—but an image understood itself, reciprocally, as embodied." Her project centers on artists that explore this tension directly. Her first example is a video installation by the artist Pipilotti Rist called *Sip My Ocean* (1996). Literally and metaphorically immersive, this piece mixes images of the artist floating in a blue fluid, while singing a song. Jones offers us a technical psychoanalytic reading, building on her earlier analysis of Joan Copjec and Jacques Lacan and then she says: "If I could have Pipilotti Rist, if I could *be* Pipilotti Rist, I would be simultaneously completely free . . . and completely situated." Jones makes a surprising turn and compares this immersive experience to the Catholic doctrine of transsubstantiation, in which the communion wafer becomes the body of Christ (*hoc est corpus meum*, in the traditional Latin liturgy). Here the signifier achieves complete equivalence with the signified, a gesture she sees as being performed by Mel Gibson's controversial film *The Passion of the Christ* (2003), which claimed to represent the "true" Christ. In each case it is "never enough—the tendency of the body when rendered representationally through technologies of visual imaging to exceed oppositional models of signification." Following Lev Manovich, Jones allows for the possibility that digital and computer-aided media might work this relationship differently "without disavowing the inexorable gap that haunts the human relationship to the world of things."

As both cyberpunk novelists and syncretic religions would insist, there are those that live in this gap. Following the recent ground-breaking exhibition curated by Henry John Drewal, first at the Fowler Museum at UCLA and later at the National Museum for African Art in Washington DC, we can now understand the water divinity Mami Wata as a leading variant of this globalizing "media." As her name suggests, Mami Wata is a transculturation of African and Atlantic world water spirits with European ideas of the mermaid and the modern performance of difference. In a dazzling feat of intellectual detective work, Drewal has shown how the modern form of Mami Wata, now known worldwide, was derived from a circus performer from Samoa known as Maladamatjaute. She worked as a snake charmer in Hamburg in the 1880s, where she was photographed and depicted in a chromolithograph. This latter was then exported to India where it was reproduced and sent on to Africa. From this point, about 1900, the image of a snake charmer with light brown skin and long wavy hair has been a dominant variant of Mami Wata figures. Sometimes she is seen in association with the Hindu goddess Lakshmi.

Often her body is like that of a mermaid, with a form of fish tail from the waist down. Mami Wata is a powerful figure, described by Drewal as the "capitalist deity," demanding close attention from her followers. She pays great attention to her personal appearance to the point of vanity but, as alluring as she may be, she is cold and to be feared. Hers is the disjunctive body of immersion, a "tradition" reinvented as an Anglo-African-Asian embodiment of hope, fear and desire. She embodies a circulation that does not always circulate, but may fail or drown; a desire that cannot be reciprocated precisely because of her unique form; and a body that refuses the disciplinary codes of the "normal." As she crosses the line between life and death, Mami Wata defies the Western rationality that both mocks such imaginings and intensely wants them: *Harry Potter, The Pirates of the Caribbean, Twilight* to name just the most recent film franchises that play on such desires. Cinema is an appropriate medium for Mami Wata whose attribute is the mirror, not as reflection but as a boundary, a place of communication and of travel.

René Descartes

OPTICS

Discourse one: light

THE CONDUCT OF OUR LIFE depends entirely on our senses, and since sight is the noblest and most comprehensive of the senses, inventions which serve to increase its power are undoubtedly among the most useful there can be. And it is difficult to find any such inventions which do more to increase the power of sight than those wonderful telescopes which, though in use for only a short time, have already revealed a greater number of new stars and other new objects above the earth than we had seen there before. Carrying our vision much further than our forebears could normally extend their imagination, these telescopes seem to have opened the way for us to attain a knowledge of nature much greater and more perfect than they possessed . . . But inventions of any complexity do not reach their highest degree of perfection right away, and this one is still sufficiently problematical to give me cause to write about it. And since the construction of the things of which I shall speak must depend on the skill of craftsmen, who usually have little formal education, I shall try to make myself intelligible to everyone; and I shall try not to omit anything, or to assume anything that requires knowledge of other sciences. This is why I shall begin by explaining light and light-rays; then, having briefly described the parts of the eye, I shall give a detailed account of how vision comes about; and, after noting all the things which are capable of making vision more perfect, I shall show how they can be aided by the inventions which I shall describe.

Now since my only reason for speaking of light here is to explain how its rays enter into the eye, and how they may be deflected by the various bodies they encounter, I need not attempt to say what is its true nature. It will, I think, suffice if I use two or three comparisons in order to facilitate that conception of light which seems most suitable for explaining all those of its properties that we know through experience and for then deducing all the other properties that we cannot observe so easily. In this I am imitating the astronomers, whose suppositions are almost all false or uncertain, but who nevertheless draw many very true and certain consequences from them because they are related to various observations they have made.

No doubt you have had the experience of walking at night over rough ground without a light, and finding it necessary to use a stick in order to guide yourself. You may then have

been able to notice that by means of this stick you could feel the various objects situated around you, and that you could even tell whether they were trees or stones or sand or water or grass or mud or any other such thing. It is true that this kind of sensation is somewhat confused and obscure in those who do not have long practice with it. But consider it in those born blind, who have made use of it all their lives: with them, you will find, it is so perfect and so exact that one might almost say that they see with their hands, or that their stick is the organ of some sixth sense given to them in place of sight. In order to draw a comparison from this, I would have you consider the light in bodies we call "luminous" to be nothing other than a certain movement, or very rapid and lively action, which passes to our eyes through the medium of the air and other transparent bodies, just as the movement or resistance of the bodies encountered by a blind man passes to his hand by means of his stick. In the first place this will prevent you from finding it strange that this light can extend its rays instantaneously from the sun to us. For you know that the action by which we move one end of a stick must pass instantaneously to the other end, and that the action of light would have to pass from the heavens to the earth in the same way, even though the distance in this case is much greater than that between the ends of a stick. Nor will you find it strange that by means of this action we can see all sorts of colors. You may perhaps even be prepared to believe that in the bodies we call "colored" the colors are nothing other than the various ways in which the bodies receive light and reflect it against our eyes. You have only to consider that the differences a blind man notices between trees, rocks, water and similar things by means of his stick do not seem any less to him than the differences between red, yellow, green and all the other colors seem to us. And yet in all those bodies the differences are nothing other than the various ways of moving the stick or of resisting its movements. Hence you will have reason to conclude that there is no need to suppose that something material passes from objects to our eyes to make us see colors and light, or even that there is something in the objects which resembles the ideas or sensations that we have of them. In just the same way, when a blind man feels bodies, nothing has to issue from the bodies and pass along his stick to his hand; and the resistance or movement of the bodies, which is the sole cause of the sensations he has of them, is nothing like the ideas he forms of them. By this means, your mind will be delivered from all those little images flitting through the air, called "intentional forms,"[1] which so exercise the imagination of the philosophers. You will even find it easy to settle the current philosophical debate concerning the origin of the action which causes visual perception. For, just as our blind man can feel the bodies around him not only through the action of these bodies when they move against his stick, but also through the action of his hand when they do nothing but resist the stick, so we must acknowledge that the objects of sight can be perceived not only by means of the action in them which is directed towards our eyes, but also by the action in our eyes which is directed towards them. Nevertheless, because the latter action is nothing other than light, we must note that it is found only in the eyes of those creatures which can see in the dark, such as cats, whereas a man normally sees only through the action which comes from the objects. For experience shows us that these objects must be luminous or illuminated in order to be seen, and not that our eyes must be luminous or illuminated in order to see them. But because our blind man's stick differs greatly from the air and the other transparent bodies through the medium of which we see, I must make use of yet another comparison.

Consider a wine-vat at harvest time, full to the brim with half-pressed grapes, in the bottom of which we have made one or two holes through which the unfermented wine can flow. Now observe that, since there is no vacuum in nature (as nearly all philosophers acknowledge), and yet there are many pores in all the bodies we perceive around us (as experience can show quite clearly), it is necessary that these pores be filled with some very subtle and very fluid matter, which extends without interruption from the heavenly bodies to us.

Now, if you compare this subtle matter with the wine in the vat, and compare the less fluid or coarser parts of the air and the other transparent bodies with the bunches of grapes which are mixed in with the wine, you will readily understand the following. The parts of wine at one place tend to go down in a straight line through one hole at the very instant it is opened, and at the same time through the other hole, while the parts at other places also tend at the same time to go down through these two holes, without these actions being impeded by each other or by the resistance of the bunches of grapes in the vat. This happens even though the bunches support each other and so do not tend in the least to go down through the holes, as does the wine, and at the same time they can even be moved in many other ways by the bunches which press upon them. In the same way, all the parts of the subtle matter in contact with the side of the sun facing us tend in a straight line towards our eyes at the very instant they are opened, without these parts impeding each other, and even without their being impeded by the coarser parts of the transparent bodies which lie between them. This happens whether these bodies move in other ways—like the air which is almost always agitated by some wind—or are motionless—say, like glass or crystal. And note here that it is necessary to distinguish between the movement and the action or tendency to move. For we may very easily conceive that the parts of wine at one place should tend towards one hole and at the same time towards the other, even though they cannot actually move towards both holes at the same time, and that they should tend exactly in a straight line towards one and towards the other, even though they cannot move exactly in a straight line because of the bunches of grapes which are between them. In the same way, considering that the light of a luminous body must be regarded as being not so much its movement as its action, you must think of the rays of light as nothing other than the lines along which this action tends. Thus there is an infinity of such rays which come from all the points of a luminous body towards all the points of the bodies it illuminates, just as you can imagine an infinity of straight lines along which the actions coming from all the points of the surface of the wine tend towards one hole, and an infinity of others along which the actions coming from the same points tend also towards the other hole, without either impeding the other.

Moreover, these rays must always be imagined to be exactly straight when they pass through a single transparent body which is uniform throughout. But when they meet certain other bodies, they are liable to be deflected by them, or weakened, in the same way that the movement of a ball or stone thrown into the air is deflected by the bodies it encounters. For it is very easy to believe that the action or tendency to move (which, I have said, should be taken for light) must in this respect obey the same laws as the movement itself. In order that I may give a complete account of this third comparison, consider that a ball passing through the air may encounter bodies that are soft or hard or fluid. If the bodies are soft, they completely stop the ball and check its movement, as when it strikes linen sheets or sand or mud. But if they are hard, they send the ball in another direction without stopping it, and they do so in many different ways. For their surface may be quite even and smooth, or rough and uneven; if even, either flat or curved; if uneven, its unevenness may consist merely in its being composed of many variously curved parts, each quite smooth in itself, or also in its having many different angles or points, or some parts harder than others, or parts which are moving (their movements being varied in a thousand imaginable ways). And it must be noted that the ball, besides moving in the simple and ordinary way which takes it from one place to another, may move in yet a second way, turning on its axis, and that the speed of the latter movement may have many different relations with that of the former. Thus, when many balls coming from the same direction meet a body whose surface is completely smooth and even, they are reflected uniformly and in the same order, so that if this surface is completely flat they keep the same distance between them after having met it as they had beforehand; and if it is curved inward or outward they come towards each other or go away from each other in

the same order, more or less, on account of this curvature . . . It is necessary to consider, in the same manner, that there are bodies which break up the light-rays that meet them and take away all their force (namely bodies called "black," which have no color other than that of shadows); and there are others which cause the rays to be reflected, some in the same order as they receive them (namely bodies with highly polished surfaces, which can serve as mirrors, both flat and curved), and others in many directions in complete disarray. Among the latter, again, some bodies cause the rays to be reflected without bringing about any other change in their action (namely bodies we call "white"), and others bring about an additional change similar to that which the movement of a ball undergoes when we graze it (namely bodies which are red, or yellow, or blue or some other such color). For I believe I can determine the nature of each of these colors, and reveal it experimentally; but this goes beyond the limits of my subject. All I need to do here is to point out that the light-rays falling on bodies which are colored and not polished are usually reflected in every direction even if they come from only a single direction . . . Finally, consider that the rays are also deflected, in the same way as the ball just described, when they fall obliquely on the surface of a transparent body and penetrate this body more or less easily than the body from which they come. This mode of deflection is called "refraction."[2]

[. . .]

Discourse four: the senses in general

Now I must tell you something about the nature of the senses in general, the more easily to explain that of sight in particular. We know for certain that it is the soul which has sensory awareness, and not the body. For when the soul is distracted by an ecstasy or deep contemplation, we see that the whole body remains without sensation, even though it has various objects touching it. And we know that it is not, properly speaking, because of its presence in the parts of the body which function as organs of the external senses that the soul has sensory awareness, but because of its presence in the brain, where it exercises the faculty called the "common" sense. For we observe injuries and diseases which attack the brain alone and impede all the senses generally, even though the rest of the body continues to be animated. We know, lastly, that it is through the nerves that the impressions formed by objects in the external parts of the body reach the soul in the brain. For we observe various accidents which cause injury only to a nerve, and destroy sensation in all the parts of the body to which this nerve sends its branches, without causing it to diminish elsewhere. . . .[3] We must take care not to assume—as our philosophers commonly do—that in order to have sensory awareness the soul must contemplate certain images[4] transmitted by objects to the brain; or at any rate we must conceive the nature of these images in an entirely different manner from that of the philosophers. For since their conception of the images is confined to the requirement that they should resemble the objects they represent, the philosophers cannot possibly show us how the images can be formed by the objects, or how they can be received by the external sense organs and transmitted by the nerves to the brain. Their sole reason for positing such images was that they saw how easily a picture can stimulate our mind to conceive the objects depicted in it, and so it seemed to them that the mind must be stimulated to conceive the objects that affect our senses in the same way—that is, by little pictures formed in our head. We should, however, recall that our mind can be stimulated by many things other than images—by signs and words, for example, which in no way resemble the things they signify. And if, in order to depart as little as possible from accepted views, we prefer to maintain that the objects which we perceive by our senses really send images of themselves to the inside of our brain, we must at least observe that in no case does an image have to resemble the object

it represents in all respects, for otherwise there would be no distinction between the object and its image. It is enough that the image resembles its object in a few respects. Indeed the perfection of an image often depends on its not resembling its object as much as it might. You can see this in the case of engravings: consisting simply of a little ink placed here and there on a piece of paper, they represent to us forests, towns, people, and even battles and storms; and although they make us think of countless different qualities in these objects, it is only in respect of shape that there is any real resemblance. And even this resemblance is very imperfect, since engravings represent to us bodies of varying relief and depth on a surface which is entirely flat. Moreover, in accordance with the rules of perspective they often represent circles by ovals better than by other circles, squares by rhombuses better than by other squares, and similarly for other shapes. Thus it often happens that in order to be more perfect as an image and to represent an object better, an engraving ought not to resemble it. Now we must think of the images formed in our brain in just the same way, and note that the problem is to know simply how they can enable the soul to have sensory awareness of all the various qualities of the objects to which they correspond—not to know how they can resemble these objects. For instance, when our blind man touches bodies with his stick, they certainly do not transmit anything to him except in so far as they cause his stick to move in different ways according to the different qualities in them, thus likewise setting in motion the nerves in his hand, and then the regions of his brain where these nerves originate. This is what occasions his soul to have sensory awareness of just as many different qualities in these bodies as there are differences in the movements caused by them in his brain.

[. . .]

Notes

1 A reference to the scholastic doctrine that material objects transmit to the soul "forms" or "images" (Fr. *espèces*, Lat. *species*) resembling them.

2 Discourse Two and Three are omitted here.

3 There follows an account of the function of the nerves and animal spirits in producing sensation and movement. Cf. *Treatise on Man*, AT XI 132 ff and *Passions*.

4 See note 1 above.

Georgina Kleege

BLINDNESS AND VISUAL CULTURE:
AN EYE WITNESS ACCOUNT

IN APRIL 2004, I WAS INVITED to speak at a conference on visual culture at the University of California, Berkeley. Speakers were asked to respond to an essay by W. J. T. Mitchell titled, "Showing Seeing: A Critique of Visual Culture," which offers a series of definitions of the emergent field of visual studies, distinguishing it from the more established disciplines of art history, aesthetics and media studies. As an admitted outsider to the field of visual studies, I chose to comment on the following statement: "Visual culture entails a meditation on blindness, the invisible, the unseen, the unseeable, and the overlooked" (Mitchell 2002, 170). In my last book, *Sight Unseen*, I attempted to show blindness through my own experience, and a survey of representations of blindness in literature and film. At the same time, I wanted to show seeing, to sketch my understanding of vision, drawn from a lifetime of living among the sighted in this visual culture we share. I started from the premise that the average blind person knows more about what it means to be sighted than the average sighted person knows about what it means to be blind. The blind grow up, attend school, and lead adult lives among sighted people. The language we speak, the literature we read, the architecture we inhabit, were all designed by and for the sighted.

If visual studies entails a meditation on blindness, it is my hope that it will avoid some of the missteps of similar meditations of the past. Specifically, I hope that visual studies can abandon one of the stock characters of the western philosophical tradition—"the Hypothetical Blind Man" (Gitter 2001, 58). The Hypothetical Blind Man—or the Hypothetical as I will call him for the sake of brevity—has long played a useful, though thankless role, as a prop for theories of consciousness. He is the patient subject of endless thought experiments where the experience of the world through four senses can be compared to the experience of the world through five. He is asked to describe his understanding of specific visual phenomena—perspective, reflection, refraction, color, form recognition—as well as visual aids and enhancements—mirrors, lenses, telescopes, microscopes. He is understood to lead a hermit-like existence, so far at the margins of his society, that he has never heard this visual terminology before the philosophers bring it up. Part of the emotional baggage he hauls around with him comes from other cultural representations of blindness, such as Oedipus and the many Biblical figures whose sight is withdrawn by the wrathful God of the Old Testament or restored by the redeemer of the New. His primary function is to highlight the importance

of sight and to elicit a frisson of awe and pity which promotes gratitude among the sighted theorists for the vision they possess.

I will not attempt to survey every appearance of the Hypothetical throughout the history of philosophy. It is enough to cite a few of his more memorable performances, and then to suggest what happens when he is brought face-to-face with actual blind people through their own first-hand, eye-witness accounts. Professor Mitchell alludes to the passages in Descartes' *La Dioptrique* where he compares vision to the Hypothetical's use of sticks to grope his way through space. Descartes's references to the Hypothetical are confusing and are often conflated by his readers. In one instance, he compares the way the Hypothetical's stick detects the density and resistance of objects in his path, to the way light acts on objects the eye looks at. In a later passage, Descartes performs a thought experiment, giving the Hypothetical a second stick which he could use to judge the distance between two objects by calculating the angle formed when he touches each object with one of the sticks. Descartes does not explain how the Hypothetical is supposed to make this calculation or how he can avoid running into things while doing so. I doubt that Descartes actually believed that any blind person ever used two sticks in this way. In fact, the image that illustrates his discussion shows the Hypothetical's dog sound asleep on the ground, indicating that the Hypothetical is going nowhere. Even so, Descartes' description of the way a blind person uses one stick reflects a basic misunderstanding. He imagines that the blind use the stick to construct a mental image, or its equivalent, of their surroundings, mapping the location of specifically identified objects. In fact, then as now, a stick or cane is a poor tool for this kind of mental imaging. The stick serves merely to announce the presence of an obstacle, not to determine if it is a rock or a tree root, though there are sound cues—a tap versus a thud—that might help make this distinction. In many situations, the cane is more of an auditory than a tactile tool. It seems that in Descartes' desire to describe vision as an extension of or hypersensitive form of touch, he recreates the blind man in his own image, where the eye must correspond to the hand extended by one or perhaps two sticks.

The most detailed depiction of the Hypothetical came about in 1693, when William Molyneux wrote his famous letter to John Locke. He proposed a thought experiment where a blind man who had learned to recognize geometric forms such as a cube and a sphere by touch, would have his sight restored through an operation. Would he be able to distinguish the two forms merely by looking at them? The Molyneux question continues to be debated today, even though the history of medicine is full of case studies of actual blind people who have had their sight restored by actual operations. Apparently, Molyneux was married to a blind woman, which has always led me to wonder why he did not pose his hypothetical question about her. Perhaps he knew that others would object that marriage to a philosopher might contaminate the experimental data. There was a risk that the philosopher might prime her answers or otherwise rig the results. Certainly in commentary on actual cases of restored sight, debaters of the Molyneux question are quick to disqualify those who were allowed to cast their eyes upon, for instance the faces of loved ones, before directing their gaze at the sphere and the cube.

Denis Diderot's 1749 "Letter on the Blind for the Use of Those Who See" is generally credited with urging a more enlightened, and humane attitude toward the blind. His blind man of Puiseaux and Nicholas Saunderson, the English mathematician, were both real rather than hypothetical blind men. As he introduces the man from Puiseaux, Diderot is at pains to supply details of his family history and early life to persuade his reader that this is a real person. Significantly, the man from Puiseaux is first encountered helping his young son with his studies, demonstrating both that he is a loving family man, and capable of intellectual activity. But the questions Diderot poses generally fall under the pervu of the Hypothetical. Certainly, many of his remarks help support Descartes' theory relating vision to touch:

> One of our company thought to ask our blind man if he would like to have eyes. "If it were not for curiosity," he replied, "I would just as soon have long arms: it seems to me my hands would tell me more of what goes on in the moon than your eyes or your telescopes."
>
> (Diderot 1999, 153)

Diderot praises the blind man's ability to make philosophical surmises about vision, but does not have a high opinion of blind people's capacity for empathy:

> As of all the external signs which raise our pity and ideas of pain the blind are affected only by cries, I have in general no high thought of their humanity. What difference is there to a blind man between a man making water and one bleeding in silence?
>
> (Diderot 1999, 156)

The phrasing of the question here suggests an afterthought. I imagine Diderot, at his table, conjuring up two men, one pissing, one bleeding. While his visual imagination is practiced in making these sorts of mental images, he is less adept at tuning his mind's ear. He recognizes that for the blood to be spilt at a rate sufficient to create the same sound as the flowing urine, the bleeding man would normally cry out in pain. So he imagines, in effect, a bleeding mute. But he fails to take into account the relative viscosity, not to mention the different odors, of the two fluids. But Diderot cannot think of everything.

Now I imagine a blind man wandering onto the scene. My blind man is not quite the one Diderot imagines. For one thing he is a bit preoccupied; the philosophers have dropped by again. They talk at him and over his head, bandying about names that are now familiar to him: Locke, Molyneux, Descartes. They question him about his ability to conceptualize various things: windows, mirrors, telescopes—and he responds with the quaint and winsome answers he knows they have come for. Anything to get rid of them. Distracted as he is, the sound of the bleeding mute's plashing blood registers on his consciousness. Lacking Diderot's imagination, however, the thought does not occur to him that this sound emanates from a bleeding mute. His reason opts instead for the explanation that the sound comes from some man relieving his bladder—a far more commonplace phenomenon, especially in the mean streets where the blind man resides. It is not that the blind man has no fellow feeling for the mute. Come to think of it, the mute would make a good companion. He could act as a guide and keep an eye out for marauding philosophers, while the blind man could do all the talking. But the blind man does not have enough information to recognize the mute's dilemma. The only hope for the bleeding mute is to find some way to attract the blind man's attention, perhaps by throwing something. But surely, such a massive loss of blood must have affected his aim. While the blind man, living as he does at the margins of his society, is accustomed to being spurned by local homeowners and merchants who find his presence unsightly, and so might flee the bleeding mute's missiles without suspecting that his aid is being solicited.

The blind man quickens his pace as best he can. The mute succumbs at last to his mortal wound. And the philosopher shifts to another topic.

I am wrong to make fun of Diderot, since his treatment of blindness was at once far more complex and far more compassionate than that of other philosophers. And it is not as if his low opinion of the blind's ability to empathize with others' pain has ceased to contribute to attitudes about blindness. Consider this anecdote from recent history. Some weeks after September 11, 2001, the blind musician Ray Charles was interviewed about his rendition of "America the Beautiful," which received a good deal of air time during the period of heightened patriotism that followed that event. The interviewer, Jim Gray, commented that

Charles should consider himself lucky that his blindness prevented him from viewing the images of the World Trade Center's collapse, and the Pentagon in flames: "Was this maybe one time in your life where not having the ability to see was a relief?" Like Diderot, the interviewer assumed that true horror can only be evinced through the eyes. Many eyewitness accounts of the event however, were strikingly nonvisual. Many people who were in the vicinity of Ground Zero during and soon after the disaster found it hard to put what they saw into words, in part because visibility in the area was obscured by smoke and ash, and in part because what they were seeing did not correspond to any visual experience for which they had language. People described instead the sound of falling bodies hitting the ground, the smell of the burning jet fuel, and the particular texture of the ankle deep dust that filled the streets. But for the majority of television viewers, eye-witnesses from a distance, those events are recalled as images, indelible, powerful, and eloquent. To many, like the reporter interviewing Ray Charles, it is the images rather than the mere fact of the events that produce the emotional response. The assumption seems to be that because the blind are immune to images they must also be immune to the significance of the events, and therefore must be somehow detached from or indifferent to the nation's collective horror and grief.

It is fortunate for anyone interested in dismantling the image of blindness fostered by the Hypothetical Blind Man that we have today a great many first-hand accounts of blindness. In recent decades, memoirs, essays and other texts by actual blind people attempt to loosen the grip the Hypothetical still seems to hold on the sighted imagination. Thanks to work by disability historians, we are also beginning to have older accounts of blindness drawn from archives of institutions and schools for the blind around the world. One such account is a text written in 1825, by a twenty-two-year-old blind French woman named Thérèse-Adèle Husson. Born in Nancy into a petit bourgeois household, Husson became blind at nine months following a bout of smallpox. Her case attracted the attention of the local gentry who sponsored a convent education for her, and encouraged her to cultivate her interests in literature and music. At the age of twenty she left home for Paris where she hoped to pursue a literary career. Her first text, "Reflections on the Moral and Physical Condition of the Blind" seems to have been written as a part of her petition for aid from the Hôpital des Quinze-Vingts, an institution that provided shelter and financial support to the indigent blind of Paris. For the most part, her text follows the example of comportment and educational manuals of the time, offering advice to parents and caretakers on the correct way to raise a blind child, and to young blind people themselves on their role in society. It is by turns, formulaically obsequious and radically assertive, since she writes from the premise—revolutionary for the time—that her first-hand experience of blindness gives her a level of expertise that equals or surpasses that of the institution's sighted administrators. While it is unlikely that Husson's convent education would have exposed her to the work of Descartes or Diderot, she considers some of the same questions previously posed to the Hypothetical. It is possible that the provincial aristocrats, who took up her education, may have engaged in amateurish philosophizing in her presence. For instance, like Diderot's blind man of Puiseaux, she prefers her sense of touch to the sight she lacks. She recounts how, at the time of her first communion, her mother promised her a dress made of chiffon, then, either as a joke or in an attempt to economize, purchased cheaper percale instead. When the young Husson easily detected the difference through touch, her mother persisted in her deception, and even brought in neighbor women to corroborate. Whether playing along with the joke, or as a genuine rebuke of her mother's attempt to deceive her, Husson retorted:

> I prefer my touch to your eyes, because it allows me to appreciate things for what they really are, whereas it seems to me that your sight fools you now and then, for this is percale and not chiffon.

> (Husson 2001, 25)

In a later discussion of her ability to recognize household objects through touch, her impatience seems out of proportion, unless we imagine that she frequently found herself the object of philosophical speculation by literal-minded practitioners:

> We know full well that a chest of drawers is square, but more long than tall. Again I hear my readers ask what is a square object! I am accommodating enough to satisfy all their questions. Therefore, I would say to them that it is easy enough to know the difference between objects by touching them, for not all of them have the same shape. For example, a dinner plate, a dish, a glass can't begin to be compared with a chest of drawers, for the first two are round, while the other is hollow; but people will probably point out that it is only after having heard the names of the articles that I designate that it became possible for me to acquire the certainty that they were hollow, round, square. I will admit that they are right, but tell me, you with the eyes of Argus, if you had never heard objects described, would you be in any better position to speak of them than I?
>
> (Husson 2001, 41)

Her emphasis on square versus round objects as well as her tone and her taunt, "You with the eyes of Argus," suggests an irritation that may come from hearing the Molyneux question one too many times. She is also arguing against the notion that such words as "square" and "round" designate solely visual phenomena, to which the blind have no access and therefore no right to use these words.

Almost a century later, Helen Keller gives vent to a similar irritation at literal-minded readers. In her 1908 book, *The World I Live In*, she gives a detailed phenomenological account of her daily experience of deaf-blindness. Early on, she footnotes her use of the verb "see" in the phrase, "I was taken to see a woman:"

> The excellent proof-reader has put a query to my use of the word "see." If I had said "visit," he would have asked no questions, yet what does "visit" mean but "see" (*visitare*)? Later I will try to defend myself for using as much of the English language as I have succeeded in learning.
>
> (Keller 2003, 19)

Keller makes good use of her Radcliffe education to show that the more one knows about language the harder it is to find vocabulary that does not have some root in sighted or hearing experience. But, she argues, to deny her the use of seeing-hearing vocabulary would be to deny her the ability to communicate at all.

In their 1995 book, *On Blindness*, two philosophers, one sighted and one blind, conduct an epistolary debate that might seem to put to rest all the old hypothetical questions. Unfortunately, Martin Milligan, the blind philosopher, died before the discussion was fully underway. If he had lived, we can assume not only that he and his sighted colleague, Bryan Magee, would have gotten further with their debate, but also that they would have edited some testy quibbles about which terms to use and which translation of Aristotle is more accurate. Milligan, who worked primarily in moral and political philosophy, and was an activist in blind causes in the United Kingdom, forthrightly resists the impulse to allow the discussion to stray far from the practical and social conditions that affect the lives of real blind people. For instance, he cites an incident from his early life, before he found an academic post, when he was turned down for a job as a telephone typist on a newspaper because the employer assumed that he would not be able to negotiate the stairs in the building. He identifies this as

one of thousands of examples of the exaggerated value sighted people place on vision. Any thinking person has to recognize that sight is not required to climb or descend stairs. He asserts that the value of sight would be that it would allow him to move around unfamiliar places with greater ease. He concedes that vision might afford him some aesthetic pleasure while viewing a landscape or painting, but insists that he can know what he wants to know about the visible world from verbal descriptions, and that this knowledge is adequate for his needs, and only minimally different from the knowledge of sighted people. He accuses Magee of voicing "visionist"—or what I might call "sightist"—attitudes that the differences between the sighted and the blind must be almost incomprehensibly vast, and that vision is a fundamental aspect of human existence. Milligan says that these statements seem

> to express the passion, the zeal of a missionary preaching to the heathen in outer darkness. Only, of course, your "gospel" isn't "good" news to us heathens, for the message seems to be that ours is a "darkness" from which we can never come in—not the darkness of course that sighted people can know, but the darkness of never being able to know *that* darkness, or of bridging the vast gulf that separates us from those who do.
>
> (Magee and Milligan 1995, 46)

This prompts Magee to cite his own early work on race and homosexuality, as proof of his credentials as a liberal humanist. He also speculates, somewhat sulkily, about whether the first eighteen months of Milligan's life when his vision was presumed to be normal, might disqualify him as a spokesman for the blind, since he might retain some vestige of a visual memory from that period. Later, Magee consults with a neurologist who assures him that the loss of sight at such an early age would make Milligan's brain indistinguishable from that of a person born blind. And so the discussion continues.

Along the way, Magee makes some claims about sight that seem to me to be far from universal. For instance, he states:

> By the sighted, seeing is felt as a *need*. And it is the feeding of this almost ungovernable craving that constitutes the ongoing pleasure of sight. It is as if we were desperately hungry all the time, in such a way that only if we were eating all the time could we be content—so we eat all the time.
>
> (Magee and Milligan 1995, 104)

Magee asserts that when sighted people are obliged to keep their eyes closed even for a short time, it induces a kind of panic. To illustrate his point, he notes that a common method of mistreating prisoners is to keep them blindfolded, and this mistreatment can lead them to feel anxious and disoriented. I suspect that his example is influenced by traditional metaphors that equate blindness with a tomb-like imprisonment. Surely a blind prisoner, accustomed to the privation of sight, might still have similar feelings of anxiety and disorientation, due to the threat, whether stated or implied, of pending bodily harm.

To his credit, Magee does allow that some blind experiences are shared by the sighted. Milligan describes how many blind people negotiate new environments, and can feel the presence of large objects even without touching them as "atmosphere-thickening occupants of space." Magee reports that when he

> was a small child I had a vivid nonvisual awareness of the nearness of material objects. I would walk confidently along a pitch black corridor in a strange house

and stop dead a few inches short of a closed door, and then put out my hand to grope for the knob. If I woke up in the dark in a strange bedroom and wanted to get to a light-switch on the opposite side of the room I could usually circum-navigate the furniture in between, because I could "feel" where the larger objects in the room were. I might knock small things over, but would almost invariably "feel" the big ones. I say "feel" because the sensation, which I can clearly recall, was as of a feeling-in-the-air with my whole bodily self. Your phrase "atmosphere-thickening occupants of space" describes the apprehension exactly. I suddenly "felt" a certain thickness in the air at a certain point relative to myself in the blackness surrounding me. . . . This illustrates your point that the blind develop potentialities that the sighted have also been endowed with but do not develop because they have less need of them.

(Magee and Milligan 1995, 97–98)

Here, and in a few other places in the correspondence, Magee and Milligan seem to be moving in a new direction. It is not merely that they discover a shared perceptual experience, but one that is not easy to categorize as belonging to one of the five traditional senses. Here, a "feeling" is not the experience of texture or form through physical contact, but an apprehension, of an atmospheric change, experienced kinesthetically, and by the body as a whole. This seems to point toward a need for a theory of multiple senses where each of the traditional five could be subdivided into a number of discrete sensory activities, which function sometimes in concert with and sometimes in counterpoint to others. Helen Keller identified at least three different aspects of touch that she found meaningful: texture, temperature, and vibration. In fact, she understands sound as vibrations that the hearing feel in their ears while the deaf can feel them through other parts of their bodies. Thus she could feel thunder by pressing the palm of her hand against a windowpane, or someone's footsteps by pressing the soles of her feet against floorboards.

What these blind authors have in common is an urgent desire to represent their experiences of blindness as something besides the absence of sight. Unlike the Hypothetical, they do not feel themselves to be deficient or partial—sighted people minus sight—but whole human beings who have learned to attend to their nonvisual senses in different ways. I have deliberately chosen to limit my discussion here to works by people who became blind very early in life. One of the most striking features of the Hypothetical Blind Man is that he is always assumed to be both totally and congenitally blind. Real blindness, today as in the past, rarely fits this profile. Only about 10–20 percent of people designated as legally blind, in countries where there is such a designation, are without any visual perception at all. It is hard to come by statistics on people who are born totally blind, in part because it only becomes an issue when the child, or her parents, seek services for the blind, which tends to occur only when the child reaches school age. We can assume that more infants were born blind in the past, since some of the most prevalent causes of infantile blindness have been eliminated by medical innovations in the nineteenth and twentieth centuries. Nevertheless, in the past, as now, the leading causes of blindness occur later in life, and often leave some residual vision. Some may retain the ability to distinguish light from darkness, while others may continue to perceive light, color, form, and movement to some degree. Some people may retain the acuity to read print or facial expressions, while lacking the peripheral vision that facilitates free movement through space. And regardless of the degree or quality of residual vision, blind people differ widely in the ways they attend to, use or value these perceptions.

Although the situation of the Hypothetical is rare, his defenders are quick to discount anyone with any residual sight or with even the remotest possibility of a visual memory. In traditional discussions of blindness, only total, congenital blindness will do. In a review of my

book *Sight Unseen*, Arthur Danto asserted that I had too much sight to claim to be blind (Danto 1999, 35). He quoted a totally blind graduate student he once knew who said that he could not conceptualize a window, and that he was surprised when he learned that when a person's face is said to glow, it does not in fact emit light like an incandescent light bulb. Danto does not tell us what became of this student or even give his name, using him only as a modern-day version of the Hypothetical. He then goes on to relate the history of the Molyneux question.

If only the totally blind can speak of blindness with authority, should we make the same restriction on those who talk about vision? Is there such a thing as total vision? We know that a visual acuity of 20/20 is merely average vision. There are individuals whose acuity measures better than 20/20, 20/15, or even 20/10. Such individuals can read every line of the familiar Snellan eye chart, or, as in the case of Ted Williams, can read the print on a baseball whizzing toward their bat at a speed close to ninety miles per hour. How many scholars of visual culture, I wonder but won't ask, can claim such a level of visual acuity?

What visual studies can bring to these discussions is an interrogation of the binary opposition between blindness and sight. It is clearly more useful to think in terms of a spectrum of variation in visual acuity, as well as a spectrum of variation in terms of visual awareness or skill. The visual studies scholar, highly skilled in understanding images, who loses some or even all her sight, will not lose the ability to analyze images and to communicate her observations. In his essay, "Showing Seeing," W.J.T. Mitchell describes a classroom exercise in which students display or perform some feature of visual culture as if to an audience that has no experience of visual culture. The exercise assumes that some students will be better at the task, while others might improve their performance with practice, and in all cases their aptitude would have little, if anything, to do with their visual acuity. The skill, as I understand it, is in the telling as much as it is in the seeing—the ability to translate images in all their complexity and resonance into words.

And as we move beyond the simple blindness versus sight binary, I hope we can also abandon the clichés that use the word "blindness" as a synonym for inattention, ignorance, or prejudice. If the goal is for others to see what we mean, it helps to say what we mean. Using the word in this way seems a vestigial homage to the Hypothetical, meant to stir the same uncanny frisson of awe and pity. It contributes on some level to the perception of blindness as a tragedy too dire to contemplate, which contributes in turn to lowered expectations among those who educate and employ the blind. It also contributes to the perception among the newly blind themselves that the only response to their new condition is to retire from view.

I will leave you with a futuristic image of blindness. In Deborah Kendrick's story, "20/20 with a Twist," Mary Seymour, chief administrator of the department of visual equality, looks back on her life from the year 2020. In this blind Utopia, the major handicaps of blindness have been eliminated; private automobiles were phased out a decade earlier and technologies to convert print to Braille or voice had become ubiquitous and transparent. Of course, Mary reflects, it was not always like this. Back in the dark ages of the 1980s and '90s, Braille proficiency had ceased to be a requirement for teachers of blind children, Braille production facilities and radio reading services were shut down, and blind children were no longer being educated at all. Mary and other blind people who had grown up in an earlier, slightly more enlightened period, banded together to lead a nonviolent, visionary rebellion to bring down the oppressive regime. They tampered with the power supply—since darkness is no impediment to blind activity—scrambled computer transmissions and disrupted television broadcasts. All across the country, television screens went blank while the audio continued, interrupted periodically by the revolutionary message: "You, too, can function without pictures."

The rebel leaders were captured, however, and forced to undergo implantation of optic sensors, which, the captors reasoned, would transform them into sighted people who would see the error of their ways and abandon the cause. But the rebels persisted. The power supply was shut down completely. The government fell, and the captured leaders were liberated in triumph.

Significantly, the optic sensors did not transform the revolutionary leaders into sighted people. Rather, each acquired only a facet of visual experience. One gained the ability to perceive color. Another developed a sort of telepathic vision, allowing him to form images of places at great distances. Mary's sensor gave her a kind of literal hindsight, making her able to create a detailed mental picture of a room, only after she had left it. These bits and pieces of vision serve as a badge of the former rebels' heroic past, and allow them to perform entertaining parlor tricks, but are otherwise easy to disregard.

This is a far cry from the Hypothetical. In Deborah Kendrick's image of the future, blindness is a simple physical characteristic rather than an ominous mark of otherness. If the Hypothetical Blind Man once helped thinkers form ideas about human consciousness surely his day is done. He does too much damage hanging around. It is time to let him go. Rest in peace.

References

Charles, Ray. Interview. *The Today Show*. NBC Television, October 4, 2001.

Danto, Arthur. 1999. Blindness and Sight. *The New Republic* 220 (16):34–36.

Diderot, Denis. 1999. *Thoughts on the interpretation of Nature and other philosophical works*. Ed. David Adams. Manchester: Clinaman Press.

Gitter, Elisabeth, 2001. *The imprisoned guest: Samuel Howe and Laura Bridgman, the original deaf-blind girl*. New York: Farrar, Straus and Giroux.

Husson, Thérèse-Adèle. 2001. *Reflections: The life and writing of a young blind woman in post-revolutionary France*. Eds. Catherine J. Kudlick and Zina Weygand. New York and London: New York University Press.

Keller, Helen. 2003. *The world I live in*. Ed. Roger Shattuck. New York: New York Review Books.

Kendrick, Deborah. 1987. 20/20 with a Twist. In *With Wings: An Anthology of Literature by and about Women with Disabilities*, eds. Marsha Saxton and Florence Howe. New York: Feminist Press at the City University of New York.

Magee, Bryan and Milligan, Martin. 1995. *On blindness*. Oxford and New York: Oxford University Press.

Mitchell, W.J.T. 2002. Showing Seeing: A Critique of Visual Culture. *Journal of Visual Culture* 1 (2):165–181.

Carol Mavor

REDUPLICATIVE DESIRES

ALLOW ME TO BEGIN with four stories—four images—four mirror images, even—of what it means to look at and through the photographs of Clementina Hawarden.

One

The professor of art and her prize student were looking at lovely and sensual slides of Hawarden's photographs of her daughters. Flashing through the repetitive, though always captivating, images, the two women sat still in the darkened room, quietly remarking on the subtle gestures between the sisters: a pull on a lock of hair, a squeeze on an arm. The professor told her student that the photographs were about love between women and love of the self and self-love performed for the gaze of the mother. The student, a young poet on her way to graduate school in New York, told the art professor that her writing professor had once told her that "young women often write their first stories about an erotically charged, fantasized, twin sister." The art professor was disappointed to hear that these stories were always terrible.

Two

The young professor felt that she had finally grown up. Her advisor from graduate school had been invited to lecture at the university where she taught. Proud of her new independence as a real professor, she invited her advisor to her seminar. On the day of the seminar, her advisor showed up wearing the same dress as she. This made her feel all hot and embarrassed, as if they had been discovered as mother and daughter, or sisters, or as the perverse subjects of a Diane Arbus photograph. Yet, she also felt a certain delight, an almost sexual charge, from their presence in duplication. The class members tried not to be obvious with their inevitable double takes. She fed their desire (and maybe her own) by telling them that the whole thing was planned.

Three

The big party was at the famous professor's big house. Everyone looked smart and seemed to be working on their second Ph.D. rather than their first. Afterward, an older female professor felt compelled to tell her what the other women graduate students had been asking about her: "Was her femininity serious or parody?" With a sinking feeling inside her stomach and with a big smile and a roll of her eyes on her outside, she quipped, "Of course it's parody." But in her mind, she thought, "My God, I really don't know. But I'm never wearing a Laura Ashley dress again."

Four

She walked into the office and the chairman pulled her aside. He began making some remarks about her student—how the student dressed differently now—how the student had changed her hair. Continuing on, laughing yet serious, and full of odd suspicion, he asked her where she got that dress anyway. She lied, of course. She would rather die than tell him that two of her students had given it to her. "You know," he said, after masterfully managing to weave together her style of dress, her student's style of dress, and the kind of critical theory that she had been introducing to her students, "you gotta watch out for those Professor-Wanna-Bes, not all of them are capable of the demands of critical theory." But what he was really saying was "One of you is enough!"[1]

If Clementina Hawarden (a mother of eight) has taught me anything, it is that one is never enough.

In Hawarden's excessively productive world, whether through her production of eight children, or through her production of hundreds of images of her daughters, or even through her fetishization of select feminine objects within the pictures themselves, the female body infinitely reproduces itself, like a photograph.

Hawarden displays women as *ontologically* fetishistic by picturing passion as a kind of feminine doubling of the mother herself, as simulation. For example, the photographs that focus on mirrored images in actual mirrors and windows as mirrors suggest not only feminine narcissism, but also the mirroring of the mother through the daughters (Figure 26.1).[2] And by matching, twinning, and coupling girls with objects that suggest the sensuous femininity of her daughters, Hawarden fetishistically simulates her body and, in turn, those of her daughters.[3] Consider, for example, the familiar curvy vase that suggests Clementina's own blossoming breasts, turned-in waist, and hands on hips as handles made bountiful through pleats, gathers, and layers of sensual fabric—doubly so, in that we see her in the jug and in the mirror. Or see Isabella as a reflective collectomania[4] of feminine things: in the (Pandora's[5]) box decorated with shells that perches atop a table crowned by a narrow-figured vase that suggests her own slim lines; in the string of pearls; in the jeweled button; in the epergne (this time, it is not filled with fruit); in the two tiaras, one she wears on her head, the other she clenches to her breast. Consider the concertina[6] that spreads its bellows like Clementina's own skirt.

Such doubling, twinning, coupling, mirroring that is already inherent to the work is doubly emphasized by Hawarden's frequent production of stereoscopic photographs. One example is the stereo of a young Isabella in eighteenth-century-style dress. Isabella, in a billowy dress pregnant with excess, poses alongside a Gothic-style desk. The picture features Isabella as one with a spillage of girl metaphors: an Indian cabinet from whose open drawers flow eye-catching beads, an easel-back mirror that perches on the desk like an empty picture frame waiting to be filled with the image of this beautiful girl. Flowers are everywhere: she

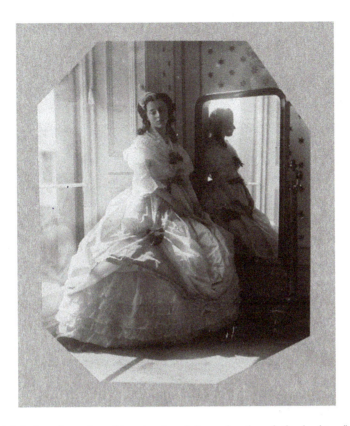

Figure 26.1 Isabella in fancy dress, "the mirroring of the mother through the daughters," Clementina, Viscountess Hawarden, c. 1862, *Untitled*, courtesy of the Board of Trustees of the Victoria and Albert Museum, London. Photo © Victoria and Albert Museum London.

holds a bouquet of them in her hand; she wears a flower wreath on her head; another wreath of flowers decorates the plant stand; a lone flower sleeps on the carpet.[7] And thanks to her mother's stereoscopic camera, such feminine reduplication (performed by objects and daughter alike) is pictured not once, but twice.

Hawarden displays women as ontologically fetishistic, but does she, in the words of Emily Apter, "feminize the fetish"? Naomi Schor, among the first to inscribe the fetish with the female body, would say no. Schor understands the female fetish, rather, as a perversion stolen from men, as simulacrum. Apter, on the other hand and in direct response to Schor, takes such objects as Guy de Maupassant's fiction and Mary Kelly's *Postpartum Document* as "real" female fetishes that prove women to be perverts in their own right. Though I am drawn to Apter's brilliant writing on the ways female fetishism has been limited and misunderstood as a "simulacrum" of the "real" male perversion—or as a perversion stolen from men, "a sort of 'perversion theft' "—my path is somewhat different.[8] Rather than arguing whether or not Hawarden's maternal love objects are simulation or thievery, or whether or not Hawarden is necessarily a deviant by her own (female) right, this chapter makes palpable the curious relationship between Hawarden's fetishistic photographs and the conceptual framework of femininity itself. My analysis of Hawarden's photographs does not so much pull the feminized fetish into view as perform its reduplicative desire.[9]

Whereas the word *duplicate* is used in various ways—as an adjective to describe something as "being the same as another," as a noun that defines "either of two things that exactly resemble each other," as a verb that emphasizes the process "to make double or twofold"—the

definition of the verb *reduplicate* is "to make or perform again."[10] I am engaged with the action of reduplicate's (re)performative character. Hawarden's photographs use her daughters to reperform Hawarden's desire again and again: through the repetition of her daughters, who are themselves repetitions of her (especially Clementina); through the fetishistic objects—such as the Gothic-style desk, whose elaborately carved legs mirror daughter Clementina's own ringlets, or the concertina, the vase, the guitar—objects that appear to stand in for an absent daughter, as if the daughter and the object were sisters, as if the daughter and the object were a couple; through the reflected images of her daughters in the mirror that Hawarden often used as a prop; and through the endless repetition of the photograph itself, as is beautifully registered in the image of Clementina and Isabella sharing a photograph of Florence.[11]

If we look closer at this curious image of the two older girls with a photograph of their younger sister, Clementina seems to hold an insistent desire for Isabella. In fact, Clementina appears actually to have pushed Isabella into the corner of the picture so as to be on top of her, as if she were a camera's close-up lens. In opposition to Isabella's space of tight confinement, the empty space behind Clementina gives her body a certain driving force, mirroring the push of her own bustle, the play of her flirtatious hair ribbon. Clementina's eyes focus on Isabella's escaping tendrils, which amorously play on what I know to be, from other photographs, a beautiful white neck. Inhaling the perfume of her sister's prissy prettiness, Clementina displays what seems to be an unremitting eroticism. The essence of her body, quietly, yet insistently, requires that her sister share her sweet looks. Clementina's hand pertinaciously poised on her sister's shoulder pulls Isabella in as she simultaneously pushes against her. Isabella's gaze is elsewhere, but her neck is tickled by Clementina's gaze: a breath not from her mouth, nor from her nose, but from her eyes. Silent, odorless, hot. The back of Clementina's expressive hands touch and fit into that beautiful space below Isabella's breasts. Clementina is becoming: she is coming into the sexuality and changing body of Isabella; she is coming into her own sexuality; and she is very becoming. Isabella will not be able to hold her stiff Victorian ladyhood much longer. Eroticism pushes out the picture's overt narrative of staged grief, like a crinoline under a skirt, a crinoline that they share with each other and with their mother.

As Peggy Phelan has demonstrated, the photograph, like the female body itself, is infinitely reproducible. They are ontological equivalents.[12] There is no real singular woman hiding behind the masquerade of womanliness, just as there is no singular photograph.[13] In Hawarden's photographs, the relationship between the category of woman, the photograph, and the female fetish reflect each other's reflections, constituting a supra-*mise en abyme*.

Indeed, Hawarden houses "femininity as always already stolen" (a tantalizing phrase that I have already stolen from Leslie Camhi).[14] Like the nineteenth-century department store that would become so spectacular toward the end of the century, with its elaborate displays of silks, gloves, hats, laces, and more, Hawarden displays for the viewer her beautiful collection of dresses and accessories, the beautiful bodies of her girls, and her collection of small and tiny objects that go in and out of view of the camera's eye (the silver cup, the Gothic desk, the wooden doll, the toy village), which are either held in a hand, perched on Hawarden's desk, presented on her table, stuck in the drawer of her Indian cabinet, or placed on the mantel. Hawarden's desire, like that of the Victorian female kleptomaniac, is contagious. I want a collection (girls, dresses, objects, photographs) of my own. I take what is already stolen (thereby ridding me of any guilt) and reduplicate its desire in my (writing) body.

Mother/daughter/doll

As girls, many of us had a collection of dolls. It is hard to say whether or not Hawarden as a girl possessed such things; the Victorian commodification of childhood with all of its ensuing

products, such as dolls and books and clothes and perambulators, was more the stuff of her daughters' lives than of hers. But once grown, Hawarden played with her daughters like dolls. As objects dressed to entice and to invite play, Hawarden's pictures of her lovely daughters beckon touching, dressing, redressing, combing, brushing, hugging. Hawarden's daughters, as part-objects of the mother/photographer, *mirror* not only each other but also their mother. Hawarden's imaging of her girls as dolls represents not only an appetite for beautiful things, an appetite for young feminine bodies, but also an appetite for self (in that the daughters are born into a culture that makes them into little mothers). I am reminded of Christina Rossetti's "Goblin Market" (1859). Like Hawarden's photographs, the poem fecundates with the delicious fruits of a doubling, ripe, adolescent, female body:

> Apples and quinces,
> Lemons and oranges,
> Plump unpecked cherries,
> Melons and raspberries . . .
> Figs to fill your mouth.[15]

Halfway through the poem, Lizzie—the twinned "little mother" to her self-same sister Laura—offers herself as (homo)erotic sacrament, cooing and wooing:

> Did you miss me?
> Come and kiss me.
> Never mind my bruises,
> Hug me, kiss me, suck my juices
> Squeezed from goblin fruits for you.
> Goblin pulp and goblin dew.
> Eat me, drink me, love me;
> Laura make much of me.[16]

Hawarden's sensual, maternal appetite for her girls is not unlike that of Lizzie and Laura for each other: both represent an eating of the other and an eating of the self.

Like the mother of twelve-year-old Janey ("Petal Pie") in Kirsty Gunn's haunting contemporary novel, *Rain* (1994), Hawarden knew that her daughters, especially (perhaps) her daughter Clementina, would become her: "Sitting at her dressing-table that night, somewhere under her smooth expression she knew it. That I would take her limbs, her hair. That some day I would become her, smooth with cosmetics and calm to the mirror's surface."[17] I know that, as a child, my own mother imagined me as a miniature copy of herself and I have always felt in turn that I was her mirror. Our connected identities register my birth as never complete. Through such pro*longing* of the Oedipal period, the mother identifies with her mother once again, longs for her and her lost childhood, becomes mother and child, and makes her own child a fetishistic object in an attempt to satisfy her double loss. (Because the child is "cut" from the mother, the child marks maternal loss; yet the child also makes the mother feel whole again and thereby marks maternal plenitude. As a result, the child really is a mother's fetish par excellence.) The birth of a girl, especially, is an everlasting process of reduplication between mother and child, between stereoscopic images. (One of my students recognized this complex imaging and reimaging in an old high school photograph of her mother and wrote: "Not only does it have a sense of aura because it is old, but because it is my mother/me. Like the multiple photographic copies of this image, I am a copy of my mother."[18])

Luce Irigaray has argued that a female's desire for the mother is one of connection and reduplication, so much so that it has affected women's gestures and play. Spinning around

Freud's famous *fort-da* story (which features Freud's grandson Ernst throwing a spool on a string back and forth as a symbolic mother-object whose coming and going he can control), Irigaray claims that this kind of male-gendered play, which distances the child from the mother's body, is difficult, if not impossible, for a girl.[19] Few girls can reduce their mother's image, their own reduplicative image, to that of a reel. Rather than physically throwing a (symbolic) reel on a string back and forth, many little girls dramatize their situation of close proximity to the body of the mother by replaying (the mother) with dolls. Drawn to the mother-centered imaginary over the father-ruled symbolic, the little girl *plays* out her situation and reproduces around and within her an energetic circular movement that protects her from abandonment, attack, depression, loss of self. Spinning around is also, but in my opinion secondarily, a way of attracting. The girl describes a circle while soliciting and refusing access to her territory. She is making a game of this territory she has described with her body.[20]

Hawarden's photography is girl play with a camera. Her photographs dramatize a close proximity to her own mother, who was also fond of fancy dress.[21] A scrapbook compiled by Hawarden's mother contains engraved clippings from "serial publications such as Heath's *Book of Beauty* and Finden's *Byron's Beauties*" and must have "nurtured" this shared and multi-generational love of sartorial drama.[22] Likewise, Hawarden turned her daughters into (glass and paper) dolls. Together, mother-daughter/daughter-mother play in a circle described by mother as camera eye. The photographs give us access to this inviting territory. Yet, like a mother's arms around her child or a child's arms around her doll, or like a jump rope that whisks its way above a girl's head and under her feet, we are at the same time refused access.

In one stereograph, Clementina plays with her jump rope while being held by her mother's camera. The rope, by traveling from the grasp of one hand and then up to the other, makes a beautiful U: it mimics the looseness and playful pleasure of Clementina's one-side-only ponytail, which itself (like string, yarn, or cord) serpentines its way down from her ear to her breast to her waist. The jump rope bars us from Clementina, just as the balcony, with its short stone wall, bars her from the outside world. Such markers (rope, stone wall) magnify the intensity of the privacy of Hawarden's undecorated rooms, our limits to discovering the secrets at hand, and photography's own trick of giving way to a real space that is unreal.

In yet another jump-rope picture, Isabella has her back to the camera and Clementina faces out with her eyes down. Between the two sisters, they hold the jump rope: it makes a short, dark, squat (umbilical) ∪ that *draws* them together. The picture looks staged. The balcony, in this picture and many others, juts out from the Hawarden home and makes a platform stage for the girls. Here, as they often do, they perform play as a play. Interpretations flow. The jump rope becomes the cord to a camera shutter. Barthes suddenly, though not unexpectedly, emerges on-stage and insists that his clever line be heard: "A sort of umbilical cord [une sorte de lien ombilical] links the body of the photographed thing to my gaze."[23] Irigaray spins out from the wings while skipping rope and blurts out: "If the mother—and girls' identities in relation to her—is invoked in girls' play, and if they choose to play with a cord, they skip around, while turning the cord over their bodies . . . They describe a circular territory around themselves, around their bodies."[24]

Playing in an oedipal continuum, refusing the abandonment of the circular gestures and circular inscriptions of a maternalized territory, Hawarden's pictures of her doll-like daughters reinscribe, recite the mother-daughter continuum of a love of same. Hawarden's body is there; it is just, as Mary Kelly has remarked in regard to our cultural distancing of the maternal body, "*too close to see.*"[25]

In the photograph of Clementina in a dark riding habit and her sister Isabella in an off-the-shoulder white dress, two self-same daughters come full circle as mirroring images of dark and light, Nycteris and Photogen, masculine and feminine, the object of desire and her pursuer (Figure 26.2).[26] Isabella, inside the Hawarden home with her back toward us, hair

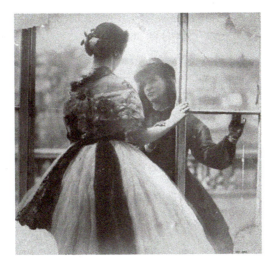

Figure 26.2 "Clementina in a dark riding habit and . . . Isabella in an off-the-shoulder white dress," Clementina, Viscountess Hawarden, *Untitled*, courtesy of the Board of Trustees of the Victoria and Albert Museum, London. Photo © Victoria and Albert Museum, London.

prim and proper, keeps her body protected and out of our view. Clementina, outside the window frame, outside the interior of the home, out on the porch, with her hair loose, opens her body for Isabella and toward us. The differences between Isabella and Clementina enhance the subtle touching that is going on between these women. For though Clementina's gaze into Isabella's eyes is enough to make the viewer blush, it is her bare right hand that causes me to swoon. Stripped of the dark glove that her left hand so openly displays, Clementina's lovely ungloved hand ever so softly but firmly clenches Isabella's right arm. I can feel the pressure. Like Lizzie and Laura in "Goblin Market," the Hawarden sisters seem to be offering two ways of life in one twinning body: that of the "mindful" Lizzie/Isabella, whose controlled feminine desire stands "white and golden . . ./Like a lily in a flood," and that of "curious Laura"/ darling, adventurous Clementina, who "sucked and sucked and sucked the more/Fruits which that unknown orchard bore;/She sucked until her lips were sore."[27] Like rings around a stone cast into a pond, the circles of Clementina's hat and brim, the circle of the black lace sash that cinches Isabella's small circle of a waist, the circle of their skirts, the circling of Isabella's rolled hair that wraps the curve of her beautiful head—all serve to echo the more general and prohibitory halo that the sisters have materially and gesturally inscribed around themselves. "Like two pigeons in one nest," Isabella and Clementina create an inviting bower into which we, as wingless outsiders, cannot enter.[28]

Look again at the photograph in which Clementina and Florence are caught as if recreating a tableau vivant from Delacroix's *The Death of Sardanapalus* where circles are, again, repeated. Clementina's arms not only bury her gaze but also encircle her face, like the tiara that she so sweetly wears. Florence's left arm gestures around not only to shut her eyes with pretty fingers but also to partially complete the fragment of a curve that her left arm begins; together, her lovely round arms, crowned by the circles of her puff sleeves, give rise to the suggestion of a tender moon. Like Ophelia, Florence's head is encircled by a wreath. Like a lover, Florence's fingers twirl Clementina's tendrils. Like Dante Gabriel Rossetti's woodblock design for the frontispiece of his sister's *Goblin Market and Other Poems*, Clementina and Isabella photographically repeat the touch, the curling up of Lizzie and Laura. All fabric and skirts, curls and crowns, they nestle together, they nest together: no sight, just touch all around. Out of the picture and into the erotic circles of my own ear, I hear and feel Clementina

and Florence murmuring, whispering, repeating, reduplicating Lizzie and Laura as they softly chant all of "Goblin Market"'s 567 lines of female sexuality over and over:

> Folded in each other's wings,
> They lay in their curtained bed:
> Like two blossoms on one stem,
> Like two flakes of new-fall'n snow,
> Like two wands of ivory
> Tipped with gold for awful kings.
> Moon and stars gazed in at them,
> Wind sang to them lullaby,
> Lumbering owls forbore to fly,
> Not a bat flapped to and fro
> Round their rest:
> Cheek to cheek and breast to breast
> Locked together in one nest.[29]

[. . .]

Notes

1 My telling of these stories of female desire has been highly influenced by Mary Kelly's own storytelling in her artist's project *Interim* (New York: New Museum of Contemporary Art, 1990), especially those told in the initial portion of the project entitled "Corpus" (1984–5).

2 The topic of Hawarden's use of mirrors is the subject of Chapter 3 [in the original].

3 My understanding of women's ontological fetishism as represented through such patterns of behavior as "narcissistic displays of isolated body parts" or performing "doll-like affectations" has been informed by Emily Apter. See especially *Feminizing the Fetish* (Ithaca, NY: Cornell University Press, 1991), 104.

4 The term is Apter's and will be further elaborated in Chapter 4 [in the original].

5 Dodier, catalogue raisonné, photograph D639, has also suggested the Pandora reading of this image, emphasizing that "the shell-covered box is [also] an example of the type of handicraft which Victorian women were encouraged to take up."

6 A concertina is a small, hexagonal accordion with a bellows and buttons for keys.

7 Dodier, catalogue raisonné, photograph D224.

8 Naomi Schor, quoted in Apter, *Feminizing the Fetish*, 104. See Naomi Schor, "Female fetishism: The Case of George Sand," in *The Female Body in Western Culture*, ed. Susan Rubin Suleiman (Cambridge, Mass.: Harvard University Press, 1986), 371. Apter sees Elizabeth Grosz's conception of lesbian fetishism as a novel and important exception to the typically male-centered perceptions of female fetishism. See Grosz's "Lesbian Fetishism," in *Fetishism as Cultural Discourse. Gender, Commodity, and Vision*, ed. Emily Apter and William Pietz (Ithaca, NY: Cornell University Press, 1993), 101–15.

9 Craig Owens, "Photography *en abyme*," *October* 5 (summer 1978), has also made use of the term "reduplicate" in relationship to photography. His perspective, like mine, focuses on photography's relationship to the mirror and especially to the concept of *mise en abyme*; however, issues of sexuality are, at most, only distantly visible in his text, and with its emphasis on linguistic theory, his writing does not touch upon feminist theory, the maternal body, nor psychoanalysis. For more on Owens's important article, see Chapter 3 below [in the original].

10 All definitions are from *Webster's Seventh New Collegiate Dictionary* (Springfield, Mass.: G. & C. Merriam Co., 1963).

11 The image looks to be, according to Dodier, D392 in the Victoria and Albert Museum collection.

12 Peggy Phelan, *Unmarked* (London: Routledge, 1993).

13 See Joan Riviere's famous essay, "Womanliness as a masquerade," *International Journal of Psycho-analysis* 10 (1929): 303–13.

14 Leslie Camhi, "Stealing Femininity: Department Store Kleptomania as Sexual Disorder," *differences: A Journal of Feminist Cultural Studies* 5, no. 1 (1993): 39.

15 Rossetti, "Goblin Market," in *The Complete Poems of Christina Rossetti*, 11.

16 Ibid., 23.

17 Kirsty Gunn, *Rain* (New York: Grove Press, 1994), 79–80.

18 Melanie Pipes, unpublished essay, 1994.

19 Freud's *fort-da* story is in *Beyond the Pleasure Principle*, 14–16.

20 Luce Irigaray, "Gesture in Psychoanalysis," in *Sexes and Genealogies*, trans. Gillian C. Gill (New York: Columbia University Press, 1993), 98.

21 Dodier, "An Introduction to the Life and Work of Clementina, Viscountess Hawarden (1822–1865)."

22 Ibid.

23 Barthes, *Camera Lucida*, 81.

24 Irigaray, "Gesture in Psychoanalysis," 98.

25 Kelly, *Interim*, 55.

26 Photogen and Nycteris are characters of "light" and "dark" in George MacDonald "The Day Boy and the Night Girl" (1879), in *Victorian Fairy Tales: The Revolt of the Fairies and Elves*, ed. Jack Zipes (London: Methuen, 1987), 175–208.

27 Rossetti, "Goblin Market," 14.

28 Ibid., 16.

29 Ibid.

Donna Haraway

THE PERSISTENCE OF VISION

[I] WOULD LIKE TO PROCEED by placing metaphorical reliance on a much
maligned sensory system in feminist discourse: vision. Vision can be good for
avoiding binary oppositions. I would like to insist on the embodied nature of all vision, and
so reclaim the sensory system that has been used to signify a leap out of the marked body and
into a conquering gaze from nowhere. This is the gaze that mythically inscribes all the marked
bodies, that makes the unmarked category claim the power to see and not be seen, to repre-
sent while escaping representation. This gaze signifies the unmarked positions of Man and
White, one of the many nasty tones of the word *objectivity* to feminist ears in scientific and
technological, late industrial, militarized, racist, and male dominant societies, that is, there,
in the belly of the monster, in the United States in the late 1980s. I would like a doctrine of
embodied objectivity that accommodates paradoxical and critical feminist science projects:
feminist objectivity means quite simply *situated knowledges*.

The eyes have been used to signify a perverse capacity—honed to perfection in the history
of science tied to militarism, capitalism, colonialism, and male supremacy—to distance the
knowing subject from everybody and everything in the interests of unfettered power. The
instruments of visualization in multinationalist, postmodernist culture have compounded these
meanings of dis-embodiment. The visualizing technologies are without apparent limit; the eye
of any ordinary primate like us can be endlessly enhanced by sonography systems, magnetic
resonance imaging, artificial intelligence-linked graphic manipulation systems, scanning elec-
tron microscopes, computer-aided tomography scanners, colour-enhancement techniques,
satellite surveillance systems, home and office VDTs, cameras for every purpose from filming
the mucous membrane lining the gut cavity of a marine worm living in the vent gases on a fault
between continental plates to mapping a planetary hemisphere elsewhere in the solar system.
Vision in the technological feast becomes unregulated gluttony; all perspective gives way to
infinitely mobile vision, which no longer seems just mythically about the god-trick of seeing
everything from nowhere, but to have put the myth into ordinary practice. And like the god-
trick, this eye fucks the world to make techno-monsters. Zoe Sofoulis (1988) calls this the
cannibal-eye of masculinist, extra-terrestrial projects for excremental second birthing.

A tribute to this ideology of direct, devouring, generative, and unrestricted vision,
whose technological mediations are simultaneously celebrated and presented as utterly

transparent, the volume celebrating the 100th anniversary of the National Geographic Society closes its survey of the magazine's quest literature, effected through its amazing photography, with two juxtaposed chapters. The first is on "Space," introduced by the epigraph. "The choice is the universe—or nothing" (Bryan 1987: 352). Indeed. This chapter recounts the exploits of the space race and displays the colour-enhanced "snapshots" of the outer planets reassembled from digitalized signals transmitted across vast space to let the viewer "experience" the moment of discovery in immediate vision of the "object." These fabulous objects come to us simultaneously as indubitable recordings of what is simply there and as heroic feats of techno-scientific production. The next chapter is the twin of outer space: "Inner Space," introduced by the epigraph, "The stuff of stars has come alive" (Bryan 1987: 454). Here, the reader is brought into the realm of the infinitesimal, objectified by means of radiation outside the wave lengths that "normally" are perceived by hominid primates, i.e. the beams of lasers and scanning electron microscopes, whose signals are processed into the wonderful full-colour snapshots of defending T cells and invading viruses.

But of course that view of infinite vision is an illusion, a god-trick. I would like to suggest how our insisting metaphorically on the particularity and embodiment of all vision (though not necessarily organic embodiment and including technological mediation), and not giving in to the tempting myths of vision as a route to disembodiment and second-birthing, allows us to construct a usable, but not an innocent, doctrine of objectivity. I want a feminist writing of the body that metaphorically emphasizes vision again, because we need to reclaim that sense to find our way through all the visualizing tricks and powers of modern sciences and technologies that have transformed the objectivity debates. We need to learn in our bodies, endowed with primate color and stereoscopic vision, how to attach the objective to our theoretical and political scanners in order to name where we are and are not, in dimensions of mental and physical space we hardly know how to name. So, not so perversely, objectivity turns out to be about particular and specific embodiment, and definitely not about the false vision promising transcendence of all limits and responsibility. The moral is simple: only partial perspective promises objective vision. This is an objective vision that initiates, rather than closes off, the problem of responsibility for the generativity of all visual practices. Partial perspective can be held accountable for both its promising and its destructive monsters. All Western cultural narratives about objectivity are allegories of the ideologies of the relations of what we call mind and body, of distance and responsibility, embedded in the science question in feminism. Feminist objectivity is about limited location and situated knowledge, not about transcendence and splitting of subject and object. In this way we might become answerable for what we learn how to see.

These are lessons which I learned in part walking with my dogs and wondering how the world looks without a fovea and very few retinal cells for color vision, but with a huge neural processing and sensory area for smells. It is a lesson available from photographs of how the world looks to the compound eyes of an insect, or even from the camera eye of a spy satellite or the digitally transmitted signals of space probe-perceived differences "near" Jupiter that have been transformed into coffee-table colour photographs. The "eyes" made available in modern technological sciences shatter any idea of passive vision; these prosthetic devices show us that all eyes, including our own organic ones, are active perceptual systems, building in translations and specific *ways* of seeing, that is, ways of life. There is no unmediated photograph or passive camera obscura in scientific accounts of bodies and machines; there are only highly specific visual possibilities, each with a wonderfully detailed, active, partial way of organizing worlds. All these pictures of the world should not be allegories of infinite mobility and interchangeability, but of elaborate specificity and difference and the loving care people might take to learn how to see faithfully from another's point of view, even when the other is our own machine. That's not alienating distance; that's a *possible* allegory for feminist

versions of objectivity. Understanding how these visual systems work, technically, socially, and psychically ought to be a way of embodying feminist objectivity.

Many currents in feminism attempt to theorize on the grounds for trusting especially the vantage points of the subjugated; there is good reason to believe vision is better from below the brilliant space platforms of the powerful (Hartsock 1983; Sandoval n.d.; Harding 1986; Anzaldúa 1987). Linked to this suspicion, this chapter is an argument for situated and embodied knowledges and against various forms of unlocatable, and so irresponsible, knowledge claims. Irresponsible means unable to be called into account. There is a premium on establishing the capacity to see from the peripheries and the depths. But here lies a serious danger of romanticizing and/or appropriating the vision of the less powerful while claiming to see from their positions. To see from below is neither easily learned nor unproblematic, even if "we" "naturally" inhabit the great underground terrain of subjugated knowledges. The positionings of the subjugated are not exempt from critical re-examination, decoding, deconstruction, and interpretation; that is, from both semiological and hermeneutic modes of critical enquiry. The standpoints of the subjugated are not "innocent" positions. On the contrary, they are preferred because in principle they are least likely to allow denial of the critical and interpretative core of all knowledge. They are savvy to modes of denial through repression, forgetting, and disappearing acts—ways of being nowhere while claiming to see comprehensively. The subjugated have a decent chance to be on to the god-trick and all its dazzling—and, therefore, blinding—illuminations. "Subjugated" standpoints are preferred because they seem to promise more adequate, sustained, objective, transforming accounts of the world. But *how* to see from below is a problem requiring at least as much skill with bodies and language, with the mediations of vision, as the "highest" techno-scientific visualizations.

Such preferred positioning is as hostile to various forms of relativism as to the most explicitly totalizing versions of claims to scientific authority. But the alternative to relativism is not totalization and single vision, which is always finally the unmarked category whose power depends on systematic narrowing and obscuring. The alternative to relativism is partial, locatable, critical knowledges sustaining the possibility of webs of connections called solidarity in politics and shared conversations in epistemology. Relativism is a way of being nowhere while claiming to be everywhere equally. The "equality" of positioning is a denial of responsibility and critical enquiry. Relativism is the perfect mirror twin of totalization in the ideologies of objectivity; both deny the stakes in location, embodiment, and partial perspective; both make it impossible to see well. Relativism and totalization are both "god-tricks" promising vision from everywhere and nowhere equally and fully, common myths in rhetorics surrounding science. But it is precisely in the politics and epistemology of partial perspectives that the possibility of sustained, rational, objective enquiry rests.

So, with many other feminists, I want to argue for a doctrine and practice of objectivity, that privileges contestation, deconstruction, passionate construction, webbed connections, and hope for transformation of systems of knowledge and ways of seeing. But not just any partial perspective will do; we must be hostile to easy relativisms and holisms built out of summing and subsuming parts. "Passionate detachment" (Kuhn 1982) requires more than acknowledged and self-critical partiality. We are also bound to seek perspective from those points of view that can never be known in advance, which promise something quite extraordinary, that is, knowledge potent for constructing worlds less organized by axes of domination. In such a viewpoint, the unmarked category would *really* disappear—quite a difference from simply repeating a disappearing act. The imaginary and the rational—the visionary and objective vision—hover close together. I think Harding's plea for a successor science and for postmodern sensibilities must be read to argue that this close touch of the fantastic element of hope for transformative knowledge and the severe check and stimulus of sustained critical enquiry are jointly the ground of any believable claim to objectivity or rationality not riddled

with breathtaking denials and repressions. It is even possible to read the record of scientific revolutions in terms of this feminist doctrine of rationality and objectivity. Science has been utopian and visionary from the start; that is one reason "we" need it.

A commitment to mobile positioning and to passionate detachment is dependent on the impossibility of innocent "identity" politics and epistemologies as strategies for seeing from the standpoints of the subjugated in order to see well. One cannot "be" either a cell or molecule— or a woman, colonized person, labourer, and so on—if one intends to see and see from these positions critically. "Being" is much more problematic and contingent. Also, one cannot relocate in any possible vantage point without being accountable for that movement. Vision is *always* a question of the power to see—and perhaps of the violence implicit in our visualizing practices. With whose blood were my eyes crafted? These points also apply to testimony from the position of "oneself." We are not immediately present to ourselves. Self-knowledge requires a semiotic-material technology linking meanings and bodies. Self-identity is a bad visual system. Fusion is a bad strategy of positioning. The boys in the human sciences have called this doubt about self-presence the "death of the subject," that single ordering point of will and consciousness. That judgement seems bizarre to me. I prefer to call this generative doubt the opening of non-isomorphic subjects, agents, and territories of stories unimaginable from the vantage point of the cyclopian, self-satiated eye of the master subject. The Western eye has fundamentally been a wandering eye, a traveling lens. These peregrinations have often been violent and insistent on mirrors for a conquering self—but not always. Western feminists also *inherit* some skill in learning to participate in revisualizing worlds turned upside down in earth-transforming challenges to the views of the masters. All is not to be done from scratch.

The split and contradictory self is the one who can interrogate positionings and be accountable; the one who can construct and join rational conversations and fantastic imaginings that change history. Splitting, not being, is the privileged image for feminist epistemologies of scientific knowledge. "Splitting" in this context should be about heterogeneous multiplicities that are simultaneously necessary and incapable of being squashed into isomorphic slots or cumulative lists. This geometry pertains within and among subjects. The topography of subjectivity is multi-dimensional; so, therefore, is vision. The knowing self is partial in all its guises, never finished, whole, simply there and original; it is always constructed and stitched together imperfectly, and *therefore* able to join with another, to see together without claiming to be another. Here is the promise of objectivity: a scientific knower seeks the subject position not of identity, but of objectivity; that is, partial connection. There is no way to "be" simultaneously in all, or wholly in any, of the privileged (subjugated) positions structured by gender, race, nation, and class. And that is a short list of critical positions. The search for such a "full" and total position is the search for the fetishized perfect subject of oppositional history, sometimes appearing in feminist theory as the essentialized Third World Woman (Mohanty 1984). Subjugation is not grounds for an ontology; it might be a visual clue. Vision requires instruments of vision; an optics is a politics of positioning. Instruments of vision mediate standpoints; there is no immediate vision from the standpoints of the subjugated. Identity, including self-identity, does not produce science; critical positioning does, that is, objectivity. Only those occupying the positions of the dominators are self-identical, unmarked, disembodied, unmediated, transcendent, born again. It is unfortunately possible for the subjugated to lust for and even scramble into that subject position—and then disappear from view. Knowledge from the point of view of the unmarked is truly fantastic, distorted, and so irrational. The only position from which objectivity could not possibly be practiced and honoured is the standpoint of the master, the Man, the One God, whose eye produces, appropriates, and orders all difference. No one ever accused the God of monotheism of objectivity, only of indifference. The god-trick is self-identical, and we have mistaken that for creativity and knowledge, omniscience even.

Positioning is, therefore, the key practice grounding knowledge organized around the imagery of vision, as so much Western scientific and philosophic discourse is organized. Positioning implies responsibility for our enabling practices. It follows that politics and ethics ground struggles for the contests over what may count as rational knowledge. That is, admitted or not, politics and ethics ground struggles over knowledge projects in the exact, natural, social, and human sciences. Otherwise, rationality is simply impossible, an optical illusion projected from nowhere comprehensively. Histories of science may be powerfully told as histories of the technologies. These technologies are ways of life, social orders, practices of visualization. Technologies are skilled practices. How to see? Where to see from? What limits to vision? What to see for? Whom to see with? Who gets to have more than one point of view? Who gets blinkered? Who wears blinkers? Who interprets the visual field? What other sensory powers do we wish to cultivate besides vision? Moral and political discourse should be the paradigm of rational discourse in the imagery and technologies of vision. Sandra Harding's claim, or observation, that movements of social revolution have most contributed to improvements in science might be read as a claim about the knowledge consequences of new technologies of positioning. But I wish Harding had spent more time remembering that social and scientific revolutions have not always been liberatory, even if they have always been visionary. Perhaps this point could be captured in another phrase: the science question in the military. Struggles over what will count as rational accounts of the world are struggles over *how* to see. The terms of vision: the science question in colonialism; the science question in exterminism (Sofoulis 1988); the science question in feminism.

The issue in politically engaged attacks on various empiricisms, reductionisms, or other versions of scientific authority should not be relativism, but location. A dichotomous chart expressing this point might look like this:

universal rationality	ethnophilosophies
common language	heteroglossia
new organon	deconstruction
unified field theory	oppositional positioning
world system	local knowledges
master theory	webbed accounts

But a dichotomous chart misrepresents in a critical way the positions of embodied objectivity which I am trying to sketch. The primary distortion is the illusion of symmetry in the chart's dichotomy, making any position appear, first, simply alternative and, second, mutually exclusive. A map of tensions and resonances between the fixed ends of a charged dichotomy better represents the potent politics and epistemologies of embodied, therefore accountable, objectivity. For example, local knowledges have also to be in tension with the productive structurings that force unequal translations and exchanges—material and semiotic—within the webs of knowledge and power. Webs *can* have the property of systematicity, even of centrally structured global systems with deep filaments and tenacious tendrils into time, space, and consciousness, the dimensions of world history. Feminist accountability requires a knowledge tuned to resonance, not to dichotomy. Gender is a field of structured and structuring difference, where the tones of extreme localization, of the intimately personal and individualized body, vibrate in the same field with global high-tension emissions. Feminist embodiment, then, is not about fixed location in a reified body, female or otherwise, but about nodes in fields, inflections in orientations, and responsibility for difference in material-semiotic fields of meaning. Embodiment is significant prosthesis; objectivity cannot be about fixed vision when what counts as an object is precisely what world history turns out to be about.

How should one be positioned in order to see in this situation of tensions, resonances, transformations, resistances, and complicities? Here, primate vision is not immediately a very powerful metaphor or technology for feminist political-epistemological clarification, since it seems to present to consciousness already processed and objectified fields; things seem already fixed and distanced. But the visual metaphor allows one to go beyond fixed appearances, which are only the end products. The metaphor invites us to investigate the varied apparatuses of visual production, including the prosthetic technologies interfaced with our biological eyes and brains. And here we find highly particular machineries for processing regions of the electromagnetic spectrum into our pictures of the world. It is in the intricacies of these visualization technologies in which we are embedded that we will find metaphors and means for understanding and intervening in the patterns of objectification in the world, that is, the patterns of reality for which we must be accountable. In these metaphors, we find means for appreciating simultaneously *both* the concrete, "real" aspect and the aspect of semiosis and production in what we call scientific knowledge.

I am arguing for politics and epistemologies of location, positioning, and situating, where partiality and not universality is the condition of being heard to make rational knowledge claims. These are claims on people's lives; the view from a body, always a complex, contradictory, structuring and structured body, versus the view from above, from nowhere, from simplicity. Only the god-trick is forbidden. Here is a criterion for deciding the science question in militarism, that dream science/technology of perfect language, perfect communication, final order.

Feminism loves another science: the sciences and politics of interpretation, translation, stuttering, and the partly understood. Feminism is about the sciences of the multiple subject with (at least) double vision. Feminism is about a critical vision consequent upon a critical positioning in inhomogeneous gendered social space. Translation is always interpretative, critical, and partial. Here is a ground for conversation, rationality, and objectivity—which is power-sensitive, not pluralist, "conversation." It is not even the mythic cartoons of physics and mathematics—incorrectly caricatured in anti-science ideology as exact, hyper-simple knowledges—that have come to represent the hostile other to feminist paradigmatic models of scientific knowledge, but the dreams of the perfectly known in high-technology, permanently militarized scientific productions and positionings, the god-trick of a Star Wars paradigm of rational knowledge. So location is about vulnerability; location resists the politics of closure, finality, or, to borrow from Althusser, feminist objectivity resists "simplification in the last instance." That is because feminist embodiment resists fixation and is insatiably curious about the webs of differential positioning. There is no single feminist standpoint because our maps require too many dimensions for that metaphor to ground our visions. But the feminist standpoint theorists' goal of an epistemology and politics of engaged, accountable positioning remains eminently potent. The goal is better accounts of the world, that is, "science."

Above all, rational knowledge does not pretend to disengagement: to be from everywhere and so nowhere, to be free from interpretation, from being represented, to be fully self-contained or fully formalizable. Rational knowledge is a process of ongoing critical interpretation among "fields" of interpreters and decoders. Rational knowledge is power-sensitive conversation (King 1987):

knowledge:community::knowledge:power
hermeneutics:semiology::critical interpretation:codes.

Decoding and transcoding plus translation and criticism: all are necessary. So science becomes the paradigmatic model not of closure, but of that which is contestable and contested. Science

becomes the myth not of what escapes human agency and responsibility in a realm above the fray, but rather of accountability and responsibility for translations and solidarities linking the cacophonous visions and visionary voices that characterize the knowledges of the subjugated. A splitting of senses, a confusion of voice and sight, rather than clear and distinct ideas, become the metaphor for the ground of the rational. We seek not the knowledges ruled by phallogocentrism (nostalgia for the presence of the one true Word) and disembodied vision, but those ruled by partial sight and limited voice. We do not seek partiality for its own sake, but for the sake of the connections and unexpected openings that situated knowledges make possible. The only way to find a larger vision is to be somewhere in particular. The science question in feminism is about objectivity as positioned rationality. Its images are not the products of escape and transcendence of limits, i.e. the view from above, but the joining of partial views and halting voices into a collective subject position that promises a vision of the means of ongoing finite embodiment, of living within limits and contradictions, i.e. of views from somewhere.

References

Anzaldúa, Gloria (1987) *Borderlands/La Frontera*, San Francisco: Spinsters/Aunt Lute.

Bryan, C.D.B. (1987) *The National Geographic Society: 100 Years of Adventure and Discovery*, New York: Abrams.

Harding, Sandra (1986) *The Science Question in Feminism*, Ithaca: Cornell University Press.

Harding, Sandra and Hintikka, Merill (eds) (1983) *Discovering Reality: Feminist Perspectives on Epistemology, Metaphysics, and Philosophy of Science*, Dordrecht: Reidel.

Hartsock, Nancy (1983) "The feminist standpoint: developing the ground for a specifically feminist historical materialism," in Harding and Hintikka (eds) (1983), pp. 283–310.

King, Katie (1987) "Canons without innocence," University of California at Santa Cruz, PhD thesis.

Kuhn, Annette (1982) *Women's Pictures: Feminism and Cinema*, London: Routledge & Kegan Paul.

Mohanty, Chandra Talpade (1984) "Under western eyes: feminist scholarship and colonial discourse," *Boundary* 2, 3 (12/13): 333–58.

Sandoval, Chela (n.d.) *Yours in Struggle: Women Respond to Racism, a Report on the National Women's Studies Association*, Oakland, CA: Center for Third World Organizing.

Sofoulis, Zoe (1988) "Through the lumen: Frankenstein and the optics of re-origination," University of California at Santa Cruz, Ph.D. thesis.

Amelia Jones

THE BODY AND/IN REPRESENTATION

[In the modern age k]nowing . . . calls whatever is to account with regard to the way in which and the extent to which it lets itself be put at the disposal of representation . . . The fundamental event of the modern age is the conquest of the world as picture.

<div align="right">Martin Heidegger 1938[1]</div>

But what is the image? . . . The image speaks to us, and seems to speak intimately to us of ourselves . . . [T]he image fulfills one of its functions[,] which is to quiet, to humanize the formless nothingness pressed upon us by the indelible residue of being. The image cleanses this residue . . . and allows us to believe, dreaming in the happy dream which art too often authorizes, that, separated from the real and immediately behind it, we find, as pure pleasure and superb satisfaction, the transparent eternity of the unreal.

<div align="right">Maurice Blanchot 1955[2]</div>

The first time human beings in the history of the world saw their self image was in water. When they knelt down to pick up the water to drink in the prehistoric times, they were there.

<div align="right">Bill Viola 2003[3]</div>

HOW DOES THE IMAGE RELATE to the self? How are imaging technologies linked to ideological conceptions of seeing and knowing that, in turn, define the subject in Euro-American culture?

A beautiful young man stares longingly at his reflection in a pool of water . . . In Caravaggio's 1598–99 version of *Narcissus*, it's the gleaming skin of his protruding knee that first catches the eye—a phallic knob of flesh thrusting forth from Narcissus's groin into the center of the picture (Figure 28.1). Thrusting forth to take attention from the languorous, longing profile of the young man's head, the knee is the reversed pupil of the eye that looks (equally longingly) at the picture, at the young man, who is a visual replacement for Caravaggio himself. *Narcissus* leads to Caravaggio's *Medusa*, painted right around the same time (Figure 28.2). Her severed

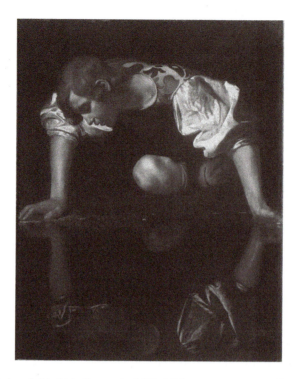

Figure 28.1 Michelangelo Merisi da Caravaggio (1571–1610), *Narcissus*. Rome, Galleria Nazionale d'Arte Antica. © 2011 Photo SCALA, Florence. Courtesy of the Ministero Beni e Att. Culturali.

head (blood gushing from the truncated neck), crown of writhing snakes (that knee, that knob, now rendered live, dangerous, petrifying), and frozen look of horror (Is *she* looking at herself in the water? Is she turning herself to stone?)—Medusa, again *as* Caravaggio (many of his early works from this period are thought to be self portraits) reifies the subject into the stone of representation. She does this with the phallic snakes that roil on her head (as if her brain has burst outward, her "mind" externalized as physical matter).

His knee, his penis, her snakes, her body-freezing dicks. Who sees? Who is a picture?

The artist, the subject, the object

Since the Renaissance art has come to be viewed and understood as the manifestation of a human subject: a situation in Euro-American culture in which even a completely abstract Jackson Pollock painting is conceived as a manifestation of Jackson Pollock. This chapter explores this trajectory of the idea of art *as* self imaging, and the complex interconnectedness of visual representation and concepts of the self in Western culture. A trajectory in which the penis (as symbolic phallus) inevitably rears its ugly head, pivotal vanishing point at the center of the picture, like an eye in reverse looking back at us; confirming the beauty of Narcissus, who is the rendering of Caravaggio (who, by most accounts, was no languid laddish beauty, but brutal in his macho self projection—at least that's the myth).[4]

It is in the European Renaissance of course that the idea of the artist, as well as the concept of the individual, emerge as such. As the nineteenth-century cultural historian Jakob Burckhardt points out in his book *The Civilization of the Renaissance in Italy*, artists of the Renaissance epitomize the "perfection of the individual" as the "all-sided man" who had

mastered a full range of intellectual and creative areas of human knowledge.[5] Burckhardt argues that Leon Battista Alberti, an architect, writer, and painter among other things, is a supreme example of the "all-sided" Renaissance man.[6] In his 1435–36 treatise *On Painting*, Alberti provided a hugely influential concrete model of visualization and painting, the terms of which came to determine the contours of modern to contemporary conceptions of the making and viewing subject in European culture. Here, Alberti describes the painter as the coherent origin of the work of art in both conceptual and literal terms. The painter (or viewing subject in general) stands at the center of an array of "visual rays," and his eye "extends its shoots rapidly and in a straight line to the plane opposite." As a painter, Alberti notes, "I inscribe a quandrangle of right angles, as large as I wish, which is considered to be an open window through which I see what I want to paint."[7] The painter thus both *sees* everything within this cone of vision and *recreates it* on the canvas, which becomes an "open window" rendering the scene in a mimetically truthful way for unmediated consumption by a receptive viewer. (Caravaggio's knee-as-vanishing point thus "becomes" our eye with its visual rays shooting into the picture; we adopt or become the phallus at the center of the projective and yet also ever-receding gaze, which nonetheless we can never fully approximate.)[8]

Alberti's artist is at the center of seeing, knowing, and making, foundational to the European "ocular epistemology" prevalent in all levels of society, from the church to the secular; for Alberti and his predecessor in developing perspectivalism, Euclid and Filippo Brunelleschi, "[s]eeing takes on the magnitude of knowing."[9] And the photographic (from early models of the camera obscura to the mechanical medium developed in the nineteenth century) comes out of this urge to see and know from a singular point of view. It is this kind of subject (centered in his individualism) which Giorgio Vasari then documented and helped reify in his 1568 book *Lives of the Artists*. Vasari's biographically based art history instantiated the tendency to think of people who painted and sculptured as individuals beyond the norm, as geniuses or subjects who transcended normal human existence through their claim to divine inspiration

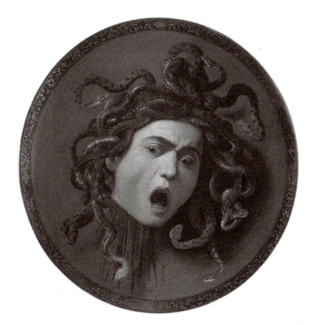

Figure 28.2 Michelangelo Merisi da Caravaggio (1571–1610), *Medusa*, detail. Galleria degli Uffizi. © 2011 Photo SCALA, Florence. Courtesy of the Ministero Beni e Att. Culturali.

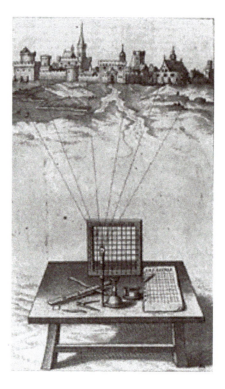

Figure 28.3 Leon Battista Alberti's "grid" or "grill" (graticola), c. 1450, Albrecht Dürer's perspectival grid, 1525 (Courtesy of the Whit Library, Courtauld Institute of Art, and Graphische Sammlung Albertina, Vienna).

(their alignment, as it were, with the ultimate making subject—god).[10] Codified by Alberti and Vasari (among others), the artist thus both epitomizes the centered individual of early modern European culture and acts as an exaggerated or special case of this individual (secured in his privileged access to visual truth through his alignment or conflation with an all-knowing god).

This confluence of beliefs and discursive articulations of the Renaissance individual points to one explanation for the rise in this early modern period of self portraiture, a genre Caravaggio already seems to mock with his self imaging as Narcissus and Medusa—a queerly self-absorbed boy and a fierce, castrating woman. Mary Garrard has noted the link between the rise of the conception of the artist as a special kind of maker linked to the divine and the genre of self portraiture in the Renaissance, noting that, with such portraits, Caravaggio broke the mold of male artists depicting themselves both as gentlemen and as a special exemplar of the human with access to transcendence. She notes that Caravaggio's *Narcissus* confirms Alberti's argument connecting painting with the divinely inspired capacity of the artist to render the truth of the world (conflating the *image* with the *self*): "What is painting but the act of embracing by means of art the surface of the pool?"[11]

Certainly, then, from the early modern period onward, the notion of the self is bound up with complex beliefs about representation, and in turn with the development of imaging technologies (among which could be counted Alberti's model positioning the painter in relation to the world and his canvas). With the rise of industrialism in the nineteenth century and the concomitant burgeoning of technologies of reproduction (photography in the early nineteenth century, then cinema and the means to reproduce images in the mass media alongside text at the end of the nineteenth century), the premium placed on the individual

artist as a source of creative genius increased. Martin Heidegger argues in his 1938 essay "The Age of the World Picture" that the modern period is characterized by the development of the "subject" as an individual at the center of knowledge, by the rise of "machine technology" (key to industrialism), and by "the event of art's moving into the purview of aesthetics" wherein "the art work becomes the object of mere subjective experience, and consequently art is considered to be an expression of human life."[12]

As Heidegger's model suggests, partly in reaction to the threat posed co the unique individual (or object) by reproductive technologies and massifying industrializing practices, the modern era is characterized by a more and more emphatic reiteration of genius and individuality up until the mid-twentieth century. This reiterative articulation of the modern subject as a unique individual—which takes the form in the art world of the artistic genius, from the Jackson Pollock of the famous 1949 *Life* magazine article asking if he was the "greatest" living artist and the 2001 Ed Harris film *Pollock* to the Pablo Picasso or Andy Warhol of a Museum of Modern Art blockbuster—can thus be viewed as a logical effect of the threat posed to the centered individual creator by technologies of representation (among other industrial developments). Modernist theory, criticism, and practice in the visual arts, tied as they have been since the nineteenth century to the developing commodity market for things of all kinds (including art and even, arguably, the artist as himself a commodity), are fundamentally caught up in this dynamic. The reiteration of the trope of the genius in modernism—almost always, until very recently, a white Euro-American man, hetereosexualized whatever his lived sexuality[13]—has everything to do, then, with the increasingly aggressive pressures placed on the belief in individualism by photographic and other technologies of production and reproduction.[14]

The paradox (as the 1949 *Life* cover story on Pollock revealed) is that it is precisely these technologies that solidify the construction of the white, heterosexual male artist as a heroic centered genius *even as they simultaneously break down this construction by producing the artist as image and thus as commodity*. Warhol's entire career pivoted around this paradox. He insistently presented and produced himself as image (and thus as queer and feminine)—issuing famous quotes such as: "If you want to know all about Andy Warhol, just look at the surface of my paintings and films and me, and there I am. There's nothing behind it"—even as the art world seemingly endlessly insists upon his coherent and original (thus firmly heterosexual and masculine) genius.[15] (And again, Caravaggio's apparent self imaging as queer boy and phallic woman seems presciently and parodically to enact the same paradox as Warhol's career and work would do centuries later.)

Psychoanalysis, not incidentally, came to being with the rise of modernism and the concomitant development of new modes of visual representation based on photographic technologies. Psychoanalysis, then, offers a historically located model for understanding how these structures of subjectification work in relation to visual images and to the visual arts and their institutions. Laura Mulvey's influential 1975 article "Visual Pleasure and Narrative Cinema" remains one of the most important attempts to articulate a contemporary visual theory based on Freudian psychoanalysis—one in this case with the specifically feminist aim of finding a means to critique or unseat the otherwise seemingly inexorable "male gaze." Per Mulvey's argument, the male gaze trapped female bodies within its purview, turning them into objects of a heterosexual, male viewing desire. As Mulvey famously notes in the essay, drawing on Freud's model of fetishism:

> In a world ordered by sexual imbalance, pleasure in looking has been split between active/male and passive/female. The determining male gaze projects its fantasy onto the female figure. In their traditional exhibitionist role women ate simultaneously looked at and displayed . . . so that they can be said to connote *to-be-looked-at-ness*.[16]

Mulvey's model could be said to rearticulate the Albertian model of the (male) artist's gaze, putting it into psychoanalytic terms in order better to critique its role in constructing sexual difference.

Mulvey's epochally influential arguments have spawned three decades of useful counter argument. For example, Joan Copjec has systematically and in a complex and nuanced way theorized structures of subjectification in relation to the visual, rejecting Mulvey's construct of a unidirectional and disembodied "male gaze" that successfully subordinates all in its path. In her 2000 essay "The Strut of Vision: Seeing's Corporeal Support," Copjec also criticizes theorists of photography and vision such as Jonathan Crary. She notes that Crary posits Alberti's crucial 1435 model of painting as a "window on the world" as exemplifying a Renaissance view (conflated with Cartesianism) of the image as being in thrall to a gaze outside it.[17] Rather than confirming the Renaissance to modern European subject as an observer in control, outside of the picture and dominating it (confirming the belief in the coherence of the individual thought to be implicit in Descartes' seventeenth-century claim "I think therefore I am"[18]), however, Copjec argues that Renaissance perspective describes a finite space bounded by its own system. The Renaissance picture is organized from within, structured by receding lines that (against intuition but in agreement with projective geometry) meet in infinity, and are *not* dominated from without by an external gaze.

I am clearly on the side of Crary in emphasizing the *ideological* force of the perspectivail logic embedded in Euro-American culture and first codified by Alberti and brought to a different level in Cartesian thought; I have noted how this logic underlies the conception of representation and, correlatively, the construction of the subject as a coherent individual "outside" the world and the picture. But Copjec offers a model for thinking the *effects* of this system differently, pointing to the always already failed aspect of this perspectivally secured subject (who is never, in fact, outside the picture at all but always, as I suggested in the Prologue, points to representation and its ideological formulations as "never enough"). I take Copjec's most important point to be her argument that Renaissance painting (arguably the paradigmatic form of Western representation, since photographic media, including cinema, are based on it) describes "not the visible world but the path of the drive to see or the drive *tout court.*"[19] Correlatively, the gaze—and the Cartesian subject in general—is not disembodied or outside the picture (as Mulvey's model, and the arguments based on it, tended to imply); and, crucially, the body *extends into and is understood as an image*—but an image understood itself, reciprocally, as embodied.

The subject in and outside of the world

This paradox is linked to one of the most profound conundrums of human existence—and one at the base of Western aesthetics (from Alberti to Kantian philosophy and beyond). Based on models such as Alberti's (which literally positions the painter at the apex of vision and then as recreating what appears in his cone of vision through perspectival rules on the canvas), Western representational structures render visible the fact that the world takes place purely in relation to the subjects within it (Alberti's viewing artist, whose senses allow him access to the world). And yet, paradoxically, the world appears to be objective—we tend to believe it exists a priori to human (subjective) perceptions of it. As Kant put it in the quotation cited in the Prologue, "[w]ithout some empirical representation to supply the material for thought, the act 'I think' would not take place."[20]

Kant attempted to resolve this dilemma in his 1790 *Critique of Judgment* by positing aesthetic judgment as a bridge between the subject and the object, the subjective and the

objective. Kant's model ultimately pivots around the idea that aesthetic judgment must be made from a position of "disinterestedness" (i.e., the object cannot have any use value or produce sensual satisfaction for the viewer—the judgment of taste is simply *contemplative* and "indifferent as to the existence of the object"), and that it is through this disinterested judgment that the gap between the object and the subject is bridged.[21]

Jacques Derrida, in his brilliant deconstructive critique of Kantian aesthetics in the 1978 book *Truth in Painting*, notes that this bridge is essentially metaphysics—that Kant must make a leap between what can be "known" through the senses (the viewer's "subjective" appreciation of the object via sight and other senses) and its essential meaning and value (its "universal" significance) only by resorting to the transcendental.[22] So the judgment of works of art, informed by Kantian aesthetics, has come to be a practice of constructing a transcendental guarantor (a divine source of meaning—god/the artist/the interpreter, as it were) to secure the judgment as truth. But, as D.N. Rodowick puts it in his summation of Derrida's arguments:

> The paradox of Kant's analysis is that his solution to the specificity of aesthetic judgments *creates* the dilemma it was designed to resolve. The very insistence on enframing—defining on one hand the self-identity of art and on the other the specificity of aesthetic judgment—is what in fact *produces* the divisions between subject and object, inside and outside, mind and nature, that the third *Critique* claims to transcend. While enclosing and protecting an interior, the frame also produces an outside with which it must communicate. If the third *Critique* is to complete its teleological movement, this externality must also be enframed—a process creating a new outside, a new necessity for enframement, and so on ad infinitum.[23]

The Kantian aesthetic, then, both provides a frame to delineate what is art and to provide it with the ultimate transcendental guarantee (the subject who knows, aligned with god) and deposits within this frame the seeds of its own destruction. For the frame both relies on and disavows the role of the judge (the interpreter) in constructing it. The aesthetic works essentially to confirm the subject *qua* subject by confirming him in his position of authority as judge of the work but this confirmation is tautological as the work relies on the subject to define it as art (again, Rodowick succinctly summarizes Derrida's arguments: "Just as the analytic of the beautiful must enframe the work of art, defining what is proper to it as an object of pure taste, what is 'proper to the subject in this experience must be exactly delimited in the conditions of aesthetic judgment"[24]).

Psychoanalysis also has its way of attempting to bridge the gap between the subjective and the objective. Copjec notes that psychoanalytic theorist Jacques Lacan (drawing on Freud) introduces a third element—that of the "*object a*" or the drive (the desire of the Other)—to describe the subject in relation to the object world.[25] This addition introduces time and the body (through desire and pleasure) into the scheme of subject formation. Crucially, then, Lacan's system willfully acknowledges the pollution of the object with the subject and vice versa, implicating the desiring (viewing) body of the subject in every image. Lacan, Copjec notes, dwells on the phenomenon of anamorphosis "to focus attention on the *impurity* of the painting's visual field insofar as it consists not only of *what the spectator sees*, but something more: the vanishing point, which is nothing other than *that which the spectator contributes to what she sees*."[26]

The "objective" world is thus always already permeated with bodily "subjectivity." And, as Copjec notes, Renaissance perspective gives the exact formula for the scopic drive and for embodied seeing—it "places the spectator *within the image*, not outside it, as Crary

contends."[27] Rather than securing us as "a spectator outside and thus transcendent to the field of vision," as Renaissance to contemporary models of vision (including, Copjec argues, Crary's model and, I would add, Mulvey's) seem to suggest or yearn for, the scopic drive immerses us in the image and as the image. At the same time, she notes, Lacan's model points to the coextensivity of the thinking self proposed by Descartes with the body or body image—there is no division between the embodied self and the image over there, nor between the mind and the body it imagines to be elsewhere (in a state of brute immanence, impervious to the mind's transcendence through thought).[28] Through such a profound interrogation the boundaries defining the human—defining the contours and ensuring the gap between people and things that sustains our conception of ourselves as discrete and contained viewing subjects (predicated on us standing "here" and seeing what is "there") even as we simultaneously attempt to leap the gap in order to "know" the thing—these boundaries begin to dissolve.

"The specter of the subject"

At this point I want to provide another way of looking at the question: Why study self imaging projects by artists, either self portrait images or technologically enhanced enactments of their bodies? The development of aesthetics in eighteenth- and nineteenth-century European philosophy marks the simultaneous death of universal belief in a transcendent guarantor (Nietzsche's death of god) and the development of a substitute system of transcendence invested in human-made objects, with their makers aligned with the missing/lost/dead god as the new guarantors of a transferable (commodifiable) kind of "transcendence." Aesthetics, then, is inexorably linked to a profound shift in the concept and understanding of human experience—of the subject's relationship to the world of things, and of a shift from the idea that the world is unknowable to the idea that the world exists to be known through human thought. As Luc Ferry has noted, aesthetics is "the field par excellence in which the problems brought about by the subjectivization of the world characteristic of modern times can be observed in the chemically pure state."[29] Following Ferry's insight, it is clear I hope that an analysis of artists' self imaging projects using the tools provided by modern and contemporary theories of human experience can tell us something profound about modern and contemporary subjectivity.

In modern and contemporary Euro-American cultures, the tension earmarked by aesthetics between subjectivity and objectivity is, as the above suggests, at the core of how humans exist in the world. Rather than the subject and object being the only elements of the structure through which the world exists (for humans), however, Copjec points out that human desire, articulated through the mind/body complex, becomes a third and most crucial component of this system. Maintaining the tension between the subjective and objective worlds rather than disavowing it by conflating the thing with the subject (the work of art with the artist; the work of art with the interpreter's reading) or keeping it radically opposed is about acknowledging the impossibly complex and uncontainable factor of desire.

The artistic projects I explore here do exactly this. Following and drawing on the insights of Lacan, Copjec, and Derrida sketched here, this book will perform interpretations of works that, I believe, retain rather than attempting to resolve or disavow this tension between the subjective and objective world—precisely by deploying the very technologies that have long served to instrumentalize the very structure of opposition built into Renaissance to modern Euro-American thought. Using technologies based on perspectival logic (most often photographically based), these artists refuse the oppositional logic they seem to entail, providing

images of the body that are *immersive* rather than safely contained, bounded, and thus potentially trapped by an external gaze. Of course, part of this dynamic will be the importance of my acknowledging my own immersion in the works, my own investment in rendering them in this way. The "internal edges" of the "passe-partout" framing the work of art, as Derrida argues in *Truth in Painting*, are often "beveled."[30] The act of interpretation (and the body and desires of she who interprets) are bound up in the process of framing and the frame, beveled, always leaks.

Enacting the subject through technology

Pipilotti Rist's work has become paradigmatic for me in this regard. She enacts bodies and subjects across and through her complex video and sound installation works, deploying complex technologies of representation (primarily digital video projection) while eschewing their tendency to instrumentalize or concretize the body as a readable and fixed sign of the subject that animates it. Rist exemplifies the potential for artists, who often work at the edges or against the grain of permissible or common ways of using technology in mass media contexts, to push technologies of visual, representation to their limits and beyond—thus to probe and even push beyond the limits of the contemporary self.

Moving myself through the galleries at the Warsaw Museum of Contemporary Art (it's 2004), I hear a jarring but hypnotic, vaguely soprano (shrieking) voice singing a short loop from a Chris Isaak pop song, "Wicked Game." I am compelled towards the source of the sound. Finding it, I am further drawn into a huge video projection image across two walls of the gallery. Pipilotti Rist's *Sip My Ocean* (1996) is about immersion, literal and figurative (Figure 28.4). It is about a woman's (the artist's) body floating through the commodity-space of the gallery, dangling provocatively before my desiring body. It is about how I "am" Pipilotti Rist (who is both the commodity object of the artwork and the ethereal origin of the work). In Copjec's and Lacan's terms, the piece is my *object a*. It instantiates my displacement, over there, as a subject (who is the object *she* desires). Rist offers herself to me, floating amniotically in a wash of blue, even as her voice surrounds me in an aural bath of misbegotten love.

If I could have Pipilotti Rist, if I could *be* Pipilotti Rist, I would be simultaneously completely free (as an object made of light) and completely situated as the phantasmagorical origin of that object's meaning and value. It is through my love of spectacle (which drew me to art history in the first place) and my over-identification with Rist as a woman almost exactly my age, my color, my body type, that I am immersed. But it is only through my "aesthetic distance" (learned through years of painful overthinking about visual images, objects, and projects) that I extricate myself from the scene. At the same time I bridge this gap by creating the bridge of aesthetic judgment Kant calls for, connecting myself to the "object" (which is also Rist's body and the space it consumes through the visual force of the video projection, drenching the wall with its limpid color and light). The paradox is enacted: I feel "in" the work, seduced by it and immersed but I have to be "outside" the image world produced by the piece in order to construct it as something I can engage that is other from myself. Through this theoretical discourse, which is my way of producing "distance" between myself and the work, I disentangle myself from the image/sound complex (which is the artist, which I want to be me). But, as Copjec's model suggests, my desire precludes my full extrication. My desire, which pollutes the "frame" I have erected to distance me from the work's immersive effects, causes me to linger within the image/body/voice (the subject [object]) that is Rist "herself."

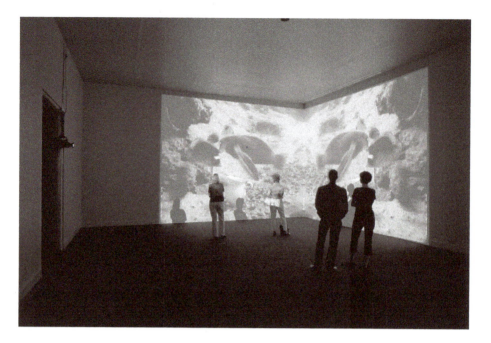

Figure 28.4 Sip My Ocean (Schlürfe meinen Ozean), 1996, audio video installation by Pipilotti Rist. Installation view at Musée des Beaux-arts de Montréal/CA. Photo by B. Merrett. Courtesy the artist and Hauser & Wirth.

Hoc est corpus meum and the gap

> A prime example given of a sign is the Eucharist and its enunciation, *hoc est corpus meum* . . . [T]he problem of the Eucharist, from a Christian perspective, is the essential problem of signification in its most general sense . . . [In the mid-eighteenth century what] was needed in effect was a formula making it possible to think the unthinkable—the idea of a perfect, pure, and transparent signifier. Such a signifier would have to be visible and material so as to articulate a signified; and at the same time invisible and immaterial in order not to obstruct the presence of the signified itself. The sign would perform actively and efficiently the ideal and perfect interchangeability of object and sign.
>
> Donald Preziosi 1989[31]

If Kantian aesthetics is about bridging the gap between the image and its referent in the "real world," between the making and the viewing subject, between the subjective and objective, then meaning-making in Euro-American culture is dominated in general by parallel systems of bridging the gap between the sign and the referent, between, the objective and the subjective. Kant's model never resolved the gap between the subjective and objective worlds except through the willful imposition of the transcendental. The virtue of the model articulated by Copjec, based on the work of Freud and Lacan, is that, while acknowledging that the gap can never be filled, it provides a way of thinking through the centrality of the body/mind complex in the object (and image) world and, correlatively, the centrality of the image to Western conceptions and experiences of the self. And it theorizes this interdependency of self and image specifically in relation to Western structures of representation, themselves built into photographic imagery. These are the crucial terms around which this book pivots.

Before delving more fully into these complex interrelations, I want to examine more closely the belief systems underlying Western conceptions of representation in relation to the self. European-based cultures conceive of representation as both collapsing and maintaining the gap between subject and object. In the Christian Eucharist, as Donald Preziosi's quotation cited above suggests, the gap is ideologically erased. In Christianity, the dominant belief system of pre-Enlightenment European societies and the dominant cultural construct defining Euro-American moral and social beliefs still, the Eucharist is based on the belief in the wafer *as* the body of Christ. As Preziosi notes, the belief runs as follows: "This really *is* Christ's body (*corpus meum*). In effect the object is assimilated to the signified; it does not really stand for or stand in for what is absent."[32]

Modern and contemporary subjects may be hard put to believe that the cracker they eat from the hand of the priest "is" the body of Christ, and yet the fantasy (of erasing the gap) lingers in newer models of signification that have become dominant in the modern and contemporary eras—based in large part on the tenets of semiotics, developed out of linguistic theory from the early twentieth century onward.[33] Semiotics, following on the above, could be said to be a secular model developed to bridge the gap between the subjective and the objective—the sign and the referent, the signifier and signified—through the interpretation of sign systems.

Traditionally, art historical interpretation—based as it is on Kantian aesthetics but also on its twentieth-century variants informed by semiotics—has functioned to bridge this gap, and to erase the vicissitudes of bodily "interestedness." This erasure of the pollution of desire and sensorial input is, arguably, motivated by the paradoxical and simultaneous desire both to reinforce and to disavow the semiotic gap between subject and object (and, correlatively, between sign and referent)—a desire that underlies post-Enlightenment Euro-American thought and, more specifically, dominant conceptions of modernism. Art history functions, precisely, to pose its interpretations as the (meaning of) the thing itself.[34] Given the tendency noted above to conflate the "thing itself" (in this case the art work) with the body/self of the artist, the importance of studying self-imaging strategies by artists should be clear—for, in most of the cases I explore here, the artists' self imaging practices by and through technologies of representation unhinge these conflations and expose the ideological motivations behind them.

Underlying this book is the belief that this *hoc est corpus meum* tendency in interpretations of the visual arts (this artwork "is" the artist) is a highly dangerous one, reinforcing as it does naïve conceptions of meaning and value as ultimately securable by an interpretive subject residing fully outside the work and untainted by its seductions. Works by artists such as Rist strategically refuse such a disavowal of the *interestedness* of interpretation, soliciting and exposing the very narcissism (identified so brilliantly by Caravaggio) that compels us to engage with visual art works in the first place. Our (over-) identification with the artist, our tendency to conflate him or her with the work, becomes complicated by the ways in which these artists either blur or exacerbate the gap between the "thing" and its "subjects" (of making and of interpretation). At this point an examination of a work that does exactly the opposite, reactively claiming the body *in* the work to be coincident with the artist *and, literally, with god,* will be instructive.

The wafer "as" Christ, the artist/filmmaker "as" god

Mel Gibson's 2003 film *The Passion of the Christ* instantiates the ongoing attempt in Euro-American visual culture simultaneously to maintain but also suspend or erase the gap in order to secure a phantasmagorically coherent subject of making and viewing. It seeks to maintain it in order to keep the world in the oppositional model of subject/object, with no interference of the

body and desire; it seeks to erase it in order to confirm the image (and its interpretations) "as" the real. It is precisely the density of contradictions put into play by this film—which ultimately labors to "prove" Christ's transcendence of the flesh and the "truth" of Gibson's fundamentalist view of the world through one of the most highly conventional and coded systems of representation available (Hollywood cinema)—that make it a useful point of discussion in understanding what is at stake in self imaging at the turn of the twentieth and twenty-first centuries.

The Passion attempts to disavow the uncertainties of the globalized world of late capitalism (where no one is sure what bodies mean or where they begin and end) by both reiterating the split between the signifier and the signified (reaffirming the existence of the referent (the white male body of Jim Caviezel as Christ)) while simultaneously asserting the collapse of the sign into the "thing itself" (Caviezel/Christ as Gibson—the author *as* god).

Gibson's film labors to accomplish this by giving the viewer the "real" body of Christ but paradoxically via the hyper-simulacral time-honored representational codes of conventional Hollywood cinema. In the twenty-first century, cinematic and other modes of visual representation have replaced the wafer as standing in for the lost object (the quintessential transcendental subject: god).

The media surrounding the release of the film celebrated its realism. In particular Christian media obsessively praised its truthfulness, and extolled Gibson's "passion," conflating the director with Christ—making the film a self-imaging practice and confirming the tendency to view the artistic genius as (a) god. Russell Hittinger and Elizabeth Lev's 2004 article "Gibson's Passion," for example, argues that the film is "the best movie ever made about Jesus Christ," implying, as Gibson himself has tended to do in interviews, that it represents the "true" Christ. They cite Gibson himself as saying he set out to "transcend language with the message through an image"—indicating Gibson's purveyance of the myth of the image as unmediated, as both real and transcendent at once—a postmodern version of the *hoc est corpus meum* explicitly confirmed by the director.[35]

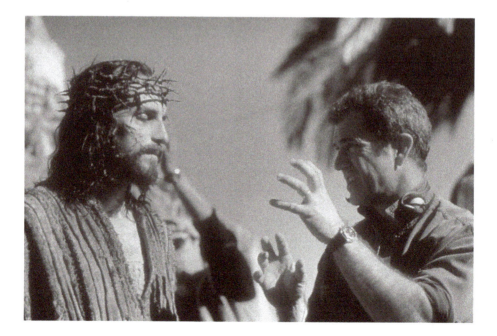

Figure 28.5 Mel Gibson directing *The Passion of the Christ*, 2004. © Icon Prod./Marquis Films/The Kobal Collection/Philippe Antonello.

Gibson's comments about the film, including those in which he stresses the importance of his own Catholic beliefs in subtending his "passionate" rendering of the "real" body of Christ (via the actor Jim Caviezel), are deeply unsettling, drawing on the long history of cinematic realism—itself based on literary and photographic codes aimed at establishing an illusionistic appearance of a "real world." Gibson's conceit is to collapse Leon Battista Alberti's 1435 theory of the painting as a picture as a window onto the world into Martin Heidegger's mid-twentieth-century notion of a commodity-obsessed age of the world picture. While the age of the world picture is characterized, as suggested earlier, by the rise of the notion of art as an expression of an individual genius who replaces the former "God" of a believing era, it is also still firmly anchored by Christian values. Heidegger thus notes:

> On the one hand, the world picture is Christianized inasmuch as the cause of the world is posited as infinite, unconditional, absolute. On the other hand, Christendom transforms Christian doctrine into a world view (the Christian world view), and in that way makes itself modern and up to date.[36]

Gibson's film epitomizes the "making modern and up to date" of the Christian world view. Siphoned through the dazzle of Hollywood special effects, camera work, and visual style, and the celebrity body of Jim Caviezel, Gibson's new fundamentalism repositions the body as The Body (of Christ), the ultimate transcendental signifier whose meaning and value, while linked to Gibson as its "creator" (who in turn gains value himself), is ultimately secured through its *hoc-est-corpus-meum* conflation with god himself. The frightening power of *The Passion* is its capacity to engender or at least provide justification for blind belief in the transcendental signifier—a power testified by the newspaper, magazine, and internet coverage and in its adoption by the American religious right as rendering the "truth" of Christianity. The paradox is complete: all is revealed (as visual truth) through the movie screen. You *will* believe in Caviezel's body, not as a secondary representation of a preexisting "referent" but as a *manifestation of the real*, a real that is itself paradoxically transcendent.

As an aside, it is fascinating to note that Gibson accomplished this in part by directing his cinematographer to mimic the world of Caravaggio's paintings—thus copying a post-Renaissance fake pictorial universe in order to create the cinematic illusion of a "real" environment. Caravaggio's hyperbolic visual style is faked cinematically in order to sustain the myth that Caviezel's body *is coincident with* that of Christ, who is himself, of course, powerful through his transcendence not because of his earthly moment of embodiment (where his body was "real")—the paradoxes, and bodies (Christ-Caravaggio-Caviezel-Gibson) accumulate.[37] Gibson, and the believers whose eyes/bodies suck up the skin of his film[38] like they are sucking up the veritable body of the man/god himself (whether of Christ or Caviezel or Gibson is unclear), seem to want to circumvent, repress, or disavow the radical shifts of the post-Renaissance period—both the unsettling recognition that god might be a production of the same desire for reassurance and recentering of the human that, arguably, motivated the development of Renaissance perspective and the photographic media it spawned, and the equally powerful tendency to attempt to replace this lost god with the modern individual (exemplified by the artistic genius).

The fact that Gibson seems bent on disavowing the death of god proclaimed over a century ago by Friedrich Nietzsche through the quintessentially modern, and representational, mode of cinema only proves the stickiness with which all these terms both contradict and yet in other ways subtend each other. Correlatively, Gibson seems to want to collapse the distinction between signifier and signified in order to return to a *premodern* fantasized time in the past when the body of Christ could be believed to transcend signification itself. One could argue that there is no gap between signifier and signified for Gibson

because he wants Caviezel/Christ, and by extension himself, to be secured as the unquestionable origins of meaning and value, not because he is acknowledging the postmodern dissolution of the possibility of believing in a dichotomous and reassuringly fixed semiotic model of representation. Gibson's film, rather, seeks to reassure. The film points to the dangerous confluence of premodern with twenty-first-century fundamentalist belief systems, as well as the parallel between the latter belief system and the uncertainties unleashed by global capitalism and enacted in postmodern culture.

Postmodernism and the gap

Postmodern theorists such as Guy Debord and Jean Baudrillard in the 1960s, 1970s, and 1980s provided a particular model to explain the demise of the early modern to modern system of signification, where the gap between sign and referent is sustained (and, we have seen, simultaneously disavowed). They noted its replacement by a society of the spectacle in which:

> the scene and the mirror no longer exist; instead, there is a screen and network. In place of the reflexive transcendence of mirror and scene, there is a non-reflecting surface, an immanent surface where operations unfold—the smooth operational surface of communication.[39]

By the accounts of such theories, the core defining feature of postmodernism is precisely the collapse of the gap between signifier and signified into a frenzy of simulation in which the slippage of the signifier precludes any fixing of meaning.[40] Furthermore, if, as Debord and Baudrillard argued, postmodernism, appeared to entail a loss of the referent (what people were accustomed to view as the "real"), since the explosion of computer culture in the 1980s and following, an even more radical model of signification (or its disappearance as we know it) has emerged. In a 1996 essay entitled "Disneyworld Company," Baudrillard notes:

> [W]e are no longer in a society of spectacle, which itself has become a spectacular concept. It is no longer the contagion of spectacle that alters reality, but rather the contagion of virtuality that erases the spectacle . . . We are no longer alienated and passive spectators but interactive extras [*figurants interactifs*]; we are the meek lyophilized members of this huge "reality show" [of Disneyworld]. It is no longer a spectacular logic of alienation but a spectral logic of disincarnation; no longer a fantastic logic of diversion, but a corpuscular logic of transfusion and transubstantiation of all our cells; an enterprise of radical deterrence of the world from the inside and no longer from outside, similar to the quasi-nostalgic universe of capitalistic reality today. Being an extra [*figurant*] in virtual reality is no longer being an actor or a spectator. It is to be out of the scene [*hors-scène*]; to be obscene.[41]

Notably, Baudrillard proposes that postmodernism is defined by the loss of the referent but also insists that this includes the loss of the body as such. It will probably already be clear that I intend to counter this common tendency, promoted most aggressively by Baudrillard himself, to posit an end to embodiment and materiality as the key effect of postmodern culture. In fact, I would argue that the idea of the body as a referent among others is continuous with the modernist logic of differential signification outlined above and explored in the Prologue. Baudrillard's erasure of the body reiterates modernism's erasure of the body—as that which entails a subject who desires (and thus pollutes the oppositional logic of semiotics). Again, it is

the *never enough*—the tendency of the body when rendered representationally through technologies of visual imaging to exceed oppositional models of signification—that is of interest to me here.

To counter Baudrillard's rather simplistic framework, it is worth noting (per Copjec's arguments) that even Disneyworld exists in and through human desire, as engaged through the body, itself as coextensive with the mind and emotions (with, that is, the self). Technotheorist Lev Manovich offers a usefully nuanced reading of the effects of new media culture on our understanding of how representation and signification work, a reading that opens back into an appreciation of the role of the *incarnated* subject in apprehending the vast networked worlds of contemporary visual cultures. Manovich stresses first that in the digital era,

> signs themselves now exist as digital data, which makes their transmission and manipulation even easier . . . computer representation makes every image inherently mutable—creating signs that are no longer just mobile but also forever modifiable . . . [I]n contrast to photography and film, electronic telecommunication can function as two way communication.[42]

In differentiating this new mode of information transfer from older photographic modes, Manovich notes that analogue photographs (such as Bayard's self portrait discussed earlier) take their meaning through spatial *distance*, a gap (again) between the subject/viewer and the object/other (we see Bayard there but "know" that he "existed" in another space and time, as indexically "proven" by the analogue photographic image). This distance "allows the subject to treat the Other as object; in short, it makes objectification possible."[43] Manovich then goes on to point to the potential of new modes of communication and representation (loosely speaking, digital and computer-aided) to work differently, to refuse this distance that is objectifying, but *without disavowing the inexorable gap that haunts the human relationship to the world of things.* This tenuous and always shifting, but never fully disavowed or erased gap in very recent culture, dominated by digital modes of representation, is another way of understanding the "never enough."

New modes of communication, which no longer function via a simple signifier/signified opposition (since in digital culture, as Manovich points out, we can no longer be assured of a preexisting referent to which the signified can pretend to be attached, and the signifiers can be endlessly mutated according to random or intentional interference) do not, however, just do away with the oppositional structures behind Renaissance-to-modern conceptions of how signification works. It should be clear from the above discussion, at any rate, how tenacious such structures are both *ideologically* and otherwise in discourses and institutions from art history to postmodern theory to the art gallery and the university.

Vivian Sobchack and Laura U. Marks have, like Manovich, explored the potential of film and other new media to open out new modes of subjectivity that are resolutely embodied. Drawing on Heidegger's notion of modernism as the age of the world picture, Sobchack notes that in this regime "our bodies become increasingly distanced in images, increasingly viewed as 'resources,' and increasingly lived as 'things' to be seen, managed, and mastered."[44] The tendency in late capitalist culture is for our bodies to become objects and commodities. Drawing on Maurice Merleau-Ponty's phenomenological model of the body/space continuum, Sobchack argues, in contrast, that we must resist this mode of thinking (which, in fact, as Heidegger's arguments make clear, rests on precisely the same visual model of subjectification we have seen develop from the Renaissance—refined and perfected in modernism). We must resist thinking, as Baudrillard does, of the body as an object. We must avoid seeing the body as:

objectively posited and perceived from the vantage of an "other" [and shift] to also *feeling* what it is to be "my" body as it is lived and perceived by me from my side of it . . . [This rethinking must] inform critical thought with a phenomenological understanding of "the" body that includes and resonates with "our" own bodies . . . [O]ur bodies are lived and make meaning in ways that include but far exceed the particular sense and image-making capacities of vision.[45]

Finally, as Sobchack notes in the quotation cited earlier, "even the most ordinary images find their value, their substance, their impetus, in the agency and investments of our flesh."[46]

In her two books *Skin of the Film: Intercultural Cinema, Embodiment, and the Senses* and *Touch: Sensuous Theory and Multisensory Media*, Laura U. Marks draws on the work of Sobchack and others to offer a complementary analysis of the subject/object relations put into play in contemporary cinematic, new media projects.[47] Marks proposes a model of *haptic visuality*, where the screen image is apprehended through a synaesthetic visual encounter involving touch, smell, and other aspects of embodiment; haptic visuality is counterposed to optic visuality (the latter defined in relation to the Albertian-Cartesian-Kantian-modernist notion of vision as disembodied and so "cleansed" of the vicissitudes of desire).[48]

In this way, of course, Marks's model counters the Kantian notion of the "disinterested" aesthetic encounter, supposedly disembodied and purged of sensory static. Through her arguments linking haptic visuality to subjectification, Marks returns us to Copjec's points but through the specific register of new media signification. Optic visuality is motivated by the subject's fear of loss and functions to shore up the subject's power by attempting to resuscitate his wholeness (optic visuality lies behind the Mulveyan notion of the male gaze, a strong explanatory model for how this system functions to disavow the fear of castration or death put into play by representation).[49] Rather than thus disavowing this fear, haptic visuality, in contrast, implies the acknowledgment of the inevitability of castration/death. Haptic visuality celebrates the immersion of the subject into the object via desire. As Marks concludes, "[w]hat is erotic about haptic visuality, then, may be described as a respect of difference, and concomitant loss of self, in the presence of the other . . . [a] giving-over to the other,"[50]

Given these complexities, it becomes clear that Gibson's film promotes the most dangerous kind of ideological occlusion. These arguments point to the crucial importance of delineating the difference between the kind of collapse of distance in Gibson's film (a collapse that ultimately returns a transcendental signifier/referent to secure the picture) and the kind noted and explored by many scholars or practitioners of new technologies of representation or new media as potentially liberatory or at least dislocating of previous modes of centralized imperial power. These new ways of thinking and making propose an embrace of a kind of representation that both maintains the body as a locus of subjective meaning, interpretation, and cultural experience and engagement and takes place without the guarantee of a transcendental signifier, and without the firm boundaries between sign and referent. Without this guarantee and without these boundaries, centralized power is no longer possible in its modern (totalitarian) formulations—although of course other modes of power, perhaps more dangerous for their insidious diffusion across networks of exchange, are certainly still operative. While acknowledging the latter potential, I will argue for the embrace of the loss of boundaries, as having radical political potential, through the artistic projects I examine here.

My arguments in this book, then, will be as complex as the contradictions I examine. I will look at works by artists such as Pipilotti Rist to explote the ways in which they open up rather than disavow the collapse of semiotic models of meaning and Renaissance to modern conceptions of the subject as implicitly disembodied, standing in one empowered place legislating meaning, freed from the messy vicissitudes of desire. Such works point to the way

in which the digital era's radical unhinging of the signifier/signified dichotomy, linked to its unhinging of the subject/object dichotomy subtending aesthetics, can make us rethink who we are and why rather than precipitate (as with Gibson) an attempt to resecure a transcendental signifier (the body of Christ as it were) at the core of signification.

We cannot ignore what we used to call the referent—in images representing subjects, the referent being the body that pollutes the subject/object relations that Kant attempted to purify. But at the same time we cannot rely on this referent to be coincident with a "real" or "live" body that secures a stable, coherent, or even recognizable self (so much I have personally learned from my long-term engagement with live performance). The works I explore here produce the body-as-referent precisely as a means of destroying the objective stability implied by the semiotic notion of the term.

What I am suggesting is that we have the choice to refuse to stand at the apex of the cone of vision offered us by Gibson's film—that same apex claimed by Alberti five centuries ago—instead pressing our wet, pulsating, smelly bodies against the clinically ungiving screen in an orgy of refusal. Or, downloading the film to our laptops, we could press hands hot against the smooth plastic and metal mouse, warping and mutating the surfaces of the images' container (the pixels through which the bodies in the film are rendered across the computer screen)—violently dislocating the surfaces of Caviezel's/Christ's/Gibson's suffering body by interactively thrusting our bodies into the picture.

Rather than an instrumentalized and instrumentalizing "world picture," then, the visual representation of the body (as in Rist's work) becomes the *never enough* of lived experience.

Sipping My Ocean, **again**

> The screen is a magic lamp. The machine throws pictures at us that we recognize from behind our eyelids: pictures from the moments in our unconscious when we are half-awake, euphoric, nostalgic or nervous. Through formal manipulation (colour-staining, digital distortion, layered perforation) and hyper-speed we lure the subconscious out of the machines and hold a mirror to our own subconscious.
>
> Pipilotti Rist 1993[51]

Returning to Pipilotti Rist's work—which, as the quotation here suggests, exists in a confluence of image, screen, space, sound, body—I experience it as epitomizing the kind of keeping in play of the tension between subject and object (by the invocation of desire) in which I am most interested. Rist refuses the tendency of photographic media to reduce bodies to consumable and exchangeable things, the tendency Heidegger noted as central to the construction of the world as a picture, to be dominated and consumed by the "subject" anchored over here. Her work puts into play the new relations of signification produced by the emergence of digital representation—wherein the signifier is no longer a stable (or semi-stable) mark that refers to something in the real world; wherein what we *see* on the screen may have no relation to anything outside of its own constituent components (pixels). At the same time, Rist's work also insistently includes the body (both her own, that of other women, and that of the spectator of her work) and so points to the *never enough* of representation in relation to embodied experience. Rist's images are not things and yet they are "of" things (including people), which they project onto things and spaces. As such, I experience through them the thingness of myself, and yet simultaneously my inescapable mindfulness (for how else, other than through my embodied senses, which transmit meaning through the circuits that ultimately comprise my thought processes, could I comprehend them?).

Figure 28.6 Sip My Ocean (Schlürfe meinen Ozean), 1996, installation by Pipilotti Rist (video still). With 2 projections reflected in the corner of the room, 1 player, 1 audio system, sound written by Chris Isaak interpreted/covered by Anders Guggisberg & P. Rist. Courtesy the artist and Hauser & Wirth.

The questions I want to ask in this book, then, via projects such as Rist's, have to do with what new kinds of subjects/objects are produced by global capitalist image culture. In order even to begin to do this, however, I have to engage with earlier moments in the dialectical rhythm established between imaging technologies, aesthetics, and conceptions of the self (moments such as 1840, with Bayard in his self-annihilating self portrait). Bayard seems to have intuited very early on the annihilating power of the photographic image—the way in which, through its very drive to sustain the presence of the body/self, it kills it (Christian Metz notes, the photographic take is "immediate and definitive, like death . . . [It] is a cut inside the referent").[52] Rist, working in a vastly different moment, embraces the death of imaging in order to body forth the life of the subject through desire. It is *only* through embodied desire, after all, that our relation with the world (of people and things) is sustained.

Artists tend to push at the seams of these apparent contradictions, getting *inside the image* in order to keep these various tensions (the image versus the thing itself; the subject consti-tuted by culture versus the subject constituting culture) in place. The image of the artist tells us precisely that, while we now (in our late capitalist postmodern era) "know" that every-thing is a simulacrum, an image, a representation (and thus, per Heidegger, circulable as a commodity), we also "know" that this simulacral world always leaks. Something always escapes the image (the image is, again, *never enough* to contain the bodies it renders). The voice of Rist, singing Isaak's song badly, wafts through the spaces of the gallery to remind us that subjects continue to take up space, to suffer, to think, to experience even the visual register in a synaesthetic way (*I hear* Rist's saturated colors even as I *see* her voice screeching the words to Isaak's song; I smell the whir of the projector, as well as the body of the spectator standing next to me). Subjects continue to be objects. Of desire.

Notes

1 Heidegger, "The Age of the World Picture" (1938), in *The Question Concerning Technology and Other Essays*, trans. William Lovitt (New York: Harper & Row, 1977), 132, 134.

2 Blanchot, "The Two Versions of the Imaginary," *The Space of Literature*, trans. Ann Smock (Lincoln, NE, and London: University of Nebraska Press, 1982), 254–55.

3 Viola in "Interview mit Bill Viola über seine neue Installation *Five Angels for the Millennium*" im Gasometer Oberhausen im Centro, April 22, 2003. This interview was published in the online journal *Kultural Extra* (October 2004), at: http://www.kultura-extra.de/compuart/portrait/bill_viola_interview.html. The English version here is from the translation published online at: http://www.5angels.net/presse/pressemappe.htm. I am grateful to Juan Jimenez, whose unpublished work on Viola introduced this quotation to me.

4 Derek Jarman's 1986 film *Caravaggio* certainly portrays the artist in these mythical terms while also providing a critical matrix through which to interrogate them.

5 Burckhardt, *Civilization of the Renaissance in Italy* (1860), trans. S.G.C. Middlemore (New York: Harper & Row, 1958), 147.

6 See ibid., 148–49; and Alberti, *On Painting* (1435–36), trans. John R. Spencer (New Haven: Yale University Press, 1979).

7 Alberti, *On Painting*, 46, 56.

8 On the history of the "cone of vision" idea and its roots in Euclid's *Optics*, see Victor Burgin "Geometry and Abjection," in V. Burgin, *In/Different Spaces: Place and Memory in Visual Culture* (Berkeley: University of California Press, 1996), 39–56.

9 Suren Lalvani uses the term "ocular epistemology" and uses this formulation of seeing as knowing in his *Photography, Vision, and the Production of Modern Bodies* (Albany: State University of New York Press, 1996), 1, 7. He also notes the importance of (as common myth has it at least) Filippo Brunelleschi's 1425 model of perspective to European models of perspectivism such as Alberti's, and discusses the development of the mechanical camera out of the camera obscura; see 3–4, 9–16.

10 In the Preface to Part One of the *Lives*, for example, Vasari notes how "heaven" guided the Tuscans to return to "pristine forms" in the thirteenth century; reprinted in Eric Fernie (ed.), *Art History and Its Methods* (London: Phaidon, 1995), 32. On this point see also Griselda Pollock and Rozsika Parker, "God's Little Artist," in R. Parker and G. Pollock, *Old Mistresses: Women, Art, and Ideology* (New York: Pantheon, 1981), 82–113.

11 Mary D. Garrard, *Artemisia Gentileschi: The Image of the Female Hero in Italian Baroque Art* (Princeton, NJ: Princeton University Press, 1992), especially 353ff; this quote on 365.

12 Martin Heidegger, "The Age of the World Picture," 116.

13 *Pace* the artworld's tendency to heterosexualize Caravaggio or, even more ironically, Andy Warhol. On the artist as commodity see my essay "The Contemporary Artist as Commodity Fetish," in Henry Rogers (ed.), *Art Becomes You* (Birmingham: forthcoming).

14 Heidegger discusses the philosophical aspects of this confluence, and the modern formation of the 'subject' per se in "The Age of the World Picture;" see 128.

15 This often cited Warhol quotation was placed at the opening of the Tate Modern's website advertising their version of the 2002 Warhol retrospective, which originated at the Museum of Contemporary Art, Los Angeles. My reading of Warhol here is informed by the excellent critiques pointing out this exhibition's egregious erasure of Warhol's sexuality written by Robert Summers, Jennifer Doyle, and Tom Folland (only the latter of which was published, as "Canadian Art International: Andy Warhol Takes LA," in *Canadian Art* (Winter 2002); available online at: http://www.canadianart.ca/articles/Articles_Details.cfm?Ref_num=86.

16 Mulvey's article was first published in *Screen* and is reprinted in Amelia Jones (ed.) *Feminism and Visual Culture Reader* (New York and London: Routledge, 2003), 47–48.

17 Joan Copjec, "The Strut of Vision: Seeing's Corporeal Support," in Carolyn Bailey Gill (ed.) *Time and the Image* (Manchester: University of Manchester Press, 2000), 35–47. Copjec is referring to the influential historical and theoretical accounts of the rise of the photographic out of a history of perspectivism in Crary's important book *Techniques of the Observer: On Vision and Modernity in the Nineteenth Century* (London and Cambridge, MA: MIT Press, 1990), see especially 47.

18 In his 1637 Discourse 4; see René Descartes, *Discourse on Method* and *The Meditations*, trans. F.E. Sutcliffe (Harmondsworth: Penguin, 1968), 54.

19 Copjec, "The Strut of Vision," 43.

20 From Kant, *Critique of Pure Reason* 1781; (London: Macmillan, 1929), 169, 378 [B158]); cited and translation modified by Alexander García Düttmann, "Lifeline and Self Portrait," trans. Humphrey Bower, *Time and the Image*, 23–24.

21 See Kant, *The Critique of Judgment*, trans. James Creed Meredith (Whitefish, Mont.: Kessinger Publishing, [2006?]), 34. Heidegger points out that the very concept of the subject anchoring such models of negotiating the gap is a particularly modern (eighteenth-century and following) formulation: "The interweaving of these two events, which for the modern age is decisive—that the world is transformed into picture and man into *subiectum* [the subject as that-which-lies-before]—throws light at the same time on the grounding event of modern history . . . [T]he more extensively and the more effectually the world stands at man's disposal as conquered, and the more objectively the object appears, all the more subjectively, i.e., the more importunately, does *the subiectum* rise up . . ." In "The Age of the World Picture," 133.

22 See Derrida, *Truth in Painting* (1978), trans. Geoff Bennington and Ian McLeod (Chicago: Chicago University Press, 1987), especially "The Parergon," 37–82.

23 D.N. Rodowick, "Impure Mimesis, or the Ends of the Aesthetic," in Peter Brunette and David Wills (eds), *Deconstruction and the Visual Arts: Art, Media, Architecture* (Cambridge, UK, and New York: Cambridge University Press, 1994), 98–99.

24 Ibid., 100.

25 Copjec, "The Strut of Vision," 44–45.

26 Ibid., 39.

27 Ibid.

28 Ibid., 43.

29 Luc Ferry, *Homo Aestheticus: The Invention of Taste in the Democratic Age* (1990), trans. Robert de Loaiza (Chicago and London: University of Chicago Press, 1993), 3.

30 Derrida, *Truth in Painting*, 13.

31 Preziosi, *Rethinking Art History: Meditations on a Coy Science* (New Haven: Yale University Press, 1989), 103.

32 Ibid.

33 For an excellent history and theory of semiotics see Kaja Silverman, *The Subject of Semiotics* (New York: Oxford University Press, 1983).

34 Preziosi argues this point extensively and convincingly in *Rethinking Art History*; see note 31.

35 See Russell Hittinger and Elizabeth Lev, "Gibson's Passion," *First Things: The Journal of Religion, Culture, and Public Life* (2004), Copyright 2004 First Things 141 (March 2004): 7–10; available online at: http://www.firstthings.com/ftissues/ft0403/opinion/hittingetlev.html. Ironically, showing how tenuous the political alignments are in relation to such cultural representations, one of the reviews of the film in the Christian media criticizes it for its classical cinematic realism, calling it "religion as *Lethal Weapon*"; see Sevak Gulbekian, "Catholic Realism," March 28, 2004; at: http://www.thetruthseeker.co.uk/article.asp?ID=1649.

36 Heidegger, "The Age of the World Picture," 117.

37 Gibson's cinematographer was Caleb Deschanel. On Gibson's fascination with Caravaggio, see Holly McClure, "First Person: Mel Gibson's 'Passion' for Jesus," *Baptist News* (Feb 24, 2003), available at http://www.sbcbaptistpress.org; Gibson states directly his simplistic belief in the real in his discussion of Caravaggio: "The only reason anyone knows anything about this guy is from prison records . . . But I think his work is beautiful. I mean it's violent, it's dark, it's spiritual and it also has an odd whimsy or strangeness to it. And it's so real looking. I told Caleb I wanted my movie to look like that and he said, 'Yeah, OK.' " That Gibson would view Caravaggio's exaggerated compositions and theatrical narratives as realistic (not to mention his dismissal of art historical accounts of the artist!) is telling in itself. The ideological dangers of Gibson's approach are exposed in the article discussing the contradiction of Gibson's fascination with this "bisexual pervert," Caravaggio, in the deeply disturbing, homophobic rant "Caravaggio: The Evil-Doer Whose Work Inspired *The Passion*;" at: http://www.cryingvoice.com/Gibson_film4.html (unauthored; created April 29, 2004).

38 This is a reference to Laura U. Marks's book *The Skin of the Film: Intercultural Cinema, Embodiment, and the Senses* (Durham, NC: Duke University Press, 2000), which I will discuss at greater length below.

39 The "Society of the Spectacle" refers of course to Guy Debord's epochal book by that title, published in 1967, and available now online in a 2002 translation by Ken Knabb at: http://www.bopsecrets. otg/SI/debord/. The quotation here is Jean Baudrillard, "The Ecstasy of Communication," trans. John Johnston, in Hal Foster (ed.), *The Anti-Aesthetic: Essays on Postmodern Culture*, (Seattle: Bay Press, 1983), 126–27.

40 Largely these ideas are underpinned in their popular understanding by a much removed oversimplification of the theories of Continental philosophers working in the post-1960 period, most impor-

tantly those of Roland Barthes and Jacques Derrida. Barthes's notion of the death of the author and Derrida's notions of *significance* and *différance* may seem at a glance to describe the "death" of meaning and the subject but, as Derrida himself put it, "the death of the writer and/or the disappearance of the objects he was able to describe—does not prevent a text from 'meaning' something. On the contrary, this possibility gives birth to meaning as such, gives it out to be heard and read." Derrida, "Speech and Phenomena: Introduction to the Problem of Signs in Husserl's Phenomenology," in *Speech and Phenomena and Other Essays on Husserl's Theory of Signs*, trans. David Allison (Evanston, IL: Northwestern University Press, 1973), 93.

41 Baudrillard, "Disneyworld Company," originally published in *Liberation* (4 March, 1996), available in translation by François Debrix in *CTheory.Net* at: http://www.ctheory.net/articles.aspx?id=158.

42 Lev Manovich, *The Language of New Media* (Cambridge, MA, and London: MIT Press, 2001), 174.

43 Ibid.

44 Vivian Sobchack, " 'Is Any Body Home?': Embodied Imagination and Visible Evictions," in Hamid Naficy (ed.), *Home, Exile, Homeland: Film, Media, and the Politics of Place* (London and New York: Routledge, 1998), 6.

45 Ibid., 12.

46 Ibid., 25.

47 Marks, *The Skin of the Film* and *Touch: Sensuous Theory and Multisensory Media* (Minneapolis: University of Minnesota Press, 2002).

48 Sobchack also promotes an idea of synaesthetic vision in her book *The Address of the Eye: A Phenomenology of Film Experience* (Princeton, NJ: Princeton University Press, 1992), 77–78; as does Mieke Bal, who argues that "vision is itself inherently synaesthetic" in her essay, "Visual Essentialism and the Object of Visual Culture," *Journal of Visual Culture*, vol. 2, no. 1 (2003), 9.

49 As Mulvey writes, "the female figure [in the filmic representation] connotes something that the look continually circles around but disavows: her lack of penis, implying a threat of castration and hence unpleasure . . . The male unconscious has two avenues of escape from this castration anxiety," one of which paradoxically involves invoking precisely the represented figure that caused the anxiety in the first place, turning the woman's body into a fetish through representation "so that it becomes reassuring rather than dangerous." Mulvey, "Visual Pleasure and Narrative Cinema," 49.

50 Marks, *Skin of the Film*, 191, 192–93.

51 Rist, "Preface to *Nam June Paik: Jardin Illuminé*" (1993), reprinted in Peggy Phelan, Hans Ulrich Obrist, Elisabeth Bronfen, *Pipilotti Rist* (London: Phaidon, 2001), 133.

52 Christian Metz, "Photography and Fetish," *October* 34 (Fall 1985), 84.

Henry John Drewal

FOREVER MODERN: MAMI WATA VISUAL CULTURE AND HISTORY IN AFRICA

Mammy-wota . . . You can always tell them, because they are beautiful with a beauty that is too perfect and too cold.

Chinua Achebe (1972, 43)

EVERY CHILD SWIMS IN ITS MOTHER'S womb before taking a first breath of air. In this sense and in others "water is life." In Africa and the African Atlantic world, people recognize the essential and sacred nature of water by honoring and celebrating a host of water spirits. The identities of these divinities, however, are as slippery and amorphous as water itself. Only the frames of history, art, and culture can contain them, giving them shape, contour, substance, and specificity. Yet even these frames are subject to change, and when they undergo a metamorphosis, so do the attributes, personalities, identities, and actions of these fascinating and ambiguous spirits.

Mami Wata, often portrayed with the head and torso of a woman and the tail of a fish, is at once beautiful, jealous, generous, seductive, and potentially deadly. A water spirit widely known across Africa and the African diaspora, her origins are said to lie "overseas," although she has been thoroughly incorporated into local beliefs and practices. Her powerful and pervasive presence results from a number of factors. Of special note, she can bring good fortune in the form of money, and as a "capitalist" par excellence, her power increased between the fifteenth and the twentieth centuries, the era of growing international trade between Africa and the rest of the world.

Mami Wata's very name, which may be translated as "Mother Water" or "Mistress Water," is pidgin English, a language developed to lubricate trade. The countless millions of Africans who were torn from their homeland and forcibly carried across the Atlantic between the sixteenth and nineteenth centuries as part of this "trade" brought with them their beliefs and practices honoring Mami Wata and other ancestral deities. They reestablished, revisualized, and revitalized these spirits and deities, who often assumed new guises: Lasirèn, Watra Mama, Maman de l'Eau, or Mae d'Agua. Subsequently, these faiths flourished. Worshippers of Mami Wata and other water divinities have typically selected local as well as global images, arts, ideas, and actions; interpreted them according to indigenous precepts; invested them

with new meanings; and then re-presented them in novel and dynamic ways to serve their own specific aesthetic, devotional, social, economic, and political aspirations.

Mami's powers, however, extend far beyond economic gain. Although for some she bestows good fortune and status through monetary wealth, for others, she aids in concerns related to procreation—infertility, impotence, or infant mortality. Some are drawn to her as an irresistible seductive presence who offers the pleasures and powers that accompany devotion to a spiritual force. Yet she also represents danger, for a liaison with Mami Wata often requires a substantial sacrifice, such as the life of a family member or celibacy in the realm of mortals. Despite this, she is capable of helping women and men negotiate their sexual desires and preferences. Mami also provides a spiritual and professional avenue for women to become powerful priestesses and healers of both psycho-spiritual and physical ailments and to assert female agency in generally male-dominated societies. Rapid socioeconomic changes and the pressures of trying to survive in burgeoning African urban centers have increased the need for the curative powers of Mami Wata priestesses and priests.

Half-fish and half-human, Mami Wata straddles earth and water, culture and nature. She may also take the form of a snake charmer, sometimes in combination with her mermaid attributes and sometimes separate from them (see below). And as if this formidable water spirit weren't complicated enough in her "singular" manifestation, the existence of *mami watas* and *papi watas* must also be acknowledged. They comprise a vast and uncountable "school" of indigenous African water spirits (female and male) that have specific local names and distinctive personalities. These are honored in complex systems of beliefs and practices that may or may not be shared with the water spirit Mami Wata.

An Efik sculpture portraying Mami Wata as a human-fish-goat-priestess handling a bird and a snake demonstrates her hybridity and powers of transformation. She can also easily assume aspects of a Hindu god or goddess without sacrificing her identity. She is a complex multivocal, multifocal symbol with so many resonances that she feeds the imagination, generating, rather than limiting, meanings and significances: nurturing mother; sexy mama; provider of riches; healer of physical and spiritual ills; embodiment of dangers and desires, risks and challenges, dreams and aspirations, fears and forebodings. People are attracted to the seemingly limitless possibilities she represents, and at the same time, they are frightened by her destructive potential. She inspires a vast array of emotions, attitudes, and actions among those who worship her, those who fear her, those who study her, and those who create works of art about her. What the Yoruba peoples say about their culture is also applicable to the histories and significances of Mami Wata: she is like a "river that never rests."

The mermaid: arrival of a European water spirit image in Africa

Mermaids, and to a lesser extent mermen, have populated the human imagination for millennia. Some of the earliest have their origins in the fertile river valleys of Mesopotamia (e.g. the merman spirit of River Urat, circa 900 BC, in the Museum of Ethnology, Berlin-Dahlem), Africa's Nile Valley, and later the Mediterranean world of the Phoenicians, Minoans, Greeks, and Romans. For the Greeks and Romans, mermaids—like the part-bird, part-human sirens—symbolized danger. In Christian Europe of the Middle Ages, the mermaid entered bestiaries and other arts in the twelfth and thirteenth centuries where she usually appeared in a strongly moralizing context as a symbol of vanity, immorality, seduction, and danger (see Hassig 1999).

By the fifteenth century, when Europeans began to explore beyond Mediterranean waters, they carried with them images of mythic creatures—dragons, griffins, unicorns, centaurs, and especially the mermaid. These images assumed different forms within the

material culture of sailors, merchants, and explorers and might appear as book illustrations, prints, playing cards, flags and other heraldic devices, trademarks (like the mermaids and mermen on Dutch clay pipes traded in many parts of Africa since the seventeenth century), watermarks, and perhaps tattoos. Songs, dances, games, and the playing of musical instruments may also have made direct reference to sirens or mermaids. European belief in the existence of such creatures is confirmed by the fact that in January of 1493 Christopher Columbus recorded the sighting of three mermaids off the coast of Haiti, then known as Hispaniola. He wrote that they "came quite high out of the water" but were "not so beautiful as painted, though to some extent they have the form of a human face" (Columbus [1493] 2001, 154).

And what did Africans think and do when they first saw Europeans and their depictions of water spirits or mermaids? According to the accounts of some of the earliest European travelers and to some African oral histories, many Africans associated Europeans with the sea and water spirits, an impression that would have been reinforced by the sight of their large sailing vessels coming into view from below the horizon. One of the earliest European accounts of African ideas about Europeans was written by Alvise da Cadamosto, who voyaged to the western coast of Africa near Cape Verde in the years 1455 and 1456:

> It is asserted that when for the first time they saw sails, that is, ships, on the sea (which neither they nor their forefathers had ever seen before), they believed that they were great sea-birds with white wings, which were flying, and had come from some strange place . . . some of them . . . thought that the ships were fishes . . . Others again said that they were phantoms that went by night . . . Thus, as they did not understand the art of navigation, they all thought that the ships were phantoms.
>
> (Cited in Crone 1937, 20–21)

These curious-looking visitors, their possessions, and especially their icons, must have made a profound impression on Africans of the time. João De Barros's fifteenth-century accounts described "Abbyssinians [Africans]" who "bowed down and adored the figurehead of the Portuguese flagship—a wooden statuette of the Angel Gabriel" (cited in Jayne [1910] 1970, 47). Written descriptions from the centuries that followed these fifteenth-century encounters tell a similar tale. Thomas Astley ([1745] 1968, 104–5), for example, includes an account that occurred during the voyage of the Frenchman André Brue to the islands of Bissao and Bissagos in 1700. When a visiting African was questioned as to why he had elaborately sacrificed a rooster aboard the ship carrying Brue, he indicated "that the People of his Country looked on the Whites as the Gods of the Sea; that the mast was a Divinity that made the Ship walk, and the Pump was a Miracle, since it could make Water rise-up, whose natural Property is to descend."

From nineteenth-century central Africa comes another anecdote. Camille Coquilhat was a military agent for King Leopold of Belgium and commander at a post on the Congo River among the "Ba-Ngala" peoples. This post was located about 100 kilometers from the Atlantic and later became known as Coquilhatville, Mbandaka (located in present-day Democratic Republic of the Congo). On June 6, 1884, he wrote:

> these naïve people believe that I take cowries, beads, and brass rods from the womb of the earth; others believe that these beautiful goods come from the bottom of the water; whites are for them aquatic persons and that I sleep under the river. But all of them agreed that I am related to Ibanza, a god or a devil of whom they speak often. The more I deny this supernatural affiliation, the more they believe it.
>
> (Coquilhat 1888, 215)

Others have documented similar responses in the twentieth century. P. Amaury Talbot cited an origin myth for Kalahari Ijo masked dances in honor of water spirits that links them with Europeans ([1932] 1967, 309). G.I. Jones noted the Igbo belief that Europeans originated from the water (1937, 79). And the Kongo had their own views about Europeans as water spirits, for they were "white" and came from the sea, the passage between this world and the next, and they brought "rich gifts unknown in 'this' world" (Hilton 1985, 50). Despite the difficulties encountered in verifying and interpreting early European accounts, which are drenched in prejudice and ignorance about Africa and Africans, the number and persistence of such reports from different parts of Africa and different eras may offer certain insights for assessing the early reception of Europeans and their visual culture.

At about the same time that Christopher Columbus was seeing mermaids in the Atlantic, an African sculptor, a member of the Sapi peoples living on Sherbro Island off the coast of Sierra Leone, was carving the image of one on an ivory saltcellar, commissioned by a visiting Portuguese explorer or merchant. As his model, the artist used an image supplied to him by his Portuguese client. Though the mermaid was copied from a European model, the Sapi sculptor immediately "Africanized" her for she is flanked by two crocodiles, ancient African symbols for water spirits and a central image associated with water spirits among the descendants of the Sapi, the Bullom and Temne. As their familiarity with European mermaid lore increased, Africans interpreted, adapted, and transformed the image of a European mermaid (and later, other images) into a representation of an African deity—Mami Wata—evolving elaborate systems of belief and sacred visual and performance arts in the process.

Although the wellspring of the visual culture and history of Mami Wata will always remain conjectural, I would suggest that much textual and visual evidence indicates that the concept of Mami Wata, if not her name, originated long before the massive dispersal of Africans to the Americas (from the sixteenth to nineteenth century) and the colonial era (1900–1957). The antiquity and prevalence of indigenous African beliefs in water deities, widely imaged as hybrid human-aquatic creatures, served as a basis to understand and translate European mermaid myths and images into African ones from the first momentous Euro-African contacts in the fifteenth century.

Given their ideas about Europeans, Africans could have quite easily come to regard European icons, such as the figureheads on ships (Figure 29.1) and other marine sculptures, as representations of water spirits. Several works have been documented in African water spirit shrines in widely dispersed locales in Africa that support this supposition. Among the Bidjogo on the West African coast, a Baroque-style (1550–1750) figurehead dominated a shrine on Formosa Island (Figure 29.2; Bernatzik 1944, pl. 177). A figurehead from a ship wrecked off the coast of southern Africa in the 1870s was allegedly acquired by Africans and incorporated into a shrine in honor of local sea divinities (Pinckney 1940, 27, 130). Another, a Janus marine sculpture (Figure 29.3), formerly in the Daniel Brooks Gallery, New York, was allegedly collected in southeastern Nigeria before 1975. Most likely it came from a trading vessel plying the West African coast. Red pigmentation around the eyes, often used on people and on sculptures in eastern Nigeria (Jones 1984, 33), suggests that it may have been used in a ritual context.

Field data that I collected in Nigeria in 1975 and 1978 link European marine sculpture directly with water spirits and Mami Wata. In one case, a figurehead given in about 1910 to a Yoruba man who worked for a British trading company in Lagos was identified by its owners as Mami Wata (Figure 29.4). Among the Awori Yoruba, a famous local carver, Olaniyan, copied a figurehead for use in a shrine around the end of the nineteenth century. When that copy rotted, its owner, a devotee of the Yoruba water goddess Yemoja, brought it to Kilani Olaniyan, grandson of the sculptor, to have it copied (Olaniyan, personal communication, 1978). The effort made to preserve the original form of the European

Figure 29.1 Mermaid figurehead from an unidentified vessel, c. 1900–1925. Museum Collection, OF 53. Gift of Clifford W. Ashley & N.C. Wyeth, 1935. (35.383 OF 53). © The Mariners' Museum, Newport News, VA.

Figure 29.2 This Baroque-style (1550–1750) figurehead formerly dominated a shrine used by the Bidjogo peoples on Formosa Island off the West African Coast. Photograph from Bernatzik, 1944, pl. 177. Courtesy of Henry John Drewal.

Figure 29.3 This two-headed marine sculpture may have been used in a ritual context in southeastern Nigeria. Photograph by Henry John Drewal, 1975. Courtesy of Henry John Drewal.

Figure 29.4 A ship's figurehead, originally given to a Yoruba man around 1910, was referred to as Mami Wata by its owners in 1975. Photograph by Henry John Drewal, Lagos, Nigeria, 1975. Courtesy of Henry John Drewal.

sculpture—a three-quarter female figure with long flowing hair—in its two African repro-
ductions further suggests the impact of foreign objects in African water spirit and Mami Wata
worship.

The figureheads adorning European ships may have inspired another African sculptural
genre in the port of Brass in the Niger River Delta. As William Fagg suggests, a rich and
powerful merchant, Ockiya, made himself "king" and commissioned portrait effigies of
himself and family members in the mid-nineteenth century (Fagg 1963, pl.III). Such figures
had arms that were carved separately and mortised to the body, probably a local Brass adop-
tion of European carpentry techniques, as most African sculptures were traditionally made
from a single block of wood.

In the port city of Old Calabar beginning in the 1890s, Efik women, particularly of the
Ironbar family, in Duke Town at the mouth of the Cross River in southeast Nigeria, devel-
oped a tradition of punch-decorated work on imported brass trays (Figure 29.5; Coote and
Salmons 2008: 258–275). They served as gifts during the rites of passage held for young girls
who were transitioning into womanhood. This tradition manifests complex connections
between several cultural phenomena: local water spirits, in particular Nnimm, who presides
over the rites; the institution of the fatting room (*ufok nkubo*) and the fatting-room girls
(*mbobo*); Ekpe, the leopard society; and *nsibidi*, the local pictographic script for initiates. As
Robert Farris Thompson has written:

> Women had their secrets too, knowledge of supernatural underwater transfor-
> mations, lore about fish that were really leopards, leopards that were really
> kings, and many other forces. They slyly interposed some of these "heavy,"
> awesome images in the decoration of outwardly secular objects—calabashes,

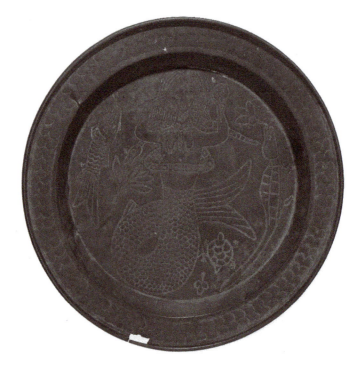

Figure 29.5 Mami Wata tray, southeast Nigeria, twentieth century, repousee brass, 45.7 × 45.7 × 6.4 cm.
Collection of Randall Morris and Shari Cavin. © Cavin-Morris Gallery.

stools, and trays—confident that the deeply initiated would catch the glint of
power veiled by decoration.

(Thompson 1983, 247)

These trays may have represented the water divinity Nnimm in the form of the mermaid,
later to be known by the name Mami Wata (Coote and Salmons 2008).

At about the same time that Efik women at Old Calabar were hammering out mermaids
on brass dishes, Edward A. Asamani, an Ewe and a missionary-trained carpenter turned
sculptor, was creating delicate ivory finials for umbrellas, house decorations, and staffs. He
initially carved these as souvenirs for German soldiers and colonial officials. Following the
departure of the Germans at the end of World War I, however, he began carving ivory and
ebony chiefly emblems for British and local patrons in eastern Gold Coast, present-day Ghana
(Quarcoopome, personal communication, 2004).

Mami Wata and the image of the snake charmer

Half-human, half-serpent images for water spirits, widespread throughout Africa—like the
half-human, half-fish creatures discussed above—set the stage for the arrival and incorpora-
tion of a very particular European image of an "Oriental other" that resonated deeply within
African water spirit arts: a snake charmer. The West has had a long and enduring fascination
with the "exotic." By the second half of the nineteenth century, this interest had spread
beyond the European upper and middle classes to a much wider audience. During the
Victorian era with its rigid social norms, people turned to the exotic to provide a "temporary
frisson, a circumscribed experience of the bizarre" (Clifford 1981, 542). Institutions such as
botanical and zoological gardens, ethnographic museums, and circuses and "people shows"
(Völkerschauen) provided vehicles for such escape.

One of the most significant centers for such developments was the northern German
port and trading center of Hamburg, which was in many ways Europe's gateway to the
exotic. It was an important member and leader of the Hanseatic League, a group of wealthy
independent city-states on the North Sea that developed powerful import/export companies
with vessels that plied the world's oceans. Hamburg's contacts with distant lands fed the
popular European appetite for things foreign. While illustrated accounts of adventures
abroad proliferated in books, magazines, and newspapers, the exotic became tangible as a
growing number of African, Asian, and Indian sailors appeared in the port of Hamburg and
other European maritime centers (cf. Bitterli 1976; Debrunner 1979).

Carl G.G. Hagenbeck worked as a fish merchant in St. Pauli in the port area of
Hamburg. This area was also a popular "entertainment" center for sailors and others. In
1848, a fisherman who worked the Artic waters brought some sea lions to Hagenbeck,
which he in turn exhibited as a zoological "attraction." The immediate success of this venture
led to a rapidly enlarged menagerie of exotic animals from Greenland, Africa, and Asia
(Niemeyer 1972, 247).

Sensing the public's enormous appetite for the bizarre, Hagenbeck decided to expand
his imports to include another curiosity—exotic people. The first of these arrived in 1875, a
family of Laplanders, who had accompanied a shipment of reindeer. This was the modest
beginning of a new concept in popular entertainment known as the *Völkerschauen,* or "people
shows" (Benninghof-Luhl 1984). In order to advertise his new attractions, Hagenbeck turned
to Adolph Friedländer, a leading printer who quickly began to produce a large corpus of
inexpensive color posters for Hagenbeck, whose most extravagant spectacle was doubtless
his "International Circus and Ceylonese Caravan," seventy artists, craftspeople, jugglers,

magicians, and musicians together with many wild animals. The caravan was witnessed by over a million people within a six-week period (Niemeyer 1972, 251).

Hagenbeck hired a famous hunter named Breitwiser to travel to Southeast Asia and the Pacific to collect rare snakes, insects, and butterflies. In addition to these, Breitwiser, brought back a wife, who under the stage name "Maladamatjaute" began to perform as a snake charmer in Hagenbeck's production. A chromolithograph poster made for Hagenbeck by Friedländer's company in the 1880s featured her (Figure 29.6; Malhotra 1979, 99). A Hamburg studio photograph taken about 1887 shows Maladamatjaute attired for her performance (Figure 29.7). The style and cut of her bodice, the stripes made of buttons, the coins about her waist, the armlets, the position of the snake around her neck and a second one nearby, the nonfunctional bifurcated flute held in her hand, and her facial features and coiffure: all duplicate those seen in a snake charmer chromolithograph from the Friedländer lithographic company, the original of which has not yet been found (Figure 29.8). What we do have, however, is a reprint, made in 1955 in Bombay, India, by the Shree Ram Calendar Company from an original sent to them by two (Indian?) merchants in Kumase, Ghana. In a letter to me dated June 17, 1977, the manager of the Calendar Company, M.G. Karandikar, stated that the print had been copied "without changing a line even from the original."

There can be little doubt, therefore, that Maladamatjaute was the model for the image. Her light brown skin placed her beyond Europe, while the boldness of her gaze and the strangeness of her occupation epitomized for Europeans her "otherness" and the mystery and wonder of the "Orient." As Maladamatjaute's fame as a snake charmer spread, her image

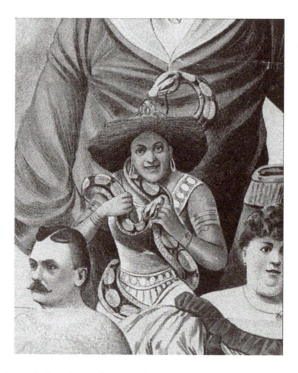

Figure 29.6 This detail of a "people show" is taken from a circus poster created by the Adolph Friedländer Company in the 1880s in Hamburg, Germany, for Carl Hagenbeck. It illustrates the snake charmer Maladamatjaute, who was almost certainly the model for the snake charmer print that by 1900 would be interpreted as an image of Mami Wata in Africa. Photograph by Henry John Drewal, 1980, reproduced with the kind permission of Ruth Malhotra. Courtesy of Henry John Drewal.

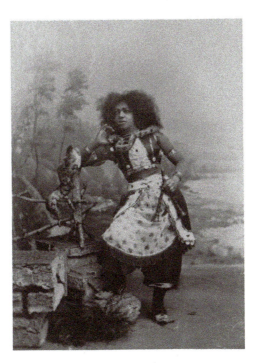

Figure 29.7 A studio photograph of Maladamatjaute taken in Hamburg, Germany, c. 1887, shows her attired for her performance. Notice the style and cut of her bodice, the stripes made of buttons, the coins about her waist, the armlets, the position of the snake around her neck and a second one nearby, the non-functional bifurcated flute held in her hand, and her facial features and coiffure—all identical to features in the print that became Mami Wata's image in Africa (see next image). Published with the kind permission of Wilhelm Zimmermann. Courtesy of Henry John Drewal.

began to appear in circus flyers and show posters for the Folies Bergère in Paris (see, for example, Musée des Arts Décoratifs, Paris, no. 480), as well as in the United States. Soon after, and probably unknown to Maladamatjaute, her image spread to Africa—but for very different reasons and imbued with very new meanings.

The snake charmer as Mami Wata in Africa

Not long after its publication in Europe, the snake charmer chromolithograph reached West Africa, probably carried by African sailors who had seen it in Hamburg. European merchants stationed in Africa, whether Germans or others, may have also brought Maladamatjaute's seductive image to decorate their work or domestic spaces.

For African viewers, the snake charmer's light brown skin and long black wavy hair suggested that she came from beyond Africa, and the print had a dramatic and almost immediate impact. By 1901, about fifteen years after its appearance in Hamburg, the snake charmer image had already been interpreted as an African water spirit, translated into a three-dimensional carved image, and incorporated into a Niger River Delta water spirit headdress that was photographed by J.A. Green in the Delta town of Bonny. The headdress clearly shows the inspiration of the Hamburg print. Note especially the long, black hair parted in the middle; the garment's neckline; the earrings; the position of the figure's arms and the snakes; and the low-relief rendering of the inset with a kneeling flute player

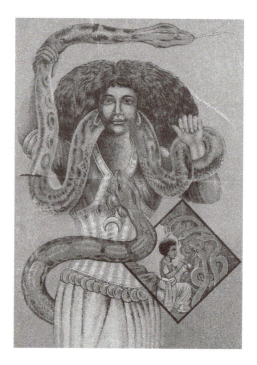

Figure 29.8 Adolph Friedländer Company (possibly Christian Bettels), The Snake Charmer (1955 Shree Ram Calendar Company (Bombay, India) copy edition of the original 1880s Adolph Friedländer chromo-lithograph). Chromolithograph, 36.5 × 25.4 cm. Private Collection. Courtesy of Henry John Drewal.

surrounded by four snakes. The image of Maladamatjaute, the "Hindoo" snake charmer of European and American renown, had begun a new life as the primary icon for Mami Wata, an African water divinity with overseas origins, joining and sometimes replacing her manifestation as a mermaid.

The style and iconography of the print help to explain its rapid, widespread acceptance. Its naturalism contributed to its being understood by Africans as a "photograph" of a foreign spirit. As one Igbo priestess told me, "someone must have gone under the water to snap it" (Opara, personal communication, 1975). As a product of Western technology, this "photograph" was an instance of the medium reinforcing the message. The snake, an important and widespread African symbol of water and the rainbow (especially along the Ghana/Togo/Benin/Nigeria coast), was a most appropriate subject to be shown surrounding, protecting, and being controlled by Mami Wata. The position of one snake arching over the head of Mami Wata reinforced its link with the ancient indigenous celestial serpent, the rainbow deity Dan/Aido Wedo, as is seen in Joseph Ahiator's painting and in Ewe murals.

Other elements in the print linked it with myths concerning and images of mermaids. The snake charmer shared the complexion, facial features, long, flowing hair, and breathtaking. appearance of mermaids. Without exception African respondents have stressed the extraordinary beauty and power of her bold, intense gaze and composure. One Yoruba man, recalling the first time he saw the Mami Wata chromolithograph during his youth in Lagos, around 1921, admitted that he nearly "peed in his pants" when he beheld the striking beauty with her long flowing hair and her snakes.

Symbols of wealth also contributed to parallels between mermaid lore and the snake charmer image. Golden armlets, earrings, neckline, pendant, and waist ornaments in the print combined to evoke the riches that Mami Wata promises to those who honor her. The

theme of wealth that underlies much of Mami Wata worship is sometimes exaggerated in her sculpted images, as in an Ibibio sculpture.

As Africans usually depict complete figures in their arts, the rendering of Mami Wata as a half-figure in the chromolithograph was taken to be significant by African viewers. In discussing this aspect of the print, devotees have pointed out that the unseen lower portion of the snake charmer indicates that Mami Wata is "hiding her secret," that is, her fish tail. The ambiguous rendering of the cloth below the waist, which is reminiscent of scales, probably reinforced this idea. The overall blue-green background and the absence of contextual images such as buildings or a landscape (except for the rocks in the inset with the flute player) contribute to the impression of an underwater scene. These features seem to have inspired the shrine environments of some Mami Wata devotees.

In Hamburg in the early 1900s, the Dralle company created and marketed a perfume called "Mami Water." It was intended specifically for the African trade and more specifically for devotees of Mami Wata. Its label depicts a mermaid, combing her long hair and admiring herself in a mirror. She is accompanied by a snake (Figure 29.9). This Mami Wata perfume label served as the model for a wonderful wall mural in eastern Ghana (Figure 29.10), which combines three streams of Mami imagery—mermaid, snake charmer, and a Hindu goddess (in this case Lakshmi; see below). It seems that the perfume and its label were later reproduced in Nigeria (Herbert Cole, personal communication, 2002). This chain of reproduction illustrates a remarkable fluidity of image, imagination, consumption, and devotion.

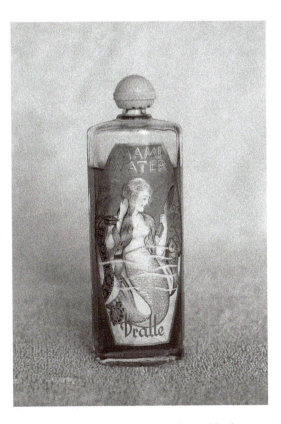

Figure 29.9 This bottle of "Mami Water" perfume was manufactured by the German company Dralle, for the African trade, in the early 1900s. Courtesy of Herbert M. Cole. Photograph by Henry John Drewal. Photograph courtesy of Henry John Drewal.

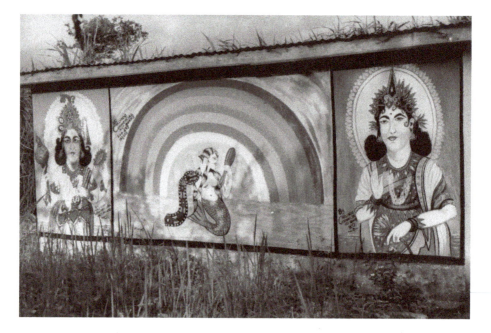

Figure 29.10 The Dralle "Mami Water" perfume label (see previous figure) inspired the central portion of this wall mural in eastern Ghana. The artist has added the rainbow, sign of the celestial serpent deity Dan/ Aido Wedo, above the mermaid's head. On the side panels, he has depicted another *mami wata*, Marni Titi, who is based upon a Hindu print of the goddess Lakshmi. Photograph Henry John Drewal, 1975, near Kpetonu, Ghana. Courtesy of Henry John Drewal.

In the nearly 100 years since the arrival of the snake charmer print in Africa (and especially after 12,000 copies were printed in Bombay, India, in 1955 and sent to traders in Kumase, Ghana), the image has traveled widely, first in West and subsequently in Central Africa. In the 1960s the snake charmer print was also reproduced in London (and other locales as well), with stronger color contrasts and a darker-complexioned Mami. Artists in many different places, inspired by the image, have created an imaginative array of forms celebrating Mami Wata. Various copies of copies continue to circulate widely in sub-Saharan Africa where, as of 2005, the influence of the print can be discerned in at least fifty cultures in twenty countries, from Senegal to Cameroon and beyond.

References

Achebe, Chinua, *Girls at War and Other Stories* (London: Heinemann, 1972), p. 43.

Astley, Thomas, *A New General Collection of Voyages and Travels* (New York: Barnes and Noble, [1745] 1968), pp. 104–5.

Bernatzik, Hugo-Adolf, *Im Reich der Bidyogo* (Leipzig, 1944). pl. 177.

Bitterli, Urs, *Die "Wilden" und die "Zivilisierten"* (Munich: Beck, 1976).

Clifford, James, "On Ethnographic Surrealism," *Comparative Studies in History and Society*, 23, 1981, 542.

Cole, Herbert, personal communication, 2002.

Columbus, Christopher, *The Journal of Christopher Columbus*, trans. Clements R. Markham (Boston: Adamant Media Corp. [1493] 2001), p. 154.

Coote, Jeremy, and Jill Salmons, 2008. "Mermaids and Mami Wata on Brassware from Old Calabar." In *Sacred Waters: Arts for Mami Wata and other Divinities in Africa and the Diaspora*, edited by Henry John Drewal. (Bloomington: Indiana University Press), pp. 258–275.

Coquilhat, Camille, *Sur le Haut-Congo* (Paris: J. Lebegue, 1888), p. 215.

Crone, Gerald R., *The Voyages of Cadamosto* (London: Hakluyt Society, 1937), pp. 20–21.

Debrunner, H.C., *Presence and Prestige: Africans in Europe* (Basel, 1979).

Fagg, William, *Nigerian Images* (New York: Praeger, 1963).

Hassig, Debra, *The Mark of the Beast* (New York: Garland, 1999).

Hilton, Anne, *The Kingdom of Kongo* (Oxford: Clarendon, 1985), p. 50.

Jayne, K.G., *Vasco da Gama and his Successors* (New York: Barnes and Noble [1910] 1970), p. 47.

Jones, G.I., "Mbari Houses," *Nigerian Field* no 6. 1984, 33.

Niemeyer, Guenter, *Hagenbeck* (Hamburg, 1972), p. 247.

Olaniyan, Kilani, personal communication, 1978.

Opara, M., personal communication, 1975.

Pinckney, P., *American Figureheads and their Carvers* (New York: WW Norton, 1940), pp. 27, 130.

Quarcoopome, Nii, personal communication, 2004.

Thompson, Robert Farris, *Flash of the Spirit* (New York: Random House, 1983), p. 247.

Part 3 (a): Further reading

Crary, Jonathan. *Techniques of the Observer*. Cambridge, MA: MIT Press, 1991.

Davis, Lennard J. *Bending Over Backwards: Disability, Dismodernism, and Other Difficult Positions*. New York: New York University Press, 2002.

Descartes, René. *Discourse on Method, followed by Dioptics*. 1637

Drewal, Henry John (ed.). Mami Wata: Arts for Water Spirits in Africa and its Diaspora. UCLA: Fowler Museum, 2008.

———. *Sacred Waters: Arts for Mami Wata and Other Divinities in Africa and the Diaspora*. Bloomington: Indiana University Press, 2008.

English, Darby. *How to See a Work of Art in Total Darkness*. Cambridge, MA: MIT Press, 2007.

González, Jennifer A. *Subject to Display: Reframing Race in Contemporary Installation Art*. Cambridge, MA: MIT Press, 2008.

Haraway, Donna *The Donna Haraway Reader*. New York: Routledge, 2003.

———. *When Species Meet*. Minneapolis: University of Minnesota Press, 2008.

Jones, Amelia. *Self/Image: Technology, Representation and the Contemporary Subject*. New York: Routledge, 2006

——— (ed.). *The Feminism and Visual Culture Reader*. 2nd ed. New York: Routledge, 2010.

Kleege, Georgina. *Sight Unseen*. New Haven: Yale University Press, 1999.

Mavor, Carol. *Reading Boyishly: Roland Barthes, J. M. Barrie, Jacques Henri Lartigue, Marcel Proust, and D. W. Winnicott*. Durham, NC: Duke University Press, 2007.

Part 3 (b) Histories and memories

IN THINKING ABOUT VISUALITY, history becomes a central but by no means simple problem. Visuality was named by Carlyle as the means of visualizing history as it happens by the Great Man or the Hero. So it is both a particular view of history and a means of framing it from the perspective of the autocrat or imperial leader. Needless to say, a critical visuality studies opposes such a view of history but also needs to interpret it, while forging a different perspective. The chapters in this section approach the formation of the particular form of looking that enabled what Jonathan Beller calls the cinematic mode of production; the place of museums in late democracies; how iconoclasm has been constructed as central to global Islam; and the place of 9-11 in contemporary American memory. None of these topics is the kind of history Carlyle used to satirize as "Mr Dry-As-Dust." To the contrary, they have in common only that they continue to provoke strong discussion, even disagreement. Nor is this history as it is taught in the History department at most universities. It is in process.

The late, lamented Anne Friedberg, cinema scholar and visual culture studies pioneer, shows in the extract from her classic *Window Shopping: Cinema and the Postmodern* how the convergences that we often associate with the digital in fact began in the nineteenth century. She identified a "historical framework of pre-cinematic mobile and virtual gazes" that combined to form the "frenzy of the visible" long familiar to students of the late nineteenth century. Setting the Panopticon in the context of now-forgotten technologies such as the diorama and the panorama, she showed how these gave the viewer a sense of "virtual spatial and temporal mobility," creating a powerful illusion of travel amd movement to other countries and even time periods. A paradox resulted: "as the 'mobility' of the gaze became more 'virtual,' . . . the observer became more immobile. The effects of the diorama and the cinema required a static observer, who deployed this "mobile virtual gaze" in order to attain "visual mastery over the constraints of space and time." With the development of personal computing devices from laptops to mobile phones and tablets, it would seem that the mobile virtual gaze now has a greater range, depending on wireless or network coverage, even though the attention of the viewer must still concentrate on the device, rather than the real space in which they are located.

In the extract from her book *Tourists of History*, the visual and memory studies scholar Marita Sturken develops such associations in regard to "Ground Zero," the site of the former World Trade Center in New York City, destroyed in the attacks of September 11, 2001. For Sturken, Ground Zero is a complex overlay of material space, memory and "a space defined by and experienced through media technologies, a place constantly mediated through images, a place "visited" through web sites and by tourists, a place filled with photographs that is itself relentlessly photographed." As such it is a key site in the present-day "tourism of history," an assemblage of "consumerism, media images, souvenirs, popular culture, and museum and architectural reenactments." Ground Zero is at once held to be sacred and the justification for a decade of war. She examines the materiality of site by means of the immense quantities of dust produced by the collapse of the towers, a dust that was itself sacralized as containing particles of human remains but also became understood as toxic. Sturken's analysis shows how this discourse of the sacred was transformed into a public space of tourism by means of the mass deployment of images, a process that was then commodified by means of souvenir merchandise (almost all made in China for global irony). She shows how the initial impulse to create shrines, where objects might be left, has been replaced by a plethora of kitsch souvenir shopping and tourism that creates a "tourism of history" site from the once unpopular World Trade Center. As the still unresolved debates over the museum for the site make clear, such processes are not simple and entail the forgetting of key contradictions: "while the souvenir

culture of Ground Zero helps to produce a narrative of innocence, in which the U.S. and New York were sites of unsuspecting and unprovoked attack, the discourse of heroism that attempts to inscribe firefighters with quasi-military status, must resist such qualities of innocence." After the killing of Osama bin Laden, tourists again flocked to Ground Zero, as did President Obama, making this double-edged discourse of innocence and war once again clearly apparent.

The image culture of Ground Zero explicitly draws on former images of war but implicitly reaffirms discourses of colonialism and "innocence" of the colonizer confronted with the "burdern" of imperial responsibility and war. As the former "jewel in the crown" of the British Empire, it is perhaps not surprising, then, that India is rapidly becoming central to visual culture studies. I mean this in several ways: scholars and practitioners of visual culture of Indian background are opening new fields of investigation, even as India becomes more and more significant for visual culture, whether in the Imperial period, as the exemplary post-colonial nation or in today's ferment of globalization. The historian Sumanthi Ramaswamy has been at the center of this project and her chapter extracted here deals with the very visualization of India itself. In order for "India" to become an independent nation, it needed to set aside colonial representation, literally and metaphorically. In her genealogy of the image of Mother India, or Bharat Mata, she shows that it has been intertwined with that of the map of India. Following Mitchell's question, what do such pictures want, Ramaswamy replies: "it wants the patriotic Indian to be prepared to surrender life and limb to the Indian national territory." Departing from the observation made by historian J. R. Hale "that without a map 'a man could not visualize the country to which he belonged,'" she notes that the colonial project was dependent on such mapping. At the same time, colonial wisdom held that "Hindus as a rule are deficient in observation." Thus colonization was both enabled and justified by the technology of visualizing via maps. While much has been written about the figure of Mother India, especially in the context of folk art, Ramaswamy's striking intervention is to show how closely she has been associated with the map of India as a popular patriotic investment that she calls "barefoot cartography." While this association might be rendered in a variety of registers, Ramaswamy emphasizes how it came to imply willingness to sacrifice the viewer's own body for that of the mapped but immaterial body of India. Patriotism was this associated with violence from the inception of the (postcolonial) nation.

The subaltern studies historian Dipesh Chakrabarty turns our attention to the museum, not to debate curatorial or display strategies but to consider it as a key national institution of what he calls "late democracy." In a manner reminiscent of Rancière, Chakrabarty distinguishes two forms of modern democracy. The first he calls "pedagogical," meaning that the person has to be educated into citizenship, above all by reading. Museums were, however, also a part of this process in which an abstract rationality was inculcated. Alternatively, there is what may be called a "performative" democracy in which political rights are attained automatically and without question. Chakrabarty calls attention to the ways in which, as recently as 1956, leading white Australians argued for a "gradual" granting of rights to Aboriginals dependent on their achievement of "civilization." Such gradualism was overwhelmed by movements from decolonization to feminism and revolution. The museum has had to adapt to such performative demands as well, much to the dismay of some. These new modalities of museology give greater weight to the lived and the particular, such as the wave of memory and trauma museums. This move stresses the embodied and the visualized over the previously hegemonic abstract reason, with the result that: "by opening out to questions of the embodied and the lived, museums address certain formations of the public in modern democracies that academic disciplines do not."

This embodied historicity was experienced and described by Frantz Fanon in his classic *Black Skin, White Masks*, first published in 1952. Born in the French colony of Martinique

and trained as a psychologist, Fanon came to France for his advanced training. In this extract, he describes the novel experience of being singled out as an object, when a white child cries out on a train: "Look, a Negro!" This classification is felt as a "crushing objecthood," making him into a specimen, or type, rather than a person. Using the language of dialectics, Fanon perceives the experience as a negation, one that rendered him into a certain "history and above all, *historicity*." This was a triple position: "I was responsible at the same time for my body, for my race, for my ancestors. I subjected myself to an objective examination, I discovered my blackness, my ethnic characteristics; and I was battered down by tom-toms, cannibalism, intellectual deficiency, fetichism [sic], racial defects, slave-ships." Negated out of his body by the gaze of the other, hailed as a specimen of a colonized type, a person who must "not only . . . be black; he must be black in relation to the white man," a blackness that is above all a historical register of stereotypes, classifications and experiences.

Fred Moten further explores the deployment of "blackness" in his substantial essay "The Case of Blackness." A respected poet as well as a professor of literature and a key figure in visual studies programs at the University of California, Irvine, and then the University of Southern California, Moten thinks through "blackness" in the context of the work of art, "[its] thingliness, its madness, its lateness." To do so, he begins by thinking through the passage from Fanon we have just discussed, asking "What is it to be an irreducibly disordering, deformational force, while at the same time being absolutely indispensable to normative order, normative form?" This phrasing is a re-complication, via Fanon, of Du Bois's question: "How does it feel to be a problem?" Moten sees that part of the issue is making a person into an object and undertakes a reading of Heidegger on "The Thing." While some may find this "difficult," it is, after all, a discussion of the "problem" of blackness that has resisted easy solution. Further, many have insisted that visual culture "deal" with the object and that is what Moten tries to do here. In the next section, he reads a conversation between the (white) abstract expressionist painter Ad Reinhardt and the (black) free jazz musician Cecil Taylor, organized by Bell Telephone and the Canadian Broadcasting Company for a then hi-tech simultaneous telephone conversation—what we would now describe as a conference call. The topic was equally remarkable: "[b]lack as a special concept, symbol, paint quality; the social-political implications of the black; black as stasis, negation, nothingness and black as change, impermanence and potentiality." Whereas Ad Reinhardt opened by talking about black in art, Taylor in the course of a striking intervention at once returns the topic to the question of "black dignity," which he rightly claims as an "integral part of the American experience" in music, dance, language and politics. Joined by the Italian video pioneer Aldo Tambellini, Taylor engaged Reinhardt in a debate between an aesthetic of the everyday and Reinhardt's assertion of a "Fine Art" aesthetic. Setting these comments in the context of Clement Greenberg's influential art criticism, Moten reads Reinhardt as seeking "a freedom *from the community* in the most highly determined, regulative, *legal* sense of that word," which he understands to mean "the black community." In a free-flowing associative reading, Moten continues to interface this debate across the work of abstract painter Piet Mondrian, distinguishing it from the later action painters of the New York school, for its understanding of the importance of rhythm in paintings like *Victory Boogie Woogie*, bringing such work in dialogue with Taylor, Frantz Fanon and W. E. B. Du Bois. The final section interweaves as "contrapuntal fields or fugue states" this aesthetic discussion with a return to Fanon and the question of psychopathology in the colonial state of emergency. In the light of the uprisings across North Africa and the permanent crisis concerning "race" in the United States, this extended discussion takes on a new urgency of its own and fully repays the energy required to engage with it.

This section has intentionally cut across time and space in order to reinforce the embodied paradoxes of memory and history. Whether it has been the colonial nation, the independent

nation-state or the racialized minorities within colonial states, claims to innocence or virtue have persistently been reinforced with violence and war. From souvenir kitsch to poster art, museum display and fine art, visual images have further embedded such associations in each of the case studies represented here, reinforcing my sense that visuality is a technique of coloniality. The next section thus deals with histories of colonality in its colonial, decolonial and postcolonial variants.

Anne Friedberg

THE MOBILIZED AND VIRTUAL GAZE IN MODERNITY: FLÂNEUR/ FLÂNEUSE

The second half of the nineteenth century lives in a sort of *frenzy of the visible*. It is, of course, the effect of the *social multiplication of images*: ever wider distribution of illustrated papers, waves of print, caricatures, etc. The effect also, however, of something of a geographical extension of the *field of the visible* and the representable: by journeys, explorations, colonizations, the whole world becomes visible at the same time that it becomes appropriatable.

> (Jean-Louis Comolli, "Machines of the Visible" (emphasis added))

In societies where modern conditions of production prevail, all of life presents itself as *an immense accumulation of spectacles. Everything that was directly lived has moved away into a representation.*

> (Guy Debord, *Society of the Spectacle* (emphasis added))

[I]N THE NINETEENTH century, a wide variety of apparatuses extended the "field of the visible" and turned visualized experience into commodity forms. As print was disseminated widely, new forms of newspaper illustration emerged; as lithography was introduced, the caricatures of Daumier, Grandville, and others burgeoned; as photography became more widespread, the evidentiary means of public and family record were transformed. The telegraph, the telephone, and electricity increased the speed of communications, the railroad and steamship changed concepts of distance, while the new visual culture—photography, advertising, and shop display—recast the nature of memory and experience. Whether a "frenzy of the visible," or "an immense accumulation of spectacles," everyday life was transfigured by the "social multiplication of images."

Yet there remains a historiographical debate about whether this new predominance of the visible produced a crisis of confidence in the eye itself, or whether it was the coincident increase in optical research which produced this frenzy of visual cultures. The same historiographic debate pervades the history of the arts; either the invention of photography produced a crisis that led to continued optical research, or the nineteenth-century obsession with optical research produced a crisis that led to photography. In order to organize the vast

historical process that led to the emergence of the cinema it is necessary to enter into this debate, a dispute that festers at the roots of modernity.

In this chapter, I begin by describing the "observer" in modernity, situating the emergence of the cinema in the historical framework of precinematic mobile and virtual gazes. Such a "situated" approach to the cinematic apparatus necessitates an account of the imbrication of images in the social relations of looking. The flâneur will serve as a model for an observer who follows a style of visuality different from the model of power and vision so frequently linked with modernity—what Michel Foucault dramatically described as "un régime panoptique."[1] The trope of flânerie delineates a mode of visual practice coincident with—but antithetical to—the panoptic gaze. Like the panopticon system, flânerie relied on the visual register—but with a converse instrumentalism, emphasizing mobility and fluid subjectivity rather than restraint and interpellated reform.

The panoptic gaze has been invoked by feminist theorists to underline the one-way power of gendered looking, where women have internalized the voyeuristic gaze and are always subjectively "objects of the look."[2] As we examine divergent models of the observer in modernity, a refutation of theories of the panoptic gaze will have significant ramifications on accounts of gendered spectatorship. The panoptic gaze may indeed suggest a model for the increased priority of the visual register, but there were alternative gazes that, while still reordering the importance of the visual, produced different—more fluid—forms of subjectivity.

Gender, to follow Teresa de Lauretis's recent formulation, "is the product of various social technologies" that include "*cinema . . .* institutionalized discourses, epistemologies, and critical practices, *as well as practices of daily life*" (emphasis added).[3] And although gender seems a necessary component of debates about the role of vision in modernity and postmodernity, genealogies of the nineteenth-century observer have, as we shall see, retained a resistance to the gendered subject. Once we establish the flâneur's mobility, we will see the necessity of charting the origins of his female equivalent, the flâneuse.

Modernity and the "panoptic" gaze

It is in this *episteme*, as Foucault would have it, that new modes of social and political control were institutionalized by "un régime panoptique." Foucault places the panoptic model in a pivotal position in the epistemological shift from eighteenth-century empiricism to the invention of a transcendental concept of "man." In a dramatic passage in *The Order of Things*, he describes this transition as "the threshold of modernity." Foucault finds the origins of modernity in the reordering of power and knowledge and the visible.[4]

The panopticon

Jeremy Bentham's panopticon device (1791) provided the model for Foucault's characterization of panoptic power and the "disciplines" of imagined scrutiny.[5] (*Discipline* has been the common English translation for Foucault's term, *surveiller*.) Invoked as a philosophic model for the scopic regime of power through the visual register, the panopticon was an apparatus—a "machine of the visible," to use Comolli's phrase—which controlled the seer-seen relation. In the panopticon, an *unseen seer* surveys a confined and controlled subject. The panopticon produces a subjective effect, a "brutal dissymmetry of visibility"[6] for both positions in this dyad: the *seer* with the sense of omnipotent voyeurism and the *seen* with the sense of disciplined surveillance.

Foucault described the panopticon as an "architectural mechanism,"[7] a "pure architectural and optical system" that did not need to use force because the "real subjection is born *mechanically* from a *fictitious relation*."[8] The panopticon structure was then, in a sense, a "building-machine" that, through its spatial arrangement, established scopic control over its inhabitants.

The architectural system of the panopticon restructured the relation of jailer to inmate into a scopic relation of power and domination. The panopticon building was a twelve-sided polygon. Using iron as a skeleton, its internal and external skin was glass. The central tower was pierced by windows that provided a panoramic view of separate peripheral cells. Light from the outer walls illuminated each cell. The panoptic subject was placed in a state of "conscious and permanent visibility."[9] The panopticon prison was thought of as a spatial reformatorium that could change and "correct" subjectivity by architectural means. As Foucault describes it:

> The *seeing machine* was once a sort of dark room into which individuals spied;
> it has become a transparent building in which the exercise of power may be
> supervised by society as a whole.[10]

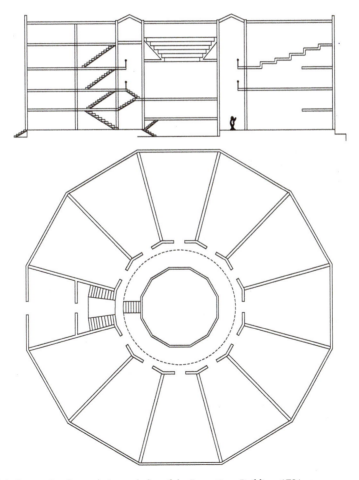

Figure 30.1 Jeremy Bentham, section and plan of the Panopticon Building, 1791.

Prisoners were objects of an *imagined* scrutiny, where the internalized sense of surveillance changed the disposition of external power:

> He who is subjected to a field of visibility, and who knows it, assumes responsibility for the constraints of power . . . he becomes the principle of his own subjection. By this very fact, the external power may throw off its physical weight; *it tends to the non-corporeal;* and, the more it approaches this limit, the more constant, profound and permanent are its effects.[11]

> (emphasis added)

Foucault uses the panoptic model to illustrate how, when power enters the visual register, it "tends to the non-corporeal." In the panopticon prison, confinement was successfully maintained by the barrier walls of the prison, but the subjective changes in the inmate were to be produced by the incorporation of the imagined and permanent gaze of the jailer. Bentham's panopticon was designed for other uses than the prison—the factory, the asylum, the hospital—but all of these uses were for institutions where enclosure was a priority.

Hence, the panopticon model has served as a tempting originary root for the inventions that led to the cinema, an apparatus that produces an even more "mechanically . . . fictitious relation" and whose "subjection" is equally internalized. Feminist theorists have invoked the "panoptic" implant as a model for the ever-present "male gaze," while "apparatus" film theories relied more on the immobility and confined spatial matrix of the prison. The prisoners in Plato's cave provide, in Jean-Louis Baudry's emphatic account, an origin for cinematic spectatorship with immobility as a necessary condition.

As an analogy for cinematic spectation, the model of the panoptic guard (the *unseen seer* in the position of omnipotent voyeurism) is not literal, but figurative and metaphoric. Like the central tower guard, the film spectator is totally invisible, absent not only from self-observation but from surveillance as well. But unlike the panoptic guard, the film spectator is not in the position of the central tower, with full scopic range, but is rather a subject with a limited (and preordained) scope. The film spectator's position is one of such *imaginary* visual omnipotence. It is the condition of invisibility which is the premise, in the argument of Baudry, for the spectator-subject's confusion of representation and self-generated perception, what Baudry deemed an "over-cathexis" with representation, a position that guarantees the dependence on the constructed view provided by representation.[12] The panoptic model emphasizes the subjective effects of imagined scrutiny and "permanent visibility" on the *observed*, but does not explore the subjectivity of the *observer*.

In re-examining the emergence of the cinema, one can trace the roots of an instrumentalization of visual culture which is coincident with, but also different from, the paradigm of panoptic visuality. A brief comparison of the panopticon (1791) with two other important devices—the panorama (1792) and the diorama (1823)—will suggest alternative models for visuality.

The panorama and the diorama were building-machines with a different objective: designed to *transport*—rather than to *confine*—the spectator-subject. As we shall see, these devices produced a spatial and temporal mobility—if only a "virtual" one. The panoramic and dioramic observer was deceptively accorded an *imaginary* illusion of mobility. In Walter Benjamin's conversely demonstrative rhetoric, cinematic spectatorship functioned as an explosive ("dynamite of a tenth of a second") that freed the spectator from the "prison-world" (*Kerkerwelt*) of nineteenth-century architectural space.[13]

Modernity and the "virtual" gaze

The panorama

> At leisure let us view from day to day,
> As they present themselves, *the spectacles*
> *Within doors:* troops of wild beast, bird and beasts
> Of every nature from all climes convened,
> And, next to these, *those mimic sights that ape*
> *The absolute presence of reality*
> Expressing as in mirror sea and land,
> And what earth is, and what she hath to shew—
> *I do not here allude to subtlest craft,*
> By means refined attaining purest ends,
> But imitations fondly made in plain
> Confession of man's weakness and his loves.
> Whether the painter—*fashioning a work*
> *To Nature's circumambient scenery*
> (William Wordsworth, *Prelude*, 1805,
> Seventh Book, lines 244–57, emphasis added)

As Wordsworth notes, the panorama was not the "subtlest craft" for presenting "the absolute presence of reality." But its "spectacles / Within doors" of "every nature from all climes" used "circumambient scenery" to create an artificial elsewhere for the panoramic spectator.

The panorama was a 360-degree cylindrical painting, viewed by an observer in the center. The illusion presented by the panorama was created by a combination of realist techniques of perspective and scale with a mode of viewing that placed the spectator in the center of a darkened room surrounded by a scene lit from above. The panorama was first patented by the Irishman Robert Barker, who took out a patent for panoramic painting in Edinburgh in 1787 and opened the first completely circular panorama in Leicester Square in London in 1792. (Recall the years of Bentham's work on the panopticon, from 1787 to 1791.) Barker's inspiration for the panorama came, according to an anecdote told by historian Olive Cook, in a manner worthy of comparison to Bentham's panopticon prison:

> The invention of the Panorama is usually attributed to Robert Barker, an Edinburgh painter. In about 1785 he was put into prison for debt and was confined to a cell lit by a grating let into the wall at the junction of wall and ceiling. One day he was reading a letter and to see more clearly carried it below the grating. *The effect when the paper was held in the shaft of light falling from the opening was so astonishing that Barker's imagination was set working on the possibilities of controlled light flung from above upon pictures of large dimensions.*[14]
>
> (emphasis added)

If "controlled light" served to survey and measure the wards in the panopticon prison, in an opposite way it also served to create the visual illusions of the panorama.

The panorama did not physically *mobilize* the body, but provided virtual spatial and temporal mobility, bringing the country to the town dweller, transporting the past to the present. The panoramic spectator lost, as Helmut Gernsheim described, "all judgement of distance and space" and "in the absence of any means of comparison with real objects, a perfect illusion was given."[15] The panorama offered a spectacle in which all sense of time and

space was lost, produced by the combination of the observer in a darkened room (where there were no markers of place or time) and presentation of "realistic" views of other places and times.

The ideology of representation in the panoramic painting must be placed in the context of the concurrent reconceptualization of the idea of the horizon and of perspective (the first hot air balloon was launched in 1783 and aerial balloonists found vistas that radically changed the landscape perspective) and the "cult of immensity" in painting, where scale was a factor in the concept of illusionist immersion. In addition, the panorama developed out of the context of earlier "screen" entertainments.

The "magic lantern" devices of Athanasius Kircher, Johannes Zahn, and others introduced a form of projected entertainment spectacle that relied on controlled light projected through glass slides: drawn figures of skeletons, demons, and ghosts appeared on a screen surface. In his text of 1646, *Ars Magna Lucis et Umbrae*, Kircher (1601–80)—a Roman Catholic priest—published his procedures for projecting ghostly apparitions. Whether, as Musser argues, Kircher sought to demystify the "magic" of the lantern or whether, to the contrary, he trained a new legion of mystifiers, the eerie effects produced by these luminous projections established an early link between two potentially competing systems of subjective interpellation: religion and optics. Kircher concealed the lantern from his audiences by placing it on the other side of the screen. He could change the distance of the lantern, vary the sizes of his figures. Musser traces the roots of cinema in these forms of late eighteenth-century forms of "screen practice." These entertainments—shadow plays, phantasmagorias, lantern displays—relied on dark rooms and projected light.

Philip Jacob de Loutherbourg, a French-born painter and stage designer who came to England in 1771, had designed a viewing system, the *eidophusikon* (1781), which also relied on spectators in a darkened auditorium viewing an illuminated (10 foot by 6 foot) translucent screen, with light projected from behind. The eidophusikon spectacle produced simulations of sunsets, fog, and dawn accompanied by sound effects and harpsichord music. In Paris, a device called the phantasmagoria similarly relied on a lantern with lens to project drawings of celebrities from Voltaire to Rousseau to Marat. Étienne-Gaspard Roberton—a self-styled *aéronaute* to whom the invention of the parachute is attributed—devised a magic lantern show set in a Capuchin monastery. The phantasmagoria made its début in Paris from 1797 to 1800, traveled to London from 1801 to 1803, and arrived in New York in 1803.

Phantasmagorias, panoramas, dioramas—devices that concealed their machinery—were dependent on the relative immobility of their spectators, who enjoyed the illusion of presence of virtual figures. These apparatuses produced an illusion of unmediated referentiality. Other optical entertainments that required viewing devices—the stereoscope, the phenakistoscope—were dependent on quite different optical principles and hence produced diverse subjective effects.

Benjamin saw a direct relation between the panoramic observer and the flâneur:

> The city-dweller . . . attempts to introduce the countryside into the city. In the panoramas the city dilates to become landscape, as it does in a subtler way for the *flâneur*.[16]

Before the advent of illustrated print journalism in the 1840s, the panorama supplied a visual illustration of places and events that one could read about in print. The panorama not only appealed to the public interest in battles and historical illustration, but also to a fascination with landscape art, travel literature, and travel itself. As Richard Altick argues, the panorama was the "bourgeois public's substitute for the Grand Tour."[17]

Dolf Sternberger has emphasized that the lure of these entertainments was not in their verisimilitude with reality, but rather in their deceptive skills, their very artificiality.[18] As an early epitome of the lure of artificiality, in 1823 Yorkshireman Thomas Hornor climbed the top of St Paul's with sketching implements and telescopes and sketched London in 360-degree detail. Hornor's gigantic rendering was housed in Decimus Burton's Colosseum. The building took years to build (1824–29) but, when finished, encased a panorama of remarkable verisimilitude: a simulated London viewed from the top of a simulated St Paul's. The rooftop location of this panorama necessitated a new design feature: the first hydraulic passenger lift ("ascending room") carried spectators who did not wish to climb the stairs. The elevator was a mechanical aid to mobility; the gaze at the end of this "lift" was virtual.

The panorama was taken to Paris in 1799 by Robert Fulton, who had purchased the foreign patent rights. Two rotundas for the panorama were built in Paris on Boulevard Montmartre. In the interior were two paintings, one that displayed a view of Paris from the Tuilleries and another that showed the British evacuation during the Battle of Toulon in 1793. The immediate city—the Paris of only blocks away—was presented to itself; but so was a distant city (Toulon) at a distant time (six years before). Sternberger has aptly named these panoramic paintings, "captured historical moments(s)."[19]

In 1800, the Passage des Panoramas was built to connect the Palais Royal to the panorama on Boulevard Montmartre. The cylindrical panorama building was connected directly to the Passage des Panoramas—one entered through the arcade. The panorama was lit from above by the same glass and iron skylight as the arcade. . . .

The diorama

Louis Jacques Mandé Daguerre, later famed for his 1839 invention of a photographic process he named the daguerreotype, began his career as an assistant to the celebrated panorama painter, Pierre Prévost. In 1822, Daguerre debuted a viewing device that expanded upon the panorama's ability to transport the viewer, an apparatus he called the diorama.

Like the *diaphanorama*—in which translucent watercolors were illuminated from behind—the dioramic illusion relied on the manipulation of light through a transparent painting. Daguerre's visitors looked through a proscenium at a scene composed of objects arranged in front of a backdrop; after a few minutes, the auditorium platform was rotated 73 degrees to expose another dioramic opening. The diorama was designed to construct and restructure—through light and movement—the relation of the viewer to the spatial and temporal present. A scene was transformed through the manipulation of daylight, which shifted the temporal mood. The diorama differed significantly from the panorama: the diorama spectator was immobile, at the center of the building, and the "views" were mobilized as the entire diorama building with its pulleys, cords, and rollers became a machine for changing the spectator's view.

When the diorama opened in Paris in 1822, it displayed two distant tableaux: "The Valley of Sarnen," a scene from Switzerland, and "Interior of Trinity Church—Canterbury Cathedral," a scene from England. Of the thirty-two scenes exhibited during the seventeen years of its existence, ten of the paintings were interiors of distant chapels or cathedrals. As a local newspaper account indicated: "We cannot sufficiently urge Parisians who like pleasure without fatigue to make the journey to Switzerland and to England without leaving the capital."[20]

Helmut and Alison Gernsheim extend this description of the diorama as a substitute for travel: "The many foreign views, too, no doubt had a special appeal to the general public who, before the days of Cook's Tours, had little chance of travelling abroad."[21]

Dioramas opened in other cities, in Breslau in 1826, in Berlin in 1827, in Stockholm in 1846, and in Frankfurt in 1852. (Thomas Cook's first guided tours of the continent were in 1855.) There were other variations on the diorama. The *pleorama*, which opened in Berlin in 1832, had the audience seated in a ship and taken for an hour's "voyage," as the illusion of movement was created by the backcloth moving slowly across the stage. This device emphasized the equation otherwise implicit between travel and viewing scenes of the distant and of the past.

In 1839, Daguerre's diorama on Rue Sanson in Paris was destroyed by fire. In that same year, he patented a technique for *fixing* images on copper plates, the "daguerreotype." Few dioramic or panoramic paintings survive. The illusions produced were dependent on the effects of artificial light, and many of the paintings, and the buildings which housed them, ended in flames. The "captured historical moment" could be more securely impounded on a photographic plate. Benjamin will remark on this historical coincidence; photography emerged from the ashes of the diorama.

Both the panorama and its successor, the diorama, offered new forms of virtual mobility to their viewers. But a paradox here must be emphasized: as the "mobility" of the gaze became more "virtual"—as techniques were developed to paint (and then to photograph) realistic images, as mobility was implied by changes in lighting (and then cinematography)—the observer became more immobile, passive, ready to receive the constructions of a virtual reality placed in front of his or her unmoving body.

The panopticon versus the diorama

Like the panopticon, the diorama-building was an architectural arrangement with a center position for the *seer* with a view to "cells" or "galleries." Yet unlike the observation tower of the panopticon, the diorama platform turned (the auditorium rotated 73 degrees) to mobilize the viewer. The diorama had a *collective observer*, a shared audience on the moving platform. Dioramas and panoramas were not directly instruments of social engineering (cf. Fourier's phalanstery) but were, nevertheless, conceived of as satisfying a social desire or curiosity—a desire to have visual mastery over the constraints of space and time. The technology of the diorama relied on spectator immobility, but offered a visual excursion and a virtual release from the confinements of everyday space and time.

But if the panopticon was dependent on the enclosure of the look, the inward measure of confined but visible subjects, the diorama was dependent on the imaginary expansion of that look. Unlike the jailer-surveyor, the dioramic spectator was not attempting mastery over human subjects, but was instead engaged in the pleasures of mastery over an artificially constructed world, the pleasure of immersion in a world not present.

In the diorama, the spectator sat on a darkened center platform and looked toward the brightness of the peripheral scenes: transparent paintings where light was manipulated to give the effect of time passing—a sunset, or the changing light of the day. In the panopticon, the role of light was to indict, to measure. In the diorama, light played a deceptive role. In the panopticon, there was no spatial illusion, no fooling with time. Both panoptic and dioramic systems required a degree of spectator immobility and the predominance of the visual function. And it is this notion of the confined *place* combined with a notion of *journey* that is present simultaneously in cinematic spectation.

[. . .]

Notes

1 Michel Foucault (1979) *Discipline and Punish*, translated by Alan Sheridan, New York: Pantheon Books. Originally published as *Surveiller et Punir* [Paris, 1975].

2 See Mary Ann Doane, Patricia Mellencamp, and Linda Williams (eds) (1984) *Revision*, Los Angeles: AFI, p. 14. John Berger (1972) *Ways of Seeing*, London: Penguin Books. Laura Mulvey (1975) "Visual Pleasure and Narrative Cinema," *Screen* 16 (3), Autumn; Joan Copjec (1989) "The Orthopsychic Subject," *October* 49, Summer: 53–71.

3 Teresa de Lauretis (1987) *Technologies of Gender*, Bloomington: Indiana University Press, p. 2.

4 Michel Foucault (1970) *The Order of Things: An Archaeology of the Human Sciences*, translated from *Les Mots et Les Choses*, New York: Random House, p. 319.

5 Jeremy Bentham (1962) *Panopticon, Works of Jeremy Bentham Published under the Superintendence of His Executor, John Bowring*, 11 vols, New York: Russell and Russell.

6 Jacques-Alain Miller (1987) "Jeremy Bentham's Panoptic Device," translated by Richard Miller, *October* 41, Summer: 4.

7 Foucault, *Discipline and Punish*, p. 204.

8 Ibid., p. 205.

9 Ibid., p. 201.

10 Ibid., p. 207.

11 Ibid., pp. 202–3.

12 Jean-Louis Baudry, "The Apparatus: Metapsychological Approaches to the Impression of Reality in the Cinema," translated by Jean Andrews and Bertrand Augst in *Narrative, Apparatus, Ideology*, p. 316.

13 Walter Benjamin (1969) "The Work of Art in the Age of Mechanical Reproduction," in *Illuminations*, translated by Harry Zorn, New York: Schocken Books, p. 236.

14 Olive Cook (1963) *Movement in Two Dimensions*, London: Hutchinson and Co., p. 32.

15 Helmut Gernsheim and Alison Gernsheim (1968) *L.J.M. Daguerre: The History of the Diorama and the Daguerreotype*, New York: Dover Publications, p. 6.

16 Benjamin, "Paris—Capital of the Nineteenth Century," translated by Edmund Jephcott, in *Reflections*, New York: Harcourt Brace and Jovanovich, 1979, p. 150.

17 Richard D. Altick (1978) *The Shows of London*, Cambridge, MA: Harvard University Press, p. 180.

18 Dolf Sternberger (1977) *Panorama of the Nineteenth Century*, translated by Joachim Neugroschel, New York: Urizen Books, p. 13.

19 Ibid., p. 13.

20 Gernsheim and Gernsheim, *L.J.M. Daguerre*, p. 18.

21 Ibid.

Marita Sturken

TOURISM AND "SACRED GROUND": THE SPACE OF GROUND ZERO

Note: This chapter is a shortened and slightly revised version of Chapter 4 of *Tourists of History: Memory, Kitsch, and Consumerism from Oklahoma City to Ground Zero* (Duke University Press, 2007).

O N OCTOBER 14, 2001, weeks after it had become clear that there were no survivors left to be pulled from the rubble at Ground Zero in New York, and with the recognition that the bodies of many of those who had died would never be recovered, the City of New York decided to distribute the dust. Mayor Giuliani set up a procedure through which the families of the dead received an urn of the dust from the site for a memorial ceremony. The dust (which was otherwise being hauled from the site to the Fresh Kills landfill on Staten Island) was gathered into fifty-five gallon drums, covered by American flags, blessed by a chaplain at Ground Zero, and given a police escort to One Police Plaza.[1] Officials wearing white gloves scooped the dust into 4,000 small urns, each engraved with 9–11–01 engraved on it and wrapped in a blue velvet bag.[2] By this ritual, the dust was transformed into a substance that was understood to be sacramental and ceremonial (handled with white gloves), moved from drums (indicating refuse) to urns (indicating individuals, ashes, the remains of life)—yet also official (accompanied by police escort) and national (covered by flags).

This attempt to make the dust of Ground Zero sacred, to turn it into a relic, reveals many aspects of the construction of meaning at Ground Zero in the years since 9/11. While analyses of 9/11 have tended to focus on the role of spectacle in the event, as the years have gone by, it is the material refuse of 9/11 that has, at least in New York City, been most fraught with conflict and contested meanings. The dust is simultaneously ashes, refuse, evidence, and a fatal contaminant. Its status remains ambiguous and troubling. Even to this day, certain family members of the dead continue to advocate that it be returned to Ground Zero from Fresh Kills. And, starting in 2005, several young (and previously healthy) people who had worked as rescue workers at Ground Zero or employees who fled the area died of respiratory disease that was attributed directly to their exposure to the dust at Ground Zero. They are most likely the first of many survivors of 9/11, rescue workers, and janitors who worked in the cleanup whose lives will be shortened by the time they spent at Ground Zero.[3]

It is, perhaps, in the dust of Ground Zero that the meanings of this site are most complexly embodied.

Ground Zero was created in the moment on September 11, 2001, when the World Trade Center collapsed, shockingly, in a cloud of dust and debris that, as some witnesses said, "chased" down the streets of lower Manhattan in New York. Within a few hours, the media had found the name and it stuck.[4] Ground Zero is a name pulled from history, its origins inextricably tied to the destruction of nuclear bombs. The term "ground zero" implies a kind of nuclear obliteration yet it also, ironically, conveys a starting point, a tabula rasa. As Amy Kaplan writes, "We often use 'ground zero' colloquially to convey the sense of starting from scratch, a clean slate, the bottom line," a meaning that, she says, resonates with the "often-heard claim that the world was radically altered by 9/11, that the world will never be the same."[5]

As a term, "ground zero" defines New York as the focal point of 9/11, inscribing the space within a narrative of exceptionalism in which New York is the most important and unique aspect of 9/11. The term effectively erases the other events of 9/11, including the plane crash at the Pentagon, which killed 189 people, and the crash of Flight 93 in Shanksville, Pennsylvania, which killed forty people. The idea of ground zero as a blank slate or as the targeted center of the bombing thus sets into motion a set of narratives about 9/11, both the narrative that the site of lower Manhattan is the symbolic center of the event of 9/11 and the narrative that 9/11 was a moment in which the United States lost its innocence. This sense of historical exceptionalism hovers behind the nomenclature of lower Manhattan as Ground Zero—not only in disavowal of the original meaning of the term but also in the belief, widely circulated and deployed politically, that history itself was transformed on 9/11.

Yet what is Ground Zero as a place or a destination? It is, of course, a temporary name. As a place that is defined as existing in-between two places (the World Trade Center and its replacement) Ground Zero is more a concept than a place. It is an ephemeral space, yet one charged with meaning. In the years since September 2001, Ground Zero has become a site of destruction and reconstruction, of intense emotional and political investments, a highly over-determined space. It is a place inscribed by local, national, and global meanings, a neighborhood, a commercial district, a tourist destination, a place of protest, and a site of memory and mourning. The narratives that have been layered on Ground Zero reveal the complex convergence of political agendas and grief in this space, as if, somehow, the production of new spatial meanings will provide a means to contain the past, deal with the grief, and make sense of the violent events that took place there. The narratives and meanings produced at Ground Zero matter at the local level precisely because they have impacted in profound ways the redesign of an enormous area of a densely populated city and because they reveal the problematic relationship between urban design and commercial interests that govern a metropolis such as New York. These meanings and narratives matter at a national level when they are deployed in the service of national agendas, within a broader global context in which images of the United States are exported with political consequences. Ground Zero is a site where practices of memory and mourning have been in active tension with representational practices and debates over aesthetics, a place, one could say, defined and redefined by a tyranny of meaning.

Ground Zero is also a space defined by and experienced through media technologies, a place constantly mediated through images, a place "visited" through web sites and by tourists, a place filled with photographs that is itself relentlessly photographed. Indeed, the space of Ground Zero was, from the moment of its naming, already defined through mediatization. The collapse of the World Trade Center towers was witnessed by an extraordinary number of viewers, by those standing on the rooftops and streets of Manhattan, Brooklyn, and New Jersey, by millions of television viewers throughout the United States, and by many millions

of television viewers worldwide. 9/11 is thus often seen as an event of the image, in which some new register of the spectacular was "achieved."

I am interested in examining how the reconfiguration of Ground Zero as a site of cultural memory production has produced particular narratives of redemption that participate in the production of innocence and the political acquiescence of what I have termed the "tourism of history" in American culture. By using the term "tourism of history" I am pointing to the modes through which the American public is encouraged to experience itself and the nation's relationship to history through consumerism, media images, souvenirs, popular culture, and museum and architectural reenactments, modes that have as their goal a cathartic yet distanced "experience" of history. The tourist is a figure who stands outside of any particular location or history, who peers in while feeling no responsibility for what they see. A tourist relationship to history deploys a pose of innocence, a distance from economic, cultural and historical impact, and is steeped in a culture of comfort. U.S. culture functions in ways that have encouraged a tourist relationship to history, one that allows the American public to feel distanced from global politics and world events and to see our role in them as innocent, separate, and exceptional.

My focus in this chapter is on the discussions and debates that have taken place around Ground Zero, and the overabundance of meanings that have been generated about this site. Ground Zero has been transformed from a site of destruction and loss into a battleground, over which the families of the dead, politicians, real estate developers, and designers claim ownership. A discourse of sacredness, one derived from its status as a place where many died, is in conflict with a discourse of urban economics and urban renewal. At the same time, the symbolism of Ground Zero and the lost World Trade Center towers has been deployed as the justification for a series of wars and destructive policies of the U.S. government. In this sense, an examination of the meanings of Ground Zero can tell us a lot about how national meanings converge with local politics in a place that many people, for many different reasons, feel belongs to them.

Spectacle and mourning

It is impossible to consider the meanings projected upon Ground Zero without first considering the role played by images, and in particular spectacular images, in its making. The space of Ground Zero is haunted by the images that were produced on the day of September 11, images that have been described by so many as "cinematic." The spectacle was heightened by the twinned timing of the impact of the two planes, so that a huge number of people on the streets in New York and throughout the world on television were watching the north tower burning when the second plane hit. The image of spectacle is a central aspect of 9/11's exceptionalist discourse. Yes, it is said in this exceptionalist narrative, other violent historical events have killed more people, have destroyed cities more completely, have been more devastating politically, yet none has reached this level of spectacle, none were seen live by so many millions of people, none looked like this. Yet, the essence of spectacle is an erasure: the awe-inspiring image of the explosion masks the bodies that are incinerated within it.

In the aftermath of 9/11, the images of spectacle were countered by a proliferation of images and street-level mourning throughout the city. The striking, clean images of the towers exploding were mediated by a profusion of posters for the missing and snapshot images, a proliferation of photographs in a vernacular intervention into the street life of the city. Small and spontaneous memorials sprang up around the city, in Union Square, and at numerous fire stations. These shrines, which included photographs, candles, and messages written to the dead and missing, as well as numerous images of the now-lost twin towers,

clearly indicated that in times of loss, the act of leaving an object at a meaningful site is a cathartic one. Leaving flowers, writing collective messages, and lighting candles were declarative acts that aimed to individualize the dead. Whereas the images of spectacle produced an image of a collective loss, of a "mass body," these rituals sought to speak of the dead as individuals. As such, these objects and messages attempted to resist the transformation of the individual identity of the victims into a collective subjectivity, and thus resist the mass subjectivity of disaster.[6]

Dust

The towers of the World Trade Center were made of steel, concrete, asbestos, wood, plastic, and glass; they were filled with desks, computers, tables, and paper, yet they crumbled into dust. In one of the most noted lines of the documentary *9/11*, one of the firefighters says, "You have two 110-story office buildings. You don't find a desk, you don't find a chair, you don't find a computer. The biggest piece of telephone I found was a keypad and it was this big. The building collapsed to dust. How are we supposed to find anybody in this stuff? There's nothing left of the building."[7] There was an unbelievability in the transformation of such formidable buildings into particles of dust. How could so many material objects be reduced so quickly to dust? How could those buildings, those objects—those people— suddenly be gone?

The dust dominated the images of the immediate aftermath of the towers' collapse. It was infinitely photographable, producing haunting images of a cityscape coated in dust as if it were a few inches of snow, transforming the outline of debris into a strange, layered set of shapes. In one well-known image by photographer Susan Meiselas, a figurative statue sitting in a park (*Double Check* by J. Seward Johnson) is blanketed in dust and debris, as if he were a businessman frozen in time. The owner of Chelsea Jeans, a clothing store that eventually closed down a year later for lack of business, kept preserved a window in which the rows of pants were coated with the dust; an image of a tea set covered in the dust was featured in the *New York Times*; the mayor refused to clean the dust off the shoes he wore on his first trip to Ground Zero; people wrote messages in it, which were then photographed by the *New York Times*.[8] People's experience of the trauma of that day was gauged in terms of their proximity to the dust—those who wandered the streets coated in it, those who went home with it on their clothing, in their hair, on their faces.

The dust of the collapse of the World Trade Center acquired many meanings in the months after 9/11. It was initially a shocking substance—something uncanny and strangely familiar. Some of it was recognizable—papers, remnants of the ordinary business of life before that day, now transformed. Balance sheets from financial firms, previously objects of mundane business transactions, were transformed into historical objects and collectable items, materials conveying poignancy and loss. It is easy to remember years later that in the first few days after September 11, there was an urgency to find any survivors in the rubble, an ultimately doomed mission. What is often forgotten is that the city also had an urgent need to clean up the streets of lower Manhattan near the New York Stock Exchange, so that it could reopen the following Monday. Even as the shock of what had happened was still being registered, the city deployed an army of sanitation trucks to scour away the dust. Thus dust was initially understood as a substance that had to be cleaned away so that life could continue, and as an impediment to moving forward. It was also quickly experienced as a form of contamination, clogging people's lungs.

Soon, though, the dust was imbued with new meanings. Once it became clear that very few people had survived the cataclysmic collapse of the two buildings, the dust was defined

not simply as the refuse of the towers' collapse, but as the material remains of the bodies of the dead (ultimately, only 1,592, or 58 percent, of the 2,749 people killed were identified). Processes of grief often involve a need for a material trace of the dead. At Ground Zero, this need transformed the dust into a new kind of substance, one freighted with significance, which resulted, as I have noted, in it being blessed and placed in urns for the families who wanted it. As Patricia Yaeger writes, this revealed the "impulse to convert this detritus into something hallowed and new."[9] Yaeger writes that the detritus of the World Trade Center towers was disturbing precisely because its status was unclear—"is it rubble or body part?" As such, it can be seen as a polluting substance, in Mary Douglas's terms.[10] It coated surfaces with specks of life, death, body, paper, and building. The dust needed to be scrubbed away precisely because of its liminal status—as both refuse and body. And it was removed, intensely and efficiently, along with the larger chunks of building debris, to the Fresh Kills landfill. There, body parts were still sought after, but the debris had already been transformed through its location into the category of rubbish.

The multiple meanings placed upon the dust at Ground Zero are indicators of the ways that various discourses have come into conflict there, including those of sacredness, commerce, and urban design. The desire to see the dust as a means to render present the dead is deeply connected to concepts of sacredness at the site. The recoding of the dust is also implicated in the controversy of the role that Fresh Kills landfill on Staten Island has played in the meanings generated at Ground Zero, and how those meanings have intersected with the definition of science that has emerged in the process of DNA identification. Although a huge effort was made to locate any remaining body parts that might have been sent to the landfill, rather than recovered from Ground Zero, there is lingering concern that the landfill is a repository for the remains and ashes of the dead.

Thus, even after it was relegated to the dump, the dust of Ground Zero continued to haunt precisely because its status was not trash. Dust is not, as Carolyn Steedman argues, about refuse or rubble so much as it is about a cyclical materiality. It is a reminder of continuity, a vestige of what was that continues to exist. The dust in the archive, she argues, evokes the material presence of the past—a "not-going-awayness" and an imperishability of substance. She writes, "Dust is the opposite thing to Waste, or at least, the opposite principle to Waste. It is about circularity, the impossibility of things disappearing, or going away, or being gone. Nothing *can be* destroyed."[11] Attempts to preserve the dust are interventions into this cycle of materiality; as such, they are attempts to arrest the moment of crisis.

The photograph

The dust defined the materiality of the pile at Ground Zero, yet the defining medium of the street-level response in the aftermath of the towers' destruction was the still photograph. The emergence of photographs was almost immediate, as the city was quickly plastered with flyers for those who were missing. These missing posters, made in desperation by friends and family members, were posted near hospitals and rescue centers and on the streets of lower Manhattan, rapidly filling up the visual landscape at eye level. Each of these images began as one of hope, imbued with the belief that person would be found, would be *recognized*. Yet, within a week of the towers' fall, it became clear that there would be very few survivors, and the missing posters were transformed into images that marked, if not catalogued, the dead. The posters remained within the cityscape, tenaciously clinging to buildings and signposts, becoming increasingly faded and torn, their deterioration a kind of evocation of grief. The images on these missing posters powerfully evoked a kind of prior innocence—people smiling in vacation photos and at family gatherings, testimony to a time "before" when such a

context, such an event, was unimaginable. The temporal rupture of these images demonstrated in many ways the power of the still image to convey a mortality and finality. The identifying text, at once forensic as it noted particular physical characteristics ("eyes: blue" "eagle tattoo on right arm") and personal in its plea ("Have you seen John?") was transformed from the language of identification into one of fate: "1 World Trade Center, Marsh 97th Floor," "Cantor Fitzgerald," "Last seen on 102nd Floor of One World Trade Center."

The photographs in these posters were freighted with new meaning. These photographs of people alive and naive about events to come acted as counter-images to the iconic images that came to define 9/11, not only the images of spectacle but also the haunting images of people falling/jumping to their deaths. As they were transformed into memorials, the missing posters were themselves eulogized. Eventually, many of the posters were assembled into an exhibition, *Missing: Last Seen at the World Trade Center, September 11, 2001*, which traveled around the U.S. the following year, and many posters are now a part of various archives about 9/11, thus, to a certain extent, completing their transformation from objects of searching and hope to historical objects of mourning.[12]

It is striking that still photographs seem to have played a dominant role in the response to 9/11. Initially, the site of Ground Zero was considered to be taboo for photographing and, as Marianne Hirsch writes, police told people to "show respect" by putting their cameras away.[13] Thus, in the moment of crisis, photography was initially seen as a suspect activity and hand-made posters near the barrier of Ground Zero told people to put their cameras away. As one poster admonished, "I wonder if you really see what is here or if you're so concerned with getting that perfect shot that you've forgotten this a tragedy site, not a tourist attraction."[14]

Nevertheless, even in the early weeks, rescue workers and volunteers were photographing at the site, and there was a proliferation of amateur images throughout the city. By December, there were several photographic exhibitions that were quickly installed in open storefronts, where anyone could bring their snapshots and videotape, the most popular of which was the exhibit *Here Is New York*, which was later released as a book, and which by December had sold inexpensive copies of over thirty thousand images.[15] These shows were hugely popular with both tourists and New Yorkers. It thus seems as if the urge to both take photographs and to look at the images of disaster was a means of assimilating the event.

While missing posters and snapshots proliferated an array of amateur images throughout the city, certain photographs emerged quite rapidly as image icons of 9/11. The firefighters were the iconic figures of 9/11, and their deaths were the focus of enormous public grieving. It is thus not surprising that one of the most lauded images to have been created of 9/11 was a photograph of firefighters. This image, take by Thomas E. Franklin of the *Record* newspaper of Bergen County, New Jersey, shows three firefighters looking upward as they raise a flag at Ground Zero, as enormous piles of debris tower over them. The Franklin image won the Pulitzer Prize and has been widely disseminated, appearing on a huge variety of merchandise, both official and unofficial. It circulated through a broad array of cultural formats, ending up being reenacted at sports events and, among other places, as a display honoring firefighters at Madame Tussaud's Wax Museum and as a snow globe.

As has been widely noted, the Franklin image did not emerge in isolation but is itself a reference to, if not a reenactment of, one of the most famous images of American history, of American soldiers raising the U.S. flag at Iwo Jima during World War II. Indeed, in may ways the gesture of three firefighters raising the flag at Ground Zero was *already a reenactment* of the Iwo Jima photograph, a reenactment by both the firefighters and the photographer. The original Iwo Jima image, which also won a Pulitzer Prize and was later immortalized in bronze in the Marine Corps War Memorial, is so central to American concepts of triumph and sacrifice, that it is consistently the source of remakes.[16]

Those images that gain iconic status establish a set of codes through which subsequent images are defined—they create an iconography for depicting certain kinds of events. This is particularly the case with images that tap into concepts of national identity. There is thus a tendency on the behalf of photographers to attempt to create (and the public to embrace) pictures that fit into familiar codes and narratives of sacrifice and heroism. It is now known that many firefighters were sent to their deaths through faulty communication and misguided, if understandable, decisions and that they did not have to die in such numbers. Yet narratives of heroism serve to make their deaths seem less futile. The remaking of the Franklin image was thus about fusing the firefighters into a narrative of U.S. military victory, a remarkable feat given that it is an image of an event in which the U.S. had been attacked and hundreds of firefighters had died; it was also about remaking the image of 9/11 from an image of catastrophe and loss into one that could be deployed as a military response.[17]

The iconic photograph of the firefighters raising a flag at Ground Zero, however, was also the subject of a debate over representation. The photograph became the model for a planned memorial to the firefighters in which the sculptor changed the three white firefighters into a racially diverse group—one white, one Latino, and one black—and the firefighters rejected it as an attempt at political correctness.[18] This demonstrates in many ways the limits of figurative representation in an era of heightened sensitivity about difference; in other words, contemporary codes of representation do not allow a figurative statue to be without racial meaning.[19] If the firefighters in the statue are all white, which they were in the photograph, then the memorial exposes the reality of the New York City fire department, which is that it is, despite many attempts to integrate it, 94 percent white in a city that is less than 50 percent white.

The photograph of the three firefighters takes place at Ground Zero, but its focus is on the renewal signified by the firefighters and the patriotic significance of the flag-raising, rather than its depiction of the site of Ground Zero. Images of Ground Zero are, like the site itself, weighted with meaning that, like the flag from the Franklin photograph, can be exported with specific political intent. Shortly after 9/11, the photographer Joel Meyerowitz, who had spent years photographing the World Trade Center towers from the roof of his building farther uptown, was granted access to photograph the site during the months in which the debris was cleared. Meyerowitz's photographs are stunning images. In them, the massive piles of debris are rendered beautiful under the bright spotlights of the demolition crews. Meyerowitz works with a large-format camera, and the images are printed large, thirty by forty inches, so that they have a lush, luminescent quality.

Meyerowitz's images are not simply works that document what happened in the clearing of Ground Zero. They are aesthetic objects, with an artistic visual power. As such, they have an effect that is both intimate and spectacular, what Liam Kennedy has termed "an epic quality and scale" that lends an aura and weightiness to them.[20] It is likely for these reasons that twenty-eight of the Meyerowitz images (including images of the pile and of rescue personnel at Ground Zero) were selected by the U.S. State Department in 2002 for an exhibition that traveled around the world for two years, to targeted areas in North Africa and the Middle East, such as Dar es Salaam, Istanbul, Kuwait, and Islamabad as well as numerous sites in South America, Asia, and Europe, as a form of cultural diplomacy.

The easy deployment of Meyerowitz's images as public diplomacy, in which they were exhibited with quotes from President Bush, Secretary of State Colin Powell, and former New York Mayor Rudolph Giuliani, raises questions about how their aesthetics function. As Kennedy points out, Meyerowitz's emphasis on the role of the images as an archive was also a means to downplay their acknowledged beauty, yet it was precisely their visual beauty that made them potential cultural messengers of the Administration's attempt to justify its response to 9/11, the war in Iraq. The rhetoric of the texts in the exhibition makes this

connection clear. As the statement from Assistant Secretary of State Patricia Harrison reads, "The exhibition will convey to foreign audiences the physical and human dimensions of the recovery effort, images that are less well known overseas than those of the destruction of September 11. Joel Meyerowitz captures the resilience and the spirit of Americans and of freedom-loving people everywhere."[21]

The Meyerowitz photographs are a compelling example of how attempts to find redemption in disaster and to find meaning in death and destruction can be easily deployed for particular political purpose. When used as cultural diplomacy, with the explicit attempt to create a better image of the United States throughout the world (at a time when it was engaged in war), these photographs are vulnerable to the charge that, as Kennedy puts it, they affirm an exceptionalism about 9/11 "that the United States is the epicenter of the culture of humanity."[22] This exceptionalist narrative was intricately a part of the discourse of sacredness that emerged at Ground Zero.

Sacred ground and the footprints

As the realization took hold soon after September 11 that there were many bodies that would never be recovered, the ground on which the towers had stood was declared by many to be "hallowed" or "sacred." The concept of sacred ground enabled many things at the site, and has been a particularly powerful discourse both at Ground Zero and in national politics.

What does it mean when sites of violence are declared sacred? The term *sacred* implies a religious meaning, and it has been the case that many religious figures have performed ceremonies at Ground Zero. Yet, the discourse of sacred ground at Ground Zero comes not from the blessings of priests but, rather, from the loss of life that took place there. Traditionally, in American culture, ground has been considered sacred when blood has been spilled on it, most specifically in relation to Gettysburg.[23] The connections made between Gettysburg and Ground Zero, which have included numerous readings of the Gettysburg Address at anniversary ceremonies at the site, explicitly confer patriotic meaning on the site, a move that situates the 9/11 dead within the history of the sacrifice of soldiers who have died for the nation.

The status of Ground Zero as sacred ground is highly contested, precisely because of the potential limitations and broad effects such symbolic meaning has. A site of sacred ground is charged with meaning. It implies not daily life but worship, contemplation, and a suspension of ordinary activities. In a sacred space, all activities have meaning, all are transformed into rituals. Sacred ground cannot be, for instance, a neighborhood, which is defined by the ongoing everydayness of life, work, commerce, and public interaction. Indeed, one could argue that it is precisely a kind of mundane everydayness and routine that defines the familiar sense of a neighborhood. Thus, notions of Ground Zero as sacred ground are antithetical to the stakes held by residents and workers in lower Manhattan and have been a constant source of concern for them.

There are important consequences to the amount of space at Ground Zero that has been designated as sacred in relation to the space that is being reclaimed for everyday life. Of those spaces, the footprints of the two towers have been designated the most sacred. Early on in the design process, in July 2002, Governor Pataki promised the families of the dead that he would not allow buildings to be built on the footprints of the towers.[24] From the beginning the many different design proposals for the site treated the footprints of the towers, which are each two-hundred feet on each side and about one acre in size, as sanctified locations. The master plan for the site by architect Daniel Libeskind and the memorial design, *Reflecting Absence*, by Michael Arad fully inscribe this hierarchy of space, with the footprints designated solemn and unique spaces, voids in a public plaza.

The importance placed on the two footprints of the towers is deeply ironic when one considers how the World Trade Center complex was experienced when it stood. Built by the Port Authority of New York and New Jersey in 1970 by architect Minoru Yamasaki, the twin towers had long been considered to be not only examples of banal modernism, but ineffective examples of urban design, what architecture critic Paul Goldberger calls an "antiurban" design.[25] The complex was notable for all the myriad ways that it did not integrate into the surrounding neighborhood. The plaza of the twin towers was notorious as a badly designed area, neither conducive to public gathering nor even, for most people, the primary entry point to the towers. It is fairly safe to say that the foundations, or "footprints," of the buildings were truly unremarkable while the towers stood.

Given that the concept of "the footprint" is unlikely to have emerged from people's personal experience with the World Trade Center complex prior to its destruction, one must ask how it has acquired such important symbolic meaning. The idea of a building's footprint evokes a sense that a structure is anchored in the ground. It is also anthropomorphic, as it implies that the building left a trace, like a human footprint, in the ground. The emphasis on the footprints of the two towers demonstrates a desire to situate the towers' absence within a recognizable tradition of memorial sites. The idea that a destroyed structure leaves a footprint evokes the site-specific concept of ruins in modernity. In the case of Ground Zero, one could surmise that the desire to reimagine the towers as having left a footprint is, thus, a desire to imagine that the towers *left an imprint* on the ground. Their erasure from the skyline was so shocking and complete that there have been constant attempts to reassert them into the empty sky. The desire for the buildings to have had a footprint could thus be seen as a kind of struggle with their absence.

As Philip Nobel writes, the choice to designate the footprints as sacred evokes the ghostly presence of the twin towers' original architect Minoru Yamasaki: "The designation of the footprints as holy ground has had a devastating effect on the planning possibilities at Ground Zero, but the two enormous squares also made a very awkward site for the memorial they were fated to contain. Their sanctification was Yamasaki's revenge . . . his critics were forced to genuflect to his meaningless geometry."[26] In this process, the footprints of the buildings are asked to stand in for the dead, to give the vanished dead a home, a place where they are imagined to be, where one could imagine "visiting" them, to make them present in the absence of their remains.

Tourist destination

The transformation of the space of Ground Zero from a site of emergency to one of recovery to one of tourism took place within a relatively short period of time. Indeed, it could be argued that through the vast numbers of images generated of the World Trade Center collapse, the site was immediately the focus of consumption from its inception. Initially, as I have noted, lower Manhattan was a restricted area, blocked off from view, in which looking was discouraged. Yet, even one week later, people, many of them in the role of tourists, were headed downtown to try and get a look.[27] By December, the police who were patrolling the boundaries of the area had become more accommodating to the crowds because, as one told me, "people have the right to look." As early as November, the site of Ground Zero was being called "the city's hottest attraction," even though officials in the tourist industry, while desperate to revive tourism in the city, were reluctant to acknowledge the trend.[28] On December 30, a viewing ramp, commissioned by the city and designed by four well-known architects: David Rockwell, the team of Elizabeth Diller and Ricardo Scofidio, and Kevin Kennon, was opened by St. Paul's Chapel and tickets were distributed in order to

accommodate the large crowds who came to see the view.[29] By the spring, the *New York Times* and other publications were running travel features on where to eat downtown after visiting Ground Zero, effectively constructing the site as a tourist destination. Indeed, in March 2002, the *Los Angeles Times* characterized the act of dining out in lower Manhattan in symbolic terms: "Going out to dine in the shadow of ground zero would be unthinkable if it weren't an act of defiance in the face of terrorism and a vote of support for the beleaguered neighborhood."[30] In late fall, American Express ran an ad campaign about downtown Manhattan business, showing people opening their stores and restaurants, with the words, "Their electricity has come back. Their phone service has come back. Now it's your turn." When it reopened in Spring 2003, the Millennium Hilton Hotel, right across from the site, became a draw for tourists.[31]

It is important to note that the transformation of Ground Zero from a place of emergency to a place of tourism is not in conflict with the desire to see it as sacred ground. Like those diners who felt they were performing a symbolic support of the neighborhood, many of the tourists at Ground Zero were, particularly in the first months, acting both as tourists and as mourners. Tourist locations, like sacred sites, are places people make pilgrimages to. While standing on the viewing platform that first year, most people responded in ways that evoked both mourning and tourism—they stood looking in shock, they cried, and they took photographs of what they saw. Ironically, however, the space of Ground Zero is a uniquely un-photogenic space. Tourists patrol its perimeter with cameras in hand, yet it is rendered in photographs as a kind of banal space of emptiness—a void, but in some senses a meaningless one. This may be one reason why photographs and postcards of the World Trade Center, rather than images of Ground Zero, are what are sold there.

The mixture of tourism and mourning was a part of the response to 9/11 from the start. Within a week, as World Trade Center postcards were rapidly sold, it was reported that New Yorkers themselves were buying souvenirs of the city and purchasing large amounts of patriotic merchandise.[32] There was also an immediate commerce of World Trade Center artifacts and trinkets on eBay, which then came under criticism and created a charity auction to compensate.[33] For several years later, the deep hole at Ground Zero was surrounded by an open fence that allows viewers to look throughout the site along its perimeter. At one point, in response to the large numbers of people visiting the site, the Port Authority set up a photographic display about the history of the area that includes a timeline of the date of September 11 and over the years has presented various exhibitions along the periphery. This frames Ground Zero as a pedagogical exhibition, and thus allowed it to be seen as an exhibit itself, rather than as a construction site. Tens of thousands of people have visited Ground Zero every day, and now with the opening of the memorial in 2011, it is increasingly defined as a site of tourism.

The emergence of Ground Zero as a tourist site also redefines lower Manhattan through paradigms of tourism. Lower Manhattan is not new to tourism, most obviously because the twin towers were themselves a tourist destination, though almost exclusively for tourists taking the elevators to the observation deck on the north tower. Yet, the post-9/11 tourism of Ground Zero is markedly at street level, and involves a much less formalized commercialism. It is a place where trinkets, souvenirs, and commodities are sold. The proliferation of commodities includes FDNY hats and T-shirts, NYPD dolls and glass replicas of the twin towers, the vast majority "made in China" (Figure 31.1).

The tourism at Ground Zero integrates with the informal street economy of New York City. New York City has a complex system of street vendor licenses in operation, which enable a broad, legal economy of street vending. Because these licenses are limited, there is also a vast network of illegal street vendors, most of whom are part of broad international and immigrant networks. It is one of the ironies of post-industrial and global economies that the majority of patriotic American merchandise, such as small flags and "I Love New York" stickers, are produced outside the U.S. in China and Korea.

This economic network responded rapidly to the events of 9/11, apparently fully aware that certain kinds of objects, such as models of the towers, had instantly become desirable. Souvenir distributors in New York produced new souvenir designs about 9/11 as early as September 12 that were then sent to their manufacturers in Korea and China, who churned out new merchandise in four days. Once air traffic resumed, the souvenirs were shipped in and pins, decals, and buttons with the flag, the twin towers, and the Statue of Liberty began appearing on street corners within a week.[34]

The intermixing of patriotic merchandise with the 9/11 merchandise sold at Ground Zero has the effect of constantly reinscribing the space as one of national meaning. While it is now a commonplace to see the site within national terms because of the nationalistic response to the attacks of 9/11, the fact remains that several hundred people who were killed there were not American citizens. Nevertheless, the presence of patriotic merchandise at Ground Zero helps to mediate potential criticism of the level of kitsch in many of these souvenirs, and the questionable practice of selling merchandise at a site of mourning. In their ethnography of the vendors and consumers at Ground Zero during 2002, Molly Hurley and James Trimarco found a range of responses from consumers about the appropriateness of selling memorabilia at the site, dominated by a concern that, whatever the motives of consumers to acquire a memento, no one should make a profit from violence.[35] Hurley and Trimarco note that the police patrol the area with a certain code about what kinds of objects should be sold and who should sell them. Street vendors are much more likely to be subject to the wrath of police officers for selling 9/11 merchandise, than that of consumers, even though local stores that sold similar merchandise were not targeted.[36] Here, the question of what constitutes a "proper" object of remembrance and a memorial commodity is particular fraught, and one that will certainly factor into the construction of the memorial museum and a gift shop at Ground Zero. While the networks that provide these souvenirs at Ground Zero are now part of informal economic networks, these cheap souvenirs are part of a much broader consumer economy related to 9/11, an economy that includes a huge number of books, from journalistic accounts to academic analyses, and a plethora of objects, both high and low end, that imagine, and reimagine the two towers.

Inevitably these souvenirs raise questions of the role of kitsch and reenactment in the cultural memory of traumatic events. It is the case that 9/11 has generated an extraordinary number of kitsch objects. As Salon writer Heather Havrilesky wrote on the first-year anniversary, "sifting through the consumer fallout from 9/11 can incite the kind of cultural vertigo heretofore only achieved by spending several hours in a Graceland giftshop."[37] It is worth reflecting on how this kitsch functions. Daniel Harris writes in an essay on "The Kitschification of Sept. 11, "Do we need the overkill of ribbons and commemorative quilts, haloed seraphim perched on top of the burning towers and teddy bears in firefighter helmets waving flags, in order to forget the final minutes of bond traders, restaurant workers and secretaries screaming in elevators filling with smoke, standing in the frames of broken windows on the 90th floor waiting for help and staggering down the stairwells covered in third degree burns? . . ."[38]. Harris points to the many ways in which kitsch can smooth over violence and tragedy, and in which kitsch objects constitute a kind of political acquiescence. The souvenirs at Ground Zero can only engage with history in very limited ways. They are objects that focus on loss and memory in ways that inevitably collapse history into simple narratives. The focus of such objects is invariably not the *why* of such events or the complexities of history so much as it is about producing narratives of redemption and comfort. Thus, many of the objects that circulate at Ground Zero are objects that offer a kitsch embrace of redemption, with images of angel figures surrounding the twin towers and an affirmation of rescue workers

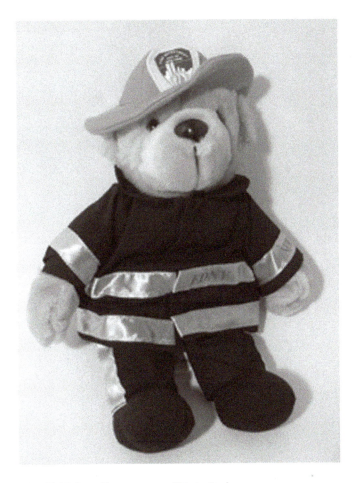

Figure 31.1 FDNY Teddy Bear. Photo courtesy of Marita Sturken.

in a snow globe, in which the police car and fire truck stand next to the two magically-still-standing towers. This emphasis on redemption is a key element in the deployment of such events for political gain.

The purchasing of souvenirs at Ground Zero is in many ways the shadow activity to the shrines that sprang up in New York in the days after 9/11. The shrines indicated a need that people felt to leave objects in a ritualistic fashion (see Fig. 31.2). The souvenir economy provides a different relationship to objects at Ground Zero. Instead of leaving an object, people take an object away. As an object purchased at the site, a souvenir offers a trace of that place, a veneer of authenticity just as any souvenir object intends to do. Thus, even if it is purchased at the airport, a keychain with the Eiffel Tower offers up a connection to the place of Paris. The souvenirs sold at Ground Zero, and to an only slightly lesser extent around Manhattan, are thus a means of marking place, of creating connections to this highly over-determined and intensely symbolic site.

The fervent tourism at Ground Zero, which has only increased since the memorial has opened, is a primary example of what I am calling the tourism of history. The site of Ground Zero is, by necessity as a site of mourning, stripped of its larger political meaning and situation within global politics. As a tourist destination, it is situated as a unique site, an exceptional one, in which the terrorist attacks that created it can only be defined within it as having come from out of the blue (Fig. 31.3). Any attempt to situate 9/11 within broader

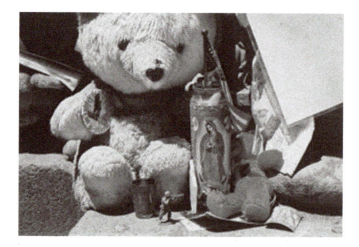

Figure 31.2 Shrine in New York, September 2001. Photo by Alberto Zanella. Courtesy of Marita Sturken.

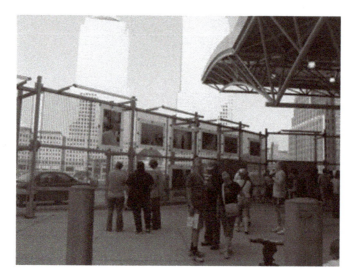

Figure 31.3 Tourists at Ground Zero, August 2006. Photo courtesy of Marita Sturken.

historical contexts at the site of Ground Zero has inevitably clash with the inscription of the site as one of unique and immense loss. The souvenir culture at Ground Zero functions as a means to provide connection to the site, to testify to a visitor's pilgrimage there, and to provide comfort—the comfort of kitsch, and the comfort that commerce continues (see Fig. 31.4). The paradoxes of this comfort are many—while the souvenir culture of Ground Zero helps to produce a narrative of innocence, in which the U.S. and New York were sites of unsuspecting and unprovoked attack, the discourse of heroism that attempts to inscribe firefighters with quasi-military status, must resist such qualities of innocence.

As such, these objects also participate in a kind of reenactment, a stasis in which the moment of the towers' fall is imagined to not yet have taken place. In the constant

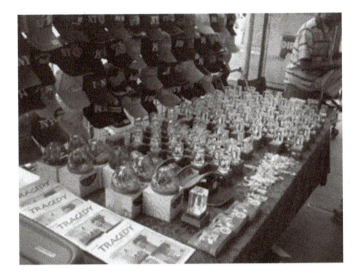

Figure 31.4 Souvenirs for sale at Ground Zero, 2003. Photo courtesy of Marita Sturken.

reinscription of the twin towers, these objects project a fantastic time, in which the towers still stand yet are charged with the meaning of their loss, their presence reenacted.

Notes

1 The name Fresh Kills, which has the potential to sound morbid in this context, is actually derived from the Dutch language, in which *kills* means streams. There are many names in New York that come from its early Dutch settlers.

2 Amy Waldman, "Mementos: With Solemn Detail, Dust of Ground Zero is Put in Urns," *New York Times*, October 15, 2001, B11.

3 The death of NYDP detective James Zadroga, 34, received the most attention. Emergency Medical Technicians Timothy Keller, 41, and Felix Hernandez, 31, also died from lung-related diseases after fighting for workers' compensation. In addition, the family of Felicia Dunn-Jones, a civil rights lawyer who worked one block from the World Trade Center and who died five months after the attacks, was awarded compensation by the Sept. 11 Victim Compensation Fund. Erika Martinez, "Hidden Victims of WTC," *New York Post*, January 17, 2006, 15; Anthony DePalma, "Debate Revives as 9/11 Dust is Called Fatal," *New York Times*, April 14, 2006, B1; and Anthony DePalma, "Medical Views of 9/11 Dust Show Big Gaps," *New York Times*, October 24, 2006, A1, B4. See also Ridgely Ochs, "Their '9/11 Plague': Almost 5 years after the Terror Attacks, New, Critical Cases Are Surfacing," *Knight Ridder Tribune Business News*, June 1, 2006, 1.

4 According to Michael Tomasky, the first use of the term in print was by Associated Press reporter Larry McShane in the evening of September 11, in which he wrote, "Shortly after 7 PM, crews began heading into ground zero of the terrorist attack to search for survivors and recover bodies." Michael Tomasky, "Battleground Zero," *New York Review of Books*, May 1, 2003, 18.

5 Amy Kaplan, "Homeland Insecurities: Transformations of Language and Space," in *September 11 in History: A Watershed Moment?*, ed. Mary L. Dudziak (Durham, NC: Duke University Press, 2003), 56.

6 See Michael Warner, "The Mass Public and the Mass Subject," in *The Phantom Public Sphere*, ed. Bruce Robbins (Minneapolis, MN: University of Minnesota Press, 1995), 234–56.

7 *9/11*. DVD. Directed by Jules, Gédéon Naudet, and James Hanlon (2002, Paramount Pictures).

8 Michael Kimmelman, "Art in Ashes, Drama in Dust," *New York Times*, August 19, 2002, B1; Randal Archibold, "Preserving a Tea Set That Captured the Moment," *New York Times*, September 6, 2002, A21; Christy Ferer, "Unforgotten Soldiers," *New York Times*, October 25, 2001, A21; and Dan Barry, "From a World Lost, Ephemeral Notes Bear Witness to the Unspeakable," *New York Times*, September 25, 2001, B9.

9 Patricia Yaeger, "Rubble as Archive, or 9/11 as Dust, Debris, and Bodily Vanishing," in Greenberg, *Trauma at Home: After 9/11*, 187.

10 See Mary Douglas, *Purity and Danger: An Analysis of Concepts of Pollution and Taboo* (New York: Routledge, [1966] 1980).

11 Carolyn Steedman, *Dust: The Archive and Cultural History* (New Brunswick, N.J.: Rutgers University Press, 2002), 164.

12 See http://www.bronston.com/missing/. For a discussion of the mixed responses to the exhibit, see Barbara Kirshenblatt-Gimblett, "Kodak Moments, Flashbulb Memories: Reflections on 9/11," *Drama Review* 47.1 (Spring 2003), 30–31.

13 Marianne Hirsch, "I Took Pictures: September 2001 and Beyond" in *Trauma at Home: After 9/11*, ed. Judith Greenberg (Lincoln, NE: University of Nebraska Press, 2003), 69–86.

14 Quoted in Kirshenblatt-Gimblett,"Kodak Moments," 14.

15 See Kari Andén-Papadopoulus, "The Trauma of Representation: Visual Culture, Photojournalism and the September 11 Terrorist Attack," *Nordicon Review* 24 (2003), http://www.nordicom.gu.se/common/publ_pdf/32_089-104.pdf; and Kirshenblatt-Gimblett, "Kodak Moments." *Here Is New York: A Democracy of Photographs* (New York: Scalo, 2002), http://ww.hereisnewyork.com, was conceived and organized by Alice Rose George, Gilles Peress, Michal Shulan, and Charles Traub. Funds raised by selling copies of the images for $25 each were donated to the Children's Aid Society.

16 See Karal Ann Marling and John Wetenhall, *Iwo Jima: Monuments, Memories, and the American Hero* (Cambridge, MA.: Harvard University Press, 1991).

17 See Andén-Papadopoulus, "The Trauma of Representation."

18 Kevin Flynn, "Firefighters Block a Plan for Statue in Their Honor," *New York Times*, January 18, 2002, A21. See also John Ydstie, host, Leon Wynter, reporter, story on the New York Fire Department, Weekend Edition Saturday, National Public Radio, February 16, 2002.

19 This conflict echoes in many ways the response to the Frederick statue that was erected next to the Vietnam Veterans Memorial in Washington, D.C., which numerous people have speculated on the racial identity of the three soldiers, and whose presence made the female veterans feel left out. See Marita Sturken, *Tangled Memories: The Vietnam War, the AIDS Epidemic, and the Politics of Remembering* (Berkeley: University of California Press, 1997), 56–57.

20 Liam Kennedy, "Remembering September 11: Photography as Cultural Diplomacy," *International Affairs* 79.2 (March 2003), 320.

21 The exhibition is available at http://www.911exhibit.state.gov.

22 Ibid., 326.

23 See Edward T. Linenthal, *Sacred Ground: Americans and Their Battlefields* (Urbana, IL: University of Illinois Press, 1991).

24 Pataki's remark was apparently spontaneous enough to have taken others involved in the early stages of the rebuilding process by surprise. See Paul Goldberger, *Up From Zero: Politics, Architecture, and the Rebuilding of New York* (New York: Random House, 2004), 212.

25 See Goldberger, *Up From Zero*, 28. There are several excellent books on the history of the World Trade Center including Eric Darton, *Divided We Stand: A Biography of New York's World Trade Center* (New York: Basic Books, 1999), and James Glanz and Eric Lipton, *City in the Sky: The Rise and Fall of the World Trade Center* (New York: Times Books, 2003).

26 Philip Nobel, *Sixteen Acres: Architecture and the Outrageous Struggle for the Future of Ground Zero* (New York: Metropolitan, 2005), 116–17.

27 Gail Collins, "New York Notes: 8 Million Survivors in Need of Affection," *New York Times*, September 17, 2001, A14.

28 See Janet Wilson, " 'Sacred Ground' in N.Y.," *Los Angeles Times*, November 29, 2001, A1, A19; and Susan Saulny, "Pilgrimage to New York City: Paying Respects and Spending Little," *New York Times*, December 29, 2001, B1.

29 See John Leland, "Letting the View Speak for Itself," *New York Times*, January 3, 2002, B14. Some observers commented that the ramp bore a resemblance to the Vietnam Veterans Memorial in its form.

30 S. Irene Virbila, "Ground Zero: Downtown Restaurants Have Reopened, Stirring Up Hope," *Los Angeles Times*, March 17, 2002, L1, L11.

31 Steve Cuozzo and Gillian Harris, "Room to Reflect: Hotel's Ground Zero Views Are Drawing Guests," *New York Post*, July 7, 2003, 11.

32 *Los Angeles Times*, "After the Attack: The New Yorkers: Big Apple Pride is in Fashion," September 19, 2001, A21.

33 Mick Broderick and Mark Gibson, "Mourning, Monomyth and Memorabilia: Consumer Logics of Collecting 9/11," in Heller, *The Selling of 9/11*, 201.

34 Lynette Holloway, "Wholesalers, in Rush to Market, Got Sept. 11 Souvenirs on Street," *New York Times*, December 8, 2001, D1.

35 Molly Hurley and James Trimarco, "Morality and Merchandise: Vendors, Visitors and Police at New York City's Ground Zero," *Critique of Anthropology* 24.1 (2004), 61–64.

36 Ibid., 71.

37 Heather Havrilesky, "The Selling of 9/11," Salon.com, September 7, 2002, http://www.salon.com/2002/09/07/purchase_power/.

38 Daniel Harris, "The Kitschification of Sept. 11," Salon.com, January 25, 2002, http://www.salon.com/news/feature/2002/01/25/kitsch/.

Sumathi Ramaswamy

MAPS, MOTHER/GODDESSES, AND MARTYRDOM IN MODERN INDIA

The geography of a country is not the whole truth. No one can give up his life for a map.

<div align="right">Rabindranath Tagore, 1919[1]</div>

The best of all Good Companions to take with you to a strange place is undoubtedly a MAP.

<div align="right">W.W. Jervis, 1938[2]</div>

THE STRANGE PLACE TO WHICH I take you in this chapter is death, specifically, death for the nation's territory, although whether a map is undoubtedly a good companion for you on this journey I leave for you to decide, for I hope to persuade you to the contrary.

Several years ago, Benedict Anderson suggested that in an age marked by the dissolution of older beliefs regarding fatality and immortality and the paralyzing disenchantment that followed, nationalism emerged to recalibrate the meaning of death. He further insisted that unless we explore the connection between nationalist ideologies and death and immortality, it is impossible to understand why so many millions kill and are willing to die on behalf of what is, after all, an abstraction: "These deaths bring us abruptly face to face with the central problem posed by nationalism: what makes the shrunken imaginings of recent history generate such colossal sacrifices?" (Anderson 1991, 7). More recently, Joan Landes has insisted, "The nation is a greedy institution—economically, physically, and emotionally It is the object of a *special kind of love*—one whose demands are sometimes known to exceed all others, even to the point of death" (2001, 2; emphasis added).

In this chapter, I reflect on these assertions by considering patriotic pictures produced in colonial and postcolonial India in order to understand how these attempt to transform the national territory into a tangible and enduring object of such a special kind of love that it is deemed deserving of the bodily sacrifice of the citizenry. In doing so, I intend this pictorial chapter to advance our understanding of "the *passion* of nationalism, of the heroism, self-sacrifice and sense of righteousness which it can provoke" (Kitching 1985, 109). What place do patriotic pictures occupy in the economy of such

passion? This is the question I set out to answer by introducing the three anchor images of this chapter.

The first of these, a print from the late 1940s from Calcutta, shows Mother India, or Bharat Mata, the female personification of the Indian nation and its territory (Figure 32.1). Holding the Indian national flag in one hand, she stands on a partially visible terrestrial globe, on which is also perched a figure identifiable to the visually cued Indian viewer as Bhagat Singh, a young man from Punjab who was hanged by the British colonial state on March 23, 1931. He is handing her his bloodied head, presumably severed by the sword that lies next to him, while blood from his decapitated body flows onto the globe, and onto some roughly marked territories that appear to be parts of India and the adjacent country of Burma. In return, Mother India blesses him for his act of corporeal sacrifice.[3]

The second picture from around the same time was printed in Bombay soon after Mohandas Gandhi's assassination in New Delhi on January 30, 1948 (Figure 32.2). The Mahatma's life story is arranged in visual vignettes around the central image of his bullet-marked body standing on a terrestrial globe, onto which is painted the rough outline of a place we recognize as the subcontinent. As in Figure 32.1, in this picture as well, the blood from his carefully placed wounds drips down to earth, forming a puddle on the map of India. That the artist did not miss the tragic irony of the apostle of nonviolence being gunned down by an assassin's bullet is clear from the smoking revolver placed on the map of India drawn on the globe.

Fast-forwarding to 1984 and to the assassination of Prime Minister Indira Gandhi on October 31, my third image is an election billboard from December of that year on display in a crowded marketplace in Hyderabad (Figure 32.3). Blood from Indira's wounded body, draped in a white checked sari, flows onto a map of India holding her dying body. Inscribed

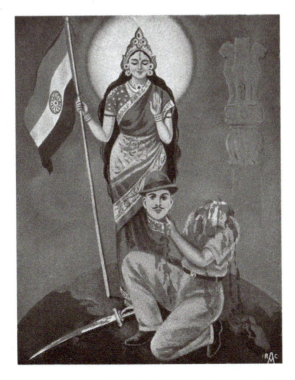

Figure 32.1 *Shaheed Bhagat Singh* (Martyr Bhagat Singh), artist not known, late 1940s. Chromolithograph published by Rising Art Cottage, Calcutta. Collection of Christopher Pinney, Cambridge.

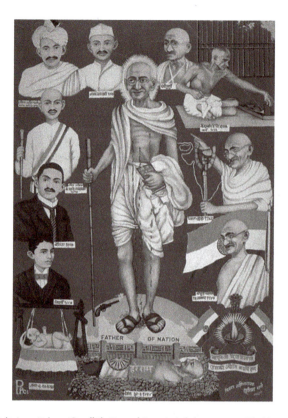

Figure 32.2 *Bapuji ki Amar Kahani* (Gandhi's Eternal Story), Lakshminarayan Khubhiram Sharma, c. 1948. Print published by Picture Publishing Company, Bombay. Courtesy of Sumathi Ramaswamy.

across the billboard in Telugu is the paraphrase of a statement that Indira uttered in Hindi, rather presciently, a day before her death in a campaign speech in Bhubaneshwar: "When my life is gone, every drop of my blood will strengthen the nation."

What do these pictures want, I ask, inspired by the argument of W. J. T. Mitchell's book by the same title (2005)? And correspondingly, what does the map of India—the common protagonist of all three pictures—want of its viewer? To anticipate my response, I suggest that it wants the patriotic Indian to be prepared to surrender life and limb to the Indian national territory, much in the manner of Bhagat, Gandhi, and possibly Indira. It wants martyrs for its cause. But I am getting ahead of myself—I need to begin with the ruses by which a place named India deemed to occupy a particular part of the earth's surface, came to be visually inscribed on a sheet of paper, and seemingly attained a life of its own from this very act of cartographic emplacement.

Geo-graphing India

As others have argued, the mapped form of the nation enables the whole country to be seen at one glance and synoptically, allowing the citizenry to take "visual and conceptual possession" of the entirety of the land that they inhabit as an imagined collective (Helgerson 1986, 51). The historian of the European Renaissance J. R. Hale once observed that without a map, "a man could not visualize the country to which he belonged."[4] More recently, Thongchai

Winichakul has insisted that "our conception of the nation with its finely demarcated body comes from nowhere else than the political map . . . A modem nation-state *must* be imaginable in mapped form" (1996, 76). If it were not for the map of the nation, in these readings, the geo-body would remain an abstraction, leaving its citizen-subjects without any visual means to *see* the country, especially as an integral whole, to which it is anticipated they are attached. Arguably, without the aid of the map, it would simply not be possible to even conceive of the country as a unified bounded whole, let alone see it. Patriotism in modernity requires peculiarly novel technologies of persuasion. On the face of it, the map of the national territory is among the most intriguing—and compelling—of these technologies.

And yet, much work has to be done with and on the modern map of the nation to make it patriotically adequate and efficacious, to compel men (and some women) to die for and on its behalf. For even though the map form might enable the nation-space to be synoptically seen and perceived as a unified whole, and though it might allow the state to make the country visually legible and controllable (Scott 1998, 11–52), it also renders it profoundly un-homely, laid out on an impersonal cartographic grid on the face of the earth, emptied of quotidian meanings and local attachments and, most consequentially, voided of prior sentiments of longing and belonging. As recent scholarship on the disciplinary histories of geography and cartography demonstrates, the procedures and protocols of these globalizing sciences over the course of the late eighteenth and the long nineteenth century overwhelmingly resulted in

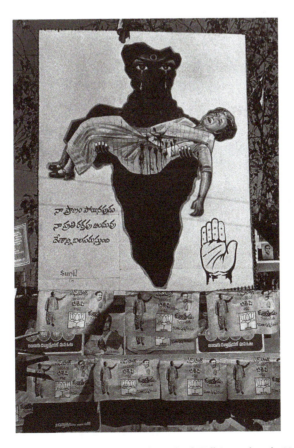

Figure 32.3 "When My Life Is Gone, Every Drop of My Blood Will Strengthen the Nation," Sunil, 1984. Election hoarding, Hyderabad. Photograph by Raghu Rai. Courtesy of Raghu Rai, New Delhi.

their seizing intellectual possession of the earth and asserting mastery over it through empirical observation, systematic classification, and calculating rationalization (Godleweska and Smith 1994). The world came to be cognitively tamed as it was measured, mapped, and rendered manageable. These sciences are a telling example of the Cartesian imperative to see the world as a representable object that Martin Heidegger wrote about when he proposed that "the fundamental event of the modern age is the conquest of the world as picture." In the age of the world picture, "the word 'picture' now means the structured image that is the creature of man's producing which represents and sets before. In such producing, man contends for the position in which he be that particular being who gives the measure and draws up the guidelines for everything that is" (Heidegger 1977, 134). Consequently, the age of the world picture does not mean a picture of the world in the sense of being its copy, "but the world conceived and grasped as a picture" (129), so that it appears as an "enframed" image. For Heidegger, such an enframing is revelatory of the emergence of the modern subject, who stands abstracted from a world that he could observe, manipulate, and have at his "disposal." "[T]he fact that the world becomes picture at all is what distinguishes the essence of the modern age. . . . There begins that way of being human that mans the realm of human quality as a domain given over to measuring and executing, for the purpose of gaining mastery over that which is as a whole" (130–32). Conceived, grasped, and enframed as a disposable object of calculation and mastery, the earth stands disenchanted.

If we follow Max Horkheimer and Theodor Adorno in their assertion that the "program of the Enlightenment was the disenchantment of the world; the dissolution of myths and the substitution of knowledge for fancy" (1972, 3), then the colonial program in India, launched at the height of the European Enlightenment, was the progressive, albeit fitful and incomplete, disenchantment of a place named India. For the colonial state in India, ruling the country was premised on knowing the country, such knowing and subsequent mastery beginning with the topographical, and doggedly dedicated to the "geo-graphing" of the land as it was made visible to the eye, measurable by instruments, and chartable on a map (Sparke 2005, xiv). Convinced that "Hindus as a rule are deficient in observation," and that they lack scientific curiosity, the colonial project claimed to write the true and correct geography of India, rescuing it empirically from the "fabulous" and "fanciful" spatial conceptions embedded in Hindu texts (Ramaswamy 2000, 595). Regardless of the prevalence of enchanted or picturesque visions of land and landscape produced within an Orientalizing episteme, the India of *official* colonial geography was an abstract, rational, mathematized place, emptied of fanciful "inspiration" and fabulous imagery (Edney 1997). As Christopher Bayly notes, colonial Indian geography schoolbooks, modeled as they were on an eighteenth-century British geographic tradition influenced by Locke and Hume, were "relentlessly matter-of-fact and empirical. Geography was a science of measurement and description," interrupted every now and then with "unsystematic racialist assertion" (1996, 311–12). In particular, the method of colonial geography was "deliberately dry and un-theoretical, *an antidote to romance and imagination*" (309; emphasis added). Not surprisingly, it banished native spatial visions that were not compatible with such aspirations to the margins of the normative.

That many Indians in the colonial and postcolonial period succumbed to the lure of the map form, which enabled their country to be normatively presented as whole and complete, is quite clear from the hold of the science of cartography on official practice and, in some measure, on the popular imagination well after British rule ended in the subcontinent. Yet, to many others, the map of India in and of itself appears not to have been an adequate representative device for picturing their country as *homeland* and *motherland*. It is to some such dissenting voices that I now turn in order to explore their potential to disrupt the disenchanted disciplines of modern geography and cartography, as well as to mark the inherent limitations of such transgressions. For, at the very least, this dissent leads me to ask, can the

patriot feel "at home" in a geo-graphed India? Where indeed is the home (land) that the patriot is willing to kill and die for after geography and cartography have done their disciplining work? How is a space of calculation transformed into a field of care in which the devoted citizen might dwell with a sense of longing and belonging? (Tuan 1977).

To respond to such questions, I begin with three voices—all male, all elite and upper caste, all Bengali Hindu, and all products of a modern education—from roughly the same moment in the early years of India's long nationalist century. First, a character named Sandip in the 1916 Bengali novel *Ghare Bhaire (The Home and the World),* written by one of the emergent nation's foremost thinkers, Rabindranath Tagore, insists that when he gives up his life fighting for the nation, "it shall not be on the dust of some map-made land," for "the geography of a country is not the whole truth. No one can give up his life for a map" (1985, 90–91).[5] The sentiment expressed by Rabindranath's fictional protagonist finds a real-life echo in Bipin Chandra Pal, a nationalist who was just as forthright in refusing to entirely cede to colonial science the terrain that was India in a book revealingly titled *The Soul of India* (1911 [1923 in refs]): "The outsider knows her as India. The outsider sees her as *a mere bit of earth,* and looks upon her as *only* a geographical expression and entity. But we, her children, know her even today. . . . as our Mother" (1923, 106; emphasis added). A few years earlier, across the subcontinent in Baroda, when an interlocutor asked his then-teacher Aurobindo Ghoshe for advice on how to become patriotic, he is believed to have pointed to a wall map of India hanging in his classroom and replied, "Do you see this map? It is not a map, but the portrait of *Bharat-mata* [Mother India]: its cities and mountains, rivers and jungles form her physical body. All her children are her nerves, large and small. . . . Concentrate on Bharat [India] as a living mother, worship her with the nine-fold *bhakti* [devotion]."[6]

All three utterances are revealing, for they signify not an outright rejection of the colonial geographic and cartographic project as much as an underscoring of its inadequacy ("not the whole truth," not "a mere bit of earth," "not [just] a map"). The modern map form of the country is indispensable, for, after all, it gives concrete shape to India in its entirety, following the precise protocols of mathematical cartography; it provides the basis for rule and governance, and it demarcates what belongs within its borders and what does not. In other words, it gives tangible form to a nation yearning for form. But nonetheless, as these voices from the start of the new century testify, doubts surfaced about this novel device that magically gave form to the ephemeral abstraction that is the nation: Could one (be made to) die for such a map, for the sake of what were, after all, lines drawn on a piece of paper? Indispensable it might be, but in and of itself, it seemed inadequate to compel the patriot to sacrifice life and limb.[7] This inadequacy was to be countered and compensated for by reminding Indians, in case they had forgotten this ancient truth under the hegemony of empire and its schooling and bureaucratic practices, of what "India" really was: not a "mere bit of earth" nor the "dust of some map-made land" of statist geography but a "living mother," Bharat Mata or Mother India. Her body—female, divine, Hindu—comes to be deployed—poetically, prosaically, and pictorially—to anthropomorphically (re)claim an India seized and enframed as map by scientific geography and cartography.

Anthropomorphized map, carto-graphed Mother/Goddess[8]

Much has been written by others on the emergence of the gendered representation of India as "Mother India" in the last quarter of the nineteenth century in Bengal, from where her popularity soon spread over the subcontinent during the course of the next few decades (for a review of this literature, see Ramaswamy 2002). This exceptional female figure appears as both divine and human; as "Indian" but also reminiscent of female figurations of the nation

from other parts of the world, especially the imperial West; as invincible but also vulnerable; as benevolent but also bloodthirsty; as comely maiden but also as ageless matron; and as guardian goddess of the nation but at the same time in need of her sons' care and protection. Here, I build on this scholarship while drawing attention to the specific ways in which the gendered and divine form of Bharat Mata is pictured in a whole host of visual media, including calendar art and wall posters, paintings, textbook illustrations and jacket covers of nationalist pamphlets and books, newspaper cartoons and mastheads, advertisements, and the occasional commercial film (Neumayer and Schelberger 2007; Ramaswamy 2001, 2003; Sen 2002). While the persistence of the figure of Mother India in such pictures may not be surprising given the popularity of female divinities in the region, her association with modern cartographic devices such as maps and terrestrial globes is an innovation indeed. For, as historians of cartography insist, mapped knowledge is "hard won knowledge," a product of sustained cultural, intellectual, and pedagogic work (Wood and Fels 1992, 5). That even the relatively unlettered and unschooled frequently used the map form of the nation—its geo-body—to picture Mother India at a time when literacy rates in the colony were appallingly low is remarkable testimony to the emergence of a set of practices and techniques that I refer to as "barefoot cartography," whose primary creative influence and aesthetic milieu is the art of the bazaar.

Patricia Uberoi has defined bazaar or calendar art as "a particular style of popular color reproduction, with sacred or merely decorative motifs . . . The art style extends beyond calendars and posters. In fact, it is a general 'kitsch' style which can be found on street hoardings, film posters, sweet boxes, fireworks, wall-paintings, and advertising, and in the knickknacks sold in fairs" (1990, 46). In this wider sense, bazaar art is ubiquitous across the nation, providing it with a shared visual vocabulary across regions and communities otherwise divided from each other (Freitag 1999). Historian of art Kajri Jain (2007) has brilliantly analyzed the social, moral-ethical, and commercial networks within which bazaar images have been produced, evaluated, disseminated, and consumed from the late nineteenth century into the present. And Jyotindra Jain has usefully shown how this art form uses "a visual language of collage and citation which, in turn, act[s] as a vehicle of cultural force, creating and negotiating interstices between the sacred, the erotic, the political, and the colonial modern" (2003, 13). Most influentially, Christopher Pinney has insightfully explored the visual politics of the deployment of bazaar imagery, which is enormously revealing of the "corpothetic" sensibility that undergirds its anticolonial impulses (Pinney 2004)[9]

My own work builds on this scholarship while focusing on the deployment of the modern map form of the nation in and by that sector of bazaar art that I identify as patriotic because of its investment in and devotion to the territorial idea of India (albeit variously configured over time and across different interests). My conceptual analytic of barefoot cartography is meant to distinguish patriotic art's investment in the map form from the state's command of mapmaking ventures, which are conducted with modern instruments of surveillance, measurement, and inscription by trousered and booted men of secular science.[10] As I have already emphasized, the modern state's normative involvement in mapping is instrumental and regulative: to make land visually legible for rule and resource management and to determine sovereignty and police borders. From this perspective, the modern map is a classic example of a "state simplification," and as such, it attempts to systematize and demystify the state's terrain in the dispassionate interest of command and rule (Scott 1998). In contrast, barefoot cartography in India, even while cheekily reliant on the state's cartographic productions, routinely disrupts it with the anthropomorphic, the devotional, and the maternal. Undoubtedly, the barefoot is in contested intimacy with command cartography, as it dislodges the state's highly invested map form from official contexts of production and use and re-embeds it—sometimes to the point of only faint resemblance—in its own pictorial

productions; in doing this, barefoot mapmaking reveals its own corpothetic and idolatrous investment in national territory, in contrast to command cartography's mathematized grids and lines of power. In particular, barefoot cartographic work suggests that, at least for some Indians, the map of India—that symptomatic scientific artifact used to delimit a measured territory called India—is not an adequate representation in and of itself for mobilizing patriots to the point of bodily sacrifice, indispensable though it might be for bestowing a credible form upon the emergent nation. It has to be supplemented by something else, and that something else is more often than not the gendered divinized body of Mother India. Thus, barefoot mapmaking is not antagonistic or antithetical to state and scientific cartography in a simplistic manner. Rather, after the fashion of so much else in colonial India, where the gifts of empire and science were simultaneously disavowed and desired, patriotic popular mapmaking takes on the map form but pushes it in directions not necessarily intended for it by either science or state.

India's barefoot mapmakers are almost always male, generally Hindu, and not always products of formal schools or art training. Even with no obvious education in maps or training in their use, in the science of their production, or the aesthetics of their creation, these men play no small role in popularizing what Benedict Anderson refers to as the "logo" outline form of the national geo-body so that it becomes recognizable and familiar, not needing the crutch of naming or identification, "pure sign, no longer compass to the world" (1991, 175). Regardless of the various social, economic, regional, and ideological differences that might prevail among them or the changes they might undergo over time, these men warrant being treated as a unified field in terms of their inexpert, undisciplined, and informal relationship to the science of cartography and its mathematized products, to which they turn for various purposes. Their lack of specialist cartographic expertise should not, however, be read to mean that they are naïve or apolitical. On the contrary, there are highly complex and competent ways in which a specialized product—one of the most prized inventions of Europe, and consolidated by colonial surveyors and their Indian assistants through many decades of triangulation, measurement, and inscription—is dislodged from its official circles of circulation and use and put to purposes that exceed those of science or state. In fact, I would even venture that in the late colonial period, when few Indians went to school and studied geography books or encountered maps and globes in their classrooms, it was through the mass media that the map form of the nation was rendered familiar to the average citizen, as it traveled—albeit in a highly condensed, even caricatured, form—across the subcontinent, incorporated into newspaper mastheads and cartoons, merchandise labels and advertisements, god posters and calendars, and such. As it has circulated in this manner, the fidelity and integrity of the mapped form of the nation has varied, ranging from rough-and-ready sketches of the Indian geo-body to highly specific renderings with an astonishing attention to physiographic detail. From such a motley range of barefoot cartographic creations spanning the twentieth century, I have identified five different ways in which the anthropomorphic form of the mother/goddess is thrown into the company of the nation's geo-body represented by the map of India, and vice versa. The result of this convergence is that the mathematized map of India is "anthropomorphized," while the gendered body of Mother India comes to be "carto-graphed."

First and most commonly, Bharat Mata literally occupies the map of India, partly or substantially filling up cartographic space with her anthropomorphic form (see, e.g. Figure 32.4). There are many ingenious ways in which her body blurs or undoes the carefully configured boundaries and borders of command cartography. This is particularly true of contested national spaces such as Kashmir or Pakistan, even parts of Sri Lanka, which are frequently claimed by ingenious arrangements across the map of Mother India's limbs, hair, or clothing.

If in such pictures the body of the mother/goddess, distinct from the outline map of the nation, anthropomorphizes the map by moving in to occupy it, there are others in which parts of Bharat Mata merge with the Indian geo-body so that the two are, in parts, undistinguishable. Thus, in a circa 1931 lithograph that was proscribed by the colonial state, the lower half of Mother India's body disappears into the map of India (extending toward and including Burma), on which are delineated the country's rivers, mountain ranges, and other physical features (Figure 32.5). The dependence of barefoot cartography on statist mapped knowledge is clearly on display here, as is the fact that the latter is not simply taken on board without adjoining it with the anthropomorphic form of Mother India. Thus, an image such as this connects with an important suggestion made by some key intellectuals early in the twentieth century that there is no distinction between the country named India by colonial geography and Bharat Mata, who resides in all its constituent parts. As Aurobindo Ghose insisted rhetorically in 1905, "What is a nation? What is our mother country? It is not a piece of earth, nor a figure of speech, nor a fiction of the mind. It is a mighty female power *(shakti),* composed of all the powers of all the millions of units that make up the nation" (1956, 436).

In a third configuration, rather than occupying the cartographic space of India or merging with it, Bharat Mata stands (or sits) on a map of the nation whose outline is sometimes sketched on a terrestrial globe that is sometimes shown partially and, at other times, as a whole sphere gridded by latitudes and longitudes (e.g. Figure 32.1). In such pictures, Mother India appears as the mistress of a carto-graphed world, her crowned head reaching into the

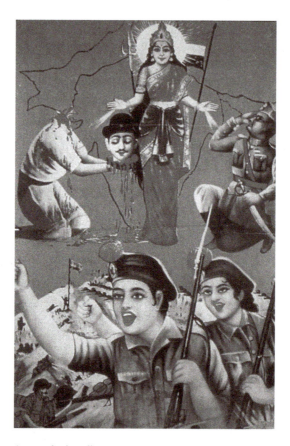

Figure 32.4 *Ma ki Pukar* (Mother's Call), artist not known, 1966. Print published by Murari Fine Arts, Delhi. J. P. S. Uberai and Patricia Uberoi Collection, Delhi.

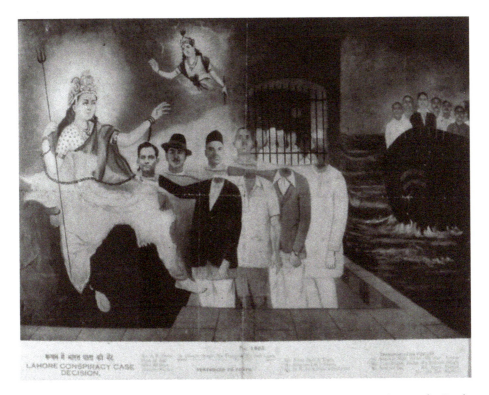

Figure 32.5 *Bandhan Mein Bharata Mata Ka Bhent*: Lahore Conspiracy Case Decision—Sentenced to Death, No. 1403, artist not known, c. 1931. Single leaf print, 50 x 36 cm, possibly published by Anarkali, Lahore. National Archives of India, New Delhi, No. 1789 (Proscribed Literature: Hindi). Courtesy of National Archives of India, New Delhi.

firmament as the national territory that she embodies on the globe on which she rests is visually inscribed, frequently, as the only one that matters on the face of this earth. The conceit of the modern terrestrial globe, Denis Cosgrove's recent study shows, is that it seemingly privileges no specific point on the earth's surface, "spreading a non-hierarchic net across the sphere." The dispassionate and disenchanted goal of the science of cartography in this regard is to generate "uniform global space" (2001, 105–6, 114). Yet India's barefoot mapmakers betray their patriotic predilections by appropriating the normative terrestrial globe and putting it to a very different purpose by virtually erasing the presence of other lands and other nations from the surface of the earth, so that frequently only "India" looms large and visible, anthropomorphized and sacralized by the body of Bharat Mata perched perkily on it.

In terms of a growing intimacy between the mother/goddess and the mapped form of the nation, the most consequential development occurs when the map of India as ground and as prop is dispensed with. In its place, Mother India's anthropomorphic form literally comes to stand in for the map of India, outlining in this process the cartographic shape of the country. In such pictures, even without a map form, the mapped image of the country is presumed. For example, a 1937 chromolithograph titled *Vande Mataram*, (I Revere the Mother), printed in the South Indian city of Coimbatore (possibly to celebrate the recent victories of the Congress Party in the country-wide elections), shows Bharat Mata clad in the flag of the nation (Figure 32.6). The contours of her body sketch out the mapped outline of India, as her tricolor sari (with the Gandhian spinning wheel drawn along its border) billows out to claim the territorial spaces of the emergent nation.

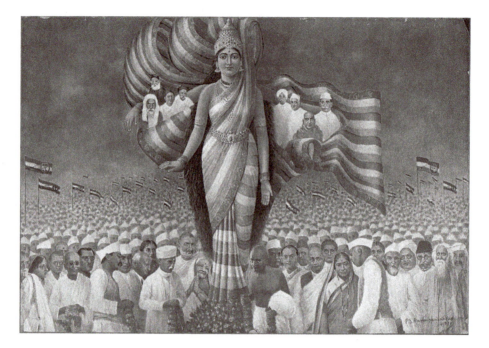

Figure 32.6 *Vande Mataram* (I Revere the Mother), P. S. Ramachandra Rao, 1937. Chromolithograph published by Rao Brothers, Coimbatore. Courtesy of Erwin Neumayer, Vienna.

Finally, especially in the years after independence, Mother India moves out of the carto-graphic space of the nation to either sit or stand in front of the map of India, which appears as a shadowy silhouette in the background (Figure 32.7). Such pictures offer an important contrast to the dominant representation in the earlier decades of the century of the carto-graphed Bharat Mata, as if with freedom from colonial rule, Mother India's claim on India's geo-body is secure enough to not have her occupy it or merge into it, as her visual votaries obviously felt compelled to do during the colonial period. The map of India continues to be necessary to her visual persona because it establishes, along with the flag of the nation, the distinctiveness of Bharat Mata as a territorial deity of the country. All the same, as the freedom movement draws to a close and India's independence from colonial rule is secured, the map of India can be relegated to the background, a shadowy prop into which she can move in times of national crisis or threat.

In his memoirs, published in 1936 at the height of the anticolonial struggle against British rule, Jawaharlal Nehru, destined to become the new nation's first prime minister, worried over the mystifying corporeality that seemingly animated the patriotic common sense of his fellow citizens:

> It is curious how one cannot resist the tendency to give an anthropomorphic form to a country. Such is the force of habit and early associations. India becomes *Bharat Mata,* Mother India, a beautiful lady, very old but ever youthful in appear-ance, sad-eyed and forlorn, cruelly treated by aliens and outsiders, and calling upon her children to protect her. *Some such picture rouses the emotions of hundreds of thousands and drives them to action and sacrifice.*
>
> (1980, 431; emphasis added)

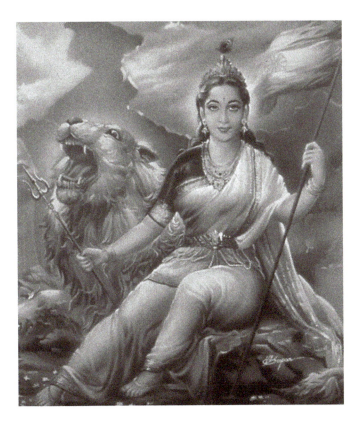

Figure 32.7 *The Motherland*, V. A. Sapar, 1967. Print, 37 x 36 cm. Publication details unknown. J. P. S. Uberoi and Patricia Uberoi Collection, Delhi.

The nation, we have been told, yearns for form. What these pictures reveal to us, what even Nehru's rationalism concedes, is that in colonial and postcolonial India, that yearning is never just content with the form bestowed upon the country by the scientific map, indispensable though it may be in delineating borders and boundaries, measuring distances between places, and drawing out the contours of mountains and rivers and forests and fields. For "action and sacrifice," patriotic pictorial practice routinely turns to the figure of Mother India to supplement the mapped form in the many ways that I have identified—occupying it and filling up cartographic space; merging partly with it; seated or standing on it; vacating it in order to relegate it to a shadowy silhouette; and most destabilizing of all, dispensing with it entirely. Once brought into proximity with the country's map form, the plenteous divine female body shows up the insufficiency of one of the Enlightenment's and colonial science's most consequential inventions. In the process, the map stands anthropomorphized, divinized, and feminized. The ground is pictorially prepared, in a manner of speaking, for the map to receive the sacrifice of men.

Between men, map, and mother

In resorting to the figure of Mother India to supplement the mapped form of the nation, barefoot cartography reveals as well its preoccupation with male bodies, especially the "big men" of official Indian nationalism.[11] Such men are, as is apparent from the titles of patriotic prints, the "Jewels of India," the "Architects of Indian Resurrection," the "Gems of the

Nation." When women appear at all in the company of the map of India, which is not all that frequently, they are invariably shadowy presences or pictured as honorary men; they are generally not the principal object of the barefoot mapmaker's adulation. In striking contrast to much popular art in India, where women are hypervisible in incarnations ranging from the goddess to the vamp, it is men who are accorded prominence in patriotic pictures, thus reiterating the dominant truth about nationalism as a masculinist project, fantasy, and hope. In such pictures, Bharat Mata appears as "the conduit through which collusions and collisions" between patriotic men are worked out, allowing in this process bonds of male homosociality to evolve between them (Krishnaswamy 1998, 47). Drawing on Eve Sedgwick's work (1985), I suggest that the nation is preeminently pictured as a male homosocial arena in which men jostle for power and privilege but also work out their mutual fascinations, anxieties, and hostilities through and around the exceptional figure of Bharat Mata.

Thus, in many productions of barefoot mapmakers, Mother India shares the cartographic space of India that she occupies with male patriots, many of them identifiable figures from the dominant official nationalist pantheon, most especially Mahatma Gandhi or "Bapu," "Pandit" Nehru, and "Netaji" Bose (but never, of course, Muhammad Ali Jinnah).[12] Together, the extraordinary mother and her devoted, mostly Hindu sons pictorially repossess what had hitherto appeared to be the domain of the British Empire—colored pink or red—in numerous colonial maps, atlases, and globes. Indian territory now passes under their joint custodianship, a custodianship in which the new (big) men of India own and rule the territory in the name of the mother. As Manu Goswami has noted in her study of the new discourses on territory that emerged in late colonial north India, "The resolutely 'subject-centered' language of possession was transposed from individuals (upper-caste, Hindu, male) in relation to land to Bharat [India] as a national territorial possession. Bharat Mata marks the historically significant reconstitution of colonial spatiality into national property" (2004, 203). These patriotic pictures are exemplary of this significant reconstitution in that they draw upon the artifact of the map, through which all manner of claims to territorial possession have been imagined, anticipated, and made in modernity, and in that they deploy the figure of the mother— convenient for the transformation of the mathematized colonial territory of India from a terrain of statist calculation into a nationalist homeland—to seal the deal in favor of the male citizenry.

Not surprisingly, when she appears in the company of her men, Bharat Mata is generally shown as a stilled figure whose primary visual function is to draw attention to the activity going on around her, namely, the labor performed on behalf of the map of the nation and its territory by prominent male citizens. In return for their patriotic and filial service, her hand reaches out to bless the men occupying the map of India, almost as if signaling her approval of *their* proprietary relationship to *her* territory. So much so that, especially around the time of Indian independence and after, Mother India's body is dispensed with completely, and only the heads or busts of her sons occupy the map of India in a gesture that Pinney has aptly characterized as the mapping of "physiognomy onto cartography" (1997, 847). It is as if with freedom from colonial rule, the male citizenry's proprietary claim over Indian national territory is also secure, and map and man can relate directly to each other without the mediating figure of the mother.

In barefoot cartography and the patriotic imagination that animates it, the ideal of masculinity is pictured as placing one's life and limb at the service of map and mother. Rejecting worldly pleasures and privileges, the ideal Indian man casts himself in this role, and he is pictured as selflessly dedicated to Mother India and the territory she embodies, although there are diverse models of filial service on display. Self-effacing service to the nation and its territory might be the road to visibility in the world of patriotic pictures, yet barefoot cartographic practice also reveals its ambivalences and anxieties—as well as pride—about the

ultimate patriotic endgame for men, the crowning glory of martyrdom. The martyred male body—"the body in bits and pieces" (Axel 2001, 149), bloodied, decapitated, or hanged—is the honorable prize of the pictorial transaction between men and maps in the name of the mother. Thus, nationalist ideology—masculinist though it might be in conception and practice—brought with it its share of burdens and tragedies for men along with privilege, power, and visibility. Male martyrdom to map and mother in the name of India, subsequently offered to other male citizens as worthy of emulation, is exemplary of this net of risk and death in which some men found themselves entangled.[13]

We get a glimpse of the barefoot mapmaker's ambivalence about these larger-than-life men and their apparent mastery in prints that depict the life story of the leader as a pictorial biography. In contrast to Mother India, who rarely appears aged, decrepit, or dead in any patriotic production, being as she is both the immortal goddess and the very embodiment of an ever-youthful nation, however ancient its origins, her sons are very mortal indeed: They are born, grow into young men, age into adults, and even die, their very mortality ultimately marking the limit of their mastery. An example of this is a print from the 1950s, *Jawahar Jiwani* (Life of Jawahar), by the same artist who produced one of the anchor images discussed earlier (Figure 32.2). The focus of this print is Prime Minister Nehru, who stands on a globe centered on a partially outlined map of India (left unnamed). His feet are firmly planted on Indian territorial space, making it his own even as his body and head reach into the firmament, suggesting that here is a man who has the world and India at his feet. Any sign of enduring mastery, however, is undone by the fact that he looks quite old, his customary pensive look supplemented by unmistakable signs of aging. He may be a master of the globe and of India, but that he is still a mere mortal is clearly underscored by the artist in the representation of various episodes from his life ranging from his birth to his development into youth and his maturation into adulthood and old age, arranged as visual vignettes around the central figure of the frail, aging prime minister. A lifetime achieving mastery, the print appears to suggest, leads not to perennial immortality but to old age and eventually death.

This is even more striking in the print by the same artist that I introduced earlier titled *Bapuji ki Amar Kahani* (Gandhi's Eternal Story, Figure 32.2). Painted by the Nathadwara artist Lakshminarayan Khubhiram Sharma, the poster presents a series of visual vignettes of Gandhi from his birth in a cradle swathed in the (recently created) Indian national flag to his death, his body ready for cremation and draped in the tricolor, his last words *Hare Ram,* "O God," inscribed in Hindi across it. Sharma appears to have modeled these vignettes on readily available photographs of Gandhi at key moments in his eventful life: as a young London-bound student, as a stylish barrister in South Africa, as a *satyagrahi* who had cast off his Western ways, and then, from his later career as a nationalist leader back in India, launching and leading the historic Dandi march, behind bars at his spinning wheel, launching the Quit India movement, and so on. These vignettes are, in turn, arranged clockwise around what Sharma obviously saw as the central feature of Gandhi's "eternal" life—his martyrdom for the nation and its map, an image that does *not* exist in the photographic record. Occupying the center of the poster is the smiling, *dhoti*-clad image of Gandhi, holding a staff in one hand and carrying a red book (possibly the Bhagavad Gita, his favorite scripture) in the other. Bright red blood from three carefully placed bullet wounds in his chest drips down to form a puddle on the outline map of the Indian nation etched on the face of a terrestrial globe. Photographic realism gives way to patriotic mythography.

The patriotic artist's visualization of the Mahatma's bloodied carto-graphed body is taken to its logical extreme in a recent painting by one Dr. Vijay Goyal on exhibit in the National Gandhi Museum in New Delhi in which the artist has painted in oil and blood Gandhi standing on a globe with the outline map of India (and some adjoining territories). That the doctor-turned-artist was willing to use blood—perhaps his own—to pictorially

reenact and perform on canvas the primal act of the Mahatma's bleeding to death for the nation and map is a telling, if macabre, indication of the corporeal penchants of patriotic art. Goyal's literally bloody painting shows Gandhi with not one but three heads (two of them painted in the colors of the national flag), signifying his apotheosis and his assimilation into the Hindu pantheon with its many multiheaded and multilimbed gods. Indeed, in the pictorial transaction between (big) men and the map in the name of the mother, Gandhi's special task is to secure the blessings of the (Hindu) gods for the project of Indian nationalism. His body serves as the conduit between the earthly India, which is metonymically represented by the map form, and the celestial realm, which is inhabited not just by the deities of the Hindu pantheon such as Krishna or Shiva but also, in the eclectic spirit of Gandhian nationalism, by the Buddha and Jesus. With his progressive canonization and apotheosis, especially after 1948, Gandhi, too, leaves the earthly realm and joins this divine sphere, from which he showers his blessings on "India" and the men (and the occasional women) who occupy it, pictorially transforming in the process the disenchanted terrain of colonial calculation into the hallowed *punyabhumi* (blessed land) of the (Hindu Indian) nationalist imagination. A revealing example of this is an anonymous print possibly from 1948 and published by the Bombay-based Shree Vasudeo Picture Co. titled *Swargarohan* (Ascent to Heaven), in which Gandhi rises to heaven in a pavilion. The Hindu trinity—Shiva, Vishnu, and Brahma—along with their wives, waits to welcome him. Instead of eagerly looking toward this heavenly welcome, he gazes down on the world below that he has departed from, signified in the print by a globe on which is drawn a physiographic map of India, clearly appropriated from command cartography. Gandhi's apotheosized gaze, however, transforms India from a mere geo-graphed land on the face of the earth into a special territory worth dying for, as he demonstrated in and by deed (Ramaswamy 2008).

His sacrifice for map and mother is all the more endearing to the patriotic artist, for if there is one man who is shown most masterfully in command of the Indian map in these pictures, it is certainly Gandhi, who is undoubtedly the most ubiquitous hero of this genre of political art. Although in his prolific verbal discourse, Gandhi did not invoke Mother India as often as some of his contemporaries, especially those who were overtly Hindu nationalist, he is clearly her favorite son in popular Indian visual productions. In posters and prints from the 1920s on, she looks to him to save her, smiles upon him as he breaks the chains that bind her, sheds tears over his passing, gathers up his bullet-punctured bloodied body into her arms, and heralds his entry into heaven. His inexhaustible command of nation and territory is striking in a circa 1948 picture by K. R. Ketkar, *Amar Bharat Atma* (Immortal Soul of India), which visualizes Gandhi's cremation at Rajghat in New Delhi (Figure 32.8). As the fumes from his funeral pyre vaporize into the skies above, they are transformed into the shadowy contours of a cruciform map of India, out of which Gandhi's head emerges, smiling cheerfully over his own cremation. The print seems to suggest that even in death, Gandhi's body and the geo-body of the nation are inseparable: Such is the strength of the bond between the map and this particular man, who is the "immortal soul of India."

Gandhi's apotheosis also provides the occasion for the patriotic artist to imagine what life after death might be like for the nation's martyrs. In prints published around 1948, such as *Gandhiji ki swargyatra* (Gandhi's Pilgrimage to Heaven), by the Bombay-based poster artist Narottam Narayan Sharma (Pinney 2004, 140), and in the Calcutta artist Sudhir Chowdhury's *The Last Journey of Bapuji* (Neumayer and Schelberger 2007, plate 259), the Mahatma is shown being carried to paradise in a celestial chariot pulled by either angels or swans; waiting to greet him in the heavens above are the Hindu gods, as well as the Buddha, Jesus, and Nanak. In another anonymous circa 1948 print called *Svarg mein Bapu* (Gandhi in Heaven), while Gandhi ascends to heaven on a winged bird, Mother India (her sari and flowing tresses carefully arranged to produce a rough mapped shape of India) stands below with tears flowing

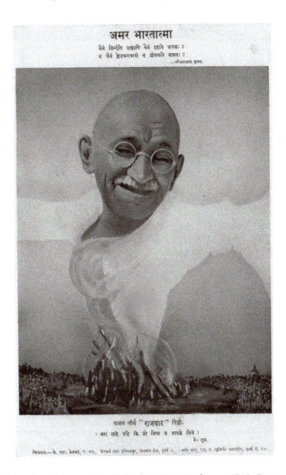

Figure 32.8 *Amar Bharat Atma* (Immortal Soul of India), K. R. Ketkar, c. 1948. Print published by Ketkar's Art Institute, Bombay. Courtesy of Erwin Neumayer, Vienna.

down her face, recalling another dramatic print from Calcutta called *Bapuji on Eternal Sleep* (circa 1948) in which she, in a manner that powerfully echoes the Pietà, holds Gandhi's bullet-scarred body in her arms, blood from his wounds dripping down to Indian territory lush and luxuriant (Neumayer and Schelberger 2007, plate 261; Ramaswamy 2008). Such prints appear to suggest that although Gandhi might have died a mortal, he lives on eternally as befits a true martyr. Not surprisingly, in Sharma's *Bapuji ki Amar Kahani, the* Mahatma's dead body is visually subordinated to the martyr's living body, which wears a beatific smile notwithstanding the multiple wounds that puncture the chest (Figure 32.2).

The patriotic artist's adulation of Gandhi and his pictorial honoring of his martyrdom are perhaps not surprising in that he visually reiterates official as well as popular nationalism's reverence for the Mahatma, although his recasting as a carto-graphed body is a singular contribution of barefoot mapmaking, as I will explain a little later. The most dramatic images of martyrdom for map and mother in patriotic visual practice are perhaps not so much of Gandhi, however, but of a relatively unknown young man who came to be immortalized through popular pictures. On March 23, 1931, Bhagat Singh (b. 1907), a young Punjabi with avowedly socialist and atheist views on the nation and the world, was hanged by the colonial state (along with his "co-conspirators," Rajguru and Sukhdev) for assassinating a British police officer in Lahore in 1928. Almost immediately, Bhagat Singh's execution became the subject of the patriotic artist's visual imagination and has remained popular until today, much of this

art converting his death through hanging into martyrdom by the sword for mother and map. A new category of male patriot thus became popular in patriotic visual imagination, frequently designated by a complex and charged category, *shaheed* or "martyr." The Arabic word *shaheed*, used in a Qur'anic context and in an Islamic universe for pious Muslims who died heroically bearing witness to God's truth, is resignified to refer to patriots who willingly—even eagerly—shed their blood for the ostensibly secular truth of the nation and its map.

In his recent exploration of Indian chromolithographs, Pinney rightly notes the compelling prominence of this hitherto unknown young man in popular visual practice of the last century, so that in an official colonial inscription, "for a time, he bade fair to oust Mr. Gandhi as the foremost political figure of the day" (2004, 124). Offering a skillful analysis of Bhagat Singh's visual persona in popular prints (in which he always appears as a young man with a striking moustache, wearing Western clothes, his head adorned by the ubiquitous trilby), which are interpreted as the artist's admiration for his "audacious mimicry" and ability "to pass" as the white man, Pinney also insists that "official nationalism may have decried the activities of revolutionary terrorists, but popular visual culture asserted the nation's debt to those prepared to kill and be killed in the cause of freedom" (2004, 136). Indeed, it is with Bhagat's death that martyrdom for the nation becomes a sustained visual subject that captures the imagination of India's barefoot mapmakers, as well as the attention of the colonial state's censorship apparatus.

Some time after Bhagat's death by hanging appeared a print titled *Bandhan Mein Bharata Mata Ka Bhent: Lahore Conspiracy Case Decision—Sentenced to Death, No. 1403* (Figure 32.5). Proscribed by the colonial authorities, the print features Bharat Mata as a two-armed goddess, her hands bound in chains; only the upper part of her body is visible, the lower half merging into a topographic outline map of India, on which the principal rivers and some mountain ranges are faintly visible. Facing her are the decapitated bodies of several young men whom the print identifies as J. N. Dass, S. Bhagat Singh, Rajguru, and Sukhdev. Strikingly, each decapitated male body is shown dispassionately offering his head to Mother India, Bhagat Singh's standing out prominently with trilby still proudly on, eyes staring defiantly ahead. In this print, and in others published around the same time and subsequently, the severed heads of these youthful martyrs, especially Bhagat's, are described in Hindi as *bhent* (gift) or as *bali* (sacrificial offering), and additionally qualified in English or Hindi as "first," "curious," and even "wonderful." The recipient of this "wonderful" or "curious" *bhent* or *bali* is invariably Mother India, who sometimes receives the head(s) impassively, at other times with tears flowing down her face, her arms and legs bound in chains, but also sometimes, reaching out to receive the macabre offering all too eagerly. Frequently she is in the company of the map of India: occupying it, merging with it, or sitting on a globe with the outline of India drawn on it. Even when the map of India is not present, Indian national territory is almost always suggested in the background by snow-capped mountains, luxuriant green fields, gushing streams, and silhouettes of temples, pictured through an aesthetic that I characterize as "patriotic pastoral" (see also Jain 2003; Pinney 2004, 93–103). In many such pictures, the lush, life-affirming plenitude of the background only shows up more dramatically the act of life-effacing martyrdom to map and mother being performed in the foreground.

Most strikingly, in many a print, blood from Bhagat's severed head (and, sometimes, his decapitated torso) gushes out to form a puddle on the map of India (see, e.g. Figures 32.1 and 32.4). When Richard Lannoy traveled in India in 1958, he photographed a patriotic print of Bhagat Singh posted in a goldsmith's stall alongside some "god posters" in a Banaras bazaar. The print shows Bhagat kneeling on a globe with the partial outline of the map of India drawn on it and colored yellow. Blood from his decapitated body flows down as red rivulets onto the map below him, while blood from his severed head, which he offers to Mother India, gathers in a puddle at her feet (Lannoy 1999, plate 494). Years later, in a recruitment poster from the mid-1960s called *Ma ki pukar* (Mother's Call), Bharat Mata occupies a map of India,

the halo around her head characteristically occluding the contested territory of Kashmir (Figure 32.4). Bhagat Singh, dressed in white shorts and shirt, kneels in front of her and dispassionately hands over his severed head (with eyes closed, but still wearing the trilby). Blood from the severed head gushes onto Bharat Mata's feet and onto the map of India; bright red blood also spurts out of the decapitated torso. Although it is important to reiterate that Bhagat was executed by hanging and not by decapitation, his martyrdom for mother and map is generally shown as such, for it allows the barefoot mapmaker to connect his death at the hands of a cold, calculating colonial state apparatus to the desired and desirable death of other exemplars of selfless devotion—such as the eighteenth-century Sikh martyr Baba Dip Singh, but others as well across India's many religions, including Islam—whose passing is depicted in a similar manner as bloody bodily mutilations in popular devotional art.[14]

And what of Bharat Mata's role in this visual pedagogy constituted around the wounded or decapitated body of the martyr?[15] Another picture from the early 1930s by Prabhu Dayal might be helpful here (Figure 32.9). Titled *Svatantrata Ki Vedi par Biron Ka Balidan: Bharat Ke Amar Shaheed* (Sacrificial Offerings on the Altar of Freedom by [Our] Heroes: India's Immortal Martyrs), it shows a female figure with a crown on her head standing in the foreground with a bloodied axe in one hand and a severed head in another, while other heads and decapitated bodies lie strewn around. Two young men—one of them clearly Bhagat Singh in his trademark trilby—wait before "the altar of freedom," their heads ready to be axed by the goddess. In this print, Prabhu Dayal pictures the unnamed goddess (possibly Mother India) as directly responsible for the death of her devoted sons in a manner comparable to several bloodthirsty

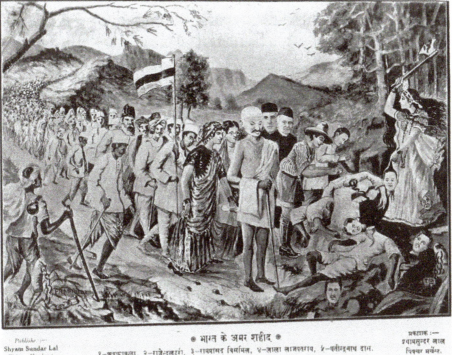

Figure 32.9 *Svatantrata Ki Vedi par Biron Ka Balidan: Bharat Ke Amar Shaheed* (Sacrificial Offerings on the Altar of Freedom by [Our] Heroes: India's Immortal Martyrs), Prabhu Dayal, c. 1931. Print published by Shyam Sunder Lal, Picture Merchant, Cawnpore. Courtesy of Urvashi Butalia, New Delhi. From the personal collection of Urvashi Butalia.

goddesses of the Hindu pantheon. This is a rare picturization, for in a majority of other cases, the most Bharat Mata does is arm her warriors with the sword of battle—the sword with which they presumably kill others, and possibly behead themselves as well. As the national movement picks up in fervor and as Gandhian nonviolence appears to yield few concrete results, the print suggests that the mother might not be satisfied with anything less than the bloody offering of the heads *(balidan)* of her most devoted sons.

Indeed, the corporeal fragment of the severed bloodied head as the gift *(bhent)* or sacri-ficial offering *(bali)* to map and/or mother becomes such an over-determined signifier of (youthful) male martyrdom in the patriotic visual economy that even the premature and accidental death of Subhash Chandra Bose—who was not executed by the colonial state—is pictured in a similar manner in prints such as *Subhashchandra Bose Ki Apoorva Bhent* (Subhash Chandra Bose's Extraordinary Gift) by an unknown artist, possibly from around 1945 (Figure 32.10). Here, a headless Subhash—a favorite of the patriotic artist—stands upright, holding his own severed (and smiling) head, from which blood gushes onto a framed outline map of India inscribed with his trademark slogan *Jai Hind,* "Victory to India." Here, the martyr's blood appears to pictorially nourish and rejuvenate the nation's geo-body, presumably also fed by the bloodied bodies attached to the other severed heads shown in the picture. Similarly, in a striking circa 1947 print called *Shaheed Smrity* (Memory of Martyrs), the Bengali artist Sudhir Chowdhury places Bharat Mata in a patriotic pastoral landscape with the sun rising on the horizon (Pinney 2004, 136). Nehru (no great patron of this brand of violent nationalism) stands in front of her, gesturing to a number of plates that have been placed before her,

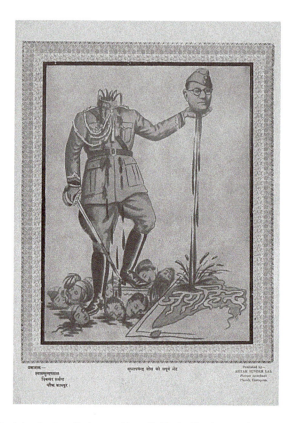

Figure 32.10 *Subhashchandra Bose Ki Apoorva Bhent* (Subhash Chandra Bose's Extraordinary Gift), artist unknown, 1945. Print published by Shyam Sunder Lal, Cawnpore. Courtesy of Erwin Neumayer, Vienna.

clearly as a ritual offering on the occasion of the independence of India. On each plate is the head of a young man, each one identified by name: Bhagat Singh, Khudiram Bose, Surya Sen, Debvrata, Rameshwar, and Kanailal Dutt. These men were either hanged or shot to death for various anticolonial intransigencies and assassinations, but here their deaths are pictorially translated as decapitation, and their heads are visualized as ritual offerings to Bharat Mata in a manner that echoes Nanak's injunction to his Sikh followers, "If you want to play the game of love, approach me with your head on the palm of your hand. Place your feet on this path and give your head without regard to the opinion of others."[16]

Indeed, there is a new "game of love" at play in twentieth-century India, and its object is the nation—and the mother and the map. This love finds expression in barefoot cartographic practice in an emergent aesthetic of the wounded and dismembered male body centered on the severed head, decapitated torso, bullet-scarred chest, and gushing life-blood locked to the nation's anthropomorphized geo-body. The martyred male is a dispassionate carto-graphed body sacrificed to the untarnished whole that is the national territory. This, barefoot cartographic work seems to suggest, is the ultimate fate of masculine patriotism in modern India—and one that has the blessings even of the apostle of nonviolence, Gandhi, who in several prints even showers his blessings on such violent expressions of devotion to Bharat Mata. The martyred male body, even when in bits and pieces, invariably appears in a state of perfect composure, devoid of pain or suffering, even taking pleasure in sacrificing itself to the whole that is the nation. It is indeed an exceptional body, prepared to go to bits and pieces so that the body politic does not. At the same time, these pictures disavow the empirical fact of death, as the selfless patriot is shown transcending death by identifying with the greater life of the nation that lives on and, indeed, is renewed by the shedding of his blood.

And what of women martyrs in this macabre visual pedagogy constituted around the wounded or decapitated male body in the service of map and mother? Although feminist scholarship has recovered the stories of several women from the 1930s who were involved in anticolonial acts of insurgency to the point of death (Forbes 1980), their passing is not visu-ally celebrated by the barefoot mapmaker in the manner reserved for male martyrs as sacri-fice to map and mother. Indeed, in this regard, contrary to Pinney's recent provocative argument (2004) about popular visual culture in India offering an alternative take on the official narrative sketched out by a dominant nationalism, patriotic artists are rather evasive in visualizing the death of the female patriot. To do this would possibly expose Mother India herself to pictorial death and herald the end of the patriotic project.

This is why I think that the violent death of Prime Minister Indira Gandhi in October 1984 offers a visual dilemma for barefoot cartography. In comparison with the men I have discussed here, and especially unlike the man with whom she shared her famous surname and unlike her equally famous father Jawaharlal, Indira is not a particular favorite of India's patri-otic artists, who generally picture her in rather unimaginative and uninteresting ways (Neumayer and Schelberger 2007, 181–92). This was to change after the 1971 Bangladesh liberation war, when she came to be likened to the goddess Durga in popular and visual discourses, her own secular and socialist political inclinations notwithstanding. Popular pictures, political iconography, and the modernist imagination of artists such as Maqbool Fida Husain also consolidated the image of Indira as India, and India as Indira, so that Mother India seamlessly became Mother Indira and vice versa. Indira comes to occupy the map of India in a manner that echoes images of Bharat Mata from earlier in the century. It is such a woman and icon whose violent assassination confronted artists of modern India, and they responded in various ways. On the one hand, Husain painted a series of fascinating abstract images of the event showing Indira's faceless body falling horizontally to the ground. At the other end of the visual spectrum, folk artists of Bengal produced a scroll painting narrating the life of the prime minister that begins with a carto-graphed Indira holding aloft the Gandhian flag (with

its trademark spinning wheel) and ends with her ascent to heaven after her assassination (Blurton 1989). The poster artists of the bazaar responded in inconsistent ways to the horror of the assassination. On the one hand, in N. Sharma's *Prime Minister of India,* which visualizes the life story of the prime minister in a manner akin to L. K. Sharma's picturing of the life of the Mahatma that we saw in Figure 32.2, the fact of her violent death is completely glossed over as Indira's body is shown peacefully at rest (Neumayer and Schelberger 2007, 192). On the other hand, soon after her assassination, the Meerut-based H. B. Raja, who earlier had produced images of the martyrdom of Bhagat Singh, Chandrasekhar Azad, and others, painted *Indira Gandhi: Mere Khun Ka Har Katara Desh Ko Mazbut Karega* (Indira Gandhi: Every Drop of My Blood Will Strengthen the Nation; see Pinney 2004, 180). As Pinney notes,

> Indira is reported to have said this ["every drop of my blood will strengthen the nation"] at a rally in Orissa shortly before her death and her supporters believed this to be her premonition of her own murder. . . . Raja mirrors this linguistic message with a visual trace of Indira's blood—several drops and rivulets at the bottom left of the image—on what must be the surface of the image. Like all his [Raja's] images, this picture lacks depth. Indira is not a body located in three-dimension space but a flat representation looking out at the viewer, and the most significant space of the image is not behind the picture plane, but *in front,* where the blood drips . . . In Raja's portrait the only space that matters is that between Indira and the viewer, the space determined by her gaze meeting one's own and in which the viewer can reach out and touch the blood on the surface of the image.
>
> (2004, 179–80)

Raja was heir to a tradition of producing political pictures that did not hesitate to show the martyrdom of men such as Bhagat or Bose in the most macabre manner. And yet, he refuses to show a decapitated or even wounded Indira here, although the very manner of her death, as well as the martyred status she had attained by virtue of such a death, lends itself to such representation.

Indira's ruling Congress Party did not, however, hesitate to turn macabre in this regard. Soon after the assassination, a number of street hoardings were put up in public spaces in the South Indian state of Andhra Pradesh during the national elections of December 1984 (which carried the Congress and Indira's son Rajiv to power). These show her dead face in profile, mapped across the Indian geo-body, or the bloodied body of the slain woman occupying a map of India, blood from her wounds dripping profusely down to the map (Rai 2004, 129, 142–43). Inscribed across these hoardings are words from her last speech, "When my life is gone, every drop of my blood will strengthen the nation."[17] The most dramatic of such hoardings shows a highly anthropomorphized map of India (colored black) holding the slain body of Indira in its "arms" (Figure 32.3). Blood from Indira's slain body drips down onto the map of India, its red color standing out against the white background of Indira's checked sari and the black map. Tears flow down the map's "face." Inscribed once again in Telugu are Indira's last words: 'When my life is gone, every drop of my blood will strengthen the nation."

In contrast to the carto-graphed male martyr, who wears an air of serene composure, even nonchalance, Indira's face in these hoardings is contorted and grotesque. This is certainly a body in pain, to draw upon Elaine Scarry's (1985) formulation, not one that seemingly enjoys or transcends it. There is no attempt in these images to flinch from visually imagining "the female subject in her apprehension of pain" (Sunder Rajan 1993, 33). In turn, the death of Mother Indira has transformed the map of India as well in Figure 32.3. Painted a solid, even demonic black, it is simultaneously a geo-body that has been reduced to tears as it clutches at her wounded, bleeding body. The dangers of visualizing the carto-graphed body

of any female martyr, but especially someone like Indira, are on full display here. Assimilated as she is into the figure of Mother India so that "India is Indira, Indira is India," the death of Indira also means the potential destruction and demise of Bharat Mata and, hence, of the map of India and the territorial totality that it iconizes. The limits of the barefoot mapmaker's patriotism are reached in this hoarding, which rans the risk of pointing to the death of the very mother and map for which many of its martyrs gave up their lives in his visual imagination.

The carto-graphed martyr in the age of the national picture

Every now and then, barefoot mapmaking appears to perform an autocritique of its own praise practices. A striking illustration published in November 1931 on the cover page of the Hindi magazine *Abhyudaya* shows a map of India with the emaciated (and dead or dying) body of a peasant—the Everyman—crucified on the cross of *lagaan* (tax) occupying the outline map of India, blood from his wounds dripping on to the nation's geo-body (Figure 32.11). His hands still pathetically hold on to a small sickle in one and a sheaf of grain in the other while birds representing smallpox, drought, deluge, poverty, and influenza peck away at him; his grieving family huddles at the base of the cross. The farmer-as-martyr surely mocks the more dominant image of the map of India as the abode of the plenteous and glorious Bharat Mata, as we are reminded by Nehru's powerful rationalist

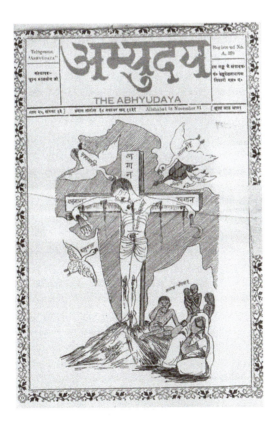

Figure 32.11 *Lagaan* (Tax), artist unknown, 1931. Illustration on cover of Hindi magazine *Abhyudhaya*, Allahabad. PP Hin F 49 British Library (APAC: Proscribed Publications Collection). British Library. © The British Library Board (PP Hin F 49).

critique of "the force of habit" that anthropomorphized India as "Mother India, a beautiful lady:"

> And yet India is in the main the peasant and the worker, not beautiful to look at, for poverty is not beautiful. Does the beautiful lady of our imaginations represent the bare-bodied and bent workers in the fields and factories? Or the small group of those who have from ages past crushed the masses and exploited them, imposed cruel customs on them and made many of them even untouchable? We seek to cover truth by the creatures of our imaginations and endeavor to escape from reality to a world of dreams.
>
> (1980, 431)

I return us from the world of Indian visual dreams to scholarly reality by focusing on the carto-graphed body of the patriot/martyr, a product of the contingent intersection of the cultural politics of corporeality and cartography in the age of the national picture. The carto-graphed body of the patriot/martyr, I want to insist, is specifically the outcome of a scholarly exercise in pictorial history, for it is only this kind of historical investigation that brings it to visibility. As Mitchell notes, "An imbrication of the sayable and the seeable, telling and showing, the articulable and the visible occurs at every level of verbal expression, from speech to writing to description, figuration, and formal/semantic structure" (1995b, 542–3). Correspondingly, rarely do images circulate in public spaces without some connection to the verbal and the textual; there are few pure images untouched by the verbal, the discursive, and the linguistic. Pictorial history challenges us to dwell on the overlapping, zone between the sayable and the seeable so as to shuttle back and forth between the two. It exhorts us to explore those aspects of the human experience that are unsayable and nonverbalizable, but also correspondingly, to come to terms with those that are unpicturable, even unseeable. Such a study compels us to pay attention to phenomena that cannot readily or immediately be translated into language, that are unsayable and *only* seeable. The image of the carto-graphed patriot/martyr, then, is one such only seeable image. It is the sedimentation of an ineffable surplus that can only be excavated by the practices of a new pictorial history that takes seriously Mitchell's argument that pictures "want equal rights with language not to be turned into language" (2005, 47).[18] Poetry and prose on the patriots and martyrs whom I have considered in this chapter abound in the official and subaltern verbal archives of the subcontinent, yet these will not yield the figure of the carto-graphed martyr, which is exclusively a product of the pictorial archive. Such images recall for me the title of James Elkins's powerful book, *On Pictures and the Words That Fail Them* (1998).

In the visual economy of popular messianic nationalism, to invoke Pinney (2004), Bhagat's death, and the death of other martyrs, made sense only when seen as an act of selfless sacrifice for the mother/land. Ironically, the only way to see that motherland as an integral whole is to resort to the indispensable modern science of cartography, inadequate though that might be in capturing the affective intensity with which the patriot relates to the geo-body of the emergent nation. And this is because the form of the map *alone* makes India visible as an integral whole and identifiable as a particular piece of bounded territory on the face of the earth. Barefoot cartographic practice transforms that which is indispensable but inadequate by supplementing the mapped form of the nation with the anthropomorphic presence of Mother India, producing in the process a cartography of affect and patriotic efficacy to counter the impersonal and gridded lines of power of command cartography. Its productions synoptically enframe the map of India, the mother/goddess, and the martyr's body to pictorially show what is unutterable and verbally inexpressible. The carto-graphed body of the martyr with its livid blood dripping down to the map of the nation is the ineffable surplus made visible by the practice of pictorial

history. In the words of Tagore's Sandip (with whose pronouncement I began this chapter), "Such are the visions which give vigor to life, and joy to death!" (1985, 91).

Notes

Sumathi Ramaswamy (sumathi.ramaswamy@duke.edu) is Professor of History at Duke University, in Durham, North Carolina.

1 Rabindranath Tagore (1985, 90–91).

2 Jervis (1938, 9).

3 The print is possibly based on a painting done in the 1930s by Rup Kishore Kapur (1893–1978) that might have been published soon after as a chromolithograph. We learn from Kapur's grandson that "The day Bhagat Singh was hanged, [Kapur] painted in a day [a picture] of Bhagat Singh beheaded, giving his head on a plate to Bharat Mata. Bharat Mata is weeping. He painted it and [displayed it in Sambal] and shouted Bande Mataram [I revere the Mother] and he was taken by the police and was imprisoned for one or two years" (quoted in Pinney 2004, 128).

4 Quoted in Harley (1983, 26).

5 First published at the height of World War I and translated into English (under the author's supervision) in 1919, *Ghare Bhaire* has been hailed by most critics as a passionate critique of nationalism, especially its more extremist, violent, and irrational manifestations. Tagore's Sandip is the very antithesis of the ideal man and citizen of the world, to which the poet-novelist himself aspired.

6 Quoted in Dave et al. (1962, 38).

7 Here, I am adapting Dipesh Chakrabarty's well-known call to "provincialize" Europe and its thought (Chakrabarty 2000).

8 The neologism "carto-graphed" is meant to draw attention to the yoking together of the human or divine body and cartographic products such as maps and globes to produce a particular kind of spatial knowledge. In this study, a carto-graphed figure is one that is inscribed in the form of a map or drawn to accommodate, outline, or be attached to the map form of a country.

9 By "corpothetic," Pinney means the sensory embrace of and bodily engagement with images that is so characteristic of the modern visual regimes of the subcontinent, especially at the popular and devotional level across numerous religious, regional, and ethnic divides.

10 I write this in spite of the fact that recent scholarship has effectively shown the extensive reliance by the British on native subordinates (bare feet and all!) in *the* work of the colonial surveys and mapping of the subcontinent (Raj 2006). My use of this conceptual category also draws on the everyday reality of the average Indian's privileging of bare feet to perform numerous tasks ranging from the sacred to the mundane. Further, many images of artists at work on the subcontinent show them doing so with bare feet. As important, though, the analytic is meant to capture a metaphorical sense of "barefootness" as a condition of being that facilitates a more earthbound and sensory, even corpothetic, relationship to soil, land, and territory than is arguably possible when following the protocols of a lofty and rarified science such as cartography.

11 I borrow the term "big man" from the anthropological work of Mattison Mines, who uses it to develop a model of leadership and status building through "the redistribution of benefits, [the leader's] generosity as a broker, and [the leader's] prestige." Some women can also be "big men" (Mines and Gourishankar 1990).

12 Other than the anonymous Muslim body signified invariably by a fez-capped head, the only Muslim men whom I have seen in these pictures in the company of the map of India are those "loyalists" associated with the Congress Party, such as Maulana Abul Kalam Azad, and a relatively unknown associate of Bhagat Singh's called Ashfaqullah who was hanged by the colonial state in 1927.

13 For a detailed analysis of the deployment of the discourses of martyrdom in contemporary Hindu nationalism, see Christiane Brosius (2005, 233–78).

14 For other examples and helpful discussions regarding them, see Brosius (2005, 258–61, 322–23) and Fenech (2000, 158–77).

15 I borrow the notion of "visual pedagogy" from Antoine de Baecque's work on revolutionary France, in which he argues that images of the wounded bodies of the martyrs of the Revolution were deployed again and again in paintings and prints in order to "make compassion arise," to "open the path of political awareness" in the community, and to produce "a ritualized call to political action" (1997, 281–307).

16 Quoted in Fenech (2000, epigraph).
17 I thank Srinivasacharya kandala for translating the Telugu texts in these pictures.
18 As an adjective, "ineffable" refers to that which "cannot be expressed or described in language; too
 great for words; transcending expression; unspeakable, unutterable, inexpressible," according to the
 Oxford English Dictionary. Mitchell refers to images as "vehicles of experiences and meanings that
 cannot be translated into language" (1995a, 208) and as "sedimentaions of a non-verbalizable surplus"
 (2005, 9–10, 344).

References

Anderson, Benedict. 1991. *Imagined Communities: Reflections on the Origin and Spread of Nationalism*.
 London: Verso.

Axel, Brian Keith. 2001. *The Nation's Tortured Body: Violence, Representation, and the Formation of a
 Sikh "Diaspora."* Durham, N.C.: Duke University Press.

Baecque, Antoine de. 1997. *The Body Politic: Corporeal Metaphor in Revolutionary France, 1770–
 1800*. Trans. Charlotte Mandell. Stanford, Calif.: Stanford University Press.

Bayly, Christopher. 1996. *Empire and Information: Intelligence Gathering and Social Communication in
 India, 1780–1870*. Cambridge: Cambridge University Press.

Blurton, Richard. 1989. "Continuity and Change in the Tradition of Bengali PaTa-Painting." In *The
 Sastric Tradition in Indian Arts*, vol. 1, ed. Anna L. Dallapiccola, 425–51. Stuttgart: Steiner.

Brosius, Christiane. 2005. *Empowering Visions: The Politics of Representation in Hindu Nationalism*.
 London: Anthem Press.

Chakrabarty, Dipesh. 2000. *Provincializing Europe: Postcolonial Thought and Historical Difference*.
 Princeton, N.J.: Princeton University Press.

Cosgrove, Denis. 2001. *Apollo's Eye: A Cartographic Genealogy of the Earth in the Western Imagination*.
 Baltimore: Johns Hopkins University Press.

Dave, J. H., et al. 1962. *Munshi: His Art and Work*. Vol. 1. Bombay: Shri Munshi Seventieth
 Birthday Citizens' Celebration Committee.

Edney, Matthew H. 1997. *Mapping an Empire: The Geographical Construction of British India, 1765–
 1843*. Chicago: University of Chicago Press.

Elkins, James. 1998. *On Pictures and the Words That Fail Them*. Cambridge: Cambridge University
 Press.

Fenech, Louis E. 2000. *Martyrdom in the Sikh Tradition: Playing the "Game of Love."* Delhi: Oxford
 University Press.

Forbes, Geraldine. 1980. "Goddesses or Rebels? The Women Revolutionaries of Bengal." *Orach*
 11 (2): 1–15.

Freitag, Sandria B. 1999. "Visions of the Nation: Theorizing the Nexus between Creation,
 Consumption, and Participation in the Public Sphere." In *Pleasure and the Nation: the History,
 Politics and Consumption of Public Culture in India*, ed. Rachel Dwyer and Christopher Pinney,
 35–75. Delhi: Oxford University Press.

Ghose, Aurobindo. 1956. "Bhavani Mandir." *Sri Aurobindo Mandir Annual* 15: 14–27.

Godlewska, Anne, and Neil Smith, eds. 1994. *Geography and Empire*. Oxford: Blackwell.

Goswami, Manu. 2004. *Producing India: From Colonial Economy to National Space*. Chicago:
 University of Chicago Press.

Harley, J. B. 1983. "Meaning and Ambiguity in Tudor Cartography." In *English Map-Making,
 1500–1650*, ed. Sarah Tyacke, 22–45. London: British Library.

Heidegger, Martin. 1977. "The Age of the World Picture." In *The Question Concerning Technology
 and Other Essays*, by Martin Heidegger, 115–54. New York: Garland.

Helgerson, Richard. 1986. "The Land Speaks: Cartography, Chorography, and Subversion in
 Renaissance England." *Representations* 16: 51–85.

Horkheimer, Max, and Theodor W. Adorno. 1972. *Dialectic of Enlightenment*. Trans. John Cumming. New York: Seabury.

Jain, Jyotindra. 2003. "Morphing Identities: Reconfiguring the Divine and the Political." In *Body. City: Siting Contemporary Culture in India*, ed. Indira Chandrasekhar and Peter C. Seel, 12–45. New Delhi: Tulika Books.

Jain, Kajri. 2007. *Gods in the Bazaar: The Economies of Indian Calendar Art*. Durham, N.C.: Duke University Press.

Jervis, W. W. 1938. *The World in Maps: A Study in Map Evolution*. 2nd ed. New York: Oxford University Press.

Kitchinc, Gavin. 1985. "Nationalism: The Instrumental Passion." *Capital and Class* 25: 98–116.

Krishnaswamy, Revathi. 1998. *Effeminism: The Economy of Colonial Desire*. Ann Arbor: University of Michigan Press.

Landes, Joan B. 2001. *Visualizing the Nation: Gender, Representation, and Revolution in Eighteenth-Century France*. Ithaca, N.Y.: Cornell University Press.

Lannoy, Richard. 1999. *Benares Seen from Within*. Varanasi: Indica Books.

Mines, Mattison, and Vijayalakshmi Gourishankar. 1990. "Leadership and Individuality in South Asia: The Case of the South Indian Big-Man." *Journal of Asian Studies* 49 (4): 761–86.

Mitchell, W. J. T. 1995a. "Interdisciplinarity and Visual Culture." *Art Bulletin* 77 (4): 534–52.

———. 1995b. "What Is Visual Culture?" In *Meaning in the Visual Arts: Views from the Outside*, ed. Irving Lavin, 207–17. Princeton, N.J.: Institute for Advanced Study.

———. 2005. *What Do Pictures Want? The Lives and Loves of Images*. Chicago: University of Chicago Press.

Nehru, Jawaharlal. 1980. *An Autobiography*. Delhi: Oxford University Press.

Neumayer, Erwin, and Christine Schelberger. 2007. *Bharat Mata: Printed Icons from the Struggle for Independence in India*. Delhi: Oxford University Press.

Pal, Bipin Chandra. 1923. *The Soul of India: A Constructive Study on Indian Thought and Ideas*. 2nd ed. Madras: Tagore.

Pinney, Christopher. 1997. "The Nation (Un)Pictured: Chromolithography and 'Popular' Politics in India." *Critical Inquiry* 23 (3): 834–67.

———. 2004. *Photos of the Gods: The Printed Image and Political Struggle in India*. Delhi: Oxford University Press.

Rai, Raghu. 2004. *Indira Gandhi: A Living Legacy*. New Delhi: Timeless Books.

Raj, Kapil. 2006. *Relocating Modern Science: Circulation and the Construction of Scientific Knowledge in South Asia, 17th–19th Centuries*. Delhi: Permanent Black.

Ramaswamy, Sumathi. 2000. "History at Land's End: Lemuria in Tamil Spatial Fables." *Journal of Asian Studies* 59 (3): 575–602.

———. 2001. "Maps and Mother Goddesses in Modern India." *Imago Mundi* 53: 97–113.

———. 2002. "The Goddess and the Nation: Subterfuges of Antiquity, the Cunning of Modernity." In *The Blackwell Companion to Hinduism*, ed. Gavin Flood, 551–68. Oxford: Blackwell.

———. 2003. "Visualizing India's Geo-Body: Globes, Maps, Bodyscapes." In *Beyond Appearances? Visual Practices and Ideologies in Modern India*, ed. Sumathi Ramaswamy, 151–90. New Delhi: Sage.

———. 2008. "The Mahatma as Muse: An Image Essay on Gandhi in Popular Indian Visual Imagination." In *Art and Visual Culture in India, 1857–1947*, ed. G. Sinha. Mumbai: Marg Publications.

Scarry, Elaine. 1985. *The Body in Pain: The Making and Unmaking of the World*. New York: Oxford University Press.

Scott, James C. 1998. *Seeing Like a State: How Certain Schemes to Improve the Human Condition Have Failed*. New Haven, Conn.: Yale University Press.

Sedgwick, Eve Kosofsky. 1985. *Between Men: English Literature and Male Homosocial Desire*. New York: Columbia University Press.

Sen, Geeti. 2002. *Feminine Fables: Imaging the Indian Woman in Painting, Photography, and Cinema.* Ahmadabad: Mapin.

Sparke, Matthew. 2005. *In the Space of Theory: Postfoundational Geographies of the Nation-State.* Minneapolis: University of Minnesota Press.

Sunder Rajan, Rajeswari. 1993. *Real and Imagined Women: Gender, Culture, and Post-colonialism.* London: Routledge.

Tagore, Rabindranath. 1985. *The Home and the World.* Trans. Surendranath Tagore. Repr. ed. Madras: Macmillan.

Thongchai Winichakul. 1996. "Maps and the Formation of the Geo-Body of Siam." In *Asian Forms of the Nation*, ed. Hans Antlöv and Stein Tønnesson, 67–91. London: Curzon Press.

Tuan, Yi-Fu. 1977. *Space and Place: The Perspective of Experience.* Minneapolis: University of Minnesota Press.

Uberoi, Patricia. 1990. "Feminine Identity and National Ethos in Indian Calendar Art." *Economic and Political Weekly (Review of Women's Studies)* 25 (17): WS41–48.

Wood, Denis, and John Fels. 1992. *The Power of Maps.* New York: Guilford Press.

Dipesh Chakrabarty

MUSEUMS IN LATE DEMOCRACIES

Two models of democracy

BEFORE I GET ON to the matter of museums and their evolving relationship to democracies—my real subject in this short and sketchy essay—let me begin by explaining briefly what I see as the two models of democracy that coexist and sometimes clash in contemporary democratic polities. In the interest of brevity and exposition, I will keep my models separate and simple. Nineteenth-and early twentieth-century ideas of democracy assumed a pedagogical understanding of politics. One was never born political even if it were thought that every human being had the capacity or the potential to take part in political life. But the condition of being human was not equated to the condition of being political. It was assumed that becoming a citizen, possessing and exercising rights, called for appropriate forms of education. Societies were understood to have both high and low forms of culture. Education provided the capacity for discernment—access to high culture—that the citizen needed. This could be self-education. It could be education through the right kind of experience. More commonly, however, it was thought that it fell to the educational institutions of modern societies to provide citizenly competence. Universities, museums, libraries, exhibitions and other comparable bodies assumed this task.[1] A crucial aspect of this education was the capacity for abstract conceptualisation and reasoning. The book became the key object embodying this assumption. The importance given to the written language as the medium of instruction signified the high place accorded in this mode of thought to the trained, human capacity for abstraction. Abstract reasoning made it possible for the citizen to conceptualise such imaginary entities as "class," "public," or "national" interest and adjudicate between competing claims. Rationality was not merely a procedural aspect of disputations in life; it was itself thought to be an instrument of unity in public discussions. Rationality could help us appreciate our interests and arrange them mentally in the right order of priority. The public sphere was not only imagined as potentially united and unifiable; such unity was itself a value. For Marxists, "class" could be the rational key explaining and promoting a unity between diverse underprivileged groups. For nationalists, something like "national interest" could be a factor that overrode all divisions born of sectional interests. For liberals, rationality could lead to appreciation of that which was in the interest of all. Expanding the area of

agreement through education and rational argumentation was seen as way of strengthening the fabric of national life.

This pedagogical understanding of citizenship is not history. It is not something we have left behind. Many of our institutional and personal actions are based on this understanding. Yet twentieth-century practices of mass-democracy—both in the West and in countries such as India—are also predicated on a very different understanding of the political. Following Homi Bhabha's usage of the terms "pedagogic" and "performative," we may call the second model of democratic politics a "performative" one.[2] The political, in this model, is not fundamentally a matter of pedagogy. The citizen is not someone who comes or is produced at the end of an educational process in which the school, the university, the library, and the museum intervene. In this conception that has increasingly dominated debates in and about public life in democracies since the 1960s, to be human is to be already political. Statements such as "everything is political," or "the personal is political" are reflections of this point of view. An Australian example will illustrate my point about the difference between the two models of democracy. A. P. Elkin, Professor of Anthropology at the University of Sydney from 1934 to 1956, advocated citizenship for Aboriginals but supported only "a gradual granting" of such rights. Only "civilised" Aboriginals, according to him, were fit for citizenship.[3] Elkin, in my terms, stood for the first model. Yet when Aboriginals finally obtained (partial) citizenship in 1967, the decision obviously did not reflect Elkin's position.[4] Any Aboriginal, formally educated or not, was now seen as entitled to the rights of the citizen. The same point could be made with respect to the Indian decision, on the attainment of independence, to adopt universal adult franchise as a citizenly right in a society that was predominantly non-literate. This was part of a global trend the beginnings of which can be traced back at least as far as the 1920s when the fear of Bolshevism, for example, induced Western governments to extend to working classes in many countries the rights of organisation and protest. The acquisition of these rights was no longer made conditional on any preparatory work on behalf of the people. In short, the pedagogical or tutelage model of politics simply could not keep pace with the speed with which the world got politicised last century. The Soviet revolution, anti-colonial mass nationalisms in the non-West, and emergence of mass politics in the West were important contributors to the process until the 1950s. And then came the "new" social movements and counter-cultural movements of the 1960s, first-wave feminism with its slogan "the personal is political," and the politics of multiculturalism and indigenous rights in the Western democracies. The spread of consmerism and the mass media has been an inextricable part of this search for forms of mass democracy. For the rise of the mass-consumer and the question of his or her rights—a growing concern of capitalist democracies—entailed both understandings of the political. The consumer is a subject of pedagogy. She or he is routinely taught many of his or her rights. There are associations and journals that aim to do just that. But the right of a consumer to choose or refuse a product (for whatever reasons) is a basic right, independent of education in these rights.

Understandably, educational institutions such as the university or the museum have not been immune to the growing tension between the pedagogic and performative kinds of democracy. The so-called "culture wars" of the 1980s that saw the canons of the Western academy being both vigorously challenged and defended, the rise of varieties of cultural relativism, the accent on diversity and the politics of identity, the coming of postmodern and postcolonial criticism, have all left their mark on these institutions. These debates around pedagogic versus performative kinds of democracy are inconclusive but it can be safely said that very few, if any, museums or universities will now want to go back to the purity of nineteenth- or early twentieth-century propositions and ignore the discussions of postcolonial, indigenous and multicultural critics. Nor would they want to deny the reality of consumerist practices within which public institutions are situated. But that said, interesting and

rigorous debates still take place in particular institutions about the specific mix of the two models of politics with which particular situations should be handled. The ensuing decisions, needless to say, are principled as well as political and pragmatic. They do not offer any universal solutions to our dilemmas but I look on these debates as a reminder of tension between the pedagogic and the performative models of democracy. This tension is what we have to negotiate as we contemplate the futures, in late democracies, of the class of institutions we call "museums."

Like the university, the museum also has had to accept that education and entertainment are not opposed to each other. But museums, for reasons I go into below, have been more affected by the process than universities. They have had to embrace the proposition that their clientele have choice and their preferences need to be addressed; that education will largely have to pay for itself and that state-funding will have to be supplemented by endowments and revenue. Along with this have come debates that have challenged the authority of the museum in deciding what could be collected and exhibited. Museums have been drawn into debates about the past, its representation and ownership, debates often driven by the so-called politics of identity. The last point has been a particularly sensitive one for peoples struggling for forms of cultural sovereignty. Indigenous peoples in various parts of world (including Australia) have successfully challenged the idea that everything could be exhibited to anybody or that scientific curiosity represented a greater human interest than a particular group's cultural use and possession of objects. As a result, museums have also emerged as a key site for cultural politics arising over questions of the past in late democracies.

Museums, democracy and the politics of experience

I want to suggest that if the pedagogic model of democracy privileges the capacity for abstract reasoning and imagination in the citizen, the performative one brings into view the domain of the embodied and the sensual. And that is what makes the roles of visual and other sensual practices different in the two models. Think of the education that once aimed to give the citizen the capacity to conceive of and visualize abstract things, such as the idea of the nation. There were visual aids, of course: maps, statues and other images of national unity. But the way school and university disciplines such as history, geography, political science and anthropology enabled one to think the nation or community was through developing skills for visualizing abstractions. I still vividly remember a question a non-literate peasant-girl who hailed from a village in the district of the 24 Parganas near Calcutta once asked me as she accompanied my cousin, her family and myself making our way to Calcutta from Delhi by car in 1973. A domestic maid in my cousin's home, she had lived in Delhi for quite a few years now and been exposed to television and cinema. And yet, a few miles away from Delhi and her curiosity stoked by unfamiliar surroundings, she asked, "Tell me, Dipeshda [my older brother, Dipesh], is Kashmir a part of the 24 Parganas?" We all laughed at her "ignorance" of Indian geography, but the incident also told me how much one's geographical imagination was a matter of education and training in visualizing—through instruments such as the map—completely imperceptible entities like the nation.

In pedagogic models of democracy, citizenship is based on the capacity for reasoning. This capacity is assumed to stand supreme as the machine through which all information needs to be processed. It is as if the pedagogic model privileges the brain over the senses. The museum of the past would collect and put in juxtaposition objects and artefacts that never belonged together in their natural/cultural distribution in the world. The zoological garden would do the same with animals, and libraries with books. All these arrangements would privilege the conceptual or the analytic over the lived. The zoo would make a catalog come

alive, as it were. Museums and archives—both modern institutions for preserving relics of the past—were close to each other in principle at their moments of origin. Just as the museum curator ignored the sensory aspects of the exhibits, historians trained in the traditions of their science would seldom include in their narratives the tactile or sensory part of their research. The experience of old brittle documents going to pieces in their hands, the smell of old newspapers, the strain on the eye caused by past styles of handwriting, the allergy attacks they might suffer from the dust in the archives—in short, everything that made the so-called relic of the past a part of the lived present as well—would be put to one side in order for the past to emerge in clear distance from the present. Why would the senses be so relegated to the background in the work of the analytic? Because, it was assumed in this way of thinking, that it was only through analytic reasoning that one reached the deeper, general and invisible "truths" about society, whatever they were—class, economic forces, natural laws. That which was merely perceptual, not subordinated to reason—and, in that sense, part of the lived experience—gave us access to only the local and particular.

The analytic, one might say, always wanted to subordinate "experience" or the "lived" to itself.[5] Yet the realm of experience has asserted itself more and more in academic history or anthropology whenever these disciplines have tried to respond to the pressures of democracy. But not always with happy results. Historians in the 1960s and seventies explored "oral history" assuming that the experiences reported by people would nicely fill out stories available in the archives, and thus democratise the discipline of history without challenging its basic precepts. Instead they found themselves in the land of memories which always blurred the distinction between the past and the present that was crucial for historical analysis and objectivity.[6] A disciplinary unease exists between the field of memory and academic history. Anthropologists have similarly wrestled with strategies to release the lived and the experienced from their traditional subjection to analysis but with mixed results. The reasons are not far to seek. The vision of the political that academic disciplines are wedded to belongs to my first model of democracy: citizenship as the capacity for abstract reasoning. Indeed, without such reasoning, the critical-political edge of the social sciences would be blunted. How would you otherwise visualize as concrete and real such invisible entities as capital, social structure, instrumental rationality, and so on? And without these categories, how would one develop modern critiques of social relations?

Museums, being public places where one does not usually require special qualifications to enter, have been more open to the pressure of mass democracies and have had to address more directly issues of experience. They have therefore also had to be more sensitive to the politics that question the presumed primacy of the analytic over the lived. In his well-known essay "On Collecting Art and Culture," the anthropologist James Clifford gives an early instance of this from the life of the Musée de l'Homme in Paris. He cites an essay published in 1986 by Anne Vitart-Fardoulis, a curator at the museum. Vitart-Farduolis describes how one day a Native American man walked into the museum and suddenly, by talking in a personal and intimate way about "a famous intricately painted animal skin," challenged the primacy of the analytic over the lived:

> The grandson of one of the Indians who came to Paris with Buffalo Bill was searching for the [painted skin] tunic his grandfather had been forced to sell to pay his way back to the United States when the circus collapsed. I showed him all the tunics in our collection, and he paused before one of them. Controlling his emotion, he spoke. He told the meaning of this lock of hair, of that design, why this color had been used, the meaning of that feather . . . This garment, formerly beautiful and interesting but passive and indifferent, little by little became . . . [an] active testimony to a living moment through the mediation of

someone who did not *observe* and *analyze* it but who *lived* the object and for whom
the object lived. It scarcely matters whether the tunic is really his grandfather's.[7]

I do not have to remind the reader that this Native American man could have walked into
a museum in the nineteenth century and said the same things but he would not have been
heard. Why do we hear him now? Because the politics of identity—the question of who can
speak for whom—are, like it or not, part of the cultural politics of a liberal democracy. The
more our attention has turned to the formerly "colonized" within the West, the more anti-
colonial themes and questions have come to mark liberal democracies' attempts at multicul-
turalism. The history of colonialism and of colonial knowledge shows how the universalistic
and humanist analytic frames of the social sciences were once used to classify, control and
subordinate the colonised both within and outside the West.[8] It was the same process that
also resulted in the pre-colonial knowledge systems of the colonised now living subjugated
lives, relegated to the supposedly parochial and untheoretical realms of "experience." It is
precisely against such politics of knowledge that the cry goes up from time to time from the
ranks of the historically-oppressed, "to hell with your archives, we have the experience!."[9]

In opening themselves up to the politics of experience, museums have gradually moved
away from the archives, a modern institution with which they once shared paradigms of
knowledge. For the politics of experience orients us to the realms of the senses and the
embodied. This is never achieved by the capacity for abstract reasoning. It takes us away from
the senses, it trains us to be skeptical of the evidence they produce about the world. University

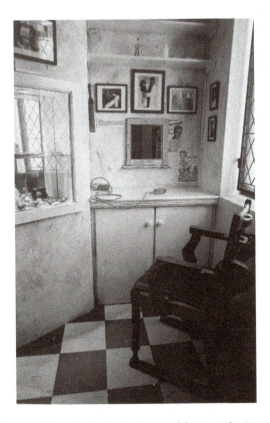

Figure 33.1 Barbershop installation in the *Digging Deeper* exhibition at the District Six Museum, Cape
Town, South Africa. Photo © Paul Grendon and the District Six Museum.

education, on the other hand, can train us, as I have said, to visualize as concrete that which is invisible to the natural eye. But it speaks to (and of) a disembodied subject of history, a position that we individually are called to inhabit when we know the world from that position. The museum of today, however, increasingly opens itself up to the embodied and the lived. It provides as much "experience" as abstract knowledge. And this is directly a part of my second model of democracy.

Let me illustrate this briefly with the example of the District Six Museum in Cape Town, South Africa. As many readers will know, District Six was a well-known "mixed" neighborhood in Cape Town that was literally bulldozed between 1966 and 1984 to make it into an area for the Whites. Thousands of people lost their dwellings overnight. Families and neighbors were torn apart and dispersed. The museum grew organically out of the protest movement that fearlessly challenged this brutal act of undemocracy. Started in 1994, the museum developed into a site for communal memory, not a nostalgic monument to a dead past but a living memory that is part of the struggle against racism in post-Apartheid South Africa. Older residents and their children visit the museum to imbibe the memories that inform their present struggles. The museum makes special effort to remember the streets of the neighborhood. Here is a part of a testimony from one of the visitors to the museum, showing how the logic of remembering, as distinct from that of history, leads inexorably to the realms of the sensory and embodied:

> The streets of my childhood in Sea Point survive as the bones of an articulated skeleton remain preserved. On visiting there, my memories jostling, it occurred to me that this act of remembering can be likened to watching a video—in reverse motion . . . Around the bones grow organs for living and sometimes flesh . . . But the process of remembering is filtered and textured, entangling stages of then and now. It culminates in an evocation of old-new things, rather than the "flesh" of what was once there. A process that is at the same time so intimate and yet beyond our grasp . . . Along streets we *all* made our way, linking beacons of home, school and the shop. In a recurring dream verging on nightmare, I pick my way in nauseating dread along the Main Road toward school, bearing a heavy suitcase . . . And memories push forward; hot pavements, the scream of seagulls and the droning foghorn, yellow-foaming sea and crackling palm fronds; but the strongest memory-sense of all, the smell of watermelon, permeating from the fresh-cut grass of the beachfront lawns, to the residents of the nearby hotels, flats and scattered houses.[10]

You can see in this quotation how memory, eventually, can never be separated from the domain of the senses, for memory always has elements that are embodied. We cannot even predict these embodied memories in their entirety. This actually produces a paradoxical result for what is often disparagingly called "identity politics." It is true that the politics of diverse identities in democracies often lead people to make indefensible claims connecting experience with identity. For instance, it could be claimed—and often is—that only the members of a particular group have the right or the capacity to understand/represent the group because they have the necessary and requisite experience. Sometimes, as I have already said, knowing particular histories of oppression helps us to empathise with these claims. But the very nature and politics of experience actually belies such claims. The realm of the lived ultimately belongs to embodied existence. And experience always touches on this level. It follows then that experience does not have to always connote a subject (or an identity) defining the experience as such. Experience is not always subjective in a psychological sense, if by psychology we refer to processes that go on only in the brain.[11] The body also has experiences

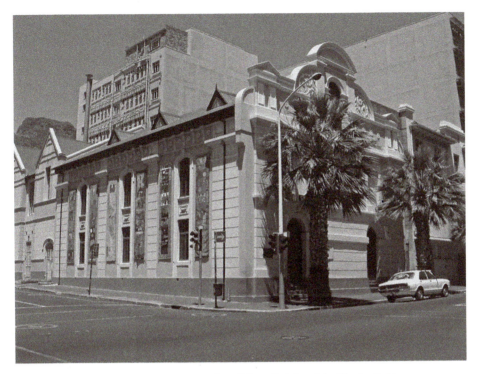

Figure 33.2 Exterior, District Six Museum. Photo © Lutz Kosbab and the District Six Museum.

and remembers them. The politics of identity thus often reaches out to a level that actually defeats any project that the "politicians of identity" may have of making identities appear fixed, immutable and essentialised. For who can tell ahead of any event what the mind-body complex may or may not remember? Experience, thus, does not have to speak to a politics of identity.

By opening out to questions of the embodied and the lived, museums address certain formations of the public in modern democracies that academic disciplines do not address. A democracy needs an informed public and public debates. Academic models of knowledge privilege information that, supposedly, the brain processes. These models of knowledge marginalise the senses. Democracies have moved on to a variety of politics in which information is not simply packaged for the brain to process; information is now also what addresses other senses—of seeing, hearing, smelling, and touching. In the democracy of the masses and the media, the realms of the embodied are increasingly politically powerful. It is not that the expertise and rationality produced by the traditional academic disciplines are redundant or irrelevant. But their traditional skepticism towards the embodied and the sensory will not help us in understanding why memory and experience—in other words, embodied knowledge— will play as important roles in the politics of democracies as the disembodied knowledge academic disciplines aspire to. Museums, more than archives and history departments, have travelled the distance needed to keep up with changes that mark late democracies.

Notes

1 See the Introduction to Simon During ed., *The Cultural Studies Reader*, (London and New York: Routledge, 1999) for a discussion of these issues.
2 Homi Bhabha, "Dissemination: Time, narrative and the margins of the modern nation" in his *The Location of Culture*, (London and New York: Routledge, 1994), pp. 139–170.

3 Geoffrey Gray, "From Nomadism to Citizenship: A P Elkin and Aboriginal Advancement" in Nicolas Peterson and Will Sanders eds., *Citizenship and Indigenous Australians: Changing Conceptions and Possibilities*, (Cambridge: Cambridge University Press, 1998), pp. 55–76.

4 For a discussion of the complexities and ambiguities of the 1967 referendum in Australia, see Bain Attwood and Andrew Markus, "Representation Matters: The 1967 Referendum and Citizenship" in Nicolas Peterson and Will Sanders (eds), *Citizenship and Indigenous Australians: Changing Conceptions and Possibilities*, (Melbourne: Cambridge University Press, 1998), pp. 118–40.

5 See the last chapter to my book *Provincializing Europe: Postcolonial Thought and Historical Difference*, (Princeton, New Jersey: Princeton University Press, 2000).

6 Joan Scott's much-cited essay, "The Evidence of Experience," in *Critical Inquiry*, 17, Summer 1991, pp. 772–797, reproduces, this time with a post-structuralist suspicion of the subject, the social analyst's scepticism about the usefulness of "experience" as a guide to social realities.

7 Vitart-Fardoulis cited in James Clifford, "On Collecting Art and Culture" in his *The Predicament of Culture: Twentieth-Century Ethnography, Literature, and Art*, (Cambridge, Mass.: Harvard University Press, 1988), p. 246. Emphasis added.

8 Bernard Cohn, *Colonialism and its Forms of Knowledge*, (Princeton, New Jersey: Princeton University Press, 1998) is a classic statement of some of the issues involved here.

9 I discuss this more in my essay "Globalization, Democratization, and the Evacuation of History?" in Jackie Assayag and Veronique Benei (eds), *East in West*, (Delhi: Permanent Black, forthcoming).

10 Lalou Meltzer, "Past Streets" in Ciraj Rasool and Sandra Prosalendis (eds), *Recalling Community in Cape Town*, (Cape Town: District Six Museum, 2001), pp. 21–22.

11 Joan Scott's essay "The Evidence of Experience" seems to make this assumption.

Frantz Fanon

THE FACT OF BLACKNESS

"**D**IRTY NIGGER!**"** Or simply, "Look, a Negro!"
 I came into the world imbued with the will to find a meaning in things, my spirit filled with the desire to attain to the source of the world, and then I found that I was an object in the midst of other objects.

Sealed into that crushing objecthood, I turned beseechingly to others. Their attention was a liberation, running over my body suddenly abraded into nonbeing, endowing me once more with an agility that I had thought lost, and by taking me out of the world, restoring me to it. But just as I reached the other side, I stumbled, and the movements, the attitudes, the glances of the other fixed me there, in the sense in which a chemical solution is fixed by a dye. I was indignant; I demanded an explanation. Nothing happened. I burst apart. Now the fragments have been put together again by another self.

As long as the black man is among his own, he will have no occasion, except in minor internal conflicts, to experience his being through others. There is of course the moment of "being for others," of which Hegel speaks, but every ontology is made unattainable in a colonized and civilized society. It would seem that this fact has not been given sufficient attention by those who have discussed the question. In the *Weltanschauung* of a colonized people there is an impurity, a flaw that outlaws any ontological explanation. Someone may object that this is the case with every individual, but such an objection merely conceals a basic problem. Ontology—once it is finally admitted as leaving existence by the wayside—does not permit us to understand the being of the black man. For not only must the black man be black; he must be black in relation to the white man. Some critics will take it on themselves to remind us that this proposition has a converse. I say that this is false. The black man has no ontological resistance in the eyes of the white man. Overnight the Negro has been given two frames of reference within which he has had to place himself. His metaphysics, or, less pretentiously, his customs and the sources on which they were based, were wiped out because they were in conflict with a civilization that he did not know and that imposed itself on him.

The black man among his own in the twentieth century does not know at what moment his inferiority comes into being through the other. Of course I have talked about the black problem with friends, or, more rarely, with American Negroes. Together we

protested, we asserted the equality of all men in the world. In the Antilles there was also that little gulf that exists among the almost-white, the mulatto, and the nigger. But I was satisfied with an intellectual understanding of these differences. It was not really dramatic. And then. . . .

And then the occasion arose when I had to meet the white man's eyes. An unfamiliar weight burdened me. The real world challenged my claims. In the white world the man of color encounters difficulties in the development of his bodily schema. Consciousness of the body is solely a negating activity. It is a third-person consciousness. The body is surrounded by an atmosphere of certain uncertainty. I know that if I want to smoke, I shall have to reach out my right hand and take the pack of cigarettes lying at the other end of the table. The matches, however, are in the drawer on the left, and I shall have to lean back slightly. And all these movements are made not out of habit but out of implicit knowledge. A slow composition of my *self* as a body in the middle of a spatial and temporal world—such seems to be the schema. It does not impose itself on me; it is, rather, a definitive structuring of the self and of the world—definitive because it creates a real dialectic between my body and the world.

For several years certain laboratories have been trying to produce a serum for "denegrification;" with all the earnestness in the world, laboratories have sterilized their test tubes, checked their scales, and embarked on researches that might make it possible for the miserable Negro to whiten himself and thus to throw off the burden of that corporeal malediction. Below the corporeal schema I had sketched a historico-racial schema. The elements that I used had been provided for me not by "residual sensations and perceptions primarily of a tactile, vestibular, kinesthetic, and visual character,"[1] but by the other, the white man, who had woven me out of a thousand details, anecdotes, stories. I thought that what I had in hand was to construct a physiological self, to balance space, to localize sensations, and here I was called on for more.

"Look, a Negro!" It was an external stimulus that flicked over me as I passed by. I made a tight smile.

"Look, a Negro!" It was true. It amused me.

"Look, a Negro!" The circle was drawing a bit tighter. I made no secret of my amusement.

"Mama, see the Negro! I'm frightened!" Frightened! Frightened! Now they were beginning to be afraid of me. I made up my mind to laugh myself to tears, but laughter had become impossible.

I could no longer laugh, because I already knew that there were legends, stories, history, and above all *historicity*, which I had learned about from Jaspers. Then, assailed at various points, the corporeal schema crumbled, its place taken by a racial epidermal schema. In the train it was no longer a question of being aware of my body in the third person but in a triple person. In the train I was given not one but two, three places. I had already stopped being amused. It was not that I was finding febrile coordinates in the world. I existed triply: I occupied space. I moved toward the other . . . and the evanescent other, hostile but not opaque, transparent, not there, disappeared. Nausea. . . .

I was responsible at the same time for my body, for my race, for my ancestors. I subjected myself to an objective examination, I discovered my blackness, my ethnic characteristics; and I was battered down by tom-toms, cannibalism, intellectual deficiency, fetishism, racial defects, slave-ships, and above all else, above all: "Sho' good eatin'."

On that day, completely dislocated, unable to be abroad with the other, the white man, who unmercifully imprisoned me, I took myself far off from my own presence, far indeed, and made myself an object. What else could it be for me but an amputation, an excision, a hemorrhage that spattered my whole body with black blood? But I did not want this revision,

this thematization. All I wanted was to be a man among other men. I wanted to come lithe and young into a world that was ours and to help to build it together.

[. . .]

Note

1 Jean Lhermitte, *L'Image de notre corps* (Paris, Nouvelle Revue critique, 1939), p. 17.

Fred Moten

THE CASE OF BLACKNESS

1

THE CULTURAL AND POLITICAL DISCOURSE on black pathology has been so pervasive that it could be said to constitute the background against which all representations of blacks, blackness, or (the color) black take place. Its manifestations have changed over the years, though it has always been poised between the realms of the pseudo-social scientific, the birth of new sciences, and the normative impulse that is at the heart of—but that *strains against*—the black radicalism that *strains against* it. From the origins of the critical philosophy in the assertion of its extra-rational foundations in teleological principle; to the advent and solidification of empiricist human biology that moves out of the convergence of phrenology, criminology, and eugenics; to the maturation of (American) sociology in the oscillation between good-and bad-faith attendance to "the negro problem;" to the analysis of and discourse on psychopathology and the deployment of these in both colonial oppression and anticolonial resistance; to the regulatory metaphysics that undergirds interlocking notions of sound and color in aesthetic theory: blackness has been associated with a certain sense of decay, even when that decay is invoked in the name of a certain (fetishization of) vitality.

Black radical discourse has often taken up, and held itself within, the stance of the pathologist. Going back to David Walker, at least, black radicalism is animated by the question, What's wrong with black folk? The extent to which radicalism (here understood as the performance of a general critique of the proper) is a fundamental and enduring force in the black public sphere—so much so that even black "conservatives" are always constrained to begin by defining themselves in relation to it—is all but self-evident. Less self-evident is the normative striving against the grain of the very radicalism from which the desire for norms is derived. Such striving is directed toward those lived experiences of blackness that are, on the one hand, aligned with what has been called radical and, on the other hand, aligned not so much with a kind of being-toward-death but with something that has been understood as a deathly or death-driven nonbeing. This strife between normativity and the deconstruction of norms is essential not only to contemporary black academic discourse but also to the discourses of the barbershop, the beauty shop, and the bookstore.

I'll begin with a thought that doesn't come from any of these zones, though it's felt in them, strangely, since it posits the being of, and being in, these zones as an ensemble of specific impossibilities:

> As long as the black man is among his own, he will have no occasion, except in minor internal conflicts, to experience his being through others. There is of course the moment of "being for others," of which Hegel speaks, but every ontology is made unattainable in a colonized and civilized society. It would seem that this fact has not been given enough attention by those who have discussed the question. In the *Weltanschauung* of a colonized people there is an impurity, a flaw, that outlaws [*interdit*] any ontological explanation. Someone may object that this is the case with every individual, but such an objection merely conceals a basic problem. Ontology—once it is finally admitted as leaving existence by the wayside—does not permit us to understand the being of the black man. For not only must the black man be black; he must be black in relation to the white man. Some critics will take it upon themselves to remind us that the proposition has a converse. I say that this is false. The black man has no ontological resistance in the eyes of the white man.[1]

This passage, and the ontological (absence of) drama it represents, leads us to a set of fundamental questions. How do we think the possibility and the law of outlawed, impossible things? And if, as Frantz Fanon suggests, the black cannot be an other for another black, if the black can only be an other for a white, then is there ever anything called black social life? Is the designation of this or that thing as lawless, and the assertion that such lawlessness is a function of an already extant flaw, something more than that trying, even neurotic, oscillation between the exposure and the replication of a regulatory maneuver whose force is held precisely in the assumption that it comes before what it would contain? What's the relation between explanation and resistance? Who bears the responsibility of discovering an ontology of, or of discovering *for* ontology, the ensemble of political, aesthetic, and philosophical derangements that comprise the being that is neither for itself nor for the other? What form of life makes such discovery possible as well as necessary? Would we know it by its flaws, its impurities? What might an impurity in a worldview actually be? Impurity implies a kind of non-completeness, if not absence, of a worldview. Perhaps that non-completeness signals an originarily criminal refusal of the interplay of framing and grasping, taking and keeping—a certain reticence at the ongoing advent of the age of the world picture. Perhaps it is the reticence of the grasped, the enframed, the taken, the kept—or, more precisely, the reluctance that disrupts grasping and framing, taking and keeping—as epistemological stance as well as accumulative activity. Perhaps this is the flaw that attends essential, anoriginal impurity—the flaw that accompanies impossible origins and deviant translations.[2]

What's at stake is fugitive movement in and out of the frame, bar, or whatever externally imposed social logic—a movement of escape, the stealth of the stolen that can be said, since it inheres in every closed circle, to break every enclosure. This fugitive movement is stolen life, and its relation to law is reducible neither to simple interdiction nor bare transgression. Part of what can be attained in this zone of unattainability, to which the eminently attainable ones have been relegated, which they occupy but cannot (and refuse to) own, is some sense of the fugitive law of movement that makes black social life ungovernable, that demands a para-ontological disruption of the supposed connection between explanation and resistance.[3] This exchange between matters juridical and matters sociological is given in the mixture of phenomenology and psychopathology that drives Fanon's work, his slow approach to an encounter with impossible black social life poised or posed in the break, in a certain intransitive evasion of crossing, in the wary mood or fugitive case that ensues between the

fact of blackness and the lived experience of the black and as a slippage enacted by the meaning—or, perhaps too "trans-literally," the (plain[-sung]) sense—of things when subjects are engaged in the representation of objects.

The title of this essay, "The Case of Blackness," is a spin on the title of the fifth chapter of Fanon's *Black Skins, White Masks*, infamously mistranslated as "the fact of blackness." "The lived experience of the black" is more literal—"experience" bears a German trace, translates as *Erlebnis* rather than *Tatsache*, and thereby places Fanon within a group of postwar Francophone thinkers encountering phenomenology that includes Jean-Paul Sartre, Maurice Merleau-Ponty, Emmanuel Levinas, and Tran Duc Thao.[4] The phrasing indicates Fanon's veering off from an analytic engagement with the world as a set of facts that are available to the natural scientific attitude, so it's possible to feel the vexation of certain commentators with what might be mistaken for a flirtation with positivism. However, I want to linger in, rather than quickly jump over, the gap between fact and lived experience in order to consider the word "case" as a kind of broken bridge or cut suspension between the two. I'm interested in how the troubled, illicit commerce between fact and lived experience is bound up with that between blackness and the black, a difference that is often concealed, one that plays itself out not by way of the question of accuracy or adequation but by way of the shadowed emergence of the ontological difference between being and beings. Attunement to that difference and its modalities must be fine. Perhaps certain recalibrations of Fanon—made possible by insights to which Fanon is both given and blind—will allow us to show the necessity and possibility of another understanding of the ontological difference. In such an understanding, the political phonochoreography of being's words bears a content that cannot be left by the wayside even if it is packaged in the pathologization of blacks and blackness in the discourse of the human and natural sciences and in the corollary emergence of expertise as the defining epistemological register of the modern subject who is in that he knows, regulates, but cannot be black. This might turn out to have much to do with the constitution of that locale in which "ontological explanation" *is* precisely insofar as it is against the law.

One way to investigate the lived experience of the black is to consider what it is to be the dangerous—because one is, because we are (Who? We? Who is this we? Who volunteers for this already given imposition? Who elects this imposed affinity? The one who is homelessly, hopefully, less and more?) the constitutive—supplement. What is it to be an irreducibly disordering, deformational force while at the same time being absolutely indispensable to normative order, normative form? This is not the same as, though it does probably follow from, the troubled realization that one is an object in the midst of other objects, as Fanon would have it. In their introduction to a rich and important collection of articles that announce and enact a new deployment of Fanon in black studies' encounter with visual studies, Jared Sexton and Huey Copeland index Fanon's formulation in order to consider what it is to be "the thing against which all other subjects take their bearing."[5] But something is left unattended in their invocation of Fanon, in their move toward equating objecthood with "the domain of non-existence" or the interstitial space between life and death, something to be understood in its difference from and relation to what Giorgio Agamben calls naked life, something they call raw life, that moves—or more precisely cannot move—in its forgetful non-relation to that quickening, forgetive force that Agamben calls the form of life.[6]

Sexton and Copeland turn to the Fanon of *Black Skins, White Masks*, the phenomenologist of (the lived experience of) blackness, who provides for them the following epigraph:

> I came into the world imbued with the will to find a meaning in things, my spirit filled with the desire to attain to the source of the world, and then I found that I was an object in the midst of other objects.

> (*Black Skins*, 77)

[J'arrivais dans le monde, soucieux de faire lever un sens aux choses, mon âme pleine du désir d'être à l'origine du monde, et voici que je me découvrais objet au milieu d'autres objets.][7]

Fanon writes of entering the world with a melodramatic imagination, as Peter Brooks would have it—one drawn toward the occult installation of the sacred in things, gestures (certain events, as opposed to actions, of muscularity), and in the subterranean field that is, paradoxically, signaled by the very cutaneous darkness of which Fanon speaks. That darkness turns the would-be melodramatic subject not only into an object but also into a sign—the hideous blackamoor at the entrance of the cave, that world underneath the world of light that Fanon will have entered, who guards and masks "our" hidden motives and desires.[8] There's a whole other economy of skins and masks to be addressed here. However, I will defer that address in order to get at something (absent) in Sexton and Copeland. What I am after is something obscured by the fall from prospective subject to object that Fanon recites— namely, a transition from thing(s) (*choses*) to object (*objet*) that turns out to version a slippage or movement that could be said to animate the history of philosophy. What if we bracket the movement from (erstwhile) subject to object in order to investigate more adequately the change from object to thing (a change as strange as that from the possibility of intersubjectivity that attends majority to whatever is relegated to the plane or plain of the minor)? What if the thing whose meaning or value has never been found finds things, founds things? What if the thing will have founded something against the very possibility of foundation and against all anti- or post-foundational impossibilities? What if the thing sustains itself in that absence or eclipse of meaning that withholds from the thing the horrific honorific of "object"? At the same time, what if the value of that absence or excess is given to us only in and by way of a kind of failure or inadequacy—or, perhaps more precisely, by way of a history of exclusion, serial expulsion, presence's ongoing taking of leave—so that the non-attainment of meaning or ontology, of source or origin, is the only way to approach the thing in its informal (enformed/enforming, as opposed to formless), material totality? Perhaps this would be cause for black optimism or, at least, some black operations. Perhaps the thing, the black, is tantamount to another, fugitive, sublimity altogether. Some/thing escapes in or through the object's vestibule; the object vibrates against its frame like a resonator, and troubled air gets out. The air of the thing that escapes enframing is what I'm interested in—an often unattended movement that accompanies largely unthought positions and appositions. To operate out of this interest might mispresent itself as a kind of refusal of Fanon.[9] But my reading is enabled by the way Fanon's texts continually demand that we read them—again or, deeper still, not or against again, but for the first time. I wish to engage a kind of preop(tical) optimism in Fanon that is tied to the commerce between the lived experience of the black and the fact of blackness and between the thing and the object—an optimism recoverable, one might say, only by way of mistranslation, that bridged but unbridgeable gap that Heidegger explores as both distance and nearness in his discourse on "The Thing."

Michael Inwood moves quickly in his explication of Heidegger's distinction between *Ding* and *Sache*: "*Ding*, 'thing,' is distinct from *Sache*, 'thing, (subject-)matter, affair.' *Sache*, like the Latin *res*, originally denoted a legal case or a matter of concern, while *Ding* was the "court" or "assembly" before which a case was discussed."[10] In Heidegger's essay "*Das Ding*," the speed of things is a bit more deliberate, perhaps so that the distinction between things and human affairs can be maintained against an explicatory velocity that threatens to abolish the distance between, which is also to say the nearness of, the two: "[T]he Old High German word *thing* means a gathering, and specifically a gathering to deliberate on a matter under discussion, a contested matter. In consequence, the Old German words *thing* and *ding* become the names

for an affair or matter of pertinence. They denote anything that in any way bears upon men, concerns them, and that accordingly is a matter for discourse."[11] The descent from Old High German to Old German is held here and matters. The trajectory of that descent is at issue such that we are to remain concerned with the detachment and proximity of "a gathering to deliberate" and "contested matter." It might even be worthwhile to think of the gathering *as* contested matter, to linger in the break—the distance and nearness—between the thing and the case in the interest of the ones who are without interests but who are nevertheless a concern precisely because they gather, as they are gathered matter, the internally differentiated materiality of a collective head. The thing of it is, the case of blackness.

For Heidegger, the jug is an exemplary thing. The jug is a vessel; it holds something else within it. It is also "self-supporting, or independent." But "[d]oes the vessel's self-support alone define the jug as a thing?"

> The potter makes the earthen jug out of earth that he has specially chosen and prepared for it. The jug consists of that earth. By virtue of what the jug consists of, it too can stand on the earth, either immediately or through the mediation of table and bench. What exists by such producing is what stands on its own, is self-supporting. When we take the jug as a made vessel, then surely we are apprehending it—so it seems—as a thing and never as a mere object.
>
> Or do we even now still take the jug as an object? Indeed. It is, to be sure, no longer considered only an object of a mere act of representation, but in return it is an object which a process of making has set up before and against us. Its self-support seems to mark the jug as a thing. But in truth we are thinking of this self-support in terms of the making process. Self-support is what the making aims at. But even so, the self-support is still thought of in terms of objectness, even though the over-againstness of what has been put forth is no longer grounded in mere representation, in the mere putting it before our minds. But from the objectness of the object, and from the product's self-support, there is no way that leads to the thingness of the thing.
>
> (Heidegger 167)

This is to say, importantly I think, that the "jug remains a vessel whether we represent it in our minds or not" (167). (Later Heidegger says: "Man can represent, no matter how, only what has previously come to light of its own accord and has shown itself to him in the light it brought with it" [171].) Its thingliness does not inhere in its having been made or produced or represented. For Heidegger, the thingliness of the thing, the jug, is precisely that which *prompts* its making. For Plato—and the tradition of representational thinking he codifies, which includes Fanon—everything present is experienced as an object of making where "object" is understood, in what Heidegger calls its most precise expression, as "what stands forth" (rather than what stands before or opposite or against). In relation to Fanon, Kara Keeling calls upon us to think that which stands forth as project and as problem. Accordingly, I am after a kind of shadow or trace in Fanon—the moment in which phenomenology strains against its own, shall we say, reification of a certain philosophical experience, its own problematic commitment to what emerges from making, in order to get at "a meaning of things." Though decisive and disruptive in ways that remain to be thought, that strain is momentary in Fanon, momentarily displaced precisely by that "representation of what is present, in the sense of what stands forth and of what stands over against as an object" that never, according to Heidegger, "reaches to the thing *qua* thing" (168–69).

For Heidegger, the jug's being, as vessel, is momentarily understood as being-in-its emptiness, the empty space that holds, the impalpable void brought forth by the potter as

container. "And yet," Heidegger asks, "Is the jug really empty" (169)? He argues that the jug's putative emptiness is a semi-poetic misprision, that "the jug is filled with air and with everything that goes to make up the air's mixture" (169). Perhaps the jug, as thing, is better understood as filled with an always already mixed capacity for content that is not made. This is something other than either poetic emptiness or a strictly scientific fullness that understands the filling of the jug as simple displacement. As Heidegger puts it, "Considered scientifically, to fill a jug means to exchange one filling for another." He adds,

> These statements of physics are correct. By means of them, science represents something real, by which it is objectively controlled. But—is this reality the jug? No. Science always encounters only what *its* kind of representation has admitted beforehand as an object possible for science.
>
> . . . Science makes the jug-thing into a nonentity in not permitting things to be the standard for what is real.
>
> Science's knowledge, which is compelling within its own sphere, the sphere of objects, already had annihilated things as things long before the atom bomb exploded. The bomb's explosion is only the grossest of all gross confirmations of the long-since-accomplished annihilation of the thing: the confirmation that the thing as a thing remains nil. The thingness of the thing remains concealed, forgotten. The nature of the thing never comes to light, that is, it never gets a hearing. This is the meaning of our talk about the annihilation of the thing.
>
> (170)

"The Lived Experience of the Black" bears not only a lament over Fanon's own relegation to the status of object; it also contains a lament that it suppresses over the general annihilation of the thing to which transcendental phenomenology contributes insofar as it is concerned with *Sachen*, not *Dinge*, in what remains untranslatable as its direction toward the things themselves. Insofar as blackness remains the object of a complex disavowing claim in Fanon, one bound up precisely with his understanding of blackness as an impure product—as a function of a making that is not its own, an intentionality that could never have been its own—it could be said that Fanon moves within an economy of annihilation even though, at the same time, he mourns his own intentional comportment toward a hermeneutics of thingliness. Is blackness brought to light in Fanon's ambivalence? Is blackness given a hearing—or, more precisely, does blackness give itself to a hearing—in his phenomenological description (which is not but nothing other than a representation) of it? Studying the case of blackness is inseparable from the case blackness makes for itself in spite and by way of every interdiction. In any case, it will have been as if one has come down with a case of blackness.

Meanwhile, Heidegger remains with the question of the essential nature of the thing that "has never yet been able to appear" (171). He asks, What does the jug hold and how does it hold? "How does the jug's void hold" (171)? By taking and keeping what it holds but also, and most fundamentally, in a way that constitutes the unity, the belonging together, of taking and keeping, in the *outpouring* of what is held. "The holding of the vessel occurs in the giving of the outpouring. . . . We call the gathering of the two-fold holding into the outpouring, which, as being together, first constitutes the full presence of giving: the poured gift. The jug's jug-character consists in the poured gift of the pouring out. Even the empty jug retains its nature by virtue of the poured gift, even though the empty jug does not admit of a giving out" (172). What is it to speak of this outpouring, to speak of the thing, the vessel, in terms of what it gives, particularly when we take into account the horror of its being made to hold, the horror of its making that it holds or bears? This question is necessary and decisive precisely insofar as it insists upon a rough-hewn accompaniment to Heidegger's talk of gift and

consecration. Sometimes what is given is refusal. How does refusal elevate celebration? Heidegger invokes the "gush" as strong outpouring, as sacrificial flow, but perhaps what accentuates the outpouring, what makes it more than "mere filling and decanting," is a with-holding that is aligned with refusal, a canted secret (173). At any rate, in the outpouring that is the essence of the thing/vessel dwells the Heideggerian fourfold of earth, sky, divinity, and mortals that precedes everything that is present or that is represented. The fourfold, as staying and as appropriation is where thing approaches, if not becomes, event. This gather-ing, this event of gathering, is, for Heidegger, what is denoted in the Old High German word "thing." By way of Meister Eckhart, Heidegger asserts that "*Thing* is . . . the cautious and abstemious name for something that is at all." He adds:

> Because the word *thing* as used in Western metaphysics denotes that which is at all and is something in some way or other, the meaning of the name "thing" varies with the interpretation of that which is—of entities. Kant talks about things in the same way as Meister Eckhart and means by this term something that is. But for Kant, that which is becomes the object of a representing that runs its course in the self-consciousness of the human ego. The thing-in-itself means for Kant: the object-in-itself. To Kant, the character of the "in-itself" signifies that the object is an object in itself without reference to the human act of repre-senting it, that is, without the opposing "ob-" by which it is first of all put before the representing act. "Thing-in-itself," thought in a rigorously Kantian way, means an object that is no object for us, because it is supposed to stand, stay put, without a possible before: for the human representational act that encounters it.
> (176–77)

Meanwhile, in contradistinction to Kant, Heidegger thinks being neither as idea nor as posi-tion/objectness (the transcendental character of being posed) but as thing. He might be best understood as speaking out of a clearing, or a flaw, that also constitutes a step back or away from the kind of thinking that produces worldviews or, at least, that particular worldview that accompanies what, for lack of a better turn, might be called intersubjection. Fanon offers, by way of retrospection, a reversal of that step back or away. In briefly narrating the history of his own becoming-object, the trajectory of his own being-positioned in and by representational thinking, Fanon fatefully participates in that thinking and fails to depart from the "sphere of mere attitudes" (Heidegger 181). At the same time, Fanon, and the experience that he both carries and analyzes, places the Heideggerian distinction between being (thing) and *Dasein*—the being to whom understandings of being are given; the not, but nothing other than, human being—in a kind of jeopardy that was already implicit, however much it is held within an interplay between being overlooked and being overseen.

So I'm interested in how the ones who inhabit the nearness and distance between *Dasein* and things (which is off to the side of what lies between subjects and objects), the ones who are attained or accumulated unto death even as they are always escaping the Hegelian positioning of the bondsman, are perhaps best understood as the extra-ontological, extra-political constant—a destructive, healing agent; a stolen, transplanted organ always eliciting rejec-tion; a salve whose soothing lies in the abrasive penetration of the merely typical; an ensemble always operating in excess of that ancient juridical formulation of the thing (*Ding*), to which Kant subscribes, as that to which nothing can be imputed, the impure, degraded, manufac-tured (in) human who moves only in response to inclination, whose reflexes lose the name of action. At the same time, this dangerous supplement, as the fact out of which everything else emerges, is constitutive. It seems to me that this special ontic-ontological fugitivity of/in the

slave is what is revealed as the necessarily unaccounted for in Fanon. So that in contradistinction to Fanon's protest, the problem of the inadequacy of any ontology to blackness, to that mode of being for which escape or apposition and not the objectifying encounter with otherness is the prime modality, must be understood in its relation to the inadequacy of calculation to being in general. Moreover, the brutal history of criminalization in public policy, and at the intersection of biological, psychological, and sociological discourse, ought not obscure the already existing ontic-ontological criminality of/as blackness. Rather, blackness needs to be understood as operating at the nexus of the social and the ontological, the historical and the essential. Indeed, as the ontological is moving within the corrosive increase that the ontic instantiates, it must be understood that what is now meant by ontological requires special elucidation. What is inadequate to blackness is already given ontologies. The lived experienced of blackness is, among other things, a constant demand for an ontology of disorder, an ontology of dehiscence, a para-ontology whose comportment will have been (toward) the ontic or existential field of things and events. That ontology will have had to have operated as a general critique of calculation even as it gathers diaspora as an open set—or as an openness disruptive of the very idea of set—of accumulative and unaccumulable differences, differings, departures without origin, leavings that continually defy the natal occasion in general even as they constantly bespeak the previous. This is a Nathaniel Mackey formulation whose full implications will have never been fully explorable.[12] What Fanon's pathontological refusal of blackness leaves unclaimed is an irremediable homelessness common to the colonized, the enslaved, and the enclosed. This is to say that what is claimed in the name of blackness is an undercommon disorder that has always been there, that is retrospectively and retroactively *located* there, that is embraced by the ones who stay there while living somewhere else. Some folks relish being a problem. As Amiri Baraka and Nikhil Pal Singh (almost) say, "Black(ness) is a country" (and a sex) (that is not one).[13] Stolen life disorders positive value just as surely as it is not equivalent to social death or absolute dereliction.

So if we cannot simply give an account of things that, in the very fugitivity and impossibility that is the essence of their existence, resist accounting, how do we speak of the lived experience of the black? What limits are placed on such speaking when it comes from the position of the black, but also what constraints are placed on the very concept of lived experience, particularly in its relation to the black when black social life is interdicted? Note that the interdiction exists not only as a function of what might be broadly understood as policy but also as a function of an epistemological consensus broad enough to include Fanon, on the one hand, and Daniel Patrick Moynihan, on the other—encompassing formulations that might be said not only to characterize but also to initiate and continually re-initialize the philosophy of the human sciences. In other words, the notion that there is no black social life is part of a set of variations on a theme that include assertions of the irreducible pathology of black social life and the implication that (non-pathological) social life is what emerges by way of the exclusion of the black or, more precisely, of blackness. But what are we to make of the pathological here? What are the implications of a social life that, on the one hand, *is not what it is* and, on the other hand, is irreducible to what it is used for? This discordant echo of one of Theodor W. Adorno's most infamous assertions about jazz implies that black social life reconstitutes the music that is its phonographic.[14] That music, which Miles Davis calls "social music," to which Adorno and Fanon gave only severe and partial hearing, is of interdicted black social life operating on frequencies that are disavowed—though they are also amplified—in the interplay of sociopathological and phenomenological description. How can we fathom a social life that tends toward death, that enacts a kind of being-toward-death, and which, because of such tendency and enactment, maintains a terribly beautiful vitality? Deeper still, what are we to make of the fact of a sociality that emerges when lived experience is distinguished from fact, in the fact of life that is implied in the very phenomenological

gesture/analysis within which Fanon asserts black social life as, in all but the most minor ways, impossible? How is it that the off harmony of life, sociality, and blackness is the condition of possibility of the claim that there is no black social life? Does black life, in its irreducible and impossible sociality and precisely in what might be understood as its refusal of the status of social life that is refused it, constitute a fundamental danger—an excluded but immanent disruption—to social life? What will it have meant to embrace this matrix of im/possibility, to have spoken of and out of this suspension? What would it mean to dwell on or in minor social life? This set of questions is imposed upon us by Fanon. At the same time, and in a way that is articulated most clearly and famously by W. E. B. Du Bois, this set of questions is the position, which is also to say the problem, of blackness.

2

Now I want to place the problem of blackness, and the question of dwelling on and in minor social life in relation to the work of art, to the question of the artwork's thingliness, its madness, its lateness. I'd like to bring the set of questions that is black social life into relief by way of, and by passing through, the notion of chromatic saturation and the illicit commerce it bears between the language of music and the language of vision. I'll do so by turning to an audiovisual ensemble comprising Ad Reinhardt and Cecil Taylor, Albert Ammons and Piet Mondrian. Something is unhinged in this set that might recalibrate in multiple ways our sense of the black/white encounter, particularly insofar as we acknowledge certain possibilities that emerge in and from impossible black social life when the city is about to be born and when minor conflict—its outlaw ontology, and its interdicted, criminal life—tends toward death but, escaping all ends, moves in relation to thrown ends, to a vast, stupendous range of throwing ends. I'll argue that Mondrian is deregulated by the urban underground he'd been dreaming of; that his great, final picture, *Victory Boogie Woogie*, is all black, is all of what had been absorbed in black, is the explication of a dissonant, chromatic saturation, the inhabitation of a break or border, the disruption embedded in the grid's boundaries. I want to amplify (Ammons, father of the jug, in Mondrian and) Taylor in Reinhardt, where Taylor is severely threatened with submergence in Reinhardt's intractable misunderstanding of what is done through Reinhardt, by forces Reinhardt can neither understand nor assimilate due to his attempt to encompass what pierces and absorbs him. I'll try to illuminate Taylor's attempt to open things up in exchange with Reinhardt: embodying sound in a discourse of sight, making sound matter like an irruptive thing, enacting the victory of refusing to arrive, saying—Here we are, never having got here, dancing an insistent after effect evading each and every fatal occasion, each minor occasion that is not one.

(There are other resonances that I know I won't get to: broken speeches of fugitive ontologues recorded in the texture of a black line; a boundary diffused into epiphenomenal swatches, later to become what seems to be unrecorded but showing up sounding everywhere; black differences, not only the collective heads in Reinhardt's unacknowledged black social thingliness, but also an unstable black cube named Gene Smith, mugging rupped-up proprieties like an other Tony Smith [Saginaw, Michigan] blowing up Michael Fried from way downtown, way outside. [I have gone off privately in public, in Fred Oakley's club, the *Neue Plastik*, just outside of Fordyce, Arkansas, in order to talk to somebody. Gone to curve angles. Bend and drop these notes right where you lost them, to get at what remains—unattainable, unrepresentable—of the thing. My flaw.])

In *Art as Art: The Selected Writings of Ad Reinhardt*, there is a text called "Black as Symbol and Concept."[15] Barbara Rose, the volume's editor, tells us that it's a transcript of Reinhardt's

contribution to a discussion involving Taylor and five other artists based in New York or Toronto: Aldo Tambellini, Michael Snow, Arnold Rockman, Stu Broomer, and Harvey Cowan. I am particularly interested in the encounter between Taylor and Reinhardt that Rose's transcription erases. That encounter is, I think, part of a far larger structure of impossible erasures (of the impossible). This is to say that there seem to be some fundamental incommensurabilities that animate the encounter. One is black and the other white, which means not just different experiences that differently color their thinking about color but also Reinhardt's palpable inability to take Taylor seriously, a handicap that more often than not still structures interracial intellectual relations. The more important one, at least for my purposes, has to do with the fact that one is a musician and the other a painter, and this means they speak in those different, seemingly incommensurable languages about that for which the term "chromatic saturation" is only a beckoning gesture. Unfortunately, as we'll see, Reinhardt reads blackness at sight, as held merely within the play of absence and presence. He is blind to the articulated combination of absence and presence in black that is in his face, as his work, his own production, as well as in the particular form of Taylor. Mad, in a self-imposed absence of (his own) work, Reinhardt gets read a lecture he must never have forgotten, though, alas, he was only to survive so short a time that it's unclear how or whether it came to affect his work.

On August 16, 1967, with the cooperation of Bell Telephone Company and the Canadian Broadcasting Corporation, *Arts/Canada* magazine organized this "simultaneous conversation," devoting a full issue to this discourse on "[b]lack as a special concept, symbol, paint quality; the social-political implications of the black; black as stasis, negation, nothingness and black as change, impermanence and potentiality."[16] Reinhardt initiates things by saying black is interesting "not as a colour but as a non-colour and as the absence of colour." He adds, "I'd like then to talk about black in art—monochrome, monotone, and the art of painting versus the art of culture" ("Black," 3). In the notion of blackness as absolute dereliction, as absence of color and antithetical to admixture, Reinhardt moves on a parallel track to Fanon or, at least, to a certain reading of Fanon. He proceeds by way of a bad or, at least, meaningless example: "Here is a quotation from [Japanese landscape painter Katsushika] Hokusai: 'there is a black which is old and a black which is fresh. Lustrous black and dull black, black in sunlight and black in shadow. For the old black one must use an admixture of blue, for the dull black an admixture of white, for the lustrous black, gum must be added. Black in sunlight must have grey reflections.' I want to read that because that doesn't have any meaning for us" (3). One wants to consider the relation between what Reinhardt understands to be meaningless—a small treatise on the relation between impurity and internal difference in the case of the color black—and what Fanon understands as rendering ontological explanation criminal. What does the color black do to the theory of color (as the manifestation of absence turned to the excessive, invaginative more-than-fullness of impurity)? What does the black or blackness do to ontological explanation (as fugal, centrifugal, fugitive ontological, and epistemological disruption)? For Reinhardt, the multiplicity of symbolic meanings that have been attached to the color black—sinfulness, evil, femininity, maternity, formlessness, and the "yearning for whiteness in the West that counters and accompanies these meanings"—are and must be detachable from the absence (of difference) that defines and is internal to the color black (3). This detachment is in the interest of "the negativeness of black" (3), which interests Reinhardt and which can, again, be understood in relation to something Fanon both desires and desires to appose.

A bit later in the conversation, Taylor intervenes.

> I think for my first statement I would like to say that the experience is two-fold and later, I think you'll see how the two really merge as one experience.

"Whether its bare pale light, whitened eyes inside a lion's belly, cancelled by justice, my wish to be a hued mystic myopic region if you will, least shadow at our discretion, to disappear, or as sovereign, albeit intuitive, sense my charity, to dip and grind, fair-haired, swathed, edged to the bottom each and every second, minute, month: existence riding a cloud of diminutive will, cautioned to waiting eye in step to wild, unceasing energy, growth equaling spirit, the knowing, of black dignity."

Silence may be infinite or a beginning, an end, white noise, purity, classical ballet; the question of black, its inability to reflect yet to absorb, I think these are some of the complexes that we will have to get into.

(4)

Taylor's musico-poetic intervention, which quotation marks mark as an intervention within an intervention, is a re-inaugural rupture. Taylor interrupts himself and the conversation he joins by raising the question of black dignity in a discourse on black art. He moves differently to Reinhardt, whose opening of the discussion is followed and carried forth in a kind of uninterrupted seriality by other participants in the conversation—Arnold Rockman, Michael Snow, Harvey Cowan, and Stu Broomer—before Taylor leaps, or breaks, in. Reinhardt will brook no interruption; this is confirmed in Rose's reproduction of "his" text. In interrupting and/or starting over, Taylor speaks, at the same time, in a kind of counterpoint to or with Reinhardt. Moreover, his speaking is, immediately, of an experience of black/blackness that places his intervention in a Fanonian phenomenological mode. To speak of experience and, later, of existence, is to move counter to Reinhardt's overly stringent essentialism. Deeper still, Taylor speaks by way of hue, mysticism, and myopia, all of which show up for Reinhardt as derangements. ("There is something wrong, irresponsible and mindless about colour," he says, "something impossible to control. Control and rationality are part of any morality" [6].) Taylor moves against Reinhardt (in his best Kantian/Greenbergian aesthetico-ethical mode) in a set of lyric gestures charting a trajectory to "spirit, the knowing, of black dignity" (4). In this sense he speaks not only out of but also of the lived experience of the black. This is to say that Taylor moves, by way of but also through Fanon, in the wake of an experience, an aesthetic sociality, that Fanon never can fully embrace insofar as he never really comes to believe in it, even though it is the object, for Fanon, of an ambivalent political desire and a thing (of darkness) he cannot acknowledge as his own. In other words, Taylor speaks of and out of the possibilities embedded in a social life from which Fanon speaks and of which he speaks but primarily as negation and impossibility. This simultaneous conversation becomes, by way of a kind of ghostly transversality, a dialogue between Taylor and Fanon in which Reinhardt serves as the medium.

Other remote participants might later emerge, in addition to the tentative, minimal address to the things Taylor says we'll have to get into. Taylor and Fanon are the underground of this conversation, all up in wherever black/ness and color hang. It remains for Taylor to make his claim on black aesthetico-social life, on the "spirit, the knowing, of black dignity," more explicit in his next intervention:

I think Richard Wright wrote a book . . . called *Black Power*. Unfortunately, newspapers must sell, and I think they give a meaning of the moment to something which has long been in existence. The black artists have been in existence. Black—the black way of life—is an integral part of the American experience—the dance, for instance, the slop, Lindy hop, applejack, Watusi. Or the language, the spirit of the black in the language—"hip," "Daddy," "crazy," and "what's happening," "dig." These are manifestations of black energy, of

black power, if you will. Politically speaking, I think the most dynamic force in American political life since the mid-1950s has been the black surge for equal representation, equal opportunities and it's becoming an active ingredient in American life.

(6)

It's a kind of Ralph Ellison formulation that might seem more characteristic of Wynton Marsalis than Taylor but for the fact that it waits upon a Fanonian understanding of mixture or impurity as disruption even as it waits for Fanon to get to the related nonexcluded, nonexclusive understanding of mixture, of color, as constitutive of blackness and of blackness or black as a constitutive social, political, and aesthetic power. It's a kind of Stokeley Carmichael formulation.

Meanwhile, between Taylor's formulation and Reinhardt's next intervention, Rockman offers a kind of regulative mediation that displaces Taylor's invocation of the priority and inevitability of another mixture that black instantiates and is by calling upon a certain discourse or structure of (black) feeling. He refers to the poem that erupts out of Taylor's first intervention as "a very moving experience" (6). He also invokes an earlier point in the discussion when Snow referred to his father's blindness. Blindness, according to Rockman, is an internal blackness that is opposed to the exterior or inessential blackness of which Taylor speaks in his invocation of black life, energy, and power. He adds, in a Fanonian vein, that "the whole negro bit is a creation of the white world" (7). This moment is important in that it mediates between Taylor and Reinhardt, allows Reinhardt to avoid Taylor's intervention, his invocation of the social even as it places Taylor between Rockman's feelings and Reinhardt's antisocial frigidity, both of which emerge against a black background. Reinhardt follows this apparent escape route, which moves by way of the assumed inessentiality of black life, in his objection to the introduction of blindness as sentimental. For Reinhardt, issues of blindness, space, and sexuality move away from what he calls "the highest possible discussion," which would be on "an aesthetic level" (7). Taylor's invocation of a necessarily social aesthetic, a black aesthetic and sociality whose essence is a politics of impure or impurifying facticity, is by-passed. Reinhardt is disturbed by Taylor's intervention. Though he never really addresses it, he is clearly unhappy with its power to make the discussion "go off into too many subjects" (7). Reinhardt adds:

> Well, of course, we have enough mixed media here. I just want to again stress the idea of black as intellectuality and conventionality. There is an expression "the dark of absolute freedom" and an idea of formality. There's something about darkness or blackness that has something to do with something that I don't want to pin down. But it's aesthetic. And it has *not* to do with outer space or the colour of skin or the colour of matter. . . . And the exploitation of black as a kind of quality, as a material quality, is really objectionable. Again I'm talking on another level, on an intellectual level.
>
> (7)

One can feel Taylor fuming from an underground to which Reinhardt would have relegated him without mentioning him in his Friedian rejection of mixture-as-theatricality. And yet Taylor's occupation of this underground, precisely in the richness of its black aesthetic and intellectual content, is inhabited by way of Taylor's refusal and not his being rendered or regulated. Rockman, duly chastened by the dismissal of his sentimentalism, meekly asks Reinhardt to explain his objection to glossy black. Interestingly, Reinhardt dislikes glossy black because it reflects and because it is "unstable" and "surreal" (7). The reflective

quality of the color black—as well as the capacity of the black to reflect—have, of course, been introduced by Taylor. Only now, however, can these issues be addressed by Reinhardt on his own high level. Glossy black disturbs in its reflective quality. "It reflects all the necessarily social activity that's going on in a room" (7). But this is also to say that glossy black's reflection of the irreducibly social is problematic precisely because it disrupts the solipsism of genuine intellectual reflection that painting is supposed to provide. Glossy black denies the individual viewer's absorption into a painting that will have then begun to function also as a mirror, but a mirror that serves to detach the viewer from the social and that characterizes that detachment as the very essence of intellectual and aesthetic experience. Reinhardt wants what he refers to as "less distractions and less intrusions tha[n] colour or light or other things might make" (8). Taylor, having spoken of and from blackness as aesthetic sociality, of and from the eternal, internal, and subterranean alien/nation of black things in their unregulatable chromaticism, must have been fuming.

The discussion moves again along the lines and laws that Reinhardt lays down. Objection to Reinhardt is held within an old discourse that combines primitivism, futurism, and blackness as the disavowal of physicality. I'm speaking of Tambellini's invocation of the Soviet cosmonaut who, upon experiencing outer space, says, "Before me—blackness, an inky-black sky studded with stars that glowed but did not twinkle; they seemed immobilized." Tambellini continues:

> Here again is a primitive man, a caveman, but he's the caveman of the space era. I see him as the most important man. It's immaterial who he is; it's even immaterial what his name is. But that's what our children are going to be, that's what the future is going to be, and this is what the extension of man has got to. He's got to get rid of this whole concept of black pictures or of black anything as a physical object. He's got to realize that he is black right now.
>
> (12)

Against the grain of Tambellini's enthusiasm for whatever transcends the material, out of his own particular and exclusionary intellectualism, and taking up the question of sentiment or emotion again, Reinhardt responds: "The reason for the involvement of darkness and blackness is, as I've said, an aesthetic-intellectual one, certainly among artists. And it's because of its non-colour. Colour is always trapped in some kind of physical activity or assertiveness of its own; and colour has to do with life. In that sense it may be vulgarity or folk art or something like that. But you'd better make sure what you mean by emotion, that's what I would say" (12–13). And now the encounter between Taylor and Reinhardt can really begin, interrupted only by a couple of brief but telling interjections by Tambellini (though it should be noted that for Reinhardt the encounter brings into play other ghostly eminences for whom Taylor is a medium: Marcel Duchamp, whose theatrical excess, which Taylor might be said to embody, is an object of Reinhardt's particular anti-theatrical prejudice; and Piet Mondrian, whose dramatic politics, which Taylor might be said to embody, Reinhardt mistakes for asceticism).[17]

Taylor:	Would you give us a definition?
Reinhardt:	Well, Clive Bell made it clear that there was an aesthetic emotion that was *not* any other kind of emotion. And probably you could only define that negatively. Art is always made by craftsmen—it's never a spontaneous expression. Artists always come from artists and art forms come from art forms. At any rate, art is involved in a certain kind of perfection.

	Expression is an impossible word. If you want to use it I think you have to explain it further.
Taylor:	In pursuit of that perfection, once it is attained, what then? What is your reaction to that perfection?
Reinhardt:	Well, I suppose there's a general reaction. I suppose in the visual arts good works usually end up in museums where they can be protected.
Taylor:	Don't you understand that every culture has its own mores, its way of doing things, and that's why different art forms exist? People paint differently, people sing differently. What else does it express but my way of living—the way I eat, the way I walk, the way I talk, the way I think, what I have access to?
Reinhardt:	Cultures in time begin to represent what artists did. It isn't the other way around.
Taylor:	Don't you understand that what artists do depends on the time they have to do it in, and the time they have to do it in depends upon the amount of economic sustenance which allows them to do it? You have to come down to the reality. Artists just don't work, you know, just like that—the kind of work, the nature of their involvement is not separate from the nature of their existence, and you have to come down to the nature of their existence. For instance, if they decide to go into the realm of fine art, there are certain prerequisites that they must have.
Tambellini:	This guy floating in space has more to do with the reality that I'm living in than some idiotic place with walls and pictures in it. This man made one of the most poetic statements I've heard in my life. And furthermore I recognize the act he performs out there; he's destroying every possible square idea I've ever known, every possible notion that man can any longer be up and down. In the tradition of Mondrian you have the floor and the top; the tradition of Egyptian and western man is in the horizontal and the vertical. I don't work with that concept. It is the concept of nature. But he's telling me what's going on there. When the black man breaks out of his tradition, he's telling me what he's feeling, he's telling me what western man has done. He's telling me about segregation, he's telling me directly "see what your museums are, preservation of your own culture," "see what the radio is, the propaganda for your own culture," "see what this newspaper is, the propagation of your own . . ." and this space guy says to me, "see what the universe is up there, something which has no ups and downs," "see what space is, total darkness." He's telling me something I have to deal with. I have to create some kind of images.

<div align="right">("Black," 13–14)</div>

The distinction between what Tambellini has and doesn't have to deal with, along with Tambellini's off translation of Taylor's formulations, given in a manner that is foreshadowed by Rockman's, serve to sanction Reinhardt's dismissal, and provide another context for the relegation, of Taylor's appeal. It is, after all, Reinhardt who makes judgments, who speaks with a kind of juridical authority. But Reinhardt is not trying to hear the case Taylor makes for (another understanding of) blackness. Reinhardt continues, in response now to Tambellini (and setting up Taylor's final disruption, an invocation to something like a phenomenological description of the artist's routine):

Reinhardt:	This hasn't anything to do with your day-to-day problems.
Taylor:	Day-to-day problems? What do you mean by day-to-day problems?

Reinhardt: The artist has a day-to-day routine.

Taylor: What is that routine specifically?

Reinhardt: It is boring, drudging . . .

Taylor: My work gives me pleasure. But the minute I walk outside there is enough that is evil and ugly and full of that which I call drudgery and boredom for me not to want it in my work and around me. Poverty is not a very satisfying thing.

Aldo said it very clearly, western art is involved and has been involved with one perspective, one idea, one representation of one social-racial entity and aesthetic; and I'm saying that I must be aware of that, in what that has meant to black men or to the Indians. I have to be aware of the social dynamics of my society in order to function. I don't only have a responsibility to myself, I have a responsibility to my community.

Reinhardt: As a human being, not as an artist.

Taylor: Now look, you are not the one, you are positively not the one to talk about human beings, since you rule out the human element in your art. That kind of dichotomy is very common in the west, and it has resulted in paranoia.

And so, therefore, I'm involved in making people aware of the black aesthetic. That fine art which you talk about is an exclusive art, and it excludes not according to ability, but according to wealth.

Tambellini: I don't even go to the god damn museums any more. I get the creeps, god damn it, I get depressed for months—it reminds me what the fucking black man must feel when he walks in the damn upper class of this society. I see the god damn slums in this country. I know how it feels to be black and walking the streets of a white society and as a white man, I feel what this damn ruling class is doing to anybody creative. They are set up there to destroy, because I can not go along with this intellectualization of protecting this particular class, this particular structure.

Reinhardt: There was an achievement in separating Fine Art from other art.

Taylor: The Russian ballet masters took the peasants and made them fine dancers; but the spirit of the ballet comes from the peasant.

Reinhardt: Tambellini suggested that we may abandon the historical approach to art, and get into a kind of simultaneity in which you have all twenty-five thousand years of art and you have to think about it. Quoting an astronaut isn't meaningful.

Tambellini: To me it's essential and meaningful.

Reinhardt: Not you as an artist, but maybe as a human being. It is certainly interesting to me as a human being.

Taylor: It is interesting to me as a musician, because it has to do with space, and space automatically implies time. Like I'm involved with rhythm, and rhythm is like the marginal division of time. Of course Reinhardt visualizes blackness as some kind of technical problem. I visualize it as the quality that shapes my life, in terms of the quality of the acceptance that my work gets or does not get based on the fact that it is from the Afro-American community.

Reinhardt: But your art should be free from the community.

("Black," 14–16)

As their encounter and their general contribution to the discussion concludes, it becomes clear that Reinhardt operates within a strict antipathy to thingliness—which Reinhardt

mistakes, perhaps after Michael Fried, for objecthood—in or as artworks, which, in turn, requires the freedom (which, for Reinhardt, is associated in its absoluteness with darkness and an idea of formality) of art and the artist from the community, from politico-theatricality, from the city or *polis* as world stage.[18] That antipathy is anticipated in the art criticism of Clement Greenberg and, even more stringently, in that of Greenberg's protégé, Fried, both of whom move within what Yve-Alain Bois, in an essay on Reinhardt, describes as "a clear demarcation between pictoriality and objecthood" ("Limit," 15). Reinhardt believes intensely in the legitimacy of the demarcations between art/ists and community, pictoriality and (objecthood-as-)thingliness, but those demarcations are irreparably blurred by Reinhardt's most important work, his celebrated series of black paintings. This blurring is a source of anxiety for Reinhardt, whose allergy to mixture is an allergy to thingliness. That intolerance of the blurring of art and life, in the words of Marcel Duchamp and Allen Kaprow, is famously formulated by Fried as a disavowal of theater, which is associated with the thingly in art, with what Bois intimates that Greenberg might have called "the passage of the picture into the realm of things" ("Limit," 16). Painting becomes something like a new kind of sculpture, according to Greenberg, and Bois describes this logic as that which led Frank Stella's black paintings, and presumably Reinhardt's, to look *almost* like objects. Reinhardt's formulations on black are meant to stave off the slide into thingliness, the complete fall into the world of things. He wants his work to represent (which is to say to present themselves as)—as Mondrian's paintings do, according to Greenberg, and in spite of their overallness, their sculpturality—"the scene of forms rather than . . . one single, indivisible piece of texture."[19] To insist upon the distinction between the canvas as scene and the canvas as thing is to detach oneself from the scene as much as it is also to represent the scene. It is to establish something like a freedom *from the community* in the most highly determined, regulative, *legal* sense of that word, in the sharpest sense of its constituting a field in which the human and the (disorderly) thing are precisely, pathologically, theatrically indistinct. Let's call this community the black community, the community that is defined by a certain history of blackness, a history of privation (as Taylor points out) and plenitude, pain and (as Taylor points out) pleasure. It is from and as a sensual commune, from and as an irruptive advent, at once focused and arrayed against the political aesthetics of enclosed common sense, that Taylor's music—I'm thinking in particular of a recent work titled *All the Notes*—emerges.

Interestingly, Mondrian is invoked by both Greenberg and Reinhardt in the interest of, on the one hand, establishing the difference between easel painting's representational essence and minimalist, literalist, thingliness and, on the other hand, maintaining the separation of art and life that Duchamp and his minimalist descendants desired. At the same time, there is a syntactic, compositional "equivalence"—a social life of forms within the painting—that animates Mondrian's work. It is not merely an accident that this social life—of which Mondrian writes a great deal in his extended meditation on neo-plastic art production's relation to the city, to the bar, to jazz—is spoken of in theatrical terms as "the scene of forms" by Greenberg, who recognizes (or at least reveals) more clearly than Reinhardt or Fried an *irreducible* theatricality.[20]

That theatricality or social life has a politics as well, which Taylor constantly recognizes and invokes, but to deaf ears. And it's important to note that deafness places the severest limitations on the visual imagination. Reinhardt cannot, or refuses to, hear, if you will, a certain chromatic saturation that inhabits black as that color's internal, social life. The many colors that are absorbed and reflected in the color black, and in and as black social life, on the other hand, flow with an extraordinary theatrical intensity in *Victory Boogie Woogie*. It is as if they were poured out of (the father of) the jug, which is and is more than its "absence;" as if Ammons's rhythms inhabit and animate the painting, thereby challenging formulations regarding either its emptiness or its flatness, and vivify it as a scene in the form of tactile and

visual translation and rearticulation of sound. But this is not all. The intensity of Mondrian's last work, as Harry Cooper argues, constitutes something like a critique of neo-plasticism's insistence on the dualistic equivalence—which is necessarily a reduction—of differences within the paintings by way of the unleashing of a certain occult instability, to which I shall return.[21] Such mixture, in which painting becomes phonotopography, would seem profoundly against the grain of Reinhardt, who claims Mondrian as an ancestor. However, the texture and landscape of black social life, of black social music, are given in *Victory Boogie Woogie*, making visible and audible a difference that exists not so much between Reinhardt's and Mondrian's paintings but between the way they deal with what might be understood as the social chromaticism of the color black and of blackness-in-color in their paintings. Taylor is more attuned, in the end, to what he might call the "sliding quadrants" that demarcate Mondrian's late New York rhythms, rhythms that don't blur so much as restage the encounter between art and life.[22] *Victory Boogie Woogie* is a scene of forms as well as a thing within the black community of things.

This becomes clearer by way of Bois, who concludes his essay "Piet Mondrian, *New York City*" in this way: "When . . . asked . . . why he kept repainting *Victory Boogie Woogie* instead of making several paintings of the different solutions that had been superimposed on this canvas, Mondrian answered, 'I don't want pictures. I just want to find things out.' "[23] Cooper thinks the recollection of this exchange comes through the filter of the post-Pollock mythology of the action painter, as Bois calls it; but no one is more vigilant regarding that mythology than Bois, who places Reinhardt against it, and Cooper himself takes note of Mondrian's increasing obsession with revision, which we might think not only as repetition but also as a kind of pianistic repercussion (Bois, "Piet Mondrian," 134). If action-painter-style expression is understood as a sort of choreographically induced interior voyage, this seems not at all what Mondrian had in mind. The question, of course, concerns finding things out precisely in their relation to obsessional revision, and perhaps Mondrian knew what Taylor knew and Reinhardt did not: that repercussive revision and a certain inventive discovery are fundamental protocols of black socio-aesthetic activity. This is a question concerning sound and movement or, more precisely, a kind of audio-theatricality that is the essence of political consciousness.

And Mondrian's paintings are political if Bois is correct when he says that "an 'optical' interpretation of Mondrian, conceived in the assurance of immediate perception, cannot account for his New York paintings" ("Piet Mondrian," 182). This is to say that the political in Mondrian is initialized as an excess, though not an erasure, of the optical, as an interplay of the sensual and social ensembles in the constant cutting and augmentation of their fullness. Cooper moves us more firmly in the direction of a mediated, more than visual perception and interpretation of Mondrian's work not only by attending carefully to the structural trace of boogie-woogie piano in Mondrian's improvisatory, revisionary compositional practice but also by offering a brief history of the color black's career in Mondrian's late phase. He notes, along with Bois, that the black lines that instantiated dualistic equilibrium by "bounding color planes" proliferate and are made glossier, more reflective before Mondrian, in exile and at the unfinished end of a twenty-year project, under the influence of boogie-woogie, "burst[s] the pod of painting and disseminated its elements across a broken border" (Cooper, "Mondrian," 136, 142). This is to say not only that the border is crossed, that something moves through it; it is also to say, or at least to imply, that the border is (already) broken, that what it had contained within itself pours out. Any accounting of what the limit contains must also be an accounting of the contents of the limit. This is a matter of touch—of painterly and pianistic feel. Color pouring from as well as across the border records and reverses the sound, the social music, which had been poured into the painting. The rhythmic story of left hand, right hand, explodes into every note that can and can't be played, in every possible shade and shading of that note. Implicature erupts from the primary and the tonic as if the

painting were one of Taylor's cluster bombs, his detonated rainbows, his inside figures played outside. Mondrian all but discovers certain ochres and blues in his strange, estranged home-coming, in appositional placements of the primary that allow for the secondary, for the minor that had been repressed, to emerge. He could be said to interpret, from the standpoint of a radical political-aesthetic, the rhythmic images of his country. He joins Ammons in joining what we will see Fanon come to recognize as "that fluctuating movement which [the] people are just giving shape to, and which, as soon as it has started, will be the signal for everything to be called into question."[24] That country, that broken body, is black. That crossed, broken border is also a broken vessel. Crossing borders and oceans in serial exile, crossing over into the dead zone, involves staging the appositional encounter, which has always already started, of blackness and color for Mondrian. The native returns to places he's never been to get ready for one last trip. We're always crossing this frontier we carry. The smuggler who crosses is the border, its contents pouring out. Invasion out from the outside continues. Black explodes violently, victoriously in Mondrian's last painting, his careful, painstaking ode to proliferation, impurity, and incompleteness. It is the victory of the unfinished, the lonesome fugitive; the victory of finding things out, of questioning; the victorious rhythm of the broken system. Black(ness), which is to say black social life, is an undiscovered country.

Du Bois might say that it is the evident incalculability in human action that infuses *Victory Boogie Woogie*. He might claim, more pointedly, that Mondrian brings to certain fields of atten-tion and inattention the evident incalculability of black life that corresponds to black life's evident rhythms in spite of how those rhythms might seem to lend themselves to the easy arith-metic of so many births and deaths or so many heavy beats to the bar.[25] In fact, it is the evidently incalculable rhythm of the life of things that Mondrian had been finding out in New York City, that he had been after for a long time if his meditations on the relationship between jazz and neo-plastic are any indication. In the end, what remains is Mondrian's insistence on his late paintings as a mode of "finding things out," as things bodying forth a self-activated, auto-excessive inquiry into the possibility of a politics of the melodramatic social imagination. In Mondrian's city, things making and finding one another out actively disrupt the grids by which activities would be known, organized, and apportioned. Mondrian's late paintings show the true colors with which blackness is infused. The paintings are an open, textured, mobile, animated, content-laden border, a sculptural, audio-theatrical outskirts, whose chromatic saturation indi-cate that Mondrian's late, exilic, catastrophic work was given over to a case of blackness.

Like the more than mindless, more than visceral, events and things whose meaning is unattained even as their political force is ascertained, for Fanon, chromatic saturation has repercussions:

> If we study the repercussions of the awakening of national consciousness in the domains of ceramics and pottery-making, the same observations [regarding the artist's forging of an invitation to participate in organized movement] may be drawn. Jugs, jars, and trays are modified, at first imperceptibly, then almost savagely. The colors, of which formerly there were but few and which obeyed the traditional rules of harmony, increase in number and are influenced by the repercussion of the rising revolution. Certain ochres and blues, which seemed forbidden to all eternity in a given cultural area, now assert themselves without giving rise to scandal.
>
> (*Wretched*, 242)

Fanon speaks of repercussions that we might take to be the rhythmic accompaniment to this new harmonic disruption of the traditional, of the very idea of the authentic and any simple recourse to it. Yet repercussion implies a repetition, however different and differentiating,

of a beat that, when it is understood as resistance in the broadest sense, lies radically and anoriginally before us. Moreover, while the repercussive chromaticism of which Fanon speaks is no simple analogue to the primary rhythms of Mondrian in New York, one cannot help but hear in his paintings a striving for what is underground and anoriginal in the city, for what is held in and escapes the city's limits, the interiority of its black border or bottom, the bottom in which its unwelcome bo(a)rders dwell politically as well as poetically.

Fanon shares Du Bois's Kantian ambivalence toward the tumultuous derangements that emerge from imagination and that are inseparable from the imaginative constitution of reason and reality. The ambiguity is shown in what elsewhere appears as a kind of valorization of the depths that are held and articulated in the surface of actual events, as the call for intellectuals to linger in the necessarily rhythmic and muscular music of the "*lieu de déséquilibre occulte*" (which Constance Farrington translates as "zone of occult instability" and Richard Philcox translates as "hidden fluctuation") wherein "*son âme et que s'illuminent sa perception et sa respiration*" (Farrington: "our lives are transfused with light;" Philcox: "their perception and respiration [is] transfigured.")[26] Note in the choice of translations a return to one of the problems with which we started, crystallized here in the distinction between our lives and their perception and respiration. The difference between "our" and "their" does not displace, by way of a politico-intellectual detachment, nearness with absolute distance. Rather, it attends the claim—which is to say that imaginative flight, that descent into the underground—that finding (the) people and things requires. On the other hand, it most certainly can be said to recover a gap, a border of black color, that in the end Fanon demands that we inhabit alongside the ones who have always been escaping the absolute dereliction of the reality to which they have been yoked.

Meanwhile, Reinhardt sees black as a kind of negation even of Mondrianic color, of a certain Mondrianic urban victory. Like all the most profound negations, his is appositional. This is to say that in the end the black paintings stand alongside Mondrian's late work and stand as late work in the private and social senses of lateness. Insofar as blackness is understood as the absence and negation of color, of a kind of social color and social music, Reinhardt will have had no music playing, or played as he painted, or as you behold—neither Ammons's strong left hand or Taylor's exploded and exploding one. But blackness is not the absence of color. So far is black art also always late work, correspondent to the victory of escape. The blackness of Mondrian's late work is given in Reinhardt's black negation of it just as Taylor amplifies and instantiates a black sociality hidden and almost unreproducible in Reinhardt and his paintings that overwhelms or displaces the antisociality of a black-and-white exchange that never really comes off either as instrumentalist dismissal or objectifying encounter. We could call such instantiation, such violence, the accomplishment of the unfinished, the incomplete, the flawed. It's a victory given in left-out left hands and their excluded handiwork, in impossible recordings on tape, on tape, on taped-over rerecordings, on broken flutes and fluted wash stands in which maker's wash their right hands and their leftout left left hands. It is the unfinished accomplishment of a victory that finished accomplishment takes away. Mondrian's victory is Harriet Jacobs's—it occurs in a cramped, capacious room, a crawl space defined by interdicted, impossible, but existent seeing and overhearing. It's a victory that comes fully into relief only when taken by way of the gift of one's freedom. What one desires, instead, is the unfinished victory of things who can't be bought and sold especially when they are bought and sold. Left hands stroll in the city, fly off the handle like left eyes, burn playhouses down, fly away, crash and burn sometimes then come out again next year on tape and fade away.

Meanwhile, Reinhardt's dream of a painting freed from the city would return whatever animates what Cooper calls the "riot of blocks" that animate *Victory Boogie Woogie* to its cell ("Mondrian," 140). Reinhardt might have said, might be one of the inspirations for, what Adorno writes in "Black as an Ideal:" "To survive reality at its most extreme and grim, artworks that do not want to sell themselves as consolation must equate themselves with that

reality. Radical art today is synonymous with dark art; its primary color is black. Much contemporary art is irrelevant because it takes no note of this and childishly delights in color."[27] For Adorno, "The ideal of blackness with regard to content is one of the deepest impulses of abstraction" (*Aesthetic Theory*, 39) Moreover, "there is an impoverishment entailed by the idea of black," according to Adorno, to which "trifling with sound and color effects" is a mere reaction (39). It is, however, precisely through a consideration of the unstable zone between the lived experience of the black and the fact of blackness, between the color black and what it absorbs and reflects, what it takes in and pours out, that we can begin to see how it is possible to mistake impossibility or impoverishment for absence or eradication. That zone, made available to us by the broken bridge of mistranslation, is where one lives a kind of oscillation between virtual solitude and fantastic multitude (which could be said to be the very theme of Mondrian's late work that Reinhardt takes it upon himself to negate and therefore inadvertently confirms, or of a certain lateness in Fanon's work that a certain earliness in his work seeks to negate but inadvertently confirms). This canted zone or curved span moves between a fact and an experience that, in themselves and in the commerce between them, remain inaccessible to all concepts of and desires for the racial *object* and unavailable to the protocols of dematerializing representation.

Finding things out, getting at the meaning of things, turns out to mean and to demand an investigation of instability, a courting of tumult, of riot, of derangement, of the constitutive disorder of the *polis*, its black market, border, and bottom, the field of minor internal conflict, of the minor occasion or event through which the essence of an interminable struggle takes form. It means settling down in the uninhabitable, where one is constrained to reinitialize what has been dismissed as the pathontological in the discourse of the militant ontopathologist. It means producing mad works—prematurely, preternaturally late works—that register the thingly encounter, works that are both all black and in which black is conspicuous in its absence, between blackness and chromatic saturation.

3

In the attention he pays in his late work to mental disorder and/as anticolonial refusal, Fanon understands that such blackness as Mondrian is infused with and performs shows up in color, that it is more than merely mindless and irresponsible, as Reinhardt believed. Now the interplay between blackness, color, madness, and late work that I have been trying to consider demands a turn to this important and familiar passage from "On National Culture," in Philcox's translation of *The Wretched of the Earth*:

> [T]he colonized intellectual frequently lapses into heated arguments and develops a psychology dominated by an exaggerated sensibility, sensitivity, and susceptibility. This movement of withdrawal, which first of all comes from a petitio principi in his psychological mechanism and physiognomy, above all calls to mind a muscular reflex, a muscular contraction.
>
> The foregoing is sufficient to explain the style of the colonized intellectuals who make up their mind to assert this phase of liberating consciousness. A jagged style, full of imagery, for the image is the drawbridge that lets out the unconscious forces into the surrounding meadows. An energetic style, alive with rhythms bursting with life. A colorful style, too, bronzed, bathed in sunlight and harsh. This style, which Westerners once found jarring, is not, as some would have it, a racial feature, but above all reflects a single-handed combat and reveals how necessary it is for the intellectual to inflict injury on

himself, to actually bleed red blood and free himself from that part of his being already contaminated by the germs of decay. A swift, painful combat where inevitably the muscle had to replace the concept.

Although this approach may take him to unusual heights in the sphere of poetry, at an existential level it has often proved a dead end.

(157)

Fanon's reading of the staging that launches the colonized intellectual's reflexive grasp at authenticity must itself be read in its relation to his analysis of the particular psychosomatic disorders that colonialism fosters and that resistance to colonialism demands. This is to say that the muscle's problematic replacement of the concept needs also to be understood as psychosomatic disorder. The problem of the colonized intellectual as the condition of im/possibility of emergent national culture shows up with a certain clarity in Fanon's attention to mental disorders under colonialism even when the limits of psychopathology are exposed.

> The increasing occurrence of mental illness and the rampant development of specific pathological conditions are not the only legacy of the colonial war in Algeria. Apart from the pathology of torture, the pathology of the tortured and that of the perpetrator, there is a pathology of the entire atmosphere in Algeria, a condition which leads the attending physician to say when confronted with a case they cannot understand: "This will all be cleared up once the damned war is over."
>
> (216)

Whose case is it? Who's on the case? Are we to consider the pathological fantasy that "this will all be cleared up;" or the decayed orbit of diagnosis that leads from the failure to understand down to that fantasy; or must we be concerned with the one big case of an entire pathological public atmo/sphere. In any case, the cases with which Fanon is concerned here are instances of psychosomatic pathology, "the general body of organic disorders developed in response to a situation of conflict" (216). In a note, Fanon characterizes the tradition of Soviet psychological theorization of these disorders as "putting the brain back in its place" as "the matrix where precisely the psyche is elaborated." That tradition operates by way of a terminological shift from "psychosomatic" to "cortico-visual" (216n35). Such disorders are both symptom and cure insofar as they constitute an avoidance of complete breakdown by way of an incomplete outwitting, in Fanon's terms, of the originary conflict.

Fanon continues by turning to a disorder that is seemingly unique to the Algerian atmosphere:

> g. Systemic contraction, muscular stiffness
> These are male patients who slowly have difficulty making certain movements such as climbing stairs, walking quickly, or running (in two cases it is very sudden). The cause of this difficulty lies in a characteristic rigidity which inevitably suggests an attack on certain areas of the brain (central gray matter). Walking becomes contracted and turns into a shuffle. Passive bending of the lower limbs is practically impossible. No relaxation can be achieved. Immediately rigid and incapable of relaxing of his own free will, the patient seems to be made in one piece. The face is set, but expresses a marked degree of bewilderment.
>
> The patient does not seem to be able to "demobilize his nerves." He is constantly tense, on hold, between life and death. As one of them told us: "You see, I'm as stiff as a corpse."
>
> (218–19)

Fanon offers an anticipatory explication:

> Like any war, the war in Algeria has created its contingent of cortico-visceral illnesses . . . This particular form of pathology (systemic muscular contraction) already caught our attention before the revolution began. But the doctors who described it turned it into a congenital stigma of the "native," an original feature of his nervous system, manifest proof of a predominant extrapyramidal system in the colonized. This contraction, in fact, is quite simply a postural concurrence and evidence in the colonized's muscles of their rigidity, their reticence and refusal in the face of the colonial authorities.
>
> (217)

Perhaps these contractions comprise a staging area for questions. What's the relation between the body seeming to be all of one piece and the uncountable set of minor internal conflicts that Fanon overlooks in his assertion of the absence of black interiority or black difference? Is jaggedness an effect or an expression of rigidity, reticence, or refusal? Is such gestural disorder a disruptive choreography that opens onto the meaning of things? At the same time, would it not be fair to think in terms of a gestural critique (of reason, of judgment)? Muscular contraction is not just a sign of external conflict but an expression of internal conflict as well. Perhaps such gesture, such dance, is the body's resistance to the psyche and to itself the thing's immanent transcendence, the fissured singularity of a political scene.

But is this anything other than to say that dance such as this moves in a pathological atmosphere? It is fantastic and its rigor is supposed to be that of the mortis, the socially dead, of a dead or impossible socius. The point, however, is that disorder has a set of double edges in the case (studies) of Fanon. Such disorder is, more generally, both symptom and cure—a symptom of oppression and a staging area for political criminality. And such disorder is deeply problematic if the onto-epistemological field of blackness is posited as impossible or unexplainable; if the social situation of blackness is a void, or a voided fantasy, or simply devoid of value; if resistance itself is, finally, at least in this case, a function of the displacement of personality. Fanon seeks to address this complex in the transition from his description of muscular contraction to his understanding of the relation between what has been understood to be a natural propensity to "criminal impulsiveness" and the war of national liberation. Now the relation between the colonized intellectual and his impossible authenticity is to be thought in its relation to that between "the militant" and "his people," whom the militant believes he must drag "up from the pit and out of the cave" (219). At stake is the transition from romantic identification with the pathological to the detached concern of the psychopathologist who ventures into the dead space of the unexplainable in the interest of a general resuscitation. Fanon is interested in a kind of rehabilitation and reintegration that the militant psychopathologist is called upon to perform in the interest of procuring "substance, coherence, and homogeneity" and reversing the depersonalization of "the very structure of society" on the collective as well as individual levels (219). For Fanon, the militant cortico-visceral psychopathologist, the people have been reduced "to a collection of individuals who owe their very existence to the presence of the colonizer" (220). A set of impossible questions ought to ensue from what may well be Fanon's pathological insistence on the pathological: Can resistance come from such a location? Or perhaps more precisely and more to the point, can there be an escape from that location; can the personhood that defines that location also escape that position? What survives the kind of escape that ought never leave the survivor intact? If and when some thing emerges from such a place, can it be anything other than pathological? But how can the struggle for liberation of the pathological be aligned with the eradication of the pathological? This set of questions will have been symptoms of the psychopathology of the

psychopathologist—in them the case of the one who studies cases will have been given in its essence. It is crucial, however, that this set of questions that Fanon ought to have asked are never really posed. Instead, in his text Fanon insistently stages the encounter between anti-colonial political criminality and colonially induced psychopathology. In so doing he discovers a certain nearness and a certain distance between explanation and resistance as well.

Fanon is embedded in a discourse that holds the pathological in close proximity to the criminal. At stake in this particular nearness is the relation between psychic and legal adjustment. In either case, the case *is* precisely in relation to the norm. But the case of a specifically colonial psychopathology, in its relation to the case of a specifically anticolonial criminality, has no access to the norm. Moreover, if in either case there were access to the norm, that access would be refused and such refusal would be folded into the description of criminal, pathological anticolonialism. In such cases, what would be the meaning of adjustment or "reintegration"? What does or should the liberation struggle have to do, in the broadest sense, with the "rehabilitation of man"? The flipside of this question has to do, precisely, with what might be called the liberatory value of ensemblic depersonalization. This is Fanon's question. He achieves it, in the course of his career, by way of an actual engagement with what is dismissed in *Black Skins, White Masks* as the "minor internal conflicts" that show up only in contradistinction to authentic intra-racial intersubjectivity but that is taken up, in *The Wretched of the Earth*, with all of the militant psychopathologist's ambivalence, under the rubrics of "cortico-visceral disorder" (muscular contraction) and "criminal impulsiveness" in its irreducible relation to "national liberation."

While Fanon would consider the zealous worker in a colonial regime a quintessentially pathological case, remember that it is in resistance to colonial oppression that the cases of psychopathology with which Fanon is concerned in *The Wretched of the Earth*—in particular, those psychosomatic or cortico-visceral disorders—emerge. What's at stake is Fanon's ongoing ambivalence toward the supposedly pathological. At the same time, ambivalence is itself the mark of the pathological. Watch Fanon prefiguratively describe and diagnose the pathological ambivalence that he performs:

> The combat waged by a people for their liberation leads them, depending on the circumstances, either to reject or to explode the so-called truths sown in their consciousness by the colonial regime, military occupation, and economic exploitation. And only the armed struggle can effectively exorcise these lies about man that subordinate and literally mutilate the more conscious-minded among us.
>
> How many times in Paris or Aix, in Algiers or Basse-Terre have we seen the colonized vehemently protest the so-called indolence of the black, the Algerian, the Vietnamese? And yet in a colonial regime if a fellah were a zealous worker or a black were to refuse a break from work, they would be quite simply considered pathological cases. The colonized's indolence is a conscious way of sabotaging the colonial machine; on the biological level it is a remarkable system of self-preservation and, if nothing else, is a positive curb on the occupier's stranglehold over the entire country.
>
> (220)

Is it fair to say that one detects in this text a certain indolence sown or sewn into it? Perhaps, on the other hand, its flaws are more accurately described as pathological. To be conscious-minded is aligned with subordination, even mutilation; the self-consciousness of the colonized is figured as a kind of wound at the same time that it is also aligned with wounding, with armed struggle that is somehow predicated on that which it makes possible—namely, the explosion

of so-called truths planted or woven into the consciousness of the conscious-minded ones. They are the ones who are given the task of repairing (the truth) of man; they are the ones who would heal by way of explosion, excision, or exorcism. This moment of self-conscious self-description is sewn into Fanon's text like a depth charge. However, authentic upheaval is ultimately figured not as an eruption of the unconscious in the conscious-minded but as that conscious mode of sabotage carried out every day—in and as what had been relegated, by the conscious-minded, to the status of impossible, pathological sociality—by the ones who are not, or are not yet, conscious. Healing wounds are inflicted, in other words, by the ones who are not conscious of their wounds and whose wounds are not re-doubled by such conscious-ness. Healing wounds are inflicted appositionally, in small, quotidian refusals to act that make them subject to charges of pathological indolence. Often the conscious ones, who have taken it upon themselves to defend the colonized against such charges, levy those charges with the greatest vehemence. If Fanon fails to take great pains to chart the tortured career of rehabilita-tive injury, it is perhaps a conscious decision to sabotage his own text insofar as it has been sown with those so-called truths that obscure the truth of man.

This black operation that Fanon performs on his own text gives the lie to his own formu-lations. So when Fanon claims, "The duty of the colonized subject, who has not yet arrived at a political consciousness or a decision to reject the oppressor, is to have the slightest effort literally dragged out of him," the question that emerges is why one who is supposed yet to have arrived at political consciousness, one who must be dragged up out of the pit, would have such a duty (220). This, in turn, raises the more fundamental issue, embedded in this very assertion of duty, of the impossibility of such non-arrival. The failure to arrive at a political consciousness is a general pathology suffered by the ones who take their political conscious-ness with them on whatever fugitive, aleatory journey they are making. They will have already arrived; they will have already been there. They will have carried something with them before whatever violent manufacture, whatever constitutive shattering is supposed to have called them into being. While noncooperation is figured by Fanon as a kind of staging area for or a preliminary version of a more authentic "objectifying encounter" with colonial oppression (a kind of counter-representational response to power's interpellative call), his own formula-tions regarding that response point to the requirement of a kind of thingly quickening that makes opposition possible while appositionally displacing it. Noncooperation is a duty that must be carried out by the ones who exist in the nearness and distance between political consciousness and absolute pathology. But this duty, imposed by an erstwhile subject who clearly is supposed to know, overlooks (or, perhaps more precisely, looks away from) that vast range of nonreactive disruptions of rule that are, in early and late Fanon, both indexed and disqualified. Such disruptions, often manifest as minor internal conflicts (within the closed circle, say, of Algerian criminality, in which the colonized "tend to use each other as a screen") or muscular contractions, however much they are captured, enveloped, imitated, or traded, remain inassimilable (231). These disruptions trouble the rehabilitation of the human even as they are evidence of the capacity to enact such rehabilitation. Moreover, it is at this point, in passages that culminate with the apposition of what Fanon refers to as "the reality of the 'towelhead' " with "the reality of the 'nigger,' " that the fact, the case, and the lived experi-ence of blackness—which might be understood here as the troubling of and the capacity for the rehabilitation of the human—converge as a duty to appose the oppressor, to refrain from a certain performance of the labor of the negative, to avoid his economy of objectification and standing against, to run away from the snares of recognition (220). This refusal is a black thing, is that which Fanon carries with(in) himself, and in how he carries himself, from Martinique to France to Algeria. He is an anticolonial smuggler whose wares are constituted by and as the dislocation of black social life that he carries, almost unaware. In Fanon, black-ness is transversality between things, escaping (by way of) distant, spooky actions; it is

translational effect and affect, transmission between cases, and could be understood, in terms Brent Hayes Edwards establishes, as diasporic practice.[28] This is what he carries with him, as the imagining thing that he cannot quite imagine and cannot quite control, in his pathologizing description of it that it—that he—defies. A fugitive cant moves through Fanon, erupting out of regulatory disavowal. His claim upon this criminality was interdicted. But perhaps only the dead can strive for the quickening power that animates what has been relegated to the pathological. Perhaps the dead are alive and escaping. Perhaps ontology is best understood as the imagination of this escape as a kind of social gathering; as undercommon plainsong and dance; as the fugitive, centrifugal word; as the word's auto-interruptive, auto-illuminative shade/s. Seen in this light, black(ness) is, in the dispossessive richness of its colors, beautiful.

I must emphasize my lack of interest in some puritanically monochromatic denunciation of an irreducible humanism in Fanon. Nor is one after some simple disavowal of the law as if the criminality in question had some stake in such a reaction. Rather, what one wants to amplify is a certain Fanonian elaboration of the law of motion that Adorno will come to speak of in Fanon's wake. Fanon writes, "Here we find the old law stating that anything alive cannot afford to remain still while the nation is set in motion, while man both demands and claims his infinite humanity" (221). A few years later, in different contexts, Adorno will write: "The inner consistency through which artworks participate in truth always involves their untruth; in its most unguarded manifestations art has always revolted against this, and today this revolt has become art's own law of movement [*Bewegungsgesetz*]" (*Aesthetic Theory*, 168–69) and "Artworks' paradoxical nature, stasis, negates itself. The movement of artworks must be at a standstill and thereby become visible. Their immanent processual character—the legal process that they undertake against the merely existing world that is external to them—is objective prior to their alliance with any party" (176–77). In the border between *Black Skins, White Masks* and *The Wretched of the Earth*, the body that questions is a truth that bears untruth. It is a heavy burden to be made to stand as the racial-sexual embodiment of the imagination in its lawless freedom, and the knowledge it produces exclusively, particularly when such standing is a function of having one's wings clipped by the understanding.[29] However the burden of such exemplarity, the burden of being the problem or the case, is disavowed at a far greater cost. So that what is important about Fanon is his own minor internal conflict, the viciously constrained movement between these burdens. On the one hand, the one who does not engage in a certain criminal disruption of colonial rule is pathological, unnatural; on the other hand, one wants to resist a certain understanding of the Algerian as "born idlers, born liars, born thieves, and born criminals" (*Wretched*/P, 221). Insofar as Fanon seems to think that the colonized subject is born into a kind of preconscious duty to resist, that the absence of the capacity to perform or to recognize this duty is a kind of birth defect that retards the development of political consciousness, Fanon is caught between a rock and a crawl space. Against the grain of a colonial psychological discourse that essentially claims "that the North African in a certain way is deprived of a cortex" and therefore relegated to a "vegetative" and purely "instinctual" life, a life of involuntary muscular contractions, Fanon must somehow still find a way to claim, or to hold in reserve, those very contractions insofar as they are a mobilization against colonial stasis (225). Against the grain of racist notions of "the criminal impulsiveness of the North African" as "the transcription of a certain configuration of the nervous system into his pattern of behavior" or as "a neurologically comprehensible reaction, written into the nature of things, of the thing which is biologically organized," Fanon must valorize the assertion of a kind of political criminality written into the nature of things while also severely clipping the wings of an imaginative tendency to naturalize and pathologize the behavior of the colonized (228). Insofar as crime marks the Algerian condition within which "each prevents his neighbor from seeing the national enemy" and thereby arriving at a political consciousness, Fanon must move within an almost general refusal to look at the way

the colonized look at themselves, a denial or pathologization or policing of the very sociality that such looking implies (231). Here Fanon seems to move within an unarticulated Kantian distinction between criminality as the teleological principle of anticolonial resistance and crime as the unbound, uncountable set of illusory facts that obscure, or defer the advent of, postcolonial reason. This distinction is an ontological distinction; it, too, raises the question concerning the irreducible trace of beings that being bears.[30]

This is all to say that Fanon can only very briefly glance at or glance off the immense and immensely beautiful poetry of (race) war, the rich music of a certain underground social aid, a certain cheap and dangerous socialism, that comprises the viciously criminalized and richly differentiated interiority of black cooperation that will, in turn, have constituted the very ground of externally directed noncooperation. It turns out, then, that the pathological is (the) black, which has been figured both as the absence of color and as the excessively, criminally, pathologically colorful (which implies that black's relation to color is a rich, active interinanimation of reflection and absorption); as the cortico-visceral muscular contraction or the simultaneously voluntary and impulsive hiccupped "jazz lament" that in spite of Fanon's formulations must be understood in relation to the acceptable jaggedness, legitimate muscularity, and husky theoretical lyricism of the bop and post-bop interventions that are supposed to have replaced it (176). Because finally the question isn't whether or not the disorderly behavior of the anticolonialist is pathological or natural, whether or not he is born to that behavior, whether or not the performance of this or that variation on such behavior is "authentic:" the question, rather, concerns what the vast range of black authenticities and black pathologies does. Or, put another way, what is the efficacy of that range of natural-born disorders that have been relegated to what is theorized as the void of blackness or black social life but that might be more properly understood as the fugitive being of "infinite humanity," or as that which Marx calls wealth?

> Now, wealth is on one side a thing, realized in things, material products, which a human being confronts as subject; on the other side, as value, wealth is merely command over alien labour not with the aim of ruling, but with the aim of private consumption, etc. It appears in all forms in the shape of a thing, be it an object or be it a relation mediated through the object, which is external and accidental to the individual. Thus the old view, in which the human being appears as the aim of production, regardless of his limited national, religious, political character, seems to be very lofty when contrasted to the modern world, where production appears as the aim of mankind and wealth as the aim of production. In fact, however, when the limited bourgeois form is stripped away, what is wealth other than the universality of individual needs, capacities, pleasures, productive forces, etc., created through universal exchange? The full development of human mastery over the forces of nature, those of so-called nature as well as of humanity's own nature? The absolute working-out of his creative potentialities, with no presupposition other than the previous historic development, which makes this totality of development, i.e., the development of all human powers as such the end in itself, not as measured on a *predetermined* yardstick? Where he does not reproduce himself in one specificity, but produces his totality? Strives not to remain something he has become, but is in the absolute movement of becoming?[31]

Though Fanon is justifiably wary of anything that is presented as if it were written into the nature of things and of the thing, this notion of wealth as the finite being of a kind of infinite humanity—especially when that in/finitude is understood (improperly, against Marx's grain)

as constituting a critique of any human mastery whatever—must be welcomed. Marx's invocation of the thing leads us past his own limitations such that it becomes necessary and possible to consider the thing's relation to human capacity independent of the limitations of bourgeois form.

Like the (colonial) states of emergency that are its effects, like the enclosures that are its epiphenomena, like the civil war that was black reconstruction's aftershock, like the proletariat's anticipation of abolition; it turns out that the war of "national liberation" has always been going on, anoriginally, as it were. Fanon writes of "a lot of things [that] can be committed for a few pounds of semolina," saying, "You need to use your imagination to understand these things" (231). This is to say that there is a counterpoint in Fanon, fugitive to Fanon's own self-regulative powers, that refuses his refusal to imagine those imagining things whose political commitment makes them subject to being committed, those biologically organized things who really have to use their imaginations to keep on keeping on, those things whose constant escape of their own rehabilitation as men seems to be written into their nature. In such contrapuntal fields or fugue states, one finds (it possible to extend) their stealing, their stealing away, their lives that remain, fugitively, even when the case of blackness is dismissed.

Notes

At the outset of this attempt to consider blackness in its relation to fugitivity and translation, I must express my gratitude for two groundbreaking examples. See Daphne A. Brooks, *Bodies in Dissent: Spectacular Performances of Race and Freedom, 1850–1910* (Durham, NC: Duke University Press, 2006), and Brent Hayes Edwards, *The Practice of Diaspora: Literature, Translation, and the Rise of Black Internationalism* (Cambridge: Harvard University Press, 2003).

1 Frantz Fanon, *Black Skins, White Masks*, trans. Charles Lam Markmann (1967; London: Picador, 1970), 77–78.
2 For more on translation and its relation to the concept of "anoriginal difference," see Andrew Benjamin, *Translation and the Nature of Philosophy: A New Theory of Words* (London: Routledge, 1989).
3 I am invoking, and also deviating from, Nahum Dimitri Chandler's notion of paraontology, a term derived from his engagement with W. E. B. Du Bois's long anticipation of Fanon's concern with the deformative or transformative pressure blackness puts on philosophical concepts, categories, and methods. For more on para-ontology, see Chandler, *The Problem of Pure Being: W. E. B. Du Bois and the Discourses of the Negro* (New York: Fordham University Press, forthcoming).
4 For more on Fanon's relation to phenomenology, see David Macey, *Frantz Fanon: A Biography* (New York: Picador, 2001), 162–68.
5 Jared Sexton and Huey Copeland, "Raw Life: An Introduction," *Qui Parle* 13, no. 2 (2003): 53.
6 There is a certain American reception of Agamben that fetishizes the bareness of it all without recognizing the severity of the critique he levels at movements of power/knowledge that would separate life from the form of life. The critical obsession with bare life, seen in its own vexed relation with the possibility of another translation that substitutes naked for bare and perhaps has some implications, is tantamount to a kind of sumptuary law. The constant repetition of bare life bears the annoying, grating tone that one imagines must have been the most prominent feature of the voice of that kid who said the emperor has no clothes. It's not that one wants to devalue in any way the efficacy of such truth telling, such revelation; on the other hand, one must always be careful that a certain being positive, if not positivism, doesn't liquidate the possibility of political fantasy in its regulation of political delusion. There's more to be said on this question of what clothes life, of how life is apparell'd (as John Donne might put it); this, it seems to me, is Agamben's question, the question of another commonness. So why is it repressed in the straight-ahead discourse of the clear-eyed? This question is ultimately parallel to that concerning why Foucault's constant and unconcealed assumptions of life's fugitivity are overlooked by that generation of American academic overseers—the non-seers who can't see, because they see so clearly—who constitute the prison guards of a certain understanding of the carceral. Judith Butler might say that they see too clearly to see what lies before them. See her analytic of the "before" in the second chapter of her *Gender Trouble: Feminism and the Subversion of Identity* (New York: Routledge,

1989). See also Giorgio Agamben, *Homo Sacer: Sovereign Power and Bare Life*, trans. Daniel Heller-Roazen (Stanford, CA: Stanford University Press, 1998), and *Means without Ends: Notes on Politics*, trans. Vincenzo Binetti and Cesare Casarino (Minneapolis: University of Minnesota Press, 2000).

7 Frantz Fanon, *Peau noire, masques blancs* (Paris: Éditions du Seuil, 1952), 88.

8 This is an image—taken from Denis Diderot's reading of Samuel Richardson—that Brooks deploys in his analysis of melodrama. See Peter Brooks, *The Melodramatic Imagination: Balzac, Henry James, Melodrama, and the Mode of Excess* (1976; New Haven, CT: Yale University Press, 1995), 19.

9 Or it might show up as a refusal of the resonance of Fanon in Sexton and Copeland, or in Achille Mbembe and David Marriott, or in important new work by Kara Keeling and Frank Wilderson. See Keeling, " 'In the Interval': Frantz Fanon and the 'Problems' of Visual Representation," *Qui Parle* 13, no. 2 (2003): 91–117 (wherein she takes up that passage in Fanon with which I began, thereby both authorizing and directing the course of my own reading; wherever I might diverge from her under-standing, I do so only as a function of her thinking, in kinship and respect). See also Keeling, *The Witch's Flight: The Cinematic, the Black Femme, and the Image of Common Sense* (Durham, NC: Duke University Press, 2007); David Marriott, *On Black Men* (New York: Columbia University Press, 2000); Achille Mbembe, *On the Postcolony*, trans. A. M. Berrett et al. (Berkeley: University of California Press, 2001); Frank Wilderson III, *Red, White, and Black: Cinema and the Structure of U.S. Antagonisms* (Durham, NC: Duke University Press, forthcoming).

10 Michael Inwood, ed., *A Heidegger Dictionary* (Oxford: Blackwell, 1999), 214.

11 Martin Heidegger, "The Thing," in *Poetry, Language, Thought*, trans. Albert Hofstadter (New York: Harper and Row, 1971), 174; hereafter cited in the text.

12 For more on the relation between evasive previousness and unavailable natality, consult Mackey's multivolume epic *From a Broken Bottle Traces of Perfume Still Emanate*, especially the first installment, *Bedouin Hornbook*, Callaloo Fiction Series, vol. 2 (Lexington: University of Kentucky Press, 1986).

13 See Amiri Baraka (LeRoi Jones), "Black Is a Country," in *Home: Social Essays* (New York: Morrow, 1966), 82–86, and Nikhil Pal Singh, *Black Is a Country: Race and the Unfinished Struggle for Democracy* (Cambridge: Harvard University Press, 2004).

14 See Theodor W. Adorno, "On Jazz," trans. Jaime Owen Daniel; modified by Richard Leppert, in *Essays on Music* (Berkeley: University of California Press, 2002), 472.

15 "Black as Symbol and Concept," in *Art as Art: The Selected Writings of Ad Reinhardt*, ed. Barbara Rose (Berkeley: University of California Press, 1975), 86–88.

16 "Black," *Arts/Canada* 113 (October 1967); hereafter cited in the text.

17 Yve-Alain Bois cites the following statement by Reinhardt: "I've never approved or liked anything about Marcel Duchamp. You have to choose between Duchamp and Mondrian." See Bois, "The Limit of Almost," in *Ad Reinhardt*, ed. William Rubin and Richard Koshalek (New York: Rizzoli, 1991), 13.

18 Bois wonders if the non-sentence Reinhardt pronounces on theater ("Theater, acting, 'lowest of the arts' ") alludes to Fried's in/famous essay on what he took to be the degrading force of theatricality in minimalist art, "Art and Objecthood." The essay originally appeared in *Artforum* a couple of months before Reinhardt's death on August 31, 1967, a couple of weeks after his encounter with Taylor. See Bois, "Limit," 13 and 30n21. Also see Reinhardt's unpublished notes from 1966 to 1967 collected by Rose under the title "Art-as-Art," in *Art as Art*, 74, and Michael Fried, "Art and Objecthood," in *Art and Objecthood: Essays and Reviews* (1967; Chicago: University of Chicago Press, 1998), 148–72. I would like to acknowledge the influence of Paul Kottman's ideas regarding what he calls "the politics of the scene" on my attempt to think through this interplay of politics and theatricality.

19 Clement Greenberg, "The Crisis of the Easel Picture," in *The Collected Essays and Criticism: Arrogant Purpose*, 1945–1949, 4 vols., ed. John O'Brian (Chicago: University of Chicago Press, 1986), 223, quoted in Bois, "Limit," 17.

20 See, for instance, Mondrian's 1927 essay "Jazz and Neo-Plastic," in *The New Art—The New Life: The Collected Writings of Piet Mondrian*, ed. and trans. Harry Holtzman and Martin S. James (1986; New York: Da Capo, 1993), 217–22.

21 See Harry Cooper, "Mondrian, Hegel, Boogie," *October* 84 (Spring 1998): 136.

22 See/hear Cecil Taylor, *Segments II (Orchestra of Two Continents): Winged Serpent (Sliding Quadrants)* (Milan: Soul Note, 1985).

23 Yve-Alain Bois, "Piet Mondrian, *New York City*," in *Painting as Model* (Cambridge: MIT Press, 1990), 183.

24 Frantz Fanon, *The Wretched of the Earth*, trans. Constance Farrington (New York: Grove Press, 1968), 227; hereafter abbreviated *Wretched*/F.

25 See W. E. B. Du Bois, "Sociology Hesitant," *boundary 2* 27, no. 3 (2000): 41.

26 Frantz Fanon, *Les damnés de la terre* (1961; Paris, 1991), 273. See also *Wretched*/F, p. 227, and Frantz Fanon, *The Wretched of the Earth*, trans. Richard Philcox (New York: Grove Press, 2004), 163;

hereafter abbreviated *Wretched*/P. Forgive my oscillation—undertaken primarily due to considerations of style (which is not only eternal, as Mackey says, but fundamental)—between the poles of these translations.

27 Theodor Adorno, *Aesthetic Theory*, trans. Robert Hullot-Kentor (Minneapolis: University of Minnesota Press, 1997), 39.

28 See Brent Hayes Edwards, *The Practice of Diaspora: Literature, Translation, and the Rise of Black Internationalism* (Cambridge: Harvard University Press, 2003).

29 This is a Kantian formulation that I have elsewhere tried to explicate by way of the work of Winfried Menninghaus. See my "Knowledge of Freedom," *CR: The New Centennial Review* 4, no. 2 (2004): 269–310. See also Menninghaus, *In Praise of Nonsense: Kant and Bluebeard*, trans. Henry Pickford (Stanford, CA: Stanford University Press, 1999), and Immanuel Kant, "On the combination of taste with genius in products of beautiful art," in *Critique of the Power of Judgment*, trans. Paul Guyer and Eric Matthews (Cambridge: Harvard University Press, 2000), 196–97.

30 Perhaps this paradox—wherein the colonized intellectual must deconstruct and disavow what the anticolonial revolutionary has to claim, in a double operation on and from the same questioning, questionable body; wherein national consciousness and mental disorder are interinanimate—is proximate to what Gayatri Chakravorty Spivak thinks under the rubric of the " 'native informant' as a name for that mark of expulsion from the name of Man." Perhaps Fanon's late work operates as something on the order of a refusal of that expulsion and of that name, even in his invocation of it. See Spivak, *A Critique of Postcolonial Reason: Toward a History of the Vanishing Present* (Cambridge: Harvard University Press, 1999), 6.

31 Karl Marx, *Grundrisse: Foundations of the Critique of Political Economy*, trans. Martin Nicolaus (New York: Vintage Press, 1973), 487.

Part 3 (b): Further reading

Chakrabarty, Dipesh. *Provincializing Europe: Postcolonial Thought and Historical Difference*. Princeton, NJ: Princeton University Press, 2000.

English, Darby. *How to See a Work of Art in Total Darkness*. Cambridge, MA: MIT Press, 2007.

Fanon, Frantz. *Black Skin, White Masks*. New York: Grove, 1967.

Friedberg, Anne. *Window Shopping: Cinema and the Postmodern*. Berkeley: University of California Press, 1993.

Fusco, Coco, and Brian Wallis. *Only Skin Deep: Changing Visions of the American Self*. New York: International Center of Photography in association with Harry N. Abrams, Inc., Publishers, 2003.

Hirsch, Marianne. *Family Frames: Photography, Narrative and Postmemory*. Cambridge, MA: Harvard UP, 1997.

Moten, Fred. *In the Break: The Aesthetics of the Black Radical Tradition*. Minneapolis: University of Minnesota Press, 2003.

Pinney, Christopher. *Camera Indica: The Social Life of Indian Photographs*. Chicago: University of Chicago Press, 1997.

Pinney, Christopher, and Nicolas Peterson. *Photography's Other Histories*. Durham, NC: Duke University Press, 2003.

Ramaswami, Sumathi. *The Goddess and the Nation: Mapping Mother India*. Durham, NC: Duke University Press, 2010.

Read, Alan. *The Fact of Blackness: Frantz Fanon and Visual Representation*. London: Institute of Contemporary Arts, 1996.

Roach, Joseph R. *Cities of the Dead: Circum-atlantic Performance*. New York: Columbia University Press, 1996.

Sturken, Marita. *Tourists of History: Memory, Kitsch and Consumerism from Oklahoma City to Ground Zero*. Durham, NC: Duke University Press, 2008.

Taylor, Diana. *The Archive and the Repertoire: Performing Cultural Memory in the Americas*. Durham, NC: Duke University Press, 2003.

Part 3 (c) (Post/De/Neo)colonial visualities

AS THE HYBRID TITLE OF THIS SECTION suggests, the colonial legacy is at once far from expunged and it is still unclear how it should even be named. As Saraj Maharat's chapter in the opening section indicates, postcolonialism, which dominated discussion in the 1990s, is now under question. Meanwhile the term "decolonial," first coined in relation to Latin America, has come into wider circulation. If visuality visualizes conflict, its first form, one might even say its primal form, is that of the encounter between worlds that has come to be known as "1492," referring to the encounter between Europe and the Americas but also the expulsion of first the Moors and then the Jews from Spain. In this sense, Natalie Melas has defined the postcolonial as "a condition linked to the cultural logic subtending the history of European conquests begun five hundred years ago, conquests that brought, for the first time, the world as an empirical totality into human apprehension" (2007: xii). The full implications here are somewhat breathtaking: modernity may be taken to have begun, as the decolonial theorists would have it, in "1492," which, while not being a literal date, gives a far wider span of space and time to that concept than is standard. Second, conflict and conquest are inherent to that modernity, not unfortunate accidents, named by Anibal Quiano as the "coloniality of power." Last but not least, the "global" as a sense of apprehending the planet as part of that coloniality is co-eval with it, which is to say, it too is half a millenium old. To these complexities, we must now add the neo-colonial, the return of direct or indirect colonial rule since the formal decolonizations of the post-Second World War period. Clearly the events of the past decade in the Middle East, Iraq and Afghanistan suggest that a neo-colonial resurgence has been widespread and, while its future is uncertain, no end is yet in sight.

In the present moment, Timothy Mitchell's now classic chapter "Orientalism and the Exhibitionary Order" appears all the more prescient. Mitchell shows how the visual representation of the "Orient" in nineteenth-century anthropological exhibitions both created and displayed what he calls "Orientalist reality" (1992). Orientalism is the name given by the postcolonial scholar Edward Said, himself in exile from Palestine, to the Western concept of an imaginary space called the Orient, which was variously situated from the Jewish East End of London to the South of Italy, Greece and all the European colonies in North Africa, the Middle East and Asia. In short, the Orient was not a delineated physical space so much as the idea of the radically Other, defined by that difference and marked by exoticism, despotism and the disinclination to labor (Said, 1978). Consequently, Mitchell defines Orientalist reality "as the product of unchanging racial or cultural essences," which were held to be diametrically opposed to those of the "West," an equally imaginary space. This binary division of the world has recently returned under the guise of such formulae as "the clash of civilizations." Such essences were displayed to a curious Western public at the repeated World's Fairs and Exhibitions of the period (1851–1914). Mitchell fascinatingly places this now familiar account in counterpoint with the views of Middle Eastern visitors to those exhibitions, who found it curious that Europeans were so obsessed with "spectacle," a word for which they could find no equivalent in their own languages. The function of these displays was to provide what one catalog of the period called "an object lesson." That lesson taught, as Mitchell puts it:

> Objectiveness was a matter not just of visual arrangement around a curious spectator, but of representation. What reduced the world to a system of objects was the way their careful organization enabled them to evoke some larger meaning, such as History, or Empire, or Progress.

This system he calls the "exhibitionary order," which was able to display the varied and contradictory elements of "race" and racial difference and give them an apparent coherence.

What, one should ask, are the components of today's exhibitionary order that continue to promulgate similar modalities of difference?

In the extract from Malek Alloula's study *The Colonial Postcard*, another classic locus of Orientalism is examined: "There is no phantasm, though, without sex and in this Orientalism ... a central figure emerges, the very embodiment of the obsession, the harem" (1986). In Arabic, *haraam* means forbidden, while *harim* refers to a forbidden place and thus also refers to the women's quarters of certain traditional households, which are forbidden to strange men. Embroidering from centuries of stories concerning the imperial harem in Istanbul, the European imagination had transformed every *harim* into a hotbed of sensuality and sexuality. France colonized much of North Africa, beginning with its invasion of Algeria in 1830, leading to a new genre of exoticizing Orientalist art, ranging from canonical figures like Eugène Delacroix and Ingres to lesser-known specialists like Gérôme and Fromentin and a horde of now-unknown artists churning out genre work for the Orientalist salons of the day. In the twentieth century, this fine art production was supplemented by the mass-reproduced photographic postcard, printed in great numbers. Taking on the artistic Orientalist nude, the favorite subject of these postcards was the *algérienne*, that is to say, the Algerian woman in various states of undress. Writing after the Algerian revolution (1954–62), Alloula wanted above all to "return this immense postcard to its sender," the French colonizer. Alloula argued that the veiled woman was a provocation to the European photographer because her light-colored clothing caused a "whiteout" in the bright sun, blanking out all detail. The women's peephole gaze from behind the veil mirrored the photographer's own gaze from beneath the cloth of the tripod cameras in use at the time. Thus "the photographer feels photographed . . . *he is dispossessed of his own gaze.*" The response was to remove the obstacle to the gaze and force the lifting of the veil for the camera, so that the photographer "will unveil the veil and give figural expression to the forbidden." From the teasing postcards showing a woman slightly lifting her veil to the popular images of half-naked Algerian women was simply the working out of this logic. The colonial gaze must see and make an exhibition of these women, which is then rendered as a form of the aesthetic. This discourse has returned with a vengeance. First the 2002 invasion of Afghanistan was justified as a liberation of women from the *burqa*, an all-enveloping cloak worn by some Afghans, which provided a dramatic spectacle for Western cameras. While that argument has quietly been forgotten, the issue has indeed now returned to sender. France has passed a law forbidding the veiling of the face and, at the time of writing in May 2011, some fifty citations have already been issued. Criminalizing behavior in the name of Republican liberties is precisely the kind of contradiction that results from colonial visualities.

From the other side of the colonial color line, Suzanne Preston Blier gives an evocative account of how the operations of coloniality transformed one visually dramatic form of African art, namely the Fon *bocio* figure. In the Fon region of West Africa, located in present-day Benin and southwestern Nigeria, slavery did not disappear with the end of the Atlantic slave trade but continued domestically to supply labor for palm-oil plantations. Indeed from the sugar plantations of nineteenth-century Queensland to tomato farms in present-day Florida, forced labor for primary products has continued. By 1900, as many as one-third of the population in the Danhome area of Benin were plantation slaves. The violence of slavery was powerfully visualized in the period genre of gagged and bound Fon *bocio* sculptures, which contrasted with the smoothly rounded sculptural forms produced for the nobility of the time. As Blier explains in this extract from her prize-winning book *African Vodun*, these sculptures "offered a way of both accepting and refusing the negative by helping their users 'think-through-terror,' as [Michael] Taussig would say . . . Art provides one way of uttering what is otherwise unutterable." While Alloula regretted that the gaze of the Algerian women was nowhere represented in the colonial postcards—although it can be found in the 1940s work of Algerian photographer and novelist Mohammed Dib—subaltern experience is given visible expression in the Fon *bocio* figure.

The "terror" described by anthropologist Michael Taussig in the citation from Blier above referred to the colonial terror visited on the peoples of Central America and the Congo region of Africa during the rubber boom of the early twentieth century. Of course, since 2001 that term has resonated more powerfully with what the Bush administration named the "global war on terror," a phrase officially retired by President Obama but still in media circulation. In general one might see this as an instance of what has been called the boomerang effect, whereby a force released by a world power (usually but not always the United States) rebounds against it. Perhaps the most striking example of the boomerang effect has been the Taliban, funded by the U.S. when it fought against the Soviet occupation of Afghanistan and now the object of a decade-long war by the U.S. and its allies.

The place of the image in religion has been at the center of debates worldwide for centuries (Latour and Weibel, 2002). The iconoclastic movement in the Eastern church in the eighth and ninth centuries CE led to a break with the Roman Catholic church, just as the Protestant Reformation of the sixteenth century was to condemn the place of images in religion. Although Islam and Judaism are now known for opposing representational images, that has by no means always been the case—as seen in the representational Jewish art at the Dura-Europos synagogue from the third century. While Islam is now often described as being aniconic from the inception, art historian Finbarr Barry Flood has shown that the proscription against images came in the *Hadith*, or sayings of the Prophet, rather than in the Qu'ran itself, that have been interpreted in very different ways. When the Taliban ordered the destruction of the statues of Buddha at Bamiyan in 2001, they were careful to ensure that Western media representatives had access to the scene as part of their long-term use of global visual media to promote their archaizing form of Islam. In a remarkably wide-ranging chapter across time and space, Flood shows that what are often presented as eternal certainties have been contested and often interpreted in strikingly different ways. In some cases, medieval figures had lines drawn across their throats and were otherwise treated "as if they were animate beings," just as the Taliban slapped a sculpted figure in the Kabul Museum. Indeed, Flood notes that it is possible the Bamiyan Buddhas had already suffered iconoclastic destruction of their faces long before 2001. In a fascinating cross-cultural comparison, Flood shows how the destruction of the Buddhas was differently received in India and in the West and the knowing way in which the Taliban exploited Western ambiguities concerning the distinction between a cult object and an art object. Pointing out that scholars as different as Walter Benjamin and the anthropologist Alfred Gell have seen museums as a place of worship, leading to iconoclastic attacks such as that by Suffragette Mary Richardson on *The Rokeby Venus* in 1914, Flood stresses that it was "precisely their common role as fetishes of Western modernity that rendered *The Rokeby Venus* and the Bamiyan Buddhas desirable targets for modern iconoclasts." In short, the ambivalences of Western and Islamic attitudes to images are alike part of a response to globalized modernity rather than being counterpoints of "progress" and "tradition."

The curator and critic Okwui Enwezor, well-known for exhibitions such as Documenta XI and "Africa: A Short Century," develops this theme by locating contemporary art in a "postcolonial constellation," produced by "the intersection between imperial and postcolonial discourses." Enwezor highlights the central role of exhibitions in creating modern and contemporary art practice. In the present dramatic expansion of the "art world," he sees two dominant themes: a persistent search for novelty on the one hand, and an insistent demand that art maintain its presumed "autonomy" from culture on the other. He develops this analysis by examining the hang of the permanent collection at Tate Modern in London, which opened in 2000 with a set of thematic exhibitions, deliberately designed to contrast to the historiographic approach of New York's Museum of Modern Art. Enwezor finds instead troubling continuity with the appropriation of the body of the colonized in the Congo as part of the "nude" section without any such counterbalance as the work of Rotimi Fani-Kayode, the

Nigerian-British artist. Fani-Kayode represented the African body "as a vessel for idealiza-tion," in contrast to the colonial stereotypes that "have been the stock-in-trade of Modernism." At the same time as such museums flatten distinct artistic traditions into one "African" expe-rience, "the very idea that there might be an African concept of modernity does not even come up." If there is to be a decolonial global culture, "innovation is as much about the coming to being of new relations to cultures and histories . . . as it is about the ways artists are seen to be bound to their national and cultural traditions." For Enwezor, this presents an opportunity for a historically and institutionally grounded engagement with global capitalism.

The stakes of that interface are made very clear in the extract from Israeli architect Eyal Weizman's book *Hollow Land: Israel's Architecture of Occupation*. He describes a tactic used by the Israeli Defence Force (IDF) since 2002, in which they move through walls and other components of the built environment, rather than taking the streets. The city is "not just the site . . . but the very medium of warfare." It transpires that through its Operational Theory Research Institute, the IDF has been developing an understanding of theorists like Deleuze and Guattari that led them to this spectacular new form of warfare. This Institute creates theory for the "low intensity" warfare that the US Army now calls counterinsurgency and indeed has worked with them on this issue. It is often said that the Israel/Palestine dispute is at the heart of global conflict today and in this key instance that is not just an observation but a fact of military strategy. The tactic of "swarming," for instance, was first conceived in the U.S. and then applied in the Occupied Territories. Problem-solving is accomplished by networks in non-linear fashion. Thus in response to barricades and mines at the Balata refugee camp in 2002, the IDF devised the tactic of "walking through walls." Instead of attacking as expected in one place at a time, the IDF broke up into smaller units, each of which attacked simultaneously, creating their own pathways *through* buildings, not around them. Weizman notes the "influence of post-modern, post-structuralist theoretical language" in forming what the IDF calls its "interpretation of space." Such language also sanitizes the violence involved, creating "a military fantasy world of boundless fluidity." Weizman surprises the reader again by comparing this tactic to the work of Gordon Matta-Clark, whose "anarchitecture" (Anarchic architecture) was one of the buzzwords on the New York City art scene in 2011. The IDF actually showed examples of Matta-Clark's famous "building cuts" to demonstrate their new tactic of "smoothing space." If it is something of a shock to see the resolutely anticolonial work of Deleuze and Guattari connected to anarchist architecture by the IDF, this is perhaps only because the academic left tends to overestimate its conceptual intelligence in relation to the military. This form of counterinsurgent visuality is a salutary reminder that visuality was and remains a cutting-edge tactic of coloniality: it is theirs, not ours, and they make better use of it.

Timothy Mitchell

ORIENTALISM AND THE EXHIBITIONARY ORDER

IT IS NO LONGER UNUSUAL to suggest that the construction of the colonial order is related to the elaboration of modern forms of representation and knowledge. The relationship has been most closely examined in the critique of Orientalism. The Western artistic and scholarly portrayal of the non-West, in Edward Said's analysis, is not merely an ideological distortion convenient to an emergent global political order but a densely imbricated arrangement of imagery and expertise that organizes and produces the Orient as a political reality.[1] Three features define this Orientalist reality: it is understood as the product of unchanging racial or cultural essences; these essential characteristics are in each case the polar opposite of the West (passive rather than active, static rather than mobile, emotional rather than rational, chaotic rather than ordered); and the Oriental opposite or Other is, therefore, marked by a series of fundamental absences (of movement, reason, order, meaning, and so on). In terms of these three features—essentialism, otherness, and absence—the colonial world can be mastered, and colonial mastery will, in turn, reinscribe and reinforce these defining features.

Orientalism, however, has always been part of something larger. The nineteenth-century image of the Orient was constructed not just in Oriental studies, romantic novels, and colonial administrations, but in all the new procedures with which Europeans began to organize the representation of the world, from museums and world exhibitions to architecture, schooling, tourism, the fashion industry, and the commodification of everyday life. In 1889, to give an indication of the scale of these processes, 32 million people visited the Exposition Universelle, built that year in Paris to commemorate the centenary of the Revolution and to demonstrate French commercial and imperial power.[2] The consolidation of the global hegemony of the West, economically and politically, can be connected not just to the imagery of Orientalism but to all the new machinery for rendering up and laying out the meaning of the world, so characteristic of the imperial age.

The new apparatus of representation, particularly the world exhibitions, gave a central place to the representation of the non-Western world, and several studies have pointed out the importance of this construction of otherness to the manufacture of national identity and imperial purpose.[3] But is there, perhaps, some more integral relationship between representation, as a modern technique of meaning and order, and the construction of otherness so

important to the colonial project? One perspective from which to explore this question is provided by the accounts of non-Western visitors to nineteenth-century Europe. An Egyptian delegation to the Eighth International Congress of Orientalists, for example, held in Stockholm in the summer of 1889, traveled to Sweden via Paris and paused there to visit the Exposition Universelle, leaving us a detailed description of their encounter with the representation of their own otherness. Beginning with this and other accounts written by visitors from the Middle East, I examine the distinctiveness of the modern representational order exemplified by the world exhibition. What Arab writers found in the West, I will argue, were not just exhibitions and representations of the world, but the world itself being ordered up as an endless exhibition. This world-as-exhibition was a place where the artificial, the model, and the plan were employed to generate an unprecedented effect of order and certainty. It is not the artificiality of the exhibitionary order that matters, however, so much as the contrasting effect of an external reality that the artificial and the model create—a reality characterized, like Orientalism's Orient, by essentialism, otherness, and absence. In the second half of the article, I examine this connection between the world-as-exhibition and Orientalism, through a rereading of European travel accounts of the nineteenth-century Middle East. The features of the kind of Orient these writings construct—above all its characteristic absences—are not merely motifs convenient to colonial mastery, I argue, but necessary elements of the order of representation itself.

La rue du Caire

The four members of the Egyptian delegation to the Stockholm Orientalist conference spent several days in Paris, climbing twice the height (as they were told) of the Great Pyramid in Alexandre Eiffel's new tower, and exploring the city and exhibition laid out beneath. Only one thing disturbed them. The Egyptian exhibit had been built by the French to represent a street in medieval Cairo, made of houses with overhanging upper stories and a mosque like that of Qaitbay. "It was intended," one of the Egyptians wrote, "to resemble the old aspect of Cairo." So carefully was this done, he noted, that "even the paint on the buildings was made dirty."[4] The exhibit had also been made carefully chaotic. In contrast to the geometric layout of the rest of the exhibition, the imitation street was arranged in the haphazard manner of the bazaar. The way was crowded with shops and stalls, where Frenchmen, dressed as Orientals, sold perfumes, pastries, and tarbushes. To complete the effect of the Orient, the French organizers had imported from Cairo fifty Egyptian donkeys, together with their drivers and the requisite number of grooms, farriers, and saddlers. The donkeys gave rides (for the price of one franc) up and down the street, resulting in a clamor and confusion so lifelike, the director of the exhibition was obliged to issue an order restricting the donkeys to a certain number at each hour of the day. The Egyptian visitors were disgusted by all this and stayed away. Their final embarrassment had been to enter the door of the mosque and discover that, like the rest of the street, it had been erected as what the Europeans called a façade. "Its external form was all that there was of the mosque. As for the interior, it had been set up as a coffee house, where Egyptian girls performed dances with young males, and dervishes whirled."[5]

After eighteen days in Paris, the Egyptian delegation traveled on to Stockholm to attend the Congress of Orientalists. Together with other non-European delegates, the Egyptians were received with hospitality—and a great curiosity. As though they were still in Paris, they found themselves something of an exhibit. "*Bona fide* Orientals," wrote a European participant in the Congress, "were stared at as in a Barnum's all-world show: the good Scandinavian people seemed to think that it was a collection of *Orientals*, not of *Orientalists*."[6] Some of the

Orientalists themselves seemed to delight in the role of showmen. At an earlier congress, in Berlin, we are told that

> the grotesque idea was started of producing natives of Oriental countries as illustrations of a paper: thus the Boden Professor of Sanskrit at Oxford produced a real live Indian Pandit, and made him go through the ritual of Brahmanical prayer and worship before a hilarious assembly. . . . Professor Max Müller of Oxford produced two rival Japanese priests, who exhibited their gifts; it had the appearance of two showmen exhibiting their monkeys.[7]

At the Stockholm Congress, the Egyptians were invited to participate as scholars, but when they used their own language to do so they again found themselves treated as exhibits. "I have heard nothing so unworthy of a sensible man," complained an Oxford scholar, "as . . . the whistling howls emitted by an Arabic student of El-Azhar of Cairo. Such exhibitions at Congresses are mischievous and degrading."[8]

The exhibition and the congress were not the only examples of this European mischief. As Europe consolidated its colonial power, non-European visitors found themselves continually being placed on exhibit or made the careful object of European curiosity. The degradation they were made to suffer seemed as necessary to these spectacles as the scaffolded facades or the curious crowds of onlookers. The facades, the onlookers, and the degradation seemed all to belong to the organizing of an exhibit, to a particularly European concern with rendering the world up to be viewed. Of what, exactly, did this exhibitionary process consist?

An object-world

To begin with, Middle Eastern visitors found Europeans a curious people, with an uncontainable eagerness to stand and stare. "One of the characteristics of the French is to stare and get excited at everything new," wrote an Egyptian scholar who spent five years in Paris in the 1820s, in the first description of nineteenth-century Europe to be published in Arabic.[9] The "curiosity" of the European is encountered in almost every subsequent Middle Eastern account. Toward the end of the nineteenth century, when one or two Egyptian writers adopted the realistic style of the novel and made the journey to Europe their first topic, their stories would often evoke the peculiar experience of the West by describing an individual surrounded and stared at, like an object on exhibit. "Whenever he paused outside a shop or showroom," the protagonist in one such story found on his first day in Paris, "a large number of people would surround him, both men and women, staring at his dress and appearance."[10]

In the second place, this curious attitude that is described in Arabic accounts was connected with what one might call a corresponding *objectness*. The curiosity of the observing subject was something demanded by a diversity of mechanisms for rendering things up as its object—beginning with the Middle Eastern visitor himself. The members of an Egyptian student mission sent to Paris in the 1820s were confined to the college where they lived and allowed out only to visit museums and the theater—where they found themselves parodied in vaudeville as objects of entertainment for the French public.[11]

> They construct the stage as the play demands. For example, if they want to imitate a sultan and the things that happen to him, they set up the stage in the form of a palace and portray him in person. If for instance they want to play the Shah of Persia, they dress someone in the clothes of the Persian monarch and then put him there and sit him on a throne.[12]

Even Middle Eastern monarchs who came in person to Europe were liable to be incorporated into its theatrical machinery. When the Khedive of Egypt visited Paris to attend the Exposition Universelle of 1867, he found that the Egyptian exhibit had been built to simulate medieval Cairo in the form of a royal palace. The Khedive stayed in the imitation palace during his visit and became a part of the exhibition, receiving visitors with medieval hospitality.[13]

Visitors to Europe found not only themselves rendered up as objects to be viewed. The Arabic account of the student mission to Paris devoted several pages to the Parisian phenomenon of "*le spectacle*," a word for which its author knew of no Arabic equivalent. Besides the Opéra and the Opéra-Comique, among the different kinds of spectacle he described were "places in which they represent for the person the view of a town or a country or the like," such as "the Panorama, the Cosmorama, the Diorama, the Europorama and the Uranorama." In a panorama of Cairo, he explained in illustration, "it is as though you were looking from on top of the minaret of Sultan Hasan, for example, with al-Rumaila and the rest of the city beneath you."[14]

The effect of such spectacles was to set the world up as a picture. They ordered it up as an object on display to be investigated and experienced by the dominating European gaze. An Orientalist of the same period, the great French scholar Sylvestre de Sacy, wanted the scholarly picturing of the Orient to make available to European inspection a similar kind of object-world. He had planned to establish a museum, which was to be

> a vast depot of objects of all kinds, of drawings, of original books, maps, accounts of voyages, all offered to those who wish to give themselves to the study of [the Orient]; in such a way that each of these students would be able to feel himself transported as if by enchantment into the midst of, say, a Mongolian tribe or of the Chinese race, whichever he might have made the object of his studies.[15]

As part of a more ambitious plan in England for "the education of the people," a proposal was made to set up "an ethnological institution, with very extensive grounds," where "within the same enclosure" were to be kept "specimens in pairs of the various races." The natives on exhibit, it was said,

> should construct their own dwellings according to the architectural ideas of their several countries; their . . . mode of life should be their own. The forms of industry prevalent in their nation or tribe they should be required to practise; and their ideas, opinions, habits, and superstitions should be permitted to perpetuate themselves. . . . To go from one division of this establishment to another would be like travelling into a new country.[16]

The world exhibitions of the second half of the century offered the visitor exactly this educational encounter, with natives and their artifacts arranged to provide the direct experience of a colonized object-world. In planning the layout of the 1889 Paris Exhibition, it was decided that the visitor "before entering the temple of modern life" should pass through an exhibit of all human history, "as a gateway to the exposition and a noble preface." Entitled "Histoire du Travail," or, more fully, "Exposition retrospective du travail et des sciences anthropologiques," the display would demonstrate the history of human labor by means of "objects and things themselves." It would have "nothing vague about it," it was said, "because it will consist of an *object lesson*."[17]

Arabic accounts of the modern West became accounts of these curious object-worlds. By the last decade of the nineteenth century, more than half the descriptions of journeys to

Europe published in Cairo were written to describe visits to a world exhibition or an international congress of Orientalists.[18] Such accounts devote hundreds of pages to describing the peculiar order and technique of these events—the curious crowds of spectators, the organization of panoramas and perspectives, the arrangement of natives in mock colonial villages, the display of new inventions and commodities, the architecture of iron and glass, the systems of classification, the calculations of statistics, the lectures, the plans, and the guidebooks—in short, the entire method of organization that we think of as representation.

The world-as-exhibition

In the third place, then, the effect of objectness was a matter not just of visual arrangement around a curious spectator, but of representation. What reduced the world to a system of objects was the way their careful organization enabled them to evoke some larger meaning, such as History or Empire or Progress. This machinery of representation was not confined to the exhibition and the congress. Almost everywhere that Middle Eastern visitors went they seemed to encounter the arrangement of things to stand for something larger. They visited the new museums, and saw the cultures of the world portrayed in the form of objects arranged under glass, in the order of their evolution. They were taken to the theater, a place where Europeans represented to themselves their history, as several Egyptian writers explained. They spent afternoons in the public gardens, carefully organized "to bring together the trees and plants of every part of the world," as another Arab writer put it. And, inevitably, they took trips to the zoo, a product of nineteenth-century colonial penetration of the Orient, as Theodor Adorno wrote, that "paid symbolic tribute in the form of animals."[19]

The Europe one reads about in Arabic accounts was a place of spectacle and visual arrangement, of the organization of everything and everything organized to represent, to recall, like the exhibition, a larger meaning. Characteristic of the way Europeans seemed to live was their preoccupation with what an Egyptian author described as "*intizam almanzar*," the organization of the view.[20] Beyond the exhibition and the congress, beyond the museum and the zoo, everywhere that non-European visitors went—the streets of the modern city with their meaningful facades, the countryside encountered typically in the form of a model farm exhibiting new machinery and cultivation methods, even the Alps once the funicular was built—they found the technique and sensation to be the same.[21] Everything seemed to be set up before one as though it were the model or the picture of something. Everything was arranged before an observing subject into a system of signification, declaring itself to be a mere object, a mere "signifier of" something further.

The exhibition, therefore, could be read in such accounts as epitomizing the strange character of the West, a place where one was continually pressed into service as a spectator by a world ordered so as to represent. In exhibitions, the traveler from the Middle East could describe the curious way of addressing the world increasingly encountered in modern Europe, a particular relationship between the individual and a world of "objects" that Europeans seemed to take as the experience of the real. This reality effect was a world increasingly rendered up to the individual according to the way in which, and to the extent to which, it could be made to stand before him or her as an exhibit. Non-Europeans encountered in Europe what one might call, echoing a phrase from Heidegger, the age of the world exhibition, or rather, the age of the world-as-exhibition.[22] The world-as-exhibition means not an exhibition of the world but the world organized and grasped as though it were an exhibition.

The certainty of representation

"England is at present the greatest Oriental Empire which the world has ever known," proclaimed the president of the 1892 Orientalist Congress at its opening session. His words reflected the political certainty of the imperial age. "She knows not only how to conquer, but how to rule."[23] The endless spectacles of the world-as-exhibition were not just reflections of this certainty but the means of its production, by their technique of rendering imperial truth and cultural difference in "objective" form.

Three aspects of this kind of certainty can be illustrated from the accounts of the world exhibition. First there was the apparent realism of the representation. The model or display always seemed to stand in perfect correspondence to the external world, a correspondence that was frequently noted in Middle Eastern accounts. As the Egyptian visitor had remarked, "Even the paint on the buildings was made dirty." One of the most impressive exhibits at the 1889 exhibition in Paris was a panorama of the city. As described by an Arab visitor, this consisted of a viewing platform on which one stood, encircled by images of the city. The images were mounted and illuminated in such a way that the observer felt himself standing at the center of the city itself, which seemed to materialize around him as a single, solid object "not differing from reality in any way."[24]

In the second place, the model, however realistic, always remained distinguishable from the reality it claimed to represent. Even though the paint was made dirty and the donkeys were brought from Cairo, the medieval Egyptian street at the Paris exhibition remained only a Parisian copy of the Oriental original. The certainty of representation depended on this deliberate difference in time and displacement in space that separated the representation from the real thing. It also depended on the position of the visitor—the tourist in the imitation street or the figure on the viewing platform. The representation of reality was always an exhibit set up for an observer in its midst, an observing European gaze surrounded by and yet excluded from the exhibition's careful order. The more the exhibit drew in and encircled the visitor, the more the gaze was set apart from it, as the mind (in our Cartesian imagery) is said to be set apart from the material world it observes. The separation is suggested in a description of the Egyptian exhibit at the Paris Exhibition of 1867.

> A museum inside a pharaonic temple represented Antiquity, a palace richly decorated in the Arab style represented the Middle Ages, a caravanserai of merchants and performers portrayed in real life the customs of today. Weapons from the Sudan, the skins of wild monsters, perfumes, poisons and medicinal plants transport us directly to the tropics. Pottery from Assiut and Aswan, filigree and cloth of silk and gold invite us to touch with our fingers a strange civilization. All the races subject to the Vice-Roy [sic] were personified by individuals selected with care. We rubbed shoulders with the fellah, we made way before the Bedouin of the Libyan desert on their beautiful white dromedaries. This sumptuous display spoke to the mind as to the eyes; it expressed a political idea.[25]

The remarkable realism of such displays made the Orient into an object the visitor could almost touch. Yet to the observing eye, surrounded by the display but excluded from it by the status of visitor, it remained a mere representation, the picture of some further reality. Thus, two parallel pairs of distinctions were maintained, between the visitor and the exhibit and between the exhibit and what it expressed. The representation seemed set apart from the political reality it claimed to portray as the observing mind seems set apart from what it observes.

Third, the distinction between the system of exhibits or representations and the exterior meaning they portrayed was imitated, within the exhibition, by distinguishing between the exhibits themselves and the plan of the exhibition. The visitor would encounter, set apart from the objects on display, an abundance of catalogs, plans, signposts, programs, guidebooks, instructions, educational talks, and compilations of statistics. The Egyptian exhibit at the 1867 exhibition, for example, was accompanied by a guidebook containing an outline of the country's history—divided, like the exhibit to which it referred, into the ancient, medieval, and modern—together with a "notice statistique sur le territoire, la population, les forces productives, le commerce, l'effective militaire et naval, l'organisation financière, l'instruction publique, etc. de l'Egypte" compiled by the Commission Impériale in Paris.[26] To provide such outlines, guides, tables, and plans, which were essential to the educational aspect of the exhibition, involved processes of representation that are no different from those at work in the construction of the exhibits themselves. But the practical distinction that was maintained between the exhibit and the plan, between the objects and their catalog, reinforced the effect of two distinct orders of being—the order of things and the order of their meaning, of representation and reality.

Despite the careful ways in which it was constructed, however, there was something paradoxical about this distinction between the simulated and the real, and about the certainty that depends on it. In Paris, it was not always easy to tell where the exhibition ended and the world itself began. The boundaries of the exhibition were clearly marked, of course, with high perimeter walls and monumental gates. But, as Middle Eastern visitors continually discovered, there was much about the organization of the "real world" outside, with its museums and department stores, its street facades and Alpine scenes, that resembled the world exhibition. Despite the determined efforts to isolate the exhibition as merely an artificial representation of a reality outside, the real world beyond the gates turned out to be more and more like an extension of the exhibition. Yet this extended exhibition continued to present itself as a series of mere representations, representing a reality beyond. We should think of it, therefore, not so much as an exhibition but as a kind of labyrinth, the labyrinth that, as Derrida says, includes in itself its own exits.[27] But then, maybe the exhibitions whose exits led only to further exhibitions were becoming at once so realistic and so extensive that no one ever realized that the real world they promised was not there.

The labyrinth without exits

To see the uncertainty of what seemed, at first, the clear distinction between the simulated and the real, one can begin again inside the world exhibition, back at the Egyptian bazaar. Part of the shock of the Egyptians came from just how real the street claimed to be: not simply that the paint was made dirty, that the donkeys were from Cairo, and that the Egyptian pastries on sale were said to taste like the real thing, but that one paid for them with what we call "*real* money." The commercialism of the donkey rides, the bazaar stalls, and the dancing girls seemed no different from the commercialism of the world outside. With so disorienting an experience as entering the façade of a mosque to find oneself inside an Oriental café that served real customers what seemed to be real coffee, where, exactly, lay the line between the artificial and the real, the representation and the reality?

Exhibitions were coming to resemble the commercial machinery of the rest of the city. This machinery, in turn, was rapidly changing in places such as London and Paris, to imitate the architecture and technique of the exhibition. Small, individually owned shops, often based on local crafts, were giving way to the larger apparatus of shopping arcades and department stores. According to the *Illustrated Guide to Paris* (a book supplying, like an exhibition

program, the plan and meaning of the place), each of these new establishments formed "a city, indeed a world in miniature."[28] The Egyptian accounts of Europe contain several descriptions of these commercial worlds-in-miniature, where the real world, as at the exhibition, was something organized by the representation of its commodities. The department stores were described as "large and well organized," with their merchandise "arranged in perfect order, set in rows on shelves with everything symmetrical and precisely positioned." Non-European visitors would remark especially on the panes of glass, inside the stores and along the gas-lit arcades. "The merchandise is all arranged behind sheets of clear glass, in the most remarkable order. . . . Its dazzling appearance draws thousands of onlookers."[29] The glass panels inserted themselves between the visitors and the goods on display, setting up the former as mere onlookers and endowing the goods with the distance that is the source, one might say, of their objectness. Just as exhibitions had become commercialized, the machinery of commerce was becoming a further means of engineering the real, indistinguishable from that of the exhibition.

Something of the experience of the strangely ordered world of modern commerce and consumers is indicated in the first fictional account of Europe to be published in Arabic. Appearing in 1882, it tells the story of two Egyptians who travel to France and England in the company of an English Orientalist. On their first day in Paris, the two Egyptians wander accidentally into the vast, gas-lit premises of a wholesale supplier. Inside the building they find long corridors, each leading into another. They walk from one corridor to the next, and after a while begin to search for the way out. Turning a corner they see what looks like an exit, with people approaching from the other side. But it turns out to be a mirror, which covers the entire width and height of the wall, and the people approaching are merely their own reflections. They turn down another passage and then another, but each one ends only in a mirror. As they make their way through the corridors of the building, they pass groups of people at work. "The people were busy setting out merchandise, sorting it and putting it into boxes and cases. They stared at the two of them in silence as they passed, standing quite still, not leaving their places or interrupting their work." After wandering silently for some time through the building, the two Egyptians realize they have lost their way completely and begin going from room to room looking for an exit. "But no one interfered with them," we are told, "or came up to them to ask if they were lost." Eventually they are rescued by the manager of the store, who proceeds to explain to them how it is organized, pointing out that, in the objects being sorted and packed, the produce of every country in the world is represented. The West, it appears is a place organized as a system of commodities, values, meanings, and representations, forming signs that reflect one another in a labyrinth without exits.

[. . .]

Notes

This is a revised and extended version of "The World as Exhibition," *Comparative Studies in Society and History* 31, (2) (April, 1989): 217–36, much of which was drawn from the first chapter of *Colonising Egypt* (Cambridge: Cambridge University Press, 1988). I am indebted to Lila Abu-Lughod, Stefania Pandolfo, and the participants in the Conference on Colonialism and Culture held at the University of Michigan in May, 1989, for their comments on earlier versions.

1 Edward Said, *Orientalism* (New York: Pantheon, 1978).

2 Tony Bennett, "The Exhibitionary Complex," *New Formations* 4 (Spring, 1988): 96. Unfortunately, this insightful article came to my attention only as I was completing the revisions to this article.

3 See especially Robert W. Rydell, *All the World's a Fair: Visions of Empire at American International Expositions, 1876–1916* (Chicago: University of Chicago Press, 1984); see also Bennett, "Exhibitionary Complex," op. cit.

4 Muhammad Amin Fikri, *Irshad al-alibba' ila mahasin Urubba* (Cairo, 1892), 128.

5 Fikri, *Irshad*, 128–29, 136.

6 R.N. Crust, "The International Congresses of Orientalists," *Hellas* 6 (1897): 359.

7 Ibid.: 351.

8 Ibid.: 359.

9 Rifa 'a al-Tahtawi, *al-A'mal al-kamila* (Beirut: al-Mu'assasa al-Arabiyya li-l-Dirasat wa-l-Nashr, 1973), 2: 76.

10 Ali Mubarak, *Alam al-din* (Alexandria, 1882), 816. The "curiosity" of the European is something of a theme for Orientalist writers, who contrast it with the "general lack of curiosity" of non-Europeans. Such curiosity is assumed to be the natural, unfettered relation of a person to the world, emerging in Europe once the loosening of "theological bonds" had brought about "the freeing of human minds" (Bernard Lewis, *The Muslim Discovery of Europe* [London: Weidenfeld & Nicholson, 1982], 299). See Mitchell, *Colonising Egypt*, 4–5, for a critique of this sort of argument and its own "theological" assumptions.

11 Alain Silvera, "The First Egyptian Student Mission to France under Muhammad Ali," in *Modern Egypt: Studies in Politics and Society*, ed. Elie Kedourie and Sylvia G. Haim (London: Frank Cass, 1980), 13.

12 Tahtawi, *al-A'mal*, 2: 177, 119–20.

13 Georges Douin, *Histoire du règne du Khédive Ismaïl* (Rome: Royal Egyptian Geographical Society, 1934), 2: 4–5.

14 Tahtawi, *al-A'mal*, 2: 121.

15 Quoted in Said, *Orientalism*, 165.

16 James Augustus St John, *The Education of the People* (London: Chapman and Hall, 1858), 82–83.

17 "Les origines et le plan de l'exposition," in *L'Exposition de Paris de 1889*, 3 (December 15, 1889): 18.

18 On Egyptian writing about Europe in the nineteenth century, see Ibrahim Abu-Lughod, *Arab Rediscovery of Europe* (Princeton: Princeton University Press, 1963); Anouar Louca, *Voyageurs et écrivains égyptiens en France au XIXe siècle* (Paris: Didier, 1970); Mitchell, *Colonising Egypt*, 7–13, 180 n. 14.

19 Theodor Adorno, *Minima Moralia: Reflections from a Damaged Life* (London: Verso, 1978), 116; on the theater, see, for example, Muhammad al-Muwaylihi, *Hadith Isa ibn Hisham, aw fatra min al-zaman*, 2nd edn (Cairo: al-Maktaba al-Azhariyya, 1911), 434, and Tahtawi, *al-A'mal*, 2: 119–20; on the public garden and the zoo, Muhammad al-Sanusi al-Tunisi, *al-Istitla 'at al-barisiya fi ma'rad sanat 1889* (Tunis: n.p., 1891), 37.

20 Mubarak, *Alam al-din*, 817.

21 The model farm outside Paris is described in Mubarak, *Alam al-din*, 1008–42; the visual effect of the street in Mubarak, *Alam al-din*, 964, and Idwar Ilyas, *Mashahid Uruba wa-Amirka* (Cairo: al-Muqtataf, 1900), 268; the new funicular at Lucerne and the European passion for panoramas in Fikri, *Irshad*, 98.

22 Martin Heidegger, "The Age of the World Picture," in *The Question Concerning Technology and Other Essays* (New York: Harper & Row, 1977).

23 International Congress of Orientalists, *Transactions of the Ninth Congress, 1892* (London: International Congress of Orientalists, 1893), 1: 35.

24 Al-Sanusi, *al-Istitla 'at*, 242.

25 Edmond About, *Le fellah: souvenirs d'Egypte* (Paris: Hachette, 1869), 47–48.

26 Charles Edmond, *L'Egypte à l'exposition universelle de 1867* (Paris: Dentu, 1867).

27 Jacques Derrida, *Speech and Phenomena and Other Essays on Hussel's Theory of Signs* (Evanston, Ill.: Northwestern University Press, 1973), 104. All of his subsequent writings, Derrida once remarked, "are only a commentary on the sentence about a labyrinth" ("Implications: Interview with Henri Ronse," in *Positions* [Chicago: University of Chicago Press, 1981], 5). My article, too, should be read as a commentary on that sentence.

28 Quoted in Walter Benjamin, "Paris, Capital of the Nineteenth Century," in *Reflections: Essays, Aphorisms, Autobiographical Writings* (New York: Harcourt Brace Jovanovich, 1978), 146–47.

29 Mubarak, *Alam al-din*, 818; Ilyas, *Mashahid Uruba*, 268.

Malek Alloula

FROM *THE COLONIAL HAREM*

The Orient as stereotype and phantasm

ARRAYED IN THE BRILLIANT COLORS of exoticism and exuding a full-blown yet uncertain sensuality, the Orient, where unfathomable mysteries dwell and cruel and barbaric scenes are staged, has fascinated and disturbed Europe for a long time. It has been its glittering imaginary but also its mirage.

Orientalism, both pictorial and literary, has made its contribution to the definition of the variegated elements of the sweet dream in which the West has been wallowing for more than four centuries. It has set the stage for the deployment of phantasms.

There is no phantasm, though, without sex, and in this Orientalism, a confection of the best and of the worst—mostly the worst—a central figure emerges, the very embodiment of the obsession: the harem. A simple allusion to it is enough to open wide the floodgate of hallucination just as it is about to run dry.

For the Orient is no longer the dreamland. Since the middle of the nineteenth century, it has inched closer. Colonialism makes a grab for it, appropriates it by dint of war, binds it hand and foot with myriad bonds of exploitation, and hands it over to the devouring appetite of the great mother countries, ever hungry for raw materials.

Armies, among them the one that landed one fine 5 July 1830 a little to the east of Algiers, bring missionaries and scholars with their impedimenta as well as painters and photographers forever thirsty for exoticism, folklore, Orientalism. This fine company scatters all over the land, sets up camp around military messes, takes part in punitive expeditions (even Théophile Gautier is not exempt), and dreams of the Orient, its delights and its beauties.

What does it matter if the colonized Orient, the Algeria of the turn of the century, gives more than a glimpse of the other side of its scenery, as long as the phantasm of the harem persists, especially since it has become profitable? Orientalism leads to riches and respectability. Horace Vernet, whom Baudelaire justly called the Raphael of barracks and bivouacs, is the peerless exponent of this smug philistinism. He spawns imitators. Vulgarities and stereotypes draw upon the entire heritage of the older, precolonial Orientalism. They reveal all its presuppositions to the point of caricature.

It matters little if Orientalistic painting begins to run out of wind or falls into medioc-
rity. Photography steps in to take up the slack and reactivates the phantasm at its lowest level.
The postcard does it one better; it becomes the poor man's phantasm: for a few pennies,
display racks full of dreams. The postcard is everywhere, covering all the colonial space,
immediately available to the tourist, the soldier, the colonist. It is at once their poetry and
their glory captured for the ages; it is also their pseudo-knowledge of the colony. It produces
stereotypes in the manner of great seabirds producing guano. It is the fertilizer of the colonial
vision.

The postcard is ubiquitous. It can be found not only at the scene of the crime it
perpetrates but at a far remove as well. Travel is the essence of the postcard, and expedition
is its mode. It is the fragmentary return to the mother country. It straddles two spaces: the
one it represents and the one it will reach. It marks out the peregrinations of the tourist, the
successive postings of the soldier, the territorial spread of the colonist. It sublimates the spirit
of the stopover and the sense of place; it is an act of unrelenting aggression against sedentari-
ness. In the postcard, there is the suggestion of a complete metaphysics of uprootedness.

It is also a seductive appeal to the spirit of adventure and pioneering. In short, the post-
card would be a resounding defense of the colonial spirit in picture form. It is the comic strip
of colonial morality.

But it is not merely that; it is more. It is the propagation of the phantasm of the harem
by means of photography. It is the degraded, and degrading, revival of this phantasm.

The question arises, then, how are we to read today these postcards that have super-
imposed their grimacing mask upon the face of the colony and grown like a chance or a
horrible leprosy?

Today, nostalgic wonderment and tearful archeology (Oh! those colonial days!) are very
much in vogue. But to give in to them is to forget a little too quickly the motivations and the
effects of this vast operation of systematic distortion. It is also to lay the groundwork for its
return in a new guise: a racism and a xenophobia titillated by the nostalgia of the colonial
empire.

Beyond such barely veiled apologias that hide behind aesthetic rationalizations, another
reading is possible: a symptomatic one.

To map out, from under the plethora of images, the obsessive scheme that regulates the
totality of the output of this enterprise and endows it with meaning is to force the postcard
to reveal what it holds back (the ideology of colonialism) and to expose what is represented
in it (the sexual phantasm).

The Golden Age of the colonial postcard lies between 1900 and 1930. Although a late-
comer to colonial apologetics, it will quickly make up for its belatedness and come to occupy
a privileged place, which it owes to the infatuation it elicits, in the preparations for the
centennial of the conquest, the apotheosis of the imperial epoch.

In this large inventory of images that History sweeps with broad strokes out of its way,
and which shrewd merchants hoard for future collectors, one theme especially seems to have
found favor with the photographers and to have been accorded privileged treatment: the
algérienne.

History knows of no other society in which women have been photographed on such a
large scale to be delivered to public view. This disturbing and paradoxical fact is problematic
far beyond the capacity of rationalizations that impute its occurrence to ethnographic attempts
at a census and visual documentation of human types.

Behind this image of Algerian women, probably reproduced in the millions, there is
visible the broad outline of one of the figures of the colonial perception of the native. This
figure can be essentially defined as the practice of a right of (over)sight that the colonizer
arrogates to himself and that is the bearer of multiform violence. The postcard fully partakes

in such violence; it extends its effects; it is its accomplished expression, no less efficient for being symbolic. Moreover, its fixation upon the woman's body leads the postcard to paint this body up, ready it, and eroticize it in order to offer it up to any and all comers from a clientele moved by the unambiguous desire of possession.

To track, then, through the colonial representations of Algerian women—the figures of a phantasm—is to attempt a double operation: first, to uncover the nature and the meaning of the colonialist gaze; then, to subvert the stereotype that is so tenaciously attached to the bodies of women.

A reading of the sort that I propose to undertake would be entirely superfluous if there existed photographic traces of the gaze of the colonized upon the colonizer. In their absence, that is, in the absence of a confrontation of opposed gazes, I attempt here, lagging far behind History, to return this immense postcard to its sender.

What I read on these cards does not leave me indifferent. It demonstrates to me, were that still necessary, the desolate poverty of a gaze that I myself, as an Algerian, must have been the object of at some moment in my personal history. Among us, we believe in the nefarious effects of the evil eye (the evil gaze). We conjure them with our hand spread out like a fan. I close my hand back upon a pen to write *my* exorcism: *this text.*

Women from the outside: obstacle and transparency

> The reading of public photographs is always, at bottom, a private reading.
> (Roland Barthes, *Camera Lucida*, 1981)

The first thing the foreign eye catches about Algerian women is that they are concealed from sight.

No doubt this very obstacle to sight is a powerful prod to the photographer operating in urban environments. It also determines the obstinacy of the camera operator to force that which disappoints him by its escape.

The Algerian woman does not conceal herself, does not play at concealing herself. But the eye cannot catch hold of her. The opaque veil that covers her intimates clearly and simply to the photographer a refusal. Turned back upon himself, upon his own impotence in the situation, the photographer undergoes an *initial experience of disappointment and rejection*. Draped in the veil that cloaks her to her ankles, the Algerian woman discourages the *scopic desire* (the voyeurism) of the photographer. She is the concrete negation of this desire and thus brings to the photographer confirmation of a triple rejection: the rejection of his desire, of the practice of his "art," and of his place in a milieu that is not his own.

Algerian society, particularly the world of women, is forever forbidden to him. It counterposes to him a smooth and homogeneous surface free of any cracks through which he could slip his indiscreet lens.

The whiteness of the veil becomes the symbolic equivalent of blindness: a leukoma, a white speck on the eye of the photographer and on his viewfinder. *Whiteness is the absence of a photo, a veiled photograph, a whiteout in technical terms*. From its background nothing emerges except some vague contours, anonymous in their repeated resemblance. Nothing distinguishes one veiled woman from another.

The veil of Algerian women is also seen by the photographer as a sort of perfect and generalized mask. It is not worn for special occasions. It belongs to the everyday, like a uniform. It instills uniformity, the modality of the impossibility of photography, its disappointment and deficiency of expression.

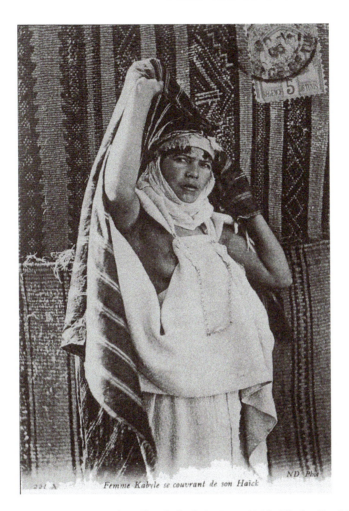

Femme Kabyle se couvrant de son Haick

Figure 37.1 Kabyl woman covering herself with the haik (From Malek Alloula, *The Colonial Harem*, Manchester University Press, 1985).

It will be noted that whenever a photographer aims his camera at a veiled woman, he cannot help but include in his visual field several instances of her. As if to photograph one of them from the outside required the inclusion of a *principle of duplication* in the framing. For it is always a group of veiled women that the photographer affixes upon his plate.

One may well wonder about this peculiarity since it could easily be overcome by technical means through the isolation and the enlargement of a detail. This everyday technique of printmaking is never used, however. Does this indicate, perhaps, that the photographer's frustration is generalized and not amenable to being directed toward one individual in the group? Does this mean that his frustration is an induced effect? The society he observes reveals to him the instinctual nature of his desire (voyeurism) and challenges him beyond the defenses of his professional alibi. The exoticism that he thought he could handle without any problems suddenly discloses to him a truth unbearable for the further exercise of his craft.

Here there is a sort of ironic paradox: the veiled subject—in this instance, the Algerian woman—becomes the purport of an unveiling.

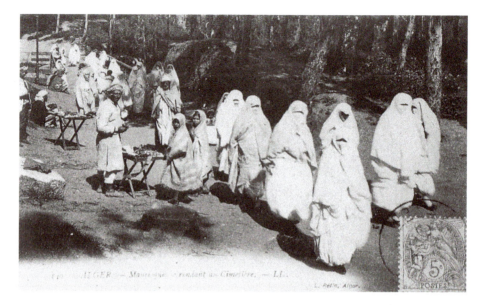

Figure 37.2 Moorish women on their way to the cemetery (From Malek Alloula, *The Colonial Harem*, Manchester University Press, 1985).

But the veil has another function: to recall, in individualized fashion, the closure of private space. It signifies an injunction of no trespassing upon this space, and it extends it to another space, the one in which the photographer is to be found: public space.

These white islets that dot the landscape are indeed aggregates of prohibition, mobile extensions of an imaginary harem whose inviolability haunts the photographer-voyeur. They are scandalous, or at least perceived as being so. By their omnipresence, they revive frustration. They also recall the existence of the well-known pseudo-religious taboo of the Muslims: the figural depiction of the human body prohibited by Islam.

These veiled women are not only an embarrassing enigma to the photographer but an outright attack upon him. It must be believed that the feminine gaze that filters through the veil is a gaze of a particular kind: concentrated by the tiny orifice for the eye, this womanly gaze is a little like the eye of a camera, like the photographic lens that takes aim at everything.

The photographer makes no mistake about it: he knows this gaze well; it resembles his own when it is extended by the dark chamber or the viewfinder. Thrust in the presence of a veiled woman, the photographer feels photographed; having himself become an object-to-be-seen, he loses initiative: *he is dispossessed of his own gaze.*

This varied experience of frustration is turned by the photographer into the sign of his own negation. Algerian society, particularly the feminine world within it, threatens him in his being and *prevents him from accomplishing himself as gazing gaze.*

The photographer will respond to this quiet and almost natural challenge by means of a double violation: he will unveil the veiled and give figural representation to the forbidden. This is the summary of his only program or, rather, his symbolic revenge upon a society that continues to deny him any access and questions the legitimacy of his desire. The photographer's studio will become, then, a pacified microcosm where his desire, his scopic instinct, can find satisfaction.

And so, now in the studio, adorned for the occasion, is one of the numerous models whom the photographer will have wear the veil. As if it were at once part of an exorcism or an act of propitiation, she is drawing the veil aside with both hands in a gesture of inaugural

invitation that the photographer has staged (richness of dress, jewelry, smile, etc.), first for himself, and second for the viewer. Separated from the group that rendered her nondescript, the model is holding a pose, haloed in artistic soft focus, the metaphorical equivalent of intense exultation.

This is a determinant moment for what follows because this is where the machinery, or rather the machination, is set in motion. The entire distorting enterprise of the postcard is given here in schematic form. It is contained in the gesture of drawing the veil aside—a gesture executed at the photographer's command and destined to be followed by others. When she completes them, the *algérienne* will no longer have anything to hide.

Suzanne Preston Blier

VODUN ART, SOCIAL HISTORY AND THE SLAVE TRADE

A man without force is without the essential dignity of humanity.

(Frederick Douglass, *Life and Times*)

To have seen a country is not the same as to have lived it.
[Edumɛ kpokpo a, me edumɛ yiyi o]

(Gen proverb)

BETWEEN 1710 AND 1810 over a million slaves (principally of Fon, Aja, Nago, Mahi, Ayizo, and Gedevi descent) were exported on English, French, and Portuguese vessels out of the Bight of Benin and what was then called the Slave Coast of Africa (Curtin 1969: 228; Manning 1982: 335). This trade, which continued from the region in varying degrees through the end of the nineteenth century, contributed to one of the greatest intercontinental migrations in world history (Curtin 1967; Polanyi 1966; Law 1991). Many of those who were sent from this area were brought to Brazil and various Caribbean islands. The slave trade had dire consequences not only for the men and women who crossed the Atlantic but also for many of those who remained in Africa. In the kingdom of Danhome the acquisition and trading of slaves had assumed dimensions of a national industry. To a large extent, the Danhome state economy was based upon annual raids and military expeditions against neighboring groups and villages, the primary purpose of which was to capture men, and to a lesser extent women and children, who could be sold for profit.

In the course of these campaigns, which often took place soon after harvest, many people lost their lives immediately in confrontations with the Danhome troops; others lost their freedom, homelands, and dignity when they were taken prisoner and were brought to the Danhome capital, where they were either sold into slavery or were kept as prisoners, later to be killed in state ceremonies or forced into involuntary life-long servitude in the state militia, court harems, plantation labor groups, or households of the governing elite.

Those fortunate enough to flee the advancing Danhome armies also suffered greatly. Most returned to their homes to find their farms burned, their granaries emptied, their animals stolen, or slaughtered, and their houses and temples destroyed. For them the answer often was further flight and hiding. With the famines that often followed, medical problems,

infertility, and high infant mortality were rampant (see Manning 1982). The prime targets of the slave raids, primarily young men, were precisely the ones who would have been essential in providing the labor needed to rebuild and sustain the community. Without them, survival was tenuous. Although the situation often was dire, it would have been intolerable without a viable means of both comprehending and coping with the difficult conditions. This included the prominent use of *bocio* and *bo*. No matter what the misfortune, works of this type provided a means of personal and social response to the attendant problems or concerns.

The physical and psychological suffering experienced by persons living in (or near) the Danhome state during the period of international slavery was not to any degree dissipated when the slave trade was outlawed by European states in the nineteenth century. Coinciding with this ban was a new European demand for palm oil to be used in the industrial production of soap. This need was accompanied by the setting up of large oil palm plantations in Africa. In Danhome these plantations were worked by slaves overseen by the kings and other powerful persons. The slaves were obtained, as before, through warfare and raids. Thus at the same time that European states sought to end the horrors of international slavery, they simultaneously encouraged the acquisition and extensive use of slave labor within Africa for palm oil production. The social impact of this economic change was great, for by 1900 fully one-quarter to one-third of the population in the Danhome area were first- or second-generation slaves, many of whom were working on plantations (Manning 1982: 192).

With the French conquest of Danhome in 1894, the difficult conditions of rural peoples appear to have been little improved. Although the French were able to enforce a cessation of the slave raids that had been used to acquire plantation labor, colonial officials to a large degree reinforced and gave legitimacy to essential conditions of the past by allowing princes and newly appointed *cercle* chiefs to retain control over many of their former slaves and the lands they worked. As late as the 1930s, when Herskovits, along with several members of the Danhome aristocracy, visited a village of slave descendants, the latter showed clear indications of fear and discomfort (Herskovits 1967, 1: 103–4; Blier 1988: 140). As Patrick Manning points out in reference to the above incident (1982: 192), "The heritage of slavery in this region where slavery and slave trade were so much a part of life for centuries is deeply and subtly ingrained."

The fundamental links between individual disempowerment and emotional expressions thereof find ample evidence in *bocio*. Often bound tightly in cords, these works evoke the image of a prisoner. They suggest what the Fon call *kannumon*, "thing belonging [in] cords," i.e., the enslaved person. Such individuals, themselves signifiers of personal demise, were potent reminders of the disturbing effects of war, poverty, insecurity, and loss of freedom. As Ahanhanzo Glélé, a descendant of the powerful nineteenth-century ruler King Glélé, notes (1974: 158): "The *kannumon* came from several sources: regular wars (war prisoners), commerce (individuals bought from Hausa, Bariba, and Nago merchants), the ravaging of populations not under Agbome domination, and generally poor people in the state of dependence."

The prominence of cords and binding in commoner *bocio* traditions is a poignant reference to the trauma which resulted from state-induced or supported violence. If slaves, ex-slaves, and the many others who were fearful of enslavement suggest what W.B. Friedman (1956: 175) calls potent "bundles of power," *bocio* can be said to represent these bundles in manifestly visual ways. *Bocio* arts, I maintain, were not merely intended to be reflections of violence and danger, but rather were thought to offer important strategies for responding to the difficult social conditions in which people found themselves at this time. These sculptures were not indifferent or adiaphoric to the sufferer's plight, but served as a means of readdressing wrongs and dissipating attendant anxiety.

Yet resolution of individual and social tension represents but one aspect of each sculpture's textual meaning, for these works also are provocative signifiers of the danger of leaving difficulties unresolved. Such works offered a way of both accepting and refusing the negative by helping their users to objectify conflict and to "think-through-terror," as Taussig would say (1987: 5). As Marcuse suggests (1978: 9), art provides one with a way of uttering what is otherwise unutterable, allowing one to escape from one's bondage however defined. *Bocio* through this means enabled area residents to gain a certain sense of control over the sometimes grave social, political, and physical conditions around them.

In several impassioned books on the difficulties of colonialism in Algeria, psychiatrist Frantz Fanon has argued (1968) that the psychological ills suffered by Algerians during their war for independence often were attributable to the horrors of the political situation in which they found themselves. In both precolonial and postcolonial Danhome, many inhabitants also suffered from various forms of psychological trauma. *Bocio* functioned in a certain sense as counterfoils and complements to such problems, responses to what Clifford Geertz discussed (1983: 55–70) in terms of psychopathology encouraged by social disorder. The visual power of *bocio* objects reveal in key respects the social and personal impact of such insecurity and disempowerment. This is an art in which a full range of anxieties is manifestly felt. And in so far as anxiety derives from the feeling of helplessness that fear evokes, *bocio* help to relieve related concerns in the face of life's lesser and greater traumas. Works of this sort no doubt were made and used prior to the slave trade. Indeed the specific problems which these works are commissioned to address include a range of personal and familial concerns which sometimes had little relation to war or slavery. None the less, these sculptures appear to have assumed special poignancy and meaning in the area owing to the often difficult circumstances promoted by the slave trade. Related images express what Marcuse calls (1978: 19–20) a "consciousness of crisis" (*Krisenbewusstsein*).

The power of *bocio* counteraesthetics

Questions of the social and psychological grounding of *bocio* arts are addressed in provocative ways in the potent aesthetic concerns which they define. *Bocio* aesthetic criteria accordingly offer a unique ground against which to explore questions of art, power, and expression generally. Perhaps not surprising in light of the above discussion of political difference and distance, *bocio* aesthetic signification is closely bound up with societal (and countersocietal) values such as dissonance, force, destruction, decay, and danger. *Bocio* arts, as we will see, express not only an aesthetic of negativity, but also what Kristeva calls *frappe* or shock.

With these works, as in any art corpus identified so closely with social and psychological expression the aesthetic criteria used in sculptural evaluation are complex. The "strong" object, explains Sagbadju (7.1.86), "is not something of beauty." Ayido observes similarly (5.2.86) that "one does not need to carve a sculpture so that it is attractive in order to have it work." In art as in life, two terms are employed by the Fon to indicate general attractiveness: *aco* and *dɛkpɛ*. The former refers to things which are ornamental, delicate, refined, decorative, dressed, and tidy, and the latter designates ideas of beauty, elegance, and attractiveness generally. The vast majority of commoner *bocio* clearly stand out in marked contrast to these two aesthetic ideals. These sculptures are not ornamental, refined, elegant, or attractive in any standard sense of the words. Nor do these figures conform to the variant secondary aesthetic criteria that are said by Fon artists to be important to them in evaluating beauty in sculptural form. The latter include qualities such as youthfulness (*dekpe*—beauty in Fon is synonymous with youth), smoothness (*didi*), completeness (*bisese*), and correctness (*pepe*). As we have seen within commoner *bocio*, there also is little to suggest youthful grace, surface polish, a sense of finish, or exacting anatomical detail.

These lacks are all the more striking in view of the strong emphasis in the kingly *bocio* arts which is given to refined features and attributes which are elegant, ornamental, polished, and exacting in form. Thus whereas Fon royal *bocio* arts conform in essential ways to local beauty criteria, commoner works emphasize counteraesthetic, even antiaesthetic values and features of ugliness. The counteraesthetics of commoner *bocio* arts are of considerable interest in this light because they constitute in essence the aesthetic of choice of the subaltern groups living in this area—the rural residents, nonroyals, and those generally suffering from the effects of disempowerment.

What is suggested here is that artists of commoner *bocio*, aware of the diminished political statuses of their patrons, to some extent reified the latter's positions by emphasizing certain counteraesthetic features in their arts. The two Fon terms used to indicate a negation or lack of beauty, *magnon* (which also signifies "ignorant" and "unschooled") and *gnlan kan* (designating "bad" or "beastly"—literally "bad cord"), suggest a complementary emphasis on attributes perceived to be rural or outside the encultured mainstream, as defined by the elite. The artists, activators, and users of commoner *bocio*, by intentionally avoiding qualities associated with beauty and refinement in royal art contexts, promoted status difference through privileging antithetical forms of aesthetic expression. While associated concerns were never discussed by local artists or *bocio* users, the visual differences between commoner and royal *bocio* aesthetic expression are striking.

Secondary aesthetic criteria employed to designate the lack or negation of beauty (*magnon* and *gnlan kan*) underscore these status differences in interesting ways. One feature said to characterize works showing a lack or negation of beauty is messiness (*gudu gudu*: disorderly, piggish, mixed up, troubled; from *gu*, designating things which are spoiled, corrupted, inutile, wasted, or negated). Commoner *bocio*, in conforming to this counteraesthetic of messiness and disorder, may in some way be seen to complement the confusion and disorder that defined many of their users' lives. In local divination sessions in which commoner *bocio* are discussed, these concerns come up with considerable frequency.

Three other values said to characterize commoner *bocio* counteraesthetics also have important sociopolitical and psychological complements. These include fury (*adan*), strength (*sien*, "resistant," "solid"), and force (*hlon hlon*). Associated qualities are revealed most importantly in audience responses to *bocio* . . . Like *gudu*, "disorderly," the above also offer insight into *bocio* signification. Accordingly, *adanwato*, "father of fury," is the term frequently used to describe powerful people in the community who are able to bring their influence to bear on others living around them. . . . Each *bocio* serves similarly as an "object of fury," something which accords its users considerable power. Ancillary meanings of the term *adan*, the most important of which are audaciousness, anger, intrepidness, hardness, courage, coerciveness, and scolding (Segurola 1963: 4), also are of interest. In their roles as aggressive and protective forces, *bocio* display similar values. Supplemental associations of the Fon term *hlon hlon* ("force") carry provocative secondary meanings as well, in this case, of violence, vengeance, and vindictiveness (Segurola 1963: 227). These attributes complement at once the sometimes embattled social and political contexts in which such objects are made and the force that is thought to be necessary to counter danger and difficulties that lie in life's path.

The selection of *bocio* materials for their physical and metaphoric strength and the emphasis in these works on knotting and tying suggest in turn the strength (*sien*) which these objects are intended to express through their forms and functioning. The prominent use of raffia cord, with its characteristic solidity and resistance, is significant too, for comparable strength is essential to *bocio* roles in turning away danger and discord from their various owners. Appropriately ancillary meanings of the counteraesthetic term *sien* designate things which are courageous, insistent, secure, resistant, persevering, tenacious, forceful, severe, opinionated, hardheaded, and hardened (Segurola 1963: 471). Similar qualities are vital to

bocio in their roles in helping one to survive or better one's condition in life. Seeing these and related visual properties within sculptural form no doubt gave local viewers a sense of assurance and security in the face of various difficulties. Through emphasizing aesthetics of shock which in various ways privilege conflict, contradiction, chaos, obscurity, mystery, and brute force, these works convey an emotional energy of considerable potency.

[. . .]

References

Blier, Suzanne Preston (1988) "Melville J. Herskovits and the Arts of Ancient Dahomey," *Res* 16 (Autumn): 124–42.

Curtin, Philip D. (ed.) (1967) *Africa Remembered: Narratives by West Africans from the Era of the Slave Trade*, Madison: University of Wisconsin Press.

Curtin, Philip D. (1969) *The Atlantic Slave Trade: A Census*, Madison: University of Wisconsin Press.

Douglass, Frederick ([1883] 1972) *The Life and Times of Frederick Douglass*, New York: Bonanza Books.

Fanon, Frantz (1968) *The Wretched of the Earth*, trans. Constance Farrington, New York: Grove Press.

Friedman, W.B. (1956) "Changes in Property Relations," *Transactions of the Third World Congress of Sociology*: 1–2.

Geertz, Clifford (1983) *Local Knowledge: Further Essays in Interpretive Anthropology*, New York: Basic Books.

Glélé, Maurice Ahanhanzo (1974) *Le Danxomè: Du pouvoir Aja à la nation Fon*, Paris: Nubia.

Herskovits, Melville J. [1938] (1967) *Dahomey: An Ancient West African Kingdom*, vols 1 and 2, Evanston, Ill: Northwestern University Press.

Law, Robin (1991) *The Slave Coast of West Africa 1550–1750: The Impact of the Atlantic Slave Trade on an African Society*, Oxford: Clarendon Press.

Manning, Patrick (1982) *Slavery, Colonialism, and Economic Growth in Dahomey, 1640–1960*, New York: Cambridge University Press.

Marcuse, Herbert (1978) *The Aesthetic Dimension: Toward a Critique of Marxist Aesthetics*, Boston: Beacon Press.

Polanyi, Karl, with Abraham Rotstein (1966) *Dahomey and the Slave Trade: An Analysis of an Archaic Economy*, Seattle: University of Washington Press.

Segurola, R. Père B. (1963) *Dictionnaire Fon-Française*, Cotonou: République du Benin Procure de L'Archidiocèse.

Taussig, Michael (1987) *Shamanism, Colonialism and the Wild Man*, Chicago: University of Chicago Press.

Finbarr Barry Flood

BETWEEN CULT AND CULTURE: BAMIYAN, ISLAMIC ICONOCLASM AND THE MUSEUM

He turned his head like an old tortoise in the sunlight. "Is it true that there are many images in the Wonder House of Lahore?" He repeated the last words as one making sure of an address. "That is true," said Abdullah. "It is full of heathen *būts*. Thou also art an idolater."

"Never mind *him*," said Kim. "That is the Government's house and there is no idolatry in it, but only a Sahib with a white beard. Come with me and I will show."

—Rudyard Kipling, *Kim*

In other words, the unique value of the "authentic" work of art has its basis in ritual, the location of its original use value. This ritualistic basis, however remote, is still recognizable as secularized ritual even in the most profane forms of the cult of beauty.

—Walter Benjamin, "The Work of Art in the Age of Mechanical Reproduction"[1]

THERE CAN BE LITTLE DOUBT that the recent destruction of the monumental rock-cut Buddhas at Bamiyan by the former Taliban government of Afghanistan will define "Islamic iconoclasm" in the popular imagination for several decades to come (Figs. 39.1, 39.2). To many commentators, the obliteration of the Buddhas seemed to hark back to a bygone age, reinforcing the widespread notion that Islamic culture is implacably hostile to anthropomorphic art. Even those who pointed to outbursts of image destruction in medieval and early modern Europe saw these as stages on the road to Western modernity;[2] the persistence of the practice in the Islamic world seemed to offer implicit proof of an essential fixation on figuration fundamentally at odds with that modernity.

Common to almost all accounts of the Buddhas' demolition was the assumption that their destruction can be situated within a long, culturally determined, and unchanging tradition of violent iconoclastic acts. Collectively or individually, these acts are symptomatic of a kind of cultural pathology known as Islamic iconoclasm, whose ultimate origins, to quote K.A.C. Creswell's telling comment, lie in "the inherent temperamental dislike of Semitic races for representational art."[3] The iconoclastic outburst of Afghanistan's rulers thus

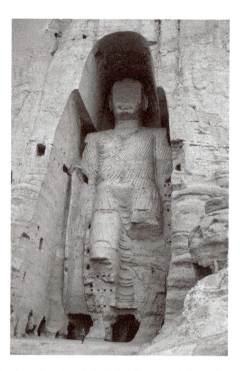

Figure 39.1 Large Buddha (exterior, from below); Kushan period, 1st–5th century, before destruction, Bamiyan, Afghanistan. Photo: Richard Edwards, 1968. University of Michigan History of Art VRC, ACSAA # 2871. © Asian Art Archives, Univ. Michigan (AAAUM).

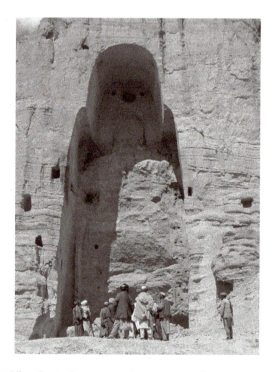

Figure 39.2 Large Buddha, after its destruction in 2001, Bamiyan. © Reuters/CORBIS.

confirmed the status of that country as out of time with Western modernity, by reference to an existing discourse within which image destruction indexed the inherently medieval nature of Islamic culture.[4] As Carl Ernst has noted recently, the traditional one-dimensional portrait of Muslim iconoclasm "does not acknowledge its subjects as actors in historical contexts."[5]

The conception of a monolithic and pathologically Muslim response to the image, which substitutes essentialist tropes for historical analysis, elides the distinction between different types of cultural practices. It not only obscures any variation, complexity, or sophistication in Muslim responses to the image but also a priori precludes the possibility of iconoclastic "moments" in Islamic history, which might shed light on those complex responses.[6] To use a European analogy, it is as if the destruction of pagan images by Christians in late antiquity, the mutilation of icons in ninth-century Byzantium, the iconoclastic depredations of the Reformation, and the events of the French Revolution could all be accommodated under the single rubric Christian iconoclasm.

The methodological problems stemming from the naturalization of historical acts need hardly be highlighted, and they are compounded by three further aspects of traditional scholarship on Islamic iconoclasm. The first is the idea that Islamic iconoclasm is the product of a specific theological attitude, with only secondary political and no aesthetic content. A second, closely related assumption is that the iconoclastic acts of medieval Muslims were primarily directed at the (religious) art of the non-Muslim "other."[7] The third, and most striking, peculiarity of the existing discourse on iconoclasm in the medieval Islamic world is that, remarkably for a practice that concerns the physical transformation of material objects, such discussions are almost always confined to texts, making only passing reference to surviving objects, if at all. Moreover, the dominance of the text has been marked by the essentialist approach to Islam and the image referred to previously, with a corresponding failure to interrogate or problematize the vocabulary of iconoclasm. Despite the abundant material evidence, there is, as yet, not a single systematic survey (textual or material) of what precisely was done in any region of the medieval world to images by Muslims who objected to them. As a result, rhetorical claims of image destruction have often been taken at face value, even when not borne out by archaeological or art historical evidence.[8]

In this short paper, which deals with a broad sweep of material, I want to draw attention to some of the problems with the traditional paradigms that I have just outlined, to illustrate some of the many paradoxes that complicate our notion of Islamic iconoclasm, and to highlight areas for future investigation. Although there are other facets of the history and historiography of Islamic iconoclasm that merit analysis,[9] my aim here is twofold. First, I want to undertake a critique of essentialist conceptions of Muslim iconoclasm that draws attention to the fact that figuration has been a contested issue even between Muslims and that emphasizes that there have been iconoclastic "moments" in Islamic history when the debate (and its physical correlate in image destruction) waxed in intensity. Second, I intend to highlight some complementary political aspects of what has largely been conceived of as a theological impulse. Both of these concerns inform the historical overview of iconoclastic practice in the first two sections of the essay, which provide the context for an analysis of the Bamiyan episode that follows in the third and final section.

The primary focus will be on the iconoclastic practices of Muslims living in the eastern Islamic world, especially Afghanistan and India. If I ignore the relationship with Byzantium here, it is primarily to compensate for an ethnocentric bias that has led to the discourse on figuration in the Islamic world being dominated by the arts of Christendom and the Mediterranean. These are, in any case, less relevant to the eastern Islamic world in the tenth through twenty-first centuries than they are to the Levant in the eighth.[10] The discussion is intended to construct a context for the final part of the essay, in which the destruction of the Bamiyan Buddhas will be reconsidered. It will be argued that their obliteration indexed not a

timeless response to figuration but a calculated engagement with a culturally specific discourse of images at a particular historical moment.

Proscriptive texts and iconoclastic praxis

The opposition to figuration in Islam is based not on Qur'anic scripture but on various Traditions of the Prophet, the Hadith.[11] The two principal objections to figuration in the prescriptive texts are a concern with not usurping divine creative powers[12] and a fear of *shirk*, a term that came to mean polytheism and idolatry but originally meant associating other gods with God.[13] Both suggest a concern with the materialism of worship in non-Islamic traditions. While Muslim polemicists frequently accused those of other faiths of indulging in polytheism and idolatry, however, it is important to remember that such accusations were a stock-in-trade of medieval religious polemics, even monotheist polemics.[14] Muslims themselves are often accused of idolatry in Christian and Jewish polemical texts, which might compare Muslim veneration of the Ka'ba and the practices associated with it to those of the (self-evidently idolatrous) Hindus.[15]

There is a general consensus in the Hadith forbidding all representations that have shadows (whose defacement is obligatory), and some schools of thought go so far as to liken artists to polytheists.[16] Such proscriptions were undoubtedly a factor in both promoting aniconism (the eschewal of figural imagery) and motivating acts of iconoclasm (the destruction or mutilation of existing figural imagery), but their impact on the arts in general varied greatly according to time and place.[17] After initial experiments, the substitution of text for figural imagery on gold coins in 696–97 (and on silver two years later) marked a decisive moment in the development of an official iconography, with the epigraphic issues of the Umayyad caliphate establishing an enduring precedent for Islamic numismatics.[18] Even after this date, however, variations in attitudes to figuration existed, for some later Islamic rulers issued coins bearing figural imagery.[19]

The decoration of early Islamic palaces, lavishly ornamented with sculpture and paintings containing anthropomorphic elements (including Christian priests and churches), stands in contrast to the religious architecture of the same period, in which the ornament is primarily vegetal and epigraphic.[20] The aniconic decoration of the Dome of the Rock in Jerusalem (691–92) and of early Islamic mosques points to a distinction between secular and religious art, which is clearly demonstrated in the facade of the mid-eighth-century palace of Mshatta in Jordan, on which the use of figural ornament is interrupted at a point corresponding to the location of an interior mosque.[21] There are, however, anomalies: it was only in 785 that the figures (*tamāthīl*) on a silver Syrian censer donated by the caliph 'Umar (r. 634–44) to the mosque of Medina were rendered innocuous (probably by decapitation; see below) by the governor of the city.[22] This remedial action falls within the period in which the earliest traditions regarding images were codified, according to a recent reevaluation, hinting at further shifts in attitudes to figuration between the late seventh and late eighth centuries.[23]

Detailed studies of figural ornament in medieval Islamic religious architecture are few and far between (medieval Anatolia being better represented than most other regions of the Islamic world in this respect),[24] but as a general rule, figuration continued to be eschewed in the decoration of medieval mosques and *madrasas* (religious schools). Occasional exceptions include pre-Islamic monuments converted for use as mosques, in which figural ornament was often, but not always, defaced.[25] In those mosques and *madrasas* where figural ornament did appear,[26] it was generally avoided in the area around the prayer niche (mihrab), in accordance with specific injunctions, but even here exceptions exist.[27]

By contrast, anthropomorphic and zoomorphic images proliferated in the secular arts. The ubiquity of figural ornament is especially noticeable in the arts of the eastern Islamic world from the eleventh century on, where one finds even three-dimensional sculpture produced in a wide range of media.[28] Neither abstract ornament nor epigraphy (which assumed some of the iconographic value of figural ornament) was immune to the tendency toward figuration, with ambiguous zoomorphic forms emerging from vegetal scrolls and the stems of letters inscribed on some medieval objects acquiring heads, eyes, and other anthropomorphic facial features (Fig. 39.3).[29]

There is no evidence to suggest that the divine image was represented in the Islamic world (despite occasional tendencies toward anthropomorphism), but in the eastern Islamic world, depictions of the prophet Muhammad survive from the thirteenth century on.[30] In later paintings the Prophet is sometimes (but not always) portrayed with his face veiled or otherwise obscured; this reticence about the face finds a counterpart in the activities of medieval iconoclasts in the Islamic world, as we shall see below.

The profusion of figural ornament in every imaginable artistic medium attests that the gap between proscription and practice could be a wide one. Medieval Islamic attitudes to figuration varied from individual to individual and could change over time, or with the advent of new political regimes with different cultural values. Consequently, Muslims opposed to icons of various sorts, whether the art of previous Muslim generations or those of the cultures with which Islam came in contact, developed practical strategies for dealing with them. Just as rabbinical tradition suggested ways of neutralizing existing images that satisfied the spirit (if not always the letter) of Jewish proscriptions on figuration, so the Hadith afforded some guidance as to what to do with images.[31] Two basic alternatives emerge from the various Traditions dealing with figuration: recontextualization in a manner that made clear that the images were in no way venerated (by reusing figural textiles as floor cushions, for example), or decapitation, so that they became inanimate, that is, devoid of a soul (*rūḥ*).[32] Interestingly, no distinction appears to be made between two-dimensional and three-dimensional

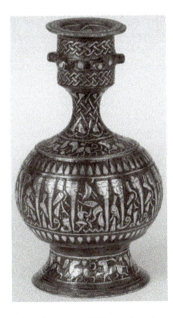

Figure 39.3 Rosewater sprinkler with anthropomorphizing epigraphy, eastern Iran or Afghanistan, bronze, c. 1200, inv. no. 65/1998. © The David Collection, Copenhagen.

representations. Defacement (or the mutilation of the affective parts of the face, such as the eyes and nose) often substituted for decapitation, a practice that finds a precedent in early accounts of the prophet Muhammad's iconoclastic activities, such as this passage in the ninth-century *Book of Idols*:

> When on the day he conquered Mecca, the Apostle of God appeared before the Ka'bah, he found the idols arrayed around it. Thereupon he started to pierce their eyes with the point of his arrow, saying, "Truth is come and falsehood is vanished. Verily, falsehood is a thing that vanisheth [Qur'an 17:81]." He then ordered that they be knocked down, after which they were taken out and burned.[33]

Although the phenomenon has never occasioned serious study, from medieval Andalusia to Iran one finds all of the practices outlined above employed by Muslims against images created by other Muslims.[34] Some of this iconoclastic activity undoubtedly arose from individuals acting on their own initiative. A good example of such private initiative is described amid a lively account by the Ottoman writer Evliya Çelebi of an auction of fine goods held by the pasha of Bitlis in eastern Anatolia in 1655. Potential bidders apparently were allowed to peruse the goods in their quarters overnight, for our tale concerns one individual who showed a penchant for an illustrated manuscript of the *Shāh-Nāma*, the Persian Book of Kings:

> When the witty fellow brought it to his tent and began leafing through, he saw that it contained miniatures. Painting being forbidden according to his belief, he took his Turkish knife and scraped the narcissus eyes of those depicted, as though he were poking out their eyes, and thus he poked holes in all the pages. Or else he drew lines over their throats, claiming that he had throttled them. Or he rubbed out the faces and garments of the pretty lads and girls with phlegm and saliva from his mouth. Thus in a single moment he spoiled with his spit a miniature that a master painter could not have completed in an entire month. . . . When the auctioneer opens the book and sees that all the miniatures are ruined, he cries, "People of Muhammed! See what this philistine has done to this *Shāh-nāme*. . . . he poked out the eyes or cut the throats of all the people in the pictures with his knife, or rubbed out their faces with a shoe-sponge."[35]

That the offending iconoclast was eventually lashed and stoned as his punishment for defacing the manuscript serves as a reminder of just how contested the issue of figuration could be, even between Muslims. The drawing of a line across the throat should be understood (as the auctioneer clearly understood it) as a symbolic decapitation, which in the case of other painted images and sculptures often found more literal expression (Figs. 39.4, 39.5). The practice is attested by a number of surviving manuscripts and miniature paintings, most famously the thirteenth-century St. Petersburg *Maqāmāt* (Fig. 39.6).[36] Equally, the efface-ment (or, more correctly, defacement) of the image and the particular focus on the eyes are consistently evident in the work of Muslim iconoclasts from the early Islamic period on (Fig. 39.7), although by no means exclusive to them.[37]

The anecdote cited above illustrates the uneven and sometimes inconsistent ways in which a lingering unease with figuration in the Islamic world could serve to inspire the icono-clastic practices of pious individuals. In addition to such individual initiatives, it is possible to identify "state-sponsored" iconoclastic moments whose primary target could be either the symbols of the "other" or the art produced during the reigns of Muslim predecessors. The edict against images issued by the caliph Yazid in 721 is an early example of the first type, even

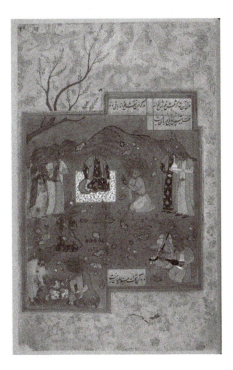

Figure 39.4 Princely feast, from the *Khamsa* of Nizami, Iran, 1574–75, with later iconoclastic alterations. London, India Office © The British Library Board. (Library ms 1129, fol. 29.)

Figure 39.5 Luster tile, Iran, early 14th century, with later iconoclastic alterations (the heads of the birds removed). Faience; painted with lustre and cobalt blue. IR-1363–1365. The state Hermitage Museum, St. Petersburg. Photograph © The State Hermitage Museum/photo by Vladimir Terebenin, Leonard Kheifets, Yuri Molodkovets.

if recent research suggests that contemporary alterations of church mosaics are likely to have been undertaken by local Christian communities rather than knife-wielding iconoclasts sent by the caliph.[38] Whether these changes resulted from internal scruples about figuration or external pressure generated by Muslim opposition to images is unclear, but the central issue, within early Muslim-Christian polemic, was the veneration of icons rather than the question

Figure 39.6 *Maqāmāt* of al-Hariri, Iraq, c. 1240, with later iconoclastic alterations, fol. 32v. St Petersburg. The Russian Academy of Sciences.

Figure 39.7 Reused capital with face removed, probably at the time of construction, late 12th or early 13th century. Qutb Mosque, Delhi. Reproduced with permission of Finbarr Barry Flood.

of images per se.[39] Moreover, as the embodiment of both a major doctrinal difference between Christianity and Islam (the resurrection of Christ) and a symbol of Christian hegemony associated with the Byzantine enemy, the cross was a more consistent target of iconoclastic polemics than the icon.[40] In this regard, it might be compared to the *minbar* (pulpit) in a mosque, which was the place from which the loyalty of the community to a given ruler was publicly affirmed in the sermon (*khuṭba*) each Friday. As a symbol of both religious and political authority, the *minbar* no less than the cross was also targeted for desecration or destruction by those Muslims who rejected the political authority that it embodied, often for religious reasons.[41]

An iconoclastic moment of the second type, primarily directed against the art produced by earlier Muslims (although it included the destruction of Hindu icons), occurred in Delhi in the fourteenth century. This was part of a broader reassertion of orthodoxy by Sultan Firuz Shah Tughluq (r. 1351–88), who records its impact in his apologia:

> In former times it had been the custom to wear ornamented garments, and men received robes as tokens of honor from kings' courts. Figures and devices were painted and displayed on saddles, bridles, and collars, on censers, on goblets and cups, and flagons, on dishes and ewers, in tents, on curtains and on chairs, and upon all articles and utensils. Under Divine guidance and favour I ordered all pictures and portraits to be removed from these things, and that such articles only should be made as are approved and recognised by Law [*Sharīʿa*]. Those pictures and portraits which were painted on the doors and walls of palaces I ordered to be effaced [*maḥw*].[42]

Archaeological evidence suggests that ceramic vessels with figural imagery in Firuz Shah's palace were indeed smashed at this time, while contemporary texts refer to prohibited images being replaced with depictions of gardens and trees, in accordance with the proscriptions on figuration.[43]

As far as we can tell, the practices described by Firuz Shah Tughluq are similar to those employed against images carved on the architectural elements from Hindu temples reused in Indian mosques during the preceding century (Fig. 39.7). A considerable investment of energy and resources evidently went into both undertakings, reminding us that the determinants of iconoclasm are not just political or religious but also economic, and that the iconoclastic process can be bureaucratic, calculated, and protracted.[44] The picture is further complicated by the fact that many instances of Islamic iconoclasm, including those witnessed in early Indian mosques, appear to be the product of a negotiation between iconoclasts and iconophiles, with the latter modifying existing images either for financial remuneration or to prevent more extensive alterations by those opposed to figuration.[45] This being so, it might be useful to make a distinction here between *instrumental* iconoclasm, in which a particular action is executed in order to achieve a greater goal, and *expressive* iconoclasm, in which the desire to express one's beliefs or give vent to one's feelings is achieved by the act itself.[46]

In many cases, the use of decapitation and defacement by Muslim iconoclasts represents not expressive iconoclasm but a type of instrumental iconoclasm, for it permitted the licit survival of preexisting images in the prescribed way, albeit in altered form. Destruction is, by its nature, difficult to confirm, but all the evidence indicates that iconoclasts in the medieval Islamic world only rarely destroyed images, in the sense of physically obliterating them. This is true even for those textual accounts of expressive iconoclasm that appear to describe clear-cut cases of image destruction. In 1528, for example, the Mughal emperor Babur (r. 1526–30) recorded his response to a number of monumental rock-cut Jain tirthankaras encountered on a visit to a suburb of Gwalior: "On the southern side is a large idol, approximately 20 yards tall. They are shown stark naked with all their private parts exposed. . . .

Urwahi is not a bad place. In fact, it is rather nice. Its one drawback was the idols, so I ordered them destroyed."[47] An archaeological coda to Babur's tale indicates that "destruction" did not involve the total obliteration of the images, which survived minus their heads, and were later provided with stucco replacements.[48] Evidently, references to destruction in medieval texts and inscriptions, whether referring to images or buildings, need to be treated with caution. This is not necessarily because such texts were written to deceive (although we should consider the claims they make in relation to the audience that they addressed) but because "destruction," in Arabic and Persian texts and epigraphs, like "reconstruction" in Roman texts, "was a general and non-denotative ideal, the expression of which could take several forms."[49]

Just as references to reconstruction in Roman rebuilding texts may "have been more visually meaningful to the reader in the context of an improved surface appearance with minimal structural change,"[50] so "destruction" in medieval Islamic texts could meaningfully refer to transformations of buildings and objects that fell far short of physical obliteration. When motivated by iconoclasm, such transformations are consistently focused on the head and face; although Babur was apparently offended by the nudity of the Jain images, he "destroyed" them by amputating the head rather than any other body part. This is consistent with iconoclastic practice elsewhere in South Asia and in other parts of the Islamic world.[51] In some cases, desecration and ritual defilement were considered sufficient to "destroy" religious icons by demonstrating their impotence in the face of such an affront, an intention that also underlies some iconoclastic practice in medieval Europe.[52] Seen in this light, the dichotomy between creation and destruction that underlies much writing on iconoclasm offers too reductive a reading of iconoclastic practice.[53] As the Hadith dealing with images suggest, and iconoclastic practice in the medieval Islamic world implies, this was less an attempt to negate the image than to neutralize it.

Religious "otherness" clearly was not the sole determinant of Islamic iconoclasm, for, as the examples scattered throughout this essay indicate, the kinds of iconoclastic practices associated with the treatment of non-Islamic imagery by medieval Muslims were indistinguishable from those that Muslim iconoclasts employed against images made by their co-religionists. In terms of these practices, Muslim iconoclasts are themselves indistinguishable from other types of iconoclasts, for the same focus on the head and face is a feature of Roman, Early Christian, and Byzantine iconoclasm, and the eyes of fifteenth-century Catholic images were scratched out by sixteenth-century Protestant reformers, even as French revolutionaries decapitated the icons of the ancien régime.[54] In all of these cases, "The aim is to render images powerless, to deprive them of those parts which may be considered to embody their effectiveness. This is why images are very often mutilated rather than wholly destroyed."[55] The undertaking highlights a fundamental ambiguity regarding the status of the image, which lies at the heart of much iconoclastic practice. The destruction of the idol assailed by the prophet Muhammad in the passage from the *Book of Idols* cited above is divided into different moments, which seem to index respectively a process of neutralization and destruction often repeated in later Muslim encounters with idols.[56] The hiatus between the two moments is a crucial one, suggesting as it does that the idol is imbued with a degree of animation or efficacy, whose source is to be sought perhaps in the supernatural presences inhabiting some of the idols encountered in other accounts of the Prophet's iconoclastic activities.[57] The notion that the image is the abode of a malign spirit or that it possesses quasimagical powers,[58] which seems to underlie the concern shown by the Hadith with "deanimating" existing images by depriving them of the potential to possess breath or spirit *(rūḥ)*, contrasts with the emphasis on the impotence of idols and images in most writings on the subject within the Old Testament tradition espoused by Islam.[59] The idea that the image is both inert matter and the potential abode of evil or malevolent spirits is, however, common to both Zoroastrian and Early

Christian polemics against images.[60] The ambiguities arising from the dual status of the image are reflected in the practices of Muslim iconoclasts in South Asia (and undoubtedly elsewhere), a point well made by André Wink:

> It was essential to render the image powerless, to remove them from their consecrated contexts. Selective dilapidation could be sufficient to that purpose. It is hard to gauge the depth of religious convictions here. Did fear play a role in the iconoclastic destruction of the early Muslim conquerors in India? Were the images destroyed, desecrated or mutilated because they were potent or impotent?[61]

To put the question another way, should the drawing of a line across the throat be understood as "an effort to indicate the inanimate and therefore nonreal status of the figures,"[62] or as an attempt to deprive them of the possibility of animation, as the Hadith seem to imply? One answer lies in the way images were treated, and the focus on the head, eyes, and nose. This may have been intended to neutralize images in a manner determined by Prophetic precedent, but it also accords with the way in which shame, transgression, or lack of fidelity was inscribed on the body of contemporary living beings. It is particularly striking that the Hindu icons destroyed as part of Firuz Shah Tughluq's reassertion of orthodoxy were burned in a place otherwise reserved for public executions and the punishment of criminals.[63]

The treatment of anthropomorphic images as if they were animate beings is a recurring characteristic of pre- and early modern iconoclasm that was already apparent to medieval observers.[64] In his description of the damage done to Christian images in the churches of Antioch during the Seljuq occupation of the city in the late eleventh century, William of Tyre notes:

> The pictures of the revered saints had been erased from the very walls—symbols which supplied the place of books and reading to the humble worshippers of God and aroused devotion in the minds of the simple people, so praiseworthy for their devout piety. On these the Turks had spent their rage *as if on living persons;* they had gouged out eyes, mutilated noses, and daubed the pictures with mud and filth.[65]

If we are to believe recent anthropological and art historical scholarship on iconoclasm, the "confusion" of signifier and signified noted here arises from a universal tendency to invest the image with the capacity for animation to varying degrees.[66] Visiting vengeance or shame on the image as if on the body of a living person, iconoclasts engage with the image as if it were animate. Reports of Taliban officials reproving the statue of a seminaked bodhisattva in the Kabul Museum by slapping it across the face suggest how remarkable the degree of engagement with the icon can be. I will return to this episode below.

Bamiyan and medieval Afghan iconoclasm

The rock-cut tirthankaras of Gwalior that offended Babur recall the Bamiyan Buddhas in more than stature or medium; the latter may also have been the target of medieval iconoclasts. Even before their destruction in 2001, both Buddhas were faceless above chin level (Fig. 39.8).[67] Ironically, many of those who bemoaned the destruction of the Bamiyan Buddhas but were unfamiliar with them assumed that this fate was illustrated by images of the Buddhas *before* the Taliban had attacked them. It has often been stated that the Buddhas were originally provided with masks of wood or copper, but little evidence has been adduced for this. It is equally possible that the upper parts of the faces were deliberately mutilated,

Figure 39.8 Small Buddha, Bamiyan, detail of the face before destruction. Photo courtesy of the Conway Library © Courtauld Institute of Art.

reflecting the activities of medieval iconoclasts, for whom the face would have been an obvious target.[68] Buddhist monastic institutions in the Bamiyan Valley suffered iconoclastic damage even before the advent of Islam: in the fifth or early sixth century the Hephtalite ("White Hun") ruler Mihirikula, who had Shaivite leanings and was opposed to Buddhism, is said to have destroyed the monastic settlement at Bamiyan.[69] Despite such setbacks, Buddhism continued to flourish here after the advent of Islam, for there were practicing Buddhists in the valley as late as the ninth or tenth century, and even in the eleventh century it was not fully Islamicized.[70] The wealth of the Bamiyan monasteries attracted the attention of hostile rulers, and in 870 the Saffarid ruler Ya'qub ibn Layth (r. 867–79) raided the area, seized a number of precious metal icons, and is said to have destroyed a temple.[71] The removal of the faces, if the result of iconoclastic activity, might have been undertaken at this time, for the practice of defacing pre-Islamic anthropomorphic images was certainly known in eastern Iran in the ninth and tenth centuries. In his history of Bukhara, for example, the tenth-century writer Narshaki describes pre-Islamic doors reused in the Great Mosque of Bukhara, which bore the images of "idols" with their faces erased, but were otherwise intact.[72]

Any iconoclastic transformations of the Buddhas did little to dampen their enthusiastic reception by medieval Muslims, however. Between the tenth and thirteenth centuries, the Bamiyan Buddhas were often referred to in Arabic and Persian literature, where (along with remains of Buddhist stupas and frescoes) they were depicted as marvels and wonders.[73] Several writers emphasize that nowhere in the world can one find anything to equal the Bamiyan Buddhas, popularly known as *Surkh-but* (red idol) and *Khink-but* (gray idol).[74] Medieval accounts of the Bamiyan Buddhas often locate them within discussions of Indian religious practices and iconolatry, topics that were to increasingly preoccupy Arab and Persian

writers as the cultural contacts between eastern Iran and India grew between the tenth and twelfth centuries, the result of military conquest and trade.[75] The idols *(aṣnām)* of Bamiyan were the subject of a lost work by the celebrated scholar al-Biruni, whose book on India, including a sophisticated explication of Indian religion and image worship, has survived.[76]

Paradoxically, this eleventh-century work was written at the court of Mahmud of Ghazna, a historical figure who has assumed a paradigmatic role as the Muslim iconoclast par excellence in South Asia.[77] As was the case in other parts of the Islamic world, iconoclastic practice in medieval Afghanistan existed within a spectrum of responses to the image (religious or otherwise), which also included aesthetic appreciation, awe, fascination, revulsion, and scholarship. An indication of the rather complex attitude to figuration that prevailed at the Ghaznavid court is provided by the ubiquity of three-dimensional sculpture and anthropomorphic reliefs and frescoes, which led to admiring comparisons with idol temples in the work of contemporary poets.[78] References to non-Muslim religious idols *(but)* and idol temples *(but-khāne)* appear elsewhere in the poetry of the period as emblems of physical beauty or indexes of constancy and fidelity to a beloved.[79] Mahmud "the idol-breaker" also issued bilingual Indian coins with a Sanskrit legend in which Muhammad is described as the avatar of God, a concept that, while somewhat unorthodox in an Islamic context, was clearly intended to frame Islamic doctrine within an Indic paradigm.[80] In the following century, Afghan rulers of India went further, continuing coin issues featuring the images of Hindu deities, despite their portrayal in contemporary histories and inscriptions as bastions of religious orthodoxy. However economically sensible this numismatic continuity may have been, it alerts us once again to the divergence between the normative values underlying textual rhetoric and the pragmatic concerns that governed actual practice when it came to the issue of figuration and non-Muslim religious imagery.[81]

Further paradoxes lie in the fact that the central event of Islamic iconoclasm in South Asia concerns not, as one might expect, a precious metal anthropomorphic icon but a *linga*, an aniconic stone image of Shiva, brought to Afghanistan. The *linga* was housed in one of the most celebrated temples of medieval India, which stood in the coastal town of Somnath in Gujarat. In 1025 Mahmud raided Somnath and looted its temple. According to some renditions of the tale, the temple Brahmans attempted to ransom the icon, offering vast amounts for its safety. Mahmud rejected the offer, famously repudiating the idea that he should be known as a broker of idols rather than a breaker of them.[82] The *linga* was subsequently broken, and part of it used to form the threshold of the entrance to the mosque of Ghazna, a practice for which there are earlier textual and archaeological parallels, not just in the Islamic world.[83] The remainder was thrown down in the hippodrome *(maydān)* of Ghazna, where it joined a decapitated bronze image of Vishnu, looted on a previous Indian expedition.[84] According to other accounts, it was set at the entrance to Mahmud's palace, so that the thresholds of both palace and mosque were composed of fragments of the *linga*.[85]

The Somnath episode is traditionally seen as pitting a monolithic South Asian iconophilia against a monolithic Muslim iconophobia. Just as divergent attitudes to images are represented simultaneously in the culture of medieval Afghanistan, however, it is becoming increasingly obvious that the relationship between figuration and veneration in medieval South Asia was considerably more complex than has been acknowledged to date. Images were contested between different sects and faiths, sometimes leading to the desecration and destruction of portable icons or the erasure and mutilation of images in temples and shrines.[86] Such events often occurred at times of military conquest or political change and may be seen as reflecting the close interrelations between centers of political and religious authority in medieval South Asia. The relation between icon and ruler is particularly well documented for the Shiva *linga*,[87] whose looting, display, and desecration clearly carried a powerful political message, even if framed within the context of orthodox conformity.

The looting of portable icons was a common practice in medieval South Asian warfare even before the advent of the Muslims in the eleventh and twelfth centuries.[88] Ignoring the lurid idol-bashing rhetoric of the medieval Islamic sources, therefore, the triumphalism inherent in the seizure and display of the Somnath *linga* in the dynastic shrines of Ghazna was in no way at odds with the rhetoric of contemporary South Asian kingship. What does distinguish Ghaznavid practice is the treatment afforded the *linga* and other looted Hindu icons brought to Ghazna.[89] Although images were sometimes subjected to destruction in medieval South Asia, looted icons were usually treated with respect and incorporated into the victor's pantheon in a subordinate capacity, often as doorkeepers. While invoking the "Hindu trope by which defeated enemies were subordinated into door guardians," the Somnath *linga* became the focus of a kind of performative iconoclasm, recontextualized to be trampled on in a quotidian repudiation of idolatry by the populace of Ghazna.[90] Although this gesture is usually viewed through the lens of religious rhetoric, it also represents the literal enactment of a metaphoric conceit common to medieval Islamic and South Asian rulers by which a victor claims to have trampled the defeated underfoot. The idea is enshrined in the titles of the Ghaznavid sultans, who (along with many other eastern Islamic dynasts) styled themselves "lords of the necks of the people," a title that, while politically charged, was devoid of any sectarian associations.[91] The motif of a victorious ruler trampling a defeated rival was a common expression of royal victory rhetoric that was often adopted by iconoclasts; the use of a shoe sponge to erase the painted faces of book illustrations in the anecdote cited earlier shows how adaptable the concept was.[92] Similar adaptations are evident in medieval South Asia, where epigraphic claims of kings to have placed their feet on the necks of defeated rivals seem to be reflected in a remarkable series of tenth-century images from eastern India (an area contested between Buddhist and Hindu sects) that show Buddhist deities trampling their Hindu equivalents.[93]

Within an Islamic context, the trampling of the displayed icon is a necessary condition of its performance in this theatrical commemoration of victory, for it obviates any accusation that the icon was venerated, extending a general principle established in the Hadith (by which an anthropomorphic image may be tolerated if sat or trampled on) to an aniconic image of Shiva.[94] Other of the Hindu icons displayed in Ghazna were decapitated, in accordance with the alternative mode prescribed for displayed images.

The trampling of the tutelary deities of defeated rulers, no less than their display within the shrines of the victorious, highlights the role of such icons as synecdoches, whose treatment in secondary contexts is directly related to their ability to articulate the idea of incorporation, however notional.[95] In both Islamic and Indic discourses of looting, the recontextualized icon, whether desecrated or venerated, affirmed the center while indexing the shifting periphery. The geographic dispersal of religious authority and political power in the medieval Islamic world was often reflected in the treatment of looted icons. Ya'qub ibn Layth dispatched the icons seized in Bamiyan to the caliph in Baghdad, for example, with a request that they be forwarded to Mecca, thus situating the indexes of his territorial expansion within the key centers of religious and political authority.[96] Mahmud's reported dispatch of fragments from the Somnath icon to Mecca and Medina provides a more literal reflection of this cultural fragmentation.[97]

As a heterotopia dedicated to the collection and display of defunct and antique icons, Mahmud's mosque at Ghazna has much in common with the European museum, especially those museums established to commemorate the work of European missionaries.[98] In both cases selected objects assume a didactic function as visual cognates of a concept of progress indexed by the end of idolatry; the recontextualized idol indexes a bringing into the fold dependent on the shifting economic, cultural, and military frontier. Within the European museum, exotic religious icons could also be assimilated as visually interesting in their own right, and even as art objects, a transmutation reflected in Mark Twain's description of

nineteenth-century Banaras as "a vast museum of idols."[99] The hegemonic connotations of this shift from cult to culture came to the fore in surprising ways during the recent Bamiyan episode.

Mullah Omar and the museum

As the examples discussed above indicate, Muslim iconoclasts have historically availed themselves of a number of options sanctioned by tradition that fall far short of physical obliteration; the Bamiyan Buddhas may themselves have attested this, as did the erasure of the faces of figural images in public places in Kabul after the advent of the Taliban.[100] Although the act invoked the rhetoric of the Islamic past or was represented as a reversion to medieval practice, by either standard the destruction of the celebrated Bamiyan Buddhas was highly anomalous. We may never know for certain why the Taliban altered their previous policy on pre-Islamic antiquities in February 2001. The edict that inspired the action and the various pronouncements that followed suggest, however, that the Taliban's iconoclastic outburst was a peculiarly modern phenomenon, an act that, "under the cover of archaic justifications, functioned according to a very contemporary logic."[101] The timing of the edict, and the fact that it reverses an earlier undertaking to protect the Buddhist antiquities of Afghanistan, suggest these events had less to do with an eternal theology of images than with the Taliban's immediate relation to the international community, which had recently imposed sanctions in response to the regime's failure to expel Osama bin Laden.[102]

The Wahhabi version of Islam espoused by the regime's Saudi guest may have played a role in the events of February 2001, for the destruction of objects and monuments considered the focus of improper veneration has been a characteristic of Wahhabism from its inception.[103] However, as Dario Gamboni has pointed out, "often elaborately staged destructions . . . of works of art must be considered as means of communication in their own right, even if the "material" they make use of is—or was—itself a tool of expression or communication."[104] In this case, the eventual transport of Western journalists to the site to record the void left by the Buddhas' destruction (Fig. 39.2) suggests that the intended audience for this communiqué was neither divine nor local but global: for all its recidivist rhetoric, this was a performance designed for the age of the Internet.

One can make a good case that what was at stake here was not the literal worship of religious idols but their veneration as cultural icons. In particular, there are reasons for thinking that the Taliban edict on images represented an onslaught on cultural fetishism focused on the institution of the museum as a locus of contemporary iconolatry. The uncritical reception of a rationale that appeared to confirm Orientalist constructions of "Islamic iconoclasm" as an essential cultural value served to obscure a number of paradoxes that hint at the broader cultural significance of the events.[105] To begin with, there are no Buddhists left in Afghanistan to explain the curious concern about the worship and respect afforded the idols in Mullah Omar's edict (see App. below), a fact acknowledged in the Taliban's paradoxical statement that the presence of practicing Buddhists in the country would have guaranteed the continued existence of the images.[106] Moreover, it should be borne in mind that the destruction of monumental sculpture was part of a broader iconoclastic program that arguably had its most disastrous effects not on images still in situ but on those housed in what was left of the museums of Afghanistan.[107] According to one report, the Bamiyan episode was initiated after Taliban officials, horrified at being confronted by a seminaked bodhisattva in the Kabul Museum, slapped it across the chest and face.[108]

Apocryphal though this story may be, in subsequent statements, Mullah Omar made clear the perceived relationship between iconolatry and the museum. Faced with the threat

to destroy the Buddhist icons, Western institutions offered to purchase the offending items, in effect legitimizing the practice of looting Afghan antiquities from which some had bene-fited in the preceding decades. In an attempt to save some artifacts, Philippe de Montebello, the director of the Metropolitan Museum of Art in New York, reportedly pleaded with the Taliban, "Let us remove them so that they are in the context of an art museum, where they are cultural objects, works of art and not cult images."[109] The response of Mullah Omar was telling, although its significance was missed at the time. The mullah replied on Radio Sharīʿa by posing the rhetorical question to the international Muslim community: "Do you prefer to be a breaker of idols or a seller of idols?"[110] If the question sounds familiar, it was intended to, for it self-consciously invokes the very words attributed to Sultan Mahmud of Ghazna when confronted with the offer of the Somnath Brahmans to ransom their icon.[111] Although icono-clasm is often stigmatized as an act stemming from ignorance,[112] this was a gesture that was particularly well informed about its own historical precedents. The artful mining of the Islamic past for authoritative precedent recalls Mullah Omar's earlier "rediscovery" of the celebrated *burda* (cloak) of the Prophet, in a Kandahar shrine, which made it possible for him to align himself with a historical chain of caliphs who had earlier laid claim to this cloak of legitimacy.[113]

The significance of these events was not lost in India, where the Somnath episode still resonates politically.[114] In contrast to the dominant Western view that the Bamiyan debacle evidenced the eternal medievalism of Islam, in India it was represented as the return of the repressed. Jaswant Singh, foreign minister of a Hindu nationalist government, told the Indian parliament that India "has been cautioning the world against this regression into medieval barbarism."[115] Accordingly, the traditional tropes of medieval desecration were invoked in a very modern way, with the radical Vishwa Hindu Parishad (World Hindu Council) protesting outside the United Nations headquarters in Delhi threatening to destroy Indian mosques in response to the destruction of the Buddhas.[116] In turn, a Taliban spokesman in New York weakly suggested that the actions in Bamiyan were in fact a (much delayed) response to the destruction of the Babri Mosque at Ayodhya in 1992, in whose wake large numbers of Indian citizens perished in sectarian violence.[117]

The truly global implications of this event derive, however, from the fact that Mullah Omar's words were directed not eastward, toward the Hindus of India or the Buddhist communities beyond, but westward, toward European and American museum directors seeking to ransom the ill-fated images. By his careful choice of language, Mullah Omar appropriated the authority of the Mahmud legend while transposing the Brahmanical guard-ians of a religiously idolatrous past with the museological purveyors of a culturally idolatrous present.[118]

The idea of the museum as the locus of a kind of idolatry may seem absurd, since the distinction between cult icon and art object is an ancient one in Western epistemology and, historically, has tended to be asserted as a defense against radical acts of iconoclasm.[119] Moreover, as a response to French revolutionary iconoclasm,[120] the institution of the museum is itself the signifier of a shift from cult to culture that has indexed the transition to modernity in the West from at least the eighteenth century on.[121] If this was some idiosyncratic misreading of Western cultural institutions and values, however, it finds an uncanny echo in the writing of Walter Benjamin and others, for whom the original use value of the artifact continues to inform its reception as an art object.[122] Although rooted in the "timeless theology of images" paradigm that I have criticized here, the tension between Abdullah's reading of the "Wonder House" of Lahore as the locus of idolatry and Kim's perception of it as a governmental institution for the dissemination of Western rationality in my epigraph anticipates a paradox highlighted in the work of a modern anthropologist such as Alfred Gell:

I cannot tell between religious and aesthetic exaltation; art-lovers, it seems to me, actually do worship images in most of the relevant senses, and explain away their de facto idolatry by rationalizing it as aesthetic awe. Thus, to write about art at all is, in fact, to write about either religion, or the substitute for religion which those who have abandoned the outward forms of received religions content themselves with.[123]

As its etymology (and often its architecture) implies, the museum is a type of secular temple, a "temple of resonance," within which modernity is equated with the desacralization and even "silencing" of inanimate objects by their transmutation into museological artifacts.[124] The ability of these muted idols to speak in novel ways is intrinsic to their existence as art, however. This is clear from one of the foundation documents of the modern museum, Abbé Grégoire's 1794 call for an institution to protect French national patrimony from the depredations of revolutionary iconoclasm: "In this statue, which is a work of art, the ignorant see only a piece of crafted stone: let us show them that this piece of marble breathes, that this canvas is alive, and that this book is an arsenal with which to defend their rights."[125] The work of David Freedberg and Gell suggests that the animation implied here is something more than a metaphoric conceit. As the latter notes, "in the National Gallery, even if we do not commit full-blown idolatry, we do verge on it all the time," a point that the 1978 attack on Nicolas Poussin's *Adoration of the Golden Calf* was presumably intended to underline.[126] It is in the museum that what might be crudely termed the secular and religious discourses of Euro-American iconoclasm coincide. Given the ways in which the aesthetic, economic, and institutional aspects of modernity are articulated around the transmutation of the cult image into cultural icon, it is hardly surprising that in the modern nation-state, the museum rather than the church is the primary target of "traditional" iconoclastic behavior.[127] At the other extreme, occasional attempts to venerate the museological artifact also serve to highlight the often uneasy relationship between cult image and cultural icon.[128] Both in theory and in practice, it seems that the distinction underlying Philippe de Montebello's appeal to the Taliban is far from clear-cut.

As its origins in European religious and revolutionary iconoclasm imply, the institution of the museum, no less than the objects it houses, is a culturally constructed artifact, a product of a particular cultural attitude toward the past. As Gell puts it,

> We have neutralized our idols by reclassifying them as art; but we perform obeisances before them every bit as deep as those of the most committed idolater before his wooden god . . . we have to recognize that the "aesthetic attitude" is a specific historical product of the religious crisis of the Enlightenment and the rise of Western science, and that it has no applicability to civilizations which have not internalized the Enlightenment as we have.[129]

As a product of the European Enlightenment, the museum stands among the range of institutions that construct and project a cultural identity defined in relation to the nation-state.[130] At a global level, the institution is part of the paradoxical interplay between structural similarity and cultural difference that characterizes the "community of nations." The objects it houses are central to its role in articulating and consolidating an idea of a national culture defined in relation to the cultures of this broader community.[131] As Carol Duncan notes, "What we see and do not see in our most prestigious art museums—and on what terms and whose authority we do or don't see it—involves the much larger questions of who constitutes the community and who shall exercise the power to define its identity."[132] Historically, the museum has often served to highlight the hegemonic nature of the "universal" values underlying the concept of nationhood that it embodies.[133] On the one hand, there is the awkward relation between the

museum, colonization, and modernity.[134] On the other, there are the tensions between the idea of the museum as a showcase for national patrimony, the idea of art as a universal human value, and the historical collecting practices of many Euro-American museums vis-à-vis colonial and postcolonial states.[135] The gap between theory and practice here is often obscured by the assertion (implicit or explicit) that the inhabitants of lands such as Afghanistan are incapable of curating their own patrimony. This argument, a stalwart of the colonial era that resurfaced again during the Bamiyan episode, is somewhat ironic given the damage done to many South and Central Asian archaeological sites in the nineteenth century by European scholars collecting for museums.[136] Moreover, it can be argued that the shift in signification inherent in the resocialization of the artifact within the museum, its transmutation from cult image to cultural icon, has much in common with the semiotic structure of iconoclasm itself.[137]

In the destruction of recontextualized museum artifacts, the literal and metaphoric senses of "iconoclasm," the destruction of images and an attack on venerated institutions, coincide.[138] It has been suggested that certain acts of iconoclasm directed against Western museums represent "protests against exclusion from the cultural 'party game' in which only a minority of society participates."[139] Similarly, Taliban iconoclasm can be understood as constituting a form of protest against exclusion from an international community in which the de facto hegemony of the elite nations is obscured by the rhetoric of universal values. As an index of an idea of community that frequently falls far short of the ideal (and nowhere more so than in Afghanistan, where superpowers did battle by proxy), there could be few better targets to make the point. If the destruction of Afghan antiquities in March 2001 represented an attack on "a separate Afghan identity,"[140] this was a concept of identity rooted in the "universal" values of the nation-state. Just as the *linga* from Somnath served to evoke a relationship between Ghazna and the wider (Indic and Islamic) world, the Buddhas in the Kabul Museum referenced the incorporation of Afghanistan into a global community of nations. Their destruction represented the definitive rejection of that ideal in favor of an equally hegemonic notion of pan-Islamic homogeneity constituted in opposition to it.[141] This relationship between the art object, Taliban iconoclasm, and the international community was noted by Jean Frodon in an insightful article on the Bamiyan episode, which appeared in *Le Monde:*

> If a transcendence inhabits these objects, if a belief that the fundamentalists perceive in opposition to their religion is associated with them, it is this and only this: to be perceived as art objects (which evidently was not the meaning that those who sculpted the Bamiyan giants in the fifth century of our era gave to them). This cultural belief, elaborated in the West, is today one of the principal ties uniting what we call the international community (which is far from containing the global population). It is against this, against a rapport with a world valorizing a nonreligious relation with the invisible, that the explosive charges that annihilated the Buddhas were placed.[142]

A further irony lies in the fact that the Afghan Buddhas were ideally suited to play the role assigned to them in the Bamiyan episode, for they first came to the attention of Western scholarship as evidence of a classical European influence on the early medieval art of the region. Indeed, the very idea of representing the Buddha anthropomorphically was ascribed to the impact of "the mysteriously transmitted Grecian touch."[143] Within this epistemological tradition, the origins of both the Bamiyan Buddhas and the museum as an institution lie in the same foundational stratum of classicism on which the universalizing values of the Enlightenment were constructed.[144] It was precisely as a reaction to the hegemonic cultural, economic, and political power of this Enlightenment tradition that the destruction of the Buddhas was undertaken.

The attack on the museum as an institution enshrining idolatrous cultural values resonates with a second rationale offered for the Taliban's iconoclastic edict: that it highlighted the hypocrisy of Western institutions. These "will give millions of dollars to save un-Islamic stone statues but not one cent to save the lives of Afghani men, women and children;" as Sayed Rahmatullah Hashimi, a Taliban envoy to the United States, put it, "When your children are dying in front of you, then you don't care about a piece of art."[145] Here, the concern with the materiality of non-Islamic worship that we saw articulated in the Traditions regarding figuration coincides with a critique of "Western" materialism. The reluctance of the international community to aid Afghanistan, even in the face of a major threat of famine, derived from the earlier imposition of sanctions, an extension to Afghanistan of a type of collective punishment that had previously been visited on the civilian population of Iraq, with devastating effects. It is also worth noting that the destruction of Buddhist antiquities followed an earlier massacre of the minority Hazara population of the Bamiyan Valley, which barely merited a mention in the European and American press, firmly focused as it was on the issue of the Buddhas.[146]

In claiming to be drawing attention to a fetishistic privileging of inanimate icons at the expense of animate beings, the Taliban find themselves in curious company, for there is a striking parallel here with one of the most (in)famous acts of modern European iconoclasm. On March 10, 1914, Mary Richardson slashed Diego Velázquez's celebrated seventeenth-century work *The Rokeby Venus* where it hung in the National Gallery, London (Fig. 39.9). This action, undertaken as part of a broader campaign for universal suffrage, was specifically intended to draw attention to the treatment of the imprisoned Emmeline Pankhurst. In Richardson's own words,

> I have tried to destroy the picture of the most beautiful woman in mythological history as a protest against the government for destroying Mrs. Pankhurst, who

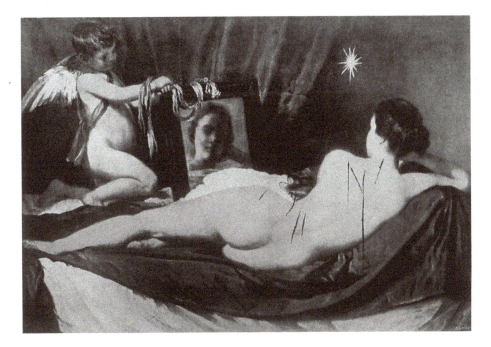

Figure 39.9 Diego Velázquez, *The Rokeby Venus*, detail, ca. 1640–48, after the attack by Mary Richardson in 1914, London, The National Gallery (before the repairs). Picture by Topham/Topham Picture point/ Press Association Images. Courtesy of The Press Association.

is the most beautiful character in modern history. . . . If there is an outcry against my deed, let everyone remember that such an outcry is an hypocrisy so long as they allow the destruction of Mrs. Pankhurst and other beautiful living women, and that until the public cease to countenance human destruction the stones cast against me for the destruction of this picture are each an evidence against them of artistic as well as moral and political humbug and hypocrisy.[147]

Freedberg has pointed out that iconoclasts seeking publicity target art objects precisely because

The work has been adored and fetishized: the fact that it hangs in a museum is sufficient testimony to that, just as the hanging of pictures in churches is testimony to religious forms (or less overtly secular forms) of adoration, worship, and fetishization. Furthermore—especially in the twentieth century—the better the art, the greater the commodity fetishism.[148]

As the "idol of the marketplace," the fetishized art object illustrates the relationship between cultural and financial capital in a manner that highlights "the problem of the nonuniversal and social construction of value."[149] Issues of gender notwithstanding, it was precisely their common role as fetishes of Western modernity that rendered *The Rokeby Venus* and the Bamiyan Buddhas desirable targets for modern iconoclasts opposed to the values that they seemed to embody.[150] Such actions reveal the double nature of the fetishized image or icon, which, as signified, can expose and even avenge wrongs inflicted on living persons, while as signifier, it facilitates "the dismissal of moral judgements passed on the destruction of what 'was only a picture' " in the case of *The Rokeby Venus*,[151] or only stones in the case of the Buddhas. In doing so they exploit the potential of the art object and its associated iconolatry to undermine the subject-object distinction in which Enlightenment epistemology is grounded. As Igor Kopytoff notes in his discussion of the cultural biography of things, "To us, a biography of a painting by Renoir that ends up in an incinerator is as tragic, in its way, as the biography of a person who is murdered."[152] Similar ironies underlie the central paradox of iconoclasm: visiting vengeance on the fetishized icon by slapping, slashing, or smashing, iconoclasts no less than iconophiles engage with the power (if not the animateness) of the image.[153]

None of this is intended to condone the actions of any of the players in the events of March 2001, but it is imperative to recognize that those events have a logic rooted not in the fictions of an eternal or recurring medievalism but in the realities of global modernity. The Bamiyan episode demonstrates the ease with which an index of cultural change rooted in specific historical circumstances can be ascribed to an essential cultural pathology. As I emphasized at the outset, this ahistorical paradigm should be rejected in favor of approaches that historicize iconoclastic events, acknowledging the agency of those involved, examining their motivation, and interrogating the narratives on which we depend for our information, whether courtly histories, fragmentary artifacts, or Radio Sharī'a. In the unfortunate event that the traditional attitude to "Islamic iconoclasm" were to prevail two hundred, five hundred, or one thousand years from now and we came across a reference to the destruction of the Bamiyan Buddhas, we would invariably assume that this was a typically Islamic response to the image. In doing so, we would be overlooking the coexistence between the Buddhas and the Muslim population that marveled at them for over a millennium before they were obliterated by the Taliban. To miss the political portents in this radical break with tradition on the part of the ruling regime would be a serious omission, as subsequent events have demonstrated. Worse still is the fact that to memorialize these events as just one more

example of "Islamic iconoclasm" would be to valorize the monument to their own brand of cultural homogeneity that the Taliban created at Bamiyan.[154]

Appendix

The Taliban's edict on images

This is an unofficial translation of the edict concerning the destruction of religious images, prepared by the United Nations staff in Kabul, which was compiled by the Afghanistan Research Group (ARG) and circulated in an electronic newsletter as "News from Afghanistan" on March 2, 2001. The edict was published in Pushtu by the state-run Bakhtar News Agency and broadcast on Radio Sharīʿa on February 27, 2001. It has not proved possible to obtain a transcript of the original text; the sole transliterated Arabic term was garnered from among the partial translations given in other sources.

Edict issued by the Islamic State of Afghanistan, in Kandahar on the 12th of Rabiul— Awwal 1421 (February 26, 2001): On the basis of consultations between the religious leaders of the Islamic Emirate of Afghanistan, religious judgments of the ulema and rulings of the Supreme Court of the Islamic Emirate of Afghanistan, all statues and non-Islamic shrines located in different parts of the Islamic Emirate of Afghanistan must be destroyed. These statues have been and remain shrines of unbelievers and these unbelievers continue to worship and respect them. God Almighty is the only real shrine [ṭāghūt] and all fake idols should be destroyed.[155] Therefore, the supreme leader of the Islamic Emirate of Afghanistan has ordered all the representatives of the Ministry of Promotion of Virtue and Suppression of Vice and the Ministries of Information to destroy all the statues. As ordered by the ulema and the Supreme Court of the Islamic Emirate of Afghanistan all the statues must be destroyed so that no one can worship or respect them in the future.

Notes

The research for this paper was undertaken while I was an Ailsa Mellon Bruce Senior Fellow at the Center for Advanced Study in the Visual Arts, the National Gallery of Art, Washington, D.C., in 2001. A Smithsonian Senior Fellowship at the Arthur M. Sackler Gallery in Washington, D.C., enabled me to write it in the spring of 2002. I would like to extend a warm thanks to both institutions for their support. My thanks are also due to Zoë Strother, Serpil Bağci, and Massumeh Farhad for bringing various articles and books cited in the course of this essay to my attention, and to the anonymous reviewers of the piece for their insightful comments. For his critical insights and perennially sharp eye. I am particularly grateful to Zahid Chaudhary. Unless otherwise noted, translations are mine.

1 Rudyard Kipling, *Kim* (London: Penguin Books, 1989), 54; and Walter Benjamin, "The Work of Art in the Age of Mechanical Reproduction," in *Illuminations*, trans. Harry Zohn (London: Fontana Press, 1992), 217.

2 Daphné Bézard, "When Europe Also Destroyed Its Images," *Art Newspaper* 116 (July–Aug. 2001): 28.

3 K.A.C. Creswell, "The Lawfulness of Painting in Islam," *Ars Islamica* 11–12 (1946): 166. In fact, it is striking how frequently the language of pathology permeates discussion of the topic. See, for example, Patricia Crone on the ability of Islam to make "epidemic what had hitherto been merely endemic;" Crone, "Islam, Judeo-Christianity, and Byzantine Iconoclasm," *Jerusalem Studies in Arabic and Islam* 2 (1980): 59.

4 There are a number of paradoxes and tensions in the ways in which Islamic iconoclasm was portrayed in the course of the Bamiyan episode, the most obvious being the contradiction between representations of Islamic culture as timeless and unchanging and the assumption that the actions of the Taliban indexed an atavistic reversion to medieval practice that is a recurring feature of Islamic societies; see

n. 115 below. Both representations entail a denial of coevality, which is a common feature of Euro-American discourse on "others" (Johannes Fabian, *Time and the Other: How Anthropology Makes Its Object* [New York: Columbia University Press, 1983], 32–34) and which is particularly acute in relation to representations of Islamic cultures. As Mahmut Mutman notes, in Orientalist discourse, "the West constitutes its own history, its time and itself, among other things, through its difference from the East by characterizing the latter as lacking in history, civil society," and so forth; Mahmut Mutman, "Under the Sign of Orientalism: The West vs. Islam," *Cultural Critique*, winter 1992–93, 175. Thus, Afghanistan was represented as a land whose inhabitants have "the eyes of the ancient mariner," in which even indexes of modernity such as the camera become signs of the persistence of the past, a country the United States is trying to "jolly along" to modernity; Maureen Dowd, "Brutes and Hunks," *New York Times*, Nov. 28, 2001; and Tim Weiner, "Time Out of Joint in a Ruined Land," *New York Times*, Nov. 26, 2001.

5 Carl W. Ernst, "Admiring the Works of the Ancients: The Ellora Temples as Viewed by Indo-Muslim Authors," in *Beyond Turk and Hindu: Rethinking Religious Identity in Islamicate South Asia*, ed. David Gilmartin and Bruce B. Lawrence (Gainesville, Fla.: University Press of Florida, 2000), 116. Similar issues arise in connection with representations of Jewish iconoclasm, which (as Creswell's comments suggest) has also been conceived of in essentialist terms. For good critiques of such representations, see Joseph Gutmann, "The 'Second Commandment' and the Image in Judaism," in *No Graven Images: Studies in Art and the Hebrew Bible* (New York: Ktav, 1971), 1–14; and Charles Barber. "The Truth in Painting: Iconoclasm and Identity in Early-Medieval Art," *Speculum* 72 (1997): 1022–23.

6 As Oleg Grabar notes, 45. "The most obvious difference between Byzantine and Islamic iconoclasm is that the former is usually spelled with a capital 'I' and the latter with a small 'i.' This secondary typographical distinction illustrates first of all the difference between a historical moment (these are presumably capitalised) and an attitude or mode of behaviour, the latter being apparently too common to deserve capitalization." For a theoretical discussion on the supposed roots of this essential attitude, see Marshall G.S. Hodgson, "Islâm and Image," *History of Religions* 3 (1969): 220–60.

7 See André Wink, *Al Hind, the Making of the Indo-Islamic World*, vol. 2, *The Slave Kings and the Islamic Conquest 11th–13th Centuries* (New Delhi: Oxford University Press, 1997), 317, paraphrasing Grabar, 45: "Unlike Christian iconoclasm, Islamic iconoclasm was virtually always directed against non-Muslim objects, with the exception of the late defacing of miniatures in manuscripts by pious librarians."

8 For example, V. L. Ménage, "The Serpent Column in Ottoman Sources," *Anatolian Studies* 14 (1964): 169–73.

9 A further important facet of Islamic iconoclasm, not dealt with here, concerns the general assumption that iconoclastic acts result from a type of anti-aesthetic impulse. I have argued elsewhere that in certain contexts, decapitated and defaced figures have a positive aesthetic value and should be considered as new works generated from those that they supersede; Finbarr Barry Flood, "Refiguring Iconoclasm: Image Mutilation and Aesthetic Innovation in the Early Indian Mosque," in *Negating the Image: Case Studies of Past Iconoclasms*, ed. Anne MacLanan and Jeffrey Johnson (Aldershot: Ashgate, 2005), 15–40.

10 The relationship between Byzantine iconoclasm and Islamic aniconism and iconoclasm has been debated in detail in numerous publications: Grabar; Crone (as in n. 3); G.R.D. King, "Islam, Iconoclasm, and the Declaration of Doctrine," *Bulletin of the School of Oriental and African Studies* 48, no. 2 (1985): 267–77; Sidney H. Griffith, "Theodore Abū Qurrah's Arabic Tract on the Christian Practice of Venerating Images," *Journal of the American Oriental Society* 105 (1985): 53–73; Terry Allen, *Five Essays on Islamic Art* (Manchester, Mich.: Solipsist Press, 1988), 18–22; and Sidney H. Griffith, "Islam, Images and Christian Icons: A Moment in the Christian/Muslim Encounter in Early Islamic Times," in *La Syrie de Byzance à l'Islam VIIe–VIIIe siècles*, ed. Pierre Canivet and Jean-Paul Rey-Coquais (Damascus: Institut Français de Damas, 1992), 121–38. For an interesting assessment of the "internal" determinants of early Islamic aniconism, see Emiko Terasaki, "The Lack of Human and Animal Figural Imagery in the Public Art of the Umayyad Period," M.A. thesis, University of California, Los Angeles, 1987, 26–56.

11 The Hadith concerning figuration are scattered through a number of collections of Traditions. The classic studies are those of Rudi Paret: Paret; idem, "Das islamische Bilderverbot und die Schia," in *Festschrift Werner Caskel: Zum siebzigsten Geburtstag 5. März 1966 Gewidmet von Freunden und Schülern*, ed. Erwin Gräf (Leiden: E. J. Brill, 1968), 224–32. A more accessible and recent discussion of the Traditions regarding figuration and their sources can be found in van Reenen.

12 Paret, 43–44; Crone (as in n. 3), 67; and A. J. Wensinck [T. Fahd], "Sūra 1. In Theological and Legal Doctrine," in *The Encyclopedia of Islam*, new ed. (Leiden: E. J. Brill, 1960–97), vol. 9, 889.

13 Hawting, 22, 49. Similar concerns are articulated in Early Christian and Jewish polemics against images; Paul Corby Finney, *The Invisible God: The Early Christians on Art* (New York: Oxford University Press, 1994), 43–53; and Barber (as in n. 5), 1033–34.

14 A. A. Vasiliev, "The Iconoclastic Edict of the Caliph Yazid II. A.D. 721," *Dumbarton Oaks Papers* 9–10 (1956): 26; and Hawting, 67–87.

15 John V. Tolan, "Muslims as Pagans and Idolaters in Chronicles of the First Crusade," in *Western Views of Islam in Medieval and Early Modern Europe: Perception of the Other*, ed. David R. Blanks and Michael Frassetto (New York: St. Martin's Press, 1999), 97–117; and Hawting, 85.

16 Wensinck (as in n. 12), 889–90.

17 Even in the textual tradition a certain ambivalence to figuration emerges, for after the conquest of Mecca the prophet Muhammad ordered the paintings of prophets, angels, and trees that decorated the interior of the Ka'ba to be erased, while sparing an image of Jesus and Mary; Uri Rubin, "The Ka'ba, Aspects of Its Ritual Function and Position in Pre-Islamic and Early Islamic Times," *Jerusalem Studies in Arabic and Islam* 8 (1986): 97–131; and van Reenen, 40.

18 Sheila S. Blair, "What Is the Date of the Dome of the Rock?" in *Bayt al-Maqdis, 'Abd al-Malik's Jerusalem*, ed. Julian Raby and Jeremy Johns, pt. 1, Oxford Studies in Islamic Art, 9 (Oxford: Oxford University Press, 1992), 64–67.

19 For example, Helen Mitchell Brown, "Some Reflections on the Figural Coinage of the Artuqids and Zengids," in *Near Eastern Numismatics, Iconography, Epigraphy and History: Studies in Honor of George C. Miles*, ed. Dickran Kouymjian (Beirut: American University in Beirut, 1974), 353–58.

20 Terasaki (as in n. 10); Oya Pancaroğlu, " 'A World unto Himself': The Rise of a New Human Image in the Late Seljuq Period (1150–1250)," Ph.D. diss., Harvard University, 2000, 14–23; and Patricia Crone and Shmuel Moreh, *The Book of Strangers: Mediaeval Arabic Graffiti on the Theme of Nostalgia Attributed to Abu'l-Faraj al-Isfahānī* (Princeton: Markus Wiener, 2000), 24.

21 Grabar, 45–47, 49.

22 Abū 'Alī, Aḥmad ibn 'Umar ibn Rusta, *Kitāb al-'Alāq al-nafīsa*, ed. M. J. de Goeje (Leiden: E. J. Brill, 1892), 66.

23 Van Reenen, 70.

24 Mehmet Önder, "Konya kal'ası ve figürlü eserleri," *VI. Türk Tarih Kongresi, Ankara 20–26 Ekim 1961* (Ankara: Türk Tarih Kurumu Basimevi, 1967), 145–69; Jean-Paul Roux, "Mosquées anatoliennes à décor sculpté," *Syria* 57 (1980): 305–23; and Pancaroğlu (as in n. 20).

25 Aḥmad b. 'Abd Allāh Ṭabarī, *The History of al-Ṭabarī*, vol. 13. *The Conquest of Iraq, Southwestern Persia, and Egypt*, trans. and annot. Gautier H. A. Juynboll (Albany: State University of New York Press, 1989), 23, 30; J. Pedersen, "Masdjid," in *The Encyclopaedia of Islam*, new ed., vol. 6 (Leiden: E. J. Brill, 1991), 650; and Flood, chap. 7.

26 For example, Arthur Upham Pope, "Representations of Living Forms in Persian Mosques," *Bulletin of the Iranian Institute* 6, no. 1 (1946): 125–29; and Roux (as in n. 24).

27 Rudi Paret, "Die Entstehungszeit des Islamischen Bilderverbots," *Kunst des Orients* 11, nos. 1–2 (1976–77): 230. It has been suggested, to my mind not entirely convincingly, that reused animal capitals around the mihrab of the Aqsa mosque in Jerusalem in its early 8th-century incarnation were left unaltered and only later defaced; John Wilkinson, "Column Capitals in the Ḥaram al-Sharīf," in *Bayt al-Maqdis, 'Abd al-Malik's Jerusalem*, ed. Julian Raby and Jeremy Johns, Oxford Studies in Islamic Art. 9 (Oxford: Oxford University Press, 1992), 134–38. More convincing is the documented appearance of figural scrolls on the 13th-century capitals flanking the mihrab of the Jami' al-Nuri in Hama, Syria; Ernst Herzfeld, "Damascus: Studies in Architecture, II," *Ars Islamica* 10 (1943): 45. For another possible mihrab with figural ornament, see Tariq Jawad al-Janabi, *Studies in Mediaeval Iraqi Architecture* (Baghdad: Republic of Iraq Ministry of Culture and Information, 1982), 175–76, pl. 164.

28 Ernst J. Grube, "Islamic Sculptures: Ceramic Figurines," *Oriental Art*, n.s., 12 (1966); Eva Baer, "The Human Figure in Early Islamic Art: Some Preliminary Remarks," *Muqarnas* 16 (1999): 32–41; and Pancaroğlu (as in n. 20). In addition, pre-Islamic three-dimensional sculpture was reused in bath-houses (Henri Pérés, *La poésie andalouse en arabe classique au XIe siècle* [Paris: Adrien-Maisonneuve, 1953], 331–33), on city walls (Robert Irwin, *Islamic Art in Context: Art, Architecture and the Literary World* [New York: Harry N. Abrams, 1997], 211), and apparently, in one case, a mosque (Crone [as in n. 3], 68 n. 37). Such classical or late antique sculptures might be described as idols but, as with their counterparts in Constantinople (see n. 119 below), they were valued for both their aesthetic and talismanic properties. I hope to explore the apotropaic or talismanic reuse of pre-Islamic figural sculpture in a future essay.

29 This is particularly true of the arts of eastern Iran in the 12th and 13th centuries; Adolf Grohmann, "Anthropomorphic and Zoomorphic Letters in the History of Arabic Writing," *Bulletin de l'Institut d'Égypte* 38 (1955–56): 117–22; Anthony Welch, "Epigraphs as Icons: The Role of the Written

Word in Islamic Art," in *The Image and the Word: Confrontations in Judaism, Christianity, and Islam*, ed. Joseph Gutmann (Missoula, Mont.: Scholars Press, 1977), 63–74; Erica Cruikshank Dodd and Shereen Khairallah, *The Image of the Word: A Study of Quranic Verses in Islamic Art*, 2 vols. (Beirut: American University in Beirut, 1981); Raya Shani, *A Monumental Manifestation of the Shīʿite Faith in Late Twelfth-Century Iran: The Case of the Gunbad-i ʿAlawiyān, Hamadān*, Oxford Studies in Islamic Art, 11 (Oxford: Oxford University Press, 1996), fig. 98e; and Robert Hillenbrand, "The Ghurid Tomb at Herat," in *Cairo to Kabul: Afghan and Islamic Studies Presented to Ralph Pinder-Wilson*, ed. Warwick Ball and Leonard Harrow (London: Melisende, 2002), 142–43, fig. 12.6.

30 Priscilla P. Soucek, "The Life of the Prophet: Illustrated Versions," in *Content and Context of Visual Arts in the Islamic World* (University Park, Pa.: Penn State University Press, 1988), 193–217; and Robert Hillenbrand, "Images of Muhammad in al-Biruni's *Chronology of Ancient Nations*," in *Persian Painting from the Mongols to the Qajars: Studies in Honour of Basil W. Robinson* (London: I. B. Tauris, 2000), 129–46.

31 E. E. Urbach, "The Rabbinical Laws of Idolatry in the Second and Third Centuries in the Light of Archaeological and Historical Facts." *Israel Exploration Journal* 9 (1959): 232–33.

32 Ahmad ibn Hanbal, *Musnad*, 6 vols. (Cairo, 1313/1895), vol. 2, 305, 308, 390, 478; Paret, 46–47; and idem (as in n. 27), 158, 176. For an extensive list of the various collections of Hadith in which this Tradition appears, see van Reenen, 33, 54. A precedent for it can be found in some Jewish traditions on figuration, which held that while sculpture was unacceptable, floor mosaics were permissible, since they were trodden on; Urbach (as in n. 31), 237 n. 89. Conversely, it was precisely this fact that later led Christian authorities to forbid the use of sacred images on pavements and floors; Carole Evelyn Voelker, "Charles Borromeo's *Instructiones Fabricae et Supellectilis Ecclesiasticae*," Ph.D. diss., Syracuse University, 1977, 230.

33 Nabih Amin Faris, *The Book of Idols* (Princeton: Princeton University Press, 1952), 27. On the pre-Islamic idols of Mecca, see G.R.D. King. "The Sculptures of the Pre-Islamic *Haram* at Makka," in Ball and Harrow (as in n. 29), 144–50. Note, however, that Hawting disputes, largely on historiographic grounds, the evidential basis of such attempts to reconstruct the Meccan pantheon.

34 Pope (as in n. 26), 129; Jerrilynn D. Dodds, ed., *Al-Andalus, the Art of Islamic Spain* (New York: Harry N. Abrams, 1992), no. 40; and Mikhail B. Piotrovsky and John Vrieze, *Art of Islam: Heavenly Art, Earthly Beauty* (Amsterdam: Lund Humphries, 1999), 34, no. 188.

35 Robert Dankoff, *Evliya Çelebi in Bitlis* (Leiden: E. J. Brill, 1990), 294–97.

36 Yuri A. Petrosyan et al., *Pages of Perfection: Islamic Paintings and Calligraphy from the Russian Academy of Sciences* (St. Petersburg: Electa, 1995), 144–55; and Irwin (as in n. 28), 82.

37 Griffith, 1992 (as in n. 10), 130; Gyöngi Török, "Bilderstürme durch die Türken," in *L'art et les révolutions, section 4: Les iconoclasmes*, ed. Sergiusz Michalski, Actes du XXVIIe Congrès International d'Histoire de l'Art, Strasbourg 1–7 septembre 1989 (Strasbourg: Société Alsacienne pour le Développement de l'Histoire de l'Art, 1992), 260–74, fig. 4.

38 Vasiliev (as in n. 14); Robert Schick, *The Christian Communities of Palestine from Byzantine to Islamic Rule: A Historical and Archaeological Study*, Studies in Late Antiquity and Early Islam, 2 (Princeton: Darwin Press, 1995), 218–19; and Barber (as in n. 5), 1022.

39 King (as in n. 10), 270; and Oleg Grabar, *The Formation of Islamic Art* (New Haven: Yale University Press, 1987), 86.

40 King (as in n. 10), 269–73; Griffith, 1985 (as in n. 10), 60–65; and Hawting, 82–83.

41 Janina M. Safran, *The Second Umayyad Caliphate* (Cambridge, Mass.: Harvard University Press, 2000), 40; and Finbarr Barry Flood, "The Medieval Trophy as an Art Historical Trope: Coptic and Byzantine 'Altars' in Islamic Contexts," *Muqarnas* 18 (2001): 55–56.

42 Abdur Rashid and M. A. Mokhdoomi, *Futuhat-i-Firoz Shahi* (Aligarh: Aligarh Muslim University, 1949), 14; translation from H. M. Elliott and John Dowson, *The History of India as Told by Its Own Historians* (reprint, Delhi: Low Cost Publications, 1990), vol. 3, 382. Despite such assertions of orthodoxy, the same sultan erected a celebrated if enigmatic monument next to the Great Mosque of his capital, Firuzabad, in which was incorporated an antique Buddhist pillar guarded at each of the four corners of the monument by a single monumental stone lion; Anthony Welch, "Architectural Patronage and the Past: The Tughluq Sultans of Delhi," *Muqarnas* 10 (1993): 317.

43 Ellen S. Smart, "Fourteenth Century Chinese Porcelain from a Tughlaq Palace in Delhi," *Transactions of the Oriental Ceramic Society* 41 (1975–77): 201; B. N. Goswamy, "In the Sultan's Shadow: Pre-Mughal Painting in and around Delhi," in *Delhi through the Ages: Essays in Urban History, Culture and Society*, ed. R. E. Frykenberg (Delhi: Oxford University Press, 1986), 133; and van Reenen, 46.

44 See, by way of comparison, the involvement of the state bureaucracy in the iconoclastic activities of Assyrian rulers; Zainab Bahrani, "Assault and Abduction: The Fate of the Royal Image in the Ancient Near East," *Art History* 18, no. 3 (1995): 367.

45 Schick (as in n. 38), 218–19; Flood (as in n. 9).

46 I owe this useful distinction to Andrew P. Gregory, " 'Powerful Image': Responses to Portraits and the Political Uses of Images in Rome," *Journal of Roman Archaeology* 7 (1994): 89.

47 Ernst (as in n. 5), 115. Taken out of context, this account might be seen as attesting an implacable aversion to figuration, but as Ernst points out, in the entry for the following day Babur describes a visit to a group of temples, which he compares to Muslim religious schools (*madrasas*), mentioning, without comment, the presence of stone-carved icons.

48 Alexander Cunningham, *Four Reports Made during the Years 1862–63–64–65*, Archaeological Survey of India Reports, vol. 2 (reprint, Delhi: Indological Book House, 1972), 365.

49 Edmund Thomas and Christian Witschel, "Constructing Reconstruction: Claim and Reality of Roman Rebuilding Inscriptions from the Latin West," *Papers of the British School at Rome* 60 (1992): 137. For a general discussion of the problems associated with textual reports of monument destruction in medieval South Asia, see Alka A. Patel, "Islamic Architecture of Western India (Mid 12th–14th Centuries): Continuities and Interpretations," Ph.D. diss., Harvard University, 2000, 319–20.

50 Thomas and Witschel (as in n. 49), 139.

51 Zehava Jacoby. "Ideological and Pragmatic Aspects of Muslim Iconoclasm after the Crusader Advent in the Holy Land," in Michalski (as in n. 37), 17–18.

52 S. M. Yusuf, "The Early Contacts between Islam and Buddhism," *University of Ceylon Review* 13, no. 1 (1955): 12, 17; and Hans Belting, *Likeness and Presence: A History of the Image before the Era of Art*, trans. Edmund Jephcott (Chicago: University of Chicago Press, 1994), 279, originally published as *Bild und Kult: Eine Geschichte des Bildes vor dem Zeitalter der Kunst* (Munich: C. H. Beck, 1990). This could be achieved through physical contact with ritually impure animals, for example; Yohanan Friedmann, "The Temple of Multān: A Note on Early Muslim Attitudes to Idolatry," *Israel Oriental Studies* 2 (1972): 177; and A. Guillaume, *The Life of Muhammad* (Karachi: Oxford University Press, 1997), 208.

53 Flood (as in n. 9).

54 Freedberg, 415; Bézard (as in n. 2).

55 David Freedberg, "The Structure of Byzantine and European Iconoclasm," in Bryer and Herrin (as in n. 6), 169.

56 See, for example, Ṭabarī (as in n. 25), vol. 23, *The Zenith of the Marwānid House*, trans. Martin Hinds (1990), 194.

57 Hawting, 51, 107.

58 Priscilla P. Soucek, "Taṣwīr 1: Painting and Other Representational Arts," *The Encyclopaedia of Islam*, new ed., vol. 10 (Leiden: E.J. Brill, 1999), 362.

59 Qur'an 26:72–73; Moshe Halbertal and Avishai Margalit, "Idolatry and Representation," *Res* 22 (1992): 19–20.

60 Mary Boyce, "Iconoclasm among the Zoroastrians," in *Christianity, Judaism, and Other Greco-Roman Cults, Studies for Morton Smith at Sixty*, ed. Jacob Neusner (Leiden: E. J. Brill, 1975), 97; William Pietz, "The Problem of the Fetish, II," *Res* 12 (1987): 31: and Finney (as in n. 13), 54–56. Although the icon was inert matter (*hyle*), it could be inhabited by the malevolent spiritual beings that precipitated image worship. Such beings entered into the material of the image at the moment of consecration, which was conceived of as an act of ensoulment. The identification of consecration as the moment of animation is common to both iconoclasts and iconophiles. In Hindu consecration rituals, for example, the icon is believed to become animated precisely by the entry into it of a divine presence, "just as a soul must enter a human body to instill life into it;" Richard H. Davis, "Loss and Recovery of Ritual Self among Hindu Images." *Journal of Ritual Studies* 6, no. 1 (1992): 47.

61 Wink (as in n. 7), 327.

62 Sandra Naddaff, *Arabesque: Narrative Structure and the Aesthetics of Repetition in the 1001 Nights* (Evanston, Ill.: Northwestern University Press, 1991), 115.

63 Rashid and Mokhdoomi (as in n. 42), 23; and Flood.

64 Carl Nylander, "Earless in Niniveh: Who Mutilated 'Sargon's' Head?" *American Journal of Archaeology* 84 (1980): 332; Bahrani (as in n. 44), 381; Peter Stewart, "The Destruction of Statues in Late Antiquity," in *Constructing Identities in Late Antiquity*, ed. Richard Miles (London: Routledge, 1999), 165–66; and Gamboni, 32.

65 William of Tyre, *A History of Deeds Done beyond the Sea*, trans. Emily Allwater Babcock and A. C. King. 2 vols. (New York: Octagon Books, 1941), vol. 1, 296, emphasis mine.

66 Freedberg: Gell, 14–19.

67 See also Oskar von Niedermayer, *Afghanistan* (Leipzig: Karl W. Hiersemann, 1924), pls. 217, 218.

68 Nancy Hatch Dupree, "The Colossal Buddhas and the Monastic Grotto," *Marg* 24, no. 2 (1971): 18, 22.

69 André Wink, "India and Central Asia: The Coming of the Turks in the Eleventh Century," in *Ritual, State, and History in South Asia, Essays in Honour of J. C. Heesterman*, ed. A. W. van den Hoek, D.H.A. Kolff, and M. S. Oort (Leiden: E. J. Brill, 1992), 754.

70 Gianroberto Scarcia, "A Preliminary Report on a Persian Legal Document of 470–1078 Found at Bāmiyān," *East and West*, n.s., 14 (1963): 73–85; idem, "Sull'ultima 'islamizzazione' di Bāmiyān," *Annali dell'Istituto Orientale dell'Universitario di Napoli* 16 (1966): 278–81; and Deborah Klimburg-Salter, *The Kingdom of Bāmiyan: Buddhist Art and Culture of the Hindu Kush* (Naples: Istituto Universitario Orientale and IsMEO, 1989), 41.

71 W. Barthold, "Bāmiyān," in *The Encyclopaedia of Islam*, vol. 1, pt. 2 (Leiden: E. J. Brill, 1913), 634; Melikian-Chirvani, 24; and Clifford Edmund Bosworth, *The History of the Saffarids of Sistan and the Maliks of Nimruz (247/861 to 949/1542–43)* (Costa Mesa: Mazda, 1994), 105–6.

72 Abu Bakr Muhammad Narshakhi, *The History of Bukhara*, trans. Richard N. Frye (Cambridge, Mass: Mediaeval Academy of America, 1994), 49. The Buddhas are said to have sustained subsequent damage at the hands of the Mughal emperor Aurangzeb (a stock figure of Muslim iconoclasm in South Asia) and the Persian ruler Nadir Shah; Barthold (as in n. 71), 643; Benjamin Rowland Jr., *Ancient Art from Afghanistan: Treasures of the Kabul Museum* (New York: Asia Society, 1966), 95; and Grabar, 45.

73 Guy Le Strange, *The Lands of the Eastern Caliphate* (Cambridge: Cambridge University Press, 1905), 418; Muhammad ibn Ishaq ibn al-Nadim, *The Fihrist*, trans. Bayard Dodge, 2 vols. (Chicago: Kazi, 1998), vol. 2, 82.

74 Melikian-Chirvani, 23–26, 59–60.

75 V. Minorsky, "Gardizi on India," *Bulletin of the School of Oriental and African Studies* 12, no. 2 (1948): 629–39; Ratty D. Bhurekhan, "Hindu Religious Beliefs and Practices as Reflected in the Accounts of Muslim Travellers of Eleventh Century," *Indian History Congress: Proceedings of the 25th Session, Poona 1963* (Calcutta: n.p., 1964), 170–75; Bruce B. Lawrence, "Shahrastānī on Indian Idol Worship," *Studia Islamica* 38 (1973): 61–73; and Yohanan Friedmann, "Medieval Muslim Views of Indian Religions," *Journal of the American Oriental Society* 95 (1975): 214–21.

76 Melikian-Chirvani, 60; and Sachau, vol. 1, 111–24.

77 Davis, 96–99.

78 Simon Digby, "The Literary Evidence for Painting in the Delhi Sultanate," *Bulletin of the American Academy of Benares* 1 (1967): 50–51; and Kjeld von Folsach, *David Collection: Islamic Art* (Copenhagen: Davids Samling, 1996), nos. 273–77. For the palace compared to a temple (*bahār*), see Melikian-Chirvani, 69; and Julie Scott Meisami, "Palaces and Paradises: Palace Descriptions in Medieval Persian Poetry," *Princeton Papers* 8 (2001): 25, 27.

79 Assadullah Souren Melikian-Chirvani, "The Buddhist Ritual in the Literature of Early Islamic Iran," in *South Asian Archaeology, Proceedings of the 6th International Conference of the Association of South Asian Archaeologists in Western Europe* (Cambridge: Cambridge University Press, 1981), 274.

80 Hirananda Sastri, "Devanāgarī and the Muhammadan Rulers of India," *Journal of the Bihar and Orissa Research Society* 23 (1937): 495.

81 Flood, chap. 3.

82 John Briggs, trans., *History of the Rise of Mohamedan Power in India, Translated from the Original Persian of Mahomed Kasim Ferishta* (London, 1829; reprint, New Delhi: Oriental Books Reprint Corporation, 1974), vol. 1, 43–44; and Muhammad Nazim, *The Life and Times of Sultān Maḥmūd of Ghazna* (Cambridge, 1931; reprint, New Delhi: Munshiram Manoharlal, 1971), 221. This accords with the Tradition that the Prophet urged the Meccans to destroy their idols rather than sell them (van Reenen, 40). The injunction was apparently broken by the Umayyad caliph Muʾawiya (r. 661–80), who sold idols looted in Sicily to the idolatrous inhabitants of Sind (Sachau, vol. 1, 124), although this may be an invention of anti-Umayyad propagandists. Stories regarding the rejection of ransom for icons are also found in connection with European iconoclasm; Freedberg (as in n. 55), 170 n. 58. See also n. 111 below.

83 In the 9th-century *Book of Idols*, a pre-Islamic Arabian idol named dhu al-Khalaṣa is said to have been reused as the threshold of the entrance to a mosque; Faris (as in n. 33), 31. A comparable reuse of the *linga* is attested archaeologically in the early Islamic mosque at Banbhore in Sind, where several were employed as the lowest steps of a flight of stairs leading to each of the entrances to the Great Mosque; S. M. Ashfaque, "The Grand Mosque of Banbhore," *Pakistan Archaeology* 6 (1969): 198–99. The veracity of the traditions regarding the treatment of the Somnath *linga* seems to be borne out by the find of an image of Brahma at Ghazna with its face worn away by the passage of feet; Umberto Scerrato, "The First Two Excavation Campaigns at Ghazni, 1957–1958," *East and West*, n.s., 10 (1959): 40. See also nn. 32 above and 92 below.

84 Sachau, vol. 1, 117; Elliott and Dowson (as in n. 42), vol. 2, 454.

85 H. G. Raverty, *Ṭabaḳāt-i-Nāṣirī: A General History of the Muhammedan Dynasties of Asia, Including Hindustan*, 2 vols. (1881; reprint, New Delhi: Oriental Books Reprint Corporation, 1970), vol. 1, 82.

86 Karl-Heinz Golzio, "Das Problem von Toleranz in Indischen Religionen anhand epigraphischer Quellen," in *Frank-Richard Hamm Memorial Volume, October 8, 1990*, ed. Helmut Eimer (Bonn: Indica et Tibetica, 1990), 89–102; Wink (as in n. 7), 310–11; Phyllis Granoff, "Sacred Objects in Medieval India: Anti-image Polemics and Their Legacy," abstract of a paper presented at the annual meeting of the Association for Asian Studies, San Diego, March 9–12, 2000, available from www.aasianst.org/absts/2000abst/Inter/I-175.html; and Flood, chap. 7.

87 Hermann Kulke, *Kings and Cults: State Formation and Legitimation in India and Southeast Asia* (New Delhi: Manohar, 1993), 15; and Michael D. Rabe, "Royal Temple Dedications," in *Religions of India in Practice*, ed. Donald S. Lopez (Princeton: Princeton University Press, 1995), 239–40.

88 Davis, 54–68.

89 Sachau, vol. 1, 117.

90 Davis, 108.

91 Sheila S. Blair, *The Monumental Inscriptions from Early Islamic Iran and Transoxiana* (Leiden: E. J. Brill, 1992), 183–84.

92 A similar principle is evident in the Jews of Sardis trampling the defaced pagan reliefs laid face-down on the forecourt of their synagogue or the Christians of Gaza trampling paving from the Holy of Holies of the Marneion in their approach to the church that replaced it; George M.A. Hanfmann, *Sardis from Prehistoric to Roman Times: Results of the Archaeological Exploration of Sardis 1958–1975* (Cambridge, Mass.: Harvard University Press, 1983), 176; and Helen Saradi-Mendelovici, "Christian Attitudes to Pagan Monuments in Later Antiquity and Their Legacy in Later Byzantine Centuries," *Dumbarton Oaks Papers* 44 (1990): 54.

93 Gulab Chandra Choudhary, *Political History of North India from Jain Sources (c. 650 AD to 1300 AD)* (Amritsar: n.p., 1964), 287; and B. P. Sinha, "Some Reflections on Indian Sculpture (Stone or Bronze) of Buddhist Deities Trampling Hindu Deities," in *Dr. Sathari Mookerji Felicitation Volume* (Varanasi: Chowkhamba Sanskrit Series Office, 1969), 97–107.

94 Note that in the Hadith, both sculpted stones and unsculpted found objects are recognized as having the capacity to function as idols; Hawting, 106.

95 For a full discussion of this topic, see Flood, chap. 2.

96 Milton Gold, trans., *The Tārīkh-e Sistān* (Rome: Instituto Italiano per il Medio ed Estremo Oriente, 1976), 171.

97 Raverty (as in n. 85), vol. 1, 82.

98 Fisher 20; and Nicholas Thomas, *Entangled Objects: Exchange, Material Culture, and Colonialism in the Pacific* (Cambridge, Mass.: Harvard University Press, 1991), 155–56. For the idea of the heterotopia as a single space dedicated to the juxtaposition of several spaces that are culturally, chronologically, or otherwise incompatible, "a sort of simultaneously mythic and real contestation of the space in which we live," see Michel Foucault, "Of Other Spaces," *Diacritics* 16 (1986): 22–27.

99 Mark Twain, quoted in Diana L. Eck, *Darśan: Seeing the Divine Image in India* (Chambersburg, Pa.: Anima Books, 1981), 14; and Fisher, 20; Howard Risatti, "The Museum," *Art Journal* 51, no. 4 (1992): 106.

100 Pamela Constable, "Taliban Ban on Idolatry Makes a Country without Faces," *Washington Post*, Mar. 26, 2001, A20.

101 Jean-Michel Frodon, "La guerre des images, ou le paradoxe de Bamiyan," *Le Monde*, Mar. 23, 2001.

102 Isabel Hilton, "Blaming the Breakers of Statues," *Guardian*, Mar. 7, 2001. For the suggestion that the earlier undertaking to protect Afghan antiquities was similarly motivated by the Taliban's concerns with its relation to the international community, see Robert Kluyver. "L'optique culturelle des Tâlebân," in *Afghanistan, patrimoine en péril: Actes d'une journée d'étude, 24 février 2001* (Paris: CEREDAF, UNESCO, 2001), 55–59.

103 Esther Peskes, "Wahhābiyya: The 18th and 19th Centuries," *The Encyclopaedia of Islam*, new ed., vol. 11 (Leiden: E. J. Brill, 2000), 40, 42–43. According to recent reports, Afghan Taliban refused to carry out the destruction, which was both initiated and executed by al-Qaeda members; *Art Connection*, BBC World Service broadcast, Nov. 17, 2001; "Documents Detail al-Qaeda Training of Foreign Fighters," *Washington Post*, Nov. 22, 2001, A35.

104 Gamboni, 22; see also Freedberg, 409; and "Taliban Open Afghan Museum, Statues Gone," *New York Times*, Mar. 22, 2001. Nigel Spivey notes that this was "a spectacle of iconoclasm staged under Western eyes, surely designed less to offend practicing Buddhists than to enrage the high priests of

UNESCO;" Spivey, "‡'Shrines of the Infidel': The Buddhas at Bamiyan," *Apollo* 156 (July 2002): 28–35, at 28.

105 As Edward Said wrote of an earlier Middle Eastern crisis, "the drama has unfolded as if according to an Orientalist program: the so-called Orientals acting the part decreed for them by what so-called Westerners expect . . . Westerners confirming their status in Oriental eyes as devils;" Edward Said, *Covering Islam: How the Media and the Experts Determine How We See the Rest of the World* (New York: Vintage Books, 1997), 56. On the mutual interdependence of "tradition" and "modernity," see also Mutman (as in n. 4), 184, 187–88; and, more generally, Nicholas B. Dirks, "History as a Sign of the Modern," *Public Culture* 2 (1990): 25–32.

106 Associated Press, "Taliban: Statues Must Be Destroyed," *Guardian*, Feb. 26, 2001.

107 Qadratullah Jamal, the Taliban information minister, referred to the destruction of artifacts in Bamiyan, Ghazni, Hadda, Herat, Jalalabad, and Kabul; Associated Press, "Taliban Destroying All Statues," Mar. 1, 2001, circulated electronically by the Afghanistan Research Group as "News from Afghanistan" 01/015, Mar. 2, 2001. In addition, in Kabul, works in the National Gallery were threatened, and some of the National Film Archives destroyed; Kevin Sullivan, "Taliban Had Wrong Impression: Artists Tricked Police to Save Work with Banned Images," *Washington Post*, Jan. 2, 2002, A1, A8. The scale of the holdings of Buddhist art in Afghan museums is evident from the fact that before the Soviet invasion, more than half the exhibition space of the Kabul Museum had been dedicated to the display of Buddhist antiquities; Ann Dupree, Louis Dupree, and A. A. Motamedi, *A Guide to the Kabul Museum* (Kabul: n.p., 1968). Ironically, it is reported that published guides to the collections of the Kabul Museum were used by the Taliban in the selection of objects for destruction; Maev Kennedy. "Bacchus Survives Orgy," *Guardian*, May 3, 2002, 11. For images that reveal the scale of destruction in Bamiyan and the Kabul Museum, see Kristin M. Romey, "The Race to Save Afghan Culture," *Archaeology* 55 (May–June 2002): 18–25.

108 Associated Press, "Taliban Praises Statue Destruction," *Guardian*, Mar. 5, 2001.

109 Reuters, "New York's Metropolitan Makes Afghan Art Offer," Mar. 1, 2001, circulated electronically by the Afghanistan Research Group as "News from Afghanistan" 01/015, Mar. 2, 2001.

110 Reuters, "Afghan Taliban Say Parts of Statues Blown Up," Mar. 5, 2001, at www.dailynews.yahoo.com/h/nm/20010305/wl/afghan_statues_dc_1.html.

111 See n. 82 above. On the role of Mahmud in recent historiography, see Peter Hardy, "Mahmud of Ghazna and the Historians," *Journal of the Panjab University Historical Society* 14 (1962): 1–36. Other Taliban supporters reportedly favored selling the Buddhist statues and using the money to alleviate an ongoing drought and famine in Afghanistan: Rory McCarthy. "Fate of Ancient Statues in Balance as Talks with Taliban Continue," *Guardian*, Mar. 5, 2001. According to later reports, fragments of the destroyed Bamiyan Buddhas were taken for sale in Peshawar; "Bamiyan Relics Up for Sale in Peshawar," *Jang*, Apr. 2, 2001, at http://www.rawa.org/statues2.html.

112 Gamboni, 13.

113 Tim Weiner, "Seizing the Prophet's Mantle: Muhammad Omar," *New York Times*, Dec. 7, 2001; Flood, chap. 5.

114 Davis, 186–221.

115 Associated Press, "India Asks Taliban for Statues," Mar. 2, 2001, H-ISLAMART list. For a discussion of the trope of medieval barbarism in relation to colonial and nationalist constructions of the past and present of Islamic South Asia, see Flood, chap. 1. For a critical overview of scholarship on the history of Islamic South Asia, see Patel (as in n. 49), chap. 6.

116 Reuters, "Indian Hindus Protest Afghan Statue Destruction," Mar. 5, 2001, at www.dailynews.yahoo.com/h/nm/20010305/wl/afghan_hindus_dc_l.html. The threat should be seen against the backdrop of the destruction of the Babri Mosque in 1992. A Mughal mosque near Asind in southern Rajasthan was also demolished by a mob in July 2001, and a temple built on its site; "Mosque Demolished," *Hindu*, July 30, 2001.

117 BBC, "Taliban 'Attack' Buddha Statues," Mar. 2, 2001, circulated electronically by the Afghanistan Research Group as "News from Afghanistan" 01/015.

118 This rhetorical transposition of the religiously idolatrous past and the culturally idolatrous present is again evident in Osama bin Laden's characterization of the United States as "the Hubal of the age," Hubal being the preeminent deity of pagan Mecca; "These Young Men Have Done a Great Deed," *Washington Post*, Dec. 29, 2001, A5. Just as for European scholars of the 19th and 20th centuries the "Greco-Buddhist" style of many of these icons rendered them positively assimilable within an existing framework of Hellenizing classicism (see n. 143 below), so Taliban rhetoric invokes the same strategy, assimilating the Buddhas negatively to the pre-Islamic idols known from Islamic historiography. This tendency can be discerned in medieval descriptions of the Bamiyan Buddhas, which are sometimes referred to as Lat and Manat, two further idols of pre-Islamic Arabia; Melikian-Chirvani,

60. The Somnath *linga* was also assimilated with the latter; Davis, 95–96. Although the rhetoric, like that of most iconoclasts, invokes a return to origins, to see this as an attempt to dissolve historical time is too reductive a reading. In the same way that an *isnād*, a chain of transmission, serves to invest a textual citation with authority by linking it to its historical precursors and, ultimately, an originary utterance, so the invocation of historical precedent (prophetic and profane) attempts not to deny the elapse of historical time between the earlier act and its reenactment in the present but to invest the present (re)enactment with a cumulative authority dependent on the existence of a chain of precedent.

119 It is already present in Eusebius's distinction between idols in religious contexts and those that adorned the civic architecture of Constantinople, which were therefore "works of art;" John Curran, "Moving Statues in Late Antique Rome: Problems of Perspective," *Art History* 17, no. 1 (1994): 47. As Curran points out, Eusebius's distinction between the secular and the sacred was an ideal one. The classical sculptures reused in Constantinople might be valued for their aesthetic properties, but the belief that they were animated, often as the result of demonic possession (see n. 60 above), was widespread and persistent; Cyril Mango, "Antique Statuary and the Byzantine Beholder." *Dumbarton Oaks Papers* 17 (1963): 59; S. G. Bassett, "The Antiquities in the Hippodrome of Constantinople," *Dumbarton Oaks Papers* 45 (1991): 87–96; Saradi-Mendelovici (as in n. 92), esp. 51; and Liz James, " 'Pray Not to Fall into Temptation and Be on Your Guard': Pagan Statues in Christian Constantinople," *Gesta* 26, no. 1 (1991): 12–20. Charles Barber has argued that at a slightly later date, the end of Byzantine iconoclasm was followed by a reconceptualization of the religious image as art object; Barber, "From Transformation to Desire: Art and Worship after Byzantine Iconoclasm," *Art Bulletin* 75 (1993): 7. See also Belting (as in n. 52), 164–83.

120 Germain Bazin, *The Museum Age* (New York; Universe Books, 1967), 173; Klaus Herding, "Denkmalsturz und Denkmalkult—Revolution und Ancien régime," *Neue Zürcher Zeitung*, Jan. 30–31, 1993, 63–64; Belting (as in n. 52), 170–71; Stephen Bann, "Shrines, Curiosities, and the Rhetoric of Display," in *Visual Display: Culture beyond Appearances*, ed. Lynne Cooke and Peter Wollen, Dia Center for the Arts Discussions in Contemporary Culture, no. 10 (Seattle: Bay Press, 1995), 15–29; and Dominique Poulot, "Revolutionary 'Vandalism' and the Birth of the Museum: The Effects of a Representation of Modern Cultural Terror," in *Art in Museums*, ed. Susan Pearce, New Research in Museum Studies, 5 (London: Athlone, 1995), 192–214.

121 Robert S. Nelson, "The Discourse of Icons. Then and Now," *Art History* 12 (1989): 145. On the transformation of the religious image into an art object in early modern Europe, see Belting (as in n. 52), 458–90. See also n. 123 below.

122 Benjamin (as in n. 1), 217–18, 237.

123 Gell, 97. Even without discussing commodity fetishism here, the Gell passage bears comparison with Marxist critiques of ideology, "which begins historically as an iconoclastic 'science of the mind' designed to overturn 'idols of the mind,' " and "winds up being characterized as itself a new form of idolatry;" W.J.T. Mitchell, *Iconology: Image, Text, Ideology* (Chicago: University of Chicago Press, 1986), 167. Like the fetishism involved in ideology itself, the fetishism resulting from the aesthetic attitude that Gell refers to "is part of an iconoclastic rhetoric that turns against its users;" ibid., 204.

124 Carol Duncan, "Art Museums and the Ritual of Citizenship," in *Exhibiting Cultures: The Poetics and Politics of Museum Display*, ed. Ivan Karp and Steven D. Lavine (London: Smithsonian Institution Press, 1991), 91; Fisher, 19–20; and Joan R. Branham. "Sacrality and Aura in the Museum: Mute Objects and Articulate Space," *Journal of the Walters Art Gallery* 52–53 (1994–95): 33.

125 Abbé Grégoire, quoted in Poulot (as in n. 120), 194.

126 Freedberg, 378–85; Gell, 62. An unnamed gallery spokesperson commented at the time, without any apparent trace of irony: "I can't think why anyone would want to do this to a painting. . . . It is not offensive. It just depicts the Israelites dancing around the golden calf;" "Poussin Painting Slashed in London," *Washington Post*, Apr. 4, 1978, A14.

127 John Dornberg, "Art Vandals: Why Do They Do It?" *Artnews*, Mar. 1987, 102–9; Freedberg, 407–27; Jeffrey Kastner, "Art Attack," *Artnews*, Oct. 1997, 154–56; and Gamboni, 190–211.

128 Smita J. Baxi. "Problèmes de sécurité dans les musées Indiens," *Museum* 26, no. 1 (1974): 52; Branham (as in n. 124), 37; and Goetz Hagmuller, "Darkness and Light," at www.asianart.com/articles/darkness/index.html.

129 Gell, 97.

130 Benedict Anderson, *Imagined Communities* (London: Verso, 1991), 182–84; and Mark Crinson, "Nation-Building, Collecting and the Politics of Display," *Journal of the History of Collections* 13, no. 2 (2001): 231–50. The idea that ancient monuments constitute a type of national patrimony, so that whoever attacks them "is excluded *de facto* from the community of citizens," is already present in Abbé Grégoire's impassioned writing in favor of the museum; Poulot (as in n. 120), 203–4.

131 Fisher, 8; Brian Macaskill, "Figuring Rupture: Iconology, Politics, and the Image," in *Image and Ideology in Modern/Postmodern Discourse*, ed. David B. Downing and Susan Bazargan (Albany: State University of New York Press, 1991), 249.

132 Duncan (as in n. 124), 102.

133 For a critique of the hegemonic potential of universalism, see S. Sayyid, "Bad Faith: Anti-essentialism, Universalism and Islamism," in *Hybridity and Its Discontents: Politics, Science, Culture*, ed. Avtar Brah and Annie E. Coombes (New York: Routledge, 2001), 261: "universalism is the expansion of one particularity so that it can consume other particularities. What distinguishes the universalist particularity from any other particularity is empire, in other words historical and contemporary forms of power relations."

134 Anderson (as in n. 130), 182–84; Thomas Richards, "Archive and Utopia," *Representations* 37 (winter 1992): 118; Risatti (as in n. 99), 106; Gyan Prakash, *Another Reason: Science and the Imagination of Modern India* (Princeton: Princeton University Press, 1999), 18–19; and Crinson (as in n. 130). See also the collection of essays edited by George W. Stocking Jr., *Objects and Others: Essays on Museums and Material Culture* (Madison: University of Wisconsin Press, 1985). The point is underlined by the fact that the conversation that provides the epigraph to this essay takes place with Kim astride the looted cannon of a Muslim ruler, relocated by the British outside the newly founded Lahore Museum.

135 Bernard S. Cohn, *Colonialism and Its Forms of Knowledge: The British in India* (Princeton: Princeton University Press, 1996), 76–105; and Duncan (as in n. 124), 89.

136 Stanley K. Abe, "Inside the Wonder House: Buddhist Art and the West," in *Curators of the Buddha: The Study of Buddhism under Colonialism*, ed. Donald S. Lopez Jr. (Chicago: University of Chicago Press, 1995), 89–90; and I. K. Sharma, "Archaeological Site Museums in India: The Backbone of Cultural Education," *Museum International* 50, no. 2 (1998): 45.

137 Fisher, 10; Stephen Greenblatt, "Resonance and Wonder," in Karp and Lavine (as in n. 124), 44; Fabio Rambelli and Eric Reinders, "What Does Iconoclasm Create? What Does Preservation Destroy? Some Observations from Case Studies of China and Japan," abstract submitted to the conference "Iconoclasm—Contested Objects and Contested Terms," Henry Moore Institute, Leeds, July 13–14, 2001.

138 Gamboni, 18.

139 Pierre Bourdieu, quoted in Dornberg (as in n. 127), 105.

140 Nancy Hatch Dupree. "Import of the Cultural Destruction in Afghanistan," *Society for the Preservation of Afghanistan's Cultural Heritage (SPACH) Newsletter* 7 (July 2001): 2.

141 Sayyid (as in n. 133), 266, sees the conflict between Islamists and their enemies not as a contest between liberalism and fundamentalism but between different types of hegemonic universalisms: "One may have one's own prejudices for preferring one to the other, but both are attempts to remake the world. Neither is sanctioned by any innate logic, both are themselves grand political projects: projects that aim to transform our cultures, histories, and societies." See also Mutman (as in n. 4), 189.

142 Frodon (as in n. 101).

143 Kipling (as in n. 1), 54; and Abe (as in n. 136), 77–84. The perceived European affinities of the Buddhas came to the fore in various ways during and after their destruction, with some observers mourning the loss of "the link between Western and Asian culture;" "Afghan Buddhas May Be Rebuilt," at www.cnn.com/2001/WORLD/europe/11/19/rec.swiss.buddhas/index.html.

144 On classicism and power, see Henri Zerner, "Classicism as Power," *Art Journal* 47, no. 1 (1988): 36: "classicism means no more than an assertion of authority, of power under whatever form." This was no less true in colonial South Asia, where classical imagery often served as a vehicle to assert political dominion; Barbara Groseclose, "Imag(in)ing Indians," *Art History* 13, no. 4 (1990): 494.

145 W. L. Rathje, "Why the Taliban Are Destroying Buddhas," *USA Today*, Mar. 22, 2001, at www.usatoday.com/news/science/archaeology/2001-3-22-afghan-buddhas.html; and Barbara Crossette, "Taliban Explains Buddha Demolition," *New York Times*, Mar. 19, 2001.

146 Barry Bearak, "Where Buddhas Fell, Lives Lie in Ruins, Too," *New York Times*, Dec. 9, 2001, A1, B10; and "Afghanistan: Taliban Massacres Detailed," Human Rights Watch press release. New York, Feb. 19, 2001, at www.hrw.org/press/2001/02/afghan0219.html. The destruction of the Bamiyan Buddhas will have future economic implications for the local Hazara community, which formerly derived some of its income from the tourism associated with the statues.

147 Mary Richardson, quoted in Gamboni, 94–95.

148 Freedberg, 409. Jean Baudrillard takes the implications of this commodity fetishism to its logical extreme, comparing the art in a museum to a gold reserve in a bank: "just as a gold bank is necessary in order that the circulation of capital and private speculation be organized, so the fixed reserve of the

museum is necessary for the functioning of the sign exchange of paintings;" quoted in Mitchell (as in n. 123), 203.

149 Mitchell (as in n. 123), 163; and Wyatt MacGaffey, "African Objects and the Idea of Fetish," *RES* 25 (spring 1994): 123; and Peter Gathercole, "The Fetishism of Artefacts," in *Museum Studies in Material Culture*, ed. Susan M. Pierce (Leicester: Leicester University Press, 1989), 73–81. See also the interesting and provocative comments of James Clifford, "Objects and Selves—an Afterword," in Stocking (as in n. 134), 244.

150 In terms of the cultural value invested in them as a result of their classical affinities, the "Greco-Buddhist" Buddhas and bodhisattvas that were the primary target of Taliban iconoclasts display several features traditionally ascribed to the fetish, among them a heterogeneous or hybrid nature and "a dependence for meaning and value on a particular order of social relations, which it in turn reinforces;" Pietz (as in n. 60), 23. See nn. 143–44 above.

151 Gamboni, 97.

152 Igor Kopytoff, "The Cultural Biography of Things," in *The Social Life of Things, Commodities in Cultural Perspective*, ed. Arjun Appadurai (Cambridge: Cambridge University Press, 1986), 67.

153 See Freedberg, 418.

154 Bearak (as in n. 146), B10: "Hundreds of years from now this may be the single footnote the Taliban have carried into the annals of time." See also Freedberg, 409, on the destruction of art as a way of acquiring fame in perpetuity.

155 *Ṭāghūt*, a Qur'anic term, can refer to either idols or idol shrines; Hawting, 55. Since the term recurs in the edict, both are presumably intended here.

References

Davis, Richard H., *Lives of Indian Images* (Princeton: Princeton University Press, 1997).

Fisher, Philip, *Making and Effacing Art: Modern American Art in a Culture of Museums* (New York: Oxford University Press, 1991).

Flood, Finbarr Barry, *Objects of Translation: Material Culture and Medieval "Hindu-Muslim" Encounter* (Princeton: Princeton University Press, 2009).

Freedberg, David, *The Power of Images: Studies in the History and Theory of Response* (Chicago: University of Chicago Press, 1989).

Gamboni, Dario, *The Destruction of Art: Iconoclasm and Vandalism since the French Revolution* (New Haven: Yale University Press, 1977).

Gell, Alfred, *Art and Agency: An Anthropological Theory* (Oxford: Clarendon Press, 1998).

Grabar, Oleg, "Islam and Iconoclasm," in *Iconoclasm: Papers Given at the Ninth Spring Symposium of Byzantine Studies, University of Birmingham, March 1975*, ed. Anthony Bryer and Judith Herrin (Birmingham, Eng.: Centre for Byzantine Studies, University of Birmingham, 1977).

Hawting, G. R., *The Idea of Idolatry and the Emergence of Islam: From Polemic to History* (Cambridge: Cambridge University Press, 1999).

Melikian-Chirvani, Assadullah Souren, "L'évocation littéraire du Bouddhisme dans l'Iran musulman," *Le Monde Iranien et l'Islam*, no. 2 (1974): 1–72.

Paret, Rudi. "Textbelege zum islamische Bilderverbot," in *Das Werk des Künstlers: Studien zur Ikonographie und Formgeschichte Hubert Schrade zum 60. Geburtstag dargebracht von Kollegen und Schülern* (Stuttgart: W. Kohlhammer, 1960), 36–48.

Sachau, Edward C., *Alberuni's India*, 2 vols. (1910; reprint. New Delhi: Munshiram Manoharial, 1983).

van Reenen, Daan, "The *Bilderverbot*, a New Survey." *Der Islam* 67 (1990): 27–77.

Okwui Enwezor

THE POSTCOLONIAL CONSTELLATION: CONTEMPORARY ART IN A STATE OF PERMANENT TRANSITION

The proper task of a history of thought is: to define the conditions in which human beings "problematize" what they are, what they do, and the world in which they live.

Michel Foucault, *The History of Sexuality*, vol. 2,
The Uses of Pleasure (New York: Pantheon, 1985)

This flood of convergences, publishing itself in the guise of the commonplace. No longer is the latter an accepted generality, suitable and dull—no longer is it deceptively obvious, exploiting common sense—it is, rather, all that is relentlessly and endlessly reiterated by these encounters.

Édouard Glissant, *Poetics of Relation* (Ann Arbor:
University of Michigan Press, 1996)

IT IS A COMMONPLACE of current historical thinking about globalization to say there are no vantage points from which to observe any particular culture because the very processes of globalization have effectively abolished the temporal and spatial distances that previously separated cultures.[1] Similarly, globalization is viewed as the most developed mode, the ultimate structure of the singularization, standardization, and homogenization of culture in the service of instruments of advanced capitalism and neoliberalism. In the face of such totalization, what remains of the critical forces of production which, throughout the modern era, placed strong checks on the submergence of all subjective protocols to the orders of a singular organizing ideology, be it the state or the market? If globalization has established, categorically, the proximity of cultures, can the same be said about globalization and art? When we ask such questions, we must remember that the critical division between culture and art has, for centuries, been marked by art's waging of a fierce battle for independence from all cultural, social, economic, and political influences.

At the same time, the modern Western imagination has used the apotropaic devices of containment and desublimation to perceive other cultures, in order to feed off their strange aura and hence displace their power. Today, the nearness of those cultures calls for new critical appraisals of our contemporary present and its relationship to artistic production.

I start with these observations in order to place in proper context the current conditions of production, dissemination, and reception of contemporary art. Contemporary art today is refracted, not just from the specific site of culture and history but also—and in a more critical sense—from the standpoint of a complex geopolitical configuration that defines all systems of production and relations of exchange as a consequence of globalization after imperialism. It is this geopolitical configuration, its postimperial transformations, that situates what I call here "the postcolonial constellation." Changes wrought by transitions to new forms of governmentality and institutionality, new domains of living and belonging as people and citizens, cultures and communities—these define the postcolonial matrix that shapes the ethics of subjectivity and creativity today. Whereas classical European thought formulated the realm of subjectivity and creativity as two domains of activity, each informed by its own internal cohesion—without an outside, as it were—such thought today is consistently questioned by the constant tessellation of the outside and inside, each folding into the other, each opening out to complex communicative tremors and upheavals. Perhaps, then, to bring contemporary art into the context of the geopolitical framework that defines global relations—between the so-called local and the global, center and margin, nation-state and the individual, transnational and diasporic communities, audiences and institutions—would offer a perspicacious view of the postcolonial constellation. The constellation is not, however, made up solely of the dichotomies named above. Overall, it is a set of arrangements of deeply entangled relations and forces that are founded by discourses of power. These are geopolitical in nature and, by extension, can be civilizational in their reliance on binary oppositions between cultures. In this sense, they are inimical to any transcultural understanding of the present context of cultural production. Geopolitical power arrangements appear in the artistic context along much the same Maginot line. The terrible tear at the core of these arrangements lends contact between different artistic cultures an air of civilizational distinctions predicated on tensions between the developed and the underdeveloped, the reactionary and the progressive, the regressive and the advanced, shading into the avant-garde and the outmoded. This type of discourse is a heritage of classical modernity, which, through these distinctions, furnishes the dialectical and ideological agenda for competition and hegemony often found in the spaces of art and culture.

The current artistic context is constellated around the norms of the postcolonial, those based on discontinuous, aleatory forms, on creolization, hybridization, and so forth, all of these tendencies operating with a specific cosmopolitan accent. These norms are not relativistic, despite their best efforts to displace certain stubborn values that have structured the discourse of Western Modernism and determined its power over Modernisms elsewhere in the world. Edouard Glissant, whose classic work *Caribbean Discourse* (James Arnold (ed.), trans. Michael Dash (Charlottesville: University of Virginia Press, 1992)) made us aware of the tremor at the roots of the postcolonial order, interprets the current understanding of global modernity as essentially a phenomenon of the creolization of cultures. He shows us that in global processes of movement, resettlement, recalibration, certain changes and shifts in modalities of cultural transformations occur, changes that by necessity are neither wholly universal nor essentially particular. Contemporary culture, for Glissant, is cross-cultural, reconstituting itself as a "flood of convergences publishing itself in the guise of the commonplace."[2] In the modern world, he intimates, all subjectivities emerge directly from the convergences and proximities wrought by imperialism. Today, they direct us to the postcolonial. The current history of Modern art, therefore, sits at the intersection between imperial and postcolonial discourses. Any critical interest in the exhibition systems of Modern or contemporary art requires us to refer to the foundational base of modern art history: its roots in imperial discourse, on the one hand, and, on the other, the pressures that postcolonial discourse exerts on its narratives today.

From its inception, the history of Modern art has been inextricably bound to the history of its exhibitions, both in its commodity function through collectors in the economic sphere and in its iconoclasm evidenced by the assaults on formalism by the historical avant-garde. It could, in fact, be said that no significant change in the direction of Modern art occurred outside the framework of the public controversies generated by its exhibitions.[3] Fundamental to the historical understanding of Modern art is the important role played through the forum and medium of exhibitions in explicating the trajectory taken by artists, their supporters, critics, and the public in identifying the great shifts that have marked all encounters with Modern art and advanced its claim for enlightened singularity amongst other cultural avatars. For contemporary art, this history is no less true, and the recent phenomenon of the curator in shaping this history has been remarkable. Nevertheless, a number of remarkable mutations in the growing discourse of exhibitions have occurred. At the same time, art has been persistently presented as something wholly autonomous and separate from the sphere of other cultural activities. Exhibitions have evolved from being primarily the presentation of singular perspectives on certain types of artistic development to become the frightening *Gesamtkunstwerk* evident in the global megaexhibitions that seem to have overtaken the entire field of contemporary artistic production. If we are to judge correctly the proper role of the curator in this state of affairs, the exhibition as form, genre, or medium, as a communicative, dialogical forum of conversation between heterogeneous actors, publics, objects, and so on, needs careful examination.

Today, most exhibitions and curatorial projects of contemporary art are falling under increasing scrutiny and attack. More specifically, they have been called into question by two types of commentary. The first is generalist and speculative in nature. Fascinated by contemporary art as novelty, consumed by affects of reification as a pure image and object of exhibitionism, with spectacle culture, such commentary is itself sensationalist, and lacks critical purpose. It tends to equate the task of an exhibition with entertainment, fashion, and the new thrills and discoveries that seasonally top up the depleted inventory of the "new." It haunts the response to so-called megaexhibitions such as Documenta, biennales, triennales, and festivals, as well as commercial gallery exhibitions of the omnibus type. It easily grows bored with any exhibition that lacks the usual dosage of concocted outrage and scandal. Impatient with historical exegesis, it contents itself with the phantasmagoric transition between moments of staged disenchantment and the incessant populist renewal of art.

The second type of commentary is largely institutional, divided between academic and museological production. It is one part nostalgic and one part critical. Adopting the tone of a buttoned-up, mock severity, it is actually based on a pseudo critical disaffection with what it sees as the consummation achieved between art and spectacle, between the auguries of pop-cultural banality and an atomized avant-garde legacy. For this kind of commentary, art has meaning and cultural value only when it is seen wholly as art, as autonomous. On this view, every encounter with art must be a scientific, not a cultural, one, the priority being to understand the objective conditions of the work in question. In modernity, the inner logic of the work of art is marked by art's removal from the realm of the social-life world that positions it as an object of high culture. Yet there is a price to be paid when it wins its autonomy from any accreted social or ideological baggage. For critics with this viewpoint, the task of the curator is to pay the greatest possible fidelity to a restrained formal diligence in artworks, one derived from values inculcated and transmitted by tradition, a flow that can only be interrupted through a necessary disjuncture, one marked by innovation. The paradox of a disjunctive innovation that simultaneously announces its allegiance and affinity to the very tradition it seeks to displace is a commonplace in the entire history of Modernism, especially in the discourse of the avant-garde.

For curators and art historians the central problematic between art and the avant-garde occurs when there is a breach in the supposed eternality of values that flow from antiquity to

the present, when the autonomy of art suddenly has to contend with the reality of the secular, democratic public sphere—itself the result of a concatenation of many traditions.[4] Even more problematic are breaches in the very conditions of artistic production. One example is what has been called elsewhere the "Duchamp effect;" another is highlighted in Walter Benjamin's much-referenced essay "The Work of Art in the Age of Mechanical Reproduction," which famously traced the changes in the dissemination of art that transform and question traditional notions of originality and aura.[5] Yet another is the encounter between modern European artists and the African and Oceanic sculptures at the turn of the twentieth century, one that resulted in the birth of cubism and much else.

Of these, the Duchamp effect was the most traditional view, because what it purports to do is delineate the supremacy of the artist: the artist as not only a form giver but also a name giver. It is the artist who decides what an object of art is or what it can be, rather than the decision being a result of progressive, formal transformation of the medium of art. For Duchamp, it is not tradition, but the artist who not only decides what the work of art is but also controls its narrative of interpretation. This idea found its final culmination in the tautological exercises of conceptual art, whereby the physical fabrication of art could, ostensibly, be replaced with linguistic description. From this perspective, artistic genius emerges from a subjective critique of tradition by the artist, against all other available data, not from an objective analysis of the fallacy of tradition.

The confrontation with African and Oceanic sculptures by European artists was a striking example from the "contact zone" of cultures.[6] This encounter transformed the pictorial and plastic language of modern European painting and sculpture, hence deeply affecting its tradition. What is astonishing is the degree to which the artistic challenges posed by so-called primitive art to twentieth-century European Modernism have subsequently been assimilated and subordinated to modernist totalization. Therein lies the fault line between imperial and postcolonial discourse, for to admit to the paradigmatic breach produced by the encounter between African sculptures and European artists would also be to question the narrative of modern art history. Nor should we forget that the non-Western objects in question were required to shed their utilitarian function and undergo a conversion from ritual objects of magic into reified objects of art. The remarkable import of this conversion is that the historical repercussion of the encounter has remained mostly confined to formal effects and thus formalist aesthetic analysis.

I cite these examples because they are material to our reading and judgment of contemporary art. The entrance into art of historically determined questions of form, content, strategy, cultural difference, and so on establishes a ground from which to view art and the artists' relationship to the institutions of art today. This breach is now visible, because it no longer refers to the eternal past of pure objects, nor to the aloofness from society necessary for autonomy to have any meaning. In his *Theory of the Avant-Garde* Peter Bürger makes this point clear:

> If the autonomy of art is defined as art's independence from society, there are several ways of understanding that definition. Conceiving of art's apartness from society as its 'nature' means involuntarily adopting the *i'art pour i'art* concept of art and simultaneously making it impossible to explain this apartness as the product of a historical and social development.[7]

The concept of *i'art pour i'art* as part of the avant-garde formulation of artistic autonomy was described by Benjamin as a *theology of art,* which "gave rise to what might be called a negative theology in the form of the idea of 'pure' art, which . . . denied any social function of art."[8] Based on this denial, Burger's analysis advances a claim for a socially determined theory

that stands at the root of two opposing traditions of art historical thought found amongst certain key practitioners today. Not surprisingly, the two opposing traditions match the rivalry discernible in the second type of commentary on curatorial procedures mentioned earlier. This is the domain most struggled over by conservative (traditionalist) and liberal (progressive) groups, both of whom have increasingly come to abjure any social function of art, except when it fits certain theories.

Two recent examples will demonstrate my point here. A roundtable discussion on the state of art criticism in 2000, published in the one-hundredth issue of the influential art journal *October,* was typically reductive.[9] Although the panelists' attack against certain populist types of criticism was indeed cogent and necessary, one could not help but detect a tone of condescension in their irritation. The composition of the speakers of the roundtable was illustrative of the way in which the modes of elision and discrimination that are recurrent in most mainstream institutions and conservative academies pervade even this self-styled progressive intellectual organ. It is, of course, universally known, that this journal, despite its revolutionary claims, remains staunchly and ideologically committed to a defense of Modernism as it has been historically elaborated within the European context and updated in postwar American art. There is nothing inherently wrong with such commitment, were it not elevated to the height of being the universal paradigm for the in fact uneven, diachronic experience of modernity. There is very little acknowledgment of the radical political strategies and social and cultural transformations developed since the decolonization projects of the postwar period outside the West. These have shaped the reception of Modernism in the work of artists outside of Europe and North America, as well as that of many within these spheres. To ignore or downplay this, after 100 issues of continuous publication, is a grave error.

The second example highlights the conservatism of traditional museums of Modern art in their treatment of Modernism. For its opening in 2000, the Tate Modern museum presented an overarching curatorial viewpoint, one that straddles a large expanse of historical developments in Modern art. The relationships between Modern art and the European artistic tradition, and between contemporary art and its modernist heritage, were central. To demonstrate these relationships and at the same time transform the methodology for rendering them in a public display, the museum moved actively between a synchronic and diachronic ordering of its message. The press was filled with speculation about the effectiveness of the museum's "radical" attempt to break with the outmoded chronological emphasis of modernist art history, its effort to inaugurate a far more dialectical exchange and adopt a discursive approach, above all in the display of the permanent collection, which was arranged according to genre, subject matter, and formal affinities. The goal was to present the history of Modern art and the transformations within it in a way that would be readily read by the general public, especially if, for example, a Monet landscape were demonstrated to be an immediate ancestor to the stone circle sculptures and mud wall paintings of Richard Long. What are we to make of this juxtaposition? It shows us, certainly, that both Monet and Long are deeply interested in nature as a source for their art. It could also evoke for the viewer aspects of spirituality and the metaphysical often connected to nature, as well as the conception of landscape as a genre of art from which artists have often drawn. Despite being a curatorial gimmick, these are interesting enough propositions for the average, unschooled museum visitor.

The rooms housing the permanent collection were divided into four themes: Still Life/ Object/Real Life, Nude/Action/Body, History/Memory/Society, Landscape/Matter/ Environment. The decisive idea was to break with a conception of modernist historiography entrenched at the Museum of Modern Art in New York since its founding more than seventy years before. Never mind that many professional visitors, namely curators and historians, whispered that this apparent boldness owed more to the lack of depth in its collection of

Modern art than any radical attempt to redefine how the history of Modern art was to be adjudicated and read publicly. The rooms were divided, like stage sets, into the four themes, such that they read much like chapters in a textbook. The resultant sense of Modern art's undisturbed progression—absent the contradictions, frictions, resistance, and changes that confound and challenge conventional ideas of Modernism—is in itself a historical conceit. Anything that might challenge this most undialectical of approaches was sublated and absorbed into the yawning maws of the Tate Modern's self-authorizing account.

One example, and by far the most troubling, of the curatorial reasoning behind this account will suffice. The Nude/Action/Body theme suggests a series of transformations in the manner in which the body has been used in Modern and contemporary art. The series of passages from *nude* to *action* to *body* suggest an image of contingency, internal shifts in the development and understanding of the human form and subjectivity as it moves from Modern to contemporary art. The image that presides over this shift is corporeal and mechanical, symbolic and functional, artistic and political, from the *nude* as an ideal to the *body* as a desiring machine.

The first gallery opens out to an eclectic selection of paintings by Stanley Spencer, John Currin, Picasso, and others. This is not an auspicious introduction. The selection and arrangement of the works in the gallery is striking, but more for its formal sensibility than in authoritatively setting out any radical thesis of the nude and the body. In the second gallery two large-scale, genuinely imposing, black-and-white photographic works, one by Craigie Horsfield and the other by John Coplans, face each other. Horsfield's picture *E. Horsfield (1987)* (1995) is in the tradition of classical modernist reclining nudes reminiscent of Cézanne's bathers and Matisse's odalisques. It is an outstanding, ponderous picture, heavy like fruit, with the graded tones of gray lending the mass of flesh a stately presence. Coplans's *Self-Portrait (Frieze No. 2, Four Panels)* (1995) is typical of his performative and fragmentary, multipaneled, serial self-portraiture, often representing his flabby, aging body. The seriality of the depicted parts reveals a body seemingly laying claim to its own sentient properties. Formal echoes of the nude from its early modernist treatments of the nude are to be found in contemporary photography, but the difference between the two lies in the idealization of the former and the self-conscious subjectivity of the latter. Modernist photography of the nude focused on forces of nature trapped in classical culture, whereas the contemporary nude is closer in spirit to Deleuze and Guattari's notion of the desiring machine consumed in the process of expressing itself.[10]

When we enter the next gallery, we find a small ethnographic vitrine embedded into one of the walls of the room. To the left is a discreetly placed LCD monitor playing extracts from two films; one by Michel Allégret and André Gide, *Voyage to the Congo,* 1928, the other an anonymous archival film, *Manners and Customs of Senegal,* 1910. The two extracts evince a theme common to travel documentary. Although temporally and spatially separated, we can place these two films within a well-known genre, in the system of knowledge that belongs to the discourse of colonial, ethnographic film studies of "primitive" peoples. (We already know much about the Western modernist fascination with "primitive" peoples' bodies, along with their Orientalist correlatives. We know that the concept of alterity was not only important for Western Modernism; it was also a focus of allegorical differentiation.) Allégret and Gide's film, and the more structurally open archival footage, provide us with much to think about in regard to Modernism, spectacle, otherness, and degeneracy. In each of the two films, we see the setting of the African village and its social life: villagers selfconsciously working on their everyday chores such as grinding grain, tending fires, minding children, or participating in a village festival of dance and song. Most striking about Allégret and Gide's film, however, is that it highlights nakedness; the nakedness of black African bodies under imperial observation. Here, nakedness as opposed to nudity yields a structure of critical differentiation

between the primitive and the Modern, between the savage and the civilized, between ideas of nature and culture.

The method of the camera work in both films appears to be objective, aiming to show "primitive peoples" as they are, in their natural space. Nevertheless, one can detect that part of its conscious structure was to show the degree to which primitive man is not to be confused with the modern man. This differentiation lends what we are viewing a quality not of empathy exactly, but, as James Clifford puts it, "a more disquieting quality of Modernism: its taste for appropriating or redeeming otherness, for constituting non-Western arts in its own image, for discovering- universal, ahistorical 'human' capacities."[11] This observation, taken *in toto* with Modernism's relationship to otherness, the primitive and the savage, bears on the distinction between the nude's formal, aesthetic status within Western modernist art and the picturing of simple nakedness with no redeeming aesthetic value commonly found in ethnographic discourse.

If the Tate Modern were an institution working beyond the smug reflex of Western museological authority it would have found right in its own context artists such as Rotimi Fani-Kayode, the Nigerian-British photographer whose work—formally and conceptually— involves a long, rigorous excursus into the distinction between the nude and nakedness as it concerns the African body. The analytic content, not to say the formal and aesthetic contradictions that Fani-Kayode's photographic work introduces us to about the black body in contrast to the modernist nude is quite telling. More substantial is its awareness of the conflicted relationship the black body has to Western representation and its museum discourse.[12] This makes the absence of works like his in the Nude/Action/Body section of the Tate Modern the more glaring. Many other practitioners deal with these issues, but Fani-Kayode is important for my analysis for the more specific reason of his Africanness, his conceptual usage of that Africanness in his imagery, and his subversion of the fraught distinction between nakedness and the nude in his photographic representation. Fani-Kayode's pictures also conceive of the black body (in his case the black male body with its homoerotic inferences) as a vessel for idealization, as a desiring and desirable subject, and as self-conscious in the face of the reduction of the black body as pure object of ethnographic spectacle. All these critical turns in his work make the Tate Modern's inattention to strong, critical work on the nude and the body by artists such as he all the more troubling, because it is precisely works like his that have brought to crisis those naturalized conventions of otherness that throughout the history of modern art have been the stock-in-trade of Modernism.

Whatever its excuses for excluding some of these artists from its presentation, there are none for Tate Modern's monologue on the matter of the ethnographic films. Alongside the screen, the wall label expounds on the matter of the films' presence in the gallery, uttering its explanation in a characteristic double-speak: "European audiences in the early 20th century gained experience of Africa through documentary films. Generally these conformed to stereotyped notions about African cultures. An ethnographic film of 1910, for instance, concentrates on the skills and customs of the Senegalese, while *Voyage to the Congo,* by filmmaker Marc Allégret and writer André Gide perpetuates preconceptions about life in the 'bush.' However, the self-awareness displayed by those under scrutiny, glimpsed observing the filmmakers subverts the supposed objectivity of the film."

These words impute both the manufacture and consumption of the stereotype to some previous era of European documentary films and audiences, which is to imply that the business of such stereotypes lies in the past, even if it has now been exhumed before a contemporary European audience for the purposes of explaining Modernism's penchant for deracinating the African subject. But if the discourse of the stereotype is now behind us, is its resuscitation an act of mimicry, or is it, as Homi Bhabha has written elsewhere, an act of anxious repetition of the stereotype that folds back into the logic for excluding African artists

in the gallery arrangement as a whole?[13] Does the repetition of the stereotype—caught, if you will, in a discursive double-maneuver—posit an awareness of the problem of the stereotype for contemporary transnational audiences? Or does the museum's label present us with a more profound question in which the wall text causally explains and masks what is absent in the historical reorganization of the museum's memory cum history? One conclusion can be drawn from this unconvincing explanatory maneuver: more than anything it entrenches European modernist appropriation and instrumentalization of Africa into the primitivist discourse of which the Tate Modern in the twenty-first century is a logical heir.

As we go deeper into the matter, our investigation has much to yield as we look further into the ethnographic desublimation (an uneasy conjunction, no doubt, between colonialism and Modernism) taking place in the museum. Beside the film screen, inside the vitrines, we find, casually scattered, postcards with the general title "Postcards from West Africa," and a small, dark, figurative sculpture, untitled, undated, identified simply as *Standing Figure*. The label tells us of the sculpture's provenance: it is from the collection of Jacob Epstein, thus conveying to us the sculpture's aesthetic aura through the synecdoche of ownership. The implication is obvious: the ownership of such a sculpture by one of Britain's important modernist artists means that he must have appreciated the sculpture first and foremost as a work of art, for the important aesthetic qualities that recommend it to the modern European sculptor. But if this is so, why then is the sculpture not more properly displayed along with other sculptures installed in the gallery? Or does its namelessness and authorlessness disable it from entering into the domain of aesthetic judgment necessary for its inclusion as an authoritative work of art?

It is no use speaking about the lyrical beauty and artistic integrity of this powerful sculpture, now so pointlessly compromised by the rest of the detritus of colonial knowledge system crammed in the vitrine. The sculpture's presence is not only remote from us, it seems to connote, not art, above all not autonomous art, but merely the idea of artifact or, worse still, evidence. Nearly a hundred years after the initial venture by Western modernists (and I do not care which artist "discovered" what qualities in African or Oceanic art first), it should have been clear enough to the curators at Tate Modern that in terms of sheer variety of styles, forms, genres, plastic distinctiveness, stylistic inventiveness, and complexity of sculptural language, no region in the world approaches the depth and breadth of African sculptural traditions. In the Congo, from where Gide and Allégret gave us deleterious impressions of their *voyage,* we find distinct traditions of sculpture such as Yombe, Luba, Mangbetu, Kuba, Teke, Lega, Songye, and Dengese. These traditions of sculpture—like many others—are as distinctly unique as they are historically different in their morphological conception of sculpture. The expressive and conceptual possibilities in the language of artists working within each group have produced sculptural forms of extraordinary anthropomorphic variety and complexity. Whether of the mask or figure, the statue or relief, a simple comparative study between them yields the active field of artistic experimentation and invention that many a modernist recognized, understood, and appreciated. But this is not communicated at all in the lugubrious gathering at the museum. What this installation communicates is neither a history nor even a proper anthropology of Modernism. Rather, the task of this "historical" instruction is more the repetition of what has become a convention in a variety of museums of Modern art. This type of instruction more obfuscates than enlightens. In fact, along with museum collections, most Western modernist museology is predicated on the repetition and circulation of disparate apocrypha and objects connected to this obfuscation.[14]

The very idea that there might be an African conception of modernity does not even come up. Nor does the possibility that between Western modernist artists in correspondence with their African contemporaries there existed and now exists an affiliative spirit of mutual influence and recognition. Instead, the vitrines as a whole posit a mode of instruction as to what is

modern and what is not. On display are Carl Einstein's well-known book *Neger Plastik* and Marcel Griaulle's accounts of the Dakar-Djibouti expedition published in the journal *Minotaure,* contemporary to Michel Lieris's famous book *L'Afrique Fantome.* This is a pantomime of "the Modern" opposed to "the primitive," which the Tate Modern has now upgraded to the most astonishing form of ethnographic ventriloquism. Having emptied and hollowed out the space of African aesthetic traditions, the rest of the gallery was filled in—with customary care and reverence—with carefully installed, "autonomous" sculptures by Brancusi and Giacometti, and paintings by the German expressionists Karl Rotluff and Ludwig Ernst Kirschner. A Kirschner painting of a cluster of nude figures with pale elongated limbs and quasi-cubist, conical, distended midsections is noteworthy and striking in its anthropomorphic resemblance and formal correspondence to both the sculpture in the vitrine and what we had been looking at in the film of the naked Congolese women and children in Gide and Allégret's film.

Given the large literature on the subject, one should take Tate Modern to task by asking whether it could not have found African artists from whatever period to fit into their dialectical scheme? The evidence emphatically suggests a larger number of candidates. The reality is that they did not do so. Not because they could not, but most likely because they felt no obligation to stray from the modern museum's traditional curatorial exclusions. So much for the claim to be mounting a dialectical display, as indicated by the titles of the rooms. In fact, what was concretely conveyed was an untroubled attitude, a singular point of view, a sense of sovereign judgment.

We should, nonetheless, concede the fact that Tate Modern was merely operating on well-trodden ground. When, for example, Werner Spies reinstalled the galleries of the Centre Pompidou, Paris, in 1999, he applied a curatorial flourish to the museum's cache of modernist paintings and sculptures, mixing them with postwar and contemporary art while assigning classical African sculpture and masks to a garishly lit vitrine wedged into a hallway-like room. A more serious example of this sort was the curatorially important, widely influential, and superbly scholarly exhibition "Primitivism and Modern Art: Affinities of the Tribal and the Modern" of 1984–1985 at the Museum of Modern Art, New York, which treated the African and Oceanic works as it did the most highly refined modernist objects. But even this valuing of them as autonomous sculptures was achieved through a sense of reification that all but destroyed the important symbolic power of the objects and the role they played in their social contexts.

In 1989, Jean-Hubert Martin curated "Magiciens de la Terre" at the Centre Pompidou, an exhibition that remains controversial. It set a different course in its response to the question that has vexed the modernist museum from its earliest inception, namely the status and place of non-Western art within the history of Modern and contemporary art. To evade this conundrum Martin elected to eliminate the word "artist" from his exhibition—mindful of the fact that such a designation may be unduly burdened by a Western bias—choosing instead the term *magicien* as the proper name for the object and image makers invited to present their art. If the MOMA and Centre Pompidou exhibitions—in New York and Paris respectively, two bastions of the history of Modern art in the world—responded critically to the controversial and unresolved aesthetic and historical debates within modernist accounts concerning art and artists from other cultures, Tate Modern, in its own attempt to further the rewriting of the modernist reception of the Other and of non-Western art, proved both unevolved and unreflexive. The entire installation was ahistorical, with no semblance of the critical content of what Habermas calls "the philosophical discourse of modernity."[15] In fact, it was marked by a subjugation of historical memory, a savage act of epistemological and hermeneutic violence.

If I have dwelt on elucidating this particular view it is only to frame what is at stake for artists and curators who step into the historical breach that has opened up today within the context

of contemporary art. As regards modernist historiography, that is another matter. But we do know that Modernism has many streams that do not all empty into the same basin. Equally evident is the fact that the rising tide of institutional interest in other accounts of artistic production will never lift all the boats into the dialectical position of tradition and continuity so beloved by museums such as the Tate Modern. This is the nub of the current skepticism toward a globalized reception of contemporary artistic practices from far-flung places with little historical proximity to the ideas transmitted from within the legacy of the Western historical avant-garde. In today's complex conditions, the legacy of the Western historical avant-garde seems inadequate to the job of producing a unified theory of contemporary art. Because of its restless, unfixed boundaries, its multiplicities, and the state of "permanent transition" within which it is practiced and communicated, contemporary art tends to be much more resistant to global totalization. Yet the last two decades have witnessed an exponential rise in the fortunes of curators, who, with their portmanteau of theories neatly arranged—befitting of their status as the enlightened bureaucrats of modernist totalization—travel the world scouring it for new signs of art to fill the historical breach.

Deftly packaged multicultural exhibitions seem, today, to be mere responses of convenience and strategy aimed at keeping at bay certain social forces that demand greater inclusion of art that reflects the complexity of societies in which museums exist. To be sure, the responses by museums and academies to the troubling questions of inclusion/exclusion have a historical basis, most obviously imperialism and colonialism. The rupture in continuity, to which imperialism and colonialism subjected many cultures, continues to have contemporary repercussions on matters such as taste and judgment. It provides many artists with an important point of disputation, and hones their capacities for figuring new values of truth within the field of contemporary art. Modern and contemporary art has demonstrated the utter impossibility of the one true judgment of art, however authoritative such judgment may seem to be.

It has long been recognized that postcolonial processes have increasingly highlighted the problematics of Western judgment over vast cultural fields in the non-Western world. Many curatorial practices today are direct responses to postcolonial critiques of Western authority. The conditions of production and reception of contemporary art evince a dramatic multiplication of its systems of articulation. This has occurred to such a degree that no singular judgment could contain all its peculiarities.

The curatorial responses to the contestations initiated both by postcolonialism and expanded definitions of art seem directed at assimilating certain historical effects that became clear only in the last three decades, especially in the 1980s and 1990s, and have accelerated since the late 1990s. I will delineate the five effects that, to me, are the most salient. They are outcomes not so much of the value system of the old world of Modernism but the postcolonial conditions of the contemporary world as such. Because modernist formalism has tended to respond to contemporary culture with hostility, the effects I am speaking of are marked, therefore, not so much by the speed of their transposition into networks and teleologies of organized totality (that is, they do not share the theology of universal history common to all modernist effects), rather, they are founded on the impermanent and aleatory. Impermanence here does not mean endless drift, or the evacuation of specificity. Rather, the structure of contemporary art's relationship to history is more transversal, asynchronous, and asystematic in nature, thereby revealing a multiplicity of cultural procedures. Contemporary art today cannot be defined by simple, singular models.

The first effect of contemporary complexity is the proliferation of exhibition forms—such as blockbusters, large-scale group or thematic exhibitions, cultural festivals, biennales, and so on—and their constant mutation. All of these have significantly enlarged the knowledge base of contemporary thinking about art and its commonplaces in museums and culture at large. This enlargement is crucial, because it has created new networks between hitherto

separated spheres of contemporary artistic production, in both the everyday engagement with the world and its images, texts, and narratives, and in what I have called Modernism's dead certainties. Even though this phase is still in a developmental stage, it has already oriented the transmission of contemporary art discourses toward a deeper confrontation with what Carlos Basualdo has called the "new geographies of culture."[16] Curatorial and exhibition systems are confronted with the fact that all discourses are located, that is, they are formed and begin somewhere, they have a temporal and spatial basis, and they operate synchronically and diachronically. The located nature of cultural discourses, along with their history of discontinuities and transitions, confronts curatorial practices with the fragility of universalized conceptions of history, culture, and artistic procedures.

The second effect initially appeared as an allegory of transformation and transfiguration, then subsequently as a mode of resistance and repetition. It is easy to underestimate today the force of the dissolution of colonialism on art and culture until we realize that, not so long ago—barely half a century—the majority of the globe (covering almost two-thirds of the earth's surface and numbering more than a billion people) were places and peoples without proper political rights. Now, with the decay of colonial state structures, it is again easy enough to mock the Utopian aspirations of self-determination, liberation from colonialism, and political independence that began to see off the imperial discourse that had characterized global modernity in its early phase. Indeed, global modernity powerfully sustained the plethora of fictions on which the idea of a national tradition in art and culture was founded. In the guise of the modern nation-state, it furnished the political identity of the modern artist, and continues, by and large, to do so. Decolonization and national identity, therefore, represent the bookends of two concomitant projects of late global modernity. On the one hand, decolonization portends to restore sundered traditions to their "proper" pasts, whilst national identity through the state works assiduously to reinvent and maintain them in the present and for the future. This is what has been called the roadmap to nation building and modernization. Decolonization, qua the postcolonial, transforms the subject of cultural discourse, while the nation-state reinvents the identity of the artist and transfigures the order of tradition for posterity. If the mode of the postcolonial is resistance and insubordination through transformation, that of the nation is consolidation and repetition through transfiguration. Out of each, the figure of the new becomes the emulsifier for either tradition and restoration, or tradition and continuity. The antinomies of the Modern and contemporary can be plainly seen. Contemporary curatorial practice is keenly aware of the uses, abuses, and usefulness inherent in this situation.

Nowhere is this discourse more palpable than in the fiery debates concerning cultural identity. Representation becomes not merely the name for a manner of practice, but, quite literally, the name for a political awareness of identity within the field of representation. In the contest of decolonized representation, innovation is as much about the coming to being of new relations to cultures and histories, to rationalization and transformation, to transculturation and assimilation, and new practices and processes, new lands of exchange and moments of multiple dwelling as it is about the ways artists are seen to be bound to their national and cultural traditions. Here, political community and cultural community become essentially coterminous. As well, beyond nationalism and national cultures, decolonization is more than just the forlorn daydream of the postcolonial artist or intellectual, for it has, attached to it, something recognizable in the ideals of modernity: the notion of progress. In the postcolonial constellation, therefore, the new in art has different kinds of self-affirmative content.

How does this square with the postmodern critique of what is derogatively referred to as "identity-based" or "multicultural" art? Notice the conflation of the terms: identity and multiculturalism. The weakness of all identity-based discourse, we were told, lay in its self-contradiction, in its attempt to conflate the universal and the particular, self and other, into the social site of artistic production. Another critique saw identity-based practices as

presuming cultural and political grounds that were too reductive and simplistic, specific and limited; and, because of their incapacity to deal with abstraction, incapable of transcending that specificity and aspiring to universal culture. Commenting on the fragmentation of modernist totalization introduced by Postmodernism, art historian Hal Foster posed the following questions: "Is this fragmentation an illusion, an ideology of its own (of political 'crisis,' say, versus historical 'contradiction')? Is it a symptom of a cultural 'schizophrenia' to be deplored? Or is it, finally, the sign of a society in which difference and discontinuity rightly challenge ideas of totality and continuity?"[17]

Putting aside for the moment the fact that identity-based discourses have been eviscerated, are we to take it that identity discourse—understood in all of its oppositionality, contingency, and discontinuity—is the specter that haunts Modernism? Further, was there a false consciousness in the belief that identity-based discourses, along with their multicultural correlatives, working in alliance with postmodernism's critique of grand narratives and universal history (including those elaborations on paradigms of asymmetrical power relations unleashed by postcolonial studies), could bring about the possibility of a decentered global cultural order? Certainly, global culture is thoroughly decentered, but its power can hardly be said to be contained. Through an unsentimental reading of Marxism and cultural ideology, Foster offers a view that permits us to pursue this question. He writes of how:

> new social forces—women, blacks, other "minorities," gay movements, ecological groups, students—have made clear the unique importance of gender and sexual difference, race and the third world, the "revolt of nature" and the relation of power and knowledge, in such a way that the concept of class, if it is to be retained as such, must be articulated in relation to these terms. In response, theoretical focus has shifted from class as a subject of history to the cultural constitution of subjectivity, from economic identity to social difference. In short, political struggle is now seen largely as a process of "differential articulation."[18]

No museum or exhibition project, even if it might wish to avoid addressing the consequences of this "differential articulation," can remain critically blind to the importance of multicultural and identity-based practices, however wrong-headed and regressive they may appear. One guiding reason for this vigilance amongst cultural institutions has to do with both the politics of enlightened self-interest and the changing of the cultural and social demographics of many contemporary societies due to large-scale immigrations of the twentieth century. In the case of the United States and Europe, the civil rights movement, antiracist movements, and the struggle for the protection of minority rights have increased the level of this vigilance. There is also the recognition of the role of the market in the institutionalization of national identity in recent curatorial projects, especially in exhibitions designed to position certain national or geographic contexts of artistic production. What is often elided in the excitation of these new national or geopolitical spaces, however, is the politics of national representation that recommends them through various national funding and promotional boards, cultural foundations, and institutions.[19] Increasingly, curators have become highly dependent on the patronage of such institutions. The neoexpressionist market juggernaut of the late 1970s and 1980s led Benjamin Buchloh to identify a similar curatorial symptom, one that trades on the morbid cliché of national identity: "When art emphasizing national identity attempts to enter the international distribution system, the most worn-out historical and geopolitical clichés have to be employed. And thus we now see the resurrection of such notions as the Nordic versus the Mediterranean, the Teutonic versus the Latin."[20]

The third effect is the explosion of and the heterogeneous nature of artistic procedures immediately at variance with the historically conditioned, thereby conventional understanding

of art within the logic of the museum. Such procedures have been theorized, quite correctly, as neoavant-garde, rather than as true ruptures from their academic obverse. However, it can be said that institutional canniness has often found inventive ways to absorb the energies of even the most insurrectional positions in art. The emergence of new critical forces has all too often become cashiered as another instance in the positivist ideology of advanced art's claim of *engagement* set forth by the institution.

The fourth effect results from the mediatization of culture, especially in the transformation of the museum form into the realm of the culture industry of mass entertainment, theatricality, and tourism. The most exact expression of the passage of museums into the concept of mass culture has been achieved through the fusion of architectural design and the museum's collection whereby the collection and architecture become one fully realized *Gesammtkunstwerk* and understood as such.[21] The fusion of the art collection with the architecture of the museum is as much a value-supplying feature as any other purpose. Out of town visitors can visit the Frank Lloyd Wright-designed Guggenheim Museum in New York or Frank Gehry's Guggenheim Bilbao, treating each as a unique work of art in its own right, or they may travel to see the buildings and visit the collections at the same time. Despite their universalist aspirations, most contemporary museums exist with the dark clouds of nationalism or ideologies of civic virtue hovering over them. Even if the aspiration of the museum is not specifically nationalist, in order to attract funding and state support, its discourse in today's competition between global cities must be decidedly nationalist in spirit.

The fifth effect, which I believe ultimately subtends the previous four, is the globalization of economic production and culture, and the technological and digital revolution that has fused them. Two factors about globalization make it fascinating in relation to this discussion: its limit and reach. While the compression of time and space is understood as one of the definitive aspects of the globalization of art and culture, the access of artists to its benefits is massively uneven. Having abandoned the values of "internationalism," there is now the idea in art discourse that the globalization of art opens the doors to greater understanding of the motivations that shape contemporary art across Europe, North America, Asia, Africa, South America, across the world at large. Paradoxically, it is globalization that has exposed the idea of a consolidated art world as a myth. Rather than a centered structure, what is much in evidence today are networks and cross-hatched systems of production, distribution, transmission, reception, and institutionalization. The development of new multilateral networks of knowledge production—activities that place themselves strategically at the intersection of disciplines and transnational audiences—has obviated the traditional circuits of institutionalized production and reception. These emergent networks are what I believe Basualdo means by "new geographies of culture." By emphasizing emergence, I wish, especially, to foreground not so much the newness of these territories (many of which, in fact, have extraterritorial characteristics) but their systematic integration into mobile sites of discourse, which only became more visible because of the advances in information technology as a means of distributing, transmitting, circulating, receiving, and telegraphing ideas and images.

How does the curator of contemporary art express her intellectual agency within the state of "permanent transition" in which contemporary art exists today? How does the curator work both within canonical thinking and against the grain of that thinking in order to take cognizance of artistic thought that slowly makes itself felt, first in the field of culture, before it appears to be sanctioned by critics and institutions? I do not have specific answers to these questions. But I do have a notion or two about how we may approach them.

From the moment exhibitions of art assumed a critical place in the public domain of social and cultural discourse amongst the political classes—within the bourgeois public sphere that first emerged actively in Europe in the aftermath of the French Revolution—exhibitions

have been constituted within the history of thought.[22] This field, as Foucault showed, is shaped above all by institutionalized power and systems of legitimation. Despite the evident fact that the institutions of art moved, inexorably, from the private, courtly domain of the feudal state to the increasingly public salons of the democratic secular state, fundamental instruments of power were still disproportionately held through patronage by the bourgeois elite in alliance with the aristocracy. Today, this process of social differentiation has entered another sphere, one dominated by capital, and contested by the forces of the so-called avant-garde. As Pierre Bourdieu puts it, "The literary or artistic field is at all times the site of a struggle between the two principles of hierarchization: the heteronymous principle, favorable to those who dominated the field economically and politically (e.g. 'bourgeois art') and the autonomous principle (e.g. 'art for art's sake'), which those of its advocates who are least endowed with specific capital tend to identify with a degree of independence from the economy, seeing temporal failure as a sign of election and success as a sign of compromise."[23]

This kind of struggle between the strategic utility of failure or success also confronts curators, and influences their judgment. For contemporary artists, the role of curators in the adjudication of success or failure—the principle between academicism and avant-gardism, between tradition and innovation—remains a key factor in public and institutional legitimation. Yet the emergence of exhibitions as a cultural activity of public institutions has been informed and governed by aesthetic criteria, disciplinary and artistic norms that designate the historical relationship of the public to all of art. While these standards are said to derive from nothing less than the ontological facture of art as an autonomous drive of artistic creativity— hence the apparently universal dimension of our grasp of art's meaning, and, as a supplement, its history—we know, as a fact of experience, that the constitutive field of art history is a synthetically elaborated one, that it is a history made by humans. Thus transcendental categories of art, including those works that seek to highlight this synthetic elaboration and as such obviate its foundational principle, still come under the putative influence and exertion of the epistemes of historical thought. Even the most radical exhibitions are constituted in this general field of knowledge and define themselves within or against its critical exertion, which is both historical and institutional. As we see in many contemporary exhibitions, the dispersed, fragmentary, and asymmetrical state of economic capitalization now endemic in all global systems has foreshortened the horizon of art. In this situation, the radical will of the curator is no less compromised. Therefore, all exhibition procedures today call for a new kind of assessment, grounded in the historical reality of the current episteme, especially if we view the task of an exhibition and the work of the curator as fundamentally contiguous. What exactly do exhibitions propose and curators organize, if not the alliance of historically and institutionally ordered experience governing the reception and relations of art and its objects, concepts, forms, and ideas by a heterogeneous and culturally diverse public? The avidity with which critics seek to confine the task of the curator and the curator's relationship to the one true history of art makes this reach for openness a pressing imperative.

All curatorial procedures that are grounded in the discursive mechanisms of "the history of art" have an optics, that is to say a lens, a way of looking, seeing, and judging art and its objects, images, texts, events, activities, histories, and the intermedia strategies that define the artwork's public existence through institutions, museums, galleries, exhibitions, criticism, and so on. Yet the power, if not necessarily the import, of curatorial judgments are limited by the almost Orwellian dispensation on the part of certain art academics toward constructing a viewpoint that is overarching in terms of its conclusions about certain artistic skills and competencies, concepts, and meanings. As a specific discipline of the Western academy, the "history of art," having taken as its charter the oversight of all artistic matters, tends to surreptitiously adopt and incorporate into its discursive field a bird's-eye, panoptic

view of artistic practice. This, in turn, appropriates and subverts subjective judgment into a sovereign assessment of all artistic production within a general framework. The curator, therefore, is not quite the sovereign we earlier made her out to be. Nonetheless, she operates (with the unambiguous sanction of historical and imperial precedent) like a viceroy, with the role of bringing the nonbelievers under the sovereign regard of the great Western tradition. It is the sovereign judgment of art history, with its unremitting dimension of universality and totality, that leads us to question whether it is possible to maintain a singular conception of artistic modernity. It also raises the question of whether it is permissible to still retain the idea that the unique, wise, and discriminating exercise of curatorial taste—or what some would call, ambiguously, "criticality"—ought to remain the reality of how we evaluate contemporary art today. Foucault's call for the problematization of the concept of thought in relation to critical praxis remains pertinent. The fields of practice in which relations of production, acculturation, assimilation, translation, and interpretation take place confront us immediately with the contingency of the contemporary norm of curatorial procedures that spring from the sovereign world of established categories of art inherited from "the history of art."

The museum of Modern art as an object of historical thought has a social life, as well as a political dimension, and its function cannot be dissociated from the complex arena of society and culture within which its discourse is imbricated. To that end, then, it is of significant interest to see in the curator a figure who has assumed a position as a producer of certain kinds of thought about art, artists, exhibitions, and ideas and their place amongst a field of other possible forms of thought that govern the transmission and reception of artistic production—someone, that is, who thinks reflexively about museums. Interestingly, in recent decades, it is artists more than curators who have interrogated the institution of the museum with considerable rigor. Even if "institutional critique," which inaugurated this critical intervention into the discursive spaces of the museum, has made itself redundant in light of the parasitic relationship it developed within the institution, it nonetheless opened up a space of critical address that few curators rarely attempt.

The challenge here is for the curator to grasp her work as a mode of practice that leads to particular ways of aligning thought and vision through the separation and juxtaposition of a number of models within the domains of artistic production and public reception. This method shows how the curator reflexively produces an exhibition, while allowing the viewer to think, see, appreciate, understand, transform, and translate the visual order of contemporary art into the broader order of knowledge about the history of art.

If we were to attempt a definition of the status of the artwork in the current climate of restlessness and epistemological challenges, it would not be a restrictive one, but an understanding of the artwork as being produced and mobilized in a field of relations.[24] A field of relations places contemporary art and its problematics within the context of historical discourses on modernity, and elucidates the challenges to, and potentialities of, curatorial work today. The incandescence of Foucault's splendid definition of the idea of "work" provides a true insight into the problem. This is how he defines work: "that which is susceptible of introducing a meaningful difference in the field of knowledge, albeit with a certain demand placed on the author and the reader, but with the eventual recompense of a certain pleasure, that is to say, of an access to another figure of truth."[25]

Situated, as curators and art academics are, on the other side of the line from which the public faces institutions of legitimation, how might we achieve this other figure of truth, especially in an exhibition context? With what aesthetic and artistic language does one utter such truth? In what kind of environment? For which public? How does one define the public of art, particularly given the proliferation of audiences? Finally, in the circumstances of the contemporary upheaval of thought, ideas, identities, politics, cultures, histories, what truth are we

talking about? The upheaval that today defines contemporary events is a historical one, shaped by disaffection with two paradigms of totalization: capitalism and imperialism, and socialism and totalitarianism. If the disaffection with these paradigms did not shift significantly the axis and forces of totalization, it did shape the emergence of new subjectivities and identities. But the dominant description of this emergence has crystallized into a figure of thought that is radically enacted in oppositional distinctions made on civilizational and moralistic terms, such as "the clash of civilizations," "the axis of evil," and the "evil empire."[26] During the late 1980s and early 1990s the culture wars in the United States were waged on similarly reductive terms, which in time cooled the ardor of those institutions tempted to step beyond their scope.[27]

My conception of the postcolonial constellation is an outcome of the upheaval that has resulted from deep political and cultural restructuring since World War II, manifest in the liberation, civil rights, feminist, gay/lesbian, and antiracist movements.[28] The postcolonial constellation is the site for the expansion of the definition of what constitutes contemporary culture and its affiliations in other domains of practice; it is the intersection of historical forces aligned against the hegemonic imperatives of imperial discourse. In conclusion, I would like to reaffirm the importance of postcolonial history and theory for accurate understanding of the social and cultural temporality of late modernity. If I recommend the postcolonial paradigm for illuminating our reading of the fraught historical context from which the discourses of Modernism and contemporary art emerged, it is only to aim toward a maturity of the understanding of what art history and its supplementary practices can contribute today toward our knowledge of art. The postcolonial constellation seeks to interpret a particular historical order, to show the relationships between political, social, and cultural realities, artistic spaces and epistemological histories, highlighting not only their contestation but also their continuous redefinition.

Notes

An earlier version of this chapter appeared in *Research in African Literature* 34, no. 4 (2003), 57–82.

1 See Fernand Braudel's discussion of the structural transformation of the flow of capital and culture by distinct temporal manifestations, the paradigmatic and diagnostic attribute of historical events in relation to their duration, in his *Civilization and Capitalism* (vol. 3 (New York: Harper and Row, 1984)), esp. 3:17–18 and 3: chap. 1.

2 Much like Gilles Deleuze and Felix Guattari, in their use of the idea of the rhizome, Glissant employs the metaphor of the prodigious spread of the mangrove forest to describe the processes of multiplications and mutations that for him describe the tremor of creolization as a force of historical changes and ruptures brought about by changes in the imperial order.

3 Admittedly, the advent of mass culture has muted the ability of exhibitions to be truly seminal in the wider cultural sense manifest in the controversies around the French salons of the nineteenth century, or the Armory Show of 1917 in New York. Dada was defined as a new artistic movement primarily through its many exhibitions and happenings. Recent art world miniscandals—such as the lawsuit brought against the Contemporary Art Center of Cincinnati upon its exhibition of Robert Mapplethorpe's homoerotic photographs in 1990, or the controversy surrounding Chris Ofili's painting of a Madonna, which used elephant dung for one of her breasts, in the Brooklyn Museum's exhibition "Sensation" in 1999—indicate the degree to which exhibitions of art remain culturally significant.

4 The Nobel economist Amartya Sen has recently given many examples of the cross-pollination of ideas between cultures—particularly in language, mathematics, and the sciences—which has continued unabated for two millennia. See his "Civilizational Imprisonments."

5 See Martha Buskirk and Mignon Nixon, *The Duchamp Effect* (Cambridge, MA: MIT Press, 1996); and Benjamin "The Work of Art in the Age of Mechanical Reproduction."

6 See Mary-Louise Pratt, "Arts of the Contact Zone."

7 Peter Bürger, *Theory of the Avant-Garde*, trans. Michael Shaw (Minneapolis: University of Minnesota, 1984), 35.

8 Benjamin, "The Work of Art in the Age of Mechanical Reproduction," 224.

9 See "A Special Issue on Obsolesence," *October,* vol. 1, no. 1 (Spring, 2002) particularly the roundtable on art criticism, 200–28.

10 See Gilles Deleuze and Félix Guattari, *Anti-Oedipus* (Minneapolis: University of Minnesota, 1983).

11 James Clifford, *The Predicament of Culture* (Cambridge, MA: Harvard University Press, 1988), 193.

12 For a thorough account and brilliant analysis of this issue, see Thelma Golden's groundbreaking exhibition catalogue *Black Male* (New York: Whitney Museum, 1994).

13 Homi Bhabha, "The Other Question," in *The Location of Culture* (New York: Routledge, 1994).

14 The same holds true for most museums of contemporary art in Europe and the United States. I have often found it curious how contemporary collections seem exactly identical, irrespective of the city in which the museum is located. The unconscious repetition of the same artists, objects, and chronology in both museums and private collections should make curators less sanguine about the independence of their judgment in connection with art and artists who may not fit easily into the logocentric logic of seriality.

15 See Jurgen Habermas, *The Philosophical Discourse of Modernity* (London: Polity Press, 1997), for an extensive treatment of the discourse of modernity and modernization, and of Modernism as their artistic and aesthetic corollary. In the chapter "Modernity's Consciousness of Time and Its Need for Self-Reassurance" he draws attention to Max Weber's contention that the concept of modernity arose out of a peculiarly "Occidental rationalism."

16 Carlos Basualdo, "New Geographies of Culture," statement on a flyer accompanying a series of public seminars organized by Basualdo at the Jorge Luis Borges National Library, Buenos Aires, Argentina, 2002.

17 Hal Foster, *Recodings* (Seattle, WA: Bay Press, 1985), 139.

18 Foster, *Recodings,* 139.

19 Some of the most active institutions are foreign policy instruments of the given countries. These include the British Council (United Kingdom), Association Française d'Action Artistique (France), Danish Contemporary Art (Denmark), Institut für Auslandsbeziehungen (Germany), Mondriaan Foundation (The Netherlands), and the Japan Foundation. They employ the export of artists and exhibitions as an active tool of cultural diplomacy, often organize curatorial tours in their respective countries, fund artists for overseas projects, support exhibitions in highly visible international cities, and tour exhibitions of art from their national collections to other parts of the world.

20 Benjamin Buchloh, "Figures of Authority, Ciphers of Regression," in Brian Wallis (ed.), *Art After Modernism* (New York: New Museum, 1984) 123.

21 The Centre Pompidou, Paris, designed by Richard Rogers and Renzo Piano; the Guggenheim Museum, Bilbao, designed by Frank Gehry; and the Milwaukee Art Museum by Santiago Calatrava are examples of this conjunction. Yet no other museum achieves this fusion most thoroughly and with such audacious rhetorical panache as Daniel Libeskind's Jewish Museum in Berlin. Libeskind's architectural narrative is so forceful and complete that any visit through the museum is nothing less than an architectural guided tour, one in which the experience of the displays is always mediated by the stronger narrative of the building.

22 See Jurgen Habermas, *The Structural Transformation of the Public Sphere* (London: Polity Press, 1992).

23 Pierre Bourdieu, *The Field of Cultural Production* (New York: Columbia University Press, 1993), 40.

24 My idea of field of relations recapitulates Bourdieu's own assessment (in *The Field of Cultural Production*) of the artistic sphere as one enmeshed in a field of activities in which "various agents and position takers collaborate in an ever expansive set of relations that define, conceive, conceptualize, and reformulate norms and methods within the field of cultural production".

25 Foucault, "Des Travaux," in *Dits et écrits* (Paris: Editions Gallimard, 1994), 4:367, quoted by Paul Rabinow in "Introduction: The History of Systems of Thought," in Michel Foucault, *Essential Works of Foucault,* vol. 1, Paul Rabinow (ed.) (New York: New Press, 1997) 1:xxi.

26 Respectively, Huntington, *The Clash of Civilization and the Remaking of World Order;* George W. Bush, State of the Union Address, January 29, 2002, in which he outlined a stark distinction between states that belong to the moral universe of the civilized [sic] world, and those others, especially Iran, Iraq, and North Korea, who, he stated, exist in the pool of darkness and are motivated by evil intentions against the peaceful, civilized world; and then U.S. president Ronald Reagan characterizing the Soviet Union in a speech to the British House of Commons, June 8, 1982.

27 Conservative critics such as Hilton Kramer, Allan Bloom, and others made fodder of any cultural form or concept seen to want to relativize the obvious categorical and empirical truth of the great Western tradition with a cultural insight that deviates from the superiority of the Western canon. Postmodernism, and latterly postcolonial theory, became the easy route to show that the emperor of multiculturalism has no clothes and must be exposed as such with the most strident ideological

attacks. Political subjectivity or social awareness of the dimension of multiplicity in any creative work was not only seen as fraudulent but also anti-Western. The culture wars destroyed any vestige of dissent within the intellectual field and exposed the weaknesses of the liberal academy. Part of the terrible legacy of this civilizational discourse is a return to consensual opposition between the Left and the Right, each pitched in its own historical bivouac. Today, to speak a measure of truth about art that contradicts the retreat back into rampant academicism is indeed a dangerous, yet occupational hazard.

28 Elaborated in Owkui Enwezor, "The Black Box," in *Documents 11—Platform 5* (Ostfildern-Ruit: Hatje Cantz Publishers, 2002).

Eyal Weizman

URBAN WARFARE: WALKING THROUGH WALLS

I have long, indeed for years, played with the idea of setting out the sphere of life—bios—graphically on a map. First I envisaged an ordinary map, but now I would incline to a general staff's map of a city centre, if such a thing existed. Doubtless it does not, because of the ignorance of the theatre of future wars.

Walter Benjamin[1]

I no longer know what there is behind the wall, I no longer know there is a wall, I no longer know this wall is a wall, I no longer know what a wall is. I no longer know that in my apartment there are walls, and that if there weren't any walls, there would be no apartment.

Georges Perec[2]

Go inside, he ordered in hysterical broken English. Inside!—I am already inside! It took me a few seconds to understand that this young soldier was redefining inside to mean anything that is not visible, to him at least. My being "outside" within the "inside" was bothering him.

Nuha Kboury[3]

THE MANOEUVRE CONDUCTED by Israeli military units in April 2002 during the attack on the West Bank city of Nablus, was described by its commander, Brigadier General Aviv Kochavi, as "inverse geometry," which he defined as the reorganization of the urban syntax by means of a series of micro-tactical actions. Soldiers avoided using the streets, roads, alleys and courtyards that define the logic of movement through the city, as well as the external doors, internal stairwells and windows that constitute the order of buildings; rather, they were punching holes through party walls, ceilings and floors, and moving across them through 100-metre-long pathways of domestic interior hollowed out of the dense and contiguous city fabric. Although several thousand Israeli soldiers and hundreds of Palestinian guerrilla fighters were maneuvring simultaneously in the town, they were saturated within its fabric to a degree that they would have been largely invisible from an aerial perspective at any given moment. This form of movement is part of a tactic that the military

refers to, in metaphors it borrows from the world of aggregate animal formation, as "swarming" and "infestation." Moving through domestic interiors, this manoeuvre turned inside to outside and private domains to thoroughfares. Fighting took place within half-demolished living rooms, bedrooms and corridors. It was not the given order of space that governed patterns of movement, but movement itself that produced space around it. This three-dimensional movement through walls, ceilings and floors through the bulk of the city reinterpreted, short-circuited and recomposed both architectural and urban syntax. The tactics of "walking through walls" involved a conception of the city as not just the site, but as the very *medium* of warfare— a flexible, almost liquid matter that is forever contingent and in flux.

According to British geographer Stephen Graham, since the end of the Cold War a vast international "intellectual field" that he calls a "shadow world of military urban research institutes and training centres" has been established in order to rethink military operations in urban terrain.[4] The expanding network of these "shadow worlds" includes military schools, as well as mechanisms for the exchange of knowledge between different militaries such as conferences, workshops and joint training exercises. In their attempt to comprehend urban life, soldiers take crash courses in order to master topics such as urban infrastructure, complex systems analysis, structural stability and building techniques, and study a variety of theories and methodologies developed within contemporary civilian academia. There is therefore a new relationship emerging within a triangle of interrelated components that this chapter seeks to examine: armed conflicts, the built environment and the theoretical language conceived to conceptualize them. The reading lists of some contemporary military institutions include works dating from around 1968 (in particular, the writings of those theorists who have expanded the notion of space, such as Gilles Deleuze, Félix Guattari and Guy Debord), as well as more contemporary avant-garde writings on urbanism and architecture that proliferated widely throughout the 1990s, and relied on postcolonial and post-structuralist theory. According to urban theorist Simon Marvin, the military-architectural "shadow world" is currently generating more intense and better funded urban research programmes than all university programmes put together.[5] If some writers are right in claiming that the space for criticality has to some extent withered away in late twentieth-century capitalist culture, it surely seems to have found a place to flourish in the military.

Seeking out the destiny of the discipline of architecture in another—the military—this chapter will examine Israel's urban warfare strategies throughout the second Intifada, and the emergent relationship between post-modern critical theory, military practice and institutional conflicts within the IDF that it brought about; in analysing these developments it will also offer a reflection on the ethical and political repercussions of these practices.

Following global trends, in recent years the IDF has established several institutes and think-tanks at different levels of its command and has asked them to reconceptualize strategic, tactical and organizational responses to the brutal policing work in the Occupied Territories known as "dirty" or "low intensity" wars. Notable amongst these institutes is the Operational Theory Research Institute (OTRI), which operated throughout the decade extending from the beginning of 1996 to May 2006, under the co-directorship of Shimon Naveh and Dov Tamari, both retired brigadier generals. OTRI employed several other retired officers, all at the rank of brigadier general, from the different corps of the IDF. Besides ex-soldiers, it employed several young researchers, usually doctoral candidates in philosophy or political science from Tel Aviv University. Until 2003, its core course, "Advanced Operational Approach," was obligatory for all high-ranking Israeli officers. In an interview I conducted with him, Naveh summed up the mission of OTRI: "We are like the Jesuit order. We attempt to teach and train soldiers to think . . . We have established a school and developed a

curriculum that trains 'operational architects'."[6] Former Chief of Staff Moshe Ya'alon, who promoted the activities of OTRI, described the significance of the institute after its closure in May 2006: "The method of operational assessment that is used today in the Regional Commands and in the General Staff was developed in collaboration with OTRI . . . OTRI also worked with the Americans and taught them the methods we had developed." The collaboration between OTRI and the US armed forces was confirmed by Lt. Col. David Pere of the US Marine Corps, who is now writing the corps' "operational doctrine manual:" "Naveh and OTRI's influence on the intellectual discourse and understanding of the operational level of war in the US has been immense. The US Marine Corps has commissioned a study . . . that is largely based on Shimon [Naveh]'s [work]. One can hardly attend a military conference in the US without a discussion of Shimon's [work]." According to Pere, the British and Australian militaries are also integrating the concepts developed at OTRI into their formal doctrines.[7]

One of the main reasons why Israeli military doctrine on urban operations became so influential among other militaries is that Israel's conflict with the Palestinians since the Intifada has had a distinct urban dimension. The targets of both Palestinian and Israeli attacks were primarily the cities of the other. Israel's new methods of ground and aerial raids were honed during the second (Al-Aqsa) Intifada and especially in "Operation Defensive Shield," the series of military raids on Palestinian cities launched on 29 March 2002, following a spate of Palestinian suicide attacks in Israeli cities. The attacks targeted different kinds of Palestinian urban environments: a modern city in Ramallah; a dense historic city centre in the Kasbah of Nablus; an international holy city in Bethlehem; and the refugee camps of Jenin, Balata and Tulkarm. The urban setting of these attacks was why they were keenly observed by foreign militaries, in particular those of the USA and UK, as they geared up to invade and occupy Iraq.[8] Indeed, during "Operation Defensive Shield" the West Bank has become a giant laboratory of urban warfare at the expense of hundreds of civilian lives, property, and infra-structure.

In my interview with Naveh, he explained the conditions that led the Israeli military to change its methods during the early years of the second Intifada:

> Although so much is invested in intelligence, fighting in the city is still incalculable and messy. Violence makes events unpredictable and prone to chance. Battles cannot be scripted. Command cannot have an overview. Decisions to act must be based on chance, probability, contingency and opportunity, and these must be taken only on the ground and in real time.[9]

Indeed, as far as the military is concerned, urban warfare is the ultimate post-modern form of warfare. Belief in a logically structured and single-track battle plan is lost in the face of the complexity and ambiguity of the urban mayhem. Those in command find it difficult to draw up battle scenarios or single-track plans; civilians become combatants, and combatants become civilians again; identity can be changed as quickly as gender can be feigned: the transformation of a woman into a fighting man can occur at the speed that it takes an undercover "Arabized" Israeli soldier or a camouflaged Palestinian fighter to pull a machine gun out from under a dress.

Indeed, military attempts to adapt their practices and forms of organization have been inspired by the guerrilla forms of violence that confront it. Because they adapt, mimic and learn from each other, the military and the guerrillas enter a cycle of "co-evolution." Military capabilities evolve in relation to the resistance, which itself evolves in relation to transformations in military practice. Although the mimicry and reappropriation of military techniques represent the discourse of a common experience, the Israeli and Palestinian methods of fighting are fundamentally different. The fractured Palestinian resistance is composed of a multiplicity of organizations, each having a more or less independent armed wing—*Iz Adin al-Qassam* for Hamas,

Saraya al-Quds (the Jerusalem Brigades) for Islamic Jihad, *Al-Aqsa Martyrs Brigade*, *Force-17* and *Tanzim al-Fatah* for Fatah. These are supplemented by the independent *PRC* (Popular Resistance Committees) and imagined or real members of *Hizbollah* and/or *Al-Qaeda*. The fact that these organizations shift between cooperation, competition and violent conflict increases the general complexity of their interactions and with it their collective capacity, efficiency and resilience. The diffused nature of Palestinian resistance, and the fact that knowledge, skills and munitions are transferred within and between these organizations—and that they sometimes stage joint attacks and at others compete to outdo each other—substantially reduces the effect that the Israeli occupation forces seek to achieve by attacking them.

According to Naveh, a central category in the IDF conception of the new urban operations is "swarming"—a term that has, in fact, been part of US military theory for several decades. It was developed in the context of the Revolution in Military Affairs (RMA) after the end of the Cold War and in particular in the doctrine of Network Centric Warfare which conceptualized the field of military operations as distributed network-systems, woven together by information technology.[10] Swarming seeks to describe military operations as a network of diffused multiplicity of small, semi-independent but coordinated units operating in general synergy with all others.

According to the RAND Corporation theorists David Ronfeldt and John Arquilla, who are credited with much of the development of this military doctrine, the main assumption of low-intensity conflict, particularly in cities, is that "it takes a network to combat a network."[11] The term is in fact derived from the Artificial Intelligence principle of "swarm intelligence." This principle assumes that problem-solving capacities are found in the interaction and communication of relatively unsophisticated agents (ants, birds, bees, soldiers) without (or with minimal) centralized control. "Swarm intelligence" thus refers to the overall, combined intelligence of a system, rather than to the intelligence of its constituent parts. A swarm "learns" through the interaction of its constitutive elements, through their adaptation to emergent situations, and in reaction to changing environments.[12]

Instead of linear, hierarchical chains of command and communications, swarms are polycentric networks, in which each "autarkic unit" (Naveh's term) can communicate with the others without necessarily going through central command. The swarm manoeuvre is perceived by the military as non-linear in *temporal* terms as well. Traditional military operations are chrono-linear in the sense that they seek to follow a determined sequence of events embodied in the idea of "the plan" which implies that actions are preconditioned to some degree on the successful implementation of previous actions. The activity of a swarm, by contrast, is based upon simultaneous actions which are dependent but not preconditioned on each other. The narrative of the battle plan is thus replaced by what Naveh calls "the toolbox" approach, according to which units receive the tools they need to deal with emergent situations and scenarios, but cannot predict the order by which these events would actually occur. By lowering the thresholds of decision-making to the immediate tactical level, and by the encouragement of local initiative, different parts of the swarm are supposed to provide answers to the forms of uncertainty, chance and uncontrolled eventualities that the nineteenth-century military philosopher Carl von Clausewitz called *friction*.[13]

The concept of the swarm is a central component of the Israeli military's concerted attempt to adopt the language of "de-territorialization" and transform what they perceived as their organizational and tactical "linearity" into "non-linearity." In this regard, a major historical reference for the teaching of OTRI was the military career of Ariel Sharon. Not only was Sharon the prime minister, and thus visible as the "commander in chief" throughout most of the Intifada, but his military career has been characterized by attempts to break away from traditional military organization and discipline. The tactics for punitive

raids on Palestinian villages and refugee camps that he developed and exercised in 1953 as commander of Unit 101, and later those that enabled his brutal counter-insurgency campaign in the Gaza refugee camps in 1971–72, in many ways prefigured Israeli tactics in dealing with the present Intifada. An indication of the historical interest that OTRI had in Sharon's military career was the last workshop organized at OTRI in May 2006, "The Generalship of Ariel Sharon," which was a form of homage to the dying Sharon, and his influence on the IDF.[14]

The attack on Balata

The Israeli security establishment has always tended to see the refugee camps as both the locus of and the urban condition for the "breeding" of resistance. The camps have thus been projected in Israel's simplified geographic imaginary as evil and dangerous places, "black holes" that the IDF dare not enter.[15] The IDF's avoidance of the Jenin and Balata refugee camps throughout the first (1987–91) and second intifadas allowed them to evolve into extraterritorial enclaves surrounded by Israeli military power; indeed, the military code-name for the Jenin camp, in which resistance groups were most strongly entrenched, was "Germania." Whether in reference to Tacitus' ambivalent description of the barbarians,[16] or in reference to the Nazi regime, this term encapsulates Israeli fear of the "evil" it believes is bred. After becoming prime minister in March 2001, Ariel Sharon persistently mocked the military for not daring to enter the refugee camps: "What is happening in the Jenin and Balata camps? Why don't you go in?" Sharon never tired of telling military officers how, in the 1970s, he "made order" in the refugee camps of Gaza with a combination of commando raids, assassinations and bulldozers.[17]

The method of "walking through walls" employed by the IDF in the attacks of "Operation Defensive Shield" had already been part of its tactical manual in matters of small-scale operations and arrests where the doorway of a home was suspected of being booby-trapped. However, as the defining mode of military maneuver in large-scale operations, it was first tested out in early March 2002 in a raid commanded by Aviv Kochavi of the paratroop brigade on the refugee camp of Balata at the eastern entrance of Nablus, just a few weeks before Operation Defensive Shield commenced. It was employed in response to tactical necessity. In anticipation of an impending Israeli attack, militants from different Palestinian armed organizations had blocked all entries to the refugee camp, filling oil barrels with cement, digging trenches and piling up barricades of rubble. Streets were mined with improvised explosives and tanks of gasoline, and entrances to buildings on these routes were booby-trapped, as were the interior stairwells, doorways and corridors of some prominent structures. Several lightly armed independent guerrilla groups were positioned within the camp in houses facing major routes or at major intersections.

In a briefing called by Kochavi prior to the attack, he explained to his subordinate officers the problems they would encounter in the impending operation. Kochavi apparently told his officers (as paraphrased by Naveh): "The Palestinians have set the stage for a fighting spectacle in which they expect us, when attacking the enclave, to obey the logic that they have determined . . . to come in old-style mechanized formations, in cohesive lines and massed columns conforming to the geometrical order of the street network." After analysing and discussing this situation with his officers, Kochavi included the following instruction in his battle command: "We completely isolate the camp in daylight, creating the impression of a forthcoming systematic siege operation . . . [and then] apply a fractal manoeuvre swarming simultaneously from every direction and through various dimensions of the enclave . . . Each unit reflects in its mode of action both the logic and form of the general maneuvre . . . Our movement through

the buildings pushes [the insurgents] into the streets and alleys, where we hunt them down."[18] Israeli troops then cut off electrical, telephone and water connections to the building including the location of internal doors and windows. In 2002, however, soldiers were still using aerial photographs on which each house was given a four-digit designation number to facilitate the communication of positions. Orientation was aided by global positioning systems (GPS) and centrally coordinated by commanders using images from unmanned drones. When soldiers blasted a hole through a wall, they crudely sprayed "entrance," "exit," "do not enter," "way to . . ."or "way from . . ."on the wall in order to regulate the traffic of soldiers and to find their way back through the labyrinth they carved out through the bulk of the city.

A survey conducted by the Palestinian architect Nurhan Abujidi, after the Nablus and Balata attacks, showed that more than half of the buildings in the Nablus Kasbah had routes forced through them, resulting in anything from one to eight openings in their walls, floors or ceilings, creating several haphazard cross-routes. Abujidi saw that the routes could not be understood as describing simple linear progression; they indicated for her a very chaotic maneuvre without clear direction.[19] Not all movement was undertaken through walls and between homes, many buildings were bombed from the air and completely destroyed, including historic buildings in the old city centre, amongst which were the eighteenth-century Ottoman Caravanserai of al-Wakalh al-Farroukkyyeh, and both the Nablusi and the Cana'an soap factories. The Abdelhade Palace, the Orthodox Church and the al-Naser Mosque were also badly damaged.[20]

The Kasbah of Nablus was the site of a radical experiment that took military activity beyond that of a mere manoeuvre. IDF officers had expressed their frustration over the fact that the quick invasion and occupation of Palestinian urban areas, such as Balata, had led to guerrillas disappearing and emerging again after the IDF's eventual withdrawal. In a war council at IDF Central Command headquarters in preparation for "Defensive Shield" at the end of March 2002, Kochavi insisted on the need to redirect the operation and make its aim the killing of members of Palestinian armed organizations, rather than allowing them to disappear or even to surrender. Kochavi's intentions were no longer to capture and hold the Kasbah, but to enter, kill as many members of the Palestinian resistance as possible and then withdraw.[21] Military operations with the sole aim of killing were in accordance with clear guidelines laid down at the political level. In May 2001, only two months after he assumed office, Sharon summoned Chief of Staff Shaul Mofaz, Avi Dichter and their deputies for an urgent meeting at his private ranch. Sharon was explicit: "The Palestinians . . . need to pay the price . . . They should wake up every morning and discover that they have ten or twelve people killed, without knowing what has taken place . . . You must be creative, effective, sophisticated."[22]

The following day Mofaz spoke to a gathering of field commanders at a 1967 war memorial in Jerusalem ("Ammunition Hill"). After ensuring that his words were not being recorded, Mofaz stated that he wanted "ten dead Palestinians every day, in each of the regional commands." In an exceptional bypassing of military hierarchy he later called lower-ranking field commanders individually on their mobile phones, saying that he wanted "to wake up every morning to hear that you went on operations and killed."[23] An atmosphere of indiscriminate revenge killing was in the air. On Mofaz's direct orders, "unnecessary killing" and the killing of civilians was rarely investigated and soldiers who killed civilians were hardly ever punished.[24] The horrific frankness of these objectives was confirmed to me in an interview with Shimon Naveh. Naveh described how in this period:

> the military started thinking like criminals . . . like serial killers . . . they got allocated an area and researched it . . . they study the persons within the enemy organization they are asked to kill, their appearance, their voice [as heard in

telephone tapping], their habits . . . like professional killers. When they enter the area they know where to look for these people, and they start killing them.

During the attack on Nablus, Kochavi ignored Palestinian requests to surrender and continued fighting, trying to kill more people, until Mofaz ordered the attack over. It was the political and international pressure brought to bear in the aftermath of the destruction of Jenin that brought the entire campaign to a quick halt. Gal Hirsh, another graduate of OTRI and Chief of Operations in Central Command during the battle, later boasted that "in 24 hours [the Palestinians] lost more than 80 of their gunmen and they could never identify where we were."[25] After the attack, Defence Minister Ben Eliezer called Kochavi on his mobile phone to congratulate him; another "well done" was passed on from Sharon.[26] Kochavi later claimed that if the political establishment had allowed him to continue fighting, his troops would have killed hundreds. The attack on Nablus was considered a success, both in terms of the number of Palestinians killed and in demonstrating both to the Israeli military and to the Palestinians that the IDF could now enter Palestinian camps and city centres at will. Kochavi's forces went on demonstrating this and entered Nablus and the Balata camp eight more times in the same way. It is mainly, but not exclusively, his enthusiastic laying out and enacting of Israeli security objectives that explain international calls for Kochavi to face a war-crimes tribunal.[27]

Inverse urban geometry

Like many other career officers, Kochavi had taken time off from active service to earn a university degree. Originally intending to study architecture, he ultimately pursued philosophy at the Hebrew University, and claimed that his military practice had been considerably influenced by both disciplines; as a military officer, he also attended OTRI courses.[28] Kochavi's description of the attacks, delivered in the context of an interview I conducted with him, is a rare and astonishing manifestation of the relation between military theory and practice,

> This space that you look at, this room that you look at [he refers to the room where the interview took place, at a military base near Tel Aviv], is nothing but your interpretation of it. Now, you can stretch the boundaries of your interpretation, but not in an unlimited fashion—after all, it must be bound by physics, as it contains buildings and alleys. The question is, how do you interpret the alley? Do you interpret it as a place, like every architect and every town planner does, to walk through, or do you interpret it as a place forbidden to walk through? This depends only on interpretation. We interpreted the alley as a place forbidden to walk through, and the door as a place forbidden to pass through, and the window as a place forbidden to look through, because a weapon awaits us in the alley, and a booby trap awaits us behind the doors. This is because the enemy interprets space in a traditional, classical manner, and I do not want to obey this interpretation and fall into his traps. Not only do I not want to fall into his traps, I want to surprise him. This is the essence of war. I need to win. I need to emerge from an unexpected place. And this is what we tried to do.

> This is why we opted for the method of walking through walls . . . Like a worm that eats its way forward, emerging at points and then disappearing. We were thus moving from the interior of [Palestinian] homes to their exterior in unexpected ways and in places we were not anticipated, arriving from behind and hitting the enemy that awaited us behind a corner . . . Because it was the first

time that this method was tested [on such a scale], during the operation itself we were learning how to adjust ourselves to the relevant urban space, and similarly how to adjust the relevant urban space to our needs . . . We took this micro-tactical practice [of moving through walls] and turned it into a method, and thanks to this method, we were able to interpret the whole space differently I said to my troops, "Friends! This is not a matter of your choice! There is no other way of moving! If until now you were used to move along roads and side-walks, forget it! From now on we all walk through walls!"[29]

Beyond the description of the action, the interview is interesting for the language Kochavi chose to articulate it with. The reference to the need to interpret space, and even to re-interpret it, as the condition of success in urban war, makes apparent the influence of post-modern, post-structuralist theoretical language. War, according to the sophisticated, sanitizing language of Kochavi is a matter of reading, and (conceptually) deconstructing the existing urban environment, even before the operation begins.

Referring to the context of Kochavi's "success," Naveh explained that: "In Nablus, the IDF started understanding urban fighting as a spatial problem." With regard to OTRI's influ-ence on these tactics he said that "by training several high-ranking officers, we filled the system with subversive agents who ask questions . . . Some of the top brass are not embar-rassed to talk about Deleuze or [the deconstructive architect Bernard] Tschumi." When I asked him, "Why Tschumi?!" (in the annals of architectural history a special place of honour is reserved to Tschumi as a "radical" architect of the left) he replied: "The idea of disjunction embodied in Tschumi's book *Architecture and Disjunction*[30] became relevant for us . . . Tschumi had another approach to epistemology; he wanted to break with single-perspective know-ledge and centralized thinking. He saw the world through a variety of different social prac-tices, from a constantly shifting point of view." I then asked him, if so, why does he not read Derrida and deconstruction instead? He answered, "Derrida may be a little too opaque for our crowd. We share more with architects; we combine theory and practice. We can read, but we know as well how to build and destroy, and sometimes kill."

In a lecture in 2004, Naveh presented a diagram resembling a "square of opposition" that plotted a set of logical relationships against certain propositions relating to military and guer-rilla operations. Headings such as *Difference and Repetition—The Dialectics of Structuring and Structure; "Formless" Rival Entities; Fractal Maneuvre; Velocity vs. Rhythms; Wahhabi War Machine; Post-Modern Anarchists; Nomadic Terrorists*, and so on, employed the language of French philoso-phers Gilles Deleuze and Félix Guattari.[31] Reference to Deleuze and Guattari is indicative of recent transformations within the IDF, because although they were influenced by the study of war, they were concerned with non-statist forms of violence and resistance, in which the state and its military are the arch-enemy. In their book, *A Thousand Plateaus*, Deleuze and Guattari draw a distinction between two kinds of territoriality: a hierarchical, Cartesian, geometrical, solid, hegemonic and spatially rigid state system; and the other, flexible, shifting, smooth, matrix-like "nomadic" spaces.[32] Within these nomadic spaces they foresaw social organiza-tions in a variety of polymorphous and diffuse operational networks. Of these networks, *rhizomes* and *war machines* are organizations composed of a multiplicity of small groups that can split up or merge with one another depending on contingency and circumstances and are characterized by their capacity for adaptation and metamorphosis. These organizational forms resonated in themselves with military ideals such as those described above.

Naveh observed that

Several of the concepts in *A Thousand Plateaus* became instrumental for us [in the IDF] . . . allowing us to explain contemporary situations in a way that we could

not have otherwise explained. It problematized our own paradigm . . . Most important was the distinction [Deleuze and Guattari] have pointed out between the concepts of "smooth" and "striated" space . . . [which accordingly reflected] the organizational concepts of the "war machine" and the "state apparatus." In the IDF we now often use the term "to smooth out space" when we want to refer to operation in a space in such a manner that borders do not affect us. Palestinian areas could indeed be thought of as "striated," in the sense that they are enclosed by fences, walls, ditches, roads blocks and so on . . . We want to confront the "striated" space of traditional, old-fashioned military practice [the way most military units presently operate] with smoothness that allows for movement through space that crosses any borders and barriers. Rather than contain and organize our forces according to existing borders, we want to move through them.

When I asked him if moving through walls was part of it, he answered that "travelling through walls is a simple mechanical solution that connects theory and practice. Transgressing boundaries is the definition of the condition of 'smoothness'."

Design by destruction

The professed effortless "smoothness" of the raids on Balata and Nablus must be compared with the difficulties, "striation" and physical destruction that the IDF attack brought on Jenin. The refugee camp of Jenin is located on the hill-slopes west of the city of Jenin, in the north of the West Bank close to the Green Line. Its proximity to Israeli cities and villages was the reason many attacks on Israeli civilians and the military originated from it, and the military was under much government and popular pressure to attack the Jenin camp. In preparation for an impending IDF attack, the commander of the camp's defences, Hazam Kubha "Abu-Jandel," a former police officer, divided the camp into fifteen zones, and assigned each to several dozen defenders, including Palestinian police officers, who prepared hundreds of improvised explosives from fertilizers.[33] The attack began concurrendy with that on Nablus, on 3 April, and started with Israeli soldiers employing rather similar methods. Military bulldozers drove into the edges of the camp, piercing holes within the external walls of inhabited peripheral buildings. Armoured vehicles then reversed into these homes, offloading soldiers through these openings directly into Palestinian homes, thereby protecting them from snipers. From there, soldiers tried to progress from house to house through party walls. As long as the fighting took place within and between homes, the Palestinian fighters, moving through tunnels and secret connections in the lower storeys where Israeli helicopter fire could not reach them, managed to hold back a section simulating a refugee camp, a downtown area with broader streets and tanks, and a neighborhood resembling a rural village. Holes have been cut through the walls of homes to allow soldiers to practise moving through them. In certain training sessions the military enlisted the stage-set designer of a well-known Tel Aviv theatre to provide the relevant props and organize the special effects.

During this period other transformations were manifest in the realm of military engineering. At a military conference held in March 2004 in Tel Aviv, an Israeli engineering officer explained to his international audience that, thanks to the study of architecture and building technologies, "the military can remove one floor in a building without destroying it completely [sic], or remove a building that stands in a row of buildings without damaging the others."[34] However exaggerated, this statement testifies to the new emphasis placed by the military on what it perceives as the "surgical" ability to remove elements of buildings supposedly without destroying the whole—essentially the military engineer's adaptation of the logic of "smart weapons."

Un-walling the wall

In historical siege warfare, the breaching of the outer city wall signalled the destruction of the sovereignty of the city-state. Accordingly, the "art" of siege warfare engaged with the geometries of city walls and with the development of equally complex technologies for approaching and breaching them. Contemporary urban combat, on the other hand, is increasingly focused on methods of transgressing the limitations embodied by the domestic wall. Complementing military tactics that involve physically breaking and "walking" through walls, new methods have been devised to allow soldiers not only to see, but also to shoot and kill through solid walls. The Israeli R&D company Camero developed a hand-held imaging device that combines thermal images with ultra-wideband radar that, much like a contemporary maternity-ward ultrasound system, has the ability to produce three-dimensional renderings of biological life concealed behind barriers.[35] Human bodies appear as fuzzy "heat marks" floating (like fetuses) within an abstract blurred medium wherein everything solid—walls, furniture, objects—has melted into the digital screen. Weapons using standard NATO 5.56mm rounds are complemented by use of 7.62mm rounds, which are capable of penetrating brick, wood and sun-dried brick (adobe) without much deflection of the bullet's trajectory. These practices and technologies will have a radical effect on the relation of military practices to architecture and the built environment at large. Instruments of "literal transparency" are the main components in the search to produce a military fantasy world of boundless fluidity, in which the city's space becomes as navigable as an ocean (or as in a computer game). By striving to see what is hidden behind walls, and to fire ammunition through them, the military seems to have sought to elevate contemporary technologies to the level of metaphysics, seeking to move beyond the here and now of physical reality, collapsing time and space.

This desire to unveil and "go beyond" the wall could itself explain military interest in transgressive theories and art from the 1960s and the 1970s. Most literally, the techniques of walking through walls bring to mind what the American artist Gordon Matta-Clark called the "un-walling of the wall."[36] From 1971 until his death in 1978, Matta-Clark was involved in the transformation and virtual dismantling of abandoned buildings. In this body of work known as "building cuts," and his approach of *anarchitecture* (anarchic architecture) using hammers, chisels and bow saws, he sliced buildings and opened holes through domestic and industrial interiors.[37] This could be understood as his attempt to subvert the repressive order of domestic space and the power and hierarchy it embodies. The "building cuts" of Matta-Clark were featured in OTRI's presentation material—juxtaposed with IDF holes cut through Palestinian walls.

Other canonical references of urban theory, touched on by OTRI, are the Situationist practices of *dérive* (a method of drifting through the different ambiances of the city that the Situationists referred to as psychogeography) and *détournement* (the adaptation of buildings to new sets of uses or purposes, other than those they were designed to perform). These ideas were conceived by Guy Debord and other members of the *Situationist International* as part of a general approach that was intended to challenge the built hierarchy of the capitalist city. They aimed to break down distinctions between private and public, inside and outside, use and function, to replace private space with a fluid, volatile and "borderless" public surface, through which movement would be unexpected. References were also made to the work of Georges Bataille, who spoke of a desire to attack architecture: his own call to arms was meant to dismantle the rigid rationalism of a postwar order, to escape "the architectural straitjacket," and liberate repressed human desires. These tactics were conceived to transgress the established "bourgeois order" of the city as planned and delivered, in which the architectural element of the wall—domestic, urban or geopolitical (like the Iron Curtain that descended upon

Europe)—projected as solid and fixed, was an embodiment of social and political order and repression. Because walls functioned not only as physical barriers but also as devices to exclude both the visual and the aural, they have, since the eighteenth century, provided the physical infrastructure for the construction of privacy and bourgeois subjectivity.[38] Indeed, architectural discourse tends to see walls as architecture's irreducible givens. If the walls attempt to harness the natural entropy of the urban, breaking it would liberate new social and political forms.

Although representing a spectrum of different positions, methods and periods, for Matta-Clark, Bataille, the Situationists and Tschumi it was the repressive power of the capitalist city that should have been subverted. In the hands of the Israeli military, however, tactics inspired by these thinkers were projected as the basis for an attack on the little protected habitat of poor Palestinian refugees under siege.

In this context the transgression of domestic boundaries must be understood as the very manifestation of state repression. Hannah Arendt's understanding of the political domain of the classic city would agree with the equating of walls with law and order. According to Arendt, the political realm is guaranteed by two kinds of walls (or wall-like laws): the wall surrounding the city, which defined the zone of the political; and the walls separating private space from the public domain, ensuring the autonomy of the domestic realm.[39] The almost palindromic linguistic structure of law/wall helps to further bind these two structures in an interdependency that equates built and legal fabric. The un-walling of the wall invariably becomes the undoing of the law. The military practice of "walking through walls"—on the scale of the house or the city—links the physical properties of construction with this syntax of architectural, social and political orders. New technologies developed to allow soldiers to see living organisms through walls, and to facilitate their ability to walk and fire weapons through them, thus address not only the materiality of the wall, but also its very concept. With the wall no longer physically or conceptually solid or legally impenetrable, the functional spatial syntax that it created collapses. In "the camp," Agamben's well-known observation follows the trace left by Arendt, "city and house became indistinguishable."[40] The breaching of the physical, visual and conceptual border/wall exposes new domains to political power, and thus draws the clearest physical diagram to the concept of the "state of exception."

Lethal theory

Military use of contemporary theory is of course nothing new. From Marcus Aurelius to Robert McNamara,[41] power has always found ways to utilize theories and methodologies conceived in other fields. The "soldier-poet-philosopher" is also a central figure of Zionist mythologies. In the 1960s, when an academic education became the standard component of a career in the Israeli military, high-ranking officers returning from studies in the United States invoked philosophy to describe the battlefield, sometimes literally the Spinozan concept of "extension" with respect to the 1967 battles of occupation.

Military use of theory for ends other than those it was meant to fulfill is not dissimilar to the way in which progressive and transgressive theoretical ideas were applied in organizing post-modern management systems in business and as efficiency indicators in technological culture. Education in the humanities, often believed to be the most powerful weapon against capitalist imperialism, could equally be appropriated as a tool of colonial power itself. This is a particularly chilling demonstration of what Herbert Marcuse warned of as early as 1964: that, with the growing integration between the various aspects of society, "contradiction and criticism" could be equally subsumed and made operative as an instrumental tool by the hegemony of power—in this case, the absorption and transformation of post-structuralist and even post-colonial theory by the colonial state.[42]

This is not to place blame for Israel's recent aggression in the hands of radical theorists and artists, or to question the purity of their intentions. It is also not my aim here to try to correct imprecisions and exaggerations in the military "reading," use and interpretation of specific theories. I am concerned primarily with understanding the various ways by which theory, taken out of its ethical/political context, may perform within the military domain.

The practical or tactical function of theory, the extent to which it influences military tactics and manoeuvres, is related to more general questions about the relation between theory and practice. However, if the new tactics of the IDF are the result of a direct translation of post-modern theory to practice, we should expect to see these tactics amounting to a radical break with traditional ones. However, they rather constitute a continuation of many of the procedures and processes that have historically been part of urban military operations. Describing acts of war as new, unprecedented, or claiming that military strategy is deeply rooted in contemporary or ancient philosophy illustrates how the language of theory itself could become a weapon in the contemporary conflict, and the institutional ecologies that sustain them. Although the concept of "walking through walls," "swarming" and other terms referring to military non-linearity may indeed imply some structural changes in military organization, claims that these developments constitute radical transformations are largely overstated. This, in itself, should bring into question the real place of theory as a generative source for the actual transformations of military practice.

Notes

1 Walter Benjamin, *One-Way Street and Other Writings*, trans. Edmund Jephcott and Kingsley Shorter, London and New York: Verso, 1979, p. 295.

2 Georges Perec, *Species of Space and Other Pieces*, ed. and trans. John Sturrock, London: Penguin Books, 1999.

3 Nuha Khoury, "One Fine Curfew Day," Jerusalem: Miftah (www.miftah.org).

4 I have witnessed some of these conferences. In January 2003 Stephen Graham passed on to me half of his ticket worth £1,000, to attend the second day of the Annual Urban Warfare Conference organized by a security institute called SMI in London. This was a surreal event where military personnel, arms dealers and academics from NATO, the UK, the United States and Israel as well as representatives of the RAND corporation, exchanged practical and theoretical views on urban military operations and essential equipment within the conference hall and over dinner. On another such military conference organized in 2002 by the Faculty of Geography at Haifa University, see Stephen Graham, "Remember Falluja: Demonizing Place, Constructing Atrocity," *Society and Space*, 2005, 23, pp. 1–10, and Stephen Graham, "Cities and the 'War on Terror' ", *International Journal of Urban and "Regional Research*, 30, 2 June 2006, pp. 255–76.

5 Simon Marvin, "Military Urban Research Programs: Normalising the Remote Control of Cities', paper delivered to the conference, *Cities as Strategic Sites: Militarisation Anti-Globalization & Warfare*, Centre for Sustainable Urban and Regional Futures, Manchester, November 2002.

6 One of the reading lists of the Operational Theory Research Institute, included the following titles: Christopher Alexander, *The Endless Way of Building: Patterns of Events, Patterns of Space, Patterns of Language*; Gregory Bateson, *Steps to An Ecology of Mind* and *Mind and Nature: A Necessary Unity*; Beatriz Colomina (guest editor), *Architecture Production*; Gilles Deleuze and Felix Guattari, *A Thousand Plateaus* and *What is Philosophy*; Clifford Geertz, *After the Fact—Two Countries, Four Decades, One Anthropologist*; Catherine Ingraham, *Architecture and the Burdens of Linearity*; Rob Krier, *Architectural Composition*; J.F. Lyotard, *The Post-Modern Condition: A Report on Knowledge*; Marshall McLuhan and Quentin Fiore, *The Medium is the Massage: An Inventory of Effects*; W.J. Mitchell, *The Logic of Architecture*; Lewis Mumford, *The Myth of the Machine*; Gordon Pask, *Cybernetics of Human Learning*; Ilya Prigogine, *Is Future Given? The End of Certainty* and *Exploring Complexity*; John Rajchman, *The Deleuze Connections*; Bernard Tschumi, *Questions on Space, Architecture and Disjunction* and *Event-Cities 2*; and Paul Virilio, *The Lost Dimension*.

7 Quotes are from Caroline Glick, "Halutz's Stalinist moment: Why were Dovik Tamari and Shimon Naveh Fired?," *Jerusalem Post*, 17 June 2006.

8 "U.S. Marines uses Israeli Tactics in Falluja Baghdad," *Middle East Newsline*, 6 (418), 10 November 2004; Justin Huggler, "Israelis trained US troops in Jenin-style urban warfare," *The Independent*, 29 March 2003; Yagil Henkin, "The Best Way Into Baghdad," *New York Times*, 3 April 2003.

9 Interviews with Shimon Naveh were conducted on 15 September 2005 (telephone), 7 March 2006 (telephone), 11 April 2006 and 22–23 May 2006 (at an intelligence military base in Glilot, near Tel Aviv). All transcripts and translations into English of the interviews were sent to Naveh for confirmation of content. All future references to the interview refer to those above unless stated otherwise.

10 Non-linear and network terminology has had its origins in military discourse since the end of World War II and has been instrumental in the conception in 1982 of the US military doctrine of "Airland Battle," which emphasized inter-service cooperation and the targeting of the enemy at its systematic bottle necks—bridges, headquarters and supply lines—in attempts to throw it off balance. It was conceived to check the Soviet invasion of Central Europe and was first applied in the Gulf War of 1991. The advance of this strand led to the "Network Centric Doctrine" in the context of the Revolution in Military Affairs (RMA) after the end of the Cold War.

11 John Arquilla and David Ronfeldt (eds), *Networks and Netwars: The Future of Terror, Crime, and Militancy*, Santa Monica, CA: RAND, 2001, p. 15; see also David Ronfeldt, John Arquilla, Graham Fuller and Melissa Fuller, *The Zapatista "Social Netwar" in Mexico*, Santa Monica, CA: RAND, 1998. In the latter book the authors explain that swarming was historically employed in the warfare of nomadic tribes and is currently undertaken by different organizations across the spectrum of social-political conflict—terrorists and guerrilla organizations, mafia criminals as well as non-violent social activists.

12 Eric Bonabeau, Marco Dorigo and Guy Theraulaz, *Swarm Intelligence: From Natural to Artificial Systems*, Oxford: Oxford University Press, 1999; Sean J.A. Edwards, *Swarming on the Battlefield: Past, Present and Future*, Santa Monica, CA: RAND, 2000; Arquilla and Ronfeldt, *Networks and Netwars*.

13 Friction refers to uncertainties, errors, accidents, technical difficulties, the unforeseen, and their effects on decision, morale and actions. See Peter Paret, "Clausewitz," in Peter Paret, *Makers of Modern Strategy, From Machiavelli to the Nuclear Age*, Oxford: Oxford University Press, 1986, pp. 197, 202. Clausewitz: "The tremendous friction, which cannot, as in mechanics, be reduced to a few points, is everywhere in contact with chance, and brings about effects that cannot be measured . . . action in war is like movement in resistant element . . . it is difficult for normal efforts to achieve even moderate results." See Carl von Clausewitz, *On War*, ed. and trans. Michael Howard and Peter Paret, Princeton, NJ: Princeton University Press, 1976 [1832], pp. 119–21. The tendency for diffusing command in battle was already apparent in Clausewitz's account of the wars of the Napoleonic era. Napoleonic command was based on the assumption that even the best operational plan could never anticipate the vicissitudes of war and that commanders must be encouraged to make tactical decisions on the spot. This was made a central tenet with the nineteenth-century Prussian General Molfke, in his *Auftragstaktik* or "mission oriented tactics." Moltke refrained from issuing any but the most essential orders: "an order shall contain everything that a commander cannot do by himself, but nothing else." See Hajo Holborn, "The Prusso-German School: Moltke and the Rise of the General Staff," in Paret, *Makers of Modern Strategy*, pp. 281–95, esp. p. 291. According to Manuel De Landa, this encouragement of local initiative and diffused command is what allows a dynamic battle to self-organize to some extent. "Maneuvre warfare," as developed by several military theorists in the period between the two World Wars and practised by the Wehrmacht as well as the Allies in European battles of World War II, is based on principles such as increased autonomy and initiative. Manuel De Landa, *War in the Age of Intelligent Machines*, New York: Zone Books, 1991, pp. 71, 78–9.

14 "The Generalship of Ariel Sharon," a round table discussion at the Operational Theory Research Institute (OTRI) of the IDE's Academy of Staff and Command. 24–25 May 2006.

15 Stephen Graham, "Constructing Urbicide by Bulldozer in the Occupied Territories," in Stephen Graham (ed.), *Cities, War and Terrorism*, Oxford: Blackwell, 2004, p. 332.

16 Tacitus, *The Agricola and The Germania*, London: Penguin Classics, 1971.

17 Raviv Druker and Ofer Shelah, *Boomerang*, Jerusalem: Keter, 2005, pp. 197, 218.

18 Quoted in Shimon Naveh, "Between the Striated and the Smooth: Urban Enclaves and Fractal Maneuvers," *Cabinet Magazine*, July 2006, pp. 81–8.

19 In the survey, Nurhan Abujidi found that 19.6 per cent of buildings affected by forced routes had only one opening, 16.5 per cent had two, 10 per cent had three, 4.1 per cent had four, 2.1 per cent had five and 1.0 per cent had eight. See Nurhan Abujidi, "Forced To Forget: Cultural Identity and Collective Memory/Urbicide. The Case of the Palestinian Territories, During Israeli Invasions to Nablus Historic Center 2002–2005," paper presented to the workshop "Urbicide: The Killing of Cities?," Durham University, November 2005.

20 In an interview for the popular Israeli daily *Ma'ariv* at the beginning of 2003, Kochavi mused about the biblical beauty of the city visible from the windows of his headquarters: "Look! Nablus is the prettiest City in the West Bank . . . especially pretty is the Kasbah that resembles the old city of Jerusalem, sometimes even prettier than it." Following a long colonial, and certainly an Israeli tradition of military officers displaying curiosity about the culture of the colonized, Kochavi consulted Dr Itzik Magen, the IDE's Civil Administration Chief of Archaeology, before the attack, regarding the historical value of some of the buildings that happened to stand in his planned zone of manoeuvre. While acknowledging a certain list of "must not destroy" (which he did not always adhere to), "simple" homes were accepted as "legitimate targets." Amir Rapaport, "City Without a Break," *Ma'ariv* Saturday supplement 10 January 2003; Eyal Weizman and Mira Asseo, in interview with Itzik Magen, 21 June 2002.
21 Amir Oren, "The Big Fire Ahead," *Ha'aretz* 25 Match 2004.
22 Druker and Shelah, *Boomerang*, p. 213.
23 Both quotes above are from ibid., pp. 213–14, 220.
24 Killing operations conducted by "Arabized" (soldiers disguised as Arabs) or uniformed soldiers now take place almost daily in the West Bank. The most common legal basis for killings during these raids is that the victim "violently attempted to resist arrest" (no such option even exists when killings are conducted remotely from the air). According to figures released by B'Tselem, between the beginning of 2004 and May 2006 alone Israeli security forces killed 157 persons during attacks referred to as "arrest operations." Sec "Take No Prisoners: The Fatal Shooting of Palestinians by Israeli Security Forces during 'Arrest Operations,' " B'Tselem, May, 2005. www.btselem.org; Al-Haq (Palestinian human rights organization), "Indiscriminate and Excessive Use of Force: Four Palestinians Killed During Arrest Raid," 24 May 2006, www.alhaq.org.
25 Quoted in Sergio Catignani, "The Strategic Impasse in Low-Intensity-Conflicts: The Gap Between Israeli Counter-Insurgency Strategy and Tactics During the Al-Aqsa Intifada," *Journal of Strategic Studies*, 28, 2005, p. 65.
26 Druker and Shelah, *Boomerang*, p. 218.
27 Aviv Kochavi captured the attention of the media in February 2006 when the Chief Legal Adviser to the IDF recommended that he not make a planned trip to a UK-based military academy for fear he could be prosecuted for war crimes in Britain; for an earlier statement implicating Kochavi in war crimes, see Neve Gordon, "Aviv Kochavi, How Did You Become a War Criminal?," www.counterpunch.org/nevegordon1.html.
28 Chen Kotes-Bar, "Bekichuvo" [Starring Him], *Ma'ariv*, 22 April 2005 [Hebrew].
29 Eyal Weizman and Nadav Harel interview with Aviv Kochavi, 24 September 2004, at an Israeli military base near Tel Aviv [Hebrew]; video documentation by Nadav Harel and Zohar Kernel.
30 Bernard Tschumi, *Architecture and Disjunction*, Cambridge, MA.: MIT Press, 1997. Naveh has recently completed the translation into Hebrew of some of the chapters in Tschumi's book.
31 Terminology mainly from Gilles Deleuze and Félix Guattari, *A Thousand Plateaus, Capitalism and Schizophrenia*, trans. Brian Masumi, New York and London: Continuum, 2004, and Gilles Deleuze, *Difference and Repetition*, New York: Columbia University Press, 1995, among other works.
32 "Sedentary space is striated by walls, enclosures and roads between enclosures, while nomadic space is smooth, marked only by 'traits' that are effaced and displaced with the trajectory." Gilles Deleuze and Félix Guattari, *A Thousand Plateaus*, p. 420. On the rhizome see Introduction, pp. 3–28, on the war machine see pp. 387–467: on the smooth and the striated see pp. 523–51. Deleuze and Guattari were aware that states or their agents may transform themselves into war machines, and that, similarly, the conception of "smooth space" may help form tools of domination.
33 Amos Harel and Avi Isacharoff, *The Seventh War*; Tel Aviv: Miskal-Yedioth Aharonoth Books and Chemed Books, 2004, pp. 254–5.
34 Quoted in Hannan Greenberg, "The Limited Conflict, This is How you Trick Terrorists," *Yedioth Aharonoth*, www.ynet.co.il.
35 Zuri Dar and Oded Hermoni, "Israeli Start-Up Develops Technology to See Through Walls," *Ha'aretz*, 1 July 2004; Amir Golan, "The Components of the Ability to Fight in Urban Areas," *Ma'arachot*, 384, July 2002, p. 97; The American Defense Advanced Research Projects Agency (DARPA) launched the *Visi Building* programme to promote the development of sensor technologies to scan structures from a distance and create detailed views of their interiors. Ross Stapleton-Gray, "Mobile Mapping: Looking through Walls for On-site Reconnaissance," *Journal for Net Centric Warfare* C4ISR, 11 September 2006.
36 Brian Hatton, "The Problem of our Walls," *The Journal of Architecture*, Volume 4, Spring 1999, p. 71. Krzysztof Wodiczko, *Public Address*, Walker Art Centre, Minneapolis, 1991, published in conjunction with an exhibition held at the Walker Art Center, Minneapolis, 11 Oct. 1992–3 Jan, 1993 and the Contemporary Arts Museum, Houston, May 22–Aug. 22, 1993.

37 Pamela M. Lee, *Object to Be Destroyed: The Work of Gordon Matta-Clark*, Cambridge, MA: The MIT Press, 2001.

38 Robin Evans, "The Rights of Retreat and the Rights of Exclusion: Notes Towards the Definition of the Wall," in *Translations from Drawing to Building and Other Essays*, London: Architectural Association, 1997, esp. p. 38; Brian Hatton, "The Problem of Our Walls," *Journal of Architecture* 4 (71), Spring 1999, pp. 66–67.

39 Hannah Arendt, *The Human Condition*, Chicago: University of Chicago Press, 1998, pp. 63–4.

40 Giorgio Agamben, *Homo Sacer: Sovereign Power and Bare Life*, Stanford, CA: Stanford University Press, 1998, p. 187.

41 Robert McNamara is of particular interest in this context, because under JFK's administration of the so-called "best and the brightest," a number of academics and business directors were promoted to executive power. With McNamara as secretary of defence, technocratic management theory became the ubiquitous language for all military matters in the Pentagon during the 1960s. Guided by theoretical "models," systems analysis, operational research, "game theory" and numbers-driven management, McNamara's group of "whizz kids" believed war was a rational business of projected costs, benefits and kill-ratios, and that if only these could be maximized, war could be won. Although the Pentagon under McNamara put much effort into modelling, and then fighting, according to these models, the Vietnamese guerrillas refused to act as "efficient consumers" in the Pentagon's market economy, or as the "rational opponents" in the "game theories" of RAND—indeed, opinion has it that this approach led to the unnecessary prolongation of the Vietnam war. Paul Hendrickson, *The Living and the Dead*, New York: Vintage Books, 1997; Yehouda Shenhav, *Manufacturing Rationality*, Oxford: Oxford University Press, 1999.

42 "With the growing integration of industrial society, these categories are losing their critical connotation, and tend to become descriptive, deceptive, or operational terms . . . Confronted with the total character of the achievements of advanced industrial society, critical theory is left without the rationale for transcending this society. The vacuum empties the theoretical structure itself, because the categories of a critical social theory were developed during the period in which the need for refusal and subversion was embodied in the action of effective social forces." Herbert Marcuse, *One-Dimensional Man, Studies in the Ideology of Advanced Industrial Society*, Boston, MA: Beacon, 1991 [1964].

Part 3 (c): Further reading

Alloula, Malek. *The Colonial Harem*. Minneapolis: University of Minnesota Press, 1986.

Blier, Suzanne P. *African Vodun: Art, Psychology, and Power*. Chicago: University of Chicago Press, 1995.

Flood, Finbarr B. *Objects of Translation: Material Culture and Medieval "Hindu-Muslim" Encounter*. Princeton: Princeton University Press, 2009.

Goldberg, David T. *The Racial State*. Malden, MA: Blackwell Publishers, 2002.

Latour, Bruno, and Peter Weibel. *Iconoclash*. Karlsruhe: ZKM, 2002.

Mbembe, Achille. *On the Postcolony*. Berkeley: University of California Press, 2002.

Melas, Natalie. *All the Difference in the World: Postcoloniality and the Ends of Comparison*, Stanford: Stanford University Press, 2007.

Mignolo, Walter, and Arturo Escobar. *Globalization and the Decolonial Option*. London: Routledge, 2010.

Mitchell, Timothy. *Rule of Experts: Egypt, Technopolitics, Modernity*. Berkeley: University of California Press, 2002.

Moraña, Mabel et al. *Coloniality at Large: Latin America and the Postcolonial Debate*. Durham, NC: Duke University Press, 2008.

Morris, Rosalind C. *Photographies East: The Camera and Its Histories in East and Southeast Asia*. Durham, NC: Duke University Press, 2009.

Ophir, Adi, Michal Givoni, and Sārī Ḥanafī. *The Power of Inclusive Exclusion: Anatomy of Israeli Rule in the Occupied Palestinian Territories*. New York: Zone Books, 2009.

Ross, Kristin. *Fast Cars, Clean Bodies: Decolonization and the Reordering of French Culture*. Cambridge, MA: MIT Press, 1995.

See, Sarita Echavez. *The Decolonized Eye: Filipino American Art and Performance*. Minneapolis: University of Minnesota Press, 2009.

Smith, Terry and Okwui Enwezor (eds). *Antinomies in Contemporary Art*. Durham, NC: Duke University Press, 2008.

Weizman, Eyal "The Politics of Verticality" at http://www.opendemocracy.net.

———. *Hollow Land: Israel's Architecture of Occupation*. New York: Verso, 2007.

PART 4

Media and mediations

ACADEMICS BEING THE CLOSE READERS that they are, they have some-
times speculated as to why different sections of the *Reader* get placed where they do in
the overall order. To avoid all such suspicions of skullduggery, I have placed the vital Media
and mediations section last in the hope that it is clear that I expect just about every reader of
the volume to want to read it. In another sense, every chapter could be in this section. It also
loops back into the opening section, linking to Mitchell's discussion of why there are no visual
media. So in the networked conception of the book, this is not the end, simply a key node.

Appropriately, therefore, the section begins with Tara McPherson's intertwining of the
history of the development of the computer operating system UNIX in the 1960s with that of
U.S. race relations in the same period. Editor of the impressive on-line journal *Vectors*,
McPherson acknowledges that each moment is foundational for different fields but shows that
there is more to be understood by their interface. For both moments led to the institution of
"powerful operating systems that deeply influence how we know self, other and society" today.
Noting wryly that new media studies quickly replicated former divides in scholarly practice by
instituting on the one hand a "cyberstructuralism" that dealt with code and on the other a set
of interrogations of race either as represented on screen or in the digital divide, McPherson
squares the circle by asking whether the "very structures of digital computation develop[ed] at
least in part to cordon off race and to contain it"? For just as U.S. racialized politics centered
around questions of segregation, UNIX code was designed around modularity and separation
in order to control complexity. The visualizing of computer operating systems thus centered
around the key techniques of visuality: classification and separation. McPherson uses a
Gramscian reading of the hegemony of "common sense" to read computer coding manuals to
fascinating effect and then reads those tactics in the lived experience of racialization, showing
that "the emerging neo-liberal state begins to adopt 'the rule of modularity.' " These patterns
of interface are not attributed as conscious enactments but as the related consequences of
these logics of modularity that underwent a radical shift in the mid-twentieth century. Implied
here is a need to critically analyze and study code in historical and politicized frames of refer-
ence in order to escape the logics of modularity.

Digital theorist Lisa Nakamura was one of the first scholars to apply concepts of
racial formation to digital cultures. In this extract from her book *Digitizing Race*, she notes

the transition from a text-based Internet in the 1990s to the highly visualized Web 2.0. She sees this as a moment of negotiation between the subject(s) and object(s) of visual culture, entailing the production of a "digital racial formation." Derived from the influential formula of Omi and Winant, this perspective suggests that "race" is constantly being (re)made and that digital media are now a key locus of that formation. This process is itself part of the deployment of digital visual capital, a marking of "users'/viewers' *relative* access to technologies of global media." Nakamura is interested in how race and gender shape this access to technology, asking how women and minorities "use their digital visual capital? In what ways are their gendered and racialized bodies a form of this new type of capital? What sort of laws does this currency operate under? It doesn't change everything, but what does it change?" These questions are addressed in relation to Jennifer Lopez's video for her song "If You Had My Love" (1999). While one might expect such a retro video to be wildly out of date, it's more striking how the idea of interface is consistent over this time period. The video shows Lopez "as an *object of interactivity*, despite her position as a star and the knowing object of the interactive gaze." The video presents "J.Lo" as a "carefully constructed racial project," such that the user in the video can access her as a "Latin Soul" or "House" performer at will. The video self-consciously performs the tropes of online pornography, presented as a form of "Internet TV," a commercial interface that still remains a fantasy today. In short, Nakamura argues, "this video walks a viewer through a process of digital racial formation." At the end of the first cycle of the Obama presidency in which a wave of optimism that racialization had perhaps been radically challenged has given way to a more pessimistic sense that white racism has been reinvigorated across Europe and the United States, Nakamura's example of vernacular digital racial formation is a timely reminder that change may be easier to say than to achieve.

From the related perspective of Indigenous media—meaning media produced by and for Indigenous peoples—in the age of global digital media, Faye Ginsburg, director of the Center for Media, Religion and History at NYU, suggests that the questions at stake are: "who has the right to control knowledge and what are the consequences of the new circulatory regimes introduced by digital technologies[?]" That is to say, the key concepts that have become so central to (digital) media studies can be usefully reformulated from the "margins" represented by Indigenous media, challenging the "evolutionary" model that is implied in so much new media rhetoric. If we talk about the "digital era" or the "digital age" that implies a time before this moment. It is all too easy to slip into imperial rhetorics and suggest that people in developing nations live in a different time period altogether. Ginsburg has striking examples of Indigenous digital media projects from the Inuit regions of Nunavut (seceded from Canada); Arrernte Aboriginal youth in the Alice Springs region of Australia; and the Northwest Coast Aboriginal peoples of Canada. As she notes in conclusion, "Indigenous media offer an alternative model of grounded and increasingly global interconnectedness created by Indigenous people about their own lives and cultures" that in turn present a different view of "the digital." The much-touted "digital divide" appears from this perspective as a means of visualizing a new mode of difference between the Indigenous and the "civilized."

As if in response to these chapters, Alex Galloway brings a wide range of reference and historical depth to his analysis of the interface, asking "what would it means to say that 'interface' and 'media' are two names for the same thing?" Galloway questions the default association of interface with a doorway or window in favor of a "layer model." In this latter, one medium is a container for another's content "in which the outside is evoked in order that the inside may take place." Working with ancient authorities like Homer and Hesiod, on the one hand, and Norman Rockwell and *Mad* magazine on the other, Galloway demonstrates that "an interface is a relational effect." This effect creates a tension between coherence and incoherence, or the workable and the unworkable, which he calls the "intraface, that is an interface internal to the interface." The intraface can be understood by reference to video games like

World of Warcraft in which the extensive array of non-diegetic information is just as important as the diegetic "action" of the game. In Galloway's terms, that means that the "outside, or the 'social,' has been woven more intimately into the very fabric of the aesthetic than in previous times." This schema allows him to present a set of models of the relationship between coherence and incoherence in aesthetics and politics. In this view, an aesthetic of coherence with a politics of coherence creates what is known as ideology, defined by Althusser as the "imaginary relation to real conditions." Galloway pithily concludes: "In short, ideology gets *modeled* in software."

Given that the virtual occurs across the multiple folds of the interface, Brian Massumi offers a key caution: "No one kind of image, let alone any one image, can render the virtual." In a chapter that resists summary because it is so lapidary, Massumi reconfigures the relationship of the digital, the virtual and the analog by insisting on the place of the reading and viewing body in this relationship. The virtual is the product of the imagination, stresses Massumi, and is not analogical. "Sensation . . . is the being of the analog, . . . a continuously variable impulse or momentum that can cross from one qualitatively different medium into another." Here he suggests the example of light waves becoming vision, an operation he calls "transduction." In this sense, the "body, sensor of change, is a transducer of the virtual." Digitization by contrast is "a numeric way of arranging alternative states so that they can be sequenced into a set of alternative routines." The famous zeros and ones are in this sense a medium of possibility (this or that) but not the virtual. Massumi dwells at length on the error of equating the digital with the virtual, a connection that can only be made via the analog. In a word-processing program, code is processed to appear on screen as words but it is still code until it is read and transduced "into figures of speech and thought." As many a student knows, the word processor's spell check is indifferent as to whether your typing of "their" should in fact be "there," although the human reader is at once aware of the difference. Massumi stresses the physical processes of interacting with screens, the boredom and inattention, as much as the raised eyebrow, for "the processing may be be digital—but the analog is the process." Perhaps the era of ubiquitous computing will change this paradoxical alternance but it has not yet done so.

In their microanalysis of the use of Magnetic Resonance Imaging (MRI) machines, Lisa Cartwright and Morana Alac give full weight to non-verbal communication and the place of the imagination in the use and interpretation of this very sophisticated visualizing technology. Bringing together skills from ethnography, science studies, visual culture and semiotics, Cartwright and Alac consider "the intersubjective enactment of imagination" in this literally clinical setting. Proceeding with due specificity and scientific clarity, they propose that "the imagination of the researcher and the research subject [are] important entities of laboratory study." Here they directly claim to be moving beyond Descartes's concept of "the mental image." Interestingly, one aspect of the MRI that they consider is perhaps the most noticeable aspect of the procedure for most patients, namely the extraordinary loud and disturbing noise it generates. Far from being the all-but-silent hiss of a science-fiction scan, the MRI is an alienating and claustrophobic experience. At the same time, the patient becomes an element in the MRI if she performs movement. For despite all the disconcerting elements mentioned, the scan relies on the patient remaining as immobile as possible. Movements that disrupt the images can be so slight as to be invisible to the technicians performing the scan and have to be retroactively deduced from the MRI results. The careful analysis here reminds us what is at stake here: for close to four hundred years, observation of the kind practised by Descartes has been hegemonic. New technologies create "images" that require not just new means of considering how certain things become visible but a recognition that "imagination is a process that occurs through intersubjective and multimodal experiences that cannot be reduced to the location of the individual or to a dominant sensory modality or paradigm as the primary one in the

production of knowledge and meaning." Cartwright and Alac suggest that feminist theories of the subject will need to be brought to bear not just on narrative cinema or popular culture but on laboratory science. Further, one might add that this collaborative visualizing transforms the hitherto dominant model of visualization as the prerogative of the Hero, whether a military leader or the scientific genius, like Einstein. This chapter is an appropriate final piece for the Reader. It shows how theory and what Trevor Paglen calls "minoritarian empiricism" can be used to combined and powerful effect to create new subjects for knowledge and new ways to think about a topic as established as the imagination. Far from being the end, this is just the beginning.

Tara McPherson

U.S. OPERATING SYSTEMS AT MIDCENTURY: THE INTERTWINING OF RACE AND UNIX

I BEGIN WITH TWO FRAGMENTS cut from history, around about the 1960s. This chapter will pursue the lines of connection between these two moments and argue that insisting on their entanglement is integral to any meaningful understanding of either of its key terms:the digital and race. Additionally, I am interested in what we might learn from these historical examples about the very terrains of knowledge production in post-World War II United States. The legacies of mid-century shifts in both our cultural understandings of race and in digital computation are still very much with us today, powerful operating systems that deeply influence how we know self, other and society.

Fragment one

In the early 1960s, computer scientists at MIT were working on Project MAC, an early set of experiments in Compatible Timesharing Systems for computing. In the summer of 1963, MIT hosted a group of leading computer scientists at the university to brainstorm about the future of computing. By 1965, MULTICS, a mainframe timesharing operating system, was in use, with joint development by MIT, GE, and Bell Labs, a subsidiary of ATT. The project was funded by ARPA of the Defense Department for two million a year for eight years. MULTICS introduced early ideas about modularity in hardware structure and software architecture.

In 1969, Bell Labs stopped working on MULTICS, and, that summer, one of their engineers, Ken Thompson, developed the beginnings of UNIX. While there are clearly influences of MULTICS on UNIX, the later system also moves away from the earlier one, pushing for increased modularity and for a simpler design able to run on cheaper computers.

In simplest terms, UNIX is an early operating system for digital computers, one that has spawned many offshoots and clones. These include MAC OS X as well as LINUX, indicating the reach of UNIX over the past forty years. The system also influenced non-UNIX operating systems like Windows NT and remains in use by many corporate IT divisions. UNIX was originally written in assembly language, but after Thompson's colleague, Dennis Ritchie, developed the C programming language in 1972, Thompson rewrote UNIX in that language.

Basic text-formatting and editing features were also added (i.e. early word processors). In 1974, Ritchie and Thompson published their work in the journal of the *Association for Computing Machinery*, and UNIX began to pick up a good deal of steam.[1]

UNIX can also be thought of as more than an operating system, as it also includes a number of utilities such as command line editors, APIs, code libraries, etc. Furthermore, UNIX is widely understood to embody particular philosophies and cultures of computation, "operating systems" of a larger order that we will return to.

Fragment two

Of course, for scholars of culture, of gender and of race, dates like 1965 and 1968 have other resonances. For many of us, 1965 might not recall MULTICS but instead the assassination of Malcolm X, the founding of the United Farm Workers, the burning of Watts, or the passage of the Voting Rights Act. The mid-1960s also saw the origins of the American Indian Movement (AIM) and the launch of the National Organization for Women (NOW). The late 1960s mark the 1968 citywide walkouts of Latino youth in Los Angeles, the assassinations of Martin Luther King, Jr. and Robert F. Kennedy, the Chicago Democratic convention, the Stonewall Riots, and the founding of the Black Panthers and the Young Lords. Beyond the geographies of the United States, we might also remember the Prague Spring of 1968, Tommie Smith and John Carlos at the Mexico Summer Olympics, the Tlatelolco Massacre, the execution of Che Guevara, the Chinese Cultural Revolution, the Six-Day War, or May '68 in Paris, itself a kind of origin story for some genealogies of film and media studies. On the African continent, thirty-two countries gained independence from colonial rulers. In the U.S., broad cultural shifts emerged across the decade, as identity politics took root and countercultural forces challenged traditional values. Resistance to the Vietnam War mounted as the decade wore on. Abroad, movements against colonialism and oppression were notably strong.

The history just glossed as "fragment one" is well-known to code junkies and computer geeks. Numerous websites archive oral histories, programming manuals, and technical specifications for MULTICS, UNIX, and various mainframe and other hardware systems. Key players in the history, including Ken Thompson, Donald Ritchie and Doug McIlroy, have a kind of geek-chic celebrity status, and differing versions of the histories of software and hardware development are hotly debated, including nitty-gritty details of what really counts as "a UNIX." In media studies, emerging work in "code studies" often resurrects and takes up these histories.

Within American cultural and ethnic studies, the temporal touchstones of struggles over racial justice, anti-war activism, and legal history are also widely recognized and analyzed. Not surprisingly, these two fragments typically stand apart in parallel tracks, attracting the interest and attention of very different audiences located in the deeply siloed departments that categorize our universities.

But why?

In short, I suggest that these two moments cut from time are deeply interdependent. In fact, they co-constitute one another, comprising not independent slices of history but, instead, related and useful lenses into the shifting epistemological registers driving U.S. and global culture in the 1960s and after.

This history of intertwining and mutual dependence is hard to tell. As one delves into the intricacies of UNIX and the data structures it embraces, race in America recedes far from

our line of vision and inquiry. Likewise, detailed examinations into the shifting registers of race and racial visibility post-1950 do not easily lend themselves to observations about the emergence of object-oriented programming, personal computing, and encapsulation. Very few audiences who care about one lens have much patience or tolerance for the other.

Early forays in new media theory in the late 1990s did not much help this problem. Theorists of new media often retreated into forms of analysis that Marsha Kinder has critiqued as "cyberstructuralist," intent on parsing media specificity and on theorizing the forms of new media, while disavowing twenty-plus years of critical race theory, feminism and other modes of overtly politicized inquiry. Many who had worked hard to instill race as a central mode of analysis in film, literary, and media studies throughout the late twentieth century were disheartened and outraged (if not that surprised) to find new media theory so easily retreat into a comfortable formalism familiar from the early days of film theory.

Early analyses of race and the digital often took two forms, a critique of representations *in* new media, i.e. on the surface of our screens, or debates about access to media, i.e. the digital divide. Such work rarely pushed toward the analyses of form, phenomenology or computation that were so compelling and lively in the work of Lev Manovich, Mark Hansen, or Jay Bolter and Richard Grusin. Important works emerged from both "camps," but the camps rarely intersected. A few conferences attempted to force a collision between these areas, but the going was tough. For instance, at the two "Race and Digital Space" events colleagues and I organized in 2000 and 2002, the vast majority of participants and speakers were engaged in work in the two modes mentioned above. The cyberstructuralists were not in attendance.

But what if this very incompatability is itself part and parcel of the organization of knowledge production that operating systems like UNIX helped to disseminate around the world? Might we ask if there is not something *particular to the very forms* of electronic culture that seems to encourage just such a movement, a movement that partitions race off from the specificity of media forms? Put differently, might we argue that the very structures of digital computation develop at least in part to cordon off race and to contain it? Further, might we come to understand that our own critical methodologies are the heirs to this epistemological shift?

In early writings by Sherry Turkle and George Landow to more recent work by Alex Galloway and others, new media scholars have noted the parallels between the ways of knowing modeled in computer culture and the greatest hits of structuralism and poststructuralism. Critical race theorists and postcolonial scholars like Chela Sandoval and Gayatri Spivak have illustrated the structuring (if unacknowledged) role that race plays in the work of poststructuralists like Roland Barthes and Michel Foucault. We might bring these two arguments together, triangulating race, electronic culture, and poststructuralism, and, further argue that race, particularly in the United States, is central to this undertaking, fundamentally shaping how we see and know as well as the technologies that underwrite or cement both vision and knowledge. Certain modes of racial visibility and knowing coincide or dovetail with specific ways of organizing data: if digital computing underwrites today's information economy and is the central technology of post-World War II America, these technologized ways of seeing/knowing took shape in a world also struggling with shifting knowledges about and representations of race. If, as Michael Omi and Howard Winant argue, racial formations serve as fundamental organizing principles of social relations in the United States, on both the macro and micro levels (55), how might we understand the infusion of racial organizing principle into the technological organization of knowledge after World War II?

Omi and Winant and other scholars have tracked the emergence of a "race-blind" rhetoric at mid century, a discourse that moves from overt to more covert modes of racism and

racial representation (for example, from the era of Jim Crow to liberal colorblindness). Drawing from those 3-D postcards that bring two or more images together even while suppressing their connections, I have earlier termed the racial paradigms of the post-war era lenticular logics. The ridged coating on 3-D postcards is actually a lenticular lens, a structural device that makes simultaneously viewing the various images contained on one card nearly impossible. The viewer can rotate the card to see any single image, but the lens itself makes seeing the images *together* very difficult, even as it conjoins them at a structural level (i.e. within the same card). In the post-Civil Rights U.S., the lenticular is a way of organizing the world. It structures representations but also epistemologies. It also serves to secure our understandings of race in very narrow registers, fixating on sameness or difference while forestalling connection and interrelation. As I have argued elsewhere, we might think of the lenticular as a covert mode of the pretense of "separate but equal," remixed for mid-century America (McPherson 250).

A lenticular logic is a covert racial logic, a logic for the post-Civil Rights era. We might contrast the lenticular postcard to that wildly popular artifact of the industrial era, the stereoscope card. The stereoscope melds two different images into an imagined whole, privileging the whole; the lenticular image partitions and divides, privileging fragmentation. A lenticular logic is a logic of the fragment or the chunk, a way of seeing the world as discrete modules, a mode that suppresses relation and context. As such, the lenticular also manages and controls complexity.

And what in the world does this have to do with those engineers laboring away at Bell Labs, the heroes of the first fragment of history this essay began with? What's race got to do with that? The popularity of lenticular lenses, particularly in the form of postcards, coincides historically not just with the rise of an articulated movement for civil rights but also with the growth of electronic culture and the birth of digital computing (with both—digital computing and the Civil Rights movement—born in quite real ways of World War II). We might understand UNIX as the way in which the emerging logics of the lenticular and of the covert racism of colorblindness get ported into our computational systems, both in terms of the specific functions of UNIX as an operating system and in the broader philosophy it embraces.

Situating UNIX

In moving toward UNIX from MULTICS, programmers conceptualized UNIX as a kind of toolkit of "synergistic parts" that allowed "flexibility in depth" (Raymond 9). Programmers could "choose among multiple shells . . . [and] programs normally provide[d] many behavior options" (6). One of the design philosophies driving UNIX is the notion that a program should do one thing and do it well (not unlike our deep disciplinary drive in many parts of the university), and this privileging of the discrete, the local, and the specific emerges again and again in discussions of UNIX's origins and design philosophies.

Books for programmers that explain the UNIX philosophy turn around a common set of rules. While slight variations on this rule set exist across programming books and online sites, Eric Raymond sets out the first nine rules as follows:

1. Rule of Modularity: Write simple parts connected by clean interfaces.
2. Rule of Clarity: Clarity is better than cleverness.
3. Rule of Composition: Design programs to be connected to other programs.
4. Rule of Separation: Separate policy from mechanism; separate interfaces from engines.
5. Rule of Simplicity: Design for simplicity; add complexity only where you must.

6. Rule of Parsimony: Write a big program only when it is clear by demonstration that nothing else will do.
7. Rule of Transparency: Design for visibility to make inspection and debugging easier.
8. Rule of Robustness: Robustness is the child of transparency and simplicity.
9. Rule of Representation: Fold knowledge into data so program logic can be stupid and robust. (13)

Other rules include the Rules of Least Surprise, Silence, Repair, Economy, Generation, Optimization, Diversity, and Extensibility.

These rules implicitly translate into computational terms the chunked logics of the lenticular. For instance, Brian Kernighan wrote in a 1976 handbook on software programming that "controlling complexity is the essence of computer programming" (quoted in Raymond 14). Complexity in UNIX is controlled in part by the "rule of modularity," which insists that code be constructed of discrete and interchangeable parts that can be plugged together via clean interfaces. In *Design Rules, Vol. 1: The Power of Modularity*, Carliss Baldwin and Kim Clark argue that computers from 1940 to 1960 had "complex, interdependent designs," and they label this era the "premodular" phase of computing (149). While individuals within the industry, including John von Neumann, were beginning to imagine benefits to modularity in computing, Baldwin and Clark note that von Neumann's ground-breaking designs for computers in that period "fell short of true modularity" because "in no sense was the detailed design of one component going to be hidden from the others: all pieces of the system would be produced 'in full view' of the others" (157). Thus, one might say that these early visions of digital computers were neither modular nor lenticular. Baldwin and Clark track the increasing modularity of hardware design from the early 1950s forward and also observe that UNIX was the first operating system to embrace modularity and adhere "to the principles of information hiding" in its design (324).

There are clearly practical advantages of such structures for coding, but they also underscore a world view in which a troublesome part might be discarded without disrupting the whole. Tools are meant to be "encapsulated" to avoid "a tendency to involve programs with each others' internals" (Raymond 15). Modules "don't promiscuously share global data," and problems can stay "local" (84–5). In writing about the Rule of Composition, Eric Raymond advises programmers to "make [programs] independent." He writes, "It should be easy to replace one end with a completely different implementation without disturbing the other" (15). Detachment is valued because it allows a cleaving from "the particular . . . conditions under which a design problem was posed. Abstract. Simplify. Generalize." (95). While "generalization" in UNIX has specific meanings, we might also see at work here the basic contours of a lenticular approach to the world, an approach which separates object from context, cause from effect.

In a 1976 article, "Software Tools," Bell Lab programmers Kernighan and Plauger urged programmers "to view specific jobs as special cases of general, frequently performed operations, so they can make and use general-purpose tools to solve them. We also hope to show how to design programs to look like tools and to interconnect conveniently" (1). While the language here is one of generality (as in "general purpose" tools), in fact, the tool library that is being envisioned is a series of very discrete and specific tools or programs that can operate independently of one another. They continue, "Ideally, a program should not know where its input comes from nor where its output goes. The UNIX time-sharing system provides a particularly elegant way to handle input and output redirection" (2). Programs:

> can profitably be described as filters, even though they do quite complicated transformations on their input. One should be able to say

program-1 . . . | sort | program-2 . . .
and have the output of program-1 sorted before being passed to program-2. This
has the major advantage that neither program-1 nor program-2 need know how
to sort, but can concentrate on its main task (4).

In effect, the tools chunk computational programs into isolated bits, where the programs'
operations are meant to be "invisible to the user" and to the other programs in a sequence (5):
"the point is that this operation is invisible to the user (or should be) . . . Instead he sees
simply a program with one input and one output. Unsorted data go in one end; somewhat
later, sorted data come out the other. It must be *convenient* to use a tool, not just possible" (5).
Kernighan and Plauger saw the "filter concept" as a useful way to get programmers to think
in discrete bits and to simplify, reducing the potential complexity of programs. They note
that "when a job is viewed as a series of filters, the implementation simplifies, for it is broken
down into a sequence of relatively independent pieces, each small and easily tested. This is a
form of high-level modularization" (5). In their own way, these filters function as a kind of
lenticular frame or lens, allowing only certain portions of complex datasets to be visible at a
particular time (to both the user and the machine).

The technical feature which allowed UNIX to achieve much of its modularity was the
development by Ken Thompson (based on a suggestion by Doug McIlroy) of the pipe, i.e. a
vertical bar that replaced the "greater than" sign in the operating system's code. As described
by Doug Ritchie and Ken Thompson in a paper for the Association of Computing Machinery
in 1974 (reprinted by Bell Labs in 1978), "A *read* using a pipe file descriptor waits until
another process writes using the file descriptor for the same pipe. At this point, data are
passed between the images of the two processes. Neither process need know that a pipe,
rather than an ordinary file, is involved." In this way, the ability to construct a pipeline from
a series of small programs evolved, while the "hiding of internals" was also supported. The
contents of a module were not central to the functioning of the pipeline; rather, the input or
output (a text stream) was key. Brian Kernighan noted "that while input/output direction
predates pipes, the development of pipes led to the concept of tools—software programs that
would be in a 'tool box,' available when you need them" and interchangeable.[2] Pipes reduced
complexity and were also linear. In "Software Tools," Kernighan and Plauger extend their
discussion of pipes, noting that "a pipe provides a hidden buffering between the output of one
program and the input of another program so information may pass between them without
ever entering the file system" (2). They also signal the importance of pipes for issues of data
security.

And consider the sequence:

decrypt key < file | prog | encrypt key > newfile
Here a decryption program decodes an encrypted file, passing the decoded char-
acters to a program having no special security features. The ouput of the program
is re-encrypted at the other end. If a true pipe mechanism is used, no clear-text
version of the data will ever appear in a file. To simulate this sequence with
temporary files risks breaching security (3).

While the affordances of filters, pipes, and hidden data are often talked about as a matter of
simple standardization and efficiency (as when Kernighan and Plauger argue that "Our
emphasis here has been on getting jobs done with an efficient use of people" (6)), they also
clearly work in the service of new regimes of security, not an insignificant detail in the
context of the Cold War era. Programming manuals and UNIX guides again and again stress
clarity and simplicity ("don't write fancy code;" "say what you mean as clearly and directly as

you can"), but the structures of operating systems like UNIX function by hiding internal operations, skewing "clarity" in very particular directions. These manuals privilege a programmer's equivalent of "common sense" in the Gramscian sense. For Antonio Gramsci, common sense is a historically situated process, the way in which a particular group responds to "certain problems posed by reality which are quite specific" at a particular time (324). I am here arguing that, as programmers constitute themselves as a particular class of workers in the 1970s, they are necessarily lodged in their moment, deploying common sense and notions about simplicity to justify their innovations in code. Importantly, their moment is overdetermined by the ways in which the U.S. is widely coming to process race and other forms of difference in more covert registers, as noted above.[3]

Another rule of UNIX is the "Rule of Diversity," which insists on a mistrust of the "one true way." Thus UNIX, in the words of one account, "embraces multiple languages, open extensible systems and customization hooks everywhere," reading much like a description of the tenets of neoliberal multiculturalism if not poststructuralist thought itself (Raymond 24). As you read the ample literature on UNIX, certain words emerge again and again: modularity, compactness, simplicity, orthogonality. UNIX is meant to allow multitasking, portability, time-sharing, and compartmentalizing. It is not much of a stretch to layer these traits over the core tenets of post-Fordism, a process which begins to remake industrial-era notions of standardization in the 1960s: time-space compression, transformability, customization, a public/private blur, etc. UNIX's intense modularity and information-hiding capacity were reinforced by its design, that is, in the ways in which it segregated the kernel from the shell. The kernel loads into the computer's memory at startup and is "the heart" of UNIX (managing "hardware memory, job execution and time sharing"), although it remains hidden from the user (Baldwin, 332). The shells (or programs that interpret commands) are intermediaries between the user and the computer's inner workings. They hide the details of the operating system from the user behind "the shell," extending modularity from a rule for programming in UNIX to the very design of UNIX itself.[4]

Modularity in the Social Field

This push toward modularity and the covert in digital computation also reflects other changes in the organization of social life in the United States by the 1960s. For instance, if the first half of the twentieth century laid bare its racial logics, from "Whites Only" signage to the brutalities of lynching, the second half increasingly hides its racial "kernel," burying it below a shell of neoliberal pluralism. These covert or lenticular racial logics take hold at the tail end of the Civil Rights movement at least partially to cut off and contain the more radical logics implicit in the urban uprisings that shook Detroit, Watts, Chicago, and Newark. In fact, the urban center of Detroit was more segregated by the 1980s than in previous decades, reflecting a different inflection of the programmer's vision of the "easy removal" or containment of a troubling part. Whole areas of the city might be rendered orthogonal and disposable (also think post-Katrina New Orleans), and the urban Black poor were increasingly isolated in "deteriorating city centers" (Sugrue, 198). Historian Thomas Sugrue traces the increasing unemployment rates for Black men in Detroit, rates which rose dramatically from the 1950s to the 1980s, and maps a "deproletarianization" that "shaped a pattern of poverty in the postwar city that was surprisingly new" (262). Across several registers, the emerging neoliberal state begins to adopt "the rule of modularity." For instance, we might draw an example from across the Atlantic. In her careful analysis of the effects of May 1968 and its afterlives, Kristin Ross argues that the French government contained the radical force of the uprisings by quickly moving to separate the students' rebellion from the concerns of labor, deploying

a strategy of separation and containment in which both sides (students and labor) would ultimately lose (69).

Modularity in software design was meant to decrease "global complexity" and cleanly separate one "neighbor" from another (Raymond, 85). These strategies also played out in ongoing reorganizations of the political field throughout the 1960s and 1970s in both the Right and the Left. The widespread divestiture in the infrastructure of inner cities might be seen as one more insidious effect of the logic of modularity in the post-War era. But we might also understand the emergence of identity politics in the 1960s as a kind of social and political embrace of modularity and encapsulation, a mode of partitioning that turned away from the broader forms of alliance-based and globally-inflected political practice that characterized both labor politics and anti-racist organizing in the 1930s and 1940s.[5] While identity politics produced concrete gains in the world, particularly in terms of civil rights, we are also now coming to understand the degree to which these movements curtailed and short-circuited more radical forms of political praxis, reducing struggle to fairly discrete parameters.

Let me be clear. By drawing analogies between shifting racial and political formations and the emerging structures of digital computing in the late 1960s, I am not arguing that the programmers creating UNIX at Bell Labs and in Berkeley were *consciously* encoding new modes of racism and racial understanding into digital systems. (Indeed, many of these programmers were themselves left-leaning hippies, and the overlaps between the counter-culture and early computing culture run deep, as Fred Turner has illustrated.) I also recognize that their innovations made possible the word processor I am using to write this article, a powerful tool that shapes cognition and scholarship in precise ways. Nor am I arguing for some exact correspondence between the ways in which encapsulation or modularity work in computation and how they function in the emerging regimes of neoliberalism, governmentality and post-Fordism. Rather, I am highlighting the ways in which the organization of information and capital in the 1960s powerfully responds—across many registers—to the struggles for racial justice and democracy that so categorized the U.S. at the time. Many of these shifts were enacted in the name of liberalism, aimed at distancing the overt racism of the past even as they contained and cordoned off progressive radicalism. The emergence of covert racism and its rhetoric of colorblindness are not so much intentional as systemic. Computation is a primary delivery method of these new systems, and it seems at best naïve to imagine that cultural and computational operating systems don't mutually infect one another.

Thus we see modularity take hold not only in computation but also in the increasingly niched and regimented production of knowledge in the university after World War II. For instance, Christopher Newfield comments on the rise of New Criticism in literature departments in the Cold War era, noting its relentless formalism, a "logical corollary" to "depoliticization" (145) that "replaced agency with technique" (155). He attributes this particular tendency in literary criticism at least in part to the triumph of a managerial impulse, a turn that we might also align (even if Newfield doesn't) with the workings of modular code (itself studied as an exemplary approach to "dynamic modeling systems" for business management in the work of Baldwin and Clark cited above).[6] He observes as well that this managerial obsession within literary criticism exhibits a surprising continuity across the 1960s and beyond. Gerald Graff has also examined the "patterned isolation" that emerges in the university after World War II, at the moment when New Criticism's methods take hold in a manner that de-privileges context and focuses on "explication for explication's sake." Graff then analyzes the routinization of literary criticism in the period, a mechanistic exercise with input and output streams of its own (227). He recognizes that university departments (his example is English) begin to operate by a field-based and modular strategy of "coverage," in which subfields proliferate and exist in their own separate chunks of knowledge, rarely

contaminated by one another's "internals" (250). (He also comments that this modular strategy includes the token hiring of scholars of color who are then cordoned off within the department.) Graff locates the beginning of this patterned isolation in the run-up to the period that also brought us digital computing; he writes that it continues to play out today in disciplinary structures that have become increasingly narrow and specialized. Patterned isolation begins with the bureaucratic standardization of the university from 1890–1930 (61–62), but this "cut out and separate" mentality reaches a new crescendo after World War II as the organizational structure of the university pushes from simply bureaucratic and Taylorist to managerial, a shift noted as well by Christopher Newfield. Many now lament the over-specialization of the university; in effect, this tendency is a result of the additive logic of the lenticular or of the pipeline, where "content areas" or "fields" are tacked together without any sense of intersection, context, or relation.

It is interesting to note that much of the early work performed in UNIX environments was focused on document processing and communication tools and that UNIX is a computational system that very much privileges text (it centers on the text-based command line instead of on the Graphical User Interface, and its inputs and outputs are simple text lines). Many of the methodologies of the humanities from the Cold War through the 1980s also privilege text while devaluing context and operate in their own chunked systems, suggesting telling parallels between the operating systems and privileged objects of the humanities and of the computers being developed on several university campuses in the same period.

Another example of the increasing modularity of the American university might be drawn from the terrain of Area Studies. Scholars including Martin W. Lewis and Kären Wigen have recently mapped the proliferation of area studies from the onset of the Cold War era to the present. They show how a coupling of government, foundations and scholars began to parse the world in finer and finer detail, producing geographical areas of study that could work in the service of the "modernization and development" agenda that was coming to replace the older models of colonial domination, substituting the covert stylings of the post-industrial for the overtly oppressive methods of earlier regimes. By 1958, government funding established university-based "area-studies centers" that grew to "some 124 National Resource Centers [by the 1990s] . . . each devoted to the interdisciplinary study of a particular world region" (Lewis and Wigen, 164). John Rowe has convincingly argued that Area Studies thrived by operating through a kind of isolationism or modularity, with each area intently focused within its own borders.

Lev Manovich has, of course, noted the modularity of the digital era and also back-tracked to early twentieth century examples of modularity from the factory line to the creative productions of avantgarde artists. In a posting to the Nettime list-serve in 2005, he frames modularity as a uniquely twentieth century phenomenon, from Henry Ford's assembly lines to the 1932 furniture designs of Belgian designer Louis Herman De Kornick. In his account, the twentieth century is characterized by an accelerating process of industrial modularization, but I think it is useful to examine the digital computer's privileged role in the process, particularly given that competing modes of computation were still quite viable until the 1960s, modes that might have pushed more toward the continuous flows of analog computing rather than the discrete tics of the digital computer. Is the modularity of the 1920s really the same as the modularity modeled in UNIX? Do these differences matter, and what might we miss if we assume a smooth and teleological triumph of modularity? How has computation pushed modularity in new directions, directions in dialogue with other cultural shifts and ruptures? Why does modularity emerge in our systems with such a vengeance across the 1960s?

I have here suggested that our technological formations are deeply bound up with our racial formations, and that each undergo profound changes at mid-century. I am not so much

arguing that one mode is causally related to the other, but, rather, that they both represent a move toward modular knowledges, knowledges increasingly prevalent in the second half of the twentieth century. These knowledges support and enable the shift from the overt stand-ardized bureaucracies of the 1920s and 1930s to the more dynamically modular and covert managerial systems that are increasingly prevalent as the century wears on. These latter modes of knowledge production and organization are powerful racial and technological oper-ating systems that coincide with (and reinforce) (post)structuralist approaches to the world within the academy. Both the computer and the lenticular lens mediate images and objects, changing their relationship but frequently suppressing that process of relation, much like the divided department of the contemporary university. The fragmentary knowledges encour-aged by many forms and experiences of the digital neatly parallel the lenticular logics which underwrite the covert racism endemic to our times, operating in potential feedback loops, supporting each other. If scholars of race have highlighted how certain tendencies within poststructuralist theory simultaneously respond to and marginalize race, this maneuver is at least partially possible because of a parallel and increasing dispersion of electronic forms across culture, forms which simultaneously enact and shape these new modes of thinking.

While the examples here have focused on UNIX, it is important to recognize that the core principles of modularity that it helped bring into practice continue to impact a wide range of digital computation, especially the C programming language, itself developed for UNIX by Ritchie, based on Thompson's earlier B language. While UNIX and C devotees will bemoan the non-orthogonality and leakiness of Windows or rant about the complexity of C++, the basic argument offered above—that UNIX helped inaugurate modular and lenticular systems broadly across computation and culture—holds true for the black boxes of contemporary coding and numerous other instances of our digital praxis.

Today, we might see contemporary turns in computing—neural nets, clouds, seman-tics, etc.—as parallel to recent turns in humanities scholarship to privilege networks over nodes (particularly in new media studies and in digital culture theory) and to focus on globali-zation and its flows (in American Studies and other disciplines). While this may simply mean we have learned our mid-century lessons and are smarter now, we might also continue to examine with rigor and detail the degree to which dominant forms of computation—what David Golumbia has aptly called "the cultural logic of computation" in his recent update of Frankfurt School pessimism for the twenty-first century—continue to respond to shifting racial and cultural formations. Might these emerging modes of computation be read as symp-toms and drivers of our "post-racial" moment, refracting in some way national anxieties (or hopes?) about a decreasingly "white" America? We should also remain alert to how contem-porary techno-racial formations infect privileged ways of knowing in the academy. While both the tales of C.P. Snow circa 1959 and the Sokal science wars of the 1990s sustain the myth that science and the humanities operate in distinct realms of knowing, powerful oper-ating systems have surged beneath the surface of what and how we know in the academy for well over half a decade. It would be foolish of us to believe that these operating systems—in this paper best categorized by UNIX and its many close siblings—do not at least partially overdetermine the very critiques we imagine that we are performing today.

Moving beyond our boxes

So, if we are always already complicit with the machine, what are we to do?

First, we must better understand the machines and networks that continue to power-fully shape our lives in ways that we are ill-equipped to deal with as media and humanities scholars. This necessarily involves more than simply studying our screens and the images that

dance across them, moving beyond studies of screen representations and the rhetorics of visuality. We might read representations seeking symptoms of information capital's faultlines and successes, but we cannot read the logics of these systems and networks solely at the level of our screens. Capital is now fully organized under the sign of modularity. It operates via the algorithm and the database, via simulation and processing. Our screens are cover stories, disguising deeply divided forms of both machine and human labor. We focus exclusively on them increasingly to our peril.

Scholars in the emerging field of "code studies" are taking up the challenge of understanding how computational systems (especially but not only software) developed and operate. However, we must demand that this nascent field not replay the formalist and structuralist tendencies of new media theory circa 1998. Code studies (and the emerging digital humanities) must also take up the questions of culture and meaning that animate so many scholars of race in fields like the "new" American Studies. Likewise, scholars of race must analyze, use and produce digital forms and not smugly assume that to engage the digital directly is in some way to be complicit with the forces of capitalism. The lack of intellectual generosity across our fields and departments only reinforces the "divide and conquer" mentality that the most dangerous aspects of modularity underwrite. We must develop common languages that link the study of code and culture. We must historicize and politicize code studies. And, because digital media were born as much of the Civil Rights era as of the Cold War era (and of course these eras are one and the same), our investigations must incorporate race from the outset, understanding and theorizing its function as a "ghost in the digital machine." This does not mean that we should simply "add" race to our analysis in a modular way, neatly tacking it on, but that we must understand and theorize the deep imbrications of race and digital technology even when our objects of analysis (say UNIX or search engines) seem not to "be about" race at all. This will not be easy. In the writing of this essay, the logic of modularity continually threatened to take hold, leading me into detailed explorations of pipe structures in UNIX or departmental structures in the university, taking me far from the contours of race at mid-century. It is hard work to hold race and computation together *in a systemic manner*, but it is work that we must continue to undertake.

We also need to take seriously the possibility that questions of representation and of narrative and textual analysis may, in effect, be a distraction from the powers that be—the triumph of the very particular patterns of informationalization evident in code. If the study of representation may in fact be part and parcel of the very logic of modularity that such code inaugurates, a kind of distraction, it is equally plausible to argue that our very intense focus on visuality in the past twenty years of scholarship is just a different manifestation of the same distraction. There is tendency in film and media studies to treat the computer and its screens as (in Jonathan Beller's terms) a "legacy" technology to cinema. In its drive to stage continuities, such an argument tends to minimize or completely miss the fundamental material differences between cinematic visuality and the production of the visual by digital technologies.

To push my polemic to its furthest dimensions, I would argue that to study image, narrative and visuality will never be enough if we do not engage as well the non-visual dimensions of code and their organization of the world. And, yet, to trouble my own polemic, we might also understand the workings of code to have already internalized the visual to the extent that, in the heart of the labs from which UNIX emerged, the cultural processing of the visual via the register of race already was already at work in the machine.

In extending our critical methodologies, we must have at least a passing familiarity with code languages, operating systems, algorithmic thinking, and systems design. We need database literacies, algorithmic literacies, computational literacies, interface literacies. We need new hybrid practices: artist-theorists; programming humanists; activist scholars; theoretical

archivists; critical race coders. We have to shake ourselves out of our small field-based boxes taking seriously the possibility that our own knowledge practices are "normalized," "modular," and "black boxed" in much the same way as the code we might study in our work. That is, our very scholarly practices tend to undervalue broad contexts, meaningful relation and promiscuous border crossing. While many of us "identify" as interdisciplinary, very few of us extend that border crossing very far (theorists tune out the technical, the technologists are impatient of the abstract, scholars of race mock the computational, seeing it as corrupt). I'm suggesting that the intense narrowing of our academic specialties over the past fifty years can actually be seen as an effect of or as complicit with the logics of modularity and the relational database. Just as the relational database works by normalizing data—that is by stripping it of meaningful context and the idiosyncratic, creating a system of interchangeable equivalencies—our own scholarly practices tend to exist in relatively hermetically sealed boxes or nodes. Critical theory and post-structuralism have been powerful operating systems that have served us well; they were as hard to learn as the complex structures of C++, and we have dutifully learned them. They are also software systems in desperate need of updating and patching. They are lovely, and they are not enough. They cannot be all we do.

In universities that simply shut down "old school" departments like—at my university, German and Geography; in the UK, Middlesex's philosophy program; in Arizona, perhaps all of ethnic studies—scholars must engage the vernacular digital forms that make us nervous, *authoring* in them in order to better understand them and to recreate in technological spaces the possibility of doing the work that moves us. We need new practices and new modes of collaboration; we need to be literate in emerging scientific and technological methodologies but also in theories of race, globalization and gender. We'll gain that literacy at least partially through an intellectual generosity or curiosity toward those whose practices are not our own. We need to privilege systemic modes of thinking that can understand relation and honor complexity, even while valuing precision and specificity. We need nimbler ways of linking the network and the node and digital form and content, and we need to understand that categories like race profoundly shape both form *and* content.

We must remember that computers are themselves encoders of culture. If, in the 1960s and 1970s, UNIX hardwired an emerging system of covert racism into our mainframes and our minds, then computation responds to culture as much as it controls it. Code and race are deeply intertwined, even as the structures of code labor to disavow these very connections. Politically committed academics with humanities skill sets must engage technology and its production, not simply as an object of our scorn, critique, or fascination, but as a productive and generative space that is always emergent and never fully determined.

Notes

1 UNIX develops with some rapidity at least in part because the parent company of Bell Labs, AT&T, was unable to enter the computer business due to a 1958 consent decree. Thus a kind of "counterculture" chic developed around UNIX. Eric Raymond provides a narrative version of this history, including the eventual "UNIX wars." His account, while thorough, tends to romanticize the collaborative culture around UNIX. For a more objective analysis of the imbrications of the counterculture and early computing cultures, see Fred Turner. See also Tom Streeter for a consideration of liberal individualism and computing cultures.

2 This quote from Kernighan is from "The Creation of the UNIX Operating System" on the Bell Labs website. See http://www.bell-labs.com/history/unix/philosophy.html.

3 For Gramsci, "common sense" is a multi-layered phenomenon that can serve both dominant groups and oppressed ones. For oppressed groups, "common sense" may allow a method of speaking back to power and of re-jiggering what counts as sensible. Kara Keeling profitably explores this possibility in her work on the Black femme. Computer programmers in the 1970s are interestingly situated. They

are on the one hand a subculture, but they are also part of an increasingly managerial class that will help society transition to regimes of governmentality. Their dreams of "libraries" of code may be democratic in impulse, but they also increasingly support post-industrial forms of labor.

4 Other aspects of UNIX also encode "chunking," including the concept of the file. For a discussion of files in UNIX, see *You Are Not a Gadget* by Jaron Lanier.

5 See, for instance, Patricia Sullivan's *Days of Hope* for an account of the coalition politics of the South in the 1930s and 1940s that briefly brought together anti-racist activists, labor organizers, and members of the Communist Party. The broad cultural turn to modularity and encapsulation was both a response to these earlier political alliances and a way to short-circuit their viability in the 1960s. My *Reconstructing Dixie* examines the ways in which a lenticular logic infects both identity politics and the politics of difference, making productive alliance hard to achieve in either paradigm.

6 To be fair, Newfield also explores a more radical impulse in literary study in the period, evident in the likes of (surprisingly) both Harold Bloom and Raymond Williams. This impulse valued literature precisely in its ability to offer an "unmanaged exploration of experience" (152).

References

"The Creation of the UNIX Operating System" on the Bell Labs website. See http://www.bell-labs.com/history/unix/philosophy.html.

Baldwin, Carliss and Kim Clark. *Design Rules, Vol. 1: The Power of Modularity*. Cambridge, MA: MIT Press, 2000.

Beller, Jonathan. "Re: Periodizing Cinematic Production." Post to IDC Listserve. September 2, 2009. Archived at https://lists.thing.net/pipermail/idc/2009-September/003851.html.

Bolter, Jay and Richard Grusin. *Remediations: Understanding New Media*. Cambridge, MA: MIT Press, 2000.

Galloway, Alex. *Protocol: How Control Exists after Decentralization*. Cambridge, MA: MIT Press, 2006.

Golumbia, David. *The Cultural Logic of Computation*. Cambridge, MA: Harvard University Press, 2009.

Graff, Gerald. *Professing Literature: An Institutional History*. Chicago, IL: University of Chicago Press, 1989.

Gramsci, Antonio. *Selections from the Prison Notebooks*. Translated and edited by Q. Hoare and G. Nowell Smith. London: Lawrence and Wishart, 1971.

Hansen, Mark B. N. *Embodying Technesis: Technology Beyond Writing*. University of Michigan Press, 2000.

Keeling, Kara. *The Witch's Flight: The Cinematic, the Black Femme, and the Image of Common Sense*. Durham, NC: Duke University Press, 2007.

Kernighan, Brian and P. J. Plauger. *Software Tools*. Reading, MA: Addison-Wesley, 1976.

Kernighan, Brian and P. J. Plauger. "Software Tools." *ACM SIGSOFT Software Engineering Notes*, Volume 1, Issue 1 (May 1976), pp. 15–20.

Kernighan, Brian and Rob Pike. *The Unix Programming Environment*. Prentice-Hall.1984.

Kernighan, Brian and D. M. Ritchie. *The C Programming Language*. Englewood Cliffs, NJ: Prentice-Hall, 1978. Second edition, 1988.

Kinder, Marsha. "Narrative Equivocations Between Movies and Games." *The New Media Book*, ed. Dan Harries. London: BFI, 2002.

Landow, George. *Hypertext: The Convergence of Contemporary Critical Theory and Technology*. Baltimore, MD: Johns Hopkins University Press, 1991.

Lanier, Jaron. *You Are Not A Gadget: A Manifesto*. New York, NY: Knopf, 2010.

Lewis, Martin W. and Kären Wigen. "A Maritime Response to the Crisis in Area Studies," *The Geographical Review* 89:2 (April 1999), 162.

McPherson, Tara. *Reconstructing Dixie: Race, Place and Nostalgia in the Imagined South*. Durham, NC: Duke University Press, 2003.

Manovich, Lev. *The Language of New Media*. Cambridge, MA: MIT Press, 2002.

Manovich, Lev. "We Have Never Been Modular." Post to Nettime Listserve. November, 28, 2005. Archived at http://www.nettime.org/Lists-Archives/nettime-l-0511/msg00106.html.

Newfield, Christopher. *Ivy and Industry: Business and the Making of the American University, 1880–1980*. Durham, NC: Duke University Press, 2004.

Omi, Michael and Howard Winant. *Racial Formation in the United States: From the 1960s to the 1980s*. New York, NY: Routledge, 1986/1989.

Raymond, Eric. *The Art of UNIX Programming*. Reading, MA: Addison-Wesley. 2004.

Ritchie, Dennis. "The Evolution of the Unix Time-sharing System," *AT&T Bell Laboratories Technical Journal 63 No. 6 Part 2, October 1984, pp. 1577-93*. Accessed online http://cm.bell-labs.com/cm/cs/who/dmr/hist.html

Ritchie, D. M. and K. Thompson. "The UNIX Time-Sharing System." *The Bell System Technical Journal 57 no. 6, part 2* (July–August 1978).

Ross, Kristin. *May '68 and Its Afterlives*. Chicago, IL: University of Chicago Press, 2004.

Rowe, John Carlos. "Areas of Concern: Area Studies and the New American Studies." *Reframing the Transnational Turn in American Studies*, eds Winfried Fluck, Donald Pease, and John Carlos Rowe (University Presses of New England, 2011).

Salus, Peter H. *A Quarter-Century of Unix*. Reading, MA: Addison-Wesley, 1994.

Sandoval, Chela. *Methodology of the Oppressed*. Minneapolis, MN: University of Minnesota Press, 2000.

Snow, C.P. *The Two Cultures and the Scientific Revolution*. Cambridge: Cambridge University Press, 1959.

Spivak, Gayatri. *In Other Worlds: Essays in Cultural Politics*. New York, NY: Routledge, 1987.

Streeter, Thomas. "The Romantic Self and the Politics of Internet Commercialization," *Cultural Studies*, Vol. 17, no. 5, Sept. 2003, pp. 648–68.

Sugrue, Thomas J. *The Origins of the Urban Crisis: Race and Inequality in Post-War Detroit*. Princeton, NJ: Princeton University Press, 1998.

Sullivan, Patricia. *Days of Hope: Race and Democracy in the New Deal Era*. Chapel Hill, NC: UNC Press, 1996.

Turkle, Sherry. *Life on the Screen: Identity in the Age of the Internet*. Simon and Schuster, 1997.

Turner, Fred. *From Counterculture to Cyberculture: Stewart Brand, the Whole Earth Network, and the Rise of Digital Utopianism*. Chicago, IL: University of Chicago Press, 2006.

Faye Ginsburg

RETHINKING THE DIGITAL AGE

I N MARCH 2005, THE UNITED NATIONS inaugurated a long-awaited program, a "Digital Solidarity Fund," to underwrite initiatives that address "the uneven distribution and use of new information and communication technologies" and "enable excluded people and countries to enter the new era of the information society" (Digital Solidarity Fund Foundation 2005). What this might mean in practice—which digital technologies might make a significant difference and for whom and with what resources—is still an open and contentious question. Debates about plans for the fund at the first meeting of the World Summit on the Information Society (WSIS) in December 2003 are symptomatic of the complexity of "digital divide" issues that have also been central to the second phase of the information summit held in November 2005 in Tunisia.[1]

In this chapter, I consider the relationship of Indigenous people to new media technologies that people in these communities have started to take up—with both ambivalence and enthusiasm—over the last decade. To give a sense of that oscillation, let me start with three quotes that articulate the range of stakes. The first—a statement leaning toward the technophilic—is from Jolene Rickard (1999), a Tuscarora artist, scholar, and community leader, introducing an online project, called CyberPow-Wow,[2] that began in 1996 in order to get more Native American art on the Web:

> Wasn't it the Hopi that warned of a time when the world would be circled by a spiders web of power lines? That time has come . . . There is no doubt that First Nations Peoples are wired and ready to surf and chat. It seems like a distant memory when the tone of discussion about computers, interactivity, and aboriginal people was filled with prophetic caution. Ironically, the image of Natives is still firmly planted in the past. The idea that Indians would be on the frontier of a technology is inconsistent with the dominant image of "traditional" Indians.

The second, more skeptical, quote is from Alopi Latukefu (2006: 4), regional manager of the Outback Digital Network (www.odn.net.au/), a digitally-based broadband network that began in 1996, linking six Aboriginal communities in Australia:

So seductive is the power of the ICT medium that it might only appear to remove centralized control out of the hands of government and into the hands of the people, giving them the notion of . . . empowerment. While ongoing struggles for self-determination play a complex role in the drive to bring the information age to Indigenous communities in Australia and around the world, it can be argued that self-determination within one system may well be a further buy in to another . . . The issue that needs to be raised before any question of Indigenous usage of the Internet is addressed is: whose information infrastructure or "info-structure" determines what is valued in an economy—whether in the local community or the greater global economy which they are linked to? . . . Associated with this is the overarching issue of who determines knowledge within these remote communities and for the wider Indigenous populations throughout Australia and beyond?

The third quote is from the Indigenous Position Paper for the 2003 WSIS and the discussion of its implications in the cultural commons debates by Kimberly Christen in her essay "Gone Digital" (2005). She first quotes the position paper: "Our collective knowledge is not merely a commodity to be traded like any other in the market place. We strongly object to the notion that it constitutes a raw material or commercial resource for the knowledge-based economy of the Information Society." Commenting on that quote, Christen points out that:

like some of their corporate counterparts, international Indigenous representatives want to limit the circulation of particular ideas, knowledge and cultural materials. In fact, they "strongly reject the application of the public domain concept to any aspect related to our cultures and identities" and further "reject the application of IPR [intellectual property rights] regimes to assert patents, copyrights, or trademark monopolies for products, data or processes derived or originating from our traditional knowledge or our cultural expressions." (328)

The issues raised in these quotations echo those I have heard in my own research with Indigenous media makers, positions that are not necessarily in contradiction. Fundamentally, they ask who has the right to control knowledge and what are the consequences of the new circulatory regimes introduced by digital technologies. Rickard articulates a desire, as an Indigenous artist, to work with digital technologies in order to link Indigenous communities to each other on their own terms, objecting to stereotypes that suggest traditional communities should not have access to forms associated with modernity Latukefu cautions that one must take into account the power relations that decide whose knowledge is valued, while the statement of the Indigenous People's Working Group offers a strong warning against the commodification of their knowledge under Western systems of intellectual property.

Why are their concerns barely audible in discussions of new media? I would like to suggest that part of the problem has to do with the rise of the term *the digital age* over the last decade and the assumptions that support it. While it initially had the shock of the new, it now has become as naturalized for many of us—Western cultural workers and intellectuals—as a temporal marking of the dominance of a certain kind of technological regime ("the digital") as is "the Paleolithic's" association with certain kinds of stone tools for paleontologists. This seems even more remarkable given certain realities: only twelve per cent of the world was wired as of January 2005 (according to statistics from the 2005 World Economic Forum in Davos, Switzerland), and only sixteen of every one hundred people on the planet were serviced with telephone land lines.[3] Digerati may see those numbers and salivate at the possibilities for entrepreneurship. But for an anthropologist who has spent a good portion of her

career looking at the uptake of media in remote Indigenous communities, the unexamined ethnocentrism that undergirds assumptions about the digital age is discouraging; indeed, the seeming ubiquity of the Internet appears a facade of First World illusions. I am not suggesting that the massive shifts in communication, sociality, knowledge production, and politics that the Internet enables are simply irrelevant to remote communities; my concern is with how the language smuggles in a set of assumptions that paper over cultural differences in the way things digital may be taken up—if at all—in radically different contexts and thus serve to further insulate thinking against recognition of alterity that different kinds of media worlds present, particularly in key areas such as intellectual property.

In this chapter, I examine how concepts such as the digital age have taken on a sense of evolutionary inevitability, thus creating an increasing stratification and ethnocentrism in the distribution of certain kinds of media practices, despite prior and recent trends to de-Westernize media studies (see Curran and Park 2000). Work in new (and old) media that is being produced in Indigenous communities might expand and complicate our ideas about "the digital age" in ways that take into account other points of view in the so-called global village.

A history of digital debates

Let me first briefly review some of the recent debates around the rhetoric of the digital age—for certainly I am not alone in my concerns, though mine may be shaped in a particular way. Within the ranks of those who have been writing and worrying about "cultural production in a digital age" and its global implications, there is some contestation as to "whether it is appropriate, given unequal access to advanced technologies (let alone more basic goods)" in different parts of the world, that the term *the digital age* be used to define the current period (Klineneberg and Benzecry 2005; 10). This debate occurs in tandem with that attached to the digital divide, the phrase invented to describe the circumstances of inequality that characterize access (or lack of access) to resources, technological and otherwise, across much of the globe. Although its users want to express well-intentioned concern about such inequities, the term invokes neodevelopmentalist language that assumes that less privileged cultural enclaves with little or no access to digital resources—from the South Bronx to the global South—are simply waiting, endlessly, to catch up to the privileged West. Inevitably, the language suggests, they are simply falling farther behind the current epicenter—whether that be Silicon Valley or the MIT Media Lab.

Some exemplary cases that have made it to the *New York Times* and the *Wall Street Journal* provide charming counterpoints of hopeful possibility stories of far-flung villages "catching up" to the West. For example, in a *New York Times* article, James Brooks (2004) describes the work of Bernard Krisher, representing both MIT's Media Lab and the American Assistance for Cambodia group in O Siengle, Cambodia, a village of fewer than 800 people on the edge of the forest that is emblematic of life for the millions of Asians who live on the unwired side of the digital divide. Through the Motoman project, the village connects its new elementary school to the Internet. Since they have no electricity or phones, the system is powered by solar panels, and, as Brooks describes it:

> An Internet "Motoman" rides a red motorcycle slowly past the school [once a day]. On the passenger seat is a gray metal box with a short fat antenna. The box holds a wireless Wi-Fi chip set that allows the exchange of e-mail between the box and computers. Briefly, this schoolyard of tree stumps and a hand-cranked water well becomes an Internet hot spot [a process duplicated in five other villages]. At dusk, the motorcycles [from five villages] converge on the

provincial capital, Ban Lung, where an advanced school is equipped with a satellite dish, allowing a bulk e-mail exchange with the outside world. (n.p.)[4]

Tellingly, this story was in the business section of the *Times,* suggesting that part of its charm is the possibility of new markets, the engine that drives even such idealistic innovation in consumer technologies; computers and the internet are hardly exceptional.

This techno-imaginary universe—of digital eras and divides—has the effect, I argue, of reinscribing onto the world a kind of "allochronic chronopolitics" (to borrow a term from Johannes Fabian's *Time and the Other* [1983]), in which "the other" exists in a time not contemporary with our own. This has the effect of restratifying the world along lines of a late modernity, despite the utopian promises by the digerati of the possibilities of a twenty-first-century, McLuhanesque global village. For the last two decades, scholars have argued about (and mostly for) the transformative power of digital systems and their capacity to alter daily life, democratic politics, and personhood. That sense of a paradigm shift is perhaps most evident in Manuel Castells's *The Rise of the Network Society* (1996). The premise of his work, of course, is that the internet has more or less created a new era by providing the technological basis for the organizational form of the information age: *the network.* In *The Internet Galaxy* (2003), Castells's scale seems to have expanded from society to the cosmos. While he celebrates the Internet's capacity to liberate, he also cautions us about its ability to marginalize and exclude those who do not have access to it and suggests that we need to take responsibility for the future of this new information age.

Taking that critique a bit farther, no less a luminary than Bill Gates, founder of Microsoft and once the personification of new media evangelism, has become an outspoken critic of that attitude. Initially, he was part of the group of U.S. executives who, at the 1998 World Economic Forum in Davos, dedicated themselves to closing the digital divide. By 2000, however, in a speech at a conference titled "Creating Digital Dividends," Gates demonstrated a remarkable change of heart, offering blistering criticism of the idea of the digital divide and its capacity to blind people to the reality of the conditions of the globe's poorest people. As he put it at the time:

> O.K., you want to send computers to Africa, what about food and electricity—those computers aren't going to be that valuable. The mothers are going to walk right up to that computer and say, "My children are dying, what can you do?" They're not going to sit there and like, browse eBay or something. What they want is for their children to live. They don't want their children's growth to be stunted. Do you really have to put in computers to figure that out?
>
> (quoted in Verhovic 2000)[5]

His clear disdain for the notion that the world's poorest people constitute a significant market for high-tech products has had an impact. The priorities of the $21-billion Bill and Melinda Gates Foundation are with health care, in particular the development and distribution of vaccines. At the January 2005 World Economic Forum, while technology guru Nicholas Negroponte was marketing a mock-up of a one-hundred-dollar laptop computer, hoping to capture China's 220 million students as possible consumers of digital technology, Gates was reported to be "in the thick of plenary discussions . . . considering ways of eliminating poverty and disease that do not encompass information technology . . . 'I think it's fascinating,' " Gates commented, "that there was no plenary session at Davos this year on how information technology is changing the world" (quoted in Markoff 2005).[6]

The Internet, of course, has been met with some optimism by those sharing concerns of broader access for freedom of expression and social movements. Manuel Castells in *The Power*

of Identity (1997) noted the range of dissident social actors, such as the Zapatistas in Mexico. Today we would add to that list an array of groups from the grassroots leftist political sentiments organized by moveon.org to right-wing Christians and militant Islamists to the Falun Gong in China. These and scores of other groups have used the Internet to shape what some call "the network logic" of anti-[corporate]-globalization movements and smart mobs, as well as its uptake by loosely linked Islamic terrorists. Additionally, a number of researchers have noted how the Internet has in many cases reduced the "price of entry" into a cultural field, creating openings for actors and organizations who were previously unable to get their work into the public, as the inclusion and insidious impact of bloggers during the 2004 U.S. presidential campaigns makes clear (Massing 2005). Clearly then, digital networks can enable the global dispersion of creative and political activity

In the cover story for its March 12–18, 2005 issue, no less an advocate of free enterprise than the *Economist* features a rethinking of the term (and terms of) "the real digital divide," along with a compelling photo of a young African boy holding an ersatz cell phone made of mud to his ear. Its lead opinion piece states that "the debate over the digital divide is founded on a myth—that plugging poor countries into the Internet will help them to become rich rapidly . . . So even if it were possible to wave a magic wand and cause a computer to appear in every household on earth, it would not achieve very much: a computer is not useful if you have no food or electricity and cannot read" (*Economist* 2005).

Ideas about what "the digital age" might offer look different from the perspective of people struggling to manage to make ends meet on a daily basis. As the *Economist* notes, research suggests that radio and cell phones may be the forms of digital technology that make the difference, once basic needs are addressed (Norris, Bennett, and Entinan 2001). My concern here, however, is to ask whether terms like *the digital divide* too easily foreclose discussion about what the stakes are for those who are out of power. Rather than imagining that we know the answers, clearly, we need to keep listening to the large percentage of the earth's population that is on the unwired side of the so-called digital divide.

Going digital: Indigenous internet "on the ground"

So what does "the digital age" feel and look like in Indigenous communities in remote regions of the world where access to telephone land lines can still be difficult? As Kyra Landzelius asks in her collection, *Native on the Net* (2006: 1): "Can the info-superhighway be a fast track to greater empowerment for the historically disenfranchised? Or do they risk becoming 'roadkill': casualties of hyper-media and the drive to electronically map everything?" Recent developments give some insight into what it might actually mean for Indigenous subjects. As Harald Prins (2001: 306) has argued regarding the place of Indigenous people in "Cyberia:"

> although indigenous peoples are proportionally underrepresented in cyberspace—for obvious reasons such as economic poverty, technological inexperience, linguistic isolation, political repression, and/or cultural resistance—the Internet has vastly extended traditional networks of information and communication. Greatly enhancing the visibility of otherwise marginal communities and individuals, the information superhighway enables even very small and isolated communities to expand their sphere of influence and mobilize political support in their struggles for cultural survival. In addition to maintaining contact with their own communities, indigenous peoples also use the Internet to connect with other such widely dispersed groups in the world. Today it is not unusual for a Mi'kmaq in Newfoundland to go on the Internet and communicate with

individuals belonging to other remote groups such as the Maori in New Zealand, Saami in Norway, Kuna in Panama, or Navajo in Arizona. Together with the rest of us, they have pioneered across the new cultural frontier and are now surfing daily through Cyberia.

Clearly Prins points to the circumstances in which use of the Internet—and more broadly the cross-platformed use of digital technologies—is being taken up in Indigenous communities on their own terms, furthering the development of political networks and the capacity to extend their traditional cultural worlds into new domains. It is that latter enterprise that I address in the following examples.

Recent initiatives demonstrate what some of these possibilities look like in three very different parts of the world: Inuit regions of Nunavut through the work of Igloolik Isuma; the work of Arrernte living in town camps in Alice Springs, Australia, creating an innovative interactive project called "UsMob;" and a digital animation project by Canadian-based Northwest Coast Aboriginal artists and storytellers who have created an animated version of the Raven tales. All are exemplary of community-based groups collaborating with a number of agencies to indigenize the use of digital technologies in the interests of storytelling as a way to generate broader understandings of their histories and cultures, for wider audiences but, most important, for their own cultural futures.[7]

Igloolik Isuma and Sila. nu

During the 1970s, as satellite-based television made its way into the Canadian Arctic, Inuit people began exploring the possibilities that these combinations of media forms offered for local productions that could be distributed over the vast expanses of Canada's north. Zacharias Kunuk, a young Inuit man, had the vision to turn these technologies into vehicles for cultural expression of Inuit lives and histories, forming a media production group called *Igloolik Isuma* (see www.isuma.ca). Kunuk worked with friends and family members, creating a remarkable team of nonprofessional actors who recreated the stories of the transformation of their lives over the last century, starting with works such as *Qaggig* in 1988 and quickly moving on to create the remarkable television series *Nunavut*, which is also the name of the recently formed Inuit-controlled territory where Kunuk's home settlement is located. The series *Nunavut* was not only a staple of TV Northern Canada (the pan-Arctic satellite station that preceded the first national Indigenous cable television station, Aboriginal Peoples Television Network [APTN]), but it also screened at the Museum of Modern Art in New York and the Pompidou Center in Paris.

Fast forward to 2001 and the premiere at the Cannes Film Festival of Kunuk's first feature, the epic recreation of a well-known Inuit legend, *Atanarjuat: The Fast Runner* (see www.atanarjuat.com); there, this first film ever made by an Inuit director in the Inuktitut language received the coveted Caméra d'Or for best first feature and went on to stunning critical and theatrical success, picking up many more awards along the way. In 2005, Kunuk and his crew shot their second feature, a Danish coproduction titled *The Journals of Knud Rasmussen,* based on the writings of the famous Inuit-Danish explorer who traveled throughout the Arctic in the 1920s exploring the transformations of Inuit life that were occurring in the early twentieth century, when Inuit shamans first encountered Christian missionaries. The journals provide the storyline for a film that provides an Inuit perspective on that fateful historical encounter.

Never content to think conventionally, Kunuk and company established an incredible Web site from the film's production location (www.sila.nu/live) that allowed us to follow

what was happening on the set on a daily basis while also sending us back to Rasmussen's journals and the key characters he met in his journeys through the Arctic.[8] Daily blogs by an "embedded" journalist and (of course) their own anthropologist provided different perspectives, while QuickTime movies showed us how multiple languages (English, French, Inuktitut, Danish) were negotiated, as well as how props and food were managed in this remote Arctic locale. Pop-ups offered a linked glossary for foreign or more arcane words. Background bios on key personnel—on and off screen—illuminated the community-based approach to filmmaking that Kunuk and his partner Norman Cohn have perfected. (My personal favorite was the interview with the lead sled dog, Tooguyuk, who "described" the trials of learning commands in both "Greenlandic" and "Igloolik" and talked about looking forward to his "girlfriend having puppies so I'm excited to be a daddy.") Inuit Web site producer Katarina Soukup explained the project and its origins:

> Isuma has wanted for a long, long time to use the Internet to connect the remote Arctic with people around the world, a way to bring people to Igloolik without the extreme expense and inconvenience of traveling here, as well as to allow Inuit to remain in their communities and out on the land without losing touch with the 21st century One dream is a nomadic media lab/TV station out on the land connected to the Internet. It just has not been technically possible until now, thanks to a high-speed data satellite phone and wireless broadband in Nunavut, making remote, nomadic computing much less expensive. The goals with the educational website are to connect people to Inuit culture through the Internet and our films. We have been creating materials for the educational market for about 2 or 3 years (e.g., the Isuma Inuit Culture Kit), and the site is another step in this direction. The project employs an innovative technical infrastructure to deliver to the world priceless Inuit cultural content, such as interactive e-learning activities, video-on-demand, customizable teacher resources, and Inuktitut language lessons. It is a platform for North-South communication and collaboration. In addition to educating the public about Inuit culture, another goal of the site is to develop a youth and educational market for our films.
>
> (quoted in Ginsburg 2005)

The site was beautifully designed in every sense. The project had two teams, one in the Arctic at Igloolik and another in Montreal. In Igloolik, the team was made up of about nine members: three videographers, one audio reporter, one photographer, and three writers who did the daily blogs, as well as eight youth trainees from the community who were learning about media production. The Sila Web site presented a remarkable demonstration of how this technology might be successfully "indigenized" to help Inuit school kids, college students in New York, Maori colleagues in New Zealand, and many others, learn about their filmmaking, the Arctic, Indigenous lives, missionization, and new ways of "understanding media" (McLuhan 1994 [1964]) and its possibilities in the twenty-first century.

Us Mob: Central Australia

A recent digitally based project has been developed by activist lawyer and documentary maker David Vadiveloo in collaboration with Arrernte Aboriginal youth living in Hidden Valley, a town camp outside of Alice Springs in central Australia. Us Mob is Australia's first Aboriginal children's television series and interactive Web site. On the site, users interact with the challenges and daily lives of kids from the camp—Harry, Della, Charlie, and

Jacquita—following multipath storylines, activating video and text diaries, forums, movies, and games that offer a virtual experience of the camp and surrounding deserts, and uploading their own video stories. The site, in English and Arrernte with English subtitles, "was launched at the Adelaide Film Festival on February 25, 2005, and simultaneously on Australian Broadcasting Corporation (ABC) TV and ABC online (see Figs. 43.1–43.3; for Web site see www.usmob.com.au).

The project had its origins in requests from traditional elders in the Arrernte community in central Australia to David Vadiveloo, who first worked with that community as their lawyer in their 1996 historic Native Title claim victory. Switching gears since then to media activism, Vadiveloo has made six documentaries with people in the area, including the award-winning *Trespass* (2002), *Beyond Sorry* (2003), and *Bush Bikes* (2001). Us Mob is the first Indigenous project to receive production funding under a new initiative from the Australian Film Commission and ABC New Media and Digital Services Broadband Production Initiative (BPI); it received additional support from the Adelaide Film Festival, Telstra, and the South Australian Film Corporation.

The Us Mob project was motivated by Vadiveloo's concern to use media to develop cross-cultural lines of communication for kids in the camps. As he put it: "After ten years of listening to many Arrernte families in Town Camps and remote areas, I am trying to create a dynamic communication bridge that has been opened by the Arrernte kids of Alice Springs with an invitation extended to kids worldwide to play, to share, and to engage with story themes that are common to all young people but are delivered through Us Mob in a truly unique cultural and physical landscape" (quoted in Ginsburg 2005). In keeping with community wishes, Vadiveloo needed to create a project that was not fictional. Elders were clear: they did not want community members referred to as "actors"—they were community participants in stories that reflected real life and real voices that they wanted heard. To

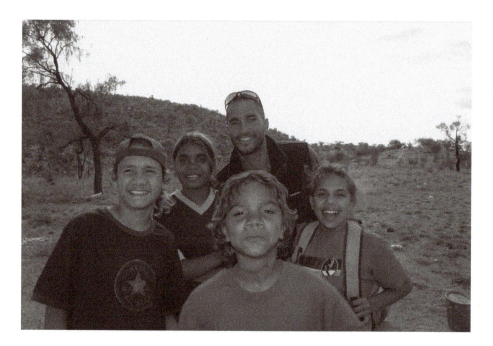

Figure 43.1 *Us Mob*'s young lead cast members (L to R) Selwyn Anderson, Cassandra Williams, Ishmael Palmer and Letitia Bartlett, with director David Vadiveloo. Photo courtesy of Us Mob Pty Ltd.

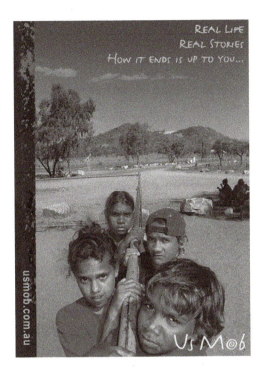

Figure 43.2 *Us Mob* promotional postcard featuring young lead cast members (L to R) Letitia Bartlett, Cassandra Williams, Selwyn Anderson and Ishmael Palmer. Photo courtesy of Us Mob Pty Ltd.

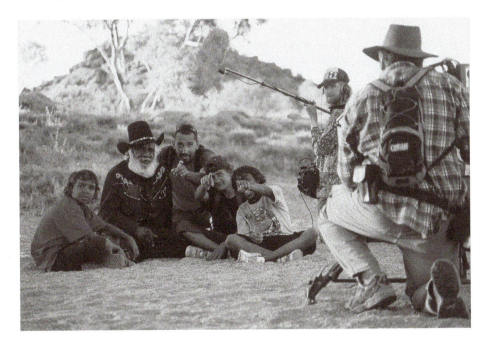

Figure 43.3 Senior Arrernte Elder, Max Stuart, flanked (L to R) by *Us Mob* cast member Ishmael Palmer, director David Vadiveloo, cast members Selwyn Anderson, Gibson Turner, sound recordist Will Sheridan and Arrernte cinematographer Allan Collins (with back to camera). Photo courtesy of Us Mob Pty Ltd.

accomplish that, Vadiveloo held workshops to develop scripts with more than seventy nonactor Town Camp residents, who were paid for their participation. The topics they raised range from Aboriginal traditional law, ceremony, and hunting to youth substance abuse and other Aboriginal health issues. Building bush bikes is the focus of one of the two Us Mob games, while the second one requires learning bush skills as players figure out how to survive in the outback.

Establishing a sense of partnership has been essential to the project. According to Vadiveloo, "The creative, executive and editorial role taken by the community at every stage was paramount to the production process. Respecting protocols and ensuring community ownership and profit-share meant the relationship between community and screen producers was always a partnership" (personal communication, February 11, 2007). The producer, Heather Croall, and the interactive producer, Chris Joyner, were integral partners for Vadiveloo. Apart from raising finance, they wrote the project together with Vadiveloo; then final scripts were written by the Indigenous screenwriter Danielle McLean. Camera work was by Allan Collins, the Indigenous, award-winning cinematographer and Alice Springs resident. Every stage of the project was supervised and approved by traditional owners and the peak Indigenous organization, Tangentyere Council, which has a profit-share agreement with the producers, on behalf of the community.

With this project Vadiveloo hoped to create a television series about and by Aboriginal youth, raising issues relevant to them, as well as an online program that could engage these young people to spend time online acquiring some of the skills necessary to be computer literate. He was particularly concerned to develop an alternative to the glut of single-shooter games online and the constant diet of violence, competition, and destruction that characterize the games they were exposed to in town. "When kids play and build together," Vadiveloo explains, "they are learning about community and consequence and that is what I wanted to see in the project" (quoted in Ginsburg 2005). And rather than assuming that the goal is for Aboriginal children in central Australia to catch up with the other side of the digital divide, based on someone else's terms, he wanted to help build a project that dignified their cultural concerns. This is charmingly but emphatically clear in the first encounter with the Us Mob home page (see www.usmob.com.au), which invites you in but notifies you that you need a permit to visit:

> Everyone who wants to play with us on the full Us Mob website will need a permit. It's the same as if you came to Alice Springs and wanted to visit me and my family, you'd have to get a permit to come onto the Town Camp. Once you have a permit you will be able to visit us at any time to chat, play games, learn about Aboriginal life and share stories. We love going out bush and we're really looking forward to showing you what it's like in Central Australia. We'll email you whenever we add a new story to the website. We really hope you can add your stories to the website cos we'd love to learn about your life too.

Us Mob and Hidden Valley suggest another perspective on the digital age, one that invites kids from "elsewhere" to come over and play on their side.

Raven Tales: Northwest Coast

Raven Tales: How Raven Stole the Sun (2004) is the first of a series of experiments in digital animation by Simon James (Kwak*waka'* wakw) and Chris Kientz (Cherokee) that create new

versions of centuries-old stories to be shown across Canada on APTN. This work reworks famous Northwest Coast myths from the Kwak*waka'* wakw, Squamish, and Haida peoples— in particular Raven, a trickster figure, along with Eagle, Frog, and the first humans. It includes voices ranging from those of well-known Native actors such as Evan Adams of *Smoke Signals* (Chris Eyre, 1998) fame to that of Hereditary Chief Robert Joseph. Cutting across centuries and generations, it uses the playful spirit of animation to visualize and extend the lives of these myths. These stories and the distinctive look of Northwest Coast design have been proven, as James, the series producer, joked during the question and answer session at the New York premiere of this work in the fall of 2004, by "10,000 years of local market research" (quoted in Ginsburg 2005).

Spicing up these stark and complex traditional stories with some contemporary humor and the wonders of digital animation is always a risk. But clearly it was a risk worth taking, when the murky darkness of the Myth Time is suddenly (and digitally) transformed from barren smoky grays to brilliant greens, the result of Raven's theft of the gift of light and its release into the world.[9]

At the New York premiere, James's father, a Kwak*waka'* wakw artist and elder, came on stage with his drum, embellished with the distinctive raven design. Inviting other Native media makers who were present to join him on stage, he sang "Wiping the Tears" to remember those who have come before and are gone and to praise the work of this new generation. When Pam Belgarde, a Chippewa woman who had produced another work shown in the session, came up, he dressed her in the traditional black and red regalia, a stunning full-length button cape with appliqués of wild roses, and a regal fur hat. As he draped the cape across her shoulders, he explained: "When we meet someone we are honored to meet, we dress them to show that we are willing to go cold in order to keep our guests warm." Simon began to beat the drum and asked us to look at the empty seats in the theater and think of those who came before; the media producers on stage lowered their eyes. At the conclusion of his song, he addressed the audience and said, "All our ceremonies need witnesses. And as witnesses, we ask you to be part of that tradition, and go and share with others what you have seen today."

In each of these cases, digital technologies have been taken up because of the possibilities they offer to bring younger generations into new forms of Indigenous cultural production and to extend Indigenous cultural worlds—on their own terms—into the lives of others in the broader national communities and beyond who can serve, in the way that Simon James expressed, as virtual witnesses to their traditions, histories, and daily dilemmas.

Conclusion

To return to the concern that motivated this chapter, I want to underscore the way that the term *the digital age* stratifies media hierarchies for those who are out of power and are struggling to become producers of media representations of their lives. It is an issue that is particularly salient for Indigenous people who, until recently, have been the object of other peoples' image-making practices in ways damaging to their lives. They do not experience these practices in the same way as other minorities: questions of the digital age look different to people struggling to control land and traditions appropriated by now dominant settler societies for as long as five hundred years.

To underscore what their work is about, I use the term *cultural activist to* describe the self-conscious way in which they—like many other people—use the production of media and other expressive forms not only to sustain and build their communities but also to transform them through what one might call a "strategic traditionalism" (to borrow from Bennett and

Blundell 1995). This position is crucial to their work but is effaced from much contemporary cultural theory addressing new media that emphasizes dislocation and globalization. The cultural activists creating these new kinds of cultural forms have turned to them as a means of revivifying relationships to their lands, local languages, traditions, and histories, and of articulating community concerns. They also see media as a means of furthering social and political transformation by inserting their own stories into national narratives as part of ongoing struggles for Aboriginal recognition and self-determination.

Increasingly the circulation of these media globally—through conferences, festivals, coproductions, and the use of the Internet—has become an important basis for a nascent but growing transnational network of Indigenous media makers and activists. These activists are attempting to reverse processes through which aspects of their societies have been objectified, commodified, and appropriated; their media productions and writings are efforts to recover their histories, land rights, and knowledge bases as their own cultural property. These kinds of cultural productions are consistent with how the meaning and praxis of culture in late modernity has become increasingly self-conscious of its own project, an effort to use imagery of Indigenous lives to create an activist imaginary. One might think of media practices as a kind of shield against the often unethical use or absolute erasure of their presence in the ever increasing circulation of images of other cultures in general, and of Indigenous lives in particular, as the Indigenous position paper for the WSIS makes clear. At every level, Indigenous media practices have helped to create and contest social, visual, narrative, and political spaces for local communities and in the creation of national and other kinds of dominant cultural imaginaries that, until recently, have excluded vital representations by First Nations peoples within their borders. The capacity of such representations to circulate to other communities—from Indigenous neighbors to NGOs—is an extension of this process, across a number of forms of mediation, from video and film to cyberspace (Danaja and Garde 1997).

Indigenous digital media have raised important questions about the politics and circulation of knowledge at a number of levels; within communities this may be about who has had access to and understanding of media technologies, and who has the rights to know, tell, and circulate certain stories and images. Within nation-states, media are linked to larger battles over cultural citizenship, racism, sovereignty, and land rights, as well as struggles over funding, airspace and satellites, networks of broadcasting and distribution, and digital broadband that may or may not be available to Indigenous work. The impact of these fluctuations can be tracked in a variety of places—in fieldwork, in policy documents, and in the dramas of everyday life in cultural institutions.

I explore the term *the digital age* because it so powerfully shapes frameworks for understanding globalization, media, and culture, creating the "common sense" discourse for institutions in ways that disregard the cultural significance of the production of knowledge in minoritized communities, increasing an already existing sense of marginalization. Rather than mirroring the widespread concern with increasing corporate control over media production and distribution, and the often parallel panic over multiculturalism (Appiah 1997), can we illuminate and support other possibilities emerging out of locally based concerns and speak for their significance in contemporary cultural and policy arenas? Institutional structures are built on discursive frameworks that shape the way phenomena are understood, naturalizing shifts in support for a range of cultural activities. In government, foundations, and academic institutions, these frameworks have an enormous impact on policy and funding decisions that, for better or worse, can have a decisive effect on practice.

Other scholars who recognize, more generally, the significance of locally situated cultural practices in relation to dominant models point instead to the importance of the productions/producers who are helping (among other things) to generate their own links to

other Indigenous communities through which local practices are strengthened and linked. For example, Rob Wilson and Wimal Dissanayake (1996: 14) point to such processes as part of "an aesthetic of rearguard resistance, rearticulated borders as sources, genres, and enclaves of cultural preservation and community identity to be set against global technologies of modernization or image-cultures of the postmodern." Indeed, simultaneous to the growing corporate control of media, Indigenous producers and cultural activists are creating innovative work, not only in the substance and form of their productions, but also in the social relations they are creating through this practice, that can change the ways we understand media and its relationship to the circulation of culture more generally in the twenty-first century.

Such efforts are evidence of how Indigenous media created over the last decade is situated at the conjuncture of a number of historical developments: these include the circuits opened by new media technologies, ranging from satellites to compressed video and cyberspace, as well as the ongoing legacies of Indigenous activism worldwide, most recently by a generation comfortable with media and concerned with making their own representations as a mode of cultural creativity and social action. They also represent the complex and differing ways that states have responded to these developments—the opportunities of media and the pressures of activism—and entered into new relationships with the indigenous nations that they encompass.

I conclude on a note of cautious optimism. The evidence of the growth and creativity of indigenous digital media over the past two decades, whatever problems may have accompanied it, is nothing short of remarkable. Formations such as these, working out of grounded communities or broader regional or national bases, offer an important elaboration of what the digital age might look like, intervening in the "left behind" narrative that predominates.

Indigenous media offer an alternative model of grounded and increasingly global interconnectedness created by Indigenous people about their own lives and cultures. As we all struggle to comprehend the remapping of social space that is occurring, Indigenous media offer some other coordinates for understanding what such an interconnected world might be like outside a hegemonic order. Terms such as *the digital age* gloss over such phenomena in their own right or as examples of alternative modernities, resources of hope, new dynamics in social movements, or as part of the trajectory of Indigenous life in the twenty-first century. Perhaps it is time to invent new language.

Notes

1 For information on the 2005 WSIS, see www.itu.int/wsis/index-pl.html.

2 As the site's founders explain at www.cyberpowwow.net/about.html, "The CyberPowWow project, conceived in 1996, is part Web site and part palace—a series of interconnected, graphical chat rooms which allow visitors to interact with one another in real time. Together, the Web site and palace form a virtual gallery with digital (and digitized) artworks and a library of texts."

3 For discussion of these statistics at the 2005 World Economic Forum, see www.weforum.org/site/knowledgenavigator.nsf/Content/New+Technologies. For an excellent discussion of the complexity of accounting for telephone statistics, see Shirky 2002.

4 The system, developed by First Mile Solutions, based in Boston, uses a receiver box powered by the motorcycle's battery. The driver need only roll slowly past the school to download all the village's outgoing e-mail and deliver incoming e-mail. Newly collected information is stored for the day in a computer strapped to the back of the motorcycle.

5 Thanks to Leo Hsu for passing this reference on to me.

6 Thanks to B. Ruby Rich for this reference.

7 For other examples, see Landzelius 2006; Prins 2002a; and Christen 2005.

8 See sila.nu/swf/journal and www.sila.nu/live. The Web site is financially supported by Telefilm Canada's New Media Fund, Government of Nunavut (Department of Sustainable Development),

Nunavut Community Economic Development, Heritage Canada (Canadian Studies Program), National Research Council (Industrial Research Assistance Program). The Nunavut Independent Television Network (NITV) is a collaborating partner, along with sponsorships from Ardicom Digital Communications, ssi Micro, and Stratos Global Corporation.

9 *Raven Tales* premiered in Los Angeles in 2005 at the National Geographic's All Roads Film Festival (www.riationalgeographic.com/allroads), which gave the project completion funds, the only digital animation in that project. The first six episodes aired on Canada's Aboriginal People's Television Network in 2006; the next seven starting in November of 2007. The final thirteen episodes will broadcast in November of 2008; overall, the twenty-six episodes include stories from tribal communities from across North America (Chris Kientz, personal communication, October 2007).

References

Appiah, A. (1997) "The Multiculturalist Misunderstanding," *New York Review of Books*, (October).

Bennett, T. and V. Blundell (1995) "First Peoples," *Cultural Studies* 9: 1–24.

Brooks, James (2004) "Digital Pony Express," *New York Times* (January 27).

Castells (1996) *The Rise of the Network Society* (Oxford: Blackwell).

Castells (1997) *Power of Identity* (Oxford: Blackwell).

Castells (2003) *Internet Galaxy* (Oxford: Oxford University Press).

Christen, Kim (2005) "Gone Digital," *International Journal of Cultural Property* 12.

Curran, J. and J.-M. Park, *De-Westernizing Media Studies* (New York: Routledge, 2000).

Danaja, P. and M. Garde (1997) "From a distance," *1997 Fulbright Symposium*.

Digital Solidarity Fund Foundation (2005). See http://www.dsf-fsn.org/en/02-en/htm.

Ginsburg, F. (2005), in *Flow: a critical forum on television and film* at jot.communication.utexas.edu/flow.

Kientz, Chris (2007) personal communication, October.

Klineneberg, E. and C. Benzecry (2005) "Introduction: Cultural Production in a Digital Age," *Annals of the American Academy of Political and Social Science*, 597 (1).

Landzelius, K.M. (2006) *Native on the Net* (London: Routledge).

Latukefu, Alopi (2006) "Remote Indigenous communities in Australia," in K. Landzelius (ed.) *Going Native on the Net* (London: Routledge).

Markoff, J. (2005) "Technology at Davos," *New York Times* (January 31).

Massing, M. (2005) "The end of news?," *New York Review of Books* (December 25).

Norris, P., W.L. Bennett and R. Entinan (2001) *Digital Divide* (Cambridge: Cambridge University Press).

Prins, Harald (2001) "Digital Revolution," in W. Haviland (ed.), *Cultural Anthropology*, 10th ed. (Forth Worth, TX: Harcourt College).

Prins (2002) "Visual Media and the Primitivist Perplex," in F. Ginsburg (ed.), *Media Worlds* (Berkeley: University of California Press).

Rickard, Jolene (1999). *CyberPowWow* at http://wwww.cyberpowwow.net/nation2nation/jolenework.html.

Shirky, Clay (2002) "Sorry Wrong Number," WIRED (October 10).

"Technology and Development" (2005) editorial, *Economist* (December 12).

Wilson, Rob and Wimal Dissanayake (1996) *Global/Local: Cultural Production and the Transnational Imaginary* (Durham, NC: Duke University Press).

Alexander R. Galloway

THE UNWORKABLE INTERFACE*

Interface as method

INTERFACES ARE BACK, OR PERHAPS they never left. The familiar
Socratic conceit, from the *Phaedrus*, of communication as the process of writing directly on
the soul of the other has, since the 1980s and 1990s, returned to center stage in the discourse
around culture and media. The catoptrics of the society of the spectacle is now the dioptrics
of the society of control. Reflective surfaces have been overthrown by transparent thresh-
olds. The metal detector arch, or the graphics frustum, or the Unix socket—these are the
new emblems of the age.

Windows, doors, airport gates, and other thresholds are those transparent devices that
achieve more the less they do: for every moment of virtuosic immersion and connectivity,
for every moment of volumetric delivery, of inopacity, the threshold becomes one notch
more invisible, one notch more inoperable. As technology, the more a dioptric device erases
the traces of its own functioning (in actually delivering the thing represented beyond), the
more it succeeds in its functional mandate; yet this very achievement undercuts the ultimate
goal: the more intuitive a device becomes, the more it risks falling out of media altogether,
becoming as naturalized as air or as common as dirt. To succeed, then, is at best self-
deception and at worst self-annihilation. One must work hard to cast the glow of unwork.
Operability engenders inoperability.

Curiously this is not a chronological, spatial, or even semiotic relation. It is primarily a
systemic relation, as Michel Serres rightly observed in his meditation on functional "along-
sidedness:" "Systems work because they don't work. Non-functionality remains essential for
functionality. This can be formalized: pretend there are two stations exchanging messages
through a channel. If the exchange succeeds—if it is perfect, optimal, immediate—then the
relation erases itself. But if the relation remains there, if it exists, it's because the exchange
has failed. It is nothing but mediation. The relation is a non-relation."[1] Thus since Plato, we
have been wrestling with the grand choice: (1) mediation as the process of imminent if not
immediate realization of the other (and thus at the same time the self), or (2) as Serres'
dialectal position suggests, mediation as the irreducible disintegration of self and other into
contradiction.[2] Representation is either clear or complicated, either inherent or extrinsic,

either beautiful or deceptive, either already known or imminently interpretable. In short, either Iris or Hermes.

Without wishing to upend this neat and tidy formulation, it is still useful to focus on the contemporary moment to see if something slightly different is going on, or, at the very least to "prove" the seemingly already known through close analysis of some actual cultural artifacts.

First though, I would like to insinuate a brief prefatory announcement on methodology. To the extent that the present project is allegorical in nature, it might be useful to, as it were, subtend the process of allegorical reading in the age of ludic capitalism with some elaboration as to how or why it might be possible to perform such a reading in the first place. In former times, it was generally passable to appeal to some legitimizing methodological foundation— usually Marx or Freud or some combination thereof—in order to prove the efficacy, and indeed the political potency, of one's critical maneuverings. This is not to suggest that those sources are no longer viable, quite the opposite, since power typically grows with claims of obsolescence; even today Marx's death drive persists under the pseudonyms of Antonio Negri, Paolo Virno, or McKenzie Wark, just as a generation ago it persisted under Jean-Joseph Goux or Guy Debord. Yet somehow today the unfashionable sheen, and indeed perceived illegitimacy, of the critical tradition inherited from the middle of the nineteenth century and the beginning of the twentieth, with Marx and Freud standing as two key figures in this tradition but certainly not encompassing all of it, makes it difficult to rally around the red flag of desire in the same way as before. Today the form of Marxism in common circulation is still the antiseptic one invented a generation ago by Louis Althusser: Marx may be dissected with rubber gloves, the rational kernel of his thought cut out and extruded into some form of scientific discourse of analysis—call it critique or what have you. On the other front, to mention psychoanalysis these days generally earns a smirk if not a condescending giggle, a wholesale transformation from the first half of the twentieth century in which

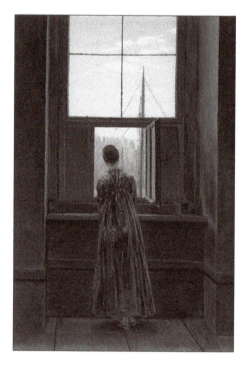

Figure 44.1 Caspar David Friedrich, "Woman at a Window," 1822. Alte Nationalgalerie, Berlin.

Freudianisms of various shapes and sizes saturated the popular imagination. Realizing this, many have turned elsewhere for methodological inspiration.

Nevertheless, Marx and Freud still allow us the ability to do two important things: (1) provide an account of the so-called depth model of interpretation; (2) provide an account of how and why something appears in the form of its opposite. In our times, so distressed on all sides by the arrival of neoliberal economism, these two things together still constitute the core act of critique. So for the moment Marx and Freud remain useful, if not absolutely elemental, despite a certain amount of antiseptic neutering.

But times have changed, have they not? The social and economic conditions today are different from what they were one hundred or one hundred and fifty years ago. Writers from Manuel Castells to Alan Liu to Luc Boltanski have described a new socioeconomic landscape, one in which flexibility, play, creativity, and immaterial labor—call it ludic capitalism—have taken over from the old concepts of discipline, hierarchy, bureaucracy, and muscle. In particular, two historical trends stand out as essential in this new play economy. The first is a return to romanticism, from which today's concept of play receives an eternal endowment. Friedrich Schiller's *On the Aesthetic Education of Man* (1795) is emblematic in this regard. In it, the philosopher uses dialectical logic to arrive at the concept of the play-drive, the object of which is man's "living form." This notion of play is one of abundance and creation, of pure unsullied authenticity, of a childlike, tinkering vitality perennially springing forth from the core of that which is most human. More recently, one hears this same refrain in Johan Huizinga's book on play *Homo Ludens* (which has been cited widely across the political spectrum, from French Situationists to social conservatives), or even in the work of the poststructuralists, often so hostile to other seemingly "uninterrogated" concepts.[3]

The second element is that of cybernetics, a synthesis across several scientific disciplines (game theory, ecology, systems theory, information theory, behaviorism) that, while in development during and before World War II, seemed to gel rapidly in 1947 or 1948, soon becoming a new dominant. With cybernetics, the notion of play adopts a special interest in homeostasis and systemic interaction. The world's entities are no longer contained and contextless but are forever operating within ecosystems of interplay and correspondence. This is a notion of play centered on economic flows and balances, multilateral associations between things, a resolution of complex systemic relationships via mutual experimenting, mutual compromise, mutual engagement. Thus, nowadays, one "plays around" with a problem in order to find a workable solution. (Recall the dramatic difference in language between this and Descartes's "On Method" or other key works of modern, positivistic rationality.)

Today's play is a synthesis of these two influences: romanticism and systems theory. If the emblematic profession for the former is poetry, the latter is design. The one is expressive, consummated in an instant; the other is iterative, extending in all directions. The two became inextricably fused during the second half of the twentieth century, subsumed within the contemporary concept of play. Thus what Debord called the "juridico-geometric" nature of games is not entirely complete.[4] He understood the ingredient of systemic interaction well enough, but he understand the romantic ingredient. Today's play might better be described as a sort of "juridico-geometric sublime." Witness the Web itself, which exhibits all three elements: the universal laws of protocological exchange, sprawling across complex topologies of aggregation and dissemination, and resulting in the awesome forces of "emergent" vitality. This is what romantico-cybernetic play means. Today's ludic capitalist is therefore the consummate poet-designer, forever coaxing new value out of raw, systemic interactions (consider the example of Google). And all the rest has changed to follow the same rubric: labor itself is now play, just as play becomes more and more laborious; or consider the model of the market, in which the invisible hand of play intervenes to assess and resolve all contradiction, and is thought to model all phenomena, from energy futures markets, to the "market"

of representational democracy, to haggling over pollution credits, to auctions of the electro-magnetic spectrum, to all manner of supercharged speculation in the art world. Play is the thing that overcomes systemic contradiction but always via recourse to that special, ineffable thing that makes us most human. It is, as it were, *a melodrama of the rhizome*.

Following these types of periodization arguments, some point out that as history changes so too must change the act of reading. Thus, the argument goes, as neoliberal economism leverages the ludic flexibility of networks, so too must the critic resort to new methodologies of scanning, playing, sampling, parsing, and recombining. The critic might then be better off as a sort of remix artist, a disc jockey of the mind.

Maybe so. But while the forces of ludic distraction are many, they coalesce around one clarion call: be more like us. To follow such a call and label it nature serves merely to reify what is fundamentally a historical relation. The new ludic economy is in fact a call for violent renovation of the social fabric from top to bottom using the most nefarious techniques available. That today it comes under the name of Google or Monsanto is a mere footnote.

So let me be the first to admit that the present methodology is not particularly rhizomatic or playful in spirit, for the spirit of play and rhizomatic revolution have been deflated in recent years. It is instead that of a material and semiotic "close reading," aspiring not to reenact the historical relation (the new economy) but to identify the relation itself as historical. What I hope this produces is a perspective on what form cultural production and the sociohistorical situation take as they are merged together. Or if that is too much jargon: what form art and politics take. If this will pass as an adequate syncretism of Freud and Marx, with a few necessary detours nevertheless back to Gilles Deleuze and elsewhere, then so be it.

Yet the ultimate task in this essay is not simply to illustrate the present cocktail of methodological influences necessary to analyze today's ludic interfaces, for that is putting the cart before the horse. The ultimate task is to reveal that this methodological cocktail is itself an interface. Or more precisely, it is to show that the interface itself, as a "control allegory," indicates the way toward a specific methodological stance. The interface asks a question and, in so doing, suggests an answer.

Two interfaces

Begin first with the received wisdom on interfaces. Screens of all shapes and sizes tend to come to mind: computer screens, ATM kiosks, phone keypads, and so on. This is what Vilém Flusser called simply a "significant surface," meaning a two-dimensional plane with meaning embedded in it or delivered through it. There is even a particular vernacular adopted to describe or evaluate such significant surfaces. We say "they are user-friendly," or "they are not user-friendly." "They are intuitive" or "they are not intuitive."

But at the same time it is also quite common to understand interfaces less as a surface but as a doorway or window. This is the language of thresholds and transitions already evoked at the outset. Following this position, an interface is not something that appears before you but rather is a gateway that opens up and allows passage to some place beyond. Larger twentieth-century trends around information science, systems theory, and cybernetics add more to the story. The notion of the interface becomes very important for example in the science of cybernetics, for it is the place where flesh meets metal or, in the case of systems theory, the interface is the place where information moves from one entity to another, from one node to another within the system.

The doorway/window/threshold definition is so prevalent today that interfaces are often taken to be synonymous with media themselves. But what would it mean to say that "interface" and "media" are two names for the same thing? The answer is found in the *layer*

model, wherein media are essentially nothing but formal containers housing other pieces of media. This is a claim most clearly elaborated on the opening pages of Marshall McLuhan's *Understanding Media*. McLuhan liked to articulate this claim in terms of media history: a new medium is invented, and as such its role is as a container for a previous media format. So, film is invented at the tail end of the nineteenth century as a container for photography, music, and various theatrical formats like vaudeville. What is video but a container for film. What is the Web but a container for text, image, video clips, and so on. Like the layers of an onion, one format encircles another, and it is media all the way down. This definition is well-established today, and it is a very short leap from there to the idea of interface, for the interface becomes the point of transition between different mediatic layers within any nested system. The interface is an "agitation" or generative friction between different formats. In computer science, this happens very literally; an "interface" is the name given to the way in which one glob of code can interact with another. Since any given format finds its identity merely in the fact that it is a container for another format, the concept of interface and medium quickly collapse into one and the same thing.

But is this the whole story of the interface? The parochialism of those who fetishize screen-based media suggests that something else is going on too. If the remediation argument has any purchase at all, it would be shortsighted to limit the scope of one's analysis to a single medium or indeed a single aggregation under the banner of something like "the digital." The notion of thresholds would warn against it. Thus a classical source, selected for its generic quality, not its specificity, is now appropriate. How does Hesiod begin his song?

> The everlasting immortals . . .
> It was they who once taught Hesiod his splendid singing . . .
> They told me to sing the race of the blessed gods everlasting,
> but always to put themselves at the beginning and end of my singing.[5]

A similar convention is found in Homer and in any number of classical poets: "Sing in me Muse, and through me tell the story of." The poet does not so much originate his own song as serve as a conduit for divine expression received from without. The poet is, in this sense, wrapped up by the Muse, or as Socrates puts it in the *Phaedrus*, possessed. "To put themselves at the beginning and end"—I suggest that this is our first real clue as to what an interface is.

Most media, if not all media, evoke a similar liminal transition moment in which the outside is evoked in order that the inside may take place. In the case of the classical poet, what is the outside? It is the Muse, the divine source, which is first evoked and praised, in order for the outside to possess the inside. Once possessed by the outside, the poet sings and the story transpires.

Of course, this observation is not limited to the classical context. Prefatory evocations of the form "once upon a time" are common across media formats. The French author François Dagognet describes it thus: "The interface . . . consists essentially of an area of choice. It both separates and mixes the two worlds that meet together there, that run into it. It becomes a fertile nexus."[6] Dagognet presents the expected themes of thresholds, door-ways, and windows. But he complicates the story a little bit in admitting that there are complex things that take place inside that threshold; the interface is not simple and trans-parent but a "fertile nexus." He is more Flusser and less McLuhan.[7] The interface for Dagognet is a special place with its own autonomy, its own ability to generate new results and conse-quences. It is an "area of choice" between the Muse and the poet, between the divine and the mortal, between the edge and the center.

But what is an edge and what is a center? Where does the image end and the frame begin? This is something with which artists have played for generations. Digital media are

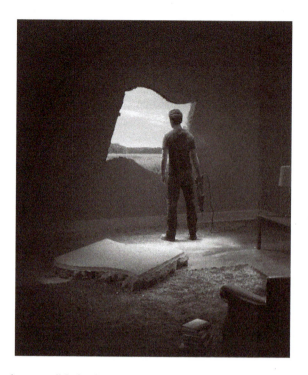

Figure 44.2 "Windows vs walls" (detail). Promotional Campaign, Microsoft, 2008. Used with permission from Microsoft.

exceptionally good at artifice and often the challenge comes in maintaining the distinction between edge and center, a distinction that threatens to collapse at any point like a house of cards. For example, the difference is entirely artificial between legible ASCII text, on a Web page, for example, and ASCII text used in HTML markup on that same page. It is a matter of syntactic techniques of encoding. One imposes a certain linguistic and stylistic construct in order to create these artificial differentiations. Technically speaking, the artificial distinction is the case all the way down: there is no *essential* difference between data and algorithm, the differentiation is purely artificial. The interface is this state of "being on the boundary." It is that moment where one significant material is understood as distinct from another significant material. In other words, an interface is not a thing, an interface is always an effect. It is always a process or a translation. Again Dagognet: a fertile nexus.

To distill these opening observations into something of a slogan, one might say that *the edges of art always make reference to the medium itself*. Admittedly, this is a common claim, particularly within discourse around modernism. But it is possible to expand the notion more broadly so that it applies to the act of mediation in general. Homer invokes the Muse, the literal form of poetry, in order to enact and embody that same divine form. But even in the song of the poem itself, Homer turns away from the narrative structure, in an apostrophe, to speak to a character as if he were an object of direct address: "And you, Atrides . . .," "and you, Achilles."

To develop this thread further, I turn to the first of two case studies. Norman Rockwell's "Triple Self-Portrait" (1960) presents a dazzling array of various interfaces. It is, at root, a meditation on the interface itself. The portrait of the artist appears in the image, only redoubled and multiplied a few times over. But the illustration is not a perfect system of representation. There is a circulation of coherence within the image that gestures toward the

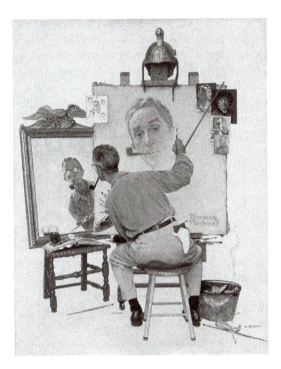

Figure 44.3 Norman Rockwell, "Triple Self-Portrait," *The Saturday Evening Post*, February 13, 1960. (SEP 2/13/1960). Printed by permission of the Norman Rockwell Family Agency Book Rights Copyright © 1960 The Norman Family Entities.

outside, while ultimately remaining afraid of it. Three portraits immediately appear: (1) the portrait of an artist sitting on a stool, (2) the artist's reflection in the mirror, and (3) the half-finished picture on the canvas. Yet the image does not terminate there, as additional layers supplement the three obvious ones: (4) a prototypical interface of early sketches on the top left of the canvas, serving as a prehistory of malformed image production, (5) on the top right, an array of self-portraits by European masters that provide the artist some inspiration, and (6) a hefty signature of the (real) artist at center right, craftily embedded inside the image, inside another image.

This complicated circulation of image production produces a number of unusual side effects that must be itemized. First, the artist paints in front of an off-white sweep wall, not unlike the antiseptic, white nowhere land that would later become a staple of science fiction films like *THX 1138* or *The Matrix*. Inside this off-white nowhere land, there appears to be no visible outside—no landscape at all—to locate or orient the artist's coherent circulation of image production. But second, and more important, is the dramatic difference in representational and indeed moral and spiritual vitality between the image in the mirror and the picture on the canvas. The image in the mirror is presented as a technical or machinic image, while the picture on the canvas is a subjective, expressive image. In the mirror, the artist is bedraggled, dazzled behind two opaque eyeglass lenses, performing the rote tasks of his vocation (and evidently not entirely thrilled about it). On the canvas, instead, is a perfected, special version of himself. His vision is corrected in the canvas world. His pipe no longer sags but shoots up in a jaunty appeal. Even the lines on the artist's brow lose their foreboding on canvas, signifying instead the soft wisdom of an elder. Other dissimilarities abound, particularly the twofold growth in size and the lack of color in the canvas image, which while seemingly more perfect is ultimately muted and impoverished. But there is a fourth layer of this

interface, the "quadruplicate" supplement to the triple self-portrait: the illustration itself. It is also an interface, this time between us and the magazine cover. This is typically the level of the interface that is most invisible, particularly within the format of middlebrow kitsch of which Rockwell is a master. The fact that this is a self-conscious self-portrait also assists in making that fourth level invisible because all the viewer's energies that might have been reserved for tackling those difficult "meta" questions about reflections and layers and reflexive circulation of meaning are exercised to exhaustion before they have the opportunity to inter- rogate the frame of the illustration itself.

To put it in rather cynical terms, the image is semiotic catharsis, designed to keep the viewer's eye from straying too far afield, while at the same time avoiding any responsibility of thinking the image as such. The image claims to address the viewer's concerns within the content of the image (within what should be called by its proper name, the *diegetic* space of the image). But it only raises these concerns so that they may be held in suspension. In a larger sense, this is the same semiotic labor that is performed by genre forms in general, as well as kitsch, baroque, and other modes of visceral expression: to implant in the viewer the desires they thought they wanted to begin with, and then to fulfill every craving of that same artificial desire. Artificial desire—can there be any other kind?

But still, what is an edge and what is a center? Have I avoided the question? Is Rockwell evoking the Muse or simply suspending her? Where exactly is the line between the text and the paratext? The best way to answer these questions is not to point to a set of entities in the image, pronouncing proudly that these five or six details are textual, while those seven or eight others are paratextual. Instead, one must always return to the following notion. An interface is not a thing; an interface is a relation effect. One must look at local relationships within the image and ask: how does this specific local relationship

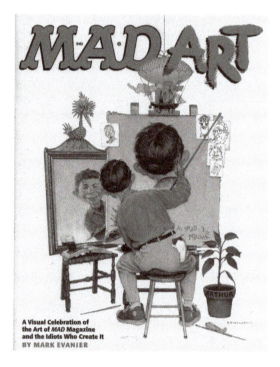

Figure 44.4 Richard Williams, "Untitled (Alfred E. Neuman Self-Portrait)." Source: Mark Evanier, *Mad Art* (New York: Watson-Guptill, 2002), front cover.

create an externalization, an incoherence, an edging, or a framing? (Or in reverse: how does this other specific local relationship within the apparatus succeed in creating a coherence, a centering, a localization?) But what does this mean? Project yourself into Rockwell's image. There exists a diegetic circuit between the artist, the mirror, and the canvas. The circuit is a circulation of intensity. Nevertheless, this does not prohibit the viewer from going outside the circuit. The stress here is that one must always think about the image as a process, rather than as a set of discrete, immutable items. The paratextual (or alternately, the nondiegetic) is in this sense merely the process that goes by the name of outering, of exteriority.

To laugh at the joke, intimated but never consummated by Rockwell's triple self-portrait, one should turn to the satire produced a few years later by Richard Williams for *Mad* magazine.[8] The humor comes from *Mad*'s trickster mascot. Being an artist of such great talent, he not only paints a portrait of himself but does so from the viewer's subjective vantage point. It is a short circuit.

Unlike Rockwell's avatar, *Mad*'s mascot has no concern for making himself look better in art, only to make himself appear more clever. There is no anxiety in this image. There is no pipe; there are no glasses. It is in color. It is the same head, only bigger. And of course, it is the view of the back of the head, not the face, front and forward. The mode of address is now the core of the image: Rockwell's eyes were glazed, but the *Mad* mascot here is quite clearly addressing the viewer. There is an intensity of circulation within Rockwell's image, whereby each added layer puts a curve into the viewer's gaze, always gravitating centripetally toward the middle. But in Williams's *Mad* satire those circular coherences are replaced by three orthogonal spikes that break the image apart: (1) the face in the mirror looks orthogonally outward at the magazine reader, (2) the seated figure looks orthogonally inward and not at the mirror as the laws of optics would dictate, and likewise (3) the canvas portrait faces orthogonally inward, mimicking the look of the big orthogonal Other, the magazine reader. Every ounce of energy within the image is aimed at its own externalization.

Looking back at the history of art-making, one remembers that addressing the viewer is a very special mode of representation that is often saved or segregated or cast off and reserved for special occasions. It appears in debased forms like pornography, or folk forms like the home video, or marginalized political forms like Brechtian theater, or forms of ideological interpellation like the nightly news. Direct address is always treated in a special way. Narrative forms, which are still dominant in many media, almost entirely prohibit it. For example, by the 1930s in film, direct address is something that cannot be done, at least within the confines of classical Hollywood form. It becomes quite literally a sign of the avant-garde. Yet *Mad*'s fourth interface, the direct address of the image itself, is included as part of the frame. It is entirely folded into the logic of the image. The gargantuan head on the canvas, in turning away, is in reality turning toward, bringing the edge into the center.

Rockwell and *Mad* present two ways of thinking about the same problem. In the first is an interface that addresses itself to the theme of the interface; Rockwell's is an image that addresses image-making in general. But it answers the problem of the interface through the neurosis of repression. In orienting itself toward interfaces, it suggests simultaneously that interfaces don't exist. It puts the stress on a coherent, closed, abstract aesthetic world. On the other hand, the second image solves the problem of the interface through the psychosis of schizophrenia. It returns forever to the original trauma of the interface itself. Reveling in the disorientation of shattered coherence, the second image makes no attempt to hide the interface. Instead, the orthogonal axis of concern, lancing outward from the image, seizes the viewer. In it, the logic of the image disassembles into incoherence. So the tension

between these two images is that of coherence versus incoherence, of centers creating an autonomous logic versus edges creating a logic of flows, transformations, movement, process, and lines of flight. The edges are firmly evoked in the second image. They are dissolved in the first.

Thus the first is an image that is internally consistent. It is an interface that works. The interface has a logic that may be known and articulated by the interface itself. It works; it works *well*.

On the other hand, the second is an image that doesn't work. It is an interface that is unstable. It is, as Maurice Blanchot or Jean-Luc Nancy or Mehdi Belhaj Kacem might say, *désoeuvré*—nonworking, unproductive, inoperative, unworkable.

Intraface

The earlier conventional wisdom on interfaces as doors or windows now reveals its own limitation. One must transgress the threshold, as it were, of the threshold theory of the interface. A window testifies that it imposes no mode of representation on that which passes through it. A doorway says something similar, only it complicates the formula slightly by admitting that it may *closed* from time to time, impeding or even blocking the passengers within. The discourse is thus forever trapped in a pointless debate around openness and closedness, around perfect transmission and ideological blockages. This discourse has a very long history, to the Frankfurt School and beyond. And the inverse discourse, from within the twentieth-century avant-garde, is equally stuffy: debates around apparatus critique, the notion that one must make the apparatus visible, that the "author" must be a "producer," and so on. It is a Brechtian mode, a Godardian mode, a Benjaminian mode. The *Mad* image implicitly participates in this tradition, despite being lowbrow and satirical in tone. In other words, to the extent that the *Mad* image is foregrounding the apparatus, it is not dissimilar to the sorts of formal techniques seen in the new wave, in modernism, and in other corners of the twentieth-century avant-garde.

The *Mad* images speaks and says: "I admit that an edge to the image exists—even if in the end it's all a joke—since the edge is visible within the fabric of my own construction." The Rockwell image speaks and says: "Edges and centers may be the subject of art, but they are never anything that will influence the technique of art."

It would be helpful to invent a new term to describe this imaginary dialogue between the workable and the unworkable: the *intraface*, that is, an interface internal to the interface. The key here is that the interface is *within* the aesthetic, not a window or doorway separating the space that spans from here to there. Gérard Genette, in his book *Thresholds*, calls it a " 'zone of indecision' between the inside and outside."[9] It is no longer a question of choice, as it was with Dagognet. It is now a question of nonchoice. The intraface is *indecisive* for it must always juggle two things (the edge and the center) at the same time.

But what exactly is the zone of indecision? What two things face off in the intraface? It is a type of aesthetic that implicitly brings together the edge and the center. The intraface may thus be defined as an internal interface between the edge and the center but one that is now entirely subsumed and contained within the image. This is what constitutes the zone of indecision.

Now things get slightly more complicated, for consider the following query: Where does political art happen? In many cases—and I refer now to the historically specific mode of political art-making that comes out of modernism—the right column (Fig. 44.5) is the place where politicized or avant-garde culture takes place. Consider, for example, the classic debate between Aristotle and Augusto Boal: Aristotle, in his text on poetics, describes a cohesive

Text	Paratext
Diegetic	Nondiegetic
Image	Frame
Studium	Punctum
Aristotle	Brecht
Rockwell	*Mad*
Hitchcock	Godard
Transparency	Foregrounding
Dromenon	Algorithm
Realism	Function
Window	Mirror
3D model	Heads-up-display
Half-Life	*World of Warcraft*
Representation	Metrics
Narcissus	Echo

Figure 44.5 Centers and Edges.

representational mode oriented around principles of fear, pity, psychological reversal, and emotional catharsis, while Boal addresses himself to breaking down existing conventions within the expressive mode in order that mankind's political instinct might awaken. The edge of the work is thus an arrow pointing to the outside, that is, pointing to the actually existing social and historical reality in which the work sits. Genette's "indecision" is, in this light, a codeword for something else: *historical materialism*. The edges of the work are the politics of the work.

But to understand the true meaning of these two columns (Fig. 44.5) today, we must consider an example from contemporary play culture, *World of Warcraft*. What does one notice immediately about the image (Fig. 44.6)? First, where is the diegetic space? It is the cave backdrop, the deep volumetric mode of representation that comes directly out of Renaissance perspective techniques in painting. Alternately, where is the nondiegetic space? It is the thin, two-dimensional overlay containing icons, text, progress bars, and numbers. It deploys an entirely different mode of signification, reliant more on letter and number, iconographic images rather than realistic representational images.

The interface is awash in information. Even someone unfamiliar with the game will notice that the nondiegetic portion of the interface is as important if not more so than the diegetic portion. Gauges and dials have superseded lenses and windows. Writing is once again on par with image. It represents a sea change in the composition of media. In essence, the same process is taking place in *World of Warcraft* that took place in the *Mad* magazine cover. The diegetic space of the image is demoted in value and ultimately determined by a very complex nondiegetic mode of signification. So *World of Warcraft* is another way to think about the tension inside the medium. It is no longer a question of a "window" interface between this side of the screen and that side (for which of course it must also perform double duty), but an intraface between the heads-up-display, the text and icons in the foreground, and the 3D, volumetric, diegetic space of the game itself—on the one side, writing; on the other, image.

What else flows from this? The existence of the internal interface within the medium is important because it indicates the implicit presence of the outside within the inside. And,

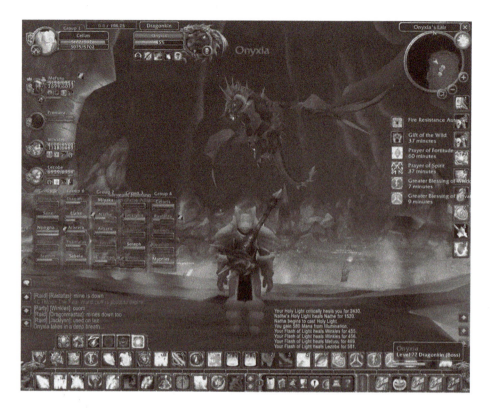

Figure 44.6 Blizzard Entertainment. *World of Warcraft*, 2004. Game still.

again to be unambiguous, "outside" means something quite specific: the social. Each of the terms previously held in opposition—nondiegetic/diegetic, paratext/text, the alienation effects of Brecht/emotional catharsis of Aristotle—each of these essentially refers to the tension between a progressive aesthetic movement (again, largely associated with but not limited to the twentieth century) and a more conventional one.

Now the analysis of *World of Warcraft* can reach its full potential. For the question is never simply a formal claim, that this or that formal detail (text, icon, the heads-up-display) exists and may or may not be significant. No, the issue is a much greater one. If the nondiegetic takes center stage, we can be sure that the "outside," or the social, has been woven more intimately into the very fabric of the aesthetic than in previous times. In short, *World of Warcraft* is Brechtian, if not in its actually existing political values, then at least through the values spoken at the level of mediatic form. (The hemming and hawing over what this actually means for progressive movements today is a valid question, one that I leave for another essay and another time.) In other words, games like *World of Warcraft* allow us to perform a very specific type of social analysis because they are telling us a story about contemporary life. Of course, it is common for popular media formats to tell the story of their own times; yet the level of unvarnished testimony available in a game like *World of Warcraft* is stunning. It is not an avant-garde image, but, nevertheless, it firmly delivers an avant-garde lesson in politics. At root, the game is not simply a fantasy landscape of dragons and epic weapons but a factory floor, an information-age sweat shop, custom tailored in every detail for cooperative ludic labor.

By now it should be clear why the door or window theory of the interface is inadequate. The door-window model, handed down from McLuhan, can only ever reveal one thing, that

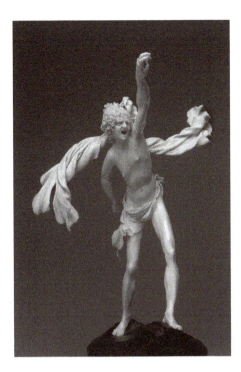

Figure 44.7 Furienmeister. "Fury," c. 1610. Kunstkammer, Kunsthistorisches Museum, Vienna.
© Kunsthistorisches Museum, Vienna.

the interface is a palimpsest. It can only ever reveal that the interface is a reprocessing of something that came before. A palimpsest the interface may be; yet it is still more useful to take the ultimate step, to suggest that the layers of the palimpsest themselves are "data" that can be interpreted. To this degree, it is more useful to think of the intraface using the principle of parallel aesthetic events that themselves tell the viewer something about the medium and about contemporary life. A simpler word is "allegory." And on this note it is now appropriate to revisit the "grand choice" mentioned in the opening section on methodology: that representation is either beautiful or deceptive, either intuitive or interpretable. There is a third way: not Iris or Hermes but the "kindly ones," the Eumenides. For representation, as in Aeschylus's play, is an incontinent body, a frenzy of agitation issuing forth from the social body (the chorus). An elemental methodological relation thus exists between my three central themes: (1) the structure of allegory today, (2) the intraface, and (3) the dialectic between culture and history.

Regimes of signification

We are now able to return to Norman Rockwell and *Mad* magazine and, extrapolating from these two modes, make an initial claim about how certain types of ludic texts deal with the interface. The alert observer might argue: "But doesn't the Rockwell image confess its own intimate knowledge of looking and mirroring, of frames and centers, just as astutely as the *Mad* image, only minus the juvenile one-liner? If so, wouldn't this make for a more sophisticated image? Why denigrate the image for being well made?" And this is true. The Rockwell image is indeed well crafted and exhibits a highly sophisticated understanding of how

interfaces work. My claim is less a normative evaluation elevating one mode over the other and more an observation about how flows of signification organize a certain knowledge of the world and a commitment to it.

I will therefore offer a formula of belief and enactment: *Rockwell believes in the interface but doesn't enact it, while* Mad *enacts the interface, but doesn't believe in it.*

The first believes in the interface because it attempts to put the viewer, as a subject, into an imaginative space where interfaces propagate and transpire in full view and without anxiety. But at the same time, as media, as an illustration with its own borders, it does not enact the logic of the interface, for it makes it invisible. Hence it believes in it but doesn't enact it.

By contrast, the second voyages to a weird beyond filled with agitation and indecision and, in arriving there, turns the whole hoary system into a silly joke. Hence it enacts it but doesn't believe in it. If the first is a deobjectification of the interface, the second is an objectification of it. The first aims to remove all material traces of the medium, propping up the wild notion that the necessary trauma of all thresholds might be sublimated into mere "content," while the second objectifies the trauma itself into a "process-object" in which the upheaval of social forms are maintained in their feral state, but only within the safe confines of comic disbelief.

We are now in a position to make more general observations about the aforementioned ideas of coherence and incoherence. First, to revisit the terminology: coherence and incoherence compose a sort of continuum, which one might contextualize within the twin domains of the aesthetic and the political. These are as follows:

1) A "coherent aesthetic" is one that works. The gravity of the aesthetic tends toward the center of the work of art. It is a process of centering, of gradual coalescing around a specific being. Examples of this may be found broadly across many media. Barthes's concept of the *studium* is its basic technique.

2) An "incoherent aesthetic" is one that doesn't work. Here gravity is not a unifying force but a force of degradation, tending to unravel neat masses into their unkempt, incontinent elements. "Incoherent" must not be understood with any normatively negative connotation: the point is not that the aesthetic is somehow unwatchable, or unrepresentable. Coherence and incoherence refer instead to the capacity of forces within the object, and whether they tend to coalesce or disseminate. Thus the *punctum*, not the *studium*, is the correct heuristic for this second mode.

3) A "coherent politics" refers to the tendency to organize around a central formation. This brand of politics produces stable institutions, ones that involve centers of operation, known fields and capacities for regulating the flow of bodies and languages. This has been called a process of "state" formation or a "territorialization." Coherent politics include highly precise languages for the articulation of social beings. Evidence of their existence may be seen across a variety of actually existing political systems including fascism and national socialism but also liberal democracy.

4) An "incoherent politics," rather, is one that tends to dissolve existing institutional bonds. It does not gravitate toward a center nor does it aspire to bring together existing formations into movements or coalitions. It comes under the name of "deterritorialization," of the event, of what some authors optimistically term "radical democracy." The principle here is not that of repeating past performance, of gradually resisting capitalism, or what have you, as in the example of Marx's mole. Instead, one must follow a break with the present, not simply by realizing one's desires, but by renovating the very meaning of desire itself.

(Let me repeat that coherent and incoherent are nonnormative terms; they must be understood more as "fixed" or "not fixed" rather than "good" or "bad" or "desirable" or "undesirable." I have already hinted at the analogous terms used by Deleuze, "territorialization" and "deterritorialization," but different authors use different terminology. For example, in Heidegger, the closest cognates are "falling" [*verfallen*] and "thrownness" [*Geworfenheit*].)

With these four thus arrayed, one may pair them up in various combinations to arrive at a number of different regimes of signification. First, the pairing of a coherent aesthetic with a coherent politics is what is typically known as *ideology*—the more sympathetic term is "myth," the less sympathetic is "propaganda." Thus in the ideological regime, a certain homology is achieved between the fixity of the aesthetic and the fixity of the political desire contained therein. (This is *not* to say that for any ideological formation there exists a specific, natural association between the aesthetic and the political but simply that there is a similarity by virtue of their both being coherent.) Hence all forms of ideological and propagandistic cultural forms, from melodrama to Michael Moore, Matthew Arnold but also Marx, would be included in this regime. Given the references evoked earlier, it would be appropriate to associate Rockwell with this regime also, in that his image displays an aesthetic of coherence (the intense craft of illustration, the artist as genius, the swirling complexity of the creative process), and a politics of coherence (mom-and-apple-pie and only mom-and-apple-pie).

However, if the terms are altered slightly, a second pairing becomes visible. Connecting an aesthetic of incoherence to a politics of coherence, one arrives at the *ethical* regime of signification.[10] Here there is always a "fixed" political aspiration that comes into being through the application of various self-revealing or self-annihilating techniques within the aesthetic apparatus. For example, in the typical story of progressive twentieth-century culture, the one told in Alain Badiou's *The Century* for example, the ethical regime revolves around various flavors of modernist-inspired leftist progressivism. Thus, in Brecht, there is an aesthetic of incoherence (alienation effect, foregrounding the apparatus), mated with a politics of coherence (Marx and only Marx). Or again, to evoke the central reference from above, the *Mad* image offers an aesthetic of incoherence (break the fourth wall, embrace optical illusion), combined with a politics of coherence (lowbrow and only lowbrow). And of course, many more names could be piled on: Jean-Luc Godard in film (tear film apart to shore up Marxist-Leninism); Fugazi in punk (tear sound apart in the service of the D.I.Y. lifestyle); and so on. However, it should be pointed out that modernist-inspired leftist progressivism is not the end of the story for the ethical regime. I intimated already, by calling the game Brechtian, that I wish to classify *World of Warcraft* under this regime. But why? I have given all the reasons already: the game displays an aesthetic of incoherence in that it foregrounds the apparatus (statistical data, machinic functions, respawn loops, object interfaces, multithreading, and so on), while all the time promoting a particularly coherent politics (protocological organization, networked integration, alienation from the traditional social order, new informatic labor practices, computer-mediated group interaction, neoliberal markets, game theory, and so forth). So, *World of Warcraft* is an "ethical" game simply by virtue of the way in which it opens up the aesthetic on the one hand while closing down politics on the other. Again, I am using a general (not a moral) definition of the term ethical, as a set of broad principles for practice within some normative framework. That *World of Warcraft* has more to do with the information economy, and Godard's *La Chinoise* has more to do with Maoism, does not diminish either in its role within the ethical regime.

A third mode now appears, which may be labeled *poetic* in that it combines an aesthetic of coherence with a politics of incoherence. This regime is seen often in certain brands of modernism, particularly the highly formal, inward-looking wing known as "art for art's sake" but also, more generally, in all manner of fine art. It is labeled "poetic" simply because it aligns itself with *poesis*, or meaning-making in a general sense. The stakes are not those of metaphysics, in which any image is measured against its original, but rather the semiautonomous "physics" of art, that is, the tricks and techniques that contribute to success or failure within mimetic representation as such. Aristotle was the first to document these tricks and techniques, in his *Poetics*, and the general personality of the poetic regime as a whole has changed little since. In this regime, lie the great geniuses of their craft (for this is the regime within

which the concept of "genius" finds its natural home): Alfred Hitchcock or Billy Wilder, Deleuze or Heidegger, much of modernism, all of minimalism, and so on. But you counter: "Certainly the work of Heidegger or Deleuze was political. Why classify them here?" The answer lies in the specific nature of politics in the two thinkers and the way in which the art of philosophy is elevated over other concerns. My claim is not that these various figures are not political but simply that their politics is *incoherent*. Eyal Weizman has written of the way in which the Israeli Defense Forces have deployed the teachings of Deleuze and Félix Guattari in the field of battle. This speaks not to a corruption of the thought of Deleuze and Guattari but to the very receptivity of the work to a variety of political implementations (that is, to its "incoherence"). To take Deleuze and Guattari to Gaza is not to blaspheme them but to deploy them. Michael Hardt and Negri, and others have shown also how the rhizome has been adopted as a structuring diagram for systems of hegemonic power. Again this is not to malign Deleuze and Guattari but simply to point out that their work is politically "open source." The very inability to fix a specific political content of these thinkers is evidence that it is fundamentally poetic (and not ethical). In other words, the "poetic" regime is always receptive to diverse political adaptations, for it leaves the political question open. This is perhaps another way to approach the concept of a "poetic ontology," the label Badiou gives to both Deleuze and Heidegger. While for his own part, Badiou's thought is no less poetic, he ultimately departs from the "poetic" regime thanks to an intricate—and militantly specific—political theory.

The final mode is the most elusive of the four because it has never achieved any sort of *bona fide* existence in modern culture, neither in the dominant position nor in the various "tolerated" subaltern positions. This is the dirty regime wherein aesthetic incoherence combines with political incoherence. We shall call it simply *truth*, although other terms might also suffice (nihilism, radical alterity, the inhuman). The truth regime always remains on the sidelines. It appears not through a "return of the repressed," for it is never merely the dominant's repressed other. Instead, it might best be understood as "the repressed of the repressed," or using terminology from another time and another place, "the negation of the negation." May we associate certain names with this mode, with an incoherence in both aesthetics and politics? May we associate the names of Nietzsche? Of Georges Bataille? Of Jacques Derrida? The way forward is not so certain. But it is perhaps better left that way for the time being.

So in summary, these are the four regimes of signification:

(1) Ideological: an aesthetic of coherence, a politics of coherence;
(2) Ethical: an aesthetic of incoherence, a politics of coherence;
(3) Poetic: an aesthetic of coherence, a politics of incoherence;
(4) Truth: an aesthetic of incoherence, a politics of incoherence.

Some commentary on this system is in order before existing. First, the entire classification system seems to say something about the relationship between art and justice. In the first regime, art and justice are coterminous. One need only internalize the one to arrive at the other. In the second, the process is slightly different: one must destroy art in the service of justice. In the third it is inverted: one must banish the category of justice entirely to witness the apotheosis of art. And finally, in the fourth, redemption comes in the equal destruction of all existing standards of art and all received models of justice.

Second, after closer examination of these four regimes, it is clear that a hierarchy exists, if not for all time, then at least for the specific cultural and historical formation in which we live. That is to say: the first mode is dominant (albeit often maligned), the second is privileged, the third is tolerated, and the final is relatively sidelined. I have thus presented them here in order of priority.

But the hierarchy has little value unless it can be historicized. Thus an additional claim is helpful, reiterated from the above section on *World of Warcraft*: if anything can be said about the changing uses of these regimes in the age of ludic economies it would be that we are witnessing today a general shift in primacy from the first to the second, that is to say, from the "ideological" regime to the "ethical" regime. Ideology is in recession today; there is a decline in ideological efficiency. Ideology, which was traditionally defined as an "imaginary relationship to real conditions" (Althusser), has in some senses succeeded too well and, as it were, put itself out of a job. Instead, we have simulation, which must be understood as something like an "imaginary relationship to ideological conditions." In short, ideology gets *modeled* in software. So in the very perfection of the ideological regime, in the form of its pure digital simulation, comes the death of the ideological regime, as simulation is "crowned winner" as the absolute horizon of the ideological world. The computer is the ultimate ethical machine. It has no actual relation with ideology in any proper sense of the term, only a virtual relation.

I stress, however, in no uncertain terms, that this does not mean that today's climate is any more or less "ethical" (in the sense of good deed doing) or more or less politicized than the past. Remember that the ethical mode (#2) is labeled "ethical" because it adopts various normative techniques wherein given aesthetic dominants are shattered (via foregrounding the apparatus, alienation effects, and so on) in the service of a specific desired ethos.

Finally, given that it is common to bracket both the ideological form (#1) and the truth form (#4), the one banished from respectable discourse out of scorn and the other out of fear, the system may be greatly simplified into just two regimes (#2 and #3), revealing a sort of primordial axiom: *the more coherent a work is aesthetically, the more incoherent it tends to be politically*. And the reverse is also true: *the more incoherent a work is aesthetically, the more coherent it tends to be politically*. The primordial axiom (of course it is no such thing, merely a set of tendencies arising from an analysis of actually existing cultural production) thus posits two typical cases, the ethical and the poetic. In simple language, the first is what we call politically significant art; the second is what we call fine art. The first is Godard, the second is Hitchcock. Or, if you like, the first is *World of Warcraft* and the second is *Half-Life*. The first enacts the mediatic condition but doesn't believe in it; the second believes in the mediatic condition but doesn't enact it.

In the end, we might return to our mantra, that the interface is a medium that does not mediate. It is unworkable. The difficulty, however, lies not in this dilemma but in the fact that the interface never admits it. It describes itself as a door or a window or some other sort of threshold across which we must simply step to receive the bounty beyond. But a thing and its opposite are never joined by the interface in such a neat and tidy manner. This is not to say that "incoherence" wins out in the end, invalidating the other modes. Simply that there will be an intraface within the object between the aesthetic form of the piece and the larger historical material context in which it is situated. If an "interface" may be found anywhere, it is there. What we call "writing," or "image," or "object," is merely the attempt to resolve this unworkability.

Notes

* This essay was first developed on the invitation of Eric de Bruyn as a seminar on "the interface" at the University of Groningen in the Netherlands on October 24, 2007.

1 Michel Serres, *Le Parasite* (Paris: Éditions Grasset et Fasquelle, 1980), 107 (my translation). For the theme of "windows" one should also cite the efforts of the software industry in devising graphical user interfaces. The myth is branded by Microsoft, but it is promulgated across all personal computer platforms, "progressive" (Linux) or less so (Macintosh), as well as all manner of smaller and more flexible devices. A number of books also address the issue, including Jay David Bolter and Diane

Gromala, *Windows and Mirrors: Interaction Design, Digital Art, and the Myth of Transparency* (Cambridge, MA: MIT Press, 2003), and Anne Friedberg, *The Virtual Window: From Alberti to Microsoft* (Cambridge, MA: MIT Press, 2006).

2 John Durham Peters puts this quite eloquently in his book *Speaking Into the Air* (Chicago: Univ. of Chicago Press, 1999). For Peters, the question is between telepathy and solipsism, with his proposed third, synthetic option being some less cynical version of Serres: mediation as a process of perpetual, conscious negotiation between self and other.

3 Johan Huizinga, *Homo Ludens: A Study of the Play Element in Culture* (Boston: Beacon Press, 1950).

4 Guy Debord, *Correspondance*, vol. 5, *Janvier 1973–décembre 1978* (Paris: Librairie Arthème Fayard, 2005), 466 (my translation).

5 Hesiod, *Theogony*, trans. Richmond Lattimore (Ann Arbor: Univ. of Michigan Press, 1959), 124.

6 François Dagognet, *Faces, Surfaces, Interfaces* (Paris: Librairie Philosophique J. Vrin, 1982), 49 (my translation).

7 Admittedly McLuhan is sharper than my snapshot will allow. Describing the methodology of Harold Innis, he evokes interface as a type of friction between media, a force of generative irritation rather than a simple device for framing one's point of view: "[Innis] changed his procedure from working with a 'point of view' to that of the generating of insights by the method of 'interface,' as it is named in chemistry. 'Interface' refers to the interaction of substances in a kind of mutual irritation." Marshall McLuhan, "Media and Cultural Change," in *Essential McLuhan* (New York: Basic Books, 1995), 89.

8 I first learned of this delightful satire by attending a lecture by the artist Art Spiegelman at New York University on October 6, 2007.

9 Gérard Genette, *Seuils* (Paris: Éditions du Seuil, 1987), 8 (my translation).

10 I take some terminological inspiration from Jacques Rancière's amazing little book *Le partage du sensible: esthétique et politique* (Paris: La Fabrique, 2000), published in English as *The Politics of Aesthetics: The Distribution of the Sensible*, trans. Gabriel Rockhill (New York: Continuum, 2004). Any similarity to his ethical-poetic-aesthetic triangle is superficial at best, particularly in that his "ethical" is closely aligned with a Platonic moral philosophy, while mine refers primarily to an ethic as an active, politicized practice. Yet overlap exists, as between both uses of the term "poetic," as well as a rapport between his "aesthetic" and my "truth" to the extent that both terms refer to an autonomous space in which the aesthetic begins to refer back to itself and embark on its own absolute journey.

Brian Massumi

ON THE SUPERIORITY OF THE ANALOG

THE VIRTUAL, AS SUCH, is inaccessible to the senses. This does not, however, preclude figuring it, in the sense of constructing images of it. To the contrary, it requires a multiplication of images. The virtual that cannot be felt also cannot but be felt, in its effects. When expressions of its effects are multiplied, the virtual fleetingly appears. Its fleeting is in the cracks between and the surfaces around the images.

Images of the virtual make the virtual appear not in their content or form, but in fleeting, in their sequencing or sampling. The appearance of the virtual is in the twists and folds of formed content, in the movement from one sample to another. It is in the ins and outs of imaging. This applies whether the image is verbal, as in an example or parable, or whether it is visual or aural. No one kind of image, let alone any one image, can render the virtual.

Since the virtual is in the ins and outs, the only way an image can approach it alone is to twist and fold on itself, to multiply itself internally. This happens in each of the "parables" in this book. At a certain point, they knot up: infoldings and outfoldings, redoublings and reductions, punctual events falling away from themselves into self-referential encompassment, pasts projecting ahead to futures buckling back into the moment, extended intensities and intensifying extensions. The virtual can perhaps best be imaged by superposing these deformational moments of repetition rather than sampling differences in form and content. Think of each image receding into its deformation, as into a vanishing point of its own twisted versioning.[1] That vanishing into self-variety is the fleeting of the virtual—more appearingly than in the in-between and around of the single-image forms and contents, however thoroughly resequenced by cut-and-paste (combinatorics). The folding-vanishing point is the literal appearance in words—or vision or hearing—of a virtual image center. Take the images by their virtual centers. Superpose them. You get an overimage of images of self-varying deformation: a unity of continuous separation from self. It is there that the virtual most literally, parabolically appears.

This is to say that the virtual is best approached *topologically*. Topology is the science of self-varying deformation. A topological figure is defined as the continuous transformation of one geometrical figure into another. Imagine a pliable coffee cup. Join the surfaces of the brim, enlarge the hole in the handle, and then stretch it so that all its sides are equally thick. You get a doughnut. You could then tie this doughnut into complex knots. All of the

geometrical figures you can create in this way are versions of the *same* topological figure. Topological unity is, in and of itself, multiple. Of course, it is impossible actually to diagram every step in a topological transformation.[2] Practically, only selected stills can be presented. Once again, the need arises to superpose the sequencings. It is only in that superposition that the unity of the figure can be grasped as such, in one stroke. That one stroke is the virtual image center of the figure. It is virtual because you cannot effectively see it or exhaustively diagram it. It is an image because you can, for all of that, figure it, more or less vaguely, in the imagination. Imagination is the mode of thought most precisely suited to the differentiating vagueness of the virtual.[3] It alone manages to diagram without stilling. Imagination can also be called intuition: a thinking feeling. Not feeling something. Feeling thought—as such, in its movement, as process, on arrival, as yet unthought-out and unenacted, post-instrumental and preoperative. Suspended. Looped out. Imagination is felt thought, thought only-felt, felt as only thought can be: insensibly unstill. Outside any given thing, outside any given sense, outside actuality. Outside coming in. The mutual envelopment of thought and sensation, as they arrive together, pre-what they will have become, just beginning to unfold from the unfelt and unthinkable outside: of process, transformation in itself.

Whatever medium you are operating in, you miss the virtual unless you carry the images constructed in that medium to the point of topological transformation. If you fall short of the topological, you will still grasp the possible (the differences in content and form considered as organizable alternatives). You might even grasp the potential (the tension between materially superposed possibilities and the advent of the new). But never will you come close to the virtual.

Topology is a purely qualitative science. It is not empirical, if empirical investigation is meant as progressing from description to prediction. It has no predictive value.[4] Incapable of directly referencing anything other than its own variations, it is more analogical than descriptive. It is not, however, an analog *of* anything in particular. It is not an analog in the everyday sense of a variation on a model. Here, there is no model. Only infolding and unfolding: self-referential transformation. The analog is *process*, self-referenced to its own variations. It resembles nothing outside itself. A topological image center literally makes the virtual appear, in felt thought. It is more apparitional than empirical. Sensation, always on arrival a transformative feeling of the outside, a feeling of thought, is the being of the analog. It is matter in analog mode.[5] This is the analog in a sense close to the technical meaning, as a continuously variable impulse or momentum that can cross from one qualitatively different medium into another. Like electricity into sound waves. Or heat into pain. Or light waves into vision. Or vision into imagination. Or noise in the ear into music in the heart. *Or outside coming in*. Variable continuity across the qualitatively different: continuity of transformation. The analog impulse from one medium to another is what was termed in the last chapter a transduction. In sensation the thinking-feeling body is operating as a transducer. If sensation is the analog processing by body-matter of ongoing transformative forces, then foremost among them are forces of appearing as such: of coming into being, registering as becoming. The body, sensor of change, is a transducer of the virtual.

Possibility, for its part, can be approached quantitatively. Probability is one of the forms the possible's quantitative expression may take. Probabilities are weightings of possibilities according to the regularity with which they might be expected to appear. Since probability approaches possibilities en masse, it approximates potential. Probability commits what René Thom calls an "imposture"[6] by expressing the potential it approximates in a way that makes it seem that by quantifying, it had made the outcome of the potential predictable, effectively converting it into the mode of possibility. It hasn't, of course. It only approaches possibility, just as it only approximates potential. The problem is that modes of inactuality are stubbornly qualitative. Quantifying conversions of them always leave a qualitative remainder. This is

easily seen with probability, in the fact that it has nothing at all to say about any given conjunction. It says nothing about what will happen in any given case. It is not about particulars, let alone singularities. It targets only the general level, applying not to the event but only to an averaging of the mass of events. It concerns laws of large numbers.

Potential doesn't "apply" to the event either: it makes it. Potential was described in the last chapter as a multiplicity of possibilities materially present to one another, in resonance and interference. Their coming-together is singularly, compulsively felt, so intensely that the sensation cannot be exhausted in one go. Potential strikes like a motor force, a momentum driving a serial unfolding of events. The immanence of that forcing to each event in the series was termed a virtual center. The virtual center is like a reserve of differentiation or qualitative transformation in every event. It is the sufficient reason of the series. The virtual center never appears as such. It is insensate. It cannot be felt. It appears only in the potentials it drives and the possibilities that unfold from their driving: unfelt, it cannot but be felt in its effects. Each event in a serial unfolding is a sensible analog of that unexpressed effecting: its sensible (embodied) concept.

Both quantification and qualitative transformation, or analog series formation, involve a deactualization. Deactualizations are modes of thought, defined in the last chapter as a processual excess over the actual. They are not deactualizations in the sense that they erase or replace the actual. Rather, they double and redouble it: augment it. Quantification participates in the mode of thought commonly called instrumental reason (the thinking out of possibilities). Qualification is addressed by what was characterized in the last chapter as operative reason (the tweaking of potential). When most attentive to the virtual, qualification deforms into the topoontological exercise of *contingent reason* (thought bending back to participate in its own emergence from sensation; imagination, or intuition in Bergson's sense).

The actual occurs at the point of intersection of the possible, the potential, and the virtual: three modes of thought. The actual is the effect of their momentous meeting, mixing, and re-separation. The meeting and mixing is sensation. Sensation stretches on a continuum from the absolute immanence of virtual center to the far end of potential, where it just extends into possibility. No actuality can be fully imaged, since it emerges from, projects into, and recedes into inactuality. Bodies and objects, their forms and contents, do not account for all of it. They do not catch the momentum. To look only at bodies and objects is to miss the movement. An image of the movement of the actual's appearing—its driving, dynamic excess over itself—is an image of thought.[7] An image of thought is an imaging of the imageless. In other words, it is necessarily analogic, incomplete at any and every particular conjunction, complete only in its openness: its continuing. Topology, as a modeling of continuous transformation, can be taken as an image of thought.

There is another deactualization process in addition to quantification and qualification: *codification*. The digital is a numerically based form of codification (zeros and ones). As such, it is a close cousin to quantification. Digitization is a numeric way of arraying alternative states so that they can be sequenced into a set of alternative routines. Step after ploddingly programmed step. Machinic habit.

"To array alternative states for sequencing into alternative routines." What better definition of the combinatoric of the possible? *The medium of the digital is possibility, not virtuality*, and not even potential. It doesn't bother approximating potential, as does probability. Digital coding per se is possibilistic to the limit.

Nothing is more destructive for the thinking and imaging of the virtual than equating it with the digital. All arts and technologies, as series of qualitative transformations (or in Deleuze and Guattari's involuted evolutionary vocabulary, "machinic phylums"),[8] envelop the virtual in one way or another. Digital technologies in fact have a remarkably weak connection to the virtual, by virtue of the enormous power of their systematization of the possible.

They may yet develop a privileged connection to it, far stronger than that of any preceding phylum. But that connection has yet to be invented or, at best, is still an inkling. It is the strength of the work of Pierre Lévy (against Baudrillard) to emphasize the participation in the virtual of earlier technologies—in particular writing—and (following Deleuze) to insist on a distinction between the possible and the potential as an integral part of any thinking of the virtual.[9] The meeting, mixing, and re-separation of the virtual, the possible, and potential concern the appearance of the actual—its emergence from an imageless interrelating. The actual is an appearance in the sense that its perception (its extension into possible action) is an effect of a process that is itself imperceptible and insensate (but moves through sensation). Equating the digital with the virtual confuses the really apparitional with the artificial. It reduces it to a simulation. This forgets intensity, brackets potential, and in that same sweeping gesture bypasses the move through sensation, the actual envelopment of the virtual.

Digital technologies have a connection to the potential and the virtual *only through the analog*. Take word processing. All of the possible combinations of letters and words are enveloped in the zeros and ones of ASCII code. You could say that entire language systems are numerically enveloped in it. But what is processed inside the computer is code, not words. The words *appear* on screen, in being read. Reading is the qualitative transformation of alphabetical figures into figures of speech and thought. This is an analog process. Outside its appearance, the digital is electronic nothingness, pure systemic possibility. Its appearance from electronic limbo is one with its analog transformation. Now take digital sound: a misnomer. The sound is as analog as ever, at least on the playback end, and usually at the recording end as well (the exception being entirely synthesized music). It is only the coding of the sound that is digital. The digital is sandwiched between an analog disappearance into code at the recording and an analog appearance out of code at the listening end.

Take hypertext. All possible links in the system are programmatically prearrayed in its architecture. This has led some critics to characterize it not as liberating but as downright totalitarian. While useful to draw attention to the politics of the possible, calling hypertext totalitarian is inaccurate. What it fails to appreciate is that the coding is not the whole story: that the digital always circuits into the analog. The digital, a form of inactuality, must be actualized. That is its quotient of openness. The freedom of hypertext is in the openness of its analog reception. The hypertext reader does something that the co-presence of alternative states in code cannot ever do: serially experience effects, accumulate them in an unprogrammed way, in a way that intensifies, creating resonances and interference patterns moving through the successive, linked appearances. For the hypertext surfer, the link just departed from overlaps with the next. They doppler together. They are not extensively arrayed, beside and outside each other, as alternatives. Neither are they enveloped in each other as coded possibilities. They are co-present in a very different mode.

The analog process of reading translates ASCII code into figures of speech enveloping figures of thought, taken in its restrictive sense of conscious reflection. There is no thought that is not accompanied by a physical sensation of effort or agitation (if only a knitting of the brows, a pursing of the lips, or a quickening of heartbeat).[10] This sensation, which may be muscular (proprioceptive), tactile, or visceral is backgrounded. This doesn't mean it disappears into the background. It means that it appears as the background against which the conscious thought stands out: its felt environment. The accompanying sensation encompasses the thought that detaches itself from it. Reading, however cerebral it may be, does not entirely think out sensation. It is not purified of it. A knitting of the brows or pursing of the lips is a self-referential action. Its sensation is a turning in on itself of the body's activity, so that the action is not extended toward an object but knots at its point of emergence: rises and subsides into its own incipiency, in the same movement. The acts of attention performed during reading are forms of incipient action. It was asserted in the last chapter that action and

perception are reciprocals of each other. If as Bergson argued a perception is an incipient action, then reciprocally an action is an incipient perception. Enfolded in the muscular, tactile, and visceral sensations of attention are incipient perceptions. When we read, we do not see the individual letters and words. That is what learning to read is all about: learning to stop seeing the letters so you can see *through* them. Through the letters, we directly experience fleeting visionlike sensations, inklings of sound, faint brushes of movement. The turning in on itself of the body, its self-referential short-circuiting of outward-projected activity, gives free rein to these incipient perceptions. In the experience of reading, conscious thought, sensation, and all the modalities of perception fold into and out of each other. Attention most twisted.

All of this equally pertains to inattention. Distraction, too, is accompanied by character-istic, self-referential actions: scratching, fidgeting, eyes rolling up or around in their sockets as if they were endeavoring to look back in at the brain. Every predominantly visual activity is an economy of attention and distraction, often with a pronounced tendency toward one or the other pole. Television assumes and fosters a certain inattention, as the viewing body is invited to zap channels or slip relays to other activities into the commercial slots and slow patches. Watching movies and reading books command considerably more attention, and thus tend toward the other direction. Hypertext surfing combines both modes. Link after link, we click ourselves into a lull. But suddenly something else clicks in, and our attention awakens, perhaps even with a raised eyebrow. Surfing sets up a rhythm of attention and distraction. This means that it can fold into its own process a wider range of envelopments and reciprocities of sensation, incipient perception, and conscious reflection. This is particu-larly true of a structurally open hypertext environment like the World Wide Web (as opposed to closed architectures like hypertext novels on CD-ROM or DVD or the commer-cial reference packages included in many computer purchases). While it is still true that everything on the Web is preprogrammed, the notion of a dictatorship of the link carries less weight. Search engines allow un-prearrayed linking, and the sheer size of the Web means that it is always changing, with sites constantly coming into and out of existence. (In 2001 it was estimated that Web pages were being posted at a rate of eight million per day.) The open architecture of the Web lends itself to the accumulation of analog effects. The increase in image and sound content alongside text provides more opportunities for resonance and inter-ference between thought, sensation, and perception.

A crucial point is that all the sense modalities are active in even the most apparently monosensual activity. Vision may ostensibly predominate, but it never occurs alone. Every attentive activity occurs in a synesthetic field of sensation that implicates all the sense modal-ities in incipient perception, and is itself implicated in self-referential action. Each read meaning or conscious reflection that arises is environed by this synesthetic field. Since every-thing in the field is in incipiency and folding, it is only vaguely felt, or side-perceived, like a fringe around formed perceptions and reflections. A determinate meaning or clear reflection may emerge from that vagueness, but it cannot entirely separate itself from it. It remains attached to its conditions of emergence, as by a processual umbilical cord.

When the hyperlink surfer moves from one link to the next, the conditioning synesthetic fringe of sensation moves with the flow. At the next link, the complexion of its vagueness will have changed. One sense may stand out more from the perceptual infusion of the always accompanying fringe-flow of sensation. The vagueness may sharpen into a selective perceptual focus or a clarity of thought that strikes the foreground of consciousness in a flash of sudden interest or even revelation. Or the vagueness may thicken into a lull or daze. Boredom. Who hasn't experienced that on the Web? The boredom often comes with a strange sense of foreboding: a sensing of an impending moreness, still vague. Next link. The effects doppler from one link to the next as the sense modalities enveloped in the dominant of vision phase into and out of each other, and into and out of clear expression and

reflective consciousness. The dopplering is responsible for the overall quality of the surfing process. There is an allure to that process, a pull to surf, that cannot be explained any other way. From the point of view of notable results, most hypertextual sessions are remarkably thin. If it were just a matter of the form or content of the screens taken separately, or even in a combinatoric, the experience would add up to very little. Surfing, however, like its televisual precursor, zapping, is oddly compelling. Given the meagerness of the constituent links on the level of formal inventiveness or uniqueness of content, what makes surfing the Web compelling can only be attributed to an accumulation of effect, or transductive momentum, continuing across the linkages. This accumulation of effect is to a certain degree a potentialization of the relay.

Potentialization. The mode in which the successive linkage events are co-present to each other on the receiving end of the digital processing is potential: a felt moreness to ongoing experience. Potential, it was argued earlier, appeals to an analogic virtual as its sufficient reason, as well as beckoning the possible as its thought-extension. Whatever action, perception, reflection eventuates represents a germinating of that potential. Potential, in return, is a situating of the virtual: its remaining immanent to each and every actual conjunction in a serial unfolding, to varying effect. The possibility stored in the digital coding at the instrumental basis of the process has potentialized, in a way that carries a virtual center of self-varying experience across the running of code-bound routines. The coded possible has been made a motor of transductive potential and analogic virtuality. In the actual play between the digital system of the possible, its potentializing effects, and the analogic charge of virtuality both conditioning those effects and carried by them, new thoughts may be thought, new feelings felt. These may extend into new possibilities in actual situations outside the machine and the screen experience. Seeds of screened potential sown in nonsilicon soil. Relay to the world at large.

Digital processing as such doesn't possibilize let alone virtualize. The digital is already exhaustively possibilistic. It can, it turns out, potentialize, but only indirectly, through the experiential relays the reception of its outcomes sets in motion. Those relays may even more indirectly seed as-yet uncoded possibilities: inventions (as defined in the last chapter). Whatever inventiveness comes about, it is a result not of the coding itself but of its detour into the analog. *The processing may be digital—but the analog is the process.* The virtuality involved, and any new possibility that may arise, is entirely bound up with the potentializing relay. It is not contained in the code.

It is of course conceivable that the digital may succeed in integrating analogic process ability into its own operations. Adaptive neural nets approach this, since they are capable of generating results that are not precoded. They automatically produce unforeseen results using feedback mechanisms to create resonance and interference between routines. In other words, what is coded is recursivity—machined self-referentiality. The digital processing becomes self-modulating: the running of the code induces qualitative transformation in its own loopy operation. Evolutionary digitality. Machinic invention. There are also more literal attempts under way to integrate analog process into digital processing. These include robots powered by biological muscles produced in laboratory cultures and attempts to plug digital devices directly into living neurons. On other fronts, the sight-confining helmets of early virtual reality systems have given way to immersive and interactive environments capable of addressing more directly other-than-visual senses and looping sense modalities more flexibly and multiply into each other, packing more sensation into the digitally-assisted field of experience—and, with it, more potentialization. The notion of ubiquitous computing championed for many years by the MIT Media Lab seems less futuristic by the day. The idea is that inconspicuous interfaces can be implanted in everyday environments in such a way as to seamlessly and continuously relay digitally coded impulses into and out of the

body through multiple, superposable sense connections, eventually developing into an encompassing network of infinitely reversible analog-digital circuiting on a planetary scale.[11] After all, the earth itself has always been the ultimate immersive environment.

Perhaps the day is not far off when the warnings that this chapter began with—not to confuse the digital with the virtual—will be anachronistic. But, for the time being, the warnings hold. Certainly, if there is one day a directly virtual digitality, it will have become that by integrating the analog into itself (biomuscular robots and the like), by translating itself into the analog (neural nets and other evolutionary systems), or again by multiplying and intensifying its relays into and out of the analog (ubiquitous computing). The potential for this becoming of the digital is missed as long as the relationship between the digital and analog is construed in mutually exclusive terms, as if one entirely replaced the other. A commonplace rhetoric has it that the world has entered a "digital age" whose dramatic "dawning" has made the analog obsolete. This is nonsense. The challenge is to think (and act and sense and perceive) the co-operation of the digital and the analog, in self-varying continuity. Apocalyptic pronouncements of epochal rupture might sell well, but they don't compute. When or if the digital virtual comes, its experience won't be anything so dramatic. It will be lullingly quotidian: no doubt as boring as the Web can be.

The "superiority of the analog" over the digital alluded to in the title does not contradict this closing call to think the two together. It refers to the fact that the paths of their co-operation—transformative integration, translation, and relay—are themselves analog operations. There is always an excess of the analog over the digital, because it perceptually fringes, synesthetically dopplers, umbilically backgrounds, and insensibly recedes to a virtual center immanent at every point along the path—all in the same contortionist motion. It is most twisted. The analog and the digital must be thought together, asymmetrically. Because the analog is always a fold ahead.

Notes

1 Gilles Deleuze, *Francis Bacon: Logique de la sensation* (Paris: Éd. de la Différence, 1981), 15–18.

2 C.S. Peirce, *Reasoning and the Logic of Things*, ed. Kenneth Laine Ketner (Cambridge, Mass.: Harvard University Press, 1992), 2, 71–72, 246–68. See also Deleuze, *Francis Bacon*, 65–71, and Deleuze and Guattari, *A Thousand Plateaus: Capitalism and Schizophrenia*, trans. Brian Massumi (Minneapolis: University of Minnesota Press, 1987), 91, 140–42, 510–13.

3 See Gilles Deleuze, *Kant's Critical Philosophy*, trans. Hugh Tomlinson and Barbara Habberjam (Minneapolis: University of Minnesota Press, 1984), 17–18, 50–52, and *Difference and Repetition*, trans. Paul Patton (New York: Columbia University Press, 1994), 320–21.

4 René Thom, interview, *Le Monde*, 15549 (22–23 January 1995).

5 Deleuze, *Francis Bacon*, 73–81; Gilbert Simondon, *L'individu et sa genèse physico-biologique* (Grenoble: Millon, 1995), 263–68; Muriel Combes, *Simondon: Individu et collectivité* (Paris: PUF, 1999), 20–24.

6 René Thom, interview.

7 Gilles Deleuze and Félix Guattari, *What Is Philosophy?*, trans. Hugh Tomlinson and Graham Burchill (New York: Columbia University Press, 1993).

8 Deleuze and Guattari, *A Thousand Plateaus*, 406–407, 409–410.

9 Pierre Lévy, *Becoming Virtual: Reality in the Digital Age*, trans. Robert Bononno (New York: Plenum, 1998).

10 William James, "The Feeling of Effort," *Collected Essays and Reviews* (New York: Russell and Russell, 1969), 151–219.

11 Nicholas Negroponte, *Being Digital* (New York: Alfred A. Knopf, 1995).

Lisa Nakamura

DIGITAL RACIAL FORMATIONS AND NETWORKED IMAGES OF THE BODY

VISUAL CULTURE'S ENGAGEMENT with the substance of images holds particular promise and offers critical purchase precisely when brought to bear on digital objects, which do possess distinctive cultures of bodily representation, flow, privacy, identity, and circulation and have created unique communicative and institutional contexts. The purpose of this chapter is to turn the lens of visual culture studies as grounded in these contexts on a topic that has received little attention from scholars of new media: the popular Internet and its depictions of racialized and gendered bodies.

In earlier work I discussed the ways in which the Internet facilitates identity tourism, creating a new form of digital play and ideological work that helped define an empowered and central self against an exotic and distant Other.[1] However, because the Internet has become an everyday technology for many Americans since that time, the postmillennial Internet has little to gain by identifying itself as an exotic form of travel or access to novel experiences. The adoption of the Internet by many more women and users of color since the nineties has occasioned innumerable acts of technological appropriation, a term Ron Eglash deploys to describe what happens when users with "low social power" modify existing technologies such as the Internet. While in *Cybertypes* I focused on the constraints inherent in primarily textual interfaces that reified racial categories, in this work I locate the Internet as a privileged and extremely rich site for the creation and distribution of hegemonic and counterhegemonic visual images of racialized bodies. In the early nineties the popular Internet was still a nascent media practice, one in which default whiteness and maleness were the result of serious digital divides that resulted in primarily male and white users. Since then, the Internet's user populations have become much more diverse. This has resulted in an explosion of use that has all but eliminated the sense of a default normative identity in all parts of cyberspace; there are many Internet spaces, such as pregnancy bulletin boards, blogs, and livejournals that may now assume a default female user, and others such as petition and dating Web sites that assume users of color.

This book traces that ongoing history since the era of the text-only niche Internet, which was used by a much more exclusive and exclusionary group of users, to its present state as a mass-media form with a popular (but still far from racially balanced) American audience. My readings of digital representations of the body created for deployment on the postgraphical

Internet since 2000 attempt to trace a cultural formation in motion, to read it back through its referents in old media and earlier racial formations, in order to write a digital history of the present. We are in a moment of continual and delicate negotiation between the positions of the object and the subject of digital visual culture. To repurpose Omi and Winant's influential theory of racial formation, in this book I wish to posit a theory *of digital racial formation*, which would parse the ways that digital modes of cultural production and reception are complicit with this ongoing process. While scholars from a variety of disciplines have produced valuable work that traces the history of digital racial formation, in many cases predating the Internet and the World Wide Web, and have revealed the ways in which people of color have had extensive involvements with digital technologies, such as music sampling, telecommunications in the context of forms of urban labor like taxi driving, and complex forms of indigenous weaving, these have not been especially visual, and their emphasis on recovering suppressed histories of racialized involvements with technologies has purposely de-emphasized the Internet as a way of reframing the digital divide discourse that persistently envisioned users of color as backward and uninvolved in technology.[2]

Studies of cyberculture have long noted, for good or ill, the identification of a mobile perspective in the context of networked communications with a privileged, omnipotent, yet fragmented gaze. Scholars and critics write about interactivity as if it were a drug, the drug of choice for cultural elites or "networked subjects." " 'Choice,' 'presence,' 'movement,' 'possibility' are all terms which could describe the experiential modalities of websurfing," as Tara McPherson writes, and during the Web's relatively short commercial history, they have been integral to the rhetoric of the new networked economy that sells "choice and possibility" as a side effect of digital/analog media convergence.[3] This celebration of fulfilled user volition can be, as she points out, illusory, especially when linked to the enhanced ability to buy things with one click. However, the distinction here seems to be between different varieties of user experience, to paraphrase William James; while there are disagreements about just how empowering digital interactivity may be, there seems little argument about its offering its users more in the way of agency. Indeed, there is a way in which possessing the "volitional mobility" afforded by the Web, in particular, constitutes a particular kind of viewing subject, one who possesses and is empowered by "visual capital."[4] The Internet has created and defined digital visual capital, a commodity that we mark as desirable by conferring on it the status of a language unto itself; we speak now of digital literacy as well as visual and the ordinary sort of literacy. Manovich's *The Language of New Media* presumes that digital media constitute a new logic or typology of meaning. Though he is careful to interrogate this assumption, it is often claimed that interactivity is the salient aspect of this language that distinguishes it from others. Interactivity is envisioned as empowering—the act of clicking and moving one's perspective in the context of the dynamic screen is figured as creating interacting subjects. The myriad ways that interactivity creates a fragmented and decentered subject have been the target of recent critiques; Hall's and Armstrong's are fairly typical. In this chapter I wish to ground my discussion of the popular Internet and its involvement in the process of digital racial formation by examining the ways that visual capital is created, consumed, and circulated on the Internet. If we are starting to understand what the *subject* of interactivity might look like or be formed, what or who is its *object*?

For there must be one. Parks defines visual capitalism as "a system of social differentiation based on users'/viewers' *relative* access to technologies of global media."[5] This is welcome language in that it stresses *ongoing* processes of differentiation in access, rather than assuming that access to technologies like the Internet are binary; either you "have" or "have not." The problematic that I wish to delineate here has to do with parsing the multiple gradations and degrees of *access* to digital media, and the ways that these shadings are contingent on variables such as class position, race, nationality, and gender. However, it is important to

avoid reifying these terms, and to instead stress that they are, in part, constituted by the subject's relation to these very technologies of global media. These questions of identity constitution via digital technologies have tended to get elided in critical discussions of Internet access, or when they are discussed, it is often as inconvenient stumbling blocks that stand in the way of the ultimate goal: universal access. What has yet to be explored are the ways that race and gender permit differential access to digital visual capital, as well as the distinctive means by which people of color and women create and in some sense redefine it. Women and people of color are both subjects and objects of interactivity; they participate in digital racial formation via acts of technological appropriation, yet are subjected to it as well.

In John Berger's influential visual culture primer *Ways of Seeing*, the subject is defined as that which views, and the object as that which submits or is subjected to the gaze: he dubs these two positions that of the "surveyor" and the "surveyed."[6] He is most famously concerned with the gendering operations of the gaze in portraiture and pornography, but his success in creating a critical framework and methodology has much to do with his parsing of power relations in the field of the visual. Digital visual culture presents a challenge to this formulation: while the difference between the viewer and the viewed, the producer/artist and the subject/model, was clear in more traditional art (while reading Berger, it is always clear who he means by "artist," "spectator/owner," and "object" of representation), it is not so clear when discussing networked digital media. New media are produced and consumed differently. In addition, we often get the double layer of performance that comes with the viewer's act of clicking.

So rather than focusing on the idea that women and minorities need to get online, we might ask: How do they use their digital visual capital? In what ways are their gendered and racialized bodies a form of this new type of capital? What sort of laws does this currency operate under? It doesn't change everything, but what does it change? This brings us back to the privileging of interactivity and its traditional linkage with the creation of a newly empowered subject.

According to Lev Manovich's provocative "myth of interactivity," "interactive media ask us to identify with someone else's mental structure." Rather than allowing the user to have an open-ended, seemingly limitless and boundless experience of reading, Manovich stresses the rigidity of hyperlinking as a mode of experiencing information: when "interactive media asks us to click on a highlighted sentence to go to another sentence . . . we are asked to follow pre-programmed, objectively existing associations."[7] According to this interpretation, we are ideologically interpellated into the "new media designer's mental trajectory," just as in Hollywood film we are asked to "lust after and try to emulate the body of the movie star." Manovich's formulation allows us to trace the process of identification that occurs with new media use: he compares it to the viewer's process of identification with the star's body in the realm of film. And just as we have a well-developed theory of cultural capital and viewer identification involving stars, so too must we now view the interface as an object that compels particular sorts of identifications, investments, ideological seductions, and conscious as well as unconscious exercises of power.[8] In addition, just as star bodies provoke the viewer's gaze and must necessarily function as part of what Omi and Winant call a "racial project," so too do new media objects. Interactivity is indeed a myth and will remain so until and unless its participation in the gendered and racialized construction and distribution of embodied perspectives, or particular "mental trajectories" (a far from neutral term), is examined in light of cultural formation theory. New media designers are not yet movie stars, but as interfaces become ubiquitous means of accessing media of all kinds, their work enters the popular sphere and the public culture, and hence a corresponding interest in their modes of instantiating identity—their unavoidable implication in creating "mental trajectories" that we must all follow—must emerge from cultural and media theory. Instead the interface itself becomes

a star, and just like other sorts of stars, it works to compel racialized identifications; interfaces are prime loci for digital racial formation.

Part of the attraction of racial formation theory as espoused by Omi and Winant originally, and subsequently by the cultural theorists Lisa Lowe, Paul Gilroy, and George Lipsitz, is its impressive flexibility: it is defined as "the sociohistorical process by which racial categories are created, inhabited, transformed, and destroyed . . . a process of historically situated projects in which human bodies and social structures are represented and organized."[9] The Internet certainly represents and organizes human bodies and social structures in digital games, Web sites, CMC applications such as IM (Instant Messenger) and IRC (Internet Relay Chat) that involve a visual component, as well as in myriad interfaces. The interface serves to organize raced and gendered bodies in categories, boxes, and links that mimic both the mental structure of a normative consciousness and set of associations (often white, often male) and the logic of digital capitalism: to click on a box or link is to acquire it, to choose it, to replace one set of images with another in a friction-free transaction that seems to cost nothing yet generates capital in the form of digitally racialized images and performances. "Racial projects," defined by Omi and Winant as "simultaneously an interpretation, representation, or explanation of racial dynamics, and an effort to reorganize and redistribute resources along particular racial lines," produce race and initiate changes in power relations (125). When users create or choose avatars on the Internet, they are choosing to visually signify online in ways that must result in a new organization and distribution of visual cultural capital.

Racial formation theory has not often been used in reference to new media, however, partly because the frame of reference is so different (and because the early Utopian bent to Internet criticism meant that discussions of difference, especially if viewed as "divisive," were avoided). The difference between old and new media lies in the new media's interactivity, as mentioned before, but is also related to the blurred line between producers and consumers. Though utopian claims regarding the Internet's ability to abolish the position of the passive viewer, making everyone a potential publisher or creator of media, are less valid than previously thought (early predictions about everyone's eventually having or even wanting a personal home page have fallen far short of reality, though the popularity of blogs, vlogs, and social networks such as Facebook and MySpace are coming closer to this ideal), it is possible now, since the massification of the Internet in the United States, which is my frame of reference, to view media on the Internet as the product of non-cultural elites.

Since the turn of the century, the continuum of Internet access in the United States has gotten wider and broader—it is best compared to Rich's lesbian continuum and Parks's formulation of varying degrees of visual capital in the sense that everyone has *some* position in relation to it. Rather than a "digital divide" that definitively separates information haves from have-nots, the Internet has occasioned a wide range of access to digital visual capital, conditioned by factors such as skill and experience in using basic Internet functions such as "search" in addition to less-nuanced questions such as whether or not one possesses access at all.[10] While earlier racial formation theory assumed that viewers were subject to media depictions or racial projects that contributed to racialization, and that these projects were ongoing and differential but nonetheless worked in a more or less one-way fashion, new media can look to an increasingly vital digital cultural margin or counterculture for resistance.

AIM buddies, pregnant avatars, and other user-created avatars allow users to participate in racial formation in direct and personal ways and to transmit these to large, potentially global audiences of users. Intersectional critical methods are vital here; digital visual culture critique needs to read both race and gender as part of mutually constitutive formations. For example, in the case of sports gaming, most celebrity avatars are men because of the dominance of men in the commercial sports industry, and many of them are black for the same

reason. Yet black men are underrepresented as game designers, and it would be wrong-headed to mistake the plurality of racialized digital bodies in blockbuster games such as Electronic Arts' *Madden Football* to indicate any kind of digital equality in terms of race or gender.

What does an object of interactivity look like? In Jennifer Lopez's music video "If You Had My Love" (1999) the singer portrays herself as the object, not the subject, of the volitional mobility afforded the Web user. Shots of Lopez tracked by surveillance cameras alternate with her image as represented in a Web site: she shares the stage and gaze with the new media design interfaces in which she is embedded in an extremely overt way. This puts a new spin on the traditional female position as object of the gaze. While the video and its implied Web interface allow the user multiple points of entry into her digital image—streaming, still, live, buffered—Lopez herself is never represented as the user or viewer of this communicative technology, only as the viewed. In this way, the video gestures toward the traditional formulation of the gaze as described by John Berger in relation to traditional portraiture and the tradition of painting and visual representation generally. In other words, Lopez presents herself in this video as an *object of interactivity*, despite her position as the star and the knowing object of the interactive gaze. Examining this video enables a double viewing of interactivity and the star's body, the way that the object of desire (the star) can work with the subject of interactivity—figured misleadingly in this video as the user. In fact, it is really the invisible interface designer whose work conditions the limits and possibilities of interactivity in this case; if we view the media complex that is J. Lo as herself a carefully constructed "racial project," we can see the ways that the range of clickable options and categories available to the presumptive user in this video conditions the sorts of understandings of her raciality that are articulated to us. In this video we are asked to identify not just with the Web designer's way of thinking but with the viewer's way of clicking as well. The conditions of watching this video require us to see from the computer user's perspective; we cannot but shoulder-surf, since the setup only allows us to view the star's body by watching her movements on a Web site, a Web site that we do not control or click through. This is also a decidedly gendered gaze, since we are often put in a position in which we must watch a male watcher watching; we must witness his interactivity as our means to visualize the body of the woman.

In this video we have access to the star's body *through* the viewer's mind. We see her as he sees her, through interface use. This split represents a paradigmatic dichotomy in gender theory: the body is that of the Latina, the woman of color, and the mind is that of a white man. As Donna Haraway writes in her famous "Manifesto for Cyborgs," an essay that Csordas describes as "an anxious celebration of our contemporary transformation into cyborgs,"[11] the "offshore woman" or the woman of color in the integrated circuit of information technology production is framed as an object rather than a subject of interactivity. There is much at stake, however, in observing the ways that members of the Fourth World—women of color, members of linguistic and ethnic minority cultures, the global underclass—negotiate their identities as digital objects and in incremental ways move them toward digital subject-hood. The reason for this is that, as Chela Sandoval stresses quite strongly in *Methodology of the Oppressed*, a work that takes Haraway's notion of the cyborg subject and develops it into a strategy for acquiring power for women of color in the context of a technologized world, "the methodology of the oppressed can now be recognized as the mode of being best suited to life under neocolonizing postmodern and highly technologized conditions in the first world; for to enter a world where any activity is possible in order to ensure survival is to enter a cyberspace of being."[12] In other words, it is precisely because the world inhabited by wired, technologized, privileged subjects requires constantly shifting and contingent work skills, educational preparation, and cultural expertise that the "technologies developed by subjugated populations to negotiate this realm of shifting meanings" can prove indispensable.

The Fourth World has always been "just-in-time," having lacked the luxury of guarantees and assurances of care from the state. Indeed, Jennifer Lopez's deployment of shifting visions of ethnicity brokered through Web and television interfaces represents this sort of impressively flexible range of movement through identity positions, one that seeks its niche through the volitional mobility of the interacting viewer.

This music video, Jennifer Lopez's first, was number one for nine weeks in 1999. Lopez's DVD biography on "Feelin' So Good" informs us that "If You Had My Love" was her first number one single, as well as her first video, and that it was certified platinum. The hit topped the Hot 100 for five weeks in 1999, and the single sold 1.2 million copies outside the United States as of 2000. Importantly, the biography describes her as a "multimedia success." In keeping with this notion, it was also digital from the ground up, not just in terms of its production, though much is made of its links with the Web in the "Banned from the Ranch" Web site. (Banned from the Ranch is the name of the production company that programmed the fictional Web interface deployed in the film.) Its subject matter, the way that it compartmentalizes physical space, virtual space, music genre niches, and modes of interaction, is in keeping with the logic of new media as explained in Manovich's seminal work on the topic: it combines modularity and automaticity with the added benefit of simulated liveness. In addition, Jennifer Lopez's rise as star coincides with the Internet's rise as a mainstream visual culture with its own interventions into traditional media cultures. In 1999 we can witness the shift occurring from one mode of influence, old media to new, to another, new media to old.

Like the *Matrix* films, the "If You Had My Love" video visually represents active navigation through data. Clicking on links enables the implied viewer to loop through time: by backtracking, the viewer can instantly restart at the beginning of the video or rewind to watch a favorite bit repeatedly. However, unlike these films and other science fiction films, the video presumes muitichanneled viewing in the context of everyday life rather than in an overtly fictional and phantasmatic future. The video opens with a scene of a man sitting at his computer desk in a darkened room of his apartment and typing the words "Jennifer Lopez" into a search field in a Web browser. Her Web site pops up on his screen, and she starts singing and dancing as he watches, alternately typing on the keyboard, which he holds on his lap as he leans back and strokes his own neck and face in an overtly cybersexual gesture. (Early writing on virtual identity by Sandy Stone posited that phone sex was the best metaphor for Internet-enabled telepresence; Lopez's video acknowledges Stone's assertion with a nod to the Internet's most technologically sophisticated, long-standing, and profitable usage: distributing visual images of pornography.)[13] The rest of the video consists of scenes of Jennifer Lopez viewed through her as-yet-fictional Web site as we witness people in a wide selection of networked computing environments watching her: we see a young girl in her bedroom with her computer, a pair of mechanics watching a wall-mounted television with an Internet connection, a rank of call center workers with headphones and computers, and two young Latina women using a laptop in their kitchen. These scenes clearly reference television/Internet convergence as they depict both public and private televisual screens and solitary and shared instances of screen usage.

But more importantly this is one of the most intimate scenes of computer interface usage I can remember seeing; intimate because it is about desire mediated through the computer, men masturbating as they surf the Web to look at sexy images of celebrity female bodies.[14] It is also intimate because it is *close;* as we watch the man keyboarding and mousing, we see Lopez's image respond interactively to it; as he manipulates his joystick, we see a large black ceiling-mounted surveillance camera follow her into one of her "rooms," and computer windows pop up, close, promote, demote, and layer in response to his typing and clicking. The page on the site titled "Jennifer's Rooms" lists buttons and icons for "Corridor, Living Room, Shower, Hair Dryer, Bathroom, and Dressing Room," thus spatializing the Web site

in terms that evoke the star's private home and the space of intimacy. The surveillance cameras and arrangement of the interface as clickable "rooms" enforce webbed voyeurism, evoking the visual culture of liveness through Webcams, and a particular sort of eroticized, privileged view of the star. (Of course, videos have always purported to give a privileged look at a star. The fiction of volitional viewing enacted in this video is a fantasy of networking in the context of interactivity.) Indeed, the video visualizes the interface user's volitional mobility via the cursor, which functions as his proxy in this scene, as it does when we use the World Wide Web generally. We are seeing as he sees: it is an act of witnessing voyeurism. But more importantly we are seeing the mechanics by which he manipulates the view of Lopez as the video's audience watches; the apparatus of the keyboard, mouse, and joystick is foregrounded and in constant use.

The Jennifer Lopez online page features navigation links at the bottom for "Gallery, Lopez Dance, and Jennifer's Rooms." The video as a whole operates as a record of a navigational session within multiple nested interface frames, one of which is called "Internet TV," overtly referencing a greatly anticipated technological convergence that still has yet to arrive and was certainly far from a reality in 1999. The other menus we see at the bottom of the initial interface's splash screen are "sights and sounds, chat, links, views, news & info, contests, gallery," thus displaying the conventional organization and categorization of media types common to conventional Web sites rather than television or video.

This video's mode of production differs quite a bit from those that came before it (but helped to determine those that came after), and this difference is the basis for a fascinating press release by Banned by the Ranch, the production company hired to create the computer interfaces featured in the video. Why did the video's producers feel the need to commission a fictional interface and browser in their attempt to invoke the World Wide Web? The producers address this question quite explicitly on their Web site, explaining that Web-savvy audiences in the nineties require "realistic looking interfaces" to create *televisual* verisimilitude; in other words, in order for the virtual to look realistic, interfaces have to look like they could be "real" as well, and in this case the "real"—Internet Explorer, Netscape, or AOL's proprietary browsers, which were familiar to Internet users at that time—just wouldn't do. This creation of a brand-new interface might also be motivated by some caution regarding copyright law—Apple's "look and feel" lawsuit against Windows had recently brought the notion of the interface as private property into the public eye. In addition, there may also have been concerns regarding conflicts of interest. For example, the films *You've Got Mail* (1998) and *Little Black Book* (2004) feature America Online and Palm personal assistant interfaces prominently; in the first case, corporate partnerships or "synergy" between media companies made this possible, and in the second, conflicting industry interests almost scuttled the project. Problems arose when executives at Sony Pictures Entertainment, one of the companies that was to distribute the film *Little Black Book*, realized that Sony manufactured its own PDA device, the Clié, which competed for market share with Palm. Luckily, the film was greenlighted *after* the Clié went out of production, solving Sony's conflict of interest problem regarding interface use. Giving screen time in a mass-market film to a particular interface has always been seen as an exceedingly valuable form of marketing or product placement, particularly because the logic of the films usually requires that viewers pay close attention to the devices to follow important plot points. The device itself is less the point than is the foregrounding of a particular type of screen within a screen, an interface.

As mentioned before, the interface is itself a star of Lopez's video and is coming to take on starring roles in other types of non-desktop-based digital media, like films, videos, and console games. Creating a fictional interface solves potential problems with industry conflicts as well as contributing toward the sense of an alternative networked world accessible through the desktop computer, giving yet one more means of control to media producers. The

deployment and visualization of "fictional software" created for Lopez's video, which was dubbed "NetBot" by Banned from the Ranch and originally developed for the graphics on the hit youth film *American Pie*, envisions software interfaces as key aspects of a televisual image's believability or realness, It is interesting to note that the production of the video preceded that of the star's "real" Web site: Banned by the Ranch's "intention was to make sure the videos' web site would match the real-life Jennifer Lopez web site . . . a site that was yet to be developed" in 1999, a time in which it was clear that the music video was a crucial medium for musicians finding a global market, while the Internet was not. The Lopez site was ultimately designed by Kioken, a high-flying and innovative Web site design business that went bankrupt in 2001.

The "Lopez Dance" screen offers several menu choices: "Jazz, Latin Soul, and House" (we don't see "Jazz" enacted in the diegetic space of the embedded performance, perhaps because this is one of the few popular genres that Lopez is not associated with in any way; it represents a purely speculative and fictional future, one that has a racialized authenticity all its own). Articulating these musical genres highlights the star's diversity, ironic in the case of "If You Had My Love," which, like most of Lopez's other songs, borrows liberally from these genres but doesn't itself recognizably belong to any genre at all except pop, and works as a way to sell and brand otherwise unidentifiable music, very important when half of all music that is listened to is not sold to a listener but rather "shared" among listeners, or stolen. The "Latin Soul" sequence, launched when the male viewer clicks on the link that activates it, depicts Lopez in a short, tight white dress as she performs flamenco-inspired arm gestures and salsa-type moves to techno-salsa music. This musical interlude functions like a cut scene in a video game such as *Grand Theft Auto: Vice City* and *GTA: San Andreas* in that it fragments the narrative and in this case the musical flow. The logic of abrupt movement from one genre of music or media to another reflects the fragmented attention of the viewer, tempted as he is by the array of choices presented by the interface. We are switched from one to another at his pleasure. The pleasure of the interface lies partly in its power to control movement between genres and partly in the way that it introduces musical genres that audiences may not have known even existed. J. Lo's readiness to fill different musical, national, and ethnic niches reflects the logic of the video and of the interface and its audiences; as she shifts from cornrowed hip-hop girl with baggy pants and tight shirts to high-heeled Latina diva to generic pop star with straightened hair and yoga pants, we see the movement as well between identities that characterizes her construction in this video as a digital media object of interactivity. She becomes an object of volitional ethnicity as she is constructed as an object of the user's volitional mobility.

Most importantly, this video walks the viewer through a process of digital racial formation; in a cut scene that functions as the transition to the world "inside" the interface that we see when it is clicked, shards and bits of gray confetti take flight past the viewer's perspective to represent the way data is supposed to look. As this "white noise" resolves itself into a signal, a coherent visual image coalesces from these pieces of data into images of Jennifer Lopez dancing in the nationalized and racialized genre that the user has chosen, and we can see the formation of the colored and gendered body from undifferentiated pixels, at the pleasure of the viewer, and also the formation of the bodies of color, race, language, and nation as playing particular roles, performing particular work, in the context of new media. Like J. Lo, Filipino and Russian Internet "brides" are also clickable, women who can be randomly accessed via the Web. Their performances online are certainly different in kind and quality from that of the site's designer or user: their job is to perform a kind of racialized submission, to the viewer's interactive gaze and to the geopolitics that compel their digitized visual identity performance. In the case of the video, the cursor functions as a visual proxy that in this case stands in for the viewer; it is itself a kind of avatar and in recent times a

televisual stylistic convention familiar to us in all sorts of contexts, used in PowerPoint presentations as well as in children's programming, such as *Dora the Explorer's* use of the computer cursor superimposed on the screen as a point of identification for children. Though Dora's viewers can't control the cursor, they can witness the cursor's movements and implied user control, thus enforcing visual if not functional media convergence between the computer and the television. Sarah Banet Weiser's work on *Dora* emphasizes the ways in which race is marketed as a "cool" way to help children learn language skills, one that hails Latino and other viewers of color in ambivalent, largely apolitical, and "postracial" ways.[15] *Dora the Explorer* depicts the Latina main character as an avatar who guides the child-viewer through the logic of the learning-game interface but does not stand in for the viewer herself: the Latina Dora is an object rather than a subject of interactivity, just as Nickelodeon posits the show's audience as primarily white, middle-class, and able to afford cable, rather than as viewers who "look like" Dora herself.

The visual culture of the female object (rather than subject) of interactivity has yet to be written. The varied audiences depicted watching Jennifer Lopez via streaming video online represent varied subject and object positions and points of gender and ethnic identification: black men and white men from both the working class and the growing ranks of information workers at a call center and from the home office click on her as an object of desire; young girls in suburbia and young Latina women in domestic spaces click on her as an object of identification in a gesture of interactivity that may have something to do with staking out a position as a future subject of interactivity. Surveillance cameras, a technology whose function is to police the division between subject/object relations, are depicted here in the context of the Internet as a means to give instant and interactive access to the star to all groups. The early promise of the Internet to make every user a potential "star" has since contracted to offer seemingly deeper or more intimate user access to stars from "old" media instead. The history of the Webcammed image, traced by Steven Shaviro from its origins in the Trojan Room Coffee Machine in the computer laboratory at Cambridge University, which went online in 1991, to Jennifer Ringley's Jennicam, which went online in 1996 (and has since gone offline), reveals a progression from an original fascination with the apparatus of webbed vision itself—the "liveness" of the Webcammed image, even in relation to an object as intrinsically unexciting as a pot of coffee—to a particular investment in the naked female body as an object of vision via the Internet.[16]

The thesis of this video is the thesis that describes our media landscape since 1999: convergence has created a condition within which stardom itself has become "multimedia." It is nothing new for stars to excel in multiple media: actors sing, dancers act, singers dance, and many stars have marketed perfumes, clothing, and other commodities successfully. These provide multiple modes of identification with stars. However, the "If You Had My Love" video sells multiple points of entry to the star, multiple ways of seeing and surveilling that are framed as exactly that, exploiting the interface as a visual culture that purveys an ideal and mutable female body of color, perpetually and restlessly shifting "just in time" to meet fickle audience preferences. In this book, I trace how the mediation of digital user and object identity as citizens, women, and commodities on the Internet is regulated and conditioned by the types of interfaces used to classify, frame, and link them.

To argue for the necessary intervention of visual culture studies into Internet studies, one might ask: how does the Internet's visual culture create, withhold, foreclose, distribute, deny, and modulate the creation of visual and digital capital? Visual media are as often as not viewed through the lens (and logic) of the computer-driven interface, making ways of negotiating, navigating, and situating oneself via its landscape of chapter titles, hyperlinks, and menus a necessary aspect of media use. DVDs, satellite and cable television and radio, and DVRs like TiVo and Replay all compel menu trees of choices, choices that, when made,

foreclose other choices. The narrowing and piecing-up of the formerly continuous image stream of a film into named and discrete chapters, as in the case of many commercial cinematic DVDs, and the separation of songs into genres like "Electronica," "Boombox," and "R and B/Urban," as in the case of Sirius satellite radio playlists, breaks up what had been a more flow-oriented media experience into digitized separate "streams" (or "channels," as Sirius labels them). This packetizing of media into different categories follows ethnic, linguistic, national, and racialized lines. The "If You Had My Love" video mirrors this logic of the interface and its policing of categories by chopping up and streaming the star's image-body into identifiable ethnic and racialized modes—black, white, and brown.

Jennifer Lopez has been dubbed a multimedia star partly because she appears in several electronic media, but she also has established herself in the world of offline, nonephemeral commodities such as fashion and toiletries. This convergence of separate spheres—"real" versus virtual, abstract versus concrete commodities—mirrors the convergence of media displayed in her video, and also her own converging of differing positions vis-à-vis her own ethnic identity. Her real-life transformation from an "ethnic star," defined primarily by her appearances in "ethnic films" such as Selena and Mi Familia in which her racialized Latina body serves to authenticate the "realness" of the Latino mise-en-scène, to a "global" or unracialized star, as in Out of Sight and The Wedding Planner, is mirrored in the video's modes of identity management via the interface.[17] The interface lets you "have" Jennifer Lopez in a variety of ethnic and racialized modes by clicking on one of many links.[18] It addresses the audience by figuring her kinetic body as plastic, part of a racial project of volitional racialization through interface usage.

The "If You Had My Love" video compels a different sort of media analysis than had been necessary before the massification of networked, interfaced visual communications like the Internet. Earlier modes of reading television and film do not suffice because of the prominence of the interface as more than just a framing device; interfaces function as a viewing apparatus, and in many cases they create the conditions for viewing. Rigorous readings of Internet interfaces in and outside their convergences with photography, film, television, and interfaces from other visual genres such as stand-alone digital games are crucial for understanding how modern race and gender are constructed as categories and (sometimes, sometimes not) choices. The increasingly visual nature of the graphical Internet after 1995 calls for a displacement in our modes of critique from an earlier scholarly focus on textuality to those that examine the Internet's visual culture in a broader way. The extensive nineties literature that celebrated digital textuality's postmodern open-endedness and constructedness by emphasizing the interactivity offered the user, who became an active user rather than a passive consumer, tended to neglect the specifically visual in favor of developing text-based arguments.[19]

Notes

1 See Lisa Nakamura, Cybertypes (New York: Routledge, 2002).

2 Ron Eglash et al. (eds), Appropriating Technology (Minneapolis: University of Minnesota, 2004); Alondra Nelson, Tuy Tu, and Alicia Hines, Technicolor: Race, Technology and Everyday Life (New York: New York University Press, 2001); Tal, The Unbearable Whiteness of Being.

3 Tara McPherson, " 'Re-load' Liveness, Mobility and the Web," in Mirzoeff (ed.), The Visual Culture Reader (New York: Routledge, 2002), 468.

4 Lisa Parks, "Satellite and Cyber-Visualities," in Mirzoeff, The Visual Culture Reader.

5 Ibid., 284 (italics mine).

6 John Berger, Ways of Seeing (London: BBC, 1973), 46.

7 Lev Manovich, Languages of New Media (Cambridge, MIT Press, 2001), 61.

8 On the topic of stars, see Dyer and MacDonald, Stars; and Michael DeAngelis, Gay Fandom and Crossover Stardom (Durham: Duke University Press, 2001).

9 Howard Winant and Michael Omi, *Racial Formation in the United States* (New York: Routledge, 1994), 124.

10 See Esther Hargittai, "Digital Inequality," in Kathryn Neckerman (ed.) *Social Inequality* (New York: Russell Sage Foundation, 2004); and Hargittai, "Internet Access and Use in Context," *New Media and Society* 6: 1 (2004).

11 Thomas Csordas, cited in Nancy Scheper-Hughes, "The Global Traffic in Human Organs," *Current Anthropology* 41: 2 (2000).

12 Chela Sandoval, *Methodolofy of the Oppressed* (Minneapolis: University of Minnesota Press, 2000), 176.

13 Sandy Stone, *The War of Desire and Technology* (Cambridge, MA: MIT Press, 1995).

14 See scholarship on Virtual Valerie for an account of nonnetworked virtual pornography. Media convergence brought about by the Internet demonstrates the ways that this video offers the same view that television does; however, television has become more sexualized since the early nineties, while the Internet is a relatively decentralized many-to-many medium that has always distributed pornography.

15 Sarah Banet Weiser, "Consuming Race on Nickelodeon," Unpublished MS (2005).

16 Steven Shaviro, *Connected* (Minneapolis: University of Minnesota Press, 2003), 77.

17 See Rey Chow, *Ethics After Idealism* (Bloomington: Indiana University Press, 1998), for a discussion of the power of "ethnic film" to authenticate difference via visual depictions of a exotic ethnic past.

18 See Mary Beltrán's work on Jennifer Lopez's transformations across different racial identities (Mary Beltrán, "The Hollywood Latina Body as a Site of Social Struggle," *Quarterly Review of Film and Video* 19: 1 (2002)).

19 See Steven Johnson, *Internet Culture* (New York: Basic Books, 1997); George P. Landow, *Hypertext 2.0* (Baltimore, MD: Johns Hopkins University Press, 1999); and Sherry Turkle, *Life on the Screen* (New York: Simon & Schuster, 1995).

Lisa Cartwright and Morana Alac

IMAGINATION, MULTIMODALITY AND
EMBODIED INTERACTION:
A DISCUSSION OF SOUND AND MOVEMENT
IN TWO CASES OF LABORATORY AND
CLINICAL MAGNETIC RESONANCE IMAGING

IN THIS PROJECT WE COMBINE an analysis of multimodal interaction (e.g., Goodwin, 2000a; 2000b; Heath and Hindmarsh, 2002) in magnetic resonance (MR) laboratory with a reading of a patient experience in the MR clinical context. We consider the co-construction of meaning and experience in these two contexts, focusing on the intersubjective enactment of imagination (Murphy, 2004, 2005) between researchers, and between patient and clinical technician (for a treatment of imagination in the workplace see also Suchman, 2000). We propose that meaning is spatially and intersubjectively enacted in embodied practice through gestures (which in some cases can be acoustic as well as visually perceived events), vocalizations (acoustic events which may be linguistic or nonlinguistic), relationships of gaze and body position, and negotiation of representations and instrumental modalities in the environments of the magnetic resonance laboratory and clinic (Alac and Hutchins 2004, Alac 2006). Actors in the fields of enactment we consider include bodies, equipment, representations, as well as the space of the imagination.[1]

Our concern particularly rests with what does not explicitly appear in the visual images observed by laboratory researchers, but what is deduced and articulated—in a word, imagined between them—on the basis of images. We propose that these performances by researchers of activity they together imagine the research subject to have performed but which were not directly observed are worthy of consideration for what they can tell us about the function of imagination in the production of meaning and in the constitution of the representation of the research subject in the laboratory or the clinic. Our contribution, then, is to introduce the idea of the imagination of the researcher and the research subject as important entities of laboratory study. Further, we stress that the performance of the researcher or technician of an imagined process that an other body undergoes inside the vacuum tube—a performance enacted before the technician, apprentice or collaborator researcher, is another important representational and imaginative aspect of laboratory and clinical work processes.

Embodied performance, vocalizations and speech are elements we can empirically observe and analyze to get at these aspects of making visible researchers shared imagined aspects of another's unobserved behavior or feeling. Our emphasis in part, then, is the researcher bodies that interact with elements in the visual, spatial, and acoustic field to perform an interior image of another, absent body that he or she hopes to better know or understand. This requires an analysis that accounts for the movements, utterances and relationships of bodies in the visual field as well as for data such as images, text, graphs, and computer screens, as observation of these sites helps up to understand what lies outside our reach: namely, the nature of the imagination. Movement is important to our discussion because the two cases we discuss involve interpretation of fMR (functional magnetic resonance) images.[2]

When we hear the term imagination, we typically understand this to mean the images and ideas, percepts and symbolic representations held by or in the mind of the individual subject as he or she comes to understand objects, others, and experiences in the world through embodied sense perceptions. The locus of imagination is typically understood to reside in the mind of the individual, with communication between individuals functioning as a means of externalizing and communicating precepts or symbolic material intersubjectively. Imagination tends to be discussed in relationship to works of art and creative expression, not scientific practice. Finke, Ward and Smith (1993) describe imagination in a manner that emphasizes the verbal as well as visual nature of imagined entities, and the fact that imagination results in the production of something new and not merely a recollection of something already known (as in memory processes). For them imagination is

> the process by which people mentally generate novel objects, settings, events, and so on. It is more global than mental imagery in the sense that although these imagined entities might take on the form of mental images, they need not. Imaginative products can also exist in the form of verbal description. Imagination is also more restrictive than mental imagery in the sense that it must involve the generation of something new, whereas certain manifestations of mental imagery can be purely recollective.
>
> (Finke, Ward, Smith 1993, 115)

We embrace the expanded focus from mental imagery to the verbal, and the emphasis on the function of imagination beyond memory. However, we orient our use of the concept of imagination differently in a few ways. First, we emphasize that imagination is more radically multimodal, as well as more dynamically intersubjective and co-constructed, than this model of images and words allows.[3] Second, with Murphy (2005), we challenge the idea that the mind is the holding ground for imagination. The process of the co-construction of imagination, in the settings we describe below, occurs in a highly fluid and interactive manner between researchers or clinical technicians as they produce or analyze MR data; but it also includes other active agents that move imagination's co-construction beyond the models of conversation and human communication. As has been shown by sociologists and anthropologists of laboratory practice,[4] included as agents or actors in the networked processes of laboratory work with living himan bodies are not only patients and research subjects, but also representational data, instruments, technologies, bodies of knowledge in the field tacitly and explicitly recalled, and many other entities and artifacts (Knorr Cetina 1999; Latour 1999; Pickering 1992, 1995).

Second, we emphasize that the metaphor of the mental image (Descartes, 1642/1984) which is at the root of the term imagination leaves us without adequate means to describe other sensory forms of imagination's enactment including and beyond the verbal. These include nonverbal vocalization and produced sound; the tactile and felt aspects of embodied

interaction; and the intersubjective performance of gesture, bodily movement, and gaze that give shape to relationships between bodies in space (Alac 2006, Alac and Hutchins 2004). These experiences are not fully captured in the idea of "image" that is at the core of the concept of imagination. Mark Johnson, in his book on moral imagination and the implications of cognitive science for ethics, notes: "metaphor is one of the principal mechanisms of imaginative cognition" (Johnson 1993, 33; see also Johnson, 1987, 1991 and Fauconnier & Turner, 2002). We suggest that what the researcher "imagines," whether understood as mental image imagination (Fodor, 1975; Kosslyn, 1980; Pylyshyn 1973; Tye 1991), verbal description (Finke, Ward and Smith) or metaphor (Johnson 1987, 1991), takes shape in the space of interaction through modalities and representations that go well beyond these more familiar forms to include nonlinguistic vocalization, gesture, and embodied interactions. Moreover, these may escape signification in the strict sense. Although these processes unfold through social interaction, our point is not the simple one that they are therefore socially or culturally constituted and not strictly "of the mind." We remain concerned with aspects of interaction that occur in material interaction but nonetheless escape the realm of shared representation and meaning strictly speaking. Our approach is to emphasize that what is experienced as "of the mind" or "in the mind," and what is felt without registering as consciously recognized meaning, remains of critical importance even as we shift the focus to the space of social interaction and knowledge and meaning production.

Third and relatedly, we are concerned with the concept of imagination's historical link to that which is "not real," that which exists only in a location of mind we identify as "the imagination," or to the Platonic idea of mental precepts as representations of the real.[5] Imagination, multimodally and intersubjectively produced, we propose, is a strong aspect of moving along the production of scientific knowledge and meaning, even as imagination carries these associations of the imaginarty and/as the "not real."[6] Our aim is not to show that imagination helps us to arrive at the real, or at knowledge and meaning, but rather to uncover the ambiguous and complex place of imagination as an essential component of the real and of meaning in diagnostic and research-based interpretive practices.

Finally, we suggest that the intersubjective production of imagination need not entail either the conscious involvement or the physical presence of every agent involved. For example, the researcher need not consciously perform a gesture or vocalization for that movement or utterance to take on meaning and have consequences in the shared space where meaning is produced. And a research subject or patient who is not present at the time that researchers or technicians analyze his or her MR brain data is no less present as an agent in the process of co-constructing the meaning of his or her data set. He or she may be constituted—imagined—as living, present, and willful, active agent in the process of analysis that unfolds around his or her MR data.

Two of the concerns that emerge in our discussion below are the questions, when does the research subject or patient become visible or present in the process of interpreting his or her MR data; and how does this "making visible" of the research subject occur? Our project differs from other recent work on MR imaging in that we attempt to bring into view the subjectivity of the research subject or patient. However, we do so not to constitute this subject in a realist or humanist sense, as subjects whose humanity is left out of the laboratory picture, for example, but to emphasize the embodied presence and agency of the human subject as always present in laboratory and clinical processes. Scholarly work on MRI in sociology and anthropology has tended to focus on brain imaging, and has taken up the status of the brain as the conceptual locus of what it means to be human in the current research and popular context (Beaulieu 2002, 2004; Dumit 2004, Roepstorff 2001). In the processes we discuss, the brain and spinal cord are the objects of concern as well for precisely these reasons. In the interactions we describe, however, what we see produced among practitioners is an

imagined sense of the human subject as a whole body and a cognizant subject whose move-ments signify agency, even as the brain or spine are the isolated objects of scientific or clinical concern. Furthermore, practitioners use their own bodies to make sense of and construct meaning and knowledge about the bodies they study. For example, as we will explain below, in interpreting data, researchers often perform and enact what they imagine to be the imaged body's trajectory as it performed within the imaging process whose documentation they review after the body is gone from the laboratory or clinic. In addition to imagining, on the basis of documentation, what the body actually did, they also introduce ideas about the kinds of bodily behavior and movement one would expect of a research subject. In the examples we discuss, the presence of the whole body and its actions, understood to be motivated by the human subject, are experienced by researchers as constant problems to be negotiated, managed, and ultimately cleansed away in laboratory and clinical analyses.

We discuss the external expression of imagination in two sets of examples, presented in an intertwined way. In one case, researchers or technicians individually or collaboratively (in teams) imagine and perform the experience that an other body, the body of the research subject or patient that they work with, has undergone during a magnetic resonance imaging process, in order to interpret and communicate research or clinical images or data. In another case, we narrate a process wherein the research subject inside the tube imagines himself or herself to be constituted in relationship to an other human subject, the technician who conducts the imaging process, and who stages and prompts the patient or research subject's performance inside the machine. In what follows, we interpret these two scenes of perform-ance of imagination as they are enacted both multimodally and intersubjectively. This action takes place in the laboratory or clinic, and importantly includes the space inside the vacuum tube that houses the imaged body. The interior of the vacuum tube is an underconsidered site of physical experience, observation, and of activity that is a scene of at times intense imagina-tion and speculation on the part of technicians or researchers, even as it is a space they cannot, in many respects, see.

Embodied performance, vocalization and speech between subjects who together inter-pret MR images are elements we may empirically observe and analyze to discern the trajec-tory of the researchers' individual and collective mental image of another's unobserved behavior or feeling. In our discussion of researchers below, our emphasis is upon bodies that interact with elements in the visual field to externally demonstrate an interior image of another whose movements he or she hopes to better know, understand, or communicate. We interpret the movements, utterances, and bodily relationships performed in the visual field by researchers as they work in teams to view and interpret the images positioned before them, in the absence of the body of the research subject whose images are being interpreted.

In our first case, a discussion of researcher interaction, our emphasis is in part upon the pedagogical aspects of interactions in which the process of enacting the production of an image and its interpretation requires instruction and guided performance between experts and novices. We follow the interactive process in which researchers sit together before a computer screen, looking and gesturing toward their own bodies and the body of their colleague as they collaboratively not only produce but also inhabit the meaning of the MR body image before them. We assume neither that the expert always remains in the instruc-tional mode, nor that the novice refrains from interpretive or definitive acts. The relationship of expert to novice is fluid and shifting. What concerns us is not only the two bodies of the researchers and their fluid interaction, but the multivalent relationship that also includes the image screen and the mental screens of the researchers, as well as the imagined, absent body whose representations inhabit those screens, and whose performance is the object of the researchers' concern. In multimodal studies of conversation in workplace and laboratory practice, applied linguist Charles Goodwin has emphasized dialogic, multiparty activity,

gesture, and performance as aspects requiring careful consideration. His studies of multi-modal semiotic interaction in the workplace and in laboratory practices have included visual documentation as an empirical record of interactions, and in some cases graphs, charts, and pictures have been taken into account as modalities requiring consideration in the analysis of these contexts. We draw on the technique of multimodal laboratory analysis used by Goodwin (2003a, 2003b, 2003c). Our approach differs from his, however, in that we emphasize the imagination as a crucial element in laboratory and clinical communication. We draw upon our respective areas of expertise as a researcher trained in semiotics and cognitive science who works in the mode of ethnographic documentation of laboratory work (Alac) and a communication and media scholar who works in qualitative methods of visual analysis (Cartwright) to render a discussion across these two domains.

Bodies, in our account, are elements that perform semiotically and affectively in the visual field, interacting with nonhuman elements in that field to bring meaning to the MR image. Our account is based on empirical observation of those aspects of the clinical and laboratory experience that are most intangible. But we wish to approach these through the tangible aspects of the psychic relationship of interlocutor and actors, human and nonhuman, and the tangible enactment of the imagined activity or feeling co-constructed in that setting. To do this requires attention not only to speech and data representations, as would be expected in a semiotic analysis, but also to vocalization, gesture, bodily positioning, and intersubjective movement—elements of the dialogic that go beyond representation and conversation.

Sound and movement present useful entry points for the discussion of visuality in scientific practice. Magnetic resonance has been associated with imaging for most of the technique's history. Sound, however, is a phenomenologically pervasive, one might even say intrusive, part of this modality. It is emphatically present in the production of MR data. Studies of MRI have emphasized the interpretation of recorded image and numerical data reports, with little discussion of the acoustic experience of the MR data production process as experienced by the researcher, the technician, the patient or the research subject. Sound is a significant absence in social studies of MRI, considering the extent of its presence for researchers and technicians who work with this modality regularly, and for patients and research subjects who encounter sound unexpectedly when they are anticipating an "imaging" study. Below we introduce a discussion of the acoustic experience of MR data production, and the role of sound in the enactment of coaching the patient through the imaging process, as well as in the researcher's process of explaining and classifying MR data for the benefit of a co-worker. Our point about sound is that it is viscerally present and physically experienced, though rarely addressed as a significant factor in social studies of MR laboratory work. Second, we emphasize that sound serves a role as a representational and explanatory model in coaching the patient or research subject, and in teaching or explaining the MR process from researcher to researcher. Sound is thus an empirically felt disturbance in the production process of MR "imaging" data for researchers, technicians, patients and research subjects. But it is also nonetheless pragmatically enlisted as a semiotic resource in this process of relating to one another about the process among all of these interlocutors. A "disturbance" thus becomes a semiotic and mediational agent.

Regarding movement, which we also suggest is characterized as absence: In discussions of cinematic movement and temporality it is common to refer to the function of the sequential ordering of static frames and the incremental differences between those frames as significant factors.

Meaning, if we follow Sergei Eisenstein's use of the dialectic for film study, is produced in the dialectical collision of frames, and not in a single image. Researchers using structural magnetic resonance images to produce a set of anatomical images that offer a representation

of a given structure, such as a brain, at times follow a similar logic of reading differences between images for meaning. Some important information may reside in differences between frames and not within a given image: The appearance of spatial disjuncture within a given structure may, for example, be a product of the subject's unwanted movement in the scanner, leaving the researcher in the position of having to account for apparent movement in an imaging modality designed to document static anatomical form. Below we use the case of an interaction among researchers interpreting disjuncture between MR images in a series as a means of demonstrating documentation of something (namely, movement) that was neither intended to appear in the image, nor present in any one of these images per se. We emphasize, below, that movement is a visual absence, a troubling element hinted at in artifacts. Imagining the research subjects' unauthorized movements inside the tube thus becomes paramount to the researchers' process of seeing. It becomes of crucial importance to the researchers to identify in the image, and represent, perform, and experience in their own bodies, the aberrant movements they imagine the patient to have performed inside the tube—movements the researchers neither saw nor clearly documented, except as artifact.

Our point, then, in describing this process, is to demonstrate that methodologically when we analyze the visual we need to take into account not only aspects such as vocalization, gesture, bodily movement, and sound but also the imagination as it gives life to events unseen, unheard, and undocumented except as absence—in the differential between visual frames, for example, or as, in the case of sound, by-product of a process that produces numerical or visual data. Our point is not the familiar one that science strives to make visible and concrete that which is unseen, or that meaning is co-produced (this has by now been widely demonstrated). Rather, we emphasize that imagination, enacted intersubjectively through embodied performance and expression and interpreted through processes of identification and projection, is a crucial aspect of the processes of interpretation for the researcher, technician, and patient. While we will not elaborate this point here, this suggests that studies of scientific visuality might further consider issues such as identification, spectatorship, and subjectivity as aspects of laboratory and clinical experience.[7]

Sound as pedagogical agent in the interaction among researchers in the laboratory

In a functional MRI scanning process, the attainment of experimental data is not directly dependent upon sound per se. The high decibel "acoustic noise" is due to the vibration produced by the interaction between the static magnetic field and the time-dependent currents in gradient wires. Such noises may become a severe impediment for successful research in cognition, especially when acoustic rather than visual stimuli are used (e.g., research on language comprehension). However, the following excerpt from a functional (time-based, not static anatomical) magnetic resonance image (fMRI) apprenticeship (observed by Alac) shows how reenactment of sound can play an important role in the acquisition of expertise and in the construction of a shared professional vision (Goodwin, 1994, Alac and Hutchins 2004, Alac 2006).

The interaction described took place between a new member of the laboratory—Nick (N), and the experienced practitioner Eric (E). The new member was being taught the procedure of fMRI data analysis. As a part of the apprenticeship, Nick played the role of an experimental subject: before the analysis of the experimental data, he was scanned in the fMRI facility. In this process, lab members have an experimental subject, while Nick is more engaged in the viewing and analyzing of data, in order to further his understanding of the procedure.

The excerpt below details a part of the interaction where the two practitioners are seated in front of a laboratory computer. Eric explains to Nick how the data are organized:

EXCERPT 1

1	E:	Ok there are <u>three</u> studies (0.2) tha:t (0.1) were in this
2		directory. //There was,
3	N:	//Three?
4	E:	Yeah. (There) = cause there is localizer. Do you remember at the
5		very //beginning
6	N:	//At the beginning of functionals?
7	E:	No at the beginning of the //MP-rages
8	N:	//Oh ok
9	E:	You remember you've heard sort of clicking ch-ch-ch ((*imitates the*
10		*sound*)) and then you got just a quick ah ba:um, ba:um, ba:um,
11		((*imitates the sound*)) and then it was quiet and G. said this
12		was the warm up and here is the real one? That's the localizer.[1]

[1] Transcription conventions adopted with some changes from Sacks, Schegloff, & Jefferson (1979), and Goodwin (1994).

// The double oblique indicates the point at which a current speaker's talk is overlapped by the talk of another.

= The equals sign indicates no interval between the end of a prior and start of a next piece of talk.

(x.x) Numbers in parentheses indicate elapsed time in tenths of seconds.

: The colon indicates that the prior syllable is prolonged.

__ Underscoring indicates stressing.

() Parentheses indicate that transcriber is not sure about the words contained therein.

(()) Double parentheses contain transcriber's comments and extralinguistic information, e.g., about gesture, bodily movements, and actions.

Punctuation markers are not used as grammatical symbols, but for intonation:

. Dot is used for falling intonation;

? Question mark is used for rising intonation;

, Comma is used for rising and falling intonation.

In the beginning of the scanning process, the experimental subject is placed in the MRI scanner. After she or he is *aligned* so that the head is at the center of the magnet, a *localizer scan* is collected. The scan gives the exact location of the brain. Nick queries the number of studies in the directory (line 3), demonstrating his uncertainty about the meaning of the localizer scan. Eric, rather than providing a detailed linguistic and technical explanation of what a localizer scan is and when it is taken, chooses to imitate the sound produced by the scanner (lines 9 through 10). His voice, by bodily reenacting the *acoustic noise* that accompanied the scanning process, arouses a recall of the experience for Nick. Eric involves his body to provide an explanation of what is a localizer scan. Nick's comprehension is then achieved through an embodiment of Eric's embodied understanding: Nick re-enacts the experience of being in the scanner, following Eric's vocal prompt.

Although Eric's vocalizing constructs objects of knowledge and rationality, it is neither linguistic nor graphical in form. Rather, it is a nonlinguistic acoustic event. In this manner, noise, what was previously regarded as an undesired and undesirable aspect of the scanning

session, is reintroduced into the process of data analysis as a semiotic agent. Noise, reproduced through the vocal performance of the researcher, assumes an explanatory role that is strongly affective. It stimulates a kind of bodily recall in Nick, who then is prompted to re-enact his own experience in the scanner. The confounding factor of noise becomes an important element in the embodied procedure of sense-making between researchers.

Sound as medium between patient and technician

Here we shift to a different context—our second case in point, that of a patient undergoing a clinical MRI process. We introduce the term *acoustic envelope* to describe the enclosed space of the scanner. The term acoustic envelope was used in the writings of film theorist and historian Mary Ann Doane (1980) to describe the experience of the spectator as listener enveloped by sound in the space of the movie theater. Among sound technicians of the mid-twentieth century, acoustic envelope is a term that refers to the boundary of a listening or recording site and the sound of the ambiance, the air, within it (Burris-Meyer, 1941).

The acoustic envelope can also be thought of as a cue, in addition to the spectrum, that allows us to distinguish one sound from another. We use the concept of the acoustic envelope in both senses here, to read the patient or research subject's experience in the MR image-making procedure. Doane (citing psychoanalytic theorist Guy Rosalato) notes that the means of sound deployment in cinema establish "certain conditions for understanding" that obtain in the intersubjective relation between film and spectator (Doane 1980, 380). We borrow this concept to adapt it to the space of the MR imaging process, where the means of *producing* (not deploying) images establish "certain relations of understanding" between subjects (technician, patient) and other elements of the apparatus, establishing for these human subjects, we will suggest, an "acoustic envelope" that offers both the alienating loss of embodied self and the shoring-up of a safe, reflective space of self-recognition through such techniques as piped music and the wiring of the MR space for closely miked conversation between the patient in the vacuum tube and the technician seated outside the room, behind a protective windowed wall. Our discussion is performed through a close reading of the MR clinical examination.

We first describe the nature of sound in this environment. Sound is introduced early on in the imaging process. This is indicated on a symbolic level in the product names of Siemens MR machines: Symphony, Allegra and Harmony are three familiar models. Sound is also introduced early on in the imaging process as a means of alleviating the stress of the noise produced by these machines. Warning the patient that the imaging process will be cold and noisy, the hospital MR unit's operating system technician offers the patient a blanket and headphones, and assists him or her in the selection of a radio station or musical genre. Listening is one of the components of comforts offered in the MR tube.

The technician instructs the patient in the precise sequence of events he or she will experience. Measures of time for each aspect of the process will be signified by changes in qualities of sound. The technician explains that he will exit the room but remain in close touch through headphones wired to his station outside the room. Inside the coil, for a minute, the patient will hear a slow deep banging, then for three minutes a series of rapidly pulsed high short signals. This will be followed by a pause, and then another three-minute sequence of a different tone and rhythm would ensue.

Although the patient might mistake the sound sequences as evidence of the image "take," it is in fact the quiet time after the pulsing of sound durting which the protons "relax" or decay, and it is during this "down" time that significant data is registered for measurement. Imaging (signal recording) takes place, then, in a period of silence after a long noisy period of proton activation. Movement comes into play here in relationship to sound. The patient is

Figure 47.1 The Siemens 1.0 Harmony. "With magnetic resonance tomography from Siemens, sports injuries can be diagnosed quickly and reliably. Siemens equips medical practices and hospitals in the skiing areas." © Siemens AG

told how long after the pulse sequence it is necessary to keep one's body immobile in order for data to be acquired. The technician emphasizes that immobility during these periods of is essential to a successful take.

Some people, the technician explains, find the loud sounds disturbing. The additional sound offered by the headphones and music are meant to alleviate that problem. This technician then places in our subject's hand another sound apparatus designed to manage an overwhelming experience of disturbance: a rubbery orb—a pressure-sensitive signal device wired to the computer-control booth outside the room. This is the patient's sigalling device, the hotline to report any experience of distress to the technician. This orb will, in fact, be the patient's sole means of communicating to the technician for the duration of the exam. She is to squeeze it only in the event that she wants to abort the procedure—if she feels pain or overwhelming panic, for example. The technician then points to the large window opposite the machine. He will be positioned there, right outside that window. The patient will be audible to him through the panic button only during imaging passes, and otherwise through an intercom that he switches on in between passes. Near the computer positioned on the other side of this window the patient may be able to see an office chair placed in just the right spot for the technician to keep an eye on the machine while manning the controls of the computer which affords him a view into the tube, and onto the image generated as each phase of the process is complete.

Once slid inside the MR coil, the patient, if her eyes remain open, might notice the smooth, borderless white plastic that curves closely about her body. This surface houses the vacuum layer that shields her from the intense cold of the superconducting magnet coiled around her body. This is a pure modernist space devoid of representaiton that is not only literally but also figuratively cold. Devoid of edges, of shadow and light, of texture, and of color, the inside of the coil is the logician's dream of empty space. The magnetic coil is

bathed in liquid helium kept at 452.4 degrees below zero, a temperature that keeps the wire's resistance low, reducing the electricity needed to make it operate. The patient might close her eyes as her attention is drawn from this blank white surface to the music that passes through the headphones into her ears, a familiar signifier of culture and sociality, of pleasure and warm feeling.

Ensconced face up in the chilly coil, wrapped in a blanket and the scratchy sound of loud radio, the patient might wait a few moments for the other radio process to begin, the one she had been warned about, the loud pulsing of radio waves in conjunction with the scanner. Her thoughts might turn to the technician perched outside the observation window, glancing in at her and the machine periodically as he programms the scanner's functions on the computer. That piece of equipment was turned so that its back faced the window, making its screen a corner insert in the frame that was his view onto the room.

As the Siemens machine whirs into action, our subject might recall that the MR process is loud; that the sound is *noise*. But chances are that nothing she had read or heard reported had prepared her for the experience of MR sound beyond volume, as rhythm, timbre, pitch. Its precision, its intensity, and its organizational logic are remarkable, though unmarked, uncharted in advance for the lay listener.

At the end of the first session, the technician's voice in likely to pass into the coil, much like voice-off narration in a cinema house. In the closest of miking, it passes directly to our subject's ear, through her headphones. The voice in this figuration ensconces the hearer, wrapping the patient in a spatial envelope that may imply safety (the technician is close, is in control, is watching over her). And yet the voice is potentially threatening in that it is so intimate yet the voice of a stranger in a setting where a strange and potentially revealing medical procedure has been undertaken. Sound and voice thus become the devices of spatial configuration and interpenetration and of intersubjective coupling and separation between technician and subject, making for a nervous proximal affinity between strangers. This bond is, antithetically, also characterized by professional distance: the technician observes from outside the protective glass window, the images he observes may already offer him restricted knowledge about something she is still unaware of regarding her own body. Yet it is also characterized by empathetic closeness: the technician not only sees into the patient's interior, he is present there with her in the coil through the sound of his voice, bringing the human warmth into to a cold and solitary space.

Movement

We refer to the movement of the research subject, which is experienced by the subject but imagined not seen by the researcher or technician, recognized by the artifact of misaligned consecutive images and retrospectively reconstructed in the imagination of the researcher(s). We also consider the bodily movement of the technicians or researchers, who enact the movement of the subject that they imagine took place, performing it in order to feel it themselves, to make sense of the data, and to enact it in a pedagogical manner for the other researcher, who may be a junior colleague or student. As well, there is the actual movement of the body in the MR machine, which was not directly observed. Finally, we can consider the movement from the screen image to the body of the researcher as the latter performs movement that was actually never observed, and as one researcher observes the other incorporating and performing the imagined movement, and then acts it out herself.

In addition to sound, another confounding factor—motion, and its role in under-standing—is analyzed in the text that follows. Similarly to the previous section, this portion of the text reports on an apprenticeship interaction. Once again, the experimental data were

previously collected, and the apprenticeship takes place through the process of data analysis. However, the activity described here is situated in a cognitive neuroscience laboratory that largely practices scanning of a brain damaged patient population. Hence, the experimental subject of the scanning session was not the practitioner herself, but a clinical patient. The interaction reports on practitioners' involvement in assessing the existence of artifacts in the experimental data.

Over the course of the experiment a series of brain images are recorded. Each scan or image represents a brain slice. During the preparation of the experimental data for statistical examination, among other types of manipulation, researchers need to assess if the brain slice representations can be aligned. The assessment is achieved by viewing slices (in the axial, sagittal, and coronal view) represented on the computer screen over the time-course of the experiment (Figure 47.2). The researchers, by using mouse commands, alternate the view of individual images on the screen. The goal is to check if the representations of the brain slices align with each other. When nonalignment is detected, the researchers try to correct it. This is done in order to prevent the appearance of visible defects in the images (i.e., blurry splotches) once the statistical analysis has been performed. When the nonalignment is pervasive throughout the data, the data set has to be rejected.

As the excerpt from interaction will attest (Excerpt 2), the nonalignment between the brain images is explained in terms of the subject's movement that caused it. The artifact, caused by thr subject's movement, is called the *motion artifact*. In motion artifact the movement of the subject is considered to be an *artifactual cause*, rather than the *visible regularity of independent "natural" phenomena* (Lynch, 1989). While the subject's brain and its function (evoked by experimental stimuli) are seen as independent natural phenomena, the potentially unintentional movement of the body is considered to be the cause of an intrusion or distortion in the visibility of fMRI images.

Figure 47.2 Semiotica (full screen). Photo courtesy of Morana Alac.

Notice, however, that what is believed to be the cause of the nonalignment (the move-ment) can only be inferred from its effect (the nonalignment of images). Rather than simply anchoring this nonalignment in the movement that caused it, the subject's movement is inferred from nonalignment. While the images are present on the computer screen and can be directly compared, the movement of the subject could not have been seen or experienced by the researchers while the subject was laying in the scanner. The movements that the subject produces during the scanning section are usually too small to be seen on the computer monitor where MRI technicians and researchers supervise what goes on in the scanner. While in the previous section the apprentice's prior experience was potentially evoked, in this example the experience is entirely created during the data analysis activity. Since the subject of the scanning session was a clinical patient and not the apprentice herself, the practitioners create, rather than re-create the experience of being in the scanner. The excerpt from inter-action will illustrate how practitioners to recreate such an experience and to ground the circular explanatory flow between the images and the subject's movement (the images are not comprehended alone; they are understood in respect to the subject's movements; simul-taneously, the researchers imagine such movements by grounding them in the brain images) engage their own bodies in the production of meaning.

The excerpt reports on an interaction between two fMRI practitioners. The practitioners are seated in front of a computer screen in the cognitive neuroscience laboratory. The person on the left is an advanced graduate student, Gina (G). Gina teaches Ursula (U)—a newcomer to the laboratory, seated on the right—how to analyze fMRI experimental data. The excerpt from the interaction was recorded during an early stage in the practice of data analysis where experimental data need to be prepared for statistical examination. Each image on the computer screen represents a brain slice at a particular moment of the experiment. Ursula's task is to check for alignment between images in the series (representing the time-course of the experiment). This is done in order to keep experimental data clean from motion artifacts.

EXCERPT 2

1 U: Up? *((Stretches up))*

2 G: Yep again *((Nods))*
3 And then actually it looks like there is more involvement,
4 I am thinking there is more involvement=
5 in the front or in the back can you tell?

((Taps the front and then the back of her head with a pencil))

6 U: *((Works with the computer))*

7 Back?

((G. keeps touching the back of her head))

8 G: Yeah right so you can see the voxels=

((Points with the pencil towards the screen and moves the pencil up and down))

9 in the back moving a lot more that the voxels in the front

((Turns the pencil in the vertical position and moves it now up and down. At the same time she nods with her head. The novice approves by nodding))

10 so she is (.) this is an interesting movement because most people
 would=

11 if you think if you think laying in the scanner=

((Pushes back against the of the chair))

12 most people would nod=

((Nods with her head))

13 before they

14

((Movement of her neck against the back of the chair. The novice executes in parallel the same type of movement))

15 cause your neck does'nt=

((Points to the back of her neck))

16 really stretch quite that way=

((Moves up and stretches her neck))

17 right?
18 U: (No)
19 G: So I don't know what she is doing *((Gesture of surprise))*
20 but she is doing this. Hhhhh *((Laugh))* for some reason

Figure 47.3 Excerpt 2. All images courtesy of Morana Alac.

Practitioners involved in the process of detection of nonaligned brain images need to identify motion artifacts in the images in order to exclude them from the further data analysis. A pervasive component of the process is the embodied performance of the experimental subject's movements. To understand the nonalignment between images the practitioners use their bodies to model the hypothetical movements of the subject. In line 1 Ursula stretches up to perform the subject's movement. Her stretching makes the feature present in the experimental data available in the public space of action. At the same time the performance signals Ursula's capacity to look at the images as an fMRI practitioner. In line 2 Gina approves.

Lines 3–7 show another multiparty interpretation moment. Now Gina takes lead guiding Ursula's understanding of digital images. She does so by enacting the linkage between the images with the imagined and enacted movements. In line 3, by saying "it looks like," Gina first directs the attention towards the screen. Subsequently, she points to her own head (Line 5) as the imagined head of the experimental subject. The indexical gesture links the semiotic field of images and the field of the embodied performance, and guides Ursula in answering Gina's question as to whether the difference between the images corresponds to a movement of the front or the back of the subject's head (line 5). To answer the question, Ursula directs her gaze from Gina's head to the computer screen and back (line 6). In line 7 she expresses her hesitant answer verbally: "Back?" During her search for the answer Gina keeps touching the back of her head guiding so Ursula's reading of the digital images.

To strengthen Ursula's answer Gina further elaborates the performance of the *subject's movement in the images*. In line 8 she uses the pencil to point toward the screen, and moves it up and down. In such a way she projects the movement onto the images while enacting the selected features of the images in the public space of action. While the indexing portion of the gesture points towards the voxels that exist in the digital realm, the iconic/symbolic character of the sign recreates the voxels' movement in the physical space of action. As if *pulling the voxels* from the digital image onto the enacted movement gesture, the indexical gesture facilitates the *semiotic contagion* between the digital screen and the public space of embodied action. Subsequently (line 9) Gina slightly retracts her gesturing hand toward herself. She turns the pencil in the vertical position and moves it again up and down. This change in the pencil's position strengthens the iconicity of the gesture while it weakens its indexical character. The focus of the action is now on the enacted movement rather than the digital brain images. While Gina performs the voxels' movement through the pencil

movement, she nods with her head performing so the subject's supposed movement through the movement of her own head. At this point, in contrast to her hesitant answer in line 7, Ursula can confidently confirm her understanding by nodding (line 9).

Gina liberates the movement from the flat world of the computer screen, incorporating it into her own body, and performing it and feeling it as a means of knowing it.

Now that the movement has been liberated from the flat world of the computer screen, Gina can further elaborate and comment on it (lines 10–17). Of particular interest is the performance and elaboration of the movement in a hypothetical space of action where the practitioners' bodies assume multiple discursive roles of individual, general, and imagined bodies. In order to underline the unusual nature of the subject movement, Gina asks Ursula to imagine herself in the scanner. Up to this point the practitioners were basing the supposed subject movement in the brain images on the computer screen. This anchoring of the subject's movement in the images gave the movement a sense of reality. In contrast, by evoking the hypothetical scenario, the practitioners are now deliberately creating an imaginary movement that cannot be seen in the images. Yet, this imaginary movement represents the space of the expected, correct, and hence in some sense *real* movement.

Such a hypothetical space of the correct movement is largely constructed through Gina's use of her own body. Through the multimodal discursive practice, Gina's body assumes the role of Ursula's or the *human body in general* imagined to be laying in the scanner: "if you think laying in the scanner;" "most people would." Moreover, in creating her explanation, the expert explores the resources directly present in the material environment surrounding her as potential semiotic objects.

While saying "if you think, if you think laying in the scanner," the expert pushes abruptly against the back of the chair. Through this movement the chair gets *transported* into the hypothetical space where it assumes a crucial role in the discursive action. While the expert's body in the vertical position maps to a human body in the horizontal position, the chair on which the practitioner is sitting stands for the scanner table on which the subject is laying. Because the chair shares some affordances with the scanner table (i.e., it is flat, it supports a person's back, etc.), and it happens to sustain the Gina's body during the teaching session, Gina is able to enact the movement that *most people would* (line 12) produce in the scanner and the *one that is unexpected*. While common movements are those constrained by the physical characteristics of the scanner table, an *interesting movement* (line 10) is not.

When uttering: "Cause your neck doesn't=really stretch quite that way" (lines 15–16), Gina points at the back of her neck (line 15). By indexing the specific part of her own body, she inscribes ephemeral marks onto the general, *most people's body* that lies in the scanner. In line 16 she briefly moves up and stretches her neck in order to enact the movement that the subject performed in the scanner. At the same time she provides an embodied demonstration of the way in which "your neck doesn't really stretch:" she "moves" in an "interesting" way.

Ursula, who is looking at and manipulating the screen, executes the same type of movement performed by Gina in line 14. She understands Gina's explanation through her own embodied performance of it. Rather than passively observing Gina, she coordinates with her and performs the *impossible* movement herself. This allows her to promptly answer the Gina's question (line 18), verbally confirming the impossibility of the movement. By translating the difference between brain images into an effective physical motion, she learns that "your neck doesn't really stretch quite that way" (lines 15–16).

By comparing the general body and its movements constrained by the physical structure of the scanning environment to the subject's body, the expert categorizes the subject movement as *interesting* (line 10) and incomprehensible: "I don't know what she is doing but she is doing this ((laugh)) for some reason" (lines 18–19). In approximately 15 seconds of action, the expert's body *travels* from being a prototypical body (lines 11–15), to the subject's body

(line 16), and finally becoming again a signifier of her own body (lines 18–19). At this point she ceases enacting imaginary bodies, and comments on their behavior. But even so, when expressing surprise (line 18) and laughter (line 19), her body is not just an envelope for internal, abstract thought, but a critical component of meaning production.

Conclusion

Earlier in this paper we posed the questions, when does the research subject or patient become visible or present in the process of interpreting his or her MR data; and how does this "making visible" of the research subject occur? Above we have tried to show, through a microanalysis of a research laboratory and a sketch of a clinical MRI procedure, that "becoming visible" is not only, and is not even primarily, connected to the faculty of sight, or to the aspect of imagination captured in the concept of mental imagery or verbal representation. Rather, making visible entails aspects of embodied feeling and enactment. Furthermore, the experience of "making visible" occurs not most importantly in the mind of the researcher(s), but in the interactions among researchers or technicians, patients or research subjects, and the various other actors or agents that comprise the scene. Our point, again, is not simply that "making visible" or seeing is a cultural, social or shared process and not strictly cognitive in the sense of being located in the individual mind. Rather, we emphasize that imagination is a process that occurs through intersubjective and multimodal experiences that cannot be reduced to the location of the individual or to a dominant sensory modality or paradigm as the primary one in the production of knowledge and meaning. Where, then, do we locate human subjectivity? And who, then, is the subject of these interactions, if not the individual researchers, technicians, and patients or research subjects who each play a part in the inter-actions documented? To address these questions, we would need to move further into the concepts of intersubjectivity and the intra- and inter-psychic aspects of imagination. While we cannot move forward with this project at the conclusion of our paper here, we propose that a theory of subjectivity that takes into account the specificity of the psyche and the factor of the unconscious is new ground that the cultural studies of science would do well to consider. For this project, we propose a return to feminist theories of the subject, based in psychoanalytic concepts, combined with work in distributed cognition and laboratory analysis. Although we cannot move this project forward here, we propose this constellation of approaches as a fruitful direction for the cultural study of science and communication.

Notes

1 The literature on imagination in cognitive semantics includes Faucconier and Turner 2002 and Johnson 1987, 1991, 1993.

2 Introduced to MR imaging in 1992 (Connelly 1993), function study came late to this imaging modality as compared to others (ultrasound, PET, and SPECT). fMRI's current primary use is to "map" the function of the various regions of the human brain. This time-based technique was an outgrowth of echo-planar MR processes introduced by Peter Mansfield (1977). In current echo-planar MR imaging, one nuclear spin excitation is required to produce a single image, compared to the minutes required in traditional MR techniques to produce enough data for a single image.[2] "In 1987 echo-planar imaging was used for the first time to perform real-time motion studies of a single cardiac cycle (Chapman 1987)." By 1992 fMRI echo-planar imaging had been adapted to the imaging of function in the regions of the brain responsible for thought and motor control.

3 On the co-construction of meaning in workplace interactions, see Goodwin 1994–2003.

4 On practice as performativity in ethnomethodological and sociological science studies see for example Lynch 1993; Lynch and Woolgar 1990; and Pickering 1992. Pickering (1995) refers to as

"the mangle" of human and material agency. In Pickering's "dance of agency," scientists as "active, intentional beings" tentatively construct new machines, adopting a passive role and monitoring the performance of the machine (1995:21–22). Knorr-Cetina (1999) distinguishes between science as practice and science as cognition in ways that are significant to our discussion but will not be developed here for reasons of space.

5 http://www.etymonline.com/index.php?search=imagination&searchmode=none

6 Although we cannot elaborate on this point here, imagination involves the work of fantasy and the unconscious. We propose that this is an inevitable, everyday aspect of meaning and knowledge production, even if it has been under-considered in the study of laboratory and clinical interactions. This angle is not fully developed here for reasons of space.

7 These concepts, identification and projection, are drawn from psychoanalytic feminist theory of spectatorship and will not be fully developed here for reasons of space. See Cartwright 2008 for a full account of the meaning of these terms.

References

Alac, M. 2006 How Brain Images Reveal Cognition: An Ethnographic Study of Meaning Making in Brain Mapping Practice. Doctoral thesis, Department of Cognitive Science, University of California at San Diego.

——2004 "I see what you are saying." Action as Cognition in fMRI Brain-Imaging Practice. *Journal of Cognition and Culture* 4, no. 3, 629–661.

Beaulieu, A. 2004 "From brainbank to database: The informational turn in the study of the brain," *Studies in History and Philosophy of Science Part C: Studies in History and Philosophy of Biological and Biomedical Sciences* 35(2): 367–390, Special issue on "the Brain in the Vat."

Block, N. (ed.) 1981 *Imagery*, Cambridge, Mass.: MIT Press.

Burris-Mayer, H. 1941 "Development and Current Uses of the Acoustic Envelope," *Journal of the Society of Motion Picture Engineers* 37, no. 1, 109–114.

Cartwright, L. 2008 *Moral Spectatorship*. Durham, NC: Duke University Press.

Chapman, B., R. Turner, R.J. Ordidge, M. Doyle, M. Cawley, R. Coxon, P. Glover, P. Mansfield. 1987 "Real-Time Movie Imaging from a Single Cardiac Cycle by NMR," *Magnetic Resonance Medicine* 5, 1987, 246–254.

Descartes, R. 1642/1984 "Meditations on First Philosophy," In *The Philosophical Writings of Descartes*, vol. 2, J. Cottingham et al. (eds.), Cambridge: Cambridge UP.

Doane, M. A. 1980 "The Voice in the Cinema: The Articulation of Body and Space," *Yale French Studies* 60 (1980), 33–60. Reprinted in Leo Braudy and Marshal Cohen, *Film Theory and Criticism: An Introductory* Reader, Fifth Edition, New York and London: Oxford, 1999, 363–375.

Dumit, J. 2004 *Picturing Personhood: Brain Scans and Biomedical Identity*, Princeton, New Jersey: Princeton UP.

Fauconnier, G. & Turner, M. 2002 *The Way We Think: Conceptual Blending and the Mind's Hidden Complexities*, New York: Basic Books.

Finke R., Thomas, W. & S. Smith 1993 *Creative Cognition*. Cambridge, Massachusetts: MIT Press.

Fodor, J. 1975 "Imagistic Representation," In Block (ed.), 1981.

Goodwin, C. 1994 "Professional Vision," *American Anthropologist* 96(3): 606–33.

——1995 "Seeing in Depth," *Social Studies of Science* 25: 237–74.

——1997 "The Blackness of Black: Color Categories as Situated Practice," in L. Resnick, R. Säljö, C. Pontecorvo and B. Burge (eds.), *Discourse, Tools and Reasoning: Essays on Situated Cognition*, New York: Springer-Verlag.

——2000a "Practices of Seeing, Visual Analysis: An Ethnomethodological Approach," in T. van Leeuwen & C. Jewitt (eds.), *Handbook of Visual Analysis*, London: Sage.

——2000b "Action and embodiment within situated human interaction," *Journal of Pragmatics*, 32: 1489–1522.

——2003a "Pointing as Situated Practice." In K. Sotaro (ed.), *Pointing: Where Language, Culture and Cognition Meet*, Mahwah, NJ: Lawrence Erlbaum, 217–41.

——2003b "The Semiotic Body in its Environment," In J. Coupland & R. Gwyn (eds.), *Discourses of the Body*, New York: Palgrave/Macmillan, 19–42.

——2003c "Conversational Frameworks for the Accomplishment of Meaning in Aphasia," in C. Goodwin (ed.), *Conversation and Brain Damage*, Oxford: Oxford University Press, pp. 90–116.

Heath, C. & J. Hindmarsh 2002 "Analysing Interaction: Video, ethnography and situated conduct" In T. May (ed.) *Qualitative Research in Action*, London: Sage, 99–121.

Johnson, M. 1987 *The Body in the Mind: the Bodily Basis of Meaning, Reason and Imagination*, Chicago: University of Chicago Press.

——1991 "The Imaginative Basis of Meaning and Cognition," In S. Küchler and W. Melion (eds.), *Images of Memory: On Remembering and Representation*, Washington: Smithsonian Institution Press, 74–86.

——1993 *Moral Imagination: Implications of Cognitive Science for Ethics*, Chicago: University of Chicago Press.

Knorr-Cetina, K. 1999 *Epistemic Cultures: How the Sciences Make Knowledge*, Cambridge, Mass.: Harvard UP.

Kosslyn, S.M. 1980 *Image and Mind*, Cambridge, Mass.: Harvard UP.

Latour, B. 1999 *Pandora's Hope: Essays on the Reality of Science Studies*, Cambridge, Mass.: Harvard UP.

Lynch, M. 1993 *Scientific Practice and Ordinary Action: Ethnomethodology and Social Studies of Science*, Cambridge: Cambridge UP.

Mansfield, Peter. 1977 Multi-Planar Image-formation Using NMR Spin Echoes. *Journal of Physics C-Solid State Physics* 10, no. 3, L55–L58.

Murphy, K. 2004 "Imagination as Joint Activity: The case of architectural interaction," *Mind, Culture, and Activity*, 11 (4), 267–278.

——2005 "Collaborative Imagining: The interactive use of gestures, talk, and graphic representation in architectural practice," *Semiotica* 156–1/4, 113–145.

Pickering, A. 1992 *Science as Practice and Culture*, Chicago: Chicago UP.

——1995 *The Mangle of Practice: Time, Agency and Science*, Chicago: Chicago UP.

Pylyshyn, Z. 1973 "What the Mind's Eye Tells the Mind's Brain—A Critique of Mental Imagery," *Psychological Bulletin* 80, 1–24.

Roepstroff, A. 2001 Brains in Scanners: An Umwelt of Cognitive neuroscience. *Semiotica* 134, 747–765.

Suchman, L. 2000 "Embodied Practices of Engineering Work" In *Mind, Culture and Activity* 7:1–2, 4–18.

Tye, M. 1991 *The Imagery Debate*, Cambridge, Mass.: MIT Press.

Part 4: Further reading

Cartwright, Lisa. *Moral Spectatorship: Technologies of Voice and Affect in Postwar Representations of the Child*. Durham, NC: Duke University Press, 2008.

Everett, Anna. *Learning Race and Ethnicity: Youth and Digital Media*. Cambridge, MA: MIT Press, 2008.

Galloway, Alex. *Gaming*. Durham, NC: Duke University Press, 2005.

Gitelman, Lisa. *Always Already New: Media, History and the Data of Culture*. Cambridge, MA: MIT Press, 2006.

Latour, Bruno. *We Have Never Been Modern*. Cambridge, MA: Harvard University Press, 1993.

Massumi, Brian. *Parables for the Virtual: Movement, Affect, Sensation*. Durham, NC: Duke University Press, 2002.

McPherson, Tara. *Digital Youth, Innovation, and the Unexpected*. Cambridge, MA: MIT Press, 2008.

Nakamura, Lisa. *Digitizing Race: Visual Cultures of the Internet*. Minneapolis: University of Minnesota Press, 2008.

Sterne, Jonathan. *The Audible Past: Cultural Origins of Sound Reproduction*. Durham, NC: Duke University Press, 2003.

——. *The Sound Studies Reader*. Routledge, 2008.

Wardrip-Fruin, Noah, and Pat Harrigan. *First Person: New Media as Story, Performance, and Game*. Cambridge, MA: MIT Press, 2004.

Wilson, Pamela and Michelle Stewart, *Global Indigenous Media: Cultures, Poetics and Politics*, Durham, NC: Duke University Press, 2008.

Index

Page numbers in **bold** refer to figures